THE CELTS

THE CELTS

Edited by
Sabatino Moscati (Coordinator)
Otto Hermann Frey
Venceslas Kruta
Barry Raftery
Miklós Szabó

With the assistance of
Ermanno Arslan
Daniele Vitali

RIZZOLI
NEW YORK

With the patronage
of the President
of the Italian Republic

This book has been published
on the occasion of the exhibition
The Celts, the Origins of Europe
Palazzo Grassi, San Samuele 3231, Venice
March - December 1991

Palazzo Grassi wishes to thank
all the Organizations, public and private,
in Italy and abroad,
that have in various ways
generously contributed
to the realization of the exhibition

Special thanks to the authors
for their valuable contribution
to the iconographical research

Editorial Director
Mario Andreose

Designed by
Pierluigi Cerri
with
Andrea Lancellotti
Costanza Melli

Editor-in-chief
Carla Tanzi

Editorial Staff
Andrew Ellis
Giulio Lupieri
Simonetta Rasponi
Carol Rathman
Enrica Sacchi
Gilberta Stivanin

Picture Research
Joana Rausch

Production Staff
Carla Bonacina
Silvano Caldara
Giuseppina Magro
Roberto Moroni

Secretary
Luisa Gandolfi

Translators
Andrew Ellis
Brian Fleming
Roberta Kedzierski
Robert Mann
Susan Meadows
Jeremy Scott
Katherine Singleton
Alexandra Speirs

First published in the
United States of America in 1991 by
Rizzoli International Publications, Inc.
300 Park Avenue South
New York, NY 10010

Originally published in Italian
under the title *I Celti*

Copyright © 1991
Gruppo Editoriale Fabbri,
Bompiani, Sonzogno,
Etas, S.p.A.,
Via Mecenate 91, Milan, Italy

LC 91-52773
ISBN 0-8478-1407-6

Printed and bound in Italy by
Gruppo Editoriale Fabbri S.p.A., Milan

Contents

Scientific Patronage

Österreichische Akademie
der Wissenschaften
Austria

Académie Royale des Sciences
des Lettres et des Beaux-Arts
Belgium

The Bulgarian Academy
of Sciences
Bulgaria

Institut de France
France

The German Archaeological
Institute
Germany

British Academy
Great Britain

Royal Irish Academy
Ireland

Accademia Nazionale
dei Lincei
Italy

The Yugoslavian Academy
of the Sciences and the Arts
Yugoslavia

Koeninklijke Nederlandse
Akademie van Wetenschappen
The Netherlands

The Rumanian Academy
Rumania

Real Academia de la Historia
Spain

Magyar Tudomanyos
Akademia
Hungary

Organizing Committee

Paul-Marie Duval
*Académie des Inscriptions
et Belles-Lettres
Paris*

Jean Leclant
*Académie des Inscriptions
et Belles-Lettres
Paris*

Sabatino Moscati
*Unione Accademica Nazionale
Rome*

Martin Almagro-Gorbea
*Universidad Complutense
Madrid*

Bernard Andreae
*Istituto Germanico Archeologico
Rome*

Ermanno Arslan
*Museo Archeologico
Milan*

Dragan Božič
*Slovenska Akademija znanosti
in umetnosti
Ljubljana*

Jiři Břeň
*Národní Muzeum
Prague*

Anne Cahen
*Musées Royaux d'Art
et d'Histoire
Brussels*

Alain Duval
*Musée des Antiquités Nationales
Saint-Germain-en-Laye*

Markus Egg
*Römisch Germanisches
Zentralmuseum
Mainz*

Christiane Eluère
*Musées des Antiquités Nationales
Saint-Germain-en-Laye*

Otto Hermann Frey
*Philipps-Universität
Marburg*

Andres Furger-Günti
*Schweizerisches Landesmuseum
Zurich*

Borislav Jovanović
*Archaeological Institute
Belgrade*

Tibor Kovacs
*Magyar Nemzeti Muzeum
Budapest*

Venceslas Kruta
*École Pratique des Hautes
Études
Paris*

Delia Lollini
*Soprintendenza Archeologica
Ancona*

Ferdinand Maier
*Römisch-Germanische
Kommission des Deutschen
Archäologischen Instituts
Frankfurt*

Guido Achille Mansuelli
*Università degli Studi
Bologna*

Jean-Pierre Mohen
*Musée des Antiquités Nationales
Saint-Germain-en-Laye*

Fritz Moosleitner
*Salzburger Museum Carolino
Augusteum
Salzburg*

Cristiana Morigi
*Museo Civico Archeologico
Bologna*

Bruno Passamani
*Civica Galleria d'Arte Moderna
Brescia*

Barry Raftery
*University College
Dublin*

Michael Ryan
*Irish Antiquities National
Museum
Dublin*

Ulrich Schaaff
*Römisch Germanisches
Zentralmuseum
Mainz*

Ian M. Stead
*The British Museum
London*

Miklós Szabó
University of Budapest

Daniele Vitali
*Università degli Studi
Bologna*

Patrick F. Wallace
*National Museum of Ireland
Dublin*

Zenon Wozniak
University of Krakow

Vlad Zirra
*Archaeological Institute
Bucharest*

Scientific Commission

Martin Almagro-Gorbea
Bernard Andreae
Ermanno Arslan
Paul-Marie Duval
Otto Hermann Frey
Venceslas Kruta
Jean-Pierre Mohen
Sabatino Moscati
Barry Raftery
Miklós Szabó
Daniele Vitali

Lenders

The exhibition was made possible thanks to the cooperation of the following institutions from 24 countries:

Austria
Asparn-Zaya, Museum für Urgeschichte
Eisenstadt, Burgenländisches Landesmuseum
Golling (Salzburg), Heimat museum
Klagenfurt, Landesmuseum für Kärnten (Ausgrabungen Magdalensberg)
Mannersdorf, Museum Mannersdorf
Salzburg, Salzburger Museum Carolino Augusteum
St. Pölten, Stadtmuseum St. Pölten
Vienna, Bundesdenkmalamt - Abteilung für Bodendenkmale
Vienna, Ines-Marisa Elhofer
Vienna, Naturhistorisches Museum, Prähistorische Abteilung

Belgium
Brussels, Musées Royaux d'Art et d'Histoire
Brussels, Services des Fouilles de la Région Wallonne
Ghent, Keltenmuseum
Leuven, Département d'Archéologie Université K.U. Leuven

Bulgaria
Sofia, Narodnija Arheologitcheski Musej

Czechoslovakia
Bratislava, Archeologické Múzeum
Bratislava, Historiscké Múzeum SNM
Brno, Moravské zemské Muzeum
Kolín, Regionální Muzeum
Komárno, Oblastné podunaijské Múzeum
Litoměřice, Okresní Vlastivědné Muzeum
Michalovce, Zemplínske Múzeum
Nitra, Archeologický ústav SAV
Plzen, Západočeské Muzeum
Prague, Archeologický ústav CSAV
Prague, Muzeum Hlavního Města Prahy
Prague, Národní Muzeum
Prague, Pamatkove ustav Stredoceskeho
Staatschloß Křivoklát, Castle Collection
Duchcov, Castle Collection
Rimavská-Sobota, Gemerské Múzeum
Roztoky u Prahy, Středočeské Muzeum
Tábor, Hussiten-Museum
Teplice, Regionalmuseum

Denmark
Copenhagen, Nationalmuseet
Hojbjerg, Forhistorisk Museum Moesgaard

France
Aix-en-Provence, Musée Granet
Alès, Musée du Colombier
Alise-Sainte-Reine, Société des Sciences Historiques et Naturelles de Semur-en-Auxois, Musée d'Alesia
Angoulême, Musée des Beaux-Arts d'Angoulême
Autun, Musée Rolin
Avignon, Musée Calvet
Besançon, Musée des Beaux-Arts et d'Archéologie
Breteuil, Musée Archéologique de la Région de Breteuil

Châlons-sur-Marne, Musées Municipal
Chalon-sur-Saône, Musée Denon
Châtillon-sur-Seine, Musée Archéologique
Compiègne, Musée Antoine Vivenel
Epernay, Musée Municipal
Guiry-en-Vexin, Musée Archéologique Départemental du Val d'Oise
Lione, Musée de la Civilisation Gallo-Romaine
Marseilles, Musée d'archéologie méditerranéenne - Centre de la Charité
Morlaix, Musée des Jacobins
Nancy, Musée Historique Lorrain
Nantes, Musées Départementaux de Loire-Atlantique-Musée Dobrée
Paris, Bibliothéque Nationale
Paris, Musée du Louvre
Penmarc'h, Musée Préhistorique Finistérien-Université de Rennes
Reims, Musée Saint-Rémi
Rennes, Musée de Bretagne
Roanne, Direction Régionale des Antiquités Historiques Rhône Alpes
Roanne, Musée Dechelette
Rouen, Musée Départemental des Antiquités
Sens, Musée de Sens
Soulac sur Mer, Musée Archéologique
St. Brieuc, Conseil Général des Côtes d'Armor
St. Etienne, Robert Perichon
St. Germain-en-Laye, Musée des Antiquités Nationales
St. Remy-de-Provence, Hôtel de Sade, Collection Municipale
Tarbes, Musée de Tarbes
Toulouse, Musée Saint-Raymond
Troyes, Musée des Beaux-Arts et d'Archéologie

Germany
Bad Homburg, Klaus Belz
Berlin, Staatliche Museen Preussischer Kulturbesitz, Antikenmuseum
Berlin, Staatliche Museen Preussischer Kulturbesitz, Museum für Vor- und Frühgeschichte
Bonn, Rheinisches Landesmuseum Bonn
Koblenz, Mittelrhein-Museum
Cologne, Diözesan- und Dombibliothek
Frankfurt, Museum für Vor- und Frühgeschichte, Archäologisches Museum
Jena, Vorgeschichtliches Museum der Friedrich-Schiller Universität
Karlsruhe, Badisches Landesmuseum
Mainz, Römisch-Germanisches Zentralmuseum
Munich, Prähistorische Staatssammlung
Munich, Staatliche Münzsammlung
Nuremberg, Germanisches Nationalmuseum
Römhild, Steinsburgmuseum
Saarbrücken, Landesmuseum für Vor- und Frühgeschichte
Straubing, Gäubodenmuseum
Trier, Rheinisches Landesmuseum

Wilhelmshaven, Niedersächsisches
Institut für Historische Künstenforschung

Great Britain
Alnwick, The Duke of Northumberland
Armagh, The Dean and Chapter of
St. Patrick's Cathedral
Bedford, Bedford Museum - North
Bedfordshire Borough Council
Belfast, Ulster Museum
Cardiff, National Museum of Wales
Edinburgh, National Museums of
Scotland
Liverpool, Trustees of the National
Museums and Galleries of Merseyside,
Liverpool Museum
London, Museum of London
London, Trustees of the British Museum
Oxford, Ashmolean Museum
Reading, Reading Museum and Art
Gallery
Taunton, Somerset County Museum -
Somerset Archaeological and National
History Society
Wisbech, Wisbech and Fenland Museum

Hungary
Budapest, Budapesti Történeti Múzeum
Budapest, Magyar Nemzeti Múzeum
Budapest, MTA Régészeti Intézete
Debrecen, Déri Múzeum
Esztergom, Balassa Bálint Múzeum
Györ, Xántus János Múzeum
Keszthely, Balatoni Múzeum
Miskolc, Herman Ottó Múzeum
Nyiregyháza, Jósa András Múzeum
Székesfehérvár, István Király Múzeum
Szolnok, Damjanich János Múzeum
Szombathely, Savaria Múzeum
Vác, Tragor Ignác Múzeum
Veszprém, Bakonyi Múzeum

Ireland
Cork, Cork Public Museum
Dublin, Council of the Royal Irish
Academy
Dublin, Department of Archaeology
University College
Dublin, National Museum of Ireland
Dublin, Trinity Library
Sixmilebridge, The Hunt Museum -
Craggaunowen Project at the University
of Limerick

Italy
Adria, Museo Archeologico Nazionale
Ancona, Soprintendenza archeologica
delle Marche
Asola, Museo Civico Archeologico
Bergamo, Civico Museo Archeologico
Bologna, Direzione Museo Civico
Medievale
Bologna, Museo Civico Archeologico
Bologna, Soprintendenza Archeologica
dell'Emilia Romagna
Bolzano, Museo Civico
Brescia, Civici Musei d'Arte e Storia
Como, Civico Museo Archeologico
"P. Giovio"

Este, Museo Nazionale Atestino -
Soprintendenza Archeologica del Veneto
Gambolò - Pavia, Museo Archeologico
Lomellino, Castello Litta
Genoa, Soprintendenza Archeologica della
Liguria
Mantua, Museo Archeologico Nazionale
Milan, Civiche Raccolte Archeologiche e
Numismatiche
Milan, Soprintendenza Archeologica della
Lombardia
Modena, Museo Civico Archeologico
Etnologico
Naples and Caserta, Soprintendenza
Archeologica delle province
Padua, Museo Civico Archeologico
Padua, Soprintendenza Archeologica del
Veneto, Istituto di Archeologia
dell'Università
Pieve di Cadore, Museo della Magnifica
Comunità Cadorina, Soprintendenza
Archeologica del Veneto
Reggio Emilia, Civici Musei
Rome, Assessorato alla Cultura
(X Dipartimento) Musei Capitolini
Rome, Museo Nazionale Romano,
Medagliere
San. Ginesio, Museo Civico "Scipione
Gentili"
Siena, Parrocchia del S.S. Salvatore,
Abbadia San Salvatore
Turin, Museo di Antichità
Trento, Museo Provinciale d'Arte
Venice, Museo Archeologico Nazionale
Verbania Pallanza, Museo del Paesaggio
Vercelli, Museo Camillo Leone

Luxembourg
Luxembourg, Musée National d'Histoire
et d'Art

The Netherlands
Nijmegen, Provinciaal Museum G.M.
Kam

Norway
Bergen, Historisk Museum Universitetet i
Bergen
Tromsø, Tromsø - Universitetet i Tromsø
Oslo, Universitetets Oldsaksamling

Poland
Warsaw, Pánstwowe Muzeum
Archeologiczne

Portugal
Braga, Museu Regional D. Diogo de
Sousa
Lisbon, Museu Nacional de Arqueologia

Rumania
Alba Iulia, Muzeul Jude Jean Unirii
Arad, Muzeul Judeţean Arad
Baia Mare, Musée de Maramures
Bistrit-Nasaud, Musée de Bistrita-Nasaud
Bucharest, Musée National d'Histoire
Carei, Musée de Carei
Cluj-Napoca, Musée d'Histoire de la
Transylvanie

Oradea, Museo "Tara Crisurilor"
Satu Mare, Musée de Satu Mare

Spain
Avila, Junta de Castilla y Léon - Museo
de Avila
Burgos, Museo de Burgos
Cordoba, Museo Arqueológico Provincial
de Córdoba
Jaen, Museo Provincial de Jaen
La Coruña, Museo Arqueológico "Castello
de San Anton"
Madrid, Museo Arqueológico Naciónal
Salamanca, Museo de Salamanca
Seville, Museo Arqueológico de Sevilla
Soria, Museo Numantino

Sweden
Stockholm, Statens Historiska Museum

Switzerland
Berne, Bernisches Historisches Museum
Bienne, Musée Schwab
Geneva, Musée d'Art et d'Histoire
Lausanne, Musée Cantonal d'Archéologie
et d'Histoire
Martigny, Fondation Pierre Gianadda
Neuchâtel, Musée Cantonal d'Archéologie
Nyon, Musée du Leman
Zurich, Schweizerisches Landesmuseum

USA
Boston, Museum of Fine Arts
Houston, Menil Collection
New York, Mr. Robin Martin
New York, Metropolitan Museum of Arts

USSR
Oblasnij Muzej Užgorod-Ukraine

The Vatican City
Città del Vaticano, Musei Vaticani

Yugoslavia
Belgrade, Arheološki Institut (Muzej
Djerdapa)
Belgrade, Muzej Grada Beograda
Belgrade, Narodni Muzej
Brežice, Posavski Muzej
Celje, Pokrajinski Muzej
Ljubljana, Mestni Muzej
Ljubljana, Narodni Muzej
Negotin, Narodni Muzej Krajine
Novi Sad, Vojvodjanski Muzej
Novo Mesto, Dolenjski Muzej
Novo Mesto, Zavod za varstvo naravne
in kulturne dediščine
Osijek, Muzej Slavonije
Pozarevac, Narodni Muzej
Sarajevo, Zemaljski Muzej Bosne i
Hercegovine
Vrsac, Narodni Muzej
Zagreb, Arheološki Muzej

The diverse cultures that make up the vast and heterogeneous European community have been informed, to varying degrees, by a wide range of influences. The Roman and Greek cultures as well as Christianity and Judaism, are just a few of the more important of these.

Each of the populations on the European continent, however, has individual characteristics which reflect its earliest origins. The so-called Latin, the Germanic, the Anglosaxon, and the Slavic, with their subgroups, all have their own distinguishing features that are displayed not only in language but also in attitudes and ways of thinking. The evolution of these tendencies led to the emergence of highly diverse cultures where common features have not necessarily produced common links. Indeed, while they may have effectively been bridges, offering instances of communication, and the bases for a European dialogue that has always existed, such shared features have never been able to overcome the particular characteristics derived from each of the various sources.

Now, one of the most dynamic areas of research undertaken by the sciences that use the historical method is precisely that of delving into the past of whole population groups in search of their ultimate origins.

In fact, in Europe, such sciences cannot restrict themselves to archaeological research, as is the case in the study of the vanished civilizations of the Near East, such as the Sumerians, the Assyrians, the Babylonians, the Hittites, or the ancient Egyptians. In our case we are delving to the roots of the living, and the fruits of archaeological research are perceived as keys for understanding our own world, rather than for reconstructing a long-dead past.

This was the main concept behind Palazzo Grassi's approach to the Phoenicians, a people about whose disappearance there can be no doubt. Our aim was not only to reassemble the picture but also to discover whether, and to what extent, the Phoenicians might still be considered part of our civilization.

And now we come to the exhibition on the Celts. The subject is even more fascinating inasmuch as it is commonly agreed that all European cultures can trace their roots to Celtic origins.

While many passages have been obliterated, many have in fact been assimilated. Not only those peoples we might call Roman but also those who can be called barbarian—that is, "foreign" in the literal sense of the original Greek word—can be identified as parts of a common matrix. Such a matrix may have left fewer visible and tangible signs than the Latin culture did, but the aim of this exhibition is to highlight those traits, and reconstruct those features that trace its continuing and almost immutable presence.

Once again Palazzo Grassi is marrying the display of artifacts with the study of a civilization, a study that starts with a reconnaissance of the places and what has been found there, and proceeds with an appraisal of the time-periods and the differences that existed despite a basically common origin, culminating in an attempt to identify these peoples' movements and society.

With this exhibition, which is much more than a simple display of artifacts, Palazzo Grassi hopes to give rise to a moment of reflection.

The experts we called upon to help and whose help was given with enthusiasm and disinterest, discovered it to be an opportunity for taking a fresh look at hypotheses and ideas. The public too is invited to take part in this. For, rather than having our halls thronged with crowds looking for curiosities, what we want to see is people who are alive to the message that we are offering, which is the same as that offered by the Celts.

"The Celts, the Origins of Europe" was the name we chose for the exhibition, and those origins are what we believe lies at its heart. This exhibition is a tribute both to the new Europe which cannot come to fruition without a comprehensive awareness of its unity, and to the fact that, in addition to its Roman and Christian sources, today's Europe traces its roots from the Celtic heritage, which is there for all to see.

Feliciano Benvenuti

Honorary Committee

*The President of the Italian
Council of Ministers*
On.le Dott. Giulio Andreotti

*The European Commissioner
for Culture, Information
and Communication*
M. Jean Dondelinger

The Italian Foreign Minister
On.le Dott. Gianni De Michelis

*The Italian Minister
for Education*
On.le Dott. Gerardo Bianco

*The Italian Minister
for the Environment*
On.le Avv.
Ferdinando Facchiano

*The Italian Minister
for Scientific Research*
Prof. Antonio Ruberti

*The President
of the Veneto Region*
Dott. Gianfranco Cremonese

*The Mayor
of the City of Venice*
Avv. Ugo Bergamo

*His Excellency the Ambassador
of Austria*
Friedrich Froelichsthal

*His Excellency the Ambassador
of Hungary*
Gyorgy Misur

*His Excellency the Ambassador
of Germany*
Friedrick Ruth

*His Excellency the Ambassador
of the Irish Republic*
Christopher P. Fogarty

*His Excellency the Ambassador
of Switzerland*
Francesca Pometta

*His Excellency the Ambassador
of Spain*
Emilio Menendos del Valle

*His Excellency the Ambassador
of France*
Gilbert Perol

*His Excellency the Ambassador
of Yugoslavia*
Dusan Strbac

*His Excellency the Ambassador
of Denmark*
Jb Ritto Andreasen

*His Excellency the Ambassador
of Belgium*
André Rahir

*His Excellency the Ambassador
of Great Britain*
Stephen Loftus Egerton

*His Excellency the Ambassador
of Czechoslovakia*
Jiri Holub

*His Excellency the Ambassador
of Greece*
Constantin Georgiou

*His Excellency the Ambassador
of the USSR*
Anatolij Adamisin

*His Excellency the Ambassador
of Poland*
Boleslaw Michalek

*His Excellency the Ambassador
of the Netherlands*
Piet Hein Houben

*His Excellency the Ambassador
of Rumania*
Iuliu Gheorghiu

*His Excellency the Ambassador
of Bulgaria*
Ilia Kondov
Plenipotentiary Minister

*The Director
of the Staatlichen Museen
Preussischer Kulturbesitz*
Prof. Wolf-Dieter Dube

*The Permanent Secretary
of the Real Academia
de la Historia*
Prof. Eloy Benito Ruano

*The Chancellor
of the Institut de France*
M. Edouard Bonnefous

*The President of the
Rumanian Academy*
Prof. Michail Draganescu

*The President of the
Koeninklijke Nederlandse
Akademie van Wetenschappen*
Prof. Pieter Drenth

*The Executive Secretary
of the Royal Irish Academy*
Mr. Aidan Duggan

*The President
of the Österreichische
Akademie der Wissenschaften*
Prof. Otto Hittmair

*The President
of the British Academy*
Prof. Anthony Kenny

*The President of the
Magyar Tudomanyos Akademia*
Prof. Domokos Kosary

*The President of the Deutsches
Archäologisches Institut*
Prof. Helmut Kyrieleis

*The Permanent Secretary
of the Académie des Inscriptions
et Belles-Lettres*
Prof. Jean Leclant

*The Permanent Secretary of the
Académie Royale des Sciences,
des Lettres et des Beaux-Arts*
Prof. Philippe Roberts-Jones

*The President of the Accademia
Nazionale dei Lincei*
Prof. Giorgio Salvini

*The President of the Academy
Bulgarian of the Sciences*
Prof. Blagovest Sendov

*The President of the Yugoslavian
Academy of the Sciences
and the Arts*
Prof. Jakov Sirotkovic

*The President
of the Province of Venice*
Prof. Oliviero Pillon

*The Head of Department for
Information and Publishing
Presidency of the Italian
Council of Ministers*
Dott. Stefano Rolando

*The Director General
for Cultural Affairs
Italian Foreign Ministry*
Ministro Alessandro Vattani

*The Director General for
Environmental, Architectural
Artistic and Historical Assets
Italian Ministry for Culture
and the Environment*
Prof. Francesco Sisinni

*The Director General
of Library Assets
and Cultural Institutes
Italian Ministry for Culture
and the Environment*
Prof. Francesco Sicilia

*The Rector of the
University of Venice*
Prof. Giovanni Castellani

*The President of the Unione
Accademica Nazionale*
Prof. Sabatino Moscati

*The Superintendent
for Archaeology
for the Veneto Region*
Dott. Bianca Maria Scarfi

*The Director
of the Venice University
Institute for Architecture*
Prof. Paolo Ceccarelli

Foreword

On June 20, 1990, a small meeting was held in Paris, at the Institut de France, organized by three institutions: Palazzo Grassi, the Accademia Nazionale dei Lincei and the Institut de France. Why these institutions organized the meeting and why the meeting took place in Paris needs to be explained in order to clarify the project which the three were on the point of launching.

Palazzo Grassi: Set up with a view to large exhibitions of an international stature, the institution was still basking in the extraordinary success of "The Phoenicians," its first venture into the archaeological field. On that occasion, Palazzo Grassi stated a "philosophy" and applied it: to undertake only those projects which go beyond national or continental borders, opening the door to scholarship on an international and intercontinental scale; projects which are unprecedented of their kind, both in concept and scope and which, because of their long duration and the lasting reality of a large comprehensive catalogue (presenting not only the exibition but the whole civilization under consideration), lead to permanent, far-reaching and virtually unique cultural progress.

Accademia Nazionale dei Lincei: From the very beginning, Palazzo Grassi sought the support of Italy's most distinguished scientific institute for its archaeological projects, and from the very beginning, the Accademia had granted that support gladly, with the understanding that its representatives would take part in the scientific aspect of the projects. So the archaeological exhibitions were coming into their own not only because of the unprecedented scale and the lasting quality of the results, but also because of the firm intention, brilliantly carried through, of placing those results on the highest possible level.

Institut de France: The size and international character of the Palazzo Grassi projects made it necessary for this concept to be translated into concrete fact. With the Phoenicians this had come about as a result of the project, whereas with the Celts, to whom the Palazzo Grassi planners turned their attention after their first success, this had to be set down as a premise, and for three reasons: in this field, Italian science was comparatively less advanced (though very worthily represented), Europe played a more important role and, lastly, among European countries, France was the leader. And to say France was to say the counterpart of the Accademia dei Lincei, Institut de France.

Paris: All this required a European context not just in words but in action as well. In this specific case no objections were to be expected from other European countries, considering that the French capital is both the focal point of Celtic studies and the central link in the chain of Celtic monuments and archaeological objects preserved in that country—which, it should be remembered, represents one of the most widespread and impressive collections in Europe. So to meet in Paris meant paying France and Paris a tribute shared by all.

The Paris meeting was attended by Giuseppe Donegá and Emilio Melli for Palazzo Grassi, Sabatino Moscati, with Ermanno Arslan and Daniele Vitali, for the Accademia Nazionale dei Lincei, and Jean Leclant and Paul-Marie Duval, with Venceslas Kruta and Jean-Paul Mohen, for the Institut de France, who then became the Organizing Committee of the exhibition. From their meeting emerged the general plan of the exhibition itself, which can be summed up here in the whys and the hows (organizational and executive) of the undertaking.

Why the Celts: After discovering the ancient Mediterranean world through the Phoenicians, it was hoped to discover the ancient European world through the Celts. In other words, if we looked south from Venice the first time, the second time we would look north. But the similarity, and at the same time the complementarity of the two projects, did not stop there. Recent discoveries had brought them to the fore of scholarly attention, a position which they had not previously enjoyed. This very newness to the world of scholarship, this fact of being among the least-known of the ancient civilizations, made both of them open forums for fresh and innovative analysis. Both harbored elements of mystery, their origins and the meaning of names, for instance, that were echoed by the tradition of their time and of subsequent periods.

Organization: The distinctly international format meant that the scientific authorities and representatives of all countries involved had to be rallied. This is precisely what was done over the following months. Other distinguished institutions were asked to cooperate with the two organizing academies. A scientific commission was formed, extended to include all those European scholars who, because of their position and their work, could contribute to the project and guarantee its quality. A smaller advisory committee was set up. The members of these different groups, all of which were set up and all of which functioned perfectly, are listed at the beginning of the present volume.

Realization: Exhibitions and volumes devoted to this people and this civilization were not lacking in the past, but an overall exhibition had never before been attempted. This became (in complete agreement with the intentions of Palazzo Grassi) the stated and sought-after goal. So it was to be not *an* exhibition on the Celts, but *the* exhibition on the Celts, one that incorporates everything concerning them, from their origins in central-eastern Europe to their expansion into the Iberian peninsula and the British Isles, from the most remote prehistoric evidence to the remaining traces in the Middle Ages down to the threshold of modern times.

But to say realization also means saying what you want to realize, which is a question we answered by again establishing the overall view as our goal. This might sound obvious, but not when you think that in an exhibition of the archaeological finds of a civilization, it would be only natural (and is frequently the case) for the most attractive items, that is the art, to be marked out for display. Instead, with the Celts, as had already been the case with the Phoenicians, we decided that every aspect of the culture that can be culled from the remaining traces was to be taken into consideration: the organization of life, technology, beliefs and everything else, alongside the art, which is often just the visible tip of the iceberg of other suggestive but invisible realities.

This means that here as with the Phoenicians, Palazzo Grassi was especially interested in offering a fresh and significant experience to the countless visitors (and in particular, the school groups of young people who come flocking in), the experience of a world much different from ours, far removed in time and space, of a people who lived the adventure of life in such completely different conditions that the comparison can only be enlightening. We are nothing but motes of dust in space and time, but realizing it is an unforgettable experience, the only experience that enables us to understand who we are, where we come from, where we are going. For this reason, again in line with the Phoenicians, we wanted the exhibition not only to present, but also, and most of all, to tell a story. And Gae Aulenti, with her long experience, again undertook the difficult but intriguing task of bringing a vanished world back to life, maintaining the clear distinction, however, between what that world says and what we say about it. Some people are of the opinion that exhibitions should only suggest, not explain. Experience has taught us exactly the opposite. For, in fact, how else can the division between different worlds, different cultures, different mentalities be overcome if not through explanation? Sometimes the explanation may not be convincing, you say, but in that case the visitor will be able to provide his own to avoid having to indulge in always risky, often misleading, exercises in imagination.

An essential part of the exhibition is its subtitle, "The Origins of Europe." It was conceived with a mind to the great impending process of the unification of western Europe, a process that pointed eloquently to the truly unique aspect of the Celtic civilization, namely its being the first historically documented civilization on a European scale. In fact, how else could a people who fanned out from the central-eastern regions of Europe all the way to the Atlantic Ocean and the North Sea, and even as far the Black Sea, be described except in terms of their common European denominator? We felt, and still feel, that linking that past to this present was in no way forced, but indeed essential, and could very effectively call us back to our common roots.

That is what we thought and still think. But there was absolutely no way of imagining that a few months later, in a process as grand as it was unexpected, eastern Europe would throw down its barriers and swiftly, almost dramatically appropriate western political and economic systems, ultimately producing that veritable symbol of the process: German unity. We caught the reflections of this process with deep emotion, and Eastern European contributions to the exhibition, which had been requested from the start, flowed in at an astonishing rate, in a spirit of openness, cooperation, and generosity that was to become emblematic.

In this way, the Celtic exhibition itself slowly turned into a symbol of the new Europe, by now united from the Urals to the Atlantic. And let this be the last of the many elements that went to make the Palazzo Grassi project a gripping experience for those of us who come from, and who remain a part of, the scientific community. It is for this reason that we wish to thank Palazzo Grassi for the honor and responsibility conferred upon us.

Jean Leclant
Institut de France

Sabatino Moscati
Accademia Nazionale dei Lincei

The Celts and Ancient Europe

by Guido A. Mansuelli

There can be no doubt that the Celts (or *Keltoi* as the Greeks called them, *Galatae* according to Polybius, and *Galli* or *Celtae* to the Romans) were major players in the history of mainland Europe and the countries of the Mediterranean.

In the view of many Italians, these peoples first made their mark with their occupation of Rome in about 387 B.C. but, even if we only limit our research to Livy's fifth book *Ab Urbe Condita*, we see that they were on the scene well before that. Moreover we discover from Livy's account that their presence impinged, in one way or another, on many of the groups living at various times in the Italian peninsula. In chapter 32,4 he relates the tale of a certain plebeian named Caedicius who went to tell the tribunes of a strange thing that had happened to him: he was in the New Road and he heard, in the silence of the night, a voice, something more than human. It told him to warn the magistrates of imminent danger. This he did, but his lowly position (*humilitas*) led the tribunes to underestimate the warning, just at the same time as Rome was being deprived of "the one man (Camillus) who might have saved her." Meanwhile, ambassadors from *Clusium* (Chiusi) were entreating the Romans to come to their aid against the Celts.

Two chapters later, this presence, tinged with miracle, gives way to a thorough examination of the history and desire for historical accuracy leads him to establish that the Gauls arrived in Italy a good two centuries before they attacked Rome (V, 32, 5-6) and that Gaulish forces had often engaged in battle with the Etruscans, whose territory lay between the Alps and the Apennines (*loc. cit.*). The whole of chapter 34 is a thorough discussion of the *Transitus in Italiam Gallorum*, starting with the time of Tarquinius Priscus, that is, 534-508 B.C. At this time, the principal group seemed to be the Biturgis, under the leadership of their sovereign Ambitgatus, whose nephews Segovesus and Bellovesus were chosen by lot to lead emigration parties, *haud aulo lactiorem*, to wherever the gods indicated, as their homeland was becoming overpopulated. Segovesus thus went in the direction of the Hercynian Forest in Bohemia, while Bellovesus turned toward Italy.

Livy is very well-versed in the way these large tribal groups of people moved from place to place, and gives topographical and ethno-historical details showing how these events related to the movement of the Massaliots who sailed from Phocaea in Ionia under pressure from the Salluvii. The omens had told the Gauls that they were to help the Massaliots and this, in fact, is what they did. After Bellovesus's men had beaten the Tusci on the Ticino River in northern Italy, they then settled in the area that had by tradition belonged to the Insubres, who were a pagus or sub-tribe of the Aedui, and there they founded a city called *Mediolanum* (today's Milan).

From chapter 33, Livy takes a closer look at the settlement of the Celts, who were joined by the Cenomani under their commander Etitovius, and who settled between Brixia (today's Brescia) and Verona. They were then followed by the Libii and the Salluvii who took up residence alongside the territory of the Ligurians (*Laevi, antiqua gens*) on the Ticino River.

Several years were to pass before Hannibal, the famous Carthaginian leader, crossed the Alps, but he apparently benefited greatly from his thorough knowledge of the Gaulish populations.

After crossing Mount Poeninus via what is now the St. Gotthard Pass and finding the area up to the Po to be occupied, the Boii and the Lingones crossed the river on rafts, forcing the Etruscans—as well as the Umbri—to make way for them. Livy carefully sets out how the settlement of the last groups of Celts took place. The Senones (*recentissimi advenarum*) held the area from the Utens (Ronco) to the Aesis (Mount Esino). The historian then states that it was these people who besieged Clusium and Rome, but expresses uncertainty as to whether they were also being helped by other Cisalpine tribes.

In chapter 33, 4, he writes of the wars at Clusium against the Veii, stating that the Etruscans found themselves face to face with outlandish warriors with strange weapons. They promptly sought the help of the Romans, but military aid was refused, because the Senate favored a negotiated settlement (*pace potius cognosci quam armis*). This was a great tactical error; it

merely served to irritate the Gauls and hostilities immediately broke out. Livy returns to the story in chapter 37,4, still concentrating on the central Italian and Roman areas of the Italian peninsula, accusing the *tribuni militum consulari potestate*—who were replacing the ordinary magistrates—of ignorance. That he should not miss an opportunity to cast aspersions on a "popular" magistrate, even when discussing the past, is no surprise to students of his ways of thinking, nor that he should blame the sack of Rome on the Gauls' moment of irritation. With the dramatic conclusion of the war against the Celts (according to Livy, Camillus—who had been sent into exile—suddenly reappeared with an army and drove the Celts out) Livy is free to move on to a chronological account of events, though he returns to the subject several times. While we shall be referring back to Livy, we also need to look elsewhere for information; by concentrating only on Italy we risk underestimating the dimensions of the phenomenon. The great Celtic scholar Paul-Marie Duval, in his 1978 preface to Venseslas Kruta's *Les Celtes*, summed up the situation. The origins of the Celts, he writes, disappear into the mists of time from which emerged the culture, language, and way of life of both east and west. The Celts continued to be a vital force both from the pre-Christian era until the Middle Ages, and their sphere of influence spread from the North Sea to the Black Sea, including Iberia and Liguria, Pannonia, Dacia, Thrace, and the Carpathian Mountains, through to the Balkans. While their art and their crafts were exceptional from the very outset, their town planning and architectural skills emerged later, and their language had a major impact, particularly in the area we might call Gaul, during what scholars have termed the La Tène period. The Celts' influence on art and language took place in two stages, the first being from the fifth to the first centuries B.C. and the second from the First Imperial Era to the fifth century A.D. and beyond. Herodotus who was active from the time of the Persian wars through to 450 B.C. and after (a period of major significance for Celtic history) mapped out the frontiers of their empire thus: "the Istrar (later referred to as the *Danuvius* or the Danube), has its source in the Celtic lands of the Pyrenees, and crosses Europe, cutting it in half." This is the oldest reference we have to the existence of the Celtic people, and shows them spreading from the west, past the Pillars of Heracles, and across the whole of what is now Germany. The fact that the Celts did not have their own written tradition until much later gives Herodotus's quotation added weight, especially as he was giving a specific chronological reference.

If we now turn our attention to Kruta's summary, it soon becomes clear that the Celts were around long before Herodotus's mention. Their roots were deeply embedded in the proto-history of the continent and by the seventh-sixth centuries B.C. stretched from the Atlantic to eastern Europe. Livy was aware of this and, right at the beginning of *Gallic War*, Julius Caesar discusses the Celts' geographical locations and estimates numbers, stating that Gaul was held by three groups, the Belgae, the Aquitani, and the Celts (*Gallia est omnis divisa in partes tres, quarum primam incolunt Belgae, secondam Aquitani, tertiam sua lingua Celtae, nostra Galli appellantur*). Caesar's chronicle of his military campaign in Gaul is a valuable addition to Livy's account—which was written at the time of Tarquinius Priscus—as many changes had taken place in the meantime. Moreover, Caesar is recording the present while Livy was reworking the past.

Pliny the Elder is another contributor to our knowledge. Writing in the fourth century B.C., he tells of a Gaulish blacksmith who returns home after working in Rome to persuade his people to conquer Italy. This account illustrates the long-standing trade links that existed between Rome and Gaul and alludes to the privileged social position held in society by the skilled Celtic craftsmen. Elsewhere, he offers a glimpse of the rights of inheritance enjoyed by the owners of land and of large numbers of cattle; thus we begin to get an idea of the Celtic "princes," of whom we learn more through the lavish assemblages of the gravesites. In 577 B.C., a great tumulus was erected at Magdalenenberg in the Black Forest, on the upper reaches of the Brigach River (a tributary of the Danube). The grave goods have shed a great deal of light on the culture and economic activities of this princely society that deve-

loped in two phases: from the sixth to the fifth centuries B.C., and from the fourth to the third centuries B.C. Such funeral monuments are typical of the La Tène period, which takes its name from the site in Lake Neuchâtel in Switzerland.

It is useful to compare the evidence provided by these monuments with readings from Livy's Book V, chapter 33, for example, where he discusses the Celts' long-standing presence in Italy and their conflicts with the Etruscans. Remains found at Bologna, Marzabotto, and Servirola San Polo are contemporary with settlements in the *Picenum* (c. 225 B.C.), as well with as the last traces of the Celts' campaign against Rome. These remains mark the limits of an occupation that covered almost the whole of northern and central Italy and invested Italy with the ethnic culture that affected most of Europe. In addition, they enable us to establish a time-scale between one epicenter of the Celtic phenomenon and the widening of its horizons throughout the European continent.

While the Boii were starting to settle in the Po Valley at the start of the fourth century B.C., others groups were moving into Bohemia and Bavaria. Meanwhile, as the Senones were establishing their territory in the Italian Marches, their compatriots were colonizing the banks of the Yonne and Seine Rivers.

In 386 B.C., the siege of Clusium was raised. It had been the *casus belli* of the fight with Rome but, less than twenty years later, the tyrant Dionysus I of Syracuse was signing up Celtic mercenaries for his campaigns in Sparta and elsewhere.

It was during this period that the vegetal decorative style gained popularity in the Po Valley settlements. The ports of Spina and Hatria played an essential role here, as the Celts gradually appropriated Greek, Italiote and Etruscan influences which went on to have a major impact on the Celtic heritage; excellent examples of the vegetal styles were uncovered at Waldalgesheim, a woman's grave, on the Hunsrück, a tributary of the Rhine.

The next area worthy of examination is that of the banks of the Marne, the northern boundary of a settlement that has yielded a rich store of locally-made artifacts, many of which took their inspiration from Italian models, particularly those of the Po Valley.

The Senones' area of the Yonne enables us to compare the Italian experience with that of the rest of Europe. Fourth century B.C. in the Armorican peninsula in Brittany show how far that influence had spread, although it was by now starting to lose its impetus.

By the mid-fourth century B.C. we can see unusual developments in the area now called Switzerland, which archaeological excavations show to have been an obligatory crossroads of a vast area. This is confirmed by documents such as the "treasure" of Duchcov in northwest Bohemia, which consists of hundreds of pieces of jewelry and bronze showing Helvetic influences.

Kruta questions the authenticity and antiquity of the way Polybius describes the Celts in his work, particularly where he states that they had no industry, art, or science. Such a statement from a Greek "city dweller" with no frame of reference for judging what could be termed a "barbaric" people is quite comprehensible. I would add that a Greek, even Polybius, would have been in no position to judge the artistic production of the Celtic world, so different was it from what he knew.

In the third century B.C., La Tène art was reaching its zenith. Not just an ornamental style, it was highly original, inventive, and dynamic, and offers different interpretational possibilities. We need to look at the overall context to understand the import of this issue.

In the third century B.C., decorative styles in the Danube area were linked to a new group, the Volcae Tectosages, whom Caesar says settled in the Hercynian Forest in Bohemia. We have little information on their whereabouts before their settlement in Gaul (sometime around the middle of the third century), but their arrival on the scene prompted a further upset in the tribal balances of the area, comparable to what occurred during the Celtic expansion into the Balkans. Interestingly, an earlier group of Volcae, called the Arecomici, had integrated without disrupting the indigenous population noticeably.

A direct link exists between the expeditions toward Greece and the appearance of new peo-

ples on the western edges of the Celtic world: ancient tradition attributes the treasures of the Volcae, found in the sacred lake near Toulouse, to plunder from the the sacking of the sanctuary at Delphi in 279 B.C. Thus we see that something of a parallel can be drawn between the expansion of the early fourth century and the push in two different directions: the territory of origin and the areas to which archaeological evidence has shown the people moved.

After having effectively broken off relations with their Transalpine counterparts, the Senones in Italy were defeated at *Sentinum* (Sassoferrato) in 295 B.C. Victorious ten years later at *Arretium* (Arezzo), they were beaten at the battle of Lake Vadimo in 283 B.C. That same year, the Roman colony of Senagallia was established at the mouth of the river Misa in what had been the Senonese territory. Hostilities between the Celts and the Romans later resumed, leading to a rout at *Telamon* (Talamone) on the coast of central Etruria in 225 B.C. The war finally ended in 222 B.C. with a Roman victory at *Clastidium* and the occupation of *Mediolanum* (Milan).

Gaulish hopes were revived by the advent of Hannibal particularly after his decisive victory at Lake Trasimene but the Battle of the Metaurus in 207 B.C. signaled the end for him and for his allies and, in 191 B.C., the defeated Boii were forced to leave Italy altogether.

The Cisalpine area was a gateway for penetrating into the heart of Europe and the means for overcoming a crisis that was destined to open a new chapter in the history of the continent.

Accounts by the Celtic historian, Trogus Pompeius (XXIV, 4) reports that over-population had forced the Celts to move as if by a wide *ver sacrum* (sacred spring) and a good number of them actually settled in Italy while others, guided by birds, set up home in Illyria, and still others fought their way through the barbarian-held lands to reach Pannonia. It is interesting that this historian of Volcae descent of the Augustan Age should talk about the migratory movements of the Celts and their spread across Europe using the term *ver sacrum* which is a typically Roman religious ceremony with some possible Etruscan influences. If the information available to us has not enabled us to get any idea of the historical situation before the Celts, and if it is only thanks to Herodotus that we have a reasonably good idea of their role and importance therefore in the upper Danube area (which he considered uninhabitable because of its cold climate), other scholars such as the Greek Apollonius Rhodius have put forward evidence based on legend.

We know that during the archaic and classical periods, the Greeks were little acquainted with much of the rest of the continent of Europe and thus it is difficult to explain the presence of a few Greek artifacts—such as the Hydria from Laconia—in the burial grounds at Artànd on the Tisza River in Pannonia. In his essay, *Les Celtes danubiens et l'expansion balkanique*, Miklós Szabó maintains that the piece got there by sea, via the Adriatic, but I have my doubts. The vessel could have followed a number of alternative routes from Laconia but it is unlikely that it came from Thrace especially as the inscriptions are not in the Thracian or Dacian idiom.

The Celtic penetration of the middle Danube area began toward the end of the fifth century B.C. It is difficult to see what attracted them to the Carpathian basin, although we know that they fought many battles in order to do so: Livy reports on the pre-Christian era and the Roman historian Marcus Junianus Justinus, writing in the third century A.D., chronicles the later history, with the Asiatic Greek Flavius Arrianus (Arrian) also contributing.

Arrian tells us, for example that, by 335 B.C. there was a Celtic diplomatic mission to the court of Alexander the Great, and he refers to them as the "Celts of the Ionian Sea." This is an important piece of information considering the silence of the other ancient writers on the colonization of Pannonia by the Celts.

The archaeological evidence indicates that Celtic power was consolidated in the area beyond the Danube in the second half of the fourth century B.C. Once again we are lacking in literary references to the subject and must rely on archaeological information.

A wide variety of typologically Celtic artifacts has been recovered from a broad area stretching from Bosnia to Hungary. The earliest date from the end of the fourth century B.C. Such objects have also been found further south, in the area of Macedonia and Thessaly, which may be associated with the first historical expansion of the Celts. This area was the scene of fierce struggle as the Hellenistic rulers—such as Cassander King of Macedonia in about 310 B.C.—sought to check the Celtic tribes.

During this period the Celts, under the leadership of Kerethrios, Brennos, and Bolgios, attempted to overrun the land of the Triballi in Thrace, and Poenia. These peoples, called the *Galatae* by the local populations, defeated Ptolemy Keraunos, King of Macedonia in 279 B.C., one century after Celtic mercenaries had been recruited by Dionysus I of Syracuse to fight in the Corinthian war.

At this point, the three divisions of the Celtic forces broke up and each went its separate way. Another event of 279 B.C. was the sacking of the Temple of Apollo at Delphi by the division under Brennos. The remarkable skills of this commander—mentioned by Livy—rendered Sosthenes, the Greek leader, powerless to prevent the plundering of Macedonia by the invading forces.

According to Polybius, the Celtic division commanded by Kommontorios reappeared two years later, 277 B.C., in Thrace. He says that, having defeated the Thracians, they established a kingdom in the vicinity of the city of Byzantium, from which they exacted 80 talents a year in tribute.

Led by Lutarios and Leonnorios, these groups later moved on into Asia Minor, where they fought for Nicomedes of Bithynia. While they settled for a while, they could not help getting entangled in the struggle between the Hellenic potentates; they were defeated at a major battle in 275/274 B.C. and subjected to the rule of the Seleucids. Meanwhile, it seems that the *Galatae*, defeated by Antiochus I of Syria—known as the *Soter* or Savior, moved east toward the Cilician Gates.

The art produced during the reign of Attalos I of Pergamum—monumental statuary ensembles—celebrated the hard-won victories against the Celts, even though the latter continued to be a threat. The Celts now became a major source of concern and uncertainty to the Greeks, changing allegiance frequently. In 168 B.C., one such political turnaround brought the Romans to their aid and thus assured them the independence of their community. In this way, the history of the Asian Celts merges with that of the Romans, with the Celts fighting on behalf of their new allies during the war against King Mithridates V, also known as "the Great," of Pergamum. In 25 B.C., with the death of the Galatian chieftain Amyntas, a Celt with a Greek name, Galatia became a Roman province becoming directly involved in the upheavals taking place in the high command in Rome.

In the first century B.C., the Celts of Galatia could be divided into three groups, the Tolistobogi, the Trocmii, and the Tectosages, this latter group making up the majority and living in the vicinity of Ankvra.

Galatia was unusual as it was organized as a tetrarchy, the tetrarch and other leading figures having Greek names, which shows how deep the hellenization process had gone. Eventually power devolved onto one person but this very hellenistic trend concealed, but did not eliminate, a very Celtic fabric that had much in common with its European counterparts. The Galatian Celts underwent a process of ethnic integration with the indigenous Bastarnae, in evidence from 250 B.C. The racial mix provoked considerable controversy among the ancient writers with Diodorus Siculus (c. 60-30 B.C.), Livy (59 B.C. - 17 A.D.), and Plutarch (c. 26 - c. 120 A.D.) claiming that these people were Celts, Strabo stating they were Germanic, Tactitus (c. 55-120 A.D.) opting for a Sarmatian-Germanic mix, and Appian of Alexandria (c. 160 A.D.) maintaining they were Geti. Monuments and artifacts imply a heavy Celtic influence but the Celtic element becomes fainter, disappearing entirely during the first century B.C.

After the sack of Delphi, these Celtic groups disappeared briefly. One important clue to their

whereabouts is the Greek inscription on a monument commemorating Protogenes, who saved his native town Olbia from the so-called barbaric people, a group which (the inscription reads) included Galatians. Protogenes's inscription is a vital chronological reference and is therefore more reliable than historical sources which were always subject to the authors' generalizing.

Miklós Szabó takes his evidence from Justinus who calls the Tectosages living in Pannonia the *Volcae paludes* (or Volcae of the swamps). This links them to the Volcae tribes mentioned by Caesar as living in the Hercynian Forest in Bohemia. It is first-class corroborative material to indicate the mobility of these people.

Archaeological finds confirm both the mobility and the ethnic intermingling which caused the historians such difficulties when they tried to pinpoint exact racial origins. The objects found in the areas that are now Hungary and Yugoslavia, as well as around the Carpathian Mountains and the Danube, show similarities in style and attest to a well-developed cultural exchange with the Etrurians and other Italic people.

In Book I, chapter 5 of his *Gallic War*, Julius Caesar writes of the Helvetii's practice of migrating *en masse* and of burning down their *oppida* or walled towns, villages and houses as they went. This would certainly explain the lack of remains of urban construction and monuments, and is likely to have been common to the Celts as a whole. As we saw earlier, the Helvetii also moved into the Euroasian areas and the evidence they left behind should help us to understand analogous situations elsewhere. Evidence of the existence of *oppida* or walled settlements has been found in the Cisalpine area and elsewhere and date to the third and second centuries B.C.

As time went on, Celtic objects became more and more highly decorated, this especially in the case of coinage where both realistic images and abstract and symbolic decorations were used. Celtic coinage deserves a chapter all to itself, given the range of the subject.

In book V, chapter 12 of *Gallic War*, Caesar writes of his personal experience in *Britannia* and reveals that the Celts in this area had very clear ideas of their own as to who they were and where they came from. This helps extend our survey beyond the Roman period which concluded with Caesar. Observing the experience in *Britannia* enables us to look at the Celts—and not just in Britain—up to the time of Antonius Pius, that is well after the start of the Christian era, as well as to examine what happened in Ireland, where it can be said that the Celtic experience continued through to the Middle Ages.

In some ways the documentary evidence furnished in Ireland provides the link between the Roman Empire and the outside. In terms of the Roman Empire, Ireland is interesting since the Romans never managed to gain any kind of foothold there (nor in northern *Britannia*). Ireland was known to the Greeks as Hierne (Ierne), a name that Julius Caesar latinized to Hibernia. It was first brought to the attention of the classical world by Pytheas the Massaliote explorer of the fourth century B.C. While unsure of the origins of the Celtic peoples, he believed their language was in some way linked to what was spoken in northern Gaul. Most of the documentation we have for Ireland is based on artifacts since, apart from a few notes from ocean-going explorers, nothing is written before the Middle Ages. The native population did not start to record their history until after the advent and the widespread adoption of Christianity on the island.

The Roman world thus remained in ignorance of the history of Ireland and overlooked the wealth of legends such as that of the High King Conchobar Abrat Ruadh who ruled until 73 A.D. With its roots in legend and mythology—steeped in the fantastic—Irish tradition is very radically different from the classical epics, such as those of Homer. Though it is tempting to compare the *fianna* bands of Irish warriors with the *Gesati* who fought at the Battle of the Telamon, we would be in danger of moving into very unsure ground historically. In 1987, the proceedings of an international conference on the Celts held in Bologna two years earlier were published by Fontana Editore of Imola under the title of *Celti ed Etruschi nell'Italia settentrionale dal V secolo alla romanizzazione* (Celts and Etruscans in Northern Ita-

ly from the Fifth Century to the Roman Conquest). The organizers of the conference decided to dedicate this magnificent 584-page book to me on the occasion of my seventieth birthday and, although I cannot believe that I deserve such a signal honor, I should like to thank everyone concerned, particularly my friend Professor Giancarlo Susini, the then Dean of the Faculty of Letters and Philosophy the University of Bologna and whose idea I believe this must have been because one of my research specializations was, for a long time, the Celtic civilization. I should also like to thank our other friend Dottor Daniele Vitali who was one of the editors of the Bologna volume which is destined to become a valuable resource for future research.

While I cannot look in depth at the volume, I should just like to highlight a number of pieces, the first of which is Mario Torelli's excellent essay entitled *I Galli e gli Etruschi* (The Gauls and the Etruscans), a detailed survey of the migrations of the Celts. I was delighted that his work could be included in this prestigious tome. Another outstanding piece is that by Otto Hermann Frey on belt buckles, especially as it is supplemented by excellent maps. Venceslas Kruta has provided some interesting insights into the evolution of the La Tène civilization, while Giuseppe Sassatelli, my successor as Professor in the University of Bologna, has produced a detailed study on an area of local interest here in the Emilia region, *Un "nuovo" candelabro etrusco da Spina, aspetti ellenizzanti nella cultura dell'Etruria padana* (A "New" Etruscan Candelabrum Discovered at Spina: Hellenistic Aspects in the Etruscan Culture of the Po Valley).

Christian Peyre's essay on *Fèlsina e l'organisation du territoire des Boïens selon l'historiographie antique* (Fèlsina and the Territorial Layout of the Boii as discussed in Ancient Historical Documentation) is another major resource by an old friend with whom I have many links. From Professor Jean-Paul Morel of the University of Aix-en-Provence we have *La céramique à vernis noire en Italie settentrionale* (Glazed Ceramic Work in Northern Italy) which opens up another major sphere of interest.

My links with Giuliana Riccioni go back a long way to when we worked together at the Institute of Archaeology at the University of Bologna, and she is also represented here with her work on the *necropoli spisetiche*.

Anna Maria Chieco Bianchi of the Archaeological Commission of Venice has also contributed sterling work and I should also like to mention Mariolina Gamba's essay on the necropoles of Arquà Petrarca, as well as Loredana Calzavara Capuis who looked at the issue of the Celts in the Veneto region.

Since I cannot mention everyone, I should just like to conclude with Daniele Vitali's two pieces *Monte Bibele tra Etruschi e Celti* (Mount Bibele between the Etruscans and the Celts) and *La necropoli di Piòbaico* (The Gravesite of Piòbaico) both of which are extended and comprehensive pieces on subjects that are new to the field. These two essays by my friend Vitali are some of the most important items in this entire collection. Admirably argued and complemented by outstanding supporting material, they present cogent and convincing conclusions, as well as providing a wealth of illustration.

Just one more mention, if I may, for André Rapin's examination of La Tène sword scabbards and Eva F. Peters' essay on the Celtic heritage in Pannonia during the Roman era, as well as Mitja Gustin's notes on the Nova Vas late Le Tène buckle.

The book is concluded by a detailed piece by Aldo Luigi Prosdocimi who analysed *Celti in Italia prima e dopo il V secolo a.C.* (The Celts in Italy before and after the Fifth Century B.C.). This excellently-argued substantial work is the result of an in-depth survey of documentation in the Liguria and the Celto-Ligurian areas, as well as an examination of the study of place-names and Celtic and non-Celtic aspects, its analysis of Ligurian-Lepontic linguistic variations, illustrated by excellent examples, making it a major resource to linguistic study.

Paul-Marie Duval

Celtic Art

It is not possible to speak of the Celts in general, nor of their art in particular, without defining what exactly distinguishes them from their Mediterranean contemporaries. The origins of the Celts, now lost in the mists of time, were undoubtedly European; they spoke an ancient Indo-European language—Celtic—that is still alive in the British Isles (in Ireland, Scotland and Wales) and on the continent (in Brittany). As the Celtic group expanded from the fifth century B.C. in the area between the nordic plains and the Mediterranean coast, so their own particular art forms developed and flourished.

More or less explicit reminders of Celtic civilization are still to be seen in these temperate countries: names of towns, rivers and mountains, traces of architecture, weapons, works of art and domestic items. The distribution of these traces is uneven, being most intense in the British Isles and France where the druids held power, and in Belgium and the Netherlands, northern Italy, Germany and Austria. In the Danubian countries, Czechoslovakia, Hungary, Romania and Yugoslavia there are also many reminders of the Celtic presence. In northern Spain there are fewer traces but they are proving to be more and more interesting. Celtic culture is also represented by works of art that may have been transported to Scandinavian countries (Denmark and Sweden), Poland, and even, sporadically, the southwest of Russia. However, to date at least, no Celtic works have been found in those places where the Celts did not become established even though they may have made their presence felt as mercenaries or conquerors; that is, in central Italy, Greece, Sicily and, outside Europe, in Asia Minor, Egypt and North Africa.

By contrast, when they returned to their own areas, or settled in places that subsequently became Celtic, they brought with them their booty of precious objects, coins, tools, all novelties that they then copied and transformed according to their own taste. For this reason works of art, particularly those that have some sort of inscription, have become essential for historical study.

The characteristics of the Celts' construction methods and the materials they used are interesting for the light they shed on the means they had at disposal and how they exploited such means. Before they came into contact with the Roman technology, they, like the ancient Greeks, did not have mortar. Their principal materials were unworked stone and fine hardwood. Little by little, potter's clay, glass, bronze, enamel, amber and coral came to be used, and gold and silver were not lacking. We know little of their painting or textiles (though the latter craft was certainly well developed), nor of their work in wicker, straw or leather.

On the other hand we do know something of how the Celts dressed to protect themselves from the cold; some of their clothing types have evolved into such modern-day equivalents as trousers, shoes and woolen garments. The Celts also invented the barrel, which first appeared in Belgium. They are known to have engraved iron, a practice that was widespread throughout central Europe, and they also developed an abstract and mysterious form of miniature sculpture.

Compared to other Mediterranean ethnic groups, the pattern of Celtic settlement is original on two counts. First, for the development of the *oppidum*, a sort of enormous fortress that served as the main civil, military and political center. These were usually built on hills to make access difficult for enemies, though there are rare examples of plains locations, on the banks of a river for protection. No less characteristic is the Celtic sanctuary, square or round in shape which, known by the Latin name *fanum*, came to be used in the islands and throughout Roman Gaul.

We know nothing of the Celtic religion through texts: it was transmitted orally because the druids forbade its commitment to writing. However, we do possess a five-year calendar in a Celtic language inscribed in Latin characters on a large metal plate, the pieces of which were buried in Gaul. At the earliest it dates to the second century A.D. This is a complete system, by far the most scientific and accurate semi-lunar calendar to be found in Europe until the creation of the solar calendar introduced by Caesar. Its almost perfect elaboration must have taken many years, perhaps even centuries, of scientific work by the druids.

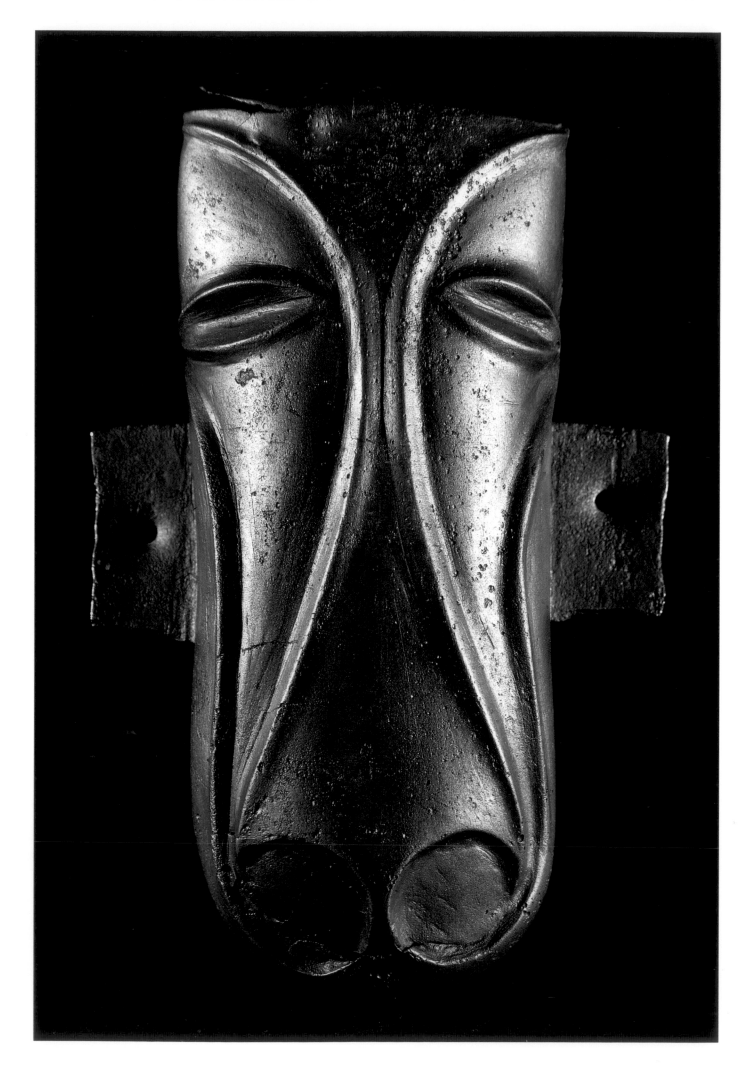

Among the great works of art of the ancient world, many stand out as being uniquely Celtic. This art was developed in a temperate climate that fostered a sense of the mysterious allure of the forest and its powerful animals. It also favored a fertile agricultural and stock-raising economy and provided a bountiful supply of water, and ample quantities of iron and stone. In their representations the Celts showed a clear preference for tribal goddesses, powerful beasts, imaginary monsters, strangely stylized animals and twisting, intertwined plants, while the male figure was all but ignored. Frequent motifs included the lotus, palmettes, mistletoe (which is a tree parasite and has sticky white berries), root madder (from which they obtained a red pigment), the thick foliage of woad, and yew, an evergreen with red berries, the life span of which is hundreds of years. Plants had an almost religious importance in everyday life, and each year the druids gathered mistletoe, a solemn event that the Gauls took very seriously. Thus, the main features of Celtic art were closely tied to the most ancient forms of Celtic paganism, and were repeated with increasing frequency in the course of the half-millennium before Christ.

The next millennium was experienced under Roman domination and gradually the representation of the human form was added to the repertoire of Celtic motifs. Thus a style developed that may be called Celto-Roman, since the subjects of Celtic and Roman art—as influenced by Etruscan, Greek and Hellenistic art as well—are often closely intermixed. The names of Celtic divinities appear on various inscriptions, texts and pictures: *Epona, Rosmerta, Taranis, Esus, Teutates...* The portraits offer us the first opportunity to learn about subjects that became widespread in a Graeco-Roman religious world replete with Celtic borrowings. Bianchi Bandinelli has shown how the Celts—whose taste for the flowing form is in keeping with their use of the compass for describing curves—little by little came to use lines and shapes that were sometimes curving, sometimes almost transformed into a geometric style (though always rather curvilinear) for all their designs, especially the simplest and most lively ones. Subjects' given attributes were broken down, abstract elements combined, allusions made by transformation, different subjects—human, animal, vegetable or abstract—juxtaposed; thus throughout temperate Europe, from the fifth century B.C. to the fifth century A.D. it is possible to detect the Celts' consistent and special talent for transforming into original creations the numerous and varied motifs of classical antiquity.

Finally, Celtic coins are an object of particular interest; in these, living subjects are so greatly transformed that they become mere triangles. Most of these coins come from Gaul, with the remainder from all other Celtic lands (with the exception of Ireland). Those minted between the third century B.C. and the first century A.D. are now being studied for their styles, which differ according to the tribe that struck them (using different techniques), and for the names and words that can be deciphered thanks to photographic and facsimile reproductions. No less interesting is the fact that the images on these coins, the most curious of which are just now finding explanation, were in fact the only form of propaganda that the tribal chiefs managed to make for themselves, thus circumventing the druids' proscription of writing.

Celtic art is today clearly defined: it offers us works that are distinct from other forms found in western antiquity. It displays a unity that is shared by the different countries of temperate Europe. Strangely, we recognize its taste for allusion, curved forms and ambiguity because we find the same traits in contemporary art. But we have yet to discover all the treasures of the Celts. Many are still buried, and others have been unearthed but not yet sufficiently studied to be properly identified. It is surprising to learn that the names of very many modern cities are of Celtic origin, London, Dublin, Paris and Milan for example. Undoubtedly there are yet more Celtic works of art awaiting discovery in the vast expanse of Europe, and perhaps even in territories beyond the seas.

The aim of this paper has been to illuminate this delicate problem, with its many unanswered questions, and to help us to resolve it, thus enhancing out understanding of art as a human expression and our appreciation of the Celtic contribution to the culture and history of the new Europe.

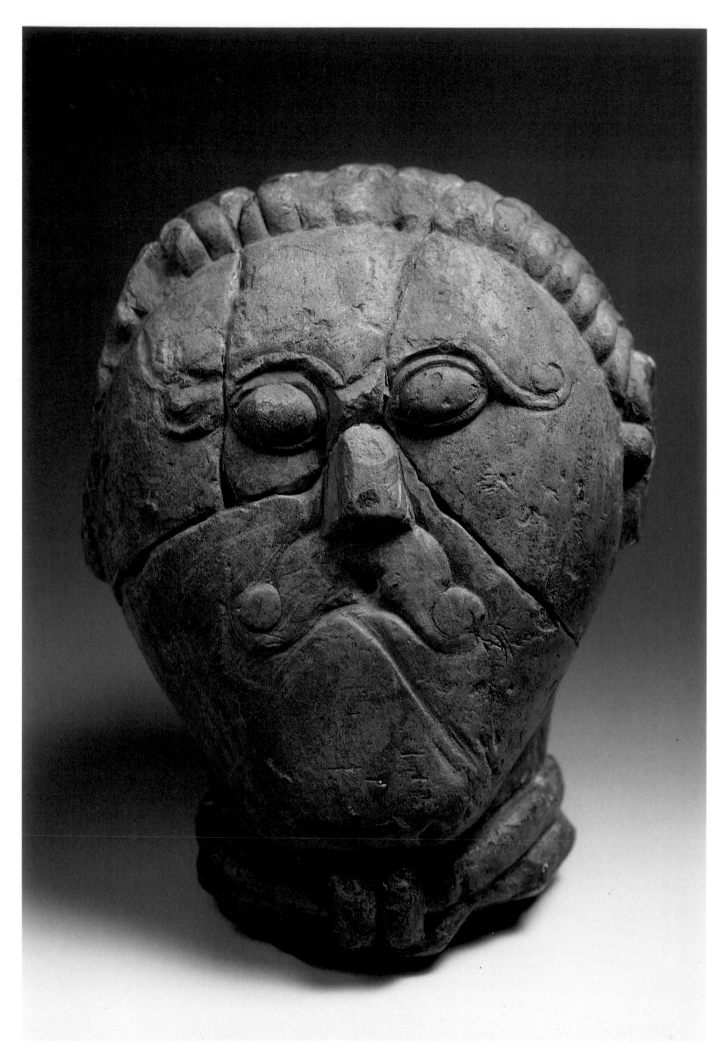

Venceslas Kruta

In Search of the Ancient Celts

*Head of deity in stone
from near the square sanctuary
at Mšecké Žehrovice (Bohemia)
2nd-1st century B.C.
Prague, Národní Muzeum*

Today, Celtic languages are spoken by a mere two million people living in a few scattered regions on the Atlantic coasts of Europe: in Armoric Brittany, Wales, and certain parts of Scotland and Ireland. In each case, the idiom of Celtic origin, be it Irish, Welsh, Scots Gaelic, or Breton, vies with a national language—with French on the European continent, and English throughout the British Isles.

This coexistence with a major language hardly favors literary creativity in the ancient Celtic vernaculars, which remain accessible to a dwindling number of people. The great modern and contemporary writers of Celtic origin inevitably wrote their works in the two main national languages, and Celtic languages have escaped extinction only through grass-roots determination to perpetuate this essential aspect of Celtic cultural identity, a heritage that is rooted deep in the history of Europe itself.

The evident importance of this endangered common heritage has prompted research into other forms of expression in those countries which rightly or wrongly might be considered specifically Celtic. The rural environment has been crucial for the survival of Celtic dialects, and the thriving interest in colorful Celtic folklore is an enduring token of the profound desire of Celtic-speaking populations to remain in touch with their culture and origins.

The public has shown a keen interest in tracing that past, particularly to counter the sense of alienation provoked by the often unruly growth of the urban environment. But an unfortunate consequence of this is a general impression that the Celts' legacy and culture is mere folklore, which, despite its variety and authenticity, hardly matches the great literary cultures of Europe. This is a misconception, because the Celtic legacy does not consist merely in folk tradition, however lively and inventive, but in numerous other perhaps less apparent aspects that are still largely uncharted, especially outside the Celtic countries themselves.

The epic literature and myths of Ireland and Wales are less widely known than Greek or Roman myths, or those of the Germanic races of the early Middle Ages, or even those of the East. In Anglo-Saxon countries, the main epic texts are available even in paperback, but in other European nations of Celtic origin publishers have devoted scant attention to this important legacy.

The highly original literature of the ancient Celts was handed down orally for many centuries and, regrettably, there is no way of tracing its path. Nevertheless, it remains one of the most precious sources at our disposal for the study of the spiritual world and philosophy of a group of peoples that played a crucial role in Europe's prehistoric and historic development.

Revived in the early Middle Ages in the British Isles with the *Matière de Bretagne* and the heroic cycles, this record of the Celtic imagination had a lasting effect on the mind of medieval man; similarly, in the 1700s, when Europe was again in metamorphosis, the Ossianic pastiche contrived by James Macpherson gave new impetus to the romantic spirit.

Likewise, Celtic figurative expression was the fruit of an entirely original process of evolution. Continually stimulated by new ideas from the Mediterranean world, Celtic art reached a stable form in the third century B.C. at the peak of the historical expansion of the Celts. Artistic expression of specifically Celtic origin completely disappeared from the continent in the first century B.C. with the advance of the Romans and subsequent annihilation of the Celts at the hands of the Germanic and Dacian races. But it survived in the British Isles and found a fecund outlet in medieval Christian art in Ireland. Thanks to the missionary activities of the island monks, this enduring imagery made its way back to the scattered pockets of Celtic territory in Europe that had escaped Roman domination.

Although it is impossible to establish a direct link, the sensibility expressed by the masterpieces of the golden age of Celtic art found its way into Gothic art, which betrays the same fondness for twining plant motifs populated with fabulous creatures and monsters, creating a shifting, multiform universe which is transformed according to the perception, mood or imagination of the observer.

It is hardly surprising that the first signs of a revival of Celtic art in the nineteenth century coincided with the rehabilitation of Gothic art—long overshadowed by an inflexible cult for

the classical aesthetic—which now acquired new respect in the eyes of the Romantics. The "Celtic Revival" that blossomed in the 1800s, particularly enthusiastically in Ireland (as an outward manifestation of an intensified national sentiment) drew inspiration mainly from Christian art, which was widely known through certain works of extraordinary beauty—manuscripts, sacred objects in gold, and scattered monuments—that had escaped plundering and destruction over the centuries.

Certain aspects of Celtic art, especially the twining plant patterns frequently combined with animal motifs and a marked penchant for sinuous lines, fit in perfectly with the trends in decorative arts at the end of the 1800s, which developed in reaction to the rigid arrangements of classical form. Certain Art Nouveau creations have striking affinities with Celtic works from the Iron Age, though these were hardly ever directly inspired by the latter (at least on the continent). As with Gothic art, the parallels in the assortment and treatment of forms stem from the common concern for the dynamics of the compositions and in a similar taste for the proliferation of different elements, usually borrowed from nature, and mainly transformed (sometimes rendered abstract) and put together with no obvious logic.

This apparent overlap of the Celtic spirit with artistic trends which are rightly or wrongly considered "anti-classical" suggests that the former is the first outspoken manifestation of this tendency in European art. This idea actually continues to be held by some. In the face of Roman ascendancy, the Celts and their artistry have become the champions of a libertarian stand against any form of oppressive order. But, while there is a fundamental conceptual gap between ancient Mediterranean art and Celtic art, the latter is inconceivable without its borrowings from the former, from which it took not only most of its repertoire, but also the ideas originally associated with them. The entire legacy was assimilated into a philosophy of life wholly Celtic in nature, generating a visual idiom of indisputable authenticity.

Celtic art should not be seen as anti-classical, as different does not necessarily mean opposite, and the subtle cross-pollination between these two complementary forms of expression are more complex than they might seem at first. What we can assert today for Celtic art holds true for other aspects of ancient Celtic culture. Much ground had to be covered before this outlook was reached, and it is still contested by those who insist on upholding a strict hierarchy for the great cultures of the past, forgetting how Europe's great diversity has always been intrinsic to its dynamic evolution.

As a result, continental Celtic art was only acknowledged toward the end of the nineteenth century, shortly after the identification of remains attributable to the historical Celts of the second half of the first millennium B.C. facilitated the systematic analysis of archaeological sources, and thus supplemented the information of the written sources with extraordinarily rich and varied evidence.

By the beginning of this century, experts acknowledged a common Celtic background for the regions of Europe that stretch from the Atlantic to the Carpathian mountains. Sometimes this recognition had an ulterior motive, namely, to endorse the nationalist spirit of certain countries which had suffered Roman colonization and later Germanic invasion.

But it was only much later that the scholars put aside their preconceptions and accepted the idea of an ancient Celtic contribution to European culture. Until then the Celts had been considered a "barbaric" intrusion on "real" culture which, region by region, arrived either through Roman occupation or through the expansion of Christianity.

Attitudes toward Celtic art are symptomatic of this problem: it was not until the 1940s that a specific category of Celtic art in pre-Roman continental Europe was identified, after which it was systematically cataloged and in-depth research made into the Celts' links with the Mediterranean. Several decades had yet to pass before an awareness of Celtic art as one of ancient Europe's leading forms of expression—and indeed an essential key to understanding later developments—spread outside the narrow circle of specialists to the general public. Despite the many studies devoted to this argument, some scholars of classical art continue to consider Celtic art a mere derivative—and a somewhat clumsy, secondary manifestation

*Bronze openwork phalera
from the chariot-burial
at Somme-Bionne (Marne)
5th century B.C.
London, British Museum*

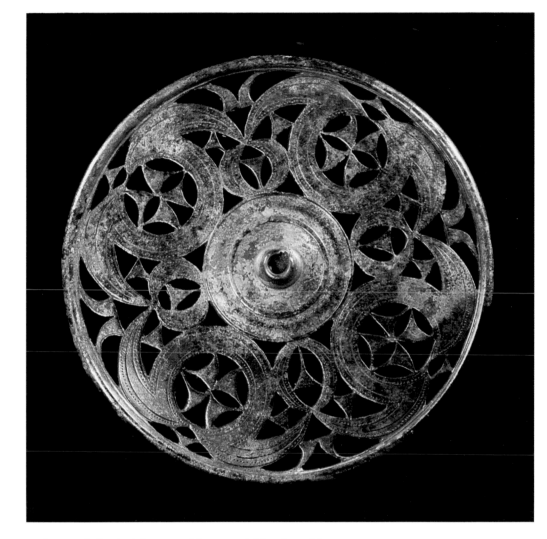

at that—of classical forms, with no real identity of its own.

This situation is much the same for the Celtic contribution to the formation and evolution of Europe during the second half of the first millennium B.C.—now well-known, largely through archaeology. Today it is more widely acknowledged (though often forgotten) that the various provinces set up by the Romans in Celtic countries benefited at the outset from a well-established industrial and agricultural system suited to local conditions and only slightly enhanced by techniques introduced during Roman colonization.

Similarly, the traditional timber architecture, adapted to imported styles and occasionally enhanced with masonry, remained predominant for private housing. Woodworking and metalworking had already reached high standards long before the Roman occupation, as attested by surviving products and working tools, which were so well suited to the task that they remained virtually unchanged until the introduction of machinery. The changes made by the Romans mainly affected production and the distribution networks, but very rarely involved improvements in the products themselves.

The same goes for farming, where pre-Roman implements (still in use until the recent introduction of machinery) enabled extensive cultivation perfectly suited to non-Mediterranean climatic conditions, and were quite new to the Romans before they took over the Celtic territories of the Po Valley in the second century B.C.

This multifaceted and omnipresent Celtic heritage involves the whole of Europe from the Atlantic to the great northern and eastern plains and right down to the northern coast of the Mediterranean. Celtic culture affected the daily lives of the area's inhabitants, from

generation to generation, and although for a great many years this culture has not been linked by a common language, it continues, unseen, to influence our culture to this day.

For example, the organization of the Celtic year, with its principal feast-days celebrating the rhythm of the seasons is echoed in the religious calendar of western Christianity. A more complete knowledge of the world of the ancient Celts will teach us much about ourselves, and may even be a means of understanding the origins of traits shared by different races across Europe today.

Nowadays, the sense of community among people of Celtic origin who share a common language has been reinforced by the need to defend an identity threatened with extinction. This linguistic kinship implies a cultural link handed down through the centuries from generation to generation, like language itself.

Such an attitude, however, tends to overlook the point that language is just one of many aspects—primordial but by no means unique—of a culture in which religion, social organization, and the economy, all directly bound to the geographical and historical context, play a decisive role. If we examine the past of Celtic-speaking people—even the relatively recent

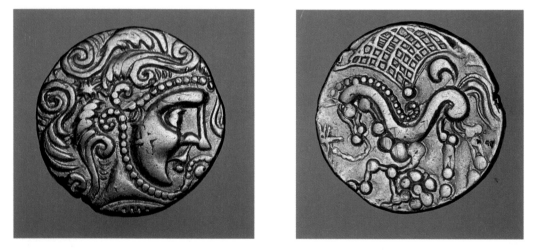

Obverse and reverse of a gold stater minted by the Parisii
End 2nd-early 1st century B.C.
Brno, Moravské Muzeum

past—we must conclude that the concept of "Celtic civilization" as something illimitable in time and space, independent of a temporal and spatial context, has no foundation in reality. As with the terms Egyptian, Greek, and Roman, the expression "Celtic civilization" makes sense only if referred to a consistent historical phenomenon. It clearly remains inextricably tied to language, but the correspondence could never be absolute, in terms of either time or geography.

The two principal approaches to studying the ancient Celts are based on different types of material—one linguistic, the other archaeological—and the conclusions are frequently divergent. Today we must admit the existence of a "linguistic identity" that corresponds to a wide range of archaeological cultures. Likewise, there is also a "cultural identity" embracing people of different languages and traditions.

The history of the archaeological identification of the ancient Celts of continental Europe is a graphic illustration of this divergence, which first emerged in the second half of the nineteenth century, after a period in which nearly all pre-Roman remains were considered Celtic.

Early attempts at linking information from written sources with the information that emerged from excavations were not always successful. Hence, when in 1860, the site of Alesia, one of the bastions of Gaulish resistance to the Roman front in Caesar's time, yielded a cache of arms dating from the Bronze Age, these were attributed to the city's "heroic defenders" of the year 52 B.C. This is where the origin of the "Gaulish" iconography, as anachronistic as it is persistent, flourishing even today in completely different contexts— from cigarette packets (*Gauloises*) to comic books (*Asterix the Gaul*)—must be sought.

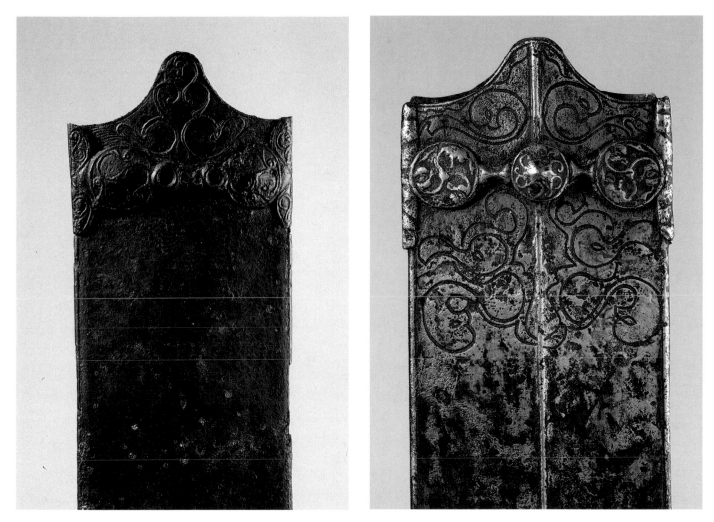

Mouth of iron scabbard with relief decorations from La Tène (Neuchâtel) End 3rd century B.C. Bienne, Musée Schwab

Mouth of iron scabbard with engraved decorations from La Tène (Neuchâtel) End 3rd-early 2nd century B.C. Neuchâtel Musée Cantonal d'Archéologie

The turning point in Celtic studies came in 1871 at the International Congress of Prehistoric Anthropology and Archaeology held in Bologna. The French scholar Gabriel de Mortillet and the Swiss Émile Desor recognized among the finds from the nearby Etruscan site of Marzabotto objects which they knew well in their own countries—arms and fibulae similar to those found in great quantities in the Iron-Age cemeteries of Champagne and the lake deposits of La Tène, which had been made public fifteen years earlier. The two scholars ascribed these objects to the Celtic invaders of the fourth century B.C., and thus gave the historical Celts an archaeological physiognomy.

The following year, Hans Hildebrand suggested splitting the pre-Roman Iron Age into two separate periods: the first was named after the vast cemetery of Hallstatt in Austria, and the second (the period to which the arms and other personal items unearthed at Marzabotto belonged) after the La Tène site. The new categories equated the Celts with La Tène civilization, and this deeply influenced the field of research for almost a century.

The identification of the Celts with La Tène was a positive step, in that it allowed archaeologists to trace the historical expansion of the Celts through the Danubian countries. But it had its drawbacks too. For a long time it hampered the recognition of earlier or even contemporary Celtic peoples that did not comply with this specific cultural framework.

A more complete and more subtle picture of the settlement patterns of the ancient Celtic population across Europe gradually emerged. First of all, an attempt was made to trace backward through time, admitting the Celtic ethos of the Hallstatt groups from which the La Tène civilization of the historical Celts was derived. Though solidly based for the sixth and even seventh centuries, the archaeological identity of the Celts becomes more speculative the

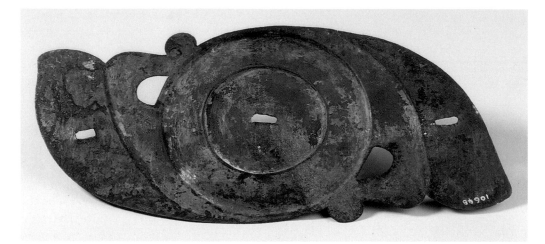

greater the distance from the reference points fixed in the written sources.

It is generally agreed that the date for the formation of Celtic languages may be pushed back to the Bronze Age (i.e., to the second millennium B.C.), but we have no means of identifying the Celtic-speaking peoples among the mosaic of anonymous cultures of that era.

The acceptance of the Hallstatt group occupying territories north of the Alps, from Champagne to Bohemia, as Celtic has not affected the idea that this vast area was the source of the conversion to Celtic culture of other regions where Celtic presence in the second half of the first millennium, is confirmed, directly or indirectly, by written or linguistic evidence. Evidence of this kind has provided new insights, fostering a general reappraisal of the entire picture.

A set of inscriptions in letters borrowed from the Etruscan alphabet came to light at a site of the so-called Golasecca Culture in northern Italy. Once they had been deciphered, the inscriptions proved indisputably to be in a Celtic language. Since the oldest of them is datable to long before the historical invasion of the Celts at the start of the fourth century B.C., the authors of the inscriptions must have been Celts whose archaeological assemblage is perfectly integrated with the peninsula's cultural context.

The discovery calls for caution, and its real significance is only beginning to be assessed. It is probable that it will enable us to set aside our distorted preconceptions and piece together all the information we have—from texts and other linguistic sources and from archaeology. It is already possible to sense the implications of a broader understanding of the Celts' role in the formation of ancient Europe.

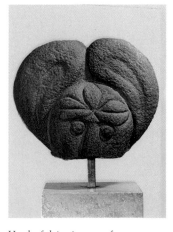

Whether speaking of the Celts or of any of the "barbarian" peoples of Europe, the same fundamental truth applies: the vague and faded traces of them found in the prehistoric grave sites take on color, life, and meaning only when they have been illuminated by the rays of the written cultures emanating from the Mediterranean area. Since virtually nothing remains of Punic and Etruscan literature we owe everything we know for certain about the ancient Celts (apart from archaeological finds) to the testimonies of the Greeks and, later, the Romans; this written inheritance is completed by only a few inscriptions.

In Ionia, geography and ethnography began to develop in the second half of the sixth century B.C. The first testimony of the Celts can be traced to this time: they are mentioned by Hecataeus in about 500 B.C. (FGrHist. 1 frag 56). It is possible that he knew the Celts living inland from the Ligurian coast of Massalia (Marseilles). Avienus, the poet of late antiquity, can probably also be dated to the sixth century B.C.; he cites the Celts as being enemies of the Ligurians based further west (*Ora marittima* 4, 132-134). Only a few, short, fragmented passages remain from Hecataeus's work; however, it has been established that it contained no ethnographic descriptions of the Celts: at the time, this tribe was still regarded as a simple and marginal phenomenon, one of many European tribes, and, as such, not worthy of particular attention. The same can be said of Herodotus, whose historiographical work was concluded in about 400 B.C. Possibly quoting from Hecataeus, he says that the Danube has its source in the territory inhabited by the Celts. This territory of the Celts extended as far as the shores of the ocean to the west, where it meets the land of the Cynetes (or Cyneses of southern Spain); this suggests the existence of Celtic tribes in the Iberian peninsula, or on the Atlantic coast of France (Herodotus 2, 33, 3; 4, 49, 3). According to him, the city of Pyrene also stood near the source of the Danube. It would be an injustice to the work of Herodotus to suggest that he is confusing it with the chain of the Pyrenees. On the whole, in fact, his writing shows that he had a good knowledge of the course of the Danube across Europe. It is certainly no coincidence that, by following his directions, we arrive in the center of the western part of Hallstatt. Trade between the tribes in this area and the tribes of the Mediterranean, especially the extremely active Greeks of Massalia, meant that people in the South knew about the Celts as early as the sixth century B.C.; then again, one can consider the ancient trade route which followed the course of the Danube as far as the Black Sea, arriving in an area that had been colonized by the Greeks; it is, therefore, quite possible that the valley of the Austrian section of the Danube was also one of the first areas to be settled by the Celts. In any case, Herodotus cannot provide us with ethnographic information about the Celts. Until the fifth century B.C., therefore, the Celts were only a tribe on the fringe of the Greek world. As for the Greeks, all they knew about them was their name and where they had settled.

Nevertheless, the Celtic world and the Greek world were coming closer. The last conclusive waves of Celtic migration to the Po Valley took place at the close of the fifth century B.C. Northern Italy became *Gallia Cisalpina*, coinciding with the end of Etruscan towns in that area. News of the sacking of Rome by the Gauls in 390 B.C. also reached Greek historians (for example, Theopompus FGrHist. 115 frag. 317). Now that they were inside mighty Gaul, the Celts began to push south, giving rise to the gradual spread of the Celtic culture in southern Gaul; Massalia itself was threatened several times, but managed to establish good relations with them. From at least the fourth century B.C., the Celts had thus acquired a reputation for being brave and extremely aggressive soldiers, and were employed by the Carthaginians, the Etruscans and the western Greeks as mercenaries. After the battle of Leuctra in 371 B.C., Dionysius I, the tyrannical ruler of Syracuse sent an expeditionary force to the aid of the Spartans, composed of Celtic and Spanish mercenaries (Xenophon, *Hellenica*, 7, 1, 20, 31); this is the first testimony of the appearance of the Celts on the Greek mainland. As a result, we find the first attempts at ethnographic description in works by Greek authors of the fourth century B.C. Plato describes them as bellicose, but also as excessive drinkers of wine (*Nomoi*, 1, 637 d); Aristotle, too, praises their temerity and the rigid discipline to which they were subjected from childhood onward (*Politica*, 7, 2, 5 p. 1324 b 12; 7, 17, 2

p. 1336 a 18), and refers to them as examples of the greatest courage, yet lacking in intelligence (*Etica Nicom*, 3, 10, 7 p. 1115 b 28; *Etica Eudem*, 3, 1, 25 p. 1229 b 28). Theopompus mentions them in his historiographical work (frag. 40, the earliest mention of the existence of the Celts in Illyria, 202; see above). The historian Ephorus mentions them as being inhabitants of Western Europe (FGrHist. 70 frag 30; 131), and emphasizes their military valor and their absolute fearlessness (frag. 131; 132: as proof of their courage, they calmly awaited high tide at the edge of the sea, thus losing many more lives than in war) and obviously on account of their good relations with Massalia, describes them as friends of the Greeks (frag. 131); his lost historiographical work contained what was, perhaps, the first ethnographic description of the Celts, and featured long-standing generalizations about barbarian tribes of the north, as if he still had a rather vague, patchy knowledge of the subject. The opinion of the Western Greek historian Timaeus agrees with this picture of the fourth century B.C.: he regards the Celts (in Greek: Galati/Galatians as descendants of Galate, son of the wild and bloody cyclops Polyphemus and the nymph, Galatea (FGrHist. 556 frag. 69). Unfortunately, the account of the journey of Pitea, who sailed round Gallia, Britannia and Northern Europe, has also been lost.

The expansionist pressure exerted by the Celts was not only directed toward the west and south, but also toward the east and southeast. The events of 335 B.C. lead us to suppose that, by means of the ancient trade route along the Danube, Celts from the Danube area soon came into contact with the Balkan peoples, the Thracians, Macedonians, and Greeks. By 380 B.C., they were already fighting the Ardiaioi tribe, who inhabited southern Dalmatia (Theopompus frag. 40). In the light of these events, and the presence of Celtic mercenaries in Greece as well as western Greek contacts with the Gaulish world, the claim that Philip II of Macedonia was assassinated with a dagger of Celtic shape or origin, the *chéltiché machaira* (Diod. 16, 94, 3) might even have had some foundation. In 335 B.C., Philip's son and successor, Alexander the Great, in the thick of his military campaign in the Balkans and the area of the Lower Danube, was approached by a delegation of Celts who must have been based roughly in the area of modern Slovenia or in the Dalmatian hinterland. This delegation, so the contemporary Ptolemy relates, made the memorable boast to Alexander that the Celts feared nothing on earth, except that the sky might fall down (Ptolemy, FGrHist. 138 frag. 2; Arrian, anab. 1, 4, 6-8). From this time, at the latest, and possibly from as early as 380 B.C., the gradual spread of Celtic influence to the valleys of the eastern Alps and Pannonia began. But nothing of this has been handed down to us; in the following decades, all the attention of the Greeks was concentrated on the gradual discovery of the east, through the campaigns of Alexander, who penetrated as far as India. Nevertheless, very soon news of the Celts was arriving with increasing frequency, on account of their push towards the southeast. Already in the time of the Diadochoi, there had been battles against wandering Galatian hordes, and in about 280 B.C., there was a dreadful incursion on the part of barbarians in Thrace, Macedonia and Greece. Some of them also reached Asia Minor, occupied the area later named Galatia and, for decades, constituted a ferocious enemy for the cities on the Greek coast. The dangerous threat that these fearless and terrible predators represented (the *furor Gallicus* was the precursor of the *furor Teutonicus*) was to characterize the Celts in the eyes of the Greeks for a long time. The poet Callimachus regards them as a tribe incapable of thinking or reflecting and goes even further than Timaeus on the subject of their mythical descent from a cyclops, saying that the Galatians were related to the Titans, the gigantic and ancestral rebel enemies of the Olympic gods of light and order (hymn. 4, 173f, 184). Even the sovereigns of Pergamum must have nurtured a similar belief when they celebrated their victories over the Galatians in the frieze above the great altar featuring the battle of the Titans.

Unfortunately, apart from a few passages by Polybius, the entire history of the Hellenistic period, like the ethnography and geography, has been lost. The *Geographika* by the great scientist Eratosthenes, who wrote about western and northern Europe, has been lost, as has the monograph in thirteen volumes by Demetrio of Byzantium (FGrHist. 162) about the movement of the Celts into Asia. The same applies to the epic poem by Simonides of Magnesia (FGrHist

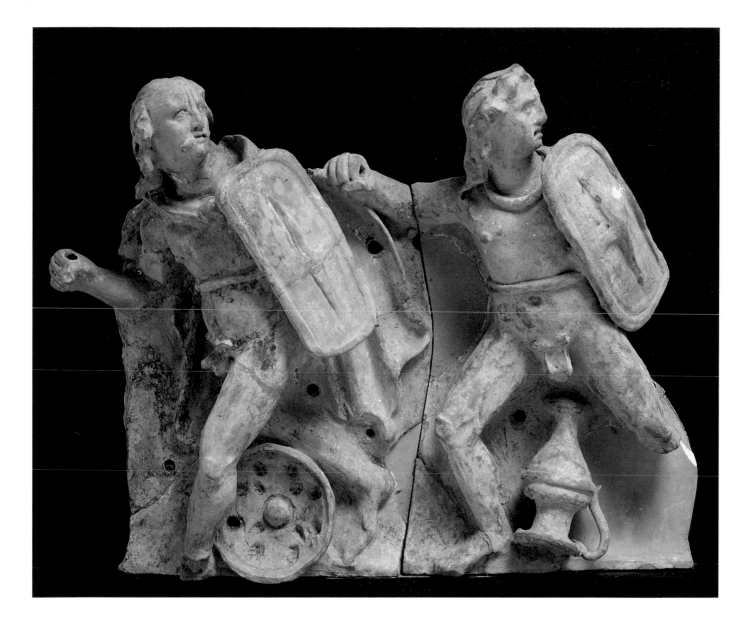

Part of stone frieze from Civitalba (Marches) depicting Gauls fleeing after sacking a sanctuary Early 2nd century B.C. Ancona, Museo Nazionale Archeologico delle Marche

163, late third century B.C.) about the war between King Antiochus I and the Galatians. It is possible that in the third century B.C. Philarkus supplied an ethnography of the Celts and the Galatians in his historiographical work (see FGrHist 81 frag 2). The several volumes of *Galatika* by Eratosthenes the Younger, written in the second century or later, have also been lost (FGrHist 745). The same subject may have been discussed by Cletophones of Rhodes (FGrHist 291). It is interesting to note that Poseidippo, a playwright of the third century B.C., was the author of a piece entitled *Il Galata*, but this, too, has been lost. The poet Euphorion, again in the third century B.C., mentions the *Gaesatae* (frag. Groningen). Hellenistic lore passed down the history of the city of Herakleia on the Black Sea, written by Memnon during the time of the empire, and a part of this survives in an extract from the patriarch Photius (FGrHist 434); it contains precious information about the Galatians of Asia Minor. In general, however, the image we have of the Celts from the Hellenistic culture was built up in a context of wars and constant fear of brutal aggression. The picture we have, then, is of a wild, barbaric, fearless, implacable tribe. Geographically, they were regarded as inhabitants of western Europe, but also of central Europe and the north as far as the land of the Scythians. The Germanic tribes living beyond this "Celtic belt" on the whole remained unknown to the South, and when news of them filtered down to the Mediterranean, they too were generally regarded as Celts. This

was so until the coming of the Cimbri and the Teutons and even later. From the fourth century B.C. onward, the Celts constituted a constant danger for other tribes as well; in fact, their name became a synonym for the threat of hordes of barbaric plunderers. This was the case of the Italici and Rome among others. In fact, Rome had founded its greatness on its role as outpost and protector of the Italian farmers from the continual threat of military attacks and raids by the Gauls.

The power unleashed by the Celtic world, embodied particularly by the brute force of the *Gaesatae*, was subdued by Rome. The city on the Tiber eventually progressed from defense to attack and, from the middle of the third century B.C. on, began to conquer Cisalpine Gaul. Since the beginning of Latin historiography can be traced to the end of the third century B.C., we have the first written testimony of the image that the Romans had of the Celts. However, apart from a few fragments, all the pre-Livian records have been lost; for example, the description of the duel fought between Titus Manlius Torquatus and a Gaul, by Claudius Quadrigarius (frag. 10a and b Peter; see also frag. 12, which should perhaps be attributed to Valerius Antias). Sadly, the historiographical work of Cato the Elder written in the second century B.C. has also been lost. In this work, he followed the traces handed down in literature about the peoples and cities of Italy and, from what we understand of the surviving fragments, also mentioned the Celtic tribes of northern Italy. His portrayal of the Celts is famous: the Gauls pursued two ideals with great fervor: valor in combat and talking common sense (frag. 34 Peter). Otherwise, we can only get an idea of the earliest picture the Romans had of the Celts from what Livy reported in the Augustan period and from the writings of Polybius. The work of this Greek historian of the second century B.C., who spent much of his life in Rome, is largely conserved in the original. It contains not only a series of well-written accounts, such as the grandiose description of the *Gaesatae* and the battle of Telamon in 225 B.C. (Polybius 2, 27-31), but also a brief, yet extremely interesting ethnographic description of the Celts of northern Italy (2, 17, 3-12). Here, Polybius supplies us with a concise but useful description of the Celtic hierarchical system, although he tends to exaggerate when, for example, he attributes only unfortified villages and private dwellings bare of any form of furnishings or fittings to the Gauls. This description is certainly not applicable to the Celts living in northern Italy in the second century B.C.; it is possible that he borrowed it from earlier Roman literature (Fabius Pictor and others). In fact, in its exaggeration of the Celts' primitive living conditions this description reflects a picture of the marauding, barbaric Celts which was widespread in the minds of Italic farmers of the period. It is also possible that his description contains influences from stereotypes of Greek literature.

Rome shook the power of the Celts. This applies to northern Italy, the Galatians of Asia Minor, the Celts of the Iberian peninsula and, lastly, to Gaul. After its victory over the Allobroges in 121 B.C., Rome destroyed the powerful kingdom of the Arverni under King Bituitus, which extended from the Pyrenees to the Rhine. The Arverni themselves were set free, but the valley of the Rhône and the French Mediterranean coast became a Roman province. In his oration *pro Fonteio* (69 B.C.), Cicero provides us with an interesting description of how, fifty years after its conquest, the new province had been economically subdued and exploited by the Romans: a large number of Roman merchants operated there, no Gaul could do business unless accompanied by a Roman citizen, and no money could change hands without registration in the trade ledgers of Roman citizens. In the same oration, Cicero did not conceal his negative opinion of the national characteristics of the Celts.

The wars against the Arverni and the conquest of Gallia Narbonensis had re-awakened interest in the Celtic world, and the colonization of the new province proffered new areas of knowledge. Not long afterwards, mortal danger drove the meaning of the European "barbarian" powerfully home. Toward the end of the second century B.C., the Germanic tribes of the Cimbri and the Teutons invaded Gallia Narbonensis and Italy itself. At that time, the Romans and Greeks did not yet know the concept of "Germani," neither did they have a specific name to denote these people. These migratory tribes were therefore regarded as Celts,

and threatened the continuation of the Gaulish surges of the fourth and third centuries B.C. This new concern reached its height in the studies of the great scholar, Posidonius (in about 135-51/50 B.C.), who was not only a great Stoic philosopher and a discerning historian and geographer, but also one of the most important ethnographers of all times. He knew the Celts from his travels which had taken him at least as far as Gallia Narbonensis and he spoke of them from first-hand experience (FGrHist. 87 frag. 15; 16; 17; 18; 33; 55). Large excerpts of his ethnographic descriptions of the Celts remain. As well as the information in his accounts, we also have the descriptions provided by the works of Strabo and Diodorus. Posidonius seems to have been particularly sensitive to ethnic and cultural detail. He describes their receptive and courageous temperament, their frankness and a certain arrogance in their way of doing things, their passion for ornaments, their obsession with honor, their convivial habits, their beliefs in an afterlife, their excitability, their priests, and their bards, who sang of the feats of the king and lords in improvised verses. He also drew attention to the importance attributed by the Celtic aristocracy to the custom of preserving the heads of enemies killed in battle as trophies (frag. 55; Strabo 4, 4, 5; Diod. 5, 29, 4-5). Posidonius reformed the earlier and patchy image of the Celts by creating a richer and more detailed one which was to remain the classic image of the Celts in ancient times. Posidonius's descriptions illuminate the obscure beginnings of the history of the Celts. It is only through his work that the inanimate objects and burial finds of the late La Tène period come to life. Through him, behind the archaeological evidence, we can recognize living human beings. It may be of interest to record here the account of Cicero, who relates that Diviziacus, a druid of the Aedui people, visited Rome in 61 B.C. and was met by Cicero and his brother; they discussed details of druidic doctrine.

From 61 B.C. onwards, the name "Germani" began to be used to refer to non-Celtic tribes east of the Rhine, a term that probably derived from northern Gaul. However, this Roman innovation was not used readily by the Greeks, so that later on, the Germani were referred to as Celts. We must, therefore, not be confused by the fact that Dion refers to Ariovistus as a Celt. Caesar's military campaign in Gaul (58-51 B.C.) opened up a completely new approach to research on the Celts. At that time, Gaul became part of the Roman world, both politically and economically, and the Roman army pushed up into the almost legendary Britain and the area beyond the Rhine. Now the Germanic tribes were recognized as being different from the Celts, and became a well-defined political entity. This new awareness was reflected first of all in Caesar's memoirs of his campaign against the Celts of Gaul, his *Gallic War*, which, fortunately, has come down to us. As well as a series of isolated details, here it is important to mention the great digression in the sixth book, in which Caesar proposes a comparison between the Gauls and the Germani, with the aim of distinguishing the two tribes (b.g. 6, 11-24; the passage about the Hercynian uplands is not authentic). Caesar may be credited with having introduced the concept of Germani to the scientific literature of ancient times. He also described the Britanni (or the British) (5, 12-14, although there is some doubt as to the authenticity of the passage). But, more than anything else, Caesar was an expert on Gaul, and in his writings he displays a high level of ethnographic expertise, rivaling that of the greatest masters of this discipline. Modern research is generally inclined to believe that Caesar dipped into literary sources on this subject, Posidonius in particular. But, in my opinion, this has not yet been clearly demonstrated. On the contrary, Caesar's writing contains some highly original work. The subjects he deals with have very few parallels in the work of Posidonius, while Posidonius supplies an enormous quantity of precious and detailed information on other topics of which there is not a trace in Caesar's work. It is possible, therefore, that by writing his Gallic ethnography, he intended to complement the work of the great scholar. Caesar concentrates on three aspects: politics, society and religion. And, as far as his writing on political and sociological matters is concerned, his reflections and factual observations constitute some of our most perceptive and important records on the Celts. His description of their system of patronage and the almost total dependence of the common

people on the aristocratic classes (b.g. 6, 13, 1-2) has often been considered a distortion of, and contradictory to, what is commonly known about the hierarchical organization of Celtic society. But here, Caesar (who elsewhere describes the institutions of the Celtic "court" in a very objective way) does not intend to provide a description of the Celtic "court" in general, but limits himself to a precise period in the history of Gaul, and, more precisely, central Gaul.

In the second century and early first century B.C., a radical change had taken place, with many consequences: the infantry, together with the war chariot, which up to then had played the leading role in battle, now lost much of their importance in favor of the cavalry. As a result, this wrought changes in the political role of the popular assembly; the military, political and economic superiority passed into the hands of the mounted aristocracy, who succeeded in upsetting the old monarchical system of most communities and concentrating power in their own hands. Caesar describes the degeneration of the ancient forms of patronage, an extreme situation which proved to be a particularly explosive mixture, politically and socially. The aristocratic republics of Gaul were, in fact, characterized by great internal instability. Here, Caesar's descriptions seem to be reliable in their penetrating and illuminating conciseness. Our knowledge of the Celtic world is based, therefore, on three main sources: Posidonius, Caesar and, now that Gaul was under Roman rule, those surveys that had become easy to carry out and of which there are echoes to be found in the works of later authors. The authors of Celtic ethnographies of the imperial period also based their work on these three sources, and it is important for us to know that the information they contain is reliable.

The historians and geographers of the Augustan period deserve special mention. Sadly, the work of the Greek Timagenes, about which there are long accounts in the writings of the historian of late-antiquity Ammianus Marcellinus (FGrHist. 88 frag. 2), has been lost. Timagenes might have played a key role in the revision and passing on of the legacy of Posidonius. The historian Diodorus offers detailed ethnological and geographical descriptions of Gaul and Britain (5, 21-22; 24-32), as does the geographer Strabo (4, 1-4; 4, 5, 1-4). Both accounts have been preserved (at least, part of the work of Diodorus) and both quote directly or indirectly—in part, possibly through Timagenes—from Posidonius, enriching this material (especially Strabo) with contemporary comments on Gaul and Britain. These are, in any case, the longest and most exhaustive ethnographies on the Celts handed down to us from ancient times. Dionysius of Alicarnassus also quoted from Roman records in his narrative on the Celtic attack on Rome (ant. Rom. 13, 6-12; see also the description of Gallia 14, 1). The most important reservoir of documentation is what remains of the monumental historical works of Livy (only for the years between the founding of Rome and 293 B.C. and the period from 218 and 167 B.C.). Here, Livy goes into great detail about all the battles between Rome and the Gauls of northern Italy, and also mentions particular episodes such as the Celtic invasion of the Veneto from the eastern Alps in 186 B.C. As for the accounts of battles between the Romans and the Gauls of Asia Minor, it is probable that Polybius was his source. The story of the Gallic invasions (Livy 5, 33, 2-35, 3) is especially interesting; here, Caesar's influence is obvious, but on the whole, Livy may well be quoting from detailed information provided by an earlier author, perhaps Cato the Elder. After Livy, a great history of the world was written by Pompeius Trogus, himself a Celt from Gallia Narbonensis, of whose work, sadly, only a short extract quoted by Justinus (third century A.D.) survives; he provides us with some interesting information about Gaul, taken in part from a story about the town of Massalia. His story of the Celtic invasions (Justinus 24, 4, 1-25, 11; see also 20, 5, 4-9; 32, 3, 6-12; 43, 4, 1-2) is the product of abstract speculations, possibly of his own invention, or possibly taken from a Greek or Roman source late in the Republic or the early imperial period (Timagenes?).

The post-Augustan period, in the first century A.D., provides us with a work containing a passage on Gaul by the Roman geographer, Pomponius Mela. Valerius Maximus, on the other hand, talks of the Celts' belief in an after-life (2, 6, 10). The epic poet, Lucan, provides us with information on certain Gallic cults that worshipped various deities (1, 444-465). Pliny the Elder also

handed down important information about the Celts, including details of druidic practices (Nat. Hist. 16, 249-251); here, we become clearly aware of the amount of detailed information available to early writers after the conquest of Gaul and Britain. The emperor Claudius had begun with the annexation of Britain in A.D. 43, while Cn. Julius Agricola, father-in-law of the historian Tacitus, led the Roman forces north as far as Scotland. When, at the end of the first century A.D., Tacitus wrote Agricola's biography, which was saved, he also traced the story of the Roman conquest, giving important information about the Celts of Britain.

Plutarch's work, written in the second century A.D., contains a few references to the Celts. We also owe isolated pieces of information to the military scribe, Polyainos (for example, 7, 50; 8, 7, 2). In his geographical work, Ptolemy the Greek mentions a large number of place-names belonging to the lands occupied by the Celts. Similar information is also contained in the *Tabula Peutingeriana*, the main part of which was probably written during the Augustan period. A great deal of information about the incursion of the Celts into Greece in A.D. 279 is offered in the description of Greece written by Pausanias four centuries later; his knowledge came from works of Greek historiography that have since been lost. Appianus, the author of a Roman history subdivided into single monographs, is a special case. In the part devoted to the Celts, he offers an overview of the battles fought by the Romans against Celtic and Germanic tribes; unfortunately, only fragments of his work have survived. They contain valuable information, for example, the superb description of an aristocrat of the La Tène culture in fragment 12, quoting directly or indirectly from Posidonius.

Of the lands inhabited by the Celts, only Ireland and Scotland had escaped Roman domination, but they did not arouse much interest among early writers, to the extent that, apart from Ptolemy perhaps, we only have a few sporadic pieces of information (the first mention of the Picts is made in A.D. 300 in *Laterculus Veronensis*, Geographi Latini Minores, A. Riese ed., p. 128). All of the other regions had been absorbed by the Roman Empire, and their history became part of the Roman Empire itself. Lack of space makes it impossible to mention here all the relevant literary sources; the same applies to all the ethnological references. However, in the works of Elianus and Atheneus, authors of the early third century A.D., we find a few isolated references of great relevance to earlier times. The *Ethnica* by Stephen of Byzantium (sixth century A.D.) saved many of the references made by earlier writers. Another historian of late antiquity who showed an ethnological interest in the Celts was Ammianus Marcellinus (mentioned earlier), who writing in the second half of the fourth century A.D., included a passage on the Celts (15, 9-12), taken from Timagenes and other, later, possibly contemporary authors. But, by then, the interest of Roman scholars had shifted to the Germani. This change in perspective had already been heralded by Tacitus in his *Germania*. As a whole, though ancient literature may have come down to us in somewhat fragmented form, it still offers a surprisingly rich and vivid range of material on the history and ethnography of the Celts.

As has already been mentioned, toward the end of ancient times interest in the Germanic tribes had largely replaced that in the Celts. The sources of ancient Mediterranean literature died out, but soon it was the turn of the literature of the early Middle Ages to provide information about Scotland, Wales, Brittany, and, in particular, Ireland. For the first time, we are listening to the voice of the Celts themselves: we no longer have to depend on literature— and fragments at that—based on the second-hand testimonies of outsiders. We know that the Celts, too, had a rich poetical tradition that covered religious narratives, sagas, philosophical and mythical doctines, as well as poetry for special occasions. But it was all part of an oral tradition, based on memory, of which regrettably nothing now remains. However, through the spread of Christianity, the Celts too acquired the skill of writing, which preserved material from their ancient tradition, such as the sagas, in books. What we discover here about the character of these people, and about the typical features of Celtic culture, about the bards, for example, often corresponds surprisingly to what we learn from ancient material from excavations and rare inscriptions, and with what the Greeks and Romans, often acting as interpreters of Celtic tradition, have passed down to us.

The Archaeological Sources

Archaeological remains from the second Iron Age (La Tène) found in those areas which, according to historical sources, were inhabited by the ancient Celts, constitute the material record of their history. It is direct but mute evidence, preserved by the land these people inhabited, tilled, or built on, by the lakes and rivers they plied. It is evidence yielded by various sources: cemeteries, habitations, fortifications, industrial worksites, places of worship, roads, bridges, river ports, coins and random materials. But it can only render a partial, patchy image of the reality of their time; it can only offer a glimpse of different aspects of their culture, and not a global picture. There are even fewer occasions on which it is possible to link this evidence to particular events, to definite figures, so that without the support of a specific written source, the history it helps to illustrate remains by definition anonymous. The value of the various clues also varies, conditioned by their very nature, by the circumstances in which they were found, by the type of soil and also by the insight and judgment developed by the archaeologist during his professional training. Advances in archaeology, in fact, end up being a reflection of how the archaeologist matured his thought processes.

It was in so-called "barbarian" Europe, where, compared with the rich Mediterranean and Middle Eastern cultures, there was less monumental evidence and writing had appeared late, that archaeology stopped being a mere illustration of history and became a self-contained source with methods and concepts all its own. In little over a century, in the wake of evolutionistic empiricism, there has been a move away from the vague "Celtic and Antediluvian Antiquities" of an antiquarian archaeology, not without its nationalistic implications, to a systematic form of archaeology in which the artifacts evolve, synchronically or di-

Aerial view of the Grossmugl barrow (Lower Austria) height 16 meters; diameter 55 meters Not yet excavated, the barrow probably contains a 6th-century B.C. tomb

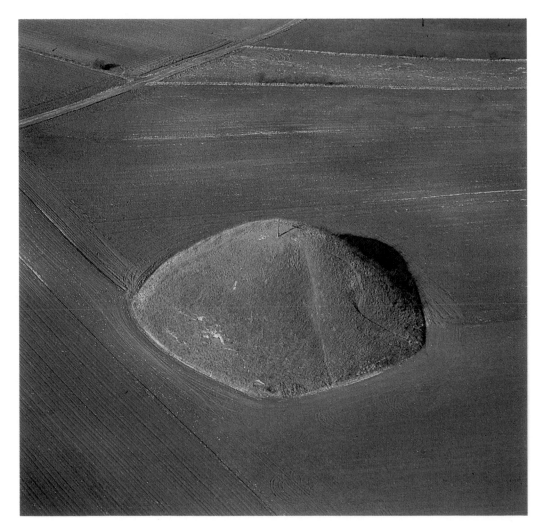

achronically, by categories of materials, by families of types. This link with the natural sciences, the prerogative particularly of pre-protohistory, is still to be found in the current trends toward an archaeology viewed as a comprehensive anthropological history in which the environmental sciences—geology, palynology, sedimentology, paleozoology, paleobotany—join hands with the anthropological sciences—biology, ethnology, demography, sociology—as well as the economic, technological, information, semiological and linguistic sciences.

These collateral sciences are applied to the whole cycle of archaeological activities, from the preliminary surveys to the actual exploration, from the analysis of the materials to the processes of dating, preservation and restoration.

General opinion tends to identify archaeological research with excavations. This romantic notion that draws on the sense of adventure, of excitement, of the unpredictable that accompanies the digging up of buried things, holds a grain of truth: excavation does take real precedence, because it is almost the only possible way to obtain complete information. But apart from chance finds, how does one go about excavating, with what means, to what purpose? With the help of archaeological prospecting techniques, complementary and preliminary to the actual excavation, the exploration can be carried out "intelligently" on the basis of both visible and invisible remains.

Part of the archaeological evidence we have comes not so much from under the ground as from the surface: individual monuments, some still in situ, like the Breton granite boundary; stones, others incorporated into or unearthed in Christian contexts, some of them already

Aerial view before excavation of the "La Perrière" cemetery with its rectangular and circular enclosures, at Saint-Benoît-sur-Seine (Aube) 3rd century B.C.
Photo Jean Bienaimé

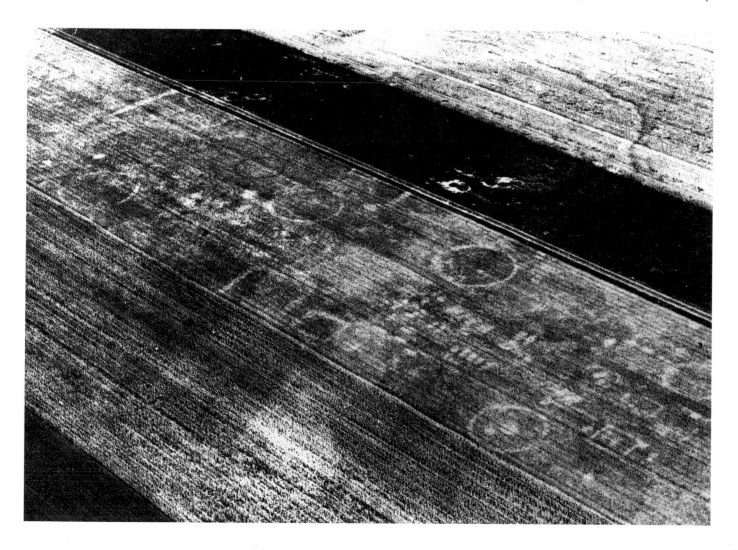

known in ancient times, like the Pfalzfed column in the Rhineland, which appears in a 1608 drawing. Other visible monuments include the thick dry-built walls that still barricade the headlands, jut into the Atlantic or enclose the Iron Age hillforts characteristic of Irish habitats. Elsewhere the whole countryside may be shaped by the remains of ancient ruins: ramparts, fortifications, tumuli are scattered around the Hallstatt princely residences, for example around the Heuneburg hillfort on the Danube or the Hohenasperg hillfort near Stuttgart. Rural landscapes are also still marked by the ancient divisions. In Great Britain, in the Netherlands, in Germany, all the way to Denmark, the so-called Celtic fields are to be found, roughly square parcels of arable land separated from neighboring fields by slight hollows. In prospecting the soil, the transition from the visible to the invisible remains is guided by a technique that began to be developed in the 1930s and 1940s: aerial photography. The vertical or oblique photographs make it possible to establish, select and clarify the contours of surface traces which, because of their patchiness or the unevenness of the land, seem to be fragmentary and incomprehensible at ground level. By highlighting color changes in the soil and the thickness of vegetation—depending on the underlying humidity—it is also possible to detect the existence of buried wall foundations, ditches, pits, road surfaces and embankments. Numerous remains from Celtic times have been discovered by this method: settlements, isolated farms, cemeteries, sanctuaries.

Chemical and geophysical analyses in turn can help locate and establish the size of ancient settlements by measuring, in the first case, the phosphoric anhydride content, in the second,

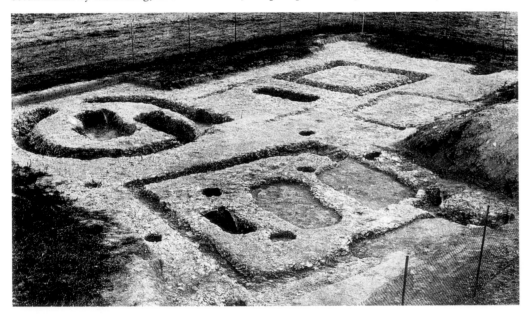

Enclosures of the "La Perrière" cemetery at Saint-Benoît-sur-Seine (Aube) during excavation 3rd century B.C.

the variations in electrical resistance between loose soil and solid rocks, or in the electromagnetic field of different bodies. Because of the rapidity and sureness of their results, these methods are particularly useful for exploring large areas where traditional methods had required a series of trial pits dug with mechanical means before the detailed excavation of a given area could be undertaken. Such was the case, among others, of the Manching *oppidum* between 1960 and 1970, when all of eight kilometers of trenches were dug before meticulous and extensive excavation was begun.

Analytical techniques are applied to virtually all the materials in all categories of objects, utilitarian and decorative (textiles, pottery, metals and metal alloys, amber, ivory, coral, glass), plant and animal remains. The purpose is not simply to come up with a generic identification, but to acquire essential historic and economic data: the material of which a given artifact is made can clarify its provenance, indicate commercial trends and trade routes, confirm its cultural significance... By the same token, plant and animal remains make it possible

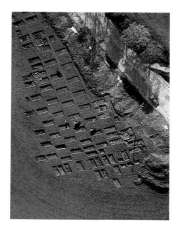

*Aerial view of excavations
at the Dürrnberg cemetery
near Hallein (Salzburg)*

*Inhumation tomb no. 1
of the "Les Vignettes" cemetery
at Marson (Marne) during excavation
5th century B.C.*

not only to distinguish between wild and domesticated species but to get a glimpse of how the farming and farmland were managed, how farm animals were kept, if they were raised for work or for slaughter, if there was a choice of species and breeds.

Another field of analysis that has undergone enormous development in recent years is dating. In terms of procedure, dating techniques have abandoned the principle of relative dating, which determines the order of events, in favor of an absolute dating, which can be applied directly to those events.

In the Roman world, dates were reckoned *ab urbe condita*, that is, from the founding of the city. Egyptologists went as far back as 3100 B.C. by perusing the list of pharaohs, with the result that the Egyptian objects discovered in Mycenae by Flinders Petrie at the turn of the century were dated 1500 B.C. Montelius succeeded in giving an absolute date to the beginning of the European Bronze Age (2000 B.C.) when in 1906 he extended cross-dating all the way from El Amarna in Egypt and Mycenae to the Tyrol, Pomerania and Sweden. This procedure, which became classical in archaeology, and in which the date of an imported object constituted a *terminus post quem* for the whole culture in which it was found, has, among other things, the drawback that the further one gets from the Mediterranean area, the less accurate the dating. Absolute dating techniques finally offer a means of control.

The radiocarbon method, which is based on determining the difference between the amount of a rare carbon isotope (C14) taken into organisms during their life cycle and its slow and regular decay after death, presents for the period in question a margin of error of over 100

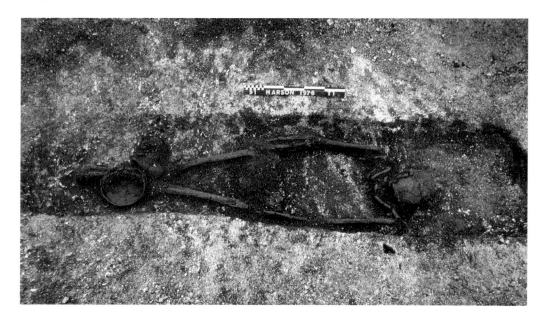

years, too large therefore to be of use. Dendrochronology, instead, supplies precise reference points. Developed by Douglass in the early 1900s, it is based on the study of the successive, more or less regular rings visibile on logs or sawn-off branches. Each ring corresponds to the annual growth of the tree and varies according to the dryness or wetness of the different years. The series of thinner or thicker rings is matched against a master plot of a given area. The size of the rings depends, however, on the species of the tree and its location, so in order to build up a plot extending over a long period of time only a particular area and a particular species can be taken into account. The central European series prepared for the oak at present goes back to 7683 B.C.

Tree-ring analysis can not only show the year the trees were cut down but also provide information as to the climatic conditions. For archaeologists the dating that results represents a *terminus ante quem*. The method, as applied to the La Tène period, provides interesting data: 430 B.C. for a timber from the pyre of the princely tomb of Altrier; 251 B.C for a beam

Cronology

		Champagne	Switzerland	Central Europe	
600 B.C.		Final Hallstatt I		Hallstatt D1	
	Late Hallstatt period	Final Hallstatt IIa	Hallstatt II	Hallstatt D2	
500 B.C.		Final Hallstatt IIb			
				Hallstatt D3	
– 460-440 B.C. –		Early La Tène Ia			
		Early La Tène Ib	La Tène Ia	La Tène A	
400 B.C.		Early La Tène IIa			pre-Duchcov phase
	Early La Tène period	Early La Tène IIb	La Tène Ib	La Tène B1	
		Early La Tène IIIa	La Tène Ic	La Tène B2	Duchcov-Münsingen phase
300 B.C.		Early La Tène IIIb			
– 270-250 B.C. –					
	Middle La Tène period		La Tène IIa	La Tène C1	
200 B.C.		Middle La Tène			
			La Tène IIb	La Tène C2	
– 160-140 B.C. –					
		Final La Tène I		La Tène D1	
100 B.C.	Late La Tène period		La Tène III		Oppidum culture
		Final La Tène II		La Tène D2	
– 50-10 a.C. –					
			Roman Gaul	La Tène D3	

46

Early Style

Orientalizing themes and motifs, inspired by the Etruscan repertory, compass-drawn decorations.
Compositions based on axial symmetry.
Maskenfibeln (Mask fibulae), gold torques, chariot fittings and phalera, belt-hooks, scabbards, wine jugs, sculpture.

450 B.C. ca. Herodotus Mentions Celtic settlements in eastern Europe and near the source of the Danube.

Continuous Vegetal Style

Also called Waldalgesheim Style. Elements borrowed from the Italic cultures are added to the basic repertory: use of the flowering stalk and the pèlta, the Celtic palmette.
Compositions with radial symmetry appear alongskide those with axial symmetry.
Use of coral for decoration; red enamel first starts to appear.
Helmets, sheathes and scabbards, chariot fittings, torques, armlets, fibulae with vegetal decoration, wine jugs, red-figure vases.

400 B.C. ca. The Transalpine Celts invade northern Italy.
387-386 B.C. The Battle of the Allia. The Celts take Rome.
369-368 B.C. Celtic mercenary activity in Greece.

335 B.C. Alexander the Great meets with a Celtic delegation on the banks of the Danube.

Plastic Style and Sword Style

Culmination of "plastic metamorphosis" (the blending of human, animal, plant and abstract forms).
Hellenistic influences.
Complex compositions incorporating various types of symmetry.
Metalwork reaches its highpoint with the lost wax technique, fake filigree, and pastillage (bronze imitation of granulation).
Colored glass bracelets and beads.
Sheathes and scabbards, torques, bracelets and anklets, fibulae, chariot fittings. The Brno Malomĕřice jug, the Bra cauldron.
The firt Celtic coins start to appear. They are directly inspired by Macedonian or Hellenistic models.

298 B.C. Celtic incursion into Thrace and defeat on Mount Haemus (Stara Planina, Bulgaria).
295 B.C. Defeat of the Senones at Sentinum.
283 B.C. Final victory of the Romans against the Senones.
279 B.C. The sack of Delphi.
278-277 B.C. Celtic groups migrate to Asia Minor.
275 B.C. Victory of Antiochus I over the Galatae of Asia Minor.

233-232 B.C. Wars between Attalus I of Pergamum and the Galatae of Asia Minor.
225 B.C. Roman victory over the Boii, Insubres and Gesetae in the Battle of Talamon.
213 B.C. ca. Probable end of the Celtic kingdom of Tylis Thrace.
191 B.C. Final defeat of the Cispadane tribe of the Boii, some of whom return to central Europe.

125 B.C. Founding of the Provincia Gallia Narbonense.
120 B.C. ca. The Germanic Cimbri and the Teutons overrun Celtic territories.

Celtic art in the Continent during the age of the *oppida*

Roman influences in the spheres of art and craftsmanship.
Painted pottery, sculptures from the south of Gaul, wood sculpture, Gaulish statuary in sheet bronze.
Peak of minting activities.

101 B.C. Defeat of the Cimbri at Vercelli.
85 B.C. ca. Roman victory over the Danubian Scordisci.
70 B.C. ca. The Teutonic tribe under Ariovistus invade the eastern part of Gaul.
58-51 B.C. Caesar conquers Gaul.
50 B.C. ca. Dacian victory over the Boii in Pannonia.

15 B.C. Drusus's Alpine expedition.
Rome conquers the Celtic territories south of the Danube.
9 B.C. Rome conquers Noricum.

of the so-called Vouga bridge at La Tène; 229 B.C. for a shield from the same site; 224 B.C. for the third pier of the Cornaux bridge below La Tène; between 120 and 116 B.C. for the second pier of the same bridge; between 225 and 65 B.C. for the timbers found in the salt mines of Bad Nauheim; 125 B.C. for the lining of the well at the Fellbach-Schmiden sanctuary; 105 B.C. for a structure unearthed in front of the east gate of the Manching *oppidum*; 33 A.D. for a wooden sculpture from the votive deposit at the sources of the Seine.

Most of the datings—however relative—are obtained through the stratigraphic interpretation of the excavations themselves. This method, borrowed from the natural sciences and in use from the dawn of scientific archaeology, is based on the observable fact that the vestiges of human life and cultures gradually accumulate and end up forming different ground levels. The layers are thicker or thinner depending on the duration in time and the environmental conditions. Simplifying, one can say that in horizontal sites, the earliest deposits are found on the deepest layer and the presence of different deposits on the same level proves they date from the same period. The stratigraphic method provides, therefore, two sorts of information: one diachronic, the other synchronic.

The Mannersdorf cemetery (Lower Austria) during excavation

The concept of contemporaneity was refined as the discipline evolved. If an archaeological layer is old and very thick, it may correspond to an extremely long period of time: years, sometimes centuries. On the other hand, in some cases it has been possibile to single out some precisely dated assemblages that correspond to a single, temporary occupation: a few hours, several days, a few months. Such is the case with "temporary occupation sites" and "closed assemblages."

A single interment grave is a "closed assemblage" by definition; it is, in other words, a group of objects—grave goods and offerings—that are to be taken as a homogeneous unit. The furnishings and parures found in the grave, though not necessarily manufactured at the same time—as in the case of the gold artifacts in the princely tomb of Hochdorf in which traces of on-the-spot work were found—were certainly deposited at the same time. So that for archaeologists, graves represent the starting point of a dating system based on the evolution of the types of objects found together among the grave goods; as types change over time according to fashion and the succession of new generations, it is possible to reconstruct—at least theoretically—the development of the cemeteries and to establish the rhythm and duration of human life in the settlement. In actual fact, this reconstruction turns out to be relatively unreliable for various reasons. Doubts arise as to the length of time certain kinds of artifacts were used (some were insensitive to changes in fashion), difficulties in distinguishing between artifacts made by different craftsmen and from different workshops and differences due to chronological evolution. Typological dating is limited by the fact that in certain periods objects can change shape very quickly, whereas in others shapes remain the same for a long time. These changes, which archaeologists interpret as chronological breaks, are not necessarily evenly distributed in time. If the change is rather clear-cut and appears in different classes of objects, it can be interpreted as marking a new phase.

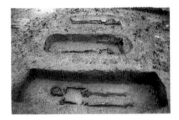

Group of Gaulish inhumation graves in Bologna-Arcoveggio during excavation (winter 1987-1988) First half of 3rd century B.C.

The formulation of dating systems based on typological criteria obviously started from the most obvious distinctions, such as the raw material used in making the various objects. In this way, Christian Jurgensen Thomsen, curator of the national museum of Denmark, in 1816 classified the archaeological collections according to three great periods: Stone Age, Bronze Age, Iron Age. Around the middle of the century, the Iron Age was assigned to the Celts. The first subdivision was based on the difference between the materials found in the cemetery of Hallstatt in Austria, first published in 1868, and those of the lake site of La Tène in Switzerland, explored in 1858. In 1872 Swedish archaeologist Hans Hildebrand drew the distinction between a first Iron Age which he called the Hallstatt period, and a second Iron Age which was given the name of La Tène and which already in 1871 at the International Conference of Anthropology and Prehistoric Archaeology of Bologna had been associated with the Celts mentioned in the ancient literary sources.

In 1885, Otto Tischler, in turn, subdivided the La Tène period into three phases—Early (I),

Middle (II) and Late (III)—on the basis of the different shapes of fibulae and swords. La Tène I was distinguished by free-pin fibulae and relatively short swords with chapes which were usually perforated, La Tène II by fibulae with the pin attached to the bow and swords with solid chapes, La Tène III by fibulae with perforated catchplates and much longer swords, often with rounded points and scabbards reinforced in a "ladderlike fashion" by numerous horizontal bars.

This system, on the whole reliable despite the many exceptions, was adopted everywhere and further perfected by various scholars, in accordance with local styles. It could be applied with little change to the Celtic materials in France (Joseph Déchelette, 1914) and Switzerland (Jakob Wiedmer-Stern, 1908 and David Viollier, 1911). In Switzerland, the exploration of the Münsinger cemeteries made a further subdivision possible: the first two phases were now broken down into La Tène Ia, Ib, Ic and IIa, IIb. In Bavaria, instead, the situation was different: there, the existence of two perfectly distinct groups of material from Tischler's first phase—an earlier group related to the tumuli, a later one from inhumation cemeteries of the type already found in Champagne, in Switzerland and Bohemia—led Paul Reinecke to propose marking out an early phase datable from the fifth century B.C (La Tène A). The subsequent phases—La Tène B, C and D—more or less followed Tischler's typological series. This dating scheme, particularly popular with German scholars, was further refined by Werner Krämer (1964), Hardmut Polen (1971) and others. Local factors or the situation of individual cemeteries—such as Champagne (Hatt-Roualet, 1976), Italy (Kruta, 1980) or the cemeteries of Jenišův Újezd in Bohemia (Kruta, 1976) — led to the development of further detailed datings. Today, however, the indispensible link to historical fact, particularly with regard to those peoples in contact with the classical world, is such that the schematization of typological periods is set aside in favor of absolute dating.

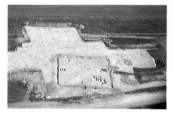

Aerial view of enclosed quadrangular cemetery of "Orgeval" in Sommersous (Marne) 3rd century B.C.

While chronological classification offers the set grid for pigeon-holing archaeological events, it does not however exhaust the exploratory possibilities. A grave is not only an individual unit but is usually a part of a whole—the cemetery—which reflects the social community in a distinct period. The grave goods found in a tomb do not necessarily sum up the dressing and working habits of a human group, since they represent a symbolic choice whose criteria elude us. For example the torques, mentioned in all ancient sources as the distinctive element of Celtic male dress, are not to be found in any Celtic warrior graves of the fourth to third century B.C. There are only a handful of exceptions, a few tombs with unusual iron torques. Even so, a great deal of information can be gleaned from burial grounds as a whole: the way the land occupied by the cemetery is organized and used, the chronological development, the tomb typology, the burial rites, anthropological and demographic data. For instance, the information which indicates the intermittent use of cemeteries in particular Celtic areas, like Champagne, Bohemia and Bavaria between the end of the fifth and the beginning of the fourth century B.C., can rightly be linked up with the great migrations to Italy and the Balkans. In the latter areas, where the expansion is documented by historical sources, the problem arises as to how to tell the difference archaeologically between the native graves and the graves of the newcomers. Apart from a few ancient, isolated instances in which the graves of the invaders differ sharply from those of the local populace, the blending of the two goes hand in hand with the process of cultural assimilation. At present, surveying the cemeteries and their location is one of the first things to be done on an excavation site.

Habitats offer a source of information, irregularly and unsystematically exploited in the past, but no less precious than cemeteries. But archaeologically speaking, they are the result of an opposite phenomenon. Whereas tombs, like votive hoards or deposits, are simultaneous depositions, hence "closed assemblages," habitats are instead the result of a sedimentation, of an accumulation of successive elements: lost, discarded or abandoned objects. As with most Bronze and Iron Age habitats, very few remains are left on the ground in Celtic settlements: trenches filled with debris, remains of open fires, post holes. Interpreting them is particularly difficult in sites that have been uninterruptedly occupied, because the constructions

will very likely have been superimposed, rebuilt or reoriented. Remains found on the same level, which give archaeologists the so-called "horizontal stratigraphy," make it possible to establish the earliness or lateness of buildings only when they are superimposed. Still, vertical stratigraphic readings are virtually nonexistent in Celtic habitats. Even in the great *oppida*, such as Manching or Staré Hradisko, there is a relatively shallow anthropic layer over the virgin soil in which the traces of later constructions are embedded.

Because of these difficulties, past generations of archaeologists neglected the excavation of protohistorical tombs. The only exception were fortified settlements, *oppida* in particular. The easy access to enclosure walls and ramparts buried in the earth, the certain wealth of remains guaranteeing interesting finds and above all a great abundance of coins, attracted

Excavation of the oppidum of Staré Hradisko (Moravia)

Aerial view of the circular oppidum known as the "Camp de la Cheppe" (Marne) 3rd-1st century B.C.

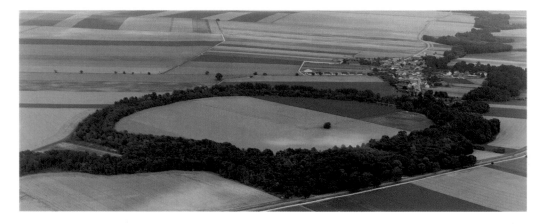

the attention not only of professional archaeologists, but also of amateurs, collectors and dealers, who sometimes—as in the case of the Bohemian *oppidum* of Stradonice—risked destroying them completely.

The excavation of settlements changed completely after World War II, as vast areas could be explored with the help of earth-moving equipment. Differences in color and texture of the ground beneath plowing level, touching on virgin earth, made it possible as well to identify rural dwellings and their territorial layout.

Technical installations, situated outside the habitations—river ports, roads, bridges—and industrial installations—metal ore mines, salt mines, open air sapropelite mines—though limited, began to be better known.

Excavating places of worship remains one of the most delicate issues, in that it is justified only when there are unmistakable traces of religious activity. In the history of this particular specialization, however, the adjective "cultural," applied to both objects and social structures, was often used to conceal ignorance and the inability to conceive different explanations.

In the light of recent discoveries, the archaeological characteristics of Celtic places of worship have begun to emerge. Open-air sanctuaries bounded by square stockades, sacrificial pits, sacred springs, temples with porticoed *cella* have all been identified and explored.

Regarding the deposits of objects—coins, parures, weapons, and so forth—a number of presumptive interpretations are possible: accidental loss, hoards, votive offerings... The context and nature of the site can sometimes suggest the right interpretation, as was the case with the "Duchcov treasure" in Bohemia, where the roughly twenty-five hundred fibulae, bracelets and rings deposited in a thermal spring seemed to point to a votive act. On the other hand, the interpretation of the weapons, unearthed in large quantities at the La Tène site in Switzerland, still remains controversial: was it a place of worship, a toll, or artisan workshops wiped out by a flood?

Isolated finds often have an importance that surpasses their intrinsic value, suggesting as they do sequences, correlations, occupancies.

Aldo Luigi Prosdocimi
In collaboration
with Patrizia Solinas

The Language and Writing of the Early Celts

The parameters that are used to study what is Celtic are of a historical, linguistic, archaeological and cultural nature; I am speaking from the linguist's point of view and, as such, with sectorial choices that are nonetheless not quite arbitrary. I must also add that viewing the matter from the disciplinary perspective does not exclude the overall history which is a right and, even more, a duty of anyone who is at work where man is concerned.

If what I believe about the Celtic language in Italy is true—that it was a fully developed language spoken by resident populations and not by mere individuals, long before the fateful year of the Sack of Rome by Brennus in about 390 B.C. (and this now seems certain)—the fact has inestimable repercussions not only on the Celtic civilization in Italy, but also on Celtic civilization *tout court* in its very being, which for me is synonymous with its process of formation. Since the late forties, with particular intensification in the last twenty years, there have been important developments, quite upsetting in certain aspects (and this is no exaggeration), from areas totally different from those of "canonical" Celticity, known also as "insular" because it refers to the British Isles where spoken Celtic languages and dialects have survived up to the present day, or to a very recent past. I should point out in passing that the Breton language of French Britanny is usually considered insular because it is held to be influenced by the areas of England on the opposite side of the Channel (though there is not total agreement on this point). Before tackling the new developments, and in order to see them in their true light, I feel I must first mention the standard knowledge based substantially on Insular Celtic—that is on recent Celtic—with a few elements of Continental Celtic, in practice old Gaulish as it was known at the beginning of this century. This knowledge in fact dates back to the early years of the century and is based on two exceptionally fine works, still fundamental and which no one has managed to replace: the *Vergleichende Grammatik der keltischen Sprachen* by Holger Pedersen and the *Handbuch des Altirischen* by Rudolph Thurneysen. Later works on the *Langue Gauloise* (Dottin 1920) and the *Dialects of Ancient Gaul* (Whatmough, 1950 foll.) have not changed the picture, nor could they have done so in the way that the developments of the last forty years can do—and partly are doing. But first, as I said, the canonical picture. The linguistic classification divides the Celtic group into Insular, which is still spoken, and Continental, made up of languages that became extinct in antiquity and have been handed down in epigraphs and personal names. In fact traditional linguistics based the classification almost exclusively on the languages belonging to Insular Celtic; this led to a subdivision of the Celtic languages into two groups, the discriminating element in this subdivision being the different fate of the Indo-European unvoiced labiovelar *κw. This developed into a velar (q) or a labial (p), hence the distinction between a "Celtic q" (or Goidelic) and a "Celtic p" (or Brythonic).

Goidelic includes first of all Irish, of which the oldest documents are the so-called Oghamic inscriptions (after the type of alphabet used), which date back to the fourth century A.D.; subsequently three phases may be distinguished: Old Irish (up to the tenth century), Middle Irish (from the tenth to the fifteenth century) and Modern Irish (from the fifteenth century to the present day); other Goidelic languages are Scottish Gaelic, taken to Scotland in the sixteenth century by speakers from Ireland, and Manx, which is now extinct. The Brythonic group includes the original Celtic languages of Britain, that is Welsh or Cymric and Cornish from Cornwall (which became extinct in the eighteenth century); also, it would appear that another member of this group is Breton, spoken in the extreme northwest of France (the hypothesis is that it was brought there, around the fifth century, by Britons who had crossed the Channel under the impulse of the Anglo-Saxon invasion).

Due to the great lack of proportion between the traces of Continental Celtic—which are very few and difficult to interpret—and the sources of Insular Celtic—composed largely of living languages, supported by a very rich tradition—comparative grammar has worked substantially on the basis of Insular Celtic, which has thus become synonymous with Celtic *tout court*. But it is clear that reconstruction operations based exclusively on this source cannot be other than partial, besides it is to be expected *a priori* that classification parameters—such as the

q ~ p opposition—deduced from Insular Celtic alone (if we except a few Gaulish contributions)—cannot be applied indiscriminately to the rest of the linguistic varieties, nor can it become a fundamental element of distinction for attributing or not attributing a given variety to the Celtic group. So, in this traditional picture too, Continental Celtic should not be seen as a series of additional facts, but as a reason for revising and rethinking the linguistic definition of Celtic.

In traditional Celtology, Continental Celtic was identified with Gaulish, which is very poorly documented and not very clear; over the last decades, revisitations and new discoveries have enormously increased the Gaulish sources and have in fact (re)discovered two other areas that have handed down varieties of Celtic through epigraphs (and partly in personal names and place names): these areas are Iberia, in particular with the Celtiberic inscriptions, and northwest Italy with the "Lepontic" and Gaulish inscriptions. The most important news comes from these areas. What is more, it does not concern only the languages since, although the data are deduced from linguistic documentation, they must be assessed in the consequent historical context: this refers to the dating of the first traces of Celtic presence in Italy, which has been situated even earlier than previous knowledge allowed, thanks to revised interpretations of epigraphic materials.

The recent news on "Gaulish" is apparently only documentary, with an increase in material that is exceptional in both quantity and quality, offered by the Chamlière inscription and, even more so, the Larzac inscription (the obvious references are the Etudes Celtiques, the Monuments Piot and the Requeil des Inscriptions Gauloises)[1]

So the real innovations are those inferred from these acquisitions, from the revision of old knowledge, from the recovery of indirect Gaulishness and from other similar sources: they are theoretical and methodological innovations which lead us to reconsider a linguistically compact Gaulish tongue, to be contrasted with another non-Gaulish Celtic tongue. Gaulish is not linguistically compact, but is variegated as one might expect from this historical situation—which is unfortunately underestimated if not ignored by linguists—so the Gauls were subdivided into peoples (or tribes or other such divisions) to an extent that was perhaps not exceptional for the ancient world, but which is certainly not contemplated nor can it be contemplated by anyone using the simple label "Gauls." And again: not only were the Gauls subdivided, but the units into which they were subdivided broke up in turn with mobility and transfers which separated these sub-subdivisions by quite considerable distances. In spite of this historical picture and in spite of the variety of dialects within so-called Gaulish, as comes through from the new documentation (and from the old, revisited), linguists are still slow in considering the concept of variety: the change of mind should lead to a reshuffling of the cards of linguistic variety within Celtic and not between Celtic units, incorrectly considered as compact, and other varieties, just as incorrectly considered compact.

Celtic Presence in Italy

For established historiography, "Celts in Italy" means Gauls, that is an ethnic group from beyond the Alps which arrived, as a result of invasions, around the year 400 B.C. This chronological picture is decidedly incorrect; however the historiographic picture behind the innovations, which are essentially linguistic, is not clear yet, also on account of the negative heredity of reconstructions of the past.

"Lepontic"—this (semi-)conventional name is used to refer to the language, known in a non-Latin alphabet, in pre-Roman inscriptions concentrated especially around the lakes of Lombardy—is indubitably Celtic (Prosdocimi 1967; Lejeune 1971; revisions of this concept are in progress: Prosdocimi *passim*); traditionally not ascribed to the Gauls, this form of Celtic expression dates back to before the fifth century, as may be inferred from the *ante quem* of the inscription at Prestino and confirmed by the *xosioiso* of the sixth century B.C. of the inscription at Castelletto Ticino,[2] while the inscription at Sesto Calende offers the possibility of going back as far as the seventh century B.C.[3]

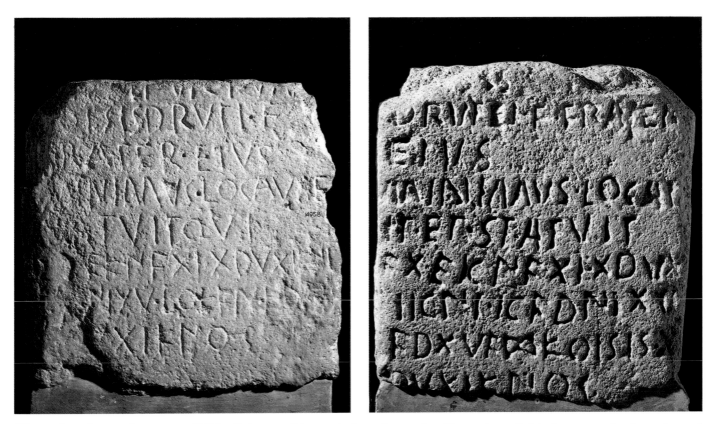

The two faces of a travertine marble stele with bilingual inscriptions in Celtic and Latin from Todi
2nd century B.C.
Rome, Museo Gregoriano

With all the possible restrictions, Lepontic still remains a Celtic language of at least the end of the sixth century B.C., not ascribed to historical Gaulish and prior to the Gaulish culture identified in archaeological finds from the La Tène period.

Let us consider a pair of examples to show the importance of this area, not only for the specific acquisitions of new materials and elements of language, but also for the possibility they offer of reviewing the theoretical premises of the approach to the renewed general picture of Celticity.

UVAMO-KOZIS in the inscription at Prestino has been etymologized as *Upamo; from this $(p > h\theta; st > t^{ts})$ I drew the prime proof of the Celtic nature of the Prestino inscription (and with it, obviously, of Lepontic). *Upamo is potentiality of *langue* (Saussure's concept of language) in every Indo-European language including Celtic. *Ghostis (Prosdocimi 1986 "Prestino") is not potentiality of *"langue"* and yet it is a term of a Celtic stratum in Italy, absent in all the other known Celtic languages and present in other Indo-European languages of ancient Italy. The presence of *GHOSTI- may be attributed to a loan in Italian Celtic from other Indo-European languages at a date prior to $st > t^s$: but, according to the model of Celtic as a development of previous dialect partitions of Indo-European, *GHOSTI- may be placed in the dialect area of Indo-European or of the Indo-Europeans in Italy, which contributed in part to the phenomenon of the development of Celtic.[4]

The so-called "Lepontic" alphabet was also used for writing second to first century B.C. Gaulish in Italy; this point was taken up by Lejeune in his recent publication 1988, RIG II,1): using the label "Italian Gaulish" he quoted five inscriptions from the area which he defines as *"sublépontique"* (Briona, Vercelli, Groppello Cairoli, Garlasco) and the inscription with indisputable Gaulish characters from Todi in Umbria.

Lejeune does not discuss coins in his article: however, coin legends cannot be ignored when speaking of the alphabet in an ideological key (national alphabet or similar) because the legends in the Lepontic alphabet on coins in a non-Lepontic area are of the greatest significance. Important questions are involved: for example the very mechanism with which the Gauls acquire the Lepontic alphabet when they want to write in different conditions of

space, time and culture implies a mechanism of ethnic-cultural recognition: this cannot fail to reflect on the separation of Lepontic from Gaulish, or at least the separation must be justified well beyond the historiographic perspective (not to be confused with the "historical" one), both old and modern.

There is also evidence of direct Celticity, but with the alphabet belonging to another tradition, which may be classified as follows:

– inscriptions in an autonomous cultural context

Example: "epigraphic Ligurian" (to be distinguished from "onomastic Ligurian" of which more will be said later): in this way I conventionally designate the language of the inscriptions on a stele from Lunigiana that can be dated to around 500 B.C., in non-adapted Etruscan alphabet; although these are very few in number and some of them are quite illegible, they have decidedly Celtic features (Maggiani, Prosdocimi 1976; Prosdocimi 1983; Maggiani 1987).

– isolated inscriptions in a non-autonomous cultural context

Example: DUBNI DANUABI (negau A; Venetic alphabet: Prosdocimi 1976)

Example: ÚLÚVERNA (opp. ÚLÚGERNA; South Piceno alphabet of the late third century B.C.: Marinetti 1978).

Then there is indirect evidence of various degrees:

a) non-Celtic language (corresponding alphabet) with Celtic onomastics

– Etruscan e.g.: MI NEMETIES'

– Venetic e.g.: MEGO DOTO VERONDARNA TIVALEI BELLENEI (see respective chart)
PADROS POMPETAGUAIOS

b) lexical loans in languages of ancient Italy, especially (but not exclusively) Latin

c) Celtic onomastics in Greek or Latin tradition (authors, inscriptions)

d) Celtic toponymy in Greek or Latin tradition (authors, inscriptions)

e) Celtic toponymy in medieval and modern toponymy

It is to be noted that the diversity of the documentation requires a historic and cultural assessment case by case, with regard to the meaning of the presence of the Celtic element: what is the meaning of this Celticity? who brought it there? in what context?

These methodological preliminaries are particularly important, or rather indispensable, for the proofs—true or presumed—of Celticity in an extraneous context at dates prior to 390 B.C. (the date of La Tène in the North and of the Senones of Brennus in Rome).

Then there are other cases still *sub iudice* for which, at the present state of knowledge, the supposed Celticity can neither be excluded nor definitely proved.

I refer here to cases such as KATAKINA and VERCENA/VIRCENA in sixth-century Orvieto[5], TRUTITIS in the dedication of the Mars at Todi (Vetter 230), that is around the year 400 B.C.[6] or MI CELOESTRA scratched on a late sixth century bucchero bowl from the urban area of Caere.[7]

Bowl with sinistroversa inscription: TIVALEI BELLENEI *from the cemetery enclosure of Piovego (Padua), 5th century B.C. Padua, Museo Archeologico del Liviano*

We shall not consider the rest of the indirect documentation (for which there is a project under way: meanwhile see "I Celti d'Italia," 1981); however I feel it may be useful, if not necessary, to pay attention to the linguistic veins that I would define as "para-Celtic."

A case in Italy is the one that I have defined "onomastic Ligurian" (Devoto's "Lepontic").[8] "Onomastic Ligurian" includes the language or languages of the Liguria of the ancients (much vaster, especially towards the north, than today's province of Liguria), but with only indirect generally onomastic or paraonomastic documentation (geonyms and micro-toponyms, as such "spoken" and therefore, in certain aspects, still belonging to the lexicon). "Onomastic Ligurian" may have Celtic phenomena (such as *gw > b) but it certainly has non-Celtic phenomena (such as the conserved p). In view of the chronology that it allows (the *Sententia Minuciorum*, the principal document, is of the year 117 B.C.) and of the historical data that testifies to the insertion or superposition of the Gauls, in this Ligurian there may be elements of Gaulish Celticity: apart from exceptional cases, such as the possible labialization of *gʷh, on principle, Celticizing traits, being attributable to incoming Gauls, have nothing to say in favour of a possible pre-Gaulish Celtic feature of this Ligurian. So there remain only the non-Celtic

traits (such as p); however it is important to add that there is no "anti-Celtic" trait. I shall not linger on this point, though it would be essential, here and elsewhere, when discussing questions of classification in which the "time" function is decisive, so that the historical realities are seen as the result of a previous forming and not as a simple continuation of existing realities, within the limits that are already seen *ab origine*: so for this aspect and, in general, for the criteria of attribution between Celtic, non-Celtic and anti-Celtic, I refer the reader to Prosdocimi 1985 "Celti in Italia prima e dopo il V sec. a.C." (Celts in Italy Before and after the Fifth Century B.C.).

The forming of a Cisalpine Celticity, as an aspect of the more ample forming of European Celticity, has not been proved but it is a sufficiently motivated working hypothesis as regards speculation, perhaps with some confirmation in facts. The logical precedent is the model of Celtic as forming, and this is not only speculative: it is a logical *a priori* of evolution in time; the factual proofs of the sequential nature of the appearance of the phenomena lie in the fact that they do not appear in all dialects, but they are not real proofs because the *a priori*, as is logically necessary, need not be proved; instead it is on the basis of this a *priori*, and of an adequate model that represents it, that the phenomenology that we are faced with may be explained. This phenomenology puts the question not, as in the past, in dichotomic terms of "Celticity–non-Celticity" but in terms of "Celtic isoglosses present," to be understood as the degree of Celticity and/or as a chronology of Celticity (on this subject too, see Prosdocimi 1987).

Celtiberian is dealt with elsewhere in this catalogue by one of the leading specialists (with whom I almost always agree); this exempts me from going into specific detail, but not from considering Celtiberian in the general picture of linguistic Celticity. Celtiberian is certainly Celtic but, as it does not share in the pan-Celtic phonetic phenomena, or associates them differently from the other varieties (or from what knowledge of them has been accumulated), it reproposes the definition of Celticity not in its having always been, and therefore in its ancientness, but in its different and/or alternative forming.

A number of defining parameters thus have to be reconsidered: alongside certain ancient features, there may be equally innovative features which are not considered because they are not focused on as such.

All this is connected, as far as Iberia is concerned, with the question of the Celticity or non-Celticity of Lusitanian; in my opinion this is more general question. Regarding the Celticity or otherwise of Lusitanian, the data may be interpreted in various ways and scholars' opinion on the matter is divided. In a recent article I brought up an argument, which I feel is strong if not decisive, in favor of Celticity, but the problem goes back farther.[9] The uncertainty of attribution is symptomatic with a previous methodological question concerning Celticity in general: what is the meaning of an attribution of Celticity, may a dichotomic criterion be used for this end rather than a linguistic parameter, considering only the presence or absence, or is it preferable and more advantageous to adopt a criterion of graduality by which—having established certain parameters—we can come to speak not of Celticity or non-Celticity, but of the degree of Celticity.

I asked the same question about "onomastic Ligurian" (above) as a marginal area, not reached by the phonetic isoglosses that identify Celticity *optimo iure*, but not in itself *nullo iure*.

As we see it, Lusitanian belongs to the group of western Indo-European dialects, some of which later developed in such a way as to be grouped *optimo iure* under the label "Celtic."

Prospects

A number of radical revisions and not simple adjustments are necessary: 1) first of all in the Italian area; 2) secondly in the European area and, within it, according to the various parameters: a) historiographic, b) archaeological, c) linguistic. I realize that divisions 1 and 2 are for the sake of convenience and force reality, but I feel they are useful in order to demonstrate how Celticity in Italy always reflects Celtic in Europe; divisions a, b and c are

necessary to combat the unity of "history" which includes them because we do not have their actual "history" but rather historic concepts and constructions based on parameters that do not overlap but which prevail alternately in order to put together a unitary historic picture that is obtained at the price of being a patchwork of partial and angular constructions.

In Italy there is a Celticity prior to La Tène. This implicates the need to reconsider the relationship between material culture and ethnic identity, of which the language is the primary component, even though its centrality is not respected.

The question arises in clear and peremptory terms: either this pre-La Tène Celticity arrived in the areas south of the Alps with a method of invasion such that archaeology is unable to identify it; or archaeology cannot identify it because the invasion (or expansion, arrival or other explanation) does not exist, or does not exist in proper terms: so the whole must be reconsidered in depth, in compatibility with this supposition, for example by imagining an arrival of language-culture without expansions and invasions. But this means a process of linguistic and cultural Celticization, therefore not a complete Celtic but a forming of Celticity: in this perspective is an Italian-Cisalpine forming of a Celticity already formed elsewhere? Or could it not be the forming at the margins of a Celticity that forms and that is all, that is without interruptions by the Alps? Also, and more than in other cases, the Italian phenomenon cannot be restricted to Italy and it may contribute essential elements to the general picture and, here especially, to the whole conceptualization.

Celtic language prior to the year 400 B.C. has characteristics shared by known Gaulish language. The model that explains this has been seen in a dual stratification, first Lepontic, then partially overlapping Gaulish (Lejeune); this is not an explanation in proper linguistic terms, but it is a historic reification, by means of a model well-known in Indo-European studies, of a presumed dichotomy in linguistic attribution. But it is precisely this linguistic dichotomy that is first to prove and try in terms of consistency. For example: having established certain traits as being differentiating in Lepontic, are these traits also differentiating with respect to a compact Gaulish form? If Gaulish is not compact, by what right can it be opposed to Lepontic? Why instead do we not reshuffle the cards and review the dialect position of this whole section of Continental Celtic? Whatever the reply, from this point of view too the Italian problem identifies with the general problem.

I would next like to exorcise an interpretative model of Gaulish expansion, the one known as the "Brennus model," that is the idea that the Gauls in Italy and other Celts elsewhere (for example the Galatians), always appear as hordes of warriors. Certainly the Sack of Rome made an impression on the whole of ancient and modern historiography; likewise the imperialist wars waged by Rome in northern Italy in the third century B.C. again saw the Gauls as formidable warriors who had always been enemies; but perhaps this perspective is viewed in reverse; if through personal names and prosopography we consider the "everyday" reality of the expansion of Celticity in different environments—Rhaeti and Veneti—not only does it not appear traumatic, but it appears to be capillary, becoming established without cultural breaks, starting from the pre-Gaulish phase of the sixth-fifth century B.C. right up to the phase immediately before Romanization. One could write a whole chapter, or rather a book, not only on this inversion of perspective, but on the fact that this contributes, if not determines, the awareness of the Gaulish (Celtic) ethnic reality also as a political force. Anna Marinetti has shown that the legends on Gaulish coins from Gallia Narbonensis do not use the Greek alphabet but the Lepontic, just as the coins at Noricum do not use the neighboring Venetic alphabet but the Lepontic;[10] I have followed this path, showing that the Gaulish inscriptions in Italy do not use the Latin but rather the Lepontic alphabet: evidently because it was ideologized as a national alphabet. The question spreads to the presumed hostility of druidic culture towards the alphabet: if this hostility ever existed, it probably was not native but was induced by the refusal of alphabets belonging to cultures that were felt to be extraneous. However there remains the fact that, although the Celts were in contact for centuries with cultures that possessed an alphabet (Greek in Gaul and Iberia, Iberic in Iberia), they

were late in using it and—except in the case of the Celts in Italy in the sixth century B.C.—adopted it during the period of Romanization; however, the Latin alphabet is not used, evidently because Romanism had to be denied in order to arrive at an ideological statement of the Celts' own political and cultural identity.

The last case is that of the creation of the Oghamic alphabet in the fourth century A.D.: this was evidently prompted by the knowledge of the Latin alphabet, but it is an original creation (perhaps with a runic model too); the whole signifies that there is an ideological desire for national self-identification.

TIVALEI BELLENEI *from Padua and* SEKENEI *from Bagnolo San Vito*

TIVALEI BELLENEI is a two-member onomastic formula (personal name « appositive) in the dative; the juxtaposition of two personal names is excluded (Prosdocimi 1982). Taken from a context in which it should not be later than the fifth century B.C., it may be attributed to Celtism on negative grounds (restriction) and on positive grounds (specific pointers).

1) Negative.

a) Both terms are formally *difficiliores* from the Venetic point of view: the b of *bellenei* is improbable for Venetic phonetics on account of hereditary words: i.e. *bh-, *gʷ- have other outcomes; we do not know the outcome of *ghʷ, for example, but, a *priori*, it should not be -; i.e. *b- which could only give the Venetic b- is, as we know, a very rare phoneme in Indo-European. Tiv- is unknown in Venetic; -al- is present but later, rare and in certain cases as a morpheme for extraneous bases (BOIALNA is one unpublished inscription).

b) The formula is anomalous because the appositive is not formed in -io-, which is found in one other case dating back to the sixth-fifth century B.C. (PUPONEI RAKOI: Pa 1). One explanation may be that a foreigner assumes an appositive of this type because he cannot assume the local one, not being entitled to it. This possibility becomes a probability in favor of a prosopography which, in this exceptional case, can be reconstructed and (later) indicates the insertion of an outsider in a Venetic environment. No argument is proof in itself, but the concentration cannot be coincidental.

2) BELLEN- corresponds to the first member of the names in Bello- to which the mythical Bellovesus belongs (cf. Schmidt 1965, p. 147). This relationship is paralleled in an inscription at Bagnolo (now published by R. De Marinis in REE in "SF" LI, 1984, pages 202-204) which includes SEKENE.I: from the punctuation it should be Venetic. Luciano Agostiniani has related this SEKEN- to the Celtic names in Sego/Seco- which include that of Segovesus, the mythical brother of Bellovesus. In spite of transcription problems, the identification seems sure, even though there remains to be considered the qualification of the precise social and linguistic situation of this form between Celtic, Venetic and Etruscan in the Etruscan town of Bagnolo in the fifth century B.C.

A History from a Prosopography?

*Pa 25 with TIVALEI BELLENEI is not isolated, but links p with other inscriptions in such a way that it is possible to construct a prosopography and sketch out a mini-history of events, in the light of institutional history. While referring to Prosdocimi 1982 for the institutional premises, I will now take up the proposal of the history of the events that underlie the following inscriptions (given in an interpretative transcription and in relative chronological order and—where possible, though very loosely—with indications of absolute chronology):

*Pa 25: TIVALEI BELLENEI (fifth century B.C.).

*Pa 26: FUGIOI TIVALIOI ANDETIOI VKU EKUPETARIS EGO (fifth-fourth century B.C.).

*Pa 28: VOLTIGEN(E)I ANDETIAIOI EKUPETARIS FREMAISTOI(KV)e VOLTIGENEIOI (fifth-fourth century B.C.).

*Pa 21: FUGIAI FUGINIAI ANDETINAI EPPETARIS (?).

Bl 1 ENONI ONTEI APPIOI SSELBOISSELBOI ANDETICOBOS ECVUPETARIS (second-first century B.C.).

Hence a possible reconstruction of events.

1) TIVAL- BELLEN- comes to Padua from outside (Andes?); as an outsider he does not have the normal onomastic formula but has an epithet (or similar) as an appositive, either because he cannot have the local onomastic formula or because he is not interested in having it (naturally with some diversity with respect to the local institutional situation with relation to the possibility of personal attitudes).

2) FUGIO- TIVALIO-, son of Tival-, assumes the local onomastic formula as an expression of a different legal status (granted/acquired or intentionally expressed); for this the patronymic (Tivalio) is not, or is not held to be sufficient as an appositive with a two-name formula, because it belongs to a legal status that does not entitle him (as a foreigner = citizen *non optimo iure*) to give a patronynmic with the value of manus (= *illius iuris*, therefore *sui iuris*) and therefore assumes a second appositive (from the area of origin, Andes?), with an appositive morphology, ANDETIO- (which presumes, as I said, that beside the patronymic appositive there is already the aristocratic appositive).

3) FUGIO TIVALIO ANDETIO has a son by a slave (*Andetia: name of the person who has the manus) whom he calls by the Venetic (and "aristocratic"?) name of *Voltigenes: this is a sign of his (achieved) social position, cause/effect of his onomastic formula.

4) a. VOLTIGENES ANDETIAIO- son (-io) of a slave (Andetia-) of Fugio, has in turn a son who assumes the appositive (-io-) from the personal name of his father (Voltigene-) as it is impossible for him to have that of his (probable) grandfather, Andetio-, as this is not allowed because it would have been passed down through a slave.

b. At Cà Oddo a certain FUGIA, Fuginia by birth, enters (-na) the manus of an Andetio-: so by chronology wife of a descendent of Fugio, with -ina which designates the manus of the gens that she entered; if, as it seems, she is the wife of an Andetio- of generations later than Fugio Tivalio, it is confirmed that Andetio is already aristocratic due to the improbability of the repetition of a personal name, hence the appositives. So we have the following family tree:

Large bowl with inscription
FUGIOI TIVALIOI..., *from Trambache Veggiano (Padua)*
End 5th-early 4th century B.C.
Este, Museo Nazionale Atestino

$$\text{TIVAL-(BELLEN-)}$$
$$\downarrow$$

[ANDETIA] \longleftrightarrow FUGIO TIVALIO ANDETIO*
\downarrow

VOLTIGENES ANDETIAIO
\downarrow

FREMAISTO VOLTIGENEIO

*FROM THE NODE FUGIO TIVALIO ANDETIO there may be:

1) a legitimate wife (this seems excluded by chrnology):

FUGIA (ANDETINA) FUGINIA \longleftrightarrow FUGIO TIVALIO ANDETIO

2) FUGIO TIVALIO ANDETIO
\downarrow

FUGIA (Andetina) FUGINIA \longleftrightarrow X (descendant)

(Between AND- in Es 17 and the ANDETICO- forms in Bl 1 there is certainly an onomastic link, but this cannot give rise to any historical link on account of the distance in both space and time.)

Bowl with inscription
VOLTIGEN[e]I ANDETIAIOI...
from Trambache, Veggiano (Padua)
End 5th-early 4th century B.C.
Este, Museo Nazionale Atestino

Notes

1. The great undertaking of publishing the Gaulish inscriptions is now in print (three volumes have come out so far), having required more than thirty years' preparation, signed by such prestigious names as Jean Paul Duval, Michel Lejeune, J.B. Colbert de Beaulieu; this monumental work excludes non-Gaulish Italian Celticity—that is the so-called Lepontic, "Ligurian" and another anonymous form—while it includes six Gaulish inscriptions on Italian soil. I have expressed my opinion on the validity of the subdivision criteria elsewhere. Here I only wish to anticipate a project, responding to a scientific necessity, for an integral and integrated edition of the Celtic inscriptions in Italy, as well as a recovery of all the Italian Celticity for which there is often indirect evidence (Venetic, Rhaetic, Latin inscriptions, glosses, place names, Latin lexicon, Romance lexicon, etc.).

2. The inscription was seen directly by Colonna and I refer to his exhaustive illustration in "Il bicchiere con iscrizione arcaica," *St. Etr.* LIV, 1988, pp. 130-164. But see also my "Note sul celtico in Italia."

3. The most ancient Transpadane inscription is the one of the late seventh century B.C. at Sesto Calende which Colonna (p. 140 of the article quoted in note 2) resumes after having already assessed it in St. Etr. XLIX, 1981, p. 9 × note 37, tab. XXIII a (containing the previous bibliography). But see also my "Note sul celtico in Italia."

4. A similar case should be that of *dhug(h)Hter, the classic Indo-European name for the daughter, unknown in continental Celtic and now attested by an inscription in Gaul (published in *Etudes Celtiques*, 1985).

5. I have shown elsewhere (Prosdocimi 1986, in Atti del Secondo Convegno Archeologico Lombardo, Como) how in my opinion De Simone (1978, "Un nuovo gentilizio etrusco di Orvieto (katakina) e la cronologia della penetrazione celtica (gallica) in Italia," PP, pp. 370-395] has not proved the Celticity of these two terms in the Orvieto of the sixth century B.C.

6. On the Todi Mars, see Roncalli 1973, "Il Marte di Todi. Bronzistica etrusca e ispirazione classica,", Mem. Pont. Acc. XI, but also A.L. Prosdocimi in "Celti in Italia prima e dopo il V secolo a.C.," Acts of the international meeting "Celti ed Etruschi nell'Italia settentrionale dal V sec. a.C. alla romanizzazione," Bologna 1987.

7. During the meeting "Il commercio etrusco arcaico" held in Rome in 1983 (*Quaderni del Centro Studi per l'Archeologia etrusco-italica* 9, Rome 1985, pp. 270-271), Giovanni Colonna proposed recognizing the transposition of a Greek κελτ˙ς in *mi kelθestra*; in the same source (p. 271) and then, at greater length, in the "Rivista di epigrafia etrusca" in *Studi Etruschi*, Mauro Cristofani challenges the interpretation, but see also A.L. Prosdocimi 1985.

8. G. Devoto "Leponzi," *Scritti Minori*, II, Florence 1967, pp. 324-335 = "Pour l'histoire de l'indo-européanisation de l'Italie septentrionale: Quelques étymologies lépontiques," *Rev. de Phil.* LXXXVIII, 1962, pp. 197-208.

9. Idg. Forsch. 94, 1989, pp. 190-206.

10. A. Marinetti's contribution will appear in the acts of the meeting "Numismatica e archeologia nel celtismo padano," held at Saint Vincent in September 1989.

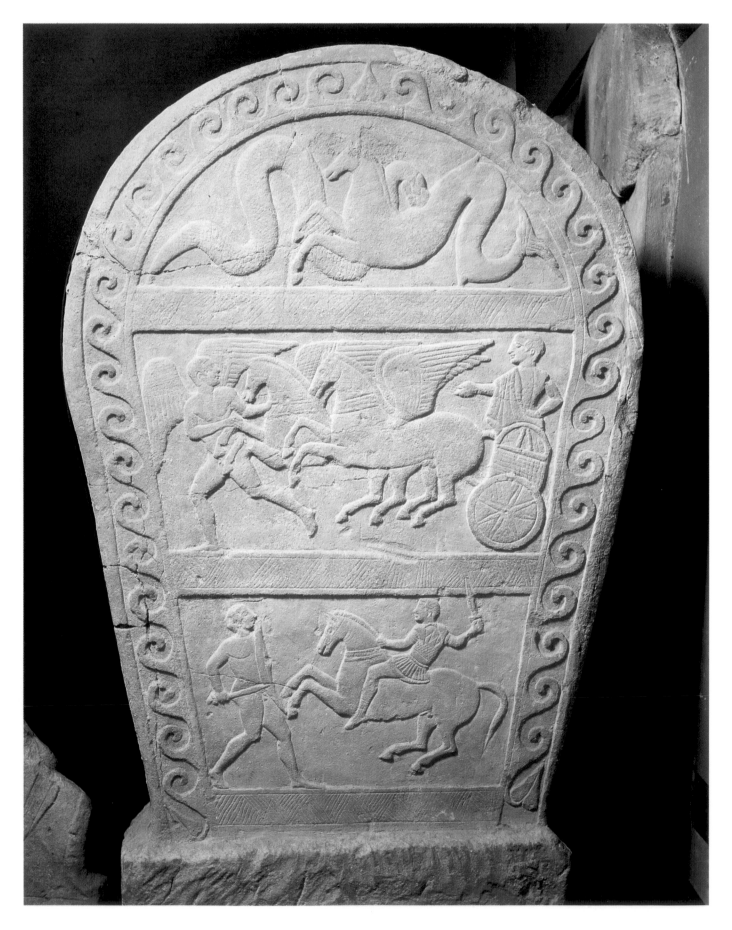

Bernard Andreae

The Image of the Celts in Etruscan, Greek and Roman Art

Etruscan funerary stele in sandstone from Bologna
Lower section: Etruscan horseman fighting Gaulish footsoldier
5th century B.C.
Bologna, Museo Civico

The Gauls, or the Celts as they called themselves, were not only imposing they stature, but also had a way of wearing their hair that gave them a particularly terrifying appearance. The classical author, Diodorus Siculus (5, 28, 2-3) describes them as follows: "The Gauls smear their hair with lime dissolved in water and sweep it back from the forehead towards the temples and the nape, so that they resemble satyrs or Pan. Their hair gets so stiff and from this treatment that it in no way differs from a horse's mane." Representations of the Gauls that show not only their physical structure, but also their tufts of hair are can only be found in the mimetic art of the Greeks, the Etruscans and the Romans, that is, in that art form that aimed to imitate nature.

These three peoples were also the ones most threatened by the invasions of the Gauls. First, it was the turn of the Etruscans who, from the sixth century B.C. onwards, were chased by the Celts out of the Po Valley, the territory that the Romans subsequently called *Gallia Cisalpina*, that is, Gallia on this side of the Alps. No representation of the Gauls has come down to us from the first period of Etruscan art: in the archaic figurative tradition, differentiations between racial phenotypes were as yet unthinkable. The earliest representation of the Gauls to have been discovered is probably that on a Faliscan *stamnos* (a bellied vase with two vertical handles), that is, from southern Etruria, dating from the first quarter of the fourth century B.C. and now in the Akademisches Kunstmuseum in Bonn Beazley, *Etruscan Vase Painting*, 1947 p. 96. This shows an Etruscan (or Roman?) warrior on foot and a horseman, who is definitely a Gaul being attacked from the right; between them is another naked warrior. The latter wears only a belt around his waist, from which hangs a long scabbard; he grips an oval shield in his left hand and brandishes a sword in his right hand. He is following the horseman with nimble steps when he suddenly realizes that the enemy is behind him, and turns his head to look. Most of the part of the vase showing the warriors attacking the group of Gauls from the right has been lost, but we can still make out the general demeanor of the figures; they have come to a sudden halt, and hold up their shields in self-defence. At the horseman's feet stretches a naked corpse with a vulture perched on his chest, in the act of ripping out his entrails. The dead man and the warrior with the belt and scabbard are clearly Gauls, because of the way their hair has been depicted, rigidly swept back. The horseman, too, is clean-shaven and his hair is swept back into tufts. However, the man attacking from the left has curly hair and a beard, as one would expect to see in Italic warriors of this period. The figures depicted on the vase provide a vivid representation of the battles of the period during which the Gauls, under the leadership of Brennus, penetrated as far as Rome, and laid siege to the city for seven months. They did not succeed in capturing the Capitoline, however, and retreated after the payment of a large ransom.

The second great event between the Gauls and the Mediterranean populations was the attack on the Temple of Apollo at Delphi which the Gauls succeeded in sacking, having worked their way around the pass of Thermopylae in 279 B.C. But the Phocaeans and the Aetolians, who were responsible for defending the sanctuary, managed to summon help quickly to drive back the Gauls. Afterwards, a rumor circulated that Apollo himself, his sister Artemis and Athena Pronaia had run to the defense of the sanctuary, and put the invaders to flight. This mythical elaboration of the historical event is alluded to in the Etruscan clay frieze from Civitalba, near Sentino. Here, in 295 B.C., a Roman army led by the consul Fabius Maximus Rullianus and Publius Decius *Mus* won a decisive victory over the Gauls, who were allied with troops of Etruscans, Umbrians and Samnites. The clay frieze, the figures of which are forty-five centimeters high, comes from an Italic temple, which was not built until after the victory of Publius Cornelius over the Boii Gauls in 191 B.C. and the return of Manlius Vulsus from his campaign against the Galatae (as the Gauls were called in the eastern Greek sphere of influence) in Asia Minor in 189-187 B.C., probably in about 160 B.C. Therefore, it was within the context of a new series of clashes between the Romans and the Gauls that it commemorates an unforgettable event that had taken place over a century before. The terror-stricken Gauls flee, faced with the victorious apparition of the gods, of which only

Artemis and Athena Pronaia are still to be seen on the frieze, but Apollo must certainly have been represented there originally, too. The deities are hard on the heels of the Gauls, threatening them with their weapons: on the left, Athena brandishes a spear while Artemis wields a bow on the right. She has struck a Gaul who has collapsed into the arms of one of his companions, reminiscent of the dead Patroclus in the so-called *Pasquino Mastro* (D. Andreae: *Antike Plastik*, 1974, pp. 87-95), created at Pergamum in about 170 B.C. Behind the goddess is another Gaul with a *sagos* (tunic made from an animal skin); he is trying to flee with an amphora under his arm and is looking backwards, having sensed that he is being pursued. Perhaps the figure of Apollo originally completed the scene on the right. On the far left, the two naked Gauls fleeing can be recognized by the torque worn at the neck, the belts around their waists, their long oval shields with central ribwork, their compact hairstyles and their long moustaches. In the center are some Gauls on foot with their chief on a chariot, assailed by the goddesses. It is a historical fact that the chief of the Gauls, Brennus, was wounded in battle fighting at Delphi and after seeing his troops to safety committed suicide.

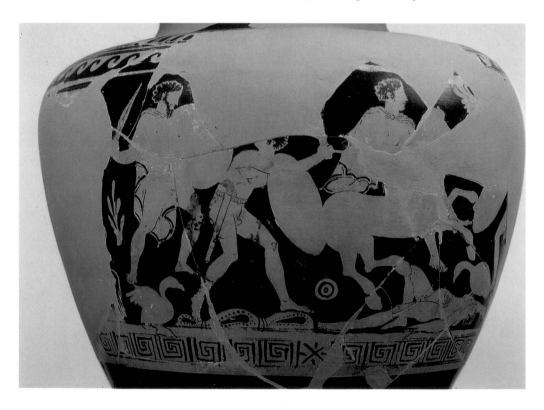

Detail of red-figure stamnos depicting combat between Gaulish and Italic infantry 4th century B.C. Bonn, Akademisches Kunstmuseum

On the subject of this interesting monument, some have advanced the theory that the frieze was modeled on a Gallic monument of Attalus I, King of Pergamum, who, is reportet to have dedicated it at Delphi in about 200 B.C.; although as yet there is no proof of this theory, the influence of Pergamene art in the Italic work is unmistakable.

Before dealing with the art of the Pergamene school, which from about 230 B.C. onwards produced the most impressive representations of the Gauls, it is worth referring to an episode of 275 B.C., that gave rise to a very typical image of the Gauls. In that year, four thousand mercenaries in the pay of Ptolemy II of Egypt in the war against the viceroy Magas of Cyrene mutinied. They were the survivors of the army of Brennus which had been broken up in Greece. Pausanias (1, 7, 2) states that the mercenaries sought to gain power over Egypt, whereas a commentator of Callimachus (4, 175-187) maintains that they intended to take over the royal treasury. It is probable that the sovereign had not paid them, because they had not presented themselves for the war against Magas. Ptolemy II succeeded in stranding the mutineers on a desert island in the Sebennytos arm of the Nile, laid them siege and al-

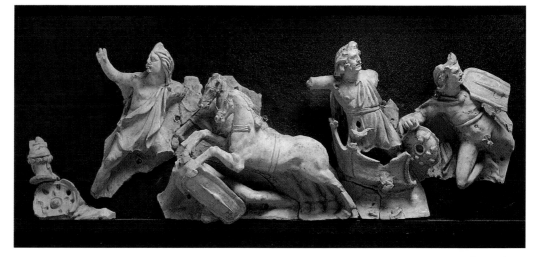

Part of stone frieze from Civitalba (Marches) depicting Gauls fleeing after sacking a sanctuary Early 2nd century B.C. Ancona Museo Nazionale delle Marche

lowed them to die of starration. The event was celebrated by the court poet, Callimachus, in his hymn to Delos, where the action of the Egyptian pharaoh against the insurgent Gauls was compared to Apollo's intervention three years earlier against the hordes of Brennus at Delphi. Callimachus defines the Gauls as "the fearless people among the last-born of the Titans," deliberately repeating the widespread error of confusing the Titans with the giants in order to make a pun the word *titanos*, or titanite (in ancient times, probably chalk), which the Gauls used to treat their hair, turning it into a compact mass of rigid tufts. The suppression of this uprising of the mercenaries was not only celebrated in a poetic hymn, but was also depicted in a monument, the only surviving piece of which, a grandiose head of a Gaul in marble, is now housed in Cairo Museum (P. Laubscher: *Antike Kunst 30*, 1987, pp. 131-134). The sculpture gives a very complete picture of the racial phenotype of the Gauls, which must have been even more striking when the original colors emphasized the fairness of the skin, the blonde hair—made even lighter by the use of titanite—and the blue eyes. The thick head of hair running down the back of the neck, swept back from the forehead into a mass of rigid tufts, the receding forehead itself, the sharp, deep-set eyes, below the almost horizontal eyebrows and the moustache covering the upper lip leave no doubt that this represents a Celt. The fragment is the earliest example of monumental sculpture relating to this ethnic group, and was the first of a whole series of similar representations. The best images of the Celts, or the Galatae, belong to the Pergamene school. The famous letter of the Apostle, Paul to the Galatians was addressed to the descendants of those Celtic groups that, in 287-286 B.C., having been summoned by King Nicomedes I of Bithynia, moved into Asia Minor and settled in eastern Phrygia, that is, the central-Anatolian territory between modern Ankara and Pessinus, between the Halys River in the east and the Sangarius in the west. From here, they set out on looting expeditions, reaching as far as the coasts; according to Polybius (18, 41), they represented a "scourge for everyone." Various authorities paid them as mercenaries, and neighboring states were forced to pay them taxes. At the same time, in Lydia, an area bordering on that occupied by the Gauls, the city of Pergamum succeeded in building up a kingdom which expanded rapidly. After the battle of Kurupedion in 281 B.C., Philetaerus of Tios, the Macedonian officer who was in charge of the military finances of the diodochus Lysimachus, at the fort of Pergamum, gradually gained is independence and founded the Attalid dynasty, named after his father, Attalus. At the outset, Pergamum also paid taxes to the Galatae, but in 230 B.C., the second descendant of the founder of the dynasty, Attalus I, dared to confront the Celts openly for the first time. He inflicted a number of defeats on them: the first in the series of battles was fought at the springs of the Kaikos River (on the banks of which, further downstream, Pergamum had been built), and became legend. In 223 B.C. at the latest, Attalus I had a huge monument erected on the acropolis at Pergamum to celebrate the victory, of which a few copies in Roman marble survive (M. Mattei: *Il Galata*

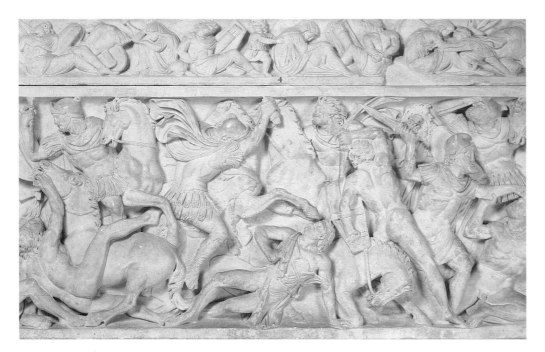

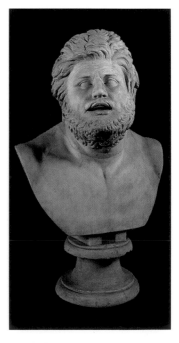

Capitolino, 1987) these give the clearest representation of the imposing stature and the un-usual hairstyle of these barbarians, who were anything but uncivilized. They include the fa-mous and perfectly conserved figures of the Dying Gaul from the Museo Capitolino, and the group showing the defeated Celtic chieftain who, having killed his wife, commits suicide (now housed in the Museo Nazionale Romano), as well as the head of the Gaul kept at the Vatican and a torso at Dresden. The enemies of the Pergamenes are not the object of disdain in these sculptures: on the contrary, they appear to have been represented with great atten-tion to detail and exceptional powers of observation. The chieftain, on seeing that his cause has been lost, has killed his wife by slitting her throat and now plunges his sword into his heart through the clavicular cavity. Stretching out his left leg in a last attempt to support his companion, whom he holds with his left arm while she slumps away from him, and bracing the toes of his right foot, he pushes his body upwards towards his hand, which is bent and powerfully twisted, throwing back his head in an impetuous gesture as if to stop a potential pursuer with the fury of his expression. The twisting movement of the whole figure so power-fully fills the space that the group cannot be assessed from any one point, but has to be looked at from every angle. The contrast between the body of the slumped, lifeless woman collapsing with bowed head at the observer's feet, and the athletic, muscular body of the man, with every fibre taut is striking. The thorax is drawn in showing the edge of the ribcage on the abdomen; his muscles contract, in a last sign of life as this commander gives himself up to death. The *chlamys* drops only slightly off his shoulder, but this detail, this instant of inertia, underscores the fact that it is the violence of the man's movement that has blocked it there, in stark contrast with the position of his head and right arm in the composition as a whole. There is something Giant-like in this figure and in that of the woman—who has shapely curves, long locks of hair and the broad facial features—hiding a stubborn challenge to the superiority of their enemies and a savage devotion to death, which is deeply moving.

The famous Dying Gaul (now in the Museo Capitolino) stands on a round base 2.75 meters high. It is part of the same votive offering, the great figures of which were probably placed in the acropolis of Pergamum, in the center of the temple of Athena. The warrior has been mortally wounded in the liver and is sitting on his shield on the ground, awaiting death. The upper part of the body seems about to collapse forwards, but with his last strength, the virile and well-constructed figure supports himself with his right arm, his hand on the ground. His

Suicidal Gaul with wife
from the group dedicated by Attalus
to the sanctuary of Athena Nikephoros
at Pergamum
Marble copy from an original bronze
Second half 3rd century B.C.
Rome, Museo Nazionale Romano

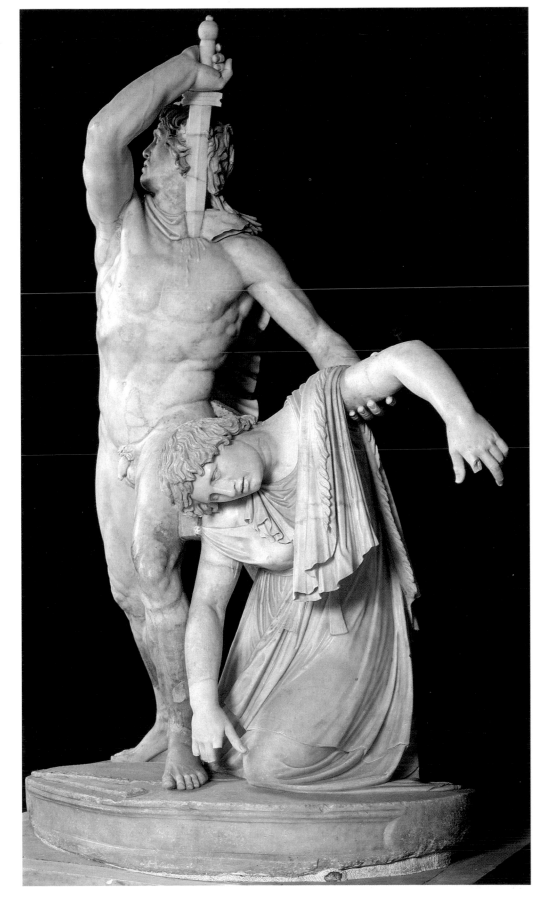

left arm and the hand he presses to the thigh he rests on support the torso and prevent him from keeling over. His knee is bent, and his right leg crosses over the foot resting on the edge of the shield. His left leg is only slightly bent and the sole of his foot still rests on the edge of the shield. The leg forms a bridge over the curved trumpet which the dying Gaul protects, along with his weapons, with his body. The outstretched leg acts as a counterbalance to the heavy head hanging forward at the other end of the composition, his gaze fixed to the ground. The trumpeter has a braided torque at his neck, his hair is dishevelled, sticking up in rigid tufts that reach down to the back of his neck. Supported by his massive neck, his face is strong, his eyebrows set in an expression of pain; his thick moustache is carefully combed down over his fleshy lips; his cheeks are oval and clean-shaven. The virile beauty of this racial type has been consciously highlighted by the artist, who glorified his adversaries in defeat so as to place his own victory on an even higher level. Along with other Gauls, some of whom were falling, some of whom had already fallen, this statue of the wounded man seated on the ground, in such a scantily plastic setting, formed a circle of defeated warriors around a figure representing their chief. The design that appears on the pedestal of the Dying Gaul, with lines projected from five concentric circles probably shows how the figures copied in the first half of the second century A.D. were to be arranged.

Two generations after the execution of this grand monument to the Gauls, after the Pergamenes had inflicted their final defeat on the Gauls in a fierce war waged between 168 and 166 B.C., they erected a second monument, this time on the acropolis at Athens (B. Palma: "Il piccolo donario pergameno", in *Xenia 1*, 1980, p. 56) which placed the annihilation of the Gauls in Asia Minor in a broad sequence of mythical and historical victories won by the Greeks over barbarian rulers. Pausanias (1, 25, 2) saw the monument in place in the fourth decade of the second century A.D. and described it as follows: "On the south wall, Attalus has put the battle against the Giants, who once inhabited Thrace and the Kassandra Peninsula, the struggle of the Athenians against the Amazons, the battle of Marathon fought against the Persians and the annihilation of the Gauls in Mysia, and every figure is two cubits high." Since there were twelve gods as well as Heracles involved in the battle against the Giants, and at least the same number of adversaries, they must have been represented, and, since

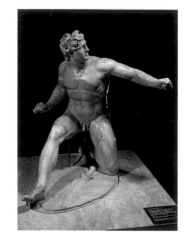

Naked Gaul kneeling
Marble
Paris, Louvre

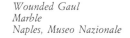

Wounded Gaul
Marble
Naples, Museo Nazionale

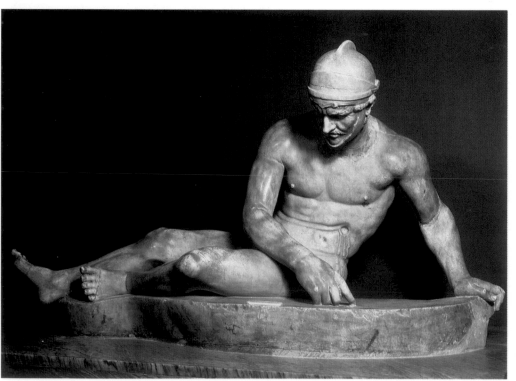

it may be supposed that the four different groups showing the battles against the Giants, the Amazons, the Persians and the Gauls were the same size, this gives a total of over a hundred figures. Such a considerable number explains the unusual choice of the dimensions of the statues, which are about 1.20 meters high, equivalent to two cubits. Since tradition tells of Dionysus being seized from the grip of a storm by the battle of the Giants and plunged into the theater dedicated to him on the southern slope of the acropolis, we must assume that the numerous figures were already assembled in a ring on the south wall of the acropolis. Seen from a distance, and particularly from below, where by a trick of perspective the figures must have seemed life-sized, and the whole, enormous composition must have seemed a real battlefield. In the last battle the Galatae had been incited to rise against the Pergamenes by Rome. It was a fight to the death, which the Pergamenes won in an all out effort at one point, having been on the brink of defeat themselves. In his *Stratagemata* (4, 8, 1), Polyphanos refers to the desperate situation in which King Eumenes found himself, only to be saved almost by a miracle. Following an attempt on his life in 172 B.C., the sovereign was left physically disabled and had to be carried onto the battlefield on a stretcher. During a defensive stage of the battle, his army was put to flight by the Gauls. Their pursuers gradually approached the king's stretcher. The king, by now resigned to his fate, ordered the stretcher to be carried to a rise beside the road. When the Galatae noticed this, they were suddenly frightened that it was simply a military stratagem and that considerable reinforcements were hiding nearby, and so gave up their pursuit.

After the final defeat of the Gauls, Eumenes II celebrated the event in a great frieze on the altar of Pergamum (now in Berlin), in which Zeus, Athena and other gods ièdefeat the Giants in the same way. Though Callimachus (*Hymn*, 4, 184) had already described the Gauls as "the fearless people among the last-born of the Titans," the comparison here is limited to the Giants. In Athens, on the other hand, Eumenes II and his brother and successor Attalus II had the conclusive victory represented as an event of historical importance on a worldwide scale. Both myth and history are used to put the Pergamene feat in the best light. It is especially interesting to compare the monument—defined as the small votive offering of Attalus, on account of the size of the statues (although, in fact, it is a monument of vast proportions)—and the large votive offering of Attalus I on the acropolis at Pergamum. Unfortunately, of the more than hundred statues making up the more recent votive offering, only ten have survived as Roman copies in marble, all of them representing the vanquished: a Giant and an Amazon in Naples, three Persians, respectively in Naples, in the Vatican and in Aix-en-Provence, and lastly, five Gauls, one in Naples, one in the Louvre in Paris and three in Venice. All of the ten figures come from Rome and represent only a selection of the monu-

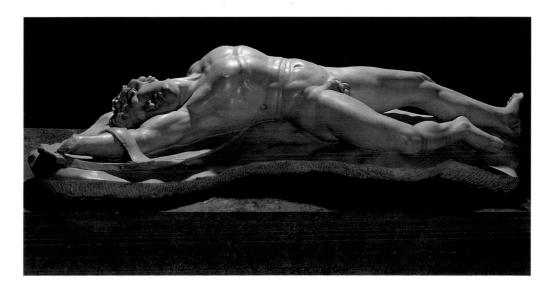

Dead Gaul
Marble
Venice, Museo Archeologico

ment as a whole, which was created, as Pliny tells us (34, 84), by the sculptors Eisigonos, Phyromachos, Stratonikos and Antigonos.

Compared with the large votive offering of Attalus, it is obvious how greatly both the plastic style and the way of seeing things changed, on the part of both and the artists and their patrons, in the seventy years that separate the two monuments. The magnanimity with which the defeat of the great enemy was represented in the earlier one is replaced, in the other, by ruthless realism and accentuated expressionism. The gigantic stature of the Gauls is only hinted at in their overdeveloped muscles; their hair appears even more compact and erect; their faces are fixed in a mask of pain.

It is interesting to see how clearly the racial phenotype of the Gauls is distinguished from that of the Giants, the Amazons and the Persians. The typology of the Giants is the same as that on the altar at Pergamum, where, by combining aspects of the iconography of the Gauls with the original Greek deities (Zeus, Pluto, Poseidon and Asklepios), the sons of the earth are made to seem the antithesis of the divine race. The Amazon is a powerful, androgynous woman with well-shaped breasts and carefully arranged hair. The limbs of the Persians are more slender than those of the Gauls; their faces are short and very broad; the hair on the forehead is short and curly. Two of them are wearing clothes and one is naked. The Gauls are naked and clean-shaven, with the exception of their leader, who is an older, bearded man, clothed and distinguished by a chiton hanging loosely from his shoulder. His right arm seems to have been restored wrongly: in the original, this character was probably thrusting the sword into his own breast as he fell. In this sculpture the magnifying effect of being seen from below is particularly obvious: to the observer, all these figures assembled around the top of a wall must have stood out almost like silhouettes.

The monument of the Gauls dedicated by the Pergamenes on the acropolis in Athens, rendering their victory eternal, is certainly not the last representation of the Celts in early art. In 160 B.C., the influence of the Pergamene representations of the struggle against the Gauls

Bearded Gaul kneeling
Marble
Venice, Museo Archeologico

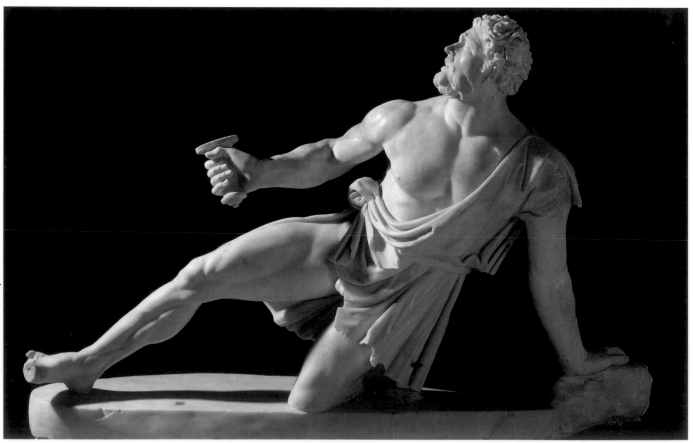

Gaul falling to ground
Marble
Venice, Museo Archeologico

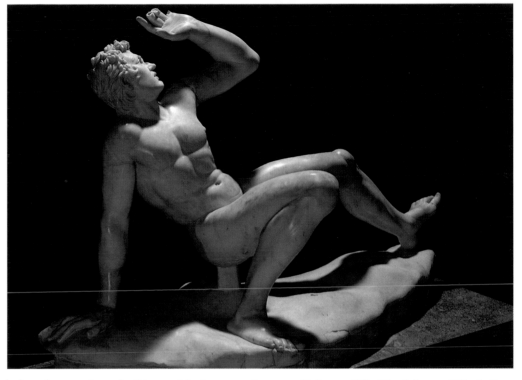

led to the creation of a frieze with the same theme at Ephesus (W. Oberleitner: "Ein hellenstische Galaterfries aus Epheso" in *Jahrbuch der Kunsthistorischen Sammlungen in Wien 77*, 1981, pp. 57-104). This is obviously the work of craftsmen and only fragments of it have survived; however, they still convey the same wild confusion of battle as in the conflicts between the Pergamenes and the Gauls. The Pergamene school had a profound influence on Roman and western representations of warfare. In the sixth decade of the second century A.D., when the Romans suddenly had to fight off an attack by the Germani from the area of the Danube, they referred to a cycle of Pergamene paintings (B. Andreae: *Rendiconti della Pontificia accademia romana di archeologia 41*, 1968/9, pp. 145-166) for the representation of this event, and translated them into bas-reliefs on a series of Roman sarcophagi in honor of military commanders who had fought on the front on the Danube. These were probably the Pergamene paintings portraying battles with the Gauls that Pausanias Mentions. Thus, 330 years after the event, the hand to hand combat between the Pergamenes and the Gauls came back to life; and we see the same kind of naked warriors, on a grandiose scale, their hair on end, torques around their necks, that appeared in the votive offerings of Attalus. Again we see the chieftain who, realizing his cause was lost, spontaneously opts for death. This figure is so similar to the one of the falling Gaul in Venice, that one cannot help but wonder whether Phyromachos, the creator of part of the small votive offering of Attalus—a painter as well as a sculptor—was not also the creator of the painting with the theme of the Gauls later copied on to the Roman sarcophagi. However, there is no doubt that these sarcophagi once more evoke the strength and courage of the Celtic warriors who had made the ancient world hold its breath from the Po Valley to Rome, from the Danube to Delphi, as far as Pergamum and even Egypt. The *metus gallicus*, or fear of the Gauls, had become proverbial in Rome, and there was a time when the Romans used to ward off danger by sacrificing a Gaul of each sex, burying them alive in the Forum Boarii (H. Bellen: "Metus gallicus—Metus Punicus. Zum Furchtmotiv in der römanische Republik", in *Abhandlungen der Akademie der Wissenschaft und der Literatur*, no. 3, 12f., Mainz, 1985).

The Dying Gaul
Marina Mattei

The Dying Gaul represents a Celtic warrior in his last death throes, fossilized in his agony. This brilliantly executed sculpture is only a fragment of a larger narrative group, and yet it forcefully embodies the idea of the Celtic people handed down to us through written texts. The sculpture also conveys the sense of crushing defeat, and is a complete work in its own right, informed with the deepest pathos.

The descriptive and symbolic potency of the theme is matched by the artist's extraordinary skill in representing the figure in the round. The viewer is invited to contemplate it from all sides, and as his gaze is expertly guided from left to right, it will take in a series of typically Celtic elements, including the sword, that will leave no doubt as to the ethnic identity of the man portrayed.

The recently completed restoration work revealed that the figure is carefully constructed within a precise geometric framework. This was brought to light when the piece was broken down and recomposed (graphically speaking) during restoration in order to determine which pieces were additions made over the centuries.

This process made it possible to calculate the piece's position within its original architectural context and understand the technical expedients used by the sculptor.

The quality of the finish varies, in correspondence with the angles from which the piece was originally viewed.

Just over half of the base has survived (the left) and most of its surface is covered with a shield with protruding central boss and "running dog" pattern. Concentric with the edge is a horn broken into two parts linked by the strap. Like the shield, the base itself is convex and the edge at the rear is different from the left edge; the front is also different, owing to a later repair.

The base therefore may have been part of a support designed ad hoc from which the convex part of the shield emerged, the true center of the image. The base's original convex shape was probably modified to integrate the finished statue with the monument.

Whoever did the job of integration also sculpted the weapons and belt. The shield may have originally been complete with a sword, but there is no way to determine where it lay.

During restoration, a slot was found beneath the plaster on the right arm (not original), suggesting that the original arm was closer to the body and acted more as a support. The same area also revealed a fold in the anatomy confirming the alteration of the arm's position.

It may be inferred that the warrior was por-

trayed still fighting back, before falling to the ground. What the sculptor wished to imply is apparent in the composition itself: as reported by many ancient authors, when Celts attacked their enemies, they screened their naked bodies behind a massive shield. By using the shield as a base for the composition, the message conveyed is one of the defenselessness of the warrior, who is portrayed with unmistakably Celtic features.

The combatant actually rises out of the base, propped up on his right, the wound in his rib cage in full view. The left arm is bent, his hand almost clasping his right thigh, and most of his weight clearly rests on his buttocks. The thick Celtic torque around the Gaul's neck conceals the fracture point where the head had once broken off.

A hole on the left side of the neck, plastered over, denotes a modification of the original position made during previous restoration. The warrior's face is very accurately sculpted with the typical features of the Celtic people—fleshy, well-defined lips (slightly parted here revealing the upper row of teeth); thick ungroomed moustache; slender nose (most probably put back in place with the original fractured part); the cheekbones are high. Furrows on the brow and temples, most noticeably in profile, emphasize the artist's desire to portray the warrior's final agony.

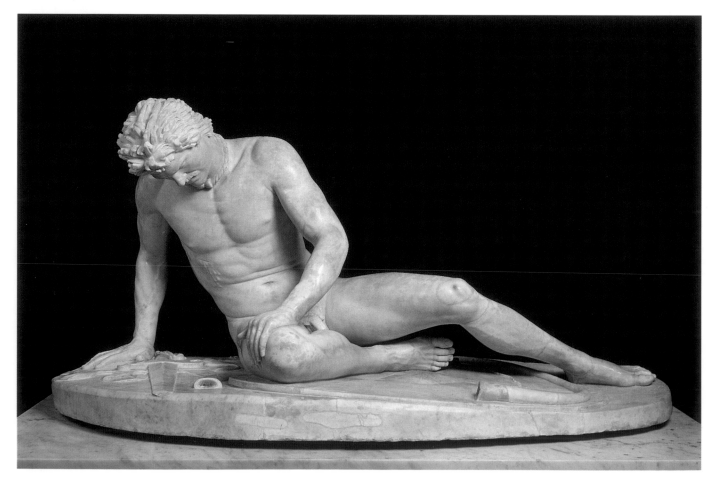

The hair is also typically Celtic—strong thick waves of hair standing out from the skull, bearing numerous scattered fractures, particularly on the top. The sides of the face show evident signs of chiseling, and in fact boring with a drill was rare. The hair on the crown of the head is less well-defined, with the surfaces modeled in rough. Probably this part was not very visible, as suggested by the fact that the entire figure, and not just the head, is leaning forward.

The warrior does not really seem resigned to his fate at all. The forward position of the arm shows a certain resistance, accentuated by the surging of his chest and slope of his shoulders; his left buttock is almost off the ground, as if he were making to get up. The furrowed brow and tense muscles in his face convey a strong sense of will rather collapse.

He almost seems to be giving a deliberate show of endurance, but the wound is fatal and resistance would be in vain. The broken horn on the plinth suggests that he had no way to summon his companions.

The technical and formal aspects all endorse the assumption that the sculpture was part of the monument erected at Pergamum by Attalus I after 228 B.C.

In eternal memory of the successful curbing of the Galatian onslaught on the cities of Asia Minor, and on the Hellenic lands in general, Attalus dedicated the images of the vanquished peoples along the base with inscriptions which have come to light on the south side of the temple of Athena.

The monument was an expression of the might of the Attalid dynasty, which championed Hellenism and was reinforced by the defeat of the Galatians.

Consequently the Dying Gaul appears to us like a summation of the moral and social peculiarities which the historian Pausanias noted in the Gauls, calling them barbarians and more alike unto beasts than men; it is a race he censures for their menacing arrogance and disdain even in the face of defeat.

In this sense, besides the quality of the marble, the structural concept, and the technique adopted, the Dying Gaul has parallels with the Galatians in the Museo Nazionale Romano taken from the same monument. The sculptural narrative follows the historians' versions with astonishing accuracy: "... not even in those who fell wounded was the fury abated [...] nor in those who were wounded by swords or spears, while there was a breath of life in them..."

The Dying Gaul likewise refuses to renounce his self-respect; defeated but not abject, he seems to be detached from his fate and aloof to his surroundings. The date of the piece has been much debated, and it is generally considered a copy of an original variously dated to the time of Trajan, Hadrian, or Caesar. A passage in Pliny regarding bronze sculptures seems to sanc-

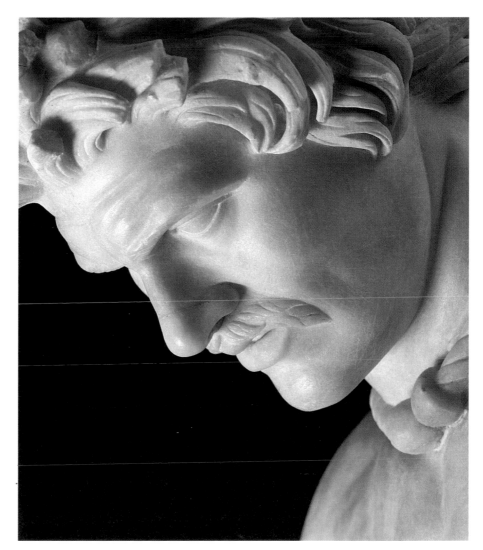

tion the longstanding theory that the marble is a copy of an earlier bronze. The attribution to an unknown artist is still under debate.

But so far there is no definitive proof that the originals were in bronze. During restoration, the marble was analyzed and found to be from the quarries of Asia Minor, bearing out suppositions of the work's geographical origin.

Finally, the astonishing compliance with what we know of the monument erected at Pergamum, and moreover the piece's patent conformity with precise formal rules linked to its insertion in the monument, tend to suggest that the Dying Gaul is not a copy but one of the original statues.

The Dying Gaul was purchased at great cost by the French monarchy in 1737 after lengthy negotiations, and was taken to France by Napoleon Bonaparte. Since then it has been on exhibition at the Capitoline Museum, Rome, and is widely regarded as one of the most significant sculptures of antiquity.

Numerous copies have been produced in various materials, at varying scales, and many detailed drawings made. It must surely have been a difficult task to reproduce a work of such complexity and so freighted with pathos.

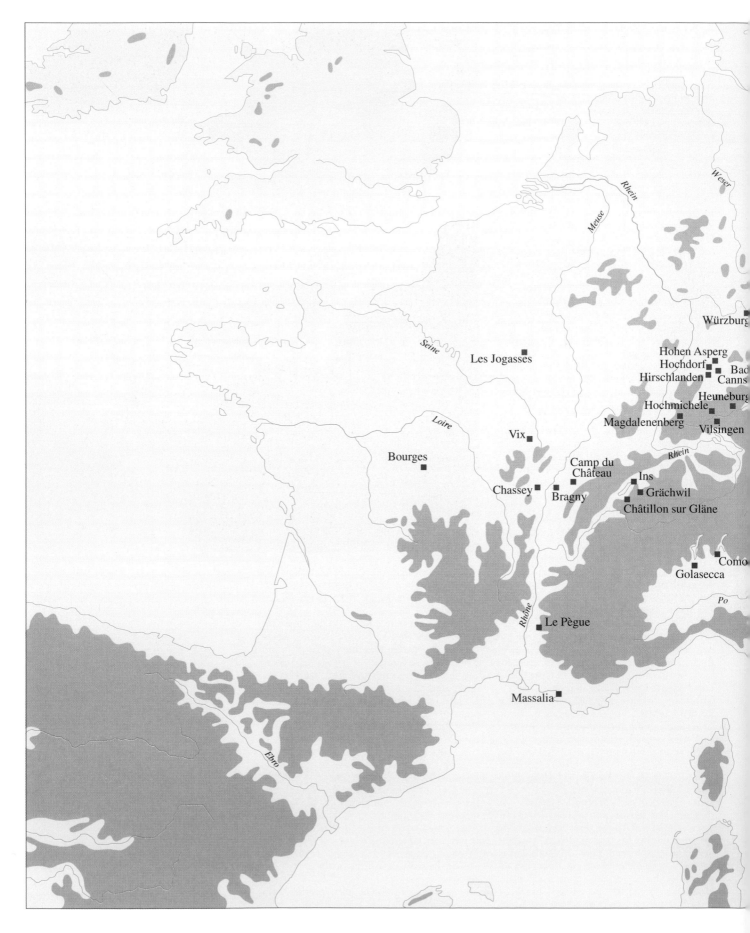

Würzburg

Hohen Asperg
Hochdorf Bad
Hirschlanden Canns
Heuneburg
Hochmichele
Magdalenenberg Vilsingen

Les Jogasses

Seine

Meuse

Rhein

Weser

Loire

Vix

Bourges

Camp du
Château

Rhein

Ins

Grächwil

Châtillon sur Gläne

Chassey

Bragny

Como

Golasecca

Po

Rhône

Le Pègue

Ebro

Massalia

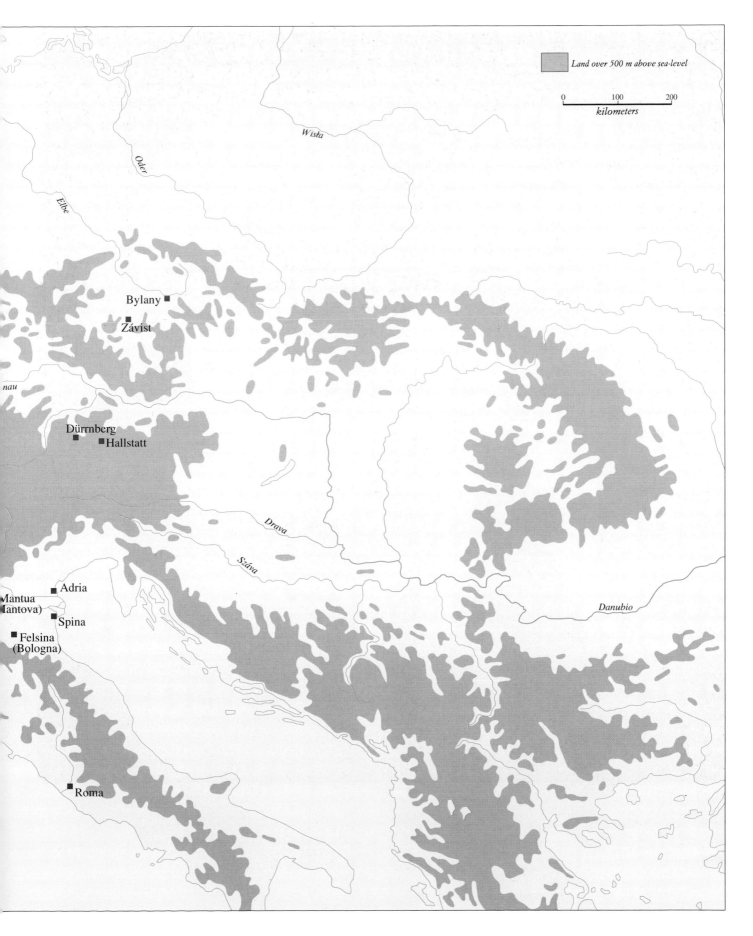

The Age of the Princes
Sixth century B.C.

Land over 500 m above sea-level

0 100 200
kilometers

Wisła

Oder

Elbe

Bylany

Závist

nau

Dürrnberg
Hallstatt

Drava

Száva

Adria

Mantua
(Mantova)

Spina

Felsina
(Bologna)

Danubio

Roma

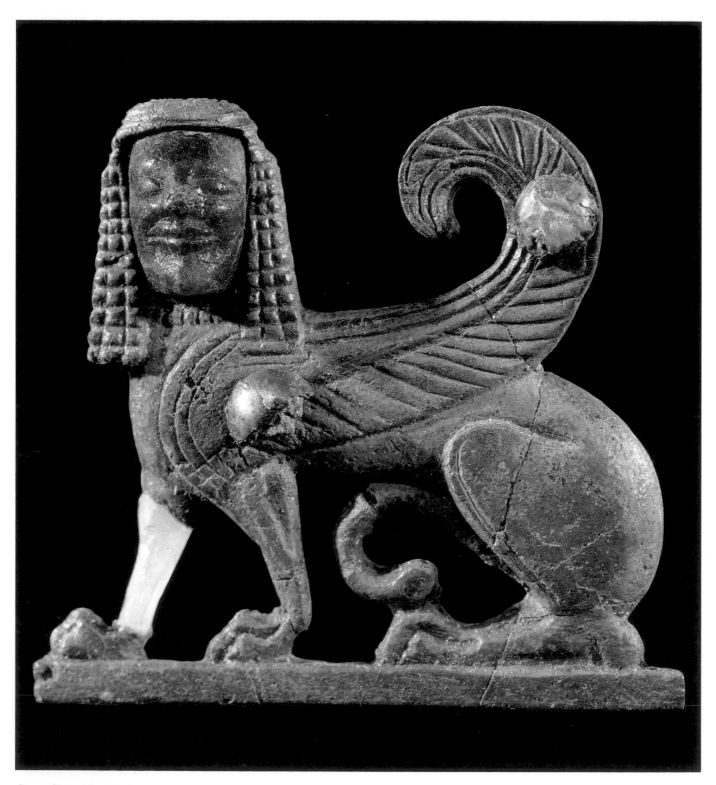

Bone sphinx with amber face
from the princely tomb
in the "Grafenbühl" barrow
near Asperg (Baden-Württemberg)
Graeco-Italian work
from end 6th century B.C.
Stuttgart
Württembergisches Landesmuseum

Otto Hermann Frey

"Celtic Princes" in the Sixth Century B.C.

The objects displayed in the first rooms of the exhibition are quite different from the others, especially the works of art. There is none of the typical decoration of curving lines; in its place, both on the pottery and on the metal objects, the simple geometrical patterns and the few examples of figurative decoration bear no relation to those that follow. If we wish to regard the artistic output as a characteristic expression of the common traditions of a people that will shed light on other aspects of contemporary life, we should ask ourselves whether the material from the sixth century B.C. was Celtic—were the "princes" of the sixth century B.C. already Celts? In reply, it has often been suggested in the past that the Celts did not penetrate central Europe until the fifth and fourth centuries B.C., from the west (though no one knew exactly where). In the sixth century B.C., therefore, we were, in theory, dealing with other peoples in central Europe.

Today, however, we are of the opinion that, despite the manifestation of changes taking place in cultural expression, we must assume a strong ethnic continuity in western Germany, Switzerland and certain areas of France. The proof lies in certain settlements, where similarities of customs in dress can be identified, and analogies exist regarding funerary and other rites, independently of the cultural changes taking place. But then, why do the cultural expressions of the sixth century B.C. play such an important part in the exhibition? Do many of the links not go back much further? For example, the formation of the Celtic language must have begun in much earlier times. Should one therefore not begin by defining the cultural development from a much earlier point in prehistory? Certainly, if anything of the kind were attempted, certain factors that characterize the later Celts would lose their definition, which is already somewhat vague. However, if we start at the sixth century B.C., we can highlight some of the origins of the subsequent generations of the Celtic people. The increasingly intense exchange of goods with the Mediterranean area on the part of the rich ruling class may, even then, have provided the Etruscans and Greeks with early knowledge of the peoples living north of the Alps. Therefore, it is probable that the Etruscans and Greeks had already conjured up an image of the Celts, although the earlier traditions handed down to us by the classical geographers and historians date back only as far as the fifth century B.C. This is the reason why this period, which in many respects constitutes a break and a new beginning, should be given greater attention as the introduction to the exhibition.

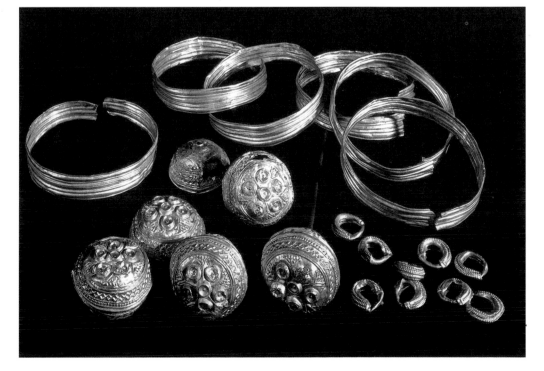

Gold jewelry from the female tomb at Ditzingen-Schöckingen (district of Hohenasperg, Baden-Württemberg) Second half 6th century B.C. Stuttgart Württembergisches Landesmuseum

Hallstatt: A Name for an Era.

In archaeology, we talk about the Hallstatt period. This term derives from a cemetery with over a thousand recorded graves containing extremely rich funerary assemblages. Towards the middle of the nineteenth century, excavations were carried out near the town of Hallstatt, in Upper Austria, in an Alpine valley, the Salzbergtal above the Hallstättersee (Lake Hallstatt). It was salt that originally attracted men of the time to this place hidden in the mountains, at a height of about a thousand meters above sea level, despite the long winters, difficulty of access, impossibility of agricultural activities and the fact that livestock could only be kept there during the summer months.

There are rock-salt deposits in various areas of the Alps. Besides Hallstatt, for example, there is the Dürrnberg, near Hallein, south of Salzburg, or nearby Bad Reichenhall. Although these two locations are important Celtic archaeological sites, Hallstatt seems to be the oldest.

The fact that a permanent settlement for the miners was established in an area of the Alps that was far from the great passes and difficult to reach shows how precious salt was for the people of the time. This must have been quite a large community, since, apart from the actual mining, all the related activities, such as digging and transportation, as well as the carpentry for the braces in the tunnels, were carried out there. Wood had to be collected not only for this purpose, but also for the huge number of torches necessary to illuminate the mining work underground. In addition, fine quality wood was needed to make handles for the mining tools and there must have been smiths in the community to attend to the task of tool maintenance. Then there were various jobs relating to transport. Therefore, the population must have consisted largely of outsiders. Once mined, the salt had to be taken long distances over difficult paths to the other side of the Alps; in fact, both the mine and the transport of the salt must have needed a certain amount of protection.

From clothing and arms found in some of the graves at Hallstatt, it is clear that people came here from faraway places, for example, from the eastern, northern and northwestern foothills of the Alps. Some finds from funerary contexts indicate the existence of contacts with places even further away, even with northern Italy, a fact that highlights the wide area of influence of this mining settlement.

Since a separate chapter deals with the rock-salt mines of Hallstatt, only a few comments are necessary here. However, it is important to remember how vital salt was to the people of the time: not only was it useful for flavoring food, but also as a preserving agent. In addition, the processes involved in leather-work necessitated large quantities of salt. In this context, it is particularly significant that the extraction of the mineral and the inherent trading activities must have involved a highly complex level of organization. The details of it and how the various work was divided up still remain largely unknown and open to speculation. In-depth research must have been necessary before extraction of the salt could begin. First of all, layers of rock many meters thick had to be opened up, a task requiring a number of years. Without going into further detail, suffice it to say that the solving of these problems proves how the economic incentive of this remote mining settlement had already reached a surprisingly high level.

The definition of the Hallstatt era, which is usually divided into an early and a later phase, corresponds to the framework of the Hallstatt cemetery. The second phase is usually subdivided, so that we generally talk in terms of the Early, Late and Final Hallstatt periods (archaeologists use the terms "Hallstatt C", "Hallstatt D1" and "Hallstatt D2-3"). Only the last two periods will be discussed in detail here. The cemetery has not only given its name to an era: the finds have led us to talk of a "Hallstatt culture." However, fairly early on, it was recognized that there were considerable regional differences, and in particular, that there was an eastern sphere of the Hallstatt culture, which had its center in the eastern Alps, and a western counterpart; it is only in the latter manifestation of the Hallstatt culture that we shall try to detect the cells which, later on, were to generate the Celts. As far as the Hallstatt period in central Europe is concerned, therefore, we should be more inclined to think of a

prevailing "period taste" rather than a great, compact culture in the strict archaeological sense. Hallstatt is situated almost on the borderline between the eastern and western spheres. The material from the cemetery can mainly be attributed to the formal western branch, although there seem to be many contacts with the east. First, we shall consider the western sphere of influence, and try to define more precisely its role in the generation of the Celtic culture.

What Was the Original Homeland of the Celts?

The so-called western Hallstatt sphere extends from Bohemia to the Massif Central and from the Alps to the Mittelgebirge. Within this large expanse of territory, with its many regions, a "core area" is usually distinguished in which, during the sixth century B.C., one group stands out from the rest, owing to its great wealth. Since wealth and rank are synonymous in this period, it is probable that this group had a decisive influence on cultural development. The group can be easily recognized, in material associated with burials, for example, by the presence of various gold objects in the graves. The most typical find consists of gold foil torques, which must have been the distinguishing mark of a chief. One of the most important sites is at Hundersingen, on the upper reaches of the Danube. The rich burials of this area, which were excavated as early as the seventh decade of the nineteenth century, were defined as "princely tombs" at the time, a term which was obviously not meant to define the exact social condition of the dead buried there: however, the definition has remained. It is worth noting that, in several places, fortified settlements were found near these graves, which were consequently given the name "princely strongholds." A large number of the "princely tombs" were opened up during the last century by people looking for precious grave goods, but it was not until after World War II that the related settlements were given serious attention. While it was known beforehand that the burial would contain precious objects intended to assist the "survival" of the dead person on his journey to the next world, expectations for the settlement yields had to be greatly lowered: the only finds would be everyday objects of relatively little value: animal bones, fragments of pottery, small ornamental objects and so on. Only in cases of violent destruction can large quantities of objects be found intact under the rubble, and then not always.

The Heuneburg and its "Princes"

The most thorough excavations to be carried out in a "princely residence" of this type were begun during the fifties on the Heuneburg, near Hundersingen. This stronghold stands not far from a related burial mound, and was inhabited for the entire span from the Early through to Late Hallstatt periods, that is, for over one hundred and fifty years. Early fortifications built according to local tradition were upgraded in the Late Hallstatt period (Hallstatt D1), to an imposing perimeter wall in unfired brick over a stone core, with a line of square bastions jutting out toward the exterior. The wall is massive, so far unmatched in central Europe. There is no doubt that it was based on Greek models of fortifications, with which the Hallstatt lords had become familiar through contact with Greek colony of Massalia, at the mouth of the Rhône (present-day Marseilles). By contrast, fortifications built in roughly the same period in northern and central Italy have no bastions. Up to now, only the southern part of the densely populated settlement inside the Heuneburg has been explored. What came to light was not a residential area for the ruling class, but instead a blacksmiths' district, where the buildings are distributed according to a precise plan. During this period, a settlement grew up outside the walls, sprawling over a territory even larger than that of the fortified zone. After only two generations, the entire complex was destroyed by a huge blaze. During the final Hallstatt period (Hallstatt D2-3), the site was again fortified according to a technique that was widespread in central Europe, and involved the use of wood, stones and earth. There were many innovations during this period. Then this second phase of fortification also met a violent end: the new wall was destroyed by fire. The internal structures were

Detail of gold cup
from princely chariot-tomb no. 1
at Bad Cannstatt (Baden-Württemberg)
6th century B.C.
Stuttgart
Württembergisches Landesmuseum

re-built with modified plans, but again, in the areas where excavations have been carried out no sign of houses belonging to the ruling class has turned up.

Phocaean wine amphorae and gray pottery attest to close links with the Greek colony of Massalia during this phase; there are also several fragments of Late Greek black figure pottery. However, the settlement's links with the Mediterranean were certainly not limited to Massalia. Some objects, which were either imported or imitations of Etruscan originals from the north of Italy, belong to this last Hallstatt phase.

In the settlement, there is considerable evidence of differentiated craft styles; objects were made from raw materials brought from far afield. All the evidence points to the fact that the "princes" employed highly specialized craftsmen and artists. We get a better idea of the nature of the role played by the Hallstatt "princes" from the burial finds. The Heuneburg is surrounded by a circle of large burial mounds, either isolated or in groups, sometimes erected on cleared ground, so that they could be seen from a distance. It is interesting to note that the "princely tombs" containing gold rings all belong to the last Hallstatt phase. None of the burials containing these status symbols relate to the earlier fortress with its unusual brick walls. Therefore, how is it possible to distinguish the tombs of members of the dominant class? There is no doubt that people belonging to the chieftain's circle were also buried in these barrows, such as those at Hohmichele and Rauhen Lehen, which contain large timber-built burial chambers. Let us look at Hohmichele a little more closely. The central wooden chamber had been robbed, a common phenomenon with the two later Hallstatt phases, a fact which confirms how precious the funerary offerings must have been. It was possible to identify the whole length of the tunnel dug by the ancient grave-robbers by tracing the trail of little glass beads left by one of the robbers, who had broken the string of his necklace as he crawled in.

At Magdalenenberg in southern Germany, near Villingen, on the eastern edge of the Black

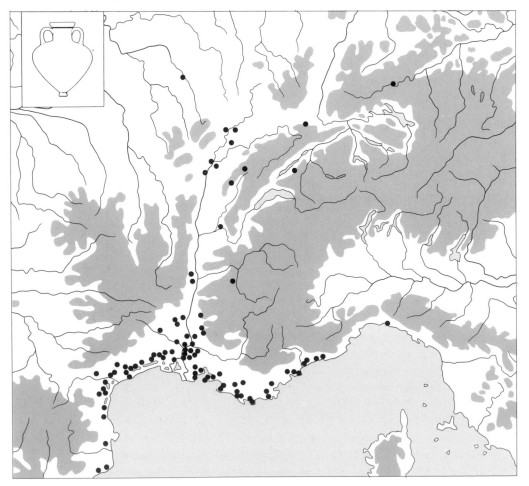

Map showing distribution of Massiliot amphorae

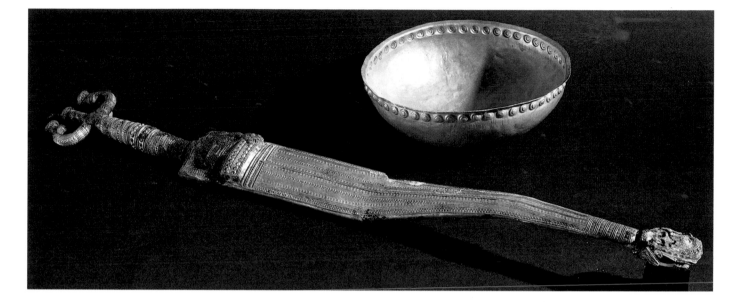

Iron dagger decorated with gold leaf and gold cup from the princely tomb at Eberdingen-Hochdorf (district of Hohenasperg Baden-Württemberg)
Second half 6th century B.C.
Stuttgart
Württembergisches Landesmuseum

Site of Magdalenenberg barrow near Villingen (Baden-Württemberg)

Forest, there is another large barrow, the central chamber of which was also robbed. The structures and other wooden objects were found to have been perfectly preserved, owing to the high degree of humidity. Three wooden spades abandoned by the robbers were found inside the chamber. It was possible to count the growth-rings in the wood, after which a dendrochronological study showed that these tools were made approximately forty-seven years after the chamber was built. We therefore have a valid basis for establishing when the robbers entered the chamber, which, at the time, was still intact.

It was also discovered that the dead had been laid to rest only a few years before the robbers' raid. In a more recent barrow, in the immediate vicinity of the Heuneburg, a human skeleton was discovered, profaned and cast aside at a time when the decay of the corpse cannot have been complete, since the bones were still in their original anatomical position. Should we deduce that, in this case, the raid was contemporary with the second destruction of the fortress? But let us return to the burial at Hohmichele. It is highly probable that the large chamber, which measured 5 by 3.5 meters, was destined for two corpses. By the time it was excavated, little remained of the grave goods, a piece of gold leaf from a belt for example. The walls of the chamber were lined with fabric; very little remained of the wagon that had been part of the funerary assemblage.

Besides a number of secondary burials with simpler funerary assemblages—some cremations in clay-brick containers or graves with wooden coffins surrounded with stones—Hohmichele contained a second large chamber situated in a rather unusual position in the barrow and which was discovered still intact. Here too, the excavators found two corpses, a man and a woman, lying side by side on animal skins laid out on the floor of the chamber. Their clothes were held in place with cast bronze fibulae of a shape typical of the period also found in many simple graves. It was remarkable that the woman wore no ornament on her head, no torques or bracelets or anything of this kind, but a long chain of glass and amber beads, which had obviously been wound around the neck several times, and distinguished her from other corpses. A piece of coral was also found. The man wore an iron ring round his neck and his belt, decorated with flat bronze mounts, was like that worn by men throughout the Late Hallstatt period, but also and predominantly by women, whose belts were richly ornamented. A large knife completed the man's weaponry, together with a quiver full of arrows, which presupposes the existence of a long bow: in fact, the remains of some string were found next to the body of the man and may have belonged to a bow. If so, it was probably a hunting weapon and not a weapon used in warfare.

Above the body of the woman was a wagon with four wheels, sumptuously decorated with

mountings in bronze and iron, typical of the funerary assemblages of the dominant class. The dead must have been brought to their last resting-place on the wagon, which must have created a scene not unlike those represented on Late Geometric vases in ancient Greece. Some of the technical details of these Hallstatt wagons may have been imported directly from Italy, where wagons, especially the two-wheeled variety, were often part of the funerary assemblages of rich people, as we encounter similar concepts in both these cultural spheres. Besides the wagon, horse-fittings had been put in the grave.

Lastly, the burial chamber at Hohmichele contained several bronze vessels, a large cauldron with iron joints and ring-handles, a small drinking vase, and a cup with a double ring of beaded decoration in relief on the rim. At the man's feet there must have been a wicker basket—

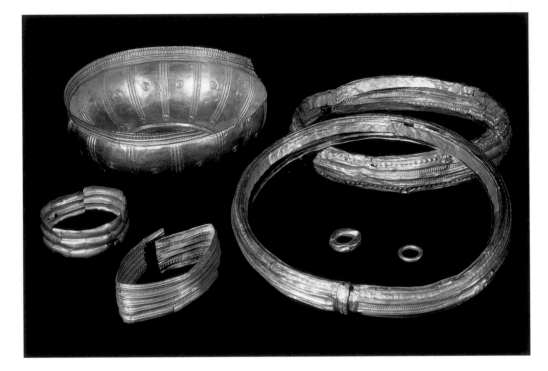

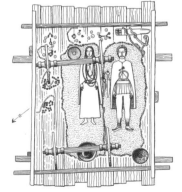

Jewelry and gold cup from the princely chariot-tombs at Bad Cannstatt (Baden-Württemberg) 6th century B.C. Stuttgart Württembergisches Landesmuseum

possibly containing fruit—of which only a few traces remained.

Large cauldrons seem to be typical finds in "princely burials" of the western sphere of Hallstatt. Objects of this kind were also found in Etruria, where the habit of placing a similar object, containing various offerings, next to the dead man probably originated. The cup with the double row of beading on the rim also has equivalents in central Italy, without which those found north of the Alps could not have been conceived. The third, small drinking vessel, on the other hand, corresponds in shape to terracotta Hallstatt vessels and confirms the existence of a local bronze-working industry of a high level.

In conclusion, a little more must be said about another find from this burial. A remnant of fabric from the woman's dress was found to be embroidered with original Chinese silk thread, which brings us immediately to the conclusion that the lords of the fortress must, even then, have had important links with places that were very far away indeed, and certainly further than had previously been imagined. It is quite clear that those buried with these kinds of objects belonged to the ruling class of the time.

Hohmichele was explored just before World War II, and a careful program of excavation was followed, which explains why there are so many and such detailed observations regarding this site. The situation is different for the later burial mounds around Heuneburg, which were excavated in the nineteenth century. Four large barrows stand out from the others: the Giessübel-Talhau group, built right next to the fortress above the external settlement, which had been destroyed, dates back to the period of the unfired-brick wall. Here too, in the

Reconstruction of chamber-tomb no. VI, with double deposition in the Hohmichele barrow near the Heuneburg (Baden-Württemberg) Second half 6th century B.C.

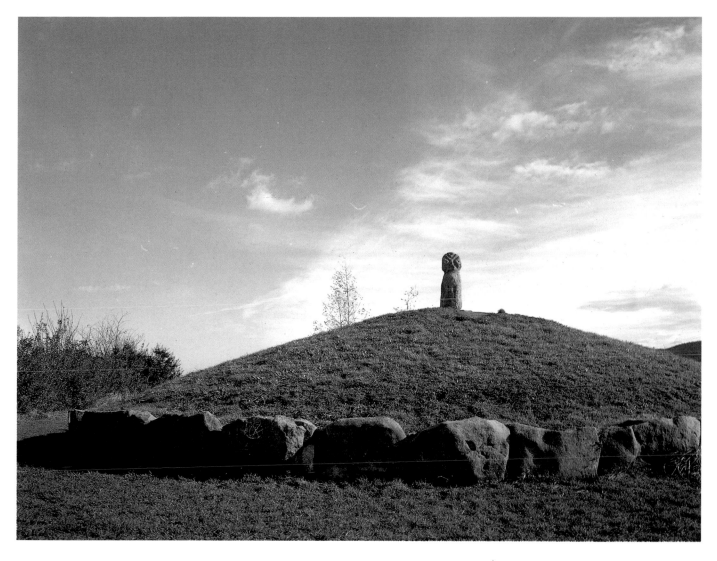

Reconstruction of 6th-century B.C. barrow with janiform stele (Baden-Württemberg) reconstructed to its state in 6th century B.C.

center of this barrow, large, timber-built chambers were discovered, with burials from a later period nearby, situated higher up in the barrow and containing equally rich funerary assemblages, as well as secondary, much simpler burials. Therefore, whole families were laid to rest here. Other finds in these "princely tombs" were processional chariots, large bronze cauldrons and other vessels of the same metal, including cups with a single beaded rim. It is almost certain that these objects were imported from Italy.

Weapons were laid next to the dead men, usually a considerable number of spears and knives. These products could hardly have been improved by the local metalworking industry, so sumptuously were they crafted and decorated. These cannot possibly have been simple war weapons. In the western Hallstatt sphere, this custom of putting a complete panoply of weapons next to a warrior for use in the next life was not widespread; the precious knives should be interpreted as the distinguishing signs of a person of rank, which accompanied him when he died. The archaeologist regards these knives as being chronologically indicative of the Late and Final phases of the Hallstatt culture. It is worth noting that in southwest Germany, during the Late Hallstatt period, they are even more widespread, whereas later on, they only appear in "princely burials."

In the last Hallstatt period (Hallstatt D2-3), fibulae underwent many variations. These ornaments, more than any other, were sensitive to changes in fashion and therefore provide the archaeologist with an extremely useful tool for dating them and their distribution. In addition to later cast bronze bows, with a modified foot, there are various shapes of fibulae with

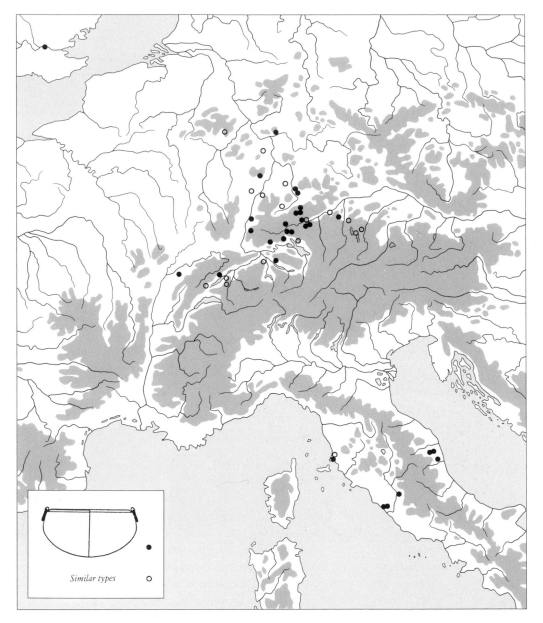

Similar types ○

decorated disc-shaped feet, all of which were found in funerary assemblages of both rich and simple burials. Often, they are inlaid with coral. Other coral ornaments have been found, as well as objects in amber. Plating was common for decorating belts, arm-rings, finger-rings and leg-rings, and so on. However, gold rings, which were often found in these barrows, have been interpreted as being characteristic of only the "princely burials," while hollow gold torques were only worn by the men. The Heuneburg and the barrows that surround it represent the most thoroughly researched "princely stronghold" of the Late Hallstatt period; however, it is not an isolated case. On the contrary, it has a whole series of parallels.

High-Ranking Men of the Late Hallstatt.

There is no lack of other Late Hallstatt (Hallstatt D1) sites with rich burials. We have already referred to the Magdalenenberg near Villingen. This is an imposing burial mound more than 100 meters in diameter and, originally, 8 high. The central chamber, made of squared-off trunks of oak, measures 8 by 5 meters, and is about 1.5 meters high. The chamber was buried under a mass of stones almost thirty meters across, with the tumulus of earth on top. Inside the upper part of the mound, 126 more secondary burials (originally, there must have been

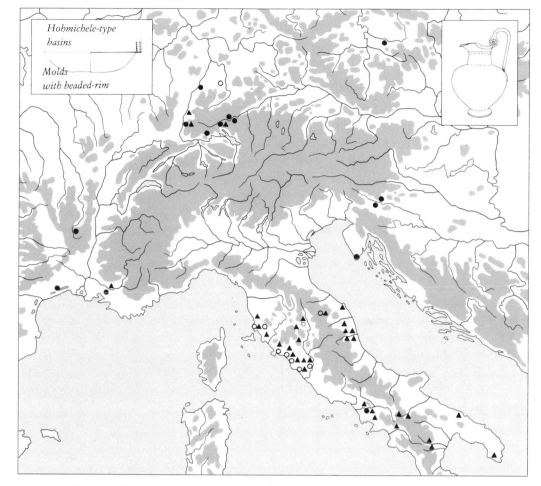

Map showing distribution
of bead-edged bronze basins
and bronze wine flagons
from Magna Graecia
7th-6th century B.C.

about 140) were discovered in the course of brief investigations. So, here too, the burial mound was used for burying the corpses of a whole community, with the large wooden chamber reserved for its most important members. Unfortunately, as mentioned earlier, it had been robbed, and it is only the presence of a few objects scattered round the chamber, including the remains of a wagon and horse-harness, that tell us that the burial belongs to the time of the foundation of the Heuneburg. Moreover, the skeleton of a piglet suggests that the dead man was accompanied by offerings of food. Ornaments and weapons from tombs that were not robbed are typical of the Late Hallstatt period. One particularly interesting find is a belt-hook of a type common in the northern part of the Iberian peninsula. Perhaps the person who originally wore it brought it to southwest Germany. The mount on a belt from another tomb is also interesting, as its decoration includes a dotted rosette pattern, imitating products of Greek or Etruscan origin.

Four kilometers from the burial mound is the Kapf, a hillfort settlement on a rise. However, excavations there were restricted to a fairly small area. The pottery found at this site suggests that the settlement was contemporary with the Magdalenenberg burial so it may be assumed that the settlement and the burial mound are contemporary. However, there are no finds typical of a "princely stronghold" in the former. It is not clear what relationship there was between a fort of this type and what is certainly the largest funerary complex built in the Hallstatt period for a man who must have belonged to the ruling class.

Another example of a rich burial site is the so-called Heiligenbuck, near Hügelsheim in the Rhine valley, not far from Rastatt. Unfortunately excavations here were carried out in the last century, and no detailed record of observations was made. This burial belongs to a slightly later period; here too, the huge mound contained a timber-built chamber which despite a stone cladding grave-robbers managed to get to. From what little was left of the grave

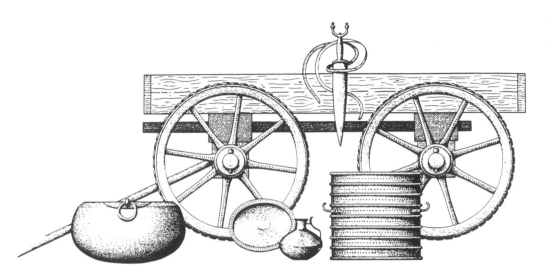

goods, it is possible to reconstruct the presence of a wagon and a bronze "serving set"; again, there was a cauldron and a cup with a double ring of beading on the rim, similar to the one at Hohmichele, as well as a small jug, produced locally, and a ribbed bucket. A fragment of the hilt of a knife confirms that the man was buried with weapons. A cast bronze fibula was also found. This important funerary assemblage, the wagon and the bronze "serving set" lead us to suppose that this, too, is the burial of a man who belonged to the ruling class of the time, and that the term "princely burial" may be correctly applied here.

The rich burial was not isolated: only 800 meters away, near the village of Söllingen, a burial mound was excavated last century, yielding a gold bracelet, a bronze torque, two cast bronze fibulae and an amber bead. The gold bracelet distinguishes the dead woman from other women's burials. Here, no settlement was found in connection with the burials.

Lastly, important funerary finds from Vilsingen in the Sigmaringen area, not far from the Danube, offer another typical example of this Hallstatt phase; again, records of the excavations carried out in the nineteenth century are inadequate, and it is impossible now to establish whether this is really a complex of finds from a single grave, or a confused conglomeration of objects of various origin; it could even be a double burial.

What is certain is that inside the tomb there was a procession chariot with mountings typical of this period, a bronze cauldron, two typical cups with double row of beading on the rim and other bronze vessels, including a flagon which is probably Etruscan, but modeled on a Greek original.

Flagons of this type are common in central Italy and have been found north of the Alps at two other sites in southwest Germany, associated with funerary assemblages typical of the period. Other graves were found very near here during the last century, but the material deriving from them, including parts of a wagon, was in a very disorderly state. The settlement relating to them may be Amalienfels, near Inzigkofen, but this theory is supported only by a few shards of Hallstatt pottery found on the surface.

Almost all the excavations were carried out a long time ago and are all badly documented, so that it is only possible to define in relative terms one of the constants that seems to accompany these large chamber-graves with their precious ornaments, processional chariots and bronze "services" for banquets and drinking ceremonies. One characteristic seems to be their connection with hillfort settlements, although exactly how they were connected cannot be clearly defined. It is interesting that the people buried in these tombs, who were definitely of high rank, are only found in large numbers in southwest Germany, where there is a fairly sparse distribution of burials.

The origins of this development belong in the earliest period of the Hallstatt culture, which

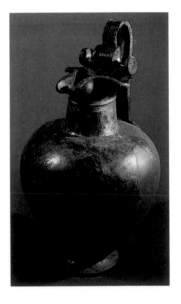

had already adopted the custom of the wagon burial with rich banqueting services. However, what typifies the period we are dealing with is the appearance of hillforts, often accompanied by the foundation of new settlements. The Heuneburg, where there are no finds dating from the earliest Hallstatt period, is an excellent example of this. Moreover, contacts with Italy took on a new dimension, as we can see from the customs of the time. As in Italy, it became common to use fibulae for fastening clothes; other aspects have already been mentioned. This is a topic that merits further examination, on the basis of the economic changes taking place and other phenomena of this kind.

The political and social structures existing during the Late Hallstatt (Hallstatt D1) and referred to here did not last long. At the Heuneburg, as mentioned before, a large fire brought this phase to an end.

The next settlement, which belongs to the last phase of the Hallstatt culture, produced fortifications of a different type, a new town-planning structure, and so on. Other centers in southwest Germany were also coming to an end. The outlying land was now used as a cemetery. Power, which was reflected in hillforts and rich burials, was concentrated in a few places that for the most part originated during the Final Hallstatt period (Hallstatt D2-3).

Map showing distribution of chariot-tombs in Middle Hallstatt period

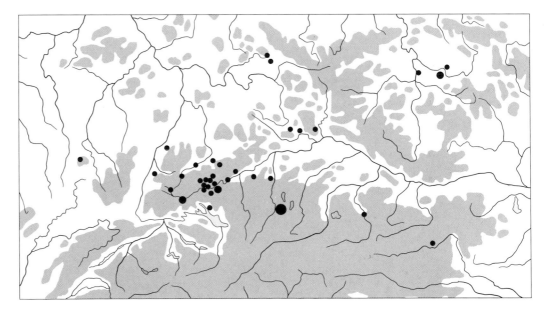

The Gold of the Late Hallstatt "Princes"

A new center grew up beside the Heuneburg near the Hohenasperg, in the region of Ludwigsburg (northern Württemberg). The Hohenasperg is an isolated hill where a "princely stronghold" almost certainly once stood, even though the protohistoric traces have been virtually wiped out by the construction of a medieval town and the a Renaissance fortress. The evidence to support the theory lies in the numerous "princely burial mounds" forming a huge circle around the hill.

The earliest burial in the complex is the grave—which survived intact—at Eberdingen-Hochdorf, systematically excavated in 1978-1979. The huge mound contained a double timber-built burial chamber, the internal dimensions of which were 4.7 x 4.7 x 1.2 meters. The floor was covered with cloth and other fabrics hung from the walls, held together by bronze fibulae. Along one wall of the chamber was a bronze couch on which the body was laid, the head supported by a pillow stuffed with herbs; fragments of his clothes and the fabrics and animal skins fragments covered him also survived; the conical hat made of birch bark can definitely be interpreted as a sort of mark of social rank. The dead man's rank is indicated particularly by the presence of a typical gold torque. A bag contained toilet objects

and three fish-hooks. A quiver containing arrows hung on the wall above the dead man. He also wore a knife, the upper side of which was gilded, probably another mark of social status. His belt and pointed footwear were covered in gold leaf. Also found were a thick gold armlet, and two fibulae, also of gold. As the waste-material left in the grave shows, the gold ornaments—apart from the torque—were made expressly for the funerary assemblage.

The back of the couch—itself a most unusual article in Hallstatt burials—is similar in shape to those found on Etruscan chairs. The best clue as to its origin lies in details of its decoration, which can be traced to an area south of the Alps; we can either assume that this sumptuous piece of furniture was imported or that a foreign craftsman worked in this area. The grave also contained a processional chariot and a "service" for banquets and drinking ceremonies: nine drinking-horns hung on the walls of the chamber, and, on the wagon, there were nine bronze plates with three large platters of the same metal. Therefore, we can assume that a funeral banquet for nine people had been planned. The drink—which analysis revealed to have been mead—was contained in a golden bowl set inside a Greek bronze cauldron with three lions resting on the rim. Two of these are definitely of southern origin, but the third is an imitation made by a local craftsman. Three handles, evidently taken from another imported bronze container, were obviously a later addition fixed very clumsily on to the edge of the cauldron using iron nails. Beside the bowl, there was also a gold cup (for drinking?). The list of finds tells us that this is the richest treasure to have survived from the Hallstatt period. The fibulae pinning the fabric to the wall of the chamber include late cast bronze examples and one with a disc-shaped foot, and allow us to date the burial to the transition phase of the Late Hallstatt period. It is impossible to establish precisely how this burial is connected with the presumed "princely stronghold" on the Hohenasperg—approximately nine kilometers away. One wonders whether here again the residence of the "princes" had necessarily to be part of a fortified complex: can we not assume that it could also exist in other forms? This is a question that, for the time being, has no satisfactory answer.

Other rich graves in the immediate vicinity were found to have been robbed back in ancient times. Let us pause for a moment to examine a site discovered during the sixties.

This is the site at Grafenhühl, right at the foot of Hohenasperg. The grave-robbers of antiquity left behind so little of the funerary assemblage from the central chamber that the enor-

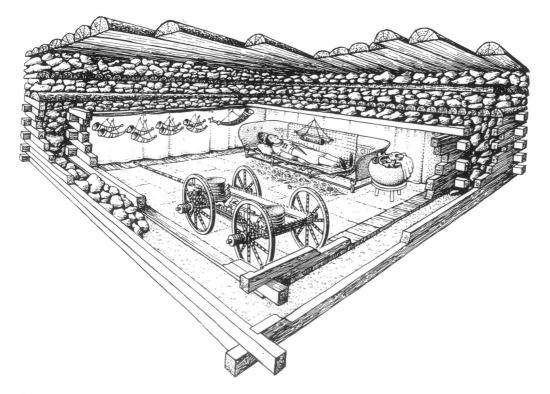

Reconstruction of princely chariot-burial beneath the Eberdingen-Hochdorf barrow (district of Hohenasperg Baden-Württemberg) Second half 6th century B.C.

*Detail of decoration from the
backrest of the bronze couch
from the princely tomb
at Eberdingen-Hochdorf
(Baden-Württemberg)
Second half 6th century B.C.
Stuttgart
Württembergisches Landesmuseum*

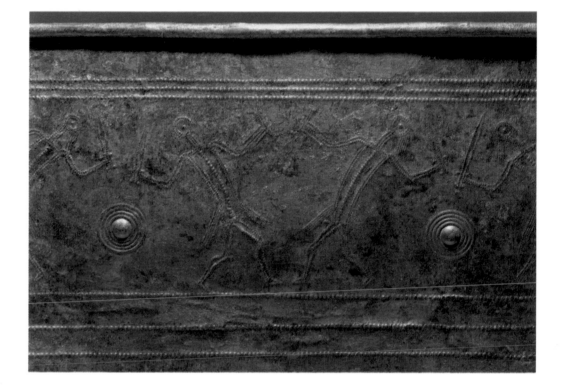

mous wealth of the burial as a whole can only be reconstructed with difficulty. The clothes of the dead man contained gold thread, which leads us to suppose that the material was a brocade of some kind. Of the belt, which was covered in gold leaf, only the hook remains; there are also two gold-plated fibulae. It seems safe to assume that much more gold was stolen by the robbers. Here again, the grave goods consisted of a processional chariot and a "service" for banquets and drinking ceremonies, the latter being represented only by a fragment of the cauldron and a tripod imported from the south with iron supports on a base of bronze lion feet which had sunk into the floor of the chamber where it had been left. At the time of the robbery, the iron was so corroded that when it was seized from the tomb, two of the feet broke off and were left in the ground. We know what the tripod must have looked like from a example found intact in a "princess's burial" of roughly the same period, at La Garenne/Sainte-Colombe, near Châtillon-sur-Seine.

The most surprising find consists in the bone and ivory decoration of a bed with inlaid palmettes and other motifs in amber. This *kline* was certainly imported from Greece, and may be paralleled with one found in a grave in the Keramikos area of Athens. Evidently, furniture of this type was regarded highly by the "Hallstatt princes," since other similar beds have been identified among the paltry remains of two other graves, thanks to the fairly complete reconstruction of the Grafenbühl model: one from a late "princely tomb" of the Heuneburg, the other from the so-called Römerhügel, also near Hohenasperg. There are also two sphinxes, one in ivory, and the other, which survived intact, in bone with amber inlays on the face. Two large nails with gold heads inserted through the wings prove that a Hallstatt artist created them to adorn an object that has not yet been identified. Some have advanced the theory that these relief carvings come from a workshop in ancient Taranto. There is also an ivory disc, possibly the remains of a mirror-handle of eastern (perhaps Syrian) origin. Although the imported objects referred to can be dated to the late seventh century or the early sixth century B.C., judging by the finds of fibulae with decorated feet, the burial dates from the end of the Late Hallstatt period, that is about 500 B.C.; these precious objects have therefore been preserved for a much longer time.

Another burial mound in northern Württemberg should be mentioned, though it contained

only modest finds and stands further away from Hohenasperg. This is the burial site of Hirschlanden, near Leonberg, where there was an exceptional find of a stone funerary stele, like the ones that probably crowned the top of many burial mounds. The statue, which is slightly smaller than life-size, is a heroic representation of a naked man with phallus erect. He wears a helmet or conical hat similar to the one found at Hochdorf, and others from the nearby "princely burial" at Stuttgart-Bad Canstatt, obviously signs of rank. The same interpretation can be given to the heavy torque, which doubtless represents a gold torque, and the knife. It is not possible to establish whether or not the man's face is covered by a mask. This is the heroic image of a dead man, decorated with the symbol of his "princely" status. Its formal aspect is obviously taken from foreign models, probably Italic sculpture such as that of the Abruzzi region or Nesactium in Istria. Ithyphallics of young men have been found at sites in both places, with exactly the same pose.

Earlier we mentioned that the total number of sites in southwest Germany that can be linked to the ruling class of this period seems to diminish, compared with the previous period. At the same time, there is an increase of the amount of gold and luxury goods imported from the Mediterranean world in funerary assemblages. Christopher Pare has interpreted the phenomenon as a "concentration of power." In the settlements, most of the Greek pottery and wine amphorae dates to this late period, suggesting intensified contact with the south. Whereas the complex equivalent in finds from the previous period were limited exclusively to southwest Germany, during the Late Hallstatt, they spread beyond this area towards the east, north and west. The map of wagon graves of this period proves this, as do the gold finds which mainly belong to this late phase.

A typical gold torque appears in Uttendorf, in Upper Austria. Wagon burials are now found near the lower reaches of the Meuse. Along the upper reaches of the Rhine and in the west of Switzerland, in centers which grew up during this phase, there are finds of wagon graves with gold torques. As for Alsace, there are sites at Hatten and Ensheim, and in Switzerland there are graves at Allenlüften and Hermrigen in the canton of Berne, at Châtonnay in the canton of Fribourg and Payerne in the canton of Waadt. "Princely strongholds" with goods imported from the Mediterranean area have been recognized, for example, on the Münsterhügel at Breisach or at Châtillon-sur-Glâne in the canton of Fribourg. In the east of France, there are now archaeological complexes that are just as rich as their southwest German counterparts, for example, the graves with gold torques at Apremont, Mercey-sur-Saône and Savoyeux, all in the *département* of Haute-Saône.

The most important example is, without doubt, the one at Mont Lassois, near Châtillon-sur-Seine, with the nearby "princely graves" of Vix, Sainte-Colombe and probably Cerilly. The settlement at Mont Lassois, an isolated hill in the valley of the River Seine, can be dated to the transition period between Late and Final Hallstatt. The graves yielded a considerable number of fragments of very high quality Greek pottery, in fact Greek black figure pottery, as well as wheel-made gray pottery from Massalia, which was just as common, and wine amphorae of the same origin. Archaeological research has not provided us with a very clear picture, owing to the poor digging conditions, however, we can state that this later complex is comparable to the one at the Heuneburg.

We have already mentioned the tripod from the "princess's grave" at La Garenne/Sainte-Colombe, presumably for a cauldron with relief griffon heads and probably of Etruscan origin. But the best example of rich funerary assemblage for a woman of the ruling class is provided by the grave at Vix, which was discovered in 1952: the woman wore rich ornaments, and in particular, a gold neck-ring decorated with winged horses, clearly the work of an artist who had trained in the south. She was found lying on the platform of a four-wheeled wagon. However, the most outstanding finds belong to the precious "service" for banquets and drinking ceremonies, partly of Greek and partly of Etruscan origin. Of special interest is the enormous bronze krater, which is the largest to survive from antiquity. Judging by the fibulae, this grave also belongs to the end of the Hallstatt period. In particular, a look at the

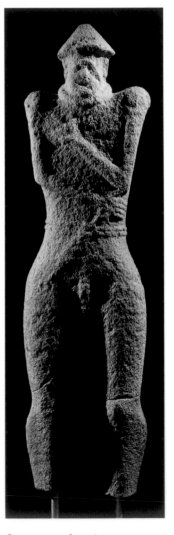

Stone statue of warrior found on the barrow at Ditzingen-Hirschlanden (Baden-Württemberg) Second half 6th century B.C. Stuttgart Württembergisches Landesmuseum

Fragments of stone statues
from Nesazio
Pola, Arheološki Musej Istre

geographical distribution of wagon graves leads us to conclude that, at least in part, the main impulses behind spread of the final phase of Hallstatt culture came from the area of southwest Germany, where pockets of social stratification and possibly also of political power may have developed, influencing the situation in the period that followed. This was probably a very complex affair, with various ripple effects. Although it is true that the whole scenario seems to merge in a single chronological period, it is also true that the archaeological material spread over a broad territory consists of recurrent types of burial assemblages with certain objects that are therefore considered to belong to the same period and which are also found in other assemblages. We tend to divide the available material into chronological categories, although, very often, we should bear in mind that complex developments were taking place that had various overlapping effects.

The Timeframe
The precise timeframe of the events mentioned always tend to be best defined by objects imported from the classical world, although, as noted, these were often kept for a long time before being put in a grave. The earliest objects date from the seventh century B.C., while the most recent date from the early fifth century. The cauldron from the Hochdorf burial, which is representative of the beginning of the Final Hallstatt period, may have been made in about 540-530 B.C. Starting from this basis, it is only guesswork as to when the indigenous products found with it were made, and from there to establish the period to which the burial belongs.

When wood is found in a good state of preservation, it is also possible to establish when a complex was built by counting the growth-rings. Unfortunately, today few analyses have been conducted with reference to the Hallstatt period. The most revealing finds come from the Magdalenenberg, near Villingen, where the central, timber-built chamber marks the beginning of the latest Hallstatt period. The oak trunks used to construct it have now been dated, after several corrections, to 622 B.C.—this pin-points the time when the trees were probably felled—which corresponds well to the evidence provided by the imported objects found in the grave.

Relations with the South
The luxury objects from the classical world found in Hallstatt burials represent only a small fraction of the articles of prestige. This suggests that these objects, rather than pointing to the development of a trade, were probably gifts that offered hopes of obtaining some kind of favor in return. We can only have an approximate idea of how the contacts were established.

To the south, one source of such contacts was the Greek colony of Massalia, not far from the mouth of the Rhône, founded in 600 B.C. by Phocaeans from Asia Minor. Subsequently, other minor Greek sub-colonies grew up along the south coast of France, where there was considerable integration with the indigenous population; in other words, the entire area was subjected to a powerful wave of Greek influence. There are many Etruscan finds from this region datable to the seventh century and the early sixth century B.C. Not long after the middle of the sixth century, increasing friction in the area caused it to be divided up into spheres of Greek and Etruscan influence.

In this later period, contacts are between the Hallstatt and other cultures mainly represented by fragments of wine amphorae from Massalia, which are, perhaps, an early indication of the proverbial fondness of the Celtic barbarians for drink, confirmed by finds from later sites. The fact that the inhabitants of central Europe made their entrance into the Greek sphere beyond the Rhône valley fairly early on is proved by the first unfired-brick wall from the Heuneburg, which was built in about 600 B.C. and which, as mentioned earlier, was certainly modeled after Greek fortifications.

The links of the Hallstatt sphere with Etruria go back even further. However, in the seventh

century and the first half of the sixth century B.C., the north of Italy, with its regional cultural groups, found itself acting as a filter between two territories, although this did not prevent a lively period of cultural exchange from ensuing, and revealing to the Mediterranean world a great deal about the hitherto obscure nature of the inhabitants of this cultural island. Only after the middle of the sixth century did the Etruscans of central Italy, who belonged to a much more developed culture, begin to penetrate north beyond the Apennines; the Etruscan city of Felsina (Bologna) and other smaller centers, such as the ports of Hatria and Spina (which also had a considerable population of Greeks) bear witness to this movement. The production and marketing of luxury goods in these cities so close to the Hallstatt world led to a further increase in bartering activities, for which the bronze Etruscan artifacts found in the "princely graves" (referred to earlier) at Hatten, Conliège, Mercey-sur-Saône, Vix and other sites provide ample evidence.

Finds in France are a striking confirmation of such exchange. And, as if in answer to the arrival of luxury goods north of the Alps, a current flowing in the opposite direction has produced fibulae typical of the late Hallstatt period in the north of Italy and, to some extent, also in Etruscan cities. However the fibulae do not constitute a "commercial item," and we can assume that the people who wore them took them to Italy from central Europe. In this connection, a military invasion seems unlikely; it is more probable that the finds of isolated material in foreign cultural spheres indicate a certain amount of human mobility, with encounters which gradually brought the Hallstatt world closer to the north of Italy.

How do these contacts link up with the other early cultures present in the intermediate territory of central Italy?

Obviously, the Hallstatt inhabitants of central Europe had other contacts, for example, with regions further north which provided them with amber. That they also procured silk from the Far East seems to be confirmed by the fragments of fabric found at Hohmichele.

Contacts with the Iberian peninsula, which had important reserves of precious metals in ancient times, are reflected in the artistic output of the time. The thick gold armlet with five decorated rings from the grave at Hochdorf has a fair equivalent in a gold torque from the

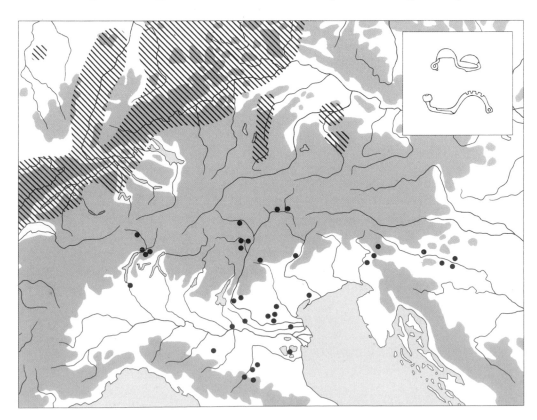

Map showing distribution of two types of Hallstatt fibulae of late 6th-early 5th century B.C. The main area, north of the Alps is shaded.

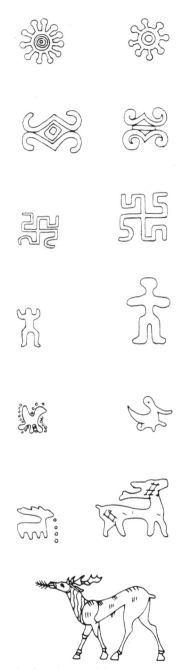

In the column on left motifs from Hallstatt objects with embossed decoration Right: their prototypes on pottery and bronzes from Este, Padua and Bologna Below: a deer on an Etruscan bucchero vase

treasure found at El Carambolo (Seville). In the same way, gold ornaments from the "princely tombs" around Mont Lassois can be compared to other products south of the Pyrenees. However, on the whole, all of these links seem to have had only a limited influence on the cultural developments of central Europe. Contacts with the Mediterranean world, on the other hand, must be interpreted in a completely different light.

We have already mentioned that these contacts at the beginning of the Late Hallstatt period had the effect of changing certain customs. Clothes were no longer held together with large pins, but with fibulae, the shape of which are clearly related to models from the Italic sphere. In the Late Hallstatt period, the evolution of fibulae took on more unusual characteristics. However, certain details, such as the incorporation of coral in the decoration of the bow, testify to the existence at this time of fashion trends with analogies both north and south of the Alps. Similarly, in this late phase, wildfowl motifs were revived in the form of ducks' heads decorating fibulae in the western Hallstatt sphere.

Contacts with the areas south of the Alps are particularly evident in the patterns worked on the richly decorated plate found on belts. Here, we are not dealing with simple decoration, because there is also some figurative representation, and it is interesting to note that it substitutes other traditional symbols; there are pictures of animals and of people, the latter represented with legs apart and feet turned sideways, like those found on molded pottery from Bologna. The animals include a deer walking along slowly, with its head held well up and its antlers pointing backwards, parallel with its back. Often, a plant still hangs from its mouth. This is an iconographic design, characteristic of the beginning of the Orientalizing process in Etruria, which was later transformed into smaller molded modules.

In this period, the Hallstatt sphere also adopted technical innovations, for example, the introduction of the potter's wheel, which appears during the last phase of Hallstatt. It is important to note that before now, high-quality pottery produced on a wheel was only found in "princely strongholds," such as the Heuneburg, and sites at Châtillon-sur-Glâne or on Mont Lassois: from this we can conclude that these advances in technology were linked to the ruling class, which was now able to employ specialized craftsmen and control trade over long distances. Other finds prove that a high level of craft traditions was gradually developing, for example, the gold objects relating to this period. Another eloquent, though isolated, piece of evidence is the large cauldron found at the Hochdorf site, mentioned above: on its rim reclined three lions, two of Greek craftsmanship, and the third by local hands. From a technical point of view, the third lion is clearly superior to its imported counterparts in terms of execution, though the attempt to imitate the actual shape the Greek models is not very successful. It is lacking in stylization and does not suggest a conscious, independent approach. We have already seen that the unusual couch from the Hochdorf grave can only have derived from furniture of Italic origin, as the decoration on the back-rest proves. On the other hand, the legs—consisting of eight female figures on wheels, so that it could be moved backwards and forwards—are probably of central European origin. Already the theory has been put forward that, in this specific case, the work was executed by a foreign artist working in the service of the "prince" of Hochdorf.

A mold was found at the Heuneburg that was used for casting handles with satyrs' heads, in imitation of those found on an Etruscan jug. Since the mold was definitely made with local clay, here again we must assume that products from the Mediterranean area were integrated or re-elaborated, which again points to the tendency of local craftsmen to seek inspiration from foreign models.

The above evidence proves how much the customers of the Hallstatt ruling class appreciated the products of the classical world. In this context, the mud-brick wall at the Heuneburg again comes to mind: its bastions modeled on Greek examples were not only of considerable defensive value, but also served to project an image.

Several references have been made to various imported objects of particular prestige from the "princely graves," and also to evidence of luxury goods from settlements, such as the frag-

ments of Greek cups, vessels for mixing wine and water and wine amphorae. Here again, other aspects must be taken into consideration, for instance, a definite adaptation to Mediterranean habits regarding drink. Besides other finds, local wheel-turned pottery demonstrates this, with a spread of new shapes of pots hitherto unknown in the Hallstatt world, such as flagons modeled on Greek or Etruscan originals.

Archaeologists can only build up an idea of historical events based on the scanty evidence left in settlements and burials; but the corresponding spiritual processes remain hidden, even though the transformations in the material sphere make it possible to speculate about the acceptance of new ideas. With the ruling class in particular, it is important to remember this gradual adaptation toward experience and life-styles from the classical world, which, however, reached a turning point with the events at the end of the Hallstatt period and for a short time afterwards.

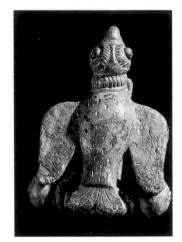

Bird-shaped bronze fibula
from tomb no. 70/2
of the Eisfeld at Dürrnberg
near Hallein (Salzburg)
5th century B.C.
Hallein, Keltenmuseum

Raffaele Carlo De Marinis

Golasecca Culture and Its Links with Celts beyond the Alps

The systematic study of the Golasecca culture was first undertaken in the 1860s and 1870s, and even when it was in its infant stage scholars were well aware of the importance of formulating hypotheses of ethnic classification. This was a far from easy task because ancient sources of information about the geographical distribution of this culture were neither copious nor very explicit. Opinion was immediately divided into two diametrically opposed camps: one group claimed that the people of the Golasecca culture were Celtic, the other, that they were Ligurian populations of Mediterranean stock, originating before the great Celtic invasion of 400 B.C. The supporters of the first thesis included Biondelli, the linguist, who was the first to publish the warrior grave discovered at Sesto Calende in 1867; A. Garavaglio, and the French scholars, A. Bertrand and S. Reinach. The most enthusiastic champions of the second thesis were P. Castelfranco and L. Pigorini.

The Ligurian theory was generally accepted and shared later by scholars such as Randall McIver, G. Patroni, and P. Laviosa Zambotti.

All the same, in many cases even the strongest supporters of the Ligurian thesis shifted toward less dogmatic positions, for very varied reasons. Pigorini was already suggesting in 1892 that these were Celtic and not Ligurian people, while Castelfranco declared that the "Golaseccans" were none other than the Insubres, an Italo-Celtic population that was already well-established in Ticino territory by the time of the first expansion of the historical Celts.

Map showing the Golasecca culture finds, 9th-5th century B.C. Shading denotes the proto-urban districts of Sesto Calende-Golasecca-Castelletto Ticino and Como

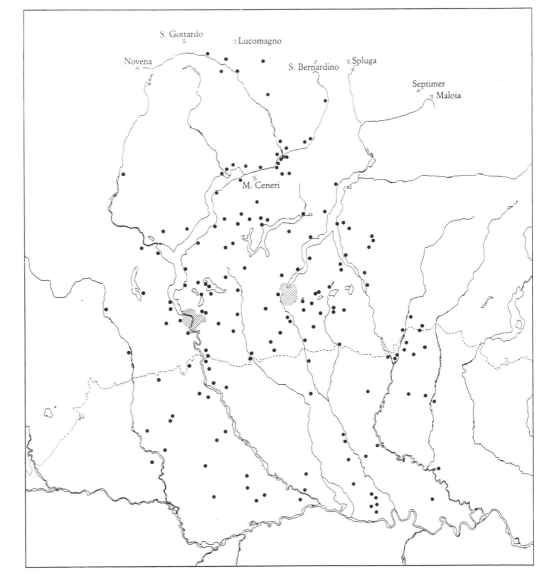

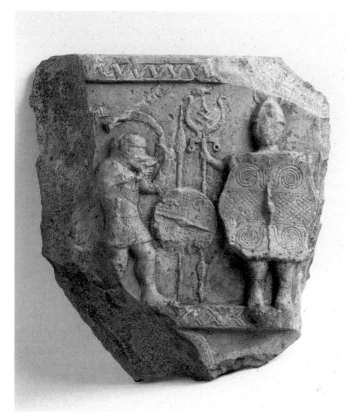

Fragments of figurative stone stelae
from Bormio (Sondrio)
5th century B.C.
Como
Museo Civico Archeologico Giovio

"Lepontic" alphabet
from the Golasecca culture
On the left: 6th-5th century alphabet
On the right: 3th-2th century alphabet

a
e
v
z
ϑ
i
k
l
m
n
p
ś
r
s
s
t
u
χ
o

Patroni too, maintained that within the vast and widespread Ligurian race, the Golasecca population constituted "a special and localized ethnic group with its own individuality" that could be identified with the Insubres. Laviosa Zambotti, who had first affirmed the importance of the Ligurian feature in the Golasecca culture, was later to admit that the possibility of its slow transformation into a Celtic ethos merited examination.

In the meantime epigraphic documentation slowly became available for a part of the territory manifesting Golasecca cultural features. Although this was limited, not particularly revealing and very late (second-first centuries B.C.), it constituted a useful frame of reference for the debate around the problem. The so-called Lepontic inscriptions, drawn up in the Lugano alphabet and arranged into a corpus by Joshua Whatmough (1933), showed numerous Indo-European elements alongside traces of a non-Indo-European stratum thought to be Ligurian. It seemed possible to recognize a language in which the process of Indo-European development had not yet become dominant, and hence the term "Celto-Ligurian" was coined for these populations, corroborated in part by ancient sources (Strabo, IV, 6-3).

Devoto is well-known for having identified a certain Indo-European stratum as "Lepontic," which he believed marked the first stage of the Indo-European development in the Ligurian world; other scholars have proposed linking this phenomenon to the Canegrate culture and to the Golasecca culture, which represents another step forward in the Iron Age (L. Pauli, 1971).

The Lepontic concept later took on various different meanings, moving closer and closer to the inscriptions drawn up in the Lugano alphabet found throughout the Como area, in the Val d'Ossola, and the Canton Ticino. M. Lejeune succeeded in establishing, finally, that this language belongs to the Celtic languages, while the special phonetic features of Devoto's Lepontic language (documented only through onomastics and toponymy) was more strictly Ligurian.

It was some time before the linguistic debate on the Lepontic question had any repercussions on the ethnographic issues surrounding the Golasecca culture, due to the mistaken conviction that the Lepontine inscription was earlier than the fourth century B.C. It was also believed that even the Prestino inscription showed more recent graphic innovations when compared with the older Lugano alphabet.

Had this been so, it would have been logical to make a connection between the Gallic character of the Lepontic inscription and the settlement of the Gauls in the Po Valley following the invasion in 388 B.C.

But this was not the case. Over the last ten years, new discoveries and a revision of the contexts of earlier ones in the protohistoric settlement near Como and Casteletto Ticino have provided new evidence that the oldest Lepontic inscriptions date as far back as the sixth and fifth centuries B.C., and can be ascribed to the populations of the Golasecca culture. Today it is possible to distinguish between an earlier alphabet, belonging to the sixth and fifth centuries, and a more recent one that can be dated to the second and first centuries B.C. The first is characterized by the presence of a *digamma*, a dotted *theta*, and the letter *A* drawn with a bar uniting the two strokes from left to right as in the Etruscan alphabet. Since the *digamma* is no longer found in the more recent alphabet, the letter *A* becomes more similar to a more or less sloping *digamma*. There are three characters for the sibilants in both alphabets: a four-stroke *sigma*, a three-stroke *sigma* and a butterfly symbol. The disappearance of the *digamma* must have occurred fairly early on because the new *A* character occurs in an inscription on a locally-made bronze *Schnabelkanne* from Giubiasco, dating to the second half of the fourth century B.C.

There are very few inscriptions of the fourth and third centuries B.C., so that the two sets of Lepontic epigraphic evidence are separated by a considerable time-lapse.

Given that the Golaseccans of the fourth and fifth centuries B.C. (i.e., the G II and IIIA periods) spoke a Celtic-type dialect, we can approach the subject of the date of its introduction into northwest Italy. Was the dialect introduced toward 600 B.C. or in a more remote

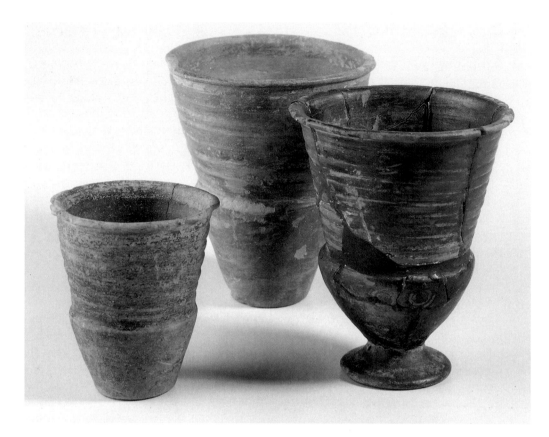

Golaseccan pottery beakers
from Ca' Morta (Como)
5th century B.C.
Como
Museo Civico Archeologico Giovio

period? In the first case, this would confirm information given by Livy (V, 34) regarding the first influx of Gauls: *Prisco Tarquinio Romae regnante*. This hypothesis can only be evaluated by a close study of the archaeological finds, but not all scholars are agreed on their interpretation. Some prefer to recognize evidence of the Celtic migration in the Hallstatt influences discernible in Golasecca toward the end of the seventh and the beginning of the sixth centuries B.C. Decisive evidence supporting this theory comes from the two warrior graves at Sesto Calende.

Others assert that archaeological finds provide no evidence of any breaks in cultural development, particularly between the seventh and sixth centuries, and hence the hypothesis of the immigration of Transalpine peoples at this time is not tenable. Consequently, the Celtic dialect of the Golasecca culture is proof of pre-Gallic Celtic in northwest Italy, attributable to populations cited in the ancient texts as Insubres, Oromobii (or Orumbovii) and Lepontii. The development of these peoples must be sought earlier, in the Bronze Age.

One period in which a break in the cultural continuity of the area in question can be felt is in the thirteenth century B.C., with the advent of the Canegrate culture.

The innovation is not, as has sometimes been suggested, represented by the introduction of cremation—which was already present in the previous Scamozzina-Monza culture—but by a completely new cultural dynamic expressed in pottery and bronzework. Both the shapes of vessel, in particular the small biconical-lenticular urns, and the decorative style characterized by series of light horizontal, oblique, or vertical fluting along the shoulder and the widest part of the vessel make Canegrate a typical western example of the Urnfield culture, and particularly representative of the fluted pottery groups preceding the Rhine-Switzerland-Eastern France (RSEF) culture.

Types similar to Canegrate pottery have been found on the other side of the Alps as well, especially in Valais, Savoy-Dauphine, and upper Provence.

The articles in bronze (brooches of the Yonne group, poppy-flower brooches, Reventin-La Poype or Canegrate-type bracelets, Mels-type knives, discoid belt clasps, Wangen a.d. Aare-

type torques) also confirm the close relations between northwest Italy and the RSEF area at that time.

In the three ensuing centuries of the late Bronze Age (twelfth to tenth centuries B.C.), the Canegrate group was progressively integrated into the southern Alpine cultural world, which determined completely different developments from those of the Urnfield culture in the RSEF area.

Some cultural elements were common to both north and south of the Alps between the twelfth and ninth centuries B.C., and there is also evidence of trade, but it was not until the eighth century B.C., with the intensification of relations between Etruria and territories north of the Po and the Alps, that the Golasecca culture began to act as a bridge between the Mediterranean and central Europe—thanks to its control of the routes to important Alpine passes such as Saint Gotthard and Saint Bernard.

Relations between the "Golasecca Celts" and the Transalpine Celts became closer and closer, while the growing importance of trade formed the basis of more marked social differences and the emergence of a dominant aristocratic order.

It is likely that the role played by Golasecca culture in north-south trade was fostered not only by the exploitation of certain features of the territory's geographical layout, but also by the ethnic affinities with the Transalpine Celts, so that intense, reciprocal cultural influences were part and parcel of trading.

Vetulonia was the leading center of Etruscan trade with the north in the seventh century B.C., while Bologna was the heart of the network of relations with the upper Po Valley, Alpine, and Transalpine territories. In this period imports to the western Hallstatt and Golasecca cultures are significant not for their quantity but for their quality; they include highly prestigious goods such as bronze melon-shaped goblets (Ca' Morta, Poiseul-la-Ville, Appenwihr, Frankfurt-Stadtwald, Brasy, Oberempt), a bronze pyxis with floral handle (Appenwihr), a double bronze-plated basin with sphinx and lion figures (Castelletto Ticino), a type of *kyathos* decorated with relief animal designs (Sesto Calende), gold beads with granulated decoration (Jegenstorf and Ins), an Arnoaldi-type corded vessel (Magny Lambert), water jars with straight handles (Ca' Morta, Magny Lambert).

The discovery of the same artifacts or products of identical origin (particularly *Vetulonia* and Bologna) north of the Alps and in Golasecca shows that trade between the Mediterranean world and the Transalpine Celts was already routed over the Alpine passes controlled by the people of the Golasecca culture at this time.

The development of the western Hallstatt and Golasecca cultures appears to have been strongly influenced by trade contacts with the Etruscan world in the Italian peninsula. Reciprocal influence can be detected in various aspects of the material culture, and are even more evident in the furnishings of rich graves.

The four-wheeled vehicles from the Hallstatt graves were of local origin, as Christopher Pare has shown in recent research, and were part of a tradition that goes back to the beginnings of the Urnfields. All the same, iron tires, hubs, linchpins, and metal trimmings indicate new technological influences from central Italy. The channels through which these contacts were established can be seen in the second warrior grave at Sesto Calende, where the shape of the wheel-hubs are directly comparable to Pare's Type 5 vehicle, found north of the Alps. The horse-bits, however, indicate a flow in the opposite direction. Platenitz-type bits from the wagon-burial at Ca' Morta (about 700 B.C.) and those with U-shaped lateral supports in the second warrior grave at Sesto Calende (early sixth century B.C.) belong to types frequently found in central Europe but not south of the Alps, except here in Golasecca.

Another aspect of these cultural exchanges is illustrated by the spread, in G I C (seventh century B.C.), of pottery with black designs on a red ground, a style of pottery that was well-known in the Hallstatt culture of the seventh and sixth centuries B.C.

Weapons constitute an excellent means of examining the cultural links between the Transalpine Celts and the Golasecca Celts. The short swords and daggers of the Golasecca culture

Chariot from Ca' Marta (Como)
5th century B.C.
Como
Museo Civico Archeologico Giovio

Swords with anthropoid hilt
from Como (top left)
Brembate Sotto (top right)
and Campberceau (Haute-Marne)
(bottom)
5th century B.C.
Como
Museo Civico Archeologico Giovio
Bergamo
Museo Civico Archeologico

during the seventh, sixth, and fifth centuries, are similar to the La Tène types. In G I C (seventh century) there were two kinds of antenna-hilted swords at Golasecca, one with a single-piece cylindrical hilt found mostly in the Helvetian plateau, southwest Germany, and Burgundy; the other had a composite hilt and is found only in Bavaria and Hallstatt.

The short swords and Neuenegg-type daggers of the second warrior grave at Sesto Calende and Ca' Morta offer further proof of the close ties with Switzerland in G II, while at the start of G III A (about 480/475-450/440 B.C.) the swords are still in Late Hallstatt style, such as those with pseudo-anthropoid hilts found at Ca' Morta (the Helmet Grave) and Brembate Sotto, and those of unknown origin in the Como museum, which are strikingly similar to the sword in tomb 4 of the Champberceau barrow, just south of Langres, the area at the source of the Marne.

The four-wheel chariot burial at Ca' Morta, also from G III A1, corresponding to the most recent phase of Ha D3 (8th horizon, Parzinger, 1988), points once again toward the western Hallstatt world, in particular toward the region of the upper Seine and Marne valleys. Not only do the technical details and physical shape link the Ca' Morta wagon to the princely grave at Vix, but in this case there was an acceptance of the Hallstatt funeral custom of including a four-wheeled wagon in aristocratic burials, forsaking the traditional two-wheeled cart of southern origins.

Around 480-475 B.C., at the start of G III A, the large protohistoric community near Como, spread over more than one hundred hectares, became the heart of commerce with Celts beyond the Alps. Trade became more and more intense toward the end of Late Hallstatt (8th horizon, Parzinger) and during La Tène A, especially with the regions from Burgundy to Berry, from Champagne to the Moselle valleys and the central Rhine valley. Trade routes crossed the Little Saint Bernard Pass toward Hinter Rein, and the Saint Gotthard pass toward Reuss and the Rhine or deviated westward to the Rhône, or eastward to the Vorder Rhine.

The spread of Golasecca objects (fibulae, bucket pendants, globular rings) in these territories illustrates the trade routes clearly. Recent discoveries proved the presence of G III A pottery in the Late Hallstatt and La Tène A site at Bragny-sur-Saône.

Situlae and ribbed buckets made in Golasecca are spread over a wide geographical area from Berry in the west to northern Germany. It is interesting, however, to note that strong evidence of links with Golasecca culture have been found in the territories northwest of the Jura. In the first century B.C. this area was apparently occupied by the Bituriges, the Aedui, and the Senones—populations which, in Livy's opinion (V, 34), contributed to the first Gallic invasion of northern Italy.

Many of the situlae, known as the Rhine-Ticino-type, must be considered as imports from the Golasecca area (e.g. Kärlich, Irlich, Melsbach, Pernant, St. Denis de Palin). Pauli has objected, due to the difference in the metal used for the rim strengthener (chiefly iron in central Europe, and lead at Golasecca), but this is refuted by the fact that not one of the over twenty examples of Rhine-Ticino situlae discovered in the Golasecca area and ascribable to G II B and III A 1-2 (about 525-400 B.C.) has lead edging. Lead reinforcements were only introduced in the fourth century in the upper Ticino area, for different kinds of situlae. As far as the ribbed buckets are concerned, the new finds at Garlasco and tomb 294 at Ca' Morta have contributed to establishing the origins and chronology.

The wide circulation of Golasecca products north of the Alps is closely related to the expansion and increase in the trading activity of the Etruscans residing in the Po Valley, who had Greece on one side and the Celts on the other. Prestige and luxury goods from the Golasecca area and the Transalpine Celtic area are the best-known evidence of this trade, but the widespread and complex network of trade flows certainly included raw materials (amber, coral, incense, and metals—especially tin, which was the basis of trade between the Mediterranean and northern central Europe) and food, including wine, oil, cereals, and salted meat. New discoveries made at Forcello di Bagnolo San Vito have begun to reveal some interesting information on this subject.

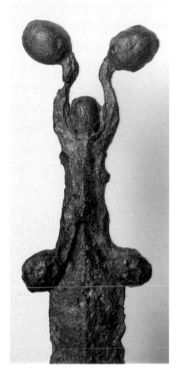

*Detail of the anthropoid
hilt of the iron sword
from Brembate Sotto (Bergamo)
5th century B.C.
Bergamo
Museo Civico Archeologico*

*Fragmented bronze "pilgrim's flask"
from Rebbio (Como)
5th century B.C.
Como
Museo Civico Archeologico Giovio*

Regular, organized trade is highlighted by the fact that the same kinds of Etruscan bronze vessels can be found in the Golasecca culture region and north of the Alps and—more importantly—they occur in the same archaeological horizons. In Ha D 3 and G III A1 we find *Schnabelkannen* with serpent handles (Brembate, tomb 11, Ca' Morta, Molinazzo, Mercy sur Saone, and Franche-Comté) and jar-like situlae with stylized palmette handles (Ca' Morta, tomb 5/1926; Brembate, tomb 8; Gourgy). A little later, in La Tène A and in G III A2 there are *Schnabelkannen* with spiral handles and lotus flower, buds, and palmette decorations engraved on the neck and base, or with horse-figures on the rim (Ca' Morta, tomb 114; Cerinasca, tomb 118; Eygenbilsen, Hermeskeil, Besseringen, Rascheid, Berschweiler, Morthomièrs).

Another example illustrates the importance of the role of the Golasecca peoples in Transalpine trade. The pilgrim's bronze flask from the Rodenbach grave betrays typical Golasecca craftsmanship. It is made up of two discs decorated with a central boss and concentric corded designs, held together by an bronze strip 8-10 centimeters wide that locks into the edges of the discs. A fragment of this type was discovered at Rebbio, near Villa Giovio, in a grave dated to G III A1, and a second one, undecorated, in the cemetery at Catione, Canton Ticino.

The organization of the Golasecca territory underwent important changes and developments in the fifth century B.C. Based on two large "proto-urban districts," Golasecca-Sesto Calende-Castelletto Ticino and Como and the surrounding area, the arrangement was superseded by a more complex network. The main points along the trade routes between the Etrurian Po Valley and the Transalpine Celts became settlements that were to become important Gaulish *oppida* in the future and later the chief Roman cities in the region: Como, Milan, Lodi, Bergamo and Brescia.

Archaeological excavations undertaken in the last decade in Milan and Bergamo have ascertained that the earliest settlements go back to G III A; in Brescia—where there were already considerable settlements in the early Iron Age—the fifth-century phase saw a decisive period of urban development. Imported items, in particular Attic wares, have been found in all these sites. Finds in Milan include a tiny fragment probably belonging to a *kantharos* (found in Via Moneta); a fragment of a cup with red figures on it, from the Biblioteca Ambrosiana; in Bergamo: a fragment of a *skyphos* with an owl design from the Convent of San Francesco; in Brescia: a black painted cup without a stem and with an internal step, from the Capitolium; in Via Mario, a small fragment of a closed vessel with red figures; in Via Musei, other fragments including a *skyphos*.

Brescia was not part of the Golasecca territory in the first Iron Age. The ethnic and cultural characteristics of Brescia in the fifth century B.C. must still be established since the levels of this period have revealed both Etruscan Po-Valley pottery and G III A pottery. It is therefore possible that Brescia represents a meeting place for Golasecca Celts and Etruscans, a kind of trading port.

We must not forget, however, that there is a bowl in the Arici college with an inscription in the Lugano alphabet on the bottom that reads: "takos." This is quite certainly a Lepontic and Gallic term, already known in the more recent stone inscription at San Bernardino di Briona ("takos toutas") where it signifies the role of "ruler of the community"—thus confirming the presence of well-organized Golasecca peoples in Brescia. The Golasecca Celts appear to have been the first founders of cities in Lombardy or at least of centers that carried out some typical functions of a city.

While existing evidence suggests that Como was the most important center in the fifth century B.C., new discoveries are gradually illustrating the role of Milan, and there can be no doubts about the Celtic origins of its name.

The decline of the great Golasecca-Sesto-Castelletto territory toward the end of 480-475 B.C. corresponds with the birth of a new, large center at Milan. Pottery ware and bronze items belonging to G III A have been found in the courtyard of the Royal Palace in Milan,

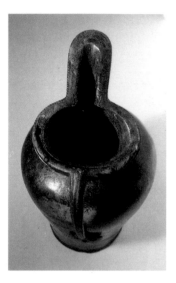

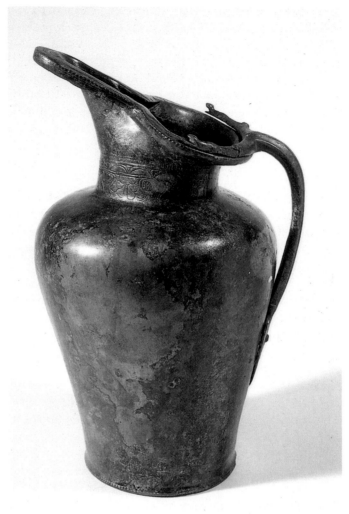

Bronze wine flagon of Etruscan
manufacture from tomb no. 114
Ca' Morta (Como)
Second half 5th century B.C.
Como
Museo Civico Archeologico Giovio

in Via Moneta, at the Biblioteca Ambrosiana, in Via Meravigli and Piazza Cordusio, while the finds at the Ospedale di Sant'Antonino outside the medieval canal ring round the city belong to a graveyard altar. The various sites of the discoveries are laid along a 750 meter-long north-west/south-east axis with a maximum width of 300 meters. They seem therefore to suggest a large settlement of about twenty hectares (compared to the ninety of the Roman city in the first century A.D.).

The traditional dependence of the Golasecca peoples on the Transalpine models of offensive weaponry continued during G III A2-3, corresponding to La Tène A (about 450-440 to the first decades of the fourth century B.C.). All the swords of this period discovered in the Golasecca area are of the La Tène A-type (Gravellona Toce, tomb 15; Cerinasca d'Arbedo, tomb 108; Castione d'Arbedo) and an iron La Tène helmet was found at Molinazzo d'Arbedo. However, the most interesting indication of links with the Transalpine Celts lies in the openwork hooks and belt-rings (*Koppelringe*). A bronze openwork hook with a floral design discovered at Melegnano was certainly imported from the Marne region. Openwork hooks and *Koppelringe* are frequently found in the Paleo-Venetian territory (late Este III) and in the Late Hallstatt culture of Slovenia. They continued to spread from around the middle of the fifth century B.C. until the first quarter of the fourth century.

According to Frey, these objects originated in central Europe and their arrival in northern Italy is considered to be possible proof of the onset of the Gallic influx, a complex process that clearly took longer than one or two years.

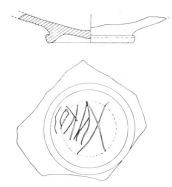

Fragment of bowl with inscription in north-Etruscan characters from Brescia (1974 excavations)

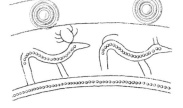

Reconstruction of the embossed decoration on the bronze situla from Trezzo d'Adda End 6th-early 5th century B.C. Milan, Civiche Raccolte Archeologiche del Castello Sforzesco

The types of openwork hooks found on either side of the Alps have, however, some substantial differences. There are two main kinds in the Transalpine Celtic region: to the west, especially in Champagne, they are bronze with lotus-flowers; further to the east, chiefly in the Hunsrück-Eifel area, they have stylized palmettes.

South of the Alps, in the G III A2 horizon, the iron hooks with circular openwork (Gazzo-type) are widespread in the Golasecca culture area (Brembate, tomb 6), in the Paleo-Venetian world (Gazzo Veronese, Este-Benvenuti 110 and 116, and Capedaglio 31) and in the Late Hallstatt-Slovenian Culture. Moreover, bronze openwork hooks with griffin designs were found at Este (Rebato 152, Benvenuti 116) or with birds facing each other (Palazzina grave) which appear as imports north of the Alps (Somme-Bionne) or as imitations (Hauviné, St. Rémy-sur-Bussy, St. Denis de Palin).

There are two varieties of bronze openwork hooks with designs of dragons facing each other in the Golasecca culture: one has a human figure in the center, the so-called "Lord of the Animals" (Castaneda 75, Sesto Calende), the other has a kind of cross of Lorraine (Giubasco, Castione, Molinazzo). The latter is dated to G III A3 (early fourth century) by a single context, Castaneda grave 75.

The openwork hooks at Este, however, might be older, as suggested by the Palazzina grave and the Benvenuti tombs 17 and 116, which have been dated from fibula-types to the second half of the fifth century B.C.

A fragment of a Ticino-type hook comparable to Castaneda 75 was recently discovered at Bozzolo, not far from the confluence of the Oglio and the Po. It was found in a cemetery with Attic and Etruscan Po-Valley material. A pottery fragment with an Etruscan inscription had already been found on this site. Unfortunately, the graves were damaged by local gravel-pit operations, and the remains of the ornaments were retrieved in an emergency excavation. Thus a wonderful opportunity for better identifying the chronology of these objects was lost. In conclusion, only the lotus-flower openwork hooks from Melegnano and Bologna (Arnoaldi cemetery) testify to the arrival of the Gauls south of the Alps. As for the custom of openwork hooks and Koppelringe, there is not enough evidence to give preference to one cultural area over another.

There is, however, extensive proof that the Transalpine Celts were acquainted with Italy—especially for commercial reasons—such as the diffusion between 500 and 450/440 B.C. of fibulae in western Late Hallstatt style. While it may be inferred that the fibulae with bird-head catchplate and coral stud on the beak originated in northern Italy, in some cases they were local replicas, and in many other cases the fibulae were undoubtedly manufactured north of the Alps. In the Etruscan center at Forcello di Bagnolo San Vito, the R-S 17-18 horizon currently being excavated has yielded no less than five Late Hallstatt fibulae, and a further three were found in surface explorations. The oldest example, a *doppel Pauken* fibel of the Mansfield dP 1/2 type, is from Phase E and dates to 500-480 B.C.; the other five are from Phases D and C, from the second quarter or midway through the fifth century. Since Phase B also contains a fragment of a La Tène A fibula, we may infer that the Celts from beyond the Alps made regular stops at the Etruscan center of Forcello.

A few observations of a more general nature may help us pinpoint the Golasecca culture more clearly in relation to the neighboring, contemporary societies. The spread of Etruscan civilization toward the north noticeably transformed the protohistorical cultures of northern Italy and central Europe—the outcome varying according to the period, the intensity of contacts and, naturally, the responsiveness or willingness to change of the local populations.

The resulting map varies from region to region; certain phenomena are unique to a given area, or common to two or more groups, creating similarities and differences that thwart attempts to draw clear outlines of the more general aggregations of people. Nonetheless, it is apparent that Golasecca culture had close links and strong affinities with the western Hallstatt culture, notwithstanding certain fundamental differences.

The clearest example of the cultural gap between territories north and south of the Alps is

writing, which was adopted in the sixth century B.C. by Golaseccans, Paleoveneti, and Rhaetian peoples. Although from the eighth century on the cultures of Este and Golasecca had a fairly similar territorial organization—consisting of "proto-urban" districts—fortified princely homesteads were a characteristic of the Hallstatt world.

After the eighth century people of high rank in Este were no longer buried with their weapons, and there are no chariot-graves at all, as in the Slovenia area during the Hallstatt period. In Golasecca and in western Hallstatt culture, however, warriors were buried with their panoply, but with significant differences. In Golasecca offensive and defensive equipment (helmets, and shin-guards) were included in the grave goods, in deference to customs observed throughout the Italian peninsula; the deceased's warrior status is further emphasized by the two-wheeled chariot. In western Hallstatt culture the vehicle is always four-wheeled, and therefore has no connection with the deceased's role as warrior. In Late Hallstatt, the panoply was discontinued, except for elaborated daggers indicating the social rank of the deceased. It was not until La Tène A that warriors were generally accorded chariot burials and a mixed panoply of offensive and defensive weaponry.

At Este, however, and in the central and southeastern Alpine areas, influence from the Italian peninsula had a marked effect on artistic expression, generating a figurative and narrative language that would later culminate in the situla art of the fifth century B.C. The same influences had less effect at Golasecca, where the emphasis continued on outlined patterns in points and embossed studs, typical of the Urnfield era, in which until as late as the mid-fifth century B.C. the old symbols of the sun and water-fowl remained, as demonstrated by the characteristic duck-pendants.

North of the Alps, western Hallstatt culture remained anchored to its tradition of geometric decoration, without ever reaching figurative narrative.

Equally strong differences seem to prevail in questions of religion. So far neither Golasecca nor western Hallstatt has yielded anything comparable with the Paleoveneti and central Alpine sanctuaries. The Mediterranean influences seemed to have merely ruffled the surface. As Herman Parzinger recently observed, it is not even definite that the southern custom of drinking wine in kraters and stamnoi, jugs and cups, was adopted by the Celts of Golasecca and Transalpine Gaul. This is suggested by the grave goods. In both territories, prized bronze vessels imported from Etruria are frequently positioned separately in the graves, or as containers for cremated remains.

Jean-Pierre Mohen

The Princely Tombs of Burgundy

Originally an ancient province of eastern France, Burgundy today includes the *départements* of Yonne, Côte d'Or, Saône-et-Loire, and Ain, and covers an extensive area of important geographical links—the Saône valley facilitates communications with Alsace, Switzerland, and Germany to the north, and at the same time with the Rhône valley and the Mediterranean to the south. The Seine valley acts as a gateway to the Paris basin and beyond to the Atlantic. These major arteries were critical for the development during the early Iron Age of a widespread civilization in Burgundy, the princely tumulus burials of which remain its outstanding manifestation. These princes, who were fond of surrounding themselves with Greek and Etruscan ware, were dubbed "Celts" in the first ancient literary sources toward the year 500 B.C. These people played a decisive role in the constitution of the Celtic koiné which began to appear from the fourth century B.C. onward.

The site of Mont Lassois (Côte d'Or)

The first spectacular discoveries took place at the end of the nineteenth century: the tumulus of Monceau-Laurent in Magny-Lambert (Côte d'Or) was excavated in 1872 under the patronage of the Commission for the Topography of the Gauls; the project was directed by Alexandre Bertrand. Another important tomb, this time found near Burgundy, was explored in Apremont (Haute-Saône) in 1879. The full splendor of the funerary offerings of these burials became apparent in the winter of 1953 when R. Joffroy and M. Moisson excavated the chamber of the Vix barrow near Châtillon-sur-Seine (Côte d'Or), where the grave goods included a Greek krater, a chariot, and a gold necklace. In-depth studies were carried out to get a clearer picture of the civilization that produced the princely tombs of Burgundy, which show close parallels with other tombs in Franche Comté, Lorraine, Alsace, southern Germany, and Switzerland. Further important finds were made by R. Joffroy and his team during excavations in the 1970s on tumuli in the cemetery of Poiseul-la-Ville (Côte d'Or).

Three major stages could be distinguished in the evolution of the princely tombs of Burgundy. The first and earliest stage spans from the end of the eighth century B.C. to the start of the seventh, and is identified by tumuli built of rubble with a central rectangular chamber delimited by upright slabs. The deceased was interred lengthwise, accompanied by sundry funerary offerings. The most striking feature of the Magny-Lambert barrow is its sheer size—it measures thirty-two meters across and almost six meters high. Alongside the deceased (a warrior) lies a large iron sword. Behind his head is a collection of bronze objects, a razor, a drinking cup, and a large cylindrical corded-ware receptacle containing a kind of

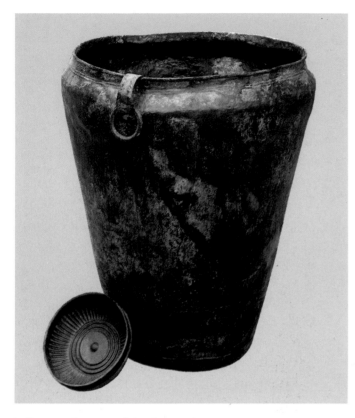

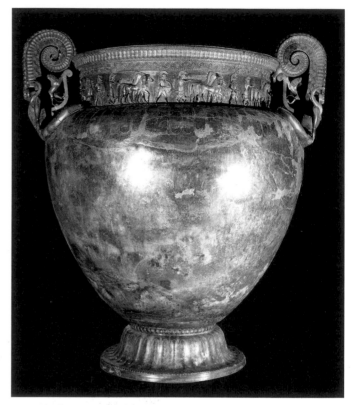

ladle. For this period, both sword and razor are classic attributes of high-ranking individuals. This one's prestige is accentuated by the presence of a drinking set, related in style to all the vessels in the tomb; the main receptacle served in the preparation of a special drink, which was a mixture of concentrated wine and water. While the components of this drinking set may have been manufactured locally, their inspiration was clearly Italic, as confirmed by the corded vessel. We may presume that, toward the year 700 B.C., this wealthy and powerful man perhaps adopted the Mediterranean custom of a funeral feast, a banquet accompanied by an intoxicating drink, usually of wine, which must have been imported.

The four tumuli of Poiseul present the same situation: each one contains the skeleton of a warrior with an iron or bronze bracelet and an iron sword measuring more than a meter long, considered by some experts to be a horseman's sword. Bronze razors were found in three of the tombs, one of which also yielded a bronze phalera, while the other two contained vessels made of sheet bronze, including a globular cauldron with two moving handles and a large situla associated with an unusual cup with ribbed decorations.

While the rich burials of the end of the Bronze Age, such as those found in Saint-Romain-de-Jalionas (Isère), are rare, the rich or princely tombs from the start of the Iron Age are more numerous, and are concentrated in certain key regions such as Burgundy and the Jura. These horsemen-warriors had mastered the use of iron, a new metal which they made a symbol of social power; they also undertook distant trading with Mediterranean cultures.

The second stage in the development of the princely tombs of eastern France begins around the year 600 B.C., and is exemplified by the tomb of Apremont (Haute-Saône) which dominates the Saône valley and forms part of a series of tumuli erected in the region encompassing the citadel of Gray. The hillock, which is 70 meters in diameter and 4 meters high, was excavated in 1879 by E. Perron. At its core, the funerary chamber is lined with planks resting on joists 15 centimeters thick. The rectangular floorplan measures 3.2 by 2.8 meters, but the original height of the roof was impossible to determine. The excavators made a very precise record of all their finds, so that in 1985, after each fragment had been systematically examined and partially restored, it was possible to suggest a full reconstruction of the objects

found in the tomb. The prince's skeleton itself lay lengthwise, the head toward the northeast, and a large gold necklace with stamped decoration round the neck. Close by there were three amber beads. Level with the prince's chest were a collection of small gold ornaments, comprising three cruciform elements and two circular mounts. Near the belt were three small ivory rings, and alongside a small ivory rod. Two fragments of a belt plate in molded iron undoubtedly belong to the same object. At the skeleton's feet, E. Perron identified a long bent iron sword and an iron razor, both covered with a pile of ash and bone fragments. These finds were located on the platform of a four-wheeled wagon on which the body had been laid out. All the functional and decorative metalwork of the wagon is made of iron. J.-M. Bouard has made a full-scale reconstruction based on H. Masurel's meticulous analysis of traces of rust on the various pieces of the wagon, together with the painstaking examination of each metal fragment, and the identification of traces of wood deposits and mineralized metal. The platform of the vehicle is shaped like a bed and rests on two axles with iron-rimmed wheels whose spokes and hubs are also trimmed with forged iron plate.

The shaft, also fitted with an iron hoop, detached, slid under the platform. It does not appear to have been articulated originally. Between the wagon wheels on the northwest side of the tomb there was a large basin in bronze, complete with three iron handles, containing a gold cup. The grave goods found in the Apremont tomb seem to date slightly earlier than the one at Hochdorf in southern Germany, as suggested by the sword, which at Hochdorf is replaced by a dagger. The two funerary assemblages have numerous features in common, however—the four-wheeled wagon, the gold cup, the cauldron for preparing the special beverage, the belt plates, the razor, the small gold ornaments, the amber beads and thick necklace in molded gold leaf. In both cases, the indigenous Celtic element is predominant. While Mediterranean imports are not what makes the princely tomb at Apremont so rich, at Hochdorf the imports are represented by two of the three lions decorating the cauldron. Here too, the presence of drinking cups indicates that the rite of the banquet was practiced, but at Hochdorf the traces of deposits found in the cauldron are not of wine but of another alcoholic beverage of Celtic manufacture, mead, made with honey from southern Germany. The capacity of the Hochdorf cauldron is 500 liters, and the one found at Apremont slightly less. The intoxicating drafts were prepared for communal ceremonies as evinced by the set of drinking horns at Hochdorf, the largest of which (in iron) is a full meter long, and perhaps reserved for the deceased prince. The Mediterranean custom of the funerary banquet, albeit in a modified form, was the privilege of princes. As elsewhere, the iron sword at Apremont is a symbol of male social status. Gold is therefore a likely criterion of personal wealth—as a material it is princely in itself, and the goldsmiths who fashioned the ornaments for the prince of Hochdorf left gold scraps and shavings among the rubble of the deceased's tomb. The gold necklaces were therefore unequivocal status symbols.

The third stage in the evolution of the princely tombs in Burgundy, around 500 B.C., is represented by the princess's tomb at Vix. In January 1953, conditions for excavating the flattened mound 40 meters in diameter were not the easiest, given the snow and the flooded terrain. R. Joffroy gathered as much information as possible and published a full survey of fragments gathered in the cube-shaped burial chamber (3 meters square), which had been gouged out of the ground and panelled with planks. Regrettably, the ceiling joists had collapsed under the weight of rock and stone above. In the northwest corner the archaeologists found a bronze krater (complete with lid), the most imposing ornamental vase that has so far come to light. It stands 1.64 meters high and weighs 208.6 kilograms. The two opposed handles are composed of a double volute framing the bust of a gorgon: two serpents emerge from the bust, their heads resting on the rim of the vase; two other serpents rise up below the arms. Between the volute of the handle and the neck of the krater the figure of a lion emerges with its head turned back. The frieze round the neck of the vessel is composed of appliqué statuettes of alternating *aurigae* and Greek hoplite figures. Also found was a vat wrought from the finest pure sheet bronze, with a capacity of 1,100 liters, with an ornamen-

tal cast metal base molding. The strainer-type lid has a handgrip on either side, and its center is embellished with a statuette of a female figure clad in a long robe, with a long shawl trailing from head to waist. This huge vessel was for mixing wine, water, and aromatic herbs, which were then filtered through the strainer-lid. On top of this, there was a silver cup with a gilt boss, two Attic cups in painted pottery, one of which bore black figures portraying combat between Greek warriors and Amazons, and of course the bronze oinochoe or vase with handles and spout. This set of vessels served for collective drinking sessions, such as at the banquet. Along the west wall stood a large basin with boss and two decorated bronze basins with straight handles. The center of the chamber was occupied by the bronze decorative elements of the wagon on which the princess was laid. The wheels had been removed and placed against the east wall. The shaft had clearly slid beneath the wagon platform. The deceased woman is adorned with jewelry—a large open necklace in gold with two bulky terminals decorated with a small winged horse was found lying near the skull, which was tilted backward. On her chest lay a large bronze coil and another necklace. A third necklace was made of beads in amber, diorite, and serpentine. The woman's clothes were fastened with eight small fibulae, many of which were embellished with coral. Her arms were adorned with two bracelets, one in lignite and one in bronze. She also wore a bronze anklet.

Besides the sheer surprise of the discovery of unique artifacts such as the krater and the gold necklace (termed a "diadem" at the time), the Vix tomb provided further reasons for excitement. First, it was a woman's tomb and, secondly, it contained many objects imported from the Mediterranean. The existence of a princely tomb with a female subject was not entirely new, as the tumulus of neighboring Sainte-Colombe was also erected in honor of a princess, who was interred with gold bracelets and earrings, laid out on a four-wheeled wagon. Other women seem to be present in the tumulus of La Motte-Saint-Valentin (Haute-Marne) and likewise at La Ronce (Loiret). Anthropological studies of the "Lady of Vix" by R. Langlois have made it possible to reconstruct the features of this roughly thirty-five-year-old woman, who evidently suffered from tooth decay. The Mediterranean artifacts in the Vix tomb include a bronze krater of Greek manufacture, Attic cups in painted pottery, the Etruscan basins and oinochoe in bronze, and the Italic coral of the fibulae. According to studies carried out by C. Eluère, the gold necklace with its little winged horses resembling Pegasus is thought to be the work of a local goldsmith inspired by Mediterranean models. Around the year 500 B.C. imports to Celtic lands from Greece or Italy began to increase in number, in particular vessels for intoxicating drinks and, hence once more, the accoutrements for performing the funerary drinking rite. Greek black-figure (and later red-figure) Greek potsherds have been found not only in the tombs but also in the dwellings on the plain, as in Bragny (Saône and Loire) and Bourges (Loir-et-Cher), and in the promontory forts such as the Heuneburg fort (Baden Württemberg), Camp du Château (Jura), Le Mont-Lassois (Côte d'Or), and the citadel of the "Lady of Vix." These luxury vessel fragments in the dwellings are frequently found alongside shards of Greek or Massiliot amphorae, which were sent full of Mediterranean wine (the Burgundy vines were not planted until many centuries later). The impression of wealth does not stem from the imports alone: there were local imitations of Etruscan vessels such as the splendid oinochoes of Basse Yutz in the Moselle region, or the pieces of hand-worked gold, like the necklace at Vix. Other equally precious products sent to Burgundy from the northern regions include amber, and certainly the furs, of which some traces remain; meanwhile from central Europe came salt mined at Hallstatt, and horses; from the Atlantic zones came the famous tin from Cornwall and Brittany. Relations over longer distances favored the expansion of ancient Celtic civilization, to which Burgundy made a full contribution. Another favorable factor in the cultural development of this region is the peaceful climate that predominated during this time. The later male graves no longer contain massive swords but more symbolic daggers, such as that found in the Hochdorf tumulus. The weapon likewise disappears from the tombs of La Garenne at Sainte-Colombe (Côte d'Or) and Klein Aspergle (Baden Württemberg). It may even be that as the princes ceased

Plan of the princely tomb of Vix (Côte d'Or) End 6th-early 5th century B.C.

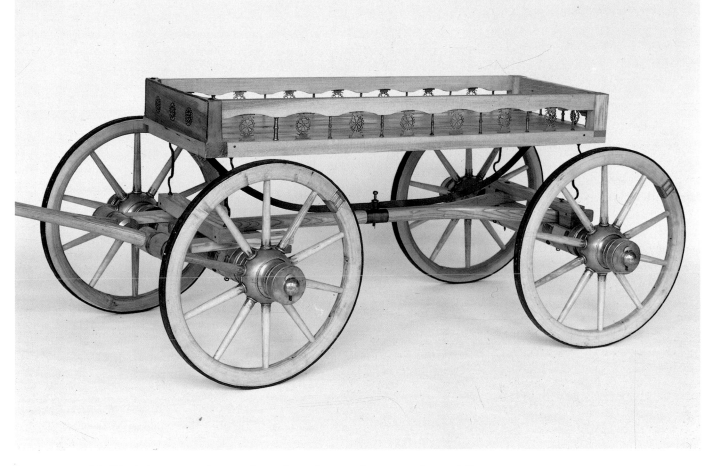

Reconstruction of the Vix chariot
(Côte d'Or)
Mainz
Römischgermanisches Zentralmuseum

to be warriors, the princesses began to rise socially.

Hillforts such as Mont-Lassois were the traditional rallying points for the population and tradespeople. Certain centers, which served as full-fledged trading posts were set up in the plain on the riverside. One such example is Bragny, on the banks of the Saône.

Midway through the fifth century, the situation changed. It would seem that the aristocracy of the ancient Celts collapsed, and that new centers of development sprang up in areas peripheral to the princely zone around 500 B.C. Hence the more opulent tombs are found in Yonne at Gurgy, in a new type of cemetery. Elsewhere, in tombs at Altrier (Luxembourg) and Dürrnberg in Hallein (Austria), new kinds of weapons, swords, lance-heads, and helmets (Dürrnberg) have turned up, belonging to classic Celts who then pursued expansion through war throughout Europe, as recounted by certain ancient written texts. Burgundy ceased to be the crucible of cultural synthesis and creation of Celtic forms and style that it had been up to 500 B.C., together with eastern France, western Switzerland, and southern Germany.

The Celtic Princes of Hohenasperg (Baden-Württemberg)

The Hohenasperg is a natural shoulder of land rising one hundred meters above the surrounding loamy farmlands midway along the Neckar River between Stuttgart and Heilbronn, and forming part of the Gipskeuper hills. Today the hill is crowned with an imposing Renaissance fort. Since the medieval town of Asperg also occupied the site, earlier remains have been largely obliterated and Hohenasperg has yielded nothing in the way of archaeological finds. Nonetheless, in Late Hallstatt period it must have been the site of a major chieftain's settlement, rivaling those at Heuneburg and Mont Lassois near Châtillon-sur-Seine in Burgundy; like the latter, Hohenasperg commands the surrounding plain. Now transformed by modern development, the original site on the summit probably covered an area of six hectares, twice that of the Heuneberg. No traces of an early external settlement area like the one at Heuneburg have so far come to light. There are definite signs of early habitation in the eastern section of Asperg, but there is no comparison with the outside settlement of the Heuneburg.

Burial Sites

South of the Hohenasperg lies a huge series of large burial mounds and rich graves, including the so-called Grafenbühl at the eastern foot of the cliff; the Kleinaspergle, another tumulus completely leveled; two large and unexplored tumuli on the plateau between Asperg and Möglingen; and, finally, the Römerhügel near Ludwigsburg, four kilometers away. It may be that the rich tombs of Cannstatt, Schöckingen and Hochdorf are in some way related to Hohenasperg, from where they are clearly visible. It is worth noting that north of Hohenasperg no comparable rich tombs have come to light, and what graves there are have yielded rather modest grave goods.

Grafenbühl

Very close to the Hohenasperg in the eastern section of the town, between numbers ten and sixteen Teckstrasse, there used to be an artificial mound known as the Grafenbühl, since destroyed by construction work. In 1964-1965 the mound was investigated by H. Zürn. The original tumulus must have measured 40 meters across and stood 2.5 meters high. The central

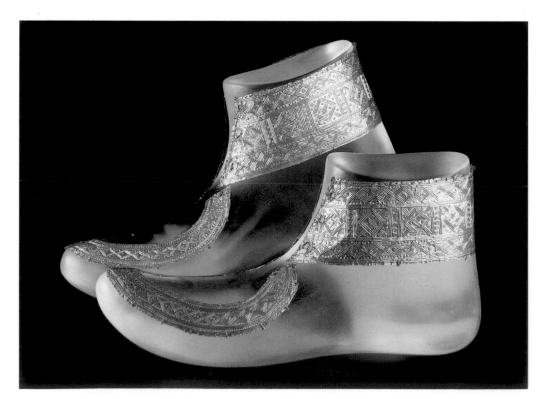

Embossed gold leaf decoration from the shoes of the chieftain buried in the barrow at Eberdingen-Hochdorf (Baden-Württemberg)
Second half 6th century B.C.
Stuttgart
Württembergisches Landesmuseum

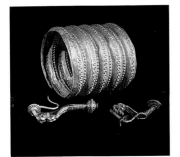

*Armlet and gold fibula
from the princely tomb
of Eberdingen-Hochdorf
(Baden-Württemberg)
Second half 6th century B.C.
Stuttgart
Württembergisches Landesmuseum*

burial chamber protruded 0.7 meters from original ground level and went to a depth of approximately 0.8 meters. The timber floor of the chamber, which measured 4.5 meters square, rested on three beams, and the roof was supported by a central post. It was unfortunately too late to establish the chamber's original height. The grave was looted not long after the burial of the bodies, so only scattered remnants of the original goods have remained. In the southwestern corner of the chamber lay the destroyed skeleton of a male approximately thirty years old. The grave-robbers clearly acted in great haste, and smashed the larger objects in the chamber. Fortunately some things escaped their notice and survived.

The clothing of the deceased was woven with fine gold thread, in a kind of brocade. All that remains of the belt is a gold-plated iron buckle; the thieves also overlooked a pair of gold-plated bronze fibulae. There is no trace of the gold ornaments that were doubtless part of the other goods, which include a drinking service—of this only fragments of the handle of a bronze vessel and part of the imported base have survived. The base consists of two solid cast-bronze lion feet belonging to a tripod roughly 80 centimeters high, evidently of Peloponnesian manufacture. Numerous fragments, mostly iron (part of the iron hub-caps, with a hub peg and parts of the metal tires), attest to the presence of a wagon. In a corner, fragments of bone and bronze—thought to be parts of a chair—covered an area measuring 0.4 meters square. Various items in amber reveal the presence of imports. A lion-foot with ivory inlay without doubt belonged to a casket or box of some kind, perhaps trimmed with rosettes in bone, while the palmettes in amber inlay perhaps belonged to a couch—an idea that is endorsed by new finds at Hochdorf. Another import, this time from Syria, is a fragment of an ivory mirror-handle. The finest pieces are two intaglio sphinxes with gilded bronze rivets. These also may have been part of some piece of furniture, produced at Taranto.

Despite the drastic plundering of the tomb, the grave goods are particularly plentiful, though we can only guess as to its original inventory. The Grafenbühl tomb must have been as well-endowed as the one at Vix. Thanks to the fibula, the tomb can be dated to Late Hallstatt (Hallstatt D II-III). The imported items are clearly older (the mirror-handle was made in the seventh century B.C.) and were added to the hoard as prized antiques. They are proof of the extensive trade links of the Hohenasperg chieftains. The Grafenbühl also contained thirty-three secondary burials dating from Late Hallstatt and Early La Tène, containing the usual lavish goods with bronze ornaments.

The Römerhügel or Belle Remise at Ludwigsburg

In the southern part of the town there is another hill, known as the Römerhügel, a tumulus that once measured 6 meters high and 60 across, today completely ruined by a reservoir. A little further west among some garden plots stands a smaller tumulus, leveled off but as yet unexplored. It can be reached from the railway station down Solitudeallee, then left up Römerhügelweg; from here the reservoir becomes visible and the tumulus behind it. The smaller tumulus is west, outside the fence.

The reservoir was dug out from the tumulus in 1877 and workmen came across a secondary chamber dug out of earth and covered with slabs. A timber floor 3.5 meters square was reinforced around the perimeter by beams supporting the timber walls. The skeleton was laid parallel to the west wall, with head pointing east. Close to the skull was a gold torque, a dagger and a whetstone alongside it, and near the right foot a gold foil fragment. At the dead man's feet were a total of four bronze receptacles—a ribbed bucket, a large cauldron, a bowl and a plate with beaded rim. On the east side of the chamber lay the remains of a four-wheeled wagon, partly decorated with bronze mounts. The remains of the harness include an iron bit and four bronze discs.

What proved to be the main burial chamber was right next to the first chamber, and it reached a depth of 1.2 meters. It was only superficially excavated; finds included strips of gold plate, a knife-handle, and small amber mounts which evidently decorated wood object, perhaps a piece of furniture or a kind of casket.

When in 1926 the reservoir was enlarged toward the south, additional fifteen secondary tombs were unearthed, all containing inhumation burials, some without grave goods, others with the usual Late Hallstatt bronze ornaments. In addition to the torques and bracelets, some fibulae and a spear-head were found; a wheel-made flask has been tentatively dated to Early La Tène.

The Burial Tumulus of Eberdingen-Hochdorf

East of Hochdorf in the "Biegel" countryside stands a large, isolated burial mound, reached from the cemetery parking lot via a country road in the direction of Schwieberdingen.

The tumulus was first investigated over 1978-1979 and yielded some extraordinary new information on tumulus construction; the intact central chamber contained a rich hoard of burial goods. The restoration of the finds and their scientific interpretation has only just begun, and so descriptions here are limited.

The barrow measures 60 meters across and is enclosed in a masonry perimeter reinforced with timber posts. At the north end the structure was more compact and higher; two stone walls led to the center of the tumulus, with a ramp between them in paved earth. This may have been the entrance through which the deceased was conveyed into the burial chamber, later covered over by the tumulus, which in the deeper parts comprises large sods of earth, with excavated soil on the top, mixed with yellow surface loess. The tomb itself is at the center of the tumulus in a trench 11 meters square and 2 meters deep; the excavated earth was spread immediately around the hole as work progressed. The chamber was designed to withstand interference from looters, a procedure not found elsewhere in the western Hallstatt area; the timber-lined chamber, 4.7 meters square, sits within a larger chamber measuring 7.4 by 7.5 meters, also timber-lined. The gap between the two chambers is packed with rubble; the ceiling was braced with joists laid in both directions, effectively sealing the tomb. The ceiling had no props and most likely soon caved in under the immense weight of the earth. Thanks to various conditions, the organic material in the chamber was found in excellent repair: the toxic effect of the corroding metal had greatly slowed down the process of bacterial decomposition, and the compact ceiling seems to have kept the water out. Hence, parts of the timber chamber and other elements in wood, leather and especially fabric were miraculously preserved. In normal circumstances, most of the finds would have quickly perished.

The skeleton is of a man aged about forty years, 1.83 meters tall—unusually tall for his race. Besides the rich array of goods and ornaments, the chamber contained other major finds, including a large drinking service, a dinner-set with accessories, a four-wheeled wagon with harnesses for two horses. There was also a bed or couch roughly 3 meters long on which the corpse was laid, a totally unexpected addition to these traditional funerary accoutrements. The deceased was presented to the kinfolk on this remarkable gilded couch, wearing a gold neck-torque, a customary symbol of social status worn by Celtic chieftains (as proved by other rich tombs). Upon closer study, the other gold objects proved to be less usual and were made expressly for the occasion. They include two snake-fibulae *Schlangenfibeln*, a bracelet on the right arm, a leather belt with a broad gold mount, a gold-plated dagger, and gold shoe mounts, whose shape suggests the deceased wore pointed-toed shoes. His personal ornaments included a low, cone-shaped hat composed of two round disks of birch bark stitched together, richly adorned with circle patterns and perforations. A large iron razor and nail scissors were included in the toilet set; three fishhooks found in a breast-pocket suggest the deceased was a keen angler. A quiver complete with arrows (though without the bow) is presumably part of his hunting gear. The clothing itself was impossible to reconstruct in detail, but the samples of cloth and leather give a rough idea.

The drinking service is of outstanding quality and consists of a total of nine drinking-horns, found hanging on the south wall of the chamber. One of them is made of iron and measures one meter long; it is richly decorated with gold bands and a handle onto which variously

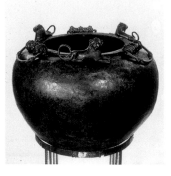

Bronze cauldron of Greek manufacture from the princely tomb of Eberdingen-Hochdorf (Baden-Württemberg) Second half 6th century B.C. Stuttgart Württembergisches Landesmuseum

shaped bone beads were attached. All that remained of the other eight horns (clearly made of bone) were their bronze handles, the gold strip that decorated the mouthpiece, plus some large balls of bone set at their ends. The service also includes a large bronze cauldron, originally placed at the northwest corner of the chamber on a wooden pedestal. The shoulder of the cauldron is decorated with large bronze lions and three solid handles. It was manufactured in a Greek workshop and therefore imported from the south. The residue found in the cauldron proved to be flower pollen, probably from a beverage of honey or mead. The cauldron also contained a hemispherical bowl of beaten sheet gold measuring 15 centimeters in diameter, which may have been a drinking-cup or ladle. The nine drinking-horns came with nine bronze platters which, together with the three large bowls (also in bronze), were stacked on the platform of the wagon. These platters with punched-boss decorated rims have turned up in other tombs. The banqueting service also includes an iron ax with wooden handle used for slaughtering animals, a spearhead, and two large iron knives for cutting meat. The four-wheel wagon had a long, narrow platform, four large wheels with solid hubs, and long shaft. The entire vehicle was trimmed with iron mounts, which has made it easy to reconstruct all its technical characteristics. The platform held harnesses for two horses, a double wooden yoke with rich bronze detailing, two sets of bridle gear complete with iron bit (the leather reins were lavishly embellished with bronze discs), and a goad 1.9 meters· long, with bronze tip. Once again, in normal conditions only the metal pieces of all these objects would have survived.

The most important article here is undoubtedly the bronze couch on which the corpse was laid. The seat and backrest are composed of six bronze plates riveted together; the sides are turned up like a Biedermeier sofa. The couch is decorated along the front with perforations: at each end is depicted a a four-wheel chariot pulled by two horses linked by a double yoke, and driven by a man carrying a shield and a lance or goad; between these two chariots three groups of two men face each other, each man holds a raised sword in one hand, and in the other hand an object that has yet to be identified; the figures have flowing hair and wear unusual skirts or aprons; they seem to be dancing rather than fighting.

Eight female figures in cast bronze hold the platform in raised hands. These figures are on castors and are linked by iron struts to make the unit more steady and solid. The platform and backrest were upholstered in hide, leather and fabric, and the deceased's head rested on a cushion of matted straw.

The couch is unique and betrays strong influences from the southeastern Alpine region, though it may have been manufactured locally.

The walls and floor of the chamber were lined with fabric tacked on with metal staples, while the patches were pinned together with twenty bronze fibulae.

*Wagon with iron trappings
from the princely tomb
of Eberdingen-Hochdorf
(Baden-Württemberg)
Second half 6th century B.C.
Stuttgart
Württembergisches Landesmuseum*

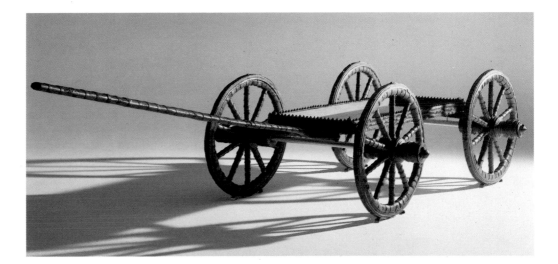

The tomb has been dated to the transition period between Hallstatt D1 and Hallstatt D2/D II, i.e., around 530 B.C.

Other burials in the Hochdorf barrow, rather poorly furnished, have suffered badly from the constant cultivation of the site. In all, three other burials were found, two of which had been dug out during the construction of the barrow itself.

The Hochdorf tomb, which lies ten kilometers from Hohenasperg, is without doubt directly linked to this chieftain's residence. It is the oldest burial found so far in the Asperg area, and attests to the wealth of the local princely class of Late Hallstatt.

Ditzingen-Schöckingen

During repairs carried out in 1951 on a granary in the village, about 100 meters south of the castle, workmen discovered the remains of a female burial complete with a rich assemblage of grave goods. The skeleton of a woman roughly twenty-five years old, laid with head to the south and feet to the north, was found in a shallow grave beneath the foundations of a wall. Alongside the skull were nine small gold rings, six bronze pins with sheet-gold heads, four coral pin-heads, a flat bronze neck-ring, a necklace of eight coral beads, and a large coral ball composed of several small pieces joined together. On either forearm the deceased wore three gold bracelets with ribbed decoration, and on the right ankle a bronze anklet. During subsequent excavations additional three spiral bracelets with serpent-head terminals were found, plus a fragment of another similar ring, two coral balls, and part of a gold pin-head.

Ditzingen-Hirschlanden

In 1963-1964 in the course of a redivision of land, about two kilometers west-southwest of the village, a second barrow was excavated. It had been considerably reduced in height already (1.2 meters high and 32 across). A second tumulus 80 meters east of the first was also explored, and although the interior was completely destroyed, the structure itself provided some surprises. The artificial hill was bordered by a stone circle 19 meters across consisting of a ring of slabs set upright into the ground roughly one meter apart; between them a low, continuous dry-wall had been raised. The slope of the tumulus may also have been clad in slabs at one time. The wall was built from carefully chosen blocks of nummulitic limestone common to the area. The tumulus itself contained another sixteen burials, some of which were probably secondary. Around the centrally-positioned tomb 1 there were two concentric rings of secondary burials (tombs 2 to 7, and 9 to 11). A further burial had been dug out

Bronze couch from the princely tomb of Eberdingen-Hochdorf (Baden-Württemberg) Second half 6th century B.C. Stuttgart, Württembergisches Landesmuseum

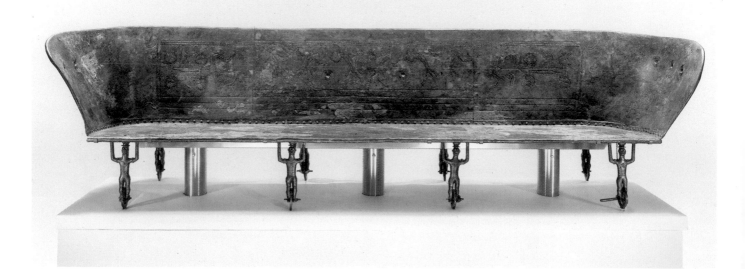

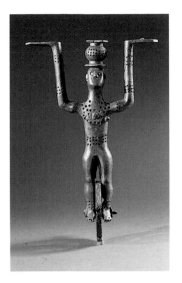

*Bronze caryatid with coral studs
one of the eight supports
of the couch from the princely
tomb of Eberdingen-Hochdorf
(Baden-Württemberg)
Second half 6th century B.C.
Stuttgart
Württembergisches Landesmuseum*

of the center of the tumulus (tomb 13), also crowned with a ring (though incomplete) of less important burials (tombs 14 to 16). Many of the burials were usually laid in a rudimentary wooden chamber (1.8 to 2 meters long and 0.4 to 0.85 meters wide). The goods contained in these burials, all inhumations were extremely simple. The oldest, tomb 1, was dug out toward 550 B.C. during Hallstatt D I; the more recent secondary burials date from the transition to La Tène (toward 450 B.C.).

The most important find by far is a rounded sandstone stele 1.5 meters high depicting a naked, life-size Hallstatt warrior (with feet missing) with headgear and a thick neck-ring—perhaps one of the torques found in the chieftains' tombs. The figure is probably wearing a mask of some kind, as the lower half of the face is deformed; from his belt (formed from two rings) hangs an antenna-hilted dagger. The style of the legs, particularly from behind, is very similar to that of the classical *kuroi* portraits. The stele was found lying outside the northern arc of the stone ring. It had once crowned the barrow; at a later date the feet were broken off and the stela keeled over, breaking in half. At the site itself there is no longer anything to be seen.

Conclusion

As in the case of the Heuneburg, the later tumuli of Hohenasperg tend to be closer to the settlement than the earlier ones. The settlement level to which the Grafenbühl and Kleinaspergle belong is more recent than the hillfort, while the more distant barrows of Ludwigsburg-Römerhügel and Hochdorf are clearly of earlier construction. However, we have yet to find the stratum of older burials like the one at Hohmichele or Ertringen-Rauher Leben; consequently, the Hohenasperg settlement most probably belongs to a later phase than the one at the Heuneburg. It is worth noting that many barrows have not yet been systematically excavated, and new finds may well alter the present picture of things. The Hohenasperg chieftains commanded a region from the Black Forest and the Schwäbischen Wald as far as Albvorland; the northern limit to this region is harder to trace, however. Despite modern urban development Hohenasperg and its burial mounds remain a formidable monument to the region's past.

The Heuneburg Hillfort and the Proto-Celtic Princely Tombs of Upper Rhineland
Wolfgang Kimming

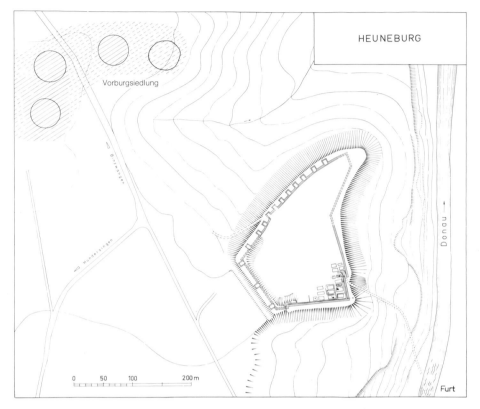

Plan of the Heuneburg hillfort (Baden-Württemberg) as it was in the 6th century B.C. Upper left corner: four barrows cover an earlier, unfortified dwelling

The *Fürstengräberkreis*, or circle of princely tombs belonging to Late Hallstatt culture was first constructed around 650 B.C. and then abruptly abandoned about 150 years later. The complex is one of the leading testimonies to the ancient Celtic presence in Western Europe.

While the information we have on this complex is based entirely on archaeological finds, the details provided by Herodotus of Halicarnassus and Hecataeus of Miletus on what are referred to as the *Keltike* of the Upper Danube provide reliable background documentation. The term *Fürstengräberkreis* was coined at the end of the last century as a consequence of the work of Schliemann in Mycenae.

Some fifty of these rich grave circles have been located and, while most are contained in barrows, others are typical "flat" graves. Given that many are situated alongside fortified settlements, it is reasonable to suppose them to be tombs of the lords of the settlements in question.

A prime example of this type of burial ground is the Heuneburg circle on the Upper Danube to the east of Sigmaringen. Located on the hilltop overlooking the once meandering river, Heuneburg was also a bustling commercial center for the immediate area, thanks to this prominent position on the ancient west-east trading route of the Danube. There were also undoubtedly many links to the south via nearby Lake Constance which gave access to the Swiss Jura and the passes of the central Alps.

The Heuneburg cemetery was systematically explored between 1950 and 1979 on the initiative of Kurt Bittel by a team from the Insistut für Vor- und Frühgeschichte of the University of Tübingen. Despite nearly twenty years' work, only half the cemetery was brought to light. Perhaps somewhat prematurely, the Deutsche Forschungsgemeinschaft (DFG) of Bad Godesberg took on responsibility for the project and, after the excavations were abandoned, arranged for the researchers to begin publishing their findings in Heuneburgstudien.

One of the discoveries was that settlements had existed in this location over specific periods, within a radius of between 300 and 150 meters from the fortified hillside overlooking the Danube.

After a middle-late Bronze Age settlement (c. 1500-1200 B.C.), the land remained uninhabited until the seventh century B.C., when a group of early Celts settled there. In the second half of the fifth century B.C., the homestead was destroyed by fire. Apart from sporadic late-Celtic and early-Roman installations, the land remained largely uninhabited until the start of the Middle Ages, between the eighth and ninth centuries A.D. Since the twelfth century, it has been used for agriculture.

The Celtic hillfort, a Hallstatt construction that existed for less than 200 years, had a somewhat checkered history, as illustrated by the complex stratification of fourteen levels; the first of these dates from the so-called Heuneburg IV-I, numbered from the bottom.

After the initial stages (IVc) comes the period of greatest growth, which includes the construction of the well-documented mudbrick wall, discussed in greater detail later. A fire devastated the entire fort toward the end of IVa. The reconstructed fort (IIIb-IIIa) also went up in flames (IIIa), and likewise the final reconstruction (II-I). The reason for these violent incidents may be associated with the periodical upheavals caused by the exodus of Celts toward the south and east.

The proto-Celtic nature of the Heuneburg complex can only be understood when examined in the context of the monuments around it. To the north, we see an extensive settlement which perhaps covered an area greater than that of the fortress itself. Built like an outwork alongside the walls, it could only have developed by order of the lords of the hillfort; building types and materials used suggest that it was constructed during the period when the fort was in its prime (IVb-IVa). It did not, however, survive the first fire (IV), and the land on which it stood was later flattened and used as a burial ground for the new chieftains of the fort (II-I); four large burial barrows were built with the recycled construction materials.

There is no better proof that Heuneburg was a settlement of a group of proto-Celtic nobles than the circle of large funerary barrows surrounding the fort. The wooden burial chambers can only be those of the lords of the fort. The predominance of gold among the grave goods found in those tombs—many of which were looted over the years— provides information not only on the social status of the persons in question, but also on the proto-Celtic cult of the dead, in which no expense was spared when it came to burying an honored person.

If we recall Homer's observations on the funerals of Patroclus and Hector, and Herodotus's reports of the ceremonial splendor of the funerals of the Scythian kings, it is apparent that the Celts' practice was in some ways similar to that of the Ancient Greeks.

Compared with the well-documented burial grounds at Vix, eastern France, or those of Hochdorf near Stuttgart, however, the proto-Celtic funerary rites adopted here are clearly more conservative. There is no trace of sacrifices of prisoners or slaves (which was a fairly widespread practice in Near Eastern countries); even the deceased's horse was spared, in contrast with the traditional slaughter that took place in Scythian tradition.

The tombs here make do with part of the harness as well as a sumptuous burial chariot. Only the thirteen-meter-high double tomb, the so-called Hohmichele, with its unlooted wooden structure VI—part of the largest of the Heuneburg barrows— suggests the possible cause of death of the two people buried there.

The woman, who was buried with a necklace of 2360 glass beads, was more likely the

wife rather than the slave of the man lying at her side. What evidence is there that they were not victims of a disease or some act of violence? The Celts' concept of life after death bore little or no relation to the Greeks' somber idea of an underworld where the souls lived on without their shadows. The Celtic tombs all contain clues that this people saw things quite differently. The Hochdorf chamber, for example, contains drinking horns, bronze dishes, and all the other requisites for a solemn banquet with eight other symbolic companions, as well as an enormous bronze cauldron containing the remains of about 400 liters of an intoxicating drink. All these items were clearly intended to smooth the way for the deceased and his companions into the world beyond. There is much to suggest that the Etruscans had a similar practice to the ceremonial banquet, a sort of final funeral gathering in the tomb, which was often decorated with scenes depicting earthly pleasures.

This link with Etruria is one of the reasons why Heuneburg became a vital storehouse of information for research into the Celts, as the site clearly shows southern influences which point to widespread contacts in the Mediterranean.

The enclosure wall three meters thick with square towers, on carefully connected stone bases supporting a wall of unfired brick four meters high, leaves no doubt as to its Mediterranean origins.

It has been confirmed that the structure dates from Heuneburg IV, during the first half of the sixth century B.C. It has yet to be established whether it was built by a mason from the south or by local people who had learned their craft in Italy. There is little point in trying to pinpoint the area from which the design came; suffice it to say that the wall is not central European in inspiration and both its conception and origins are the direct result of Mediterranean influence. By erecting this wall and the settlement within, the lord of the fort deliberately appropriated a design belonging to a civilization more evolved than his own. Both the enclosure wall and the settlement to the north show clear proto-urban influences.

After it was damaged during Heuneburg IV, the wall was not rebuilt but was razed (III, I) in preparation for a system of defenses combining wood, stone, and earth in traditional European style, a system that developed into the famous *murus gallicus*.

Links with the south do not end here, however; finds include about 100 black-figure potsherds (many of Attic origin), and a dozen or so transport urns of mixed Greek and Roman "provincial" provenance, demonstrating that the later inhabitants of Heuneburg had regular commercial contacts of every kind with the western Mediterranean. Wine figured largely in such trade. The distribution of the am-

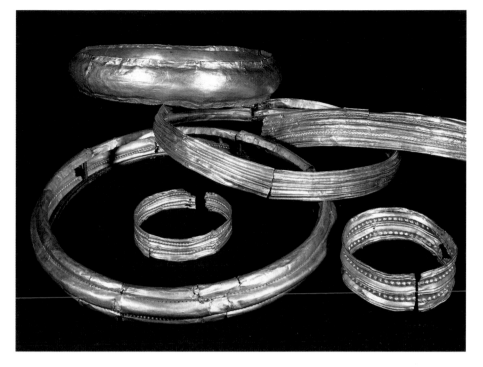

phorae would indicate that the so-called Couloir Rhôdanien, which consisted of the Rhône, Saône, and Doubs rivers, were favored routes. The Rhône must have been skirted by a road as far as Lake Léman. From there, the route passed to the East of the Jura and reached the Upper Danube via Lakes Neuchâtel, Biel, and Constance.

There must also have been a certain amount of direct traffic over the central Alps with the Golasecca peoples living in the Ticino area.

We can only hypothesize as to what products were exchanged for these southern goods, many of which ended up in the princely graves. In addition to agricultural produce and amber, slaves may also have been traded.

The Heuneburg hillfort is still the only fortified site in central Europe to have undergone thorough archaeological investigation. The results achieved thus far have generated hypotheses regarding fortifications similar to the one at Heuneburg. Most of these are believed to have been located in the northwestern pre-Alpine area, but the question of whether similar structures found in the eastern Alps are Celtic or Illyrian in origin is another issue.

There are three main features of the "Heuneburg-type" of hillfort, the first is its status as an exchange point, usually due to its location on a main trading route, often a river; the second is the presence of chieftains' tombs in the immediate vicinity of the fortress, and the third is the evidence of extensive links with the south, the manifestations of which reveal a certain privileged social group.

It may well be that these hypothetical "Lords of the Fortress" were the nobles and proto-Celtic princes often mentioned by Julius Caesar. The hillforts themselves can be taken as centers for tribal groups, and probably included a market and a religious shrine. As such they may have been the forerunners of the *oppida* described in Caesar's *Gallic War*.

The Vix Settlement
and the Tomb of the Princess
Nadine Berthelier-Ajot

The correct name for Vix and its collection of fortifications and barrows is Mont Lassois. Mont Lassois is an outcrop of calcareous rock on the left bank of the Seine. Although the mount rises to the modest height of 109 meters, it is fairly inaccessible, as the summit can only be reached via the steep slopes, and the valley bottom to the east is marshy. The fortified settlement takes advantage of the hill which, despite the natural protection of its geographical situation, has been enhanced with a rather elaborate system of defense structures.

The Seine, which runs below the site, becomes navigable for small vessels at the point where it enters the valley. Consequently the Mont Lassois site was also in an excellent position from an economic and strategic point of view, since the valley could be closed at this point, forcing the traffic along the road at the foot of the mount. Cargoes of tin arrived from the northern deposits of Cornwall, Devon, and the Cassiterides (the "Tin Islands," the exact location of which is not known), while Mediterranean products were brought up from the south. Consequently the site had

all the necessary ingredients for becoming a major crossroads for trade.

Access up the daunting cliffs to the citadel was further inhibited by an imposing series of fortifications, which included ditches, ramparts and banks. A V-shaped ditch 5.7 meters deep and 19 meters wide ran along the foot of the hill, skirting the north and west faces, where it detoured in a zigzag, and thence round the south and east faces. The ditch then took the direction of the Seine, without actually reaching it. The zigzag section on the west face provided a natural surveillance point, thanks to the

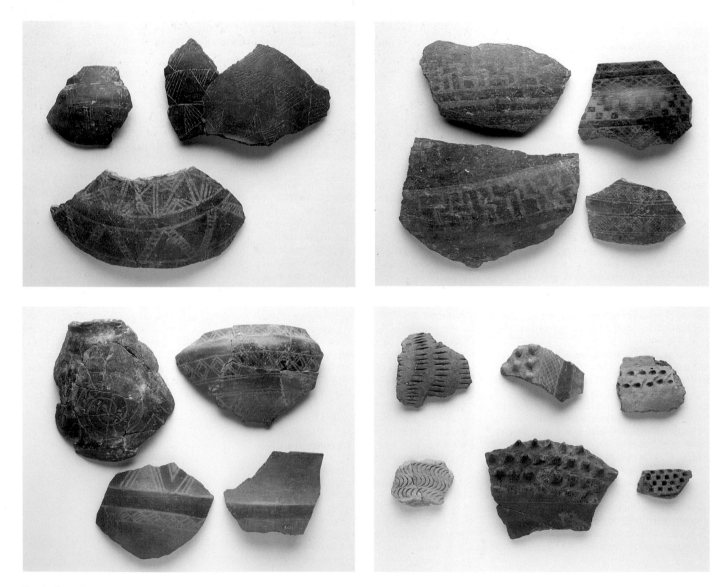

*Potsherds with painted and relief
decoration from the Mont Lassois
site (Côte d'Or)
End 6th-early 5th century B.C.
Châtillon-sur-Seine, Musée Archéologique*

116

*Gold torque from the princely
tomb of Vix (Côte d'Or)
End 6th-early 5th century B.C.
Châtillon-sur-Seine, Musée Archéologique*

break in the cliff-side, which was bridged by a square tower 3.5 meters per side, commanding the point of entry.

The material from the trench was piled up behind it to form an effective rampart ranging from thirteen to twenty meters wide and reaching three meters high at certain points. The posts running along the top have not survived, so there is no way of determining the overall height of the bank. The rampart finished near the Seine, with a ford at the north end. Two banks rose up the east flank, each one starting from a natural spring and seemingly protecting the others. These earthworks measured twenty to thirty-five meters wide at the base, and reached a height of two to four meters. The fortifications enclosed the area at the top of the hill, the cliffs and access to water, indispensable for the livelihood and activities of the inhabitants; the other side offered a 500-meter stretch of riverside access on the Seine.

The sheer size of the defense works and the area of the enclosure would suggest a fairly densely populated settlement, which excavations have so far only hinted at. The occupied areas included the hilltop, the sides and foot of the east face, near the Seine, toward the marshlands. Evidence of habitation is limited to a few holes in the ground marking the posts that lined the perimeter of the rectangular huts or cabins (5 by 2.5 meters) with walls of wattle and daub, and a central hearth.

By contrast, a wide variety of everyday objects have turned up, including fibulae, pins, jewelry, arms, and fragments of Attic and local pottery, which boasts an astonishing variety of shapes and decoration (engraved, painted, etc.).

So far archaeologists have identified only one zone of specialized craft-working in the settlement, on the west side, where finds suggest open-air workshops. Scraps and shavings of iron and bronze have been found, and splinters of bone. Our understanding of the settlement layout is limited because only a fraction of the area has been systematically excavated.

Random investigations have so far failed to yield information about the exact situation of the marketplaces where imported items such as Attic pottery and Massiliot amphorae were sold to the citadel's inhabitants.

Buried under barrows at the foot of their

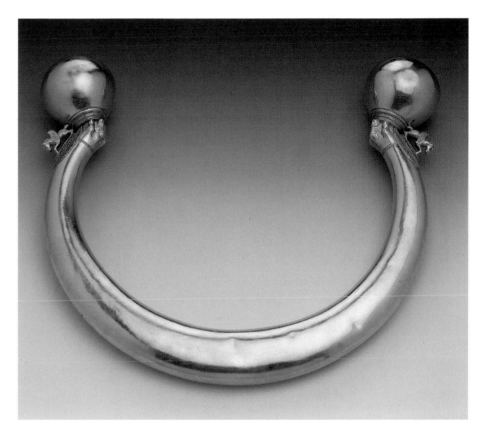

citadel, the Celtic princes have left little trace of their vast legacy except the rich graves. The deceased were interred on ceremonial chariots, together with ornaments and pottery. The Celtic princes were apparently fond of luxury goods produced in Greece (such as the *lebete* of Sainte-Colombe-la-Garenne, and the Vix krater), but they did not disdain local products (such as the earrings and bracelets of Sainte-Colombe-la-Butte), probably created in workshops annexed to the princes' "courts." Given the state of today's site, it is hard to imagine exactly what the Mont Lassois citadel looked like in the Hallstatt period, but it boasted imposing fortifications, and this sturdy material barrier in no way hindered the settlement from thriving on its lively trading business. Local trade in products of the immediate hinterland (iron, wool, wood, dyes such as ochre) was complemented by slightly more distant commerce with Tonnerois (sanguigne) and Morvan (granite), and without doubt by more

complex trade links with the Baltic and the Adriatic (amber), the Mediterranean (coral, pottery, luxury items), and the Cassiterides (tin).

The princess of Vix was probably among the last of the Mont Lassois princesses. She owed her prosperity to a very well-defined type of economy which collapsed with the arrival of the La Tène people, who imposed a different type of trading, in which sites such as Mont Lassois had no further reason to exist.

Bragny-sur-Saône (Saône-et-Loire)
Metallurgy Center, Fifth Century B.C.
Jean-Loup Fluest

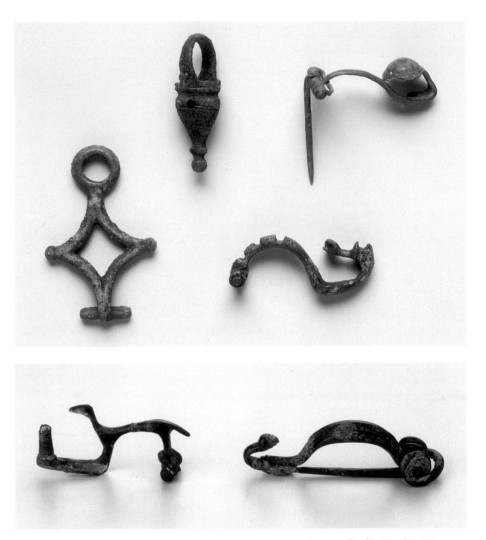

*Golasecca-type bronze pendants
and bronze fibulae from
Bragny-sur-Saône (Saône-et-Loire)
End 6th-early 5th century B.C.
Chalon-sur-Saône, Musée Denon*

The Bragny site, roughly twenty kilometers northeast of Chalon-sur-Saône, lies on a sandy argillaceous terrace on the right bank of the Saône, not far from the confluence of three rivers, the Saône, the Doubs and the Dheune.

Between 1968 and 1979 M. Guillot succeeded, despite the limited area of the excavations, in establishing the important role of iron and bronze metalwork on the site as well as the presence of a large quantity of Mediterranean imports. The settlement may be dated to the end of the sixth and beginning of the fifth centuries B.C., the Late Hallstatt period.

Relative and Absolute Chronology of the Site
There are several sites in the Burgundy and Franche-Comté regions belonging to the Late Hallstatt period, including the famous one at Vix. This has made it possible to establish a detailed relative chronology based essentially on the evolution of jewelry fashions, such as the fibulae, some of which can be dated thanks to their association with Greek pottery.

The archaeologists, however, also noted in these areas that the sites of the succeeding culture, known as Early La Tène (the end of the fifth and fourth centuries B.C.) were very few compared with, for example, the Champagne area. Was the fashion for Hallstatt jewelry short-lived in these regions? Stratigraphic excavation is one of the basic archaeological methods used to test the validity of an established chronology. Recent research at Bragny has shown, contrary to the first conclusions, that the site reveals at least two large phases of settlement divided by a brief period of abandonment.

The older levels were excavated very carefully: pseudo-Ionic pottery objects, Attic pottery of the end of the sixth or beginning of the fifth centuries, old style amphorae from Marseilles show that the village was already well established during the Late Hallstatt period.

The interval of abandonment can be easily visualized. Following the destruction of the straw roofing, pluvial erosion led to the collapse of the walls of the underground chambers excavated deep into the sandy argillaceous ground.

The last phase of settlement is characterized by the construction of metallurgy workshops and by the more or less summary reutilization of the previous buildings, and, above all, by the abundant deposits of metal scrap mixed with easily identifiable black ashes. The presence in these layers of numerous north Italic objects belonging to the Golasecca Culture, dating to the second half of the fifth century B.C., offers proof of an occupation in the second Iron Age. The Bragny site therefore allows us to establish a fairly precise distinction and date for the transition period of the fifth century, the turning-point in the history of the Celtic peoples.

*Zoomorphic fibula and La Tène-type
fibula in bronze from
Bragny-sur-Saône (Saône-et-Loire)
5th century B.C.
Chalon-sur-Saône, Musée Denon*

*Fragments of "balsamari" in
polychrome glass, and iron chisel
End 6th-early 5th century B.C.
Chalon-sur-Saône, Musée Denon*

Metallurgy Techniques in the Late Hallstatt Period

Traces of metalworking can often be found in the *oppida*, such as the one at Vix. We can say, in all probability, that workshops existed in almost all the large centers. Metalworking at Bragny took place everywhere on the three-hectare site. Iron and bronze were worked in the same places, perhaps by the same craftsmen.

Most likely, the ferrous material came from nearby deposits. It was reduced, refined and transformed into objects such as *Pauken* fibulae, or sets of toilet implements. No characteristic ingot has been found. The size of the clay furnaces and the existence of replaceable *tuyères* prove the craftsmanship of the foundry workers.

Copper was neither worked nor reduced there. Substantial quantities of bronze seem to have been melted in large clay receptacles as well as in the familiar small crucibles. A wide range of metalworking techniques has been identified: bivalve stone molds, lost-wax molds, fusion of thick plates, cutting with burins, hammering and then mounting by means of rivets and perhaps by means of brazing as the drops of tin and lead appear to suggest. Finishing and decoration was done on lathes and with burins and pumice stones. The incomplete or partly finished objects found reveal that the craftsmen produced fibulae and situlae.

The quantitative research on the scrap (nearly two tons over an area of 400 square meters) confirms that the craftsmen at Bragny had reached a level of production that implied trade outlets outside the region, which raises the question of the nature and intensity of their trade with large commercial centers such as Marseilles and northern Italy.

Socioeconomic Contacts with the Mediterranean World

Right from the time of the first discoveries, the role of Marseilles appeared to be as fundamental as that of the Rhône-Saône axis. All the same, a bronze pendant of Golasecca origins had already been identified by Feugère which testified to belated trading with northern Italy across the Alps.

Recent research established a close association between the last phase of the site and the abundance of typical Golasecca Culture objects: *Certosa*-type fibulae (a Ticinese variation), *Sanguisuga* and *Navicella* fibulae, funnel-shaped pendants, cups decorated with concentric circles or, in the earlier sites, with horses stamped on them. The presence of everyday objects in the homes, compared with the luxury objects recovered from the graves of Celtic chieftains, suggests the arrival of foreigners from Cisalpine Gaul—though it is not known if they stayed. The special relations with northern Italy are confirmed, in the early phase of the village, by the discovery of two Italic fibulae. The first is zoomorphic and the second, a duck's head, is of the kind with a coral bead in its beak (Frey).

Contrary to the theory of the complete termination of trade with Marseilles, replaced by trade routes toward Etruria across the Swiss Alps, the Bragny site in its last phase reveals the simultaneous presence of Massiliot amphorae dating to the second half of the fifth century B.C. as well as Golasecca culture objects, Phase III A. Apart from the problem these pose in a comparison of the chronologies of northern Italy and southern France, it must be said that the Bragny site had considerable economic attractions. The iron trade seems, for the moment, to have been the most plausible reason. Secondly, deposits of rock salt at Lons-le-Saunier were a mere fifty kilometers away, and those at Salins only sixty. The lack of defensive structures and rich graves around Bragny lends suppot to the theory that there was a political center in another area.

Only five percent of the site has been partially excavated so far, and yet the wealth of finds has already contributed considerably to our knowledge of European trade in the fifth century B.C.

Fragments of Massiliot amphora from Bragny-sur-Saône 5th century B.C. Chalon-sur-Saône, Musée Denon

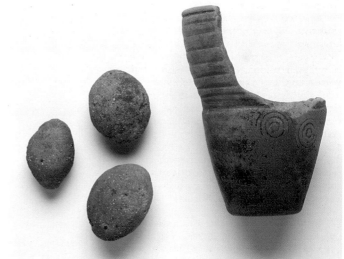

Sling projectiles in terracotta and Golasecca-type beaker from Bragny-sur-Saône (Saône-et-Loire) 5th century B.C. Chalon-sur-Saône, Musée Denon

Bourges: A Hallstatt Site in the Loire Valley

S. Delabesse and Jacques Troadec

The importance of the Bourges *oppidum* at the end of the early Iron Age became clear with the first discoveries made on the site and immediate surroundings during excavation work in the nineteenth century. The bronzes of Etrusco-Italic origin (buckets, situlae, and oinochoes) found in the graves form one of the most important collections of artifacts imported by a Hallstatt culture north of the Alps.

The Bourges site lies on a low promontory overlooking the junction of the Auron and Yèvres rivers (both tributaries of the Cher)—hence the etymology of the town's ancient name, *Avaricum*, meaning "Port to the Yèvre." At the end of the second Iron Age, *Avaricum* was the capital of the Bituriges, and was so important that Caesar termed it *urbs* in his *Gallic War*: "A city which is, or is very nearly, the most beautiful in all Gaul, and the strength and jewel of their land." The remains unearthed during the early excavations testify to multiple influences dating from the close of the Bronze Age. This can also be explained by Bourges's strategic position in the Loire basin. It was in fact one of the obligatory passages for trade between continental Europe, the Atlantic and the Mediterranean, and hence it is plausible that Bourges lay right on one of the communication routes between the Rhône corridor and the tin-rich regions of Armorica.

Control of this crossroads during the early Iron Age determined the economic development of the site and the evolution of its political organization, which saw the emergence of a dominant class distinguished by its use of imported luxury vessels.

The importance of the Bourges site during the Hallstatt period has been confirmed by excavations under way in three different areas since 1984. Settlement strata dating from the end of the first Iron Age have yielded imported pottery, including Massiliot wine amphorae, and Attic pottery of exceptional quality.

The latter comprises fragments of black-figure drinking cups decorated with palmettes (c. 520 B.C.); red-figure drinking cups (c. 480-470 B.C.); red-figure amphorae (c. 480-470 B.C.); stamnoi (c. 480-470 B.C.) found during the Collège Littré excavation, which in 1986 studied three successive settlement stages of the first Iron Age; fragments of a red-figure drinking cup (ca. 480-470 B.C.); a red-figure *skyphoi* (second half fifth century B.C.); a shallow drinking cup painted black (last quarter fifth century B.C.); fragments of red-figure Attic ware (middle and second half fifth century B.C.) found during the 1989 Rue de la Nation excavation campaign.

More recent studies have revealed another interesting fact, the adoption of imported techniques in the production of indigenous pottery, some of which (copies of Etruscan and Greek models) were wheel-made.

The relative abundance and the fine quality of imported pottery at Bourges, together with the use of the potter's wheel for local production, have enormous cultural implications. They are evidence of an ongoing process of cultural induction and attest to regular and well-established contacts with distant cultures, especially those of the Mediterranean. They also indicate the formation of a complex social hierarchy dominated by a powerful elite, and are symptomatic of a sweeping change in technical knowledge and economic structure, suggesting a transition toward a proto-urban culture.

The distribution of settlements and graves of the Hallstatt period in Bourges and the immediate vicinity indicates the need for a thorough study of the territorial organization of this site, whose size and political importance would explain the numerous references to it in the ancient texts (Livy and Caesar, for example).

The fact that the Bourges site was permanently settled from the beginning of the first Iron Age (its foundation dates to at least the end of the sixth century B.C.) proves that *Avaricum* is one of the oldest *oppida* in Gaul, and certainly one of the most interesting.

Settlements and cemeteries at Bourges (Cher)
Settlements: 1. Collège Littré; 2. Rue de la Nation
3. Saint Martin des Champs.
Tombs with imported objects
4. Les Fonds Gaydons; 5. Saint Célestin
6. Route de Dun. Other tombs: 7. Mazière
8. Pyrotechnie (plot uncertain, unmarked)
The dotted area corresponds to the complex
of sanctuaries and cemeteries dating
from the First and Second Iron Ages

Pottery in situ in the excavation
of Collège Littré at Bourges (Cher)
End 6th century B.C.

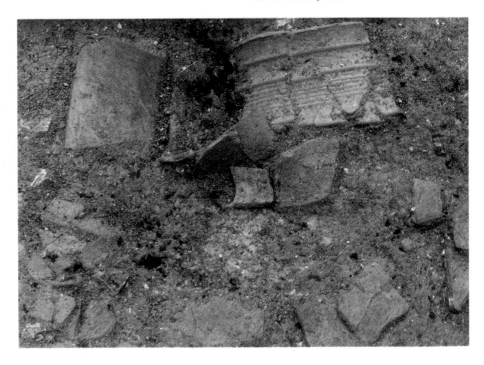

Les Jogasses
Pierre Roualet

*Selection of characteristic personal bronze
ornament types from the Les Jogasses
cemetery at Chouilly (Marne)
Group on left: end 6th century B.C.
Group on right: early 5th century B.C.
Epernay, Musée Municipal*

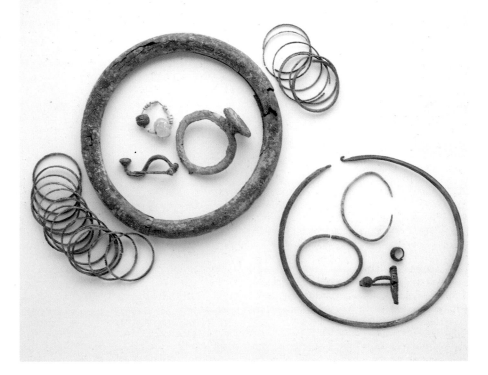

An Important Site

Situated in the municipality of Chouilly
near Epernay, the Jogasses cemetery is one
of the most important sites in Champagne.
Known since the mid-nineteenth century,
the site was first investigated, albeit un-
systematically, by some archaeologists. Ex-
cavation, resumed between 1923 and 1939
by Favret, a clergyman, brought to light
312 graves, including a group of 203 graves
datable to the end of the First Iron Age, be-
tween 530 and 475 B.C. This cemetery has
offered crucial new insights into the proto-
history or Champagne and the whole of
northeastern France. The funerary prac-
tices and the objects included as grave
goods prefigure exactly the type of goods
found in later Celtic cemeteries, up until
the second century B.C.

Grave Goods

Apart from rare exceptions, the usual rite
observed was inhumation, with the body
laid on its back in graves dug to measure,
averaging 0.8 meters deep. Examination of
the grave goods allows two periods to be
distinguished. The first involves female bu-
rials in particular, identically furnished:
large hollow torques, numerous bracelets
worn on either arm, and belts with bronze
clasp decorated with small bronze studs;
three-piece fibulae were also plentiful.
During the second period, the ratio of male
to female burials evens out. The men are in-
terred with their panoply of arms, which in-
cluded a dagger, a spear or a lance. Two
individuals carried a quiver, the metal ele-
ments of which have been found, together
with the arrowheads. The assemblages of
the women's graves are more varied com-
pared with the previous period. This is es-
pecially true of the torques, now in solid
bronze with circular or polygonal cross-
section, and for the fibulae, which have one
or two sections, with a long bow-shaped
spring. Belts and armlets disappeared, and
in their place are new ornaments, solid
bronze bracelets and boat-shaped earrings.
Practically all the pottery found in the
cemetery is found in graves from this peri-
od, with one piece in each grave. Most of
the vessels are bowls or shallow cups with
varying rim form.

Les Jogasses and Mont Lassois

The finds suggest a distinct local culture,
defined as the Jogasses culture, which was
not indigenous and was certainly imported
by small groups of peaceful immigrants.

There are close parallels with finds in north-
ern Burgundy, on Mont Lassois, the hill
that overlooks the celebrated site of Vix.
No imported objects were discovered in the
Les Jogasses cemetery, but finds at Vix and
Mont Lassois shed light on trade links and
contacts with other peoples that must have
influenced the local cultures. There were
two sources of influence. The first came
from Massilia along the Rhône Valley, the
route along which the Massiliot amphorae,
the pseudoionic vases, and ionic cups came,
and which was interrupted at the start of
the fifth century B.C. The second and more
enduring source was northern Italy, and ac-
counts for the Etruscan *oinochoe* and three

basins found in the Vix tomb.
The Vix-Mont-Lassois culture and that of
Les Jogasses enjoyed southern influences,
particularly from Italy, which persisted
through the Marnian phase that took over
from the Jogasses culture in Champagne.

*Selection of characteristic pottery
types from the Les Jogasses
cemetery at Chouilly (Marne)
End 6th-early 5th century B.C.
Epernay, Musée Municipal*

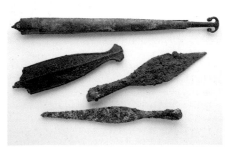

*Selection of characteristic weapon
types from the Les Jogasses
cemetery at Chouilly (Marne)
End 6th-early 5th century B.C.
Epernay, Musée Municipal*

The Celtic Hillfort of Mont Kemmel
André van Doorselaer

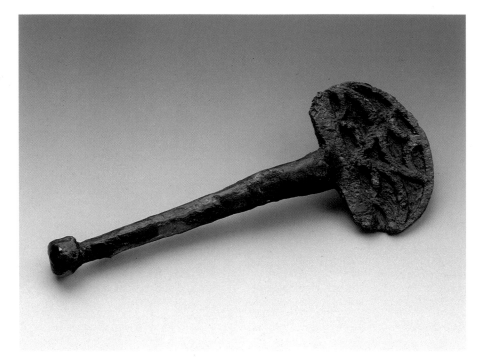

Foreword
Mont Kemmel has been famous since World War I, when it provided a key strategic position during the Battle of Flanders. Its next claim to fame was the discovery of archaeological remains during survey work from 1965 to 1967, which subsequent excavations (1968-1980) revealed to be a Celtic hillfort. The site is on the northwestern rim of the Celtic princely realm, and is at the same time the northernmost point of the area of imported Greek wares from the sixth and fifth centuries B.C.

The Site
A large rocky outcrop in the western range of hills in Flanders, Mont Kemmel stands on the watershed between the Yser and the Lys rivers, rising to a height of 154.58 meters above sea-level. The summit offers an elliptical plateau of three hectares within the 150-meter contour line, and eight hectares at the lower contour of 140 meters. Archaeological material from the site spans Middle Paleolithic to Neolithic.

The Celtic Oppidum
1. Traces of Fortications
A hundred or so surveys have revealed traces of terracing belonging to a fairly complex set of defense works that were modified at various stages. Taking full advantage of the geography of the site, the inhabitants dug out a wide, deep ditch at the rim of the cliff, and with the earth and rubble left by this operation built up a rampart behind it. In places the base of the earthworks was consolidated with piles of stones, and there are intermittent traces of palisading. Regrettably, erosion and trenchwork carried out during World War I have all but obliterated the defense structures and the remains of the dwellings. A lane ran up the furrows north of the hill, but was never used during Celtic occupation.

2. Craftwork
A terrace on the north face has yielded evidence (mainly of production failures) for the manufacture of painted pottery.

3. The Barrow
Seven hundred forty meters southeast of the center of the oppidum there is an artificial mound 3.5 meters high and 30 meters across. Excavations have disclosed a ditch running east-west, 3 meters long and 2 wide, dug to a depth of 0.75 meters in the topsoil; since there are no signs of grave goods or human remains (though the earth had not been disturbed), it must be supposed that the barrow was a form of cenotaph.

4. Pottery
The pottery is highly elaborate and varied. There was a large quantity of finer ware, mostly glazed and particularly thin (1-4 millimeters); types include situla-type vases and carinated goblets (sometimes adorned with geometric patterns), bowls, and carinated cups. The domestic wares are generally from beige to gray-brown in color, smooth or grooved, and shapes vary from cups and beakers to larger vessels for storage; they are decorated with geometric figures, comb patterns, finger or spatula indentations, or aligned cordons; sometimes clay circles or lozenges are applied and decorated with cruciform patterns.

The hoard has been dated to Early La Tène, confirmed in particular by a bucket and a goblet of Jogasses-type with painted decoration betraying Marnian influences. Another find of special note is the fragment of shiny black Attic ware.

In conclusion, Mont Kemmel is noteworthy for its abundant store of locally-produced painted ware; most of the pots are large, thin-walled (1-2 centimeters) and well-fired, made from clay mixed with organic grits, such as *chamotte*, and granules of quartz or crushed flint. The outer walls bear horizontal grooves and geometric patterns enhanced with reddish or dark-brown pigment laid on a beige slip. This type of pottery has a characteristic broad lip with a groove for the lid. One carinated fragment suggests an elongated type of situla or a krater, similar to those recently found at Kooigem (Courtrai, western Flanders).

5. Other Important Finds
Other important finds include two glass beads (one light blue, the other olive-green), a ribbed bead made from gold leaf mounted on a bronze core, a fragment of gold leaf with a plastic teardrop motif and beaded rim, a bronze ornament, an iron spindle or hub-peg for a chariot, with a decorative bronze mount, a fragment of a bracelet in shale, a piece of bronze fibula, and bronze mount with shell motif similar to one on an oinochoe found in a tomb at San Martino in Gattara near Ravenna, Italy. This object, as with the fragment of Attic ware, attests to relations between the inhabitants of the Mont Kemmel hillfort and the Mediterranean world.

From its strategic position on Mont Kemmel, the hillfort commands the surrounding countryside, the coastal plain, and the estuary of the Yser. These advantages made it a thriving center, controlling sea trade while pursuing its farming interests on the plain, iron mining on the hillside, and salt production, traces of which have been found at La Panne, Bruges, and Furnes. All these features made the site particularly attractive to the resident Celtic aristocracy.

Châtillon-sur-Glâne: A Late Hallstatt Princely Residence
Hanni Schwab

Princely residences of the Late Hallstatt culture that clearly show the influence of the Mediterranean world were discovered some time ago in southern Germany (Heuneberg) and in France (Mont Lassois) while nothing similar had been found on the Swiss plateau. Even though a large fragment of a Greek krater with black figures had been found in the last century on the Uëtliberg near Zurich, the settlement still had to be explored. Precious objects imported from the Mediterranean area had been discovered in several barrows on the Swiss plateau but the settlements to which the barrows belonged were still unknown. Châtillon-sur-Glâne was only discovered in 1973 when an amateur archaeologist found six fragments of Attic pottery with black figures, fragments of vessels with engraved decorations, a double bronze *Pauken* fibula (with drum-shaped bow) on a mound on a rocky buttress protected by a rampart and ditch at the confluence of the Saane and the Glâne rivers. Thanks to the generous support of the Schweizerischer Nazionalfond für Wissenschaftliche Forschung and the Loterie Romande, excavations, each lasting several weeks, took place every year from 1974 to 1988 with very enlightening results. The level explored so far has revealed numerous objects (some considerably damaged unfortunately) made of bronze, iron and sapropelite, especially fibulae and bracelets, as well as a mass of potsherds including locally-made storage vessels and fine pots and bowls with engraved decoration. Imports from the south consisted of more than fifty pieces of kraters with black figures, bowls and *skyphoi*, many fragments of amphorae of varying quality, from southern France and Italy and a few fragments of Phocaean, pseudo-Phocaean, and Ionian vessels. There were also Este situlae probably made locally, and Mont Lassois-type red painted pottery.

The pottery and fibulae belong to the D2/D3 phase of the Hallstatt culture and therefore make it possible to date the Châtillon-sur-Glâne settlement to a period between 550 and 480 B.C.

Châtillon-sur-Glâne was built on an important commercial route that connected Greece and Brittany and Cornwall in southern England (which had rich deposits of tin much sought after then in Greece for the large production of bronze). Transport in that period, even for inland routes, utilized boats as much as possible. Entrepôts were very important because the transfer of goods from boats to carts and beasts of burden had to be protected from attacks. There is a series of entrepôts that must have been built at around the same time along the trade route from Greece, passing through northern Italy, the Great Saint Bernard Pass, the Col-de-Mosses, the valley of the Hongrin and Saane rivers, the Swiss plateau, the Jura, the valleys of the Doub, Saône and Seine rivers, to reach Brittany. These depots are Châtillon-sur-Glâne with a port on the Saane, Le Camp-du-Château de Sallin with the port of Lesny on the Loue, Bragny near the confluence of the Doubs and the Saône, and Mont Lassois with a port at Vix on the upper Seine. Surely other entrepôts must have been located along, for example, Lake Neuchâtel, but so far nothing has been discovered. Châtillon probably made a link with the Rhine possible, by passing through the Saane and the Aare valleys. The route by which southern French imports were transported to the Saane valley and Châtillon has not yet been discovered.

Important princely barrow graves in the Châtillon neighborhood demonstrate the great importance of this fortified settlement and leave no doubt that this was a Late Hallstatt princely seat.

The hill rising in the Bois Murat, 2.4 kilometers west of Chatillon was explored in 1909 by Abbé Breuil during building works. Three large graves, their barrows practically flattened by agricultural activities, had recently been discovered near Matran, a few hundred meters further south. The largest barrow is 1.8 kilometers north of Châtillon in the Bois de Moncor. Originally it was ten meters high, and today it still has a diameter of eighty-five meters. A trial cutting through part of the mound has shown that it is, in fact, of artificial construction. It awaits more detailed investigation as do the remaining burial mounds in the Daillettes and at Port. Only one of the smaller barrows in the Châtillonwald cemetery has been excavated so far.

*Attic black-figure ware
from Châtillon-sur-Glâne
5th century B.C.
Freiburg, Musée Schwab*

Aerial view of the Châtillon-sur-Glâne site

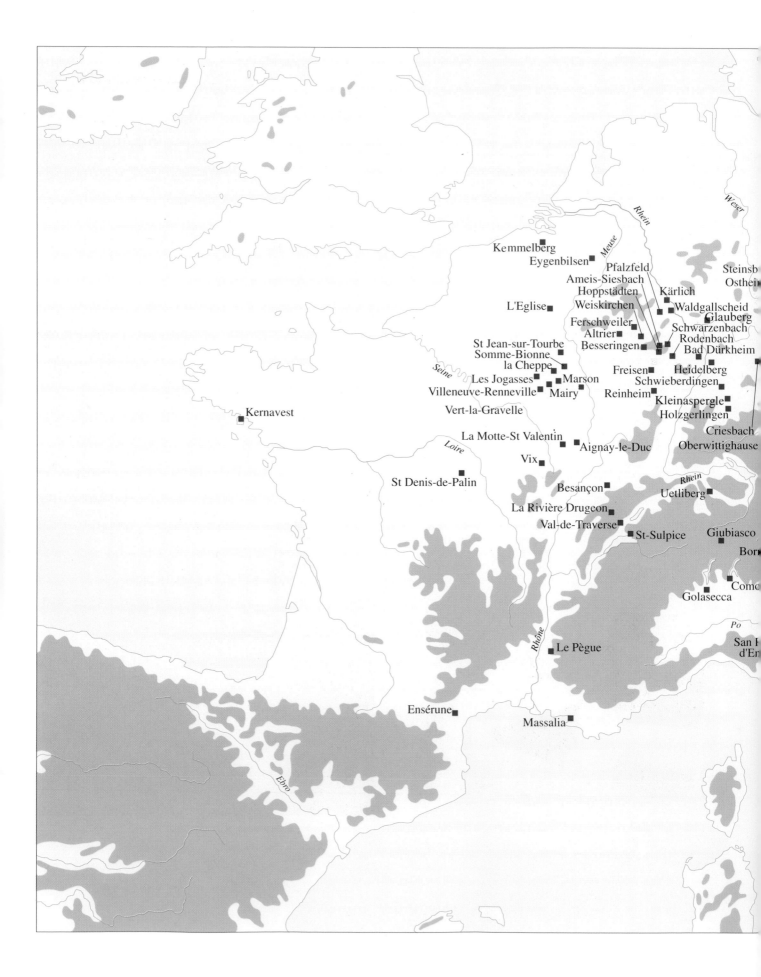

Kemmelberg
Eygenbilsen
Pfalzfeld
Ameis-Siesbach
Hoppstädten
Kärlich
Steinsb
Osthei
L'Eglise
Weiskirchen
Waldgallscheid
Glauberg
Ferschweiler
Schwarzenbach
Altrier
Rodenbach
St Jean-sur-Tourbe
Besseringen
Bad Dürkheim
Somme-Bionne
la Cheppe
Freisen
Heidelberg
Les Jogasses
Marson
Schwieberdingen
Villeneuve-Renneville
Mairy
Reinheim
Kleinaspergle
Vert-la-Gravelle
Holzgerlingen
Criesbach
La Motte-St Valentin
Oberwittighause
Kernavest
Aignay-le-Duc
Vix
Besançon
Uetliberg
St Denis-de-Palin
La Rivière Drugeon
Val-de-Traverse
St-Sulpice
Giubiasco
Bor
Com
Golasecca
San I
d'En
Le Pègue
Ensérune
Massalia

Weser
Rhein
Meuse
Seine
Loire
Rhône
Rhein
Po
Ebro

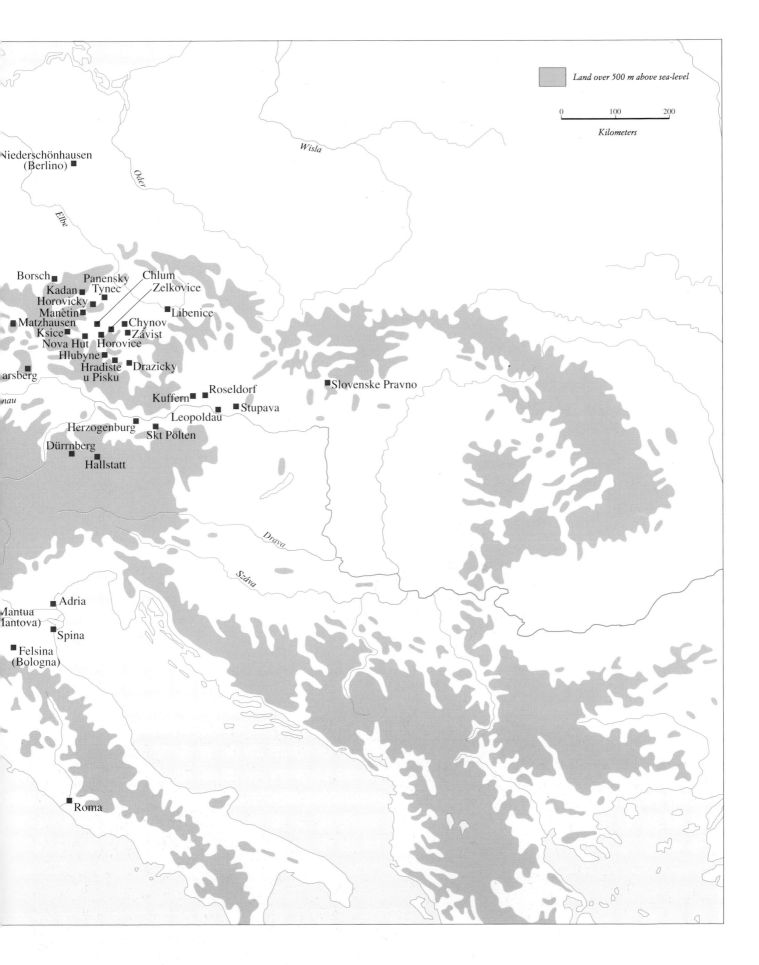

The Formation of the La Tène Culture
Fifth century B.C.

Land over 500 m above sea-level

0 100 200

Kilometers

Wisła

Oder

Elbe

Niederschönhausen
(Berlino)

Borsch
Kadan
Horovicky
Manètin
Matzhausen
Ksice
Nova Hut
Hlubyne
Hradiste
u Pisku

Panensky
Tynec
Chlum
Zelkovice
Libenice
Chynov
Závist
Horovice
Drazicky

arsberg

nau

Slovenske Pravno

Kuffern
Roseldorf
Stupava

Herzogenburg
Skt Pölten
Leopoldau

Dürrnberg
Hallstatt

Drava

Száva

Adria

Mantua
(Mantova)

Spina

Felsina
(Bologna)

Roma

Otto Hermann Frey

The Formation of the La Tène Culture in the Fifth Century B.C.

The new era takes its name from a famous archaeological site in Switzerland. Once again, it is mainly finds from cemeteries which provide us with an image of the first Celts. There are settlements too, but none of them has been studied so exhaustively as the Heuneburg, which belongs to the latest Hallstatt period. Some material comes from underwater sites and other cult deposits. There are, however, few written sources documenting this period.

Typical of of this new era is a different artistic style, again subject to influences from the Mediterranean. This was not merely imitative of Greek or Etruscan models, as is the case with some finds from the "princely" world of Hallstatt, but gave rise to new creations with an unmistakable and original artistic stamp.

This only refers to small-scale art objects, vessels, weapons, parts of wagons, and so on. Stone sculptures of larger dimensions, mainly stelae, have only occasionally been found, but here too, we have the representations of their heads or the slight suggestion of the arms. These cannot be interpreted as true sculptural representations, but rather, as the pillar at Pfalzfeld proves, as additions to a monument. Of course, it is obvious that the material found includes other signs of an important turning-point which defined the new era. New centers of regional importance appear. A new type of weapon appears in male graves, and the funerary rite reflects a new way of thinking. Unlike the customs of the Hallstatt period, the graves no longer contain a small number of typical weapons, interpreted mainly as symbols of social status. On the contrary, the dead man makes his journey to the next world well armed. Similarly, two-wheeled "war chariots" take the place of the four-wheeled funerary wagons of rich men in the Hallstatt period, and there are examples of lighter versions of these vehicles in women's graves.

Later on, there is evidence that clothes also underwent changes. Now, the man's attire includes a heavy belt with characteristic hooks; and the fibulae, which seem to have been so sensitive to changes in fashion, also show clearly differentiated forms. These may only be the outward manifestation of the Early La Tène, but there are also signs of new ideas or political and social change in a wider territorial sphere.

What Happened to the Princes of the Western Hallstatt?

What signs were there of this change in the territory which had been the heart of the western Hallstatt world, that had affected the cultural development of central Europe on such a large scale? On the threshold of the new era, a catastrophic fire had destroyed the Heuneburg, and there were no finds relating to the first La Tène period from the surrounding cemeteries. The region of Hohenasperg presents quite a different picture. About a kilometer to the south of this hill lies the "Kleinaspergle," which is also a typical "giants' tomb" burial mound, and which was also explored in the last century. The main chamber had been robbed, but a smaller lateral chamber was found still intact, containing a funerary assemblage of two Greek cups dating from the middle of the fifth century, an Etruscan bronze *stamnos*, a flagon produced locally based on an Etruscan model, two drinking-horns, a ribbed bucket and a large vessel, all of which constituted a valuable "service" for drinking. Besides these objects, there were gold ornaments, a hook from a heavy belt and other finds. The inventory of the contents of the grave immediately recalls those from the nearby "princely tombs" of the Hallstatt period. Once again, drinking vessels imported from abroad play an important role. However, in the case of the flagon, which was made in central Europe, and the articles of clothing, we are now dealing with products that are typical of the Early La Tène.

The new artistic language is well displayed by the flagon, which imitates an Etruscan beaked flagon (or *Schnabelkanne*), like those found in the Hallstatt grave at Vix in France, or other inhumation burials of the Early La Tène. However, the shape is quite different, in that the proportions have been altered, giving it a more dynamic character. The shoulder projects almost horizontally, the base is longer and slightly curved. But above all, it is the handle which has features that differ from Etruscan models. The pointed ears on the head on the bottom of the handle are reminiscent of a satyr, like the one on the joints of the Etruscan

stamnos found in the same grave; in this example, instead of being at the side, the ears protrude above the head. Not only the eyes, but also the forehead, cheeks, nose and chin are represented spherically, and the beard seems to have no clear edges, but is represented by a pattern of overlapping palmette leaves. There are similarly deformed faces with the same excessive emphasis on the features on the upper part of the handle. Whereas the deformation of animal heads on the lateral extensions of the handle is less pronounced, the "human head" in the center has the appearance of something so grotesque that, in this exaggerated form, it can no longer be interpreted as a reproduction of anything real.

Fantastic heads of this kind, which introduce us to a particular world of Celtic representation, feature in various products of the Early La Tène artistic culture. The flagon itself also has some near equivalents in the finds from Dürrnberg near Hallein, from Borscher Aue near Salzungen and from Basse-Yutz on the Moselle. As for the proportions and ornamentation themselves, they are quite distinct from their southern counterparts. The difficult work of embossing and the fusion processes involved prove that, in this case, we are dealing with the best bronze work of the time, from which we must deduce that there were excellent workshops. If we go back to the splendid metal objects of the Hallstatt era, despite the changes in style, it would seem that a craft tradition continued uninterrupted.

The two Greek cups must have been considered very precious by the Celts, since ancient cracks seem to have been repaired with bronze clamps and the fracture-lines partially covered with patches of gold, molded to make a single addition to the decoration. There are single leaves or leaf-shaped features which merge into each other, but also flower-shaped features, which are entirely composed of leaves of this kind, similar to the palmette beard on the head from the bottom of the handle on the bronze flagon. Therefore, the bronzesmiths and the goldsmiths drew their inspiration from the same repertoire of prototypes. No doubt the leaf-shaped features were inspired by classical phytomorphic decoration, and yet they are quite distinct from the original motifs. For example, the "flower-shaped design" shows that the leaves were connected in new way with precise circular arcs. Other gold objects found in the

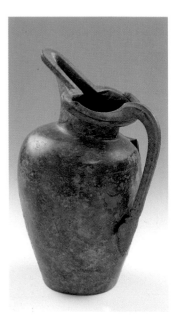

Full view and detail of a bronze wine-flagon of Etruscan origin with fine Celtic decoration engraved in the 4th century B.C. Origin unknown Besançon Musée des Beaux-Arts et d'Archéologie

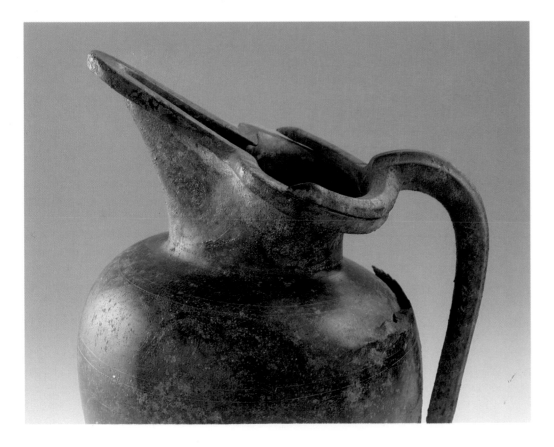

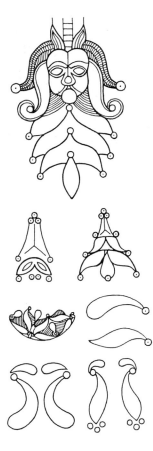

*Ornamental details of objects
from Kleinaspergle (district of
Hohenasperg Baden-Württemberg)
Second half 5th century B.C.
Stuttgart
Württembergisches Landesmuseum*

grave follow similar principles of composition. So far, the small chamber at Kleinaspergle is the only "princely tomb" of the Early La Tène to have been found in the area around Hohenasperg. It is highly probable that it was an expression of the last phase of the dynasty which had previously reigned on the Asperg. It is unlikely that the site was much later than the Late Hallstatt graves, such as that at Grafenbühl or Römerhügel. The new decorative style of the artifacts in bronze and gold seems to appear suddenly, at least in this region, without any recognizable signs of a prolonged period of experimentation. Was this rapid change in artistic production started by particularly skilled individual artists trained in the best local craft tradition? Or should we look for the origin of the new style in another area, perhaps the middle Rhineland? These are questions which cannot be investigated further here. However, in the center of what had been the western Hallstatt sphere, there are later "princely graves" which prove that there was no general break in development, and that other Hallstatt centers also continued to exist during the Early La Tène period.

Only a few years ago, on the Üetliberg above Zurich, two small ornamental gold discs were found (in a grave that had been robbed in antiquity), bearing phytomorphic decoration which seems to be closely linked to that found at Kleinaspergle. Two "Early La Tène princely tombs" with association finds of Mediterranean origin were found in the magnificent burial mound at "La Motte-St-Valentin" near Courcelles-en-Montagne in the *département* of Haute-Marne. One was the burial of an armed man, the other of a female, containing, among other things, a bronze mirror. Further east, single inhumation burials at Dürrnberg near Hallein can be described as "princely tombs." At the time this was the most important center of the Salzbergbau, where there was also a concentration of several different branches of "industrial" activity. Slightly further away, the cemetery at Hallstatt produced an "Early La Tène princely tomb." The fact that in different localities the social structures which we recognize in the "princely tombs," continued to exist through into the Early La Tène period is proved by other products of particularly high artistic quality, found in simpler graves as well as settlements. Therefore, they can only have been made by specialized craftsmen in the context of a society with differentiated social levels.

The Earliest Representations of the Celts

Among the most commonly found artifacts of this kind are fibulae with the heads of humans, animals or imaginary creatures similar to those decorating the bronze flagon from Kleinaspergle. When referring to the human heads or the more fantastic features of decoration, we use the term "masks." Similarly, we talk about *Maskenfibel*, "masked fibulae." Although the tendency to divide up the human faces into individual parts continues here, for example by giving particular emphasis to the eyebrows, and by exaggerating the eyes, nose, cheeks and especially the mouth—often adding a beard—there are many objects where the deformation is not so pronounced. There is immense variety in these artifacts, since all the pieces seem to have been cast individually and decoration subsequently applied to the surfaces. Beards and hair are often transformed into phytomorphic compositions, although they never fail to show some affinity with real hair. Very often the heads have large curls at the side. The ears, which are only rarely depicted, sometimes become pointed like the ears of an animal, and are shown up above the head. The large leaf-shaped features to be seen either near or above the head—sometimes resembling giant ears—are typical of the period and must have had a special symbolic significance, about which we can only speculate. Sometimes the faces are unshaven, but mostly they have mustaches of the sort that, later on, were to become a characteristic of the Celts. A full beard is also common. Whole human figures are rarely found. One good example is provided by the fibula from Manětín-Hrádek, near Pílsen in Bohemia. The body underneath the typically expressive head is merely hinted at. The arms are stiff and the small holes in the trunk must once have contained pieces of coral or amber. Resembling an Etruscan, the man represented is wearing short trousers with grooves intended to hold some kind of decoration. On his feet, the figure is wearing pointed shoes recalling the Etruscan fashions.

*Bronze fibula with double bird
head and coral studs
from Val de Travers (Neuchâtel)
Second half 5th century
Neuchâtel
Musée Cantonal d'Archéologie*

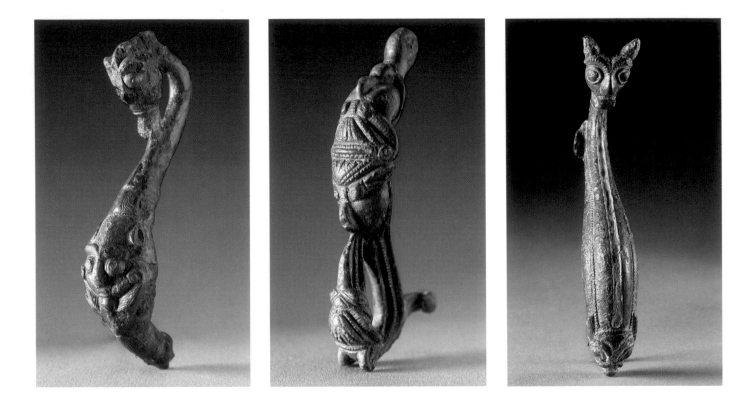

Even more interesting is a fibula from Dürrnberg on which a fully dressed man appears. He seems to be wearing a vest under another garment, the flaps of which seem to overlap slightly at the front. He is also wearing baggy, pleated trousers, an example of the famous *bracae*, to which there are references in Roman works of a later period. It is not quite clear if he is also wearing pointed shoes.

Only a few other objects from this period provide detailed pictures of the first Celts. At the northern edge of the area which has been dealt with so far, from a grave at Kärlich, near Coblenz, a small object in the shape of a horseman was found, cut from sheet bronze. His head and beard are hinted at by slight perforations, but all the lines cannot be easily interpreted. Some may represent musculature. It also features an erect phallus. A slight swelling on the forearm probably represents an arm-ring. One hand holds the reigns. The horseman is wearing a typical Early La Tène sword slung over his shoulder. The spherical object hanging from his wrist is most interesting. This is, without doubt, the head of an enemy, a typical sign of victory, to which several early historians refer in texts from later periods. For example, Strabo (IV, 4, 5) quotes Posidonius, saying: "When they return from battle, they hang the heads of their dead enemies on the necks of their horses, and take them back to hang up beside the entrance to their houses."

Undoubtedly, the most interesting representations of the first Celts are those engraved on the scabbard of the famous sword from the Hallstatt cemetery. In the grave, which can also be described as a "princely burial," there were also two spears, an iron helmet and a large knife. Among the drinking vessels was a funnel with a strainer for filtering an intoxicating drink made with aromatic herbs, or wine imported from the south. Similar funnels have been widely found in central Italy.

The sword is decorated with a complex scenic representation which is unique in the early Celtic world and can only be explained by influences emanating from the metalwork of northern Italy and the southeast Alpine sphere, the so-called "situla art" which, in the final analysis, links up again with the products of Etruscan art. On the broadest part of the scabbard, there is a procession of warriors, who are undoubtedly Celts. Three infantrymen with pointed shoes, armed with spears and the typical oval shield, are followed by four horsemen, the

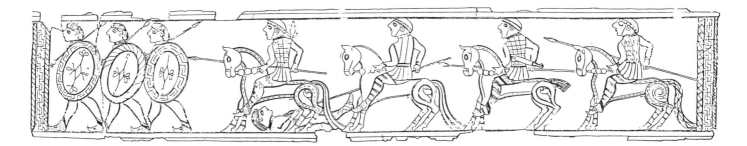

*Central section of bronze scabbard
with engraved decorations
from tomb no. 994 at Hallstatt
(Upper Austria)
Second half 5th century B.C.
Vienna, Naturhistorisches Museum*

second of whom is thrusting his spear into an enemy lying on the ground. The horsemen obviously belong to the ruling class, and are better equipped. One of them is armed with a typical sword as well as a spear. Also, the horsemen are wearing helmets identical to the iron one found in the same grave. It is not quite clear whether the upper part of his body is protected by a breastplate of checked material or leather—this sort of protection was essential for horsemen without a shield—under which a longer shirt can be seen, unless—as seems to be the case with the second rider—it is simply a single garment worn with a belt. The typical patterned trousers are tight here, and again the figures are wearing pointed shoes. Finally, a banner over the shoulder of the first rider suggests that he is the leader of the group. Here again, we know that emblems of this kind also occurred in Italy; the reigns are decorated with discs; the hind quarters of the horse, in particular, are decorated in a typically Celtic way. This exceptional representation, with its mixture of foreign and Celtic features, is therefore the earliest image we have of one of the greatly feared Celtic armies described in later written accounts. Unlike the Mediterranean world at that time, where it was usually the job of the heavily armed foot soldiers in close formation—the phalanx—to decide the outcome of battle, here, the infantrymen seem to be lightly armed, and therefore more mobile and ready to attack. The well-armed horsemen seem particularly effective, and are evidently the predecessors of the feared noble horsemen mentioned by Caesar in his account of the Gallic wars.

There is little to be said about the other scenes depicted on the scabbard. In the areas which frame the procession of warriors, there are two richly dressed men supporting a wheel between them. Is this perhaps a divine symbol? We cannot really interpret these images, nor that representing three men fighting each other on the area near the tip of the scabbard.

Analysis and Imaginary Creatures

Let us leave the extraordinary succession of scenic images on the Hallstatt sword and turn to the richly decorated fibulae and other objects with figurative decoration. In this early phase, whole animal-shaped images are still rare. The only fairly frequent finds are horse-shaped fibulae which, especially in Italy and central Europe, were already being made in the Hallstatt period. Now however, their formal structure has adapted to another period, as we see in the exaggeration of certain parts of the body. So far, fibulae with a bow in the shape of a wild boar have only been found at Dürrnberg. Other rich finds from this site include several fibulae in the shape of a flying bird. A fibula with a cockerel was found in the princely grave at Reinheim in Saarland. On another fibula from Langenlonsheim in the middle Rhineland, there is an animal which can be recognized as a lion, the head of which has human features. Large predatory animals decorate the beaked flagons mentioned above from Dürrnberg, Borscher Aue and Basse-Yutz. In the representations on the latter, the Mediterranean character of the lion-shaped images is unmistakable, and the same can be said for other imaginary animals borrowed from the Mediterranean. Some of these animals have wings, for example, the lions on the clasp from the heavy belt found in western Slovakia. On the hook of the belt from Weiskirchen in Saarland, two pairs of bearded sphinxes frame a human head. Lastly, there are griffins on belt-hooks from Champagne.

In addition to these, there are imaginary figures which seem to be exclusive to the Celtic

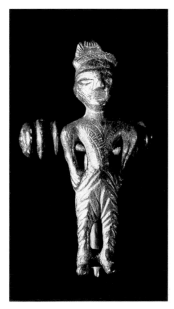

*Bronze anthropomorphic fibula
from tomb no. 71/1 of the Eisfeld area
at Dürrnberg, Hallein (Salzburg)
Second half 5th century B.C.
Hallein, Keltenmuseum*

131

Bronze fibula with double bird
head and coral studs
from Val de Travers (Neuchâtel)
Second half 5th century
Neuchâtel
Musée Cantonal d'Archéologie

Bronze shoe-shaped fibula
from Wien-Leopoldau (Austria)
Second half 5th century B.C.
Vienna, Naturhistorisches Museum

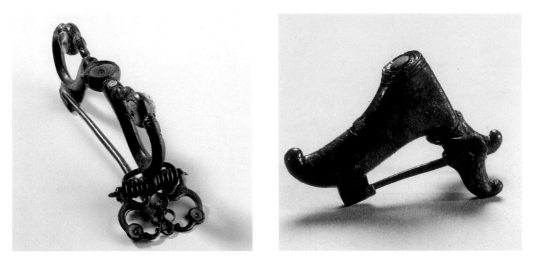

repertoire. Besides the above-mentioned fibula from Langenlonsheim bearing the lion with the human face, there is the equine figure with a bearded human face from the grave at Reinheim in Saarland. Horses with human heads also appear later on Celtic coins.

It is only rarely in the eastern sphere of Early La Tène that animal representations occur comparable with those on the Hallstatt sword. The best example is provided by the terracotta flask from Matzhausen in the upper Palatinate, on the shoulder of which there is a frieze with wild animals. These are probably supposed to be four pairs of male and female animals, a wild boar and sow, a stag and deer, and two roe-deer and geese of opposite sex. There is also an animal of prey in the act of hunting a hare.

Decorations on clasps for clothes and other objects usually take the form of animal heads. Birds' heads are the most common. Very often they are executed in such a concise way that it is impossible to give a more exact interpretation. However, at times it is possible to identify with certainty water birds, an ancient symbol already in use at the end of the Hallstatt period in the eastern sphere of this culture. But birds of prey with curved beaks are more common: previously these were unknown. As far as animal heads are concerned, the only other one to occur fairly frequently are rams' heads. Lyre motifs are often seen with griffins' heads. There is also a large number of heads belonging to imaginary creatures with pointed ears and exaggerated facial features.

Often, imaginary animals are found beside human masks. I refer again to the belt-clasp from Stupava, the belt-hook from Weiskirchen or a gold ring from Rodembach in the Palatinate. And again, for example, there are fibulae with a combination of human masks and the heads of imaginary animals, although there are also combinations of masks with birds or rams. The upper part of the handle on the Reinheim flagon is decorated with the head of a ram under a human mask, a motif which also recurs on the flagon from the grave at Waldalgesheim in the middle Rhineland, and recorded later on silver ornaments from Manerbio in the province of Brescia. The gold torque from the grave at Reinheim, on the other hand, shows human heads under the heads of imaginary creatures. Undoubtedly, these individual and combined representations, which go well beyond the imitation of reality, are an integral part of the complex repertoire of magical images of the Celtic world.

There have been numerous attempts to explain some of the motifs in the light of documentation from later periods, seeing the animals as portraying the attributes of particular deities or the deities themselves, for example. The horse with the human head from Reinheim could be Taranis, the ram-shaped motifs might be attributed to Teutates, and so on. However, since a long space of time separates these images from later documentation, during which many things may have changed, these direct connections can only remain theoretical, making it impossible to offer a more precise explanation.

However, the significance which the Celts attributed to these small figurative works of art

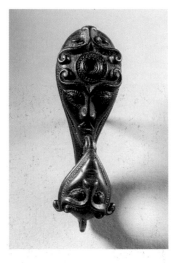

Bronze "mask" fibula
from Slovenské Pravno (Slovakia)
Second half 5th century B.C.
Nitra, Archeologický ústav SAV

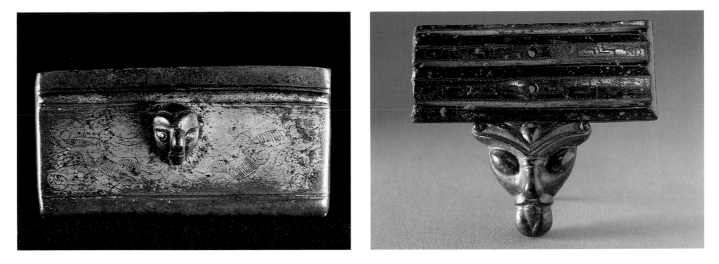

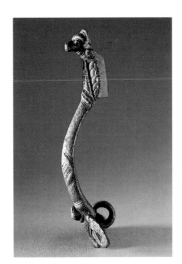

Bronze fibula with bird and sheep's
head from Panenský Týnec
(Bohemia)
End 5th century Prague
Národní Muzeum

and the *Maskenfibeln* (mask fibulae) is shown by the fact that, in Germany, a very large number have been found in settlements, and it is unlikely that we are dealing with relatively precious clothing accessories that were casually lost. If they did not end up in the ground when the settlements were destroyed, it is logical to suppose that they were buried intentionally for religious reasons.

The figurative objects of this early phase of the La Tène culture tend to occur in regional groups according to the workshops which produced them, and the fibulae demonstrate this particularly well. Thus, for example, symmetrical shapes with double masks are concentrated in the middle Rhineland area, while others with a long asymmetrical bow are found further east. It is not only certain motifs, like the wild boar or the the flying bird—there are even shoe-shaped fibulae—but also the layout of the figurative decoration that prove that objects made in this particular way originate from the workshop in the central site of Dürrnberg near Hallein, which has already been mentioned several times. A fibula with an unfinished mask was found at Kleiner Knetzberg in lower Franconia, providing evidence for an equivalent craft workshop in this high fortified settlement.

If we take the example of the human masks, it is easy to see that the ornamental pieces and other objects with figurative decoration are not only concentrated in territory previously dominated by the Hallstatt culture, in southwest Germany, but also and especially in the middle Rhineland region, which we shall look at more closely, and further east. In Switzerland and France, on the other hand, they are almost entirely absent, as the distribution map of mask fibulae shows. Only in the period after this does this ornamental motif also seem to be widespread in the west, and the same applies to the decoration using animal heads and whole animals. The griffins found in the Champagne area are the exception.

The Formal Language Is Also Adopted in Italy

In the first La Tène period, northern Italy was the most important area of contact between the Celts and the Mediterranean cultures. From the late sixth century B.C., there was already a strong Etruscan presence in the area, and numerous Etruscan colonies had been founded there. Moreover, in the area of the Veneto, the upper Adige Valley and further east, into Slovenia, there developed an artistic genre which, on account of its scenic representations, the so-called "art of the situla," showed strong ties with the products of Graeco-Etruscan art. There is a great deal of evidence to show that the Celts did not usually borrow whole scenes from the rich figurative language of the south and that, on the contrary, the figurative decoration used in their works ranged from decorative realism to magic and/or symbolism. Particular examples can be explained by ideas from situla art. The fact that there is a relationship with this art form is proved beyond all doubt by the formal execution of single motifs, like the leverets impressed on the terracotta cup from Libkovice in Bohemia, and the hare on a

plate belt-decoration from Vače in Slovenia and the bone, bird-shaped decoration from Dürrnberg, similar to a flying bird from the situla from Vače.

There is evidence of other trans-Alpine contacts, in the shape of numerous *Maskenfibeln* for example, the bows of which are reminiscent of those in northern Italian fibulae. The mirrors belonging to wealthy Celtic ladies can only be based on Etruscan models. Already attention has repeatedly been drawn to imported bronze Etruscan vessels and to the Celtic imitations they inspired. The unmistakable influence of Etruscan precursors can be seen even in the execution of individual figures, and only a few examples need be mentioned. The numerous human faces in which the hair is outlined by a a horizontal line have exact equivalents in Etruria. One example especially worthy of note is provided by a gold decoration from a "princely tomb" at Schwarzenbach in Saarland, where there are also small curls at the level of this line. It has already been mentioned that the long curls at the side have the same origin, and the same applies to the lion-like predatory animals. Their pendulous tongues, like those on the clasp from Stupava—the lions on the edge of the beaked flagon from Dürrnberg feature tongues or tendrils sprouting from their jaws—demonstrate this particularly well. There is a fragment of fibula found at Weiskirchen in Saarland featuring a lion with a double body: in Etruria, double-bodies of this kind are extremely common. Although the head is more reminiscent of an owl, which often appears in Celtic works of art, the stylization of the lion-panther image is unmistakable. There are many more comparisons showing how the Celts allowed themselves to be influenced by figurative language of Italian origin, and at the same time elaborated shapes so as to achieve a unique expression from their own world of images.

Contacts with Eastern Populations?

As part of his seminal studies on Celtic art, the great archaeologist, Paul Jacobsthal was mainly responsible for developing the idea that, besides having Etruscan roots, the formal Celtic language had other, oriental artistic features belonging to the Scýthians and the Thracians, who, in turn, had been subjected to Persian influences. Some objects, in which connections of this kind are clearly visible, will be dealt with separately. On the whole, however, not much importance is given to these contacts. Does Jacobsthal's theory really have a solid foun-

Reconstructions of zoomorphic motifs From top: bone object from the Dürrnberg bronze situla and bronze mount from Vače stamped pottery motif from Libkovice 5th century B.C.

Map showing distribution of 5th-century La Tène "mask" fibulae

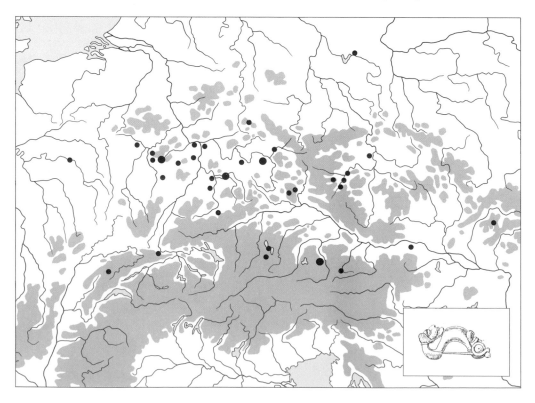

Trimming from a cup in openwork and embossed gold leaf from the princely tomb of barrow 1 at Schwarzenbach (Rhineland) Second half 5th century B.C. Berlin, Staatliche Museen Antikensammlung Preussischer Kulturbesitz

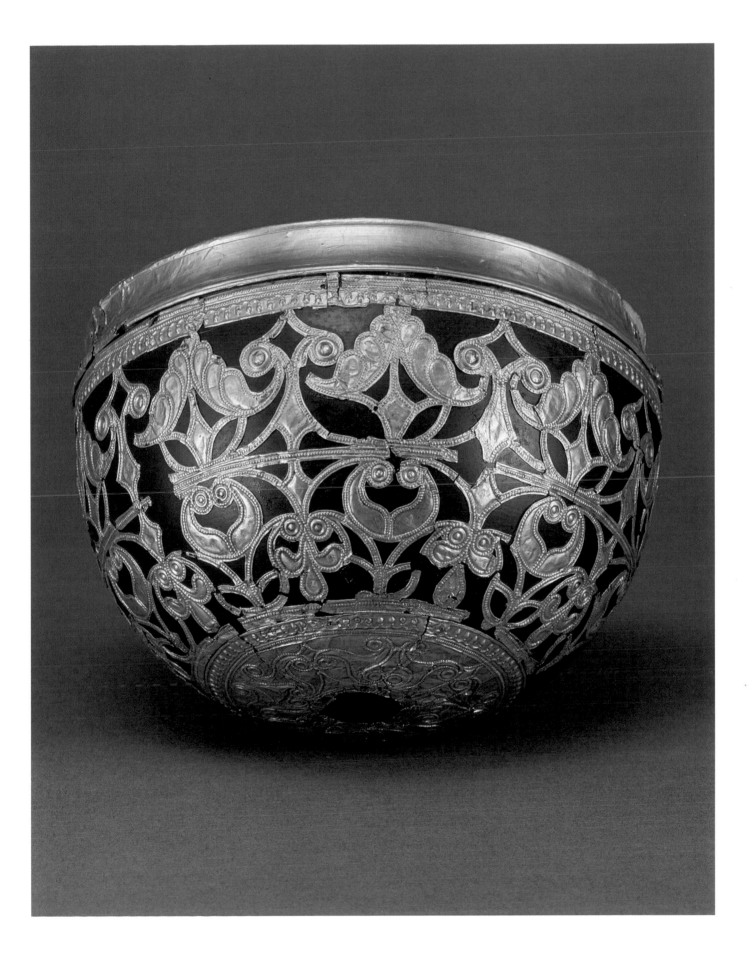

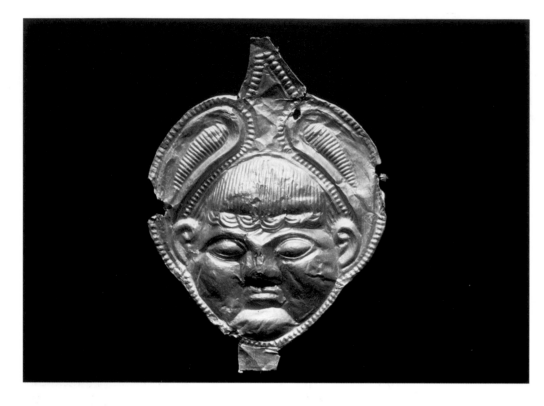

Detail and reconstruction of figured trimming in embossed gold foil from princely tomb no. 1 at Schwarzenbach (Rhineland) Second half 5th century B.C. Berlin, Staatliche Museen Antikensammlung Preussischer Kulturbesitz

dation? There are undoubtedly characteristics that constituted common ground between the Celts and tribes of oriental horsemen. Herodotus (IV, 65-66) confirms that not only the Celts, but also the Scythians used to be headhunters. The head was considered to be the center of life-force. There is an example in a belt from an earlier period from the area of the Caucasus, on which a horseman is depicted riding home. The head of an enemy hangs from the reigns of his horse. Immediately one is reminded of the horseman from Kärlich.

Drinking-horns, of which the Celts were so fond, are also typical of the Scythians and other oriental tribes, such as the Thracians, whereas in Greece, they belonged exclusively to the mythical sphere, to the centaurs and Bacchus accompanied by the satyrs. In Italy they are virtually unknown. In the Scythian Kurgans, there are numerous examples in precious metals with animal-shaped heads, made for the barbarians by eastern Greek artisans in the area of Pontus. The rich gold decoration on the drinking-horns from Kleinaspergle can only be regarded as typically Celtic works, but are the rams' heads not immediately reminiscent of Graeco-Scythian artifacts from southern Russia? It is unlikely that the Celts had a true system of commercial exchanges of luxury goods with their oriental neighbors as they did with Italy, from which strong influences on their artistic activities derived. But is it not possible that the drinking-horns were a means of recognition, gifts of hospitality, which had such an important role among ancient peoples? The animals decorating the handle of the Basse-Yutz flagon have curled up ears, and on various animal-shaped fibulae, the lips are portrayed in the same way, as in Scythian representations. Other animals have claws like the oriental beasts of legend. Is it not likely that the bird-images also originated in the East? All the evidence suggests that, at the level of the ruling classes, there were indeed contacts, and that there are certain parallels which must also be born in mind relating to artistic expression stemming from common concepts concerning respective lifestyles.

Changes in the Fifth Century

We have already mentioned that in the western zone of the Hallstatt culture, which is considered to be one of the original homes of the Celts, only a few "princely tombs" have been found which date to the Early La Tène period. Some centers, where inhumation burials are

Above: bronze plaque picturing a horseman, Kärlich (Rhineland) Below: horseman pictured on a belt from the cemetery of Tlí (Caucasus)

typical, came to an end right at the end of this phase. A few seem to have continued into the new era, only to decline during the first phase of La Tène. Finds relating to a wide area can only be linked to the decline of the settlements. Not only fortified centers on high ground, but also villages, which had also existed during the Hallstatt period, came to an end at this time. In addition, many secondary burials of the period have been found in Hallstatt burial mounds. Only during, or at the end of the first phase of La Tène do we see a change in the location of the graves. There is an increase in the number of flat graves and the extensive cemeteries which were to continue into the Middle La Tène begin to make their appearance. The male graves in these first cemeteries contain a uniform weapon assemblage of a sword and a single spear. And the level of artistic quality, from which splendid artifacts like the mask fibulae emerged also seem to undergo an initial decline. Is it possible that there was a widespread social transformation, explaining the end of the "princely tombs"? Or are these manifestations in the western Hallstatt sphere connected with disturbances which led to the expansion of the Celtic culture toward the east and south, and which we link to the migratory movements described in historical texts? At this point, it is necessary to outline, briefly, complex events which had important regional ramifications and which each require very different interpretations.

Proto-Celts on the Eastern Fringe of Central Europe?

It has been mentioned several times that the western Hallstatt area is considered to be important as one of the original homelands of the Celts. The development of the eastern Hallstatt area followed different paths, something which some have tried to explain with the theory of another ethnic substratum and similar suggestions. However, new excavations conducted mainly in western Slovakia and Lower Austria, have produced some surprising results which have multiplied by a significant factor the number of Celtic finds relating to the fifth century B.C., before the beginning of the large cemeteries containing burials without tumuli. Masterpieces of the very earliest La Tène art have been unearthed, for example, a wheel hub found near St. Pölten, the center of which features a human mask between lyres, terminating with birds' heads. A fibula in the shape of a fantastic creature comes from the same area, and a sword decorated with a mask on the pommel, and so on. If the previous finds in this area are added to these, we already find ourselves with a very dense archaeological horizon, in which the cemeteries almost invariably cease to be used at the end of this initial phase. We are therefore dealing with a phenomenon similar to the one which we have already encountered in southern Germany. Individual objects from the funerary assemblages of these graves again show clear reminders of the Hallstatt culture, for example the horned handles, which, however, already feature stamped decorations typical of the La Tène period. The only large cemetery to have been published, that at Bučany in Slovakia, is especially interesting. Here, as in the west, the complete continuity of the Late Hallstatt period at the start of the La Tène can be observed.

Is it possible that the development of the population of this area has been wrongly interpreted? Should we, perhaps, still attribute it to the central region of the Celtic world, unlike Slovenia, where, in the Hallstatt culture which survived uninterrupted until the fourth century B.C., only isolated aspects of a Celtic culture regarded as foreign took root, in the sphere of weapons?

The "Princely Tombs" of the Fifth Century B.C.

Few of the "princely tombs" of the western Hallstatt sphere continued to exist into the beginning of the La Tène. This was not the case in a large area to the north stretching from Champagne to Bohemia, where burials have been found in spacious timber chambers, often isolated from simpler graves. Typically they feature a "service" for drinking, often containing objects of Mediterranean origin, a "war chariot," which served as a vehicle to carry the dead man, and, often, gold ornaments. The distribution of these graves is exactly that of the wag-

Pottery cup with handles from tomb no. 18 of the Bučany cemetery (Slovakia) Second half 5th century B.C. Nitra, Archeologický ústav SAV

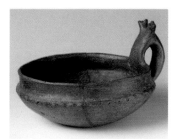

Pottery cup with handles from tomb 2 of the Bučany cemetery (Slovakia) Second third of 5th century B.C. Nitra, Archeologický ústav SAV

on burials, although in Champagne these also occur in less obviously typical burials. In the middle Rhineland, there are numerous finds of objects of Etruscan origin, of which the bronze beaked flagons are an example. These graves also reveal regional differences in funerary assemblages and the like. In Champagne, for example, horse-trappings were placed next to the chariot, something which is not common in the middle Rhineland area. We know that, here too, similar horse accessories were used, from a few horse-fittings found in water, obviously placed there for religious reasons. There are no horse-fittings at Dürrnberg, but they appear again in the "princely tombs" in Bohemia.

Metal helmets are the same. In the Marne region, many graves contain these objects, whereas they are absent in western and southern Germany. However, a find from a river in Lower Franconia proves that these helmets were well-known in this area. They appear again at Dürrnberg, Hallstatt and in Slovakia, but are absent in the graves in Bohemia. The selection of other arms placed in the graves is anything but uniform. Typically, as well as a sword, several spears including javelins, which were evidently thrown from war chariots, were also

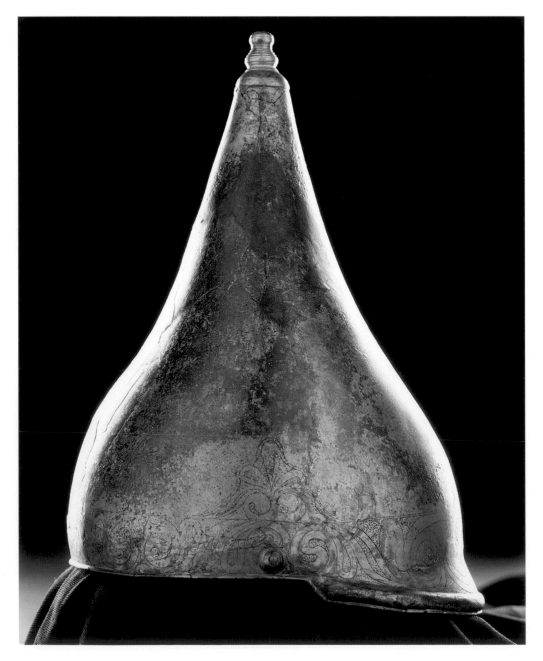

Bronze helmet with engraved ornament from the chariot tomb of Berru (Marne)
Early 4th century B.C.
Saint-Germain-en-Laye
Musée des Antiquités Nationales

Palmette and lotus-flower friezes
From top:
on trimming from Eigenbilzen
on trimming from Schwarzenbach

placed beside the "princes." Simple graves from this area have produced weapon assemblages which lead us to think in terms of isolated fighters, rather than warriors who had to fight in close formation. In Bohemia, where there are male graves containing only a sword, in the "princely tombs" the only offensive weapons are heavy spears.

The Goldsmiths of the Middle Rhineland

The most important "princely tombs" to have survived lie in the area between the Rhine and the Meuse. Although rich graves from the Late Hallstatt are more common around the Rhine, at the beginning of the La Tène their area of distribution extends into quite a different region situated further west. Many valleys feature a fortified settlement on high ground, which we can define as a "princely stronghold," with corresponding tombs. This Early La Tène sphere will be dealt with separately.

Typical of the "princely tombs" in this area are the gold objects, in which the adoption by Celtic craftsmen of Mediterranean phytomorphic decoration techniques can be clearly seen. Obviously, there are also other objects, in bronze and even iron, which are decorated in the same way. How the transformation process developed can be seen in a few examples. At Dörth "Waldgallscheid", near the Rhine, two strips of perforated sheet gold for decorating the lips of two drinking-horns were found, on which palmettes appear between S-shaped tendrils. Although the decorative scheme of these can definitely be described as Greek, the formal language is clearly different. The tendrils are not continuous, but single static fleshy shapes. The palmettes have been reduced to three leaves. But even more typical is an object of similar design from Eigenbilzen, in Belgian Limburg. This is quite clearly a frieze with palmettes and lotus flowers, already familiar from many ancient works of art. In this case, the tendril does not have a linear progression, but swollen segments are linked with small discs instead of twisting spirals. In addition, the palmettes have been reduced to three leaves, and the central petal is missing from the lotus flower. In its place, between the large petals is a keyhole shape which, in the tongue-shaped frieze on the rim decoration, had become almost unrecognizable. We continually find this casual use of individual shapes taken from ancient phytomorphic motifs.

Drinking-horn mount in openwork
and embossed gold foil
from the princely
tomb at Eigenbilzen (Limbourg)
Second half 5th century B.C.
Brussels
Musées Royaux d'Art et d'Histoire

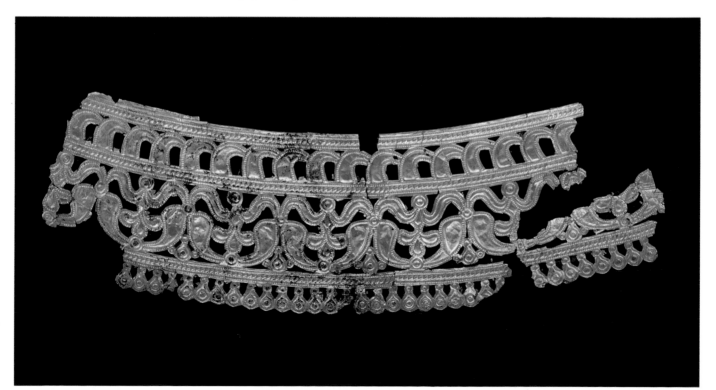

One of the most beautiful examples of plant decoration is the gold cup from Schwarzenbach in Saarland. Here, only the two bands of perforated decoration, which appear as a network of interwoven vegetal forms, are relevant. The fact that the bands are covered in lines and leaves to such an extent that the difference between the foreground and the background disappears almost completely, is fundamental. Here, on the lower part, the small sepals bring the lotus flowers closer to their classical models, than the flowers from Eigenbilzen. Hanging from the sepals, between one flower and the next, the three-leaved palmettes are completely filled with gold. The connecting floral pattern, which would have been inadmissible in a classical composition, is reduced to a minimum here. In the upper part of the decoration, there are halved lotus flowers—the small sepals leave us in no doubt about this—in a varied composition. A drawing of the two bands highlights better the typical Celtic composition of the phytomorphic decoration. The small gold discs, from which the decorative network seems to hang, play a special role. A whole series of ornaments of this type have been found in the rest of the Rhineland. These ornaments are partly in gold and partly in bronze, and we can see just how rich they could be by observing the bronze spouted flagon from Waldalgesheim. These objects are all characterized not by a continuous pattern, but by a series of single leaves or S-shapes hanging from small discs, arranged to lyres, windmills with three or four sails, festoons of leaves, and so on. Many features are arranged together within semicircles drawn with a compass. Here we are dealing with a design technique which held great significance for the Celts. In the fourth century B.C., the use of the compass, along with other technical acquisitions, became common throughout the area of the La Tène culture, making it simple to invent all kinds of decoration, from friezes of overlapping circles and arcs to complex star motifs. We know that they worked directly with a compass on metal and pottery objects because of the small holes in the center of the circles, still perfectly visible, for example, on the bronze fittings from the Chlum grave in Bohemia or on the pilgrim's flask from Dürrnberg, near Hallein. Often, a sketch was drawn using a compass, and this was then engraved on the metal with another instrument. The most beautiful compass-drawn compositions, which later freely develop the resulting images in shapes similar to flowers, are those found on the ornamental discs from horse-trappings. However, these objects are not common in the middle Rhineland because, as stated earlier, they were not placed in graves in this area. But they are very common in other parts of the Celtic world. Without going into detail, this sort of circular decoration is found on the two discs from Cuperly and Somme-Bionne, both from the Marne region, which we have illustrated in a drawing showing the composition developed on them.

Let us return to objects of the Schwarzenbach type, where the single leaves and other decorative features are arranged in a line and usually connected with discs. A whole artistic sphere can be detected in these compositions, the center of which was in the middle Rhineland region, extending into what had been the Hallstatt area as far as the Swiss Jura. There are also branches spreading toward the east.

It is only in the eastern Early La Tène area that stamped decoration is used on pottery. Here, the patterns sometimes include leaf features which originate in a tradition deriving from a center further east. This very early manifestation of Celtic art was only slightly developed in the decoration of pottery. We can observe a widespread decline of the whole area during the period which followed. The originality of the objects produced by Celtic artists is undoubtedly connected with objects from the Mediterranean world, especially Etruria, both in terms of the derivation of individual shapes and whole compositions, although these rapidly broke away from their classical prototypes. The large number of Etruscan objects found in "princely tombs" clearly show where the specialized goldsmiths in the service of the courts drew their inspiration. This only applies to important objects imported in the fifth century B.C., so that, although we do not know how long these precious foreign objects were kept, we can say that this stylistic phase of Celtic art does not go much beyond the fifth century B.C.

Motifs of Rhenish Celtic artistry of the 5th century B.C. From top: three motifs on trimming from Schwarzenbach engraved decoration from the Waldalgesheim jug on the Hoppstädten strainer on the Bavilliers scabbard two motifs on trimming from Schwarzenbach another motif on the Bavilliers scabbard on the Rheinheim jug.

Sketch of a compass-drawn pattern on a bronze phalera from Somme Bionne (Marne) Second half 5th century B.C. London, British Museum

Embossed bronze phalera with iron hoops from the chariot tomb at Hořovický (Bohemia) Second half 5th century B.C. Prague, Národní Muzeum

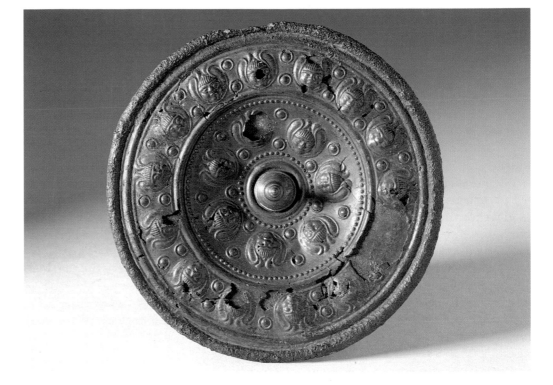

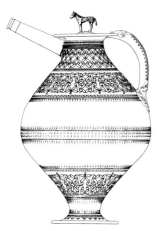

Bronze wine jug from the princely tomb at Waldalgesheim (Rhineland) 4th century B.C. Bonn, Rheinisches Landesmuseum (drawing by Kimmig)

Celtic "Princes" in Champagne

This artistic province had little influence in the west where, at the beginning of the La Tène period, there was a different kind of development, although it was not entirely unconnected. The lack of typical figurative decoration on fibulae and other objects has already been mentioned; however, there are exceptions in the form of representations of griffins, which are only typical in this region. However, especially in the "princely tombs," it is obvious that links with Italy were just as intense. Here too, there are bronze Etruscan vessels, and certain rituals also seem to have Mediterranean origins. For example, according to the Italic model, the "princes" were buried with iron meat-skewers for serving food to guests in the after-life: this custom was previously unknown in the region. It is the artistically decorated works in metal, especially bronze, which testify to an opening up toward the Mediterranean world, since these also show an initial imitation of classical phytomorphic decoration which, without any regard for its original meaning, is divided into single features and used in new compositions. In particular, it is worth noting that, unlike those in the Rhineland area, the motifs do not simply appear next to each other, but are connected in continuous patterns. S. Verger has applied the term *premier style continu*. The different principle used in composition is immediately apparent if we compare, for example, the lyre patterns which flow into each other on a yoke accessory from Somme-Tourbe, "La Bouvandeau," in the *département* of Marne, with the ones on a decorative gold strip from Kleinaspergle, in which the individual images are connected by circles.

A complex frieze of three-leafed palmettes sprouting above and below an undulating "tendril" decorates the lower rim of a helmet from a "princely tomb" at Berru, in the *département* of Marne. Although the "tendril segments" and the palmettes do not merge into each other directly, the palmettes within their semi-circular frame form a continuous image with pointed lateral leaves. It is obvious that the Celts were applying a new rhythm to their decoration when one observes the neck-guard, where the central leaf of the palmette has been eliminated and the side leaves, which are more undulating and all arranged at the same level, express quite a different movement.

The best example of this decorative style is provided by the decoration on an Etruscan

bronze beaked flagon housed in the museum of Besançon, which a Celtic craftsman has covered completely with engravings. The decoration is a labyrinth in which the foreground and the background are of equal importance.

The neck of the flagon is covered with a palmette emerging from a double spiral. The corresponding Etruscan pattern on the neck of a similar bronze amphora shows how the original motif has been taken apart and transformed by the hands of the "barbarian" artist.

The wide body of the flagon shows an ornate development of the same basic composition we found on the helmet from Berru. However it is significant that the large leaves are covered with small leaf-shaped patterns. The habit of covering tendril motifs with other patterns becomes a typical feature in the subsequent development of Celtic art. There is an interesting detail in the form of a leaf enclosed by a triangle formed of spherical segments attached to the central leaf of the large engraved palmette. Here, the background of a framed three-leaved palmette has been removed from its context and now constitutes a new motif in its own right. This detail emphasizes the extraordinary imagination of the artist in executing his work of art. Typical of Celtic decoration are the windmill motifs, one of which decorates the base of the flagon using shapes which blend with the rest of the decoration. Lastly, the shoulder of the flagon deserves our attention. Here, three-leaved palmettes, either erect or hanging, are enclosed with semi-circles on a flat base. This is a precursor of the Celtic "fan," a leitmotiv of the so-called Waldalgesheim style which typifies the next phase of development in Celtic art. Thus the *premier style continu*, which continued uninterrupted in this region, takes on a particular significance in the development of Celtic art. Similar composi-

Left: gold trimming from Kleinaspergle. Right: openwork mount from La Gorge-Meillet Somme-Tourbe (Marne) 5th century B.C.

Engraved decorations on the top of crown of the bronze helmet from Berru chariot burial (Marne) Early 4th century B.C. Saint-Germain-en-Laye Musée des Antiquités Nationales

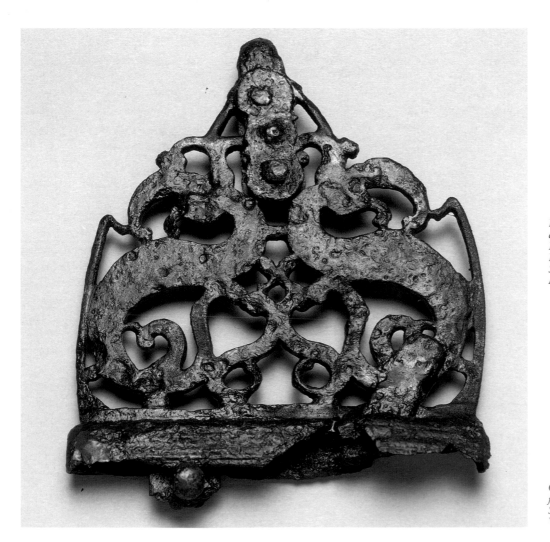

Openwork iron belt-clasp from Roseldorf (Lower Austria) Second half 5th century Vienna, Naturhistorisches Museum

*Sketch of openwork pattern
on the bronze chariot fittings
from La Bouvandeau
at Somme-Tourbe (Marne)
End 5th-early 4th century B.C.
Saint-Germain-en-Laye
Musée des Antiquités Nationales*

*Engraved decoration on one
of the "Comacchio" bronze trimmings
(left) and a detail of the engraved
decoration on a jug of unknown
origin in Besançon (right)
Early 4th century B.C.*

*Engraved decorations under the lip
of a jug of unknown origin
in the museum of Besançon
and its Graeco-Etruscan prototype
Early 4th century B.C.*

tions can be seen in many works of art from graves in Champagne, although, in this case, we are not dealing with a precisely defined artistic area, but there is also evidence of contacts and contamination resulting from objects made to the east of the area under Celtic influence. We know that there were close links with classical models from the closely related decoration on the perforated iron ornamental plate from the "princely tomb" at La Gorge-Meillet in the *département* of Marne, which features an undulating vine-shoot with lateral offshoots.

Did Groups of Celts Enter Italy as Early as the Fifth Century B.C.?
We have already referred to the fact that, at a time corresponding exactly to the beginning of the La Tène period, hooks appear which were used as clasps on the belt used for carrying arms. They were usually associated with two or four rings on which the weapons were hung, but which were sometimes transformed into purely decorative features. Although there are rare finds of these hooks in female graves, this was a typical accessory of the Celtic warrior.

It is surprising that hooks of this kind have also been found outside the central Celtic area. Numerous examples have been found in graves around the high settlement of Ensérune in Languedoc, which correspond exactly to the ones found in Champagne. Should we deduce from this that, as early as the fifth century B.C., Celtic warriors had settled with another tribe, a theory which would also support certain aspects of the weapons and other objects found?

Perforated belt-hooks of this type have been found in fairly large numbers in archaeological assemblages typical of the Late La Tène in Slovenia, where there is also evidence of Celtic swords. Since it can be considered normal for high-ranking warriors to have used better, foreign weapons (for example, elements of the panoply of the eastern horse-riding peoples have also been found in Slovenia), we must conclude that Celtic warriors were well-known and feared as early as the fifth century B.C. and that their weapons were imitated.

It is in the north of Italy, in particular, that perforated belt-hooks of this kind have been found. There are also finds of typical La Tène swords, but these occur very rarely because traditional customs did not include placing weapons next to the dead man in his grave. However, the belt-hooks show without any doubt that typical Celtic weaponry was known

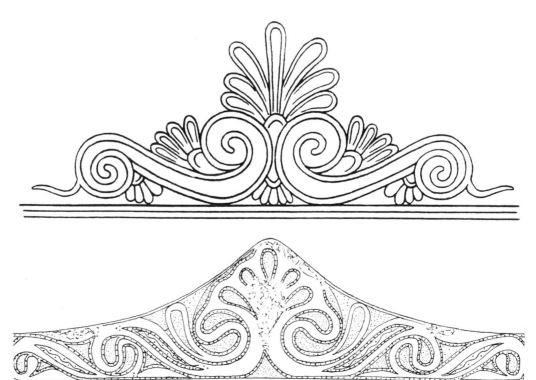

here. Finds of these hooks are especially numerous in burials in the area of the Veneto, although, if we are to lend credence to classical historians, this area was never occupied by the Celts. However, there are many aspects of the habits of the neighboring Celts that the people of the Veneto adopted, and this is supported by the finds of belt-hooks which occurred more frequently in female graves in this particular area, showing that the people were familiar with the weapons used by their fearless adversaries. With the passing of time, the extent of this process of assimilation became more pronounced, as confirmed by Polybius (II, 17, 5) in the second century B.C., according to whom the people of the Veneto were "not very different from the Celts as far as customs and dress were concerned," although they spoke a different language.

These hooks are common all over northern Italy, especially in the southern Alpine regions, but also in Etruscan centers like Felsina (Bologna). Some have exact parallels in Champagne. Should we conclude that they were brought here by the Celts who reached this area from beyond the western Alps? Some were made very successfully *in situ*, with representations of griffins, sometimes being overpowered by a man, or with birds at the side of a tree of life. They could have been made by locally trained craftsmen for foreign warriors in the Celtic style. These early products in the Celtic style stimulated the production of the first La Tène articles in central Europe, such as the hooks with lyres terminating in the heads of griffins, and other motifs. Right from the beginning of the La Tène, therefore, contacts with the north of Italy were of the utmost importance.

The earliest records of the Celts from northern Italy can be dated to between the middle of the fifth century and the early fourth century B.C. However, these hooks tend to be found more often in burials dating from the fourth century, which we usually relate to the Celtic penetrations into the north of Italy. In this case, how should we interpret the earlier finds? In the accounts by Polybius and other classical historians, the events relating to the Celtic migrations seem to be concentrated in quite a short space of time. But were they perhaps over-simplifying what actually happened? Is it not possible that, as early as the fifth century B.C., there were already groups of mercenaries who had been summoned from north of the Alps by powerful northern Italian rulers for deployment to wars in Italy? Is it not also possible that these mercenaries were so attracted by the lifestyle they found in the Po Valley, that increasing numbers of them came to settle here, to such an extent that the balance of power began to shift, and culminated in the migration of whole tribes? Or does the presence of the typical Celtic belt in this area prove that, back in the fifth century, groups of Celts were active here as brigands, although they were not yet strong enough to take over fortified seats of power? In either case, this material means that the Celtic migrations, which had spread terror over an increasingly wide area of the classical world, cannot be conceived in over-simplistic terms. In fact, at the beginning of the La Tène period, we can deduce from finds that there was an expansion which can only be interpreted in the context of a longer sequence of events.

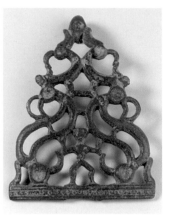

Openwork bronze belt-clasp from San Polo d'Enza (Reggio Emilia) 5th century B.C. Reggio Emilia Museo Civico Archeologico

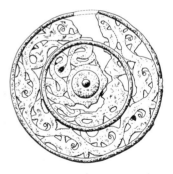

Openwork iron phalera from the chariot tomb of La Gorge Meillet at Somme-Tourbe (Marne) Early 4th century B.C. Saint-Germain-en-Laye Musée des Antiquités Nationales

*Map showing distribution
of belt-clasps in lotus form with
heraldic griffins dating from
the second half of the 5th century*

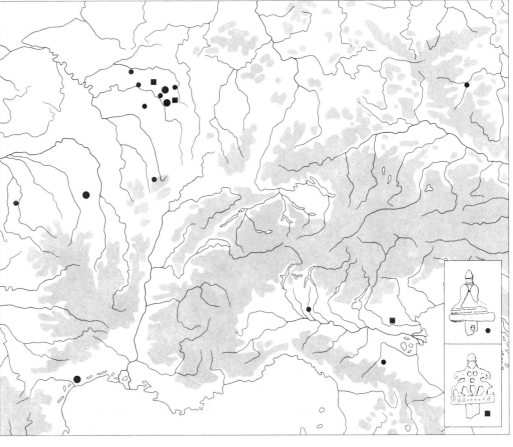

*Map showing the distribution
of palmette belt-clasps
from the second half of the 5th century*

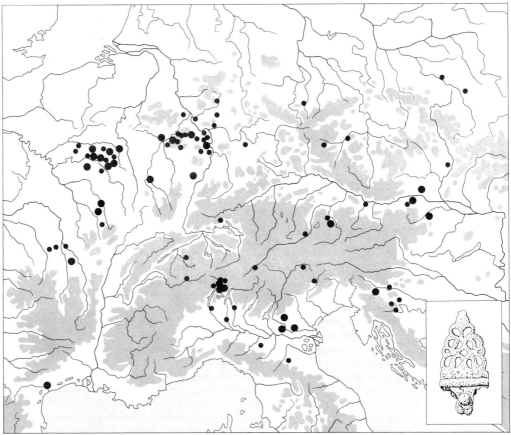

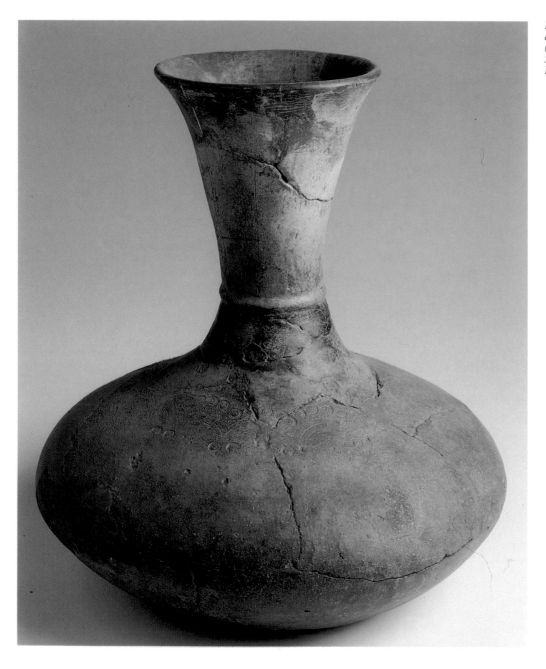

Pottery flask with stamped and engraved decoration from Hlubyně (Bohemia)
Second half 5th century B.C.
Prague, Národní Muzeum

Pierre Roualet

The Marnian Culture of Champagne

Thousands of Celtic Graves

No other region can boast as many traces of the Celtic world as Champagne. The finds have been especially numerous in the *département* of Marne and in two nearby *départements*, the south of Ardenne and the east of Aisne. Hundreds of sites and thousands of graves have been discovered in the region. Very many graves which were easily identifiable were excavated by farmers throughout all periods of history, and this has caused considerable damage. Thus for example at the beginning of the last century some graves were unearthed at Bergères-les-Vertus so that the bronze which they contained could be taken and sold. At the time nothing was known about the age of the graves and the civilization to which they might belong. Only by 1865 did people begin to understand that these were traces of the pre-Roman Celtic era. From that date until 1914 excavation was undertaken at a frenetic pace, carried out in an almost anarchic fashion by peasants working for local collectors well-known to early historians: F. Moreau in Aisne, L. Morel, E. Fourdrignier, J. de Baye and A. Nicaise in Marne.

Selection of "Marne" horizon pottery styles
Second half 5th century B.C.
Epernay, Musée Municipal

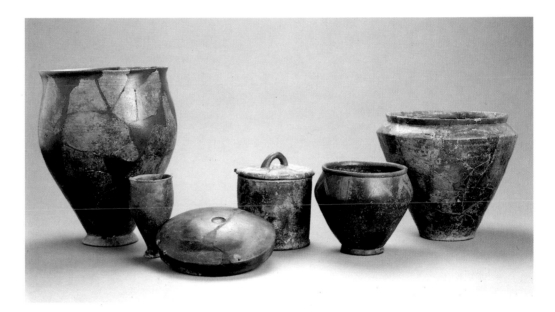

Excavation was then a matter of selectively taking buried objects, weapons and jewels, especially those which seemed in some way extraordinary. Those sites which seemed unlikely to yield such finds—habitations and cremation cemeteries—were ignored. This earliest archaeology, founded on the study of the object considered for its intrinsic documentary value, was not disinterested but in fact remains one of the bases of contemporary research. It made it possible to trace, within only a few years, a very general chronological picture and to formulate useful comparisons with other regions. Thus for example the discovery of Etruscan oinochoes at Somme-Bionne, Somme-Tourbe and Sept-Saulx showed that there were links between Champagne and Italy well before Caesar's conquest of the region. But there was little pretence of carrying out an exhaustive excavation and scanty concern for the integrity of the grave goods. Written reports, when they were published, were extremely concise. Fortunately, the excavations which have been carried out in several burial sites over the last forty years or so allow us to fill some of the gaps. Of those which have been published it is worth recalling Pernant in Aisne, Manre and Aure in Ardennes, Beine "l'Argentelle" and Villeneuve-Renneville in Marne.

Whether one considers ancient or recent excavations the evidence compels us to note that the finds dating to the fifth century B.C. are extraordinarily abundant. Finds from this century are much more numerous than finds from all the following centuries, up till the conquest. They constitute an original culture which has justifiably been called Marnian.

*Large pottery beaker with
engraved decoration showing paired
eel-like monsters from La Cheppe
(Marne)
Second half 5th century B.C.
Saint-Germain-en-Laye
Musée des Antiquités Nationales*

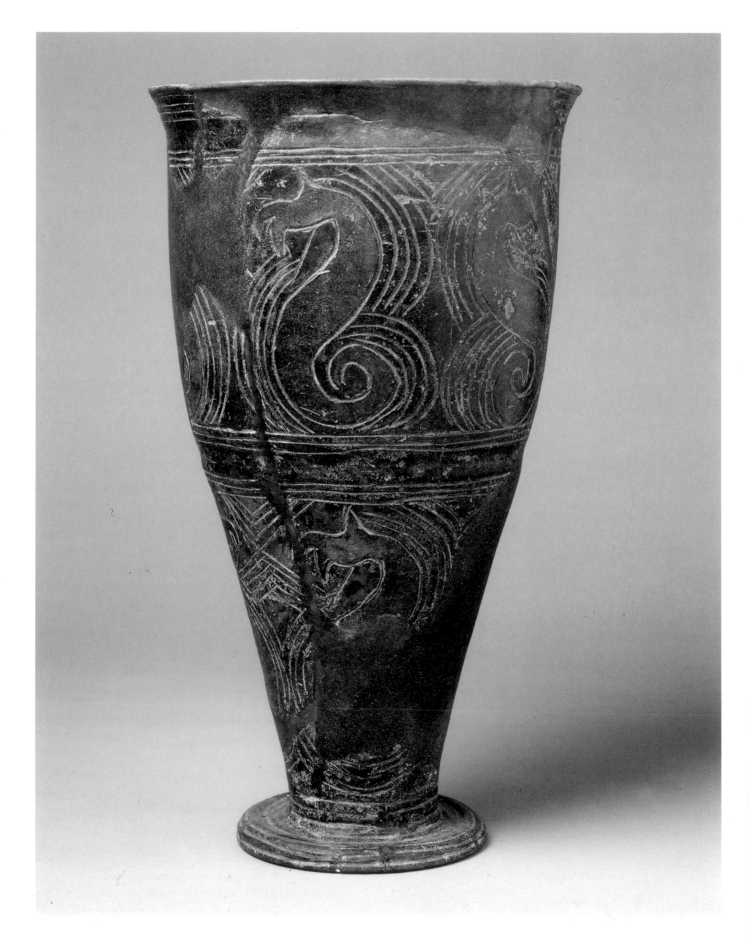

Marnian Cemeteries

The method of burial generally practiced in the fifth century B.C. was inhumation in grave pits. The cemeteries are often located on a slight rise overlooking the chalky plain on the boundary of towns or in the vicinity of ancient roads. The number of burials varies but generally ranges between twenty and one hundred. The spatial organization varies considerably from one site to another. Graves can be close to each other (Pernant) and even arranged in quite well ordered rows (Villeneuve-Renneville). Most often, though, they are very scattered with tens of graves occupying a hectare or more of land.

For a long time it has been noted that in very many cemeteries there are groups of graves separated from each other by an open space. These have generally been thought to be family groups. While this hypothesis seems plausible in the case of Beine "L'Argentelle," it is far from tenable in the case of most other sites known to us. It is important also to note the circular pits ranging from 10-20 meters in diameter which are frequently found at these sites. It is difficult to date them: while some might be as old as the nearby graves, most would seem to be evidence of an earlier occupation.

The pits which were found to contain bodies are all more or less of the same size and quite carefully dug out of the chalky subsoil. They are rectangular and on average measure 2 meters in length, 0.70 meters in width and 0.60 in depth; some of the corners are rounded while others are acute. In some of the pits there are benches, niches cut out of the walls or post holes.

The bodies were buried in supine position, the hands alongside the body or crossed on the abdomen. They were usually placed with the feet facing east, sometimes northeast or southeast. The pits were then filled in, not with the clay which had been dug up but with a very fine black soil similar to humus.

Grave Goods

A distinction should be drawn between the deceased's personal burial goods and offerings which were also buried along with the body and which were identical for both sexes. Offerings consisted of foodstuffs, identifiable by animal bones found (pig, sheep...) and terracotta vessels some of which must have contained drink, though this cannot actually be proved. Such containers are the kind of object most frequently found in graves. However their burial with the grave goods must not have been obligatory. They are not found in some 15 to 20 percent of graves studied and the great majority of other graves contain only one or two examples. The important sets of pottery of five or more vessels were only found in certain, exceptional graves. The pots would appear to have been made by hand, rather than on a wheel and carefully finished. Some are decorated with an engraved or painted geometric design. The most common shapes seem to have been inspired by Italo-Greek pots, such as kraters, amphorae, situlae and cists, all generally used for the transportation or consumption of wine. Female burial goods comprise parts of sets of ornaments, some of which were functional, used to fasten garments (belt buckles and fibulae) while others were a type of insignia (torques, bracelets). Torques worn by half of the female population from adolescence on seemed to have had particular importance. Their variety throughout the different sites where they were found does not seem to denote any diversity of ethnic origins, as is the case at the end of the fourth century and the third century B.C. The contents of the burial assemblage themselves indicate a hierarchy of the female tombs; in some of them a complete *parure* has been found—torques, bracelets, sometimes also ear-rings and pendants. In others, only one piece of jewelry was found, such as a pair of bracelets, while in still other graves not a single piece of jewelry was found.

There is also a hierarchy in the male graves. At the top of this hierarchy are the graves of warriors buried on their chariot. More than one hundred and fifty of these burials have been discovered, especially in the northeast of Champagne—five at Recy and fourteen at Mairy-Sogny. These however represent only a tiny proportion of the graves discovered, not more

Truncated cone-vase with engraved frieze of griffins from Suippes (Marne)
Second half 5th century B.C.
Saint-Germain-en-Laye
Musée des Antiquités Nationales

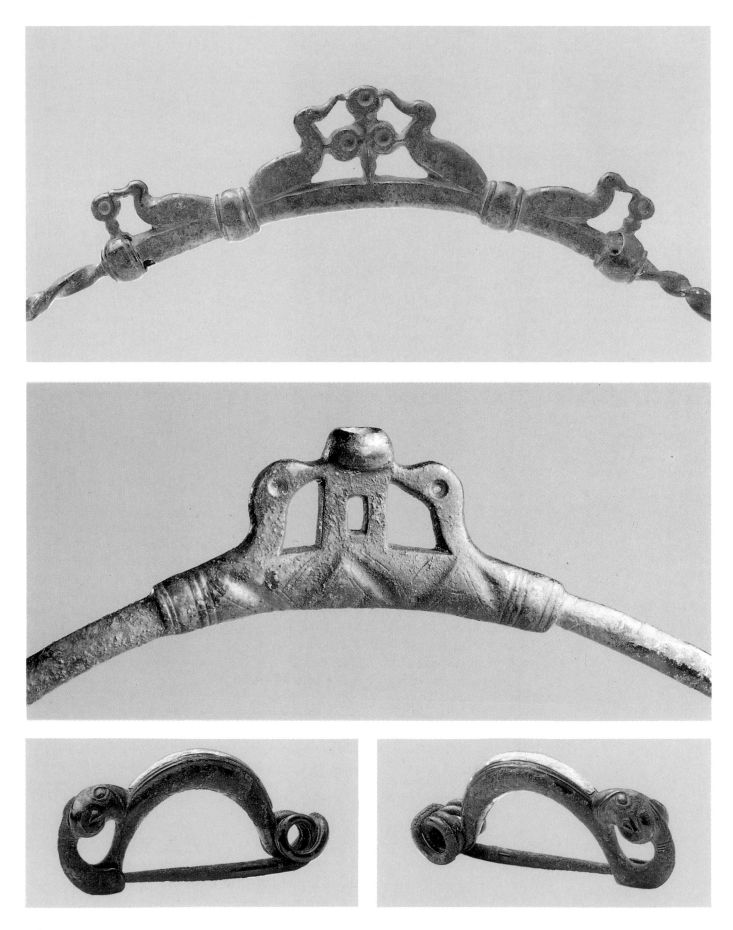

*Bronze "mask" fibula found
in the Marne river near Port-à-Binson
(Marne)
Second half 5th century
Private collection*

*Openwork bronze phalerae from
Ville-sur-Retourne (Ardennes)
Second half 5th century B.C.
Reims, Musée Saint-Remy*

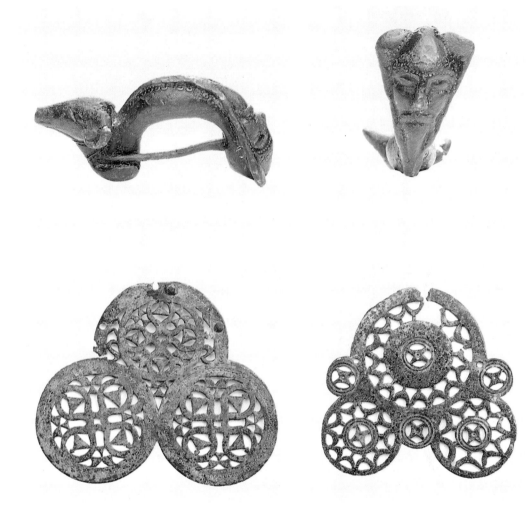

than 0.5 percent. Almost all of these graves were ransacked centuries ago; very few were found intact at the end of last century or the beginning of this century.

The graves were dug to the size of the cart with niches in which to place the wheels and shaft. The warriors were buried with their weapons: sword, lance, knife, and sometimes a finely decorated bronze helmet (Berru, Somme-Tourbe, Prunay...). Generally there is a rich set of vessels which can include bronze items: situla, basin and filter at Pernant, Etruscan oinochoes with a trefoil spout at Somme-Tourbe and Sept-Saulx. Only certain bronze parts of the cart itself have survived: wheel rims, linchpins, axle rings. The best finds are often harness parts: magnificent discs or phalerae made of decorated bronze (Cuperly, Somme-Tourbe, Saint-Jean-sur-Tourbe, Somme-Bionne...)

A second social category can also be distinguished; this comprises foot-soldiers armed with a sword, a dagger, spears and javelins. There are more of these graves than of the first category but they nevertheless represent less than 5 percent of the population buried in these cemeteries. More frequently one finds warriors buried only with more common, throwing weapons—two weapons (javelins) or three (a spear and two javelins). Finally there are many graves, presumably of males, where no weapons at all were found.

The World of the Dead, the World of the Living
These burial sites represent our only source of information about the Marnian population of the fourth century B.C. The little information yielded by the few published excavations is not of any great help, and information from Greek and Latin authors concerns a more recent period and, according to the available evidence, quite a different society.

Information from the excavation of burial sites should be used with caution however. The anthropological assessments have been made by excavators and not by qualified specialists. Furthermore, we know nothing whatsoever of the very strict rules and prohibitions which must have controlled funeral practices. This is illustrated by a striking anomaly: the very small number of infants buried, only 13 percent of all burials at Manre and Pernant, for example, is a figure which cannot correspond to the actual rate of infant mortality at the time. Another anomaly clearly emerges in the best documented sites, Pernant, Manre, Aure, Villeneuve-Renneville, and that is the high proportion of female burials. This imbalance may be the result of another factor, that is, the possible departure of some of the men at the end of the fifth century, a short time before the cemeteries were abandoned.

Taking all the sites into consideration the following observations may be made:

1. For a period of three quarters of a century between 475 and 400 B.C., that is, for four generations, the population was characterized by great stability.

2. There was a notable cultural identity throughout the region of Marne, Aisne and Ardenne where fifth-century B.C. burial sites were discovered. The differences found between sites at some distance from each other are no greater than those between sites located in close proximity and it is most likely that they arise from individual characteristics of local craftsmen.

3. Marnian society seems to have been quite egalitarian. If a hierarchy can de detected in the graves, this does not mean that the society was organized into distinct social classes. In the burial sites the poorest graves are to be found next to the richest, and there is nothing else to indicate the existence of an aristocratic class similar to those that seem to have been present in other regions. It is difficult to imagine that the warriors in the cart burials were chiefs of particular classes or tribes. If this were the case then one would have to argue that in certain regions there was a plethora of chiefs (at least six or seven contemporaneously in the Mairy-Sogny clan alone, for example) while in other areas there were no such chiefs whatsoever.

4. Taking into consideration all of the Marnian burial sites, one cannot fail to note the undeniable predominance of lavish female graves, though this could be partly explained by the small number of male graves. On the other hand it is impossible to exclude *a priori* that this may have been a matriarchal society.

5. One must admit, at least as a probable hypothesis, that Marnian society was based on family units. Every burial site was that of a village community made up of several families connected to each other by strong and privileged ties and occupying a territory that measured up to several hundreds of hectares.

As plentiful as the finds are, they nevertheless reflect a low demographic density.

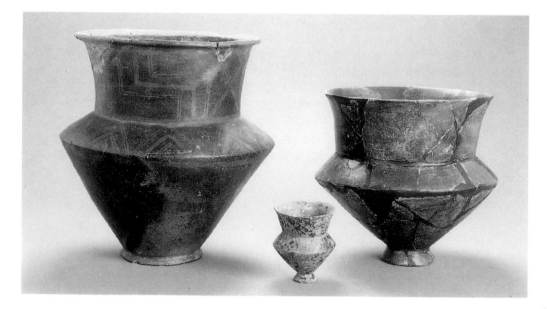

Selection of "Marne" horizon pottery types
Second half 5th century B.C.
Epernay, Musée Municipal

Dagger with sheath in bronze, iron
and wood, with compass-drawn
engraved decorations from Bouy
(Marne)
Second half 5th century B.C.
Saint-Germain-en-Laye
Musée des Antiquités Nationales

Dagger and bronze sheath with
compass-drawn decorations
from Vraux (Marne)
Second third 5th century B.C.
Châlons-sur-Marne, Musée Municipal

Iron weapons from tomb no.6 bis
at Vert-la-Gravelle (Marne)
Second half 5th century B.C.
Epernay, Musée Municipal

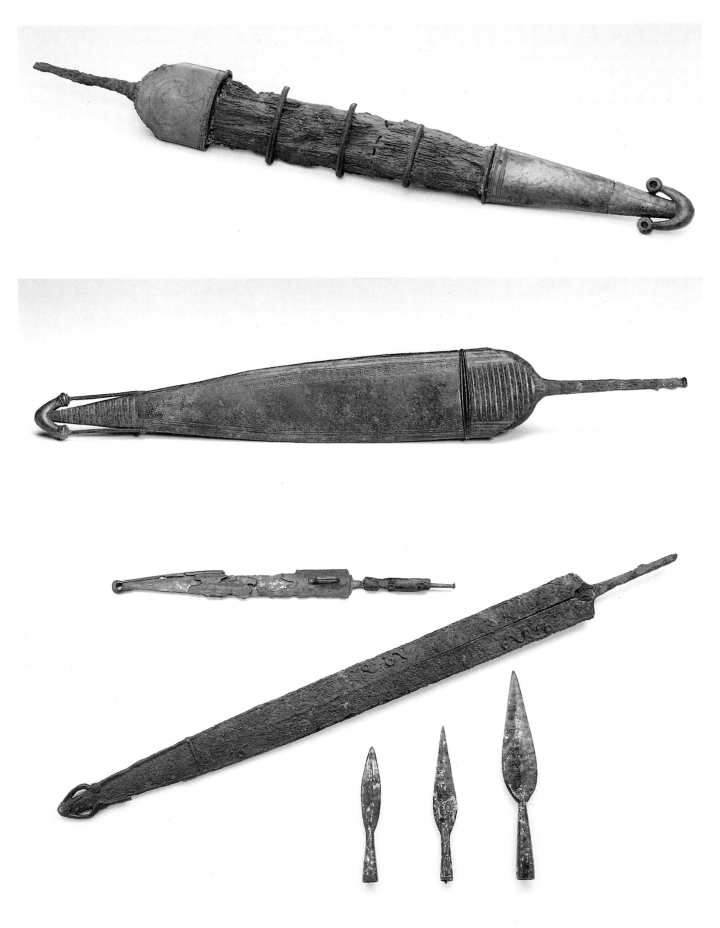

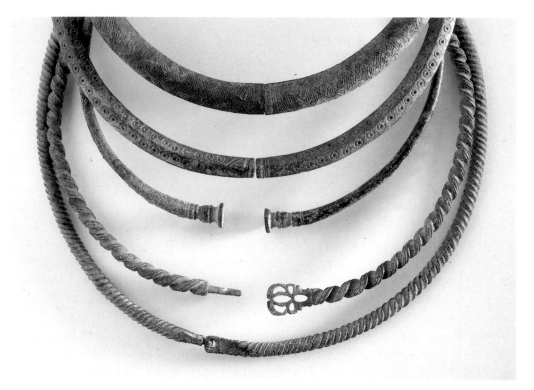

Selection of characteristic "Marne"
horizon bronze torque designs
Second and third third
of 5th century B.C.
Epernay, Musée Municipal

The Origins and Development of the Marnian Culture

Until recently it was generally held that the Marnians of Champagne were invaders from the east who settled in the area at the beginning of the fifth century B.C. Nothing was known of an indigenous population established there from the end of the Bronze Age and for several centuries to follow. In this context, traces of a foreign culture dating to about 530 B.C. appeared, undoubtedly introduced by small groups from the south, and with clear parallels to what was found at Vix (Mont Lassois). The most important find in this respect is the burial site of Jogasses, near Epernay, from which we get the name Jogassian attributed to this truly "proto-Marnian" culture. It can be argued that Marnian culture derived from the local population's assimilation of this foreign culture.

Marnian burial sites do in fact often show traces of an earlier occupation. Thus the majority of sites where circular enclosures were found were used as burial grounds during the first two-thirds of the fifth century B.C. or even earlier. This can be seen for example at Manre, Acy-Romance, Dormans, Vert-le-Gravelle "Charmont" and "Le Moulin." Many others evolved out of a primitive Jogassian nucleus, as in the case of the Jogasses burial site which continued into the Marnian period, but also at Prosnes "Les Vingt de Bruyères," Bouy "Les Varilles" and dozens of other sites.

If the Marnian period was one of great stability, study of the relative archaeological finds nevertheless reveals a slow and constant development which occurred along two different lines. First, there was a standardization of form leading to designs which were unique or almost completely dominant in the case of certain kinds of objects: small buffer torques, so-called *Marzabotto* fibulae, long swords in sheaths with an openwork point. The other line of development, concerning pottery in particular, is the growing freedom in interpretation of exotic models leading to original shapes which are both lively and graceful.

It is difficult to detect among grave goods of the close of the fifth century B.C. any warning signs of an imminent crisis. We still do not know what might have provoked the almost simultaneous mass departure of a large part of the population in about 400 B.C., or some time thereafter, an event which is of great importance in the history of Celtic Champagne.

Selection of characteristic "Marne"
horizon bronze fibula types
Second half 5th century B.C.
Epernay, Musée Municipal

Alfred Haffner

The Princely Tombs of the Celts in the Middle Rhineland

Since the last century the tombs of the sixth to fourth centuries containing gold grave goods and bronze vessels have been labeled "princely tombs." All attempts to get round this term, such as "chieftains' tombs" or "aristocratic tombs," "lavish tombs" or "rich tombs," have failed—the first two because they were no improvement on the "princely" idea, and the second because they fail to evoke the reality these tombs present.

This essay will keep to convention, although the corpus of new finds has since shown that the men, women, and children who were buried in such tombs belonged to a social class that predominated in military affairs, politics, economy, and probably religion too. This same class inevitably influenced the development of arts and crafts, either by commissioning work or by producing it themselves. These people, who dominated the proto-Celtic populations, are closer to the aristocratic echelons of Homer's *Illiad*, than to the nobility of the Middle Ages or to patrons of our own age. This goes for all the proto-Celtic centers, and not just for the ruling class suggested by the princely tombs of the Rhineland.

The central zone of the Rhineland (the Schiefergebirge) stretching from Lorraine, Luxembourg and the middle Rhine area, is particularly rich in both Hallstatt and La Tène sites. Barrow graves of the eighth to seventh centuries B.C. have attracted the attention of amateurs and professional archaeologists since the early nineteenth century.

The discovery of tombs—usually located by a barrow—containing lavish gold grave goods, bronze receptacles, and parts from chariots, sparked complex and impassioned debates as to the era, social status, and ethnic origins of the deceased contained therein. Only in the last decades of the nineteenth century and the beginning of the present have researchers such as Ernst aus'm Weerth and Paul Reinecke managed to identify the bodies in the princely tombs as members of the Celtic aristocracy of the fifth and fourth centuries, and most of the bronze vessels as Etruscan (or at least Italic); they have also successfully identified the rich decorative work of many finds as an indigenous artistic style tinged with Graeco-Etruscan influences.

This is the opinion currently held, though the contributions of generations of new researchers have greatly extended our knowledge and have made clearer the notion of the Celtic "princely tomb." They were able to do this thanks to the systematic documentation of newly discovered funeral structures. Consequently, the princely tombs are no longer an isolated group but part of the general spectrum of coeval funerary systems.

In this way, closer attention has been paid to the related settlements, the pattern of the tombs and living structures of the individual regions in specific territorial contexts, and sub-

Map showing the distribution of "princely tombs" of the 6th and early 5th centuries B.C.

Map showing the distribution of La Tène "princely tombs" of 5th-4th centuries B.C.

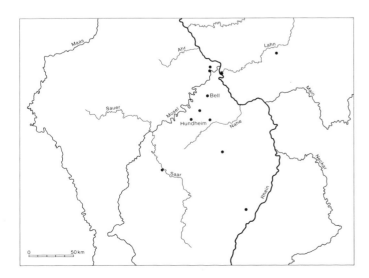

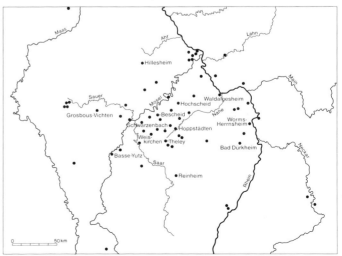

sequently in the overall framework of the archaeological phenomena of a given cultural group. So far no Late Hallstatt princely tombs from the sixth to early fifth century comparable to those of southwest Germany or Burgundy (Asperg, Hochdorf, Vix, etc.) have been discovered in the Rhineland, and nor are they expected to be. Here, in the framework of the Hunsrück-Eifel culture, a Late Hallstatt cultural group with strong local characteristics was located in the northern outskirts of the Late Hallstatt catchment of the northwestern Alpine region; the group has been identified through a small group of tombs in the eastern sector, close to the Rhine; the grave goods and construction methods suggest the emergence toward the end of the sixth century of a social group that tried to imitate the grand model of the dominating class of the late northwestern Alpine culture. In this particular set of princely tombs—the oldest found so far in the Middle Rhineland—the simple wooden biers were replaced with full-fledged funeral chambers; the barrows increased in height and now contained wagons with four (and sometimes two) wheels, together with Rhine-type bronze situlae.

Unlike the princely barrows of Early La Tène, the Late Hallstatt type are more frequently part of extensive cemeteries of barrows with simple grave goods, and were generally used over a longer timespan. As far as we can assess, the inhumed bodies in these tombs are of male individuals.

There are two examples of princely tombs from around 500 B.C., intelligently excavated and documented. The first was discovered in 1938, in one of the barrows 20 meters across in the Bell in Hunsrück area, consisting of a central, timber-lined chamber measuring 2.5 by 1.8 meters. The chamber was oriented approximately west-east, and the deceased was laid, complete with spear and bronze situla, on a four-wheeled chariot of which only the decorative iron strips remained. A convincing reconstruction was recently made by Hans-Eckart Joachim.

Like the tomb found at Bell, the chariot burial of Hundheim im Hunsrück also belongs to a barrow-type cemetery whose main period of utilization has been accurately dated to Early La Tène. In barrows 1 and 2, excavations made in 1937 revealed burial chambers in timber and stone measuring 4 by 2 meters, each containing a male skeleton and a two-wheeled char-

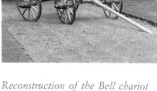

Reconstruction of the Bell chariot (Rhineland)
5th century B.C.
Bonn, Rheinisches Landesmuseum

Bronze "mask" fibula, and bronze belt-ring with coral studs from princely tomb no. 1 at Weiskirchen (Rhineland)
Second half 5th century B.C.
Trier, Rheinisches Landesmuseum

Openwork bronze belt-clasp with coral studs from princely tomb no. 1 at Weiskirchen (Rhineland)
Second half 5th century B.C.
Trier, Rheinisches Landesmuseum

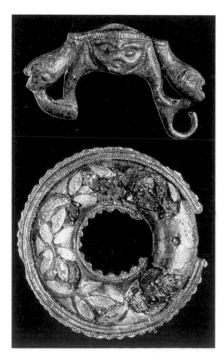

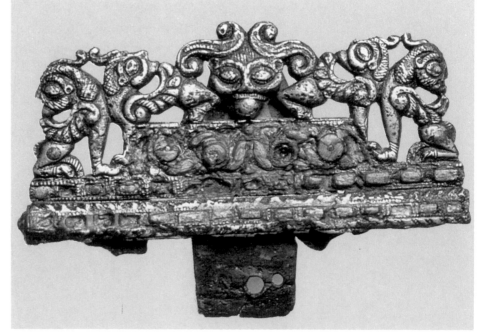

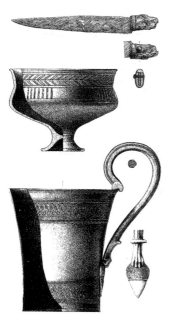

Iron knife, vase, and Etruscan kyathos from barrow no. 9 at Bescheid End 5th-early 4th century B.C.

iot. According to archaeological information, during the entire La Tène period (c. 475 B.C. to 20 B.C.) this lightweight, swift vehicle continued to be a key status symbol for the Celtic aristocracy in both life and death.

At the start of Early La Tène (c. 475 B.C.), the area between the Maas and Rhine witnessed a marked increase in the practice of princely tomb construction. The main area involved is part of the later phase of the Hunsrück-Eifel culture; there are strong indications that, in the first phase of Hunsrück-Eifel culture belonging to Late Hallstatt, an important center emerged in the western sector between the Saar and the Moselle. Excavation has revealed most important princely tombs for the period 475-350 B.C.

The hoards include torques, bracelets, fibulae, and fragments of belts in gold, bronze and iron, but also chariot decorations in bronze and iron, together with gold decorations from drinking-horns and weapons—all representative of the Celtic Early Style.

Even to this day, the true genesis of Celtic art is a mystery. The most convincing picture to my mind has been offered by Franz Fischer and Wolfgang Kimmig, who suggest that La Tène style developed in southwestern Germany, one of the centers of Late Hallstatt culture in the northwestern Alpine region. Links between this zone and Etruria had been particularly intense for some time, and here in the Late Hallstatt environment, the La Tène phase developed; the habitat offered a fertile ground for a new form of artistic idiom, which was expressed almost exclusively in the assets of the ruling class.

Nearly all these artifacts, whether in gold, bronze, or iron, are authentic masterpieces of Celtic craftsmanship and tokens of the creativity of the artisans at work in the hilly central Rhineland area.

Furthermore, finds made at Weiskirchen endorse the supposition that the figural and decorative patterns on receptacles imported from Graeco-Etruscan sources had a direct impact on the ornamentation of belt-hooks in local bronze, from which we can infer the existence of a local workshop. The "Weiskirchen workshop" was most likely the source of the beaked flagons of Basse Yutz.

Although there can no longer be any doubt as to the existence of a center producing Early Style artifacts in the sphere of Hunsrück-Eifel culture, and in Lorraine and the neighboring southern Palatinate area, we should be wary of hasty interpretations of the distribution framework for objects bearing such decorations. The area did not necessarily play a leading role, since the distribution map primarily reflects the incidence of a particular type of burial, i.e., those of the fifth- and fourth-century princely tombs. The effective distribution of Early Style artifacts may have been far greater originally and more incisive, penetrating deep into Gaul and the southern belt of Early La Tène central Europe.

Despite the abundance of princely tombs in the hilly Middle Rhineland area (and despite the efforts of generations of archaeologists) the available research leaves a great many questions unanswered. The reasons are well-known—more than half of the princely tombs were discovered in the nineteenth century, excavated with unorthodox means, and work was either undocumented or insufficiently recorded. Consequently the inventory of grave goods is incomplete or unreliable; early attempts at cleaning artifacts were frequently more damaging than revelatory. But even the tombs found in this century have brought little progress—most had been destroyed or plundered. Only for a select few cemeteries and barrow fields (such as those at Hillesheim in Eifel, and Reinheim in southern Saarland, or Bescheid, Hochscheid im Hunsrück) have the finds been substantial and their contents properly restored.

Despite these shortcomings, the date, location and structure of each tomb, their contents, and their relationship to nearby settlements and other cemeteries show that the princely

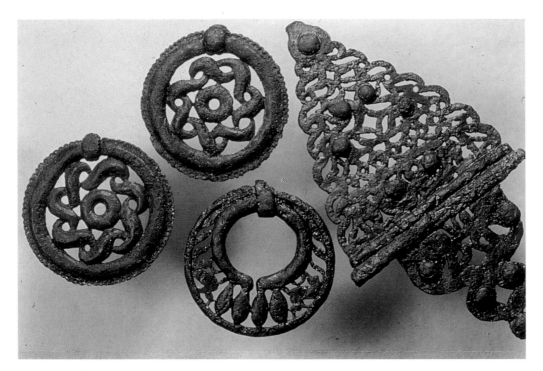

tombs of the fifth century to early fourth century B.C. follow a certain pattern. Any assessment of their common features must take into account that there were no regional guidelines for funeral rites, and so, despite discrepancies of contents or position, the tombs still clearly belong to the princely tomb group.

Most princely tombs are found in isolated barrows or in groups of no more than three. To date, the only cemeteries with princely tombs are Hochscheid (with five tombs, originally more), Hoppstädten (with eleven), and Bescheid (with sixteen). In each case the barrows are set apart from the cemetery used by the rest of the population, and are usually situated on mounds commanding the area, close to established and important trade routes. In many cases there are clear topographical links with coeval hillfort settlements in the neighborhood, particularly for larger cemeteries dating from the seventh to the third century B.C. The zones of Theley and Schwarzenbach-Otzenhausen are good examples of this association of geographical and trade-route vantage points, combined with fortified structures and a relatively dense population.

Near Schwarzenbach (which is also typical of sites with a large number of grouped princely tomb) a vast cache of ferrous material suitable for forging was found. Jurgen Driehaus and Rheinhardt Schindler have assembled convincing proof of the presence of intense metalworking in Hunsrück and Eifel during Early La Tène. Paleobotanic studies have provided similar indications that from the beginning of the fifth century the acreage of woodland there dropped sharply.

In comparison with the more simple graves, the barrows of the princely tombs are spacious. Diameters vary considerably from 25 to 50 meters across and 2.5 to 6 meters in height, presumably according to the status of the deceased within the dominating class. The same variations apply to the funeral chambers which are constructed of either timber or stone, and usually placed centrally in the barrow. Their surface areas range from 8 to 20 square meters.

Except in rare cases, the burial is of the inhumation type. The few recorded cremation burials (Schwarzenbach 1, Besseringen, Hillesheim) are otherwise like the others in terms of

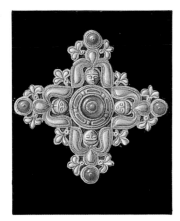

Reconstruction of gold plaque from barrow no. 1 at Weiskirchen (Rhineland) End 5th-early 4th century B.C.

their cache of effects. This may mean that the burials were double, that is, one body was cremated and the other interred but—as usually happens with the acidic soil of the Schiefergebirge—their skeletons perished completely and therefore the type of burial remains unidentifiable.

It is certain that in the princely tomb cemeteries of Bescheid and Hochscheid the cremation burials are more recent. The dead were laid on a pyre together with their funeral offerings, and the barrow was later built on the site of the pyre. At Bescheid, residues of items in gold, silver, and bronze were the only sure clue that the tombs were indeed in the princely category. These date from a late phase of Early La Tène, between approximately 320 and 250 B.C., a period in which (except for Waldalgesheim) current information indicates that no further princely tombs were built. An important aspect of funeral customs, the transition to cremation rites and the "flat" burials with ash deposits or *in situ* cremation burials (such as those found in the Hunsrück-Eifel cultural area) makes it much harder to reconstruct the funeral rites involved in the princely tombs.

The group of princely tombs in the Middle Rhineland includes burials of males, females, and occasionally even children. It is interesting to note that no female burials have yet been identified for the preceding phase of the Hunsrück-Eifel culture (excluding Waldalgesheim); this is in stark contrast with the Palatinate culture just south of here, where the lavishly-equipped female tombs of Bad Dürkheim, Reinheim, and Worms-Herrnscheim account for fifty percent of tombs found to date. Why men and women were treated differently after death has yet to be explained. It may be that, among the southern group of Middle Rhineland princely tombs the women of the ruling class were admitted to political and religious functions that in the later Hunsrück-Eifel culture became the preserve of men only.

Once again it is worth remembering that there were no rules as such for burial customs. The Celtic fondness for individuality—a hallmark of the masterpieces of Celtic artwork—is also noticeable here and perhaps affected other areas of daily life, of which there are no archaeological traces.

Bronze "mask" fibula from barrow no. 2 at Bescheid (Rhineland) Second half 5th century B.C.

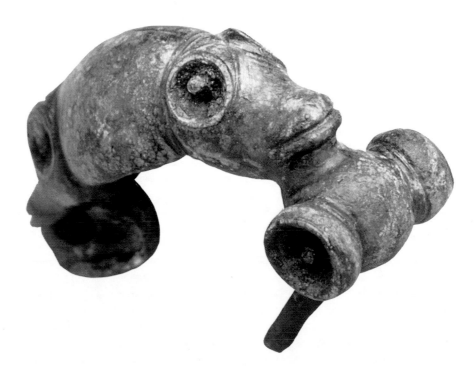

The discovery of a child's grave in 1979 at Bescheid was a great surprise. In barrow 9 of the cemetery of princely tombs, the excavators came across a burial of an eight-year-old girl, laid west-to-east. The body was richly adorned with bronze (head-bands, neck ring, two matching bracelets), an iron armlet, and a belt with a small iron clasp and two pretty rings. The child's garment was pinned across the chest with three bronze fibulae. At her feet lay a knife, a finely-wrought goblet, and a bronze Etruscan cup from the end of the fifth century, its type a rare occurrence north of the Alps. The range of wares imported from Etruria was greater than experts had previously imagined.

The child's tomb at Bescheid is the only one of its kind found so far, and dates from shortly after 400 B.C. The fact that on occasion children were also buried with such treasures is endorsed by finds made in barrow 1 at Hoppstädten, where a child was buried with a sword, spearheads and arrows, and an Etruscan beaked flagon (*Schnabelkanne*) in bronze.

In 1975-1976 four male tombs from between 450 and 400 B.C. were discovered at Hochscheid, each one centrally laid in a flattened barrow of 20 to 25 meters across. Two of the barrows were crowned by a wide circle of other tombs. The finds included double bird-head fibulae and mask-fibulae in bronze with rich coral inlay, openwork iron belt clasps, box-shaped bronze belt mounts, ornamental buttons from leather boots, a roundel-fibula with coral studs, a gold Weiskirchen-type disc used to decorate a cloak or hood, a set of bracelets. A more lavish version of this type of gold disc was found in barrow 1 at Weiskirchen in Saarland.

Among the cache of arms at Hochscheid, the sword from barrow 2 deserves special attention; the iron blade with coral-studded hilt is sheathed in a bronze scabbard with floral and zoomorphic patterns in Early Style, decorated with coral.

Bronze fibulae, bronze shoe-button toilet articles, iron dagger, painted vase, and Etruscan bronze jug from barrows at Hochscheid

Gold disc from barrow no. 6 at Bescheid (Rhineland) Second half 5th century B.C. Trier, Rheinisches Landesmuseum

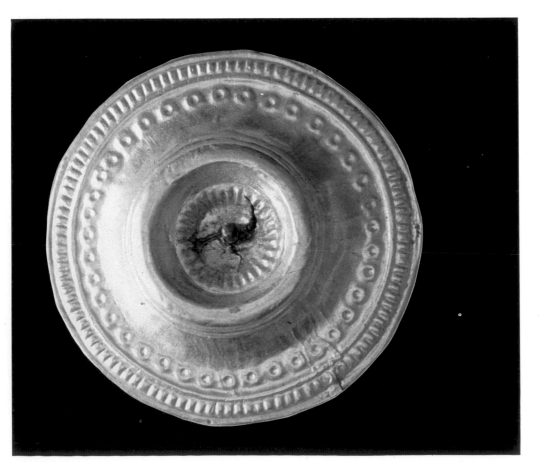

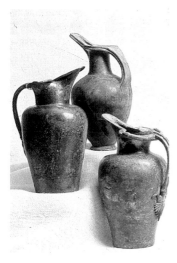

Etruscan bronze jugs from barrows
nos.1 and 4 at Hochscheid
Back: terracotta imitation from Sien
(Rhineland)
Second half 5th century B.C.
Trier, Rheinisches Landesmuseum

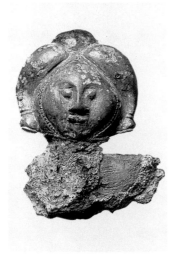

Bronze pommel in the form
of a human head from a sword
found in barrow no. 6 at Bescheid
(Rhineland)
End 5th century B.C.
Trier, Rheinisches Landesmuseum

Two of the Hochscheid warriors were also accompanied by a bronze Etruscan beaked flagon, together with high-quality local pottery. The imported beaked flagons are among the most frequently found burial treasures, and were used for pouring and mixing important beverages for secular or religious occasions—in most cases probably Italian wine. The beaked flagon had a special place in the graves of the Celtic nobility. Sometimes it indicated the communal drinking rite, and was therefore included in the grave goods to represent the full banqueting service. As the only imported container, the *Schnabelkanne* was evidently of key importance, and replicas were often made in clay or wood; in some cases other types of container (such as those recorded in Schwarzenbach 2 and Weiskirchen 1) were transformed into beaked flagons.

The largest cemetery of princely tombs, with sixteen barrows in all, was excavated between 1977 and 1979 in the Bescheid area near Treveri. Although several tombs had been looted in the nineteenth century, a great many finds were made. Mention has already been made of the child's tomb (barrow 9) and the cremation tombs containing all the treasures laid on the pyre—all of surprisingly late construction (fourth and third centuries B.C.). At Bescheid proof emerged that the princely tombs were in continuous use by local communities between approximately 475 and 250 B.C.

Barrow 6 proved to be particularly important. The deceased had been extended on his back (with head toward the west) in a funeral chamber measuring 2.5 by 4 meters. The floor and walls were lined with fabric. The deceased was dressed and wore a belt with a iron clasp with coral inlay and two rings with an incised floral pattern on the inside. The leather boots had decorated bronze buttons and small iron fasteners. To the right of the body an article of clothing had been laid, of which only a single gold disc remained. Next to it was a sword and iron scabbard with coral insets. The pommel is fashioned in the shape of a human head in the round, probably depicting a war deity or some Celtic hero. The man's panoply included three spears with long iron tips, and three socketed arrowheads. The bow was probably made of wood and had therefore perished, the shield likewise. But the less ostentatious objects are perhaps the most interesting finds in the tomb. These include arrowheads—the only ones found among the weapons in barrow 6—which are absent from the humbler burials but a frequent item in the princely tombs. It seems hasty to infer that the archers were recruited from the ranks of the aristocracy; the arrowheads seem instead to suggest that hunting—as a sport as well as for livelihood—was an important part of the aristocrats' way of life.

Food and drink had been laid in offering at the dead man's feet, with a small single-edged iron knife with Early Style gold foil decoration. There was also most likely a wooden jug. The inclusion of drinking-horns—usually in conjunction with Etruscan bronzeware—was reserved for the nobility. Drinking-horns were used in place of cups and beakers by the northern barbarian races, the Scythians, Thracians, Illyrians, and Celts, whereas cups were a crucial part of the communal drinking-sets in the Mediterranean. Scythian iconographic records establish the importance of drinking-horns in cult activity.

Unlike the tombs at Hochscheid, those in barrow 6 at Bescheid contained a chariot. Over forty iron discs decorated the shaft, platform and sides of the single-axle vehicle whose light-weight design made it equally suitable for battle or for travel. Jeannot Metzler has recently attempted to reconstruct an unsprung vehicle like the one from Bescheid with the help of new data from Gorosbous-Vichten in Luxembourg. Besides the simple model from this site, a more lavish one has turned up elsewhere, with decorations mainly in bronze and coral inserts.

We can infer that besides its practical usefulness, the chariot was an important status symbol.

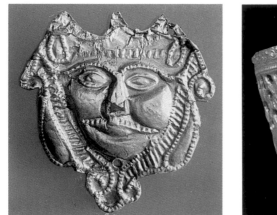

*Gold leaf appliqué, embossed
from Ferschweiler (Rhineland)
Second half 5th century B.C.
Trier, Rheinisches Landesmuseum*

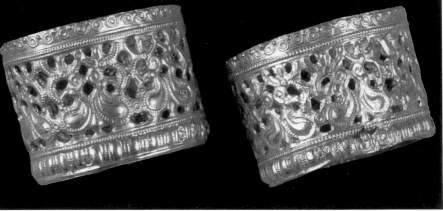

*Drinking-horn mounts in embossed
gold leaf from the princely tomb
at Reinheim (Saarland)
Saarbrücken, Landesmuseum
für Vor-und Frühgeschichte*

To conclude this brief profile of Early La Tène princely tombs, it is worth noting one feature in particular of the Bescheid cemetery. Both tumulus cemeteries are linked to an artificial earthwork 250 meters long and 4 meters wide reaching a height of almost 1 meter; it begins near barrow 4 and ends near barrow 6. Both were found to contain almost identical chariot graves. Similar ramparts in the vicinity of tumulus cemeteries are not rare in the sphere of the Hunsrück-Eifel culture; their meaning or function has not yet been established. At Bescheid many features tend to suggest that the two chariot burials are in some way related to the rampart, which provides a kind of causeway, perhaps built for a procession.

*Reconstruction of the drinking-horns
with gold leaf mounts
from the princely tomb
at Schwarzenbach (Rhineland)
Second half 5th century B.C.
Berlin, Staatliche Museen
Antikensammlung Preussischer
Kulturbesitz*

Fritz Eckart Barth The Hallstatt Salt Mines

The small commercial center of Hallstatt lies in the heart of the Salzkammergut of Upper Austria, in complete isolation. The town, which is not blessed with a very good climate, stands on the steep side of the lake bearing the same name, and, originally, could only be reached by boat. However, from the second half of the second millennium B.C. onward, it was the scene of intense activity, from the time when its deposits of rock-salt began to be exploited in earnest. Although to begin with, the inhabitants were content to draw salt water from natural springs, around the beginning of the first millennium B.C., they started to mine the "white gold."

The traces of this protohistoric subterranean mining at many points far below the earth's surface (first referred to in literature in 1311), are called *Heidengebirge* (the mountains of the pagans). They are concentrated in three areas, referred to as the northern, eastern and western groups, and constitute the remains of separate, consecutive mining activities that clearly used different mining technologies. The northern group is the earliest (1000-800 B.C.), and the western group is the most recent (dating approximately from the start of the Christian era). Chronologically speaking, the eastern group lies between the other two, and contains the remains of an activity that developed very successfully and profitably over many centuries, as is shown by the funerary assemblages of a large cemetery which has given its name to a whole period of central European history, the Hallstatt period (seventh-fifth centuries B.C.).

The cemetery was discovered in 1846 by Johann Georg Ramsauer, who was manager of the mine at the time, and, during the next two decades, the most important parts of it were excavated. We owe the discovery of almost a thousand graves with rich burial assemblages to Ramsauer's work. Ramsauer, who was an expert on mining and an exceptional observer and record-

Aerial view of the Hallstatt site
Photo Beckel

er, drew on all his experience and proved to be far ahead of his contemporaries, from the point of view of excavation techniques and recording information. In fact, he described the position of the finds and had the most important finds and graves reproduced in watercolors.

The Hallstatt cemetery's main period of use was between the seventh and sixth centuries B.C., The richness of the finds indicates a period of considerable economic prosperity and has led archaeologists to define the formal context to which they belong as the Hallstatt culture. There are only a few graves belonging to the fifth century B.C., and the rich funerary assemblages found in earlier burial sites—rich enough to allow archaeologists to speak in terms of "chieftains' graves"—are here lacking. The only exception is grave no. 994, which, in addition to a drinking service, produced a helmet, a spear and an iron sword with a figure-decorated bronze scabbard.

Thus, there is a distinct impression of an economic decline, probably due to the development of the salt mine at Dürrnberg/Hallein, which was in a more advantageous position from the point of view of communications. Mining was brought abruptly to an end by a landslide, which devastated the whole area, blocking the entrances to the shafts and filling a large proportion of the network of tunnels with morainic material. At many points in the eastern group, this material is found up to a depth of 120 meters. Tree-stumps, whole, uprooted trees and enormous lumps of limestone are still to be seen.

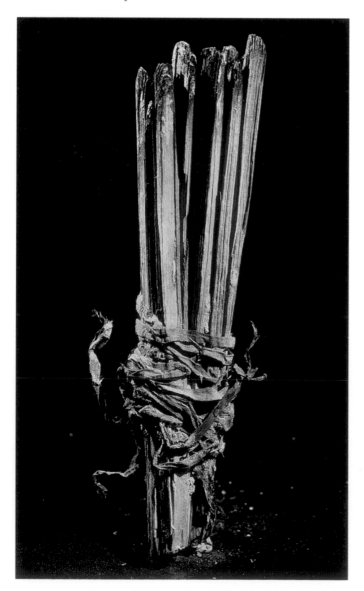

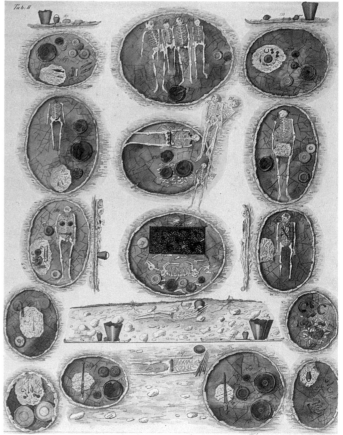

Torches from the salt mines at Hallstatt (Upper Austria) 7th-5th century B.C. Vienna, Naturhistorisches Museum

One of the plates of the so-called Protokoll Ramsauer with original paintings of the excavation of the Hallstatt cemetery (Upper Austria) conducted by Georg Ramsauer between 1846 and 1862 Vienna, Naturhistorisches Museum

The mine of the eastern group began its activity in the eighth century B.C., and it was this one more than any of the others that ensured the supply of riches for the dead buried in the cemetery. Deep, oblique shafts were dug from the surface in order to reach the rock-salt deposits, which were covered by a thick layer of alkaline deposit. From here, horizontal tunnels were dug, following the salt strata, from which side-tunnels ran toward the surface, so that several groups of miners could work at the same time. In other words, instead of digging down, they mined toward the surface, with the result that a step-shaped space was created. The small lumps of salt that fell while mining was in progress remained *in situ*, gradually filling the space beneath. The tool they used was the bronze pick with a prominently flanged head, a Late Bronze Age type. The L-shaped handle was made from pine by cutting a suitable branch at the junction with the trunk. The top third of the short handle was tapered to reduce recoil when the blow was delivered. As the damage on the end of the pick-handle—obviously caused by a mallet—shows, the mallet technique was already being used. In other words, the point of the tool was placed against the wall, without any pressure being applied, after which blows were delivered with a mallet on the base of the handle. In this way, heart-shaped furrows were dug in the mineral and the pieces in the middle were removed in blocks, which were put straight on to the market.

A particular advantage of finds from salt mines is that objects made from organic materials

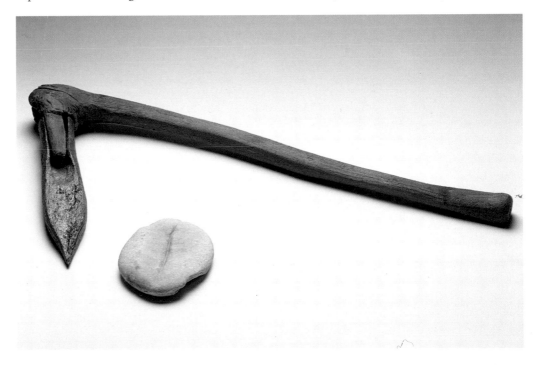

Pickax and whetstone from the salt mines of Dürrnberg (Salzburg)
6th-5th century B.C.
Salzburg
Museum Carolino Augusteum

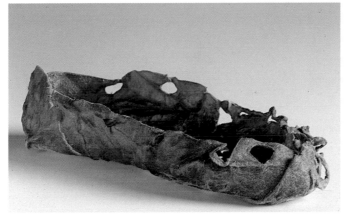

Calf-skin shoe from the salt mines of Dürrnberg (Salzburg)
6th-5th century B.C.
Salzburg
Museum Carolino Augusteum

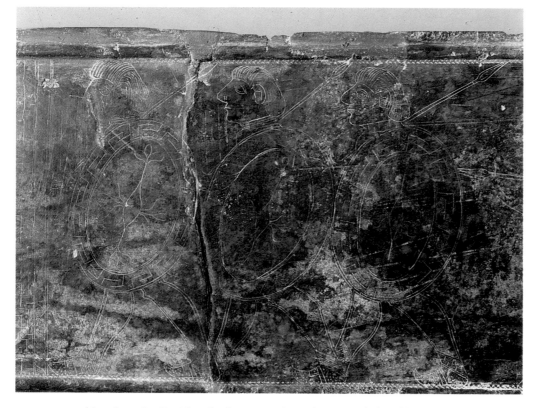

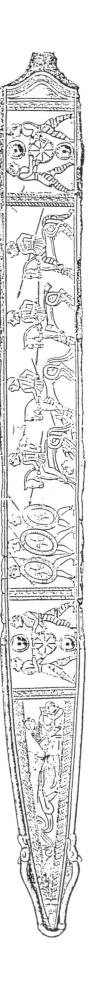

are preserved by the salt. Besides the large number of pine pick handles mentioned earlier, there are some interesting remains of clothing. To date, more than a hundred fragments of fabric have been analyzed which enable us to build up a picture of the art of weaving which was highly developed in that period. In addition to simple fabrics of the basket-weave type, cross twills were very common, and we have examples of patterned fabrics of different-colored interwoven threads. It is worth mentioning that, by this time, there is evidence that fabrics were already being cut into shapes and sewn together to make clothes.

Among the finds of fur and leather, the two shoes found in the eastern group are of special interest. These shoes, with turned down uppers, were made from a single piece of leather, bent and sewn only at the heel. There are two types of leather headwear: a pointed cap with a fur lining, and berets with a fur border.

During the fourth century B.C., as mentioned earlier, the mine associated with the eastern group met a violent end owing to a landslide, which probably also involved loss of human life. In 1734, in the Kilbwerk mine, the body of a protohistoric miner was found preserved in the salt, complete with clothing. He was buried in Hallstatt cemetery.

Fritz Moosleitner

The Dürrnberg near Hallein: A Center of Celtic Art and Culture

View of the Dürrnberg site near Hallein (Salzburg)

The ancient city of Hallein, the old center for the extraction of rock salt, stands on the western bank of the Salzach River, about 15 kilometers south of Salzburg. Dürrnberg, the plateau to the west of the city, reaches as far as the *Land*'s boundary with Bavaria. Crisscrossed by small valleys and with a steep slope leading down to the river, the plateau is now part of the urban area of the city of Hallein.

The area's rich deposits of rock salt were already being exploited in prehistoric times.

Salt as a Source of Wealth

The richest deposits of rock salt in central Europe are concentrated in the northern border of the Eastern Alps, in the Salzburg and Salzkammergut areas. At short distances from each other are the salt mines of Hallstatt, Hallein-Dürrnberg and Reichensall—each of which has a history that stretches back for millennia. The names of all three sites contains the word "hall" which in all probability was a Celtic word for salt.

Part of these deposits are covered by thick layers of limestone. Access to the salt was only possible in the areas where these layers had been eroded—though, even there, the deposits were under 30-40 centimeters of clay. The usual sign of salt deposits were salt springs—which from Neolithic times on have supplied a limited amount of salt themselves.

Modern research dates the beginning of salt mining to the end of the second millennium B.C., at Hallstatt. Large-scale works had to be completed before the rock salt could be exploited. After the layers of clay had been broken through, the miners had to dig down to the rock face; the resulting tunnels were angled at about 45 and were generally about 50-70 meters long. The Hallstatt miners could draw on experience gained in copper mining, as can be seen from the tools and methods used.

During the exploitation of the Hallstatt deposits in modern times, traces of prehistoric mining have been found between 240 and 350 meters below ground level. Due to the pressure exerted by the upper layers, the tunnels closed up after a certain time and all the objects that had been left in them—damaged tools, torches, clothing—were swallowed up in the salt, which preserved them wonderfully. In 1576, and again in 1616, the preserved bodies of prehistoric miners, complete with hair, beard and clothing, were found in the Dürrnberg salt

Wine flagons in terracotta from the Dürrnberg cemetery (Salzburg)
5th century B.C.
Hallein, Keltenmuseum

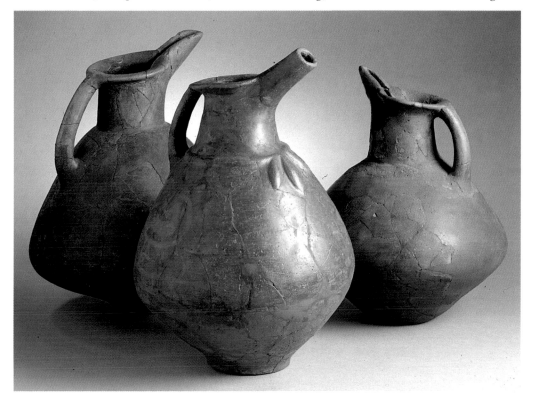

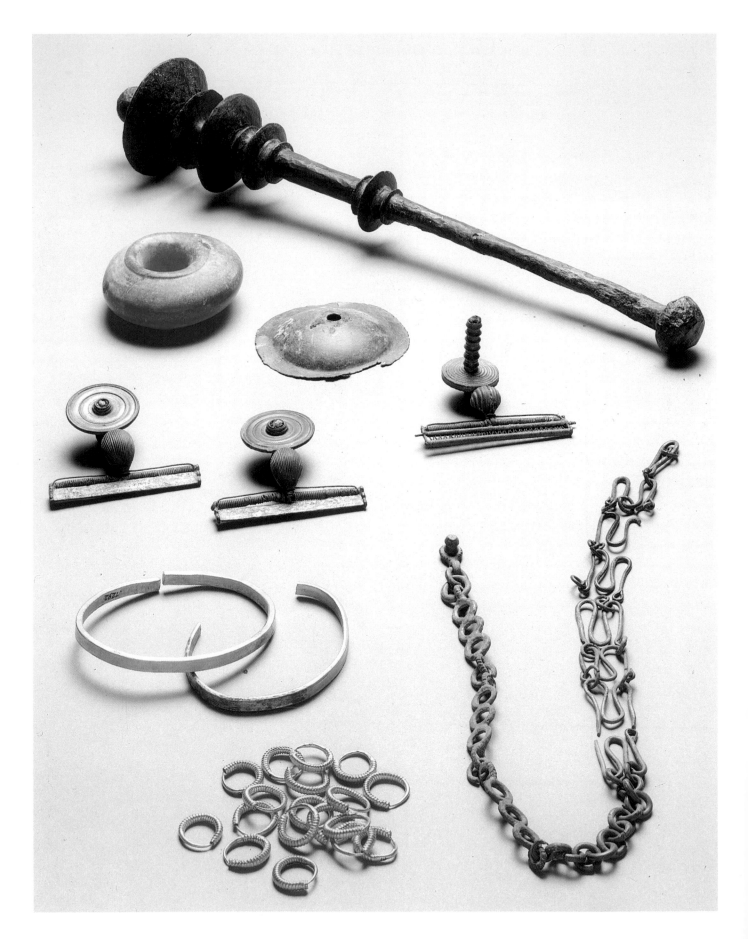

Metal objects: "scepter" in iron and bronze gold armlets and earrings tin-plated bronze fibula bronze chain and phalera and an amber bead from tomb no. 59 at Dürrnberg (Salzburg) End of 6th or early 5th century B.C. Hallein, Keltenmuseum

mines. Another prehistoric miner was discovered in the Hallstatt mine. Unfortunately there are no drawings or precise descriptions of these finds.

Of the three mines mentioned above, Hallstatt occupies the most isolated site amongst the mountains. As I have already mentioned, exploitation of the deposits started in the late Bronze Age, and reached a peak during the early Iron Age (c. 750-480 B.C.)—the era that is also known as the Hallstatt period, a name which comes from the rich finds made in the cemeteries in the Salzberg valley above Hallstatt.

The extractions from the Dürrnberg mines only seem to have started in the Late Hallstatt period (around 600 B.C.). However, its position was excellent with respect to the trade routes and in only a few decades it had overtaken its old rival, Hallstatt. In spite of this obvious supremacy, the two mines co-existed for almost two centuries, up to the years around 400 B.C. It was at that date that the Hallstatt mine went into decline, probably due to some natural catastrophe.

In the following centuries, Dürrnberg satisfied the needs of a large area of central Europe, and the local grave furnishings reflect the wealth that was derived from this salt trade. The first sign of decline in the settlement comes in the Late La Tène period (around 100 B.C.). Production then seems to shift to Reichenhall; salt-mining in Hallstatt also seems to pick up again around this period.

The Topography of the Dürrnberg

The tallest mountain of the Dürrnberg, the Hahnrainkopf, towers over the prehistoric center of salt-mining. (Its 1026-meter peak in fact stands in the neighboring Bavaria. Around this are grouped the entrances to the tunnels, which can be recognized by the mounds of material that was removed in digging them, as well as by the channels and basins that have been formed by the collapse of some.

At first the miners lived near the mine. In the sixth century, accommodation was concentrated on the Moserstein and other nearby suitable slopes. The tombs that date from this period are, without exception, to be found in the upper areas of the Dürrnberg, near the mines—in particular, on the slopes of Eislfeld and Simonbauerfeld. Following the development of an industrial center in the Dürrnberg, the fifth century settlements and tombs are spread over a wider area. Around 500 B.C. a fortified settlement was established on the Ramsaukopf upland, a rocky spur of land entirely bound by precipices. Access was only possible from the lower side of the plateau, and this was protected by massive dry-stone walls. Because of Ramsaukopf's strategic importance—the peak dominates access to the Dürrnberg—it has been interpreted as the "princely residence" of the settlement. One can assume that it housed the "Lord of Dürrnberg" and his court.

Ramsautal, a small valley at the foot of this princely residence, contained dwellings and workshops, mostly for bronze and iron smiths, potters and tanners.

The inhabited area on Moserstein was also established in the fifth century B.C. Finds have revealed the presence of crafts activities here as well: potters' workshops, metal foundries, and glass-works.

A sudden growth in population around 500 B.C. led to new sites—unsuitable for accommodation—being used for cemeteries. Tombs are to be found on rather steep slopes, such as those around Grubermühle on Moserstein and the eastern area of Dürrnberg. Each group had its own cemetery, and the graves are often close to the dwellings.

Grave Furnishings in the Dürrnberg

The wealth of the salt industry is reflected in the assemblages found in the area's tombs. The material well-being resulting from trade was not the preserve of a small group but was shared by various levels of society.

The Dürrnberg Celts generally buried their dead in wooden burial chambers, though there are rare cases of cremation (sometimes one can even find cremated and buried bodies in the

same chamber). The burial chambers were built of wooden beams and were not very deep. The wooden planks were generally laid out at ground level (sometimes they were sunk slightly), they were then given a stone covering and finally covered by the tumulus of earth. A number of these tumuli can still be seen in the area. The size of a burial chamber varies from 1 by 2 meters to about three by three meters.

Often more than one person is buried in the same chamber, but it is impossible to determine if they were buried at the same time or if the chamber was re-opened at a later date (perhaps even several times).

The dead were buried with their clothes and adornments. Men took their weapons with them to the grave. All were provided with food for the journey to the next world. Every tomb contains bones, the remains of substantial offerings of meat—such as a rib of beef, or a leg of pork, mutton or goat. Sometimes there is even an entire spit-roasted pig. There is always an iron knife for cutting the meat.

The drinks in the tomb were contained in flasks or larger metal vases. The "average citizen" had to make do with the fermented juice of berries—such as blackberries—while the "princes" were treated to imported southern wines. The utensils necessary for the funeral meal were never omitted. Up to the present 320 tombs containing a total of about 700 bodies have been discovered in the Dürrnberg. Most of them date from the period between 550 and 300 B.C. Only a few tombs date from either the first half of the sixth century or the third and second centuries B.C.

The Work of Craftsmen

The numerous ornaments and weapons found in the tombs bear witness to a high quality of craftsmanship. Most of the objects must have been produced in the Dürrnberg—this is especially true of the numerous fibulae with animal and bird heads, and *Masken* fibulae found. The craftsmen who were working for the "salt lords" followed the early Celtic style which first appeared in the first half of the fifth century B.C.

The bronze *Schnabelkanne*, or beaked flask, from tomb 112 in the Dürrnberg, is considered to be one of the most important examples of Celtic craftsmanship found in Austria. It was discovered in 1932, in a tumulus that had already been looted in prehistoric times, alongside the ornamental parts of a two-wheeled war chariot. The body of the jug is in sheet bronze, while the handle and spout were cast separately using the lost wax method. The spout was then welded to the jug, and the handle attached with rivets.

The only figurative decoration is on the handle: a beast of prey similar to a lion holds in its mouth a human head that rests on the rim of the jug. The two animal figures on the rim are smaller reproductions of the one on the handle; both of them are devouring something (an animal's tail dangles from each of their open jaws).

The shape of the jug echoes Etruscan models. However, its decoration and figurative features not only recall the work of the Estruscans but also the so-called "art of the situlae" and even work produced by the tribes of the Steppes. The Dürrnberg jug may be dated to around the second half of the fifth century B.C.

A second princely tomb (tomb 44) was discovered in 1959, during rescue excavations on the flat summit of the Moserstein. It contained the complete tomb furnishings of a warrior who, like the owner of the bronze jug, had been buried with a two-wheeled war chariot. The bronze mounts for a wooden jug with a cylindrical spout—along with a mask-shaped mount showing a bearded Celt—are particularly worthy of note. A container in the form of a pilgrim's flask contained seventeen liters of imported southern wine. The flask consisted of two connected but separate compartments that rested on a stand of four stylized human legs. This tomb also contained a large bucket-shaped vessel—with about a two hundred-liter capacity—in which was found a pottery *kylix* produced in Athens around 470 B.C.

Beneath the feet of the dead man were a handsome bronze helmet, an iron sword, a bow

Bronze wine flagon
from tomb no. 112 at Dürrnberg
near Hallein (Salzburg)
Early 4th century B.C.
Salzburg
Museum Carolino Augusteum

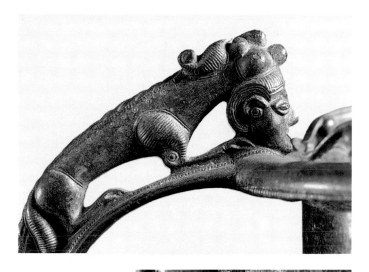

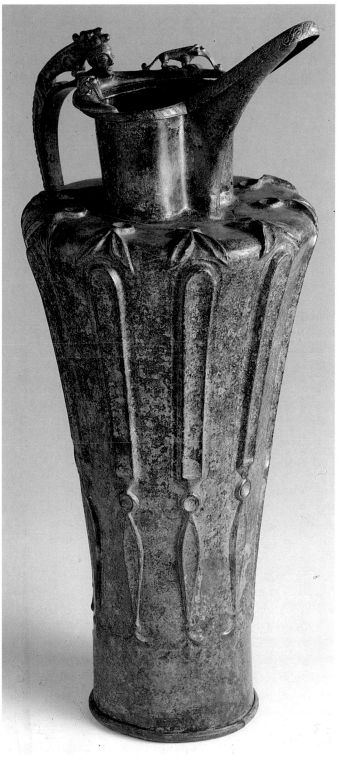

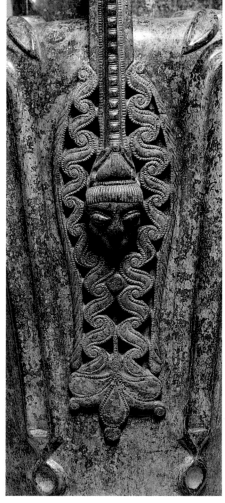

and arrow, and three lances. A small boat in sheet gold, complete with two oars, was provided for the journey of the soul into the next life.

In nearby tomb 46 more bronze mounts for a wooden jug, the cylindrical spout of which ended in a crocodile head, were found.

Of the many tombs found on the slopes of the Moserstein, the double burial of a man and woman (tomb 145) is particularly worthy of note. The pairs of bronze rings on his chest show that the man was wearing leather armor. Along with the usual sword and lance, he had a bronze helmet decorated with coral. The woman buried in the same chamber had a rich collection of fibulae.

Since 1964, the exploration of the large cemetery on the so-called Eislfeld, which borders Bavaria, has added a lot to our knowledge of the Dürrnberg site. The tomb of a priestess (no. 59) contained arm bracelets and gold hair combs, three splendid fibulae and a sort of scepter (a bronze disc set at the end of an iron shaft). Another priestess was accompanied by a symbol of the dignity of her office, a bronze sphere (tomb 118). There is a remarkable number of children's tombs, with rich collections of amulets and adornments.

The furnishings of the many warrior tombs found in the area of the so-called Simonbauernfeld in 1984 all contained daggers.

Along with locally-produced objects, the Dürrnberg tombs also contained a number of objects imported from distant lands. Along with the Greek *kylix* already mentioned there is an Etruscan beaked flagon (*Schnabelkanne*) and an amphora. A richly decorated gold ring may also have come from Etruria. Other imported objects may not have come down to us; but their existence is proved indirectly by the existence of local imitations. Take, for example, the two ringed flasks with spout and feet that recall Greek and Etruscan vessels. The stamp decoration of a pottery cup found at Dürrnberg corresponds exactly to the internal decoration of cups that were being produced in the classical world around 450 B.C.

Among imported raw materials the large quantities of amber from the Baltic deserve mention. The finds at Dürrnberg have also shown that there was close contact with the peoples of the southern Alps, in particular the Veneti. These contacts were considerable and involved different groups of the population. Not only were high-quality products imported, but their decorative motifs were copied in metal, pottery and cloth. Forms of fibulae that are typical of the southern Alps—the so-called "Certosa" fibulae, or the duck-head fibulae—were widespread among the Celts living in the foothills of the northern Alps. The Celtic *Masken* fibulae—of which a large number have been found at Dürrnberg—have the same structure as the Certosa type. The Venetic fibulae duck's head foot were the prototype for the Celtic bird-head fibulae.

The openwork belt buckles—which were worn by Celtic warriors from Champagne to Lower Austria—were based on models that came from the area at the foot of the southern Alps. Contacts with the Veneti were not limited to the exchange of goods—Venetic craftsmen actually worked for the Celtic "salt barons." One Hallstatt sword scabbard bears detailed engraving by a craftsman who clearly had a Venetic training; it represents the Celtic warriors of the northern Alps. The form of the scabbard is Celtic, but the engraving clearly corresponds to that of the so-called "art of the situlae" typical of the Venetic region and of the Hallstatt culture in Carnia. A bronze cup found at Dürrnberg—showing a deer hunt—allows us to suppose there was a Venetic craftsman working in the area. The type of object itself has never been found south of the Alps, but the decoration is carried out according to the "art of the situlae."

The presence in the area of Venetic craftsmen and merchants is also proved by the Dürrnberg tombs. The Veneti have their own tombs, which are distinguished from those of the Celts not by their structure but by their assemblages. In one tomb the entire hoard, both fibulae and weapons, are of Venetic origin. The fact that the man was laid to rest in the Celtic cemetery suggests that this foreigner had lived on the Dürrnberg for some time.

Umbilicate bowl in terracotta with stamped decoration from the Dürrnberg cemetery (Salzburg)
5th century B.C.
Salzburg
Museum Carolino Augusteum

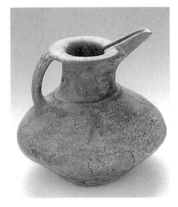

Wine flagon in terracotta with stamped decoration from tomb no. 103 at Dürrnberg (Salzburg)
5th century B.C.
Salzburg
Museum Carolino Augusteum

The Hellbrunnerberg

Ten kilometers away from the Dürrnberg is the important site of Hellbrunnerberg, near Salzburg. This steep-sided rocky plateau stands at the center of the Salzburg basin, and during the late Hallstatt period (the fourth century B.C.) was the site of a "princely residence." It is probable that the lords of Hellbrunnerberg controlled the Dürrnberg salt trade. The finds of the site—for example, the pottery imported from south and east of the Alps—revel extensive trade links with other areas. A small glass cup with handle found at Hellbrunnerberg has been shown to come from the southeastern Alps. A comparison with other types of pottery suggests that it was produced in the Santa Lucia region (Most Sve Soci) of the Isonzo valley. Seven of these glass cups were found in the Santa Lucia cemetery, and another three at Hallstatt. The Hellbrunnerberg specimen is the only one to have been discovered at a set-

Bird-head object in bone from tomb no. 102 at Dürrnberg (Salzburg) 5th century B.C. Salzburg Museum Carolino Augusteum

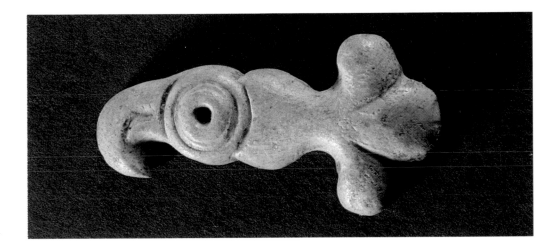

tlement rather than in a tomb. A bronze weight found at Hellbrunnerberg is a great help to our understanding of the complex trading links between the Celts and the Mediterranean world. It is disc-shaped, about 5 centimeters in diameter and 1.6 centimeters thick, and weighs 295.15 grams. On the basis of related material the weight can be dated around 500 B.C. It could come from the southeastern Alps—in particular, the Venetic region. Due to the lack of archaeological material there have been no studies of this area's system of weights and measures. It is worth recording, however, that the *minacorinzia* (= 100 drachmas) weighed 291 grams. Around 500 B.C. Corinth dominated trade in the northern Adriatic. Disc weights of this kind are known to have existed in Greece, so it is possible that the Veneti borrowed this system to use when trading with the Celts north of the Alps.

*Plan of chariot-tomb
at Somme-Bionne (Marne)
Second half 5th century B.C.*

In the second half of the nineteenth century there was a remarkable bout of treasure-hunting in Champagne, when many large La Tène cemeteries with impressive gravegoods were discovered. Peasants became skilled at prospecting and excavating, and were rewarded when the finds were acquired by keen collectors—including the Emperor Napoleon III. One of the finest collections was assembled by Léon Morel, a tax collector who lived in Reims and had connections with excavators all over Champagne. Few of the La Tène graves then excavated were adequately recorded, but it seems that a large number had already been disturbed. Sometimes the culprits were other nineteenth century excavators (there are records of graves having been opened on more than one occasion) but it seems that a lot of the damage had been done in the Iron Age. The most spectacular of the graves were cartburials, where the skeleton was found with the remains of a two-wheeled vehicle: at least 140 cartburials are known from Champagne, but very few were intact at the time of excavation. The discovery of an undisturbed cartburial must have been the ambition of every treasure-hunter in the area, and that is what was achieved at Somme-Bionne, thirty kilometers northeast of Châlons-sur-Marne, in December 1873. The burial was discovered by a Monsieur Hanusse, of La Croix-en-Champagne, whose father was also an experienced excavator: between them they had dug over a thousand La Tène burials by 1885. The grave for the cartburial was large, 2.85 by 1.8 meters and 1.15 meters deep, and it had been carefully cut to receive at least the framework of a two-wheeled vehicle. Two trenches had been dug for the wheels, so that the axle connecting them would have rested on the floor of the grave; a shallow trench in front would have received the pole, which appears to have been firmly attached to the axle; and a cross-trench at the end of the pole-trench held a harness and perhaps once housed a yoke. Morel was was soon told of the Somme-Bionne discovery, and he arrived in time to witness the excavation of the harness-trench.

Any woodwork in the grave had long since decayed, so the wheels were represented only by their iron tires, nave-hoops, felloe-clamps and linchpins. The skeleton was ful-

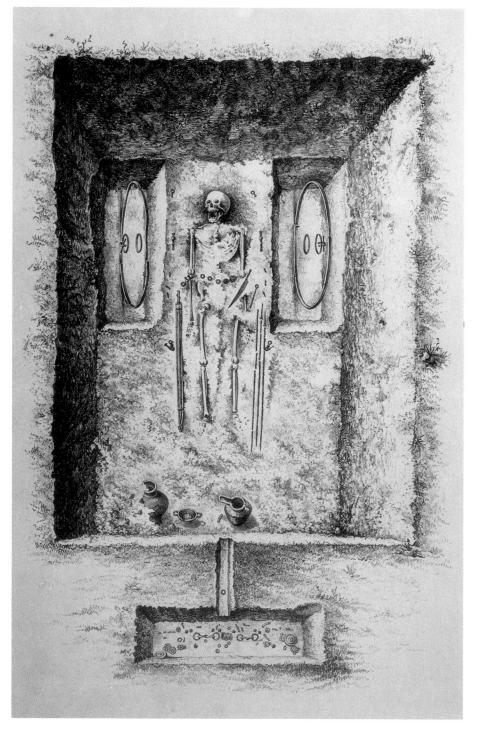

ly extended between the wheels on the line of the pole. Nothing of the bodywork of the vehicle had survived, but on the analogy of discoveries elsewhere the wooden vehicle might have been partly dismantled, to allow its body to be removed and perhaps inverted to form a canopy over the corpse. Buried with the skeleton, to the right of its legs, was a long iron sword in a bronze and iron scabbard which had been suspended from a belt whose hook is decorated with confronted animals. In a comparable position on the left side were three iron rods of unknown function, and over the left forearm was an iron knife. At the foot of the grave was a bronze Etruscan flagon, a painted red-figure Greek pottery cup (c. 420 B.C.), a decorated gold band—possibly from a drinking horn—and a single native pot. In recent years it has been suggested that the grave-group is unreliable, with the various items gathered from different sources to be sold to a guillible Morel. But this is perhaps unlikely: cartburial grave-groups are rare, and most of the artifacts here form an acceptable assemblage; the group was promptly published and displayed, and any doubts are likely to have been voiced by rival collectors and other interested antiquarians; and if a grave-group was being fabricated, then it is curious that more of the fine and readily available La Tène pots were not included. Indeed, the only native pot from the grave poses problems: it is shown (incomplete) only on the overall plan of the grave whereas all the other artifacts were illustrated in more detail, and it has never been identified in Morel's collection.

The Somme-Bionne burial is important as one of the best recorded examples of a cart-burial from Champagne, most of whose gravegoods still survive, with a Greek and an Etruscan import to demonstrate contacts (and chronological links) between the Celts and the Mediterranean civilizations. It takes pride of place in the collection that Léon Morel sold to the British Museum in 1901.

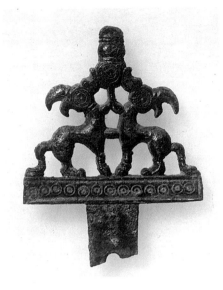

Openwork bronze belt-clasp depicting a pair of griffins from the chariot-tomb of Somme-Bionne (Marne)
Second half 5th century B.C.
London, British Museum

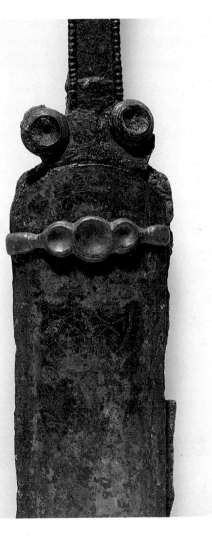

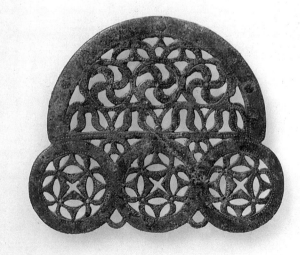

Openwork bronze phalera from the chariot-tomb of Somme-Bionne (Marne)
Second half 5th century B.C.
London, British Museum

Mouth of bronze scabbard with engraved decoration from the long sword from the chariot-tomb of Somme-Bionne (Marne)
Second half 5th century B.C.
London, British Museum

175

The Léglise Barrow Cemetery
in the Ardennes (Belgium)
Anne Cahen-Delhaye

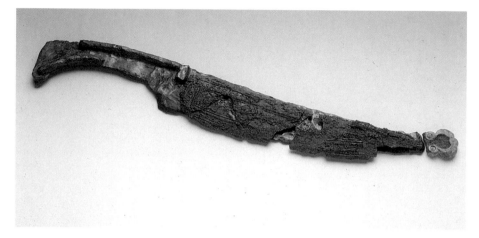

*Iron dagger with leather
relief-work sheath and bronze chape
from tomb no. 1/1 at Léglise
(province of Luxembourg)
Second half 5th century B.C.
Brussels
Service National des Fouilles*

The shale plateaux of the Ardennes on the extension of the Eifel mountain range along the Rhine, less than 100 kilometers north of Champagne, was colonized at the beginning of the fifth century B.C. by a tribal group that performed inhumation burials in barrows furnished with lavish grave goods.

In the course of two separate campaigns in 1974 and 1984 a rich cemetery at Léglise dating from the start of La Tène 1 was excavated. The cemetery was classically sited on a hilltop, and included twelve barrows ranging from fourteen to twenty-four meters long, but only fifteen to seventy centimeters high.

Each barrow contained from one to four graves, usually dug into the ground at the time of burial itself. They were filled in with a darker, softer soil, rather than with the surrounding infill. The cemetery comprised nineteen inhumation graves (four with chariots), and two cremation pyres. In various cases, both inhumation and cremation burials were found in the same barrow. Most of the burials were male, and three contained the remains of children under six years of age. There is evidence to suggest that the smallest chariot-grave was for a woman. The layout of the graves, roughly oriented along a northeast-southwest axis, is quite unusual for cemeteries in the Ardennes.

The grave goods are akin to the fifth-century Champagne repertoire: the women wore a pair of bronze armlets, smooth or twisted, a smooth torque (including one tubular torque). Alongside the bodies of the men were laid offensive weapons such as spears and javelins, the iron tips of which had a midrib and sometimes a groove: some of the deceased had two rings for hanging a weapon or tool on their belt.

Other items include flat tanged daggers with riveted hilts; one dagger had a leather sheath (well-preserved thanks to the oxide of the blade) decorated with embossed geo-metric and floral patterns.

Accessories included a fibula with vertical foot attachment—a common variation found throughout the Ardennes—and several iron belt-clasps of a strictly functional type.

Most of the pottery objects incorporated in the grave goods are carinated pieces, closely related to those of Champagne; types include situlae with geometrical painted decoration on the upper section, in the form of alternating red bands and black lines; other vessels are decorated with simple geometrical patterns repeated in grid fashion. There are also many polished conical beakers, and a large carinated urn in the form of a krater, its shoulder decorated with lozenge patterns.

Many tombs are unusually large and their shape is determined by the chariots on which the bodies were laid. The furrows were trapezoidal or triangular with curved, oval grooves to accommodate the wheels of the chariot, and a large opening to take the shaft, while the yoke was propped on infill. These graves gave vital clues as to the shape and size of the vehicle, of which only a few scraps of iron remain, including the metal tires and a decorative hub attachment.

The graves have also yielded horses' gear, usually iron horse-bits in pairs, between nine and fourteen centimeters wide, which suggests the presence of horses of various sizes, from ponies to riding-horses. Two graves also contained bronze mounts with fine openwork detailing, formerly fitted to the bridle straps. The mounts bore a running chain of triskelions forming a rosette, similar to the pattern on a yoke found at Somme Bionne in Champagne.

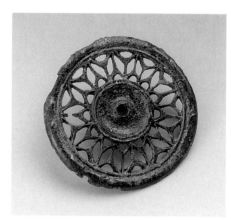
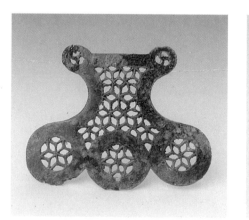
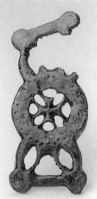

*Openwork bronze phalerae
from chariot-tomb no. IV/I at Léglise
Second half 5th century B.C.
Brussels
Service National des Fouilles*

The Barrows of the Jura
Gilbert Kaenel

*Original documents of the
excavation of a barrow, directed
in 1856 by Frédéric Troyon
in the forests of Vernand-de-Blonay
near Lausanne (Vaud)
Second half 5th century B.C.
Lausanne, Musée cantonal
d'histoire et d'archéologie*

A fundamental change in funerary practices in the cemeteries on the Swiss plateau took place during La Tène A at an advanced phase at Münsingen-Rain (or, according to our interpretation, earlier, at the center of the cemetery of Saint-Sulpice-En-Pétoleyres). This made it possible to assess with more accuracy a series of secondary graves in Hallstatt barrows, grave which are attributed to a period prior to this sweeping change in the concept of death held by the Celts of the Jura and the Swiss plateau. Unfortunately, the information comes from excavations carried out midway through the 1800s. Despite this, the documentation is complete enough to reconstruct associations, at least in some cases. Good examples are the excavations conducted by Frédéric Troyon in 1856 at Losanne-Vernand-de-Blonay, and those at Rances-Les-Montet in 1861 and 1862. In one barrow containing a principal Hallstatt burial and some secondary graves attributable to Hallstatt D1, D2, and D3, there were some inhumation burials that undoubtedly dated to La Tène A. Neither the rite nor the funerary practices distinguish these from the preceding Late Hallstatt burials—the only difference was in the grave goods, which were distinctly La Tène. Through comparisons with other finds in other regions, particularly in the middle Rhineland in southern Germany (the Hunsrück-Eifel culture), it was possible to date them to an early phase of La Tène A (fifth century B.C.). Some "technological links" with Hallstatt emerged clearly: the belt attachments, decorated with an engraved geometrical pattern of running S-shapes and compass-drawn circles belonging firmly to the ornamental repertoire of Early Style, tubular rings with three rivets, fibulae with foot and with the bow cast-molded on a clay core, and ornamented with a crest, crossbow-shaped fibulae, various knobbed ring ornaments, and tubular rings or with eyelet clasps, complete the horizon.

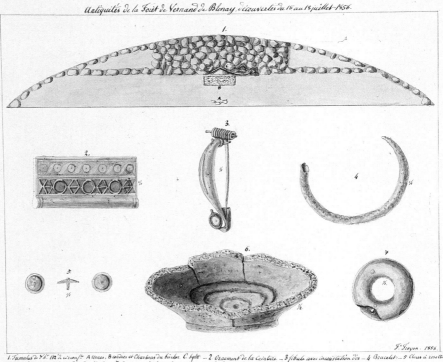

This evidence, found mainly in barrows in the Bern area, is admittedly tenuous, since in most cases it does not consist of scientifically documented associations of objects. Nevertheless, it suggests that the Jura was an area in which the La Tène culture (characterized by new types and styles in the grave goods) was rapidly implanted at the earliest phase of its development, without an obvious breach in Hallstatt traditions. From here it seems that it continued without interruption.

In the French Jura in Pontarlier, at a height of 800 meters above sea-level, excavations let by Pierre Bichet and Jacques-Pierre Mil-lotte over the last three decades have revealed the same phenomenon in the start of Early La Tène in the secondary graves of Hallstatt and Bronze Age barrows, together with original developments in certain ornaments.

Further east, in the Soletta and Basle area of the Jura hillside, a similar interpretation was proposed by Geneviève Lüscher. The most recent barrow grave was found at Obsergögen? in Canton Soletta; the grave dates from La Tène B1 (fourth century B.C.), a period in which there was a surge in "flat" grave cemeteries in Münsingen and Saint-Sulpice.

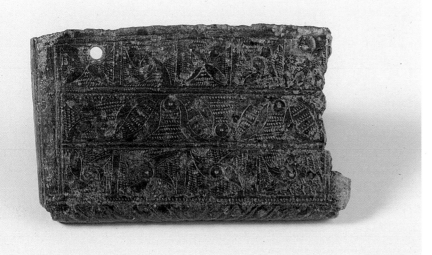

*Belt-plate in sheet bronze with
engraved decoration from the
barrow at Rances-Le Montet
(Vaud)
Second half 5th century B.C.
Lausanne, Musée cantonal
d'histoire et d'archéologie*

Kleinaspergle near Asperg
Kreis Ludwigsburg
(Baden-Württemberg)
Franz Fischer

Drinking-horn and other gold leaf
objects, silver chain
from the princely barrow-tomb
at Kleinaspergle (district
of Hohenasperg, Baden-Württemberg)
Second half 5th century B.C.
Stuttgart
Württembergisches Landesmuseum

The Kleinaspergle, a burial tumulus that is now 7.6 meters high and has a diameter of 60 meters, is the only funerary monument in the area around the Hohenasperg (only 1,000 meters away) to have retained anything like its original size. Two hundred meters to the east there used to be a twin tumulus, probably of the same dimensions as the Kleinaspergle. In 1879 the geologist Oscar Fraas used mining technology to dig a tunnel through the tumulus and explore it. In 1963 Hartwig Zürn identified a circular ditch in the tumulus (2.5 meters wide and 1.2 meters deep), and noted that the central wooden chamber (3 by 4 meters) had sunk 2.8 meters into the soil, and that it had been looted a long time before. To the west, Zürn found a more recent wooden structure (3 by 2 meters) at what had been ground level; this new addition meant that the tumulus, originally quite small, had been considerably enlarged. The second chamber contained a tomb of the Early La Tène period which later became famous. It was intact, but because it was explored by the light of a miner's lamp a lot of details were overlooked. Fraas did not find any skeleton, there was a pile of calcined bones (since disappeared) which he took to be the remains of a cremated body. The metal vases and the two Attic *kylixes* found on the site were restored at the Römisch-Germ-

anisches Zentralmuseum in Mainz. A further restoration, carried out shortly afterwards, revealed important new features.

Along the east wall of the chamber was a line of metal and pottery vases. At the northern end there was a large bronze cauldron (diameter 0.79 meters, height 0.33 meters), but no sign of handles. This vessel was of a well-known type and originally contained the remains of a wooden ladle (that has now disappeared). Nearby was a ribbed bronze bucket (height 0.24 meters). Berta Stjernquist has ascribed this to a relatively compact group of objects which she has called the "Ticino Group" because they are mainly to be found in the Ticino region. Next to this was a bronze *stamnos* (height 0.34 meters); according to tests carried out by B.B. Shefton, this piece comes from a group that was probably manufactured at Vulci or somewhere else on the Etrurian coast. Then comes the famous *Schnabelkanne*. Its recent restoration at Mainz has confirmed the fact that the bronze jug (total height, 43.5 centimeters) is slimmer than initially supposed, revealing that the piece is probably the oldest one of a group of locally-made Celtic jugs in metal and pottery, the most beautiful of which are those of Basse-Yutz in the Loire Valley and of Dürrnberg near Hallein. The handle of the Kleinaspergle jug clearly recalls an archaic

monkey head design but also shows how the Celtic artists re-elaborated the form: the re-working of the classic palmette design is especially original.

Next to these utensils there were two drinking horns, but only their gold end-tips remain. Their decoration, with its animal-head motif, particularly recalls work from Iran and the Black Sea area. The second of the two pieces should be seen as a copy of the first. These ornaments were attached to the natural horn using a complicated procedure. The completed horns most probably had several decorations in sheet gold, as well as a silver chain.

In front of the horns were the two Attic *kylixes*. Sir John Beazley dated the red-figured *kylix* by "the Master of Amphtrites" to around 450 B.C.—a date confirmed by subsequent work by Elke Böhr. The elegant black burnished *kylix* is attributed to Sotades. Both had been decorated with Early La Tène goldwork—perhaps to hide the chips around the rim. In the center of the burial chamber there were also an iron plaque covered in sheet gold, an iron belt clasp and a simple lignite bracelet. It is not easy to interpret this burial assemblage—one of the most important Early La Tène finds in central Europe. What stands out is how things are paired, from the two drinking horns, usually found in

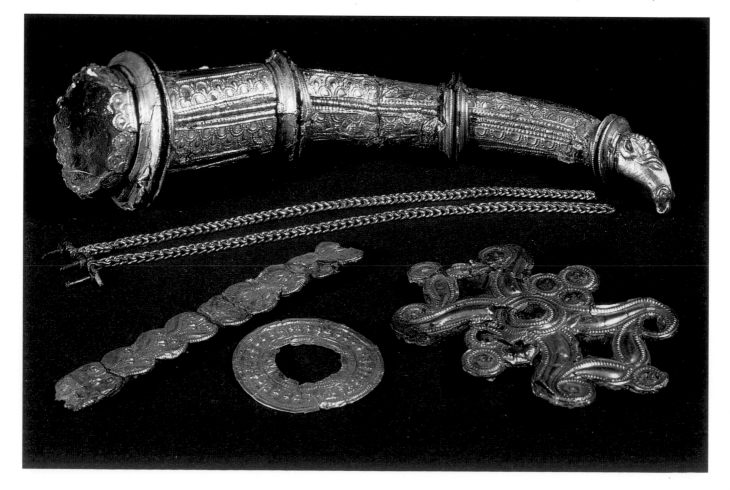

Celtic tombs, to the two Attic *kylixes*. The bucket and the *stamnos* are to be seen as containers for alcoholic drinks (maybe of different kinds): the bucket is also a "legacy" from an earlier generation. The large bronze cauldron and wooden ladle must also have served the same purpose.

It is difficult to decide if the tomb housed a man or woman—both hypotheses have been considered. The absence of weapons would support attribution to a woman, but the belt fastening (no matter how modest it may be) is definitely from a sword belt—and the lignite bracelet also supports the "male grave" theory. The Master of Amphritites *kylix* and the cist both confirm a date some time after 450 B.C.—probably around 420. Which means that the Kleinaspergle La Tène tomb is the most recent of the Hohenasperg princely burial sites.

*Openwork iron plaque
covered in embossed gold leaf
from the princely barrow-tomb
at Kleinaspergle (district
of Hohenasperg, Baden-Württemberg)
Second half 5th century B.C.
Stuttgart
Württembergisches Landesmuseum*

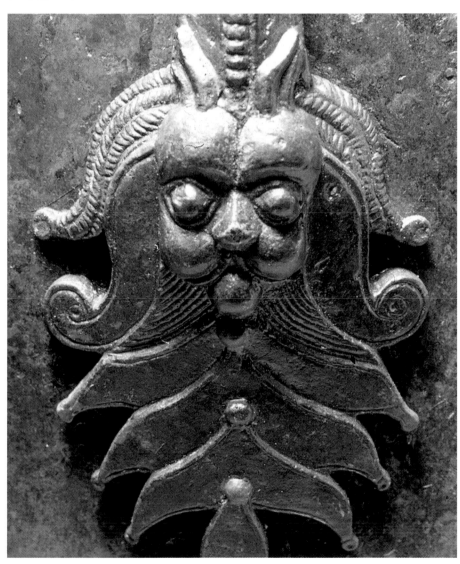

*Detail of the lower handle join
of the bronze wine flagon, inspired
by an Etruscan prototype from
the princely barrow-tomb
of Kleinaspergle (district
of Hohenasperg, Baden-Württemberg)
Second half 5th century B.C.
Stuttgart
Württembergisches Landesmuseum*

The Hillfort and Sanctuary of Závist
Karla Motyková, Petr Drda, Alena Rybová

Aerial view of excavation on the Závist sanctuary (Bohemia) 6th-5th century B.C.

Selection of bronze objects from the Závist sanctuary excavation (Bohemia) 6th-5th century B.C. Prague, Archeologický ústav ČSAV

Midway through the sixth century, right in the heart of Bohemia on the southern rim of the Prague basin, above the confluence of the Vltava (Moldau) and Berounka rivers, the Celts founded a settlement that was to become a major focus of Celtic power. The picture of this settlement has been slow in coming, but it is one of the greatest discoveries of contemporary Czech archaeology. The emergence of the Burgwall hillfort of Závist was the natural outcome of cultural changes that marked the close of an era in which the ancient realm of the princes of Bylany began to succumb to the burgeoning influence of the tumulus culture from southern and western Bohemia. This cultural area was directly linked to the regions of southern Germany, considered to be one of the classical areas of the Celtic homeland. The old Celtic settlement of Závist owed its imposing character to the craggy shoulder of land towering 200 meters over the Moldau. Initially, the encampment was not fortified though the summit of the tor was already the site of a *nemeton*. A workshop located on the road leading to this sanctuary, and clearly related to it, produced various kinds of bronze ornaments and objects with magical attributes, which were peddled not only among the local population but also to outside visitors to the sanctuary. At the turn of the sixth century, the settlement was enclosed by a solid earthen bank with timber palisading and a broad timber-laced rampart. The strongest section of the fortification contained the main gate (D) protecting the entrance bastion. The same defense system was applied to both the inner enclosure with the sanctuary and the southern area. The eastern area, which spread across a tract of flat land outside the main entrance, apparently had an exclusively commercial designation, which explains the less imposing outworks. The three-part defense system by this time had attained its maximum extension, covering a full ninety hectares of land. The stronghold reached its peak at the beginning of La Tène, during the fifth century B.C. The bulwarks were completely rebuilt and supplied with a masonry wall, while the main gateway (D) was enhanced

with stone bastions. The impressive architecture of this gateway sanctions the idea that the inner enclosure harbored an important seat of power. Excavations have not yet allowed us to identify the exact spot, but all the clues point to either of two strategic vantage-points commanding the Moldau river. The seat of great power may well have resided in an Early La Tène farmstead close to Závist, dating from the fifth century B.C. and brought to light thanks to a rescue excavation at Dolní Břežany, just 3.5 kilometers away as the crow flies. On a low protected hill stood a sizable royal dwelling accompanied by assorted outbuildings and dwellings. The value and the nature of material recovered at the site suggest the owner was of high rank, and indicated direct links with the center at Závist. The housing structures discovered in the Burgwall of Závist resemble scattered farmsteads with unpopulated areas for agriculture.

The architecture of the sanctuary on the summit of the fortified wing had a complex evolution. Sometime between the sixth and the fifth century the original palisaded rectangular *nemeton* was augmented with large timber-built dwellings. The buildings were arranged symmetrically along a central street leading to the entrance of the cult area: the constructions on the east side of the quadrangle were linked to it not only chronologically but also in terms of function. It seems that they were used by the group of inhabitants of the enclosed area from the end of Hallstatt, who were the

strongest devotees of the cult. A palisade of stout timbers set around the outside of the constructions most likely separated the ancient acropolis from the non-sacred area. The entire complex of the sanctuary and adjacent fortification were burned to the ground in the first half of the fifth century B.C., for causes as yet unknown. The fact that the flames spared the solid fortification line on the bastioned main gateway (D) would imply that the fire was not the result of armed attack from without.

The *nemeton* was promptly rebuilt, its acreage increased, and an impressive wooden building took the central position. The building, with its twin naves supported by wooden pillars, measured nine by eighteen meters and had a sturdy pitched roof with four sides.

Given its central position within the enclosure thirty-six meters square, the building was in all probability a temple. Around the site another fenced-in area stretched to the southeast as far as the new stone wall. Several objects of exceptional beauty found in and around the temple date from Early La Tène. They also attest to the growing development of "international" contacts between this seat of power and the more far-flung Celtic lands, including distant Champagne.

Around the middle of the fifth century B.C. there was a radical change of design; the ancient *nemeton* was enhanced with a second square enclosure containing the *temenos*, with a single entrance. This *temenos* was complete with its own line of for-

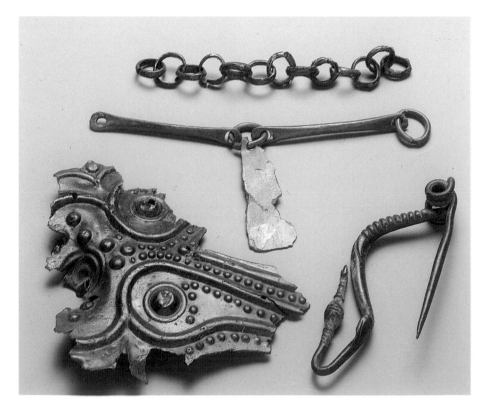

tification, which included a broad ditch and a masonry wall giving it the appearance of a citadel. This overall plan was new to Celtic lands north of the Alps. It marks the first implementation of the Mediterranean concept of the sacred enclosure. However, the architectural plan was radically altered to meet the needs of the Celtic religion, thus generating a unique architectural design. The Mediterranean ingredient is recognizable in the idea of the *temenos* as a closed, fortified locus enclosing the various sacred buildings, casually arranged and mainly built in stone. The largest of these is building I (27 meters long and 11 meters wide) and consists of a base of seven separate courses of walling which even today reach a height of 4 meters. Both the height and the technical expertise are strongly reminiscent of the Etruscan temple bases, which most likely served as models for the masons of Závist. The scattered remains of burnt timbers suggest that, here too, the base was surmounted by a wooden tabernacle. The main temple faced two separate constructions. The first, marked IV, is a low, almost square podium, reaching a maximum height of 1.5 meters; the containing wall was in stone, and the space inside simply filled with earth with no other reinforcement. The vast floorspace of almost 160 square meters leaves ample room to imagine what kind of ceremonies might have taken place there. The second construction, marked V, attracts attention with its triangular floorplan and the unusual masonry of the walls, which reach a height of almost 4 meters. The sides of the triangle, respectively 9, 10, and 11 meters long, form a daring, sharp-angled plan that required great building ingenuity and may well have obeyed some Celtic spiritual dictates. This is the light in which this kind of architecture is best assessed. The three-sided form may have symbolized the Celtic sacred trinity. The corner-posts do not serve structural purposes alone, and may have been carved with anthropomorphic details consecrated to one of the Celtic deities. Structure V was without doubt an open-air altar, but may even have doubled as an observatory for astronomical purposes.

Roughly midway between the triangular altar and the entrance to the sacred precinct stood a large building sunk a full meter into the ground. The walls still bear traces of burnt wicker trelliswork or some form of cladding in wood. The original appearance and purpose of this building are still largely hypothetical, but it may perhaps have been a sacrificial pit linked to a chthonic cult. In the Etruscan religious precincts similar pits performed the function of *bothroi* or *magmentaria*. The former were for libation sacrifices, either with blood or with beverages that soaked into the bottom; other offerings were placed in the *magmentaria* ditches. In this respect, the building in the

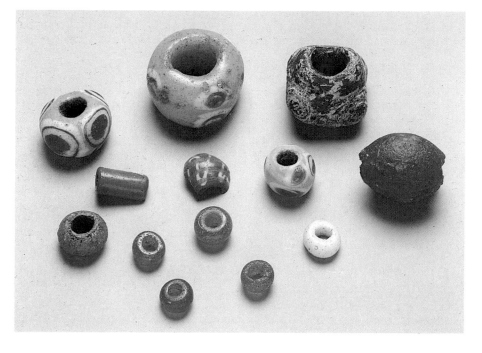

Závist acropolis needs much further study. The rudimentary construction of wall II with two layers of stones, 18 meters long and over 3 meters high, suggests that it belongs to the Závist sanctuary's earliest period. Within the acropolis it screened the sacrificial pit from the other sacred buildings. During the first phase of the sanctuary's evolution a second partition wall was added (marked III), 30 meters long and also over 3 meters high, closing off the entrance area. The low podium (marked IV) was built against it next to the filled-in sacrificial pit, and provided the conclusive architectural element of the fortified acropolis of the fifth century B.C.

The last modifications of the Závist acropolis marked the pinnacle of an evolution that lasted from the mid-sixth century to the first third of the fourth century B.C., a span of roughly 170 years. The last works involved the addition of stone caissons to create a vast raised oblong plateau. The older stone sections are still all hidden below ground. It would appear that the vast structure was never completed. We have managed to locate at its center a vast sunken structure which suggests the revival of chthonic cults. The final alterations, which erased the earlier Mediterranean arrangement, once again allow us to label the site as a Celtic *nemeton*. The wars between the first and second quarter of the fourth century B.C. triggered by the arrival in Bohemia of Celtic invaders from western Europe, clearly affected the seat of power at Závist in Early La Tène. The political upheaval was sudden, and the fortified center sank into oblivion. Scattered fragments of stone sculpture unearthed below the abandoned acropolis bear silent witness to these dramatic events.

Manětín-Hrádek
Eva Soudská

A cemetery the beginning of which is currently dated to the middle Hallstatt C period and the end to the final phase of La Tène A was excavated in the sixties and seventies in southwest Bohemia (Czechoslovakia), on cadastral territory of Manětín, community of Hrádek. The earliest Phase I is represented by interments with burial chambers and with rich pottery, and in one case with horsebits of iron. The pottery shapes include, in addition to those typical of the southwest Bohemian region, items indicative of close contacts with both the central Bohemian region—characterized by the Bylany culture—and Bavaria. Their date is Hallstatt C2. No Hallstatt C1 materials have been found here; with reference to the Grosseibstatt cemetery, the dating in absolute terms may be about the last quarter of seventh century B.C.

Phase II falls within the period Hallstatt C3-Hallstatt D1, in terms of absolute chronology, around 600 B.C. Graves of this phase have less pottery but they have yielded, in one case, a set of bronze items (a neck-ring, a bracelet and an anklet of a slightly stirrup-shaped form together with two clay rattles. In another grave there was an iron spear and in a third grave a toilet set was found.

The core area of the cemetery consists of Late Hallstatt to Early La Tène graves of the Phases III-V, dated into Hallstatt D2-3/La Tène A. The comparison with the Dürrnberg-Hallein cemetery, to which strong cultural links may be observed, indicates absolute dating to around 550-450 B.C. Graves laid on the ancient surface and covered by funerary barrows belong to Phase III. In addition to pottery (*terrina* bowls, bowls with polished-in ornaments, etc.), graves of this phase yielded hollow bracelets of sheet metal, a plating of a fibula disc made of gold or golden ringlets, exceptional fragments of an iron knife. (The date is Hallstatt D2-3.)

Phase IVA makes up a closed group in the west section of the cemetery. This consists of small cremation graves accompanied solely by pottery finds (bottle-shaped vessels, *terrina* bowls, plain bowls). The date is the beginning of Hallstatt D3.

Graves of Phase IVB (peak Hallstatt D3 period) display the highest diversity both in the layout of the grave pits and in the equipment. From these graves come such pottery shapes as *terrina*-like forms, bottle-like forms, situla- and post-shaped vessels and, moreover, blue and yellow glass beads with blue eyelets, bracelets of bronze made of metal rods, other bracelets of silver wire, fibuale or their parts, a few discs of amber plated in gold, neck-rings of the torque type, iron spears and iron knives-choppers. Grave 196, with a two-wheel chariot and with decorative harness discs (*phalerae*) belongs here.

Phase IVC includes graves with wheel-turned pottery decorated with simple stamps, fragments of a *phalera*, belt clasps, spears, a glass bead, etc. (The date is high La Tène A.)

Graves of Phase V belong to the high and terminal La Tène A period. Unlike all the preceding phases which display a cremation rite, uncremated bodies of the deceased were now laid to rest in oblong chamber graves oriented north-south and sunk in rows. The burials were equipped with wheel-turned and richly stamped pottery (bottle-like shapes, Braubach-type bowls, etc.), mask fibulae, fibuale of wire with birds' heads approaching the *Marzabotto*-type fibulae, torques, neck-rings of iron,

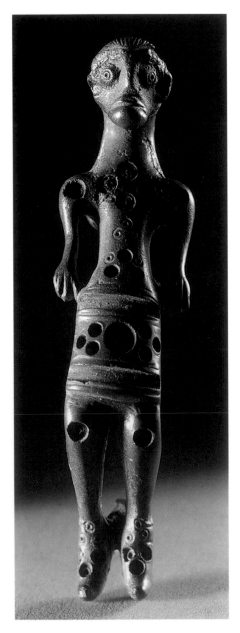

Pottery bowl with stamped decoration from tomb no. 99 at Manětín-Hrádek (Bohemia) Second half 5th century B.C. Prague, Národní Muzeum

Bronze fibula in human form from tomb no. 74 at Manětín-Hrádek (Bohemia) Second half 5th century B.C. Prague, Národní Muzeum

bronze bracelets (sometimes of wire with three swelled-up protrusions), beads of yellow and blue glass or of amber, with amber pendants and iron clasps. Unlike Phase IV, weapon finds include only choppers.

Both anthropological and archaeological analyses reveal something about the social structure of the group which laid its deceased to rest here. Both disciplines indicate that these belonged to a socially superior stratum. One of the most telling clues is the fact that a child's grave (on anthropological determination) contained a symbolic weapon gift (an iron spear of smaller dimensions). The body buried in the grave with the two-wheel chariot was anthropologically determined as a younger individual or even a child.

The ethnic classification of the occupants of this cemetery is clear. The well-discernible La Tène A character of Phase V leaves no doubts that they belonged to one of the Celtic tribes. In view of the fact that the cemetery served without interruption since Hallstatt C2, it appears virtually certain that it was used by a single ethnic group that was highly receptive to the gradually arriving cultural impulses from the southeast, including transformation of the burial rite.

An open question is the cause of the sudden abandonment of this cemetery (but not only this one) and, in consequence of this, the end of settlement of the entire southwest Bohemia. One of the possible explanations refers to the beginning of a migration phase possibly initiated by ecological transformations. Close contacts with Bavaria and Upper Austria, together with the evidence of an analogical but uninterrupted development from the Hallstatt to the Early La Tène period (even longer in some places) in these territories, implies that some of the Celtic tribes living there might have emerged in southwest Bohemia.

Conclusion

The cemetery at Manětín-Hrádek belongs to the seventh to sixth, possibly also to the fifth century B.C. In this time, the territory under consideration, together with Bavaria and Upper Austria, saw the emergence of Celtic tribes and of their rich and varied cultural contacts with the southeast, especially with Greece and north Italy. The abandonment of the cemetery was obviously connected with the interruption of settlement life in this whole region in the fourth century B.C. This may perhaps be explained with reference to an ecological situation or even by the well-known phenomenon of migration and expansion of Celtic tribes which gained its momentum at that period of time. Such a situation might be indicated by the marked prevalence of female and children's graves over exceptional male interments in the course of the latest phases of the site.

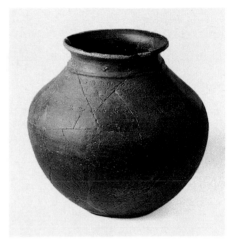

Pottery vase with stamped decoration from tomb no. 116 at Manětín-Hrádek (Bohemia) Second half 5th century B.C. Prague, Národní Muzeum

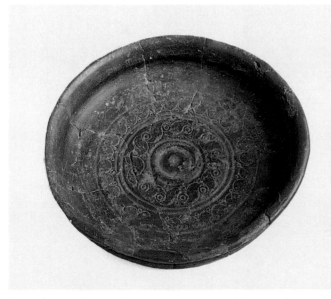

Pottery bowl with stamped decoration from tomb no. 66 at Manětín-Hrádek (Bohemia) Second half 5th century B.C. Prague, Národní Muzeum

Pottery flask from tomb no. 13 at Manětín-Hrádek (Bohemia) Second half 5th century B.C. Prague, Národní Muzeum

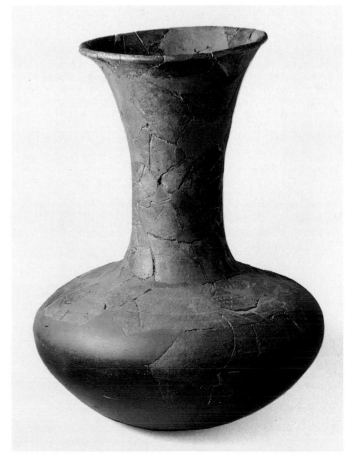

The Finds at the Chýnov Settlement
Pavel Sankot

The tumulus cemetery in the Chýnov wood was first discovered in the first half of the nineteenth century. The results of the excavations carried out during the following decades show that the site was in use from the later Bronze Age to the Early La Tène period. One particularly interesting find was the *Maskenfibel* (mask fibula) discovered by Jan Felcman during an exploration of sixteen tumuli in 1902. J.S.V. Megaw found stylistic similarities between work produced in the Rhineland and this Chýnov fibula, which V. Kruta says marks one of the outer-limits of the spread of La Tène material in Bohemia. Like the other eastern La Tène mask fibulae, this one is noteworthy for the fantastic nature of its decoration. It is a Certosa-type fibula, decorated with a pair of masks, and a setting of coral and two rows of *beads* along its bow. A *Dreiknotenring* (triple-knobbed ring) was found with it, which enables us to date the fibula to the second half of the fourth century B.C., one of the latest examples of the type.

Recent excavations have enabled us to see the site in its wider cultural and economic context. Furthermore, we can also consider Chýnov as the model for a series of similar sites to the north of Prague which have been severely damaged by intensive agricultural activity in the area. One common characteristic of these sites is the situation of a tumulus cemetery on the edge of an upland overlooking a valley along which flows one of the tributaries of the Moldau. The Chýnov wood still contains forty tumuli, the remains of a much vaster cemetery.

Another common characteristic is the presence of settlements that are contemporary with the tumulus cemeteries and are situated a few hundred meters lower down the side of the valley. The first of these settlements—500-550 meters from the site and 60 meters lower in altitude—contained a series of hand-made pottery in the Late Hallstatt tradition along with more delicate, wheel-turned, pottery sometimes bearing stamped decoration which, together with a belt buckle in open-work bronze, dates to the Early La Tène period.

The second of these settlements, contemporary with the tumulus cemetery in the Chýnov wood, was situated 800 meters from the southwestern limit of the cemetery itself. The hundreds of objects found there show that the site was inhabited from the mid- Bronze Age to the Early La Tène period. It is to the latter period that the most interesting find so far dates: a collection of iron objects found buried beneath the floor of a hut (no. 21/82), alongside a storage jar. The collection includes elements of fighting equipment (a spearhead and spear, arrowheads, the buckle and rings of a belt, sword-blade fragments), metalworking tools (hammers and files), carpentry tools (knife and chisel) and farm implements (scythes). There are also bone ornaments.

Given the wide variety of objects in the collection representing different trades and the fact that it was buried under the floor of a house, I suggest that it definitely has some specific ritual significance. However, the find is of further significance in that it reveals much about the standard of life in Early La Tène society, containing as it does objects that were previously only found in Middle to Late La Tène sites.

The pottery found at the same level as the hut 21/82 may be dated to the end of the La Tène A period, perhaps to the transition from La Tène A to La Tène B. This means it corresponds to the date of the *Maskenfibel* found in Chýnov wood and of the *Dreiknotenring* that Felcman discovered during his excavations—that is, to the last phase of La Tène A. This period could be considered a turning point: without any abrupt break with the recent Bronze Age, the local culture was radically changed by the arrival of groups of Celts who are known to historians through their practice of burying their dead in flat cemeteries. It is no accident that the largest example of such a cemetery in central Bohemia is to be found in the nearby area of Letky (close to the town of Libčice nad Vltavou). The oldest burials at that site are, in fact, contemporary with the latest tumuli so far revealed by excavations at Chýnov.

Worked bone object (knife pommel?) in the form of an animal head from the Chýnov settlement (Bohemia)
Second half 5th century B.C.
Roztoky, Středočeské Muzeum

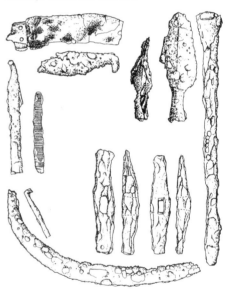

Iron objects (sickle, hammers, chisel, spearheads, files, knives) found in the Chýnov settlement (Bohemia)
Second half 5th century B.C.
Roztoky, Středočeské Muzeum

Bone instruments from the Chýnov settlement (Bohemia)
Second half 5th century B.C.
Roztoky, Středočeské Muzeum

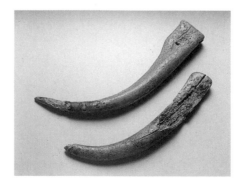

The Early La Tène Court Residence at Droužkovice
Zdeněk Smrž

The basin area of northwest Bohemia, roughly delimited by the Krušné Hory/Erzgebirge (Ore Mountains) and by the Ohře/Eger and Labe/Elbe rivers, contains in a tertiary brown-coal stratum some 80 percent of all the coal reserves of Czechoslovakia. In the course of the last forty years, some 150 square kilometers of this landscape have been destroyed by open-cast mining. One of the hundreds of sites, investigated prior to its total destruction, was the Early La Tène court residence at Droužkovice (La Tène A, i.e. the fifth century B.C.).

The whole court, with an area of 8.680 square meters, consisted of two parts: the central enclosure and a subsidiary enclosure of a large *Grubenhaus*, situated in its northwest corner. The dimensions of the central enclosure consisted of a continuous palisade sunk into trenches about one meter deep. It was unfortunately impossible to investigate in more detail the timber and post structures inside the enclosure. A small hut was situated between the palisades on the east side where a narrow entrance was located, and an interruption of the internal palisade contained a simple building in which iron-working had occurred (a smithy?).

The double palisade enclosure of the large house delimited an area of 718 square meters. The south side could have been barred by some light construction, the entrance to which was obviously through the house. The timber house (feature 1), where the exhibited sculpture was found, was 6.5 by 7 meters; it was sunk one meter into the ground and its east side was fortified by a stone wall. The character of the finds and the results of phosphate analysis point to the conclusion that the whole court was inhabited for a short period of time or not very intensively.

It is commonly assumed that northwest Bohemia belongs to the territories considered as "the cradle of the Celts." Up to now, we know of three court residences of the Droužkovice type in Bohemia. Two of these (Krašovice and Praha-Hloubětín) are disturbed and difficult to evaluate because of repeated settlement activities; the third site is being excavated. Such courts, frequently fortified by ramparts and ditches and interpreted as residences of "big men," have been found in a larger number in the Bavarian part of the Danube, where they have been discovered mainly thanks to aerial surveys.

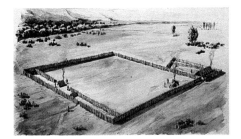

Reconstruction of the Droužkovice settlement (Bohemia)
Second half 5th century B.C.

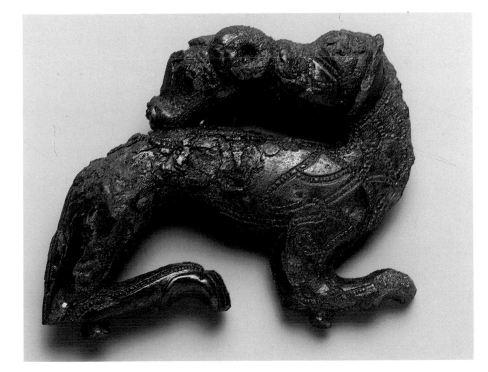

Bronze depicting a dog devouring a ram's head from the Droužkovice settlement (Bohemia)
Second half 5th century B.C.
Prague, Archeologický ústav ČSAV

The Princely Tombs of Chlum
Jan Michálek

By the beginning of the fifth century B.C. the early Celtic princedoms of the Upper Danube and Rhine, of Burgundy and the present-day Côte d'Or were in decline—a decline that was finally to involve the regions of the middle-Rhine, Champagne, the Oberpfalz, Austria and Bohemia. At the same time, importations of Etruscan products—in particular, serving sets for the ceremonial meal of the dead—from the Mediterranean area into central Europe continued to increase. One of the routes these products traveled over started in the Po Valley, passed through the Salzburg area (Dürrnberg, near Hallein), continued along the course of the Salzach, Inn and Ilz rivers, probably passing by the hill of Kunzvart, and ended in western Bohemia. These imported objects are concentrated in Bohemia and the Rhine region. They are to be found where there were surface deposits of iron minerals (Chlum, Prague 4-Modřany?), or on the route that ran north-south along the Moldau from the rich rock-salt deposits of Dürrnberg (Hradiště and the area around Písek, Prague 4-Modřany and Chýnov). The finds in the Písek area, however, are slightly shifted with respect to the rest, into an area that was rich in secondary gold deposits.

All the princely tumuli in Bohemia are characterized by the similarity of their serving sets for the ceremonial meal of the dead. In fact, they are almost identical. The presence of a pair of cups (each one accompanied by one or two *Schnabelkannen*) is typical of the whole eastern zone of early Celtic culture, for example: 1. burial tumulus of Chlum: a bronze *Schnabelkanne*, two cups; 2. Hradiště, tumulus 1/1858: a jug, two cups, a silver cup with filter; 3. tumulus (?) near Písek: handle of a bronze *Schnabelkanne*; 4. tumulus (?) of Chýnov: handle of a jug; 5. tomb (?) in Prague 4-Modřany: two handles of bronze jugs; 6. Hořovičky tumulus: two cups; 7. cremation tomb n. 13 at Hořín: two cups. All the main types of *Schnabelkannen* are represented here—which shows there was a fairly limited social group whose main activity was the discovery and exploitation of iron and gold deposits.

In the fourth century B.C. the situation changes completely. The rich tombs of princes gradually disappear, as do importations from the south. The relations between the Celtic and Mediterranean worlds now have a different basis.

In 1904, on the uplands of Chlum near Rokycany, a solitary tumulus in a field near a rock quarry was partly excavated, partly destroyed. The diameter of the tumulus was approximately 13.5 meters, and it was surrounded by a 1.5 meter-thick border of rocks and clay. The stone burial chamber at the center was sunk to a level of 1.5 meters below the surface. We cannot be sure that skeletal or cremated remains were found on the site, as Filip claims (1956, p. 272). In 1905 J.L. Píč, excavating on behalf of the National Museum of Prague, discovered a jug without its handle and, at the bottom of the tomb, two bronze cups and two pottery vases (similar to amphorae). By the west wall of the chamber lay an iron sword with its scabbard; alongside it were an iron spearhead, a knife and an axe, a piece of bronzework (which could have adorned the shaft of a lance) and a fibula in gold laminate, silver and bronze. Three more fragments of engraved bronze laminate from the tomb are now in the Rokycany museum. On the basis of the material listed above, the Chlum burial may be said to belong to the so-called "princely tomb" type. The bronze *Schnabelkanne* (the handle of which was probably spiral in form, but has not survived) has a simple plant motif decoration engraved on the neck. This demonstrates that the decoration was carried out in the Celtic style at a center of production in the eastern Early La Tène zone, and that we are almost certainly dealing with an Etruscan product (this is proved by another jug, now in the museum of Budapest, that may have come from Bohemia). The two bronze cups are straight-sided and flat-bottomed; their rim is decorated with fine semi-circular engravings, and their two handles are diametrically opposite each other and fixed with rivets. So far nothing similar to them has been found in the eastern zone of early Celtic culture. One could argue they are copies of Etruscan cups, perhaps produced in one of the early Celtic workshops of Bohemia itself. The disc-shaped fibula consists of an upper plate of gold decorated with a plant motif and lower

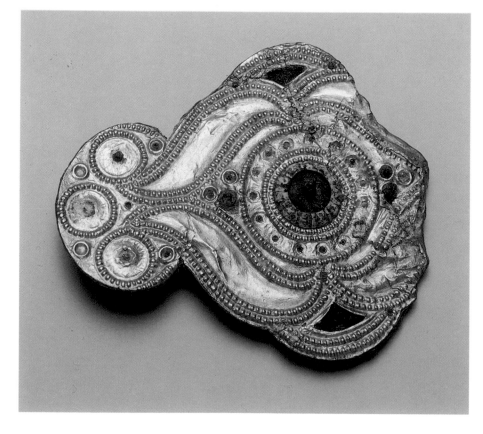

Bronze plaque, one part covered with compass-drawn silver plate engraving, and other part covered with embossed gold leaf originally decorated with coral or amber beads from the princely tomb at Chlum (Bohemia)
Second half 5th century B.C.
Prague, Národní Muzeum
Drawing by Břeň

Map showing the distribution
of Etruscan wine-jugs imported
to central Europe
1. Chlum
2. Hradiště near Písek
3. Chýnov near Louny
4. Prague Modřany
5. Near Písek

plate of bronze (with silver ornamentation) decorated with (older) geometric engravings. The iron fastening pin, which has not survived, is proof, along with the decorative scheme, that this object was imported from outside Celtic Bohemia, from the eastern Franco-Rhenish area or the region around Dürrnberg (western Austria). The decoration of the gold plate matches that of objects found at Reiheim in the Saarland, at Kleinaspergle in Baden-Württemberg, and at Dürrnberg (tomb 44/2) in Austria. The decoration of the bronze plate is very close to that of a bronze plate found at Závist near Prague (Jansová 1983, p. 54) and of a sword scabbard found at Dražičky near Tábor. The bronze trimmings for a rod or lance show semicircles and a band of small arches (that is, a floral motif) in the curvilinear style of the eastern Early La Tène area. Perhaps this is a purely abstract plant design—a highly simplified lotus flower motif.

All the objects found in the so-called Prince's Tumulus at Chlum in western Bohemia can be dated to around 430-400 B.C.

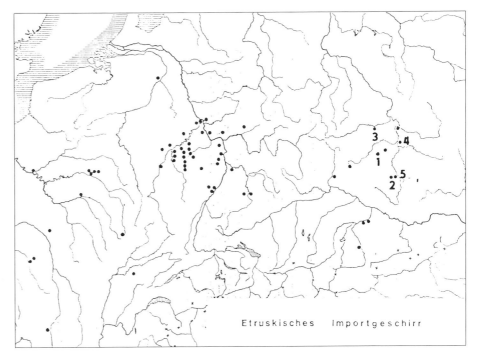

Etruskisches Importgeschirr

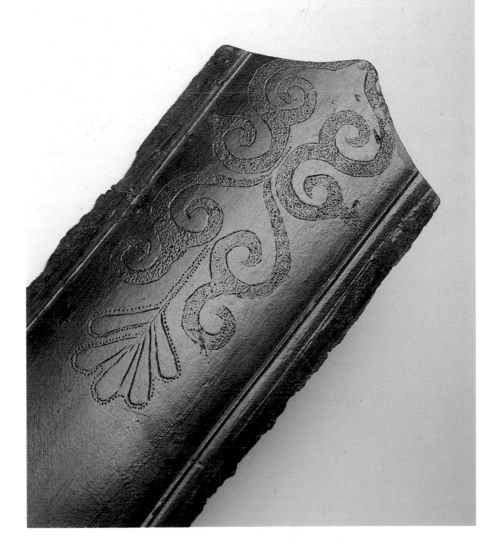

Mouth of the engraved bronze scabbard found in a barrow at Dražičky (Bohemia) Second half 5th century B.C. Tábor, Muzeum Husitského Revolučního Hnutí

187

The Steinsburg Hillfort
Karl Peschel

The Steinsburg, or Kleiner Gleichberg, is the northernmost of the two Gleichberg peaks. Situated in the southwestern corner of Thuringia and east of Römhild, the Steinsburg (literally Stone Fortress) rises with its woodlands on the border between the administrative districts of Meiningen and Hildburghausen. The top of the hill, covered by a crown of basalt, reaches a height of 641.5 meters, surging nearly 350 meters above the surrounding countryside and offering a view that ranges 80 kilometers in all directions except to the south, where it is cut off by the Grosser Gleichberg. On the Steinsburg there are three oval fortified enclosure walls that follow the contours of the terrain and which date from the second century B.C. and the first half of the first. One of the enclosures has a dirt and stone wall for protection against water. The main fortification and the inner circuit of walls were built earlier, while the whole outer circuit, which encompasses over 78 hectares, dates from the late phase of the settlement. Several remaining ruins of walls point to the possible existence of other older fortifications.

According to research initiated by A. Götze in 1900, they were built exclusively of stone without timber lacings; the walls on the outside were made of layers of basalt blocks and filled inside with crushed stone. Götze also described what he termed "inner facings," that is, retaining walls that ran inside the enclosure walls. Parts of the fortified area were uninhabitable because of the boulders and rocks scattered over the hillsides. Leveled areas on the upper slopes seem to indicate foundations of houses. The main approaches ran up the west side, more or less following the course of the medieval "wine road," traces of which are still visible, which went from Mainfranken to northern Thuringia, passing close by the Steinsburg. Valley settlements also sprang up here. The gates indicate the existence of protruding pincer-shaped side-walls or a wall corner crooked back towards the interior.

Starting from the mid-nineteenth century up until 1927, the basalt was carried off and used for other purposes and in this way parts of the enclosure wall were destroyed, changing the whole appearance with the introduction of work sites, heaps of brubble and tracks for hauling. Numerous finds—most of the bronzes, for example—came to light, but many more were lost. The material recovered came mostly from the digs that Götze carried out up until 1940 and from field work conducted during the building of a road on the western side of the hill.

Remains of older settlements date from the end of the Neolithic, the Bronze Age and more recent urnfield times, while the graves at the foot of the hill are Bronze Age tumuli. The first large settlement, probably with fortifications the same height as the main enclosure wall, sprang up between the tenth

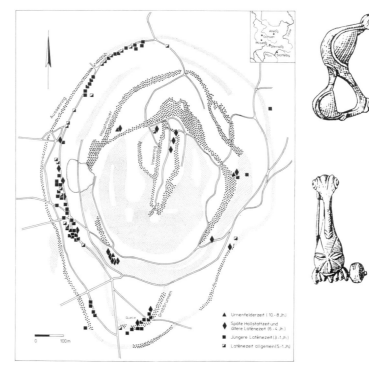

and the eighth centuries B.C.

After an interruption, also confirmed stratigraphically, the hilltop was taken into consideration again starting in the sixth century and fortified. Of the less important finds are first of all toilet articles which point to an intense population growth up to the fourth century B.C. Most of the fibulae—numbering over 150 and made almost exclusively out of solid bronze or sheet bronze and bronze wire—date from the Early La Tène period, namely the fifth century B.C. The typology of the fibulae, stemming from the late Hallstatt twin-disc types, takes on figurative traits which point to local manufacture. Within the context of Early La Tène, the Steinsburg stood at the northern border of its eastern region. More solid and filiform bird-headed fibulae were found here than in any other site comparable to Steinsburg. The inhabitants of the Steinsburg, and in the Mittelgebirg region in general, took on Celtic cultural characteristics in the Early La Tène period at the very latest, as is apparent especially in their pottery. Older bonds also existed with the northwestern Alpine region, which towards the end of the sixth century B.C. was considered Celtic by ancient writers.

After a period of a little less than two hundred years, during which the Steinsburg was practically uninhabited, the settlement reached its greatest extension starting at the end of the third century B.C. With its massive walls and the rocks strewn over the hilltop, making it difficult to reach, it looked more like a fort than an "urban" trading center.

The nature of the finds is determined by the pottery, of which at most one quarter is wheel-made and therefore manufactured locally. Articles worked in metal and grindstones also came to light, in an area restricted to the lowest part of the hillsides. A separation between the different manufacturing areas is impossible to establish. A special pottery made with graphite clay and glass rings came in from the southeast, that is from regions inhabited by the Vindelici and the Boii. Celtic coins have only been found in the surrounding area. Numerous farming implements, for tilling fields and harvesting, for example, point to a fundamentally rural life. Efforts to protect property, revealed by the presence of keys, imply a fully developed social order, and the vast, painstaking construction of the walls a rigid centralized government.

The Steinsburg stood at the border of the Celtic *oppida* and pertained to a sphere of trade that included the territories on both sides of the Thuringian Forest and the Rhône. Its inhabitants, due to tradition and geographical position, felt closer to the Celts, without sharing, however, their level of civilization. In the third quarter of the first century B.C. the settlement was abandoned, probably as the result of movements of Germanic tribes from the Elbe region. Bikourgion is the name given by Ptolemy (2, 11, 14). Most of the finds are preserved in the Steinsburg museum at the foot of the hill. Three kilometers to the southwest is a cemetery of tumuli dating from the seventh and sixth century B.C. with later graves from the second and first centuries B.C.

The St. Pölten Area in the Fifth Century B.C.

Johannes-Wolfgang Neugebauer

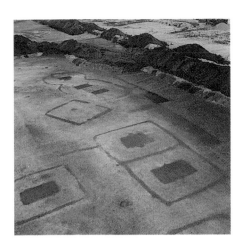

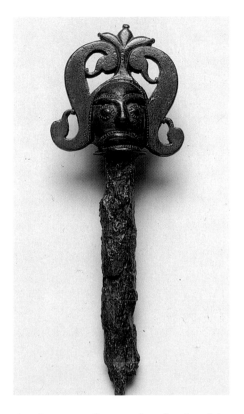

Settlements dating from the Early and Middle La Tène periods developed in two geographical areas of Lower Austria: in the Alpine foothills between Dunkelsteinerwald and Wienerwald, and in the Leithagebirge and Marchfeld areas of the Vienna basin north of the Danube. The area of the Alpine foothills contains the lower course of the Traisen (with the towns of Pottenbrun, Unterradlberg-Oberndorf, Ossarn, Herzogenburg, Inzersdorf, Reichersdorf and Franzhausen), while to the west of it lies the Fladnitzbach Valley which, in terms of both quantity and quality, is the most important center dating from the La Tène A period. The Vienna basin contains only the Vienna XXI-Leopoldau cemeteries. The most important developments of the La Tène B period occupy the area that stretches from here to the borders of the Leithagebirg (with the sites at Guntramsdorf, Katzelsdorf, Au am Leithabirge and Mannersdorf am Leithabirge). In his latest analysis of early Austrian history, published in 1980, R. Pittioni claims that the characteristics of the La Tène A period (c. 490/480-c. 400/390 B.C.) are only to be found in the culture of the Hunsrück-Eifel area, and that the La Tène A objects found north of the Alps were carried there during the migrations that took place between 400 and 350 B.C. However, in 1976 and 1977, St. Nebehay had already reviewed certain older cemeteries at Kuffern and Wien-Leopoldau (that had previously been only incompletely explored) and shown that there had been a La Tène A phase in Eastern Austria during the fifth century B.C.

Kuffern (formerly Kuffarn)
Town of Statzendorf, St. Pölten district
Between 1891 and 1899 thirteen La Tène A tombs were explored. The contents of male tomb 1 were particularly noteworthy: a decorated situla and a bronze drinking cup, along with a bronze fibula (of the Certosa type) and chain, the remains of a sword sheath with a lyre-shaped ferrule, lance and arrowheads, and a single-edged iron sword as well as pottery. Tomb 8 should also be mentioned; it contained a bronze fibula in

the form of an animal's head (from the Eastern Alps) and a large openwork iron belt fastener.

Vienna - Leopoldau
In 1937 thirteen La Tène A tombs were excavated; nine contained inhumation burials, four contained cremations. Worthy of note are the bronze *Shuhfibel* (shoe fibula) from tomb 8 and the Stupava-pottery handled cups with horn-shaped decoration (from tombs 2, 5 and 11). Near the tombs was found a bronze two-piece fibula with an S-shaped fastener with plastic decoration of dogs' heads. This material has been added to by recent work, which has tended to concentrate on the valley containing the lower reaches of the Traisen.

This tributary has its source in the Kalkalfen hills and flows into the right bank of the Danube near Traismauer. The hills flanking the twenty kilometers or so of the north-south running valley of the lower reaches of the river—between the point where the Traisen flows into the Danube and the regional (*Land*) capital, St. Pölten—enclose a plain that is 2-3 kilometers wide. Given that the present course of the river is slightly assymetrical—it is shifted to the east of the axis of the valley—a road runs along the old river bed. The lowest part of the Traisen plain is bound by quite steep slopes that rise up to a height of 6-8 meters; the upper levels are covered in loess.

The scree of the lower levels contains traces of a rapid succession of settlements (both farms and villages) and their relative cemeteries—dating, mostly, from the early Bronze Age to the La Tène period. As a result of the recent extraction of enormous quantites of gravel to be used in building projects, the Ministry responsible for archaeological sites began a series of emergency excavations in 1981. Coordinated by myself, these excavations revealed eighty new sites. Of the nearly 3000 tombs that came to light, about 270 date from the Early La Tène period; the most important cemetery was at Franzhausen, with 152 tombs containing inhumation burials and cremations.

Pottenbrunn, Town of St. Pölten
This cemetery was discovered in 1930, during the work of the B1 motorway; two inhumation and two cremation chambers dating from the Early La Tène period were explored. During work on a motorway access road and toll booth in 1981-82 another forty-two tombs were discovered: ten of these, in the eastern section of the site, apparently belonged to the Hallstatt culture, if not to the La Tène A period—the others can be dated to the B period. Worthy of note are the warrior and sword laid out within a circular enclosure (tomb 4) and three double tombs (3, 5 and 6).

Oberndorf/Ebene, Town of Herzogenburg
St. Pölten district
In 1982-83, fourteen Hallstatt cremation

chambers were discovered on the site of the new "Herzogenburg South" motorway access road and in a gravel quarry to the south of it—with four cremation tombs and eighteen burial chambers dating from the Early La Tène period. It is worth recording that the vast Iron Age cemetery (which has been only partially explored) contains many tombs of Early La Tène warriors, double graves and—in one case—a quadruple grave (several of which are contained within circular or square enclosures). Above one of the Hallstatt-C cremation chambers was the burial chamber of a woman which contained several ring ornaments (including heavy, ribbed, anklets) and a *knophfibel*, or a button fibula, with a sunken stamp (tombs 121, 2, 3 and 6). This is one of the latest Hallstatt fibulae found in central Europe and should be dated to the D3 period. One can, therefore, deduce that the site was continuously occupied from Hallstatt D3 (at the very least) right up to the initial La Tène period.

Unterradlberg, Town of St. Pölten
In 1986, in "Pfaffing"—an area a few hundred meters to the southeast of the Oberndorf/Ebene funeral site—a linchpin dating from the Early La Tène period was found lying on the ground. The lower part of this object measured 6.8 centimeters and was made of iron; this was surmounted by the main part, which measured 3.9 centimeters in length and was of cast and carved bronze. The center of the decorated area contains a bas-relief of a face with wide, protruberant eyes. The eyebrows,

189

eyelashes, mouth (with a beard?) and neck (with a necklace or collar?) are all represented using incisions and reliefs. On the head there is a lotus flower and stalk. Two S-shaped handles are arranged on either side of the face—their ends representing birds of prey with curved beaks. Both the handles and the bird heads are richly decorated with incisions. Use of the bird-of-prey head motif was widespread, especially in the bird fibulae of the La Tène A era.

Ossarn, Town of Herzogenburg
District of St. Pölten

In 1963-66 and 1969 a total of eight tombs were found in a gravel pit in an area of Ossarna called "Langwiesfeld"—one of these was surrounded by a circular funerary enclosure (or, perhaps, by two). Early bird-head fibulae and a rectangular belt mount decorated with fine incisions are proof that the site was occupied during the La Tène A period.

In the period up to 1982-83 a large number of tombs that had escaped notice must have been destroyed; only in 1984 was it possible to document systematically and explore another eighteen burial tombs. Conclusive proof of the excellence of La Tène A craftsmanship was found—above all in tomb 17 (that of a fifteen-year-old girl): along with a torque, a finger ring, a bronze fibula (only two centimeters long), a blue glass bead, a single-edged iron dagger and various pieces of pottery; a belt buckle and a decorated bronze fibula are particularly worthy of note. The belt buckle consists of a box-shaped mount divided by raised lines into three shallow sections, each panel decorated differently with finely-incised ornament consisting of sitting deer, vine tendrils and a collection of griffin or goat heads. This fastens to a plate cast in the form of a highly-stylized human-feral head. The figure-shaped fibula has a leaf-spring structure. It represents a figure with a human head whose feral ears emerge from under a helmet which extends to cover the back of the neck (or is it long hair?). The figure has animal paws and a bird's body articulated by decorative grooves (spirals on the shoulders, fanwork or palmettes to form the tail). Both the helmet and tail are inlaid with coral (now turned whitish).

Herzogenburg-Kalkofen, Town of Herzogenburg
district of St. Pölten

The 1981 construction of the "Herzogenburg North" motorway access road brought to light only an empty circular enclosure; but the "Kalkofen" zone had already been partly explored over the period 1970-72, revealing ten inhumation burials (three with circular enclosures) and a cremation area enclosed by a square of ditches—all of them from the Early La Tène period. The dating can be made with some certainty on the basis of a fragment of an animal-head fibula from the Eastern Alps and a stud

from a sword, which bears a representation of a mask (a human face with feral ears and outstretched arms forming a T).

Walpersdorf, Inzersdorf and Getzersdorf, Town of Inzersdorf-Getzersdorf, District of St. Pölten

The traces of the Early La Tène settlements in the gravel quarry to the east of the Herzogenburg-Trimauer road have been noted for some time (an animal-head fibula from the Eastern Alps and various pieces of pottery, typical of the late Hallstatt tradition, provide an important point of reference for dating purposes). There must have been a series of farms on the lower shelves formed by the Traisen—and the cemeteries were situated between the farms themselves and the land to the west of them. In Summer 1982, aerial reconaissance of the Inzersdorf area and the different types of vegetation to be found there led to the discovery and photography of a new cemetery. Between March and May 1987, the eastern extension of this cemetery was excavated (to prevent any threat to it from work in the gravel quarry). Of the twenty-two features investigated, twelve were Early La Tène tombs (eleven inhumations, one cremation) and ten were tomb enclosures.

Reichersdorf, Town of Nussdorf ob der Traisen District of St. Pölten

Discovered thanks to aerial reconaissance, the Iron Age cemetery to the east of Reichersdorf was explored in 1986 (when a road was being built through the area) and again in 1978-88 (when there was land subsidence). During the series of rescue excavations carried out on the northern zone of the cemetery, numerous Hallstatt tombs were found (both inhumation and cremation burials) and at least three Early La Tène graves.

Franzhausen, Town of Nussdorf ob der Traisen District of St. Pölten

From 1981 onwards, during gravel mining operations at the Franzhausen quarry (which covers a surface area of one square kilometer), not only were the two largest Bronze Age cemeteries of central Europe discovered (Franzhausen I and II: two thousand closely-packed graves), but the most important Iron Age cemetery of the lower Traisen valley came to light. This occupied a strip of land (300 by 120 meters) that ran north-south between the two Bronze Age cemeteries. By 1989, thirty-three Hallstatt C tombs and 152 Late Hallstatt and Early La Tène tombs had been discovered. Furthermore, funeral structures of unusual form have come to light—single and double tomb enclosures, along with square and round structures intended for religious rites. Sixty percent of the burials were inhumations and forty percent (with eleven double graves, and one triple) were cremations. Even though the tombs were looted of almost all their precious and non-ferrous

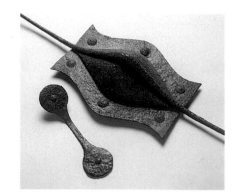

Iron shield-boss and handgrip from the wooden shield from tomb no. 295 at Franzhausen (Lower Austria) Second half 5th century B.C. Vienna, Abteilung für Bodendenkmale des Bundesdenkmalamtes

metals soon after being completed, we can get some idea of their original quality and richness from the few objects that do remain. These include decorated bronze mounts for a ceremonial shield, a bronze fibula in the form of a mask (with a griffin's head and palmettes), and other small objects in gold. The most important complex was the tomb of a warrior that formed part of the western section of burial chamber 295 (surrounded by a circular ditch). The adult male is laid out with his panoply of an iron sword, a belt with sheath, a lance, and an oval wooden shield (1.3 meters high) with a spindle-shaped boss. His clothes and underclothes were held in place with bronze fibulae, while his right ear was decorated with a gold wirering.

In light of the new finds mentioned above it would appear that the area of the lower Traisen valley was an important junction on the route between Salzburg and the Dürrnberg near Hallein and the route that ran from the Salzkammergut (Hallstatt) to southwest Czechoslovakia, western Hungary and even Slovenia. The wealth, variety and continuity of fifth-century B.C. La Tène A settlements and tombs of the lower Traisen valley could only have been possible thanks to a regular exchange of goods and to the mobility of the craftsmen who produced them. It is significant that the cemeteries often occupy land that had been used earlier for burials, in the Hallstatt period. In fact, Parzinger argues that from phase 8 onwards (the fibulae of Oberndorf/Ebene, for example) one can note the uninterrupted occupation of certain areas through phases 9 and 10 right up to the La Tène B period.

The Necropolis at Bučany
Jozef Bujna

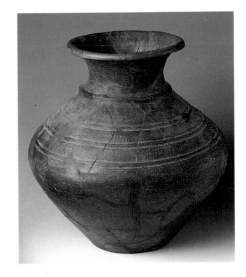

*Terracotta vase from tomb no. 18
at Bučany (Slovakia)
Second half 5th century
Nitra, Archeologický ústav
Slovenskej Akademie vied*

The cemetery of Bučany (Trnava district) containing thirty-six graves is the most extensive, easternmost find complex of the Late Hallstatt-Early La Tène period. Until recently in the territory of southwest Slovakia few sites of this period were known, just some disturbed graves at Stupava and several isolated finds (e.g. a *Maskenfibel* (mask fibulae) from Slovenské Pravno).

The graves of the Bučany cemetery were scattered alongside the margin of a massive loess terrace, running about 6 kilometers west of the Váh river in the northern margin of the Danubian lowland. The density of graves casts doubts on the original existence of barrow mounds, a characteristic of the cemeteries of the Hallstatt period. Most of the grave-pits were shallow, rectangular, and probably covered by an earth mound as in the flat cemeteries of the La Tène period. The flat graves are known also in the late Hallstatt period, though these were mainly biritual. With the exception of four cremation graves containing a Vekerzug group assemblages, all the other graves of the Bučany cemetery were inhumations. The position and orientation of the body, with the head approximately toward the south, exhibit an affinity with the flat cemeteries of the historical Celts in the late fourth and in the third centuries B.C. Traces of a wooden construction similar to the chamber graves

of the Hallstatt period have been found only in one grave, which also has the largest pit. The Hallstatt tradition of placing a number of pots—pottery sets—into the grave lasted as late as the end of the Celtic flat cemeteries. The graves contained bones of goats and sheep, the remains of a meat-based diet. Pig, so typical of the diet represented in the Celtic cemeteries, has not been attested.

The early phase of the cemetery is represented by a group of graves of the Hallstatt D/La Tène A in the northeastern part of the cemetery, disturbed by a clay pit. The other group of graves contained Early La Tène-type metal artifacts and in the pottery forms, alongside a less striking Hallstatt tradition, La Tène forms are prominent, mainly S-profiled bowls and flasks. Characteristic finds are belt-mount clasps, slightly profiled wire bracelets and Early La Tène brooches with stylized animal heads on the foot (e.g. from grave 11). The latest graves of the La Tène A/B have been found in the southwestern margin of the cemetery. Grave 18 contained a sword, and a bowl richly decorated with stamping came from grave 27.

The cemetery is situated on the borderline of the Kalenderberg culture—a local unit in the eastern Hallstatt cultural sphere—and the Vekerzug group that penetrated here from the eastern part of the Carpathian Ba-

sin. It is attributed to the North Thracian culture. The time lap between the Kalenderberg culture settlement of this site and the Early La Tène cemetery is attested by the fact that grave 27 cuts across a settlement feature. Four cremation burials containing Vekerzug equipment are identical with inhumation graves in form and orientation. Although they are an integral part of the cemetery, their assemblages are not distinctive enough to be placed to a particular phase. The cemetery represents the Late Hallstatt-Early La Tène period, which in the territory of southwest Slovakia covers the late fifth century to the first half of the fourth B.C. The burial of historical Celts in the La Tène B stage (the late fourth and early third centuries B.C.) begins in the cemeteries refounded in the area east of the territory containing the La Tène A-finds.

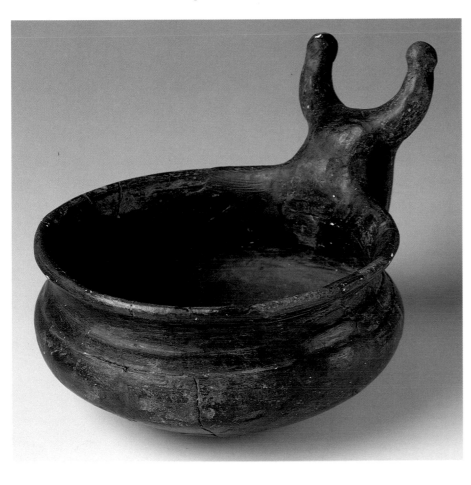

*Terracotta cup with horned handle
from tomb no. 18
at Bučany (Slovakia)
Second half 5th century
Nitra, Archeologický ústav
Slovenskej Akademie vied*

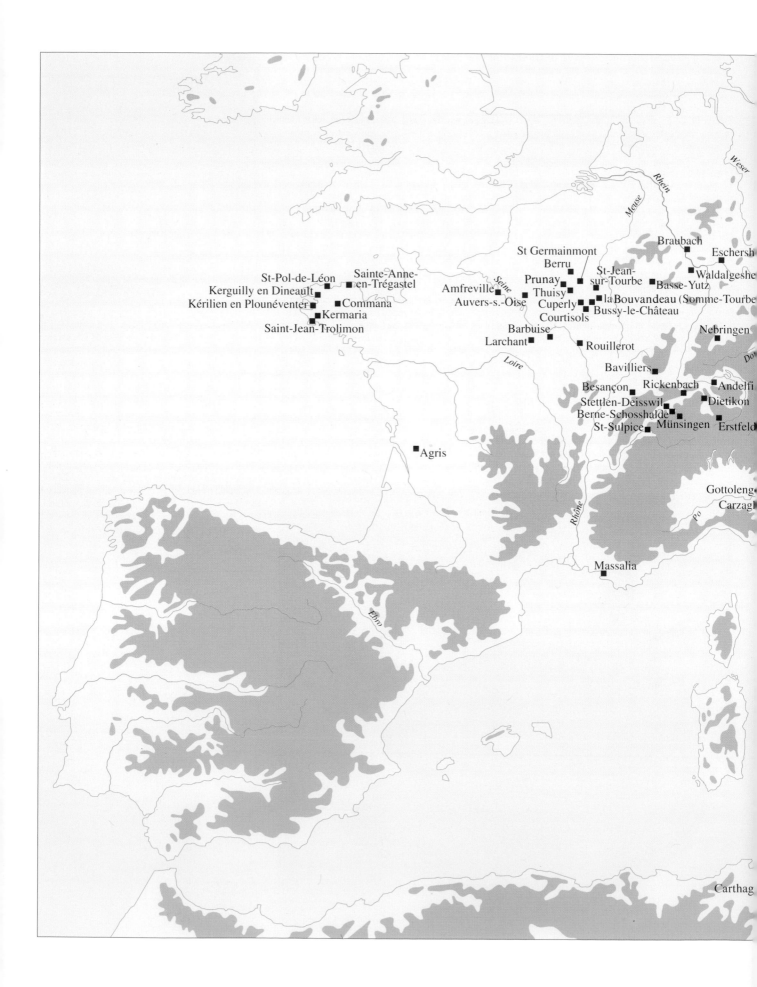

St-Pol-de-Léon
Sainte-Anne-en-Trégastel
Kerguilly en Dineault
Kérilien en Plounéventer
Commana
Kermaria
Saint-Jean-Trolimon

St Germainmont
Berru
Prunay
St-Jean-sur-Tourbe
Amfreville
Thuisy
Auvers-s.-Oise
Cuperly
la Bouvandeau (Somme-Tourbe
Courtisols
Bussy-le-Château
Barbuise
Larchant
Rouillerot

Braubach
Eschersh
Waldalgeshe
Basse-Yutz

Nebringen

Bavilliers

Besançon
Rickenbach
Andelfi
Stettlen-Deisswil
Dietikon
Berne-Schosshalde
St-Sulpice
Münsingen
Erstfeld

Agris

Gottoleng
Carzag

Massalia

Carthag

The First Historical Expansion
Fourth century B.C.

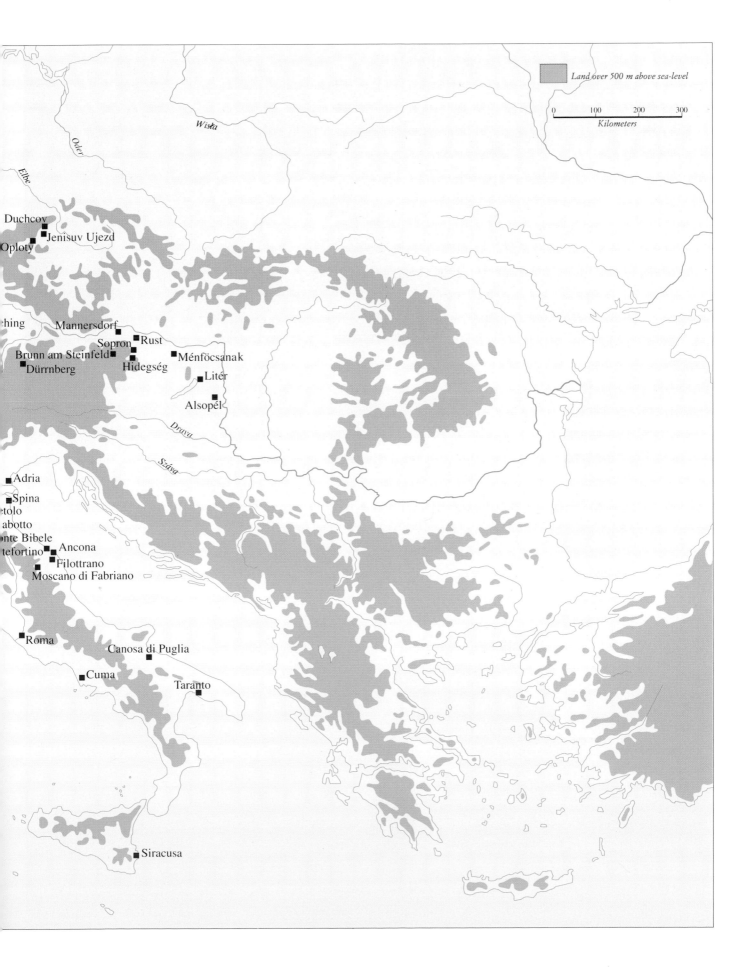

Land over 500 m above sea-level

0 100 200 300
Kilometers

Wisła

Oder

Elbe

Duchcov
Jenisuv Ujezd
Oploty

hing

Mannersdorf
Sopron Rust
Brunn am Steinfeld Ménföcsanak
Dürrnberg Hidegség
Litér
Alsopél

Drava

Száva

Adria
Spina
etolo
abotto
onte Bibele
tefortino Ancona
Filottrano
Moscano di Fabriano

Roma
Canosa di Puglia
Cuma
Taranto

Siracusa

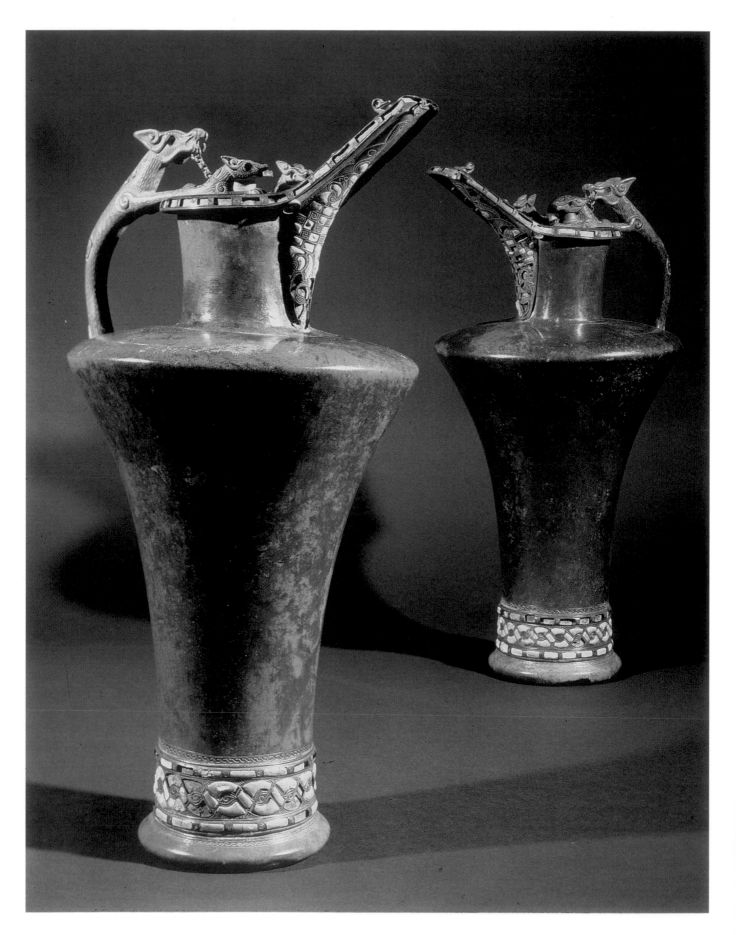

The migration of the Transalpine Celts to northern Italy at the beginning of the fourth century B.C. brought the European Celtic peoples into the annals of history. No sooner had they settled in than they pushed on again, heading southward to Rome, where they inflicted a bloody defeat on the Roman army.

The written accounts, which focus on the conflicts between Romans and Celts, unfortunately offer little information on the relations between the Celts (who were themselves divided) and other populations on the peninsula, the Etruscans and Greeks, or the Italic peoples. Here and there we can guess the effects their ventures might have had on the local hegemonies. A passage from Pompeius Trogus's *Philippic Histories* records the military alliance the Gauls offered to Dionysus I, the Tyrant of Syracuse, after the sack of Rome. Everything seems to indicate that an alliance was indeed agreed, and the Syracusan trading post at Ancona, in direct contact with the Senones, was certainly one of the main recruitment points for Celtic troops. These mercenary soldiers fought for Dionysus not only in the south of the peninsula but even in Greece. Xenophon mentions their presence in 367 B.C. together with Iberian mercenaries in the Syracusan expeditionary forces fighting against the Thebans.

These scraps of information clearly indicate that, contrary to the impression conveyed in the texts of the Roman historians (which reduce the history of the Celts on the peninsula exclusively to relations with Rome), the newcomers were well-integrated right from the time of their arrival in the complex and subtle interplay of political power struggles across the peninsula. One might even ask to what extent their immigration was prompted or at least encouraged by one of the protagonists, with the aim of introducing a new element to the power struggles, an element free from prior local connections and whose prowess on the battlefield was legendary.

Archaeological Evidence for the Invasion

The historically documented invasion of the Celts is reflected in the archaeological record by two complementary phenomena. First, there are numerous indications of sudden upheaval in the situation in northern Italy due to external causes, that are particularly evident when comparing the fourth century and the preceding one; secondly, we find a parallel appearance and rapid diffusion of La Tène elements of Transalpine origin through the areas of the peninsula in which the texts note the existence of stable or temporary settlements of Celtic groups. The oldest objects of the La Tène period that can be linked to the Celtic influx at the beginning of the fourth century are highly characteristic fibulae shaped in a regular, almost perfectly semicircular bow or with an angular upper profile. The samples of this form found in Italy are directly comparable to those which are considered the most characteristic feature of a precisely defined chronological phase, found in the area stretching from today's Champagne and Bourgogne to the westernmost rim of the Carpathian basin. Specialists have dated this phase (independently of the situation in Italy) to the first decades of the fourth century B.C. Occasionally the name "pre-Duchcov" has been given to this phase to underline the fact that the forms of personal ornaments from this period stem directly from those found in the hundreds in the votive deposit at Duchcov in Bohemia. This phase seems to correspond with significant changes in various parts of the Transalpine world. For instance, it follows the abandonment of most of the cemeteries in Champagne (until then very numerous throughout the region) and it marks in central Europe, especially in Bohemia, the introduction of cemeteries with simple inhumation burials which replace the cemeteries of Early La Tène. The early tombs, often in barrows, generally contained cremation burials, and on rare occasions presented evidence of both types of funeral rite.

The probable link between the appearance of material of this phase in Italy and the flood of Transalpine Celts into the region indicates that the event was not an isolated occurrence but part of a widespread migratory movement, not only in France—the main area of origin identified by the ancient texts—but also in territories of the eastern-central area where the La Tène culture originated.

For the moment, an exodus toward Italy is the most plausible explanation for the radical drop in population in the hitherto densely inhabited Marne area at the end of the fifth century B.C. Archaeological evidence for this period in the area reveals numerous key links with northern Italy.

This human tide included the Boii, who have been identified from the cremation burial customs distinctive to Bohemia and surrounding areas in the fifth century B.C. Their appearance suggests that the fourth-century migrants were not all from the same place, and had crossed the Alps at different points.

The evidence for the strong links that developed in the fourth century B.C. between Celtic settlers in the Italian peninsula and their hypothetical places of origin confirm, *a posteriori*, the settlers' dual origin, northwestern and central Europe. In fact, direct contact between Celts who settled south of the Po River and the Etruscan and Greek area resulted in new cultural stimuli, particularly noticeable in the artistic field. At first, the effect of these new impulses on the Transalpine world was not uniform. It appears that they initially affected only certain regions, before spreading out.

Such is the case of Champagne, where the few remaining nuclei of the population produced works of unprecedented quality completely different from traditional local material but with undeniably close links with Graeco-Etruscan culture. A comparable situation is also noticeable in Bohemia, where the new input spawned a highly original artistic horizon. Switzerland, meanwhile, served as a kind of revolving platform between the Celtic Transalpine and Cisalpine worlds, which explains the wealth and variety of material yielded by the Swiss cemeteries, and the country's close links with both cultural milieux.

Italy and La Tène Art in the Fourth Century B.C.
Today it is generally admitted that there are links between the Celtic settlement south of the Po and the innovations in Celtic art in the fourth century. Its most striking feature is an original vegetal style based mainly on foliage and palmettes, which are somewhat stylized

Bronze openwork phalera with central coral stud from the chariot tomb at Saint-Jean-sur-Tourbe (Marne) Early 4th century B.C. Saint-Germain-en-Laye Musée des Antiquités Nationales

Bronze openwork mount featuring a pair of eel-shaped creatures curled around a palmette From the chariot tomb at Cuperly (Marne) Early 4th century B.C. Saint-Germain-en-Laye Musée des Antiquités Nationales

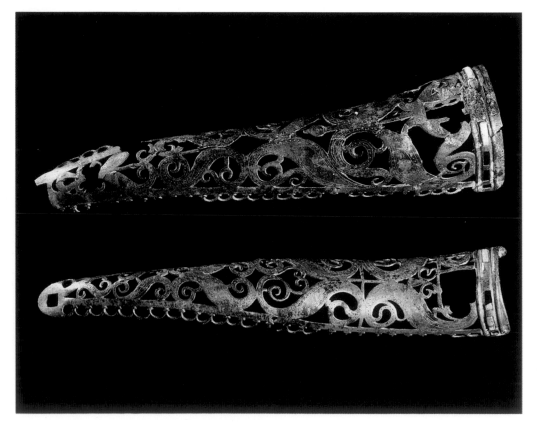

Pair of yoke or shaft mounts, in bronze openwork with coral studs from the a Bouvandeau chariot tomb at Somme-Tourbe (Marne) Early 4th century B.C. Saint-Germain-en-Laye Musée des Antiquités Nationales

Bronze openwork phalera
compass-drawn from the chariot
tomb at Cuperly (Marne)
Early 4th century B.C.
Saint-Germain-en-Laye
Musée des Antiquités Nationales

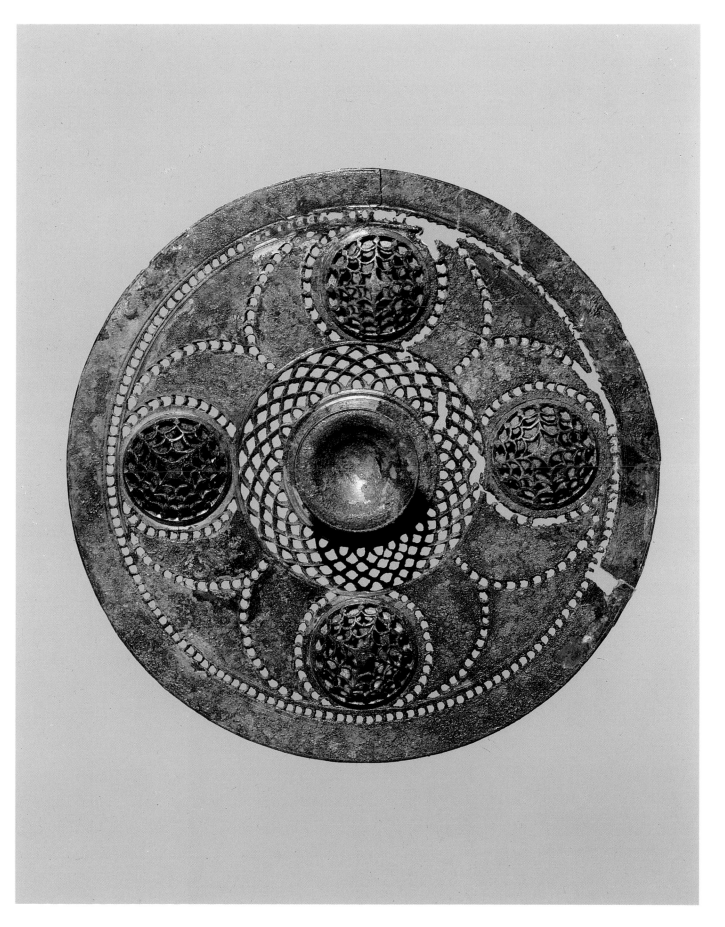

and juxtaposed in interlaced compositions. This is the "continuous plant style" called by Paul Jacobsthal "Waldalgesheim Style," after the site in the Rhineland where archaeologists discovered a hoard of rich personal ornaments. The find was particularly representative of this artistic trend and, in spite of the fact that it is unique in this area, some specialists have pinpointed it as the source of the new style.

Significantly, the earliest fibulae on which this kind of decoration appears (in both Switzerland and Champagne) are of the type mentioned earlier as being characteristic of the initial phase of Celtic settlement in the Po Valley.

The phenomenon is particularly well illustrated by the diffusion (and progressive transformation) of the decorative repertoire of the lavish bell fibulae made from precious metals. This style can be followed from the prototypes to their distant derivatives (where it is still clearly identifiable, albeit highly schematic) adorning more humble bronze La Tène fibulae, produced in quantity in the second half of the fourth century B.C. in regions as far-flung as Bohemia.

Significantly, the popularity of this kind of decoration seems to be mainly linked to a type of fibula with discoidal foot designed to hold a coral stud. In ancient times this colored material, to which the Celts certainly attributed magical properties, was one of the prime commodities of the bay of Naples and must have been traded through Cisalpine Gaul. Its relative abundance is also one of the aspects that distinguishes La Tène materials of the fourth century B.C. from those of the preceding century, during which coral was fairly scarce and used frugally. *Cabochons* or coral incrustations on fibulae and other objects (torques, scabbards and helmets) were so popular that they were soon simulated, mainly in Switzerland, with a kind of red enamel of Celtic invention. In Bohemia, even a bronze kind of *cabochon* became current, faithfully reproducing their coral prototypes, including the nail used to hold them in place.

Regrettably, very few decorated La Tène objects datable to the fourth century B.C. have so far been found in Italy, and their contexts are not very representative, uncertain, or unrecorded.

Silver fibula from Berne-Schosshalde (Berne) First half 4th century B.C. Berne, Historisches Museum

Bronze disc with embossed gold leaf and coral and enamel studs in the central element from Auvers-sur-Oise (Val-d'Oise) Early 4th century B.C. Paris, Bibliothèque Nationale Cabinet des Médailles

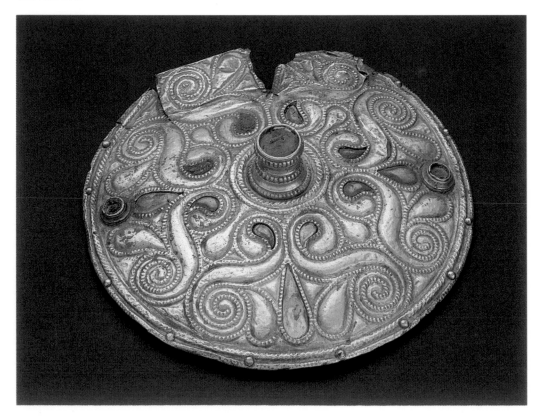

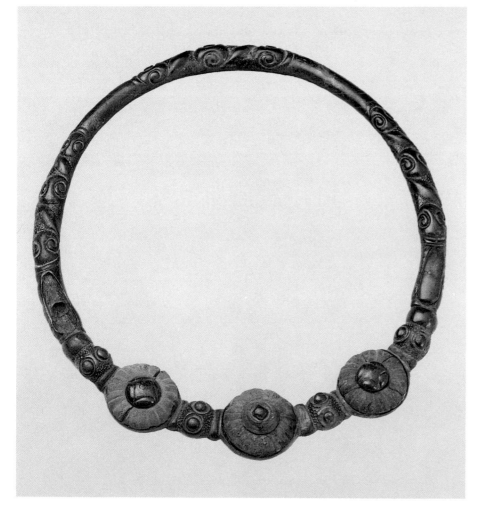

*Iron and bronze trapping mounts
decorated with finely-worked coral
from the chariot tomb
at Condé-sur-Suippes (Marne)
First half 4th century B.C.
Châlons-sur-Marne, Musée Municipal*

*Bronze torque with disc mounts in
red enamel from Beine (Marne)
Second half 4th century B.C.
Saint-Germain-en-Laye
Musée des Antiquités Nationales*

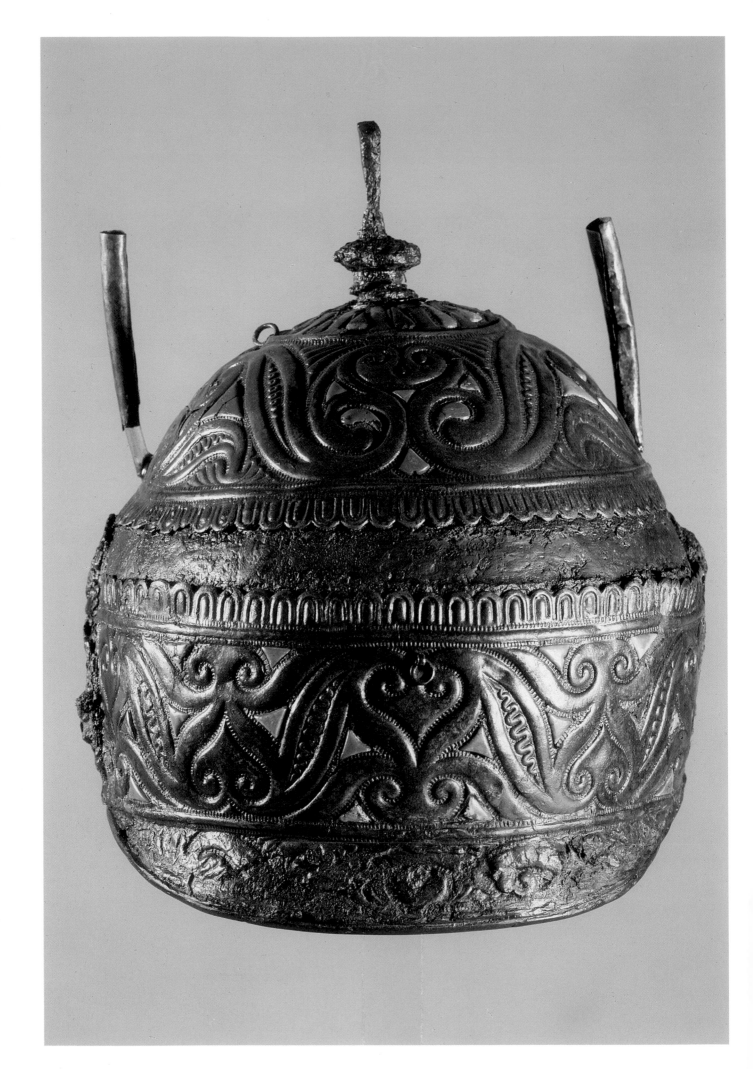

Helmet in iron and bronze
embossing and openwork
with coral studs
from Canosa di Puglia (Bari)
First half 4th century B.C.
Berlin, Staatliche Museen
Antikensammlung Preussischer
Kulturbesitz

Painted vase executed
with red-figure technique
from Prunay (Marne)
Second half 4th century B.C.
Reims, Musée Saint-Rémy

Partial reconstruction of
the decoration on the Prunay
vase (above)
Partial reconstruction
of the upper decoration on the helmet
from Canosa di Puglia (below)

Helmet in bronze, iron, gold leaf
and red enamel
from Amfreville (Eure)
Second third of 4th century B.C.
Saint-Germain-en-Laye
Musée des Antiquités Nationales

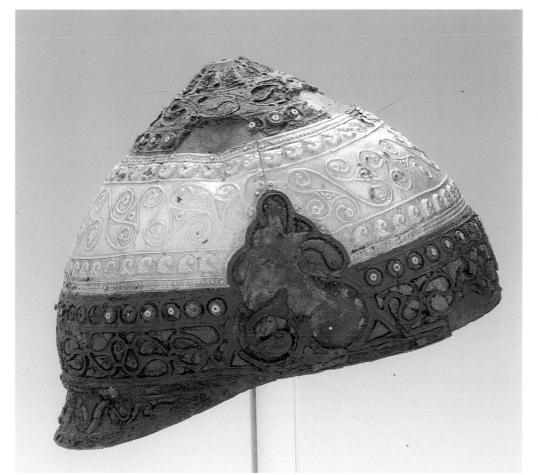

The La Tène object found furthest south is a ceremonial helmet richly decorated and incrusted with coral, discovered in a hypogeum in Canosa, Apulia. Celtic presence in this region is well documented in texts from the first half of the fourth century B.C. The complex pattern of palmettes decorating the two main bands of the helmet is closer in design to Mediterranean prototypes than to comparable motifs found on some rare Transalpine objects, such as the painted vase of Prunay in Champagne, manufactured in the second half of the fourth century B.C. using a technique based on the "red-figure" method. There is nothing to indicate that the Canosa helmet was produced outside the peninsula, because the two Transalpine ceremonial examples with which it can be compared—the helmet found in the 1800s in a defunct branch of the Seine at Amfreville, and the fabulous example found in a grotto at Agris—have no local antecedents that could explain their presence there, and must either have been imported, or made locally by craftsmen who learned their trade in Italo-Celtic climes.

Three other important items come from the cemeteries of the Senones in the Marches, and were probably all made in the first half of the fourth century B.C. The gold torque from Filottrano belongs to a series of rigid La Tène neckbands in precious metals characterized by a main symmetrical decoration around one or more central palmettes, combined with twined foliage and a secondary motif (usually leaves or running palmettes) adorning buffer-shaped terminals. There are five known examples, two of which were found out of context—at Rauris-Maschalpe (Austria), and Oploty (Bohemia)—while a third featured among burial goods of exceptional quality in a "princely" grave in Waldalgesheim (Rhineland); the fourth, accompanied like the previous one by a pair of bracelets of the same form (a common female ornament in the Marne area in the fifth century B.C.) is of unknown origin, and was bought in Belgium by the British Museum.

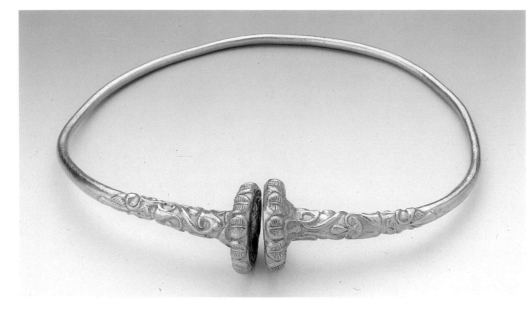

The Filottrano torque occupies an important place in the series, as the main pattern is not the same on both terminals, perhaps because the craftsman had followed two slightly different models and had some difficulty adapting them to the medium. At one time the torque was thought to be derived from Transalpine models, like the Waldalgesheim torque, but it is now believed to represent one of the first attempts at adapting Greek motifs to Celtic tastes. The same may be said for the British Museum torque, whose source of inspiration is betrayed by the rather clumsy imitation of filigree and granulation, techniques that were unknown to Celtic goldsmiths but characteristic of Graeco-Etruscan craftwork.

The ornaments of Waldalgesheim would therefore correspond to a further stage of cultural assimilation. They are a completely isolated set, with no possible stylistic links with local craftsmanship, and were therefore presumably imported, like the situla, made either at Taranto or in Campania, included among the grave goods.

The idea that the new style spread from the Italo-Celtic area is endorsed by the scabbards from Filottrano and Moscano di Fabriano. These seem to be the point of departure of a Transalpine series with the right-hand plate in bronze foil with embossed decoration, a type which includes various examples from the north of France (Larchant, Épiais-Rhus, Saint-Germainmont, Bussy-le-Château) and a scabbard found in Bohemia (Jenišův Ùjezd).

The most remarkable Celtic work of art so far found on Italian soil is a set of bronze decorations which originally adorned a convex object made from organic matter (a wooden wine-jug perhaps?). The item in question, which disappeared during World War II, was supposedly found in 1910 near Comacchio, and hence probably in one of the cemeteries of the Graeco-Etruscan settlement at Spina. With their delicate pattern of entwined foliage and palmettes, these pieces denote a decisive step in the assimilation of plant motifs borrowed from the Graeco-Etruscan repertoire. As on other works discovered in the Italo-Celtic areas, these items bear a mature version of the early patterns, considered today to be among the most original and representative of Celtic La Tène art.

Their introduction gave rise not only to a revival of the plant motifs, which from then on were predominant, but also to the invention of anthropomorphic variants of the palmettes, resulting in the total fusion of the deity's face with their attributes. This kind of allusive and polyvalent decoration, where abstract designs and plant and human elements merge almost beyond recognition, was to enjoy considerable success toward the beginning of the third century B.C. The oldest examples so far found of this kind of representation, which the specialists have dubbed "plastic metamorphosis," were found in Italy: the most striking example is the transformed palmette pattern decorating the Filottrano scabbard.

*Iron sword scabbard decorated
with embossed bronze mounts
from tomb no. 394 at Epiais-Rhus
(Val-d'Oise)
Guiry-en-Vexin, Musée archéologique
départemental du Val-d'Oise*

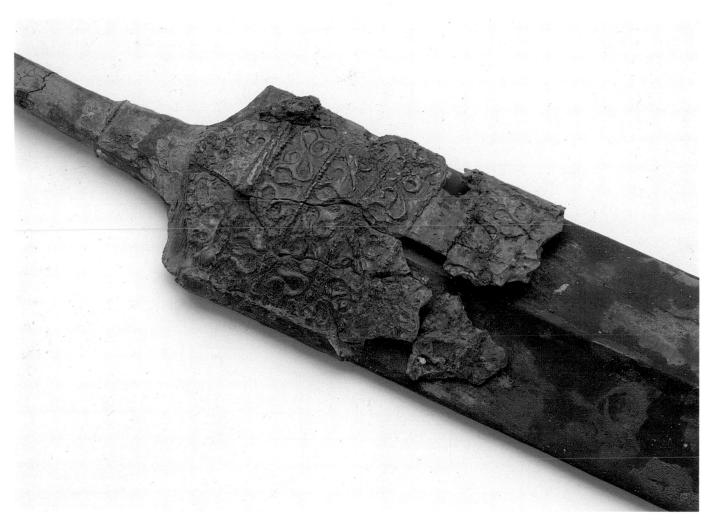

*Reconstruction of decoration on a gold
torque of unknown origin
Second third of 4th century B.C.
London, British Museum*

The influence of the Italo-Celtic world, which was crucial to the evolution of Celtic art and symptomatic of intellectual contacts about which we will never know anything of substance, were not limited to the first half of the fourth century B.C., but continued through to the start of the next century. One striking outcome of this influence is the Transalpine Celts' fondness for the *nodus Herculeus*. The pattern became most fashionable in the region between the western rim of the Carpathian basin and the territories of the Atlantic. It has even turned up in Ireland on a gold torque found at Clonmacnoise, which also bears some imitation Italianate filigree.

The influence of peninsula cultures is not limited to the more prestigious personal ornaments. It is seen in the mass-produced bronzework, whose appearance is one of the more conspicuous features of fourth-century Celtic metallurgy. The revamping of more common decorative ideas, particularly for fibulae, drew extensively on the legacy of ornaments and techniques of the early north-Italian bronzesmiths. The chronology of the material involved suggests that the transmission of this legacy came about after the invasion of Italy, undoubtedly through the Celts of Golasecca.

As these few examples show, the comparative analysis of Transalpine and Cisalpine material reveals the vital role Celtic Italy performed in the fourth century, not only as a cultural center fed by direct contacts with the Graeco-Etrusco-Italian world, but also as a focus of polarization for trends that gave unity to the La Tène world at the time.

The full nature of this role is still largely unexplored, mainly due to basically quantitative assessments of phenomena that can only be understood through a qualitative approach.

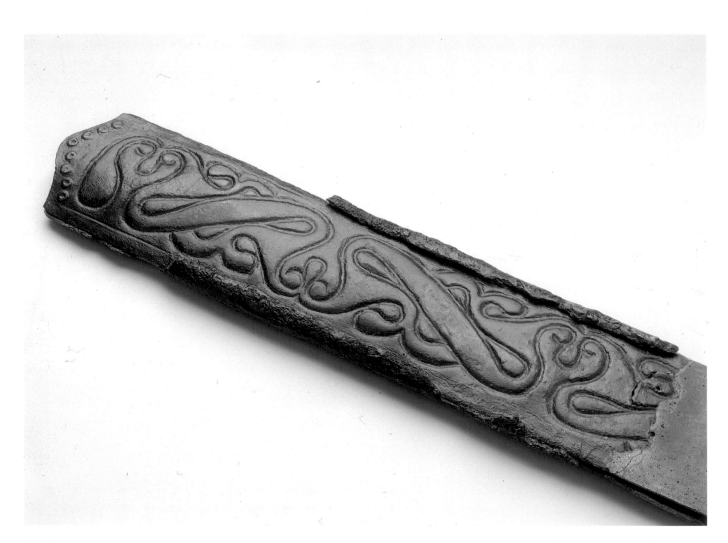

The Transalpine Peoples

There is not one positive reference in the texts to the situation of the Celts living in Transalpine territories during the fourth century B.C. In fact the only clues we have concerning the antecedents and circumstances of the invasion of Italy, and these appear belatedly, are in the works of first-century B.C. authors. The legendary story of Bellovesus and Segovesus, nephews of Ambitgatus, king of the Bituriges, as related by Livy (V, 4), places the Celts' arrival on the peninsula as part of widespread migratory activity triggered by overpopulation in central Gaul. The exodus was directed to the south by Bellovesus and toward the Hercynian uplands in southern Germany, and thence toward Danubia by Segovesus.

This event supposedly preceded the historic invasion of Italy by two centuries, as it dates back to the era of the reign of Tariquinius Priscus and the foundation of Marseilles. According to Livy, thanks to Bellovesus's army, the settlers of Phocaea were able to install themselves and fortify their position on the coast in spite of the hostility of local populations. This unlikely scenario induces doubts about the validity of the chronological details in Livy's account. At any rate they are totally at variance with the conclusions which may be deduced from an analysis of the archaeological evidence. The apparent coherence of the text is deceptive and is surely the result of the manipulation of disparate facts to make them appear logical. The historical basis is thus distorted by anachronistic additions, some of which are fictitious and are extremely hard to separate from fact. The idea of an earlier Celtic migration stemming from central Gaul is somewhat far-fetched. The dual origin of the first Celtic exodus is far more tenable. This detail in the historic account deserves closer study and careful cross-referencing with archaeological evidence.

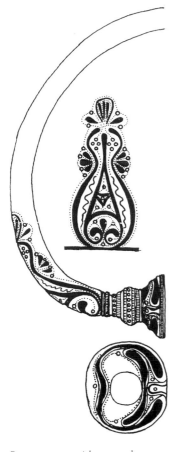

The same story crops up in a slightly different form in the works of other historians more or less coeval with Livy. Justinus, for instance, as reported by Pompeius Trogus (*Philippic Histories*, XXIV, 4), relates how three hundred thousand Celts supposedly pulled up their roots in a kind of *ver sacrum* ceremony along the lines of the sacred exodus described among the ancient pastoral people of Italy, in which a fraction of the population (one or more generations who were dedicated at birth to this sacred task) departed in the quest for new lands in which to settle.

A party of these Celts are presumed to have settled in Italy, while the rest, led by birds, reached the heart of Pannonia. This time the invasion of the peninsula therefore would have coincided with the beginnings of the Danubian expansion which, a century after the sacking of Rome, resulted in the great military expedition led by a later Brennus against Greece. The parallels in these stories betray, once again, the desire to link up events which, from the Mediterranean point of view, could be seen as emblematic. The entire description is probably an erudite pastiche of elements culled from different tales.

This impression is supported by Plutarch's observations (*Vita Camillis*, 3) on the departure of innumerable Gauls from an overcrowded homeland (which is not identified, however), and their expansion—some toward the "Boreal Ocean," and others toward the west, where they are said to have settled "between the Pyrenees and the Alps," near the Senones and the Bituriges. It was here that, later, the Gauls had their first taste of Italy's wine, which spurred them to invade the country where it was made.

These texts, with their discrepancies and apparent incompatibilities, share the idea that the invasion of Italy was induced by overpopulation in the ancestral lands of the Celts, and that this was not an isolated event but simply the most significant episode of mass migration involving the Mediterranean world, an event that deeply altered the ethnic balance of the Transalpine territories.

*Bronze torque with engraved decoration from Pierre-Morains (Marne)
Second third of 4th century B.C.
Epernay, Musée Municipal*

Archaeological Evidence
The archaeological evidence indicates clearly that if the invasion of Italy was part of a broader context of large-scale human migration, such a phenomenon cannot have occurred before

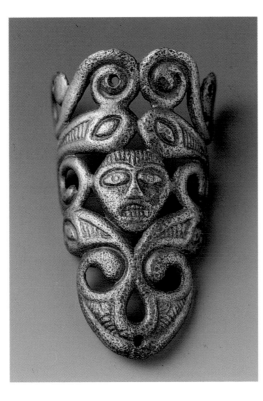
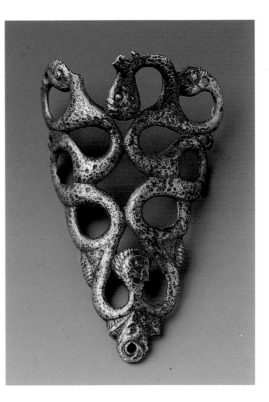

*Openwork bronze mounts from Čížkovice (Bohemia)
4th century B.C.
Litoměřice, Okresní Muzeum*

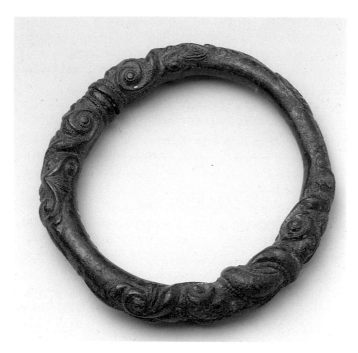

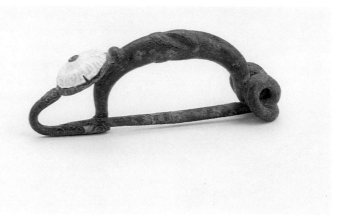

the end of the fifth century B.C. (at least according to current research), after a period of considerable stability throughout the La Tène world. The archaeological clues of this migration must be sought in the relatively brief interval characterized by the fashion of La Tène-type objects whose appearance marks the arrival of the Transalpine clans to the Po Valley during the first decades of the fourth century B.C.

The most representative of these objects—particularly the fibulae which belong to the group occasionally classed as pre-Duchcov or pre-Münsingen—enable us to distinguish fairly reliably the funerary groups of this period within the La Tène area. Their relatively modest number, even in the regions or cemeteries in which they are best represented, presumably reflects the brevity of the period in which such objects were made. Despite its conjectural nature, the study of burial patterns in the better-known cemeteries gives a fairly accurate idea of the timespan involved, which must have been at most two generations, or forty years. Because the beginning of this phase seems to coincide more or less with the historical invasion of the peninsula, its earliest possible date should be after the mid-fourth century B.C.

This somewhat brief period represents one of the decisive turning points in La Tène civilization: it actually corresponds with the reduction in number and the uniformity of the style of objects of the initial period. The new types quickly gained popularity in the area occupied by the historical Celts, which confirms the existence of extensive trading. This is also the period in which the so-called "princely" tombs began to disappear from most of the regions in which they had prevailed through the fifth century B.C. Now a counter-trend set in, characterized by the development of graves for military chieftains, clearly less prestigious and closely integrated with the cemeteries of the small communities that from here on were the basic unit of the Celtic settlement.

At this point, precious metal was only used sporadically, usually for rings. But there is nonetheless a significant rise in the use of silver, until then only very sparingly used compared with gold. This, together with the widespread use of coral, is one of the main indicators that trade with Italy, where this silver was very common, had become commonplace, and where the new prospects offered by the settlement of Transalpine tribes (with the availability of mercenaries, raids on rich townships) had just been added to the traditional forms of trade, which meanwhile flourished, since there were no longer foreign intermediaries.

The almost total disappearance of the prestigious type of fifth-century objects, at least among

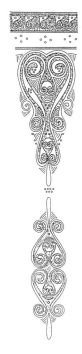

Reconstruction of the decoration
on the bronze torque from
the Les Commelles tomb at Prunay

Bronze torque with engraved
decoration from Pierre-Morains
(Marne)
Second third of 4th century B.C.
Epernay, Musée Municipal

Bronze torque from
the Les Commelles tomb at Prunay
(Marne)
Second half 4th century B.C.
Reims, Musée Saint-Rémy

the burial goods, is not accompanied by a decline in decorative work. Actually, La Tène ornamentation, revamped by the direct assimilation of Graeco-Etruscan motifs, now appeared on more common, bronze items, which until then had been decorated with simple geometric patterns only. The same applies to weaponry, such as scabbards, helmets and spear heads. Our knowledge of these designs is almost exclusively limited to artifacts in bronze, because the decorations made on iron have mostly corroded beyond recognition.

In general, grave goods at this stage reflect the difference between the military class and the rest. Those of the warriors include a sword (whose blade was a more or less standard length of sixty centimeters) and suspension rings for the belt; a spear; and, in rare cases, a metal helmet or the trim from a wooden shield. Among the other burials, the elite status of adult women is denoted by complete parures, varying according to region.

The gradual standardization of the more common decorated objects is probably due to the perfection of mass-production in specialized workshops. The relatively limited repertoire is found throughout the La Tène world. As a result of standardization, midway through the fourth century some objects underwent no significant changes for a good half-century. The two main types of fibula typical of this new La Tène phase took their name from the Duchcov site in Bohemia, renowned for its extraordinary votive deposit of about 2,500 fibulae and a series of rings dating from this period, and from the Münsingen site, near Berne, where there is a proliferation of fibulae with discoidal foot and insets of coral or red enamel. The study of the distribution of certain distinctive forms has disclosed the key role played by Switzerland in spreading the style toward the west and toward central Europe.

The assertion of this highly uniform La Tène style seems to come about midway through the fourth century B.C., a period of relative stability and consolidation of the population, and in many areas is associated with the development of flat cemeteries (usually the rite is inhumation), which have been attributed to the historical Celts since the last century. The regional diversity of dress—which offers clues to outside influences and their origins—shows that migration across the territory continued to the end of the century in question. Some of this was internal, and affected the earlier, fifth-century La Tène area, but much of it was a question of expansion, as seems to have happened in the eastern periphery, creating the conditions for the large-scale exodus toward Danubia at the start of the third century B.C.

Habitat, Society, Economy

Our knowledge of the La Tène habitat in the fourth century B.C. is still very patchy. None of the fortified sites of the preceding century seems to have been occupied, though some,

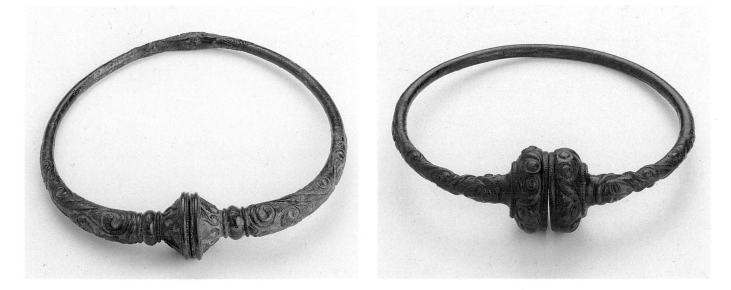

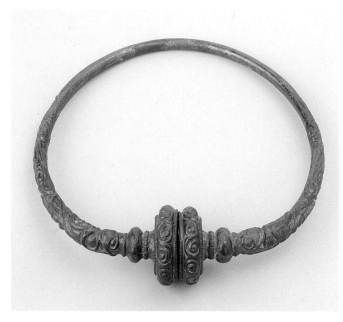

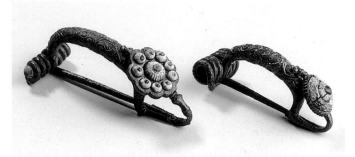

such as the one at Závist in Bohemia, were occupied by small rural communities that merely exploited the agricultural resources of the immediate surroundings. Their attitude was apparently akin to that of the Celts who settled in the ruins of the Etruscan town of Marzabotto: they buried their dead within the perimeter, without paying much attention to the remains of the ancient town, which must have been clearly visible at the time.

The rather well-known network of cemeteries seems to correspond to a dispersed rural community, the basic unit being a farm with out-buildings, as illustrated by the site of Bílina in Bohemia. This comprised a large construction with posts (probably the dwelling itself) and, ten to thirty meters away, various dug-out constructions, which are perhaps the foundations of sheds, food silos, or kilns; there are also ditches from which clay was extracted, used principally for facing the walls; sixty meters or so from the main group of buildings, there is a shed foundation dug into the ground, complete with silo. Finally, above the living area there is a small cemetery, containing three burials, confirming the relatively brief occupation of the site and the small number of inhabitants on the farm. Judging from the capacity of the silos for storing crop seeds, the group had probably comprised no more than a dozen people. But this estimate does not tally with the extent of the livestock which consisted of oxen, chickens and above all pigs, clearly a substantial part of the inhabitants diet.

Despite the lack of more precise information on farming productivity, some information can be inferred from the remarkable growth of the craft activities, which could not have existed without sufficient surplus of provisions to feed those not involved in farming. The study of the surviving material shows that the market was fairly extensive, and that most of the essential categories of objects were, at this stage, turned out in bulk by specialized craftsmen to serve a relatively large market.

This situation is illustrated particularly well in Bohemia, thanks to a series of fibulae from the votive deposit of Duchcov. The largest group comprises no less than forty fibulae that show minimal variations since they were hand-crafted, while the cast parts are absolutely identical. The funerary assemblages in Bohemia have so far yielded less than a half-dozen fibulae of this series, all found within a radius of fifty or so kilometers. It would be tempting to pinpoint the workshop that produced these items at the center of that radius, somewhere slightly west of Prague, as this region—with its rich deposits of sapropelite, a fossil material used to produce annular ornaments—was the site of an exceptional concentration of craft activities in the following century. Today, however, there are no further clues to indicate the precise location of the centers in which the fourth-century fibulae were actually manufactured.

Reconstruction of the decoration on a bronze torque from Champagne Second half 4th century B.C. Nancy, Musée Historique Lorrain

The hoard of objects from the votive deposit at Duchcov and their comparison with objects associated with burials give an idea of the vast quantity of personal ornaments produced in bronze; two or three identical objects found among burial goods could be part of a series consisting of dozens or even hundreds of pieces, which were then traded over an area of several thousand square kilometers.

The conclusions that may be drawn from other series that have turned up in fair quantity, albeit only in burials, are not so obvious. They are, however, confirmation of the existence of highly specialized workshops whose products were traded throughout the region. In Champagne, the vessels painted with the technique similar to that used in the red-figure Attic vases were produced by a very few potters, probably centered near Reims (where they are most heavily concentrated), but they have turned up in sites fifty miles away.

This lack of interest in trading everyday objects over greater distances is evidently due to the fact that local production catered to the tastes of a limited clientele within a defined ethnic group. This applies particularly to clothing. By and large, manufactured goods traveled only with their owners. Only special prestige items (such as wine jugs, arms and ceremonial chariots, ornaments of precious metal) were carried further afield through the same channels as other luxury goods such as coral, wine, amber and precious fabrics. The case of the tombs of Waldalgesheim and Mannesdorf, whose exceptionally fine grave assemblages are best explained by the distant origins of the person buried, indicates that even prestige items found outside the production area most likely made their way to these sites with their owner.

Map of Bohemia showing the distribution of the main types of fibula from the molds found in the Duchcov votive deposit and of crimped wire bracelets produced by different workshops Second half 4th century B.C.

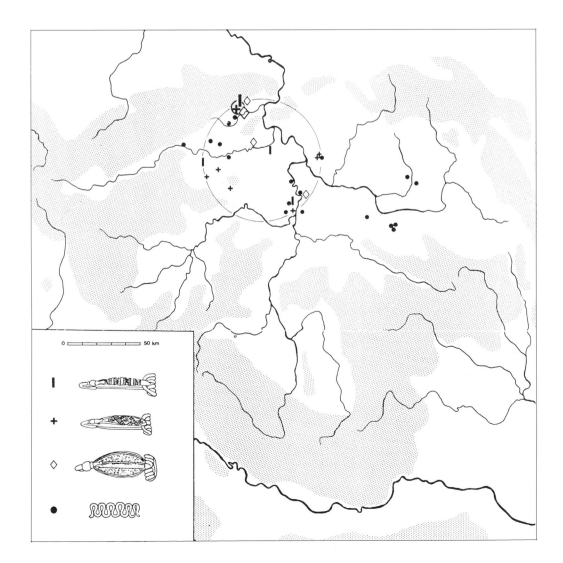

It would be wonderful to find the true explanation for the apparent changes in fourth-century Celtic society, but the information we have to go on is insufficient. The most obvious change, the supremacy of a military class whose grave goods are essentially the same as far as items of prestige are concerned, gradually took the place of the original dynasties, but we still cannot be precise about the details of the situation.

The ways in which certain areas became populated or repopulated show that this military class was made up of a small landowning nobility of "free men," doubtlessly grouped according to the inter-tribal rivalries that Polybius had in mind (*Histories*, II, 17) when he noted

Partial reconstruction of the crude decoration (above)
on the painted vase from Les Flogères at Berru (Marne, Reims, Musée Saint-Rémy), and the painted vase from tomb no. 46 at Caurel (below) Second half 4th century B.C.

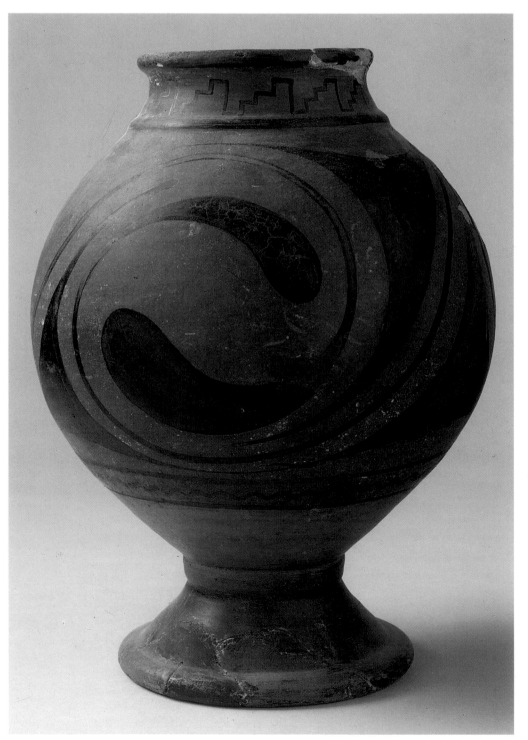

Vase painted with red-figure tecnique from tomb no. 46 of the Fosse-Minore cemetery at Caurel (Marne) Second half 4th century B.C. Saint-Germain-en-Laye Musée des Antiquités Nationales

*Embossed bronze mount
from tomb no. 10 at Brunn am
Steinfeld (Lower Austria)
Second half 4th century B.C.
Vienna
Niederösterreichisches Landesmuseum*

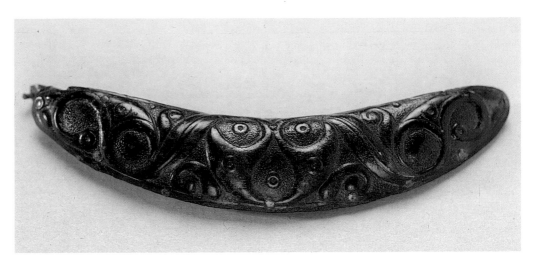

the ability of Celts who had immigrated to Italy to form *hetaeriae*. This capacity to break away from the tribal setup and form new ethnic groups, thanks to their clans, probably explains the astonishing dynamism of this military elite, whose members seem to have traveled La Tène Europe far and wide throughout the fourth century B.C., either alone or with their relatives, in groups, or in droves of tens of thousands.

The World of Ideas: Art and Religion

At first sight, there are strong indications that the fourth-century Celts underwent a religious upheaval: the ancient sanctuaries were abruptly abandoned and the figurative elements of early La Tène art gave way to a variety of plant motifs in which the ancient deities and their monstrous companions all but disappeared.

Actually the desertion of the sanctuaries, the archaeological proof for which during this period is limited to Bohemia, seems to have been the natural consequence of the emigration of those who built and frequented them. It is possible that the phenomenon did not occur in regions where the population was stable. As for art, while it is true that certain iconographic themes seem to become rare or peter out altogether, this is either because they no longer appeared on the same objects (such is the case with the pair of monsters guarding the tree of life, by then used only to decorate scabbards) or because they are often virtually unrecognizable in new highly stylized forms (such as the pair of "dragons" on scabbards, which had become designs as opposed to figures), or because they were replaced by forms with the same symbolic value from the new repertoire.

In this way, the face of the deity previously associated with the palmette and the "double mistletoe leaf" motif was substituted by the Celtic version of the palmette, which the experts have dubbed "pelta" owing to its similarity with this ancient form of shield. This resulted from the fusion of the leaves of the original motif with the pair of volutes against which they are set. This fusion may involve all the elements of the palmette or omit some, which keep their form within the La Tène motif. This is what happens with the central leaf, which becomes inscribed within the semicircular form of the "pelta."

It is impossible to gauge to what extent the human likeness of this motif when seen upside down (the nose is suggested by the drop-shaped central leaf, the cheeks by the two triangles framing it, the eyes by the simplified volutes) guided those who modified the Mediterranean palmette for the first time. They were aware of the ambiguity of the motif, as seen in the Filottrano scabbard, or the composition adorning the torque of Oploty—both of which can be dated to the mid-fourth century B.C. The exploitation of this illusion, which bears out the correspondence established between the divine face and the Celtic version of the palmette, remains nonetheless restricted in this period to a relatively limited number of objects, and did not become a widespread fashion until the beginning of the following century.

The metamorphosis of the palmette and certain related plant motifs began in the Italo-Celtic world in the first half of the fourth century B.C., and continued in the areas populated by Transalpine tribes, particularly in Champagne. The clever composition of discontinuous elements in chains of palmettes, and their modification to cope with the various kinds of supports and the whims of the artist to produce equivocal impressions, has produced astonishing running patterns of sinuous lines which, depending on the viewing angle, the lighting or the mood of the observer, seem to describe caricatures, or monstrous silhouettes.

The brutal irruption of the Transalpine Celts in northern Italy (with all its multiple consequences) seems to have been accompanied by human migration that involved not only today's Champagne region but also the central-eastern area of La Tène civilization, such as the abrupt departure (toward the end of the fifth century B.C. or the start of the next) of most of the inhabitants of Bohemia and certain neighboring regions, followed by the installation of new Celtic groups, perhaps originally from the Swiss plateau, in the natural quadrilateral which provided the heart of the Hercynian uplands mentioned by the classical authors.

It is interesting to note that the regions that seem to have provided the basic stock of those who invaded Italy—that is, the Marne area and Bohemia—appear to have been densely populated in the fifth century B.C. The idea of mass migration prompted by overpopulation—the cause offered by most of the classical authors for this sudden movement of people—is therefore not unfounded.

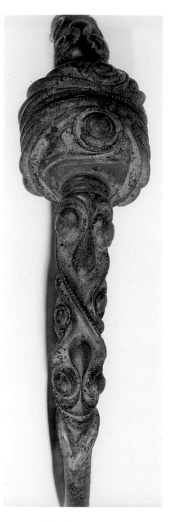

Detail of the bronze torque from Les Jogasses at Chouilly (Marne) End 4th-early 3rd century B.C. Châlons-sur-Marne, Musée Municipal

Reconstruction of the main decoration on the Les Jogasses torque (left) and a sketch of the arrangement of palmettes that inspired it

212

Detail of the golden torque
from Waldalgesheim (Rhineland)
Second half 4th century B.C.
Bonn, Rheinisches Landesmuseum

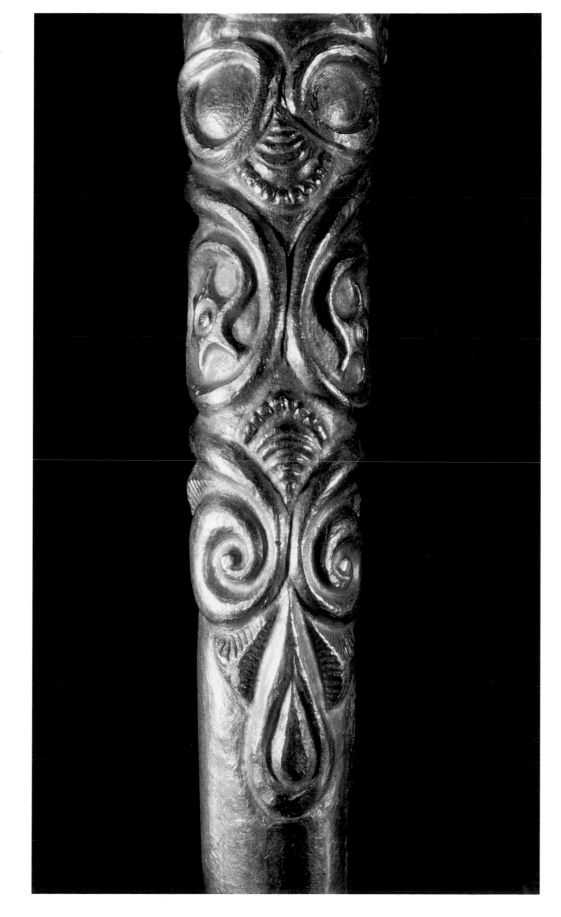

The Alps at the Time of the First Celtic Migrations

Today, we generally have a false impression of the sort of things people knew about distant lands before the development of modern means of communication. The reason for this is the nature of the written sources, particularly with regard to the Celts. They did not leave behind a written testimonial of the events of the time, nor, indeed, any literature; consequently we must rely on the few references given by Greek and Roman authors, who obviously had a Mediterranean perspective. It goes without saying that very often their writings survive only in the form of fragments, retrospective summaries or quotations. It is therefore not surprising that we really know nothing of why and how the Celts tackled the crossing of the Alps, apart from legendary interpretations or those handed down by early writers. However, those that have survived go back no earlier than the second century B.C. Yet, during those decades around 400 B.C., when the first bands of Celts penetrated Italy from north of the Alps, they must have known fairly precisely what they were looking for. "It is said that the Gauls, who had been held back by the protective bastion of the Alps, which, until then, had been thought to be invincible, were inspired to invade Italy by the fact that a Helvetian, Helicus, who resided in Rome and worked as an artisan, had brought back with him a dried fig and a bunch of grapes, as well as samples of wine and oil. It is therefore understandable that they wanted to procure these goods for themselves, even at the cost of war." The narrator of this account is Pliny the Elder—who died in A.D. 79 during the eruption of Vesuvius as a result of his thirst for knowledge. However simplistic his version of the facts may seem, it is full of information if we treat it as a commonly held idea of his time and then compare it with the archaeological evidence. The Alps are defined as a "protective bastion," but obviously only to the extent that they obstructed the passage of large numbers of people or armies. On the other hand, single travelers could certainly travel from north to south and vice versa, and even work as artisans in central Italy and take new experiences home with them. In the north, they knew how to evaluate the delights of the south. There is no doubt that contacts of various kinds existed before the great Celtic migrations took place, as indeed they did in all ages. Despite this, for the Mediterranean peoples, the mountains were always a source of worry and gave rise to a whole series of clichés. Livy, for example, (from his point of view, of course), offers a concise description of the first invasion of Italy by the Celts under the leadership of Bellovesus: "Now the Alps lay before him. I do not wonder that, to them, the mountains seemed to represent an insuperable barrier, for no one had yet crossed them, if historical accounts are true, unless we give credence to the legend of Hercules. There stood the Gallic company, brought to a halt by the towering wall, and looking for a way over those sky-high peaks and into the other world beyond." It is worth quoting Livy again: he was from Padua, a city not very far from the Alps. In his account of the crossing of the western Alps made by Hannibal in 218 B.C., he tells of how the Carthaginian leader minimized the dangers of the Alps, exhorting his army, in the presence of Celtic guides from the north of Italy, to face the trials that lay ahead: "What do they think, that the Alps are different from other mountains? Even if we imagine they are higher than the Pyrenees, in fact, no land exists that reaches as far as the sky: there are no mountains that cannot be climbed by man." The Alps were inhabited, people had built houses on them; human beings lived and multiplied there. Therefore the passes could be crossed by an army. The delegation they saw there, after all, had not flown over the Alps. And the forefathers of those Gauls were not indigenous, but had crossed the Alps as farmers, and had reached the other side of the mountains safely, often in large numbers, with their wives and children, as was the custom of migratory peoples. Therefore, what could possibly constitute an obstacle for a warrior, who had nothing but his own arms to carry? Then, however, we see ancient superstitions coming to the fore. These are forgivable from the point of view of the Carthaginians, with their auxiliary troops from Africa and Spain: "But the height of the mountains, which they now saw in front of them, the glaciers which almost seemed to melt into the sky, the miserable huts perched on rocky outcrops, the herds of livestock and draught animals that seemed dejected with the cold, renewed their fears; the human beings, who had become hairy and wild, nature

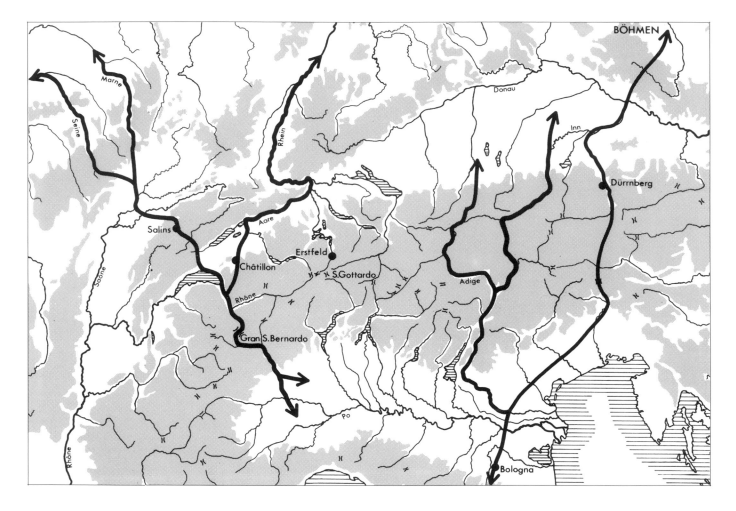

as a whole, living, yet not living, and stiffened with cold, and all those aspects which, from close up, seemed much more frightening than in the accounts, made them seem even higher." Such references, to which others from later periods could be added, help us to understand how the Alps were seen from the outside, prior to Romanticism and the development of tourism in the nineteenth century: impossible to cross, cold, alien, daunting, terrifying. There should be no reason to suppose that this impression was any different for the vast majority of the Celts of central Europe, when the first large bands pressed south into the "blessed land." And yet, the situation for them was quite different.

The Alps were inhabited by humans from Paleolithic times, from the time when the ice of the last Ice Age had melted, although the density of the population was very sparse. Numerous finds, particularly on the south side of the Alpine passes, prove that during the Mesolithic, hunters visited the Alpine regions above the timber line, where game could be captured more easily. During the Neolithic, the rearing of livestock was introduced, whereas the geographical and climatic conditions limited the possibilities of agriculture. Later, during the Bronze Age, the Alpine sphere went through a period of economic and cultural growth, when substantial deposits of copper were discovered in the area around Salzburg, in the North and South Tyrol and in the western Alps. The mineral was in short enough supply to lure people to the large valleys and the transverse side-valleys left by the passing of the glaciers. Mostly settlement was in single farms or small villages which have not changed much to this day. Larger settlements, such as market-centers or towns, did not emerge until Roman times or the Middle Ages. The bottoms of the valleys were almost invariably water-logged or subject to flooding. Moreover, apart from the valleys with a north-south orientation, they did not have many hours of sunlight. For this reason, settlements grew up mainly on higher

Plan of the main communications routes linking northern Italy with the land north of the Alps in the 5th-4th century B.C.

View of the Brenner Pass

View of the Saint Bernard Pass

terraces on the sunniest side of the valley, provided that the slope was not too steep. (They could reach several hundred meters above the rivers flowing in the valleys below.) Everyone knew their neighbors, and, during hunting parties above the timber line, used to meet up with inhabitants of neighboring valleys. In the mountains, it was no more difficult to maintain contact with one's neighbors than in other places, and in one sense, it was easier than in the immense, thickly forested areas of central Europe occupied by the Celts, thanks to the view over large distances and the fact that paths were clearly visible.

Everyone wishing to cross the Alps knew how to take advantage of these conditions: not only Hannibal, but also the groups of Celts who, in about 400 B.C., set off towards the south. Even now, there is no proof that these expeditions were of a bellicose nature: traces of fires or similar indications found in settlements cannot be dated in an exact enough way to enable us to reconstruct a "horizon of destruction" in the Alpine area around 400 B.C. There is no doubt that by the second half of the fifth century B.C., there was a period of friendly infiltration to northern Italy by small groups of Celts or possibly even individual families, the result of closer links with the Etruscans who had pushed into the Po Valley by the end of the sixth century. This climate of peaceful comings and goings did not have a great influence on the people of Alpine stock, though it was the beginning of the knowledge and links between north and south which were to develop and culminate in the large migrations later on. The routes these merchants and other travelers—and, later, whole groups of people—followed, are not known to us. It is only possible to reconstruct them on the basis of geographical data and some topographical points of reference. For example, there is one route which leads from the northwest into the western Po Valley across the Great Saint Bernard (2,469 meters). One branch of it led from the Seine-et-Marne area and Burgundy, crossed the Jura Mountains, probably in the vicinity of Salins-les-Bains, and used Lake Geneva and the Rhône for water transport as far as Martigny. A second branch originated in the fluvial system of the Rhine, took in the Aare and its tributaries as far as a settlement near Fribourg, which has been excavated, at the confluence of the Sarine and the Glâne. After this, it was necessary to travel by land, crossing the Col des Mosses, which is not particularly high (1,445 meters), thus entering the Rhône near Martigny. In this context, the chronological data is worth mentioning. The fortified settlements of Salins and Châtillon-sur-Glâne were both founded in about 550 B.C., that is, at the time when the transalpine contacts were beginning to develop. Châtillon-

sur-Glâne had already been abandoned by about 400 B.C., whereas Salins was still occupied in the fourth century B.C. In the last analysis, the reason for this must be sought in the fact that the settlement also served to defend the production of salt in the Furieuse Valley, so that it was not merely a checkpoint on an important international trading route. However, we have the impression—and this also applies to other areas of the foothills of the northern Alps—that, around 400 B.C., following the Celtic migrations, this ancient and apparently much used communications network was destroyed, or at least lost much of its previous importance. This does not mean that people ceased to use it or that the Alpine populations no longer had relations with the south or the north. However, it is certain that the era of a communications system organized over long distances—one which took advantage of rivers as well as the dangerous mountain gorges—had come to an end, at least as far as the fourth century B.C. is concerned. When the Celts entered Italy, they still knew about it and used it; but, once they had settled in the south, it was no longer such a vital link.

The same considerations can be made about the other important arteries of communication, from Lake Maggiore and Lake Como to the Alpine area of the Rhine, from the Adige Valley toward the Tyrol and Bavaria, as well as the route across the Tauern Mountains to the rock-salt mines of Hallstatt and Hallein-Dürrnberg, and from here, on toward Bohemia. This links up with the fact that, from the fifth century onwards, in the central Alps (from the North Tyrol to the Trentino) a very specific cultural group emerged (the Fritzens-Sanzeno Group), which assimilated very few of the influences arriving from both north and south and which lasted until the Romans conquered this area of the Alps in 15 B.C. In Graubünden, Celtic influences from the north are slightly more accentuated, for example, in female ornaments and the practice of stamping decorations on pottery; but, here again, this is a case of adopting certain models, and not a penetration of Celtic groups to the Alpine area.

A quite different interpretation must be given to the hoard of seven torques and armlets found near Erstfeld between the lake of the four cantons, Lake Lucerne and Schöllenenschlucht on the road toward Andermatt and the San Gotthard (2,108 meters). These finely crafted Celtic artifacts dating from about 350 B.C., or possibly a bit later, seem to be unrelated to this region. Nor should it be supposed that a local "prince" of the Swiss hinterland was rich enough to have 640 grams of gold made into an extraordinary array of female ornaments, and, moreover, in a foreign artistic style. It is logical, therefore, to deduce that the hoard was brought to the Alps from the north, and all the evidence points to the fact that it was buried intentionally under a huge rock: not, however, to safeguard it, in a moment of impending danger, but as a sacrificial offering to the supreme powers with which they had to deal in the mountains. It is certainly no coincidence that Erstfeld stands on an Alpine pass which, at the time, played an extremely minor role; in fact, prior to the building initiatives of the Middle Ages (the so-called "Devil's Bridges"), the Schöllenenschlucht was an insuperable obstacle. With the help of local guides, it could only be skirted by making a long detour at high altitude (to the east, across the Fellilücke, 2,479 meters, and, to the west, via the slope of the Bazberg). But these were such difficult access routes that not even the Romans wanted to establish permanent links here. However, is it not possible that a group of Celts on their way south deliberately chose a route that was more difficult, though shorter, and less supervised than the main routes to the east and west? Perhaps this journey was made by chiefs with the families of their group, adventurers with a group of friends prepared for anything, ambassadors bearing precious gifts to a prince in Italy. We do not know: but it is certain that guides could always be found, and once they had learned from them about the dangers awaiting them the next day, it would certainly have seemed advisable to ensure themselves the goodwill of the gods by making a precious offering, in order to reach "another part of the world" under divine protection.

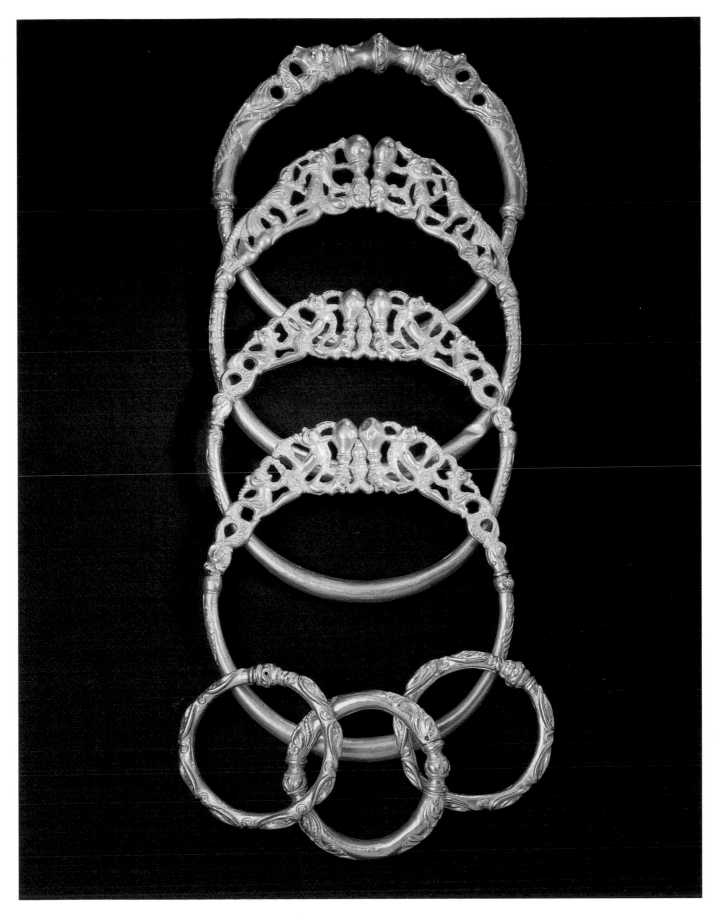

The Celts in Italy

After more than a century of neglect, when official archaeology was more interested in investigating the other civilizations that occupied Ancient Italy, the studies and discoveries of the seventies have breathed new life into Celtic archaeology in Italy.

The exhibition "The Gauls and Italy" (Rome, 1978) and the conferences on " Celtic Peoples and Cultures North and South of the Alps" (Milan, 1980) and "The Etruscans and Celts in Central and Northern Italy—from the fifth century B.C. to Romanization" (Bologna, 1985) continued the tradition of the fifth session of the Congrés International d'Anthropologie et d'Archéologie Préhistoriques held in Bologna (October, 1871). By recognizing the Celtic nature of some of the material found at Marzabotto and Bologna, this conference gave rise to the first scientific debate on the archaeology of Celtic culture in Italy.

From 1871 to the 1970s there were new discoveries, new excavations and various critical analyses of the material found enabled us to get a clear focus on the characteristics of the Celtic peoples who inhabited the Italian peninsula, and revealed the potential of this area of archaeological research—potential which is emphasized by the formation of a single area of study that embraces Celtic "history, archaeology, epigraphy and linguistics."

Nowadays we are increasingly aware of the need to draw on new sources made to have a full and substantial picture of the culture and politics of the Boii, Senones, Cenomani, Insubres, and the other Celtic peoples in Italy (of whom archaeology knows almost nothing), and in order to get a more precise idea of the relationship between the Celts of Italy, the other peoples of the peninsula and the Celts of northern Europe.

Celts and Other Italian Peoples in the Fifth Century B.C.
The finds at Castelletto Ticino and the new information we have on the subject of the Prestino inscriptions have been decisive in showing the fully Celtic nature of the peoples of the Golasecca culture, who occupied northwest Italy from the end of the Bronze Age—that is, long before the invasions of the fifth and fourth centuries B.C.

La Tène-style bronze fibulae from the Arnoaldi cemetery (Bologna)
First half 4th century B.C.
Bologna
Museo Civico Archeologico

The political and economic development of centers such as Como (or Sesto Calende) and Castelletto Ticino was favored by the fact that the Celts of Golasecca in northwestern Italy acted as go-betweens for the Estrucan world of the peninsula and the Celts on the other side of the Alps. In fact, those towns emerged where openings in the mountains made it easy (with the help of the mountain people) to transport goods across the border. Further to the east a similar role was played at the beginning of the fifth century B.C. by the Etruscans who, alone or together with the Veneti, used the services of the old Rhaetian peoples of the Adige Valley and the central-eastern Alps. This would explain the Etruscan presence across the Po Valley (which is confirmed by inscriptions and inhabited centers such as the Forcello di Bagnolo San Vito near Mantua).

Thus, we have a clearer idea of the variety of peoples who occupied the area between the Apennines and Alps during the sixth and fifth centuries B.C., although there are still gaps in our knowledge of some areas, such as that between the eastern extremes of the Golasecca culture and the Paleoveneta area—we still need further information. What emerges is the permeability of these peoples—they absorbed individuals of various origins, who integrated and adapted to local customs. We find Etruscans in the Golasecca community, Golasecca and North European Celts in Etruscan Felsina, Celts among the Liguri at Genoa, Celts among the Veneti (who even found a dynasty in the area around Padua). All of this reveals the limits of old, and sometimes even the modern, historical accounts which give a rigid, simplified version of the historical processes involving the interaction of different cultural and ethnic groups. In fact, these processes were of great temporal and spatial complexity.

When hundreds of thousands of transalpine Celts began to migrate toward Italy at the end of the fifth century B.C. the territory was already well-known in Europe for the goodness of its products, the mildness of its climate, and the fertility of its land. Commercial contacts between the peoples of Italy, first among whom were the Etruscans, and the princes and aristocrats of transalpine Europe had certainly supplied the peninsula with important raw materials (such as tin, amber and salt) but it also in a way reduced the distance created by the Alps: for those who, like the Celts of the North, were hungry for land, or were simply in search of wealth and fortune, Italy had become too important a country to ignore. The figs and wine that the Etruscan, Arrunte, used to lure the Celts into his own city of Chiusi in order to right a wrong that had been done him by a young local potentate, reveal the eco-

nomic motive behind the great migration (Livy, 33, 2-4). The same economic motive—only this time seen from the opposite point of view—is clear in the story of Helicus, a Helvetian Celt who worked in fifth century B.C. Rome as a blacksmith. The Italian figs, oil and wine that he took back home are supposed to have provoked the invasion of the peninsula (Pliny, *Natural History*, XII, 5). The invasions of the fourth century B.C. changed the relationship between Italy and Europe. No longer was there a commerce of goods and raw materials between politically and culturally autonomous entities, but rather the free circulation of individuals and groups of individuals in an area (northern and southern Alpine regions) which, in the course of two centuries, became more and more homogeneous from both a cultural (La Tène) and linguistic point of view.

The Historical Record
The Gallic invasion at the beginning of the fourth century B.C. had a profound effect on Rome, the Etruscans and the other civilizations of ancient Italy.
The expedition of the Senones against the Etruscan city of Chiusi—which possessed more land than it could possibly cultivate and thus had to surrender part to the invaders— was subsequently re-directed against Rome (Diodoro Siculus, XIV, 113; Livy, V, 36; Dionysius of Helicarnassus, XIII, 10-11).
From July 386 B.C. onward we see, before the end of the year, the tragic defeat of the Roman army on the banks of the river Allia (where it flows into the Tiber a few miles from Rome), the burning and partial destruction of the city, its looting and occupation for a period of seven months, and the near success of the attack on the Capitoline hill—foiled only by the timely warning of the geese.
Modern historians have exposed the falsifications in the ancient accounts that were designed to cover Rome's inability to recover, militarily and politically, after this catastrophic defeat. The heroic deeds of men such as Camillus, "architect" of immediate Roman revenge on the Gauls and rescuer of the gold that had had to be paid to ransom the city, are all pure invention. The Celtic sweep down from the Alps into the Po Valley occupied by the Etruscans led to the destruction of the important city of *Melpum* (the location of which is still unknown). This occurred in the same year as the Romans conquered Veii, and Dionysius, tyrant of Syracuse, was laying siege to Reggio Calabria (388-387 B.C.).

Map showing the main Celtic peoples in central and northern Italy in the 4th-3rd centuries B.C.

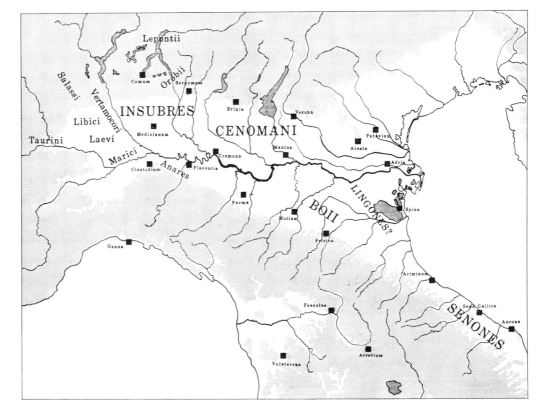

In order to drive the Greeks out of the Adriatic, Dionysius had gained control of the Veneto-Etruscan port of Adria and set up his own colony at Ancona.

In 385 B.C., to offset the power of the Etruscans, he formed an alliance with the Celts who had set fire to Rome. According to M. Sordi, the unsuccessful attack by the Gauls who had returned from southern Italy (Diodorus, XIV, 117; Strabo, V, 2.3) and the naval expedition of Dionysius against the coast of Etruria which led to the sacking of Pyrgi and its sanctuary (384-383 B.C.) were both part of a common offensive directed against the powerful city of Cere.

For more than thirty years the Gauls were either allied with Dionysius or else they supplied him with mercenaries who were deployed from the port of Ancona.

In 332 B.C. a peace treaty between Rome and the Senones was signed (Polybius, II, 18, 9). This agreement encouraged trading links between the Gauls and Etruria and facilitated the recovery of Roman power over an area stretching from the Tiber to the Po Valley, along the Adriatic coast.

The hostilities between the Gauls and Romans triggered by the latter's expansionism led to a broad-based alliance of Italic peoples, the Senones, Etruscans, Umbrians and Samnites. At first the allies enjoyed some success but they suffered a heavy defeat at *Sentinum*, in Umbria, in 295 B.C. during the third Samnite War (Polybius, II, 19, 6; Livy, X, 27, 3; 29, 17-18; 30, 8; 31, 13; Diodorus, XXI, 6).

Some years later, however, hostilities with the Senones, who came into the closest contact with the Romans, broke out once more. In 284 B.C. they attacked Arezzo, which was allied with Rome, destroyed two legions and killed the Consul in command. The Romans soon had the situation under control. They defeated the Senones and founded the Roman colony of *Sena Gallica* at the mouth of the Misa (283 B.C.).

At this point it was the Boii who tried to challenge Roman power in the Po area. With their allies the Etruscans they were defeated near Lake Vadimone in 283 B.C. The Romans and Boii signed a forty-five year peace treaty (Polybius, II, 21, 1). When the Romans pushed further north and founded the Roman colony of *Ariminum* (Rimini) in 286 B.C.—a bridgehead for future conquests in the Po Valley area and a sign of the final decline of Gallic supremacy on the Adriatic coast—the Boii did not react.

In 226 B.C. the Umbrian town of Sarsina was captured, guaranteeing control of those entrances to the valley of the Tiber which had been such weak points in the previous century.

In 232 B.C. the territory of the Senones (the so-called *Ager Gallicus*) was confiscated, divided into lots, and assigned to Roman citizens who thus became a stable component of the local population.

In 220 B.C. the Via Flaminia, a Consular road linking Rome and Rimini, was opened.

Around 240 B.C., after Rome had successfully concluded the First Punic War, there were further drives into the western Apennines, the very heart of Liguri territory, bordering the territory of the Boii. This series of campaigns forced the Boii (Peyre).

The crisis came to head in 225, when the Boii, the Insubres and mercenaries from the Valley

Bronze fibulae from the tomb at Lonato, Brodrera (Brescia) 300-250 B.C. Brescia, Museo dell'Età Romana

Bronze armlet or anklet from Acqualunga Fondo Castelbettino (Brescia) 3rd century B.C. Brescia, Museo dell'Età Romana

Pair of bronze anklets from Bettola-Milano 300-250 B.C. Milan, Civiche Raccolte Archeologiche e Numismatiche

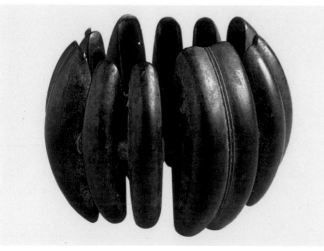

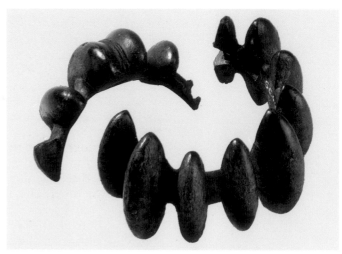

(the *Gaesati*) were defeated by the Romans and their Italian allies, including the Veneti and Cenomani (Polybius, II, 24-33).

The Boii were subjugated in 224 (Polybius II, 31, 9), and two years later so were the Insubres, whose capital *Mediolanium* and whose other center of *Acerrae* had already been captured (in 222 B.C., the battle of *Clastidium*-Casteggio; Polybius, II, 35, 1). The founding of the two Roman colonies of *Placentia* in the territory of the *Anares* and *Cremona* in Cenomani territory with 6,000 settlers each, marks the culmination of the conquest of the Gallic peoples in the Po Valley, in 218 B.C.

It was Hannibal's crossing of the Alps, in that same year of 218, that raised the hopes of the last indomitables. The destruction of *Placentia* and other military operations (such as the destruction of two legions in the *Silva Litana*, a vast forest to the south of the Po, between Modena and Reggio Emilia) in 216 B.C. reveals new activity on the part of the Boii.

However the defeats of Hasdrubal at Metauro near Senigallia in 207 B.C. and of Hannibal at Zama in 202 left the Romans free to act against the Boii, Insubres and Liguri, who were now without their Carthaginian allies. Como was conquered in 196, and in 189 the colony of *Bononia* was founded in the area of the old *Felsina*. The year previously, the colonies of Piacenza and Cremona in the Po Valley had been "re-established."

The Main Celtic Peoples in the Cisalpine Area (Fourth-Third Centuries B.C.)
The Celtic population who occupied the vast region known as *Insubrium* in the fourth and third centuries B.C. were the direct descendents of the Golasecca communities.

Livy offers a concise account of the arrival of Bellovesus, along with "Biturgi, Arverni, Senones, Aedui, Ambari, Carnutes and Aulerci" (Livy, V, 34) in an area of north-west Italy that had been called *Insubrium* since time immemorial (as a *pagus*, that is, a territory, of the

Bronze torque from Gambara (Brescia)
First half 3rd century B.C.
Brescia, Museo dell'Età Romana

Bronze torque from the cemetery at Carzaghetto - Canneto sull'Oglio (Mantua)
First half 3rd century B.C.
Asola
Museo Archeologico Goffredo Bellini

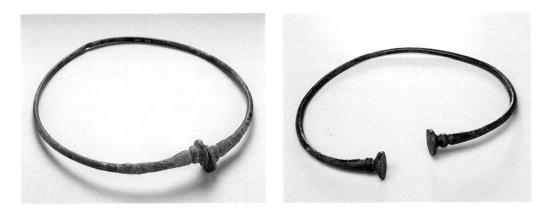

Aedui). His reconstruction reflects his keen awareness of the overlapping cultures that contributed to the history of the area, similar to the situation of the regions to the south of the Po, which were inhabited by the Etruscans, Umbrians and Liguri.

An auspicious start led to the founding of *Mediolanium*. Excavations in Milan have revealed the surprising antiquity of the center, the name of which alludes to its role as a political hub for the Insubres. We are yet to have an exact archaeological account of the process by which the new arrivals were absorbed into the existing communities.

The oldest individual tombs and cemeteries situated between the Ticino, Oglio and the Chiese rivers differ from those of the Golasecca culture, and date from the fourth to third centuries B.C.

The scarce archaeological documentation available for the older periods (from the fourth to the second centuries B.C.) has prevented us from learning anything about the funeral rites of the Insubres. But one feature that is characteristic of the area of the Insubres, though it is also found in other Cisalpine communities, are oval-shaped hollow-bossed bracelets made of two hollow, smooth parts that are hinged together, similar in form to the Danubian type.

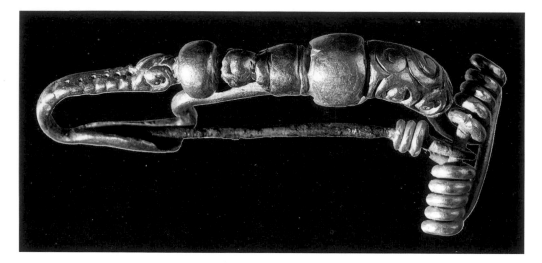

*La Tène-style gold fibula found
in or near Padua
3rd century B.C.
Padua, Museo Archeologico*

The fact that these objects occur in twos has given rise to the belief that they were anklets for Insubre women, probably linked to inhumation burial practices.

The Cenomani

Archaeological research in the plain that stretches from the Oglio-Chiese rivers to the Mincio and beyond, extending north to the area around Verona and as far south as the Po, has produced evidence of a markedly La Tène culture. The finds suggest that there was no link with the cultures of the local population, whether the Po Valley Etruscans (centered around Mantua), the settlements of Remedello-Sant'Ilario, the Veneti further west or any of the other pre-Celtic substrata that have yet to be identified.

Historical and literary sources, as well as the Celtic nature of the material found, enable us to identify the inhabitants of the region as the Cenomani.

This people arrived after the expedition of Bellovesus, led by Helitovius (Livy, V, 35), and are credited with the foundation of *Brixia* (Brescia), the capital of the population (*Caput gentis*). Excavations of the *Capitolium* have shown that the city is as ancient as the sources claim. Of all the cemeteries that have been explored—with varying degrees of thoroughness—the richest in material is that at Carzaghetto near Mantua, a cemetery with fifty-six graves that can be dated to between 320 and 250 B.C. The tombs of the warriors contain swords, sheathes, lances and La Tène belts. The tombs of the women, on the other hand, contain a typically Celtic article, the torque, a collar with large discoidal buffer terminals. This article is generally found together with bracelets and finger rings—often made out of silver—which are bent into shape or formed out of a more or less dense coil. This jewelry was usually worn asymetrically: the silver articles were worn on the right arm, the bronze (or other metal) articles on the left. Horses had also been buried in the cemetery. Another characteristic of the Cenomani tombs (not only at Carzaghetto but also at Rivalta sul Mincio and Vho di Piadena in the Campagna region) is the scarcity of pottery. The typically Celtic form of what little there is make of them he oldest examples of Celtic pottery known in Northern Italy: "slim, with a sinuous outline, wide pronounced shoulders.... and ribbing between the neck and the shoulder of the vase" (De Marinis).

Unfortunately we can no longer evaluate the importance of the cemetery at Castiglione delle Stiviere. It was destroyed by work in the gravel quarry, but not before a number of metal objects were recovered. Removed without any sort of scientific system and then collected together *a posteriori* (and not all of them at that), the objects that are today presented as forming the funeral assemblage of a single tomb most probably come from different graves.

The group of beaten bronze mounts decorated with embossed plant motifs and ribbing are particularly important. Jacobsthal interpreted them as part of a vessel made out of sheet bronze, while De Marinis has proposed that they formed the main body of a Celtic war horn (the *karnyx*) which was completed with a "discoidal bell.". The collection contains parts of an object in embossed sheet metal: the wings and the traces of claws left on a disc surely identify the figure as that of a bird. This might have been a decorative feature analogous to that present on the Çiumeşti helmet.

In the entire Cenomani territory only one helmet has been found (at Gottolengo, near Cascina Lumaghina, of a type that was widely used by the Senones and Boii.

In the second century B.C. the differences between the Cenomani and Veneti became even less noticeable, so that Polybius could write "the part near the Adriatic is inhabited by another very ancient people, the Veneti, whose customs and habits are not very different from those of the Celts—though they do have a different language" (Polybius, II, 17, 5). The proximity of the Veneti (which often forced certain cities, such as Padua, to live in a permanent state of war with the neighboring Gauls, Livy, X, 2, 9) had encouraged the creation of a common Cenomani-Veneto culture—especially in the western part of the Paleoveneto world (around Este and, to a lesser extent, Padua). The integration of the communities can be seen in inscriptions, the local production and circulation of La Tène objects, and in the adoption of a totally new artistic language (examples of which are certain decorated fibulae found at Este, and figured stelae found in Padua). This integration of ethnic groups not only led families or whole groups to relocate but also to intermarry. There is, for example, the case of the Veneto woman, *Frema*, who married a *Boialos*, a Celtic Boii—Este, Benvenuti tomb 123, fifth-fourth century, or the already mentioned *Trivalei Bellenei*, head of a new clan in the Veneto.

The Boii

The territory of the Boii stretched west as far as Modena and Parma, north to the Po River, and was bound in the northeast by the territory of the Lingonians. To the east and southeast, its boundary was marked by the Utens River (Livy, V, 35), perhaps what Pliny identified as the Vitis (*Natural History*, III, 115), that is, one of the rivers that flow through the province of Forlì, the Uso (north of Rimini), the Montone or the Ronco-Bidente.

Writing about the Cisalpine area, Cato che Censor described the Boii as being divided into 112 tribes ("The Origins," in Pliny's *Natural History*, III, 116). He further noted that this political and "administrative" fragmentation was well-suited to this vast territory with its natural geographical division—highlands and plains, forests and swamps, Apennine foothills and valleys—that had earlier been dominated by the Etruscans, Umbrians and Liguri.

The center of the Boii occupied the area of the old Etruscan town of Felsina (present-day Bologna), by then partly abandoned, or, at least, divested of the prestige it had enjoyed up to the fifth century B.C. as the capital of the Po Valley Etruscans.

No source, however, describes this as a "caput gentis," as happens with other Cisalpine Celtic settlements. The term is applied to *Mediolanium* of the Insubres and *Brixia* of the Cenomani for example. This might be due to the fact that in the area that extended from Parma to the Romagna region there existed other settlements that were as important as *Bononia*.

In effect, the material we have shows that funeral assemblages in Bologna were neither richer nor more elaborate than those in other, even apparently minor, centers.

Boii territory seems to have been divided into a network of *vici* (lowland dwellings), *tecla* (isolated farms), and *castella* (towns situated in strategic positions on higher land; Livy, 32, 31, 1-3; 33, 36, 8). The archaeological evidence we have confirms this organization.

The Boii town of Bologna has left no monuments. Modest walled structures identified at the foot of the hill, in the Porta Saragozza area (and which may still have been in use in fourth century), along with sporadic finds in the city center, indicate merely that the area was settled.

More information has come from the cemetery to the west of the city, which contains more than two hundred graves—almost all for inhumation (cremation was rare).

The fourth and third century graves lie between a deeper layer of Villanova tombs (eight-seventh century B.C.) and an upper layer of Roman graves. Only forty percent have grave goods. These finds either agree with the Etruscan customs that had become well-established in the Po Valley, or show certain innovations that can be traced back to the clothing and customs of the Celtic world.

One of the innovations is the La Tène sword, which is sometimes ritually sacrificed—as in northern Europe. There are only seven warrior tombs at Bologna, but these reveal a whole hierarchy of wealth and military rank.

Two very rich graves (Benacci 953 and Benacci Caprara I/1887) yelded bronze helmets, gold crowns, metal and pottery utensils for the funeral feast and the drinking of wine, strigils and other signs of athletic activity, dice and game counters. These contrast sharply with other, much poorer, graves (Benacci 138 or 176) which contain only a sword and sheath and almost

Bronze helmet from tomb no. 953
of the cemetery of Benacci (Bologna)
End 4th-early 3rd century B.C.
Bologna
Museo Civico Archeologico

Etruscan bronze jug with looped
handle from tomb no. 953
of the cemetery of Benacci
(Bologna)
End 4th-early 3rd century B.C.
Bologna
Museo Civico Archeologico

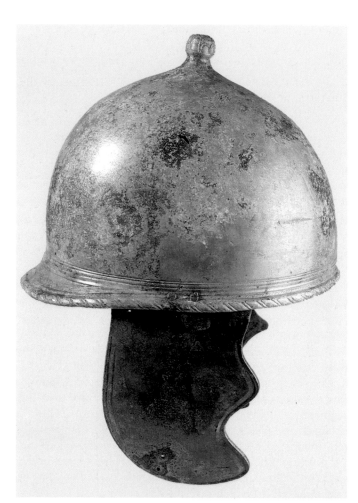

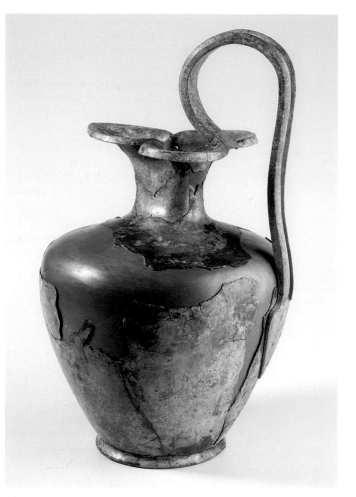

Bronze strainer and kyathoi
from tomb no. 953 of the cemetery
of Benacci (Bologna)
End 4th-early 3rd century B.C.
Bologna
Museo Civico Archeologico

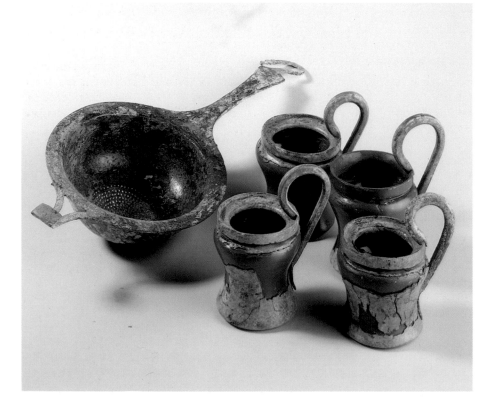

no metal vessels. However, there is also a difference between these tombs and those male graves that contain no weapons (such as Benacci 968). This contains a black-glazed vase with the Etruscan inscription *mi titles* ("I am the vase of Title"), indicating that this was an Etruscan resident of early third-century Bologna, who was buried in the part of the cemetery that was used by the Boii. This fact illustrates the dual nature of the Boii community: it was grafted onto the fabric of Po Valley Etruscan settlements and could successfully live alongside the descendents of the local peoples.

The dualism seen in the male graves can also be found in the female graves. Benacci 960, for example, contains Etruscan vases, gold earrings and a decorated bronze mirror, while tomb 114 contains a female burial with only a single iron fibula and a Celtic bracelet on the left wrist decorated with plastic motifs of Bohemian type.

The sumptuousness of certain funeral assemblages in Bologna, and its eastern territory, Monte Bibele and Romagna, equals that found in Senonian tombs. They show the same variety of elements from different areas. The only difference lies in the area of origin: Greek figured pottery, vases from the upper Adriatic, jewelry and metal vessels from southern Italy

Crown in embossed gold leaf from tomb no. 953 of the cemetery of Benacci (Bologna) End 4th-early 3rd century B.C. Bologna Museo Civico Archeologico

(Taranto and Campania) for the Senones, whereas the Boii tombs contain exclusively Etruscan material.

Other Boii material comes from the cemetery at Ceretolo, to the west of Bologna. However, this site, discovered in 1878, was excavated without any sort of scientific criteria and there is reason to doubt the authenticity of the abnormal collection of grave goods produced. Further material found during the many subsequent searches of the area suggest that the site must have contained other warrior and female graves that have now been lost.

Evidence of a vast Boii settlement further to the west, in the area around Modena, is provided by the cemeteries and isolated finds at Cognento, Saliceta San Giuliano and Magreta. Other La Tène associations can be seen in the glass bracelets found at Bibbiano (Reggio Emilia), in the minor funeral assemblages found in the Parma area, and in the warrior grave at Casaselvatica. The latter contains the La Tène weapons that were traditionally sacrificed along with the dead warrior, a few pieces of pottery, and a bronze helmet with a decorated horn in beaten sheet bronze. This can be dated to the early decades of the third century B.C., and reveals the Boii's interest in a western stretch of territory that reached from the Po Valley, through the Lunigiana and the land of the Liguri, to the west coast of the peninsula. In Liguria there have been the important finds at Ameglia. The cremations here took place in a specifically local type of wooden casket, and the graves contain funeral assemblages analogous to those in Boii territory. This shows either that the Liguri adopted Celtic weapons, or that the Celts had become part of the local culture, or both.

Beyond Bologna, the Apennines stretch from Marzabotto to Monte Bibele and the valleys of Romagna. This area is rich in funeral assemblages, often from warrior tombs, that can be dated between the end of the fourth and the second half of the third century B.C.

These complexes are to be seen as part of the *castella* (or highland centers) that were situated

in the Apennine valleys. So far the most complete excavations have been carried out at Monte Bibele and Monterenzio Vecchia in the Idice Valley. These two similar centers, five kilometers apart, form a short section of a longer limes that stretched from the Adriatic to Western Emilia, and was designed to control the passes across the Apennines.

The borders of the territory of the Senones were marked by the river *Aesis* (Esìno) in the south, and the Utens (Uso or Montone) in Romagna to the north (Livy, V, 35, 3).

Evidence of links with northern Europe (from the fifth century B.C. onward) is provided by Late Halstatt fibulae—thus connecting the area around Piceno with the problems raised by the Etruscan settlements in the Po Valley, and the question of the Veneto and the Golasecca area. Certain evidence of contacts and exchange does not rule out the possibility that Celts from the north may well have settled in the communities of the Piceno area that dated from before the invasions.

The sources we have are often contradictory, but we do know that the Senones played a leading role in the early fourth-century war against Rome and its allies; they were definitely the main participants in the 386 B.C. occupation of the city. What we have at present are cemeteries and individual tombs, whereas there is litte evidence with regard to their settlements (of whose structure and organization we know nothing). The material from the settlements at Mondolfo, Cessapalombo and Pesaro dates from the fourth-third century B.C., when the Senones were the major power in the mid-Adriatic area.

The fact that they were the established occupants of an area that was crucial for links between central Italy and the Adriatic (as well as for links with the north, along the Tiber),

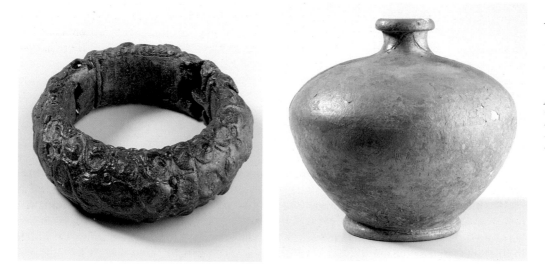

Colored glass game pieces and bone dice from tomb no. 953 of the cemetery of Benacci (Bologna)
4th-3rd century B.C.
Bologna
Museo Civico Archeologico

Hinged bronze armlet from tomb no. 114 of the cemetery of Benacci (Bologna)
3rd century B.C.
Bologna
Museo Civico Archeologico

"Trottola" vase in terracotta from female tomb no. 921 of the cemetery of Benacci (Bologna)
Mid-3rd century B.C.
Bologna
Museo Civico Archeologico

together with their alliance with Dionysus of Syracuse, meant that already by the first half of the fourth century B.C. the Senones were playing a far more important role than the other Celts in Italy.

A rich warrior tomb (dating from about 350 B.C.) has been found at Moscano di Fabriano, in the upper Esìno Valley. It contained a distinguished panoply: a bronze helmet, a La Tène sword with a sheet bronze sheath decorated with "continuous vegetal style" (known as the "Waldalgesheim" style), metal parts for a horse's harness, a sumptuous wine service including bronze vessels from Etruria or Campania and black and red figured Attic vases, a strigil and top of an unguent pot (linked with athletic activities), and a La Tène bronze fibula with plastic decoration and a disc in which to set coral.

Two of the tombs at Santa Paolina di Filottrano in the Musone Valley (which is also the site of the San Filippo d'Osimo cemetery) contained noteworthy funeral assemblages. Tomb 2 was for a woman, and contained a rich collection of gold objects, including torques decorated with continuous vegetal style, a decorated bronze mirror and a set of bronze and pottery vessels—the latter are from either Attica or the upper Adriatic area and help us to date the tomb to around the middle of the fourth century B.C. Tomb 25 was for a warrior. It con-

*Ribbed, transparent glass armlet
with yellow glass inserts
from female tomb no. 921
of the cemetery of Benacci (Bologna)
Mid-3rd century B.C.
Bologna
Museo Civico Archeologico*

*Sword, spearhead, and iron
belt-chain from the tomb
at Ceretolo (Bologna)
First half 3rd century B.C.
Bologna
Museo Civico Archeologico*

*Bronze fibula and heavy armlet
from the cemetery at Ceretolo
(Bologna)
First half 3rd century B.C.
Bologna
Museo Civico Archeologico*

tained a La Tène sword and a sheath made out of iron and sheet bronze—the latter decorated with continuous vegetal style.

The richest and most substantial cemetery of the whole area—a find that was fundamental to our knowledge of the Senones—was discovered at Montefortino d'Arcevia. The fifty or so graves were explored between 1894 and 1899 (Brizio published his results almost immediately) and enable us to trace the development of the Montefortino community over a period of five generations, from the last decades of the fourth to the end of the third century. What characterizes the population as Celtic is the armor: the La Tène sword, together with iron or bronze helmets. Almost fifty percent of the graves contained weapons underlining the importance of warriors in the community of the Senones.

The other male tombs, and nearly all the female tombs did not have features that could link them directly with the world of northern Europe.

The conjunction of two torques produced by Greek jewellers with two bracelets for each arm (as found in tombs 8 and 23)—a third torque is linked with three bracelets to be worn on the left arm (made of glass, ivory and silver; tomb 30)—has been compared with the custom of Senone women in the Marne area (Kruta). However, it is clear that the great majority of female tombs do not have this "symmetry," which it is claimed links them with the burial customs of the northern Celts. An even more inexplicable fact is that this "Celtic" custom is to be found in two tombs (8 and 23) that date from the final part of the cemetery's history (end of the third-beginning of the second century B.C.) and not from its earliest stages as might have been expected.

The assimilation of the culture and customs that had been imported from Greece to form part of the life of Etruria and central-southern Italy is clear from the objects found in the tombs: the gold and silver ornaments from southern Italy (Taranto) or Etruria, the articles for personal care (decorated mirrors, athletes' strigils, unguent pots), the predominance of imported metal or pottery sets for the comsumption of wine (from Etruria, Greece or Campania), the knives, skewers, andirons and cauldrons used in banquets.

The presence of articles similar to those found at Montefortino in tombs in Perugia (the Monteluce cemetery) and Todi (La Peschiera), and even further north in Boii territory, gives us some idea of the extent of the Senones's contacts after they became established in the Marches. We can also see the key role that this people played before the defeat of *Sentinum* in 295 B.C., and again after 232 B.C., when the *ager gallicus* was divided between Roman settlers.

Victors or defeated, their substantial wealth seems to have remained unaffected, though the source changed. Initially, it stemmed from their political independence, their value as mercenaries and their special relationship with other "nations" (firstly Syracuse, later Rome, which in 283 B.C. authorized the occupation of part of the Senone territory and the foundation of a *Sena Gallica*). However, the wealth of the Senone community in Montefortino persisted because of the particular (economic? political?) role played by the center—which either fell in line with, or else simply did not clash with, Roman plans for the area.

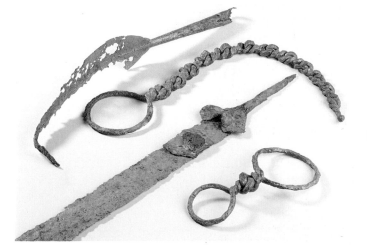

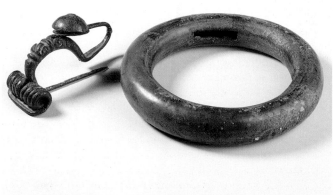

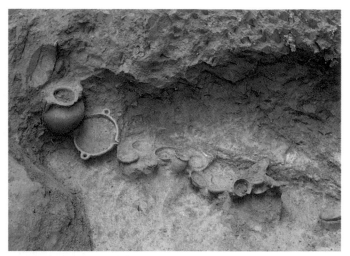

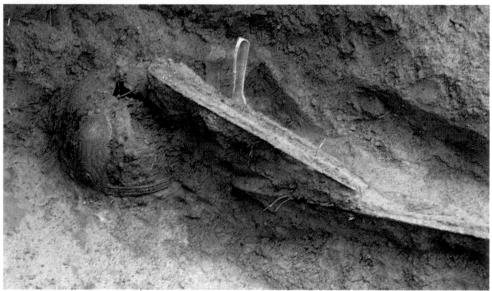

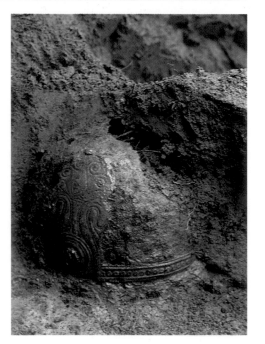

Top, left:
Idice Valley (Bologna)
View of Celtic hillfort settlements
from Monte Bibele
near Monterenzio (Bologna)
Top, right:
pottery and bronze vases
from tomb no. 116
at Monte Bibele (Bologna)
excavations in progress
Left:
detail of iron helmet with sheet
bronze decorations
from tomb no. 116 at Monte Bibele
excavations in progress
Below:
iron helmet with sheet bronze
mounts, iron meat skewers
and bronze strigil from tomb no. 116
at Monte Bibele
excavations in progress

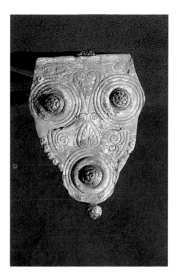

Cheek-guard in bronze decorated with vegetal and triskeles motifs Part of helmet from tomb no. 116 at Monte Bibele

The Celts in the South of Italy

The ancient literary and historical sources, especially Livy (VI, VII), repeatedly make reference to Celtic groups in southern Italy. Apulia in particular is mentioned as the base from which the Gauls launched their incursions on Rome between 367 and 149 B.C. The present state of archaeological evidence does not offer much to confirm this. What is certain is that the Gaulish communities in the south were highly mobile due to their role as mercenaries—a fact that stands at odds with the idea of Celtic roots in the territory. Furthermore, even if it were true, it was nothing like the Celts' occupation of the north where they dominated the local cultures. Attesting to the presence of Celtic warriors in the south is the rich assemblage, including an iron helmet with bronze mounts and coral insets, found in the area of Canosa di Puglia, and datable to between 330 and 300 B.C.

The Boii often reused pre-existing centers. This is clear in the Marzabotto area, where two small cemeteries occupy the streets of the Etruscan town, or the courtyards and wells of the abandoned fifth-century houses. Celtic dwellings occupied only a part of the urban area; the material dropped or thrown into the water wells shows that the houses were in continuous use through the fourth and third centuries. The tombs have a pronounced La Tène character and do not contain the Ligurian Volterra pottery (except no. 9) found in the houses. Both the warrior and female graves in Marzabotto were of the inhumation type; so far there is no evidence of cremations.

The Monte Bibele complex lies twenty kilometers to the east, in the Idice Valley. In its cemetery, almost all of the 134 tombs excavated are single graves. The large majority are inhumations, though some are cremations.

The earliest inhumation burials were on the top of the hill, and when the space ran out, the cemetery was extended down the slopes, one after the other, following the contours of the terrain. The cremations do not seem to follow such a rigorous sequence—so that late cremation sites are found alongside very ancient graves.

The regularity of layers, however, thus makes it possible to establish the chronological sequence of the burials in the Monte Bibele community.

The earliest tombs have typically Etruscan assemblages; pottery bearing inscriptions of family names are proof that this center had indeed been founded by the Etruscans.

Later in the sequence a new type emerges: adult inhumation graves that are characterized by the presence of Celtic iron weapons and fibulae.

Plan of the Monte Bibele settlement

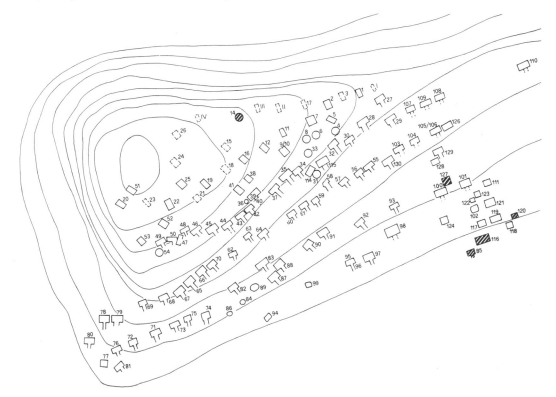

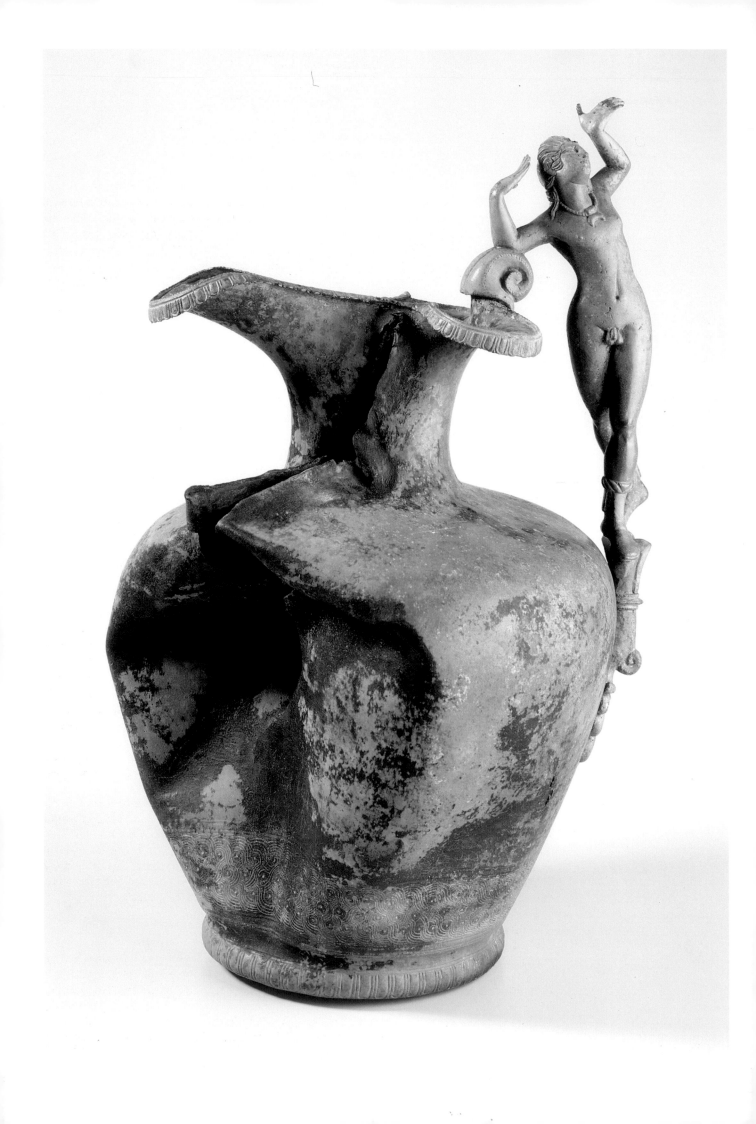

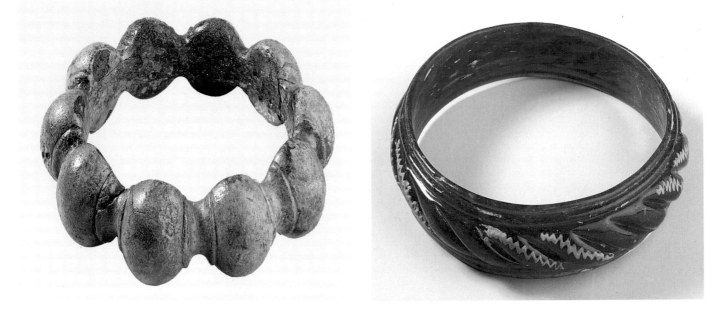

This indicates that a new element had been introduced at Monte Bibele—a group which identified itself in the use and possession of weapons, and had finally become an integral and stable part of the existing community. Some coincidences between archaeological evidence and details offered by the historical and literary sources make it possible to identify these warriors, with their Celtic weapons, as the Boii who had settled in the territories of Emilia-Romagna. The importance of this Celtic element in the population is revealed by another fact that shows Monte Bibele's strong ties and lasting trade relations with the transalpine world: it is possible to trace the development of La Tène (that is, Celtic) culture for more than a century—from around 350 to 250 B.C.—through changes in the types of weapons, the forms of sheaths, girdles and fibulae, which all correspond to those found in the Celtic regions of Europe north of the Alps.

One chieftain's grave, complete with Celtic weapons and an iron helmet (tomb 14), also contained a set of pottery vessels for two, on which the surname of an Etruscan woman (*Petnei*)—a relation of the dead man—had been scratched. It is easy to imagine that a marriage of alliance had taken place between high-ranking persons from opposite camps, solemnizing an end to hostilities: an Etruscan woman married to a Celtic chieftain.

Some arms that served for both defence and ceremony—such as the six metal helmets found decorated in the Celtic tradition, with red enamel—suggest the existence of an established military hierarchy, complete with chieftains.

The high quality of the grave goods of men and women, of warriors and civilians reveals the substantial economic power of the community and above all, its close and consistent links with the population centers in the Po Valley and Etruria (especially Volterra).

The richest assemblages include a wine-drinking service and one for the consumption of meat. There are also signs of a more cultural significance, related to sports and athletics: a strigil and jars of ointment bear witness to the success of an urban, Greek, way of life, which was copied with equal enthusiasm by the Senones and other Italian peoples.

The Lingoni

Only Polybius (II, 17, 7) and Livy (V, 35, 2) refer to this Celtic nation, situating them in an area near the Adriatic, between the Apennines and the Po River, bordering on Boii territory. Perhaps Pseudo-Scilace (between 350 and 300 B.C.) is also referring to them when, in describing the coast of the upper Adriatic, he speaks of Celts living at the Po delta, wedged between the Veneti and the Etruscans.

One should also identify as Lingoni that "large horde of Barbarians" who were such a threat to the inhabitants of Spina that the city was finally abandoned (Dionysius of Helicarnassus, I, 18, 4-5).

The only archaeological evidence we have of this people is the important collection of thirty small curved mounts of beaten and openwork bronze, decorated with running plant motifs. They are said to originate from "the Comacchio area." These mounts were applied as decoration to one or more objects (perhaps vases) made out of organic material; they constitute one of the most important examples of the art of Italian Celts.

No La Tène grave goods have come to light in Lingoni territory. In the cemetery and inhabited area of Spina the only Celtic object found was an imitation silver drachma. No swords or other La Tène objects have been found, in spite of the lively trade in black-glazed pottery and other goods that existed between Spina and the Celtic communities of the Boii area.

The Senones
According to Livy (V, 34, 5), the Senones were the last to arrive in Italy. To find a territory of their own they had to go beyond the land already occupied by other Celts and settle further south, in the Marches. Archaeological evidence, however, partly contradicts the hypothesis that these people were more recent arrivals than the other Celts. In fact, the Marches contain some of the oldest of all the funeral assemblages dating from the time of the invasions—so Livy's theory has to be rejected. Anyway, he drew his explanation from a Greek source (Polybius, II, 17, 7), and mistook the geographical sequence in which the various Celtic populations were described for a chronological one.

Celts and the Celticization of the Alpine Area
Important archaeological evidence of the Celts is to be found in the alpine area, which is usually considered more in terms of the passage between north and south than with regard to the particular communities that became established there and the ways in which they interacted with their neighbors.

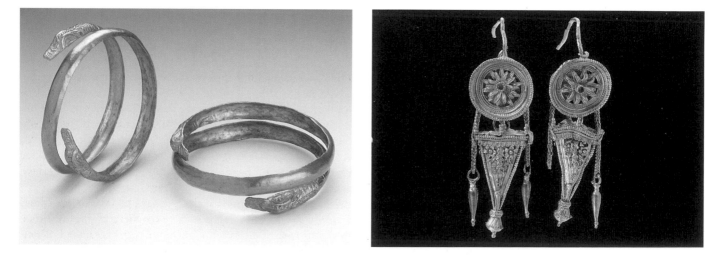

The most important single group in this world were the Rhaetians, who were subject to the influence of both the northern and Italian Celts, as can be seen from the number of La Tène objects found in the area. Ulrich Schaaff has studied the diffusion of Celtic helmets and has shown that some of the great number found in the Adige Valley are of the same type as those found in Montefortino and Monte Bibele (thus of Italian Celtic manufacture), while others have the "upturned neckguard" typical of northern helmets. Numerous La Tène swords have also been found; those at the Vadena cremation site were bent, or broken for ritual reasons. Another characteristic object based on La Tène models is the fibula with nodes along the bow and lengthwise grooving, originally fulled with coral or enamel and with a pin that ends in a disc surmounted by a human head wearing a helmet. On the basis of the diffusion of this class of object, Anne-Marie Adam and Raffaele De Marinis have underlined the vitality and extent of relations within the alpine area—from the Rhaetian territory to the Lepontian district—between the fourth and third century.
The fibula found at San Lorenzo di Sebato near Lothen (Bolzano), the bow of which is deco-

Pair of gold bracelets from tomb no. 23 at Montefortino (Ascoli Piceno) 3rd century B.C.
Ancona
Museo Archeologico Nazionale delle Marche

Pair of gold earrings from tomb no. 23 at Montefortino (Ascoli Piceno) 3rd century B.C.
Ancona
Museo Archeologico Nazionale delle Marche

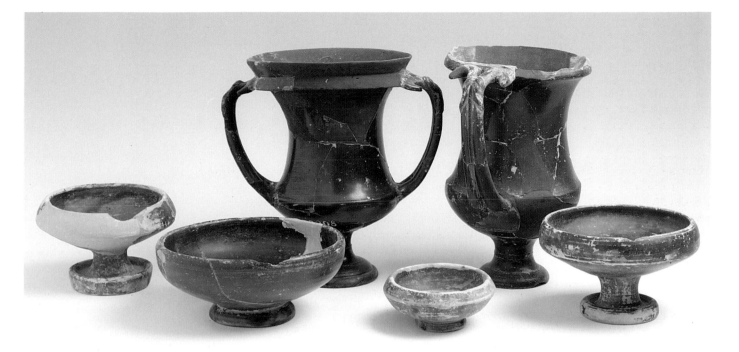

rated by a double series of triskeles linked in the continuous vegetal style, shows that there could have been Celtic workshops in the area.

The Third-Century Migrations

Rome appropriated most of the Boii territory, leaving the surviving members of the tribe with only the worst part.

The new cities and roads, the centurions and settlers, must have destroyed any hope the Boii might have had of regaining that unity which had made them more difficult to conquer than other peoples. So around the end of the third century B.C. to the beginning of the second there was a new migration—this time northwards. It is Strabo who informs us that, driven out by the Romans, the Boii tried to settle near the Celtic Taurisici in the Danube Valley but were driven out by the Dacians and then disappeared (Strabo, *Geography*, V, 1, 6).

Pliny's affirmation (*Natural History*, III, 116) that the Boii were one of the peoples to disappear from the Po Valley could bear out Strabo's claim. But it is difficult to believe that a people so firmly established in the Po Valley over two centuries could be so completely eradicated. What Pliny's claim certainly does show is that the Boii had lost all sense of political initiative and they had no national identity or idea of themselves as a surviving Celtic community.

Marie-Yvane Daire

Armorica

The relationship between the modern Breton language and the ancient Celtic tongues is by now a thoroughly explored subject. It is thought that the Breton language of Armorica is the only Celtic language still spoken on the European continent, and this is taken as proof that the western peninsula belongs culturally to the vast Celtic sphere. But what are the archaeological facts and what is evidence of the influence exerted by Celtic civilization on the peoples of Armorica in the Second Iron Age? The results of research show that, to begin with, western Armorica features typical traits of the Celtic world, equivalent to those found in central Europe, and very marked local details, of which the most spectacular are the funerary stelae and underground passages.

Armorica in the Celtic World of the Fourth Century B.C.
Pliny speaks about the Carthaginian navigator, Himilco, who, in the fifth century B.C., made a voyage that lasted four months, in which he ventured beyond the Pillars of Hercules—the modern Straits of Gibraltar—as far as the Oestrymnides Islands, in search of the British tin route. The exploration of the ocean undertaken by Pytheas of Massilia at the end of the fourth century B.C. (to which Strabo refers), enabled him to find the peninsula of Ostimioi (probably Armorica) with the cape of Kabaion at the tip (Pointe du Raz or Pointe de Penmarc'h), and bordered by islands, the last of which was called Ouximasa (the modern Ile d'Ouessant). These are two examples which show to what extent the far west was frequented by Mediterranean merchants in search of tin. Study of texts by Greek geographers (Pytheas and Timaeus, and later Polybius, Posidonius and others) proves that, during the La Tène period, there were exchanges between the western peninsulas (Cornwall in Britain and Armorica) and the Mediterranean ports of Marseilles and Narbonne. In addition to the texts, archaeological evidence—for example, a gold coin from Cyrene, minted at the end of the the fourth century B.C. and found on a beach on the northern coast of Armorica—testifies to the journeys made between the Mediterranean and the edge of Europe, along the coasts of the English Channel and the Atlantic. Connections between the Armorican peninsula and other regions of the European continent, cradle of the La Tène culture, are confirmed by the appearance of Celtic cultural traits in the west, along the Atlantic seaboard, during the Final Hallstatt and Early La Tène period (the end of the sixth and fifth century B.C.). Apart from the linguistic aspects, the existence of these links is supported by some very im-

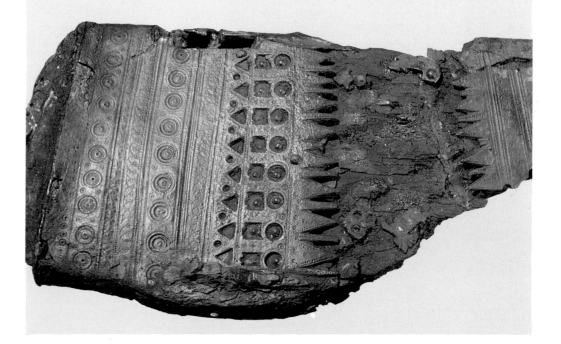

portant archaeological evidence. In the cemetery-shrine of Tronoën, fragments of an oinochoe and a helmet were found. The latter (the cap and cheek-guard) are of bronze plate and decorated with geometric patterns and pieces of coral. This object provides positive evidence of Italic influences. A necklace composed of twelve gold beads was found during the excavation of an underground passage at Tréglonou; each bead is made up of two gold shells decorated with embossed and engraved geometric patterns which fit into each other. These beads are comparable with those on the heads of certain fibulae from the Rhine area from the Late Bronze Age or Hallstatt period. Lastly, the fine dagger from Kernavest-Quiberon deserves mention: its scabbard, which is made of iron plated with bronze, features stamped motifs typical of the eastern Celtic sphere, with a curvilinear style which, during the Second Iron Age, often recurs on Armorican pottery.

Although the archaeological evidence cannot be disputed, the exact nature of these connections must still be established. Were there movements of Celtic tribes? Are they phenomena of cultural assimilation without any movements of this kind? Were they the result of the infiltration of small groups of people, especially artisans and technical experts? The existence of the various objects mentioned can be explained by the existence, if not of exchanges, at least of contacts between Mediterranean countries and central Europe, and between the latter and northern and western Europe; these objects probably circulated from one area to another, perhaps in the form of an exchange of gifts between chiefs. It is quite possible that ideas and techniques were transmitted on similar lines, leaving behind them a culture which

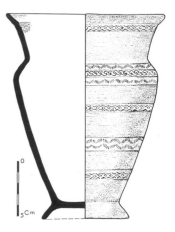

Terracotta vase with stamped decoration from the souterrains of Kerveo at Plomelin (Finistère) 5th century B.C.

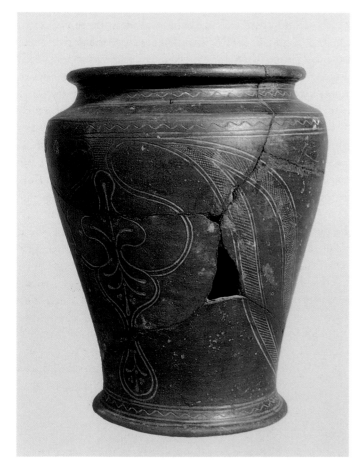

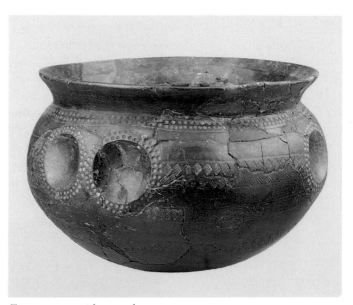

Terracotta vase with stamped decoration from Lann-Tinnikei en Plorneur (Morbihan) 5th century B.C. Saint-Germain-en-Laye Musée des Antiquités Nationales

Terracotta vase and reconstruction of engrave patterns from the Kernevez barrow near Saint-Pol-De-Léon (Finistère) 4th century B.C. Morlaix, Musée

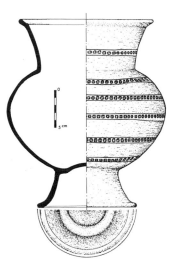

Terracotta vase with stamped decoration from tomb at Kergoglé en Plovan (Finistère) 5th century B.C.

Pottery with relief and stamped decoration from the settlement at Braden near Quimper (Finistère) 3rd-2nd century B.C.

deserves the name "Armorico-Celtic." Besides these objects, continental cultural influences are particularly noticeable in the field of pottery and, to a lesser extent, in stone-working (stelae).

Artistic Expression

Some authors agree that, on the one hand, the Marne region and, on the other, the Armorica region are the two most important artistic centers of that vast region which was later to become Gaul. Unlike other regions, few metal finds were discovered in Armorica, but, in this case, it is appropriate to talk of a real school of potters. The first manifestations worthy of Celtic art appear in the west from the early fifth century B.C., with high, hollow-based globular vessels, finely decorated with stamped motifs (the cemetery of Bagatelle at Saint-Martin-des-Champs, and that of Kergloglé at Plovan): showng bands of Saint Andrew's crosses alternated with circular motifs and upturned "bell" motifs. At first, the potters of the beginning of the Second Iron Age drew their inspiration from imported metal prototypes circulating in the peninsula. In fact, the shapes used in pottery clearly show the influence of bronze situlae and vessels (depictions on handles, pronounced carination and so on). Although the Armorican potters soon left these metal prototypes behind, in terms of the shapes of the vessels (shapes became rapidly more slender), on the other hand, they started to use a whole range of stamped decoration deriving from the ornamental relief on metalwork. Inspired by some metal objects of Italo-Celtic origin, from the end of the fifth century onward, pottery features similar motifs, for example, little arcs and palmettes; decoration with animal shapes is less common. The most important examples of this widespread manifestation of the free curvilinear style over the whole range of such stamped decorations, which drew inspiration from plants, are the magnificent vases found at Saint-Pol-de-Léon, Plouhinec and other sites. The fine sculpted curvilinear decoration with large spirals in relief (Quimper) represents a high point in this art form. The craftsmen were also masters in the use of color, as we can see from the pottery decorated with graphite (metallic gray) or hematite (red). These forms of artistic expression, on a pottery base, were prolific until the second century B.C., after which the aesthetic aspect gave way to functionality and technological perfection.

Another form of artistic expression is that of the stone-engravers, who left magnificent stelae decorated with the same Celtic motifs that appear on other kinds of objects, such as pottery: friezes with repeated S-shapes, leaves, caps, triangles, and swastikas on the stelae from Kermaria at Pont-l'Abbé (dated to the fourth century B.C.); friezes of diamonds, Greek key patterns, or double spirals on the one at Plounéour-Trez; overlapping double spirals on the one at Trégastel. These stelae from the Second Iron Age, which are not always decorated, show a great mastery of the art of working stone. Several hundred of these monoliths have been identified in this area. The top tends to be decorated and the bottom left unworked, since this part was generally below ground level. There are two main types of stele: the "low" variety, in which the worked part is hemispherical or ovoid, and the "tall" variety, which may be several meters high. In the second kind, the surfaces of the top part of the stele feature either decorated faces (which may number from four to sixteen), or longitudinal grooves, resembling the trunks of columns or a truncated-cone shape. These stone stelae are very common and constitute a feature peculiar to Armorica, both in terms of artistic expression and funerary practices.

Living Conditions and Activities

Studies of environments in the Second Iron Age (La Tène) in Armorica indicate that the landscape was largely deforested, which generated the development of marshlands where cereal crops, as well as broad beans where cultivated. This period of agricultural transition is confirmed by archaeological finds, especially in the form of numerous granite querns for grain, found in underground passages or actual houses, as well as in silo-ditches. This population of farmers lived in enclosed farms scattered around the countryside. There is no doubt that the fortified sites on top

of hills or on promontories between rivers, and especially the fortified headlands along the rugged coast, served as a temporary refuge, although some of them provide evidence to suggest that people stayed there for a lengthier periods of time. At an architectural level, the Second Iron Age in Armorica typically features houses with rectangular plans, although recent research has proved that there were also round houses, quite similar to the ones in Britain, such as the one from Talhouét at Pluvigner, which may have been built in the Early or Middle La Tène period. Many of these domestic buildings were built with wood and a paste made from clay and pieces of straw (wattle and daub) and must have had a wooden roof with a light covering of organic origin; but, especially on the Armorican coast, stone was also an important component in building, as we know from the houses with thick, faced granite walls.

These rural settlements of the Second Iron Age reflect specific regional characteristics in the form of Armorican *souterrains*, (underground passages), which constitute an architectural phenomenon of considerable importance. More than 300 have been identified in Britanny. These *souterrains* are mainly situated in the west of the Armorican Massif. The earliest date back to the First Iron Age (around 600 B.C.), but most can be dated to the Early and Middle La Tène periods. They were usually dug in a loose granitic substratum, with one or two vertical entrance-shafts of varying shape, while the *souterrain* itself consists of chambers connected by tunnels or separated by narrow openings. The total length varies from three to forty meters. The individual chambers vary in shape and are rarely more than four meters long. Apart from a few exceptions, the rooms and tunnels contain no archaeological material, whereas the entrance shafts, which were systematically blocked up when the settlements were abandoned, have produced a considerable number of finds. The underground passage at Tréglonou, for example, has produced a magnificent gold collar. The Armorican underground passages are associated with fortified camps, enclosures or settlements, but they seem to have been used for more than one domestic purpose (storing provisions, or as silos) and it is even possible that they were used for ritual and funerary purposes. At the site at Prat, for example, a fenced enclosure and an underground passage containing pottery decorated with stamped animal motifs point to occupation during the Early La Tène. Similarly, at the Early La Tène settlement at Saint-Symphorien at Paule, the silo-ditches for cereals are contemporary with an underground passage, inside an enclosure surrounded by a wide ditch. In addition to an agricultural population, Armorica also had considerable numbers of artisans, whose workshops are scattered around the countryside and the coastlines. A fair amount is known about the potters and stone-cutters, chiefly because of the prolific number of artifacts they left behind: the former produced numerous high-quality pots of various shapes, and the latter, granite stelae and querns for cereals.

As far as other craft skills are concerned, metal was widespread in Armorica from the Second Iron Age onwards. In most sites from this period, finds include various objects used both for architectural applications and agricultural work or craft skills. Moreover, most of the rural centers had a foundry or blacksmith, a fact proved by the discovery of smelting kilns and slag associated with other activities within the agricultural enclosures. The Armorican Massif has very rich iron mineral deposits on the surface, therefore the supply of raw materials cannot have been a great problem.

In Britanny there have also been finds of spindle-shaped iron ingots, which were used in the exchange of unworked metals all over Europe during the First Iron Age (Hallstatt period). There is no doubt that, within a short space of time, Armorica was able to stop importing raw materials, and produce the iron it needed for local production, and later, even export ingots to Britain. Traditionally, Armorica was oriented towards the sea and its coastal resources. Although the exploitation of sea salt dates back to at least the Bronze Age, from an archaeological point of view, it is clear that this activity underwent considerable development in the La Tène period. The workshops where the salt was boiled are scattered about the coast in the form of heaps of terracotta or fragments of brick, as well as structures of specialized workshops. Since the production of salt was associated with activities such as fish-

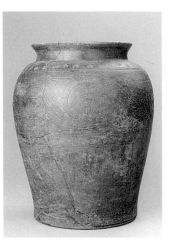

Terracotta urn with stamped and engraved decoration from Kélouer Plouhinec (Finistère) 4th century B.C. Saint-Germain-en-Laye Musée des Antiquités Nationales

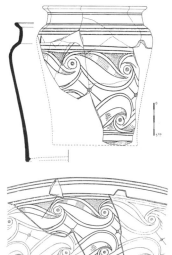

Terracotta vase with engraved decoration from Pendreff en Commana (Finistère) 4th century B.C. Penmarc'h Musée de Préhistoire Finistérienne

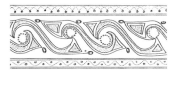

Reconstruction of the Kélouer Plouhinec vase

ing and livestock rearing, it obviously played a very important role in the economy, especially since it was possible to prepare and sell food preserved with salt.

These various facets of Armorican production were an important part of the commercial exchange which was gradually becoming established between the Atlantic coast to the west and the other insular and continental regions of the Celtic world. The sea trade routes between Armorica and the islands beyond the English Channel figured largely in such exchanges; now we know that Armorica exported many of its products to what is now Great Britain, such as iron (in ingot form), and pottery and its contents; other products, such as salt or Armorican tin, fulfilled the demand of countries on the Continent.

Burial Rites and Places of Worship

The burial rites of the Second Iron Age are typified as a whole by the re-use of previously existing structures (for quite long periods) and by a diversity of funerary customs: the round burials from the previous period were used again and smaller graves were added; there are flat graves containing cremation urns or small coffins, and inhumation cemeteries with coffins. The typical element in all these Armorican cemeteries is the existence of worked granite stelae, often consisting of refurbished megalithic monuments from an earlier period (re-worked menhirs). This is the case at the cemetery of Kerviltré at Saint-Jean-Trolimon, for example, which consisted of eighty cremation urns and the same number of skeletons, marked by half a dozen stelae. The cemetery-shrine of Tronoën at Saint-Jean-Trolimon was used from the Early La Tène until the time of Roman Gaul. It was excavated in the nineteenth century and produced some important finds, including, from the Second Iron Age, a set of twenty-five or thirty swords and sheaths from the end of the fourth century or early third century B.C., as well as bronze fibulae and, in particular, helmet fragments dated to the Early La Tène. These finds prove, beyond any doubt, that there were shrines in the vast expanses to the west which were very similar to those in other Celtic regions on the Continent, like Picardy and Burgundy. Burials from the Early La Tène, like those from

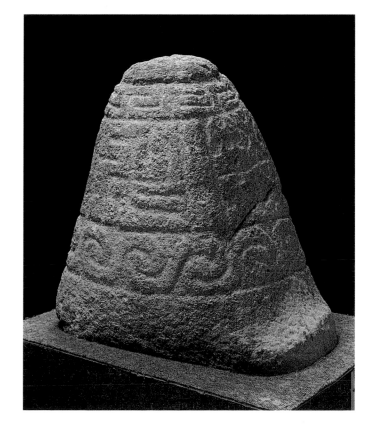

Granite pyramidal cippus (left) from Kermaria near Pont-l'Abbé (Finistère)
4th century B.C.
Saint-Germain-en-Laye
Musée des Antiquités Nationales
Above:
reconstruction of the decoration on the four sides of the cippus from Kermaria

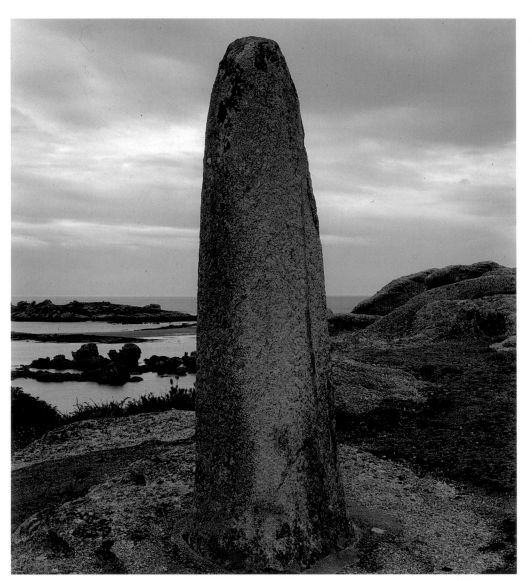

*Granite stele with engraved S-forms
from Sainte-Anne-en-Trégastel
(Côtes-d'Armor)
5th-4th century B.C.*

the Bronze Age, usually contain large amounts of pottery, although it seems that these funerary vessels (funerary urns or vessels containing offerings), some of which were decorated, may originally have been used for domestic purposes.

The Armorican people of the La Tène culture often associated spaces reserved for the dead with living areas. Take, for example, the site of Boisanne at Plouer-sur-Rance, where, during the Final Hallstatt or Early La Tène, there was a small agricultural enclosure surrounding a house with a rectangular plan and another small square enclosure used for funerary purposes. Not much is known about the religious sphere of these people, apart from the fact that they constructed rectangular ritual enclosures, similar in all respects to the *Viereckschanzen* of southern Germany.

The beginning of the Second Iron Age (La Tène) is one of the phases of early history in which the Armorican tribes can be defined fairly precisely. Despite the perennial nature of certain regional traditions, especially in the funerary sphere, the western region of Armorica was receptive to the continental influences of the new La Tène culture, adopting forms of artistic expression (sometimes re-adapting them) and even linguistic traits. All the evidence points to the fact that Armorica became integrated with the network of exchanges that linked up the various Celtic regions of Europe; but, far from undergoing a process of total cultural assimilation, the Armorican peoples of the period under discussion developed techniques and cultural characteristics that were to last until the time of the Roman conquest.

Jean-Jacques Charpy

The Champagne Region under Celtic Rule during the Fourth and Third Centuries B.C.

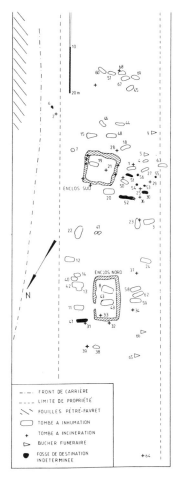

Plan of the Les Varennes cemetery at Dormans (Marne) 5th and 3rd centuries B.C.

As in the fifth century, the geographical section of Champagne occupied by the Celts during the fourth and third centuries B.C. was limited to the chalky region. Archaeological studies rely entirely on the analysis of the inhumation cemeteries. So far, no excavation work has been done on dwellings.

With the help of archaeological material from museums, we can draw up a accurate picture of the situation and test certain theories against historical facts reported in the classical sources. During the two centuries examined in this essay, the Celts were at the very peak of their prosperity. The decline that followed saw the mass migration of the Celtic populations through continental Europe. This exodus is noticeable even at the regional level.

The Cemeteries

The analysis of cemetery plans and grave goods has revealed the existence of distinct groups with features specific to their area. It is therefore possible to state that in the fifth century a group of people took up residence in the Reims area and enjoyed continual growth for two centuries. Their neighbors in the Aisne Valley, and those who settled south of the left bank of the Marne, were less permanent, and moved elsewhere for half a century (from 400 to 350 B.C.) or even more.

Cemeteries in the Reims sector. Geographically, this area is bordered by the valley of the Suippe in the north and the valley of the Vesle in the south, and lies between Reims and Suippes, respectively east and west. The "Argentelle" cemetery is one of the area's most important cemeteries. Here we can distinguish four family groups who all originally settled in the fifth century B.C., three of which had grown uninterruptedly until the third. Similar situations occur in other cemeteries, such as Caurel "Fosse-Minore," Warmeriville "La Motelle," and Witry-les-Reims "La Voie- Carlat."

Cemeteries south of the left bank of the Marne. This region, densely inhabited at the beginning of the La Tène period, saw a sudden drop in the population followed by its complete disappearance at the end of the fifth century and first decades of the fourth. Cemeteries that did not outlast the fifth century include the Villeneuve-Renneville "Le Mont Gravet" and Avize "Les Hauts-Nemerys"; the Chouilly "Les Jogasses" cemetery lasted slightly longer. The trend does not only apply south of the Marne, but to the entire Champagne region (except around Reims itself). Typical sites include Manre "Le Mont-Troté" and Aure "Les Rouliers" in the Ardennes, and Etoges "Les Petits-Noyers" and Dormans "Les Varennes" in the Marne area.

In the middle of the fourth century changes in settlement patterns are further manifested in the cemeteries.

Cemeteries in the Châlons-sur-Marne. Some groups of tombs in this area can safely be dated to the fifth century B.C. These were abandoned for two or three generations, before being used again by a group who probably came from Reims, and had been prompted to migrate by a rise in the population and subsequent shortage of land. This theory is borne out by the personal ornaments included among the grave goods, which are found throughout this geographical area. Such finds occur in cemeteries such as Poix "Les Ecoutrets" and the Grandes-Loges "Les Mortes-Vaches."

The cemeteries of the département of the southwest Marne. In the area centered on the marshes of Saint-Gond there are signs of small settlement groups the cemeteries of which contain no more than fifteen to twenty graves. The sites of the cemeteries are different from those of the fifth century. The Villeseneux cemetery is a typical example. The female ornaments found there indicate close ties with populations inhabiting the southwest fringes of the Marne (the north of the present departments of Aube and Yonne). We can conclude that the area experienced different settlement phenomena from those in and around Reims, as the Sens area had never been settled by Celts before.

Around the end of the fourth century B.C. or at the beginning of the third century B.C. a change in the cemeteries took place affecting the entire Champagne region. The cemeteries

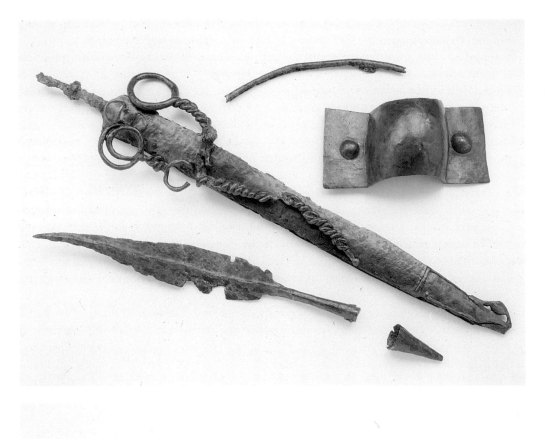

*Iron panoply composed of sword
with belt-chain, spear and butt
shield-boss and shield mount from
a tomb at the Faubourg-de-Connantre
cemetery at Fère-Champenoise
(Marne)
Second third of 3rd century B.C.
Epernay, Musée Municipal*

*Iron panoply composed of sword
with suspension rings, spearhead
shield-boss with handgrip from
a tomb at the Le Crayon cemetery
at Ecury (Marne)
First half 3rd century B.C.
Epernay, Musée Municipal*

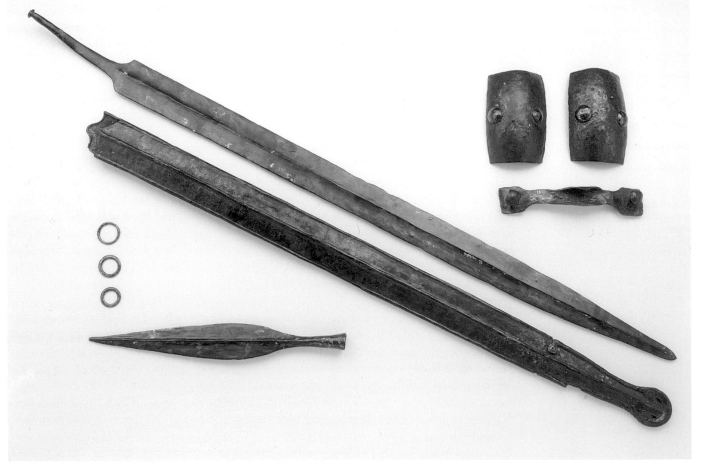

became much larger and more impressive, and some were built on abandoned fifth-century sites. The characteristic feature of these cemeteries is the rectangular enclosure.

Cemeteries superimposed on earlier sites. There are numerous examples of this type of arrangement, such as Soudé-Sainte-Croix "Le Champ-la-Bataille" and Dormains "Les Varennes," which both have an enclosure.

Cemeteries with rectangular enclosures. The forms vary considerably, and the lack of full information makes it impossible to determine any hard and fast rules governing their plan, especially where the earlier excavations are concerned. These are small isolated enclosures such as at Pleurs "Les Buttes," spread-out enclosures such as those at Dormans "Les Varennes," Cernay-les-Reims "Les Barmonts," and Saint-Benoît-sur-Seine "La Perrière" (Aube), and larger enclosures which include smaller ones in their midst, such as those at Fère-Champenoise "Faubourg-de-Connantre," Normée "Les Tempêtes" and Ecury-le-Repos "L'Homme-Mort." To complete this survey, a final category, somewhat rare in the Champagne region and datable to the second half of the third century (or early second century), must be cited.

The first cremation cemeteries (with or without enclosures). Only two examples of any im-

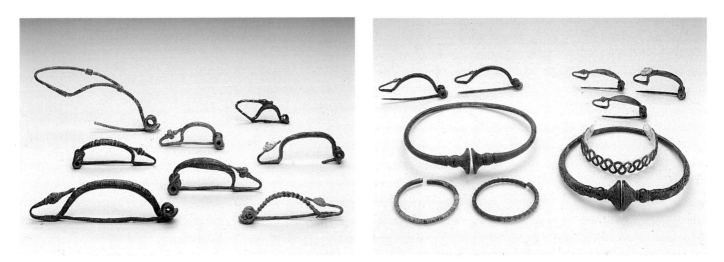

Bronze fibulae from the cemetery near Epernay (Marne) 4th-3rd century B.C. Epernay, Musée Municipal

Bronze torques, armlets and fibulae from the cemetery near Epernay (Marne) 4th century B.C. Epernay, Musée Municipal

portance, Montépreux "Le Cul-du-Sac" and Witry-les-Reims "La Neufosse" are known. These cemeteries are generally poor in grave goods, like the inhumation graves in the final phase of flat tombs in Champagne. They seem to mark a new turning point in Celtic civilization.

Some of the facts noted above may be linked to events recorded in ancient written sources, such as the scarcity of remains of males from the beginning of the fourth century, which some archaeologists associate with the military campaigns in northern Italy by Celts from Gaul, including the sacking of Rome in 390 B.C.

Grave Assemblages

While the structure of the various cemeteries gives a framework of the geographical evolution and chronology of Celtic culture in Champagne in the fourth and third centuries, the objects found in the tombs fill out the picture of the region's developments. Grave goods from this period include objects found elsewhere in Europe, and certain specific ornaments which facilitate the identification of the alien features in the population of the area.

Common elements of the Celtic world. The identity and nature of Celtic civilization has a common foundation identifiable in the arms in the male burials and the traditional ornaments in female burials.

Weaponry in the fourth and fifth centuries reflects the ethnological advances brought about

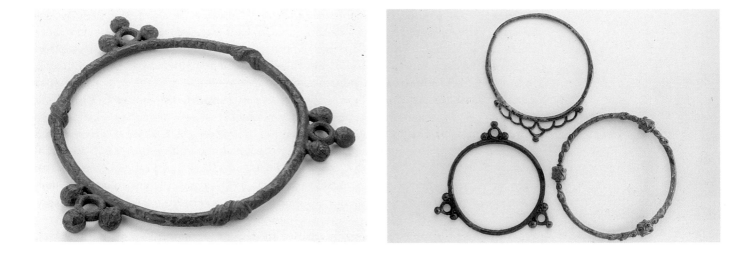

by the Celtic experience in all the armies in the ancient world, and by their expansion drives toward new lands. As elsewhere, weapons became standardized in Champagne, and consisted of a sword, a broad belt to hang it on, a shield and a spear. The sword is long, double-edged, and is carried in an iron scabbard often decorated around the top, with a chape made according to the prevailing fashion. The belt evolved from a primitive model composed of metal rings linked by leather, to a chain of long links, and finally comprised two sections made of small links. Completing the warrior's heavy equipment was a shield, made of wood with metal reinforcements (the only remaining evidence), a boss to protect the wearer's hand (originally in two parts and then one), plus the armband for holding it. The spears found so far are all different (in contrast to those of the fifth century). Types varied considerably but were perfectly suited for both thrusting and hurling. As for helmets, in Champagne none dating to this period has been found so far.

The traditional ornamental objects include fibulae, which are characteristic of female burials but rarely occur in those of the men. They can be divided into categories according to the metals from which they are made—bronze for the women and iron for the men. As we move into the third century, however, caution is needed. Bronze, a noble metal, became increasingly rare as it was mixed with other metals to make ever humbler alloys. Fibulae are one of the best dating criteria, and those found in the Champagne region do not differ from others found throughout the Celtic world.

Distinctive elements of the Champagne region. The main distinctions are found in women's ornaments, which were more susceptible to changes in style and give a better idea of the group to which the wearers belonged. The most common ornament is the torque (or neck-ring), then the bracelet, and finally the anklet.

The torque. This neck-ring is a open hoop of metal, and first appears in Champagne from the end of the sixth century B.C. For periods before the fourth century, however, the torque does not seem to have the same connotation of belonging to an ethnic group. At the beginning of the fourth century, the torques have a cone-shaped terminal at either end with finely incised decorative work, initially in the traditional geometric style, later changing to plant forms, of which the palmette was the basic element (Beine "L'Argentelle," tomb 2). Around 350 B.C. the lost-wax process brought more accentuated relief to the decoration (Beine "L'Argentelle," tomb 6). At the same time, another type emerged with large torus-shaped terminals bearing similar or derivative ornamentation (Hauviné "Verboyon," tomb 3). These neck-rings are characteristic of the Reims area. Southwest of Champagne, on the border of the *départements* of Marne, Aube and Yonne, the torques are called *ternaire* because of their three-piece plastic ornament, usually accompanied by a second motif (foliage or the *nodus herculeus*). There are several variants of this kind of personal ornament. In the easternmost corn-

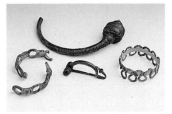

Fragmentary bronze torque and bracelets from the Mont-Desclus tomb at Bussy-le-Château (Marne) End 4th-early 3rd century B.C. Saint-Germain-en-Laye Musée des Antiquités Nationales

Bronze and glass jewelry from the new cemeteries of groups that immigrated to Champagne in the second third of the 3rd century B.C. Châlons-sur-Marne, Musée Municipal

er of Champagne, women wore buffer torques with torus-shaped terminals and three or four nodes around the ring. The distribution of such finds makes it possible to identify areas where these examples were used. In this way, intrusive elements can be recognized, for example, the *torque ternaire* found at Witry-les-Reims, the torques with torus-shaped terminals found at Soudé-Sainte-Croix, the buffer torque with torus-shaped terminals and nodes found at Caurel "Fosse-Minore," and the torque with enameled *cabochons* found at Beine "Les Bouverets." These detailed analyses enable archaeologists to follow and record the movements of populations, sometimes over great distances; for example, the *torque ternaire* found at Dobrnice (Czechoslovakia) or the one from San Polo d'Enza (near Reggio Emilia). From the start of the second century, the torques become more scarce. The metal alloys used are increasingly poor, and the ring becomes threadlike, with smaller buffer terminals (Soudé-Sainte-Croix "Le Champ-la-Bataille," tombs 1 and 12, and Montépreux "Le Cul-du-Sac," tomb 6).

Bracelets. As with the torques, the bracelets tend to denote the style of dress and social rank of the wearer. While in the fifth century B.C. matching bracelets were worn on each wrist, in the fourth they are no longer matching. The decoration of bracelets and torques evolved in parallel. In the earliest phases, they were engraved, but as time wore on they became increasingly decorated. Certain snake-formed bracelets with large links or nodes are found all over Celtic Europe. From the start of the third century B.C. a new kind of ornament in lignite or saprolite appeared alongside the traditional bronze ones. At first these minerals were used for making armlets and then bracelets, worn by both men and women. There are no precedents in Champagne for this new ornament, which indicates that it may have come from outside the region.

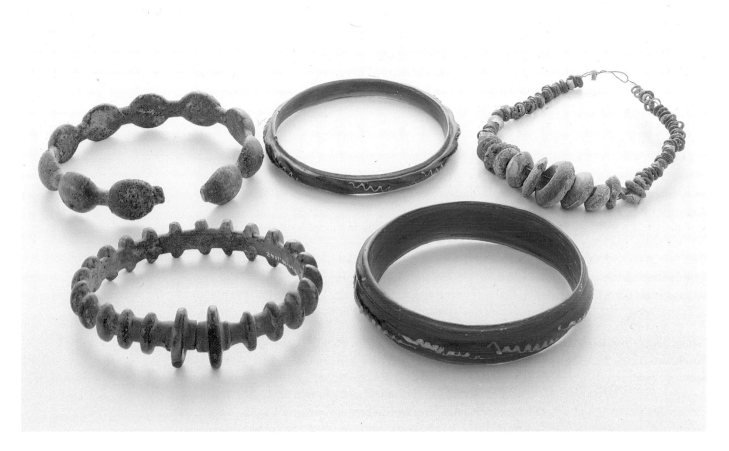

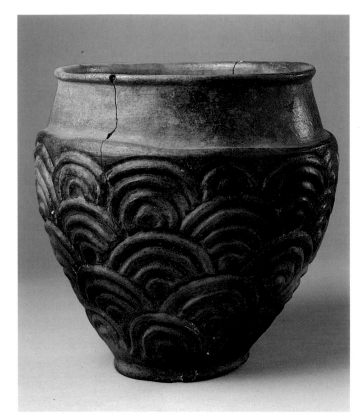

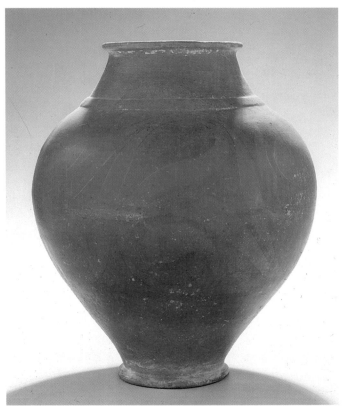

*Reconstruction of decoration
on the vase from the tomb
of Mont-Desclus
at Duny-le-Château*

Anklets. This item is not typical of Champagne, and first appears midway through the third century. Originally, anklets were worn independently from torques, and associated with a non-matching pair of circular bracelets. Venceslas Kruta has inferred from this that there were direct links with the central European populations, where this combination was common. Women, instead, wore matching torques and anklets; Kruta believes that this came about either with the integration of new arrivals to the area, or with the arrival of populations originally from the eastern frontier of Champagne, contemporary with the Danubian migration.

Pottery. During the fourth century, the potters of the Reims sector combined the new technology of the slow wheel with their knowledge of Greek ornament in Italy, and produced a highly original type of pottery. The main shape is spherical with a convex base. The body is partially covered by a red slip with black painting delimiting or creating a motif. Pottery production included situlae-shaped vessels, perpetuating the ancient custom of burying the dead with wine-drinking sets. This kind of grave deposit gradually gave way to a shorter, more culinary-type of vessel.

Outside the Reims area pottery is rare in burials. Finds include medium-sized, slip-coated pots (Gourgançon "Les Poplainnaux," tomb 19; Marson "Montfercault") and bowls (Lenharrée "Le Chemin de Vassimont").

Art. The lavishness of ornament and rarity of certain objects have spurred experts to deliberate on the problem of their origin. The most outstanding items dating from the fourth century B.C. include the torques and the red slip-coated pots with black-painted motifs. All are agreed that these objects were manufactured locally in the Reims area. Research into the third century has been concentrated on rarer items, such as the sword from Cernon-sur-Coole, the buckle from Loisy-sur- Marne, the Recy fibula, and the fibulae from Conflans-sur-Seine.

Authors are agreed on the importance of the artistic center which developed in the Danubian area at this period. Miklós Szabó has underlined the affinity of the Cernon-sur-Coole sword with the one found at Drna (Slovakia), while V. Kruta has suggested that the former arrived

Terracotta bowl with glossy finish on base from the Mont-Desclus tomb at Bussy-le-Château (Marne)
End 4th-early 3rd century B.C.
Saint-Germain-en-Laye
Musée des Antiquités Nationales

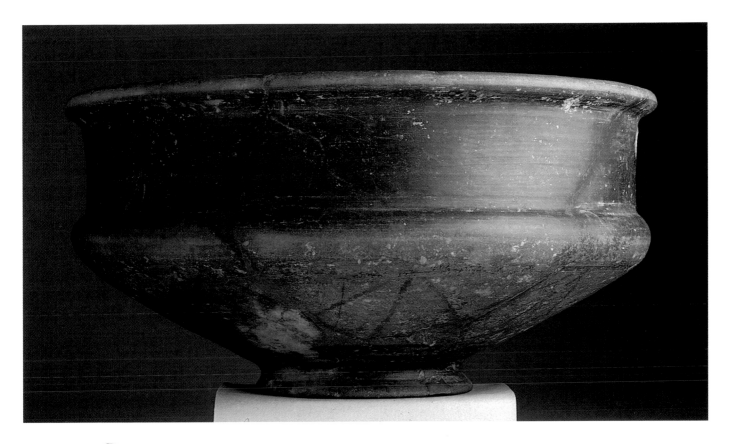

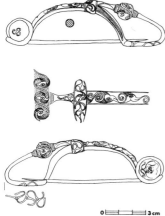

Iron fibula with elaborate animal motifs from Conflans (Marne)
3rd century B.C.
Troyes, Musée des Beaux Arts et d'Archéologie

in Champagne as a result of the wanderings of Gaulish adventurers. The buckle found at Loisy-sur-Marne is strikingly similar in design to one of the metal decorations of the oinochoe of Brno-Maloměřǐce (Moravia). According to A. Duval, the fake filigree ornamentation of the Recy fibula is comparable to objects in central Danubia. Finally, it is worth noting the resemblance between the decoration on one of the fibulae of Conflans-sur-Seine with the detail on the scabbard found at Cernon-sur-Coole.

There is some possibility that these exceptional pieces were brought into Champagne through simple trading. This is not the case for the anklets, the regular appearance of which in certain cemeteries suggests some ritual significance for a particular ethnic group. These objects are perhaps the first clues to the migration of populations from central Europe, passing through the south of Champagne on their way to the eastern lands of Picardy, Flanders, and the British Isles, the foundation populations of the Belgae, with whom Caesar was to come into contact one hundred and fifty years later.

Conclusion

Champagne in the fourth and third centuries was by no means a monolithic entity. By analyzing the cemeteries and their burial goods through the various phases of evolution, we can note certain constants and local tendencies, often enriched with exotic components.

The beginning of the fourth century B.C. remains rooted in fifth-century Marnian tradition, but with an important change in the distribution of the population, as there was only one leading center left in the Reims area. While this center grew and prospered, the rest of Champagne was generally barren, probably due to the exodus of entire populations in search of new territories in northern Italy. In the second half of the century, the distribution of ornamental objects worn by the female population reflects a progressive enlargement of the Reims area, due to the repopulation of surrounding vacant land. In southern Champagne, the inhabitants of today's Sens region gradually drifted northward. The Villeseneux cemetery illustrates this migration perfectly. This period shows marked changes in funeral rites, though

the causes are not yet known. The next period saw the creation of the first sanctuaries, some on the borders of the towns (La Villeneuve-au-Châtelot in Aube) and other cemeteries (Nor-mée "La Tempête," and Saint-Benoît-sur-Seine "La Perrière" in Aube).

In the third century the situation became quite complex. Certain smaller communities disap-peared altogether in favor of larger centers dominated by men with a standardized panoply of weapons, accompanied by their richly jeweled consorts. These new populations set up home in places that had long been abandoned. In some cases they founded new cemeteries (Fère-Champenoise "Faubourg-de-Connantre"); in others they reutilized ancient burial sites (Dormans "Les Varennes"). In this phase the first cremations, and the first personal orna-ments originating in the cultural center of the Danube appeared.

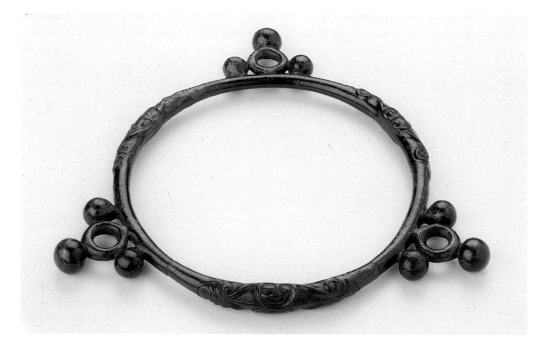

Bronze ternaire torque
from Barbuise (Aube)
Early 3rd century B.C.
Troyes, Musée des Beaux Arts
et d'Archéologie

During the second half of the third century, female ornaments became less rich, as the quality of the bronze alloys deteriorated. The trend for iron grave goods increased. As inhumation gave way to cremation, the custom of including personal objects with the dead was gradually phased out. Although no conclusive reason has yet been discovered, the horizon of the flat-tomb cemeteries throughout the Champagne region became uniform at the same period (dur-ing the second century B.C.). At the same time, the stable agricultural society (without doubt ruled by a patriarchal type of clan system) changed to a pre-urban system which resulted in social divisions based on craftsmanship, in which farmers had only a secondary role to play. The craftsmen gradually moved toward political power and founded the first towns, while the farmers devoted themselves to the production of cereal crops, clustered in scattered, family-based communities.

*Gilbert Kaenel
and Felix Müller*

The Swiss Plateau

*Plan of the cemetery at Münsingen-Rain (Berne) showing different construction phases
Early 4th-early 2nd century B.C.*

The Background to the Research

The most important archaeological evidence for analyzing the La Tène burials on the Swiss plateau came to light gradually over the period 1898-1914 in different types of site and at different moments. In 1898 architect Albert Naef (future archaeologist of Canton Vaud) excavated twenty-nine graves at Vevey-Saint-Martin. His operation was limited to the sector threatened by the widening of a road, and hence the cemetery was not investigated in its entirety. Naef's pioneering work was published after his research between 1901 and 1903, and is praiseworthy from all points of view, especially for the precision of his observations and attempts to explain the construction of the coffins, the customs, and ornaments found therein.

From 1904 to 1906 the Musée Historique at Berne proceeded to excavate the Münsingen-Rain cemetery, the largest known Iron-Age burial complex on the Swiss plateau. Ever since, the name of the museum's vice-director Jakob Wiedmer-Stern has been linked to the research project and the results, published in 1908. Though some graves must have been destroyed by local gravel quarrying, the cemetery is otherwise complete and boasts over two hundred graves. It quickly became a point of reference for research into Early and Late La Tène graves in the context of Celtic Europe, and was instrumental for determining the chronology of La Tène culture.

In 1911 a former student of Albert Naef's from Vaud, David Viollier, then working at the national museum in Zurich, undertook the excavation of the small cemetery of Andelfingen, which comprised twenty-nine tombs.

And lastly, between 1912 and 1914 Julien Gruaz carried out excavation work (or more exactly, oversaw gravel extraction operations at Saint-Suplice) at Pétoleyres for Lausanne's Musée Historique (the future Musée cantonal d'Archéologie ed d'Histoire). A total of eighty-eight tombs came to light, all attributable to La Tène and, although some were damaged or inaccurately recorded, the cemetery has been recouped in its entirety.

This article focuses on these four main operations, leaving aside the earlier nineteenth-century finds, such as those of Gempenach/Champagny in Canton Fribourg (where a vast cemetery was progressively destroyed), or the twenty-six graves of the second cemetery at Münsingen-Tägermatten excavated in 1908 and then from 1930 to 1933. It is regrettable that after such promising beginnings at the start of the century, culminating in Viollier's sum-

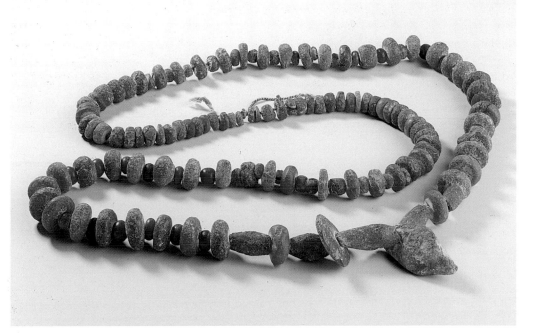

*Necklace of amber and glass beads
from tomb no. 48
at Saint-Sulpice (Vaud)
Lausanne, Musée Cantonal
d'Archéologie et d'Histoire*

251

*Bronze armlets, torques
and pendants from tomb no. 48
at Saint-Sulpice (Vaud)
Second half 5th century B.C.
Lausanne, Musée Cantonal
d'Archéologie et d'Histoire*

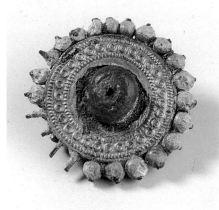

*Bronze discoidal fibula decorated
with coral and amber from tomb
no. 48 at Saint-Sulpice (Vaud)
Second half 5th century B.C.
Lausanne, Musée Cantonal
d'Archéologie et d'Histoire*

*Bronze fibula decorated with coral
from tomb no. 48 at Saint-Sulpice
(Vaud)
Second half 5th century B.C.
Lausanne, Musée Cantonal
d'Archéologie et d'Histoire*

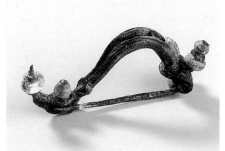

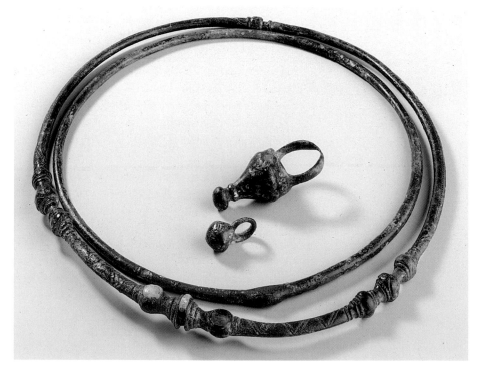

*Bronze fibulae from tomb no. 48
at Saint-Sulpice (Vaud)
Second half 5th century B.C.
Lausanne, Musée Cantonal
d'Archéologie et d'Histoire*

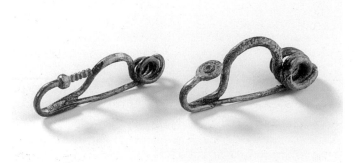

mary publication in 1916, no further cemeteries of any importance were brought to light until the excavations along the Gruyère motorway (an area barely touched upon in the past), at Gumefens-Pra Perrey, where seventeen graves were discovered in 1978 and 1979. However, during the 1950s a great many graves in small clusters were found in and around Berne, making the area the richest in finds of the entire plateau.

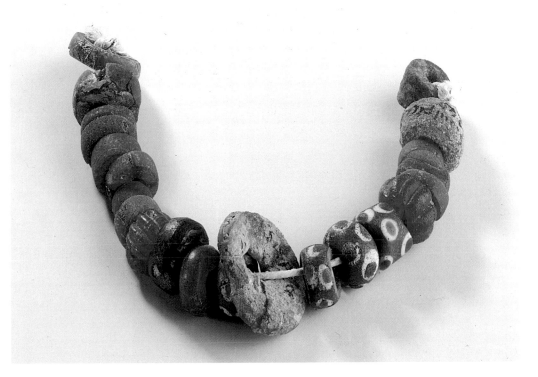

Necklace of amber and glass beads from tomb no. 48 at Saint-Sulpice (Vaud)
Second half 5th century B.C.
Lausanne, Musée Cantonal d'Archéologie et d'Histoire

Chronology

Although Naef, thanks to his contacts with Salomon Reinach and Joseph Déchelette, was able to attribute the graves at Vivey to La Tène I and II (according to the Tischler system), Wiedmer-Stern noted a vital fact at Münsingen, namely, that the oldest graves were situated in the north end and the more recent ones in the south end of the cemetery. Horizontal stratigraphy techniques facilitated the spatial reconstruction of the succession of burials over time: Wiedmer-Stern has subdivided Early La Tène into La Tène Ia, Ib, and Ic; and Middle La Tène into La Tène IIa and IIb. These subdivisions are based on the technical and morphological evolution of fibulae and ring ornaments, and their decoration. The various differences were taken up and specified by Viollier in 1911, and then again in his compendium work of 1916. This system of dating was used in the publication of Saint-Suplice in 1914 and 1915. Fifty years or so later, in 1968, Frank Roy Hodson took up the typological and chronological study of Münsingen, and proposed a further, highly detailed organization into series based on an analysis by "horizon" (from A to V) the periods La Tène Ia, Ib, Ic, IIa, and IIb, but at the same time specifying "transitional," "ancient," and "recent" phases within the La Tène Ib and Ic periods.

Most Celtic studies follow the Reinecke system, however, and German or Swiss-German authors studying Münsingen and the La Tène graves in the Swiss plateau have established the following series: LT Ia = LT A; LT Ib = LT B1; LT Ic = LT B2; LT IIa = LT C1; LT IIb = LT C2 (with some slight variations). Other important new contributions include work undertaken by Ulrich Schaaff in 1966; by Werner-E. Stöckli in 1975 (whose analysis of the cemetery in the Canton Ticino refers to the Swiss plateau, and particularly to Münsingen); by Christian Osterwalder, who in 1971-1972 published Münsingen-Tägermatten; by Bendicht Stähli, who in 1977 published the tombs in the city of Berne; by Stephanie Martin-

*Iron spearhead with engraved
decoration showing a couple of
monsters from tomb no. 57
at Saint-Sulpice (Vaud)
Second half 5th century B.C.
Lausanne, Musée Cantonal
d'Archéologie et d'Histoire*

*Detail of decorated iron scabbard
from tomb no. 7 at Saint-Sulpice
(Vaud)
Second half 4th century B.C.
Lausanne, Musée Cantonal
d'Archéologie et d'Histoire*

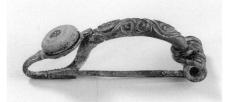

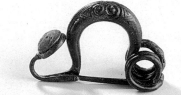

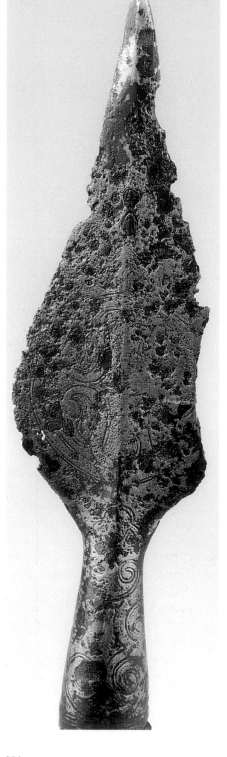

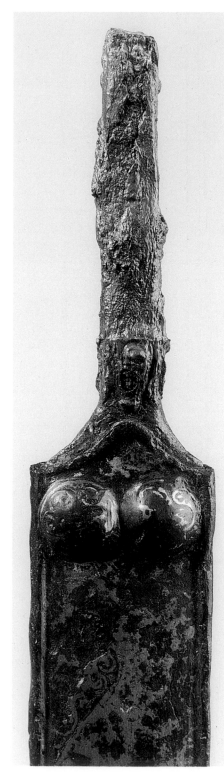

*Bronze fibula with foot decorated
with red enamel from tomb no. 7
at Saint-Sulpice (Vaud)
Second half 4th century B.C.
Lausanne, Musée Cantonal
d'Archéologie et d'Histoire*

*Bronze fibula with foot decorated
with a coral bead from tomb no. 41
at Saint-Sulpice (Vaud)
Second half 4th century B.C.
Lausanne, Musée Cantonal
d'Archéologie et d'Histoire*

*Bronze fibula with foot decorated
with red enamel cabochon
from tomb no. 57
at Saint-Sulpice (Vaud)
Second half 4th century B.C.
Lausanne, Musée Cantonal
d'Archéologie et d'Histoire*

Kilcher, who in 1981 republished Vevey; and by Gilbert Kaenel, for his contribution on Saint-Suplice and the graves in western Switzerland in 1990.

In the last two decades there seems to have been unanimous agreement over the absolute chronology. The burials at Münsingen are considered to have begun in a late stage of La Tène A, at the end of the fifth century B.C.; however, Saint-Suplice has yielded older elements at the center of the cemetery (comparable secondary graves in the barrows of the Jura). Toward 400 B.C. a transition took place to LT B1, and the transition to LT B2 is dated to the third quarter of the fourth century B.C. The beginning of LT C1 has been placed in the second quarter of the third century, and the transition to LT C2 around the year 200 B.C., a period in which the inhabitants of the plateau abandoned a centuries-old tradition of burying their dead in cemeteries; furthermore, graves for this period are extremely rare.

Funerary Practices

Though there are exceptions, the predominant form of burial during Early and Middle La Tène was inhumation in "flat tombs" with no barrow. It was the general custom to lay the body in wooden coffins, traces of which have occasionally been detected where excavation has been carried out with great care. At Andelfingen, Viollier discovered "ash deposits" covering and surrounding the deceased. In this case too the ashes could be the cinders of a wooden chest/coffin; furthermore the position of the limbs suggests that the corpse was first wrapped in a shroud. Some tombs were furnished with rows and layers of stones to prevent the corpse from coming into direct contact with the surrounding earth.

The deceased, which included men, women, and children, were buried with the same clothes and personal ornaments worn in everyday life. Some of the women's fibulae and rings showed marked signs of wear, or repairs, proving that they had been worn for some time. Young girls were adorned with miniature ornaments, often poorer in quality or crudely fashioned. The complete set of weapons for the La Tène warrior, known as the "triple panoply," was composed of sword, shield, and spear. In rare cases, the ritual practice of mutilating the weapons had been carried out; this applies particularly to swords, always sheathed in their scabbards. Pottery vessels, originally containing food and beverages for the deceased's journey into the other world, are not present in plateau graves for this period. But there were frequent cases of offerings of meat, identified in the animal bones on the grave floor; to the right of the

Torque, armlet, ring fibula with coral and enamel studs and brooch from tomb no. 40 at Saint-Sulpice (Vaud) 5th century B.C. Lausanne, Musée Cantonal d'Archéologie et d'Histoire

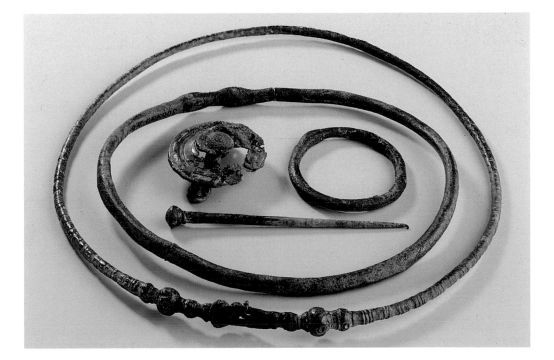

bodies of the two Münsingen-Rain warriors were remains of large rump steaks of beef.

In the case of Andelfingen, the cemetery may have been divided into specific sectors for women, men, and children; groupings of this kind have been noted at Münsingen-Rain, though they are less distinct.

As for Late La Tène (LT D), our knowledge is very limited, as the deceased were mainly cremated. It is no longer possible to determine how personal ornaments were worn, and they are damaged by fire. Furthermore, these relatively modest urn-burials are far fewer than the inhumation graves of Early and Middle La Tène. However, urn-burials are certainly more common than has been supposed until now.

The best-known example is the double burial at Engehalbinsel near Berne. A pottery urn covered by a bowl was placed in a small pit covered with potsherds. The contents included the incinerated remains of an elderly woman and a small child, five Nauheim-type fibulae, and the bones of two chickens and a piglet, also cremated on the pyre. Two other vessels clearly contained additional foodstuffs for the deceased.

Women's Costume and Ornament

As the female burials are so numerous and often furnished with rich grave goods they offer particularly useful clues to the Celts' dressing habits. Important results have been obtained in this sector by examining the cemetery of Münsingen-Rain. Briefly, the women in phase LT A wore a necklace, two bracelets, and anklets. In LT B the necklaces were no longer fashionable, whereas anklets were increased to four; the ring ornaments at Saint-Suplice and

Bronze bracelet with red enamel insets from tomb no. 29 at Andelfingen (Zurich) End 4th-early 3rd century B.C. Zurich Schweizerisches Landesmuseum

Bronze bracelet from Lausanne (Vaud) Second third of 3rd century B.C. Lausanne, Musée Cantonal d'Archéologie et d'Histoire

Bronze bracelet from Longirod (Vaud) Second third of 3rd century B.C. Lausanne, Musée Cantonal d'Archéologie et d'Histoire

256

the rest of Switzerland follow a different pattern. In LT C, bronze bracelets were superseded by other types in glass; anklets disappeared, and instead there were heavy belt-chains in bronze. Since the type of ornament and their various combinations changed quite rapidly, it is a useful clue used by archaeologists to make generational distinctions.

The significant variations of quality in the ornaments found among the female burials suggests a distinct class system. A woman with a complete set of jewelry including coral, amber, and perhaps gold, was clearly more affluent than those who had a simple bronze fibula.

Information about the textiles is very scarce. What little we do know derives only from fragments of clothing, but something can be guessed from the position of the fibulae, which were used to pin the cloth together at the shoulder and across the chest. Often, though not always, a fibula was worn on either shoulder, and one or two more at the neck or on the chest. These fastenings suggest a "peplo," a type of dress worn by women north of the Alps until Roman times.

Population and Settlement Structure

Although in geographical terms the Swiss plateau can be dealt with as a unit, the spread of certain types of ornament endorses a system of subdivision in smaller zones. Early La Tène discoid-buffer torques from eastern Switzerland, for instance, are found on the border of a wider territory of distribution stretching from Andelfingen to Basle and Frankfurt am Main. Glass bracelets are especially common in the Berne area, totaling around one hundred examples. In eastern Switzerland the above-mentioned belt-chains are thinner and lighter, while

Colored glass bracelets
from tombs in and around Berne
3rd century B.C.
Berne, Historisches Museum

Bronze fibulae from tombs
in and around Berne
4th century B.C. (left)
and early 2nd century (right)
Berne, Historisches Museum

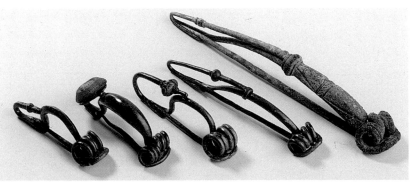

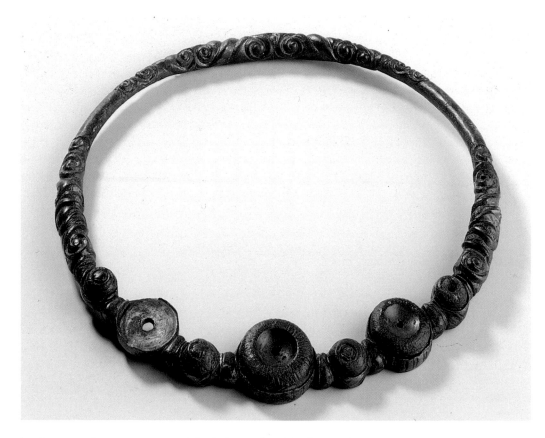

in the west they are more crudely fashioned and bulkier. The meaning behind this distribution (perhaps a question of workshops, or tribal groupings) is still without explanation.

The area between Berne and Lake Thun has yielded an unusually large number of high-quality fibulae with decoration in Waldalgesheim Style, perhaps due to the area's proximity with Italy, a source of strong aesthetic stimulus for this style of ornament.

The Berne area has also yielded a considerable number of clustered graves that were used only for short periods; it can be hence inferred that the related living complexes were equally short-lived. This fact makes the cemeteries discussed at the start of this essay of even greater relevance; these range from a few dozen to a hundred or so graves each. However, the numerous burials at Münsingen should not obscure the fact that they belonged to a coeval tribal group of modest proportions. For the time being, there is nothing to indicate what proportion of the overall population is constituted by the segment documented in the cemeteries: in the case of the Rain cemetery near Münsingen, were all the inhabitants of the settlement buried, or do the deceased represent only the upper strata of the group as a whole? The answer to this question will influence our entire understanding of the populations of the Swiss plateau.

Bronze torque with red enamel studs
from Schönenbuch (Basel)
End 4th-early 3rd century B.C.
Berne, Historisches Museum

Woman's bronze belt from
the tomb at Berne-Morgenstrasse
Berne, Historisches Museum

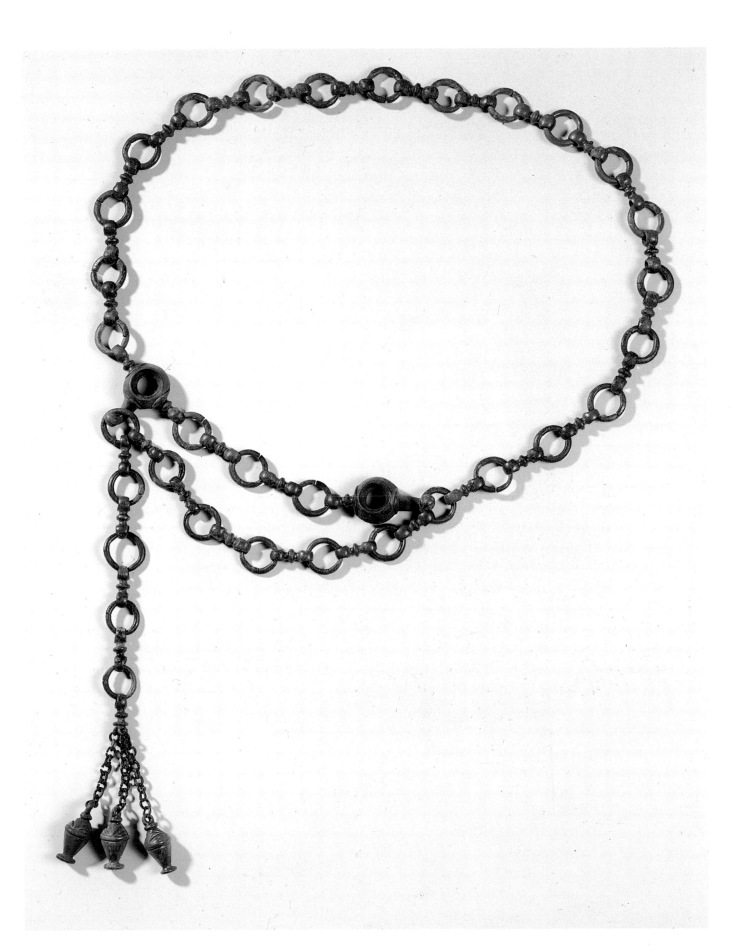

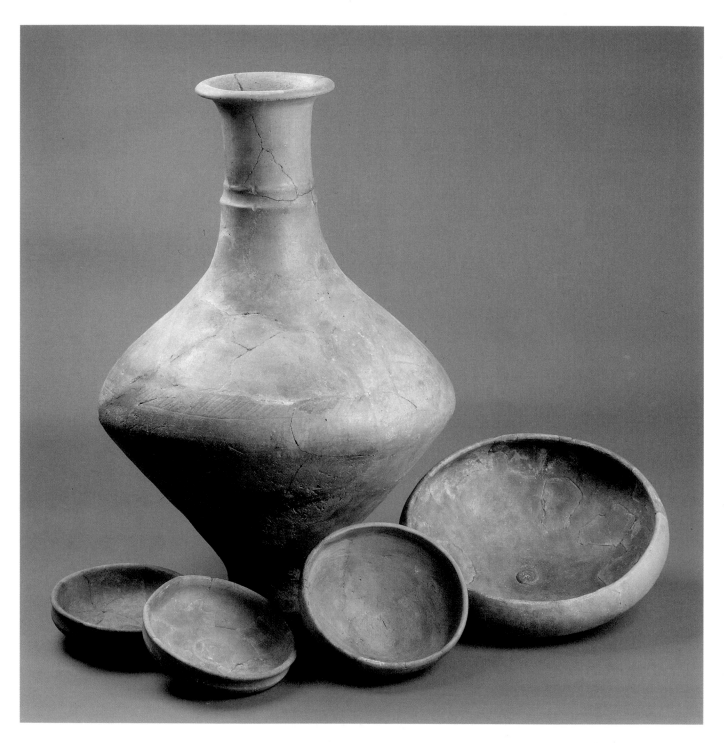

Terracotta pottery grave goods from
the tomb at Hambuch (Rhineland)
4th century B.C.
Bonn, Rheinisches Landesmuseum

Hans-Eckart Joachim

The Rhineland

The effects of the "Celtic migration" from north of the Alps toward the south and southeast are barely discernible in fourth- and third-century Rhineland. Likewise, there are few signs in the Rhineland of the influx of Celts into northern Italy around 400 B.C. and their subsequent campaigns past Rome to Sicily, and to Asia Minor in 276 B.C. This does not mean, however, that the migration left whole territories uninhabited, but merely that there was a decrease in the number of Celts in their native lands.

Since the Urnfield culture, the Rhineland, with its central Schiefergebirge and marginal areas, constituted a relatively uniform cultural territory extending from the upper Rhine Valley to the lower Rhineland. Despite modifications over time, the Urnfield culture pottery represents the essential features of the subsequent Hallstatt and proto-La Tène periods. This is of the utmost importance for evaluating the features of La Tène culture, and enables us to identify that particular cultural momentum and ethnic continuity.

The end of the Hallstatt period (early fifth century B.C.) saw the crystallization of a particular sociocultural and economic situation which culminated in the proto-La Tène civilization of the "princely tombs." While this culture was the product of contacts with the Mediterranean world, some conservative traits continued unchanged in the settlements and funeral rites. The main cemetery type consisted of barrow tombs, usually situated near sparse settlements and fortified hilltop complexes.

Though cremation was practiced from the time of the Urnfields, the prevalent type of burial in Late Hallstatt and Early La Tène was inhumation.

The aristocracy present at the beginning of Early La Tène (fifth century B.C.) endured to the fourth century B.C. alongside a population of "simple" farmers and craftsmen. Apart from the many differences between areas of the Rhineland, generally there is a sharp reduction in archaeological sites dating from the fourth century B.C., though they are spread across the entire inhabited territories of the fifth century B.C. Earlier settlements and cemeteries were abandoned and no new ones created. This phenomenon, widespread throughout the Rhineland, was not so much due to changes in settlement forms and functions as to the emigration of part of the Celtic population to the south and southeast, as many able-bodied men forsook their homeland for new horizons. The Rhine and Main regions witnessed

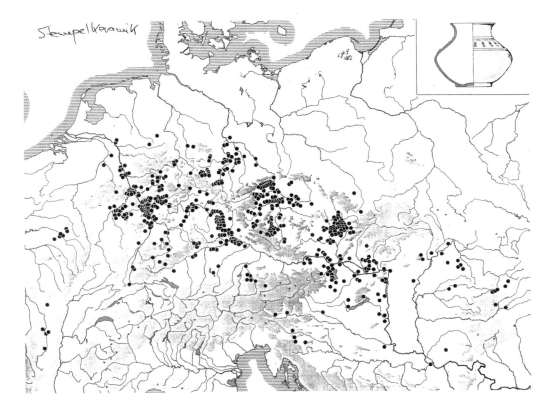

Map showing the distribution of La Tène pottery with stamped ornamentation 5th-3rd century B.C.

Torque, pairs of armlets and anklets
in bronze and ornaments from the
tomb at Hahnheim (Rhineland)
4th century B.C.
Mainz
Mittelrheinisches Landesmuseum

Torque, pairs of armlets
and anklets, fibulae in bronze
from the tomb at Mainz-Linsenberg
4th century B.C.
Mainz
Mittelrheinisches Landesmuseum

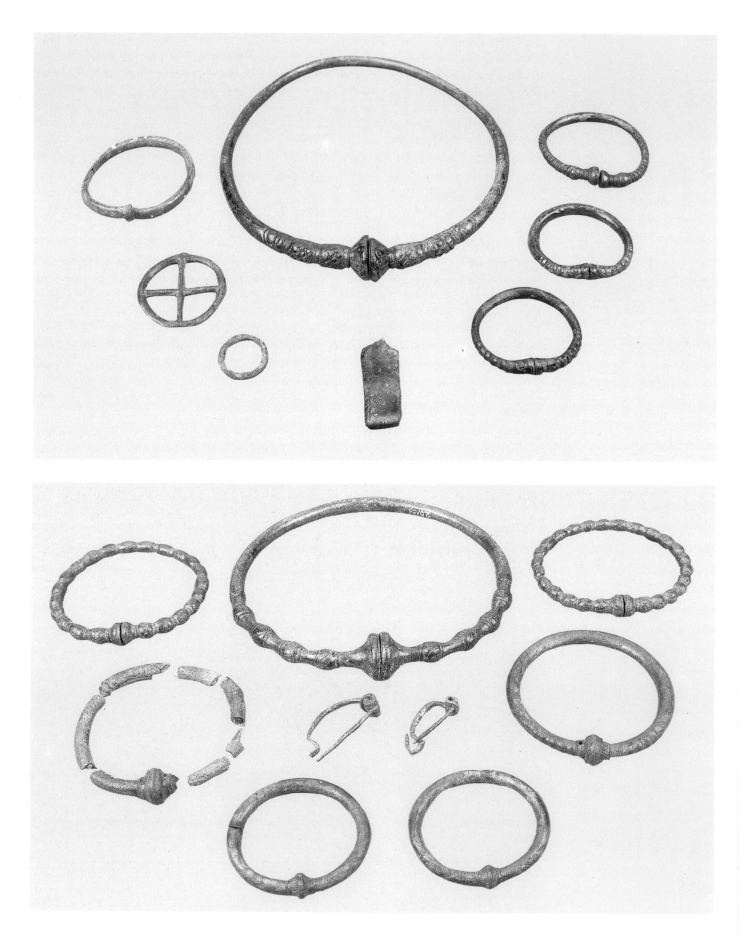

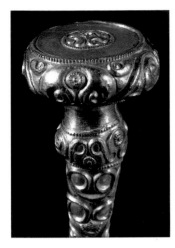

Detail of the gold torque
from the tomb at Waldalgesheim
Second half 4th century B.C.
Bonn, Rheinisches Landesmuseum

a noticeable decline in the number of warrior graves during La Tène B (particularly those containing swords), and presumably therefore a decline in the warrior population.

In the cemeteries, barrow tombs continued to be built, but underwent a sharp decline toward the end of Early La Tène (after 300 B.C.) as "flat" tombs took over as the predominant form. Meanwhile, many of the old cemeteries in use since Hallstatt became defunct, possibly as a result of mass emigration. Both inhumation and cremation burials made their appearance; both categories testify to the presence of an aristocratic class among the population, though substantially reduced in number. Among the tombs of the period, those of Waldalgesheim are the most significant. A noblewoman was buried beneath a large barrow in a funeral chamber containing a two-wheeled chariot, a yoke, a set of dishes, clothing, and jewelry, a burial just as traditional as those existing prior to 400 B.C. Equally rich were the grave goods of the great cremation burials of Bescheid; these were found to contain parts of a chariot, and bronze receptacles of possible Etruscan origin. The chariot-burial tradition of the preceding eras continued into the fourth and third century B.C., when the chariot became a status symbol and therefore conferred prestige to the burials of the higher social classes. However, for this period chariots are seldom found, precisely because the Celtic nobility had emigrated in such vast numbers.

The "ordinary" Celts largely remained in their native lands, and consequently their tombs are more frequent. One of the characteristics of the period is the cremation burial beneath barrows. As a rule, the deceased was cremated on a pyre along with his personal effects and other offerings. The ashes were then covered with a mound or barrow. In many cases this type of burial signaled the final phase of the use of barrow tombs in the older cemeteries. Flat tombs appeared at this time, containing both inhumation and cremation burials.

In the northern area of the upper Rhineland the women were bedecked with torques, armlets, and anklets, and some tombs include offerings of clay vessels. Rings vary in form and or-

Chariot grave at Hundheim
(Rhineland)
5th century B.C.
(under excavation)

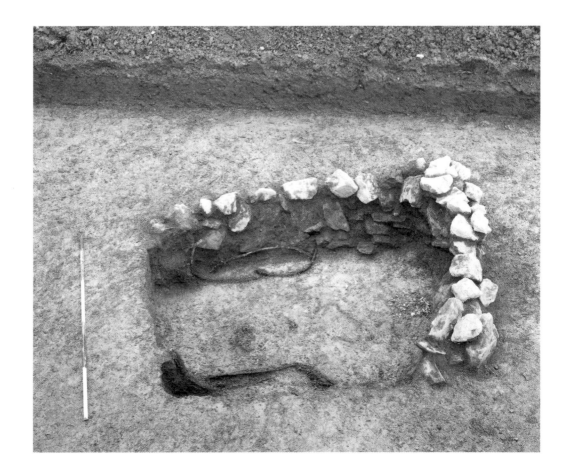

namentation according to the period; while the fibulae are designed with their foot bent backward.

Further north in the area of Schiefergebirge and down to the lower Rhine basin, pottery was traditionally more important than in the south. As in the earlier eras, pitchers and bowls were included in the drinking service for the next world, and tombs containing only metal ornaments are fewer in this region. The predominant style of cup found is the Braubach type, with its distinctive stamped decoration, named after a place in the middle Rhineland, and widely used north of the Alps from the fifth to the third century B.C. The term Braubach is applied to a wide variety of wheel-made vessels with stamped decorations. Although the receptacles discovered at Braubach proper are clearly of later date, they typify the category well, and the site is one of the few Rhineland settlements of La Tène B that can be classified with precision.

Along a narrow strip of land bordering the Rhine, and in a nearby valley there are cemeteries and settlements, established at the beginning of the fifth century B.C., which flourished until the middle of the first century B.C. The intensive settlement of such naturally unfavorable zones is probably explained by the presence of mineral resources such as iron, copper, and lead.

Samples of metal in untreated form found at the site are a sign of copper and iron mining. Both these metals were much sought after in the Rhineland, and were used in great quantity in the manufacture of ornaments, tools, and weapons.

Silver and lead were also present in Braubach, but as silver was not worked during this period, lead was considered of greater importance, due to its use in the purification of gold in Early La Tène.

This treatment in a blast-furnace and the addition of various substances produced a Rhenish-La Tène gold of great purity.

Due to its vital mineral deposits, Braubach was a magnet for prospectors, craftsmen (i.e., smiths, smelters, and metal dealers). Local grave goods indicate that some of the inhabitants were from the upper Rhineland, with close ties with the south. A spell of relative affluence in the area is testified by a distinct local pottery production.

Another key economic activity with its roots in Neolithic times was the extraction of basalt lava (tefrite) in the region of Mayen and Kottenheim in eastern Eifel. Porous basalt was used for rotary querns, which remained the most efficient method of flour production for a long time, and were distributed in great number throughout the Rhineland. Quernstones were also traded for salt from the coast and inland.

Evidence indicates that occupation of the Rhineland continued without interruption after the end of Early La Tène (around 250 B.C.). Research so far confirms that settlements continued to exist and new cemeteries with flat cremation established. These signal the beginning of Late La Tène, which represents the last climax in the culture and civilization of Rhenish prehistory which, coinciding with a surge in the population, was destined to make its entry, fairly smoothly, in the Roman era.

Hans Peter Uenze

Bavaria

During the La Tène period Bavaria, like the rest of southern Germany, was inhabited by a Celtic population. These Celts of the centuries between 500 B.C. and the Roman conquest in 15 B.C. certainly were not immigrants, but the predecessors of the Hallstatt population. Looking at the size and location of the country it is no wonder that the La Tène culture is not homogenous all over Bavaria, but presents different characteristics in the north and the south. Only by comparing the area as a whole with other regions settled by Celts can the underlying consistency be recognized.

The Bavarian La Tène period lasts for roughly 500 years and can be divided into three major stages. The first one is the Early La Tène stage, the so-called La Tène A, which covers the period between 500 and 400 B.C. It stands in a strong Hallstatt tradition: the dead were still buried under large mounds. A new figurative art style emerged and a couple of innovations in craftsmanship techniques were characteristic of this stage.

Middle La Tène starts around 400 B.C. with the age of Celtic migrations. It includes the La Tène B and C periods and lasts until about 120 B.C.

Finally Late La Tène, the La Tène D period, is the heyday of Celtic towns (*oppida*). It is brought to an end by the Germanic invasions from around 40 B.C. onward; the Roman conquest in 15 B.C. dealt the final blow.

As mentioned above, Early La Tène is characterized by strong Hallstatt traditions. In Baden-Württemberg the upper class of the Late Hallstatt Age (sixth century B.C.) might be considered "princes" or "high nobility"; the recently discovered grave of one of them, the "Prince of Hochdorf," is a dazzling display of wealth.

By comparison, the Bavarian lords of the same period seem to have been mere chieftains or petty nobility. Remains of their residences have been excavated several times in Bavaria during the last few years: they all had a more or less square plan of about fifty-sixty meters in length and were surrounded by ditches. These mansions were always built some distance away from other settlements.

Some of them were not abandoned at the end of Late Hallstatt, but they lost their former function in the fifth century B.C. What was left of the fortifications after they had been destroyed resembled a small open settlement. This observation is quite important, because it agrees with the picture we gain from the analysis of burial rites: at the end of the Hallstatt period a revolutionary change of social structures must have taken place and the former upper classes ceased to exist.

In the graves of the seventh and sixth centuries B.C., the leading Hallstatt class can be recognized by their grave goods: four-wheeled wagons and huge sets of vessels for banquets accompanied the dead to the other world. Even in the graves of ordinary people, i.e. free farmers, of the same period large sets of pottery have been found.

This suggests that the Hallstatt period was a time of wealth and hospitality, as illustrated by the situla art of the regions southeast of the Alps. Weapons are extremely rare in Hallstatt graves and seem to have a merely token function.

In the Bavarian graves of the Early La Tène, on the other hand, warriors with sword and spear emerge as members of the new upper class, while ordinary men are buried without any weapons at all.

In the Celtic graves of eastern France the new status symbols are two-wheeled chariots. In Bavaria they are missing, as are Etruscan bronze vessels and Greek pottery. Though Bavaria was far off the main trading routes and poor in mineral resources, the absence of these goods that characterize the upper class in other regions is better explained by a different social structure in Bavaria.

In the fifth century B.C. large settlements start to appear. They are more residential in the south and have no defense systems, while in northern Bavaria there are fortified, proto-urban hilltop settlements. The latter certainly served as control points along the trading routes and performed a central role in the surrounding area as well. In that respect they can be compared to Etruscan towns of the same time.

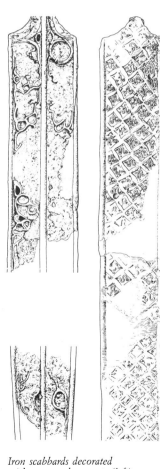

Iron scabbards decorated with openwork mounts (left) and punched mounts (right) from tombs at Manching-Steinbichel no. 2 (left) and no. 27 (right) Second third of 3rd century B.C. Munich Prähistorische Staatssammlung

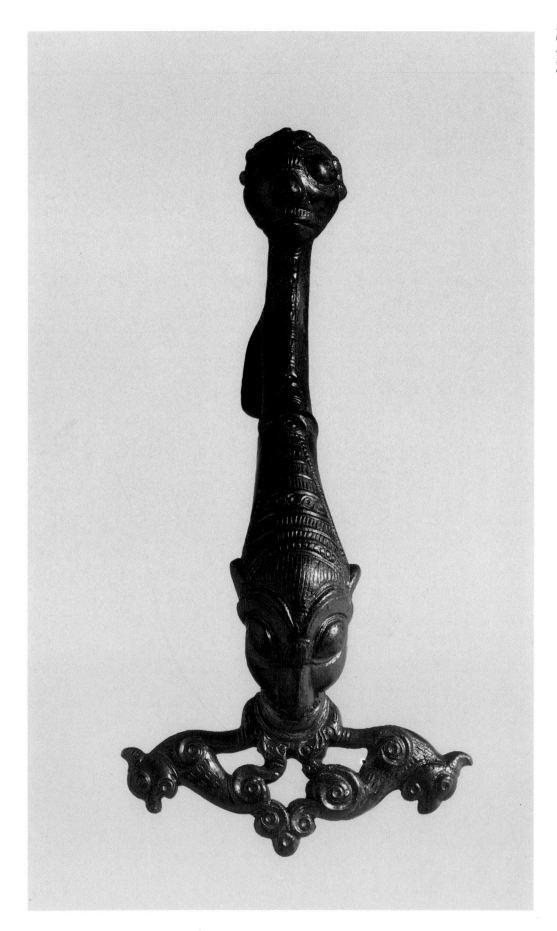

Bronze "mask" fibula from Parsberg
(Oberpfalz)
Second half 5th century B.C.
Nuremberg
Germanisches Nationalmuseum

Whole and detail of a terracotta flask engraved with animal frieze from Matzhausen (Oberpfalz) Second half 5th century B.C. Berlin Museum für Vor- und Frühgeschichte

Such town-like settlements—of which the Staffelberg near Staffelstein on the Upper Main is a representative example—must also have been centers of production and craftsmanship. Perhaps it is here where the big beads of yellow glass with "eyes" of blue and white layers (a leading type of the fifth century B.C. in Bavaria) were produced.

The graves of the fifth century contain only a single vessel, if any at all (and the majority are without). This must have been reserved for the dead person himself and could not have been used to entertain guests in the other world. This suggests that not only the social structure, but also the ideas of the afterlife changed at that time.

Another essential difference is that the pottery of the fifth century B.C., although produced on a fast-turning wheel for the first time, is not as lavishly decorated as in the Hallstatt period. While the Hallstatt vessels, especially the ware of the seventh century B.C., may be considered the most luxurious crockery of prehistoric times, Early La Tène pottery is very austere: painted decoration disappears altogether, to be replaced by simple stamped "sacred" symbols, such as the S-ornaments and circles that may have been symbols of the sun.

There is only a single example of figurative art, the flagon of Matzhausen, Ldkr. Neumarkt in der Oberpfalz. It shows a well-constructed scene of animal pairs, most often a male and a female. Each animal pair has a different stance: two wild boars face each other, two opposed deer have their heads turned back, a doe stands behind her stag, both of them grazing from left to right, a mating capercaillie, or grouse, follows his female from right to left, and finally a dog or wolf hunts a hare.

The complex structure of such animal scenes may be interpreted as the Bavarian variant of the "compass style" characteristic of early western Celtic art. The flagon is all the more remarkable because there are so few Bavarian examples of this kind.

Instead in northern Bavaria one of the finest examples of the Early La Tène mask style was found, the Parsberg fibula. Interestingly, the main body of the fibula is S-shaped when looked at from the side—and series of S's are also stamped on the Matzhausen flagon.

The start of Celtic migrations at the beginning of the Middle La Tène meant the abandonment of the fortified settlements. At the same time we face the decline of Celtic arts and crafts all over Bavaria. That is particularly true for pottery which was no longer wheel-turned. On the fibulae, human and animal heads are replaced by purely geometrical, simple decorations.

The burial rites also changed, another sign of more austere convictions. Simple, flat graves replaced those monuments for eternity, the tumuli. Small cemeteries consisting of a handful of graves each indicate that the average fourth century B.C. settlement in Bavaria was probably a small village or farmstead, with a life span of no more than a few decades.

In northern Bavaria there was still at least one fortified hilltop settlement in the fourth century B.C., the Vogelsburg near Volkach on the Main. For the Celtic population of the Schweinfurt area it served as a trading and settlement center. It is certainly no accident that a fairly

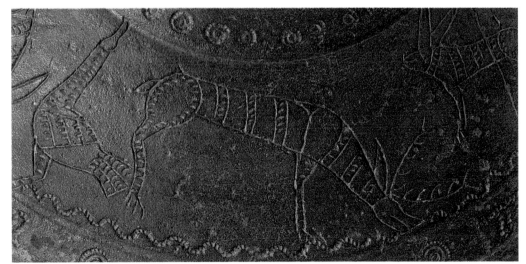

well developed form of craftsmanship survived exactly in that region. The most recent products—the flagon and bowl from Schwebheim—date from the early third century B.C. The Schwebheim flagon still looks rather clumsy compared to its counterpart from Matzhausen; what links them is the stamped decoration of highly abstract sun wheels.

While the Celtic population of the Schweinfurt area vanished early in the third century B.C., apparently there was a consolidation in southern Bavaria at the same time. Cemetery sizes suggest that larger settlements were founded again.

Personal ornaments in burials indicate that in the late fourth century B.C. at Riekofen (Ldkr. Regensburg), and in the late third or early second century B.C. at Klettham (Ldkr. Erding) and at Straubing on the Danube, Celts from Bohemia immigrated into Bavaria. Incidentally, it is worth noting that the plastic volute decoration on the anklets that came to Klettham near Erding with a Bohemian woman is a late imitation of Early La Tène S-ornaments.

In the area of the subsequent *oppidum* of Manching near Ingolstadt on the Danube, cemeteries provide evidence of two villages separated by about two kilometers, both dating from the first half of the third century B.C. In one of them, the Steinbichel cemetery, surprisingly large numbers of glass armrings have been found. These are a typical feature of third- and second-century Bavarian graves, and a purely Celtic invention. The fact that so many of them were excavated in one of the Manching cemeteries suggests that the people living there were wealthier than

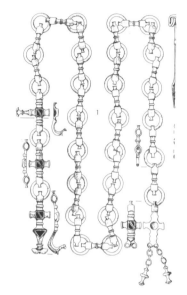

Reconstruction of the structure of a woman's belt in bronze with red enamel insets from tomb no. 37 at Manching-Steinbichel (Bavaria) 3rd century B.C.

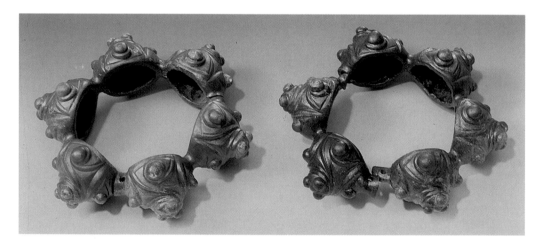

Pair of bronze anklets from Klettham (Bavaria) 3rd century B.C. Munich Prähistorische Staatssammlung

average. It should be borne in mind that material wealth is also an indication of the political power that made possible the foundation of the "town" (*oppidum*) of Manching.

In the late Middle La Tène stage a couple of innovations can be observed.

The most important of them is the formation of towns. Some of the fifth-century B.C. fortified settlements such as the Staffelberg near Staffelstein were now rediscovered. In addition, some formerly unoccupied lands saw the foundation of new towns, as in the case of the *oppida* of Manching on the Danube or at the confluence of Danube and Altmühl near Kehlheim. In the latter area strip mines exploited the iron-ore deposits in the Late La Tène period. The formation of towns is certainly a consequence of the economic consolidation after the troubled times of Celtic migrations had come to an end.

Another result of the new prosperity is a boom in craftsmanship. This boom can be seen in the production of glass armrings as much as in the reintroduction of the fast-turning pottery wheel and the growing importance of craftsmen and other professionals, who were now buried along with their tools. The doctor's grave of Obermenzing may serve as an example: among his grave goods were not only weapons (a sword, spearhead and battleshield), but also a razor blade and several medical instruments.

Finally the introduction of a monetary system in Bavaria in the second century B.C. was probably also a by-product of the economic boom. The first central European coins date from the middle of the third century B.C.

Iron weapons and surgical tools from tomb no. 7 the "doctor's tomb" at München-Obermenzing (Bavaria)
3rd century B.C.
Munich
Prähistorische Staatssammlung

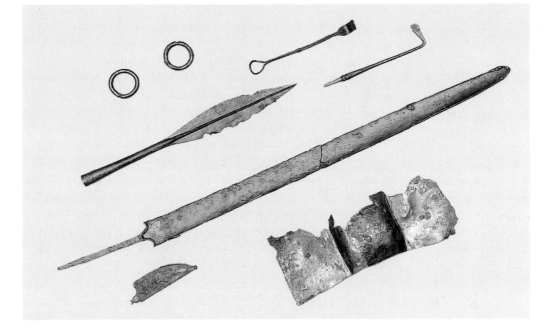

Sometime late in the Middle La Tène stage the Celtic population of Bavaria gave up the custom of inhumation and urn burials and introduced some different burial rites that left no archaeological traces. This may very well be linked with the ongoing process of urbanization. At least it is a fact that not a single cemetery has been found that relates to any of the large settlements in Bavaria, whether from the Late La Tène stage or earlier. In other words, we know only the cemeteries of those sectors of the population that lived in villages or on isolated farms. As soon as larger settlement units ("towns") developed, the old custom of burying the dead in inhumation or urn graves was given up.

The Late La Tène phase, which started around 125-115 B.C., is in every respect a continuation of late Middle La Tène. This is the time of *oppida*, of towns fortified by walls built in the *murus-gallicus* technique. We cannot yet say whether all of these settlements or only some of them had already been founded in the late Middle La Tène.

It is remarkable that in Bavaria almost all of the *oppida* are situated in the northern regions or on the Danube, whereas only one has been discovered so far in southern Bavaria, the so-called Fentbachschanze. Here in southern Bavaria the population seems to have lived mostly in unfortified settlements of various sizes.

The first *Viereckschanzen* (square enclosures) probably did not appear in Bavaria until the Late La Tène period. There is a major concentration of them in southern Bavaria, though in neighboring areas they are significantly rare. One important characteristic of these sanctuaries is their rectangular, usually square entrenchment. Some of these still today stand several meters high. The *Viereckschanze* of Buchendorf near Gauting, Ldkr. Starnberg, with a side length of roughly 100 meters may serve as an example. The entrance construction is also a characteristic feature: the wall is disrupted in the center of one of the sides (though never the northern one). The gate must have included a little bridge or drawbridge, because the trench on the outer side of the wall is not filled in at the entrance point.

Excavations at the *Viereckschanze* of Holzhausen, Ldkr. Munich, indicate that the enclosure once held a simple wooden temple, (*Umgangstempel*), a place for cinerary offerings and several offering wells.

Some time after the middle of the first century B.C. the Celtic period in Bavaria came to an end; towns and open settlements were abandoned. The reason for this was probably not the occupation of the country by the Roman legions under Drusus and Tiberius in 15 B.C., but the invasion of Germanic tribes in the decades between 50 and 30 B.C.

Pavel Sankot

The Celtic Population of Bohemia in the Fourth Century B.C.

The Latin name Bohemia is derived from the ancient historical accounts that described the area as belonging to the Celtic Boii. The appearance of this ethnic group in various areas of Europe during the period between the fifth and the second centuries B.C. was part of what is known as "the historical expansion of the Celts"—a phenomenon that had important cultural, political and social consequences for our continent.

The fifth century B.C. saw the end of both the tumulus tombs of south and west Bohemia and of the "flat" Hallstatt tombs favored by various local groups. Such cemeteries as Královice and Manětín obviously played an important role in the introduction and adoption of Early La Tène culture; their final layers contain Early La Tène burials.

Stylistic analysis of Early La Tène art found in Bohemia (*Vogelkopffibeln*, or animal-head fibulae, *Maskenfibeln*, or mask fibulae, luxury objects decorated with engravings or repoussé work) dates most of the objects to the second half of the fifth century B.C., with some more recent objects from the first half of the fourth century. As the furnishings of the tombs in the area seem to suggest, these locally-produced objects—which reveal a wide variety of forms and techniques—were destined for a fairly restricted, aristocratic, clientele. The dominant nobles of the Early La Tène period lived in fortified highland settlements—as the long research carried out to the fortified settlement of Závist has demonstrated most clearly. This center occupied a vast and well-supplied key position on the southern edge of the Prague basin. Its layout and buildings, along with the objects that have been found there, reveal that developments in Late Hallstatt and Early La Tène culture should be interpreted as the muta-

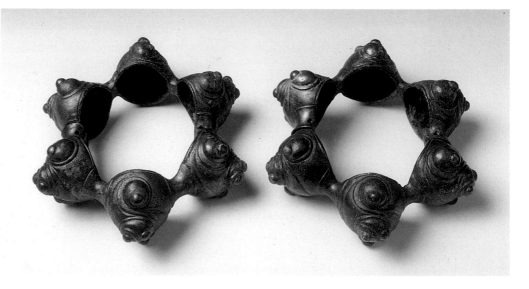

*Pair of bronze anklets
from Planany (Bohemia)
3rd century B.C.
Prague, Národní Muzeum*

tions brought about by a Hallstatt culture entering into direct contact with the Graeco-Etruscan world.

Just like the changes in the cemeteries of the various regional, and originally Hallstatt, communities, the possible developments of the Závist *oppidum* came to a sudden, and, no doubt, violent, end between the first and second quarters of the fourth century B.C. In all probability this event was caused by an attack by a people who buried their dead in the so-called Celtic flat tombs. The advent of this "flat-tomb" population marked a fundamental turning-point in the history of the region, even though there was some continuity in artistic expression and certain functional features (such as the use of the same structure of settlement, for example) continued to evolve. The completely new form of burial and grave goods meant there was no chance of autochthonous development. The bearers of this new culture most probably came from central and western regions of Switzerland and from the Baden-Württemberg area.

There are already signs of these new arrivals in the earliest part of the period marked by the

beginning of the so-called Vorduchcov horizon. They occupied three regions near the original settlement that reflect their interest in agriculture and animal husbandry—or else areas rich in raw materials (zinc, copper, gold, iron ore). This meant that the northwestern, central and eastern areas of Bohemia were—at least partly—inhabited from this date onwards. In the later La Tène period these areas would experience another phase of rich cultural development.

The Vorduchcov and the subsequent Duchcov-Münsingen layers mainly contain assemblages from the graves of those who belonged to the dominant social group of the time. The male tombs all contain a sword, lance, armor and shield. The female tombs all have a rich collection of objects that reveal the importance of personal adornment—bracelets, torques, anklets, costly bronze belts and fibulae. A structural analysis of the "flat" tombs reveals that there was already some initial form of social differentiation in Celtic communities and this is confirmed in precise accounts by the ancient historians who lived at the time of the *oppida*. The Vorduchcov layer is characterized by fibulae with parabolic and roof-shaped bows, as well as by simple forms of bracelets. However, the Duchcov-Münsingen layer is clearly influenced by the Etruscan, Greek and northern Italian worlds with which the Celts had direct contact (the so-called Waldalgesheim Style, or the *style vegetal continu*). A further development of artistic style during the fourth century led to the appearance of some specifically Bohemian objects, such as cast bracelets the terminals and wide central section of which were adorned with plastic ornament, or fibulae with plastic-ornamented bows. Later there ap-

*Pair of bronze anklets
from Horní Kšely (Bohemia)
3rd century B.C.
Prague, Národní Muzeum*

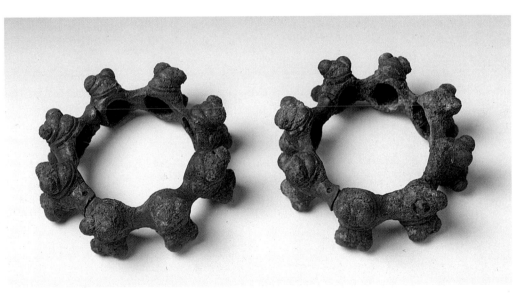

*Detail of an anklet
from Horní Kšely (Bohemia)
3rd century B.C.
Prague, Národní Muzeum*

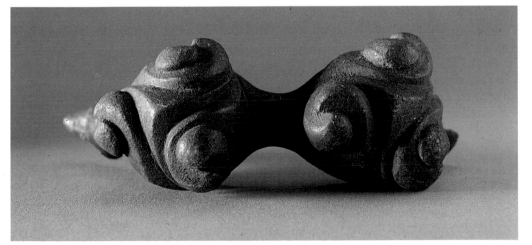

peared that whole series of plastic decorated rings—the so-called *Schneckenringe* (spiral rings). As in Moravia, the dead were buried in a lying position. The bodies were aligned north-south, and usually grouped in cemeteries of not more than twenty to forty tombs. Their size suggests there were small groups of inhabitants of about ten members, united in a basic social unit— the patrician family—whose focal point was the farmstead. Settlements of this kind can be found in the Early La Tène period and even later. At a regular interval of two or three kilometers from each other, they occupied favorable upland sites (up to an altitude of 350 meters) that had a constant supply of water and offered perfect conditions for the raising of crops and livestock. The farms included arrangements for household production and the disposal of waste (cylindrical or conical pits). The buildings were either above ground on a pylon structure that measured approximately 10 by 5 meters, or huts with a single room (a type of building specific to the area). These latter structures measured 6 to 4 meters by 4 to 2 meters, and were aligned east-west. They were partially sunken, and probably served not only as accommodation but also had an agricultural function.

Extensive excavations have revealed that there was a tendency to arrange the dwellings in a precise order, probably determined by the lie of the land (there are signs of arrangements in straight rows or in slight curves). The material found in the dwellings shows that there was a wide range of productive activity: the land was exploited to raise crops and livestock, skins were tanned, and there was also the production of fabrics and pottery. The Chýnov find has revealed the broad range of metalworking activities. Ornaments were already produced in series, and a geographical analysis of findspots indicates that there were not only farms destined to meet the daily needs of the population but also specialized centers of production designed to meet the needs of a fairly wide area. As yet there is no archaeological proof of the existence of such centers. A clear example of trading activity is the importation of shells (*Cypreacassis rufa*) and coral from the Mediterranean area, which served to decorate fibulae. The use of these materials is undoubtedly to be seen in relation to the general nature of Celtic art, which has been defined as the plastic expression of the Celtic religion.

Archaeological sources have shown this from the very iconography of the objects (plant or figurative motifs to ward off evil spirits), the function of particular types of ornaments (torques, amulets, etc) or the unusual way in which they are used (the offering of the two thousand fibulae, rings and arm bracelets buried in a cauldron near the thermal spring of Duchcov), as well as by the discovery of objects used in religious worship. The sanctuary of Libenice near Kolín, with its square plan and outlying trenches, is the predecessor of the later form of Celtic sanctuaries (*Viereckschanzen*, rectangular enclosures) that first appear in the Middle and Late La Tène periods.

Bronze bracelet with moving rings from Planany (Bohemia) 3rd century B.C. Prague, Národní Muzeum

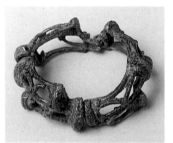

Bronze openwork bracelet from Praha-Podbaba (Bohemia) 3rd century B.C. Prague Muzeum Hlavního mešta Prahy

Bronze bracelet with relief fish decoration from Křinec (Bohemia) 3rd century B.C. Prague, Národní Muzeum

The Celtic Population of Moravia in the Fourth Century B.C.

The beginning of the Celtic occupation of Moravia can be seen as coinciding with the first historic expansion of the Celts at the outset of the fourth century B.C. Part of this expansion took place toward the east, across the Danube region, identifiable in fairly uniform archaeological material in Bavaria, in southern and western Bohemia, in the Salzkammergut and in Upper Austria. Recently archaeological evidence of the oldest Celtic occupation has widened its compass to include some areas not bordering on Moravia: in Lower Austria, in western Hungary, and in southwestern Slovakia; it also suggests the inclusion of the southern Moravian region.

Even though certain curious objects in the La Tène style were produced in these lands during the last phase of the Horákovor culture (which was part of the previous Hallstatt period), it was nevertheless not until the following period that proper La Tène Celtic settlements started to abound. They were characterized by graphite and fine pottery sometimes with stamped decoration, as well as bronze fibulae with birds' heads, and probably the famous Střelice bronze fibula with the little balls. So far our knowledge of these early Celtic settlements with their developed and partially buried foundations is limited to a number of individual objects. We are not yet able to understand the exact nature of these settlements, which developed beside water sources, although the discovery of animal bones, mostly of domestic species, would suggest that they were largely orientated toward agriculture. A significant development in grain processing which took place during this period was the introduction of square querns used for grinding, clearly derived from the Greek millstones, knowledge of which would have reached central Europe via northern Italy. Early La Tène millstones of a similar type have been found recently in the neighboring region of Bohemia. However, the Moravian objects are actually datable, and can be traced back to their probable place of production. Other forms of crafts were practiced, although evidence of this has not yet been discovered in the settlement material. One important exception is the bone matrix for the production of stamped palm motifs, a decorative element hitherto curiously absent from Moravian pottery.

Although we know of several lowland settlements, we are aware of only one fortified settle-

Bronze pendant, fibulae, glass and coral necklace of southeastern origin from a cemetery in Moravia 4th–early 3rd century B.C. Brno, Moravské Muzeum

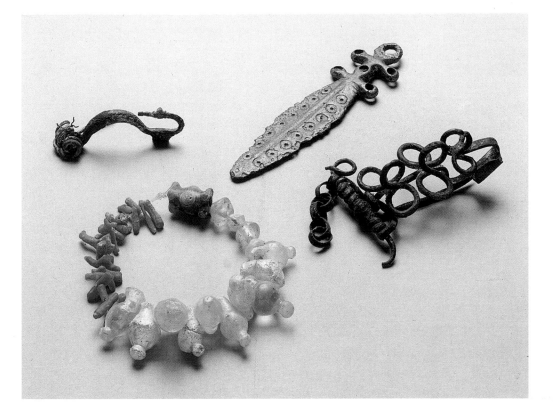

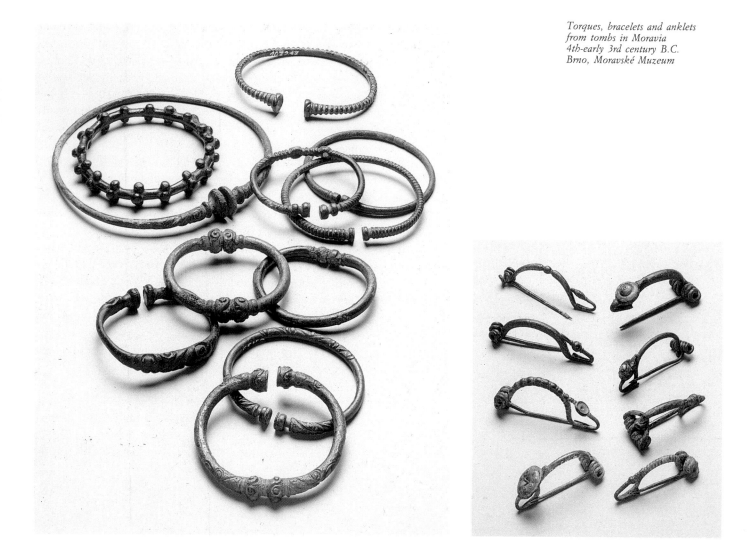

ment in Moravia which can almost certainly be said to be Early La Tène. It is situated in the "Cernov" district, on the southern border of the Draha highland, and covers an area of about 2.3 hectares. On the access side it is fortified by three impressive ramparts. Recent excavations have confirmed the date of the settlement and the fortifications, and have brought to light in certain points the construction of the three meter-wide single-phase rampart with a facade of smooth masonry which was destroyed in a fire. Two deposits of iron objects in the inner area also bear witness to the sudden devastation of the fortress. They comprised instruments and tools for agricultural purposes (ploughshar sickles) and for handicrafts (axes, chisels, a socketed hammer), as well as knives, princers, an awl, a sledgehammer and a hook key. This latter, along with the iron weight and the iron handle found in the same residential stratum, prove that the property used to be locked.

Bearing in mind the various settlements of the La Tène A period, it seems strange that no cemetery of this date has been found in Moravia, although some funerary objects have turned up. However, we can be fairly sure of their existence, no less in Moravia than in the adjacent Slovak territories and in Lower Austria. Time and further research will no doubt prove our suppositions right.

Thus the first phase of the Celtic occupation of Moravia can be traced back to the middle of the fourth century B.C. In the second half of the same century, a second wave of Celts swept into both the previously occupied southern regions of Moravia, and into the northern area, from whence the Hallstatt culture of Platěnice was derived. A particular feature of the

Bronze bracelet, from tomb no. 31 at Brno-Maloměřice (Moravia) First half 3rd century B.C. Brno, Moravské Muzeum

Ceramic molds from cemeteries in Moravia 4th-early 3rd century B.C. Brno, Moravské Muzeum

second Celtic occupation was the flat inhumation cemetery. The settlements of this La Tène B1 phase were certainly often located in favorable positions; however the new cemeteries with their flat tombs, and the destruction of the "Černov" fortress already mentioned seem likely to be the result of a second phase of Celtic settlement. Nevertheless, we are forced to admit that research into the question is not yet sufficiently advanced to allow us to delineate the exact nature of the settlements. As in the previous stage, they were probably made up of small groups of buildings, although it seems that this period saw the development of the sunken-flored huts with side poles and typical quadrangular plans. Similar huts were also a characteristic of the following La Tène age. To judge by the preponderance of domestic animal bones on settlement sites, the Celts' main source of food was provided by agriculture and animal husbandry. Deposits of slag also prove that the population was used to working iron; moreover, the discovery of crucibles and an ingot also bear witness to the production of bronze objects by means of casting.

We know of a relatively large number of Celtic cemeteries from the La Tène B1 period in Moravia, and yet we are inclined to believe that they only underwent substantial population increases during the course of the following period. The graves of these cemeteries were flat, and the bodies of the dead were placed in them with, for the most part, the head facing north. Social status was indicated by various types of double tombs, and in one exceptional case, a warrior was buried in a square grave.

Grave goods largely consisted of bronze and iron fibulae, mostly of the Dux and Münsingen

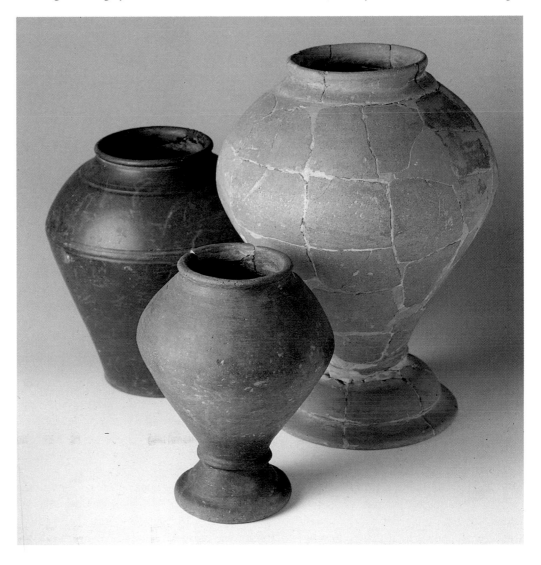

type, and of various forms of necklaces, armlets, bracelets and ankle rings, as well as pottery vessels. Burials of warriors with swords, lances and shields are also numerous in these cemeteries. Such funerary assemblages allow us to state with confidence that the Moravian cemeteries of this period belong to the western Bohemian-Bavarian tradition. Nevertheless, some of them also contain items that derive from more distant regions of Europe, from Switzerland, the middle Rhine area, and northern Italy. Objects deriving from southern Illyria found in the Moravian cemeteries (necklaces of amphora-shaped pearls and coral, rare types of fibulae) are of great historical importance, in that they allow us to date this earliest period of flat-tombed Celtic cemeteries of the La Tène B1 period to the second half of the fourth century B.C. For, according to written records, it was in this period that the Celts began their direct contacts with the Illyrians.

At the end of the fourth century B.C., the Celtic settlements in Moravia, especially in the fertile areas, had gained considerable stability. During the following third century B.C., they continued to develop and flourish, as is strikingly evident in the archaeological material. This can be partly attributed to a further Celtic wave from the southeast, which is sometimes identified with the Volcae Tectosages.

The Carpathian Basin

During the Late Hallstatt period—mid-sixth to mid-fifth centuries B.C.—most of the central and eastern Carpathian basin was populated by a people belonging to the northern facies of the Thracian culture. Known as the Vekerzug group, (after the Szentes Vekerzug site in the Tisza river basin in Hungary) they extended as far as the lower reaches of the river Váh in southwestern Slovakia. The situation in the western part of the Carpathian basin was different; here the indigenous population of the Kalenderberg culture, shaken by the intrusion from the east by the Vekerzug group, turned to western cultural influences.

It was, therefore, in this culturally complex and ethnically- disparate western side of the Carpathian basin that, starting in the fifth century B.C., the first La Tène type objects started to emerge. Until recently, these objects were found in isolated locations or in grave sites dis-

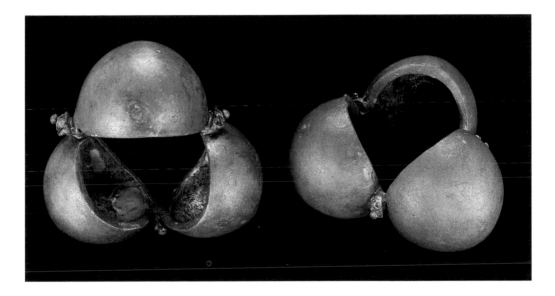

Pair of bronze anklets
from Palárikvo (Slovakia)
Second half 3rd century B.C.
Nitra, Archeologicky
ústav Slovenskej Akademie Vied

turbed by modern construction activities. From the end of the fifth to the mid-fourth centuries B.C., the area stretching from the eastern edges of the Alpine massif, through the northern part of the Burgenland (present-day Austria) to beyond the Danube, as well as western Slovakia, constituted an Early La Tène horizon. This is confirmed by the discovery of inhumation cemeteries with grave goods that included objects from the eastern Alpine area or local Hallstatt tradition (which is most evident in the pottery) and, increasingly, objects for personal adornment of western La Tène origin.

During the earlier part of this period, which can be dated to the fifth century B.C. and which corresponds to the initial stages of the Sopron-Krautacker cemetery in northwestern Hungary, the Hallstatt tradition remained strong.

The more recent period, that is, the end of the fifth to the beginning of the fourth centuries B.C. is well-illustrated by the cemetery at Bučany in western Slovakia. Most of the human remains unearthed were lying supine, heads pointing south, as in the later Celtic cemeteries. Where pottery was included, it was usually placed to the right of the body. The practice among women of the fourth and third century B.C. of wearing identical bracelets on the left and the right arms has already been documented. Anklets, which became fashionable for women in the northwest of the Carpathian basin in the third and second centuries B.C., are found only occasionally, usually in the form of heavy Hallstatt-type rings. Warriors' graves are few and far between and, when they have turned up, they contain only a sword. Another typical feature is the absence of items of above-average opulence. We can see a number of similarities between the funeral rites performed here and those of the "flat" graves of the Celts of the historical migration. Meat offerings, which are quite common, exclude pork which was, instead, typical of more recent cemeteries.

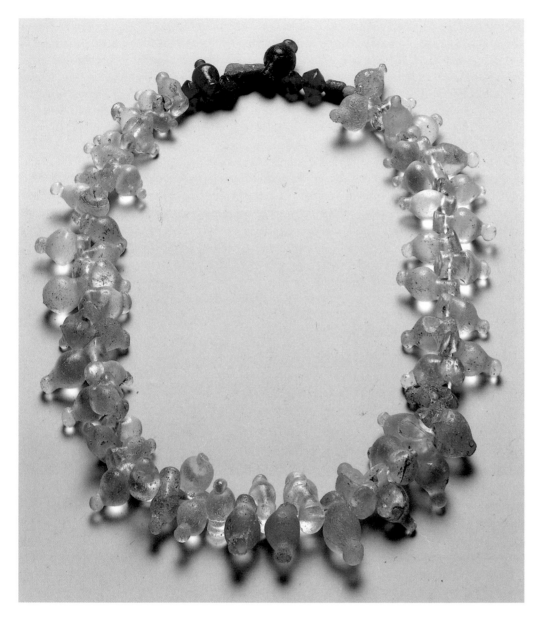

Glass necklace from Přítluky (Moravia)
4th century B.C.
Brno, Moravské Muzeum

This collection of discoveries in the western part of the Carpathian basin (datable to the end of the fifth to the mid-fourth centuries B.C.) and closely linked to the peoples of northeastern Austria, cannot be considered solely the consequence of the links established as a result of the salt trade that went on along the Danube. Nonetheless, if the ancient La Tène objects reflect the early infiltration and penetration of the Celts into the area, the first wave of invaders must have been motivated by trade. Even though certain types of ornaments show later developments in style and certain aspects of the funeral rites are closer to more recent cemeteries built by the Celts of the historical migration, no site uncovered to date was in continuous use between the end of the fifth and the start of the third centuries.

A second, major wave of invaders, which we can consider colonialist in motivation, arrived during the second half of the fourth century B.C. This was the historical expansion documented in the ancient texts. Following the course of the Danube, these peoples settled in the central part of the Carpathian basin so that there was a concentration of people in the northern parts of the Burgenland up to the Danube Bend near Vác in present-day Hungary.

Groups of Celtic immigrants crossed the Danube and headed north, ousting the Vekerzug peoples between the lower Váh and the Ipef as they went, later moving into the lowland areas

of the Little Hungarian Plain. Meanwhile, the evolution of the local population of Lusatian origin was continuing apace in the mountains in the northern part of the basin. Isolated discoveries of La Tène objects nonetheless attest to a certain Celtic penetration of the area, this time perhaps linked to the search for mineral deposits.

New cemeteries were founded in the second half of the fourth century B.C., some of which were still in use at the end of the second century B.C. The oldest parts correspond to the La Tène B1 and B2a and are typified by the strong prevalence of inhumation burials with the head pointed south.

Important persons were buried in their ceremonial vestments and were surrounded by a variety of objects in wooden funerary chambers that recall those of the Hallstatt period. The height of these chambers normally corresponded to that of the tallest pieces of pottery they contained. These more opulent tombs, with their funerary chambers, tended to be situated toward the center of areas that were rectangular in plan (at least in the earliest phase) and bordered by shallow ditches. The purpose of these enclosed areas, which were often linked, has not been established. Such rectangular areas, which could be as much as 170 square meters in size with funerary chambers reaching 11 square meters (equivalent to the size of the houses) have been found in the cemetery at Dubnik in western Slovakia.

Smaller graves have also been found, where the bodies were placed on wooden platforms. Most of the burial sites do not however manifest particular features and the body may have been placed directly in contact with the earth floor of the grave.

Graves containing two bodies, usually side by side and on occasion one above the other, are relatively frequent. Given that these were of different sexes and that their ages varied considerably, this common burial is probably the result of family ties rather than other social links.

Many of the burials in Celtic cemeteries were disturbed in ancient times, possibly by other Celts, but only on very rare occasions would this appear to have have been for the sake of grave-robbing. Many of the tombs were opened for ritual reasons as indicated by the traces found: sacrificial fires for example, or dishes, either whole or in fragments, dating from a later period. Only rarely were the skeleton and the grave goods destroyed, and this normally when the grave was to be re-used.

The set of ornaments found in the flat-grave cemeteries of the earlier period include fibulae of the type referred to as Duchcov and Münsingen, finely-grooved bracelets and anklets with molded terminals and male-female clasps, belt buckles similar to those of the fifth century B.C. and glass beads with blue "eyes" on a white background.

The females' ornamentation was completed with glass bead necklaces. The beads were mainly vase-shaped and pieces of coral and amber beads were also used. One of the most opulent of these necklaces, made up of 364 glass and 50 amber beads as well as numerous pieces of coral, was found in the cemetery at Ménfőcsanak near Győr in present-day Hungary.

These vase-shaped glass beads were very common, having reached the northwest area of the Carpathian basin and nearby southern Moravia from the area on the Sava river (in present-day Yugoslavia) where the Celts came into contact with the Illyrians. Coral, which was frequently used in necklaces found in the southwest Danubian lands, probably came by the same route. What we are looking at here is a trading route different from the one used between the Late Hallstatt and the Early La Tène periods, when coral was imported into east-central Europe via northern Italy.

Arms typically found in the graves include the sword, spear, and shield. The wooden shields start to be fitted with a two-piece metal boss. In the earlier period, wide leather belts with three metal rings—from which the sword was hung—are frequently found. These items were complemented with a razor, knife and whetstone, day-to-day requisites in other words. Adult men were buried with their full armor, while youths usually only had spears. The high proportion of "armed" burials in the cemeteries of the late fourth through to the mid-fifth centuries bears witness to the military character of the Celtic expansion.

Detail of decorated iron scabbard from tomb no. 2 at Ižkovce (Slovakia) 3rd century B.C. Michalovce, Zemplínské Múzeum

The earlier phase of flat-grave cemeteries in the western part of the Carpathian basin coincided with the Duchcov-Münsingen phase in central and western Europe, and with the end of the Hallstatt period (Kurug phase) in Danubian Yugoslavia.

The middle period of the flat-graves (La Tène B2b, 280-230 B.C.) corresponds to a gradual evolution and growth in the population, accompanied by the spread of Celts into the outer reaches of the Carpathian basin. Substantial groups of Celts settled in the southern part of central and eastern Slovakia, probably attracted by mineral resources.

This phase was characterized by the appearance of fibulae with large, globular foot, often featuring embossed decoration and the substitution of light ornamental rings with heavier knobbed types. The practice of adorning the corpse with identical bracelets on either arm was losing appeal, while rings in lignite with bronze gained ascendancy. As far as armor was concerned, the two-piece boss was replaced by a single rectangular piece. Heavy metal belts were an important new feature.

In terms of funerary rites we see greater differences emerging between the northwest, where burial continued to be the usual practice and the east and south, where cremation became the most prevalent form.

Having been defeated and ousted from Italy by the Romans, a new wave of Celts now

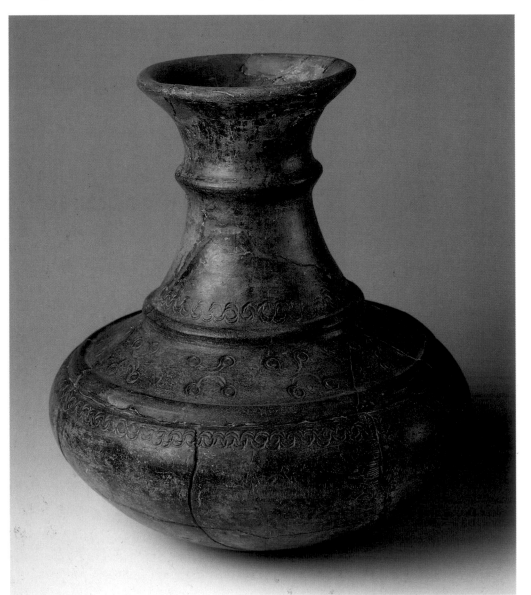

Flask of terracotta with stamped decoration from Vel'ky Grob (Slovakia)
First half 3rd century B.C.
Bratislav, Slovenské Národné Múzeum

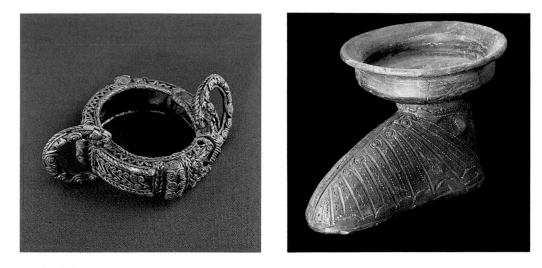

reached the northwest during the later period of the flat-graves (La Tène B2, C1, C1b, that is 230-120 B.C.). New colonial enclaves also sprang up in central and eastern Slovakia as indicated by cemeteries with richly ornamented assemblages (especially decorated scabbards) such as the one at Dřna.

The Celtic population of the Carpathian basin reached its maximum density in the first half of the second century B.C.

The practice of placing assorted pottery in the grave extended from the Late Hallstatt tumuli to the later flat-grave cemetery and is one of the distinguishing features of this horizon of the western area. The typical complement for a medium-level burial was one short and two taller vases while rich people got six, three short and three tall.

Meat was often associated with burials of the middle range and the elite and was deposited, along with other foodstuffs, in vases on the floor of the grave, to the right of the body. Pieces of chicken or fish were occasionally set out on plates. The meat, normally pork, was raw and came from young beasts, so it was top-quality fare and, while the richer tombs got a whole carcasse, less important persons had to make do with pieces. Beef has only been found in the graves of rich women or of fully-armored men and can thus be considered an indicator of elevated social status.

The cemeteries of the Early and Middle La Tène periods bear witness to a rigidly-stratified social system even if the funerary goods seem more homogenous compared to those of the Hallstatt period, inasmuch as they lack the equivalent of the so-called princely tombs. The social stratification marked by the presence of the fully-armored men's and rich women's tombs point to a change that had taken place between the Hallstatt and the La Tène periods.

The Celts' traditional social structure changed considerably during the period of expansion. Family and tribal bonds were broken and it became possible to increase one's wealth by means of military prowess and through the new ways of dividing up war spoils. Although for the most part descended from the traditional aristocracy, this "upper" class also gained new members, which changed its nature. It became "democratic," as it were. One of the expressions of this new political and economic structure is probably the emergence of the *soldurii*, mentioned by Julius Caesar in *Gallic War* (III, 22) as well as by Polybius (II, 17) right from the time of the incursions into Greece.

The occupation of new territories, the exploitation of raw materials, and the creation of trading links all encouraged economic growth and social consolidation. Production must have increased, despite the decline in the contribution to overall income made by booty as we see that there are large numbers of ornaments and decorated objects in the graves of the later period. However, the adoption of more readily available raw materials and less refined craft techniques meant that such articles could not compare in quality to the luxury products of the initial period. (*J.B.*)

As reported by classical sources, and particularly by a passage written by Pompeius Trogus and related by Justinus, at the beginning of the fourth century B.C. there was a sudden and almost simultaneous migratory drive in both Italy and Pannonia. Justinus also affirms that before their invasion of Pannonia the Celts had pushed as far as Illyria. As Pompeius Trogus had no further knowledge of the route of the invasion, his *topos* is not substantiated. The distribution of archaeological finds suggests a rather different route of penetration—moving eastward along the Danube, the Celts reached northwestern Hungary before proceeding toward the Viennese basin. Their advance is marked by a particularly high concentration of graves in Kisalföld (Small Hungarian Plain). These consist of a series of cemeteries marking the so-called historical migration of the Celts. The most important sites (or most extensively excavated) are Sopron-Bécsidomb and Ménföcsanak. But to get a clearer picture of the magnitude of the migration one must include many other sites such as Egyházasfalu, Fertömeggyes, Petöháza, Ordód-Babót. In the course of the fourth century B.C., the northern half of Transdanubian Hungary was completely overrun by Celtic culture—that is, an area ranging approximately from Lake Balaton (cf. relics found at Andráshida, Cserszegtomaj, Rezi-Rezicser, and so forth) to the mountainous chain of Vértes-Búdai Kegység (cf. remains found around Tata, burials at Szomód-Kenderhegy and Almásfüzitó). On their way, however, the incoming migrants clearly had to cross the Zala River in the western Transdanubian region, as can be inferred from findings recently published by Felsörajk.

It should be borne in mind that, given the discoveries made at Sopron-Krautacker and Pilismarót-Basaharc, La Tène culture in this particular region had somewhat earlier roots, datable to the second half of the fifth century B.C. Its consistent presence is corroborated by finds at two separate sites.

The appearance of Celtic material in the northern fringes of the Great Hungarian Plain also dates back to the fourth century (cf. finds at Vác, Püspökhatvan and Hatvan-Boldog); and the Celts had got as far as the area of Miskolc (the cemetery of Muhi-Kocsmadomb) even before 300 B.C. It is likely that the flow of migrants reached the western climes of today's Rumania, as attested principally by the cemetery of Pişcolt, whose oldest graves date with

Beads of glass, coral, rock crystal and sea-shells, used as pendants from tomb no. 53 at Pilismarót-Basarhac (Hungary) 4th century B.C. Budapest, MTA Régeszeti Intézete

certainty to the fourth century B.C. Material of approximately the same date has turned up in the region of Arad, that is, the southwestern corner of the border with Hungary. It is thought that the Celts were forced northward into Transylvania by the Macedonians. If we are to believe the summary reports published, the cemetery at Fîntînele in the Carpathian basin belongs to this early phase of Celtic settlement in western Rumania. The cemeteries in Yugoslavia, all major testaments to the phase of Celtic expansion through the Balkan regions, date back to the years of transition between the fourth and third centuries B.C.; key sites include those at Osijek in Slovenia, Karaburma near Belgrade, and Pečine near Kostolac. All three cemeteries are linked to this highly eventful period.

Pair of fibulae linked by a bronze chain from Szentendre (Hungary) End 4th-early 3rd century B.C. Budapest, Magyar Nemzeti Múzeum

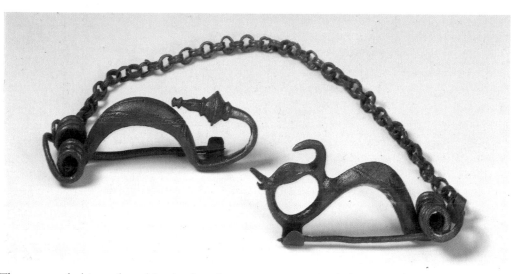

The types of objects found in the fourth-century cemeteries belong to what is classified archaeologically as the Duchcov-Münsingen phase, the main characteristics of which reflect the consequences of Celtic movements. The conquest of part of northern Italy paved the way for new cultural contacts which, linking the peninsula with Bohemia, undoubtedly also affected the western border of the Carpathian basin. Early research revealed traces of Rhenish origin in the culture of the Celts who reached Hungarian soil in the fourth century B.C. There also seems to be a marked influence of Marne cultures, mainly noticeable in styles of weapon found. Another important clue is the large terracotta plate found in tomb 377 at Pilismarót-Basaharc; its engraved decoration was copied from a metal object, most likely manufactured in the Champagne region. It is not hard to see links between the Italic assemblages of the Duchcov-Münsingen phase and Celtic objects from contemporary horizons in northwestern Hungary, as illustrated by the highly typical bracelet from Tomb D at Carzaghetto, and its parallel at Ordód-Babót. Further proof is given by the Münsingen-type fibula from group 4 of the burial goods unearthed at Ménfőcsanak; the use of coral is particularly striking, and its decoration shows variations of certain motifs of Greek origin. The clay situla discovered in tomb 18 in the same cemetery is without doubt an imitation of a bronze vase from a zone where the art of situla-making was widespread.

The objects that can be considered products of local workshops attest to a heightening of Celtic influence in the zone in question, starting from the second half of the fourth century B.C. The most significant of these are undoubtedly zoomorphic ring-shaped fibulae (e.g. the pair found at Litér) which correspond, in the Carpathian basin, to a variant of the geometrical form of zoomorphic fibulae of western La Tène A. It can be dated by its association with fibulae of the Duchcov type, for example at Szentendre. Pottery stamped with arches, lyres, triskeles, and the like, which is particularly characteristic of the so-called "oriental" area of La Tène culture, must also be mentioned; an important workshop for this kind of vessel was found in Sopron-Krautacker.

In southern Transdanubia, the so-called Pannonian cemeteries were still used in the fourth

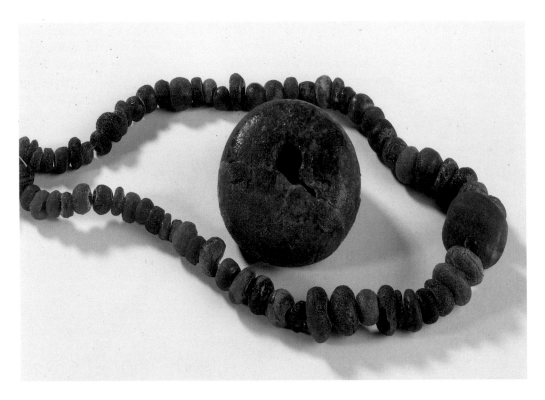

*Amber necklace, from tomb no. 63
at Pilismarót-Basarhac (Hungary)
4th century B.C.
Budapest, MTA Régeszeti Intézete*

century, and there is no doubt that this is when "neighborly relations" deteriorated, according to Pompeius Trogus, forcing the conquering Celts to engage in protracted wars with the indigenous population, who were also equipped with weapons fashioned from iron. East of the Danube, in the territory of the Great Hungarian Plain, the Celts came up against staunch resistance from the so-called Scythian or Thracian-Scythian civilization, largely made up of Persian stock.

The later cemeteries of the third century B.C. can be linked to the invasion of the Balkans. These are largely found on Hungarian soil, in regions which, as far as we can ascertain, were not inhabited by the Celts in the fourth century. Southern Transdanubia contains numerous sites illustrating their progress, for example Magyarszerdahely, Cece, Kölesd-Lencsepuszta, Apátipuszta, Pécs-Köztemetö, and so forth. Northeast Hungary boasts a conspicuous concentration of new cemeteries, such as those at Vác-Kavicsbánya, Szob, Kósd, Mátraszöllös, Kistokaj-Kültelek, Radostyán, Bodroghalom, and in the Great Hungarian Plain there are Celtic burial grounds everywhere (important ones include Jászherény-Cseröhalom, Gyoma, Békéssámson, Mörösszegapáti, Gáva-Katöhalom; those around Rumania include Çiumeşti, Sanislau, Curtuişeni, and others). The Celtic finds in Transylvania and Yugoslavia allow us to say that during the third century B.C. the Carpathian basin became completely Celticized. Archaeological sources are limited, however, and it is hard to determine whether a given set of finds dates from before or after 275 B.C., that is, whether it can be associated with the "banding together" of Celtic tribes in the hinterland that preluded the mass invasion of the Balkans, or whether it dates to the Celts' retreat as a consequence of its failure. The dating of finds from the protohistoric period is relatively imprecise, to within roughly twenty-five years in the best of cases; furthermore, the period in question is marked by the shift between Early and Middle La Tène, and consequently the archaeological material is also of a transitional nature.

Analysis of the cemeteries of the third century gives a strikingly clear account of how burgeoning Celtic power in the Carpathian basin proceeded in parallel with the steady formation of a cultural and artistic *koiné*. (M.S.)

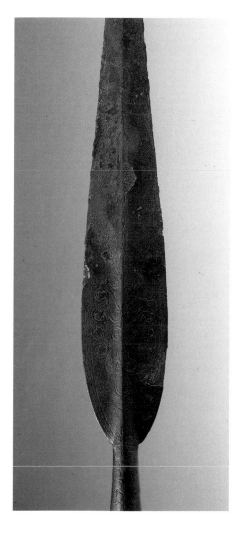

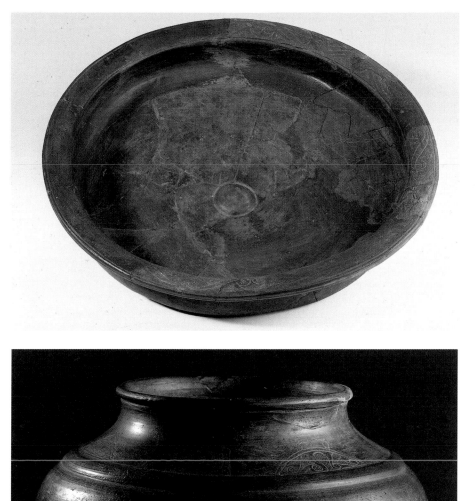

Decorated iron spearhead
of unknown Hungary origin
End 4th-early 3rd century B.C.
Budapest, Magyar Nemzeti Múzeum

Terracotta dish with decorated rim
from tomb no. 377
at Pilismarót-Basarhac (Hungary)
Second half 4th century B.C.
Budapest, MTA Régeszeti Intézete

Terracotta vase from Alsópel
(Hungary)
End 4th-early 3rd century B.C.
Budapest, Magyar Nemzeti Múzeum

The Filottrano Cemetery
Maurizio Landolfi

Filottrano lies to the south of the River Esino, near the Conero promontory, on a strip of hillside on the right bank of the Musone River. In the past, cemeteries of the Picentes have come to light as a result of chance discoveries in the eastern and southern outskirts (Ciavarini 1893, p. 260) of the modern town. About six kilometers northeast of here stands Ripabianca di Santa Paolina, on a group of low-lying hills at the confluence of the Troscione and Musone rivers, opposite the heights of San Filippo di Osimo. Here, on land belonging to Countess Coloredo di Codroipo, regular unsystematic and, unfortunately, unscientific excavations have been conducted. These and chance discoveries made between 1910 and 1913 revealed an open settlement with material from Apennine, sub-Apennine and proto-Villanova type, and led to the discovery of a settlement and a Gallic burial ground from the fourth century B.C. (Rellini 1931, coll. 133-134).

In 1915, Dall'Osso gave an inadequate account of some of the burial finds connected with this important Celtic settlement of the Senones of the Adriatic (Dall'Osso 1915, pp. 221-285). In 1937, E. Baumgärtel reassessed and published material describing fourteen burial complexes, using to some extent records from the Sopraintendenza Archeologica di Ancona, consisting of correspondence and excavation journals by L. Barrovecchio (1911), A. Bizzarri and I. Messina (1912 and 1913). Although these records are certainly not perfect, they make it possible to build up a better picture of this settlement of the Senones, which proves to be of the utmost importance for understanding the earliest phase of Celtic occupation of the central Adriatic area.

The cemetery was situated on the south-west side of the hill of Santa Paolina. Substantial evidence of the settlement connected with it seems to have been found on the top of the hill (Déchelette 1914, p. 1091, n. 1).

About thirty burials without grave goods, thought to be contemporary with the prehistoric village, and twenty-eight Gallic inhumation burials were found. Many of these proved to have been tampered with or damaged, either as a result of unauthorized excavations or agricultural activities.

The inhumations were laid supine and full length in ditches normally measuring about 2 by 0.8 meters, whereas the burials with rich associations were larger (grave 2: 4.8 x 3 m; grave 13: 3.4 x 2.7 m; grave 20: 3.7 x 1 m; grave 21: 3 x 1 m). It was noticed that the orientation of these burials differed, e.g. a north-south axis (grave 2), a northeast-south-west axis (grave 3, 4, 16 and 21), an east-west axis (grave 7, 14, 15 and 20) and south-east-north-west axis (grave 5, 23-28). Apart from the grave of a child (grave 24), the others are all adult burials. On the basis of the funerary associations alone, and in the absence of analysis and anthropological data, it was established that graves 2, 13, 14, 20 and 21 represent female burials, whereas graves 4, 7, 10, 12, 18, 19 and 22 contain warriors buried with arms.

Finds of defensive equipment included helmets of bronze and iron, while offensive equipment is represented by iron spearheads and swords with scabbards typical of the La Tène culture. The latter includes an exceptional example from grave 22, made of iron covered in bronze, with pin-prick decoration in the form of a continuous floral motif in the characteristic Waldalgesheim style of the La Tène culture.

The female graves often contained rich associations consisting of gold adornments, and objects for toilet and body care, such as mirrors, bronze cages and strigils. They were further characterized by a considerable number of domestic finds (bronze cauldrons, bundles of skewers and a group of seven iron knives) as well as rich, refined drinking services (late Greek red- and black-figure pottery, bronzes from Etruria, Praeneste and Campania, and vases from the northern Adriatic area), which also appear in the warriors' graves. In grave 2, a Celtic gold torque was found with buffers

and a crown of eleven leaves sprouting from stylized palmettes, in the abstract style favored by the Waldalgesheim style.

Some doubt has been cast on the suggestion that the craftsmanship on a sort of bronze *stamnos* is Celtic (Cristofani 1978, p. 72) and it has since been attributed to Etruscan craftsmanship (Shefton 1988, pp. 146-149), as have pieces of sheet bronze with pin-prick decoration used to adorn wooden kegs (Jacobsthal 1939, pp. 98-102).

The graves in the Gallic cemetery at Santa Paolina feature rich funerary assemblages and can be dated by the finds of Greek pottery (graves 2, 9 and 13) to around the middle of the fourth century B.C. They therefore constitute some of the earliest archaeological evidence of the presence of Gallic Senones communities in the Piceno area and are evidence of their rapid Hellenization and integration with the Etruscan-Italic peoples. This is in part due to the movements of mercenaries in the service of the Siracusani of Ancona, or a result of raids and military action in central Italy and along the coasts of the Adriatic and Tyrrhenian Seas. The funerary assemblages record the acquisition by these cisalpine Senones of cultural models belonging to advanced urban societies such as those of Greece and Etruria, and confirm the great mobility of the Senones of the Adriatic area and the many and diversified contacts they had with various geographical areas and different cultures, proving the existence of privileged relationships with southern Etruria (Praeneste), Campania, Taranto and, possibly, Macedonia.

The archaeological evidence relating to the Senones of the Adriatic would seem to indicate that the so-called Waldalgesheim "continuous vegetal" style of the La Tène culture, already referred to several times in this text, had its origins and developed in the central Adriatic area, rather than north of the Alps, and was then spread by the Senones to their places of origin (Kruta 1981, pp. 36-37, no. 105).

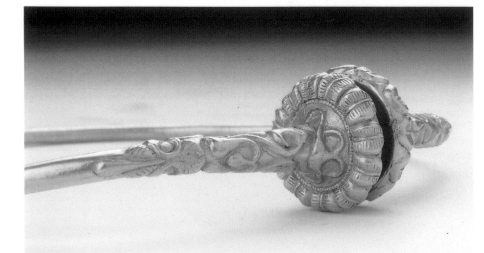

Detail of gold torque
from tomb no. 2
Santa Paolina di Filottrano (Marches)
First half 4th century B.C.
Ancona
Museo Archeologico Nazionale
delle Marche

The Burial at Moscano Fabriano
Maurizio Landolfi

The village of Moscano, in the Vallemontagnana district, is situated more than ten kilometers to the northeast of the modern township of Fabriano. It lies in the heart of the mountainous part of the upper Esino Valley, near an important pass of the Umbria-Le Marche Apennines linking the Adriatic side of central Italy with the valley of the Tiber.

In this region, following chance finds in 1955 on land belonging to the Negroni family, an inhumation burial was discovered in a ditch 2.70 by 2 meters by 1.80 meters deep. Though it had been damaged by earlier agricultural activities, it yielded a rich burial assemblage and a few bone fragments from the inhumation. Routine archaeological research has ascertained that this was an isolated burial belonging to the chief of a Celtic tribe of the fourth century B.C., and among the earliest evidence of the invasion by the Senones of the central-Adriatic area of the Italian peninsula.

That this was the grave of a Celtic warrior of high rank is confirmed by the dimensions of the grave, the presence of arms (a bronze helmet, parts of an iron sword belonging to the La Tène culture, and a Celtic sword-scabbard made from two sheets of bronze, with pin-prick decoration in the so-called Waldalgesheim style and similar to the iron and bronze version from Santa Paolina di Filottrano) and metal objects relating to horse-trappings (bronze phalerae and iron and bronze chamfreins), together with the abundant finds of bronze and pottery grave goods and the bronze Celtic fibulae.

In harmony with the princely nature of the burial, the domestic finds include an outstanding group of valuable bronzes from Etruria and Campania and a large number of Greek vases painted black or decorated with red figures, used for drinking wine, and other vases used for various purposes. The most usual table bronzes include a stamnos group (tripod, situla, *oinochoe*, colander and *echinus*), together with a *kylix*, a group of bronze *kyathoi* and a wooden keg covered with a thin layer of bronze, which compares with similar examples from Filottrano and Osimo and appears again incised on the Ficoroni bucket (Landolfi 1987, pp. 454, no. 20).

In the group of late Greek red-figure vases, in addition to a bell-shaped flagon belonging to Group G, there is a cup-shaped flagon, a *pelike*, a large *skyphos*, an incomplete *kylix*, fragments of small *skyphoi* and two *lekanides*, of which one is a replica of that found at Montefortino di Arcevia, attributed to the Otchët Group, making it possible to date the deposit within the second quarter of the fourth century B.C.

These artifacts confirm the great importance given by the Celtic aristocracy to the acquisition and exhibition of precious banqueting services. Other objects found at Moscano relate to body care and the practice of athletic pursuits, and show that the Senones of the Adriatic region adopted cultural models of Greek origin introduced to them by the people of Etruria and Campania, who had adopted many aspects of Greek culture.

The funerary association from Moscano di Fabriano, characterized by the presence of Celtic artifacts (the fibula and the sword-scabbard) and other metal objects, where the expertise of the La Tène culture linked to the so-called Waldalgesheim style is evident (the horse chamfrein, the bronze covering on the wooden keg and the grater) are further proof in support of the theory that this La Tène style was formed and developed on the Adriatic side of central Italy by the cisalpine Senones, who were the people most exposed to Greek influence and, of the Celtic groups which moved down into Italy during the fourth century B.C., the one that had settled furthest south.

Fragmentary bronze La Tène-style fibula from the tomb at Moscano di Fabriano (Marches)
Mid-4th century B.C.
Ancona
Museo Archeologico Nazionale delle Marche

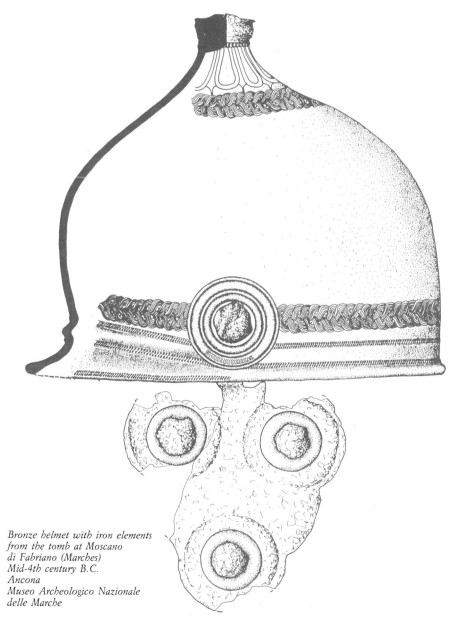

Bronze helmet with iron elements from the tomb at Moscano di Fabriano (Marches)
Mid-4th century B.C.
Ancona
Museo Archeologico Nazionale delle Marche

Monte Bibele is situated in the heart of the Bologna Apennines, thirty kilometers southeast of Bologna and fifteen kilometers from the border with Tuscany.

This mountainous massif, formed of sandstone intermixed with marl, covers a surface area of approximately 200 hectares and is typified by steep, inaccessible slopes which, to the east and west, run down to the Idice and Zena rivers.

The mountain once had a plentiful supply of sulphurous freshwater springs, and this natural wealth is hidden in the name "Bibele," recorded in medieval times in the form of "Bibulo" ("the mountain where you can drink"). At the foot of the mountain, in the Idice Valley, there are deposits of copper and iron, which were mined intensively until the last century.

The archaeological research financed by the town council of Monterenzio and the University of Bologna from 1973 and 1978 until the present day, has made it possible to make an authoritative reconstruction of the structure of the settlement that developed from the late fifth century B.C. on the highest part of the massif (between 500 and 600 meters above sea level). This complex consists of a settlement, a burial ground and at least two places of worship which, due to the specific nature of their characteristics, have made it possible to reconstruct a picture of the daily life and social relations, funerary rites and religious beliefs of the community of 200-300 people that inhabited Monte Bibele between about 400 and 200 B.C.

There had been brief periods of settlement on this site during the Copper Age (2000 B.C.) and the Late Bronze Age (1300-1200 B.C.)

During the early fourth century B.C., the mountain slope called Pianella di Monte Savino was cleared of trees and shaped into long artificial terraces reaching up to the highest part of the slope. On these platforms of earth with their supporting stone walls between forty and fifty houses were constructed in small groups, as well as a network of roads from two to three meters wide.

The unitary and regular nature of the "urban" structure suggests that it was planned and built in a short space of time.

The architecture of the houses (which cover a fairly limited area: 30-40 square meters) is closely linked to the availability of local resources (stone, earth and wood). However, excavation finds show that the living area was increased by building vertically. Post-holes found in the floors and the body of the surrounding walls have revealed the existence and position of wooden pillars which once supported the upper floors—at least one—and the roof. The latter must have been constructed of organic material, since, to date, no brick-tiles or stone slabs have been found that could have been used for this purpose.

On the ground floor, there is typically a hearth with firedogs and a terracotta base,

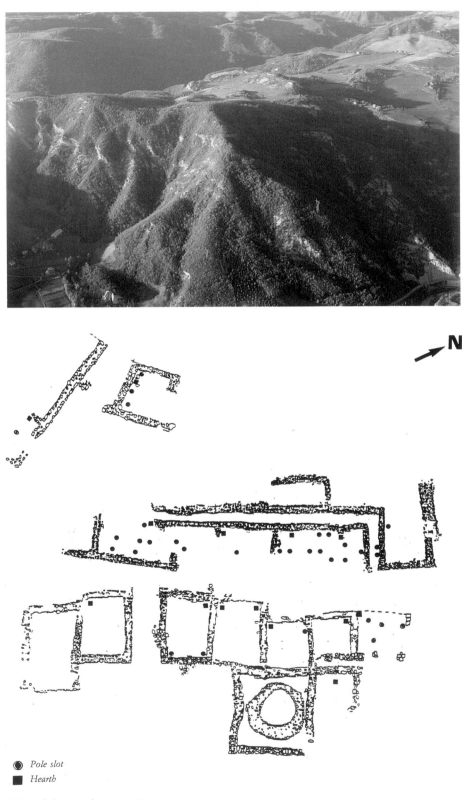

● *Pole slot*

■ *Hearth*

*Plan of the stone houses at Monte
Bibele (Monterenzio, Bologna)
4th-3rd century B.C.*

beside a floor usually made of earth. Large amounts of pottery were found on the floors, covered with a layer of ash and charcoal. They include pots used for preserving or preparing food, Greek-Italian amphorae, terracotta loom-weights and food remains, all of which were crushed when the walls collapsed during a fire that destroyed the whole settlement.

Thanks to this traumatic event, large quantities of wood, cereals, vegetables and fruit have been preserved in a carbonized state. One house, probably a storehouse, contained several hundredweight of wheat, oats, broad beans, lentils, peas, flax, acorns, olives, garlic, hazel-nuts, apples and grapeseed. Some of these were obviously imported from the plain, or from further south, but some are the products of local agriculture, as the tools with carbonized handles found inside the houses prove.

Below the settlement is a large and skillfully constructed tank, used by the Monte Bibele community to tap a spring which guaranteed a supply of fresh water.

The burial-ground is situated 200 meters northwest of the settlement on the widest of the west-facing slopes of Monte Bibele, known as Monte Tamburino. To date, 134 graves have been discovered, of which 104 are inhumations and 30 are cremations.

This sloping ground was exploited in a very rational way: for the first burials, the best, higher and more undulating ground was used; the more steeply sloping ground was used at a later stage. The graves were dug successively, following the contour of the mountain, and, when the first row was full, a new row was begun further down, and so on: (five have been identified so far). Whereas the topographical (and therefore chronological) succession of inhumations assumes a regular pattern, the succession of cremations is more erratic. In fact, late cremation burials also occur in the oldest part of the cemetery. The reconstruction of the horizontal stratigraphy of the cemetery—that is, the range of space and time represented by the burials—is fundamental to the research on Monte Bibele: once we can establish the succession of deaths, for example, it becomes possible to understand the appearance of "innovations" (the arrival of outsiders) in a community which shows a continuity of funerary rites and customs from 400 to about 250 B.C.: the older tombs and other, more recent ones contain finds typical of the Etruscan world of the Po Valley and Tyrrhenia.

The Etruscan names inscribed on pots from the burials prove that the population living on Monte Bibele was Etruscan.

After a first group of purely Etruscan burials, between 350 and 330 B.C., we come across burials of adult males with iron weapons and fibulae of Celtic origin. These innovations appear within the chronological succession of the cemetery and, later, become isolated in a separate group of burials containing prestigious military equipment. This absorption of outside influences without any obvious traumas must be explained by the arrival of an army of Celts, who were garrisoned here and became an integral part of a mixed community where the local people continued to play an important role. The presence of these Celts high in the Apennines, demonstrated by the contents of 44 burials, and their distinctive use and possession of arms, as well as their close links with countries lying north of the Alps, can be explained by their need to hold strategic positions and control trade on the main routes linking northern Italy—and the area of the Boii, between Modena and Felsina, in particular—to central Italy.

Along the route leading from the settlement to the cemetery the remains of a votive offering with fragments of Attic pottery and small Etruscan bronze sculptures was discovered. They are thought to be associated with a freshwater spring.

Another place of worship, which appears to have more potential for research, was discovered on the summit of Monte Bibele; excavations are still in progress. The top of the mountain was flattened and leveled with earth brought from the surrounding area. A rectangular platform with an east-west axis was built, the four sides of which were marked by a deep ditch where fragments of iron arms, pottery from the fourth and third century B.C. and animal bones have been found. The nature of the structure and the finds discovered there are reminiscent of those from the same period found north of the Alps at Gournay-sur-Aronde.

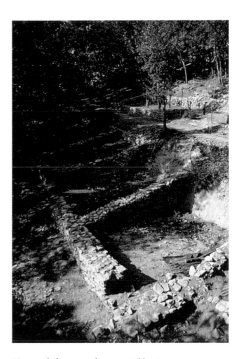

View of the stone houses at Monte Bibele (Monterenzio, Bologna) 4th-3rd century B.C.

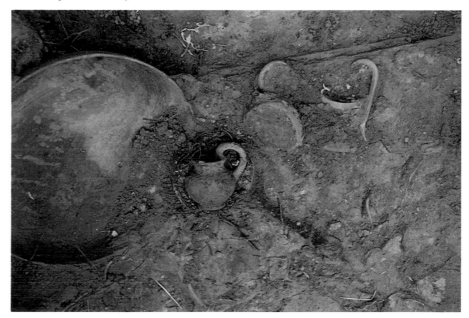

Pottery fragments from tomb no. 132 at Monte Bibele

Coins Cast with the Head of the Gaul in the Area of Ariminum
Silvana Balbi de Caro

The series of cast bronze coins bearing the head of a Celtic warrior constitutes a particularly interesting problem in the history of minting in ancient Italy. There can be no doubt that the warrior belongs to the Celtic race: both his physical features and the heavy necklace (or torque) he wears make him easily recognizable. There seems to be no significant variation on the reverse of the coins. In fact, whereas the two larger coins continue the theme of the warrior through the stylization of his arms (a round shield on the *quincunx* and a short sword and scabbard on the *quatrunx*), on smaller coins (from the *teruncius* to the *semuncia*) we find exclusively marine themes: the prow of a ship, a trident, a dolphin, a shell. The coin with the highest nominal value (the *asse*) on the scale of values represented in the limited amount of material that has come to light, is missing. The other coins on the scale include the *quincunx* (five ounces), the *quatrunx* (four ounces), the *teruncius* (three ounces), the *biunx* (two ounces), the *uncia* and the *semuncia*. The existence of the five-ounce piece confirms that the whole series belonged to a decimal monetary system, which must have been based on an *asse* subdivided into ten ounces, the theoretical weight of which seems to correspond to about 379 grams in today's terms.

The decimal division of the *asse* typical of bronze coinage along the Adriatic coast between the end of the fourth century and the first half of the third century B.C. enables us to compare the series bearing the head of the Celtic warrior with those of other tribes in the region (the Vestini) as well as some belonging to other centers on the Adriatic side of the peninsula (*Atri*, *Luceria* and *Venusia*). Moreover, now that the archaeological evidence has been published, the confirmation that most of the coins come from the countryside surrounding Rimini has led to their being attributed to the Galli Senones, who occupied the area in the fourth century B.C.. Therefore they can be linked to the period prior to the defeat of this tribe at Sentino in about 292 B.C., and to that of the Roman colonists in the years following the foundation of *Ariminum* in 269 B.C. In actual fact, from a preliminary revision of the objective information available—made in Rome on the occasion of the exhibition on "The Gauls and Italy" in 1978—it became clear that, on one hand, it was historically unacceptable to attribute a coinage to tribes of Gaulish origin exclusively on the basis of typology, without the support of any certain extrinsic data (finds associated with other objects that could be dated precisely) or intrinsic to the material itself (weights, metals, minting techniques, and so on). On the other hand it seemed too limiting *sic et sempliciter* to attribute the coins to the colony of Ariminum in the years immediately after 269-268 B.C., at a time when the Roman presence in the area had taken on well-defined connotations.

First of all, the fact that the coins bearing the head of the Celtic warrior belonged to a decimal monetary system means that this series was extraneous to the economic area covered by the earlier Roman coinage, the *asse* of which was divided into twelve ounces. In addition, the material that has come to light proves that the value of the *libra* on which the sizing of the coins was based (about 370 grams) was much higher than that of the *libra* used by the Romans (about 327 grams). The *aes grave* attributed to *Ariminum*, on the other hand, had much in common with bronze coinages that can be traced to the Vestini and to Atri—for example the decimal division of the *asse* and the value of the *libra* (about 370/380 grams)—and, as far as the decimal division of the coinage is concerned, with those from two other centers of the Italian Adriatic regions: *Luceria* and *Venusia*. *Luceria* was a Roman colony from 314 B.C., and *Venusia* from 296 B.C. Rome had also formed an alliance with the Vestini in 296 B.C. and founded the colony of *Atri* in 289 B.C., and the colony of *Ariminum* in 268 B.C. However, although the above facts make it clear that the Adriatic centers involved in the minting of the *aes grave* were now under Roman influence, the coinage phenomenon need not necessarily be attributed to a direct initiative on the part of the Romans. Although this phenomenon was stimulated by social and political innovations, uniting tribes that were far apart, and not only in a geographical sense, it is more logical, in fact, to suppose that it found its true origin among the indigenous people. The theory that the coins bearing the head of the Celtic warrior were already in circulation in this area prior to the founding of the Roman colony, in a context that had undergone profound changes since the founding of *Sentinum* and *Arretium*, compared to the years of Celtic dominance, have found confirmation in the find of a *semuncia* belonging to this coinage, and associated with two small bronze coins from *Arim(inum)*, bearing the head of Vulcan wearing a *pileus* and a warrior armed with a shield. These coins were part of a votive offering made at the time of the foundation of the colony, and were found in the levels of a site on the Roman walls of Rimini. In the light of the latest discoveries it is clear that only by a detailed analysis of the significance of the Roman presence in the various regions of ancient Italy, at a time when the ruling republican classes were attempting to bring existing systems of government into line with the new realities, can the legal foundations be clarifed. These provided the basis for the particular aspect of the ancient monetary phenomenon which resulted in the creation of the *aes grave*, the heavy bronze coinage, that was guaranteed both in terms of its weight and its nominal value, by the state that issued it.

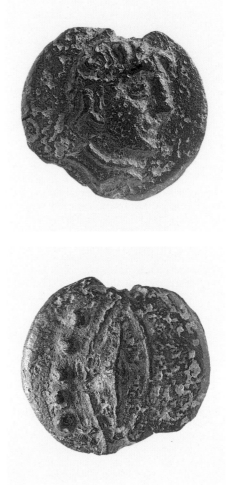

Series of cast bronze "Gaul's head" coins attributed to precolonial times from Ariminum
First half 3rd century B.C.
Rome, Medagliere del Museo Nazionale Romano

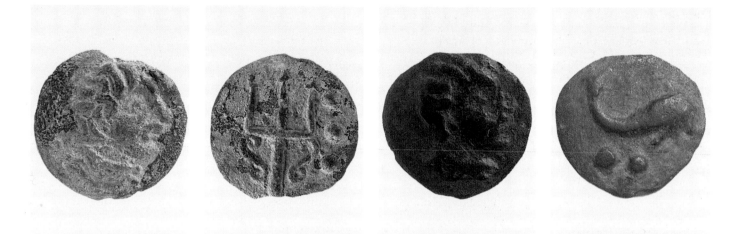

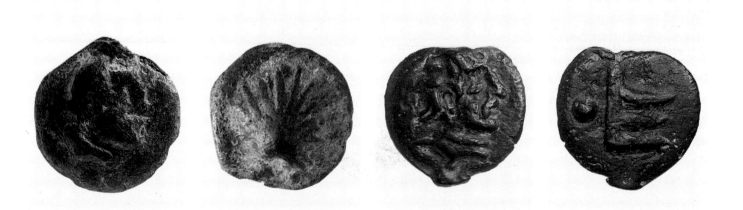

The Agris Helmet
José Gomez de Soto

Discovered piece by piece, starting in 1981, in a grotto, the Agris helmet remains incomplete and, due to the soil conditions, whatever pieces remain are probably no more than tiny fragments by now. To date we have the helmet's crown, the base of the crest, a cheek-piece, a few fragments of ornaments (in an unidentified style) from studs set into an undecorated side-band.

The helmet seems to have been deposited separately, and not as part of a burial. The other rare La Tène B elements at the site, a Dux-type fibula, and a series of red-painted shards, suggest that the grotto was rarely visited during this period. The place may have been a rock sanctuary, or have had mythical importance—a gateway to the underworld, as found elsewhere in cult practices across Europe. The horned serpent on the cheek-piece is an eminently chthonian symbol. The helmet is a far earlier work than the Gundestrup cauldron, and hence is the oldest source of this type of design encountered in the Celtic world. Furthermore, since nothing similar has yet turned up even in the more lavish burials, we must assume it was a religious object or votive offering.

The helmet is made of various different materials—iron for the crown and for several of its attachments, bronze for the appliqué strips, gold for the plating, pearled threads, and rivet heads, silver for the rivets, plus coral and organic material including glue, wood, and leather.

The ornamentation, covering practically all the available surface, takes its inspiration from the plant world, and the design is laid out, with running palmettes and lotuses, in accordance with the Early Style, which is also the source for the geometric patterns, traced with a compass. The elements of Waldalgesheim or continuous Vegetal Style are reduced to a flower-shape derived from the lotus of the Early Style, discreetly occupying the corners of the set of running S-shapes along the central register of the crown; such patterns date the helmet to the last third of the fourth century.

It is clear that the ornamental style of the Agris helmet is derived in theme and organization from northern Alpine tradition. The Italic influence is reduced to a reinterpretation of the classic Early-Style plant tracery. The arrangement in bands is clearly derived from the engraved ornamental strips on the early Celtic helmets (such as the Berru helmet)—though more intrusive here—rather than from the Montefortino-type of plating, which is more commonly found in later contexts. On the other hand, the technical brilliance of the helmet's iron crown, with its separate, riveted neck-guard, is of obvious Alpine origin. The use of gold leaf on bronze is more reminiscent of the non-Italic Celtic regions, a style epitomized by the Weiskirchen-type plaques.

It is worth noting that it is the northern Alpine region of the Celtic world which provides, at the end of the fourth century, stylistic archaisms akin to those of the Early Style. A prime example is a plaque from one of the later chariot tombs at Condé-sur-Marne. It may be, therefore, that the Agris helmet was produced in a workshop in the Celtic territories in the northern Alps, or by craftsmen who learned their trade in those provinces.

The analysis of many gold samples taken from many different pieces of the helmet has demonstrated a degree of uniformity and purity rarely found in antique artifacts (99 percent gold; 0.5 percent silver; 0.2 percent copper). Gold of this kind has so far only been found in the series of ornaments from the southwestern sector of Gaul, whose source was probably the mines of the Massif Central, which were first exploited in the Iron Age. It therefore seems likely that the helmet was made in the west. Such an eminently Celtic work could only have been made for a client of Celtic extraction, or for someone who had adopted Celtic culture entirely. At the end of the fourth century, the far west was without doubt part of the Celtic universe. From the second half of the sixth century various circumstances, and perhaps also the presence of certain ethnic elements, had opened the field to Celtic ascendancy.

Parade helmet in iron bronze, gold and coral from Agris (Charente) 4th century B.C. Angoulême, Musée de la Société Archéologique et Historique de la Charente

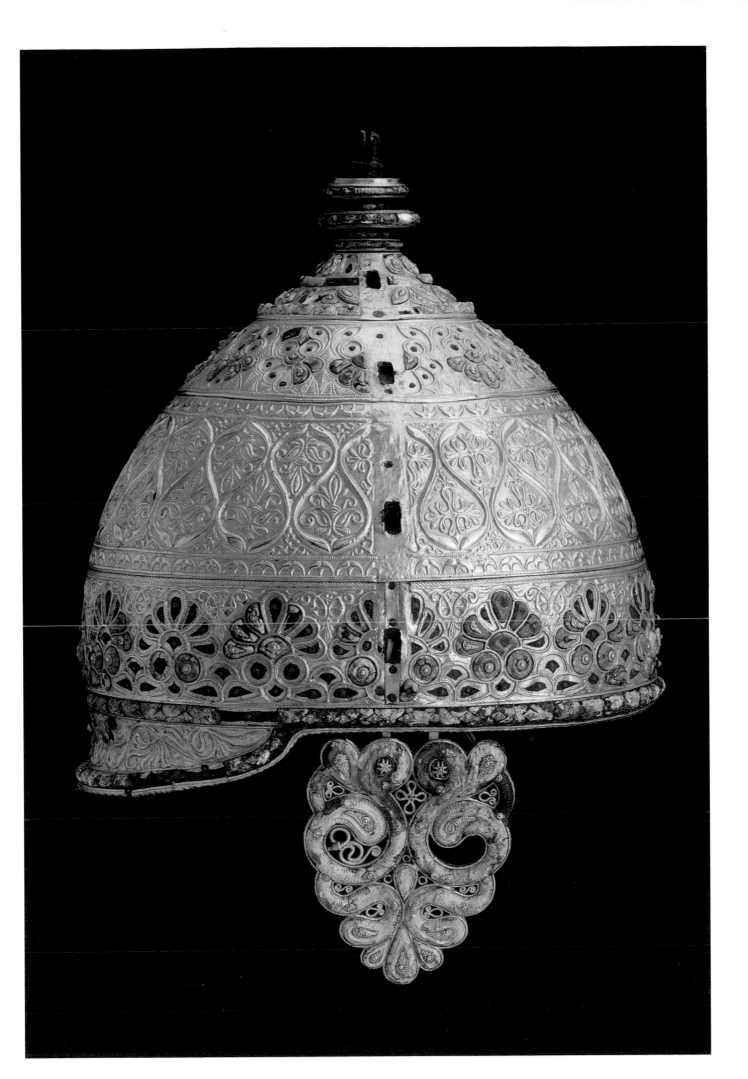

The Waldalgesheim Tomb
Hans-Eckart Joachim

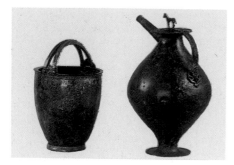

Between its chance discovery in October 1869 and November of 1870, the tomb of a Celtic noblewoman at Waldalgesheim (Kreis Mainz-Bingen, in the Rhine Palatinate) was explored five times. It is therefore easy to understand why there is no comprehensive record of the finds made on the site. The tomb, which has since been destroyed, lay to the west of the town of Waldalgesheim: beneath a tumulus it contained a wooden burial chamber (about 4 by 5 meters) surrounded by stones. There were no skeletal remains, and all we know about the position of the objects found is that a gold torque and two gold bracelets, along with a ring made of organic material were discovered 0.5 meters below ground level. Deeper down were found a bronze jug and bucket, parts of a service of utensils for a funeral meal. On the other side of the chamber were discovered parts of a two-wheel chariot—including the yoke.

The grave goods, therefore, comprise utensils for the funeral meal (jug and bucket), clothing, personal jewelry and amulets (torques, four bracelets, two anklets, ornamental discs, beads and snail shells), and parts of a chariot (with yoke) and attachments. There is also a series of bronze articles—such as mounts, rods and small rings—along with the remains of fabrics. Careful technological tests have shown that these objects

were the work of a series of individual craftsmen, or groups of craftsmen. The pieces in precious and non-ferrous metals are partly decorated with enamels; they are characteristic of the Waldalgesheim style (the name comes from this site) which emerged during the fourth century B.C., at an advanced stage of Early La Tène Celtic culture in continental Europe. The dating of this style is linked with the date of the Waldalgesheim tomb.

Comparison with other objects enables us to date the gold arm bracelets and the knobbed bronze anklets as belonging to a Late La Tène B1 phase. This is confirmed by the dating of the bronze bucket—made in Southern Italy between 370-360 and 340-320 B.C.—which could have been placed in the tomb around 350-340 B.C.

This last date is one of of the most reliable end-points we have for the conclusion of the Early La Tène period north of the Alps—from then on there were no further imports from the Mediterranean area. But along with the "modern" bucket, the Waldalgesheim tomb also contained a series of objects that were traditional in that region—and are typically found in the tombs of the Celtic princes of an earlier phase of La Tène A.

These traditional features include the tumulus structure of the tomb and wooden burial chamber, the burial gift of a two-wheeled war chariot, and the metal burial service. The *Schnabelkanne* is a particularly noteworthy "heirloom," dating from almost a generation before.

So the clothes of the noble woman of Waldalgesheim, along with the decoration of the objects destined to accompany her on her journey to the next world and the very layout of her tomb, all bear witness to both local Celtic traditions and the fashions of the time.

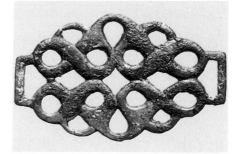

The Treasure of Duchcov
Venceslas Kruta

*Bronze finger ring from the
Duchcov deposit at Obří Pramen
Second half 4th century B.C.
Prague, Národní Muzeum*

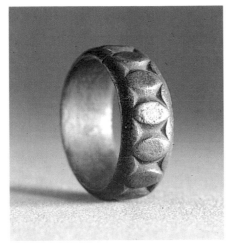

The region of northwest Bohemia at the foot of the Krušné Mountains (or Erzgebirge) has always enjoyed an exceptionally dense population. In addition to its fertile land and particularly mild, early spring, the area possessed important mineral resources, especially tin, which the inhabitants began to mine in the Bronze Age. There are also numerous thermal springs in the area, many of which are concentrated in and around the town of Teplice (Teplitz).

The region's important coal seams were first exploited from the 1850s onward. A tragic accident in one of the mines in 1879 gave rise indirectly to the discovery of what has since been called the "Treasure of Duchcov." After the accident the springs of Teplice dried up temporarily, prompting the institution of an observation network for their safeguard. The main spring is known as Obří Pramen or the "Giants' Spring" (*Riesenquelle*) in the municipality of Lahošť, 1.5 kilometers from Duchcov (Dux) and 6 kilometers from Teplice.

Until 1872 the spring issued sodium bicarbonate-rich thermal water at 25-38°C, at a rate of roughly thirty-five liters per second. When the natural well was dug out to install an artificial shaft in January 1882, at a depth of five meters excavators found a cauldron and a hoard of bronze objects, including fibulae, bracelets, and other personal ornaments, which one supposes were originally inside the cauldron. A bronze spear, dating a thousand years earlier, was found eight meters below ground level.

These finds were almost immediately dispersed—some of the objects made their way into the collection of Count Wallenstein, proprietor of the castle of Duchcov; the rest were bought up by museums or private collectors. In 1882 some pieces were donated to the Museum of the Kingdom of Bohemia (now the National Museum), and the discovery was reported to the Society of Archaeologists in Prague by collector Štěpán Berger, who published a richly illustrated article that same year. The rapid dispersal of the objects and the diverging estimates of those immediately involved in the find make it impossible to assess the exact number of objects that originally came to light. The pieces on display in museums across Czechoslovakia—Prague, Duchcov, Teplice, České Budějovice (Budweis), Chomutov (Komotau), Hradec Králové (Königgrätz), Kutná Hora (Kuttenberg), Litoměřice (Leitmeritz), Most (Brüx), and abroad in Vienna, Dresden, Nuremberg, Berlin, Mainz, London, Oxford, Budapest—imply a total of around 2,500 objects in all, consisting almost exclusively of very similar fibulae and personal ornaments such as bracelets and rings.

This highly uniform hoard may be a concentration of women's personal ornaments for some special occasion: a votive offering to a particularly venerated freshwater spring, made in special circumstances to appease the patron deity of the place. The offering was made around the end of the fourth century B.C. in a part of the region situated between the Krušné Mountains and the Moldau, where identical objects produced in the same workshops have turned up in various burials.

The characteristic features of the objects found in this deposit, especially the fibulae, are useful in establishing the repertoire of types dating from between the mid-fourth century B.C. and the beginning of the next. The name of Duchcov, as with the Swiss cemetery of Münsingen, is often used by scholars to denote this particular phase in the development of La Tène culture.

Selection of objects from the votive deposit of Duchcov Obří Pramen reported in Berger's article "Bronzy duchcovské" in the magazine Památky Archeologické, 1882

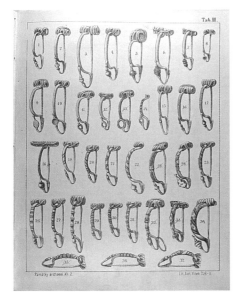

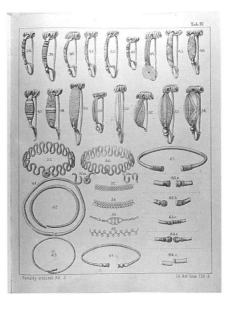

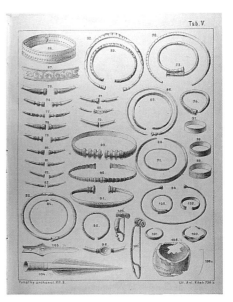

The Cemetery near St. Pölten
Johannes-Wolfgang Neugebauer

In many of the cemeteries of the lower Traise Valley analysis of different layers reveals occupation during both the La Tène A and La Tène B eras—and it is significant that signs of the latter phase are found, above all, in most of the Pottenbrunn cemeteries.

In 1981-82 work on the Krems access road to the S53 motorway and on the construction of the "Steinfeld" toll booth at the St. Pölten North junction made it possible to explore a surface area of eleven thousand square meters. One thousand four hundred and fifty prehistoric objects dating from the Early Bronze Age (the Gemeinlebarn 1 phase) came to light. An Early Bronze Age cemetery was also discovered (of the Unterwölbling cultural group, Gemainlebarn 2 phase), with seventy-three tombs containing huddled bodies. While the ten graves to the east of the B1 state highway are to be attributed to the Hallstatt or La Tène A periods, the thirty-one (perhaps thirty-four) tombs in the main burial ground to the west of the B1 date mainly from the La Tène B era. To these should also be added the four tombs that were discovered in 1930, during the construction of the motorway.

Of the thirty-nine certain La Tène tombs (both La Tène A and La Tène B), twenty-five contained inhumation burials (three were double) and eight contained cremations. Taking into account the other cremation burials that have come to light (identified by tomb enclosures or funeral implements that are still recognizable), and the three double graves, that makes a total of twenty-eight burials and fourteen cremations. The cremated and skeletal remains were examined by Doctor Maria Teschler-Nicola of the Anthropology Department of the Naturhistorisches Museum, Vienna, who showed that they belonged to five children (three infants I and II, and two youths), eighteen men and eleven women. Once more we find the scarcity of child burials which is so frequently a characteristic of La Tène tombs—though Pottenbrunn does not have that prevalence of women that is often found elsewhere.

The large number of tomb enclosures (to the west of route B1) suggests that this was no usual burial site. Twenty of the thirty-nine (or forty-two?) tombs were surrounded by ditches, fifteen of which were square, two circular, and three are double square ditches. In three cases the square enclosures adjoin—they have a side in common. Going by what has been found on the site, it would seem certain that the center of the

burial ground housed a group of important people, since most of the cemetery (at least that part of it which lies to the west of route B1) must be considered as some sort of special cemetery. Almost all the male corpses were accompanied by arms (with swords—in tomb 526 the sword had decorations in sheet gold—lance and arrowheads, shield center discs). If one also takes into account the rich accoutrements in the female graves (fibulae, ornamental rings, and above all, twisted torques—with silver vine tendril decoration in tomb 54) one cannot deny that the occupants of the graves were Celtic landowners or country nobles. Finds suggest that their farmhouses and fields could have occupied the lower terrace of land next to the river.

The cremation graves are not very deep, but the inhumation chambers are large rectangular spaces lined with wood and sunk 1.2-2.0 meters below ground level. In two cases wooden coffins have also been found. However all these security measures did not prevent the contemporaries of the deceased from sacking the tombs: most of the gold and non-ferrous metal objects have disappeared, leaving us with mainly iron objects and pottery.

On the basis of the fibulae it has been possi-

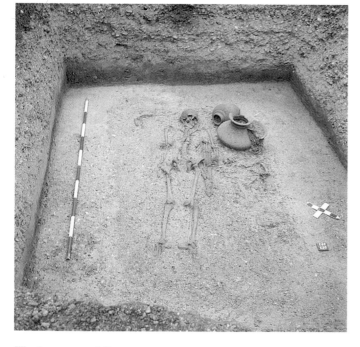

*Warrior grave no. 562
from the cemetery at Pottenbrunn
(Lower Austria) during excavation
in 1981*

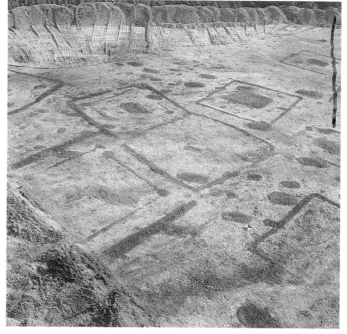

*View of the cemetery with rectangular
enclosures at Pottenbrunn
(Lower Austria)
4th-3rd century B.C.
during excavation in 1981*

ble to date most of the tombs to the west of route B1 as La Tène B, whilst those to the east of the road are to be dated earlier (bird-head fibulae, Certosa fibulae, an iron-bladed knife with a bone handle).

In conclusion it is worth making a further reference to the warrior's grave 520. This 45-to 55-year-old man was laid out in a double square grave. Along with the funeral offerings of food and drink, arms, everyday objects and ornaments, he was also accompanied by a lancet-shaped iron instrument and a two-pointed bone object (that widens out around a hole at its center). E. Künzl is of the opinion that the first object had a pharmaceutical purpose, and that the second was a pendulum or magical instrument—so the warrior buried in this tomb could be seen as a Celtic "medicine man."

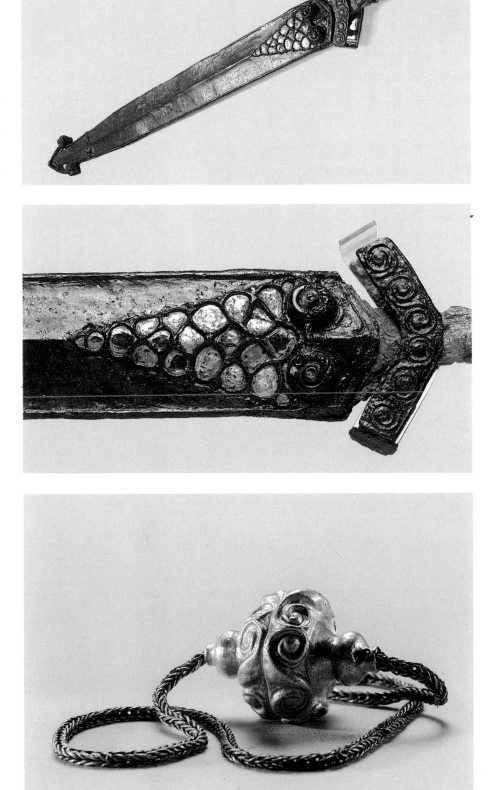

The Mannersdorf Cemetery
Johannes-Wolfgang Neugebauer

"At the start of the La Tène B, the center of gravity shifts in the Viennese basin, and a vast cultural fusion takes place in the whole Pannonian province. During phase B2/C, the finds in the tombs of the Viennese basin (as well as around the fringes of the Leithagebirge) multiply enormously (Au am Leithaberge, Brunn an der Schneebergbahn, Guntramsdorf, Neunkirchen)" (S. Nebehay 1976). These important new finds were further enriched by the discovery of the small groups of tombs at Katzelsdorf near Wiener Neustadt (the male body in tomb 1 shows a trepanation with a trilobed hole) and the cemeteries of Mannersdorf am Leithagebirge, which were systematically explored by the Abteilung für Bodendenkmale des Bundesdenkmalamtes.

The Leithagebirge range, which marks the boundary between Lower Austria and the Burgenland and runs along the eastern edge of the Viennese basin, is thirty-five kilometers long and between five and seven kilometers wide. Its rocky core is sheathed in calcareous sandstone. The gentle slopes and the adjoining plain along the Leitha were densely occupied by settlements in pre- and protohistoric times, with relative burial grounds in the immediate vicinity.

The cemetery, 200 meters long and 50 meters wide, is set on a hill three kilometers west-southwest of the town of Mannersdorf in the so-called "Im Reinthal-Sud" district. Tombs were uncovered during plowing in 1976. Early field work undertaken in 1976 and 1977 by the representatives of the Mannersdorf museum, Friedrich Opferkuh and Heribert Schutzbier, led to the discovery of four La Tène tombs, including the one referred to as number 4 containing the body of a little four-five year old girl. On the floor of the tomb, 0.94 meters underground, a sandstone coffin was found in the burial chamber of approximately 2.08 by 1.90 meters. Lying with the remains of the skeleton along the western side were the grave goods, such as Dux- and Münsingen-type fibulae, amber and glass beads, a bear's tooth, a lignite ring and other rings, armlets and anklelets. Among the vessels were a shoe-shaped vessels (*Schuhgefäss*), cylindrical beaked jug (*Röhrenkanne*), a lenticular flagon (*Linsenflasche*), and a Braubach type drinking-cup.

During subsequent digs, which the Abteilung für Bodendenkmale der Bundesdenkmalantes conducted systematically between 1978 and 1984 under the direction of Dr. Gertrud Mossler (the relative publication is being prepared) and excavation engineer Gustav Melzer, the area was almost completely explored and 236 inhumation and cremation burials were discovered. Though some of them were related to the Early Bronze Age culture of Wieselburg and to urnfield cultures, 96 were attributed to the La Tène culture (La Tène B to C1). Dr. Silvia Renhart gave an anthropological assessment of the remains in 85 inhumation graves (7 of them double) and the 2 cremation burials. Some of the burials were encompassed by circular and square enclosures, several of them linked together into a system. Numerous stone facings of the burial chambers and massive stone landmarks were also found.

Tomb 4 and tomb 13 were found, as secondary graves, at the center of the largest square tomb (16.5 meters per side). The young female adult buried there was accompanied by an extraordinary wealth of grave goods. The rich assortment of fibulae included one of the Münsingen type, its bow decorated with a series of modeled masks. Along with the various amber, coral, glass and bronze necklaces mention should be made of a wheel-shaped pendant and a gold ring. Magnificent bracelets and anklets complete the picture. As to the vessels, particularly striking is an Etruscan bronze situla with attachments for two bud-shaped handles. In addition to other superb funerary offerings, two armlets adorned with opposed volutes forming figures of eight from tomb 115 and an openwork spearhead from tomb 180 deserve special mention. In this respect, many objects prove not only the prosperity of the Mannersdorf people, but also their wide-ranging trade relations, both with the rock salt district of the inland Alps and with Italy and the neighboring areas of southwest Slovakia and west Hungary.

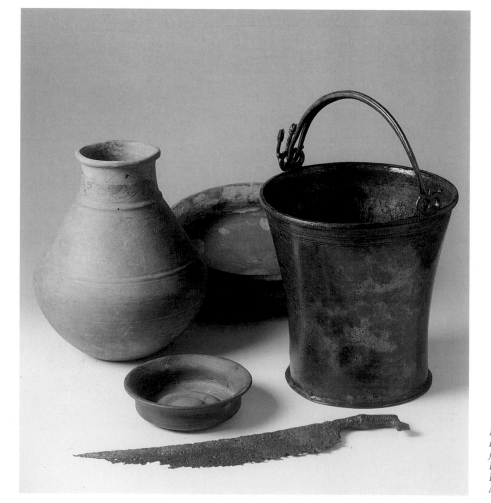

Bronze situla imported from Italy terracotta vessels and iron knife from tomb no. 13 at Mannersdorf Reinthal-Süd (Lower Austria) End 4th-early 3rd century B.C. Mannersdorf, Museum

Parts from the grave goods
of tomb no. 4 at Mannersdorf
Reinthal-Süd (Lower Austria)
glass and amber baubles, boar tusk
bronze armlet and fibula
iron fibula, lignite ring
End 4th-early 3rd century B.C.
Mannersdorf, Museum

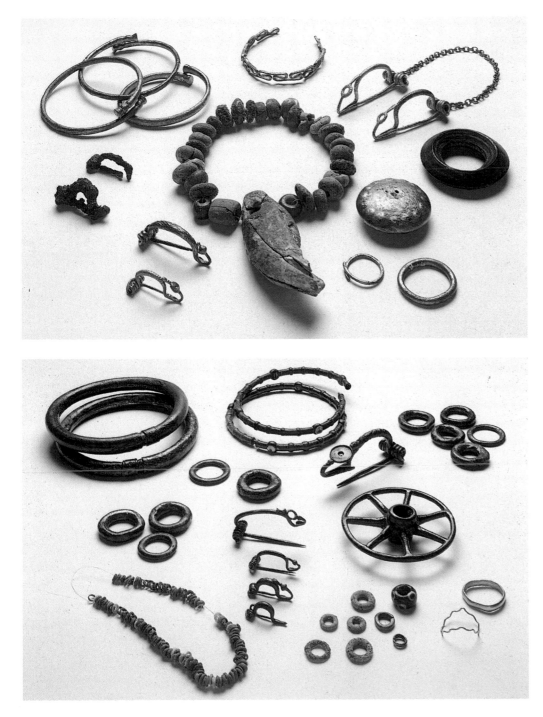

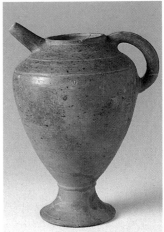

Terracotta wine jug from tomb no. 4
at Mannersdorf Reinthal-Süd
(Lower Austria)
End 4th-early 3rd century B.C.
Mannersdorf, Museum

Grave goods from tomb no. 13
at Mannersdorf Reinthal-Süd
(Lower Austria)
amber and glass baubles, gold finger
ring, bronze armlets and fibulae
End 4th-early 3rd century B.C.
Mannersdorf, Museum

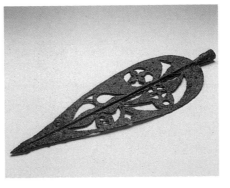

Iron openwork spearhead
from tomb no. 108 at Mannersdorf
Reinthal-Süd (Lower Austria)
End 4th-early 3rd century B.C.
Mannersdorf, Museum

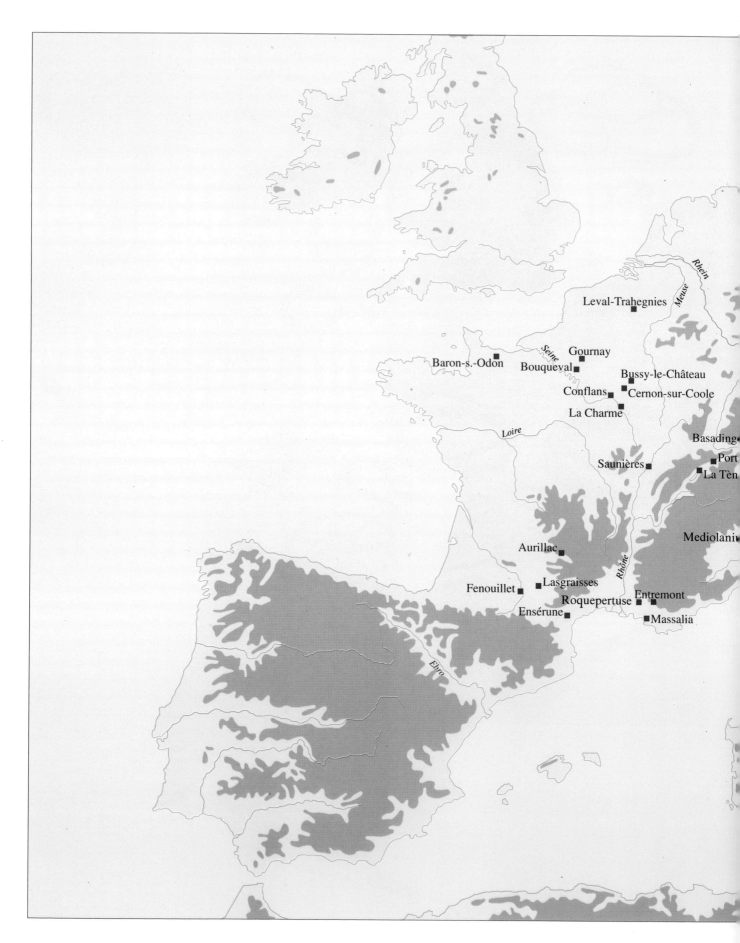

Leval-Trahegnies

Baron-s.-Odon

Gournay

Bouqueval

Bussy-le-Château

Conflans

Cernon-sur-Coole

La Charme

Basading

Port

Saunières

La Tèn

Mediolani

Aurillac

Lasgraisses

Fenouillet

Roquepertuse

Entremont

Ensérune

Massalia

Seine

Loire

Rhône

Rhein

Meuse

Ebro

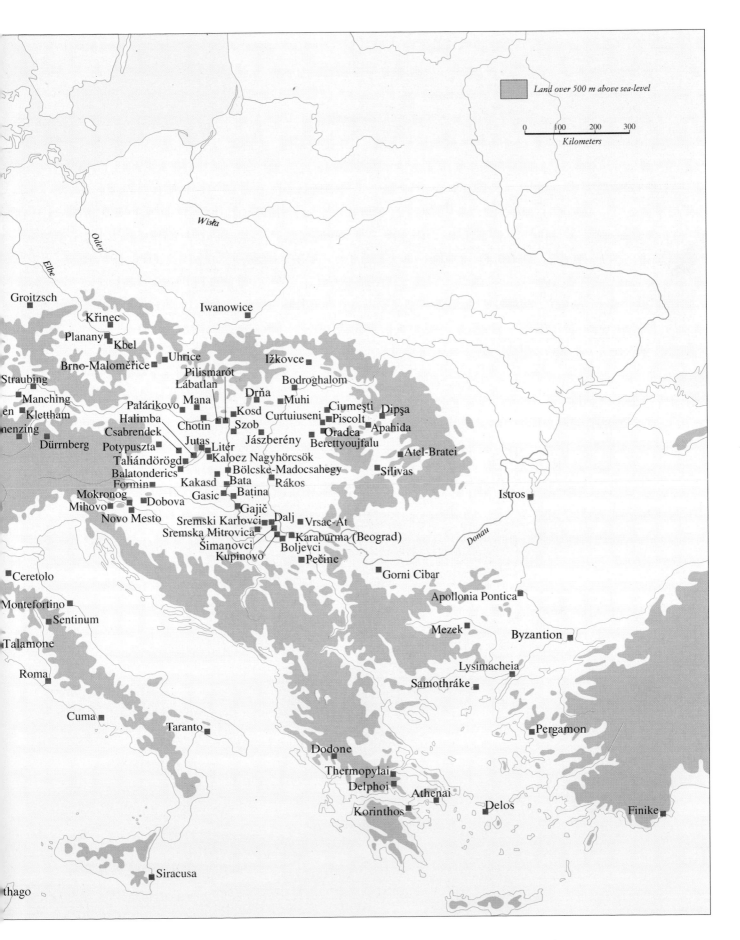

Land over 500 m above sea-level

0 100 200 300
Kilometers

Groitzsch

Iwanowice

Křinec

Planany
Kbel

Uhrice
Brno-Maloměřice
Ižkovce

Pilismarót
Lábatlan
Bodroghalom

Straubing
Drňa
Muhi

Manching
Mana
Ciumeşti
Dipşa

en Klettham
Palárikovo
Kosd
Curtuiuseni
Piscolt

nenzing
Halimba
Chotin
Szob
Oradea
Apahida

Csabrendek
Jutas
Jászberény
Berettyoujfalu

Dürrnberg
Potypuszta

Litér
Atel-Bratei

Taliándörögd
Kalocz Nagyhörcsök

Balatonderics
Bölcske-Madocsahegy
Silivas

Formin
Kakasd
Bata
Rákos

Mokronog
Gasic
Batina

Mihovo
Dobova
Istros

Novo Mesto
Gajič
Dalj

Sremski Karlovci
Vrsac-At

Sremska Mitrovica
Karaburma (Beograd)
Donau

Šimanovci
Boljevci

Kupinovo
Pečine

Ceretolo
Gorni Cibar

Montefortino
Apollonia Pontica

Sentinum

Talamone
Mezek
Byzantion

Roma
Lysimacheia

Samothráke

Cuma
Pergamon

Taranto

Dodone

Thermopylai

Delphoi
Athenai
Delos

Korinthos
Finike

Siracusa

thago

Wista

Oder

Elbe

301

The Celts and their Movements in the Third Century B.C.

View of the sanctuary at Delphi

The third century B.C. can be viewed as the last great period of Celtic expansion, with consequences that were felt throughout a vast area stretching from the British Isles and central Anatolia to the plains of northern Europe and the Mediterranean, and even as far as the northern reaches of the Black Sea.

The new drive turned out to be a determining factor in the history of the Celtic world, and involved an eastward shift in its center of gravity. This came about because of a consolidation of Celtic power throughout the middle Danube region from the second half of the fourth century B.C. By then, Celtic groups had reached the Illyrian regions further south, and collected their first resounding military victory in the Balkans with the crushing defeat of the Autariati. There is good reason to believe that the "Adriatic" Celts who made up the group of envoys sent to Alexander the Great (as mentioned in classical sources) were not in fact Gauls from Italy but Celts originating from the Pannonian hinterland, who provided a kind of springboard for the Gaulish invasion of the Hellenistic world.

In the last decade of the fourth century B.C., the Celtic thrust increased in intensity throughout the northeast of the Balkans. As quoted in Justinus, Pompeius Trogus gives a very clear idea of the chronology of events. From his account we learn that their settlement in Pannonia and the wars waged against neighboring peoples were followed by incursions on the Macedonians and Greeks. However, Celtic expansion was eventually contained in Thrace by Alexander the Great's successors, initially Cassander and then Lysimachus. After Alexander's death in the battle of Kouroupedion at the start of 281 B.C., the "Macedonian barrier" ceased to be effective and the way for Celtic penetration into the Greek heartland was thrown open.

Due to the loss of almost all historical records from the third century B.C., the more recent sources, such as Justinus's summary or the succinct outline left by Pausanias, written in Imperial times, give a very patchy and even confusing account of the Celtic invasion. Details are lacking on operations carried out by the Celtic forces, and there is no chronology of events.

We can reasonably assume that the offensive of 280 B.C. was three-pronged. The Celtic penetration of Triballi territory and Thrace was led by Kérethrios, while Illyria and Macedonia were invaded by Bolgios's warriors, and Peonia by troops under Brennus and Akichorios. The decisive blow was delivered by Bolgios's army which, early in 279 B.C., wiped out what remained of the forces of the young Macedonian sovereign, Ptolemy Ceraunus. The Galatians, as the Celts were more often called, took the wounded king prisoner and beheaded him. Their next move was nothing short of astonishing; having sealed their victory, the troops and their leader Bolgios simply withdrew to the land from which they had launched their attack. The unbarred way into Greece was an open invitation, however, and soon enough Brennus led his troops toward the south. Their progress was not without setbacks. According to Livy, in Dardania Leonnorios and Lutarios together with about twenty-thousand men left the main body of the army after a rebellion. Then, in Macedonia the troops of Brennus and Akichorios seem to have suffered heavy losses. Once beyond Thermopylae, Brennus and an elite corps of his finest warriors closed in on Delphi, whose fame had long spread outside the Greek world. But although the ancient sanctuary of Apollo suddenly found itself in a dreadful plight, the Celtic assault came to nothing. Tradition tells of a miracle worked by Apollo, and that Delphi was sacked and its treasures removed to Gaul. In reality, the rites of the *soteri*, introduced in Delphi shortly after the repulsion of the Celts, commemorated the liberation and the salvation of the sanctuary. Brennus himself was gravely wounded and, after successfully seeing his troops join up with those of Akichorios, took his own life. Akichorios in turn opted for a withdrawal of troops toward Thrace. Their fate is unknown. The army of Kérethrios, the third group involved in the Greek offensive, can be defined as the force defeated by Antigonos Gonatos in 278-277 B.C. at Lysimacheia. Thus ended the Celts' great invasion of Greece. From then on, the only Galatians to be found there were mercenaries. The fundamental problem posed by the events briefly described above is exactly how should

the Celtic invasion be interpreted. Was it really a case of migration, an attempt at colonization, or was it perhaps just a series of sacking operations? An important clue to these queries can be found in the global situation affecting the Celtic world in the third century B.C. At the time the Celts were at the height of their prosperity, and the forays southward can be best explained by a demographic explosion rather than by some outside force. The idea of a colonizing thrust as the reason behind the Balkan invasion is corroborated by the fact that the mass of Celts surging forward included women and children. Basically it was a bid to take over new terrain, a continuation of the so-called historical migration of the fourth century B.C.

The paucity of archaeological traces documenting the offensive of 280-279 B.C. is a reminder that the material evidence of a foreign invader's brief passage through another civilization's territory is usually quite slim. The rare objects that have survived are important because they belong to types common to the eastern area of the Celtic world—the Carpathian basin with Moravia, Bohemia and Bavaria. This also confirms the idea, mentioned above, that the central Danubian area was the main center of activity. When the invasion against Macedonia and Greece miscarried, many groups of Celts kept on the move.

The founders of the enigmatic kingdom of Tylis in Thrace were probably part of Brennus's army, under the command of Komontorios. Others equally intent on becoming integrated into the Hellenistic world were the Galatians of Asia Minor. This detachment, led by Leonnorios and Lutarios, had split off from the army of Brennus in Dardania. After making use of their services, Nicomedes I of Bithynia assigned them a location between his own realm and that of Antiochus I of Syria. This gave rise to a difficult period for western Anatolia, one that closed with the famous battle of elephants in 275-274 B.C. Antiochus, who earned the title of *sôter* or savior from this victory, reestablished order and forced the Galatians to withdraw to the highland areas on either side of the Halys (Kizil Irmak). This was the poorest part of Asia Minor and it is hardly surprising that the Galatians continued to instill fear and terror across the land. First, they threatened the two main urban centers Gordium and Midas, which were abandoned as a result of these incursions. Then, around 240 B.C. the Galatians interfered in issues regarding the Hellenistic states. Eventually they turned on Pergamum. They suffered a string of defeats, however, at the hands of Attalus I who endeavored (with little success) to make Galatia a vassal state.

Very little indeed is known of the material culture of the Galatians, though it is clear that as time progressed, they were gradually Hellenized. Cut off from their original La Tène roots,

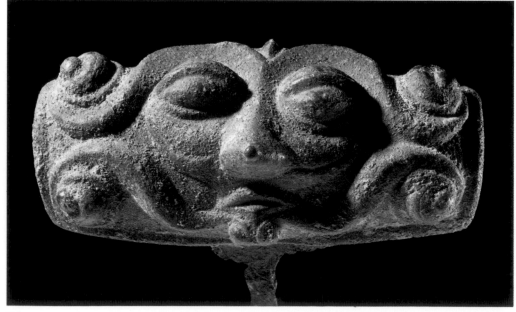

Iron and bronze hub-pin presumed from the Paris area
First half 3rd century B.C.
Saint-Germain-en-Laye
Musée des Antiquités Nationales

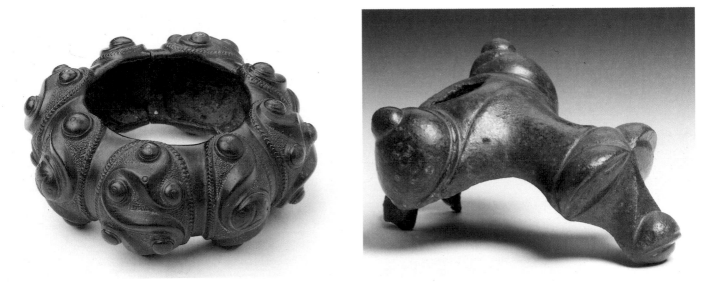

this foreign minority was unable to influence in turn the highly evolved Hellenistic culture around it. As for the conservation of language and traditions, we have only the details afforded by the ancient authors.

The failure of the Celts to expand toward the south was decisive in the spreading of Celtic culture through the Carpathian basin in general. The Greek authors offer little information on the route taken by the Celtic groups that ventured toward the Danube area. Pompeius Trogus, as quoted by Justinus (in a passage whose veracity has been challenged on various occasions), speaks of a detachment of Tectosages in southern Pannonia. The geographical name *volcae paludes* (the Volcae marshes) for the area near the confluence of the Danube and the Drava, can perhaps be traced back to the well-known *Volcae Tectosages* tribe. Thanks to Justinus we know that another group of the same nation also retreated from the Balkans after the Delphic expedition and settled in the region of Toulouse, France. Typical of the new situation created after the offensive of 280-279 B.C. was the presence of the Tectosages among the Galatians of Asia Minor, and, according to Caesar, among the tribes of the Hercynian Forest. All these observations demonstrate the difficulties in reconstructing the history of the Celtic peoples participating in the Balkan campaigns on the basis of classical written sources. On the other hand, the information on the location of Celtic groups after their withdrawal is useful for interpreting the new links that emerged, as revealed by archaeological material recently unearthed in far-flung areas across Europe.

Information on the Scordisci, another Celtic tribe from the Danube area, is more readily available, however. As recounted in Justinus, the Scordisci were a break-away group from the troops assembled by Brennus who, having pushed on toward the south, eventually settled in the area where the Save flows into the Danube. Athenaeus claims that the retreat was led by Bathanatos. The tribal name is probably derived from *Scardus mons*, a hill in the Balkans. The lands that Justinus and Pompeius Trogus attribute to the Scordisci must refer to their country of origin because, according to Strabo, they lived among the Thracians and Illyrians, and were the most important tribe from the northern sector of the Balkan peninsula.

The historical sources tend to be patchy and even contradictory. They recount movements toward the east during the third century B.C. Perhaps it was toward the second half of this century that the Bastarni made their first appearance. They were destined to play a major role in the history of the lower Danube region and Moldavia in the following centuries. According to Diodorus, Plutarch and Livy, the Bastarni were in fact Galatians (that is, Celts), and a study of the tribe's given names shows that at least part of the tribe was indeed of Celtic origin. Other sources however ascribe to them a different origin, such as Strabo, who calls them Germanic, while Appianus calls them the Getae.

An inscription by Protogenus dating from the end of the third century B.C. was made during the advance of the Celts toward the east. Olbia, a Greek port on the northern border of the Black Sea, commemorates the heroic deeds of Protogenus who defended his birthplace from the assaults of various invading races, including the Galatians. It is understandable why Greek geographers considered Meotide, that is, the sea of Azov, as being the extreme frontier of the Celtic world.

As noted above, little is known about the events that followed the abortive invasion against Macedonia and Greece. Sources talk of the movements and retreats of various Celtic groups, of their break-up and dispersal. The series of upheavals they underwent is considerable, but major details remain obscure or contradictory, and consequently a host of important questions remain unanswered. We can only await further archaeological evidence, since the written accounts are short of information that does not directly concern the Hellenistic world. The history of the Danube regions further north of the Scordisci area is largely based on ar-

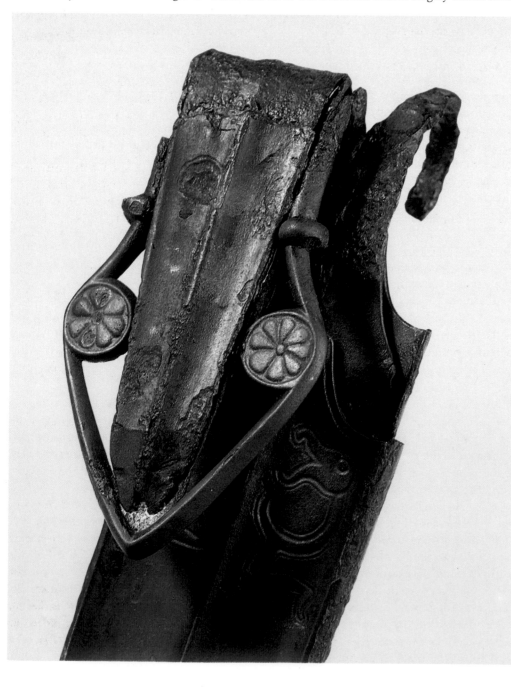

Bent iron sword and scabbard
from tomb no. 15 at Kosd (Hungary)
First half 3rd century B.C.
Budapest, Magyar Nemzeti Múzeum

Lower part of decorated scabbard
from Bölcske-Madocsahégy
(Hungary)
3rd century B.C.
Budapest, Magyar Nemzeti Múzeum

chaeological finds. This material suggests that the Balkan invasion also affected these areas. For instance, the so-called Scythian cemeteries of the Great Hungarian Plain ceased to be used in 250 B.C., when there is a sudden and massive presence of Celtic material. The last thirty years of the third century saw the apogee of Celtic culture across a region that extended from Slovakia to Sirmium, from Burgenland to Transylvania. Certain finds appear to justify the supposition that the Celts' hapless Delphi expedition had repercussions outside the area then populated by contingents of Celts from the southeastern regions; by this we mean Slovenia, Carinthia, and Moldavia.

Recent research carried out in France has clearly demonstrated the arrival of Danubian groups in Gaul toward the middle of the third century A.D. The new cemeteries of the Champagne region are sometimes built on cemeteries abandoned at the end of the fifth century B.C. Astonishing parallels exist between Champagne and the Carpathian basin, not only in the similarities of dress—such as the use of anklets by certain women—but also in the custom of small funerary enclosures and the relative frequency of the dual rite. All these phenomena are the consequence of Celtic immigration from the central Danubian region, which successfully modified the demographic make-up of northern France, even influencing the British Isles, as confirmed, among other things, by the scabbards decorated with a pair of dragons, found in the Thames. Another area settled by these peoples of Danubian origin has been identified in southern Gaul. The spread of La Tène objects with characteristic central-European features can be linked to the settlement of Volcae in the Toulouse region, confirmed by certain classical authors. Quite suddenly La Tène weaponry appears in many grave assemblages in the Languedoc area.

While the facts outlined briefly above demonstrate on the one hand the effects throughout Celtic Europe of the invasion of the Balkans, they also illustrate the dynamism of the Celts in the third century B.C. Unfortunately, the penetration of some of the more conspicuous groups into the western fringes of Celtic territory was not recorded in the classical histories, unlike the accounts for Celtic thrusts toward the southeast. As a result, any analysis based on archaeological finds is tentative.

It is extremely difficult to evaluate the presence of tribes of Danubian origin in Italy from the second quarter of the third century B.C.

It may be that these finds are linked to migrating groups, or to cultural diffusion from the new eastern focus of La Tène. It is nonetheless certain that during the period in question, the Boii, who had settled in central Emilia-Romagna, restored La Tène customs in accordance with Celtic Danubian practices.

But signs of the Celtic decline are also visible in Italy at the beginning of the third century.

Gold torque from Fenouillet
(Haute-Garonne)
3rd century B.C.
Toulouse, Musée Saint-Raymond

Gold armlet from Lasgraïsses (Tarn)
3rd century B.C.
Toulouse, Musée Saint-Raymond

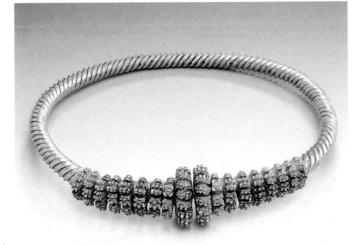

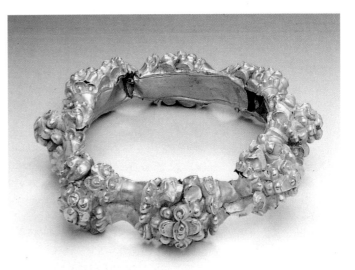

At this point, it is necessary to retrace the stages of the Roman Conquest, which lasted through most of a century, from 295 B.C. (the battle of Sentinum) through to 191 B.C., with the crushing of the Boii. The Senones were definitively beaten in 283 B.C., and their lands occupied and divided up. The new crisis that arose after 240 B.C. can undoubtedly be explained by the offensives mounted by Rome. The Boii appealed to the Transalpine races, but the resulting Gaulish coalition met with a bloody defeat in 225 B.C. at Telamon. The war ended in 222 B.C. after the victory at Clastidium (today's Casteggio) and the seizure of Mediolanum (Milan), capital of the Insubres.

A last chance was offered to the Cisalpine tribes by Hannibal's arrival in Italy, but the "national" uprising on which the Carthaginians were relying never materialized. Whatever support Hannibal received against Rome—mostly from the Boii—was of little effect. The progressive subjugation of the Celtic peoples was the inevitable consequence of the defeats the Punic armies suffered on Italian soil.

In order to describe Celtic society at the time of the massive invasion mounted in the third century it is necessary to sift through information provided by the ancient texts, especially Strabo's writings on the Galatians of Asia Minor. The highlands of northern Phrygia were occupied by three different Celtic groups: the Tolistoagii (Tolistobogii or Tolisto-Boii), the Tectosages and the Trocmi (Trogmes), names which clearly indicate that they were not separate tribes but groups that had drifted apart in the course of migration. These ethnic units later formed a "federation" under the name of *koinon galaton*, or Galatian community, in Anatolia. According to Strabo, each of these peoples was subdivided into four groups to form a tetrarchy. At their head ruled a tetrarch and a judge (*dikastes*) and a military chief (*stratophylax*) flanked by two assistants (*hypostratophylax*). The Galatian federation was governed by a council of twelve tetrarchs and an assembly of three hundred individuals. The delegates met in the common Galatian sanctuary (*drunemeton*). The assembly's power was essentially judiciary. Allowance must be made, of course, for the Hellenistic influence on the social structure of the Galatians, who were completely cut off from the Celtic world of Europe. But there is much evidence that this setup was actually a Celtic heritage. Regarding the *drunemeton*, for instance, Caesar claimed that in Gaul too there was a similar merger of judiciary and religious functions, and strong analogies crop up likewise in Ireland, though the latter was ruled over by a supreme king. Strabo explains that, among the Galatians, executive power was later concentrated in the hands of a single man. Is it admissible to use this information to describe the situation characterizing the new Pannonic epicenter of the Celtic world, or even its western sector? There is no real answer as yet, because the eastern and southern sectors of the Carpathian basin, occupied by the Celts during their retreat from Greece, were ostensibly Celtic-occupied lands with a strong underlying culture of quite different ethnic origin. In other words, La Tène civilization only took hold in certain limited pockets, so much so that in many of the other conquered regions, the Taurisci and above all the Scordisci composed a relatively meager dominating class. This explains why, in the classical sources, these two tribal names came to be applied to populations of non-Celtic extraction, and even written in non-Celtic form: *Tauristai* and *Scordistai*. It is also for this reason that more than one classical author hesitates to define the origins or cultural identity of the victorious population, given their integration with the subjugated peoples. The political and cultural situation in the Danube region is characteristic of the admixture of peoples of varying origin, who in many cases came from outside the territories annexed by the Taurisci or Scordisci. Thus, elements of the "Scythian" civilization from the Great Hungarian Plain filtered through into the dominating Celtic culture from midway through the third century B.C. As things stand today, research has highlighted the differences between "classic" regions of La Tène culture and those which were occupied with successive waves of Celtic immigration. For the time being, this picture is merely a working hypothesis awaiting confirmation from fresh information. It is important to avoid the misleading generalizations of the ancient descriptions and their many *topoi*: in the eyes of the ancient writers the Scordisci,

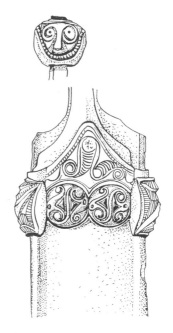

*Details of the decoration
on a scabbard from Szob (Hungary)
First half 3rd century B.C.
Budapest, Magyar Nemzeti Múzeum*

Iron weapons from a tomb
at Batina (Yugoslavia)
3rd century B.C.
Vienna, Naturhistorisches Museum

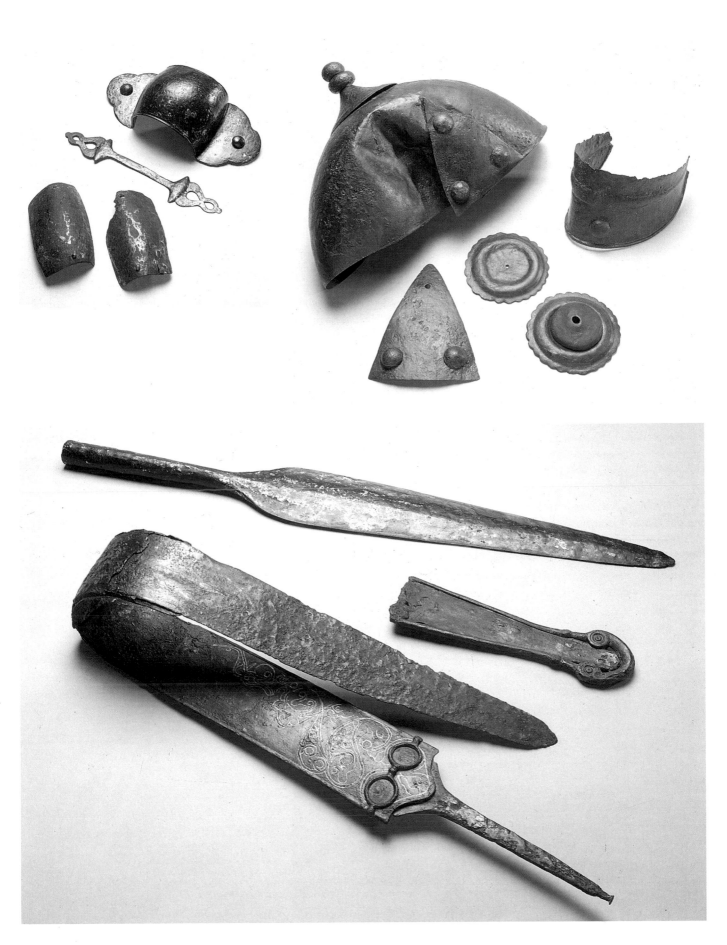

for instance, were a fierce and ruthless tribe which practiced human sacrifice and collected their foes' heads, as did other tribes in the Celtic world. But such common ethnographic links in no way reflect the social structure of the Celtic world during the third century B.C., including territories they took over at a later stage.

As for the social structure during the era of Celtic expansion, ample testimony can be found in the burial record. The most widespread, traditional form of burial was a simple inhumation but in certain regions cremation was also practiced. From the third century B.C., growing changes can be detected in funerary rites in the Carpathian basin; cremation burials are more frequent, perhaps due to influences from the indigenous races subjugated by the Celts.

La Tène cemeteries dating from the third century B.C. contain two types of burial that are important for sociological analysis: graves containing warriors buried with all their weapons, and graves containing wealthy women. The ratio of warrior graves to female graves varies according to area, as does the composition of their grave goods. The female burials in particular show regional variations in costume, and underline the ethnic identity of the individual. Less is known of third-century dwellings, though some general guidelines have emerged: the Celts ceased to live in fortified centers in favor of rather compact, rural-type settlements. In all the regions conquered by the Celts during this period the archaeological record reveals a similar pattern; their cemeteries lie in zones of fertile land, and their dwellings are modest. The findings reveal a society in which the military class was a dynamic force composed of individuals who, in general, lived in small, scattered hamlets. Analyses of cemeteries suggest that the chieftains were only slightly wealthier than the other warriors: the renowned "chieftain's tomb" at Çiumeşti is an exception, at least so far. The third-century cart burials scattered from the Paris region as far as the Bulgarian border with Turkey have demonstrated the hierarchical nature of Celtic society during the period of the Balkan expansion. These warrior chiefs may in actual fact have been free farmers bearing arms, and there is plenty of evidence to substantiate such an idea.

It is also significant that the centers of expansion were always in regions of high population growth, where land was becoming increasingly scarce.

The tombs with simpler grave goods, and the other poor graves in the cemeteries of the third

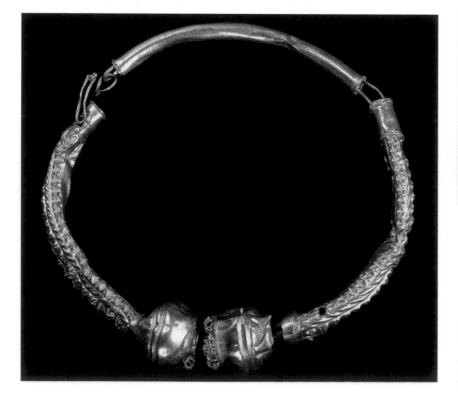

Gold torque of undefined
Hungarian origin
3rd-2nd century B.C.
Budapest, Magyar Nemzeti Múzeum

Bronze bracelet with decoration
in false filigree from Palárikovo
(Slovakia)
3rd century B.C.
Nitra, Acheologický ústav
Slovenskej Akadémie vied

*Woman's belt in bronze
with enamel mounts from Tolna
(Hungary)
3rd century B.C.
Budapest, Magyar Nemzeti Múzeum*

century B.C. belong to the lower strata of the main society, the *plebe* or commoners, and to a poor caste—presumably servants. Contradicting the *topoi* of the Greek historians and the "warlike and cruel nature" of the Celts, the cemeteries that have so far come to light in the Scordisci area seem to indicate that the third-century colonization drives were relatively peaceable—cultural items belonging to the newcomers are freely mixed with those of the indigenous population. Furthermore, there is a strong argument for the theory of a peaceful cohabitation and even perhaps an alliance between the Celts and certain Balkan tribes, as widely documented in the ancient texts; such alliances were forged almost immediately on the arrival of the Celts early in the third century B.C. These facts once more stress the importance of regional variations and their evolution in third-century Celtic society, which continued by dint of, and thanks to, their expansionist drive.

The structural mutation of the Celtic world was clearly precipitated by direct contact with native Mediterranean cultures—contact which increased in the third century B.C. with the military expeditions, mercenary service and trade relations. The introduction of Celtic coinage is an integral part of this historical scenario; it is difficult to dissociate it from that specialist business, that is, mercenary activity. What still needs clarifying is the initial impact of the minting of money. It seems to have affected the culture of the *oppida*, which date from the third century B.C.

Research has so far underlined the fundamental importance of religion in Celtic society in the third century B.C. There is even evidence of a religious revolution, which is well documented by the advent of public sanctuaries. The oldest known examples in the north of Gaul date back to the early third century. The sanctuary came to symbolize the unity of the populace, and became the fulcrum of the tribe, with territorial implications. There is therefore nothing anachronistic in Strabo's tale cited above about the reunion of delegates of the Galatian federation taking place in the common sanctuary, namely, the *drunemeton*. It goes without saying that in third-century Celtic society the role played by the religious class was fundamental, not only in the sphere of cult worship, but also in the daily conduct of public affairs.

Third-century La Tène art was thought for a long time to be mannerist compared to the crea-

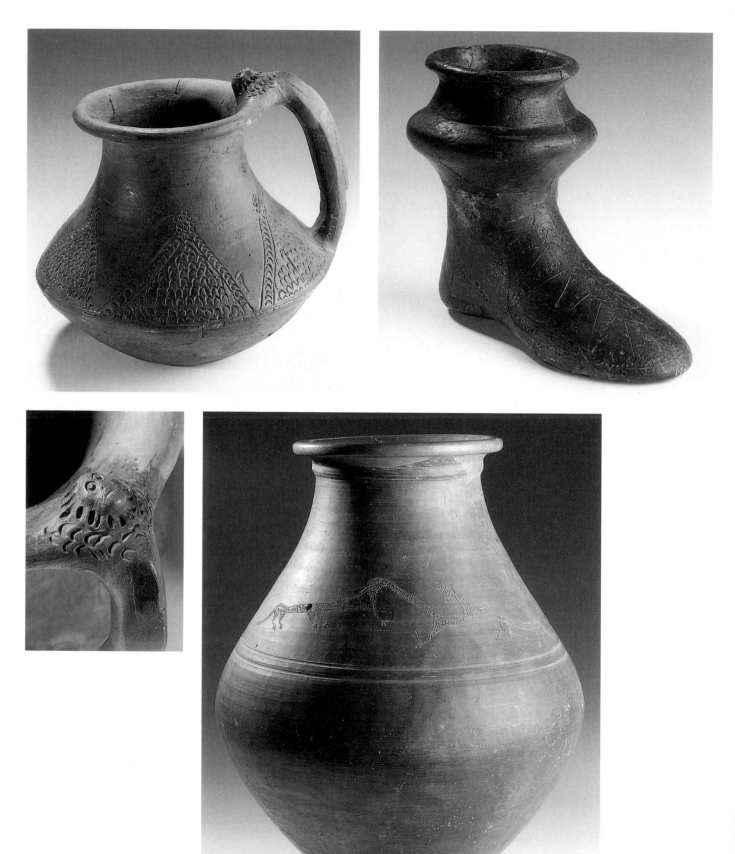

Terracotta jug with handle
attachment in the form of a human
mask and stamped decoration
from Kosd (Hungary)
3rd century B.C.
Budapest, Magyar Nemzeti Múzeum

Terracotta shoe-shaped vase
from Kosd (Hungary)
3rd century B.C.
Budapest, Magyar Nemzeti Múzeum

Terracotta vase with graffiti
portraying animals fighting
from Labátlan (Hungary)
3rd century B.C.
Budapest, Magyar Nemzeti Múzeum

tions of Celtic artists of the fifth and especially the sixth century B.C. Actually, it was a period of expansion and art was perhaps at its peak of expression during the Second Iron Age, when the artifacts' originality, power of expression, wealth of inventive and perfection of execution reached an intensity unmatched in other phases of La Tène art. The masterpieces of Early Style and Waldalgesheim (or Vegetal) Style are in fact formal variations of prototypes of Greek, Etruscan and other origin.

In the second half of the fourth century B.C., there was a transformation in those regions less in touch with the Mediterranean world—that is, Bohemia, Moravia and outlying lands—leading to the creation of a form of mass-production, reflected in the "democratization of ornament" in Celtic society. The eastward shift of the Celtic world's center of gravity in the early third century had a critical impact on artistic production. The workshops of Moravia, Bohemia and the western sector of the Carpathian basin completely mastered the art of bronze casting by the lost-wax technique, and learned how to work iron with a skill that was virtually unexcelled.

Thanks to recent research, the significant contribution of the workshops of Bohemia to the development of the Plastic Style is now recognized. Here a novel style of ornamentation was emerging, with a "new, very original, calculated plasticity" (P. Jacobsthal) not found elsewhere, used in particular for two kinds of object—fibulae with discoidal foot and solid bow, and especially solid bronze buffer torques. This new Plastic Style draws on the same basic elements as the Early Style, namely, the lyre-shape, which is often rendered with unprecedented dynamism. In the execution of the design, relief ornament takes on increasing importance.

In Bohemia, the Plastic Style reached its zenith in its second phase, toward the second quarter of the third century B.C. The most important items include hollow-bossed bracelets and anklets, and fibulae with large globular foot elements. These display a particularly accentuated use of ornament whose main motifs include S-forms, triskeles and yin-yang patterns. The compositions are complex, almost baroque, and at times characterized by exercises in spatial geometry based on curves.

The mass-production of objects similar to one another based on a few elemental patterns is indicative of the phenomenon, already mentioned, of a more democratic availability of orna-

Terracotta vase with handles terminating in rams' heads from tomb no. 40 at Kosd (Hungary) 3rd century B.C. Budapest, Magyar Nemzeti Múzeum

Small jug with handle terminating in a ram's head from Kosd (Hungary) 3rd century B.C. Budapest, Magyar Nemzeti Múzeum

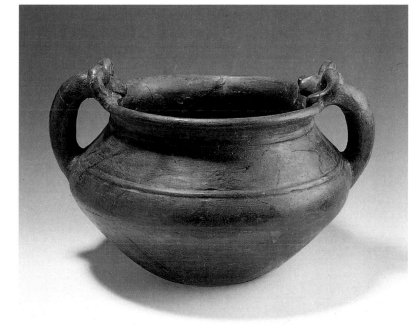
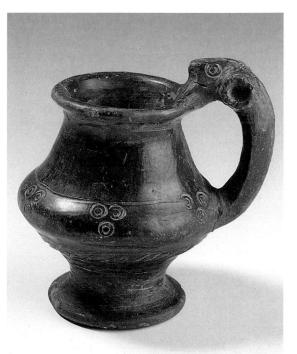

ments. Occasionally one comes across creations of exceptional finery which denote the tastes and lavish demands of a small social group, probably made up of individuals who played vital roles in the conquests themselves. Key examples are the helmet of Çiumeşti, with its bird-of-prey ornament, and the gold torques (most likely worn by warriors), such as the one of Gajič (Hercegmárok) near the Danube in northern Yugoslavia. Similar torques have turned up in the treasures of Fenouillet, Toulouse, and other sites in the south of France. The plant motifs of the ornaments in question stem from Danubian Celtic art, and their diffusion throughout the south of France is due to the migration of the Volcae Tectosages to Gaul after the Balkan invasions.

The Moravian heartland has yielded one of the unchallenged masterpieces of Celtic art, the bronze vase discovered at Brno-Maloměřice. The close links between this vase and the cauldron of Brå are of particular significance.

The shift in orientation in Celtic artistic expression is also noticeable in the appearance of swords with richly decorated scabbards. Sometimes there are striking regional variations in the decoration. This phenomenon is evidently linked to the structure of Celtic society, in which horsemen (or *equites*, to use Caesar's term) enjoyed special privileges. The Hungarian

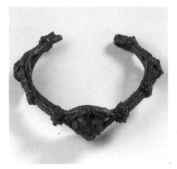

Bronze bracelet from Kupinovo (Yugoslavia)
3rd century B.C.
Zagreb, Arheološki Muzej

Detail of the animal-head handle
on the terracotta vase
from tomb no. 42 at Kosd (Hungary)
3rd century B.C.
Budapest, Magyar Nemzeti Múzeum

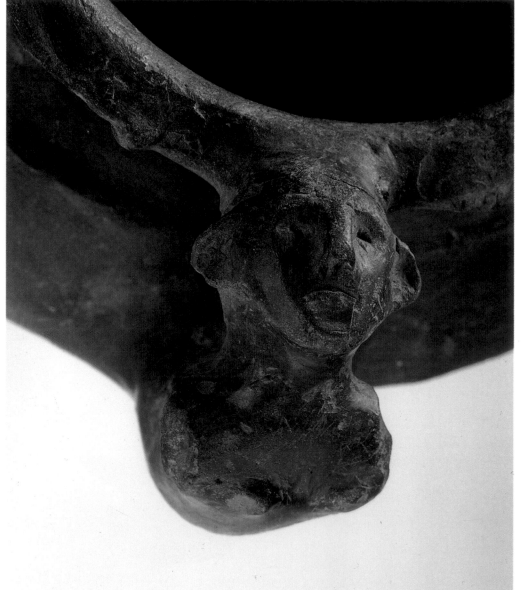

Detail of the large two-handled
terracotta vase from tomb no. 34
of the cemetery at Beograd-Karaburma
(Yugoslavia)
3rd century B.C.
Belgrade, Muzej Grada Beograda

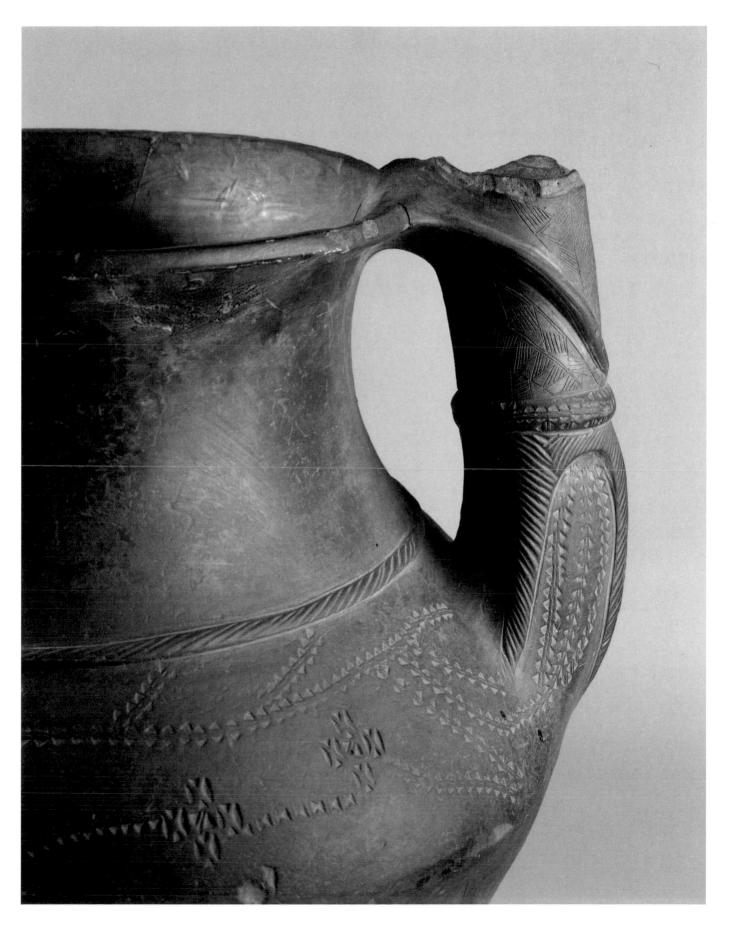

*Tow-handled terracotta vase
with human and animal masks
from Novo Mesto (Yugoslavia)
3rd century B.C.
Novo Mesto, Dolenjski Muzej*

Sword Style, which first asserts itself at the start of the third century B.C., is without doubt the most significant contribution from the Carpathian basin to the development of Celtic art. This style is comparable to the Swiss Sword Style, which dates from almost the same period. These items cannot boast the same sophistication of design and are less stylized, being closer to their prototypes, the Italianate or Etruscan vegetal motifs.

The origin of the Hungarian Sword Style lies in the regional development of what is called the Waldalgesheim Style, as can be clearly seen from the sheaths belonging to the first group of Hungarian swords. The syntax belongs to this new style: the clusters and tendrils are complicated, densely twined, with an abundance of detailed filler motifs, creating a succession in which the plant and animal forms are inextricably meshed. The finest creations, such as the famous sheath of Cernon-sur-Coole (Marne) and its equivalent of Drňa (Slovakia) are the proof that two sites far apart could yield products of the same artistic origin, the Danubian region. Their date of manufacture, 250 B.C. or a little earlier, corresponds to a highly active phase of the third century. On the sheath from Halimba (Hungary) the zoomorphic element

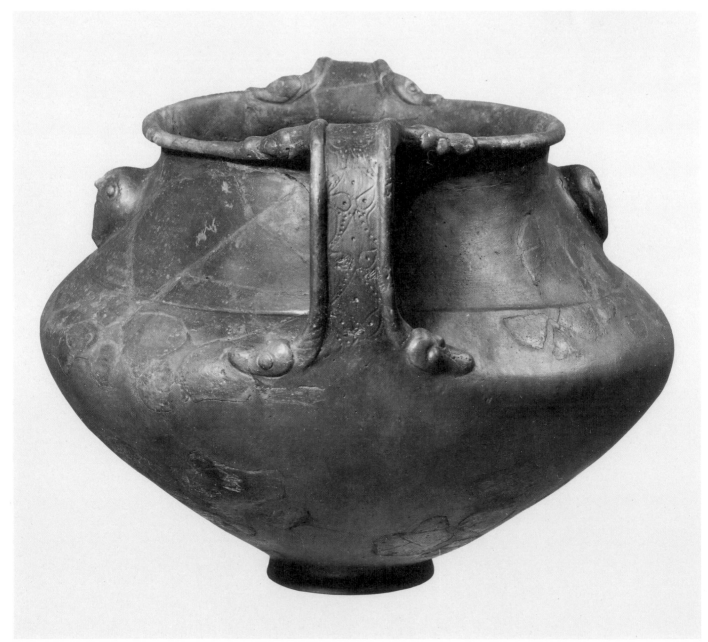

(the pair of dragons) is different from the decoration normally used on the swords. According to Navarro, the pair of dragons and the zoomorphic lyre-shape form part of what he terms an "inter-Celtic currency."

The second group of Hungarian swords is distinguished by a more geometric rendering of the original plant motifs; the gaps between the clusters are filled with neat spirals, wavy lines and triskeles. The widespread distribution of the sites denotes the stability of Celtic power in the Carpathian basin: the decorated scabbards of this second group have turned up in Slovakia, northeastern Hungary and Yugoslavia.

Celtic art production in the third century has often been defined as purely decorative. According to widespread opinion, the phytomorphic, zoomorphic and humanoid motifs and their imaginative combination were simply the upshot of the Celts' somewhat exuberant imagination. After painstaking research, progress has now been made in deciphering the probable religious meanings behind these apparently abstract patterns, and some motifs have been traced to Celtic deities of prime significance—the divine countenance, the plant element and

Terracotta vase with handles
terminating in rams' heads
from Csobaj (Hungary)
3rd century B.C.
Miskolc, Hermian Otto, Múzeum

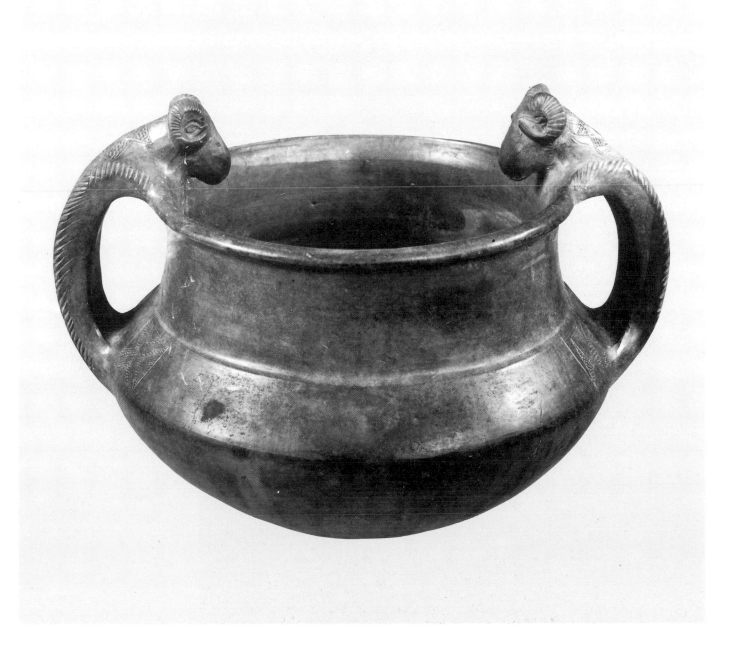

Bronze fibula with false filigree
from Mistřín (Moravia)
3rd century B.C.
Brno, Moravské Muzeum

Fragment of a bronze anklet
from Uhřice (Moravia)
3rd century B.C.
Brno, Moravské Muzeum

Gold torque from Gajić-Hercegmárok
(Yugoslavia)
3rd century B.C.
Budapest, Magyar Nemzeti Múzeum

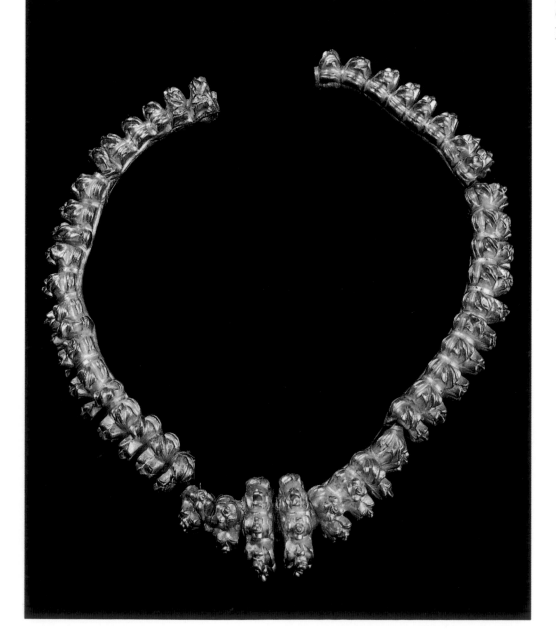

the monstrous guardians have merged into a single, ambiguous figure. It is becoming clear that the Celtic art of the third century B.C. had religious or magical functions.

The marked Danubian leanings of Celtic civilization are most noticeable in the creation of the cultural community, or a *koiné* of eastern Celts. Unlike the decorated sword scabbards, the main items of another hoard of finds brought to light in the Carpathian basin have no parallel in the west. This collection represents the most original aspect of eastern Celtic output; its underlying scheme blends La Tène features with the tradition of the indigenous or neighboring peoples. The highly original repertoire of eastern Celtic ceramics includes two-handled vessels, known as *kantharoi* or pseudo-*kantharoi*. Their appearance and continued use is explained by the Illyrio-Pannonic ethnic substratum. The more slender style of *kantharos* with clearly defined base was influenced by metal vases from Greece, an example of which was found in a Celtic burial at Szob (Hungary). This item was common throughout the Carpathian basin during the third century. Another important factor is the link established between the Hellenized regions of the Black Sea and the Carpathian basin, thanks to Celtic power in Thrace and to the advance of the Galatians as far as Olbia. Proof can be found in the diffusion of glass beads in the form of human masks, of Phoenician manufacture, in the eastern part of the Celtic world (see, for example, the specimen found at Vác, Hungary). As mentioned above, the repercussions of the encounter of the Celtic civilization with that of the Balkan area were far-reaching; the diffusion of Illyrian and Thracian elements was due to the spread of Celtic power in the lower Balkans. Another fashion worthy of note is the imitation of ornamentation in filigree on bronze cast jewelry from Moravia, which made its way through Slovakia and Hungary, as far as Yugoslavia and Rumania. This fashion is explained by Illyrian and Thracian influence, and it first appeared in a relatively early phase of the third century.

An important component of eastern Celtic art is revealed in the cultural traditions of the subjugated populations of the Great Hungarian Plain and Transylvania, whose leaders were originally from the steppes, and without doubt of Scythian stock. The funeral rites and burial goods of Celtic graves discovered in this area betray signs of cultural cross-pollination. The main artifact from this Celtic-Scythian comingling is the Celtic urn of Lábatlan (Hungary), decorated with a scene of animals fighting, which is based on Cimmero-Scythian models.

To sum up this brief overview of the artistic *koiné* of the eastern Celts, it must be emphasized that the features or motifs borrowed from various sources by the La Tène culture do not turn up in their original form, nor in a mixed form that can be clearly identified as Celto-Scythian, or Celto-Thracian, and so forth. Take, for example, the handle decorated with a head (of a bull, ram, or even human face), first encountered on vases of Balkan origin and on the jugs based on Scythian types. Another example is the urn of Lábatlan, where the Steppe-derived motif on the vase is broken up into geometrical components.

Thus it was the development of a distinctly La Tène art style through assimilation and the unique interpretation of a variety of different artistic traditions that characterized this cultural community.

Bronze fibula from Kaysezi (Turkey)
2nd century B.C.
Berlin
Museum für Vor- und Frühgeschichte

Bronze fibula from Mersin (Turkey)
Berlin
Museum für Vor- und Frühgeschichte

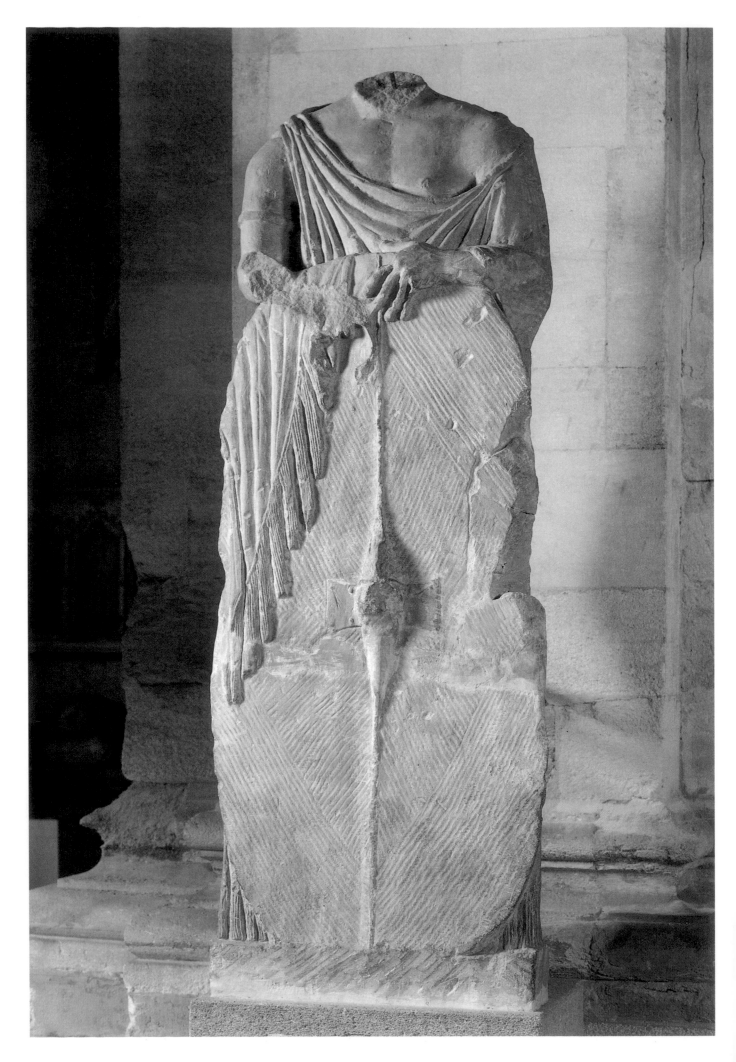

André Rapin

Weaponry

At the beginning of the fourth century B.C., the Romans managed to rid themselves of the shackles of a hundred years of Etruscan rule. Rome's meteoric rise to the greatest city on the Mediterranean witnessed another crucial turning-point—the fall of the Etruscan capital, Veii, after a ten-year siege. Everything seemed to proceed in Rome's favor, until a single event overturned the hegemonic legacy of the Eternal City: the Roman troops suffered utter defeat on the banks of the Allia, leaving the capital wide open to the barbarian hordes from the north.

The Gauls swept headlong into the capital and, as a consequence, into the annals of history. The shock wave of this catastrophic defeat was felt far outside the peninsula. The upheaval triggered by the Gauls' unexpected sack of Rome has spawned innumerable clichés and legends: the burning of the city, the geese at the Capitol, the sword cast onto the scales to increase the weight of the ransom due from the vanquished populace. Such ideas must have kindled many a fighting spirit over the centuries before finding their way into our history books. And yet, rather than signal the start of a Celtic drive further into the Roman heartland, the battle of Allia actually marked the end of Celtic expansion toward the south of the country.

A century later, the same events repeated themselves in the Balkan peninsula: the sack of Delphi toward 280 B.C. was a gruesome date in Greek history, but it likewise marked the end of this new arm of Celtic expansion toward the south, which was probably prompted by the crumbling of the empire created by Alexander the Great and the relative weakness of his successors. The ruthlessness of the Gauls subsequently became myth, and the image of the barbarian quickly replaced the more civilized figure of the Galatian. This term, the last manifestation of the Celtic populations, is the ultimate negative term and denotes the antithesis of civilization. The dying Gauls or Galatians, the slain Galatians, the "Galatomachia" and the trophies that accompanied them are prominent in classical art. The iconographic sources increase in number particularly in Asia Minor, the easternmost Mediterranean peninsula, which witnessed the last wave of Celtic contingents. Military enterprises were a pet theme of historians, and inspired monumental art forms, such as at Pergamum, spreading outside Asia Minor to the Roman world and in some of its classically-inspired artworks.

This series of events coincides with the climax of Celtic expansion in Europe, and likewise with a peak in the number of arms caches in the cemeteries. Furthermore, recent finds in sanctuaries in which the weapons number in the hundreds have made statistical studies possible. The striking similarity of all the weapons found from one end of Celtic Europe to the other reveals an authentic koine similar to that of the plastic arts, which reached their apogee during this period.

Sources Revised

It therefore looks as if the mine of documentary evidence of the third century offers an entirely new profile to the Celtic warrior, and we can finally strip him of the stereotyped idea of the ruthless barbarian.

To do this requires more than a critical analysis of the sources; we need to assess the information from the panoplies concealed beneath two thousand years of corrosion. Much of the iron of the basic military equipment is well rusted; consequently this material tends to be neglected by the museums and has been irretrievably scattered into private collections. The tens of thousands of items unearthed since the nineteenth century are therefore practically unidentifiable, or only superficially. Furthermore, they have yielded little information—witness the almost total lack of new profiles of the Celts during the last century: the anachronistic and

often irrational image of the Gauls illustrating our textbooks can hardly be called "documentary." Many such illustrations are an evocation of the phantasms that haunted our ancestors, rather than a quest for veracity.

Before this legacy of metal can be properly explored it needs cleaning and restoring. As if this were not enough, metal objects even more than other materials require the care of archaeological specialists, without which there is the risk of destroying the message that lies beneath the rust. The recent destruction of a number of metal objects through unscientific restoration techniques demonstrates this danger. This misguided act of "restoration" is the dramatic outcome of a naive passion for quick restoration that unfortunately goes beyond merely preparing the object for exhibition in a museum. The time-consuming and complex task involved in qualified restoration discloses a wealth of new information of the greatest interest.

Finally, our sources have been greatly expanded by recent discoveries of sanctuaries dedicated to arms, founded in the third century. Structures such as the one at Gournay-sur-Aronde (Oise) yield as many arms as hundreds of normal cemeteries of the same date. It goes without saying that hoards of this kind require highly specialized work, during which the gradual piecing together of data alters the way in which the objects are observed. The exhaustive auscultation involved in restoration sheds new light on the functions and technological refinement of the components of the hoard, well-known objects included. The function of offensive weapons such as swords and spears is fairly easily understood, at least in a general sense; and yet, cleaning and restoration operations have proved of capital importance for the secondary items of military equipment.

This applies to the shields and belt-chains, whose function had yet to be understood. Previously the chain links were simplistically interpreted as being merely for suspension, and their technological significance was not understood. The morphological range of these simple chains was generally attributed to stylistic considerations, when actually the each type corresponds to a technological evolution in which the plastic aspect is of little importance and sometimes even absent.

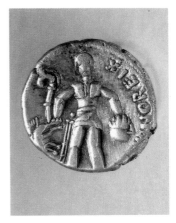

Reverse of a silver coin minted by the Aedui in the name of DVBNOREIX (Dumnorix) a warrior armed with a sword holds a carnyx (war-horn) in his right hand and a boar war insignia in the other he is probably holding the head of an enemy 60-50 B.C.

Main types of shield-bosses and iron belt-chains used in 3rd century B.C. from tombs around Epernay Epernay, Musée Municipal

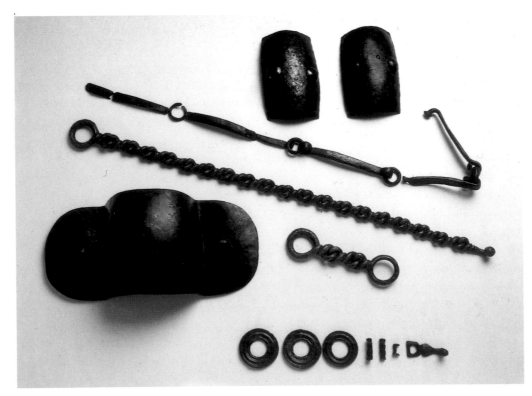

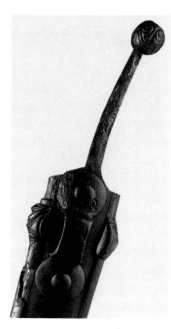

As it turned out, these links explained more than other finds about the mechanisms behind the evolution of Celtic weaponry during the third century B.C. Hence the special status of the shield bosses and belt-chains in defining the phases and mutations of the warriors' equipment. The great number and rather rapid succession of these changes and innovations ought logically to correspond to the war activity that so characterized this century, according to the written sources.

The Standard Third-Century Panoply: Cumbersome Equipment

In quantitative terms, the evolution of military equipment from the fifth century B.C. seems to follow an ascending curve through to the third century. The spears, omnipresent in early La Tène burials, gradually lose their importance in relation to other equipment; the spear and the sword remained the two basic pieces of equipment during the fourth century. Shields, on rare occasions attested by a metal fitting of some kind, were probably also present but perished completely. Helmets also become rare and their relative concentration in Cisalpine Gaul soon gave way to a fairly widespread absence in cemeteries from the first quarter of the third century onward. Apart from this exception, there was a sharp increase in the equipment carried and worn by warriors as the fourth century drew to a close. This modification of the panoplies suggests a complete change in combat techniques in use at the time. The Celts' keenness for innovation is mainly seen in the evolution of their shields (especially in the metal umbo or boss), and in the scabbard attachments, i.e., the belt-chains mentioned earlier.

The chains were basically trappings and not really part of the fighting equipment, which is why they were ignored for so long. The collective term *Dreierausrüstung* used by German archaeologists (denoting sword, spear and shield) leaves out the chains altogether. Unlike the shield and its evolving boss, the chains are exclusive to the Celts of the third century. It is precisely this four-piece set of equipment, more than the three-piece system which gives the Celtic warrior the unexpected appearance of a heavily-armed infantryman. The cause of the evolution is probably the Celts' increasingly frequent skirmishes with the hoplites, who were even more static and weighed down with their weaponry. The development reached a new peak when the weight of the chains became twice that of the sword and scabbard. The production of warrior equipment in the third century B.C. could involve up to five times more metal than those of two centuries earlier. Another characteristic of this evolution, namely, the increased length of the swords (particularly noticeable at the end of the century), may obey the same logic, but with a different end in mind, as explained in the paragraph on combat techniques.

This mounting burden of metal risked becoming a handicap rather than an advantage, and the Celts took care to reconcile the physical properties of iron with the lightness necessary for insuring the effectiveness of their weapons. This technical problem is of the utmost importance, and underlies the constant evolution of the entire combat gear.

Details of an iron sword from Szob (Hungary)
First half 3rd century B.C.
Budapest, Magyar Nemzeti Múzeum

A. The Shield

Unlike their Mediterranean counterparts, which were generally round or curved, the Celtic shields were elliptical and flat with a protruding midrib. The shape and the horizontal handgrip made the shield more maneuverable, whereas the hoplite shields were designed for a more stationary defense. The head-on clashes between these two types of footsoldier had probably prompted the Celts to reinforce the umbo or boss in the middle of the shield. In early versions it consists of two metal plates each fixed with two nails, and sometimes given a metal brace to secure the vertical join. If the boss was knocked hard, however, the nails

323

protruded dangerously on the inside; a provisional solution was to lengthen the metal plates and hence nail them further toward the shield's rim. Despite this improvement, structural weaknesses persisted around the handgrip, a feature that enabled the bearer to wield the shield. This led to a completely new form in which the round or square central bosses, which had thitherto helped reinforce the assembly of the wooden sections, became one with the midrib, enabling a more solid coupling of the handgrip with the whole. This transitory solution quickly led to the classic umbo, made from a single midrib extended to either end. By eliminating earlier inconveniences, this umbo became a central feature of the shield, guaranteeing the protection of the bearer's hand but also greatly improving the assembly of the midrib with the wooden sections and handgrip, affording solidity and maneuverability. From this point on, the variations of the midrib extensions illustrate the range available at any one time and chronicle the general evolution of combat techniques. It thus happens that at the end of the century, the smaller umbo (included merely for assembly purposes) is replaced by something ten times larger and much heavier.

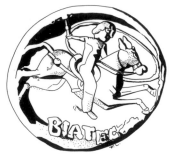

Reverse of a silver tetradrachma minted by the Boii of Pannonia in the name of BIATEC: a horseman with spur and a large shield in his left hand charges with sword raised the horse has a saddle and full reins ca. 60-50 B.C.

B. Belt-Chains

At the end of the nineteenth century the chains on the Celtic warrior's belt were finally identified as suspension for the sword. Unfortunately, the simplicity of this explanation tended to obscure their real role in the warrior's equipment. Even the most primitive of these attachments were based on three principles that remained constant throughout the evolution of the new system:

1. The harness included two metal chains, a short one across the front and a longer one across the back, attached to a solid vertical loop fixed to the back of the scabbard itself.

2. One chain was fixed to the waist strap via a loop or ring, the other via a hooked terminal; this hook was first part of the short chain, then the longer one. As for the ring, which starts with a taper or a double loop, after this transformation it became circular and of smaller diameter than those of the first two rings.

3. The links between the ends of the chains were obviously studied and modified with the utmost attention, such is the range of types. They follow a basic idea, however, that gives the body freedom to turn, while completely reducing the perpendicular movement of the sword by means of semirigid chains; the perfection of this principle continued uninterrupted throughout the third century B.C.

Reverse of a silver coin minted by the Pictones in the name of VIPOTAL[OS]: a warrior armed with a sword holds a spear in his right hand and the insignia with boar motif in his left hand 60-50 B.C.

C. Position and Function

The description of the system of sword suspension when it was in widespread use helps us understand its evolution. In order to leave the soldier's legs completely unobstructed, the sword was shifted to the side as much as possible, with the scabbard hanging from the right hip. The two end sections of the chains followed the contour of the hip but kept the sword vertical. The short chain sloped across the front of the body, and the end was hooked up to the waist-belt (made of some organic material) which passed right round the waist and back to the front. The longer chain passed right round the back and hooked into one of the holes in the end of the waist-belt, keeping it taut.

At this point the unit was no longer simply for hanging the sword on but a system to keep it in place, no matter what position the body took, whether running or in head-on combat. The semirigidity of the chains eliminated vertical jolts when the soldier was running and the scabbard was kept from swinging by the counterbalance provided by the rear chain. Furthermore, thus stabilized in a vertical position, the scabbard hardly moved at all during combat. The way in which the suspension followed the body's rotation was fundamental, but the sys-

tem was further perfected by the articulation of the links. As the body bent forward, the end of the short chain was drawn anticlockwise, allowing the links to sag. This movement was compensated by the tightening of the longer chain in the opposite sense, pulling the scabbard out and backward. This refined technology culminated in the invention of flat chain-mail, developed toward the end of the century. The chains in question manage to combine the agility and comfort of semirigid belts made from organic material with the advantage of chain-mail, produced with a skill comparable to that of the goldsmith. This technological progress lasted a full century, and has its equivalent in modern goldwork.

D. Combat Techniques

The technological advances reveal the rational evolution of weaponry for tenacious fighters who realized they had to adapt to match their adversaries. This is in stark contrast with the stereotyped image of the howling, disordered barbarian hordes with their unpredictable behavior. The development of the shields and sword-chains is clearly a coherent succession of innovations, carefully tailored to a technique where nothing could be left to chance.

In the third century, the Macedonian phalanx, which succeeded those assembled by Philip of Macedon and Alexander the Great, had became an academic model for the Mediterranean armies. This apparently invulnerable block several rows deep, bristling with spears, proved increasingly static due to the complex maneuvers needed for facing the enemy on all sides. The ploy the Celts adopted to confuse and destabilize this compact mass of men was the dy-

Evolution of La Tène shield-bosses from the early 3rd to the first half of the 1st century B.C.

Sword suspension system with metal chain and leather belt in the 3rd century B.C.

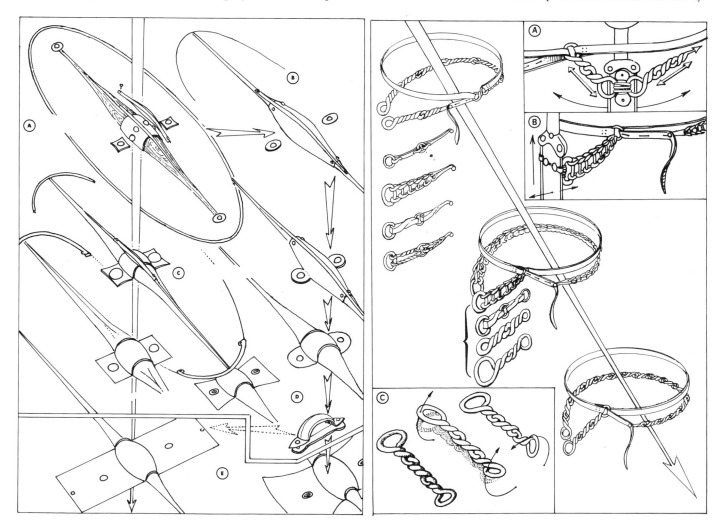

namic onslaught of their foot soldiers, whose effectiveness lay in the sheer force of their initial attack. The violence of this onslaught was crucial to the success of the operation and justified the need to be able to dash unimpeded into the enemy lines. The rapid expansion of the Celts in eastern Europe is sufficient proof of the success of this assault tactic, which was even effective against the heavily-armed hoplite soldiers. However, the tactic cost many lives and much energy, and could rarely be performed more than once. Hence the clichés in the battle accounts, which stress the Gauls' apparent indifference to death, or their sudden despair when their frontal attack was not immediately successful.

Third-century assault tactics saw the introduction of cavalry to the battlefield, once again by King Philip of Macedon and his son Alexander. Horsemen had, of course, long been present in battle but proper formation combat on horseback was first devised by the Macedonian generals. The Celts, mercenaries by nature and inclination, were practiced horsemen, and must have used horses in battle at a fairly early stage. The simple list of the effective soldiers lined opposite each other during the battle of Telamon referred to by Polybius (*Histories*, II, 27-31) highlights the relative importance of the Celtic cavalry, which comprised a fifth of all combatants, and hence twice as many employed by the enemy. The Second Punic War, which followed soon after this event, witnessed another great strategist of ancient times, Hannibal, decisively make use of these detachments of mercenary horsemen. Whether lightly armed and aimed at scattering the enemy, such as the Numidian horsemen, or heavily armed like the Celts, combat on horseback was essentially limited to dissuasive charges on the infantry, and rarely developed into close combat. In fact, when the situation forced the adversaries into close fighting, the horsemen jumped down from their mounts, as at the battle of Ticino, and engaged in traditional hand-to-hand fighting. (Polybius, *Histories*, II, 64).

The certainty of the presence of cavalry is not endorsed by archaeological material, although some vague indications are slowly emerging. The clearest sign of the appearance of cavalry on the scene is the progressive lengthening of the sword, which can be noted from midway through the century. During the first half this growth was minimal, but by the end of the century it exceeded twenty centimeters. With a blade of eighty to ninety centimeters long, the sword had become a long, straight saber, much the same as those worn by the cavalry of later eras. A weapon this size, hanging down to an average man's ankles, would clearly be too unwieldy for the infantry, preventing them from rushing into the attack.

For the horseman there was no such problem. Even when forced off his horse, he was never obliged to charge the enemy. The growing emphasis on cavalry forces did not mean that troops on foot were phased out; there was probably a full revision of combat techniques. Assault formations of the Mediterranean kind seem to have eventually got the better of the Gauls' furious onslaughts, as indicated by the rounded-off spearheads, devised to avoid wounding comrades in the rear lines. Just as they reached perfection, the belt-chains became obsolete, for cavalry and for infantry alike. The points of some spears become inordinately long until they resembled bayonets. The small shield-bosses were abandoned abruptly like the chains, in favor of bosses ten times larger that virtually covered the entire shield.

Iron scabbard decorated with pair of eel-shaped creatures from Gödöllö (Hungary) End 4th-early 3rd century B.C. Budapest, Magyar Nemzeti Múzeum

Armaments and Absolute Chronology

We know nothing of events that affected most of Celtic Europe during the third century, as the early historians' accounts cover only southern Europe. Attempts to match the technical developments outlined above with events can only be made for this particular area of the Celtic world. The comparative analysis of archaeological material should enable us to infer developments for Cisalpine and Transalpine Gauls, and establish links between Celtic material from the Balkans and material from continental Europe.

Polybius's account of events enables us to distinguish three major phases of interaction between the Celtic world and Mediterranean history, roughly as follows:
— expansion from 310 to 275 B.C.;
— settlement in new territories between 275 and 225 B.C.;
— the Second Punic War with its tragic consequences for the Cisalpine Boii tribes who had to surrender their land to the Romans in 190 B.C.
Hence two generations of warriors were involved in the expansion phase, while the three or four following generations lived in relative peace. But in Cisalpine Gaul the last two generations were greatly reduced because of the slaughter on the battlefield. These two phases of war activity, falling either side of a period of peace, need closer analysis to clarify the technological evolution.

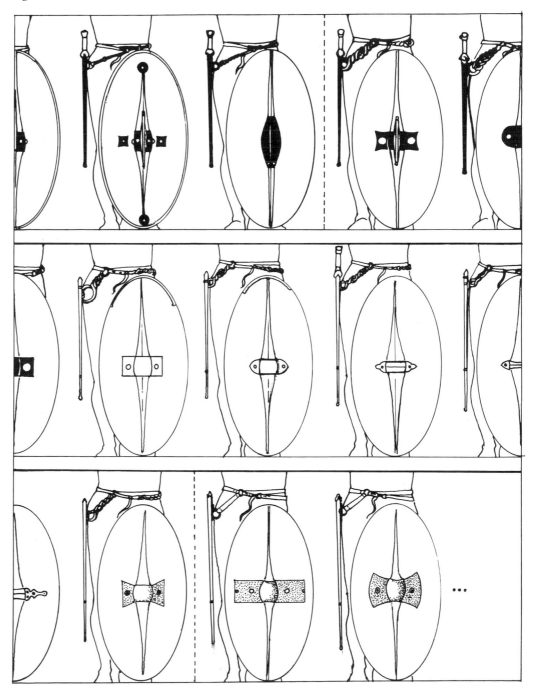

Successive alterations to the metal mount on the shield to the belt suspension, and to the length of the sword from the early 3rd to the first half of the 1st century B.C.

1. Expansion

In the year 310 B.C. a victory against the Autariate Illyrians signaled the start of Celtic settlement in the Balkans, north of Macedonia. It is likely that numerous Celtic forays on the Greek world were made possible by these bases in the Balkan interior. The last and most famous incursion, which finished in Delphi with the sack of the sanctuary, marked the start of Celtic withdrawal. The outcome of these thirty years of aggression was the creation of "kingdoms," sometimes short-lived, like the one at Tylis on the Bulgarian-Greek border, sometimes more enduring like the one set up by the Taurisci in the eastern Alpine regions and Slovenia, or by the Scordisci of Serbia and Pannonia, or even more far-flung such as the Galatian chiefdom in the heart of today's Turkey.

The veterans of these conquests were presumably buried in the new cemeteries, and in fact the panoplies of the older Scordisci and Taurisci cemeteries testify to the first innovations mentioned above, i.e., the bivalve-boss shields and the first belt-chains.

With the help of these reliable clues, it follows that Celtic expansion was not limited to the Mediterranean area alone. In fact the Danube Valley was the main human catchment area, and migration was funneled eastward into Hungary and Rumania, but also north, beyond the arc of the Carpathian mountain range, particularly toward Poland. Justinus' mention (Justinus, XXIV, 4) of Celtic migration toward the Hercynian Forest is endorsed by the finds in this area. But the expansion of the Transalpine Gauls also affected territories occupied by their southern cousins for over a century. Around 300 B.C., just as the Celtic army set foot in the Balkans, the Senones from the Adriatic tried to divert a large army of Transalpine Gauls toward Lazio in the hope that they would take their loot back across the Alps with them. For this act of complicity against the Romans, the Senones lost their independence. Rome promptly set up *Sena Gallica* in 283 B.C., signaling the demise of the Celts' southern dominion. As it happens, none of the Senone cemeteries in Italy have so far yielded war panoplies of the new kind. This absence is more likely indicative of resistance to innovation on the part of the Senones than a sign of population movement during Middle La Tène. The same resistance to change is noted among the Boii, neighbors to the Senones, though to a lesser extent. Their ignorance of the bivalve shield-bosses and their tardy adoption of the widely standardized belt-chains could be indicative of other cultural influences on the Cisalpine races, who were less implicated in the technical innovations from the north, and even less in the territorial revisions arising from the military expansion of the Transalpine tribes.

2. Settlement

The settlement process may have begun between 280 and 270 B.C., and in fact the decade that followed the sack of Delphi saw an abrupt decline in military activity involving Celtic forces, as they settled into their new territories. For this third generation, economic order took priority over the evolution of military technology. Polybius, who had long deplored the aggressive nature of the previous generations, speaks of this phase as "the necessary lapse of time during which all those who had experienced calamities died off and the younger generation, fired by their warrior spirit began to question the status quo" in the face of growing pressure from the Romans (*Histories*, II, 21).

Well isolated in the Greek heartland in Asia Minor, the Galatians succumbed more rapidly to local culture pressures, and one can imagine the interest inspired by the discovery of cemeteries of the first settlers, those on which Hellenistic culture had had least influence. For the Celts living in the European heartland, the rapid evolution of the panoplies due to unbroken war activity began to slow down, and then remained stable. The bosses and belt-chains remained unaltered. Alterations to the boss attachments were made for ornamental

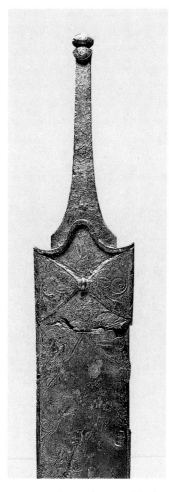

*Details of decorated iron scabbard
from Drna (Slovakia)
Rimavská Sobota
Gemerské Múzeum*

rather than mechanical purposes. Similarly, the elaboration of the chains, the links of which were now in cast bronze, imitating the twist of their iron prototypes, is further proof of standardization, which can be noted from the shores of the Atlantic to the Black Sea.

3. The Second Punic War

After fifty years of peace, in 232 B.C. the *Lex Flaminia* established the division of the Senone territories, to the consternation of the neighboring Boii. The law ushered in a new phase of friction in which the Transalpine tribes were petitioned for aid and armed clashes followed, including the battle of Telamon, mentioned earlier for its important use of cavalry. The battle cost the lives of forty thousand Transalpine and Cisalpine foot soldiers and ten thousand cavalrymen, and Polybius notes how the surviving Celtic forces fled to escape the slaughter. In this climate of repeated blood-letting, albeit on a smaller scale, a new military and social class of warrior horsemen emerged. The massacre of at least two generations of foot soldiers justified repeated appeals to the Transalpine tribes. At this point, Hannibal took advantage of the mounting tensions among the Cisalpine Gauls.

The Punic army, enfeebled and decimated by its long odyssey through the Alps, was bolstered with Gaulish infantry and horsemen; slotted in among the ranks of mercenaries, the newcomers had to submit to formations that seemed the very opposite to how their warrior forefathers had behaved. Instead of speeding into the fray they marched in orderly ranks toward the enemy, shoulder-to-shoulder with their Iberian and Carthaginian comrades-in-arms. Their job was to contain or, where possible, block the enemy's path, leaving the Punic general to conduct the assaults with his heavy or light cavalry. Hannibal's resounding success at Cannae immortalized his tactical expertise and was a lesson to all. As for the Celts, the conflicts at the end of the third century speeded the changes, until then very sluggish, in combat techniques. This time the evolution affected the cavalry rather than the foot soldiers, with the spectacular changes outlined above.

To date the cemeteries of the Boii tribes in Italy have yielded virtually the entire range of chains, but not the new panoplies documenting the last changes, in which the chains were discarded. We know that after their bitter defeat, the Celts were forced to relinquish their land to the Romans in 190 B.C. The same modifications were integrated into military equipment by their neighbors, the Insubres and Cenomani who, in the northern area of Cisalpine Gaul, enjoyed another century of independence.

As can be seen, the events around the Mediterranean fit in perfectly with the chronology of the technological phases. Logically, the periods of intense conflict prompted changes, and the peaceful phases favored the spread of standardized objects. But it should be pointed out that the drawing of these parallels between phases of conflict and the development of fighting equipment, however seductive, is purely hypothetical. We are still far from verification.

On the basis of this kind of conjecture regarding the material culture of the Cisalpine Gauls and the eastern Celts, many scholars have confirmed that the dawn of the middle phase of Celtic civilization should be backdated to the beginning of the third century, and therefore a good fifty years earlier than current chronologies suggest.

Logically, this shift back in time implies that the last Celtic phase began toward the start of the second century, but this is far from being acknowledged.

It is nonetheless crucial to consider whether a chronology of this kind based on very peripheral events can be applied outside the framework of military operations and the field of observation of the ancient Greek and Latin historians. The study of material unearthed from the sanctuary of Gournay-sur-Aronde in northern Celtic Europe has evidenced phases that are both similar to and synchronistic with events in the south. The panoplies that have emerged

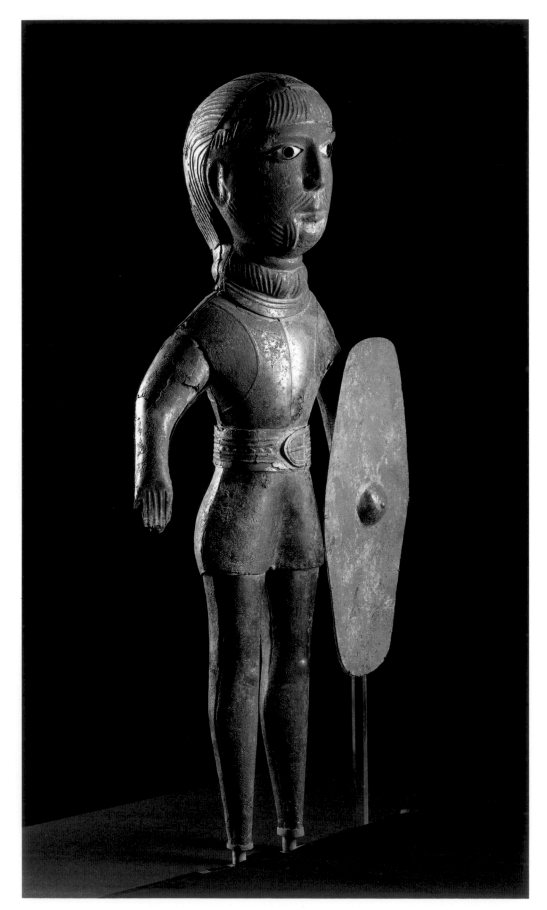

*Statue of warrior deity in embossed
bronze sheet with glass paste for eyes
from Saint-Maur-en-Chausée (Oise)
1st century B.C.
Beauvais
Musée Départemental de l'Oise*

from stratigraphic surveys in the sanctuary concur closely with the last changes that ushered in the so-called settlement phase. The fact that the foundation of a sanctuary in this northernmost fringe of Celtic Europe took place simultaneously with the creation of new territories in the Balkans is unusual but logical. The parallels actually go even further: there are proven, repeated links with deposits in the sanctuary ditch, corresponding to three or four generations of panoplies whose evolution is minimal. Finally, the manifest chronological interruption of the rebuilding of the sanctuary's structure coincides with a marked alteration in the panoplies, i.e., with the phasing out of the chains and the introduction of the new shield-bosses, which in turn coincides with the transformation of funeral rites, even in the more conservative regions such as Champagne and Bohemia. Everything takes place as if the developments of Celtic society as a whole fit in with the major military events, as if their remote echoes just happened to coincide with the events recorded in the early histories.

In the final analysis, what could be more natural for a people whose territorial expansion over two centuries was achieved through the dynamism of its warriors than this huge investment in weaponry? Examining the evolving technology of the material culture sheds fundamental light on the Celts' development. As for the arms themselves, this kind of investigation has only just begun and offers great potential for explaining phenomena, especially with the help of experimental archaeology.

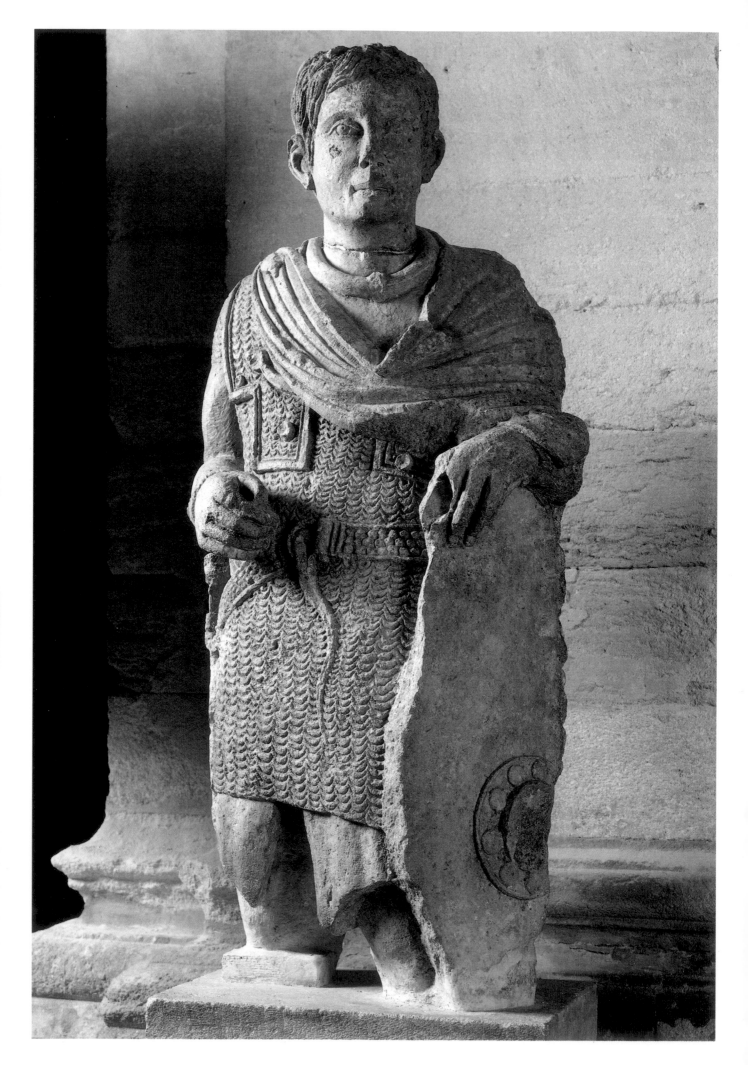

Mercenary Activity

In addition to the conquest of new territories, the Celts had another outlet for their military prowess in mercenary service, whose rapid growth from the fourth century B.C. onward played a significant role in La Tène history and civilization. Celtic mercenaries are first mentioned in classical sources shortly after the Senones stormed Rome. There are fourth-century reports of alliances between the Gauls and the ruling tyrant of Syracuse, Dionysus I (whose designs on the Adriatic were widely known), so one can suppose that the recruitment of Celtic warriors was linked to Ancona, which Syracuse founded in the fourth century B.C. The settlement of the Senones in the region of the Marches put them in direct contact with Magna Graecia and Sicily, making this new Celtic territory a magnet for any Transalpine peoples with a spirit of adventure. Classical sources mention the presence of Gauls in Apulia, and there is also talk of Celtic troops (paid by Dionysus) involved in conflicts between Sparta and Thebes. In 369-368 B.C. two thousand Gaulish and Iberian mercenaries sent by Dionysus seconded the Spartans in routing the armies of Epaminondas from the Isthmus of Corinth.

Both Dionysus II and his successor Agathocles employed Celtic mercenaries, who were also enrolled by the Carthaginians and hence had a crucial role in many phases of the Graeco-Punic wars in Sicily during the fourth century B.C.

As a result, mercenary service spurred the Celts to move ever further afield. In 307 B.C. Agathocles led his Celtic troops into Africa, invading Carthaginian soil.

After the death of Alexander the Great, there was a remarkable increase in Celtic mercenary activity, and enlistment in Hellenistic armies rose to several thousands. This new phase was strictly linked to offensive strikes against the Macedonians and Greeks, beginning with a wave of invasions in 280-279 B.C. The decisive event dates back to the end of 278 B.C. or early the following year, when Antigonos Gonatos, returning to Europe from Asia Minor, brilliantly trounced a Celtic army near Lysimacheia in Thrace. The victory signaled the final quashing of Celtic attempts to encroach on the Mediterranean world but, at the same time, it made accessible the Hellenistic armies to these awesome warriors, whose fame had spread far and wide. The victorious Antigonos was quick to enlist the remains of the Celtic forces who, under the command of Kidérios, helped him seize Macedonia. In this way, the Celtic presence on Greek soil was prolonged: Antigonos then sent his Gauls against Pyrrhus, king of Epirus, who also had some in his own ranks. The king allowed them to defile the royal tombs of Macedonia at Aigai (which is probably today's Vergina, where Greek excavations have corroborated the sacking of the supposed tomb of Philip II of Macedonia), after which the Celtic mercenaries followed him to the Peloponnesus, where he met his death at Argos. During this time, Thrace became a conspicuous reservoir for professional soldiers. In 277-276 B.C. Antigonos loaned four thousand Gauls to Ptolemy II (Philadelphus), who was at war with his brother Magas. The victory was followed by a revolt by the Celts who, imprisoned on an island on the Nile, all perished.

It was also Antigonos Gonatos who assigned Gauls to the leadership of Leonnorios and Lutarios to serve Nicomedes I. This marked the emergence of the Galatians of Asia Minor, who were principally engaged by the king of Bithynia to sort out dynastic disputes. Gauls also numbered among the ranks of the Seleucids and in a great many other countries. The historian H. Hubert has written "No oriental sovereign was able to do without his contingent of Gauls." The history of Celtic mercenaries continues in Egypt, where they fought under Ptolemy III and Ptolemy IV, who kept good relations with the Tylenes, that is, Celts who had settled in Thrace, from whence Gaulish mercenaries were regularly recruited. Celts were also to be found in the ranks of the Lagidi in 186-185 B.C. during moves to crush revolts that had broken out in Upper Egypt. An inscription on the wall of the temple of Set I confirms evidence that the Galatians knew how to write Greek.

In Italy, meanwhile, three thousand Celts were recruited by the Carthaginians in 263 B.C. and transported to Sicily to take part in the sacking of Agrigento. Difficulties in managing troops of this kind seem not to have deterred the Carthaginian forces from enlisting Celts

for the First Punic war. Antarios, a Celtic commander fluent in Punic, later instigated a revolt among the mercenaries who, in 241-237 B.C., demanded payment for their efforts. It is certain that Transalpine Gauls, paid by the Carthaginians, took an active part in belligerent activity in Sicily, Corsica and Sardinia. They were generally trustworthy soldiers and carried out their duties on the understanding that they would be regularly paid. When payment was no longer forthcoming, they began to desert, and Gaulish contingents simply defected to the Roman camp.

This Celtic "industry" of professional warmongering was one of the most important markets in the north, with its constant turnover of Alpine and Cisalpine Gauls, and would seem to explain the etymology suggested by Polybius for the name of the Gaesatae, who reached Italy in 225 B.C. "They are called Gaesatae because they are mercenaries, which is the meaning of this word." Actually, it involved the "negotiated migration" of certain tribes called in to bolster the resistance of the Cisalpine races against the Roman Republic. It is more likely that the name comes from the standard Gaulish weapon, a *gaesum* or throwing-spear.

In spite of the ample information supplied by classical authors on Celtic mercenaries,

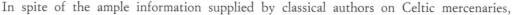

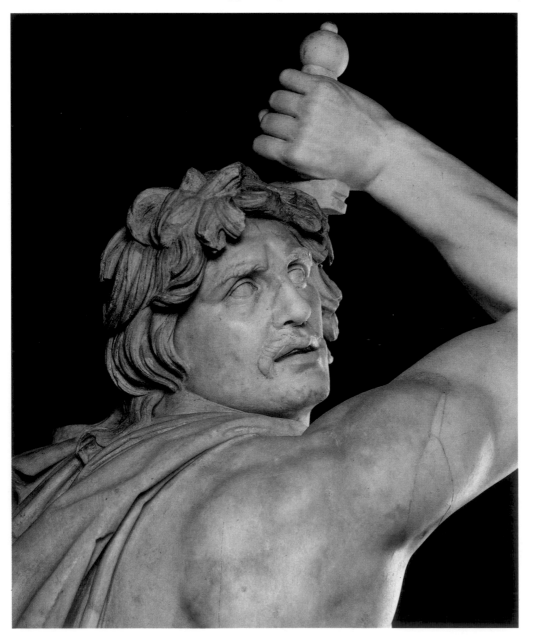

Detail of the statue of the suicidal Gaul, from the group dedicated by Attalus at the sanctuary of Athena Nikephoros at Pergamum
Marble copy of original bronze
Second half 3rd century B.C.
Rome, Museo Nazionale Romano

researchers still disagree on the exact interpretation of the phenomenon. It is still not clear how agreements were made between Celtic warriors and the Greek rulers or other foreign potentates, for instance. What form did payment take? Certainly, individual warriors were not involved, but whole squadrons, normally followed by women and children bringing sundry impedimenta. The reputation of the Celtic mercenaries, comparable to the widespread renown of Cretan archers and Numidian horsemen, is partly explained by the success of the Celtic invasions in the Mediterranean, and partly by the quality of their weaponry and expertise in combat technique.

Written sources and Greek and Roman figurative art seem to confirm the widely-held opinion that Gaulish mercenaries had their own arms, such as the broad ribbed shield, to which they remained faithful to the end. At the same time, the abundance of Hellenistic weapons on the frieze of the war monument in the Sanctuary of Athena Nikephoros in Pergamum, immortalizing the Attalids' victory over the Galatians, clearly corroborates the account afforded by Memnon, a chronicler from Heracleia in Pontus, who claims that Nicomedes I of Bithynia supplied arms to the Celts upon their arrival in Asia Minor. In the course of expedi-

Marble plaque portraying Celtic weaponry: shields, chain mail, spear bull-head carnyx from the entrance balustrade of the sanctuary of Athena Nikephoros at Pergamum Early 2nd century B.C. Berlin, Pergamonmuseum

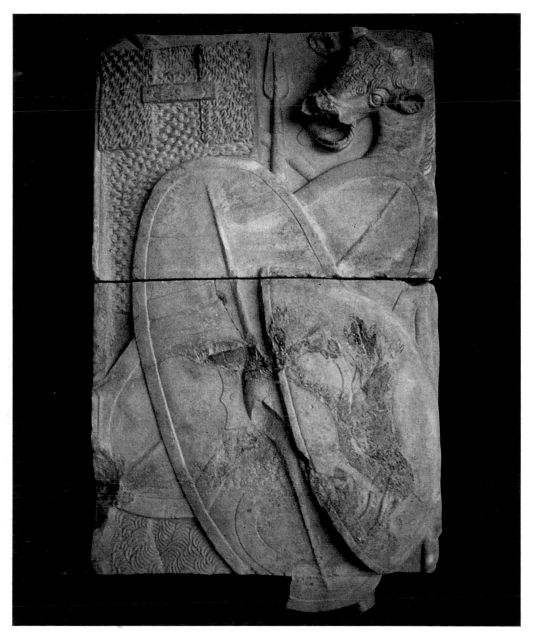

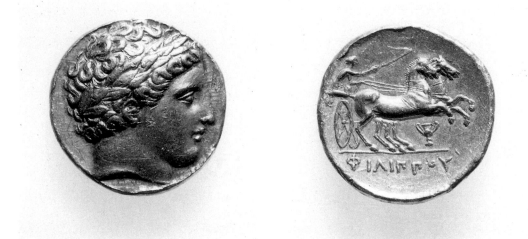

Gold Philip II staters
Munich, Staatliche Münzsämmlung

tions around the Mediterranean the Celts adopted a technique of fighting in close formation. Their terrifying first attack reputedly brought utter panic to the enemy lines, and Hellenistic armies therefore employed Celts as auxiliary troops with the job of terrifying the enemy. It is also interesting to note that, rather than return to their homeland, mercenaries frequently lingered in surrounding lands, often necessitating military intervention to reestablish order. The Celtic mercenaries recruited by Antigonos Gonatos each received a golden coin. It is difficult to say whether they were well paid, since we do not know how regularly these payments were made. Nonetheless, clearly the introduction of coins among the Celts toward the beginning of the third century B.C. stemmed from mercenary activity; and in turn the Hellenistic coinage (including *Phillippi*) found throughout the Celtic world is reasonable archaeological proof of the Celts' mercenary activity. In this case too, however, it is practically impossible to make reliable distinctions between war booty and soldiers' pay. The same problem hampers efforts to establish the circumstances of the introduction of certain Greek artifacts among the Celts in central or western Europe. Great caution is necessary when attempting to attribute Celtic relics unearthed in Italy (such as the Celtic helmet at Canosa), or in Greece (the pair of ankle rings at the Isthmus of Corinth) to Celtic mercenaries or to their entourage.

Celtic mercenary activity had begun to wane by the early second century B.C.

Borislav Jovanović
Petar Popović

The Scordisci

*Bronze fibula
from tomb no. G 3/1201
at Pečine (Yugoslavia)
First half 3rd century B.C.
Požarevac, Narodni Muzej*

According to the testimonies of the ancient writers (Strabo, Arrian), a group of Celtic emissaries visited Alexander the Great in 335 B.C., somewhere near the Danube, where he was fighting against the Balkan tribes. After a friendly reception, Alexander asked them what was their greatest fear, thinking that it must be his own name since he had reached the Celtic lands. He was quite disappointed when they replied that they were afraid of nothing on earth, only of the skies falling down on them. This anecdote demonstrates not only that the Celts were proud and fearless, but also that, at the time, they had settled in the area and that they took a keen interest in the political situation in the Balkans.

In the mid-fourth century B.C., the Celts left the Carpathian basin and with their warriors in the lead moved southward through the Danube valley. Archaeological finds indicate that they had progressed as far as the southeastern Pannonian region by the close of the same century. A rich series of warriors graves belonging to this period was recently discovered at the site of Pečine near Kostolac, south of the Danube. About fifty years after the above event, the Celts undertook a great campaign in Macedonia and Greece. After a serious defeat near Delphi in 279 B.C., "more as a consequence of the will of the Gods than on account of the force of the Greek hoplites," the various divisions of the broken army scattered in different directions. Some of them went to Asia Minor (the Galatae), some to Thrace, and the division under the leadership of Bathanatos returned along the same road, settled down at the confluence of the Danube and the Save rivers and took the name of Scordisci. From then until the Roman conquests (at the end of the first century B.C.), the Scordisci remained on the southeastern frontier of the Celtic world alongside the Hellenistic and later the Roman civilizations. Thus, they left their mark on the classical world, though it was not a favorable one; according to the historiographers, they were perceived as a constant threat from the north. The later history of the Scordisci is one of numerous raids, plunder and burning in Macedonia and Greece, which they undertook together with other Balkan tribes. The ancient writers did not mince words in describing the Scordisci as wild and aggressive Barbarians, living without any law or order. However, archaeological finds show them in a different light: the objects they fashioned were produced with great technological skill and had a high artistic value; these were mostly of a prestigious character, such as jewelry and weapons. The finds from this period (third-second century B.C.) come for the most part from cemeteries (Kupinovo, Osijek) in use over lengthy periods of time. On the site Beograd-Karaburma, ninety-six graves were excavated, dating from the third century B.C. to the first century A.D. The excavations in this part of the city were of a rescue nature, limited only to the space designated for new buildings. This

*Terracotta Kantharos
from tomb no. G 3/993 at Pečine
(Yugoslavia)
3rd century B.C.
Požarevac, Narodni Muzej*

*Terracotta vase with zoomorphic
handle from tomb no. G 13/457
at Pečine (Yugoslavia)
3rd century B.C.
Požarevac, Narodni Muzej*

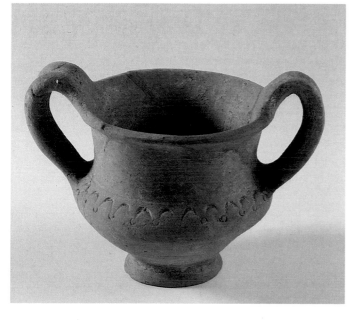

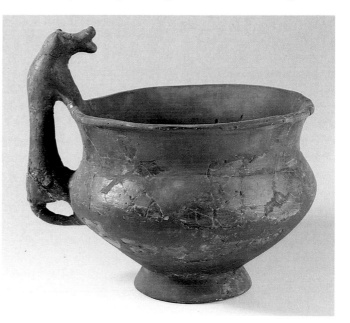

prevented the archaeologists from determining the precise location and appearance of pre-Roman *Singidunum*, the present city of Belgrade. In contrast with sites dating from the period when settlement began, between the third and second centuries B.C., the question of the nature of settlements on the Scordisci territory is still an open one. In spite of the intensive excavations in recent years, evidence is still missing. What is obvious is that this period is characterized by the absence of great concentrations of population at a single location, and therefore, by the absence of the formation of well-defined cultural layers. The settlements were probably smaller, short-lived and made of poor building material. This could be seen as one of the characteristics of the Scordisci in this period: as warriors, living at the frontiers of their world, they did not have a stable, sedentary life.

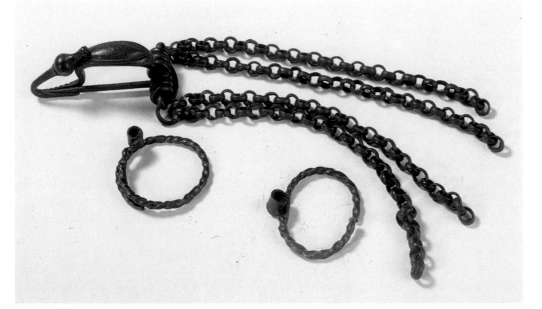

Bronze fibula with silver chain and earrings from tomb no. 63 at Belgrade-Karaburma (Yugoslavia) First half 3rd century B.C. Belgrade, Muzej Beograda

However, the fact that the Scordisci struck coins indicates a considerable level of social organization, as well as the existence of established authorities who regulated minting. Coins dating from the end of the fourth century to the beginning of the third century B.C. found in the Balkans were primarily imitations of the tetradrachmas of Philip of Macedon, and afterwards, imitations of the tetradrachmas of Alexander the Great and other Hellenistic rulers. The Balkan Celts very quickly conformed to this general tendency which gradually spread over the periphery of the Mediterranean world. The coins soon showed a patently Celtic form of visual expression, thus becoming an authentic representation of their interests and skill. In principle, the imitated model was still Philip of Macedon's tetradrachma, with a representation of Zeus on the obverse and a horseman (later just a horse) on the reverse; this is characteristic of almost all eastern Celtic and Dacian coinage. After smaller and very heterogeneous issues of an often astonishing artistic quality in the third century B.C., the coins of the close of that century to the start of the second century B.C. show a gradual typological standardization. From the mid-second century B.C. there is silver coinage (drachmas and tetradrachmas) issued in Slavonia and Śrem, with clear typological characteristics (the "Śrem type"); a representation of Zeus on the obverse and a trotting horse with a symbol of the sun—a circle with a point—on the reverse. The Śrem type of coinage lasted until the first decades of the first century B.C., and gradually underwent the following changes: increasing schematization, (often reaching abstraction), diminishing weight, and replacement of silver with bronze. Apart from this, smaller issues of a different pictorial character were coined on the same territory (the "East Slavonian type," the "Krčedin type") and should probably be ascribed to the communities living among the larger population of the Scordisci.

Fragment of the mouth of a decorated iron scabbard from Karlovci (Yugoslavia) 2nd century B.C. Zagreb, Arheološki Muzej

*Silver coins derived from
the Philip II tetradrachma
attributed to the Scordisci
3rd-2nd century B.C.
Belgrade, Narodni Muzej*

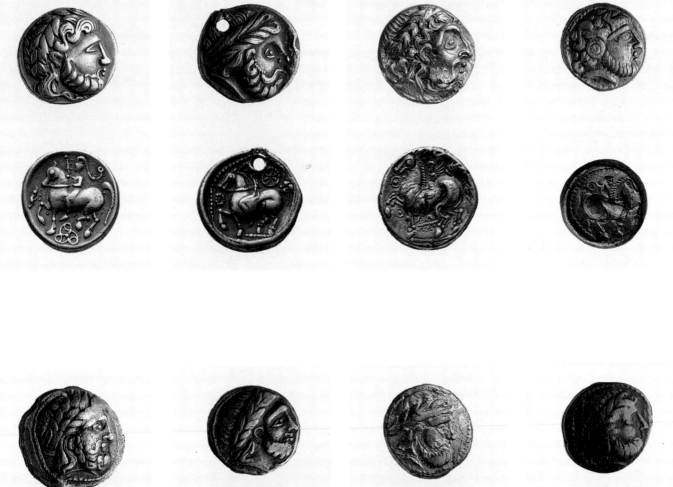

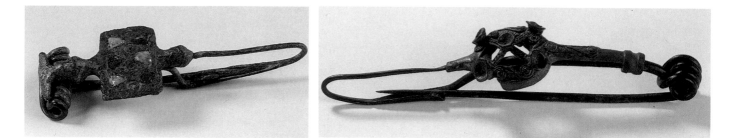

Bronze fibula with studs in yellow
and blue enamel from Boljevci
(Yugoslavia)
2nd-1st century B.C.
Zagreb, Arheološki Muzej

Bronze fibula
from Smederevo-Orešac
(Yugoslavia)
3rd century B.C.
Belgrade, Narodni Muzej

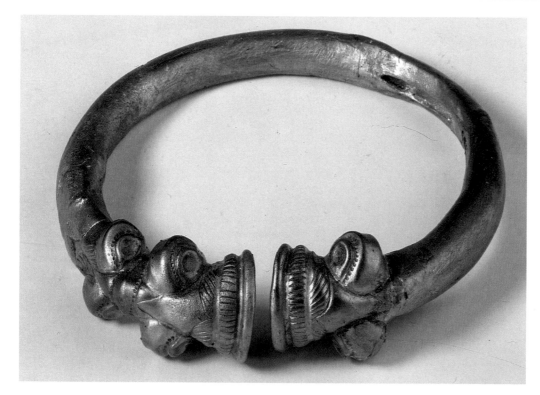

Silver bracelet from a female
cremation at Vršac-At (Yugoslavia)
Late 3rd-early 2nd century B.C.
Vršac, Narodni Muzej

For the most part, this period of coinage is the period of the Scordisci's military domination of the Balkans. There was a gradual decline in the quality of their coins: the late series were almost exclusively issued in bronze and they were rather negligently fashioned. This coincides with some historical events that had serious consequences for the future of the Scordisci. In short, their great energy, invested in war and plunder—their main sources of income—finally wore thin, for various internal and external reasons; this affected the quality of coinage, which had primarily a political and prestigious significance.

With the fall of Macedonia and the foundation of the Roman province in 148 B.C., the situation in the Balkans was considerably changed. At first, the Romans were unable to control the aggressive Barbarians, but by the end of second century B.C. and the beginning of the first century B.C., the Scordisci had suffered serious defeats. Strong pressure from the south forced them to regroup in their own territories and to turn to local resources. They founded numerous settlements, which can be included under the general Celtic phenomenon of that period, the *oppida*. However, it should be noted that on the Scordiscian territory there were no fortifications of the *murus gallicus* type. A traditional fortification technique in Pannonia and the Danube valley was an earthen wall with palisade and ditch, mainly because of the lack of stone in the region. In a great number of cases, new settlements were built on well-chosen locations of older settlements of the tell type, usually on bank of a river (Save, Bosut, Danube). These artificial hills, formed by the build-up of cultural layers, have an impressive stratigraphy, often originating in the Neolithic. They dominated the flat surroundings and offered protection and suitable living conditions to the inhabitants. Earlier earthen fortifica-

View of the fortified Iron-Age settlement of Gradina on the Bosut River (Yugoslavia) occupied during the La Tène period 2nd-1st century B.C.

Stratigraphy of the Gradina settlement on the Bosut River The La Tène and medieval layers are above the Iron-Age strata of the indigenous settlement

tions were often reconstructed, or new ones were built on their site. One such site is Gomola-va, on the left bank of the Save, of which about four thousand square meters has been explored. A cultural layer six meters thick, with stratigraphy ranging from the Neolithic to the Middle Ages has been excavated over a period of twenty years. The La Tène settlement was founded at the end of second century B.C., as demonstrated by the earliest habitation level with sunken-floored dwellings. From the middle of first century B.C. this area became a sort of industrial zone for pottery manufacture. Although a large part of the cultural layer was destroyed by the river erosion and damaged by the Roman occupation levels, it is possible to claim that the main part of the settlement was right on the bank, while the pottery kilns were kept in the eastern part. During the first century B.C., the settlement spread over the tell limits into the previously uninhabited area. The settlement was burned down, probably around the year 15 B.C., when Tiberius was conquering this territory; it was, however, rebuilt and continued be an active center during the Roman occupation.

The Gradina site on the Bosut River is a tell with a double fortification surrounded by a deep ditch filled with river water. In this case as well, the settlement spread beyond the tell limits to occupy a comparatively large area. One of the specific traits of similar fortifications in eastern Slavonia (Donja Berbina, Privlaka) are the powerful earthen walls reinforced at the top with a thick layer of baked clay. The only traces of stone walls were discovered during the excavations of the fortified settlement in Stari Slankamen on the Danube. In the flat areas, in southern Bačka, the fortified settlements had earthen walls with drainage ditches (Plavna, Turski Šanac, Čarnok).

*Fragment of multicolored glass
bracelet, from the settlement
of Gomolava (Yugoslavia)
End 2nd-early 1st century B.C.
Novi Sad, Vojvodjanski Muzej*

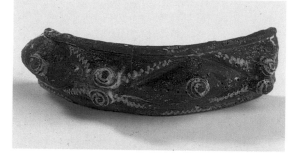

*Terracotta kantharos
from Gomolava (Yugoslavia)
1st century B.C.
Novi Sad, Vojvodjanski Muzej*

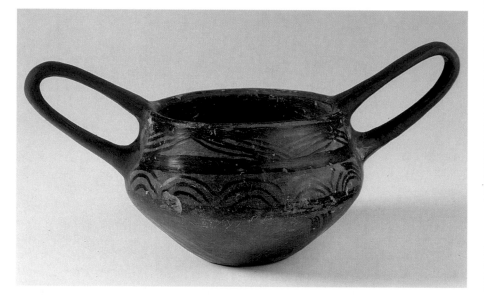

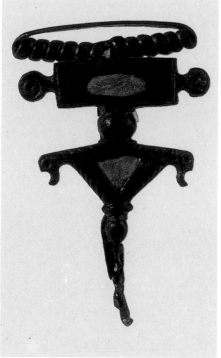

*Bronze fibula from Gomolava
(Yugoslavia)
1st century B.C.
Novi Sad, Vojvodjanski Muzej*

*Upper part of a decorated vase
from Gomolava (Yugoslavia)
1st century B.C.
Novi Sad, Vojvodjanski Muzej*

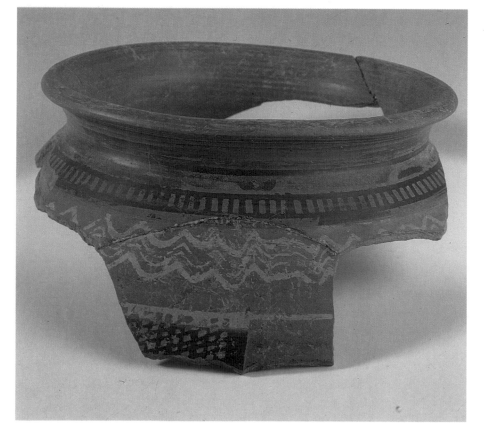

*View of the Gomolava settlement
(Yugoslavia) toward the Sava River
End 2nd-1st century B.C.*

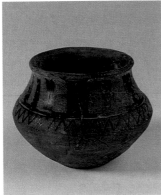

*Small terracotta vase
from the Gomolava settlement
(Yugoslavia)
1st century B.C.
Novi Sad, Vojvodjanski Muzej*

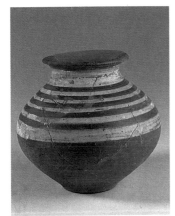

*Painted terracotta vase
from Gomolava (Yugoslavia)
1st century B.C.
Novi Sad, Vojvodjanski Muzej*

A different type of settlement, single-layered and open, has been discovered in many places in Śrem and Bačka. Such settlements, founded on somewhat higher ground and protected from subterranean waters, consisted of a small number of sunken-floored houses with tent-like roofs. Similar to the dwelling structures of the same period found in Hungary or Slovakia, these houses may have postholes at the front and back, or, more often, lack any traces of posts. Given the method of their construction, they were temporary and so were not rebuilt, but used later on as rubbish pits. The duration of these dwellings was probably dependent upon the period of time during which the soil could be cultivated in the area. Once the soil was exhausted, these typically rural settlements were abandoned and a new settlement founded in another convenient place. Most of the abundant pottery finds in these settlements have been dated to the end of the first century B.C. There is evidence that life continued in an essentially unchanged form from the early Roman period to the second century A.D., when large estates (*villae rusticae*) were established.

Clearly, the most important settlements were those of the tell type. These places had high population densities and mainly focused on agriculture, though secondary activities (such as pottery making) were also pursued; therefore, we can describe them as centers of agricultural production in which crafts and commerce were also practiced. External influences and a dynamic internal development brought about a system of settlement organization that may be described as proto-urban in character. Significant changes in the life of the Scordisci and the growing intensity of their contacts with the south are suggested by the numerous finds of drachmas from Apollonia and Dyrrachion, which became more frequent in this area by the beginning of the first century A.D. By the second half of the first century, Roman republican denarii became current, as demonstrated by the stratigraphically reliable analysis of the coins found in Gomolava.

The precise dating of the foundation of these settlements and their chronological relationships is very hard to establish. The most abundant first-century material is rather uniform pottery, while the better diagnostic material (fibulae, weapons, coins) has turned up in much smaller quantities. The archaeological evidence clearly shows that during the first century the settlement pattern became denser and denser. Only the appearance of the imported Roman products (especially bronze vessels used for wine preparation and serving) gives us chronologically precise indications. The decisive Roman penetration to the east and the Danube Valley

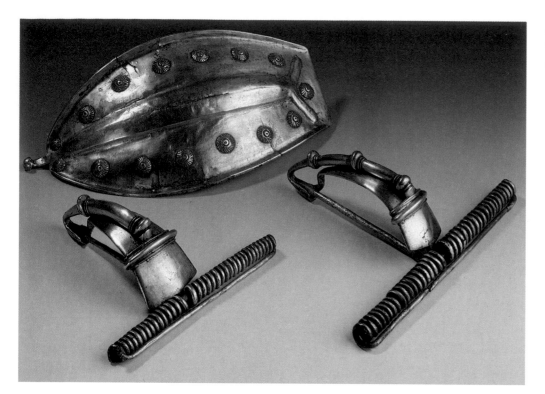

*Pair of fibulae and silver belt-clasp
from Jarak (Yugoslavia)
1st century B.C.
Zagreb, Arheološki Muzej*

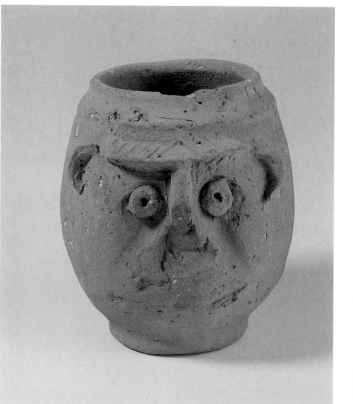

*Aerial view of the La Tène
fortified settlement of Židovar
(Yugoslavia)
2nd-1st century B.C.*

*Aerial view of Late La Tène
fortified settlement of Turski Šanac
(Yugoslavia)
1st century B.C.*

*Terracotta vase from cremation
warrior-grave n. 1
at Mala Vrbica-Ajmana (Yugoslavia)
Second half 1st century B.C.
Belgrade, Arheološki Institut
(Arheološki Muzej Derdapa)*

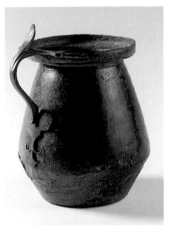

Bronze jug imported from Italy from cremation warrior-grave no. 2 at Mala Vrbica-Ajmana (Yugoslavia) Second half 1st century B.C. Belgrade, Arheološki Institut (Arheološki Muzej Derdapa)

followed Octavian's Illyrian campaign in the year 35 B.C. and the fall of Siscia. By the end of the first century B.C. the Romans occupied the strategically important territory near the Save and Danube rivers, previously held by the Scordisci; this event marks the final point in the Roman conquest of the Balkans. The numismatic evidence suggests the continuity of some of the settlements over longer periods. We have good reason to suppose that the sites on which Barbarian coins, drachmas from Apollonia and Dyrrachion and Roman republican denarii were found were the sites which were occupied continuously from the end of the second century B.C. A considerable number of them lasted in the Roman period: *Mursa* (Osijek), *Cibalae* (Vinkovci), and *Sirmium* (Sremska Mitrovica) became significant cities of the Pannonia province, while *Teutoburgium* (Dalj), *Cornacum* (Sotin), *Acumincium* (Slankamen), *Rittium* (Surduk), *Burgenae* (Banovci) etc. became important forts on the Danube limes. The Scordisci settled primarily in the flat areas, near large rivers—the Danube, the Save and the lower course of the Morava. They occupied the territory from east Slavonia with Taurisci on their western frontier and a large part of Bačka nad Śrem. Following the course of the Danube, we can see that they had penetrated all the way to the confluence of the Timok River, to northwestern Bulgaria and southeast Rumania. In the north, they occupied the area around the Danube and across the Drava, approximately up to the present Yugoslav-Hungarian border. In the south, in hilly parts of Serbia, Celtic materials are rarely found. The ancient geographer Strabo (c. 63 B.C.-A.D. 19) divided them into the Great (*Megaloi*) and the Little (*Microi*) Scordisci. He claims that the former lived west of the Morava and the latter east of it, bordering with the Triballi and the Moesi. Thanks to the new excavations

Painted terracotta vase from cremation warrior-grave no. 1 at Mala Vrbica-Ajmana (Yugoslavia) Second half 1st century B.C. Belgrade, Arheološki Institut (Arheološki Muzej Derdapa)

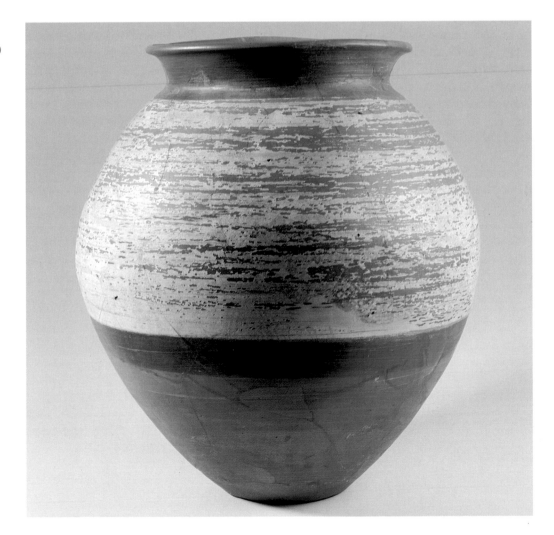

at the Iron Gates, we can today determine the territory of the Scordisci *Microi* with more precision. The Celtic sites, discovered near Mala Vrbica, Vajuga and elsewhere, offer archaeological material analogous to that of the same period found in Śrem or on the site of Beograd-Karaburma. We can, therefore, conclude that the Scordisci Microi did not live in the hilly parts of the eastern Serbia, but in the flat area from the end of the Iron Gates, Kladovo and Turnu Severin, all the way down the Danube to northwestern Bulgaria. In the burials in the Iron Gates, in addition to the Celtic material, elements of Dacian local material culture (mostly pottery) were also found; this indicates that the Scordisci *Microi* enjoyed significant cultural exchange which was not, however, peculiar to them, but a common characteristic of the Scordisci in general. Both historical and archaeological evidence shows that the Scordisci were a mixture of Celtic, Pannonian and Illyrian tribes which populated this territory. Although in the course of the last centuries B.C. the superior Celtic culture had a dominant role, some local forms of weapons and jewelry gained great popularity and were integrated into this hybrid mixture of the Celtic and Balkan traditions. Some characteristics of the Scordiscian pottery are missing from the pottery of the neighboring cognate Celts. For instance, the Scordisci used polishing in their decorative style and they continuously produced the traditional forms of Dacian pottery. The explanation of the difference between the Scordisci and the other Celts lies precisely in their ethnic diversity; a mixture of various traditions and cultures resulted in the emergence of a new community. A good illustration of this is the circular common grave in Gomolava in which the continuing strong influence of the local tradition is visible even at the end of the first century B.C. in the burial customs, the number of the dead buried in the grave, grave goods and so on. The relationship between the Scordisci and the Dacians—two culturally very different populations inhabiting this part of the Danube valley—is especially interesting. Dacian cultural elements (pottery and jewelry; for example, the silver treasure from Kovin) are frequently found not only in the eastern Scordiscian territories but in Śrem as well. Obviously, what we have here is not only the merging of cultures, but an ethnic merging as well, which probably started as soon as the Celts arrived in the Balkans. It is also well known that the Dacians and the Scordisci were often allies in the campaigns to the south. It is possible that the mixed ethnic origin enabled the Scordisci to avoid the fate of the Boii and the Taurisci who were nearly destroyed by the Dacians under Boirebista in the middle of the first century B.C.

There is no information about the political and religious life of the Scordisci to be found in the writings of the ancients. Our only sources are archaeology and numismatics and at present they are capable of offering us only very patchy information. Gradually, the arrival of the Romans on this territory by the end of the first century B.C. caused the disappearance of the Scordisci from the stage of history. As we know from epigraphic material, their traces were preserved only in eastern Śrem, the area in which *Civitas Scordiscorum* existed until the end of the first century or the beginning of the second century A.D.

Pair of decorated iron spearheads from cremation warrior-grave no. 1 at Mala Vrbica-Ajmana (Yugoslavia) Second half 1st century B.C. Belgrade, Arheološki Institut (Arheološki Muzej Derdapa)

*Terracotta cup with tall foot
from cremation warrior-grave no. 1
at Mala Vrbica-Ajmana (Yugoslavia)
Second half 1st century B.C.
Belgrade, Arheološki Institut
(Arheološki Muzej Derdapa)*

*Receptacle and ladle (simpulum)
from cremation warrior-grave no. 1
at Mala Vrbica-Ajmana (Yugoslavia)
Second half 1st century B.C.
Belgrade, Arheološki Institut
(Arheološki Muzej Derdapa)*

*Terracotta vase from cremation
warrior-grave no. 1
at Mala Vrbica-Ajmana (Yugoslavia)
Second half 1st century B.C.
Belgrade, Arheološki Institut
(Arheološki Muzej Derdapa)*

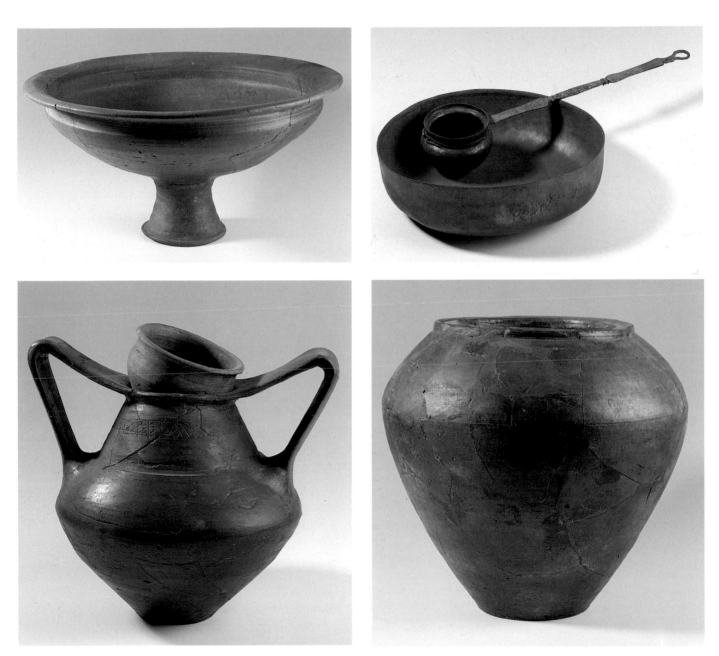

*Terracotta kantharos and small cup
from cremation warrior-grave no. 1
at Mala Vrbica-Ajmana (Yugoslavia)
Second half 1st century B.C.
Belgrade, Arheološki Institut
(Arheološki Muzej Derdapa)*

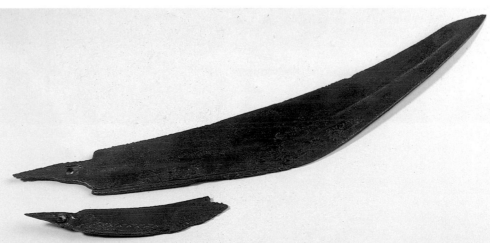

*Pair of convex-backed iron knives
(sica) from cremation warrior-grave
no. 1 at Mala Vrbica-Ajmana
(Yugoslavia)
Second half 1st century B.C.
Belgrade, Arheološki Institut
(Arheološki Muzej Derdapa)*

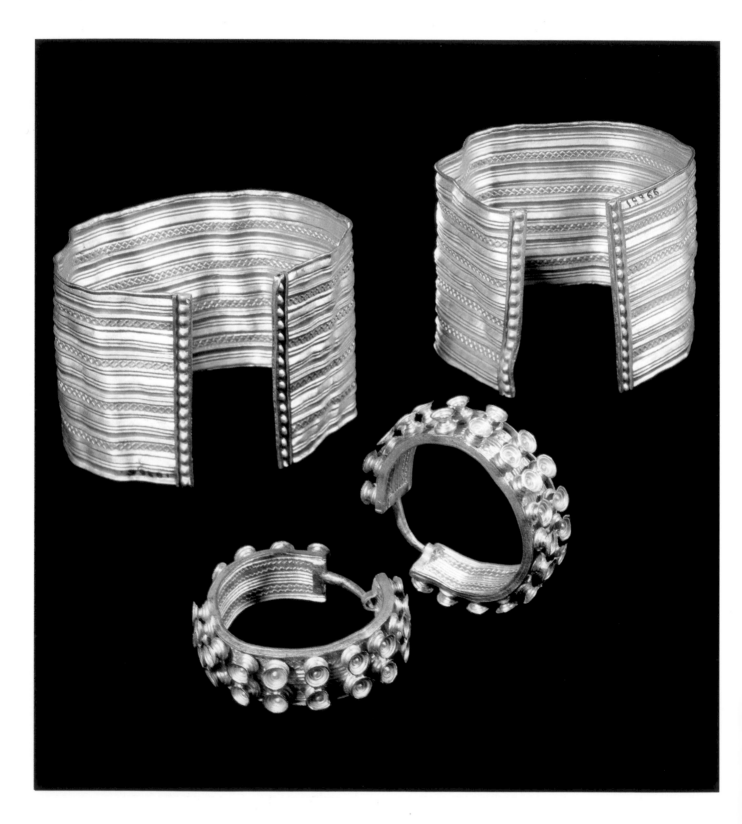

Pair of bracelets and gold earrings
from the princely tomb
in the La Butte barrow
at Sainte-Colombe (Côte d'Or)
6th century B.C.
Saint-Germain-en-Laye
Musée des Antiquités Nationales

The Celts and Their Gold: Origins, Production and Social Role

In the Twilight of the Bronze Age, the Glimmer of a New Age

In the Europe of the Late Bronze Age (1200-750 B.C.) powerful cultural groups, both Atlantic (from Ireland, Britain, Brittany, the Iberian Peninsula) and continental (from southern Scandinavia, central Europe) began to acquire gold objects. The heaviest and bulkiest of these objects were not deposited in graves, but in treasuries of offerings apparently consecrated to gods of nature. These jewels and vessels indicate the collective wealth of these peoples. At the end of the Bronze Age, in the eighth and seventh centuries B.C. there was a change in the way gold came to be used. Towards the end of the Late Bronze Age, around 1000 B.C., it had already become common practice throughout non-classical Europe to add copper to the gold; in other words, to produce an alloy, sometimes to relatively low standard (from twenty to twenty-five percent copper, often adding a certain quantity of silver to the alloy). These alloys provided the means of maintaining such a level of production as was necessary to satisfy social demands. Typological studies in fact prove that these alloys were not in fact technologically necessary but were used in response to the general concern for the need to economize on gold due perhaps to difficulties of supply.

For a period around the eighth century B.C. the situation varied from region to region. In the British Isles, as in the rest of northern Europe, Late Bronze Age production continued for one or two centuries more. In western areas of the continent there were practically no further practical developments. For example in Brittany, where goldsmithing had previously been so well developed, it disappeared almost overnight. Meanwhile, in the south of the Iberian peninsula there were influences deriving from contacts with the east. Phoenician traits are evident in the objects produced which undoubtedly originated in local workshops. This phenomenon can also be noted in certain Italian centers where, unlike the situation north of the Alps, there was practically no earlier tradition of goldmaking. Etruscan goldsmiths also learned from eastern techniques. For them this contact was a revelation which opened the way to the startling and original work of the fifth and sixth centuries B.C., including a perfect mastery of soldering techiques used to create composite objects decorated with filigree and fine grain.

North of the Alps (an area which was later to become Celtic territory), in this pivotal period,

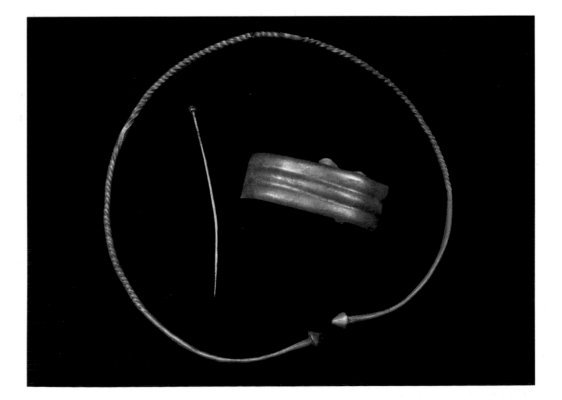

*Torque, brooch, and gold bracelet
from the grave
at Saint-Romain-de-Jalionas (Isère)
8th century B.C.
Saint-Germain-en-Laye
Musée des Antiquités Nationales*

gold manufacture was very rare. A recent discovery made at St.-Romain-de-Jalionas (Isère) has allowed us to study an eighth century B.C. "princely" tomb. Buried along with the warrior under this tumulus were bronze vessels, a sword and pendants of the type widespread in the Late Bronze, Age. But the warrior also wore gold jewelry—a pin with a vase-shaped head, a spiral torque with small studs on the outer edge and a bracelet with three large beaten rings and auricle-shaped terminals. Typologically the pin can be classified as Late Bronze Age, the spiral form of the torque is reminiscent of this period, while the bracelet reveals a variety of influences. Analysis of the composition of these objects shows that they were produced using traditional methods, that is to say, using an alloy of gold, silver and copper.

At Chaffois (Doubs) a gold ring was found in a burial containing a large Hallstatt iron sword dating to the seventh century B.C. This ring—made of twisted and soldered threads— provides us with evidence that this sort of goldmaking continued to be practiced at the beginning of the Iron Age. Rings similar to this one, about three-four centimeters in diameter would seem to be the only evidence of the art of goldmaking found in male graves of the seventh century B.C. Another ring decorated with heavy granulation was found many years ago in one of the tombs of the Hallstatt cemetery in upper Austria.

These different finds, and their rarity and chemical composition, point to a precise evolution in the social use of gold as it changed from being a common commodity to a precious material difficult to obtain and the preserve of only a privileged few. Alloying with copper was an ancient technique, and its continued use suggests that the goldsmiths were still working in the same tradition while developing new soldering techniques. It was during this period that quality control of gold first began to be practiced. This is proved by the discovery of a touchstone found at Choisy-au-Bac (Oise) in a seventh-century B.C. level in the floor of a hut where a small ingot and a ring were also found—probably the remains of a goldsmith's workshop.

Diagram of fastening mechanism for the gold torques from Vix

The Monopoly of the Sixth-Century B.C. Celtic Princes

During the sixth century B.C. gold acquired quite a new prestige. By this time it was the exclusive preserve of the chiefs, princes of small territories in Burgundy and Franche-Comté to the west, Austria to the east and also, in large numbers, in southern Germany and Switzerland.

These princes were buried with great pomp in impressive tombs distributed as far as the eye can see all around their townships. They were buried with the same symbols of power as those sculpted on the warrior of Hirschlanden, a life-size statue placed at the summit of one of these tombs in Württemberg. In addition to a dagger and a belt, these chiefs wore a large collar in beaten gold and, often, a heavy bracelet. Among the store of metal vessels placed in the funeral chamber there was often a gold cup for the libation ritual. Study of the grave of the prince of Hochdorf (Würrtemberg) shows the importance of gold in expressing social prestige. This chief was buried wearing the usual collar and bracelet but also a pair of gold fibulae; gold also adorned his dagger and belt. The immense prestige which he enjoyed during his lifetime was further expressed by the presence of a gold cup placed alongside the container which held the drink and the gold bands decorating the outside of the drinking horns. High-ranking women seemed to have less gold than the chiefs, which confirms the idea that the precious metal was first and foremost a symbol of power. Only in a few female graves, for example at Schöckingen (Württemberg) and at Urtenen and Ins (Switzerland) have there been finds of gold: hollow hair ornaments and bronze pins with large heads formed by two gold leaf shells framing a face, used to fasten garments.

By this time the use of the gold and copper alloy was almost entirely abandoned. Indigenous gold of excellent quality containing just a small amount of silver became the norm.

Gold and Women of Power

The grave of the princess of Vix (Côte d'Or) which dates to about 500 B.C. reflects the pivotal character of this era in which the customs of the sixth and fifth centuries B.C. meet. This

Gold torque terminal from the princely tomb at Vix (Côte d'Or) End 6th century B.C. Châtillon-sur-Seine Musée Archéologique

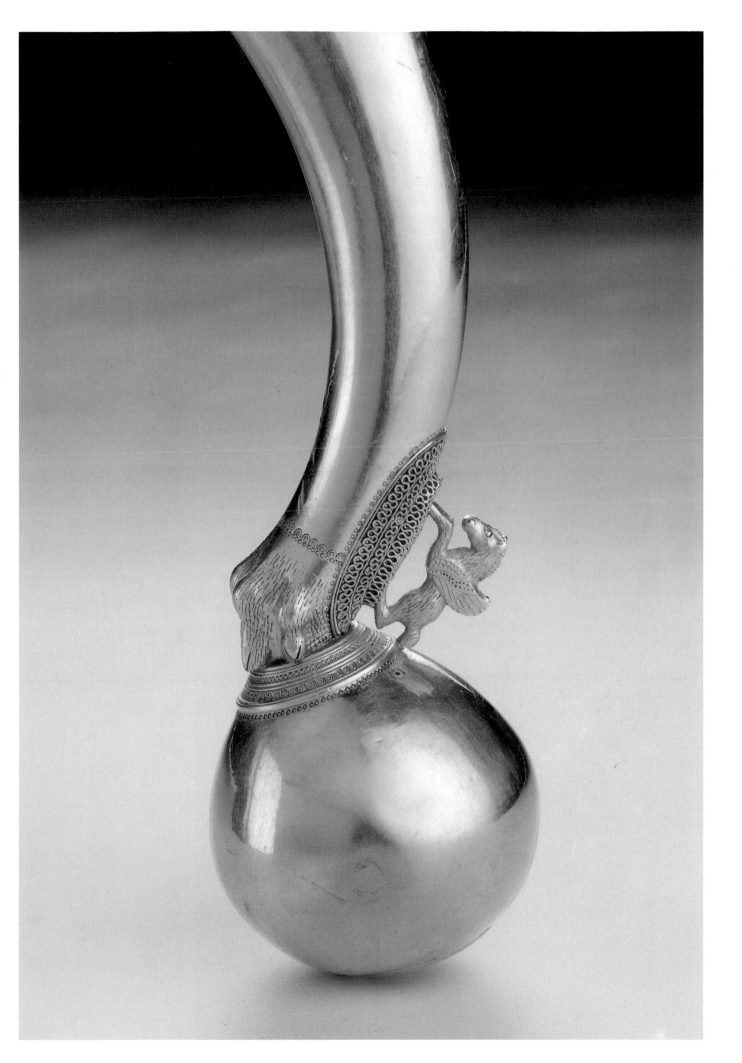

is undoubtedly a female grave but with this woman there is an extremely precious set of burial goods. Besides the drinking service, including a huge bronze krater imported from Magna Graecia, 1.64 meters high and the most important of the treasures discovered, the princess possessed gold and silver objects of outstanding quality. A large necklace, for a long time thought to be a "diadem," has recently been studied in collaboration with the Laboratoire de Recherche des Musées de France at the Louvre in Paris. Radiography has shown that it is in fact composed of about twenty separate pieces, fashioned one by one. Some are cast (for example, the little "Pegasus" figurines and the lion's paw embellishments) while others are beaten (tubular forms, hollow balls made up of two segments). The various pieces were put together using different methods: mechanically assembled, soldered either with bronze or without using any other metal, and brazing. The filigree and rows of beads decorating the little horses are extremely fine, being on average 0.2 millimeters thick, varying in height from 1.5 to 1.8 millimeters. (In other words, they are as delicate as those made by the Etruscan goldsmiths.) Much of the ornamentation is made by punching from the inside of the object. The composition of the metal of the object is quite uniform, its various parts being practically all made of pure gold, with only two percent silver content and one-two percent bronze. The silver *patera* bowl found near the krater is decorated with a small gilt indentation. Metallographic analysis of a tiny sample indicated the presence of a sheet of silver gilded by the reduction process (the layer of gold averages 5-10 microns in thickness, the maximum thickness being 30 microns). These pieces of precious metal found in the princely grave at Vix are extremely important for what they tell us about the influence in these areas of the decorative taste which came from the Mediterranean world, so closely in contact in this era to the Celts. At this period, around 500 B.C., the goldsmith tended to seek originality at all costs, to use as much embellishment as possible and to use to advantage the new effects offered by combining the use of molds and the many different techniques of manufacture and decoration. The use of hard punches, probably made of iron, to decorate surfaces was also a new technique; these very sharp tools produced a high level of precision. The processes of soldering and brazing on the same object which Celtic goldsmiths had now mastered allowed them to give full expression to a creativity previously unknown. The high quality of the precious

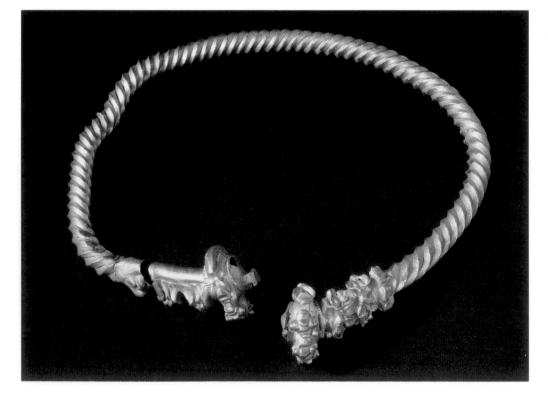

Gold torque from Civray-en-Touraine (Indre-et-Loire)
3rd century B.C.
Saint-Germain-en-Laye
Musée des Antiquités Nationales

metal objects found in the grave at Vix could only have been achieved in workshops where master goldsmiths were working. The intricate assembly of the pieces and the goldsmiths' taste for gilded silver indicate the extent to which they were influenced by their Etruscan counterparts; nevertheless, a Celtic vein undoubtedly pervades their work.

A little later, between the Rhine and the Moselle, some women were buried in graves fitted out with burial goods which were equally sumptuous, and in some instances even more magnificent than those of the majority of their contemporary warrior chiefs. The princely character of the tomb at Vix in Burgundy is not a unique case, though it is perhaps the earliest. There are other rich female graves from the fifth and sixth centuries B.C. As a matter of course the most important women wore a gold torque, at least two gold bracelets and a variety of jewels decorated with precious materials—rings, fibulae and pendants. The most famous of these fourth-century B.C. Celtic princesses' graves are those found at Rheinheim in Saarland and Waldalgesheim in Rhineland, though they are several generations apart. Like other barbarian peoples, the Celts made great use of gold as a symbol of power and these prestigious finds most certainly confirm that some Celtic women played an exceptional role in their society.

Military Decorations

During the sixth century, B.C. Celtic princes generally lost the taste for the display of wealth which their predecessors had favored, even though they continued to wear gold. Ornaments of unusual form, a type of mount made of bronze, or iron and bronze, and decorated with amber and coral have been found in a group of warrior graves in the Rhineland. They were mounted on a leather strap, a baldric perhaps, and may have been a particular honor granted to noble conquerors. These multi-colored mounts were all found in male graves and seem to have been in use for two generations.

By this time the regions between the Rhineland and Champagne were becoming more dynamic. Here, in addition to the rings and ear-rings found in graves, the Celtic warriors often wore another ornament, symbolic of prestige, a bracelet—sometimes made of gold—on the left arm. Thus they recall the description later sketched by Strabo: "They cover themselves with

Gold torque from Montans (Tarn)
3rd century B.C.
Saint-Germain-en-Laye
Musée des Antiquités Nationales

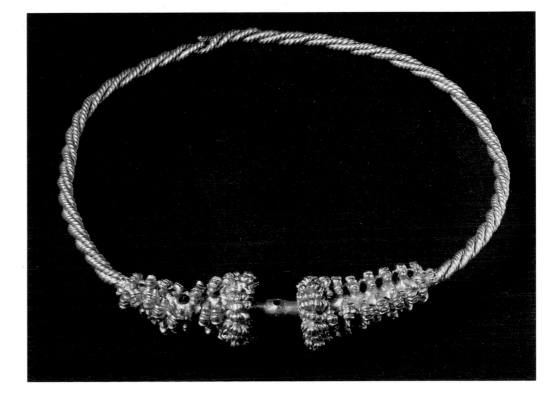

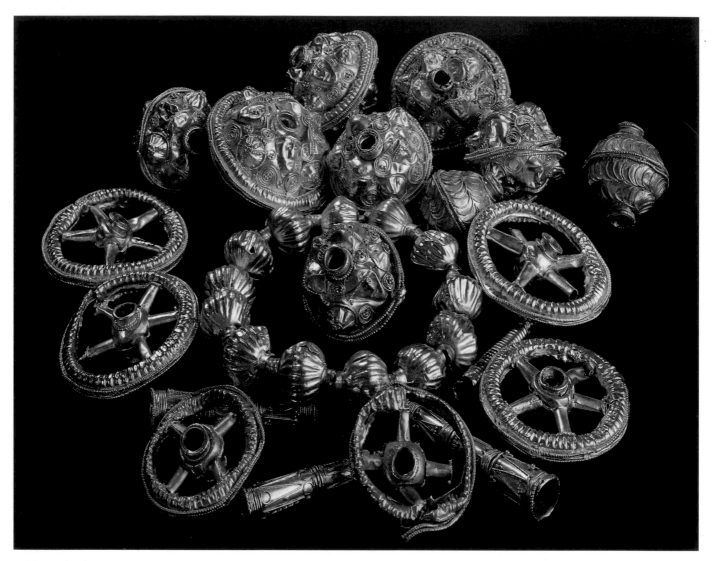

gold jewels, they wear necklaces of the same metal, armbands and bracelets of gold and their chiefs dress in fabrics dyed in lively colors and gold brocade." The most curious of these gold bracelets, examples of which were found at Hillesheim and Theley in Germany and at La Gorge-Meillet in Champagne, is that worn by the warrior of Rodenbach (end of the fifth-beginning of the sixth century B.C.). An unusual gold ring with a decoration that mixes fantastic animals and monstruous human figures, is the only gold ornament buried with this prince, who was surrounded by weapons and a luxurious set of vessels.

A whole series of circular, bronze or gold-plated iron mounts was designed to decorate obects made of organic materials: vessels, drinking horns, decorations for baldrics, belts or leather helmets. The largest of these discs, and the most westerly find, is the example from Auverssur-Oise (Val-d'Oise), an ancient discovery. It is particularly spectacular because of the embossed sheet gold which is attached to another, more solid, bronze support. The gold lends itself ideally to the embossed design, and set into the wide indentations there are pieces of coral, an extremely exotic material which was undoubtedly imbued with great symbolic meaning.

In general, the Celts did not import gold objects. The rarity of imports such as the chain and bead found at Ins near Berne (Switzerland) and the discovery of branches with leaves made of gilded bronze in the *oppidum* of Manching in Bavaria prove this rule.

Before the third century B.C. both bronze and gold torques are generally found in the graves

Beads decorated with masks wheel-shaped pendants and other parts of the gold necklace from the hoard at Szárazd-Regöly (Hungary) Second half 2nd century B.C. Budapest, Magyar Nemzeti Múzeum

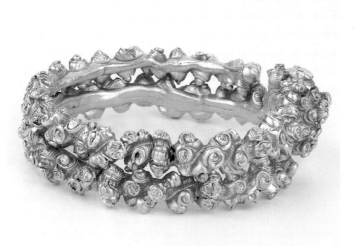

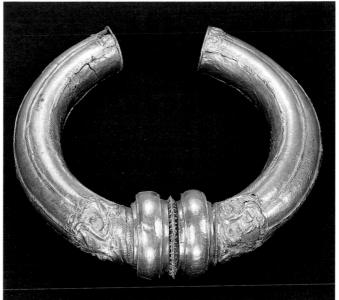

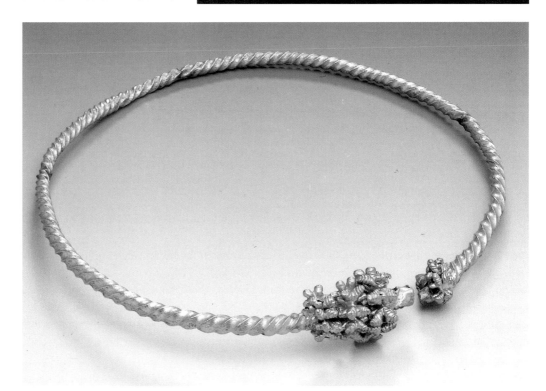

of Celtic women. For reasons which remain obscure, after this time they were worn only by men and became objects used as offerings. Stone or metal monuments provide us with illustrations of torques and of money. Of the torques dating to the Late Bronze Age (the La Tène period) those made of gold are relatively late: the phenomenon of ritual sites with offerings of gold torques dates to the fourth century B.C. These striking deposits are to be found in all Celtic areas from Erstfield in the Zurich region, to Fenouillet (Haute-Garone in the southwest of France), and as far west as Snettisham (Norfolk, England). Occasionally gold staters were also part of the treasure, as in the case of the deposit at Niederzier in the Rhineland and that of Tayac in the Gironde. Although the real situation must certainly have been very complex, we can state that the first gold coins were made as offerings to the gods.

The Celtic War Chariot
The Experimental Reconstruction in
the Schweizerisches Landesmuseum
Andres Furger-Gunti

*Reconstruction of Celtic war
chariot built by the Schweizerisches
Landesmuseum Zurich*

*Protoceltic chariot-grave
from Somme Bionne
discovered in the 1800s*

1. Source Readings on Celtic War Chariots
(esseda)

According to the historian Livy (X, 27, 30), in the battle near Sentino with the Gauls in 295 B.C. the Romans "were terrified by a new method of warfare; the enemy arrived armed, on two-wheeled and four-wheeled vehicles (*essedis carrisque superstans*); great was the noise of the horses and wheels and the Roman mounts were thrown into a panic by that fearful din to which they were unaccustomed."

In the year 55 B.C. Caesar had this to say in his account of his experience in Britain: "The method of combat is as follows: first the Britons race in all directions across the battlefield hurling spears, and the dread instilled by the horses and the noisy wheels soon bring panic to the enemy ranks; then they force their way into the cavalry lines and, jumping down off their chariots, proceed to fight on foot. The charioteers in the meantime slip out of the battle zone and arrange the chariots so that, should their kinsmen be beset by the enemy they can quickly turn back and return to their positions. Hence in battle they have the dual advantage of the mobility of horsemen and the stability of infantry. Owing to their daily practice, they are capable of reining in the galloping horses even on steep ground, and adroitly maneuver their mounts, rush forward, seize the yoke of the horses and then nimbly leap back into their chariots." (*Gallic War*, IV, 33)

Elsewhere Caesar notes that the war chariots were mainly employed against cavalry, and clearly the Britons knew how to deploy thousands at a time. Further passages in Polybius, Strabo, Diodorus, and Tacitus attest that two-horse chariots were used in the flanks on the battlefield, and that each one was manned by a charioteer and a warrior; as in the case of Homer's heroes, the chariots were reserved for high-ranking figures.

Archaeological sources give us the following picture: two-wheeled chariots are particularly frequent in tombs from the fifth and fourth centuries; they replaced the earlier Hallstatt four-wheeled wagon. In the third and second centuries B.C. there are fewer chariots, and become even more rare in the next.

But what did the chariots actually look like? The metal remains found in the tombs give us some idea. The two-wheeled war chariots were well-known throughout the ancient world but especially in Champagne. The Celts came relatively late to chariot-building, but drawing on the old traditions they quickly becoming renowned as cartwrights. Thanks to their phenomenal skill as drivers, the various Celtic types of chariot soon entered into other languages, in much the same way as today's computer in English has taken hold in other languages across the world. Words of Celtic origin defining the

different types include *carrus*, *carpentum*, *covinnus*, *petorritum*, *reda*, and *benna*.

2. Typical Features of Celtic War Chariots

The finds mentioned above and the more important occurrences on stone monuments published by Otto-Hermann Frey indicate the following common features. Above the wooden axle between the wheels was an platform open at both front and back, with varying kinds of side flaps forming wheelguards. The charioteer sat at the front, holding the reins of both horses and a riding whip. The warrior either stood or sat behind the charioteer, armed with a javelin, a shield and a sword slung across his chest.

The two-wheeled chariot was drawn by two small horses or ponies harnessed to a wooden yoke fixed to the spar. The yoke could be attached in three different ways: to the horses' backs (as shown on Celtic coins), to the withers (often considered a poor half-measure), or to their necks (as repeatedly shown in late Celtic art). Such details of Celtic war chariots have been known for a long time.

But new discoveries in recent years, have begun to suggest that the Celtic chariot was of a far more complex design than so far

thought, i.e., with the coach suspended from metal cotters.

3. The Reconstruction in the Schweizerisches Landesmuseum, Zurich

Given the situation, a few years ago the author decided to engage special craftsmen to piece together a full-scale, experimental model of a Celtic chariot, to solve technical problems and get a picture of what they were really like. The point of departure for the reconstruction came principally from objects found at La Tène C level in Neuchâtel, which may have been part of a votive deposit that sank into the lake in the second century B.C. The museum's exhibits include two authentic plaster casts, made in the last century on the site, of carved wooden yokes and a well-preserved wheel. The casts were used as models for the reconstructed chariot. La Tène also yielded linchpins which must have made it possible to remove the wheel for lubrication (Pliny speaks of a lubricant, *axungia*). The same site also yielded cotters, which have recently been the focus of the problem of suspension since new tombs revealed cotter pins of this kind in groups of four, usually in correspondence with the four corners of the presumed platform of the chariot.

The reconstructed chariot was made in ash (with wheel-hubs in elm) by an eighty-three-year-old cartwright who in his youth had built numerous carts with wooden axles. The ends of the axle were worked on a lathe to give them a gentle tapering form as used on locally-made axles dating from Roman times found in the fortified Roman camp of Zugmantel. The wheels with the curved single-piece felloes are true works of art; the ends of the felloes met up exactly

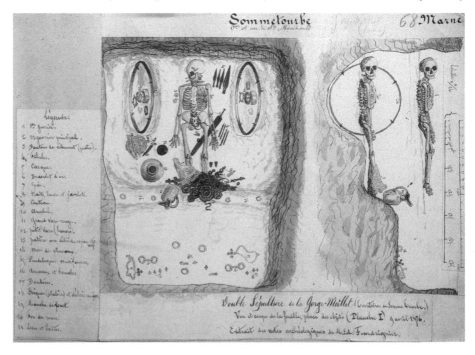

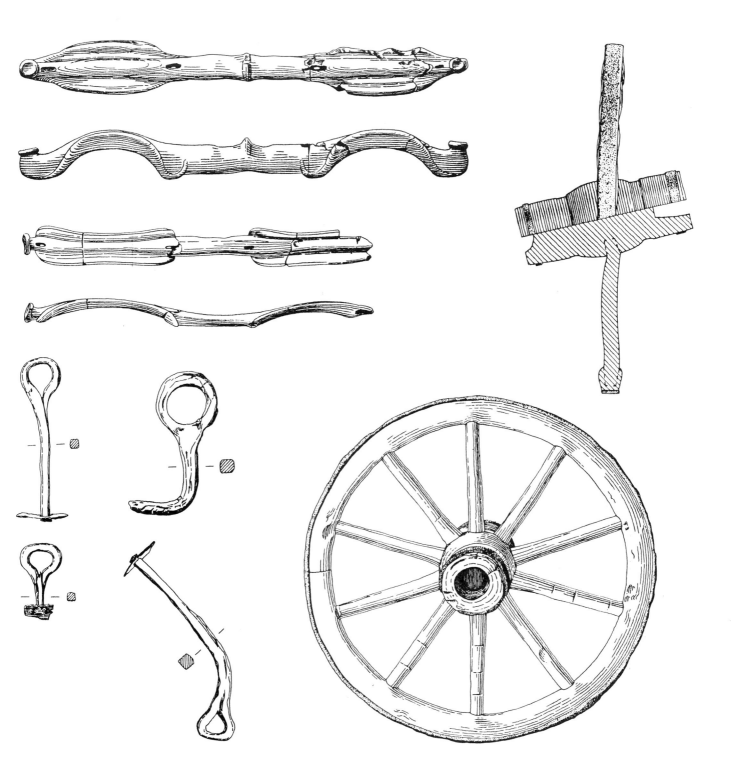

*Wooden yokes from La Tène
(Neuchâtel) preserved in molds
during excavation and iron chariot
trappings from the site
3rd century B.C.
Zurich
Schweizerisches Landesmuseum*

rather than overlap obliquely. As usual, the spokes were inserted first into the wheel-hub after soaking at length in hot water, and after ten hours they were slotted into the perfectly circular felloe, which was stretched over a solid supplementary hoop, and the tenons of the spokes fitted into the prepared slots. Finally, the tire was heated and fitted to the wheel. The problem of the linkage between the shaft and the axle was solved as follows: the rear end of the shaft and the two reinforcement arms pegged alongside them, were joined securely in the gap between lower and upper blocks of the axle. These side arms were then curved up and back to provide rests for the double cotters supplying the suspension of the coach. This was a neat solution to the unsolved question of the exact position of the cotters. As with the felloe, the curved shaft and reinforcement brackets were made by bending the wood with steam.

In Switzerland this arm is called a *Grättelarm*, and there may even be some linguistic connection between this term and the ancient Irish word *crett* for the construction of battle chariot frames.

An alternative for creating supports for the double cotters is a transverse system of suspension, as already proposed, or suspension from one axle in the forward part of the chariot. On the basis of construction evidence I favor the longitudinal suspension with the bowed *Grättelarme*. After we had put this model together, verification of its design came unexpectedly from another source.

4. Irish Texts on War Chariots

In Ireland war chariots continued to be used for a long time, and ancient Irish texts frequently mention the use of chariots closely resembling the Celtic *esseda*. Our attention was drawn to this fact by translators such as R. Thurneysen and H. Bauersfeld and, more recently and more systematically by D. Greene. As elsewhere, in Ireland too, charioteers and warriors on chariots were generally high-ranking. The sagas, which were first committed to written form in the seventh and eighth centuries A.D., illustrate some curious customs, such as the clothing of the charioteer, which included of a red-and-yellow headband to denote his status.

Charioteers were expected to master three basic techniques, which included leaping ditches, bringing the chariot to a swift halt, or changing direction sharply, and not least a dexterous handling of the whip. In the text cited below various mentions are made of strange parts of the chariot, called *fertas*: "While we were there, we saw the outlines of horses and men on swift chariots emerge from the mist. A charioteer behind them (the horses); a head; horses running at the same pace (?). Then I saw two horses... a huge chariot behind the two horses with large, solid wheel-hubs. Two matching felloes in proportion (?) Two *fertas*, hard and straight as swords. Two bridles admirably twined... (LU, 113, 9251ff., from H. Bauersfeld, 1944, p. 13) In 1944, Bauersfeld suggested the most likely shape of the *fertas*, saying "...they must mean two beams jutting from the back at either side of the wicker coach..."

In Ireland, these *fertas* were compared with strong but flexible sword-blades. They were also vulnerable, however, and could snap off on uneven ground. Hence they are unlikely to be simply a means for lifting the chariot, or handles of some kind—the strength of the *fertas* was clearly a determining factor for the stability of the entire chariot. According to a passage in the sagas of Cú Chulainn, the worthiness of the chariot depended on the stability of the *fertas*, which means they must have been an essential component of the construction itself whose exact function at the time of sagas were being written down was not exactly known, but which strikingly resemble the *Grättelarme* of our reconstruction.

5. Chariot Suspension and Harnesses

In our model, the chariot's rear suspension consists of the double cotter pins attached to the upper part of the arms.

Thus it is obvious why certain parts of the elements were richly decorated—these were parts that were in view on the chariot. In our iron prototypes, the two parts had rested on, and eventually folded over, one another. The pair of long double cotter pins firmly soldered together that were found on the site show a kink that corresponds to this fold. A strap made of cord, braided leather, catgut, or other material, may have passed through the eyelets of the double cotter pins, and run underneath the platform to be anchored to the shaft. To the front of the platform, it seems that another piece of wood or two short arms were fastened to the shaft, but we have too few clues to propose its exact reconstruction. In our model we chose a "snatch block" pegged to the shaft, which was grooved to accommodate the strap.

We suggest that the coach had a flexible suspension to ease the ride on the bumpy roads. This was integrated with the stabilizing effect of the *fertas*, and the elasticity of the material used for the straps, the tension of which in our reconstruction is easily adjusted by means of a device set beneath the shaft.

The charioteer and warrior were protected from contact with the wheels—which spun dangerously close to them—by side-screens. These came in a wide variety of shapes and sizes, judging from the documents that have come down to us. Taking our inspiration from the model shown on the *scauro denarius*, we selected a sort of arch made of steam-bent wood. The decoration stamped in the leather elements are based on the triple spiral-rosette motif used on La Tène horse trappings.

The system for harnessing the horses to the shaft and yoke made for excellent handling. While tracer reins were not introduced until later, previous reconstructions of Celtic chariots, such as the one built by C. Fox, included tracers because of references to straps (*sithbe*) in Irish texts. These *sithbe* may actually be the straps holding up the coach, as they are once specifically mentioned alongside the *fertas*. As for the shaft, in our reconstruction we placed it centrally to the rear half of the coach.

6. The Trial Run

The Franches-Montagnes horses that we chose to pull the chariot had a height of 1.65 meters at the withers, and were therefore between ten and forty centimeters taller than the generally smaller horses used by the Celts. The yoke was fixed to the back of the horses with a bellyband, and a narrower and softer band was used for the collar, and a third for the martingale. The harness was a modern military device (with buckles) fitted in the old way with four bridles (without cross bridles). After some initial hesitation, our horses were soon able to change from a normal pace to a trot or a gallop. The hundred-kilo chariot was later loaded with two or three people (180-250 kilos). The platform oscillated slightly, especially in the forward section near the double cotters. In these exposed points—especially at their articulation—the cotters clearly prevent excessive wear of the chariot straps.

As soon as we left the main road and crossed some freshly mown fields with furrows of around ten to thirty centimeters deep, the standing position quickly became very awkward. With no suspension it was virtually impossible to remain standing when the horses were trotting, and even harder to throw a spear with any accuracy. The suspension predictably took the edge off the worst jolts, and it became easier to remain standing. The sitting position of the charioteer is clearly safer, and turned out to be much more comfortable that we had imagined. When the warrior is standing, unarmed, gripping the side-screens, he provides the necessary balance and the chariot could be driven at high speed, even over small ditches.

Dimensions	Reconstruction Schweizer risches Landesmuseum	Grossbous-Vichten (by J. Metzler)	Middle Rhine area (average values by A. Haffner)
Weight	100 kg		
Total length	3.86 m		
Total width	1.82 m		
Total height	1.45 m		
Gauge (from the center of the tire)	1.34 m		1.35-1.45 m
Wheel diameter	0.86 m	0.84 m	0.80-0.95 m
Hub length	0.40 m		0.30-0.35 m
Hub diameter	0.22 m	0.16 m	0.13-0.17 m
Platform width	0.80 m	0.90 m	0.80-1.00-1.20 m
Platform length	1.19 m	1.00 m	
Shaft length (to the axle)	3.22 m		
Outer diameter of axle	6-8 cm		

All in all, the trials confirmed that our model was fully functional and that we could obtain a better distribution of weight by shifting the axle, and hence perfect the chariot's balance.

Despite all the positive results, while constructing and testing the chariot, defects in our design came to light, together with possible ways of solving them. Generally speaking, the chariot could be of slightly lighter build, with the lateral reinforcement arms slightly higher and smaller, to assist the suspension, and likewise the shaft.

The wheels too could be more lightweight and without the slight slant we gave them this time. The ends of the axle should in this case be lathe-worked without the taper, which reduces the friction with the linchpin.

7. Conclusions

One of the main questions seems to be solved, namely, the supposed longitudinal suspension used by the Celts for two-wheeled chariots proved feasible in the trial model that we built. In my opinion this also solves another problem that recently emerged in the history of technology: while the Roman chariots have transverse suspension, the first medieval wagons of the tenth century have longitudinal suspension in the form of a chassis with *stante* (vertical laths) suspended by chains or rods, or supported on belts. Given the above, this is clearly a straightforward continuation of the Celtic custom of suspension with longitudinal belts. The principle of longitudinal suspension was carried through well into the modern age.

The Settlement
and Cemetery at Ensérune
Martine Schwaller

Aerial view of the Ensérune site
(Hérault)

Dominating the plain of Languedoc at a height of over 100 meters, the hill of Ensérune stands out against a landscape of vineyards, ten kilometers west of Béziers, and fifteen kilometers east of Narbonne. At the foot of the *oppidum*, toward the north, lies the marsh of Montady, famous for its star-shaped drainage system constructed in the thirteenth century.

Ensérune itself occupies a privileged position. The sea is ten miles as the crow flies and, toward the north, the site opens onto the Cévennes foothills. To the south, the *oppidum* is skirted by a roadway that was vital in antiquity—it was a long protohistoric track linking Italy to Spain, and later became the Via Domizia during the Roman Conquests.

This high-lying habitation was first occupied midway through the sixth century B.C., and remained inhabited uninterruptedly through to the start of the first century A.D. The area's lengthy evolution can be subdivided into three phases:

- The Early Iron Age, from the end of the sixth century B.C. to the end of the fifth. The area occupied was mainly concentrated on the summit of the plateau. The huts were of perishable material, built without any apparent order, with large gaps between them. The fifth century B.C. saw the emergence of the Ibero-Languedoc horizon, a cultural phenomenon that manifested itself throughout the western Languedoc. Also dating from this period, there are clear indications of imported goods from the Mediterranean world (Greece, Etruria, etc.).

The second settlement follows directly on the first in the last quarter of the fifth century B.C, with the dwellings clustered in the eastern corner of the site. Numerous alterations took place: nevertheless the settlement was given a rampart, reinforcing its status as *oppidum* and market, while the dwellings themselves were built in dry-stone on a regular plan arranged along streets bordering each neighborhood. This layout remained unchanged until the end of the third century B.C., when buildings began to consist of a single unit.

This phase is marked by growing development and increasing trade and exchange with the surrounding cultures, as attested by discoveries in the cemetery 400 meters from the settlement at the westernmost rim of the site. This cremation cemetery was brought to light in 1915, and so far 500 tombs have been excavated, providing key insights into funeral practices of the Second Iron Age. The cemetery was in use until midway through the third century, when it was abandoned and progressively absorbed by residential expansion.

- From the end of the third century B.C. to the beginning of the first century A.D., the "town" reached its zenith of expansion, covering the entire hillside to the foot of the slopes. A new and more modest fortification protected the western approach to the site, incorporating the former cemetery. It is in this sector that the influences of Graeco-Roman architecture are most evident, with the building of multi-roomed dwellings and the addition of peristyles. Rapid technical progress can be detected in the architectural modifications, and is also noticeable in the numerous everyday artifacts.

Despite all these changes, the *oppidum* retained its traditional layout until it was abandoned. This must have taken place gradually, as there are no traces of destruction. Bit by bit the inhabitants left the overcrowded areas for the new settlements in the plain, which emerged as a result of changes in the economic organization.

The cemetery has yielded vital evidence concerning the Celtic influence; twenty percent of the cremation burials from the beginning of the third century B.C. contain a more-or-less complete classic panoply of a warrior (sword in its scabbard, chain-mail belt, spear-tip and butt, shield fittings, etc.); their occurrence in association with black-glazed pottery is of fundamental significance for the chronology. There are signs of intense trade with the Celtic world from the fifth century on, mainly involving metal objects (belt buckles, etc.) but the changes this brought were of an exclusively material nature and no ethnic interference can be inferred. The assemblage at Ensérune is predominantly Iberian, to which is added a mosaic of diverse components making its culture strikingly unique.

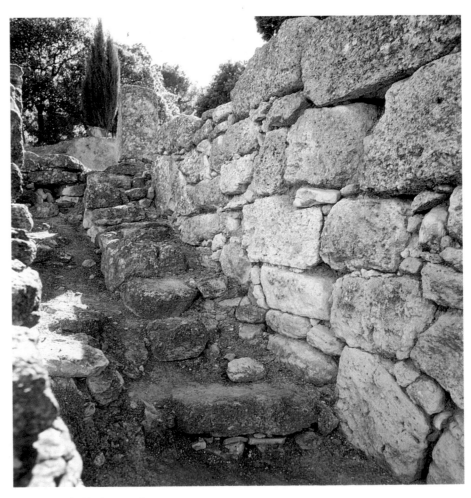

Stairway in the Ensérune settlement
(Hérault)
End 4th-1st century B.C.

*Black-painted pottery dish
from warrior-grave no. 163
at Ensérune (Hérault)
Early 3rd century B.C.
Nissan-lez-Ensérune
Musée d'Ensérune*

*Detail of the iron scabbard
from warrior-grave no. 163
at Ensérune (Hérault)
Early 3rd century B.C.
Nissan-lez-Ensérune
Musée d'Ensérune*

*Black-painted bowl
from warrior-grave no. 163
at Ensérune (Hérault)
Early 3rd century B.C.
Nissan-lez-Ensérune
Musée d'Ensérune*

*Terracotta receptacles
from warrior grave no. 163
at Ensérune (Hérault)
Early 3rd century B.C.
Nissan-lez-Ensérune, Musée d'Ensérune*

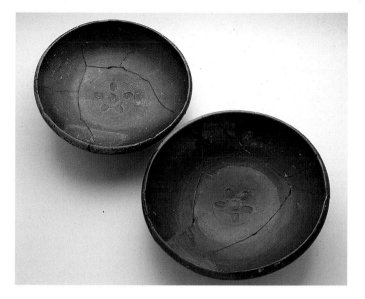

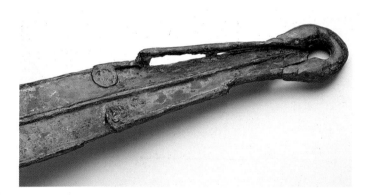

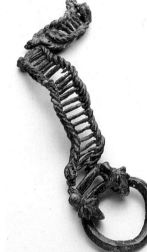

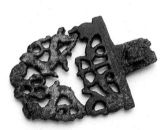

*Kantharos from warrior
grave no. 163
at Ensérune (Hérault)
Early 3rd century B.C.
Nissan-lez-Ensérune, Musée d'Ensérune*

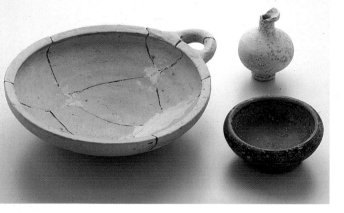

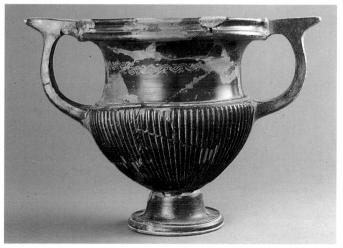

The Hillfort and Sanctuary
at Roquepertuse
Brigitte Lescure

The site of Roquepertuse (Bouches-du-Rhône, France) is situated on a rocky promontory in the Arc valley, in the municipality of Velaux, fifteen kilometers west of Aix-en-Provence.

The excavations directed by Henri de Gérin Ricard over the period 1919-1924 and resumed in 1927, yielded a spectacular assemblage of sculpted and painted works unique in southern Gaul. The assemblage consists of over two hundred fragments of the malleable local limestone, painted, engraved and sculpted, two statues of squatting men (discovered long ago), a two-faced head, a bird, a frieze with horses, and monolithic pillars on which head-shaped cavities have been hollowed out.

The stone fragments were sufficiently numerous and distinctive to allow the excavator to suggest a reconstruction, which revealed a portico with three stone pillars seventy centimeters apart, complete with lintel and bird sculpture.

The reconstruction and the information from the excavation suggested that on the upper terrace of the site there had been originally an arcaded building containing two statues.

More recent archaeological research has made it possible to place the finds in their cultural context, second Provençal Iron Age. Other buildings of the same type may have existed elsewhere, such as in the *oppidum* of Entremont, for instance, and statues of unmistakable stylistic similarity with the two squatting male figures of Roquepertuse have been discovered at Entremont (Aix-en-Provence), La Cloche (Pennes Mirabeau), Glanum (Saint-Rémy-de-Provence), Constantine (Lançon-de-Provence) and Rognac.

Thanks to their exceptional condition, the works found at the Velaux site provide a point of reference for European architectural sculpture. The site, destroyed by fire around the beginning of the second century B.C., remained uninhabited and hence was left unaltered. The first excavations in fact revealed the site just as it had been left after the fire. However, theories advanced at the time should be carefully reconsidered now that the Musée d'Archéologie Méditerréenne is due to be transferred from Château Borély to the Centre de la Charité, and a new program of study and restoration of the assemblage undertaken.

An interdisciplinary scientific commission was set up to make a detailed study of Roquepertuse, made up of experts in every discipline: conservation; the reassembling of the pieces and the preservation of the painted sections, restoration, architecture, the dressing of the stones, archaeology, scientific interpretation of the finds and their archaeological context.

The commission's work has already led to a total reconsideration of the reconstruction of the assemblage as known to the public since the 1930s. As a result an entirely new museum presentation will shortly be opened to the public.

The operation, coordinated by the Musée d'Archéologie, illustrates the growing need for close collaboration between different institutions of the scientific world. On this occasion, the project involves research into a range of unanswered questions concerning protohistoric civilizations of southern Gaul, touching on such essential areas as the study of the environment (dwellings and natural habitat), cultural practices (the iconography), and architecture. The Roquepertuse finds represent more than mere milestones in the history of art. They provide valuable insights and information, and the role of the museum is to make their interpretation easier.

Studies conducted by François Salviat have shown that the sculptural works in question were not necessarily cult figures, but illustrate the society of the period: the statues of men sitting, cross-legged, in typical Celtic fashion, adorned with torques or bracelets and dressed in armor, represent the

Stone slab painted with a marine animal from the Roquepertuse sanctuary (Bouches-du-Rhône) 3rd century B.C. Marseilles Musée de la Vieille Charité

Stone statue of deity or hero from the Roquepertuse sanctuary (Bouches-du-Rhône) 3rd century B.C. Marseilles Musée de la Vieille Charité

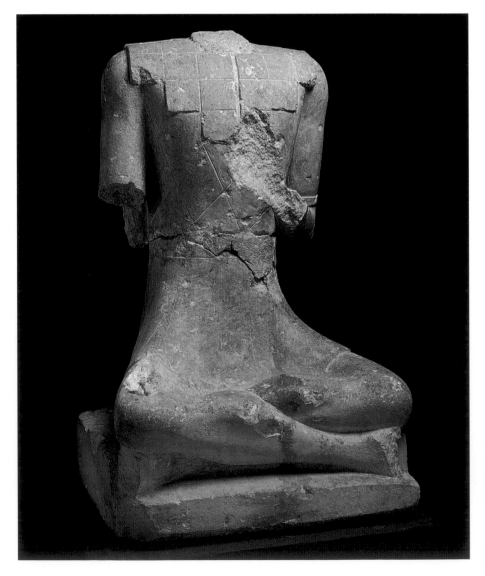

chiefs of the local aristocracy. These statues were situated in the portico, and at Roquepertuse there were at least four, probably raised on supports, as at Glanum, where finds made in 1968 shed new light on the cult of the heroic warrior.

The other pieces unearthed (the bird, the Janus-type head, the engraved horses) were part of an architectural complex built of timber and stone, of which only the stone has survived. Besides the monumental sculpture, the iconographic repertoire include painted and engraved works. The horses and geometrical friezes already mentioned are enhanced by an engraved human figure, a marine creature, and another beast with the body of a serpent, currently being cleaned. As to the origin of this group of Celtic art works, it is best seen as the expression of a protohistoric society of the Late Iron Age, heirs to a local subculture that can be traced back as far as the Neolithic age.

This assemblage is the fruit of a slow maturation of ideas at a time when a new dynamic force was affecting this society. The small stelae laid into the flooring below the upper terrace are proof that the area was used over a long period, extending from the Early Iron Age. This indicates a cultural continuity that remained unaffected by outside influences, unlike the situation in eastern Languedoc, where changes in funerary rites denote intrusive cultural influences on the farming populations (Ensérune). In Provence, the indigenous cultural assemblage is typified by pottery made without the wheel and devoid of La Tène features.

The Celtic-style metal items, abundant in the fourth and third centuries B.C., are all imported. Nonetheless, outside influences were not completely absent, as can be seen from the mold for Teste Nègre-type bracelets recently discovered at Lattes (Hérault) in an early second century B.C. context. The Roquepertuse finds belong to a cultural and artistic tradition known exclusively through statuary.

The iconography of the compositions painted or engraved on the stone, such as those on the pillars and lintel, harks back to another, earlier set of values the significance of which is now inaccessible to us. Roquepertuse also boasts the earliest and best-known examples of the ritual displaying of severed heads, believed to be a Celtic custom, described in the early histories by Diodorus Siculus, Strabo, and Posidonius who observed it in southern Gaul and more precisely in the vicinity of Marseilles. It is therefore to be wondered who were the "Celts" mentioned by these authors.

Bronze bracelets
from the La Cloche oppidum
at Pennes-Mirabeau
(Bouche-du-Rhône)
Late 3rd-early 2nd century B.C.
Marseilles
Musée de la Vieille Charité

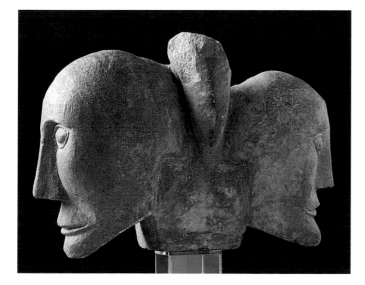

Stone head of janiform deity
from the Roquepertuse sanctuary
(Bouches-du-Rhône)
3rd century B.C.
Marseilles
Musée de la Vieille Charité

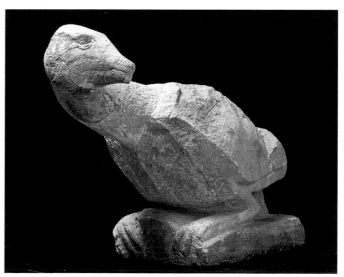

Stone statue of bird of prey
from the Roquepertuse sanctuary
(Bouches-du-Rhône)
3rd century B.C.
Marseilles
Musée de la Vieille Charité

The Celtic Sanctuary
at Gournay-sur-Aronde
Jean-Louis Bruneaux

*Iron swords, ritually bent
from the sanctuary
at Gournay-sur-Aronde (Oise)
3rd century B.C.
Compiègne, Musée Vivenel*

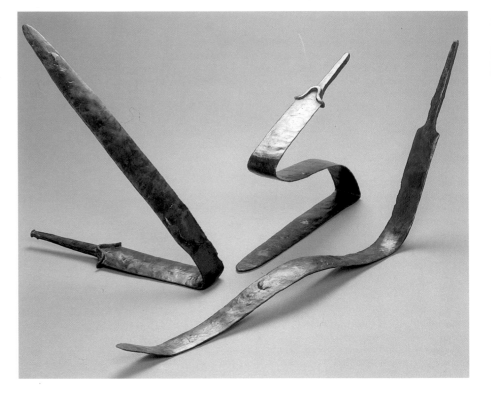

In 1975, the first sanctuary that can definitely be attributed to the Celts was found at Gournay-sur-Aronde in France. The excavation that followed brought to light many other similar discoveries, but above all it opened up a new avenue of research into La Tène civilization, that of its religion, as manifested in archaeological evidence.

Following thorough excavation and the restoration of the abundant material thus uncovered, this sanctuary and its history can now be reconstructed as follows. At the beginning of the third century B.C., groups of Celts began to make their way into the region. They were Belgae who probably originated in central Europe, and who reached these lands after protracted migration. In the vicinity of the river Aronde, the marshlands of which stretched across this area, they marked out an area surrounded by a ditch and a stockade that measured about forty meters per side. In the center, they dug out a further nine ditches around a large central ditch. It was here that the animal sacrifices took place: cattle, pigs and sheep. This first sanctuary, situated near a border separating three powerful races—the Bellovaci, the Ambiani and the Viromandui—

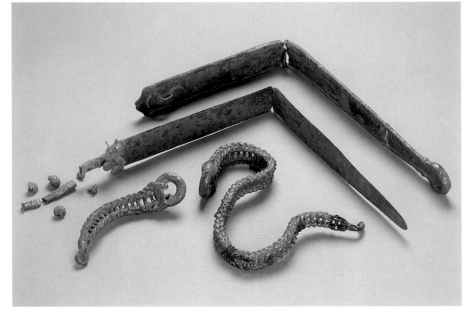

*Iron sword and scabbard, ritually bent
with iron suspension chain
from the sanctuary
at Gournay-sur-Aronde (Oise)
3rd century B.C.
Compiègne, Musée Vivenel*

*Iron sword blade with inlay
from ritual destruction
from the sanctuary
at Gournay-sur-Aronde (Oise)
3rd century B.C.
Compiègne, Musée Vivenel*

was the first sign of the appropriation of a territory. This explains the sumptuous trophies of arms or the human remains that were used from the outset to decorate the walls of the enclosure. Their bellicose intent could hardly have been missed. Of particular note were the entrance gates that faced east: surmounted by the most important trophies, which probably included a generous helping of human skulls, this entrance must have recalled the balustrade of Athena's temple at Pergamum, with its bas-relief carvings of the same Celtic arms.

In time, a small temple facing east was built on those sacrificial ditches associated with an chthonic rite that mostly involved cattle and perhaps also horses. For two centuries, worship in this sacred area was intense, and was characterized by regular sacrifices of large animals offered whole to the gods, as well as by smaller community celebrations in which men and gods partook of the meat of pigs and lambs.

At some point before the Roman conquest, the place of worship was carefully closed by its users. A new temple was built during the age of Augustus, and then a *fanum* during the Late Roman Empire. The myriad archaeological remains unearthed at Gournay (mostly arms in iron and animal and human bone) led researchers to reconsider a certain number of similar but hitherto unexplained discoveries. Numerous sanctuaries were recognized in Picardy, on the Ardenne highlands, in Burgundy and Brittany, in Poitou, but also in neighboring countries such as Belgium, Luxembourg, Germany and Switzerland. It thus became evident that the theory that identified the large quadrangular enclosures known as *Viereckschanzen* as places of worship could no longer be maintained. Research into this area is still in its infant stages, however. The archaeological sites themselves are bound to hold surprises for us. If our knowledge of animal sacrifices has inproved thanks to archaeo-zoological studies, it is also reasonable to believe that methods of excavation inspired by ethno-archaeology, and the study of votive material following restoration, will also reveal other rites that were performed in these places and to which ancient literature bears no witness. Excavations currently under way at the sanctuary at Ribemont-sur-Ancre, with its extraordinary assemblage of well-preserverd human remains, should throw some light on the way man related to these relics of trophies and sacrificial remains.

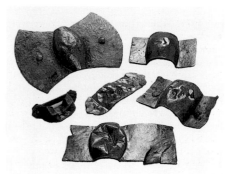

*Iron shield boss
with traces of ritual destruction
from the sanctuary
at Gournay-sur-Aronde (Oise)
3rd century B.C.
Compiègne, Musée Vivenel*

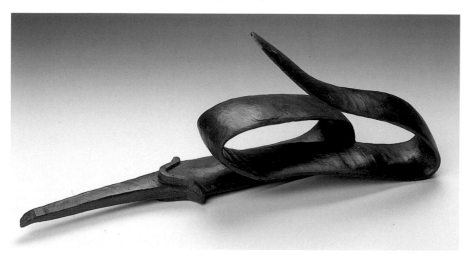

*Iron sword, ritually bent
from the sanctuary
at Gournay-sur-Aronde
3rd century B.C.
Compiègne, Musée Vivenel*

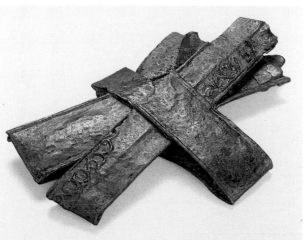

*Batch of ritually bent
iron scabbards
from the sanctuary
at Gournay-sur-Aronde
3rd century B.C.
Compiègne, Musée Vivenel*

La Tène station (Neuchâtel) is situated on the northernmost tip of Lake Neuchâtel, between today's Thielle River and the marshes of Epagnier.

The site has always attracted the curiosity of researchers, whether simply collectors of lakeside antiques, or committed scientists. The iron objects found on the site during the nineteenth century and at the start of the twentieth were so numerous that they came to be used as a reference typology in Gaulish history, and as early as 1874 the name of La Tène was officially accepted to designate the Second Iron Age. The site was excavated over a span of forty years, with interruptions of various lengths. Although seventy years have passed since the last excavations were made, the site continues to excite the interest of many archaeologists, also because the structures and objects found have given rise to a wide range of often controversial interpretations. This text aims to summarize what we know to date about La Tène.

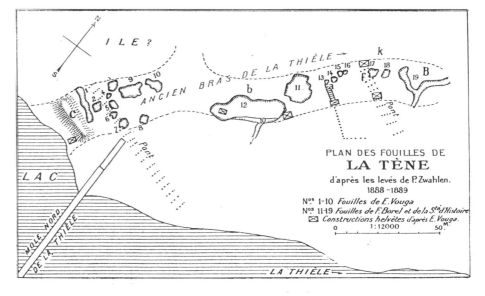

The Discovery of the Site and the Looting
The La Tène site was discovered in November 1857 by Hansli Kopp, an antiques enthusiast commissioned by Colonel Friedrich Schwab of Bienne. What he first found was a series of wooden piles, most of which were under half a meter of water. To extract the objects it was necessary to disturb the lake bottom and, with the help of pincers, free the weapons and utensils partly buried in the mud. Kopp managed to gather about forty weapons, all made of iron. Schwab remarked on the fact to an archaeologist friend Ferdinand Keller, who quickly published the objects discovered in his *Pfahlbauberichte*. Kopp and his aides carried out surveys for Emile Desort, a geologist from Neuchâtel, who immediately reported the site's discovery to the Société des Sciences Naturelles, based in Neuchâtel.

Hence, by 1860 there were two important collections of objects from La Tène, one at the Schwab Museum in Bienne, the other at the Musée Cantonal d'Archéologie at Neuchâtel. A third belonged to Alexis Dardel-Thorens, an economist from Préfargie; this group of objects was later purchased by the Volkskundemuseum in Berlin.

The collections consisted mainly of weapons (swords and scabbards, spear-heads and butts, shield-bosses, etc.), but there was also some iron jewelry (fibulae, belt-clasps) and tools (axes, cauldrons). Missing from the finds were pottery, glass objects, and bronze jewelry. The objects had clearly been assembled according to criteria of quality and not form.

Keller—a fervent archaeologist specialized in wooden pile-constructions—offered the first interpretation of the site in 1863. He considered La Tène to be a village of pile dwellings dating from Celtic times. Emile Desort in 1865 focused his attention on certain ele-

ments which were at that time of capital importance for understanding the era of the Helvetii, namely the excavations in Alesia (under the patronage of Napoleon III) and the discovery of the "battlefield" at Tiefenau, near Berne (1849-1850), which had yielded a vast amount of weapons similar to those found at La Tène. The classical texts make no mention of Celtic pile dwellings, and so La Tène was ruled out as a settlement.

Desort then proposed an interpretation which, except for a few details, would outlast a century: La Tène was an arsenal, as endorsed by the quantity of utensils and arms present on the site; and it was constructed on piles on the marshy lake border so that the enemies (the Romans or Helvetii) would not find it—a ploy that nevertheless failed to spare the construction from violent destruction.

The First Water Regulation Scheme for the Jura and the Excavations of Emile Vouga (1880-1900)
The first water regulation scheme for Jura was undertaken between 1868 and 1883, when the rivers were being dredged and canals were repaired throughout the region of the Three Lakes. The operation brought to light several sites and isolated objects dating from the Second Iron Age at Port (Berne), Brügg (Berne), Pont-de-Thielle (Neuchâtel-Berne), and La Sauge (Vaud). The La Tène site was drained off completely, making it more accessible.

At this point, Emile Vouga, a teacher in Marin, began the first proper archaeological excavation work. After discovering the timber causeways at Port and Brügg, Vouga reckoned that similar constructions had to exist at La Tène too.

Subsequently he found the timber piles of two causeways just past the old course of the Thielle River, and remnants of five buildings that once stood on the riverbanks. The archaeological objects were largely con-

centrated in the dwellings, but on the left bank of the Thielle he also found scattered human and animal bones. The first excavation campaign was suspended due to lack of funds.

Subsequent research, fairly significant, was undertaken by F. Borel, the museum curator, who discovered mainly human skeletons. Borel then sold the material he found to the civic museums of Geneva and Berne. To rectify the situation, in 1885 the cantonal administration of Neuchâtel accorded exclusive excavation rights to the city's Société d'Histoire, which engaged Emile Vouga and William Wavre (director of the local museum of archaeology) to resume research. The new campaign, however, was short-lived.

In 1885 Vouga published the results of his research in a monograph entitled *Les Helvètes à La Tène*, and Victor Gross summarized the finished research with accompanying photographs of the finds (*La Tène: un oppidum helvète*). The two authors highlighted five significant features which influenced later interpretations of the site: 1) the architectural structures included two bridges or causeways, a palisade, and a few houses; the settlement is situated on a sort of island between the main branch and a defunct branch of the Thielle; 2) the presence of numerous weapons, sometimes new, but nearly all destroyed; 3) the absence of manufacturing activities and of women's jewelry; 4) numerous human skeletons, some showing signs of injury; 5) the settlement derives strategic importance from its naturally protected position between Lake Neuchâtel and Lake Bienne, on the crossroads of the north-south and east-west routes.

On the basis of these features, Emile Vouga decided against a lakeside settlement of the Helvetii, but was hesitant about the site's being an arsenal, deposit, or isolated refuge among the marshes. Bross was more cate-

*The site of La Tène after the drop
in the level of the lake at the
end of the last century*

*Fishing for objects
at La Tène (Neuchâtel)*

gorical, and claimed that La Tène was an *oppidum* or an observation post bordering the Gaulish road linking the Rhône and the south to the Rhine, to the borders of the Helvetian world. Numerous of his contemporaries hazarded interpretations of the site, hypothesizing that it had a military function (arms deposit, observation point, fortified shelter); others opted for a commercial explanation (workshop for the production of arms, storehouses, trade center); others still preferred a combination of the two (an arms deposit that became a fortified shelter on the arrival of the enemy). Whatever the case, the site was abandoned and destroyed after a battle or a massacre of some kind.

The Excavations of Paul Vouga

In 1906 a special commission was set up to resume studies on La Tène; the resulting program of excavations was to be directed by William Wavre and Paul Vouga.

The two banks and the bed of the Thielle were systematically investigated, not only where earlier excavations had been made, but also further upstream and downstream. Consequently numerous groups of objects came to light, particularly weapons and war panoplies. The wooden pieces were well-preserved (shields, spear-shafts), and several building structures also emerged. During the ten years of excavation, Paul Vouga concentrated on the structures themselves, rather than venturing further interpretations of the site; other researchers continued to put forward their own theories. Furthermore, they continued to consider La Tène a settlement with a military role. Only Joseph Déchelette (1914) took a new approach; his view was that La Tène was best interpreted as a kind of customs outpost for tax purposes, similar to *Cabillonum* (Chalon-sur-Saône), which served as a frontier post between the Aedui and the Sequani.

In his monograph on La Tène published in 1923, Paul Vouga disputed this idea, stating that the site was not on a border between two peoples, and that there was no archaeological evidence of trading to sanction such a view—the objects found are all of Gaulish origin.

La Tène was therefore, in his opinion, a land settlement protected by palisading and accessed via a bridge. The objects found were exclusively from Middle La Tène, and predominantly arms; the absence of female ornaments and articles of everyday use, the lack of any trace of metalwork production, but the presence of new objects wrapped in fabric, suggested to Vouga that the site was a fortified emporium, inhabited by warriors, on a strategic point between the three lakes of Neuchâtel, Bienne, and Morat, and on the border with the road running from the Rhône, past the Aar, to the Rhine and the Jura regions.

The place itself had been burned down, perhaps during a siege; a later flood hindered any further assault on the site.

Intepretations from 1943 to the Present Day

After 1917 no further excavations were carried out at La Tène, nor has there been an exhaustive study of the finds. But the site has never ceased to interest specialists in protohistory. In the first half of this century it was taken for granted that La Tène was a military encampment dating from Middle La Tène, deserted in the aftermath of a bloody conflict, which was followed by a devastating flood. The outpost was later transferred to Port (Berne), a similar but later site on the northern shores of Lake Bienne.

In 1952 Klaus Raddatz, an archaeologist

from northern Germany, began closely comparing the information gathered by Paul Vouga with finds made in marshland sites in Denmark and northern Germany. As pointed out earlier, La Tène lies on a tributary of the Thielle River, near the Epagnier marshlands. The etymology of the river's name suggests a sacred origin, and the quantity of weapons and skeletons gathered in the place bear a striking resemblance to votive deposits common in Scandinavia: La Tène would therefore be a cult place. This new interpretation by Raddatz not only shed light on Celtic religious practices but also made it possible to establish links between north and south.

In a study devoted to the finds made along the original course of the Thielle river, published in 1955, René Wyss linked his ideas up with the Raddatz theory, but also endorsed the site's military nature.

Other in-depth studies of several associations of archaeological material seem to confirm Raddatz's hypothesis. In 1966 Herbert Jankuhn studied animal bones found at La Tène, noting that certain species were better represented than others (an abundance of cattle and horses, and a complete absence of game) and that only certain parts of the skeletons were present (skulls,

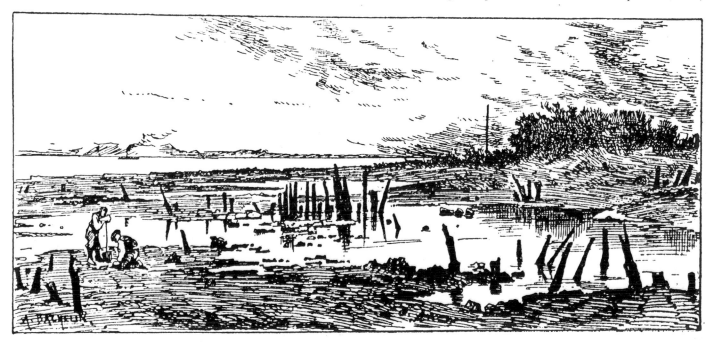

hooves, but no pelvis or long bones). Hence the material was in stark contrast with what is usually found in inhabited sites. In 1970 Renate Rolle examined the traces of blows on the human skulls found at La Tène, and advanced the idea of human sacrifices, and even cannibalism.

José de Navarro made a special study on the swords and scabbards found at La Tène, collating all the information yielded by the site. The result was a thorough overall analysis. In 1960 he published an article on the scabbards, proposing the following new view: La Tène was a cult site, the sacred enclosure was delimited by the palisade, and bridges were probably the very place where the sacrifices were carried out, the waterfront houses received pilgrims from near and far; the cult was mainly reserved for warriors, though other activities were also present (such as metalworkers and butch-

ers); during the ceremonies women were merely onlookers.

This interpretation had little support, however: Richard Pittioni (1968) pointed out the differences between La Tène and known cult sites (Duchcov in Czechoslovakia, Moritzing in Tyrol, Roquepertuse and Entremont in southern France), noting also that the sharp variations in the water-level of Lake Neuchâtel made it impossible to establish whether the site was on the marshlands or perhaps near the main river. Pittioni's chief contribution was to demonstrate that the basis for interpreting the site was still too weak.

After the discovery in 1965 of a new archaeological site at Cornaux, a few kilometers from La Tène and also on the Thielle River, Hanni Schwab (1989) was persuaded that La Tène was in fact a settlement, complete with port, destroyed by a dramatic

rise in the level of the lake.

However, an analysis of sediments made in 1977 by Ludwig Berger and Marcel Joos seemed to indicate that there were never violent currents as such in the area of the so-called bridges at La Tène; the sedimentation was due to a layer of stagnant water (creating peat), or a weak current (creating little banks of sand).

The fact remains that the puzzle of La Tène's role can only really be solved when a thorough study has been made of the entire site and the archaeological material. In the meantime, it remains a mystery.

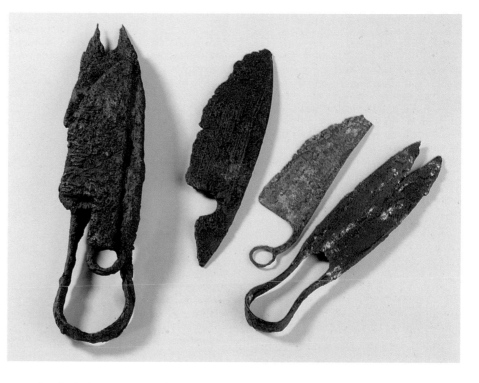

In the course of six decades of excavations, the 115 meters of river between the Vouga and Desort bridges have yielded several hundred objects of varying kinds and sometimes very well preserved. Not all the finds date to La Tène C, and nearly a tenth belong to a later phase (La Tène D, or even from Roman, medieval, or modern times). The chronological diversity of the material found at La Tène is largely due to the somewhat disorganized way in which excavation was carried out (apart from those completed between 1907 and 1918), but it is conceivable that the easternmost end of Lake Neuchâtel was inhabited for thousands of years. Hence it is essential to examine carefully the abundant material in order to exclude from our inventory artifacts of uncertain date.

There is an exceptional range and abundance of objects dating from La Tène C. One of the main features of the site is the number of organic objects found, especially wood, but also fabrics and wickerwork. The archaeologists must be given credit for the fine work they did at the beginning of the century—and in particular Paul Vouga. Although they had none of the sophisticated technical means that facilitate the conservation of material today, these pioneers engaged a conservator from the national museum to make *in situ* casts of the more fragile pieces, such as spears with their shafts, shields, games, a cartwheel, axes or sickles complete with handles, a cord, and a woven sack. The resulting copies are as valuable as the originals.

Even the iron pieces are in excellent condi-

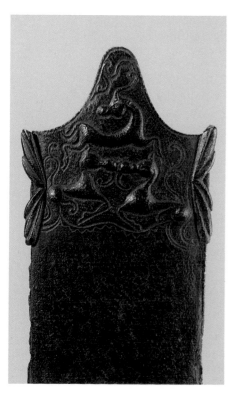

tion; they look almost "new." Their immersion in the lake mud insured that many of these swords in their scabbards, though 2200 years old, have maintained their elasticity.

Not all the finds made at La Tène were fully documented and the inventory is incomplete, but to give an idea of the sheer abundance of material, here is a brief list: 166 swords (often with scabbard), 269 spearheads, 29 shields (complete or in fragments), 382 fibulae, 158 belt-clasps, 50 knives, 25 razors, 52 pincers, 11 sickles, 22 scythes, 8 bronze cauldrons with iron hoops, 2 wooden yokes, 32 clamps, 58 phalerae, 41 axes, a hundred or more special tools (burins, files, shears), dozens of iron ingots, and so forth.

Today the collection is distributed in different museums, and there is an urgent need to continue the critical inventory commenced by José Maria de Navarro in 1972. Paul Vouga's exemplary monograph of 1923 is a direct invitation to create a corpus of archaeological documents, in which each artifact is restored, drawn, photographed, measured, described, analyzed, and compared. The rust on some of the blades probably conceals fine decorative work, as suggested by recent finds from other sites.

One fact alone emphasizes the importance of a closer study, and that is the "finished" quality of the objects, even the smaller ones. Both the quality of the materials used and the forms themselves are immediately appealing and pleasing to the touch. At the base of the blades of a pair of shears, a meandering groove engraved with a burin has turned this simple everyday tool into a work of art. The collection boasts many

such "unique" pieces, each one quite unlike the next but bearing some typical La Tène detail. Remarkably, the hoard also offers the finished products together with the tools used to fabricate them; it is not yet known, however, where the swords were forged, but the name of a nearby site, Préfargier, meaning "forge-meadow", suggests former forges in the Thielle area. Another clue arose in 1984 when a kilometer away at Martin-Les Bourguignonnes iron scraps and crucibles for smelting gold were found in the ditch of a *Viereckschanze* (or rectangular enclosure) dating from La Tène D.

Many people, when they see these objects on display at the Musée cantonal at Neuchâtel, can barely distinguish them from today's tools. And indeed, most of our do-it-yourself hobby equipment was already in use in the La Tène Iron Age.

The range of materials used includes iron, bronze, gold, potin, stone, pottery, glass (armlets), enamel, wood, wickerwork, fabrics, bone, leather, and probably also animal horn of various kinds. Each category of object would need a chapter or even a monograph study of its own. Details of manufacturing techniques are as yet unclear, but this profile of the collection gives an indication of avenues open to further exploration.

Iron. The sword, ranging from eighty-five to ninety centimeters long, sums up the quintessential skills of the Celtic metalworkers. The Celts were the first to use the hotwelding technique, which "consists in folding the ingot over on itself as many times as possible, so as to make the weapon elastic but tough." The blades themselves were

made from hard iron with a core of softer iron, affording greater elasticity. The blade was completed through forging, with a tang onto which a bell-shaped quillon was attached; the hilt (not preserved) ended in a pommel and must have been made of horn, which decayed in the river. The upper part of the blade often bears the manufacturer's hallmark or the owner's name (half-moon, clover, boar, human head in profile, etc.) heat-stamped onto the metal; this mark is a feature peculiar to swords from Switzerland and neighboring territories.

The scabbard gave the craftsman a means of expressing great technical virtuosity; it was composed of two sections of very thin iron joined along the edge by folding rather than

welding, and fastened with a chape and by one or more flattened clamps. The surface facing the body has a finely-modeled attachment for fastening the scabbard to the belt, fixed with hidden rivets. The top of the sheath is always decorated, sometimes with cut sheet metal, sometimes with designs engraved with a burin, or by embossing, or knurling. Knurling was done either by stamped decoration or with acid poured onto a pattern scored into a covering of wax. The patterns thus obtained catch in the light, while the other designs—the volutes, meanders, triskeles, omegas, dragons, horses, deers, and birds—help to make each weapon a unique piece. The scabbard was attached to the leather belt by a clasp (sometimes fitted with coral studs), rings, or a chain.

Wooden shafted weapons come in a great range of shapes including short spears occasionally used for throwing, and javelins, with long or short tang, flanges, rivet holes, corrugated edges, wings. Certain spears still have their shaft in ash and a cone-shaped, cylindrical, or faceted ferrule. These widely-used products are hardly typical, but the variety itself is a characteristic of Celtic mentality.

Some flat arrowheads with wings and a tang evince the use of the bow, a fragment of which was also found. Like its earlier Neolithic counterparts, it was made from yew. The horse trappings are well-known. The iron bit was nearly always composed of several links, and was rarely rigid. The

phalerae are in cut bronze sheet, and are sometimes embossed, sometimes decorated with enamel. The bridle includes elements in iron, bronze, enamel, creating an elaborate ensemble. All the metal elements survived beneath a coat of sand and rust. Some shields have survived intact except for the leather and basket-work cladding. They were made of rectangular or elliptical hardwood boards of 110 by 50-60 centimeters drilled through the center to take the handgrip. This was capped with an iron boss nailed to the boards. One shield, of oak, has been dated by dendrochronology to 229 B.C.

The ax was clearly a fundamental daily work-tool. Two forms have come to light, the lightweight socketed ax (formed by curving the metal plate), and the single-blade with hatchet shaft-hole, a decidedly heavier, La Tène invention.

Two types of scythe were also present, either straight-handled or bent for use with both hands. Sickles, too, occurred, one of which, broken, had been repaired with a rivet. They are all of iron and attest to agricultural activity. There was also a wide range of knives of varying sizes for all uses, some socketed, or with a straight, bent, curved, voluted tang, or ending in a ring. Axes were sharpened on a whetstone or metal hone.

Shears were used for removing wool and cutting hair. They were composed of two knives joined by a flattened tang, curved over to act as a spring. In five cases, they were found in association with razors, terminating in a ring and wrapped in a fine cloth binding, presumably part of some kind of toilet kit. Body care included depilation with tweezers in iron or bronze.

Also in iron were various special tools used for working wood, metal and leather: scissors with handles, gouges (with tang, wing, or equipped with head), planes with twin handle, curved scrapers, wood planes, hand-saws, burins, wedges, gimlet, hammer with handle in animal horn, anvil. An engraver's case of leather was found to contain nineteen fine tools, including an awl with handle, and a handpunch.

Objects associated with heating and cooking include: a large spatula that may have been a poker, and a pair of tongs twenty-eight centimeters long; a large fork with bent prongs for lifting meat from a bronze cauldron (in bronze sheet one millimeter thick) with an iron hoop, and suspended by iron handles from a long corded hearth-chain. Receptacles of this kind were clearly not intended to be placed on the ground; one had been repaired (rather poorly) with thirteen pieces of sheet metal fixed with eighty-one bronze nails, most of them hammered flat, and some brazed.

The fibulae, all with bilateral spring, are skillfully made and range from 3.7 to 13 centimeters long (one of them, a full 27 centimeters long, is a complete anomaly); the

bow is often beaded; "the catch-plate joining the foot of the bow develops into a stud, and then becomes a decorative motif that merges with the bow" (Vouga, 1923); sometimes the stud is decorated with red enamel. The chapter on ironwork concludes with a profusion of rings of all kinds, wheel tires, nave hoops (metal rings used to reinforce the axle), linchpins; some barbed fishhooks with metal suspensioned, elongated rectangular-sectioned iron currency bars in the form of "sword blades" weighing on average 700 grams; together with nails, hinges, dowels, hooks, catches, T-hinges, cock pins, and plates for joining wooden sections.

Bronze. Objects in bronze are decidedly more rare than those in iron, and the work of the coppersmith was more in demand than that of the foundryman. The thin walls of the cauldrons attest to the Celts' remarkable skill in beating out sheet metal, which had been perfected by the Hallstatt period. Certain ornamental mounts in cut metal sheet decorated with embossing (for war ensigns, helmets or chariot fittings) are among the most elegant legacies of Celtic artistry, a case of Design *ante litteram*. The phalerae, most of the bronze studs, and some of the tweezers for hair-removal are also fashioned by this technique; whereas cast objects include the coins made in potin (a lead-rich bronze), the rivets, a knife-handle, a bracelet with tintinnabulum feature nine centimeters long (perhaps for storing needles)—all cast using the lost wax process.

Gold. Nothing is known of the source of the two staters and six quarter-staters in gold, free interpretations of a coin minted by Philip II of Macedon. The obverse presents a crowned head in profile, while the reverse shows a chariot drawn by two horses. The distribution map of coins of this type confirms the theory that they are of local provenance. The alluvium of Swiss rivers probably provided the precious metal, which was also used for a chased torque.

Tin. There is no silver in the La Tène inventory, but a number of castings in tin have been found.

Stone. Three circular sections of a quern (35 to 38 centimeters in diameter), cut from fossiliferous stone, were fitted one above the other with a central hole bored for the unmilled grain; the upper section was fitted with a wooden handle slotted into a hole at the side. Excavations also revealed a whetstone and a mortar.

Pottery. This is rather scarce. The finds include pots, bowls and dishes in black or gray pottery of highly diverse quality and mostly coil-built. The pots are occasionally rather irregular and asymmetrical, but others are much finer and betray evidence of being wheel-made.

Glass. It has often been pointed out that women's ornaments are almost completely lacking from La Tène, which seems to endorse the idea of a military interpretation

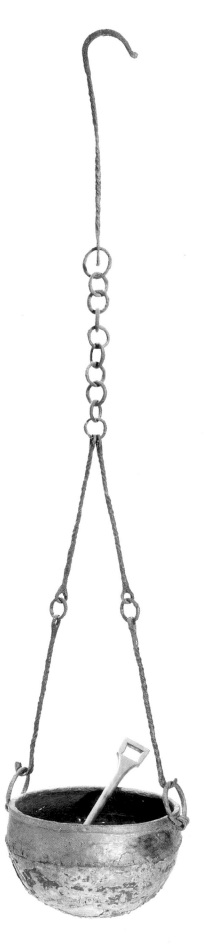

*Bronze cauldron with iron suspension
from La Tène (Neuchâtel)
3rd-2nd century B.C.
Neuchâtel
Musée Cantonal d'Árchéologie*

for the site. Two fragments of armlets in glass (one smooth, the other knobbed at regular intervals) are the only ones of their kind, whereas the burials dating from La Tène C in the Swiss plateau have yielded an impressive collection of glass bracelets in white, yellow, blue, violet, reddish-brown, and green glass, most of which were made by turning.

Copper-based red enamel poured onto certain iron or bronze objects gave an effect similar to that of coral.

Wood. While the La Tène period is part of the Iron Age, it was also ostensibly the "Wooden Age" like the preceding Hallstatt periods of the Bronze Age and Neolithic. Woodcutters, carpenters, woodworkers, craftsmen of wooden objects, and cartwrights all made use of a set of tools which, though hardly revolutionary, had reached a point of diversification that attests to their users' specialization.

The work they undertook included:
- bridges (some bridge beams were over twelve meters long);
- joinery, using tenons and mortises, but also with pieces of iron (nails, spikes, etc.);
- dugouts (one was discovered in the bay of Bevaix on Lake Neuchâtel);
- chariots (two-wheeled, but perhaps also four-wheeled wagons); at La Tène various components have been found: splinter bar, support arch for platform, perforated uprights, decorative bronze mounts, and wheels; the wheels range from 72 to 96 centimeters in diameter, with ten oak spokes, a symmetrical axle, elm wheel rims, a one-piece iron tire mounted while hot, various linchpins;
- yoke carved from a single block of timber, the largest of which measured 116 centimeters;
- a packsaddle, made of strips and splines joined with spikes or straps;
- wooden vessels, lathe-turned, of various shapes (bowls, plates, cups, dishes); only one plate, oval in shape, appears not to have been made on the lathe but with a knife; a repair was made with an iron brace;
- bucket (the chamfered rim of the base was slotted into the groove of the wooden staves);
- ladles, funnels, spoons;
- a lock (perhaps) made of wood, with an iron bolt;
- traces of an archer's bow.

Wickerwork and Fabrics. The waterlogged of the sediments helped to conserve fragments of a cord of double twine, and a twined basketry knapsack, identical to Neolithic examples found among the pile-dwellings in Lakes Neuchâtel, Bienne, and Morat.

As for the fabrics, they were preserved by the rust; some examples include wrappings containing new objects; the canvas-type weave (take one, skip one) seems to have been the rule. The presence of some iron needles, complete with eye, ranging from

7.5 to 19.5 centimeters long confirms the practice of sewing with both cloth and leather.

Leather. A tanner's equipment was found in a leather bag. A "fossilized" leather belt was found coiled round a scabbard.

Bone. Being also an organic material of animal origin, bone is mentioned here to give a complete inventory. Finds include an elongated game dice, and a carved-out container for needles (with one still present).

By way of summary: the iron sword in its scabbard, the chariot's tires applied while hot, the single-bladed hatchet with shaft hole, the file, the wood plane, the saw, the enameling, the assembly with iron fittings, the quernstone, and the coinage, all represent the technical innovations introduced into Switzerland in the La Tène Iron Age. Steel, the techniques of roughing out the iron, the potter's wheel, the horizontal lathe, were all present during the Hallstatt period. The art of woodworking, all the techniques involved in working bronze and glass, the tanged knife, the double-handled plane, the handsaw, the shaft-weapons, were all legacies of the end of the Bronze Age, a full millennium before La Tène. The use of axes, wedges, bows, yokes, dugouts, wagons, basket-weaving, cloth-weaving, and pottery, have their roots in the fourth and third millennia B.C.

The apogee of La Tène technological craftsmanship was the logical culmination of these inherited skills. The La Tène craftsmen substantially improved, refined, and diversified the legacy of the central European agricultural world (and, to a lesser extent, of the urbanized Mediterranean); this also applies to the diffusion of metallurgy. This phase of human development signaled the twilight of prehistory and the entrance into the modern age. The Gallo-Romans were able to take full advantage of all this progress, as testified by the fact that all the Latin names for chariots and vehicle parts are derived directly from Gaulish terms.

The Tomb of the Warrior
and Surgeon of München-Obermenzing
and Other Archaeological Evidence
of Celtic Medicine
Ernst Künzl

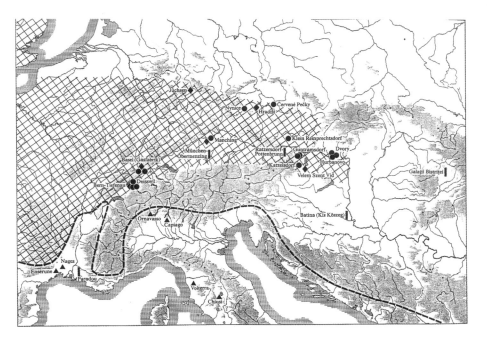

*Map showing the distribution
of archaeological evidence
of Celtic medicine
of 3rd-1st century B.C.
graves with surgical instruments* ▌
instruments from settlements ◆
bored skulls from Iron Age graves ●
*surgical instruments
dated to late Republican times* ▲

Tomb 7 in the cemetery of München-Obermenzing is an extraordinary monument (De Navarro 1975; Torbrügge-Uenze 1968 Krämer 1985). This cremation grave (La Tène C: third-early second century B.C.) contained the weapons of a warrior who was also a surgeon. The iron surgical instruments included an unidentifiable haft, a trephining-saw and a rounded-off tenaculum with an eyelet handle, which bears a remarkable resemblance to a modern early twentieth-century probe. Going by modern standards, instruments of the kind could have been used for operating both on the body and on the skull—and perhaps even as protection against meningitis Celsus I, 3; Paul of Aegina 6, 77) in the course of trepanation. Comparison with modern models, from Africa, for example (Brongers 1969) sheds light on the trephining-saw. Skull wounds were apparently sufficiently frequent for an instrument of the kind to be found among the grave goods of two other Middle La Tène tombs. The surgical instruments from Batina/Kis Köszeg (Yugoslavia), which were preserved in the Berlin museums, but unfortunately lost during the World War II, were, like the Obermenzing instruments, of Celtic manufacture. The same applies to the north Rumanian tomb of Galaţii Bistriţei which judging from the pottery, dates to La Tène, so that the undated set from Batina/Kis Köszeg may well date from the same period. The shape of the saws varies a great deal.

Celtic interest in medico-pharmaceutical problems is already apparent in the burial offerings found in the tomb of the warrior (La Tène B) of Pottenbrunn-Ratzersdorf in Austria (Urban 1989), where a kind of iron *Kränterraspel* (skull rasp) and two extraordinary bone "pendulums" were found (Wamser 1984). In the third and second centuries B.C., the imaginative production of their own surgical instruments is particularly striking because the influence of Hellenistic medicine cannot be excluded. The use of circular metallic trephines on several skulls in the cemeteries of Katzelsdorf and Guntramsdorf in Austria, could be traced back to Greek influences. The recovery rate in

these cases was, however, much lower than with the above-mentioned rasping or saw trepanation, because the imported Hellenistic technique had still not been completely mastered (Urban Teschler-Nicola-Schultz 1985). As far as it is possible to tell in paleopathological terms, the need for trepanation arose mostly as a result of wounds. The finds that have so far come to light are concentrated in the period between the fourth and the first century B.C., and mostly in the eastern zone of the Celtic settlement area. Tombs with grave goods of this kind are so far quite rare: a warrior-physician from Pottenbrunn-Ratzersdorf (La Tène B), another warrior-surgeon from München-Obermenzing, as well as the surgical instruments from Batina/Kis Köszeg and Galaţii Bistriţei. In addition there are the trepanned skulls to be ascribed primarily to La Tène D, if a dating can be hazarded at all. The copper alloy spatulae (*spathomelae*) which are constantly found in La Tène D stone settlements belong to an entirely different culture.

Useful for many purposes, cosmetic, phar-

maceutical and even surgical, spatulae have been found in Hungary, Bohemia, Thuringia, Bavaria and Switzerland; all of them were imported from the Mediterranean. The local manufacture of surgical instruments was apparently limited to the period of growth in the fourth and the third century B.C. In the third century B.C. the Hellenistic influence is obvious, following the Celtic activity in the southeast.

The discovery of the four tombs of Celtic physicians and surgeons means that in archeological terms more is so far known about Celtic medicine than about Etruscan medicine, for instance, or the medicine of republican Rome (the latter situation could change, however, with the publication of the Baratti gulf shipwrecks with their cargo of medicines dating probably from late republican times).

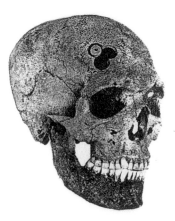

*Skull with three holes
from Katzelsdorf (Austria)
3rd century B.C.
Wiener Neustadt, Stadtmuseum*

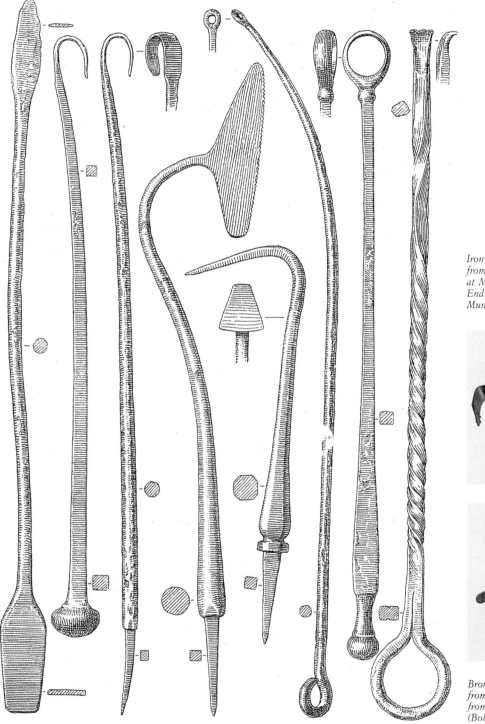

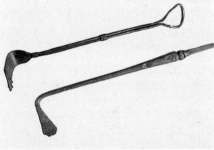

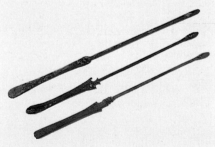

*Iron surgical instruments
from the tomb
at München-Obermenzing (Bavaria)
End 3rd-early 2nd century B.C.
Munich, Prähistorische Staatssammlung*

*Bronze surgical probes
from Late Hallstatt
from the oppidum at Stradonice
(Bohemia)
1st century B.C.
Prague, Národní Muzeum*

*Bronze surgical instruments
from Batina-Kisköszeg (Yugoslavia)
2nd-1st century B.C.*

Giengen: A Middle La Tène Cemetery
Jörg Biel

This cemetery stretched from the northern rim of the Wanne countryside at the foot of the eastern cliff of the Ripfel, now covered with modern developments (around Kettelstrasse). Discovered in 1972 when the field was being plowed, and completely excavated the next year, the cemetery contains thirteen well-spaced graves (up to 13 meters apart), including some secondary burials, and is thought to have been in use over a long period of time.

All the burials are of the cremation type, with rectangular graves dug to a depth of one meter below the present ground level. The calcined bones of the deceased were deposited centrally, with the grave goods (also burnt) and the ashes of the pyre itself. Nine of the thirteen tombs contained weapons and were therefore male burials. Three of the other four were furnished with female ornaments, and one contained a pair of iron fibulae. The structure and the objects of the warrior burials are particularly interesting. They include an iron sword with iron scabbard, a belt on which the sword hung, a spearhead with spear butt, and the remains of a shield; two or four iron fibulae and various other fragments in gold, bronze, or glass, though too badly burned to identify properly. The weapons, and particularly the swords, had been bent out of shape to make them unusable, a widespread practice at the time. The upper part of the front plates of many of the scabbards bear indented designs, usually featuring a pair of stylized dragons, like those found in La Tène itself. The front of one sheath is completely decorated with engraved patterns. The spearheads come in two shapes—either narrow, or broader and leaf-shaped. One of the heads, in iron, 75 centimeters long, is among the largest ever found. Its blade is decorated with so-called *chagrinage*, that is, the entire surface has been covered in a series of punched circles, and was probably a status symbol rather than a true weapon. Of the wooden shields only their iron bosses and metal edgings remain. The sword was often hung on a pair of metal chains with perforated decorations, attached to a leather strap or three iron rings, which were then directly fixed to the belt. The execution of the iron fibulae in the panoply burials varies considerably; some are highly complicated and finely decorated, and some pieces are as long as 21 centimeters.

The female burials show far greater diversity in terms of structure and regalia. In one instance, the deceased was cremated with all her jewelry; among the pieces still recognizable are parts of bronze fibulae, a bronze belt-chain, and a gold ring. In another grave among the ashes were a glass bracelet, two fibulae in bronze and two in iron. In the corner of a third grave was a small pit (30 centimeters deep and 30 across) containing all the woman's jewelry, which had not been burned. The two sets, clearly separated (perhaps they had been deposited in pouches), included a belt-chain in cast bronze together with bracelets and anklets, and another nineteen bronze fibulae with a fine bronze chain approximately 2.5 meters long, worn as a necklace, with three amber beads. The pit also contained parts of two iron fibulae, a fine iron chain, and small gold coin (diameter 7 millimeters, weight 0.33 grams) with a double head on one side and a small horse on the other. The coin one twenty-fourth of a Vindelic stater, possibly minted at the Manching *oppidum*, and is the oldest yet found in a central European tomb.

The little cemetery of Giengen with its grave goods, generally of higher than average quality, is without doubt the cemetery of the local nobility, though there is no trace of their settlement. It was founded in Middle La Tène (LT C1), around 200 B.C.

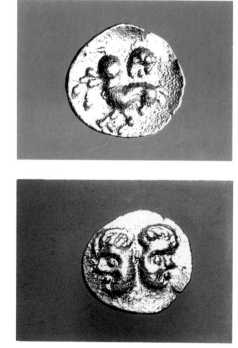

Gold 1/24th stater probably minted at Manching from tomb no. 13 at Giengen (Baden-Württemberg) End 3rd century B.C. Stuttgart Württembergisches Landesmuseum

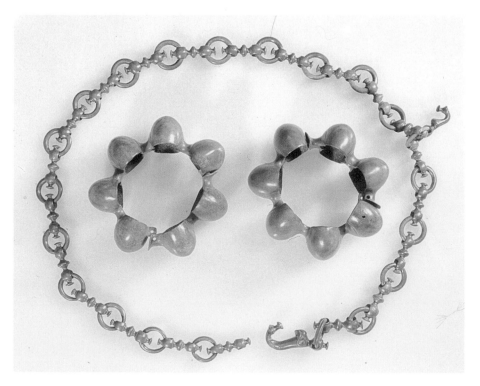

Pair of bronze anklets and a bronze belt-chain from tomb no. 13 at Giengen (Baden-Württemberg)

End 3rd century B.C. Stuttgart Württembergisches Landesmuseum

The Brå Cauldron
Peder Mortensen

*Bronze bull-head mount
from the Brå cauldron (Denmark)
3rd century B.C.
Moesgaard, Forhistorisk Museum*

Towards the end of the third century B.C. a definite Celtic influence reached Southern Scandinavia. The so-called Plastic Style of the Early La Tène period was imitated on massive Danish bronze fibulae and torques, and the shield bosses of the Hjortspring hoard are reminiscent of the earliest Celtic iron-plated bosses. At the same time a remarkable series of Celtic cauldrons began to appear in Denmark. The earliest of these is a large bronze cauldron discovered in 1952 at Brå near Horsens in eastern Jutland.

The cauldron had been broken into fragments before it was deposited. The pieces were placed in a pit in complete disorder together with a massive, socketed axe of iron. Boulders were placed on top. Scraps of leather were found in the pit, and there were impressions of leather in the oxidization both of the iron and the bronze fragments, probably representing a large leather bag in which the hoard had been assembled before it was put into the ground.

The cauldron originally consisted of an iron rim with a collar of bronze sheeting, three ring handles of iron around which hollow bronze rings had been cast, three bronze attachments, six bulls' heads of bronze—only five of which remained—and the large lower body of bronze sheeting. By putting together large portions of the body it was possible to reconstruct its shape as approximately hemispherical. The cauldron was about 70 centimetres high; it had a diameter of about 1.18 metres and a capacity of about 600 liters.

The three ring handles were originally held by the massive bronze attachments. These are almost identical, but slight variations show that they were not cast in the same mold. At the front the attachments show the head of an owl in a vivid plastic design, with a hooked beak between sharply cut eyes and eyebrows. On the upper part there are three massive, semi-circular ridges. The largest central ridge is decorated with an elegant stylized tendril which winds over the greater part of the ridge. The tendril with its spherical terminals to the many side-shoots, ending in two curved leaves recalling vegetable organisms, is a very typical Celtic design.

The most original feature of the Brå cauldron, however, is perhaps the five solid cast bulls' heads of bronze. Four of these are almost identical, with the fifth somewhat larger and particularly well preserved. The muzzle of the large head is more lifelike, and with the large sensitive eyes and the gracefully curved horns, the large head leaves the impression of representing a more weighty and mature animal than the smaller and more stylized heads.

The Brå cauldron with its ring-attachments with birds' heads and six bulls' heads reflects a tradition represented by a series of large cauldrons which can be traced by way of Italy and Greece to the Near East. Although some of these cauldrons are considerably older, they must have served as a source of inspiration that reached the Celts. They were at an early period capable of mastering the fine technique to which the Brå cauldron bears witness and of producing metal vessels of this type.

Stylistically, the decoration of the Brå cauldron is most closely related to a number of bronze mounts found in a grave at the Maloměřice cemetery near Brno in Moravia. They represent the Plastic Style characteristic of Celtic art in the third century B.C. and known from objects found in central and western Europe. The decoration of the Brå cauldron points towards an origin in the center of this area, most probably in Moravia.

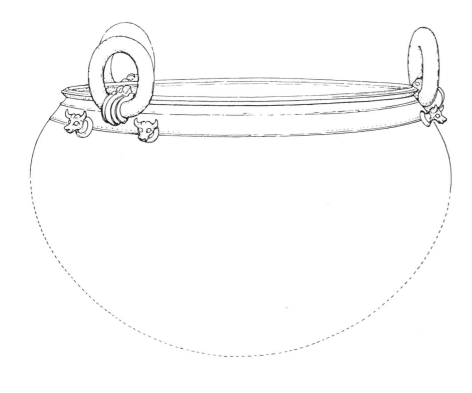

*Reconstruction of the large bronze
cauldron of Brå (Denmark)
3rd century B.C.
Moesgaard, Forhistorisk Museum*

*Bronze handle attachment
from the Brå cauldron (Denmark)
3rd century B.C.
Moesgaard, Forhistorisk Museum*

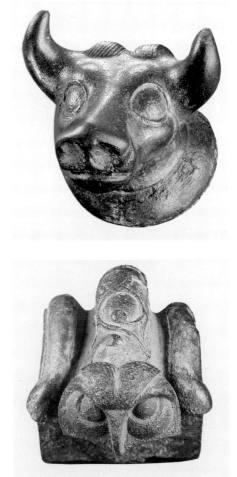

The Brno-Maloměřice
Jiri Meduna

In May 1941, during the construction of the local railway station, workers came across a large quantity of objects—mainly ornaments in cast and beaten bronze—that were subsequently collected together by local amateur archaeologists. Immediately afterwards, a Celtic cemetery containing seventy-six graves was excavated near the site of the first find.

From the autumn of 1939 onwards, work on the land in this area brought an unknown number of La Tène graves to light. It is therefore fairly probable that the May 1941 find represents furnishings of another plundered grave. The bulk of the collection is made up of sixteen cast bronze mounts, thirteen repoussé decorated bronze (or copper) and thirty-eight forged bronze nails. The find also included a fragment of a rod of forged bronze, a fragment of an iron band and five objects in *magnesium calcite*. The pieces of cast work that merit particular attention are an appliqué in the form of a griffin curved round on itself, an openwork mount with two animal masks, a mount decorated with two human masks, a fragment of a grotesque mask, and two large openwork mounts, the decoration of which rotates in opposing directions, the central motif being a large bird of prey surrounded by birds' heads, diminishing in size as they approach the rim. With the exception of the griffin, all the pieces bear signs of nail holes, especially on the rims most of which are slightly convex. The beaten bronze mounts are mainly triangular in shape and are decorated in repoussé work, bosses within flowing circles, rows of punch-marks or other, simpler, small bosses. Nail-holes are also visible on these which suggests that both types of mounts were attached to a wooden support. With the help of the cast parts it has been possible to reconstruct a cylindrical jug (*Röhrenkanne*) with a pedestal base. The jug had a lid, which was decorated with a griffin twisted round on itself.

The pedestalbase of the jug and the rim of the lid were covered with bands of bronze. We can no longer ascertain the exact positions of the beaten bronze mounts, but the testimony of one of the excavators would suggest that they were concentrated on the base of the jug. The cast decorations were all affixed using bronze nails, while traces of rust that have been found around the holes in most of the sheet-bronze mounts prove that these were attached using iron nails—none of which has survived. Judging by the re-constructed form, the height of the jug was 398 millimeters (from lip to base), 498 with the lid.

The stylistic heterogeneity of the find is particularly worthy of note. The cast mounts are worked in a clearly La Tène style (with animal and human forms all flowing together to make a single whole), while the sheet-bronze mounts are clearly of an earlier stylistic tradition: their spirit is unadulterated Hallstatt. However, there is no doubt that all the mounts belong to the same jug. On the basis of the type of casting, the Brno-Maloměřice jug may be dated to the third century B.C.

Piece of the bronze mount on a wooden jug from Brno-Maloměřice (Moravia)
3rd century B.C.
Brno, Moravské Muzeum

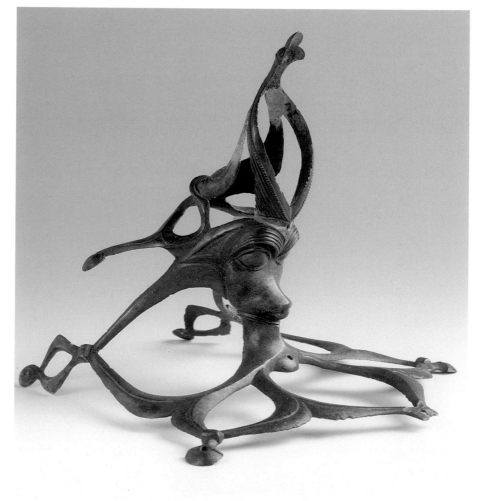

Piece of the bronze mount on a wooden jug from Brno-Maloměřice (Moravia)
3rd century B.C.
Brno, Moravské Muzeum

Piece of the bronze mount on a
wooden jug from Brno-Maloměřice
(Moravia)
3rd century B.C.
Brno, Moravské Muzeum

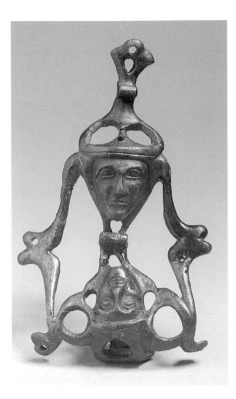

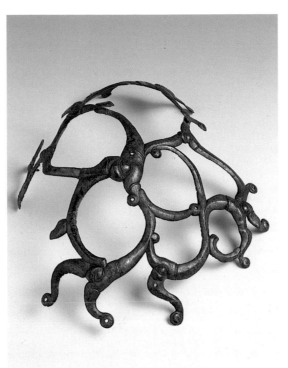

Piece of the bronze mount on a
wooden jug from Brno-Maloměřice
(Moravia)
3rd century B.C.
Brno, Moravské Muzeum

Detail of the eel-shaped creature
with bird-of-prey head
from the lid of a jug
from Brno-Maloměřice
3rd century B.C.
Brno, Moravské Muzeum

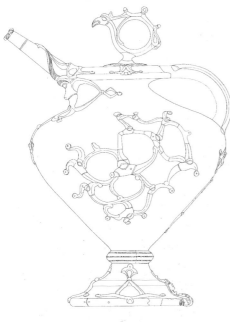

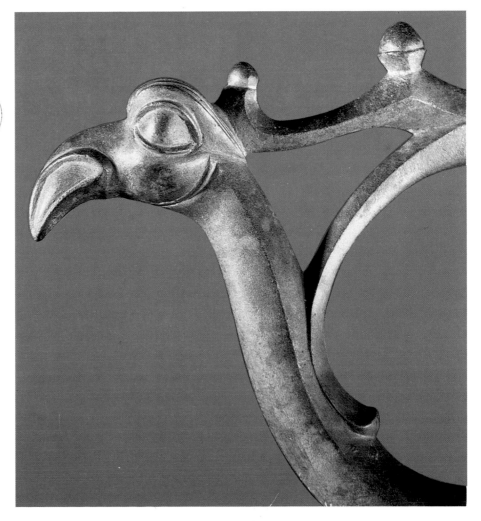

Reconstruction of the distribution
of the bronze mounts on the
wooden jugs from Brno-Maloměřice
(Moravia)

The Iwanowice Cemetery and the Celts in Poland
Zenon Woźniak

*Iron weapons and fibulae
from warrior-grave no. 9
at Iwanowice (Poland)
Second half 3rd century B.C.
Warsaw, Pánstwove
Muzeum Archeologyczne*

*Iron weapons and fibulae
terracotta vases
from warrior-grave no. 34
at Iwanowice (Poland)
Second half 3rd century B.C.
Warsaw, Pánstwove
Muzeum Archeologyczne*

The archaeological site at Iwanowice has produced some of the most important Celtic finds in Poland. Iwanowice itself lies twenty kilometers north of Cracow on the border of the Jura district in the little valley of the Dłubnia, a tributary of the Vistula in the territory of Celtic occupation spanning the third to first centuries B.C.

During excavation work in 1911 in a Hallstatt cemetery on a small hill known as the Klin, two isolated warrior graves were discovered. Grave 9 was excavated by the owner of the land, and grave 34 by the archaeologist Leon Chzlowski. Regrettably, there is no documentation on either grave. Both were presumably cremation graves. The material found is in the Państwowe Muzeum Archeologiczne, Warsaw (no. 186). The Iwanowice graves belong to the type of burials with complete war panoply (sword and iron scabbard, ring-belt, spear, and shield) dating from the second half of the third century B.C. (La Tène C1b). Complexes of this kind are rare in Celtic cemeteries of this period. The sword was rendered useless by bending, a custom that rapidly spread in the third century B.C.

among Celts, together with the rite of cremation.

The grave goods at Iwanowice and burial rite are typically Celtic but there are also traits specific to the Celtic culture of the Carpathian basin. In particular, the engraved spearhead from grave 9 has equivalents in spearheads found at Csabrendek in Hungary, and Neunkirchen in Lower Austria. The palmette-derived curvilinear pattern on the Iwanowice spear is a classic example of Hungary Sword Style. The variation in scabbard designs, though executed in the same style, is due to the difference in size of the decorated area. The designs on the fibulae also correspond to those of the Carpathian area. The two shield bosses, with triangular-sectioned central rib and trapezoid or triangular wing pieces, are more typical of the eastern Celtic assemblage.

The Iwanowice graves are among the earliest Celtic finds in the Cracow area. The Celts first reached these lands around the mid-third century B.C. Aspects of Celtic culture persisted through to the first century A.D., albeit intermixed with local in-

fluences. Traces of Celtic presence are especially noticeable in the remains of many scattered rural dwellings, whose inhabitants were mainly artisans (potters and ironsmiths), making use of the local rock salt and trading with their northern neighbors. Traces of electrum coins minted in the first century B.C. have also been found (Cracow-Mogiła). Among the Celtic material from the Cracow area (coins, glass ornaments, sapropelite rings, metal rings, graphite, painted, and other types of pottery) are imports from other Celtic territories, particularly Bohemia, Moravia and the Carpathian basin. Contacts with the latter became noticeably stronger in the first century B.C.

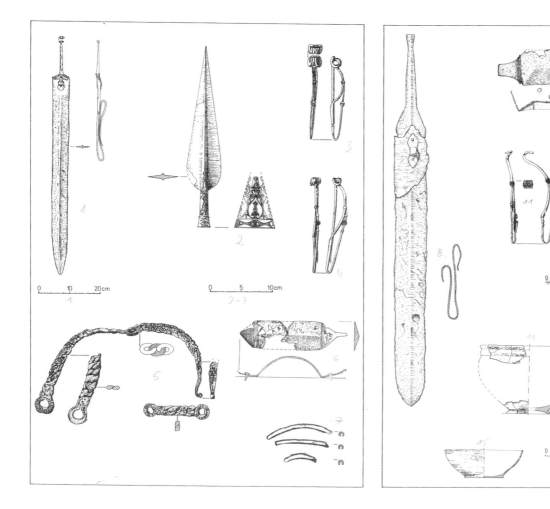

The Sopron-Krautacker Settlement
Elisabeth Jerem

From 1937 to 1988 important excavations were carried out along the southwestern border of the town of Sopron on the Austrian-Hungarian border, not far from the border with Czechoslovakia. In this stretch of farmland, known as the Krautacker, an area of over 20,000 square meters was excavated, and revealed a settlement with evidence of several phases of development, and a nearby cemetery.

The site lies in the valley between the Sopron hillside (Denburg in German) and the Rust mountain chain, on a low plateau formed by three rivers—the Zeiselbach, the Ikva, and the Litelbach. The site, which lies between 215 and 221 meters above sea level, was in the path of the ancient European trade route known as the Amber Route. This excellent position explains why finds range in date from the Copper Age to the late Middle Ages, and also why there are traces of various stylistic influences.

The golden era of this settlement can be dated from the sixth to the first century B.C., a period of continuous growth confirmed by items found in the cemetery. Two-thirds of the 182 graves unearthed date from the Urnfield culture. Fifty-four graves belong to the end of Hallstatt-Early La Tène. Of particular importance are the finds from the fifth century B.C., representative of this transition phase between Hallstatt and Early La Tène and which have good parallels in material from neighboring settlements in Austria and southwestern Slovakia. Contact with other regions can also be detected. This was made possible by the highly important trade routes linking this area through the Dürrnberg (near the Austrian town of Hallein) with southern Bavaria, and southern Moravia with Bohemia and, more importantly, further south toward Slovenia and Italy.

Funerary practices and clothing varied greatly across the Celtic world. Differences between graves and grave goods make it possible to identify a set of regional groups. The marked similarities in funerary rites in the area around Lake Neusiedler even suggest a single ethnic group. Some cemeteries contained round or square tombs, sometimes finished with stone flags or rough-hewn stones. Other recurrent features include timber and stone paneling, and wooden coffins. Besides inhumation graves with the standard orientation of the body (head to the south or southeast), there are also graves containing urns with calcined remains indicating the observance of cremation rites.

It was a universal custom among eastern Celts to include deposits of food and drink in graves. The meat offered (usually accompanied by a knife) was usually pork, though traces of beef and mutton have also been recorded, and in rare cases even chicken. The drinking vessels (flasks, bowls—in early graves, cups with handle, and later goblets—and sometimes pots) formed a complete service, and were deposited in the grave in a precise order. Items of clothing, personal ornament and weapons are among the more common finds.

The 385 objects brought to light in the coeval settlement give clues of vital importance as to the internal arrangement of the compound, which included farms and commercial premises of various kinds. Of special importance is the evidence of manufacturing, such as bronzeworking and ironworking. The six kilns discovered attest to a thirty-year tradition of quality pottery craftsmanship in the Sopron district. It is estimated that the Sopron wares (fine impressed pottery and graphite pots) were traded over a radius of forty kilometers, as far as Leithagebirge and in the region east of Lake Neusiedler as far as the point where the Rába flows into the Danube near the town of Györ. It was not until the change to hilltop settlements and the subsequent foundation of the Roman town of *Scarbantia* that the Celtic villages lost their importance.

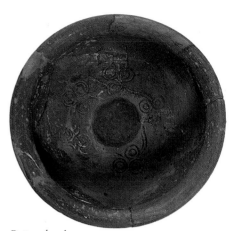

Pottery bowl
from dwelling no. 370
at Sopron-Krautacker
4th century B.C.
Budapest, MTA Régeszeti Intézete

Pottery situla with molded
and carved decorations
from tomb. no. 11
a Sopron-Krautacker
5th century B.C.
Budapest, MTA Régeszeti Intézete

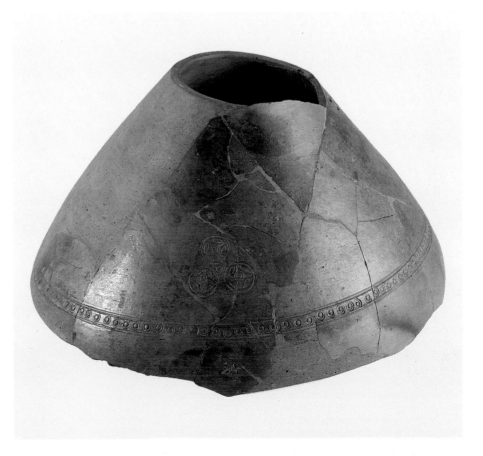

Pečine: An Early La Tène Burial Site
Borislav Jovanović

Bronze fibula with discoidal foot decorated with a red enamel stud from female cremation burial no. G3/1201 at Pečine (Yugoslavia) First third of 3rd century B.C. Pŏzarevac, Narodni Muzej

Terracotta vase from female cremation burial no. G3/1201 at Pečine (Yugoslavia) First third of 3rd century B.C. Požarevac, Narodni Muzej

During the lengthy rescue excavations of the ancient city of *Viminacium* on the Pečine site, a partly preserved cemetery was discovered, dating from the Early La Tène. It consists of forty-three graves, twenty-three of which are inhumations and seventeen cremations. Nine of the inhumation graves are of a population which inhabited this part of the Danube Valley in the Early Iron Age—the Triballi and Moesi. All the dead were laid in rectangular graves at approximately the same depth and measuring 1.50 x 1.60 meters.

That the large majority of the graves date from the same period is easily detected by the similarities of grave goods and burial rites. The metal jewelry, mostly fibulae and bracelets from La Tène B, is characteristic of Pannonia and the Danube Valley, as confirmed by the presence of fibulae of the Münsingen and Duchcov type. Bracelets with segments of relief or made out of solid bronze wire with large terminals also belong to this period. Short spears, rectangular shield bosses and iron belts bear out this dating. Numerous examples of wheel-made pottery are similar to finds at La Tène (LT B) sites in central Europe and southern Pannonia. In absolute dating, we are at the end of the fourth and the first half of the third century B.C.

Some finds from this site deserve special attention. Of the jewelry, the most interesting pieces are the bronze fibulae decorated with carved coral or glass paste, a coral bead bracelet trimmed with circular and spiral motifs and twisted silver wire earrings of Scythian origin. Of the pottery, the most striking is a footed biconical pedestal bowl with a handle in the stylized shape of an animal, which again proves the influence of the Iron Age Scythian zoomorphic style. The *oinochoe* found in a cremation grave of a warrior has early Hellenistic characteristics and may have been imported from southern Macedonia. Aside from this, the influence of Hellenistic pottery is clearly apparent in the widespread use of two-handled goblets (*kantharus*). Their Hellenistic prototypes are present at the Pečine site. Still, the ancient Balkan tradition in the manufacture of similar vessels also continued into the Early Iron Age, so we should think here in terms of two converging influences rather than simply a Hellenistic one. The amphora with stamped grape-leaf motifs in symmetrical cruciform arrangements is the first occurrence of its kind in the northern Balkans.

Native burials excavated at the center of the site can also be grouped chronologically. The grave goods they contain are rather meager: "omega-type" decorative pins, curved iron knives, spears and hand-modeled pottery. All these grave goods indicate the same dating for the native burials—the end of the fourth century B.C. The Pečine site belongs to the Early La Tène period in the Balkans, but Celtic buri-

als continued to exist here up until the first century B.C. The great majority of the graves, however, is from the time of the Celtic invasion of Greece. It is likely that the site grew up near a large military encampment, a rallying point for the Celtic troops before the attacks on Greece. In other words, this was the starting-point for those ancestors of the Gauls portrayed on the famous altar of Pergamum, built in 220 B.C by Attalus I Soter who conquered the Celts of Asia Minor.

Information acquired in Pečine and at other Celtic sites in the Danube Valley and in Pannonia demonstrate that the Celtic invasion of Macedonia and Greece was an organized movement of the eastern. Celts and their allies, the native population of the central Balkans.

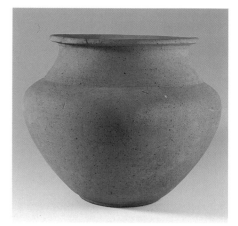

Bronze fibula from female cremation burial no. G3/1201 at Pečine (Yugoslavia) First third of 3rd century B.C. Požarevac, Narodni Muzej

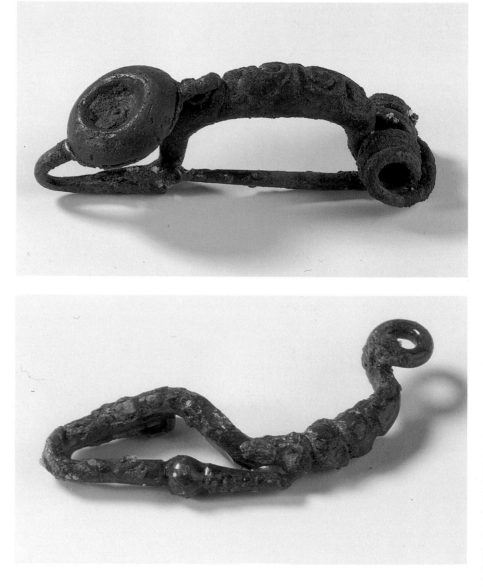

The La Tène Cemetery at Pişcolt

Joan Nemeti

The cemetery at Pişcolt, at the boundary point called "Nisipărie," was investigated between 1970 and 1977. The cemetery was situated on a sand dune of oval form, with present dimensions of 350 by 300 meters. From the 185 graves dated to the La Tène period, 75 tombs are inhumations, 85 cremations in pits and 13 are cremations in urns. The other 14 graves were so disturbed that the funeral rite could not be identified. The number of inhumations is relatively large, 44.1 percent of the total number of the intact tombs. Their orientation varies but the most frequent is the nortwest-southeast orientation (21 tombs). The percentage of cremations in pits is 48.8 percent of the total. The cremations in urn-type graves are fairly rare: 7.1 percent of the total number. From an examination of tombs rite and ritual the following conclusions may be drawn:
a. the cemetery is bi-ritual;
b. graves of cremation in pits in the Hallstatt tradition are present;
c. all burial rites have common elements;
d. no funeral pyres (*ustrinum*) were discovered.
The majority of the graves contained a rich funeral inventory that allows the determination of their chronology. In order to determine internal chronology of the cemetery, the method of typological combi-

nation was used. On the basis of combining the basic types (fibulae and bracelets) four chronological horizons have been established.

Horizon I. The grave goods of these tombs consists of fibulae of type La Tène B-early Dux, bracelets with *Steckverschluss*, simple, square buckles, large knives in the Hallstatt tradition. The pottery consists of pots of local tradition made by hand and with the potter's wheel (Vekerzug culture) and pots of Celtic manufacture: *Linsenflasche*, situlae, basins with *omphalos*; the ware is burnished black or dark gray. Chronologically, this horizon may be dated to the end of subphase B1 - Krämer.

Horizon II. In this horizon are placed those tombs which contain: fibulae of Pauker type, of early Münsingen type, variants of Dux type fibulae, massive "sealed end" type bracelets, made of bronze, with nodes, tubular bracelets, Silivas-Hatvanboldog type swords. The pottery is of locally imitated classic Celtic forms, as well as of local traditional Hallstatt pots. On the basis of the relative chronology, this horizon dates to subphase B2 (Krämer) of Early La Tène.

Horizon III. These tombs are different from those of the previous horizon because, though some archaic elements of the early La Tène survive, such as fibulae of an evolved Dux type, fibulae with two spheres

at the foot, bracelets and fibulae with plastic-style ornament (*Reifenstil*), bracelets with multiple semioval forms, lignite bracelets, they are associated objects of Middle La Tène date. This period at Pişcolt cemetery, coincides with the end of Early La Tène and the transition to Middle La Tène. Chronologically this horizon is included in the La Tène B2/C1 phase (Krämer).

Horizon IV. Contains a relatively large number of tombs with a funeral assemblage made up of fibulae of Dux and Münsingen type bracelets with large semioval forms and pottery made almost exclusively on the wheel. Chronologically this horizon dates to Middle La Tène (La Tène C1 - Pittioni). the first burials at the Pişcolt-Nisiparie cemetery were made at the end of the sub-phase La Tène B1 (Krämer), and they had stopped burying here by the beginning of the sub-phase La Tène C2, period Pittioni when, especially in the northwest of Rumania the Celtic cemeteries are no longer found. (Çiumeşti, Sanislău, Curtuişeni, Tărian, Dindeşti).

Bronze fibula with relief decoration from tomb no. 189 at Pişcolt-Nisiparie (Rumania) 3rd century B.C. Carei, Muzeul Judeţean Satu-Mare

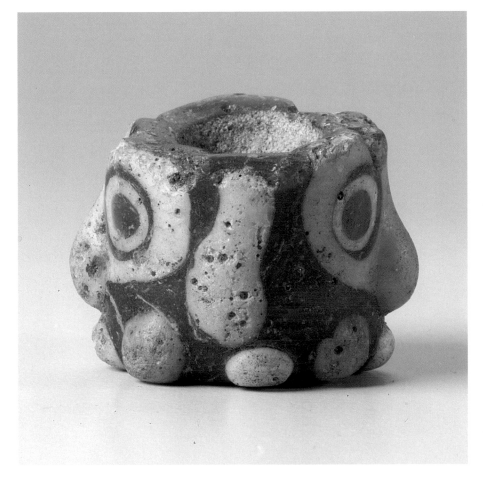

Multicolored glass "mask" bead from tomb no. 191 at Pişcolt-Nisiparie (Rumania) 3rd century B.C. Carei, Muzeul Judeţean Satu-Mare

The Cemetery of Çiumeşti and the Chieftain's Tomb
Vlad Zirra

Iron helmet crowned with bronze bird of prey with movable wings from the "chieftain's tomb" at Çiumeşti (Rumania) First half 3rd century B.C. Bucharest, Muzeul Naţional de Istorie

Çiumeşti is a village in northwestern Rumania situated on the great Nir lowlands near the Somes (Szamos) River, a tributary of the Tibisco, a few miles from the Hungarian border. In 1960, farmers working on a hillock near the center of the village came across various protohistoric remains, which archaeological excavation (begun in 1961) identified as dating to La Tène. The most striking find was a magnificent iron helmet bearing a crest in the form of a falcon with outstretched wings.

During our four-year campaign we excavated the rest of the hillock (which was found to cover a cemetery) and a fair part of another site 800 meters southwest of the burial ground itself. The cemetery revealed two different types of funerary rite; the most common was cremation, with the remains contained in urns laid in pits (twenty-one graves); the others were inhumation burials, with seven graves oriented in varying directions. The grave goods include tools, arms, personal ornaments, and funerary vessels, and have parallels throughout Transylvania of the La Tène period.

On the basis of an analysis of the types present it was possible to ascertain that the cemetery was used for approximately 100-120 years, from 240 to 130 B.C. (La Tène B and C). The same chronology applies to the objects found in the eight hut foundations uncoveredon the site, with the only difference that the manufactured objects found from the dwelling sites are more varied.

The complex of dwellings and graves offered a singular find which, unfortunately, predates our excavations. This is a funerary set belonging to a Celtic lord from the Somes-Nir plain. Apart from this exception, the cemeteries of this region show little difference between the objects and the funerary offerings, whatever the funerary rite or wealth or poverty of the graves. Most are personal ornaments in bronze or iron (fibulae, bracelets and armlets, belt-rings, and pendants), or weapons (swords with decorated scabbards, spears or lances, shields, and daggers), everyday utensils, such as razors, whetstones, curved knives, and even a small, long-handled pot. The wheel-made La Tène funerary pottery was as frequently found in association with offerings of meat, as illustrated especially by vessels in four different shapes: bowls, large biconical pots, tureens and cups (sometimes decorated). Hand- modeled vessels are also present, echoing pottery of early Dacian origin or of the so-called Szentes-Vekerzug peoples of the Early Iron Age. This pottery of fairly standard quality (particularly in the urn cremations), betrays not only the presence of natives in the region but also their coeval use of the cemetery.

As far as we know, when the farmers first began plowing the hillock that covered the cemetery, thirty-odd meters north-northwest of the cross placed on the top of the hillock, they found other graves with cremation remains. It was here that a princely tomb came to light; according to its discoverers, it contained a pile of calcined bones, an offering of a wild boar, and various funerary vessels, a helmet, and an iron cuirass, two jambs in bronze leaf, a javelin, and an iron horse bit. These prized objects betray techniques that predated the fourth century B.C. (La Tène B1, and B2) and were probably manufactured in a workshop that enjoyed considerable renown in its time.

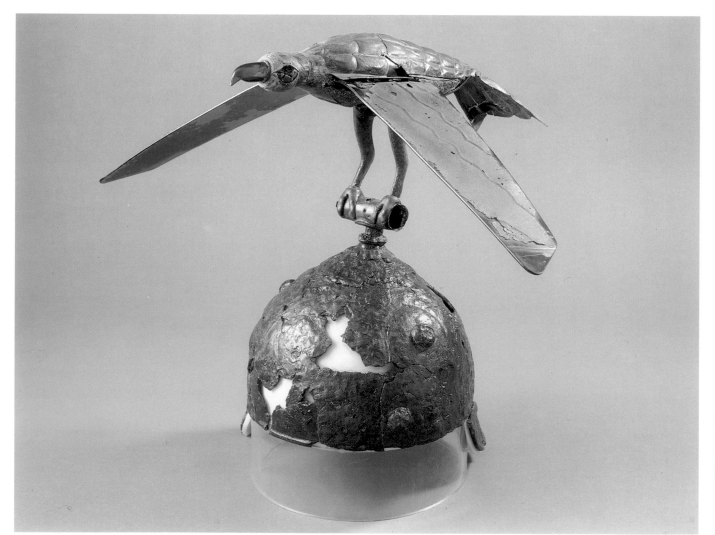

Discoidal bronze mount originally
fixed to the chain-mail
from the "chieftain's tomb"
at Çiumeşti (Rumania)
First half 3rd century B.C.
Bucharest, Muzeul Naţional de Istorie

The date of the style of the pieces is in con-
flict with the date attributed to the
cemetery as a whole. It was therefore
thought that this particular grave predated
the others, belonging perhaps to an early
settler of the region. Alternatively, the ob-
jects may have been inherited by a descen-
dant (who was clearly buried later). These
doubts were cleared up thanks to the reap-
pearance of other objects that had been re-
moved by one of the farmers upon discover-
ing the grave. The retrieved items include a
cheek-guard from the helmet, a deformed
piece of iron chainmail, fragments of an in-
cinerated fibula, two iron heels, and three
wheel-made pots; a belt complete with rings
and a fibula were particularly indicative of
a later La Tène phase (La Tène C1), and en-
dorse our theory that the objects of differ-
ent date were actually part of an in-
heritance.

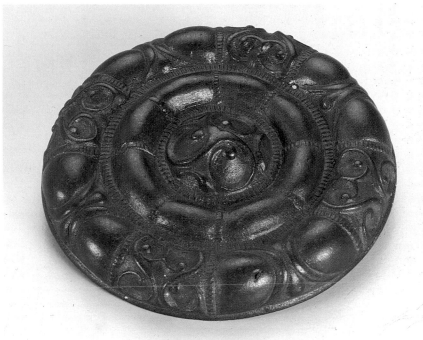

Iron spearhead
from the "chieftain's tomb"
at Çiumeşti (Rumania)
First half 3rd century B.C.
Bucharest, Muzeul Naţional de Istorie

Bronze anklet from tomb no. 19
at Çiumesti (Rumania)
Second half 3rd century B.C.
Bucharest, Muzeul Naţional de Istorie

The Chariot Burial at Mezek
Alexandre Fol

Today's village of Mezek is situated in the Rhodope mountains, Bulgaria, ten kilometers east-southeast of Svelingrad on the Maritza river (ancient Hebrus), and forty kilometers northwest of the Turkish town of Edirne (ancient Hadrianopolis). The domed sepulchre is just outside Mezek, in an archaeological setting of tumuli and hillside forts dating from the Late Iron Age (seventh to fifth century B.C.) and other sites rich in treasures from the Hellenistic and La Tène ages (fourth to first centuries B.C.). The region of Mezek is part of the broad diagonal route through the Balkans which follows the Maritza across the plain of eastern Thrace to Byzantium on the strategic tip of southern Eurasia. The tomb was scientifically investigated at the start of the 1930s, but not before local farmers had carried out some unauthorized excavations of their own. The results are therefore not conclusive. The construction itself belongs to the Mycenaean *tholos* category. It is an outspoken legacy of the diachronic but lasting influence of Late Bronze Age culture on the northern fringes of the Mycenaean *koiné* at the time of the "princely society" in Thrace during the sixth to fourth centuries B.C.

Two burials have been brought to light, the first of which has been dated according to its contents around the end of the fourth century B.C. At that time, the entrance to the tomb was surmounted by a bronze statue of a mortally wounded wild boar. The boar, pierced by a spear, symbolized the tests of "valor" to which the priest-kings of Thrace were subjected during the "royal hunt," according to Iranian-microasiatic tradition. There is no doubt fact that the deceased is a Thracian sovereign of the Odrisi family, fully documented in these Thracian lands by written texts, epigraphs and archaeological finds dating from the mid-fifth century B.C. to the beginning of the third. The second burial has yielded parts of the fittings of a chariot, including five bridle rings, the lower part of which is decorated with a highly stylized human head (bronze, width from 7.3 to 8.4 centimeters), a rectangular stud (bronze, height 12 centimeters), two flower ornaments with anthropomorphic patterns and flat back (bronze, height 12.1 centimeters), a rosette with stalk terminating in a stylized head (bronze, height 12.2 centimeters), and an ornament forked at one end decorated with an animal head (bronze, height 11.3 centimeters). These objects are definitely of Celtic origin. Their parallels, dated to the third century B.C., have been found in Moravia. There is no doubt that the second deceased was a Celtic king or prince (or a local Thracian prince, to whom a Celtic prince had made the gift of a chariot?).

Both these ideas are plausible, since the place is part of the northwestern region of the Celtic kingdom mentioned by Polybius (*Histories*, IV, 46), with its capital at Tule, which has not yet been identified. This kingdom was founded by the Celts, who in 227 B.C. had reached as far as Chersonesos (today's Gallipoli); crushed by the Macedonian king Antigonos II, the Celts failed to pass through into Asia Minor, but settled around Byzantium, where they remained until 213 B.C.

The tomb at Mezek manifests the cultural links between the two great European races, the Thracians and the Celts, an exchange which began, according to recent information, roughly midway through the fourth century B.C. Mezek is situated in the zone of the great Celtic dispersion through southeast Europe, and is therefore an important token of the syncretistic processes that spread through Europe, and led to the creation of the common basis of European culture during and after the Hellenistic era.

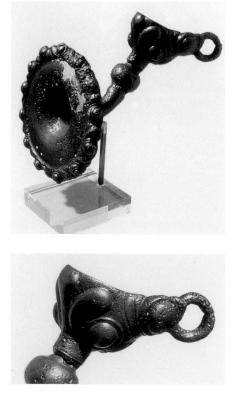

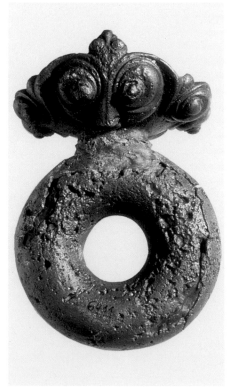

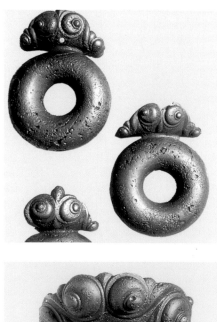

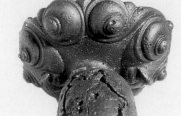

Bronze yolk-mounts
from the tomb at Mezek (Bulgaria)
First half 3rd century B.C.
Sofia
Narodnija Archeologičeski Muzej

Bronze rein-ring
from the tomb at Mezek (Bulgaria)
First half 3rd century B.C.
Sofia
Narodnija Archeologičeski Muzej

Detail of the side of one
of the rein-rings from the tomb
at Mezek (Bulgaria)
First half 3rd century B.C.
Sofia
Narodnija Archeologičeski Muzej

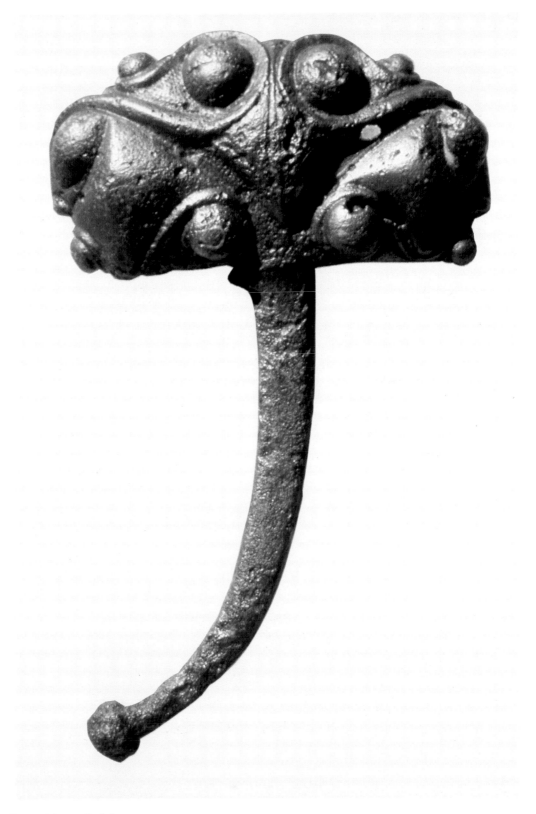

Iron and bronze linchpin
from the tomb at Mezek (Bulgaria)
First half 3rd century B.C.
Sofia
Narodnija Archeologičeski Muzej

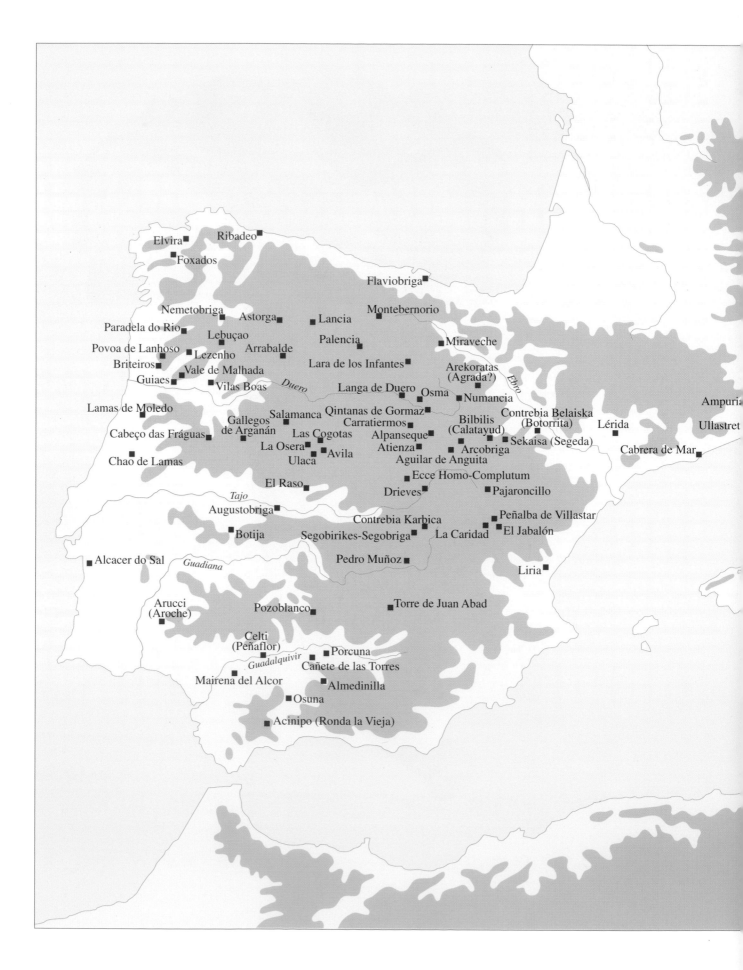

Elvira
Ribadeo
Foxados
Flaviobriga
Nemetobriga
Astorga
Lancia
Montebernorio
Paradela do Rio
Lebuçao
Palencia
Miraveche
Povoa de Lanhoso
Arrabalde
Arekoratas
Lezenho
(Agrada?)
Briteiros
Vale de Malhada
Lara de los Infantes
Guiaes
Vilas Boas
Duero
Langa de Duero
Osma
Numancia
Lamas de Moledo
Qintanas de Gormaz
Contrebia Belaiska
Salamanca
Carratiermos
Bilbilis
(Botorrita)
Lérida
Gallegos
Alpanseque
(Calatayud)
Cabeço das Fráguas
de Arganán
Las Cogotas
Sekaisa (Segeda)
La Osera
Atienza
Arcobriga
Cabrera de Mar
Chao de Lamas
Ulaca
Avila
Aguilar de Anguita
Ecce Homo-Complutum
El Raso
Drieves
Pajaroncillo
Tajo
Peñalba de Villastar
Augustobriga
Contrebia Karbica
Botija
Segobirikes-Segobriga
La Caridad
El Jabalón
Alcacer do Sal
Guadiana
Pedro Muñoz
Liria
Arucci
(Aroche)
Pozoblanco
Torre de Juan Abad
Celti
(Peñaflor)
Porcuna
Guadalquivir
Cañete de las Torres
Mairena del Alcor
Almedinilla
Osuna
Acinipo (Ronda la Vieja)

Ampuria
Ullastret

Land over 500 m above sea-level

0 100 200

Kilometers

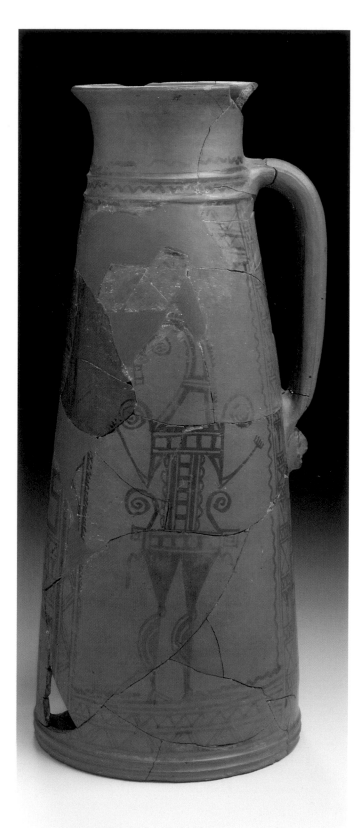

Terracotta jug painted with
mythical animal-headed figure
from Numantia (Spain)
2nd-1st century B.C.
Soria, Museo Numantino

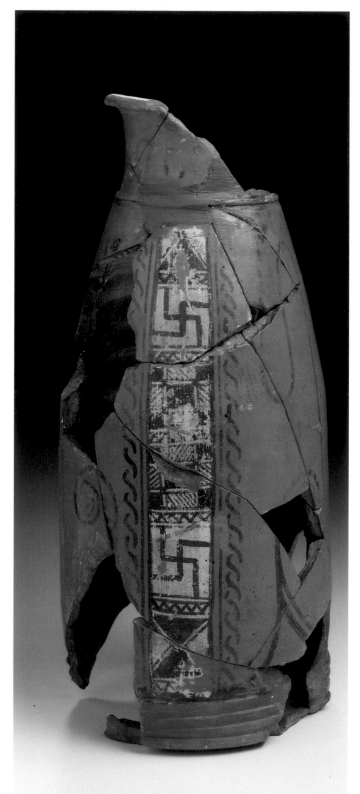

Terracotta jug painted
with geometrical patterns
from Numantia (Spain)
2nd-1st century B.C.
Soria, Museo Numantino

The Celts of the Iberian Peninsula

The Iberian peninsula, situated in the southwest corner of Europe, is of special interest, since it is the westernmost region of the vast territory occupied by the Celts. Moreover, this is the area that produced, in the fifth century B.C., the first written accounts of this ethnic group, by writers such as the Carthaginian Himilco, taken up by Avienus in his poem "*Ora marittima*" (1,185 et seq., 485 et seq.) and Herodotus (2, 33; 4, 49).

Recent studies and finds have aroused further interest. It appears that the colonial activities of the Phoenicians, Greeks and Romans offered a continuous supply of stimuli to the Celtic populations, through contacts with the Tartessians and Iberians who occupied the southern and eastern reaches of the peninsula. The result was such an enrichment of Celtic culture that today it constitutes the best body of epigraphical material prior to medieval Irish literature, direct evidence of the language and mentality of the Celts. Consequently, the study of the Celts is one of the most important aspects of the protohistory of the Iberian peninsula, since it is essential for an understanding of the formation of its ethnic groups and cultures. On the other hand, Iberia is also one of the lesser-known areas of Celtic influence, a fact which, together with the unusual nature of the people, makes it a point of increasing international interest.

The Problems

Without going into a historiographic examination of the current state of research, it is worth noting that, after the first linguistic studies carried out in the nineteenth century and the historical texts by A. Schulten, which appeared at the end of the twenties, P. Bosch Gimpera established a connection between the Celts and the urnfields discovered at that time in the northeastern part of the peninsula, and from this deduced that there had been Celtic invasions. With these theories as a basis, he applied the central European Urnfield-Hallstatt-La Tène sequence to the Iberian peninsula, which created increasing problems for archaeological research. Since archaeologists were unable to support the presumed, numerous waves of migration with evidence from excavations, they opted for a single, complex, undifferentiated invasion, which was dated to after the eighth century B.C.

Difficulties were encountered in trying to relate archaeological finds from the Iberian peninsula to central European concepts, as if the two were synonymous. They are reflected in the use of Celtic culture or invasions, Indo-European urnfields, and so on—or, to use names more in line with central European terminology, Hallstatt, post-Hallstatt or La Tène—to refer to cultural components of the Iberian peninsula which had virtually nothing to do with the above-mentioned concepts relevant to central Europe at the time. On the other hand, linguists, especially Tovar and his school, stuck to the idea of a number of invasions, two of which were fundamental. However, it was impossible to date them precisely, or say where the invaders came from and how they reached this area. One such invasion was supposed to be connected to a language which was claimed to be identifiable as pre-Celtic, among other reasons, because it had conserved the initial P, as found in the few known texts in Lusitanian. There is evidence to support this in the eastern sector of the peninsula, in the siliceous regions on the Atlantic coast. However, some linguists, Untermann for example, regard Lusitanian as another Celtic dialect, as its onomastics would seem to suggest. The real Celts, who left traces in the central areas of the Iberian Mountains and the eastern part of the Meseta at an altitude of more than one thousand meters, seem to come later. Their language, found in the form of inscriptions in the Iberian and Latin alphabets, would appear to be "Iberian Celtic," an earlier language than *gaelico* (Irish) and *britannico* (Breton), a fact which seems to correspond with its situation on the edge of the Celtic world.

For this reason, for more than a century now, the most important problem concerning the Celts of the Iberian peninsula is how to explain their origins and characteristics, despite the contradictions arising between linguists, historians and archaeologists. Since the sixties, the spread of the Urnfield culture in the northeast of the peninsula has become increasingly clear. This has meant a revision of the theories of invasion relating to this culture, since the area

does not coincide with that of the Celts as described in historical texts and linguistic evidence. Moreover, the Urnfield people of the northeast Iberian peninsula spoke Iberian; indeed the Iberian culture stems directly from them. Epigraphic evidence and historical references seem to prove that their language was neither Celtic nor of Indo-European origin.

The Indigenous Substratum

Recently, progress has been made in establishing the cultural sequence of the central areas of the Iberian peninsula which classical writers described as "Celtiberia" (Pliny, *Natural History*, 3, 29) where most of the evidence of Celtic culture comes from, and this has enabled us to understand the development of the "Celtiberian culture" even better than the they did in the classical world (Diodorus Siculus, 5, 33). Inland, from the Late Bronze Age to the middle of the second millennium B.C., the peninsula seems to have been occupied by the "Cogotas I" culture, with modest settlements on low ground, and occasionally one higher up, the existence of which is testified by refuse pits with remains of bones, engraved and impressed pottery and other remains from storage pits. Their economy was based on agriculture and pastoral farming on a local scale, based mainly on sheep and goats. At the end of the second millennium B.C., elements of Atlantic Bronze Age metallurgy were assimilated, but this influence was limited to the technological sphere.

In the first millennium, and in some cases up to the ninth century B.C., various cultural groups, primarily agricultural, appear in the central area of the Iberian Mountains—the future *Celtiberia*—and built settlements on the banks of rivers without defenses. Rare pottery finds from urnfields may reflect the penetration of small, isolated groups of farmers, belonging to a certain "cultural drift" which is characteristic of frontier areas, whereas keel shapes with geometrical decoration and bronze objects such as fibulae, swords and so on are from the proto-Tartesian nucleus of Huelva on the south Atlantic coast, where their tradition of round huts also possibly originates. However, in this case and that of the Cogotas I culture, we do not know what distinguishes them from the Urnfield tradition, in terms of funerary rites, and the same applies to other groups, such as the Soto de Medinilla culture at Duero Medio, where we find painted pottery, Atlantic Bronze A metallurgy, round houses of southern origin and a total absence of finds from funerary rites.

Their characteristics reveal a rather ancient and generalized substratum, which can be dated to the transition period between the Late Bronze Age and the Iron Age in the case of the Meseta and the western part of the Iberian peninsula, a fact which seems to coincide—and can consequently be regarded as connected—with linguistic factors relating to an early western type of Indo-European language, which are considered as "proto-Celtic." The best example of it is found in pre-Celtic ethnicons, anthroponyms and place-names which conserve the initial P, like *páramo* and which are related to the later Lusitanian language, which is clearly quite different from the Celtiberian language. These factors can be linked to certain ideological aspects of a fairly early type, one of which is an inhumation rite which leaves no archaeological evidence, a fact that differentiates it from the Urnfield tradition and the Celtiberian cemeteries. This rite may have been retained by the Celtiberi and the Vaccaei and seems to be linked to the custom of exposing the corpses of warriors who had fallen in battle to the vultures, as various sources suggest (Silius Italicus, *Punica* 2, 3; Aelian, *De ore natura animali* 10, 22) and which is confirmed by the iconography found on stelae and pottery. Also characteristic of this period are certain very early deities of anthropomorphic origin, whose names include the prefixes *Bandu-*, *Nabia-* or *Reve-* plus another component, which was not always Indo-European. Another factor is the existence of physique-worshipping cults, to which shrines are attributed connected with mountains (Ulaca, Cabeço de Fragoas, Lamas de Moledo), with water or sacred woods, the existence of which is confirmed by place names with the prefix *Nemeto-*, all of which are characteristic of the Celtic world.

These elements are particularly widespread in the west and north of the peninsula, but there is also evidence to support them, albeit to a lesser extent, in the form of certain archaic ele-

Rock shrines at Ulaca

ments which seem to continue in the Celtiberian culture of the Meseta, as if they represent a substratum that was gradually disappearing. The existence of these common factors seems to be confirmed by obvious affinities between the peoples who lived in the center of the peninsula, like the Carpetani, the Vaccaei and the Vettones, and in the west, like the Lusitani, Gallaeci and probably others, such as the Astures, the Cantabri, the Berones, the Turmo-

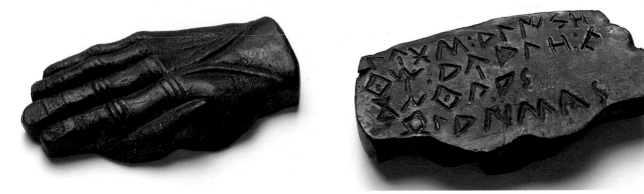

Bronze tessera
with inscription in Iberian letters
from Contrebia (Spain)
1st century B.C.
Paris, Bibliothèque Nationale
Cabinet des Médailles

gi, and the Pelendones, and by the previous substratum just mentioned, which seems to be discernible among the Celtiberi. The substratum concerned was to continue in a fragmented, isolated form, and be gradually absorbed, following the rise and progressive expansion of the Celtiberian culture in the sixth century B.C.: this theory makes it possible to explain both the cultural, socio-economic, linguistic and ideological developments between this ancient proto-Celtic substratum of the Iberian peninsula and the later Celtiberian culture.

The Formation of the Celtiberian Culture

The painted engraved pottery of the proto-Celtic people appears both in the foundations of certain fortified settlements of the "castrum" type (that is, a fortified settlement on high ground), and in cremation cemeteries in the highlands of the Meseta and the western Iberian Mountains. It can be attributed to the initial phase of the Celtiberian culture since many of these finds continue up to the arrival of the Romans, who called the inhabitants *Celtiberi*. For this reason, it is essential to analyze the cultural elements of the formative phase of these settlements and cemeteries, in order to establish their origin and ethnic significance through comparisons with the linguistic and historical evidence, although the latter occurs too late to correspond to the final phase of the Celtiberian culture.

As far as the appearance of the Celtiberian culture is concerned, there are two possible theories. One is the arrival of groups of people who brought with them, already formed, the material culture found in the the settlements and cemeteries mentioned above. This is the traditional "invasion" theory, which leaves many questions unanswered and about which many authors have written. Its weakness lies in the fact that it has never been possible to establish the origins of such groups, nor how they actually arrived. The other theory suggests that they belong to a culture of complex formation, which means that the origins of the various components must be established. On the other hand, they can be explained theoretically in a context of cultural assimilation and evolution, which corresponds better to what we now know. This theory does not exclude the possibility of movements of ethnic groups, but it seems to be limited to the sphere of material culture, which is easier to document in archaeological terms. The generalized spread of fortified settlements can be interpreted as the consequence of the establishment of a hierarchy in the territory and of increasing demographic pressure. This was the result of agricultural and pastoral innovations and the moving of flocks on a seasonal basis to ensure optimum nutrition for the animals in harsh geographical conditions. The dryness of the plains of the Meseta in summer was to be avoided, and the rigors

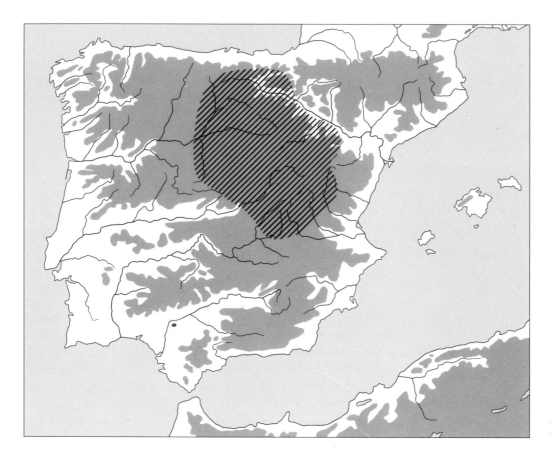

Map showing the distribution of Celtiberian culture

of the mountains in winter. This type of economy generated a demographic increase, but also led to a concentration of wealth and power in the hands of those who had control of the summer pastures. A hierarchical social organization of the warrior type is likely to have been the result of conflicts connected with the seasonal movement of flocks. This process of social stratification was accelerated by colonial trade with these elite classes and was controlled by them, since it acted as a strengthening and stabilizing agent. This theory helps to explain the similarities and differences of rich graves at the beginning of the Iron Age in southwest Europe, such as the one at Corno Lauzo in Italy, those at Grand Bassin and other sites in the south of France, or those in the Iberian peninsula. The differences and the chronological extension of the burials can be regarded not as proof of an invasion, but of the social hierarchies of warriors, the parallel natures of which suggest that there was contact between the various groups. This theory does not exclude the possibility of "invasions." Neither does it suggest that they necessarily happened, since the elite may have been the product of local developments. This does not preclude the possibility that groups of warriors took advantage of such a social organization to assert their authority and extend the area under their control.

The appearance of these hierarchies in the Meseta would have reinforced this trend, which was latent throughout the whole pastoral organization. It was encouraged by the necessity to adapt to the environment of the Meseta-Sierra and, until the introduction of iron, was very widespread and in rapid development in this region. This explains the formation of the Celtiberian culture, and its expansion. The common occurrence of the word *Ambatus*, which seems to refer to clientships, gives us an insight into the patronage-type organization of the culture under discussion. On the other hand, the *tesserae*, the small square tablets used as signs of recognition and hospitality agreements, are indicative of relations and interests sometimes in far-flung areas, and indirectly reveal an insecurity which is characteristic of this warrior environment, and confirmed in historical texts. Here, we read that the Celtiberi were both hospitable and fond of war. They had characteristic traditions such as duels between

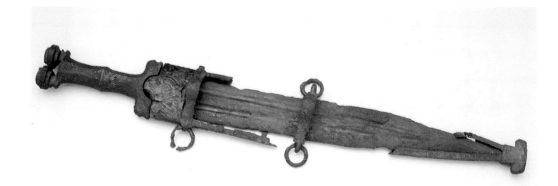

Iron antenna-sword with scabbard from the cemetery at Alcácer do Sal Lisbon, Museu Nacional de Arqueologia

Barrow of Pajaroncillo

champions (Livy, 28, 21; Silius 16, 537; Florus 1, 33), or the *devotio*, by which a man dedicated his life to his chief (Strabo 3, 4, 18; Plutarch *Sert.*, 14, 4; Valerius Maximus 2, 6, 11). In this socio-economic structure, which was perfectly adapted to its environment, mercenaries, cattle-stealing and looting raids were an integral part. This helps us to understand the expansionist trend and the consequent spread of Celtic influence to the proto-Celtic substratum, linked ideologically and linguistically to the Celtiberi. Eventually, the Roman conquest put an end to this process after almost two hundred years of fierce resistance. These people can be regarded as Celts, since ancient sources refer to them by this name, identifying them with the Celts north of the Pyrenees. Moreover, their language was called "Celtiberian" and corresponds to the above-mentioned cultural expansion which involved the previous substratum. Therefore, they may be identified with the *Celtiberi* referred to by Roman writers, the original nucleus of which can be located between the Iberian Mountains and the Meseta.

Material Culture

Archaeology is slowly recording the cultural characteristics of the Celtiberi. Not much is known about the structure and evolution of their settlements. Although some previous populations already occupied defensive settlements, such as Ecce Homo (Madrid), the increasing trend of the Celtiberi to build fortified settlements is quite characteristic. Some of these structures, such as el Jabalón (Teruel) or Pedro Muñoz (Ciudad Real), feature a central street or piazza with rectangular-plan houses built so that their external walls would form a fortified wall, as seen in the Ebro Valley. However, it is not known when this kind of settlement made its appearance and if it occurred before the phenomenon of settlements built in dominant positions, and the construction of walls and ditches. Moreover, some feature menhirs or chevaux-de-frise characteristic of the Ebro Valley in the seventh century B.C. These must have developed along with equestrian strategy, since there is no trace of them among finds from Celtiberian cemeteries until the fifth century B.C.

From the very outset through to the period of Roman domination, the funerary rite of the Celtiberian culture was that of cremation in urns, a practice spread by the Urnfield people and later, which was also inherited by the Iberian culture. There is no lack of local variations, possibly owing to ethnic, chronological and perhaps social differences, such as the appearance of tumuli in pastoral environments, like the one at Pajaroncillo, or the rows of urns with stelae in certain Celtiberian cemeteries, for example, the one at Aguilar de Anguita, which is without parallel in the European Celtic world and may indicate Iberian influence.

The assemblages of these cemeteries highlight the hierarchical nature of the society. Only the richest graves feature a complete panoply. Their characteristic weapons differ from those found in central European Celtic burials: short swords, spears, round shields, and so on. The earliest urns were handmade, with S-shaped profiles, sometimes with a high base, and can be related to the urnfields in the northeast, the development of which began with the Iron Age. The painted pottery confirms the link between cemeteries and settlements. However, while their geometric decoration is usually regarded as having derived from the area of the

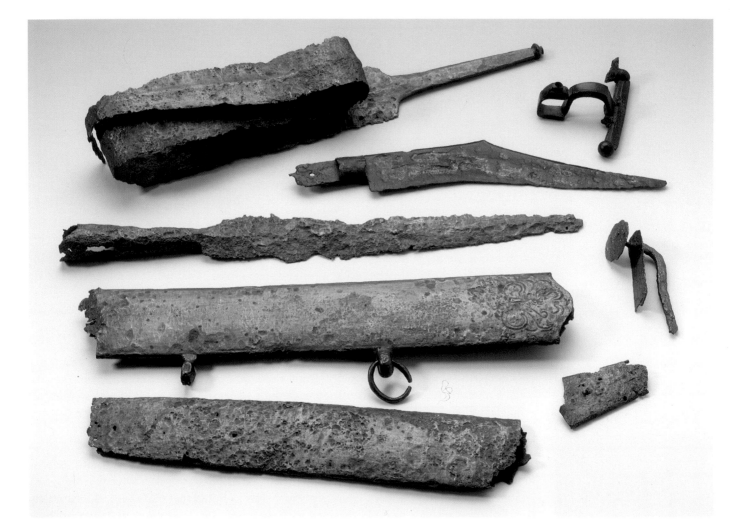

Tartessians, their shapes suggest a dual origin, since the urns and truncated-conical bowls are found in urnfields. The offering bowls, on the other hand, have their origins in the last phase of the local Late Bronze Age, the beginning of which can be explained in functional terms. The use of the same types of urns and jars spread along with the rite of cremations in urns, since every rite tends to spread with the elements of cultural material necessary for its application. Instead, the vessels used for household goods and storage are related to the alimentary habits characteristic of the substratum of local tradition.

It is very interesting to study the material in metal from the grave assemblages, especially ornaments and weapons which reflect ethnic and chronological differences. For example, the fibulae with two-part springs and the belt-hooks from the earlier burials are of colonial origin, and show definite signs of Tartessian influence. Other ornaments, such as spirals, bronze mounts, *kardiofylakes* and so on, provide quite different parallels according to when and where they were made. There is difficulty in identifying their origin and how they reached the site where they were found, owing to the chronological and geographical gap existing between the prototypes and their equivalents in the Iberian peninsula.

Weapons from these cemeteries testify to the use of iron from the beginning. They were almost certainly introduced within the colonial framework, along with curved knives. Antenna swords appear in different versions in Languedoc, the Ebro Valley and Aquitaine in cultures still featuring urnfields in the Iron Age. Their origin can be traced to the peninsular Atlantic Bronze Age culture. An example in point are the swords of the Monte Bernorio type, which are characteristic of one of the cultural groups of the hinterland, whereas short swords are usually regarded as being of Mediterranean origin. It is not surprising, therefore, that

*Silver fibulae of La Tène inspiration
from the Almanedes
and Pozoblanco hoard (Spain)
3rd-1st century B.C.
Cordoba
Museo Arqueológico Provincial*

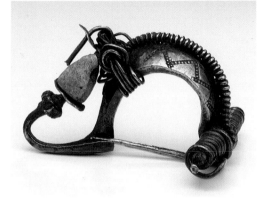

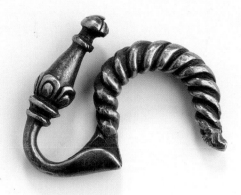

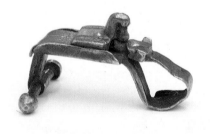

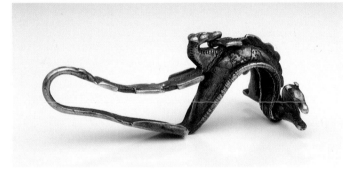

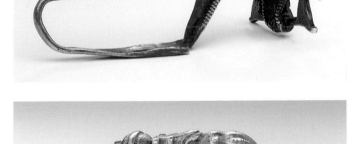

*La Tène-type silver fibula
from Torre de Juan
Abad-Ciudad Real (Spain)
3rd-2nd century B.C.
Madrid
Museo Arqueológico Nacional*

one of the earliest testimonies of these implements comes from the Iberian sculptures of Porcuna, which date from the beginning of the fifth century B.C., since the Iberian culture probably adopted part of the Celtiberian panoply, as it did other elements of the material culture of the Celts of the Iberian peninsula. In its context, the Celtic craftsmanship of the Iberian peninsula seems to have developed in a complex way, as a result of influences from various sources which clearly differentiate it from the La Tène culture common in other areas of the Celtic world. Since we must exclude the possibility that its components came from a single source, these objects do not represent the proof of an invasion. In fact, they represent objects of prestige for the warrior elite of the Iron Age, and were spread in the form of gifts then imitated by the craftsmen employed by this elite. This interpretation is particularly important in order to be able to assess creative development, since the techniques and shapes of Iberian origin convey an ideology and aesthetic feeling that are profoundly Celtic, and remained deep-rooted until the Roman period.

Detail from the so-called "warrior" vase, in painted terracotta from Numantia (Spain) 2nd-1st century B.C. Soria, Museo Numantino

Detail of a terracotta vase painted with two horses from Numantia (Spain) 2nd-1st century B.C. Soria, Museo Numantino

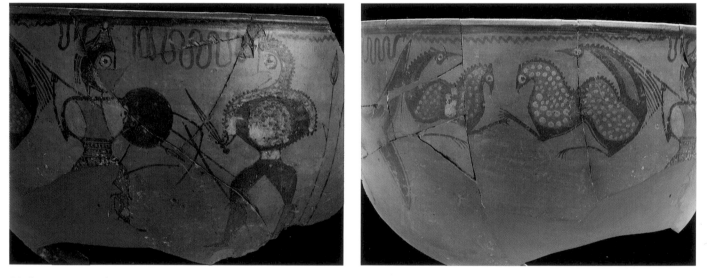

Mediterranean and Central European Influences

In parallel, contact with the Iberian world generated a progressive assimilation of Mediterranean elements during the second half of the first millennium B.C.: this aspect is essential to an understanding, based on archaeological evidence, of the cultural identity of the Celts of the Iberian Peninsula, who bit by bit drew nearer to the Iberian culture and consequently moved away from the La Tène culture typical of other parts of the Celtic world. For this reason, as knowledge of the Celtic world gradually reached the Greek-Roman classical world, the term *Celtiberico* ("Celtiberian") was applied to the cultural personality of the Celts of Spain; eventually the term was restricted to the heartland of *Celtiberia*, which was situated in the highlands of the eastern Meseta and the Iberian Cordillera.

The appearance of iron and certain weapons, fibulae and pottery provides evidence of Mediterranean stimuli from the sixth century B.C. onward, and the early use of rotary querns and the potter's wheel—before the fourth century B.C.—can be seen within this context of exchanges. The latter was used to produce "Celtiberian" pottery. Later, certain groups, such as the one at Numantia, mastered these innovations to express their own stylistic and iconographic ideas. From the sixth century onward, an alphabet, currency, town-planning on orthogonal axes and other new features were introduced, again inspired by Iberian originals. Celtiberian script derives from Iberian script. It seems to have been introduced in about the third century B.C., and was used on coins, *tesserae*, funerary stelae, inscriptions on pottery, and so on, proving that it was widespread, especially in the Ebro Valley. In this area, which was wide open to Iberian influence, they began to use large bronze tablets with inscriptions of a sacred and/or legal content, like the one found at Contrebia Belaisca I (Saragossa), which

*Terracotta plate painted
with stylized bird
from Numantia (Spain)
2nd-1st century B.C.
Soria, Museo Numantino*

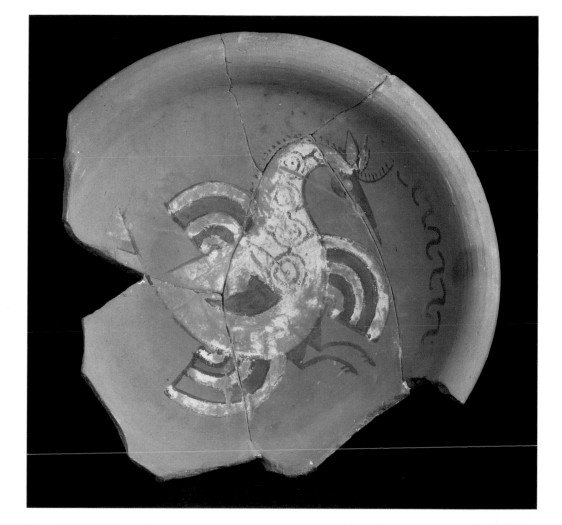

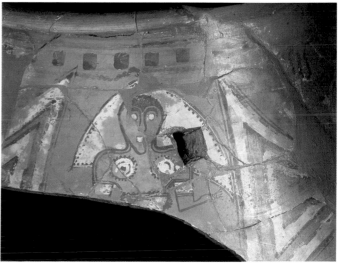

*Details of terracotta vase, painted
with female figure and animals
from Numantia (Spain)
2nd-1st century B.C.
Soria, Museo Numantino*

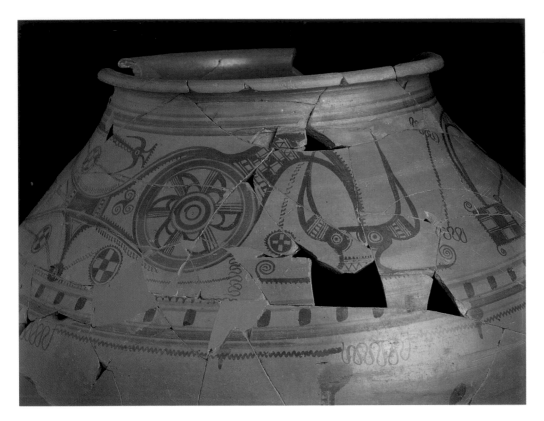

dates from the beginning of the first century B.C. and is the largest Celtic text to survive from antiquity. Another Latin text on inscribed on bronze, from Contrebia II, suggests the existence of aqueducts, public property and complex institutions which mediated inter-ethnic relations.

Although settlements larger than twenty hectares appear in the Iberian world before the sixth century B.C., the Celts of the peninsula did not build large *oppida* until just before the Roman conquest. This was at times the result of mass movements from the countryside to the towns, as suggested by such place names as *Contrebia* or *Complutum* and and by what Appianus wrote about the growth of Segeda (*Iber.* 44). Meanwhile in central Europe, the first *oppida* were springing up, a reflection of the growing socio-cultural complexity of the Celtic world. In the Iberian peninsula, this must be correlated with the process of the spread of the Iberian culture which, from the second century B.C. onward, during the last phase of Celtic culture, gave way to a strong wave of Roman influence, as the funerary stelae, laws inscribed on bronze, and other finds prove. The reach of Iberian influence can be seen in the close similarities between Celtic settlements in the Ebro Valley and the nearby Iberian settlements and the development of a monumental style of architecture with grandiose columns, like the examples at Contrebia Belaisca, and Greek-Roman villas like the one at La Caridad (Teruel), where the name of the builder was written in a mosaic of *opus signinum*. From the third century B.C. onwards, this process of urbanization must be considered within the framework of deep-rooted socio-ideological evolution, where weapons are no longer placed in burials, magistrates make their entrance, and so on.

Although the increasing Mediterranean influences are essential for an understanding of the cultural evolution, on the other hand, the contemporary introduction of individual products from the La Tène culture, such as certain types of sword, fibulae and decorative elements that were an improvement on the local types is sufficient proof for some that the peninsular Celts originated from other areas of Gaul (Lucan, 4, 10; Appianus, *Hisp.* 2). Jewelry of high quality is found, such as the torques so typical of the Celts: silver ones in the Meseta and gold ones in the northwest—clearly a symbol of social and ethnic status. The adaptation to

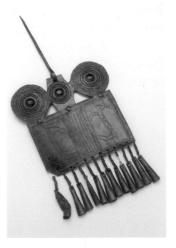

Silver torque of unknown origin
3rd-1st century B.C.
Burgos
Museo Arqueológico Provincial

Gold torque decorated
with stylized birds
origin unknown
5th-2nd centuries B.C.
Lugo, Museo Provincial

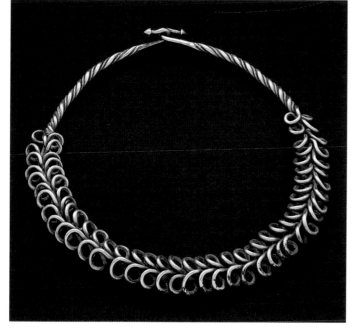

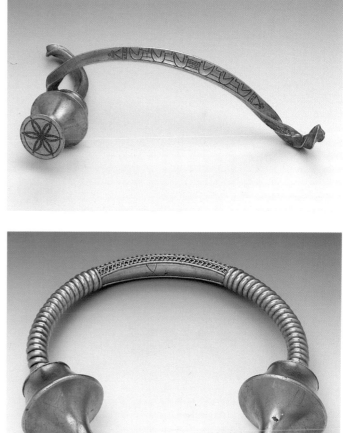

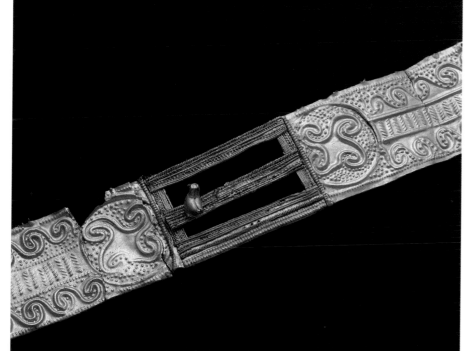

Gold torque from Burela (Spain)
5th-2nd century B.C.
Lugo, Museo Provincial

Diadem in embossed sheet gold
from Elviña (Spain)
3rd century B.C.
La Coruña
Museo Histórico e Arqueológico

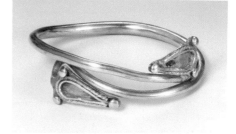

Bracelet of gilded silver
rod with leaf terminals
from the Gudies treasure
Vila Real
Lisbon, Museu
Nacional de Arqueologia

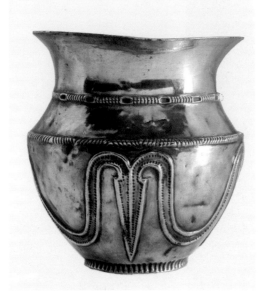

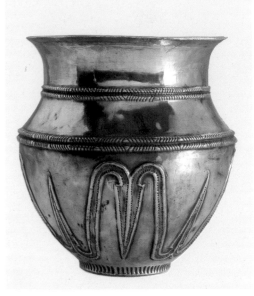

Small silver pots, from the hoard
found at Chao de Lamas (Spain)
Madrid
Museo Arqueológico Nacional

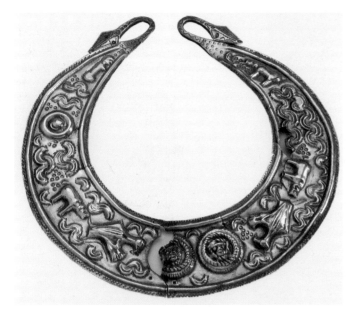

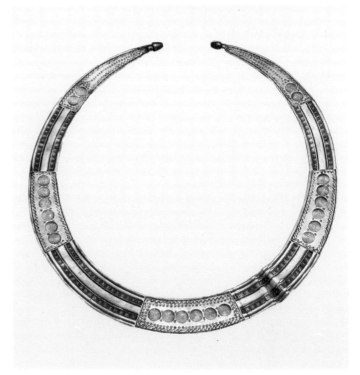

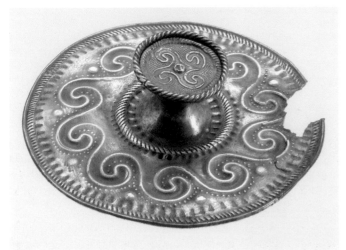

Silver neck-rings, from the hoard
found at Chao de Lamas (Spain)
Madrid
Museo Arqueológico Nacional

Silver phalera, from the hoard
found at Chao de Lamas (Spain)
Madrid
Museo Arqueológico Nacional

the traditions of local goldsmiths and their use of raw materials reveals the complexity of the Celtic cultural assimilation in the areas of the peninsula already mentioned. Similarly, these Celtic elements can be related to social customs and the typical divinities of the Celtic pantheon, such as the *Matres*, *Cernunnos* or *Lugh*.

Celtic Expansion in the Peninsula

Archaeological, linguistic, social and ideological evidence of the Iberian Celtic people seems to confirm the theory referred to earlier of the complex and gradual formation of a "Celtiberian culture." Hence, for example, the cemeteries with Celtiberian weapons and the later horse-shaped fibulae coincide with place-names ending in *-briga*, anthroponyms and place names with the prefix *Seg-*, or indications of social structure like the anthroponym *Ambatus*, the family organizations reflected in genitive plurals, the *tesserae* of hospitality pacts and also certain religious components, like the god *Lugh*. The spread of certain material, economic, linguistic, social and other characteristics over the whole of the central and western regions of the Iberian peninsula can only be explained in relation to the Celtiberian culture, so we thus have an idea of its its geographical reach. Moreover, these features seem to confirm the existence of a territorial nucleus, the Celtiberia described by early writers, in the highlands of the Iberian Mountains and the eastern Meseta, from which Celtic influence seems to have extended westward to areas which were suited to a pastoral economy and where there were compatible forms of socio-economic and cultural organization.

This process began after the formation of Celtiberian cemeteries in the seventh century B.C. The graves containing weapons from the cemetery of the Vettones at Las Cogotas prove that this people came under Celtiberian influence in the fifth century B.C. Later, their influence spread to the south of the Estremadura in Portugal and Baetica, the upper valley of the Ebro and the northwestern region, the so-called *Gallaecia*. This expansion is recorded by Pliny (3,

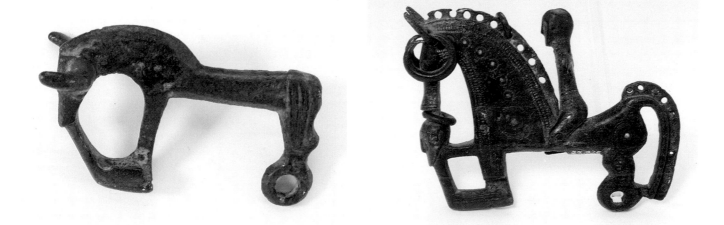

Bronze horse-shaped Celtiberian fibula of unknown origin 4th-2nd century B.C. Madrid Museo Arqueológico Nacional

Bronze cavalier-shaped Celtiberian fibula from Numantia (Spain) 4th-2nd century B.C. Madrid Museo Arqueológico Nacional

13) who states explicitly that the Celts of Baetica come from the Celtiberi of Lusitania: "*celticos a celtiberis ex Lusitania advenisse manifestum est sacris, lingua, oppidorum vocabulis quae cognominibus in Baetica distinguntur.*" The arrival of the Celtic culture explains the use of the surname *Celtius* in Lusitania: in this western area, which was originally not "Celtic," it was used as an ethnic designation. Place names with the suffix *-briga* in the west, Andalusia and the north of the peninsula, which belong to a much later period, seem to confirm the fact that Celtic influence was late in arriving here and all the more so since some names also incorporate Roman elements, such as *Augustobriga* and *Flaviobriga*.

The material evidence does not offer sufficient proof of an invasion, or, indeed, a series of invasions by the Celts within in the Iberian peninsula. However, the linguistic and cultural charac-

teristics of the Celts suggest a more forceful introduction than would have occurred with simple migration or the movement of ethnic groups, as suggested until now. More emphasis should be given to the evolution of the indigenous cultures and their interaction with the Celts.

Information must be culled from every sector—archaeological, linguistic, religious, literary—in order to construct a comprehensive, detailed picture of the Celtic world. The literary sources refer to tribal movements: for example, Caesar (*Gallic War*, 1, 51) mentions the arrival in Lérida in 49 B.C. of a horde of 6,000 Gauls—including Ruthenian archers and Gallic horsemen—and their families.

The spread of Celtic culture was a complex affair with a number of interrelated causes. Moreover, it does not appear to have been continuous; it is more likely to have been intermittent, starting with areas of direct contact, and involving a selective process of assimilation rather than authentic ethnic change.

There were movements of a more militant nature: the invasion of the Cimbri in 104 B.C. has archaeological confirmation in the form of a few hoards of coins, but many such invasions

Gold torques from Paradela do Rio (Portugal)
4th-2nd century B.C.
Lisbon, Museu Nacional de Arqueologia e Etnologia

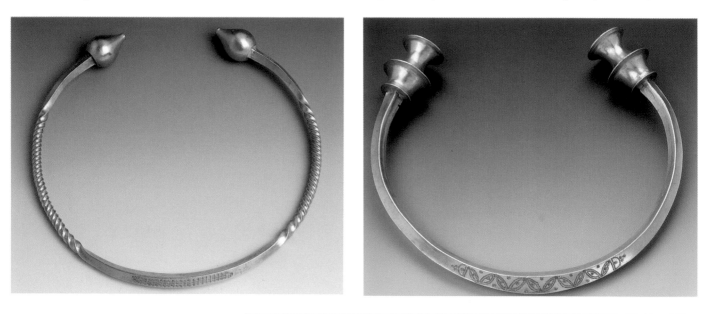

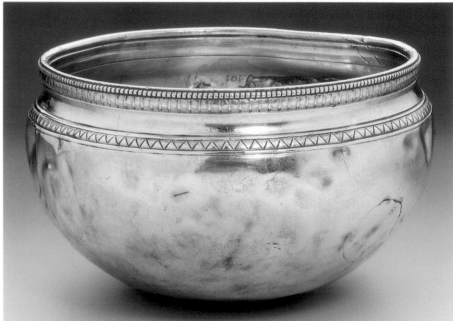

Small silver cup from the Guiaes hoard (Portugal)
3rd-1st century B.C.
Lisbon, Museu Nacional de Arqueologia e Etnologia

left no traces at all, and we must therefore assume that they had little or no effect. In other cases, they contribute to an understanding of the origins of certain tribes, such as the *Celtici* of Baetica who, according to Pliny (*Natural History*, 3, 13-1), came from *Celtiberia*. The *Celti praestamarici* of *Gallaecia*, again according to Pliny (4, 112-113) as well as Strabo (3, 3, 5) and Mela (*De Chorographia*, III, 8), reached the north of Portugal from more southerly climes. This testimony is supported by the find of two *tesserae hospitalis* at the hillfort of Monte Murado (Indalha). The list continues with the *Galli* from the Ebro Valley, the *Gallaeci*, who gave their name to modern Galicia, and there are many others.

Other times, there were small groups of warriors engaged in a *ver sacrum* type of migration. One such case is mentioned by Diodorus Siculus (5, 34, 6) in reference to the Lusitani, with whom the divinities with the prefix *Bandu-* have been connected and of which there is evidence in the west of the peninsula. There were also wide-ranging expeditions typical of all warrior societies: for example, the frequent incursions of the Celtiberi and the Lusitani who devastated Andalusia and the east of Spain (Diodorus Siculus 5, 34, 6). Sometimes, according

Gold torque from Vilas Boas (Portugal) 4th-2nd century B.C. Lisbon, Museu Nacional de Arqueologia e Etnologia

Silver armlet from the Guiaes hoard (Portugal) 3rd-1st century B.C. Lisbon, Museu Nacional de Arqueologia e Etnologia

Silver fibula decorated with a hunting scene from Cañete de los Torres (Spain) 3rd-2nd century B.C. Madrid Museo Arqueológico Nacional

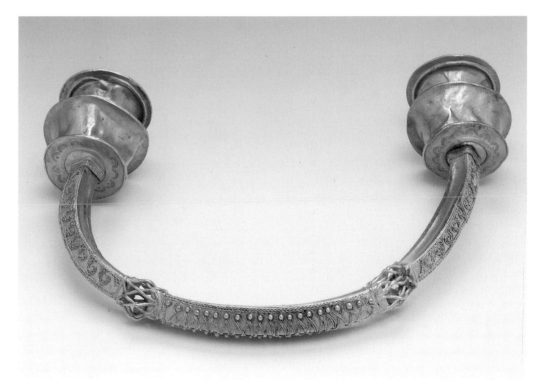
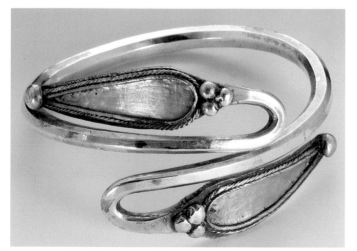
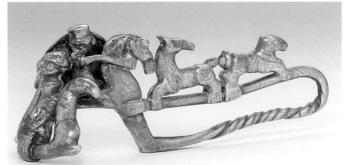

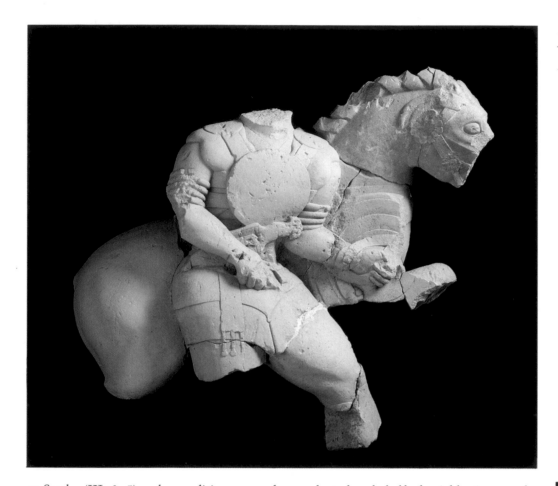

*Stone statue of a mounted warrior
from Porcuna (Spain)
4th-3rd century B.C.
Jaen, Museo Provincial*

to Strabo (III, 3, 5) such expeditions were also conducted on behalf of neighboring populations within a context of far-reaching hospitality pacts. Most of them had no effect, but some may have led to the submission of a territory to a minority of warriors from another region. This would explain the contempt of the Iacetani for the Suessitani (Livy, 34, 20), the founding of an *oppidum* by the Celtiberi in the territory of the Ausetani (Vich, Barcelona; Livy, 39, 56, 1), the dependence of the Belli on the Titi (Appianus, Iber. 44) and the predominance of the Arevaci of Numantia. The spread of Celtic influence to some settlements can be interpreted as the outcome of incursions by elite warrior groups, such as Obulco, in the area of the Turdetané, *Ipolco*, to use its numismatic name, or like the "Celtic" towns of the Baetica area, *Arucci*, *Acinipo* (Ronda, Malaga), and so on (Pliny, *Nat. hist.*, 3, 14; Ptolemy 2, 4, 11). The main consequence of such phenomena was cultural assimilation; it became a defensive measure to adopt similar ways of life, a fact noted by Strabo (3, 3, 5). This resulted in the spread of a social organization based on the warrior elite to the populations of the west, such as the Vettones, the Lusitani and the Gallaeci, whose conquests were coming under Celtic influence. This demonstrates the complexity of the Celtic components of the Castreña culture in *Gallaecia*. Its villages of round huts, its "matriarchal" tradition the absence of characteristic patronyms in child-parent relationships, the connection of its language and onomastics with Lusitanian, the survival of primitive deities with the prefix *Bandu-*,*Reve-* etc., the existence of mountain and water cults, and the lack of archaeological evidence from funerary rites are all typical of the proto-Celtic substratum. On the other hand, a certain number of quite significant implements, such as the plow or the cart, the use of "Celtic" torques and helmets, and a few local names tell us that this culture was subjected to Celtic influence quite late on, a process which was to be cut short with the Roman conquest.

In the case of the more advanced Iberian areas of Baetica and the Spanish Levant, it was mercenary activity that provided the moving force, which may explain a number of things:

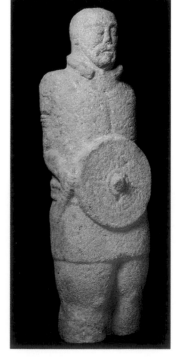

*Stone statue of a warrior
from Castro di Lezenho (Portugal)
2nd-1st century B.C.
Lisbon, Museu Nacional
de Arqueologia e Etnologia*

how the Celtic elite was able to gain control of a town and the existence of Celtic elements in Andalucia, for example, gold and silver fibulae of the La Tène type, and the use of Celtic weapons, like those found at Osuna and Liria, by the Iberians. Yet these peoples, in a more advanced cultural context, seem to have lost their own material culture while sometimes retaining their own social organization, onomastics and often their own language as elements of ethnic and class distinction. These mechanisms explain why by the time the Romans arrived, the Celtic influence was particularly pronounced in the western pastoral areas occupied by the Vettones and the Lusitani. There, Celtic expansion seems to have had a greater impact, whereas it was only beginning to be adopted in most of the northeast (*Gallaecia*), a fact which demonstrates the diachronic nature of the complex process by which Celtic influence spread in *Hispania*. It must not be forgotten that there were internal migrations within the areas already under Celtic influence, usually towards the west, where the pastoral potential of the land and the local culture presented the most attractive alternatives. Others went to the original heartland of *Celtiberia*, as shown in the raids carried out by Viriato of the Lusitani, or

Stone funerary stele with mounted warrior from Lara de Los Infantes (Spain)
1st century B.C.
Burgos
Museo Arqueológico Provincial

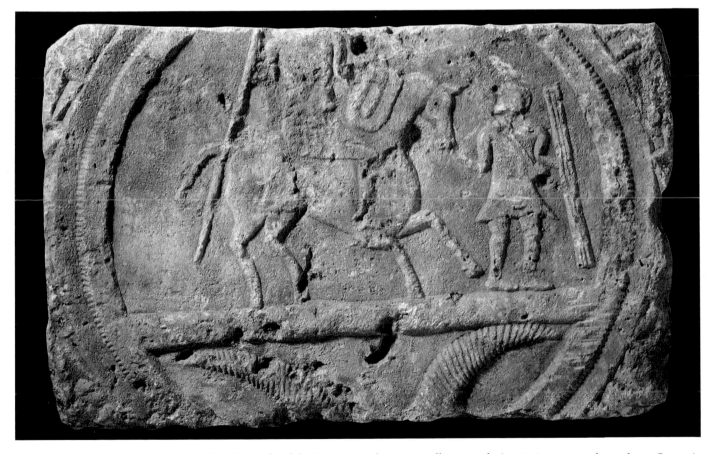

to the other side of the Pyrenees—but especially towards Aquitaine—as we learn from Caesar's account of the arrival of the Gauls at Lérida and other episodes (*Gallic War*, 3, 23; 3, 26). The overall cultural impact of the Celts took place on a broad ethnic scale, all the more interesting because of the parallel influence of the Iberian culture. What emerged were societies with their own unique characteristics. We can therefore understand the great extension and the consequent lack of uniformity apparent in the spread of Celtic influence in the Iberian peninsula, and its singularity in the context of the Celtic world as a whole. It is therefore of vital importance for a global view of the Celts and their role, since they represent one of the common origins of the variegated Europe of today.

View of the site of Numantia (Spain)

Muela de Garray, where Numantia is situated, is a high flat-topped hill at the confluence of the Duero, Tera and Merdancho rivers, in a position dominating a wide plain. The almond-shaped summit measures 550 meters from north to south and 260 meters from east to west, and features a slight elevation in the center. The first occupation of the site dates back to the Aeneolithic period and the beginning of the Early Bronze Age (2500-1600 B.C.). There is no evidence of further occupation until a thousand years later (the seventh and sixth centuries B.C.), when a fortified settlement was built, corresponding to the "Castreña Soriana culture" attributed to the Pelendones, a tribe which established itself in this mountainous region with an economy based mainly on the rearing of livestock. The settlement was founded in the middle of the fourth century B.C., at the beginning of the development of the Celtiberian culture. Later, the Pelendones were forced to move towards the north of the mountainous area by the Arevaci—the strongest Celtiberian tribe, according to Strabo—who took control of the area of Numantia. The Arevaci also had an economy based on livestock-rearing and owned rich pastures where their sheep and goat could graze. Donkeys, mules and horses were numerous and game was plentiful (deer, wild boar, hare, rabbits, bears and wolves). Agriculture completed the picture of their economic resources, although—according to historical literary sources—it was not very developed.

The extensive area of Numantia that has been excavated (roughly eleven hectares) has supplied precise information about the structures and organization of the town. In all, about nineteen streets and twenty blocks of houses have come to light. The town was built round two wide parallel streets with a northeast-southwest orientation, intersected by eleven other streets parallel with each other, forming a uniform network which left no spaces for squares (or meeting places). To the west, the network of streets was surrounded by an inner patrol wall parallel to the boundary wall. The layout and orientation of the streets meant that the town was well-defended against the inclemency of the weather.

Although some early historians, when talking about Numantia, refer to a very large town perimeter, excavations have demonstrated that the maximum axes measured 720 and 310 meters respectively, which corresponds to a surface area within the fortified area of approximately 22-24 hectares. It is not known when Numantia was founded, but, right from the outset, the regularity of the layout and the perfect urban distribution are obvious. For this reason, it is thought that it took place late in the third century B.C., when the Greek and Roman influences of reticulated town plans were already being applied.

Contrary to the testimonies of certain early classical historians, who denied the existence of walls, archaeological research has discovered fortification in various sites around the town. From the parts that have been excavated, we deduce that there was a lack of uniformity in the perimeter wall. It appears to be of less solid construction where the hill provided better natural defenses; similarly, in some areas, the houses seem to have been built right next to the wall, whereas in others, they appear to have been separated from it by a narrow inner patrol wall. The outer wall, which has a trapezoidal section and a very wide base, is built of round stones and is reinforced at intervals by square bastions; on the south side, there was a triangular bastion to protect one of the entrance gates of the town. There is a certain irregularity both in the building and the layout of the streets, which are paved with round stones of varying dimensions. Where there are drainage channels, we find large unworked pieces of stone, laid in a haphazard fashion, which served as little bridges when crossing from one side of the street to another.

The plans of the Celtiberian houses are rectangular or trapezoidal, measuring about twelve meters in length, and varying from three to six meters in width. The foundations were built in stone; the external walls and those inside dividing the rooms were built with wooden poles and mud-bricks or compressed earth and straw. A wall of earth was built by digging two parallel boards into the ground and filling the space between them with earth mixed with chopped straw, which was then pressed down with a tamper or a similar instrument. These walls were 30-40 centimeters thick. The plaster was made of mud and lime and the roof was constructed with timber beams covered with branches.

*Bell of a terracotta trumpet
in the form of a wolf's head
from Numantia (Spain)
2nd-1st century B.C.
Madrid
Museo Arqueológico Nacional*

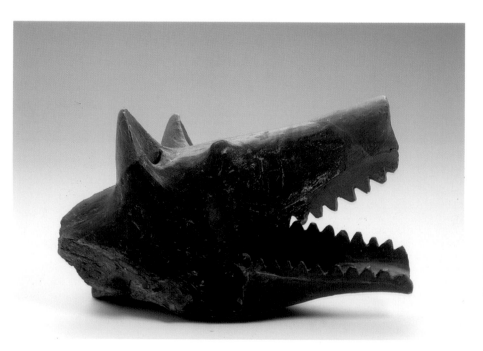

View of the settlement discovered
during excavations at Numantia
(Spain)

*View of the settlement discovered
during excavations at Numantia
(Spain)*

The houses were divided into three rooms. In the main room there was a hearth situated in the center and in the hall there was a staircase leading down to a square underground room or wine-cellar. The wine-cellar was a typical feature in the Celtiberian house; apparently, every house had one, from 1.5 to 2 meters high. These were used for storing and preserving food, although some were used not only for this purpose but also as a kind of workshop.

Early writers mention that the Celtiberi had two funerary rites; according to Silius Italicus, "they cremate people who die of illness..., but those who die in battle ...are thrown to the vultures, which are regarded as sacred." This and the many surveys which have been carried out in the cemetery—which produced no positive results—have led us to conclude that the Numantians did, in fact, expose the bodies of the fallen to the vultures, something that was to be further confirmed by scenes on pots depicting men on the ground being attacked by birds of prey.

The city of Numantia played an important part in the resistance of the Celtiberi to the Roman conquest, which took place over two ten-year periods, from 153 to 143 and from 143 to 133 B.C. To bring the situation to a rapid conclusion, Rome sent Publius Cornelius Scipio to the area. He began to besiege the town of Numantia and to prevent neighboring tribes from supplying it with food and men. They then closed in on the town in a tight circle formation which had the support of seven camps set on the hills around Numantia. The inhabitants of the town were doomed to die of starvation and the town itself was razed to the ground in 133 B.C.

After it had been destroyed, contrary to what was once thought, it did not remain uninhabited, at least, not for long. The material remains found seem to indicate that it was inhabited from at least the beginning of the first century B.C. It is to this phase of the life of the town that the most characteristic finds belong, for example, the locally produced monochromatic and polychromatic pottery. The largest number of finds belongs to the first category, which features black designs painted on a red background and hard, angular shapes. Mainly, these consist of truncated-conical jugs with three-lobed lips and cups. The paintings cover the entire surface of the vessel and feature geometric shapes (crosses alternated with "swastikas," X-shapes, checks, spirals, circles and concentric semi-circles) integrated and alternating with figures of people or animals (birds, fish and sometimes bulls) which only rarely form part of a scene.

The other group of pottery, which can be dated to between the end of the first century B.C. and the beginning of the first century A.D., features polychromatic decoration on a red or white background. The shapes are less angular and the colored paintings, which are surrounded by a black border, represent scenes with people or animals (sometimes monsters) depicted with vigorous expression. The clay trumpets found here also belong to this phase and are sometimes painted or have mouth-pieces in the shape of imaginary animals' jaws; they are reminiscent of the Celtic carnyx.

A large number of metal finds are also attributed to this phase: coins and horse- and bull-shaped fibulae, brooches, bronze spirals, straight knives, jack-knives, saws, compasses, scythes, scales, scissors and horse-bits. There is not much evidence of weapons, although the ones found continue to feature the typical characteristics of the Celtiberian phase, especially twin-hafted daggers, spear-heads, curved iron knives and ammunition for catapults. However, many of these objects and tools are difficult to distinguish from those of the imperial Roman period, since Numantia continued to be occupied intensively until the end of the fourth century B.C.

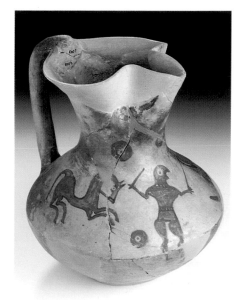

*So-called "tamer" jug
in painted terracotta
from Numantia (Spain)
2nd-1st century B.C.
Soria, Museo Numantino*

*Painted terracotta trumpet
from Numantia (Spain)
2nd-1st century B.C.
Soria, Museo Numantino*

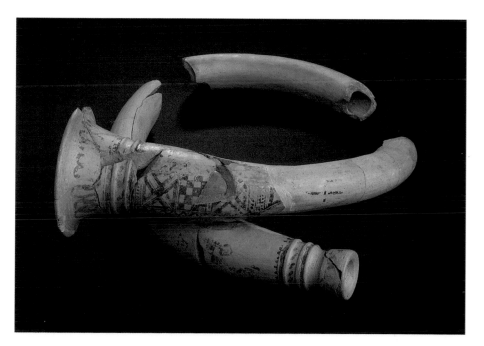

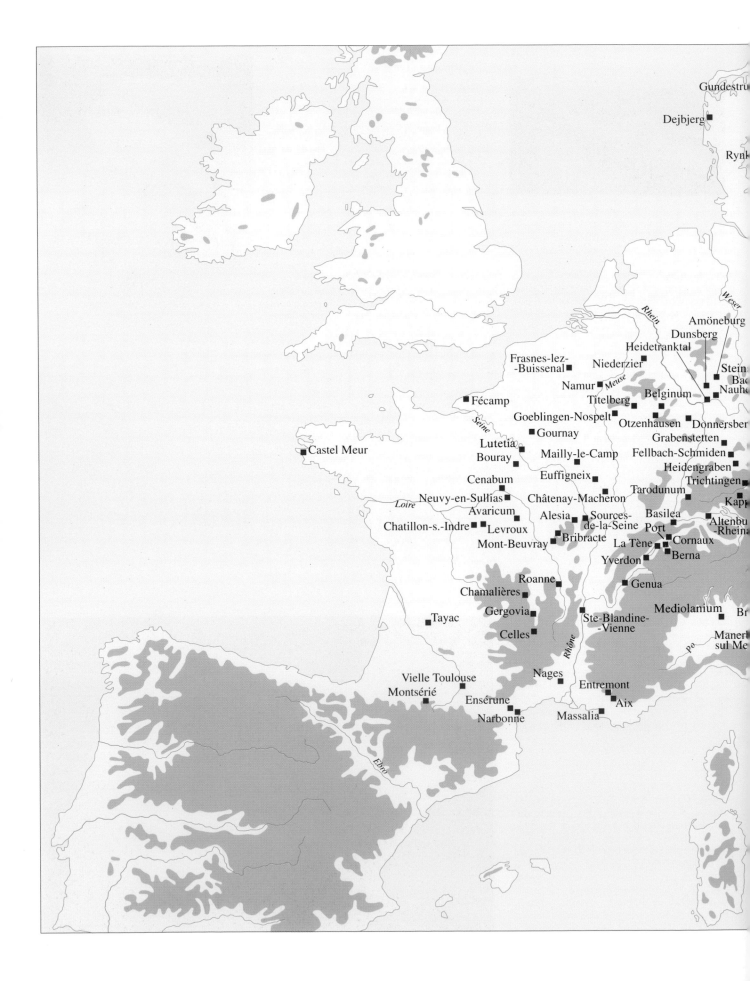

Gundestru

Dejbjerg

Rynk

Weser

Rhein

Amöneburg
Dunsberg
Heidetranktal
Frasnes-lez-
-Buissenal Niederzier Stein
 Bad
Namur *Meuse* Nauhe
Fécamp Titelberg Belginum
 Goeblingen-Nospelt Otzenhausen Donnersber
Seine Grabenstetten
 Gournay Fellbach-Schmiden
Castel Meur Lutetia Heidengraben
 Bouray Mailly-le-Camp Trichtingen
 Euffigneix Tarodunum
 Cenabum Kapp
 Neuvy-en-Sullias Châtenay-Macheron
Loire Avaricum Sources- Basilea Altenbu
Chatillon-s.-Indre Alesia de-la-Seine Port -Rheina
 Levroux La Tène Cornaux
 Mont-Beuvray Bribracte Berna
 Yverdon
 Roanne
 Chamalières Genua
 Gergovia Mediolanium Br
Tayac Ste-Blandine-
 Celles -Vienne Manert
 Rhône sul Me
 Po
 Vielle Toulouse Nages
 Montsérié Entremont
 Ensérune Aix
 Narbonne Massalia

Ebro

The Era of the Oppida
Second-first century B.C.

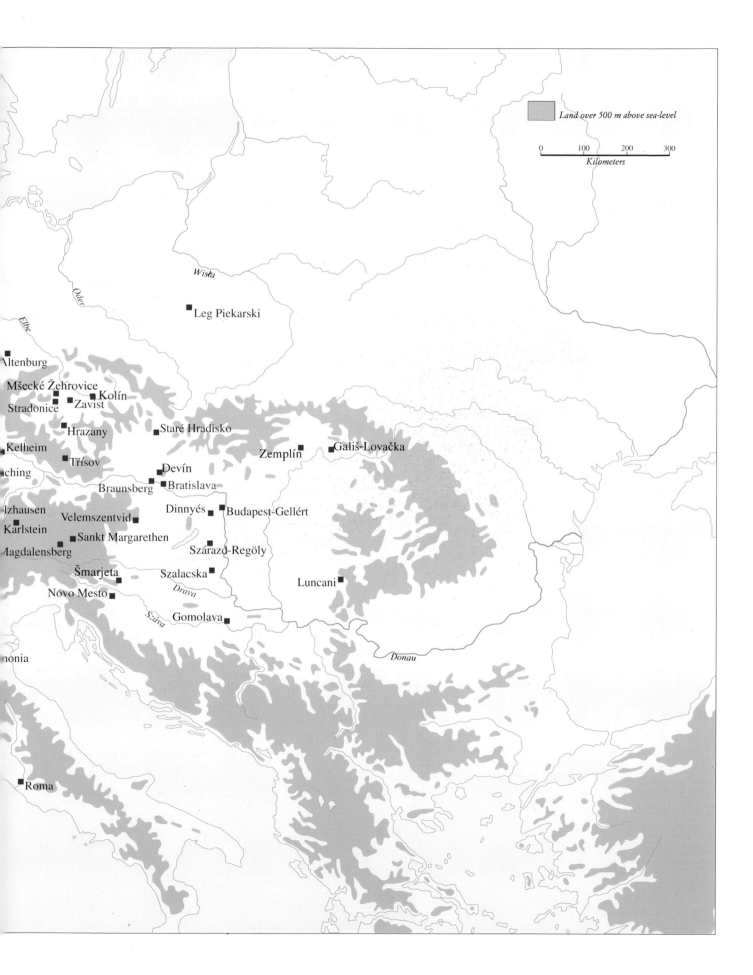

Land over 500 m above sea-level

0 100 200 300
Kilometers

Wisła

Oder

Elbe

Leg Piekarski

Altenburg

Mšecké Žehrovice

Kolín

Stradonice Zavist

Hrazany Staré Hradisko

Kelheim Zemplín Gališ-Lovačka

ching Třísov

Devín

Braunsberg Bratislava

Izhausen Dinnyés Budapest-Gellért

Velemszentvid

Karlstein Sankt Margarethen

Magdalensberg Szárazd-Regöly

Šmarjeta Szalacska Luncani

Novo Mesto Drava

Száva Gomolava

nonia

Donau

Roma

Ferdinand Maier

The *Oppida* of the Second and First Centuries B.C.

Among the most prominent surviving monuments in continental Europe of the late Celtic period are the *oppida* (sing. *oppidum*) or large fortified settlements that have an urban character. They were constructed on naturally protected sites, and some remains of the massive original perimeter walls have turned up in Gaul and on the right bank of the Rhine, as well as in Danubia. Together with the rectangular enclosures (*Viereckschanzen*) that were probably part of the *nemeta* or open-air sanctuaries created by the rural population, the *oppida* are the most significant group of monuments surviving from this time.

The first *oppida* date from the late period of the continental Celtic culture in the second and first centuries B.C. The traditional Late Bronze Age and Hallstatt hillfort construction techniques were overlaid with influences from the Celts' experience of Hellenistic and Mediterranean settlements during their expansion toward Italy and southeastern Europe. The main features of the *oppida* are the architectural construction of the walls and gates, the spacious layout and commanding view of the surrounding area. Internally, excavation has revealed the first clear signs of urbanization in Celtic society. These are all characteristics of late Celtic culture found throughout southern central Europe. The first surveys were made by Baron Stoffel, an officer under Napoleon III, who embarked on a series of historical investigations into the sites of Julius Caesar's battles in Gaul. Since then, knowledge has been based on excavations carried out in the west and east, on the careful assessment of material unearthed, and on the new and painstaking historiographical and philological interpretations of Caesar's chronicles of his campaign in Gaul, the *Commentarii de bello gallico* (*Gallic Wars*). The term *oppidum* was originally taken from the *Gallic Wars*, though today its meaning has been extended to denote major circular defense works dating from the pre-Roman Late Iron Age (La Tène). Generally speaking, the definition of the term *oppidum* now includes fortified sites that suggest the presence of large walled settlements, even if they have not been fully excavated, or if more detailed knowledge of their origin and function is not readily available. The primary function of these enclosures was to provide a central refuge. Given this, the size of the internal space suggests that the *oppidum* offered shelter for a considerable community from the surrounding areas and even farther afield. Smaller, unwalled settlements for farming and manufacturing industries (which are being discovered with increasing frequency) are not defined as *oppida*. The derivation of the concept of *oppidum* from Caesar's war campaign chronicles and the progressive extension of its application as archaeological research proceeds make it necessary to explain exactly what is meant by the term *oppidum* in its more restricted sense.

Caesar divides the settlements of Gaul into three categories: *oppida* (fortified towns), *vici* (villages) and *aedificia* or *aedificia privata* (single farmsteads). This careful subdivision not only gives a clear indication of the different types of settlement pattern, increasingly confirmed by the present-day archaeological campaigns, but also gives an idea of the function of the *oppida*. Even with their large populations, the *oppida* cannot have been entirely self-sufficient. We must assume that, to some extent at least, they also served as storage points for crops and livestock, as well as centers for the processing of raw materials to cater for both town and countryside. As a result of this they also functioned as marketplaces, especially once regular coinage came into use in the second century B.C., when coins of base metals (bronze or those known as potins), and in small denominations, made their appearance. The number of mints soon rose and the percentage of precious metal in coins was reduced with each new issue as coinage increased in circulation and became the most widespread system of payment; trade prices were regulated by centralized administrations. In any case, an overall surge in trading can be inferred from the growing differentiation of Celtic coin issue. The *oppida* in particular have yielded terracotta dies for minting coins, which suggests a drive among the

Painted terracotta vase
from Roanne (Loire)
First half 1st century B.C.
Roanne, Musée Joseph Déchelette

Painted terracotta vase
from Roanne (Loire)
Mid-1st century B.C.
Roanne, Musée Joseph Déchelette

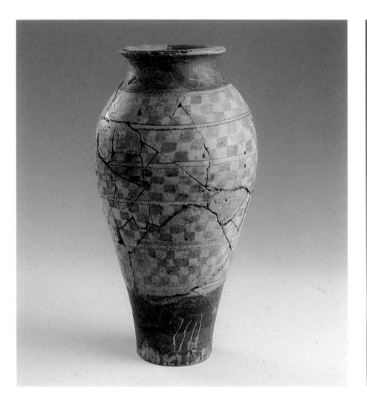

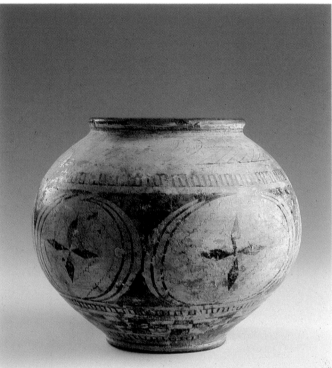

larger settlements for economic self-determination. The ongoing specialization in the production of goods and the expanding organization of the markets insured a greater autonomy in the supply and exchange of goods, as seen in the quantity and originality of the material found. A major stimulus for growth undoubtedly came from the *mercatores* or Roman trading posts installed in *oppida* throughout Gaul to cater to the Roman citizens. It is nonetheless difficult to distinguish simple everyday items that were traded locally from the mass of goods attesting to trade between distant Celtic townships—a system of exchange which may have been responsible for the manifest standardization of many manufactured goods within the Celtic world.

The term *urbs* is used sparingly in Caesar's account to highlight the importance of a handful of larger locations, such as *Alesia*, *Gergovia* and *Avaricum*. Unlike the *oppida* of free Gaul, the towns of *Tolosa* (Toulouse), *Narbo* (Narbonne) and *Vienna*, situated in the *Provincia*, were subject to provincial Roman administration, as implied by their definition as *civitates*. Caesar also uses this expression to define ethnic communities in Gaul in terms of political and administrative entities. The central role of the *oppida* in the political, economic and cultural life of the Gaulish groups (and hence their strategic importance as fortified outposts for the Roman armies), is clearly described in Caesar's *Gallic Wars*, which lists the *oppida* of twenty-nine different Gaulish tribes, with their names followed by a brief description. Some tribes, however, had control over more than one town (twelve in the case of the Helvetii). But most of the population of the time was scattered through villages and farmsteads. As for southern Germany, the diffusion of *nemeta*—rectangular enclosures that were presumably nature sanctuaries for the rural populations—and the proliferation of sites containing graphite-decorated pottery indicate a significant population in the countryside outside and between the large *oppida*.

Furthermore, over a wide geographical area numerous unfortified settlements in advantageous trading sites have yielded considerable information on the metal and pottery workshops. Some of these sites could be classed as trading posts. Their position along the navigable waterways, at harbors or fords seems to have been decisive in their development. In addi-

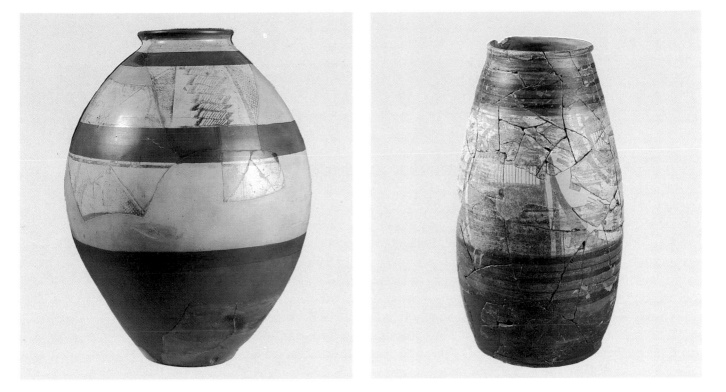

tion to the *civitates* or capitals of the separate races, there were also smaller urban-type settlements, presumably the centers of small territories, such as a *pagus*. It is reasonable to assume that not all these centers were founded at the same time. The location, size and, presumably, the number of inhabitants, varies depending on the political and economic importance of the settlement. Despite their many common features, settlement types are not consistent. More will be said on the internal structure of these living complexes later.

The inhabitants of these towns, the *oppidani*, were mainly employed in trade and manufacturing. But the enclosures must also have included farming activities of considerable importance. This is evident from the remarkable variety and the technical sophistication of the iron, bronze, glass, bone and wood products, as well as from the large-scale production of pottery. In addition to the forging of metal weapons and ornaments, there was extensive production of tools for working metals, wood, leather and fabric; farm implements were also manufactured, as well as equipment for fishing, accurate weighing devices, toiletry articles, medical instruments, various kinds of table- and kitchenware, receptacles in wood or metal, locks and keys, plus harnesses and working gear for horses and wagons. Even at this early stage, many of these instruments and tools were perfectly suited to the task, and remained unaltered until the advent of machine-made tools in our own times, in other words, until each respective manual craft became obsolete. There are also frequent signs of mining and metallurgy nearby.

In general, *oppida* sites reveal a concentration of workshops with ample markets for the distribution of manufactured goods, which soon exceeded local demand. There are indications that in some of the larger fortified centers, designated plots were left undeveloped for the grazing of livestock (oxen, sheep, goats and pigs), as seen at the Manching *oppidum*.

According to Caesar's observations, the *principes* and *druides* lived apart from the daily activities and acted as political and spiritual leaders. At the top of the social ladder, these figures had supplanted the monarchy (which had still been hereditary in the second century B.C., before a system of temporary rule was instituted) with an oligarchy. On the question of political

and military events during the war with Gaul, Caesar singles out certain members of the nobility as prime movers of the changing affairs of the *oppida*. Once such case is his account of an urgent assembly in *Bibracte* (the capital of the Aedui tribes of central Gaul), in the course of which a certain Vercingetorix was nominated supreme commander of Gaul's armed forces.

However, before the armed clashes with the Roman forces, the oppida also functioned as administrative centers. They sometimes belonged to the clients of a powerful aristocrat who each year selected from their ranks a *vergobretus* as chief administrator. He was supported by a Council of Elders, which Caesar called the "senate."

A determining factor in the political status of the *vergobreti* and the hierarchy of nobles was the extent of their personal entourage and their retinue. A distinction can be made between the vast following of *plebs*, or plebian men who bore arms and were little more than serfs, and the members of a superior class, largely impoverished, who were willing to give service and who formed the ranks of the cavalry. The position of the individual in this system must have been decided on the basis of his economic status. A leader was obliged to provide such services as personal protection, economic aid, gifts and bonuses for all these groups. Although the classical sources give a breakdown of Celtic social classes, they say nothing at all about the status of craftsmen or other people with some profession, nor of the farmers, on whom the very economy of the *oppida* depended. Caesar's account nonetheless indicates that the *nobilitas* (to which the druids also belonged) held considerable sway in economic affairs. This category also included those in charge of the minting of coins. It may be that the mass of archaeological finds from the buildings of the small number of *oppida* and unwalled settlements that have been systematically excavated and have yielded abundant proof of a flourishing industrial activity give an exaggerated idea of the extent of trade activity. On the other hand, there is a distinct possibility that it was the craftsmen and independent workers, traders and farmers who actually fostered the urban development of the large settlements. The evident thriving of all these activities in the framework of the *oppida* civilization presumes a certain degree of free trade and the personal liberty of the *oppidani*. Without this the accepted picture of the Celtic capitals would make little sense. The urban culture, doubtlessly based on southern models, must have fostered social distinctions in the townships and countryside, but our attempts at an analysis of the class structure of the *oppida* according to outside criteria are only partially satisfactory.

Even outside Gaul, the most complete information we have comes from the political histories, but the information in the classical texts is, alas, too sparse—apart from Livy's assertion that the Norici had established a state in the eastern Alps as far back as the second century

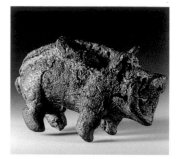

*Bronze and iron boar statuette
from Malaia Began (Ukraine)
1st century B.C.
Užgorod, Oblasnij Muzej*

*Bronze horse statuette
from the Joeuvres oppidum (Loire)
1st century B.C.
Roanne, Musée Joseph Déchelette*

*Bronze boar statuette
from the Joeuvres oppidum (Loire)
1st century B.C.
Roanne, Musée Joseph Déchelette*

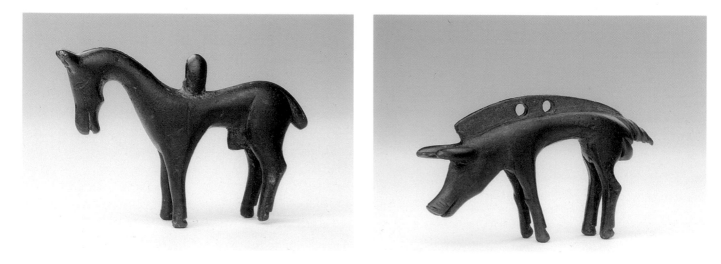

414

415

Iron cauldron suspension chain from the Gališ Lovačka settlement (Ukraine)
2nd-1st century B.C.
Užgorod, Oblasnij Muzej

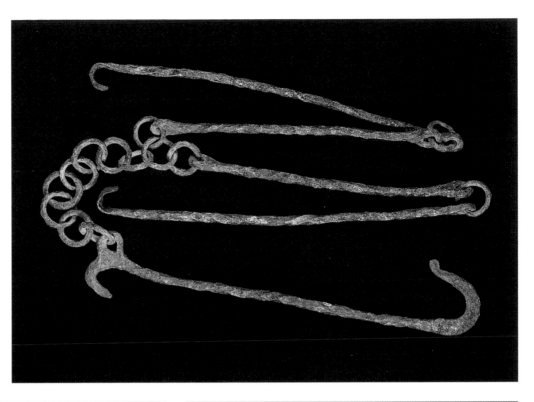

Iron dagger from the Gališ Lovačka settlement (Ukraine)
2nd-1st century B.C.
Užgorod, Oblasnij Muzej

Iron sword with anthropomorphic hilt from the Gališ Lovačka settlement (Ukraine)
2nd-1st century B.C.
Užgorod, Oblasnij Muzej

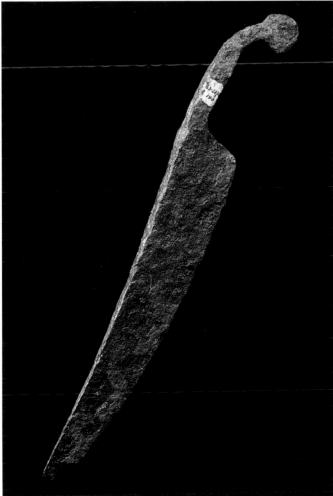

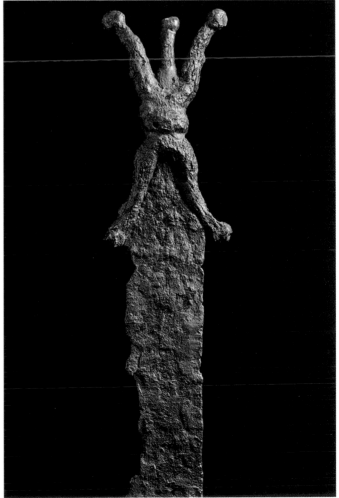

B.C. The realm had the somewhat precocious characteristics of an aristocratic republic led by a council of elders (later abolished with the restoration of the monarchy). The improvement of diplomatic relations with Rome was one of the benefits of a policy of political consolidation and openness in the southeastern Alps, preluding analogous contacts between Rome and other populations in the Alps and Gaul.

In his *Gallic Wars*, Caesar made a distinction between the numerous Gaulish *oppida* he found during his campaigns: those that end in *-briva* indicate sites near a ford, and those ending in *-dunum* and *-durum* indicate a walled fortification or hillfort.

Although the information offered by Caesar is sound only where the territories of his military campaigns are concerned, certain basic urban features he mentions have a more general application, as corroborated by archaeological research undertaken in the larger fortified settlements. This is valid if we consider the term *oppidum* in its broadest sense, that is, an urban settlement with a sizable population, which is both regional center and refuge for smaller settlements and populations over a wide area. None of the definitions that in each case highlight some specific feature can claim to be generally applicable to all late Celtic fortifications.

The reason for this lies not so much in Caesar's choice of term (which is limited to the campaign in Gaul) or in the variability of his meanings, as in the insufficient development of archaeological research.

A graphic example of the difficulties of terminology and classification is the *oppidum* near Oberursel in the Taunus mountains. The settlement has a hilltop location and a perimeter wall enclosing an area of 130 hectares and, judging from the scarcity of finds, archaeologists incorrectly classified it as a refuge for Celts living on the plain between the Rhine and the Main. The decision was reversed in 1974, when a hoard of typical *oppidum* artifacts was found on the site. Doubts will remain until excavations of a sufficient scale have been carried out. Archaeological campaigns on large *oppida* are a lengthy business, requiring vast technical

Iron scissors from the Gališ
Lovačka settlement (Ukraine)
2nd-1st century B.C.
Užgorod, Oblasnij Muzej

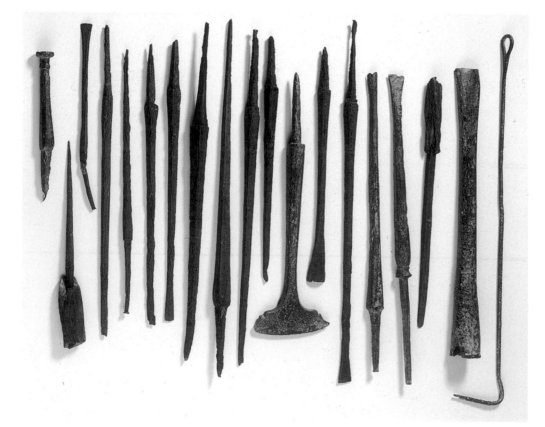

Leather bag with saddler's tools
from La Tène (Neuchâtel)
3rd-2nd century B.C.
Geneva, Musée d'Art ed d'Histoire

Bronze mount with fake filigree from the Gališ Lovačka settlement (Ukraine)
2nd-1st century B.C.
Užgorod, Oblasnij Muzej

input and a workforce not inferior to the original construction team itself. Projects of this kind also require central management, with sound financial backing. Today, involvement in a large-scale *oppidum* excavation can prove to be a highly prestigious venture throughout Europe. A case in point is the vast, international research project currently under way on Mont-Beuvray (*Bibracte*), not to mention some of the larger *oppidum* sites now being investigated: Titelberg, Mont Vully, Basel-Münsterhügel, Altenburg-Rheinau, Manching, Kelheim, Hradiště near Stradonice, Závist, Hrazany, Staré Hradisko, Třísov (Holubov) and Velem-St. Vid. A total of 170 fortified settlements broadly classifiable as *oppida* are scattered over a truly vast area stretching from the Germanic northern regions to the Roman area in the south and southeast; from southern England and the Channel to the heart of central Europe and beyond, to the foot of the eastern Alps and Danubia. All these sites were obviously chosen with great foresight: marked similarities of layout and features typical of late Celtic civilization have emerged from the results of investigations over a large area. The details of site position and outward appearance could not be described more accurately than Caesar did in his account of the *oppidum* of the Sotiates tribe: *oppidum et natura loci et manu munitum* ("a fortified town in a natural location and built by the hand of man," *Gallic War*, III, 23). This often-quoted excerpt (which should be read together with the immediately preceding description of the siege and capture of the *oppidum* itself) is in stark contrast with more recent interpretations of Caesar's definition of the *oppidum*. In this case, Caesar's definition must remain "abstract," since the *oppidum* in Aquitaine has not yet been identified.

The choice of site for each *oppidum* is clearly based on a precise set of criteria, which suggests that there must have been specific traditions regarding the construction of fortifications on high ground and their adaptation to the form of the terrain; it follows that some kind of planning on the part of the chieftains was required. The situations listed below are typical, and are repeatedly endorsed by specific cases (in parentheses): prominent hill (*Bibracte*, Donners-

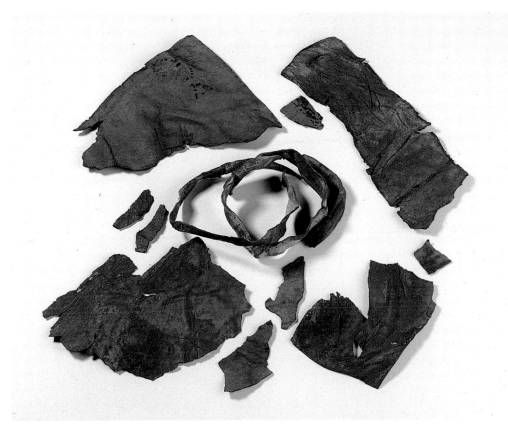

berg, Steinsburg near Römhild, Hradiště near Stradonice, Magdalensberg, Velem-St. Vid); isolated plateau (*Alesia, Gergovia, Vellodunum*-Puy d'Issolu, Mont-Lassois, Amöneburg, Glauberg, Braunsberg and so on); plateau dominating the surrounding countryside (*Noviodunum*-Pommiers, Murcens, St. Thomas-Vieux Laon, Vertault-Titelberg, Finsterlohr, Heidengraben near Grabenstetten, Staffelberg and others); spur between two watercourses (*Genava*-Geneva, *Alkimoennis*-Kelheim, Staré Hradisko); double or single river-bend (*Vesontium*-Besançon, Impernal near Luzech, Joeuvres, Enge near Berne, Altenburg-Rheinau, Třísov-Holubov, Lhotice and others); location on a plain alongside a river or between watercourses and swampy depressions (*Avaricum*-Bourges, Camp d'Attila near La Cheppe, Manching, and the oldest of this group, the capital of the Insubres in the Po Valley, *Mediolanum*-Milan).

It might be argued that identical geo-morphological conditions recurring throughout Europe obviously fostered similar solutions for prehistoric fortified settlements on high ground. So,

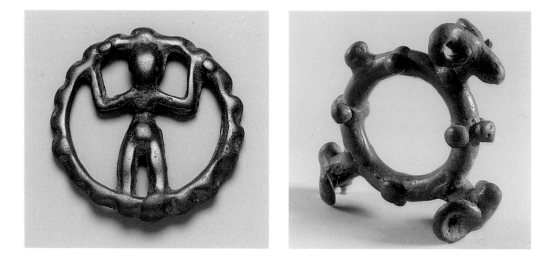

Bronze pendant from Ptení (Moravia)
1st century B.C.
Brno, Moravské Muzeum

Bronze ring with ram's head from Malhostovice (Moravia)
1st century B.C.
Brno, Moravské Muzeum

additional criteria must be identified. Important in this respect is the feature that distinguishes these high-altitude settlements from earlier ones: their size. Much larger than ever before, they enclosed areas ranging from twenty to several hundred hectares (for instance, *Alesia* measures 97 hectares, *Bibracte* 135 hectares, Heidengraben 1,500 hectares, Závist 175 hectares, Manching 380 hectares). In emergencies, the inhabitants of the surrounding territory could take refuge with their belongings, livestock and provisions. Caesar observes (*Gallic War*, VII, 28) that while under siege *Avaricum* provided shelter for around 40,000 people. Comparisons between the perimeter walls of the Celtic *oppida* and those of later medieval German towns again show that the Celtic settlements were much larger. Consequently, it makes sense to talk of the inhabitants in terms of thousands.

The natural advantages of the site were complemented by carefully studied defense works in the form of walls and gateways, remains of which are still visible today as sizable ramparts. Following the contours of the terrain, a wide, deep ditch was dug out at the outer foot of the wall, beyond a horizontal ledge known as the berm. The earth from the ditch was used as infill for the wall, or for the rear ramp (Manching has no ditch, however). An important feature is the "western Celtic" wall, the *murus gallicus*, whose structure and appearance Caesar described in great detail (*Gallic War*, VII, 23), and his observations are borne out by abundant evidence from excavations. The *oppidum* of the Cadurci on the plateau of Murcens on the southwestern slopes of the Massif Central covered eighty hectares. In the course of excavations carried out in 1868, the site yielded one of the clearest examples of *murus galli-*

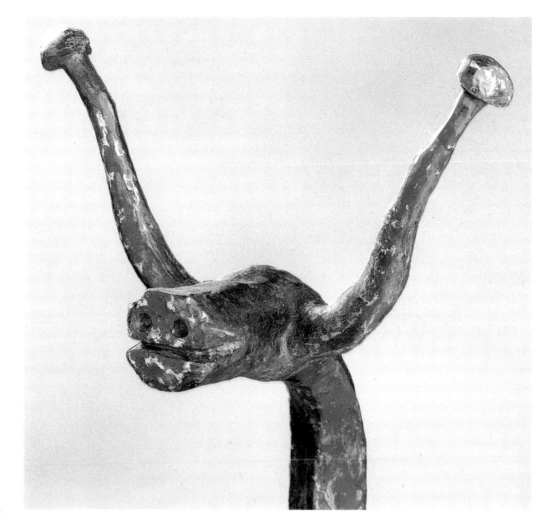

*Pair of iron wings terminating
in bulls' heads from the rich tomb
of the Bretonne forest
at La Mailleraye-sur-Seine
(Seine-Maritime)
2nd century B.C.
Rouen
Musée départemental des Antiquités*

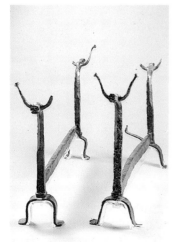

cus, thanks to the lack of later alterations to the main structure. More recent research (still under way) has verified the Murcens perimeter wall as a "classic example." If we consider the archaeological evidence from widespread locations, the following picture of the construction technique emerges: the main wall of the *murus gallicus* was reinforced with timber fastened with nails and, behind it, an earthen rampart sloped backward. The wood reinforcement consisted of a timber lacing of horizontal layers of trunks nailed at right-angles and transversely, creating a kind of scaffolding that was subsequently packed with earth and rocks. The horizontal and transverse layers were set one above the other at the joints, or cleverly interlocked. The sturdy iron nails, also mentioned by Caesar, were between twenty and thirty centimeters long, but have only turned up in the lower layers of timber. This solid walling, sometimes several meters thick (exactly four at Manching) was subsequently given a careful cladding of hewn rock, packed together in dry-wall fashion, through which the transverse beams protruded. The upper, longitudinal beams ran immediately behind the stone cladding and were therefore sunk into the wall. The typical *murus gallicus* presented a facing of perfectly interlocking stones, from four to six meters high, with the ends of the beams exposed in quincunx pattern. Along the top of the wall there was most likely a walkway screened by a wooden parapet, as wide as the wall itself and easily accessed (even on horseback) from the ramp of earth behind the wall.

Without doubt, the *murus gallicus* in wood, earth and stone represents the climax of defense wall construction in prehistoric Europe. The technique recurs in many late Celtic *oppida* from

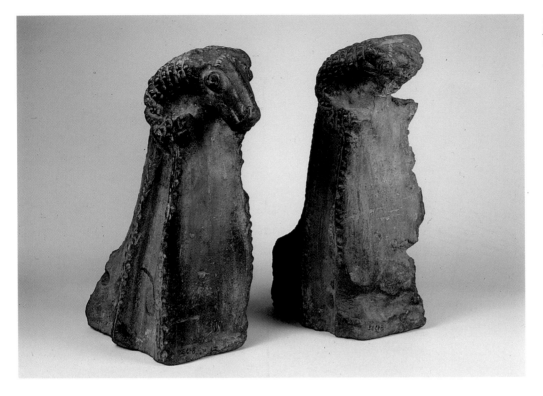

Brittany to the Danube basin in Bavaria, but the principal examples are found in Gaul itself. In Celtic territory east of the Rhine, the prevalent construction method includes piles set perpendicularly along the front, as typified by the Kelheim *oppidum* (*Alkimoennis*-Kelheim, Manching II and III, Altenburg-Rheinau, Mont Vully, Heidengraben near Grabenstetten, Finsterlohr, Staffelberg, Závist, Hrazany, Třísov-Holubov, Staré Hradisko and others, and Donnesberg on the left bank of the Rhine). This facing of poles was a sturdy barrier, largely made up of rough-hewn trunks sawn at the bottom and driven deeply into the ground (at Kelheim; instead at Manching, southern rampart Period II, they were pointed and fixed; and at Finsterlohr, Period III, they were sawn and laid along the upper face of wall). They were lined along the front somewhat irregularly though not too far apart (one or two meters). The sections between poles were packed with worked or naturally flat stones, covering the upper face of the poles (Altenburg-Rheinau), or leaving them exposed on the outside (Finsterlohr). Immediately behind the wood-and-stone facing there was the real nucleus made up of a broad infill of earth and gravel, shaped into an escarpment at the base. The typical "eastern Celtic" construction, unlike the *murus gallicus*, had vertical components only (*Alkimoennis*-Kelheim), or could be reinforced on the inside with transverse beams (Altenburg-Rheinau). In other words, the frontal poles were connected (at a height probably no longer identifiable) with transverse beams, themselves anchored to the infill at the rear. Special versions of enclosure walls have been found which involve a stone wall with poles driven behind the facing; still others have no wooden support structure, and some are simple earthen ramparts.

The latter, of vast dimensions, make up a category of their own in northwestern France, especially between the Seine and the Somme (in *Gallia Belgica*), and also in Berry. Ramparts of this kind most likely consisted of an upper palisade or a wooden parapet, surrounded by a vast ditch. The "Camp du Canada" *oppidum* near Fécamp gave its name to the group (Fécamp-type). The astonishing results of excavation work completed in the 1970s along the southern rampart of the small but important *oppidum* on Basel's Münsterhügel (with a surface area of 3.5 hectares) reveals another technique: the lacing of nailed horizontal timbers found

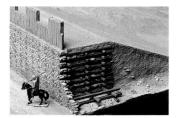

Scale model of "murus gallicus"
at Manching (Bavaria)
End 2nd-early 1st century B.C.

Diagram of two successive phases
of "murus gallicus" at Manching
(Bavaria)
2nd-1st century B.C.

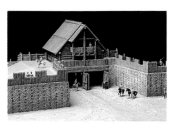

Scale model of the eastern gate
of Manching (Bavaria)
End 2nd-early 1st century B.C.

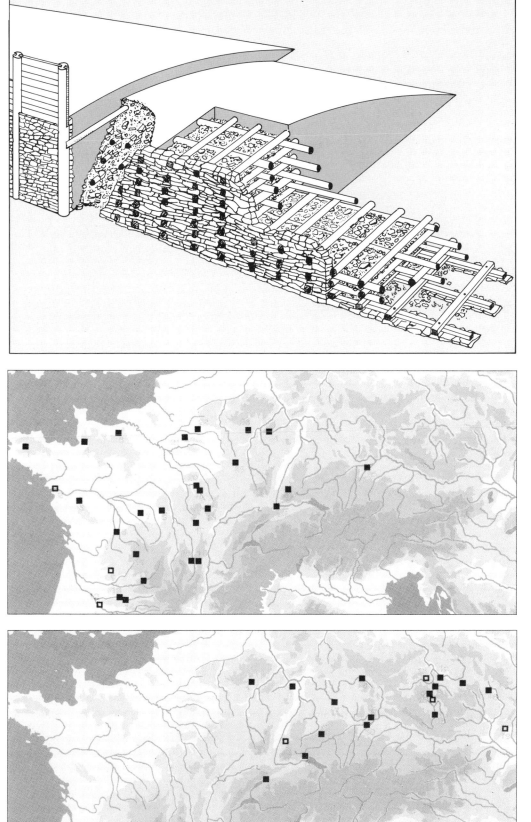

Map showing the distribution
of the murus gallicus
2nd - 1st century B.C.

Map showing the distribution
of timber-laced walls with vertical
timbers fixed into the facing
(Manching, phase II)
2nd - 1st century B.C.

in all three recognized building phases of *murus gallicus*, was complemented by a facing in stone and vertical poles, a technique normally indicative of the type found at Kelheim (wall with jutting tower heads). On the basis of the new discoveries, the director of the excavation at Münsterhügel warned against the rigid classifying of Celtic wall construction methods, and likewise of idealizing the famous passage from the *Gallic Wars*. Instead, he proposed extending the concept of *murus gallicus* as an archaeological term to include all the Late Celtic perimeter walls with a core of horizontal timbers. Irrespective of whether this cautious approach is still viable in the light of current knowledge, in Basel itself—that is, in the area where western and eastern Celtic building techniques merge—such a combination of horizontal and vertical timbers would be perfectly admissible.

Directly related to the two main wall-building techniques mentioned above are the *oppida* with in-turned entrances, in which the two ends of the enclosure are built with a recess twenty to forty meters deep, almost perpendicular or slightly funneled, creating a kind of passageway (*Bibracte*, Heidengraben near Grabenstetten, Finsterlohr, Basel-Münsterhügel). The way into the enclosure itself is therefore set back from the opening of the passage, and usually had two entrances (Manching, eastern gate). The presence of several entrances is indicated for the Gaulish *oppida* not only by Caesar, but also by those field monuments included here, which have not, however, been subjected to test excavation, and where such in-turned entrances in good condition have been found (such as the Heidetränk *oppidum* near Oberursel). The effectiveness of the defense walls of the *oppida* was further guaranteed by a deep, broad ditch dug out in front of the wall.

To date, very little is known about the layout of the town inside the enclosure. Caesar's information is very limited, and reliable extensive research, including excavations inside the defense works, is rare. In addition, there are few sites with homogeneous material in the general areas. Consequently, the debate on the possible functions of the *oppida* is far from concluded.

Evidence from excavations in certain sites offer the following somewhat simplified or idealized picture: dwellings were thatched and built with a light wooden structure. The floorplan and form can only be reconstructed on the basis of traces of color on the ground where the vertical timbers formed the threshold. These include cult structures (temple enclosures), houses, stables, granaries and workshops, as well as underground structures of various dimensions, perhaps for the storage of provisions or as well deposits for detritus. The walls of the houses were largely of rush matting faced in mud. Despite the extent of the still-unexplored areas, those which have been investigated, plus the cautious interpretation of structures with several building phases, suggest well-defined networks of living quarters and workshops, agricultural plots, streets, squares and public structures. Of particular note are the lavish stone buildings with a Graeco-Roman floorplan (courtyard houses) and the Mediterranean-style neighborhoods found at *Bibracte*, which date from the decades of prosperity that followed the wars in Gaul, though it is believed that their origins lie in the foregoing period of domination by the Celtic aristocracy. Roman styles clearly filtered through from the *Provincia Narbonensis* to the interior of Gaul at a very early stage, finding particular favor at *Bibracte*, the capital of the Aedui tribes, sworn allies of Rome from the outset. This process may have had a decisive effect on the definition of new urban structures, and is the only way to explain the rapid Romanization of the *nobilitas* and an ever-growing number of Gauls. In contrast, a much simpler building technology is found on Celtic territory on the right bank of the Rhine, in Bohemia and Danubia. Here there are no stone structures, yet, as at Manching, there are rows of buildings (workshops, stores) lining the streets, showing clearly the same characteristics of structure and layout as those described above for a similar community.

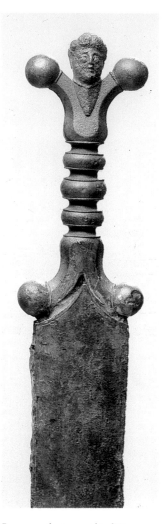

Bronze anthropomorphic hilt from the Tesson sword (Charente-Maritime) 1st century B.C. Saint-Germain-en-Laye Musée des Antiquités Nationales

The abundant archaeological material gives a faithful picture of the diversity of urban life. Alongside the various domestic items there is a wealth of goods from wide-reaching trading contacts, products of an economy highly-developed industrially and financially. Towns of this kind also included undeveloped areas within the enclosure. It was not unusual for an *oppidum* to comprise a fortified upper town (*arx*) occupying the highest point of the terrain, where the governors were also lodged (as at *Vesontium, Alesia* and the Heidetränk *oppidum* near Oberursel).

So far, little is known of the cemeteries of the large settlements. One of the reasons for this is the change in burial rite, from inhumation to cremation. Due to the simplicity of their outer structure, the tombs, containing remains of cremated bodies with burial effects of melted metal objects and shattered pottery, are generally hard to identify. Nevertheless, an important cremation site (*Ustrinum*) was brought to light immediately in front of one of the main in-turned entrances of the Heidetränk *oppidum*, containing several cremation burials.

Obverse and reverse of coin
in impure gold minted by the Bituriges
in central Gaul
1st century B.C.
Rouen
Musée Départemental des Antiquités

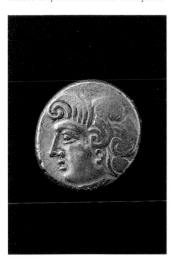

As for the origin of the *oppida*, there are distinct signs—the first of their kind in Europe—of a developing architectural form (*murus gallicus*, walls with *Pfostenschlitzmauer*, and in-turned entrances. The perimeter walls had reached new dimensions, skillfully enclosing highly uneven terrain—sometimes enclosing large tracts of land for a lower town, and sometimes securing a constant supply of fresh water by including springs or watercourses in the enclosure. Until then, these features had only been found in Hellenistic towns. The perimeter itself, the structural details of both walls and gates, and the internal layout betray marked differences from earlier fortified settlements on high ground. There is also evidence of a merging of ancient local tradition and Mediterranean influences. It seems inevitable that *Gallia Cisalpina*, where the Celts were not only in direct contact with the Italic civilizations having urban traditions, but in turn had developed urban centers in their own lands, acted as a melting-pot. It is possible that certain new building techniques spread from here northward, for example, the bulky embankment behind the main perimeter walls, resembling the agger of Italic defense works, and perhaps the technique of nailing together the core of timbers. It is probable that after the Roman occupation of the Po Valley and the consequent ebbing of Celtic power in northern Italy at the turn of the third century B.C., the Celtic groups migrated to territories north of the Alps, enriched by their experience of a developed economy and urban culture. In this "retrogressive migration" there also seems to have been an urge to promptly build large, densely populated settlements whose design perhaps borrowed something from the previous village-type of settlement. The decisive step toward the full-blown *oppidum*, as described here, came with the erection of defense walls, which probably occurred in the last fifty or even thirty years of the second century B.C. These operations may have been a response to rivalry between Celtic groups, or to a growing sense of insecurity after the invasions of the Cimbri and Teutons.

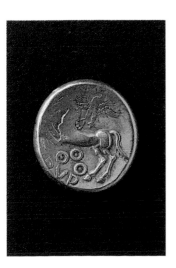

It is widely thought that the *oppida* were created in such a relatively short time because of social upheaval or similar circumstances. This is disproved by the Manching *oppidum*, which demonstrates progressive, uninterrupted growth from its early days as a village-type settlement midway through the third century B.C. At any rate, clear indications of decisive changes in the second half of the second century B.C. are indicated by the layout of the buildings and in functional organization. These changes also led to the erection of enclosing defenses. Although the specialists vary in their assessments of information and excavation material (only briefly outlined here), and even disagree over certain features of primary importance, the innovations alluded to above may be seen in the broader framework of migratory and military activity which, as documented historically and archaeologically, from the fourth century B.C. brought Celtic groups into increasingly close contact with the fringes and

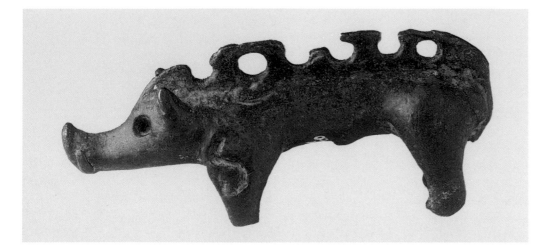

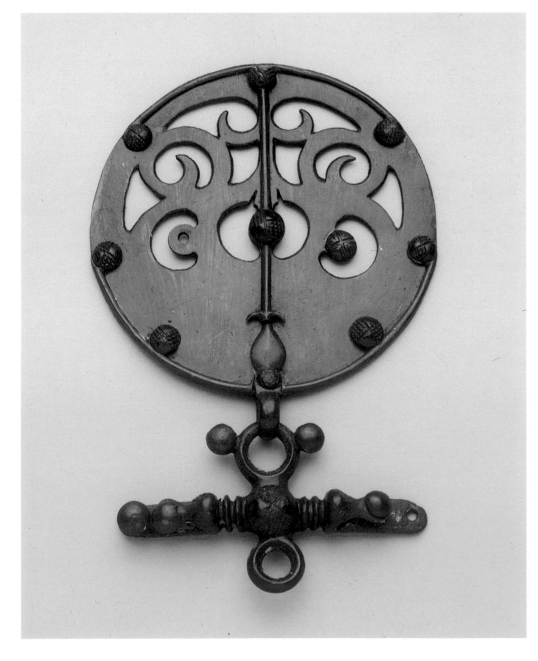

towns of the Italic and Greek world, thus promoting cultural and material exchange with the Celtic homeland north of the Alps. This signals the culmination (and ensuing conclusion) of a process that, starting in the sixth century B.C., saw the primitive settlements and strongholds of the proto-Celtic chieftains turn into complex urban schemes. The age of the *oppida* came to an end with Caesar's successful occupation of Gaul, the violent incursions of Burevista's Dacian hordes along the central section of the Danube, the occupation of Bohemia by the Marcomanni under Marbod, the penetration of smaller Germanic groups into southern Germany and, lastly, with the operations of the Roman armies under Augustus along the Rhine and in the Alpine foothills. Under the new dominion, the *oppida* were razed or abandoned. Only those in Gaul itself experienced a renewed period of prosperity, in a new Gallo-Roman guise, until the forced transfer of populations under Augustus at the end of the eventful first century B.C. Thereafter, a mere handful of *oppida* remained (*Avaricum*-Bourges, *Cenabum*-Orléans, *Lutetia*-Paris, Basel-Münsterhügel). The rest became Roman military colonies, civilian settlements and, some time later, provincial capitals. The efforts and achievements of the *oppidani* therefore endured for many years to come.

An index of Late Celtic *oppida* and map of their whereabouts accompanies the text of Ulrich Schaaff and A. Taylor, listed in the bibliography.

Hansjörg Küster

The history of vegetation

Research on the history of vegetation starts with an examination of the remains of fruits and seeds preserved in the settlement levels of prehistorical sites, and of the pollen produced by plants in the immediate surroundings of a settlement, then carried elsewhere by the wind and deposited in the sediments of lakes and marshes.

Botanists are able to cull from such research a great deal of interesting information about the environment of prehistorical man, since the overall picture of any environment is conditioned to a great extent by the nature of the vegetation, the woods and fields. These botanical studies take on special importance when, for example, explaining the situation of the late Celtic *oppidum* of Manching in Bavaria. The remains of this *oppidum* are among the greatest archaeological monuments in southern Germany. Furthermore the settlement area is located in the region alongside the Danube and its tributaries, where the environmental conditions do not seem particularly suitable for farming. It is reasonable to suppose therefore that the region had to be specially prepared for growing crops. The situation of the settlement and the incredibly vast area it occupied raises questions which the history of vegetation can answer.

Through pollen analysis it was possible to conclude that the district around Manching was

Reconstruction of the environment at the Manching site (Bavaria) 3rd-2nd century B.C.

already used as pastureland for live stock thousands of years before the construction of the *oppidum*. The original oak forest gradually gave way to a much less dense growth of trees, in which there were fewer oaks and a predominance of pines and junipers. Forests remained dense only where there was greater humidity, on the banks of the countless streams and stretches of water in the wide valley of the Danube, where alders and willows grew. The Celtic *oppidum* developed in an area where by then there were only a few trees, mostly pines. The land was easy to clear by cutting down those few trees, which at the same time provided enough heavy oak wood for building the seven kilometer-long fortification demarcating the settlement area. The enormous amount of timber also needed for building houses, as well as the stone for the rampart had to be brought in, something that only a rich community with a hierarchical organization could afford.

During excavations it turned out that not all the land within the *oppidum* walls had been occupied. Areas with numerous occupation layers were found along with others that had practically no traces of building. Analysis of samples of the soil from those areas with few buildings showed the presence most of all of weed seeds, of goosefoot and grasses. The conclusion is that the grain was threshed outside the living areas, and the chaff was left on the ground to be burned, so that remains of the threshing (weed seeds especially) have been preserved there in the earth down to the present day. Only food that was already cleaned and husked

Linseed

entered the houses. Preference was given to spelt-type cereals: barley, spelt and emmer wheat. In these cereals, the husk was so tightly attached to the seeds that during the threshing it was almost impossible to get it off, unlike the cereals used to make bread today. The seeds were carefully winnowed or "husked," but the cereal was easier to preserve with the husk on than off. Besides, granaries did not exist then, as they did in Roman times, so the wheat could only be gathered into sheaves or stored in four or six-pole granaries, or in the lofts of the houses, where dampness could seep in during the winter. The husk protected the seed against rotting. Before preparing food for cooking, the seeds had to be dried and husked and for this purpose were exposed to fire, probably in ovens that functioned like rear-loading wood stoves. Some seeds always got burned in this process, and ended up in the rubbish pits, where they have remained to the present day. The dried seeds were husked (which could be done, for example, with a quern provided it was light enough or lifted up slightly); the husks were burned and the ashes thrown into the rubbish heap, where they are still to be found in archeological deposits.

All this leads to the conclusion that the inhabitants of the *oppidum* grew grain, threshed, winnowed, stored and husked it on their own. If the grain had been imported, it would have arrived already cleaned and husked. So it is reasonable to suppose that the farmers who lived in the *oppidum* raised wheat somewhere in the vicinity, but the only nearby place was the gravel hill on which the *oppidum* itself stood, and where the fields of medieval and modern Manching are still to be seen.

Quite clearly the Celtic fields were located in that part of the *oppidum* where there are no archaeological traces of occupation. Very likely the fields themselves were enriched with man-made humus; fertilized plots of this kind are to be found almost everywhere inside the circuit of defense walls. Medieval Manching still depended almost exclusively on farmland located inside the walls themselves, so the walls not only encompassed the actual settlement, but the cultivated areas lying within its province as well. The function of the walls could therefore be seen in a different light: they marked off a boundary, not simply a town. This explains why the walls in question were seven kilometers long. Thus it becomes clear that it served not only what is considered its primary function, namely defense, but also a jurisdictional one in that the rampart separated the food-producing area of the settlement from the surrounding district: the infield from the outfield, as it were. In areas crisscrossed by rivers and streams, there was another, very important element: settlements situated on the riverbanks, even those on slightly higher land, were not completely safe from floods, and a rampart could serve as protection, to prevent crops from being washed away.

Botanically speaking, the Manching *oppidum* could appear not only as a fortified city, but also as the bounds of a village. And that this community was particularly prosperous is perfectly clear, as is proved not only by the archaeological finds but also by the fact that the soil was fertilized and fortifications built.

As in all Celtic settlements or of the central European Iron Age, cultivated crops were closely bound up with the village. The crop that was grown nearly everywhere was barley, a low-starch cereal that was not suited to making bread. Barley bran may have been used for making porridge, but barley itself may not have been intended for human consumption but only for animal feed. The most common bread-making cereals in central Europe were emmer and spelt, two close relatives of wheat, as well as oats and rye here and there. In Gaul a higher percentage of wheat is to be found. Legumes (fava beans, peas and lentils) were also cultivated, as well as non-food crops, such as flax for weaving and poppies, perhaps for obtaining opium. These are all plants that are known to have been cultivated already in prehistoric times, many thousands of years earlier (from the Neolithic), and continued to be grown down to the Middle Ages. Before, but also after the Celtic period, in Roman times and into the High Middle Ages, the same crops were grown as a rule in small farm village settlements. So Celtic farmers fit in with a long rural tradition that persisted even into post-Celtic times, which is proof that at least part of the farming population stayed on in the area after the

Romans had assured their dominion over vast European territories. Between the Celtic period and the Roman period, there was an unbroken tradition of rural settlements; this is also demonostrated by pollen analyses carried out in many central European districts. Things were very different in urban settlements, in Roman cities and *castella*, and later in medieval suburbs, religious houses and cities. Here truly urban eating habits developed that were unknown in the Celtic world as well as in Roman villages.

Traces of "city" eating, easy to find in Roman times and the Middle Ages, are almost completely lacking in the Celtic period. In no central European Celtic settlement are there signs that spices were used, whereas the Romans made abundant use of them in their cities (but not in their villages!). "Southern fruits" such as figs were also present in Roman settlements and *castella*, but not in Celtic times and not in Roman rural towns. As has been confirmed time and again, the only "urban element" to be found in Celtic communities was imported wine. In Manching a wine cask was found which had then been turned into a water butt, of exactly the same shape and made out of exactly the same wood as Roman casks, silver fir, a tree that did not grow around Manching but only in the Alps, where the commercial wine route probably passed: wine for the Celtic settlements on the Danube was brought in from the Mediterranean area.

Wheat

Inquiries into the history of vegetation seem to suggest that the Manching *oppidum* was not a city in the modern sense of the word, but rather a settlement with the typology of a village, including the arable land within its province. Despite unfavorable environmental conditions, very high level forms of organization may have developed there. Land improvement, the construction of a rampart, maybe even the use of moldboard plows to turn over and break the soil—Pliny describes them in detail, with the comment that they were characteristic of Noricum peasants—offer susprising evidence of a highly developed rural culture.

Research on the history of vegetation must be continued, not only at Manching, but in other Celtic *oppida* and settlements, as well. It may prove to be decisive to our understanding of the *oppida* and correct the picture that historians have drawn since the time of Caesar.

Poppy

In the life and economy of the Celts animal husbandry played a far more important part than hunting. This has already been stressed by authors of antiquity, such as Strabo, and was also evidenced by the animal bone samples unearthed in Celtic settlements; in these bone samples the ratio of wild animal bones was between 0. 2 and 5 percent. However, in this respect there are differences among the settlement types. In an *oppidum* such as Manching, hunting was clearly not large-scale because the area was certainly already over-hunted and agricultural land was well-developed. The inhabitants of small villages hunted more, particularly in remote, heavily forested regions.

The animal husbandry of the Celts showed the typical picture of people living a settled way of life. Its main species were pig and cattle; the first was their main meat supply, the other was the draught animal of agriculture and the main milk producer. Of these two species, pig cannot be herded over long distances, and cattle as slow-moving draught animals could only cover short distances. Strabo noted in Book IV of his *Geographika* that the Celts' "food mainly consisted of milk and different kinds of meat, particularly of fresh and salted pork." He also mentioned that they exported salted meat in large quantities not only to Rome but also to other parts of Italy. Sheep and goats were somewhat rarer, and horses were very infrequent, though the Celts were famous riders in those days. Dogs were kept in even smaller numbers but a very important species of the modern domestic fauna, the hen, another animal associated with settlement life, also played a certain role in their animal husbandry. In fact, after the introduction of the hen by the Scythians, the Celts were responsible for the spread of this bird in central and western Europe. The possibility of keeping of ducks and geese (again fowl of sedentery life) in Celtic settlements cannot be excluded either, although direct evidence of this is still missing.

The cat is missing from the domestic fauna of the Celts. It was first domesticated in Egypt and although it reached the northern Black Sea area as the pet of rich Scythians and even earlier, at the beginning of the first century B.C. Greece and Italy), it first arrived north of the Alps with Roman legionnaires. As a result, its remains can only be found in Gallo-Roman sites, at the end of the Late La Tène period.

The ass, another domestic animal originating in Egypt, was also absent in Celtic animal husbandry although it had already arrived in Italy in the Late Bronze Age. In all probability it was taken to Gaul by the conquering Roman army which used a considerable number of asses as beasts of burden. Twenty-one ass bones were found in Gallo-Roman layers of Paris, Rue Henry-Barbusse and in some other sites. Asses occurred in other Celtic sites of the Roman Empire and they were also used for producing mules. In *Aquincum*, Pannonia, the grave of a mule driver which had a tombstone with a mule representation was excavated, and in Brigetio a limestone slab shows a relief of a mule driver and two packed mules.

Celtic animal husbandry shows rather ambiguous features. Most of the remains of domestic animal species (cattle, sheep, pig, horse and hen) represent quite small numbers and rather primitive forms the occurrence of which demonstrates a low level of animal husbandry.

Celtic cattle were—along with the early medieval species—the smallest in the whole evolution of domestic cattle; in fact the height of their withers hardly exceeded 110 centimeters. Celtic cattle were slenderly built, skinny animals with short horns and narrow skulls as evidenced both by bone finds and artistic representations. That Roman cattle were at least 16-17 centimeters larger than the Celtic ones is demonstrated by a comparison of the cattle of the Celtic *oppidum* Manching and those of a Pannonian Roman town (Tác-Gorsium) and of a Roman fortress on the Danube (Intercisa). Similar comparisons can be made in Gaul too, although in such large samples (in excess of fifty thousand or even several hundreds of thousands of identified bones) are not available. Large Roman draught oxen sometimes reached

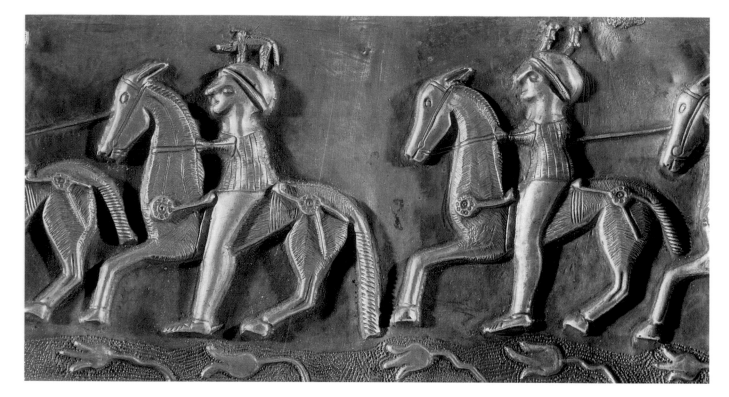

Celtic territories as well as Germanic and Sarmatian territories though naturally they did not exert any particular influence on the local cattle stock. A breakthrough happened in this field only after the Roman occupation.

Authors at the end of the nineteenth century divided the horses into a smal-bodied, slender oriental group and a large, heavy occidental group. Detailed studies of Iron Age horses in an area between the Altai Mountains and central Europe revealed, however, that the original situation was just the opposite: the eastern horses were larger with an average withers height between 136 and 138 centimeters, and the western ones were about 10 centimeters smaller. The dividing line between the two groups was somewhere between Vienna and Venice. The typical representative of the eastern group was the Scythian horse and that of the western group the Celtic one. From the viewpoint of the breeder the eastern horses were better because of their larger size. Consequently western chieftains often acquired eastern horses that were then buried with their masters, often wearing eastern gear which strengthens the proof of their eastern origins. In Italy, according to literary sources, the Veneti living around Venice often imported Scythian horses, and they kept some of them (which can be found in their graves) and sold the remainder in Greece where they became the best race horses. This is hardly surprising as they were essentially larger and stronger than Greek horses.

The horses of the Celtic oppidum of Manching and other Celtic sites were between 1.12 to 1.38 meters high in withers, an average of about 1.25 meters. Thus, we may conclude that the Celts were not great horse breeders. Caeser does not have a high opinion of their horses although, according to Strabo, the Gauls were better horsemen than foot soldiers. Strabo mentions in another chapter that the Celts, like the Britons, mainly used horse-drawn carts in their wars. This is understandable if one looks at the small horses of the Gundestrup cauldron where the legs of the riders nearly reach the ground; after all, some of the Celtic horses were under one meter high to the withers. Such horses would hardly be suitable for a successful cavalry. Nevertheless, it is true that the Celts played an essential part in developing west European equestrian traditions. They held horses in esteem and granted them a rank in their

Detail of the procession
of horsemen from the Gundestrup
cauldron (Denmark)
First half 1st century B.C.
Copenhagen, Nationalmuseet

*Stele depicting goddess Epona
from Rhineland
2nd century B.C.
Bonn, Rheinisches Landesmuseum*

mythology, as the veneration of Epona, goddess of fertility, probably started from the veneration of a horse deity. They often represented their goddess seated on horseback or surrounded with mares with foal or with horses. The extent to which horses were honored by the Celts is also indicated by the frequency with which they were represented on coins, tombstones and decorated vessels. These representations are often rather stylized, though they often reveal the characteristic features of Celtic horses: the long, facial part of the skull and the small dimensions of the body.

Although according to Strabo's description "pigs were wildly running in herds through the fields and excelled in their large size, swiftness and power, it was dangerous for strangers and even wolves to approach them." La Tène was probably the only Celtic settlement where a crossbreeding between domestic and wild pigs could be observed producing larger individuals, probably with a rough nature.

At all other sites, primitive, small pigs could be found, in fact the smallest in the entire prehistoric period. Their withers height hardly reached 70 centimeters, and because of their small size their remains can be easily distinguished from those of the large, wild swine. Their constitution was very similar to that of the neolithic "turbary" pigs, though they were essentially smaller.

The skull was similar in form to that of their wild counterparts but much smaller and somewhat shorter; in some cases they even showed a concave profile. Since the shortening of the skull, particularly its nasofacial region, is followed after some time by a decrease of the size of the teeth, the most conservative part of the animal body, it often occurred that shortened jaws had large teeth. This happened mainly with premolars (because in this part of the jaws the shortening was more pronounced). As a result the premolars were crowded or even crosswise in the upper or the lower jaw and in the molar region only the lack of the third column of the last molar (M_3) could be sporadically observed. In fact the lower P_1 was often missing, providing an early sign of the development of modern pig skulls.

The body was probably covered with thick, dense hair, as suggested by some figurines which

*Bronze boar statuette
from Báta (Hungary)
2nd century B.C.
Budapest
Magyar Nemzeti Múzeum*

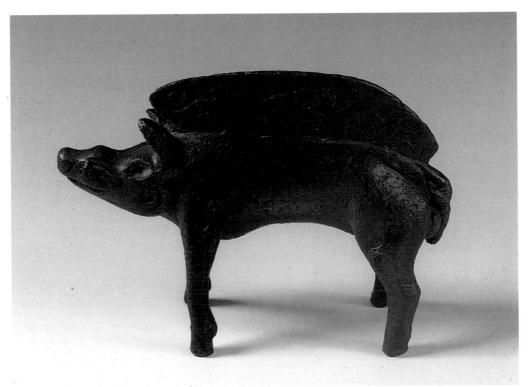

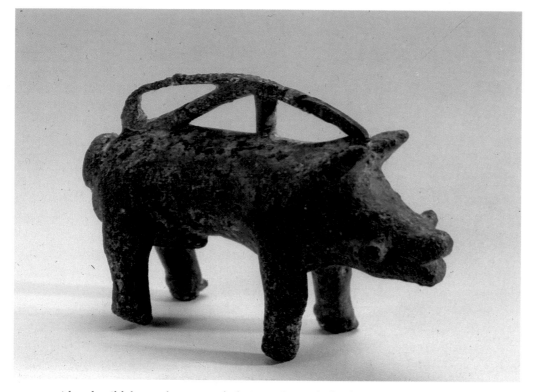

*Bronze boar statuette
from Salzburg-Reinberg (Austria)
2nd-1st century B.C.
Salzburg
Museum Carolino Augusteum*

are considered wild boars because of their tusks and the hairy crest along their spines. However, domestic boars also have large tusks even now, which the breeders remove because they would be dangerous, and the hairy crest often occurs on primitive domestic pigs too (there are many examples in the Balkans). The curly tail of these figurines is a typical characteristic caused by domestication; thus the artist either wanted to show a domestic boar or did know the difference between a domestic and a wild boar.

Among the caprovines sheep were far more common than goats in practically every site. Interestingly enough the sheep were much smaller than the goats. The ewes were 50 to 70 centimeters high in the withers; the rams were somewhat larger. More than half of the ewes were hornless; the rest had short, sometimes rudimentary horns. The rams had heavy, twisted horns, though some hornless examples also occurred among them. The probability of castration was very high. The ratio of males to females was around 1:2.

The goat bucks were similar in size to a buck in a modern improved breed; the females were smaller. It can be assumed that at least in some regions the goats were kept in small, comparatively poor households. Thus goats played the role of the "poor man's cow."

Most of the dogs belonged to a mixed and varied population. Nevertheless, well-defined breeds occurred in some of the sites. It is impossible to decide whether these breeds—dwarf dogs with a withers height of 25 to 40 centimeters and slender or twisted thick legs on the one hand, and greyhounds with typical, elongated skull and long, slender extremities on the other—were results of intentional local breeding or simply acquired from territories of the Roman Empire.

The rist breed is known from Manching, Germany and from Variscourt and Gournay, France, the greyhound from a grave of the Celtic cemetery of Pilismarót, Hungary. Knowing the high standards of Roman dog breeding one is inclined to suppose that the dwarf dogs as lap-dogs originated in the Roman Empire and that the greyhounds were true Celtic dogs. In the latter case the question of whether the Romans took their greyhounds from the Celts automatically arises. However, in northeast Africa (in Egypt) there already existed an early greyhound center and the Romans—having good contracts there—could have easily gotten

their earliest greyhounds from there. Finally, they could easily have given them to the Celts, a possibility that cannot be completely excluded.

In dog skulls tooth abnormalities similar to those of the pigs occurred with the exception of the lack of lower P_1 and the underdevelopment of the last molar. At the same time, the lower M_3 and sometimes also the M_2 were pushed back onto the ascending ramus.

As already mentioned the real dispersal of the hen was carried out by the Celts in Europe. Their chickens were small, primitive animals, hardly reaching 1 to 1.5 kilograms of body weight. Large chickens improved by crossbreeding with Greek and Median breeds such as Columella reported, were taken by the Romans to their provinces all over Europe. It is highly possible that some of the large hens or cocks had reached the Celts before the Roman conquest, as the occurrence of remains of such animals in certain Celtic sites suggests. This is not surprising because the transport of a couple of such hens could not have been an impossible task, although the moving of larger groups would certainly have been impossible.

At any rate, the number of hens kept in a Celtic settlement was not high anywhere. The fact that they occurred in the Celtic animal husbandry at all demonstrates its modern nature. (Nowadays, the hen is the commonest species farmed in the developed nations.)

The domestic goose has a long history, though exactly how long is difficult to assess because of the difficulty in distinguishing the remains from those of the wild goose. Its ancestry can be traced back to ancient Egypt in the second half of the third millennium B.C. and in Asia Minor to the fourth or fifth millennium B.C. That the Romans kept geese quite early is proven by the story of the Capitoline geese. The Celts also had them and probably had good breeds because Pliny mentioned their importation from Gallia Belgica.

Nevertheless, geese were not an important part of Celtic animal husbandry. Their numbers—if they occurred at all—were always very low in the domestic stock of Celtic settlements. They were probably smaller than their wild counterparts but almost certainly retained their original wild coloration.

The case of domestic duck is even more difficult and the number of duck remains is also rarer. The only indication of the presence of domestic duck is its role in the religious-cult imagery.

For a study of the exploitation of the Celtic domestic animals three sources are available. One is the descriptions by contemporary authors, another is the contemporary artistic representations, and the third is the animal remains themselves.

Nevertheless, all three above sources have their bias. Ancient authors often got their information second- or third-hand, and both information and descriptions could easily have been manipulated. The artists who made they the representations sometimes did not know the animals well. Not being animal breeders, they did not emphasize the important characteristics, and often they were not particularly good artists and consequently made animal representations of poor quality. The bone remains seem to be the most reliable source, being direct biological material. The only danger is that they may be evaluated incorrectly.

As for the exploitation of domestic animals, Strabo's remark, mentioned above—"their food mainly consists of milk and all kinds of meat, particularly of fresh as well as salted pork"—reveals a lot, and the detailed study of animal remains, especially patterns of slaughter of the different species, strongly supports this.

Among the Celtic animal species the horse was the only one whose meat was not consumed. This was undoubtedly connected with the special, privileged status of the horse in the Celtic society. In fact, this avoidance of horse meat was one of the earliest in the world. It probably meant that man did not want to eat the meat of his close comrade-in-arms, an animal species that was directly associated with a goddess (Epona).

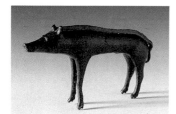

Boar statuette from Praha-Šarka
(Bohemia)
2nd-1st century B.C.
Prague, Národní Muzeum

This special status of the horse is clearly reflected in its remains too. The number of horse bones is small in settlements (the dead horses were probably buried outside the settlements). The overwhelming majority of the bones was complete and unbroken and rarely showed cut marks. Most of the animals died or were killed in their adult or mature age, and the few juvenile ones probably died of natural causes, like illnesses. The main and practically only use of the horse was as a draught and riding animal. Long-distance transport had been revolutionized by the use of horses. This was man's first successful attempt to accelerate transport beyond his own speed. As a riding animal the horse was probably used only by the upper classes and by warriors. Nevertheless, as was pointed out earlier, not the cavalry but chariots had real importance in wars, probably due to the very small size of the Celtic horses. Horses were often sacrificed by the Celts. Such sacrifices have been found, for example, at Gournay and in Ribemont-sur-Ancre (both in France).

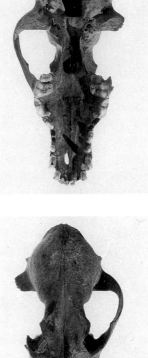

In spite of the fact that pigs were generally more numerous that cattle in Celtic settlements, cattle produced more meat simply because the quantity of meat on an ox was about that of five pigs. Nevertheless the main use of cattle was certainly not for their meat, as demonstrated by the fact that only about one-third of the cattle were killed in their juvenile and subadult age (in their first three years), thus in the time when they gave prime beef. The great majority of cattle was used as draught and milking animals. As a matter of fact, cattle (mainly oxen, but, on smaller farms, cows too) were the main draught animal, the "engine" of agriculture. For pulling a plow or a wagon at a slow pace they were excellent. However, for long-distance transport they could not compete with horses.

A very important use of cows was for their milk. Huge quantities of milk would not be given by such small, primitive cows, though based on analogies of primitive cows of the Balkans and southwest Asia, the daily milk quantity could have been 2 to 4 liters. Milk was also used for butter and cheese-making. The role of cattle as sacrificial animals in the Celtic world must not be forgotten. At sacrificial sites like Gournay whole skeletons or skulls connected to vertebrae were deposited.

The pig was a domestic animal whose only use was its meat. According to Columella the Celts exported pork in large quantities not only to Rome but to other regions of Italy as well.

Most pigs were killed as juveniles in Celtic settlements, another group in their subadult age (second and third year) and only a small breeding stock was kept for a longer time. Most of the males were killed in their youth because the subadult females could only produce young in their second or third year, and this was why they were allowed to reach this age and were only killed afterwards. Among the adult pigs, females were in the majority.

The pig played an important part in Celtic religious beliefs too. It was often sacrificed or was buried with the deceased (for example in forty-nine graves of the Celtic cemetery of Mátraszöllős, Hungary), either as a full or half carcass or more often only the meat parts, hams along with their bones were deposited. It is certain that the figurines representing boars have a religious or cult meaning too.

The meat of sheep was also consumed, though it was certainly not the main use of sheep as demonstrated by the fact that only one-third of the sheep were killed before reaching adult age. The main use of sheep was for their wool which was certainly not of very fine quality

Elongated skull of greyhound

because it was mainly used for making cloaks. (The fine-wool sheep appeared in central and western Europe along with the Roman conquest.) Milk and cheese were also produced, but their importance was undoubtedly less than that of the wool. The proof of this is that the ratio of rams plus wethers to ewes was 1:2. It shows an unnecessarily high male ratio for milk production and a good ratio for wool production because the quality of wool from large rams and wethers is certainly greater than that from the comparatively smaller ewes.

Goat meat production was clearly more important because about half of the goats were killed in their youth. The adults were milk producers. About goats' wool there is no evidence from the Celtic region but the use of goatskins is well-known.

The dog's primary importance was as a worker. They were used as hunting companions (according to Strabo the Celts used imported dogs bred in Brittania and in their wars), herd dogs, watch dogs, and lap-dogs. Dog meat was also eaten at least in certain territories or by certain tribes or classes. This is demonstrated by finds of dog bones with clearly visible cut-marks that went far beyond a simple skinning and could be considered butchering marks. Finally domestic fowl were primarily kept for their meat. Besides this, eggs could also be eaten, though the number of eggs laid was far fewer than those laid by modern breeds. Besides this, whole chickens were often placed in Celtic graves either as animal sacrifices or as food for "travel" to the other world.

In summary, one can state that Celtic animal husbandry was the last stage of primitive animal keeping of prehistoric times. In spite of the fact that its domestic species were small in size (that was a phenomenon that could be observed all over Europe thus not only in Celtic territories and could therefore rightly be considered a result of a supposed climatic deterioration), it already carried the seeds of intentional animal breeding. For the moment, however, it remains an open question whether these first attempts were the result of the internal development of Celtic animal husbandry or the effects of more developed Greek or Roman animal breeding.

Handicrafts

Susanne Sievers, Radomír Pleiner
Natalie Venclová, Udo Geilenbrügge

Wood

As a raw material, wood is as important today as it was in the La Tène era. Unfortunately, very few items of wood or other organic (and therefore perishable material) have survived. Where it has been found, however, it provides a means of accurately dating the finds, through dendrochronology. The following is a brief sketch of the significance of wood and of woodworking during the era of the great *oppida*. And, of course, wood is vital inasmuch as dendrochronology offers a means of dating many finds.

Finer woodworking such as lathe-turning can, to an extent be inferred from tools such as chisels, and gouges, but occasionally complete vessels such as bowls are preserved. Other wooden containers, for example, buckets and jars, can also sometimes be reconstructed on the basis of their surviving metal fittings. The handles of most implements, such as axes, spears, shields, yokes and ploughs, were generally of wood. In these instances, too, it is only the metal parts or fittings which normally survive. Basketry was also important and must have been a significant element, not merely in the construction of vehicles, but also in everyday life. It is only in cases of rare good fortune that engraved decoration or three-dimensionally-carved animals or humans are found. These indicate how much information concerning the daily life of the Celts is lost to us through the perishable nature of the wood. Carpentry and woodwork were generally conditioned by the availability of trees near the settlement, but timber was also transported down rivers, from other areas. Even the Celts were aware of the need to protect their woodlands, as it served both as building material and as fuel, particularly useful in metalworking. Used for building houses, stables, granaries and the like, but also for shoring defense works, timber can often only be detected from colored patches on the ground, or from gaps in the stonework.

Celtic carpentry is demonstrated by the presence of tools in varying quantities in all the *oppida* and also in non-fortified settlements. Trees were generally felled with axes, but hatchets, saws, and wedges were also used, and the logs were made into beams and planks. Solutions for joining wooden elements varied, and here again the tools provide important clues. Chisels and gouges were used to fashion mortises and tenons; bradawls were used for making tongue-and-groove joints; augers were used to bore holes in beams which were then joined with wooden pegs. Sturdy spikes were used for timber-lacing in *murus gallicus* construction; meanwhile shorter nails with bent ends, and a whole range of flat staples indicate the presence of planks and various kinds of reinforcements.

In addition to their application in house-building and stockading, joins of this type were also used in bridges, massive timber trackways, fencing, vats, ladders, and looms. They were also indispensable in the construction of furniture and chests. Chariot building was also of major importance from region to region, and various specific types of tools were developed, some of which were imitated by the Roman tools. Some chariots were for war, others for traveling. Wagons were built for transporting belongings or heavy loads, and were often essential for trade purposes.

Wooden shovel, from the salt mine at Dürrnberg (Austria)
6th-3rd century B.C.
Salzburg
Museum Carolino Augusteum

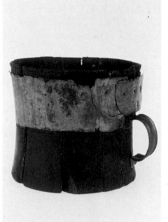

Wooden pot with bronze mount from Carrickfergus (Ireland)
1st century B.C.
Belfast, Ulster Museum

"Blockhaus"-type log building
Hallstatt (Austria)
6th century B.C.
Hallstatt, Museum

Interment in wooden vessel from Chatenay-Macheron (Haute-Marne)
2nd-1st century B.C.
Saint-Germain-en-Laye
Musée des Antiquités Nationales

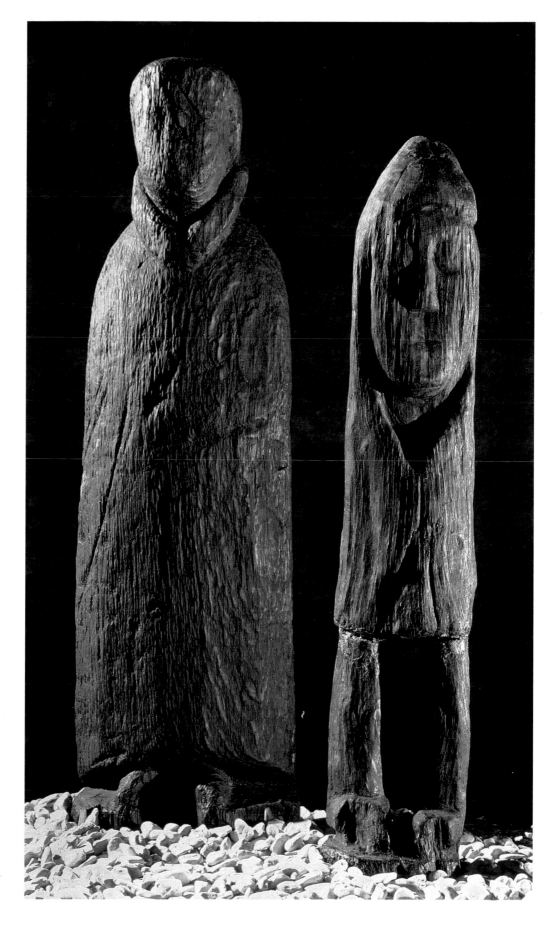

*Wooden votive pilgrim statuettes
from the source of the Seine
at Saint-Germain-Source-Seine
(Côte d'Or)
1st century B.C.
Dijon, Musée Archéologique*

The Celts were as skilled in boat-building as they were in making chariots, as noted by Caesar when referring to the vessels of the Veneti. Though very rare, material traces of Celtic merchant craft, river-going vessels, and dugouts have been found. The craft served for both fishing and travel, and especially for trade. Considering the complexities of cart- and boat-building, various specialized carpenters must have been involved. (*S.S.*)

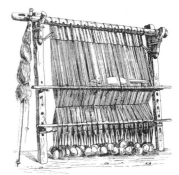

Fabrics

Due to the perishable nature of organic materials, few examples of cloth have survived. This is particularly the case for La Tène fabrics, during which period the practice of inhumation ceased throughout much of Europe, reducing our chances of finding fabrics or more durable metal goods. In any case, only scraps of cloth have turned up, and their condition makes it difficult to determine which of the two main ingredients, wool or linen, they actually contain. Nonetheless, it is often possible to establish that the thread is dextrorse or sinistrorse, or a simple thread or yarn.

Weaving techniques can often be reconstructed. It is possible to distinguish cloth, canvas, and types of twill, which lent the fabric its pattern.

It has been possible to establish for each region what kind of weaves were popular. During La Tène in France and Switzerland a 2/2 woolen fabric was produced. In Germany, Austria, Czechoslovakia, and Hungary, cloth was preferred. Unlike the Hallstatt period, there is no proof of the use of coarse yarn during La Tène. It may be assumed that it had become possible to weave finer cloth of linen, using simple thread. From Czechoslovakia there are remnants of clothes made from this type of linen stitched with red thread. Written sources mention the use of linen for women clothes, but also for sails and cushions.

The scraps of fabric are not the only evidence of the type of weave adopted, since the tools used also appear with some frequency in La Tène sites. Animal bones found among the settlement material is evidence of sheep-rearing, and hence wool production; but finds also include many wooden spinning-wheels and bone spindles. Pyramid-shaped weights for keeping the warp taut denote the use of a vertical loom (known since the Bronze Age), further borne out

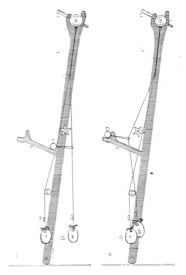

Fragment of woolen fabric from the Hallstatt salt mine (Austria) 8th-3rd century B.C. Vienna, Naturhistorisches Museum

by the discovery of various weaving combs and shuttles fitted with a wooden or bone spindle with a swiveling metal bar. Bronze and iron needles of varying thickness are common finds in the *oppida*, and were used for stitching and embroidery, as well as for upholstery work and patching clothing.

The ancient historians often comment on Celtic clothing, mentioning the *chiton* or open shirt, capes, and the men's loose-fitting trousers. The *laena* or cape was a coveted piece of clothing and the Celts traded them among other peoples. Production was often specialized— a typical trait of Celtic clothing was their fondness for brilliant colors, made from plant-dyes and used in striped or square designs. The Celts also embellished their fabrics with gold thread.

Although so rare and hard to reconstruct with accuracy, these textiles were among the Celts' most important manufactured products, and give us a clearer idea of daily life among the Celts and, in particular, of how the Celts themselves appeared. (*S.S.*)

Bronze

Publications on Late La Tène bronzework tend to indicate that, compared with iron, bronze has received scant attention. This is because, after centuries of perfection, the techniques for working bronze altered little during the Iron Age. Furthermore, during La Tène bronze was mainly employed for decorative purposes, and analyses usually focus on aspects of style. Most *oppida* have produced extensive evidence for bronze manufacture. Furnaces for smelting copper have been found, some usually with *tuyères* of clay and also slag and crucibles proving that the bronze was produced *in situ* and not just imported in small ingots. As for the final phase of preparation, a distinction must be made between casting and hammering.

Hammering required unprepared bronze plate, a mallet and other hammers. It was possible to produce an even, thin, slightly convex panel by a complicated system of alternate angles of hammering. End products included helmets, war trumpets, scabbards, and mounts for decoration of all kinds. Bronze was also very important for the manufacture of vessels. Ornaments, very often dot-and-circle motifs, were made by punching. Separate plates were joined

*Fragment of woolen fabric
from the Hallstatt salt mine (Austria)
8th-3rd century B.C.
Vienna, Naturhistorisches Museum*

and repaired by riveting or seaming. Molten tin was used to solder plates or cast parts together.

As in earlier eras, the preferred system of casting was the lost wax process. A wax model of the piece desired was coated in clay, and then the wax was melted out and molten metal poured into the resulting cavity. Once it had cooled, the clay jacket was broken off. The process allowed close copies of the same metal object, though never identical. Sometimes a two-piece mold was used—either clay or stone—but for more detailed objects it was more convenient to use a wax model.

Associated with this area of production is the process of "cast joining," in which the finished piece was coated in clay together with a wax model of the new piece to which it was to be joined, and then the lost wax process was carried out. In this way various pieces in iron or bronze could be joined together. Another system consisted of pouring molten metal in the gap between two pieces to be joined. Separate pieces of iron were also sometimes welded with copper.

In many cases, finished objects were then decorated on the lathe, a technique revealed by the lathe grooves on certain objects. Decorative work on cast-metal objects was executed with burins and files; compass points were used to draw circular patterns, the point slotted into prepared holes drilled in the metal. At a final stage, color could be added in the form of red enamel insets. Objects made in casts include terrets, handles or lugs, mirrors, fibulae, belt ornaments, and other personal decorative regalia.

Terracotta crucibles for smelting bronze from Náklo (left) and Mistřín (right) 4th-3rd century B.C. Brno, Moravské Museum

The areas assigned to bronzeworking in the individual settlements is more evident from the scraps discarded during production than from the bronze artifacts themselves, which may have been finished elsewhere.

In addition to the sections of furnaces mentioned above, sites have yielded fragments of the clay molds, which can often be traced to a given product; the stone molds give a more complete impression. Here and there unfinished products have turned up, but the majority of finds are rejects and discarded plates and bars, threads or congealed drops of metal. The equipment itself is rarely identifiable. (S.S.)

Bronze armlets decorated
with fake filigree from
Mikulčice (Moravia)
3rd century B.C.
Brno, Moravské Museum

Bronze belt element from
Kozlany (Moravia)
3rd century B.C.
Brno, Moravské Museum

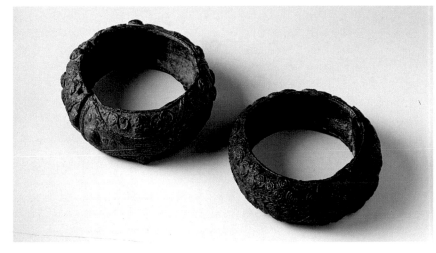

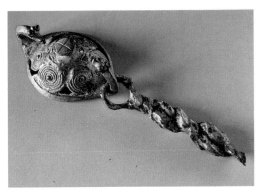

Bronze belt-chain
with red enamel studs
from Telce (Bohemia)
2nd century B.C.
Prague, Národní Muzeum

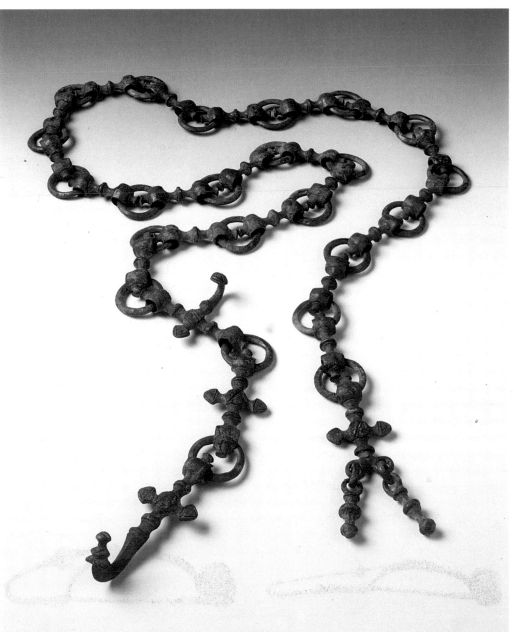

Ironworking

One of the most important phenomena in the economy of early Celts was a rapid swing in crafts and especially in iron technology during the fourth-first centuries B.C. The early Celtic world adopted the use of iron later than southern and southeastern Europe but the development of the industry was accelerated both by the capability of Celtic people and by influences radiating from advanced neighbors in the south, especially during the great Celtic expansion.

Reconstruction of knife-blades used in Celtic oppida according to metal analysis A forged iron; B soft steel C hard steel; D tempered steel The lateral lines indicate the level of immersion during the tempering process. Provenance: 1 Steinsburg 2, 4, 6 Staré Hradisko 3 Stradonice 5 Závist 7 Hostýn

The major evidence of this process is provided by archaeology. The details of the very beginnings of Celtic iron production are not yet clear. However, the sudden emergence of numerous iron weapons, long swords, lances and shield bosses as well as other objects in Celtic warrior graves of the fourth-third centuries B.C. signal the start of production of iron on a relatively large scale. Despite the criticism of the quality of Celtic swords in the late third century in northern Italy (Polybius 2.33, apparently after Q. Fabius Pictor) the recent metallographic investigations have revealed that the majority of examined swords were effective weapons equipped with steel edges and sometimes manufactured using sophisticated techniques.

Another indirect sign of extensive ironworking is the appearance of double-pointed iron ingots and word-shaped bars, already present in the fifth century and in the first century B.C. (*oppidum* of Manching). Apart from those dated finds there are more than 700 ingots deposited in undated hoards, the geographical distribution of which covers the center of the original Celtic homeland.

There are only a few iron smelting sites known from earlier periods. On the other hand, it was the Celtic civilization which yielded important foundry works, dating from the second and first centuries B.C (Switzerland, western Germany, Bavaria, Burgenland, Bohemia). Moreover, huge slag deposits in France, produced in the Gallo-Roman period, may have included traces of earlier production. Unfortunately, most of them were destroyed by later industrial exploitation. Nevertheless it seems that the Celts established the first European production districts, working on a large scale. In some of these open cast as well as underground mines were introduced, mentioned by Caesar (*gallic Wars* 7.22) or Strabo (4.2.2) especially in Gaul (Bituriges, Sociati, Petrocorii) and by Tacitus (*Germ.* 43) in the east (Cotini).

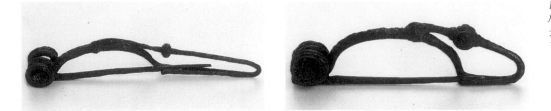

Finely-wrought iron fibulae from Conflans (Marne) 3rd century B.C. Troyes, Musée des Beaux-Arts

Two basic types of blast furnaces were used by the Celts. The first model was a large domed furnace (100-120 centimeters in diameter) the technological principle of which is, in spite of some experimentation, not yet fully understood mainly due to problems with the air supply and the heat levels of the charcoal charge. Completely different was the so-called slagpit furnace with an average diameter of 35 centimeters, consisting of a cauldron-shaped pit to receive the slag, and a shaft superstructure about 70-100 centimeters high. This type is found in the Late La Tène period in eastern regions. It may be of pre-Celtic origin. Both types produced spongy iron, heterogeneously carburized, which had to be reheated in special hearths and reforged to malleable blooms (c. 25 kilograms). This resulted in considerable losses of smelted iron.

The Celts manufactured in the later period (first century B.C.) over ninety kinds of iron artifacts including craftsmen's tools, agricultural implements, domestic equipment and structural iron. Huge assemblages came from the *oppida* which developed as centers of production and commerce (Bibracte, Manching, Magdalensberg, Stradonice, Staré Hradisko, Steinsburg and many others). The quality of most cutting tools was excellent as attested, again, by metallographic examinations of hundreds of specimens from the *oppida*. Complex techniques, involving the difficult welding together of wrought iron and carbon steel to form the cutting-edge, show the skill of the early masters. Hardening of steel by quenching began to be widely practiced. The proportion of inferior wrought-iron blades decreased to 15-30 per cent in the central Celtic domains.

The iron artifacts manufacured in the *oppida* and other major settlements were traded over a wide area, evidence for which is found in Magdalensberg in Carinthia, the ancient Noricum. The *ferrum noricum* was celebrated by ancient writers.

The early Celtic smelters and blacksmiths were founders of the great European iron working tradition. (*R.P.*)

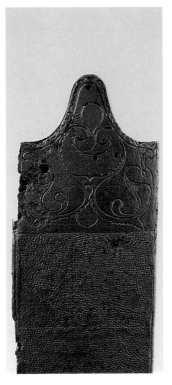

Detail of engraved decoration from the Basadingen scabbard (Switzerland) 3rd century B.C. Zurich Schweizerisches Landesmuseum

Map showing the distribution of different types of ingot of Late Hallstatt and La Tène Other symbols: a. metalworking areas b. iron mines mentioned in sources c. iron mines from archaeological evidence d. dome furnaces e. pit furnaces

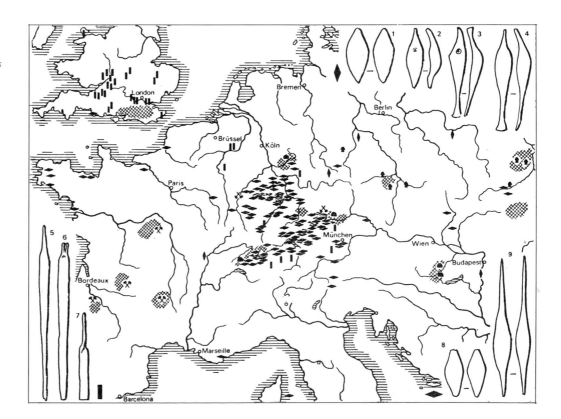

Ironsmith's tools from Nikolausberg
(Austria)
4th-3rd century B.C.
Salzburg
Museum Carolino Augusteum

Ironsmith's tools from the Manching
oppidum (Bavaria)

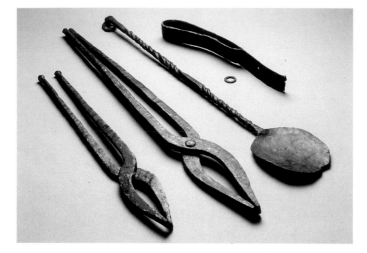

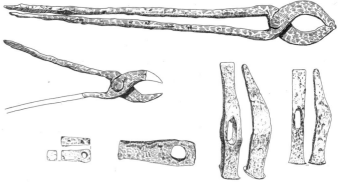

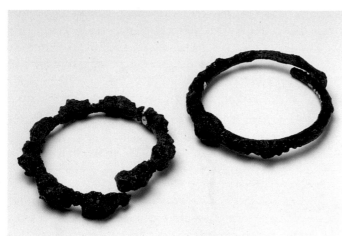

Finely-worked iron armlets
from Ponětovice (Moravia)
3rd century B.C.
Brno, Moravské Museum

Celtic dome furnace
from Unterpulldendorf
Austria (left)
and a Celtic pit furnace (right)
from Podbořany, Bohemia

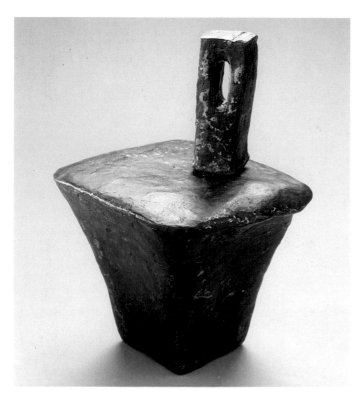

Small anvil from Nikolausberg
(Austria)
4th-3rd century B.C.
Salzburg
Museum Carolino Augusteum

Glass

Among the group of Celtic ornaments of the last two centuries of the pre-Christian era, glass objects play a prominent role is attracting the eye by their extraordinary range of colors and elegant finish. The first glass products which may be termed Celtic turn up in female graves in the second half of the third century B.C. These are glass bracelets of different colors of which blue was a special favorite. The origins of Celtic glass industry may be sought in one of the glassmaking centers of southern Europe where this craft has an age-old tradition which might have been acquired on one of the Celtic expeditions into the Mediterranean. The Celts were never content to merely borrow but developed and transformed the original models with an unusual degree of creative inventive which led to the emergence of their own unique contribution to the art of glass. So far, no conclusive evidence for the first phase of this craft—that is, the production of glass from raw materials—is available in Celtic Europe. Excavation has produced no primary documentary material such as glass furnaces or stores of raw materials and, theoretically, raw glass could have been imported. On the other hand, the second phase—glassworking, or making objects of raw glass—is attested to by finds of lumps of raw glass and especially by certain products not known outside the Celtic world. Within the sphere of European pre-Roman glasswork, Celtic glass bracelets represent the first products of their kind. Glass ornaments produced before that date included such items as small beads, pendants, small rings, pinheads, etc. While blue-green, light blue or dark blue were favored colors for glass in the third century B.C., second-century products are typically colored deep cobalt blue, frequently with yellow and white decoration and, later on, honey brown, green, or even entirely colorless. The latest shade to become fashionable, especially in the first century B.C., is violet to purple.

From the chemical viewpoint, Celtic glass belongs to the soda-lime-silica glasses and the color hues were brought about by the addition of copper, iron, cobalt and manganese. The morphological development of glass bracelets reflected changes in fashion. The earliest bracelets, which show considerable typological variation were followed in the second century by broad examples executed in rich relief which, in their turn, gave way to the narrow and quite plain rings of the first century B.C. From about the second half of the second century B.C.,

*Glass bracelet from tomb no. 1
at Bern Weissenbühl (Berne)
End 3rd-early 2nd century B.C.
Berne, Historisches Museum*

*Glass armlet from Tursko
(Bohemia)
Second half 3rd century B.C.
Prague, Národní Muzeum*

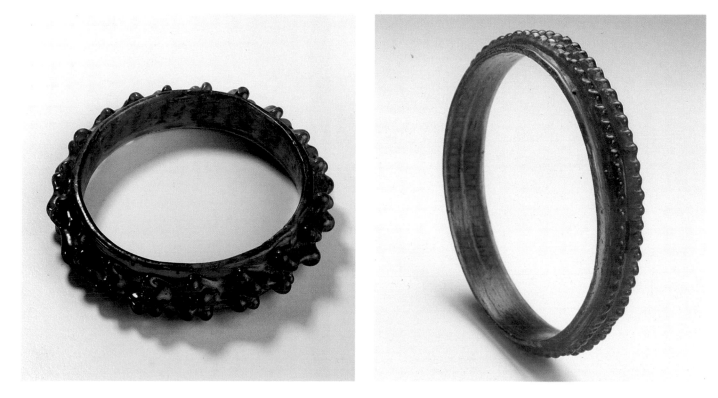

another Celtic product turns up, massive ring beads manufactured by the same technology and displaying the same glass colors as the bracelets but bearing completely different decorative elements. Other products found in excavations may have been manufactured by Celtic workshops, such as some kinds of beads and pendants or even figurines, and the possibility of experimental production of glass vessels has been suggested. However, in order to establish this conclusively chemical-technological studies must be carried out on several series of glass objects.

Identification of glass workshops is not an easy matter. In addition to finds of raw glass, their existence may be indicated by marked concentration of products and locally or regionally confined types. These criteria allow the assumption of development from a few (two-three) workshops of the third century B.C. to a larger number of sites on which glass artifacts were produced in the second-first centuries B.C. A number of workshops were situated on Celtic *oppida*, production and trade centers (e.g. Manching in Bavaria, Stradonice in Bohemia), but also on unfortified but industrially important sites (Breisach-Hochstetten in Baden-Württemberg?). From central Europe (Switzerland, southwest Slovakia) the art of glassworking was gradually diffused all over Celtic Europe.

Celtic glassmaking represents the peak of European pre-Roman glass industry not only because of the quantity and high professional level of its products but also because of the quality of the *glass* which is comparable to some modern glass items. (*N.V.*)

*Piece of raw purple glass
from the Manching oppidum
(Bavaria)
End 3rd-1st century B.C.
Munich
Prähistorische Staatssammlung*

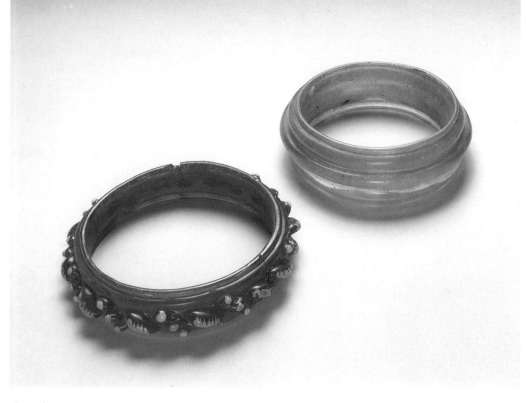

*Colored glass bracelets from tomb
no. 533 at Mihovo (Yugoslavia)
2nd century B.C.
Vienna, Naturhistorisches Museum*

*Dog figurine in multicolored glass
from tomb no. 31 at Wallertheim
(Rhineland)
2nd century B.C.
Mainz
Mittelrheinisches Landesmuseum*

Fragment of colored glass bracelets
from the Stradonice oppidum
(Bohemia)
2nd-1st century B.C.
Prague, Národní Muzeum

Beads of multicolored glass
from the Stradonice oppidum
(Bohemia)
2nd-1st century B.C.
Prague, Národní Muzeum

Bracelets of colored glass
from tombs in and around Berne
3rd-2nd century B.C.
Berne, Historisches Museum

Painted terracotta vase
from Goicent (Loire)
End 2nd-early 1st century B.C.
Roanne, Musée Joseph Déchelette

Pottery

The introduction of the potter's wheel at the start of La Tène completely revolutionized the art of pottery-making. The new device heralded the change from producing articles in limited series to meeting demand with mass production.

Until then, pots had been made from long rolls of clay built up gradually to form the walls of the vessel, the seams being smoothed out to achieve a finished look. This process was time-consuming and pots were on the whole noticeably asymmetrical. The wheel changed everything. A distinguishing feature of wheel-made pots is the tapering thickness of the walls that results from drawing the clay upwards as the pot is made.

Before the pot can be turned, the raw clay has to be carefully prepared. When mixed with certain organic substances it becomes more elastic and firing is more successful. These extra ingredients for adjusting the consistency of the clay are usually found locally, and give the pottery of each settlement its own characteristics which are a useful indication of the place of manufacture.

Pottery was fired in quite tall vertical kilns divided into two chambers by a large perforated slab—the lower chamber for combustion and the upper chamber was stacked with fresh pots to be fired. By regulating the air intake the level of oxygen in the kiln was varied, and this affected the color of the fired clay. It is not necessary to excavate these kilns for proof of their existence, as the presence of wasters or apparatus used in loading the kilns with unfired pots is sufficient proof.

As for the shapes themselves, early La Tène production was divided into two geographical areas. In the west pots tended to be more angular in profile, and in the east more rounded. As time went on the two styles became increasingly similar, though they never merged.

A good sample of the full range of wheel-made pots was found at the Manching *oppidum* in Bavaria where, thanks to years of intensive excavation and lengthy publications, admirable results have been achieved in research.

Flasks and vases from Middle La Tène continue to have a marked S-shape, with the upper half corrugated or marked with narrow grooves. In Late La Tène these features disappear, giving way to simpler profiles and smoother walls; on the whole, the later vases tend to be rounder. The Manching pots have parallels throughout Bohemia and Moravia, whereas the *oppidum* of Basle-Gasfabrik and the settlement of Basle-Münsterhügel have both yielded pottery more akin to the western style. In the latter site, the vases are streamlined, with a simpler outline, and likewise the goblets and common storage vessels, which are also found in the French settlements.

Among the more striking types of pottery are without doubt the painted wares from Middle and Late La Tène. So far it is not entirely clear whether this range represents a further development of the Early La Tène painted ware found throughout Armorica and Champagne; some stylistic affinities with Mediterranean pottery can be noted, however. The reds and whites derive from local minerals in the slip applied to the pots as a base color in horizontal bands of varying widths, and which only became colored after firing. Sometimes a further, pale brown color was then added. Popular designs included waves, cross-hatching and checkered patterns, but some pots have been found with plant motifs and curves. Wares of this quality can only be the handiwork of gifted craftsmen. One characteristic type found throughout the eastern area is made from clay mixed with graphite which, amalgamated in small chips, bestow a glistening, silvery finish giving the illusion of fine metal. In practical terms, however, this mixture made the pots highly heat-resistant and increased their conductivity, and hence were principally used as cooking pots, a theory endorsed by the fact that traces of burned foodstuffs have been found among the shards of this type of pottery.

Although graphite pottery was also known in the Early La Tène period, mass production did not begin until the era of the *oppida*. The pots were decorated on the outside with closely-spaced parallel grooves, known as "combed ornament." As time progressed, the grooves became even finer.

Painted terracotta vase
of unknown site in Champagne
Early 1st century B.C.
Châlons-sur-Marne, Musée Municipal

Sections of a Celtic kiln

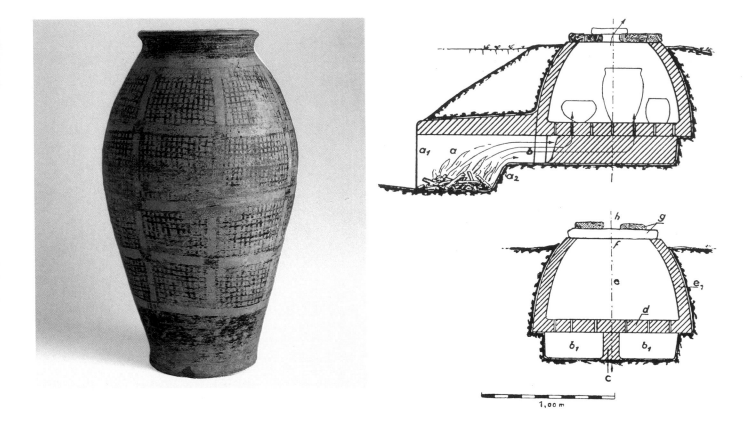

The designs impressed into the base of graphite pottery remain a mystery; sometimes they are shaped like ducks' feet, and could be the potter's hallmark or some indication of the place of production. In the course of the La Tène period there is a progressive increase in the manufacture of wheel-made pottery. At the same time hand-made pottery continued to be produced especially in peripheral zones of the Celtic world, partly in the form of imitations of wheel-made prototypes. On the other hand, there are also bulky earthen storage jars, too large to have been turned on the wheel.

With the onset of Roman occupation, shortly before the birth of Christ, despite its rich tradition Celtic pottery ceased production altogether, superseded by the products of the more evolved incoming culture, with its more advanced system of mass production. (*U.G.*)

Hans-Jörg Kellner

Coinage

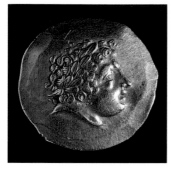

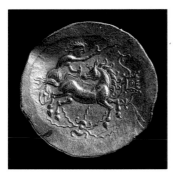

*Obverse and reverse of gold stater
from Armorica area
3rd-2nd century B.C.
Paris, Bibliothèque Nationale
Cabinet des Médailles*

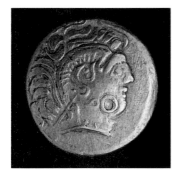

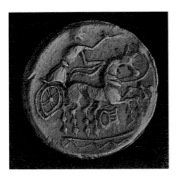

*Observe and reverse
of a Sequani gold stater
3rd-2nd century B.C.
Paris, Bibliothèque Nationale
Cabinet des Médailles*

In the third century B.C. the barter economy of the protohistoric Celts began to succumb to the influence of the more advanced Mediterranean cultures. The growing monetary economy that resulted reached a peak toward the end of the second century and the beginning of the first century B.C. As can be expected, this development mainly affected the larger *oppida* and settlements, while barter continued to be the predominant system of trade in the countryside. Today we still lack a detailed picture of these processes. Celtic coin production can really only be reconstructed from premises inferred on a regional basis.

Stimuli for the production of coinage came from two directions, both originating in Macedonian coin production toward the end of the fourth century. At this time gold staters of roughly 8.3 grams were in circulation in Macedonia, together with silver drachmas weighing 4.3 grams and tetradrachmas of four times that value. Philip II's tetradrachma and Alexander the Great's stater (bearing Athena Nike on the reverse) spread through the Balkans. Meanwhile Philip's stater with the head of Apollo on the obverse and a two-wheel chariot on the reverse made its way up the Rhône, and was quickly copied. In southern Gaul drachmas from Rhodes were also in circulation, and various imitations were made which spread toward the northeast as a prototype. The cruciform coins of southern Germany and Noricum represent its eastern variants. Another route was followed by the Massiliot drachma, which was tender along the Ligurian coast and widely imitated in northern Italy.

Why the Celts were prompted to start issuing coinage has been discussed at length. The Celts were much appreciated as mercenaries throughout the Hellenized Mediterranean world, and we can logically assume that the first coins were brought back by mercenary soldiers returning to the homeland. Early on, the coins were clearly appreciated for the value of their metal, which is why original Macedonian coins or their early imitations rarely turn up. In this initial phase, coins were not yet used in buying and selling goods, they were rather a source of fine metal and were hoarded. The returning soldiers brought a whole series of cultural acquisitions with them to the Celtic homeland. As the new urban centers burgeoned, the Celts began assiduous trading among themselves and with the classical Mediterranean world. Migration had acquainted the Celts with the superior cultures of the south, and they strove to emulate them. The reasons for introducing coins and a monetary economy were therefore varied, though economic reasons were clearly high on the list of motives.

As material evidence is so scarce and gives no clues as to origin, it is impossible to pinpoint where the first Celtic coins were issued. There is a tendency to think that the imitations were inspired by coinage imported through the Balkans, rather than from the western Mediterranean.

The first imitations date from the very beginning of the third century B.C., and were strictly limited to what the metalworking techniques permitted at the time. Only later did minting become a more widespread practice and coins more numerous and distinct from their prototypes. Original designs not copied from classical models soon emerged and the area in which regional coinage became tender widened. There are sporadic signs of the production centers around which these areas developed. Besides the lack of written information, the writing on the coins themselves give no indications; we can only therefore define the coinage centers on the basis of the distribution of finds, which are classified according to types.

The more trading thrived between Celtic groups, the more coins traveled across the land. In this way, certain gold tender such as the *Regenbogenschüsselchen* (literally "rainbow" coins) from southern Germany, strayed far from their place of origin. Coins minted in silver and humbler metals are more useful in defining sources of issue, as their use tended to be limited to local trading. The lower the value of a coin, the closer it remained to its place of origin.

These areas of issue are also the only evidence that provide a basis for establishing the tribe or people that used a certain kind of coin. Previously, research in this area was all guesswork, and we should therefore take a second look at some of those coins whose origins have already been assigned. It is impossible to cover the entire gamut of Celtic coins here, but the main groups need outlining.

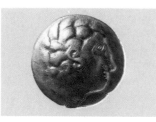
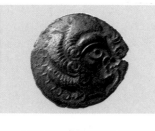

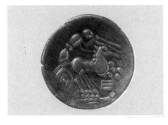
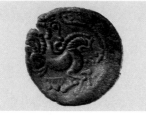

Obverse and reverse of gold stater minted by the Bituriges Vivisci 3rd-2nd century B.C. Zurich Schweizerisches Landesmuseum

Obverse and reverse of an alloy stater minted by the Coriosoliti 1st century B.C. Zurich Schweizerisches Landesmuseum

Obverse and reverse of gold stater minted in eastern Gaul 3rd-2nd century B.C. Zurich Schweizerisches Landesmuseum

The way metals were used in minting varied according to area. In southern Gaul, silver coinage was widely produced, modeled on coins from the Greek colonies of northwestern Spain and Massilia. The resident Tectosages adopted the type from Rhodes and transformed the four-leafed rose to four stylized leaves in cruciform pattern with various decorations in the fourth leaf. Whether the diffusion of this cruciform type toward southern Germany and Noricum was due to migration and not trading, is impossible to determine. The Massilia drachma spread only a short distance northward but was widely used in northern Italy where it was imitated. This created an extensive area of use for the coin, but it had limited currency further north. From what we can gather from the surviving coins of the second and first centuries B.C., direct north-south trading across the central Alps was not a major cause for the spread of coinage.

The Philip II gold stater influenced local coinage in southwestern Gaul (the Bituriges Vivisci realm) as far as the center and northern regions of the country; an extremely wide range of derivations was issued, as the silver content progressively diminished. The very distinctive form of Celtic representation was manifested in different transformations in the original model.

A particular variant emerged in northwestern Gaul, where on the obverse the horse was detached from the two-wheeled chariot and a human head added. In some issues on the obverse the face was made more emphatic in relation to the detailing of the diadem and hair (as noted in Ambiani coins), whereas in others the opposite happened. When *Gallia Narbonensis* was declared a Roman province in 125 B.C., Rome's influence spread over an increasingly large area northward up the Rhône. *Denarii romani* found their way to the north, and were widely copied. The *denarius* bearing the Dioscuri on the obverse became the Celtic *quinarius*, showing a horseman.

Alongside the issues in precious metal, there were also important bronze issues from Massilia bearing the head of Apollo and the a charging bull, which spread through the Rhône area, reaching as far as the *oppida* of Berne and Manching. These were widely imitated by the Sequani—not through conventional minting techniques, but by simple casting in bronze with a high zinc content, the coins known as potins. This manufacturing technique was practiced throughout central-east Gaul, where all manner of fantastic images appeared on the money.

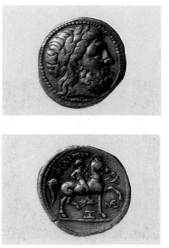

Obverse and reverse of a silver tetradrachma of Philip II of Macedon (359-336 B.C.) Zurich Schweizerisches Landesmuseum

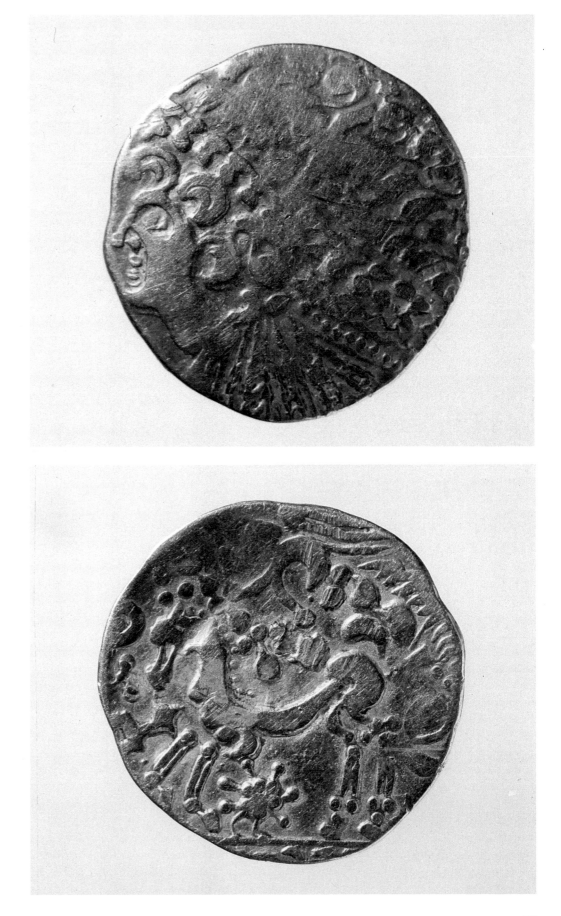

*Obverse and reverse of gold stater
minted by the Ambiani
2nd century B.C.
Zurich
Schweizerisches Landesmuseum*

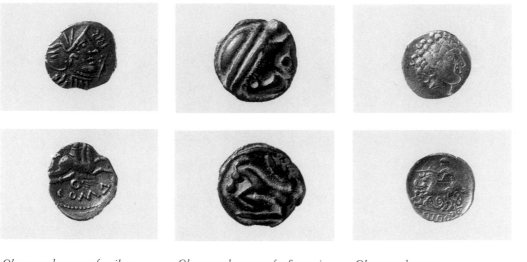

Obverse and reverse of a silver
Celtic imitation of a Roman denarius
1st century B.C.
Zurich
Schweizerisches Landesmuseum

Obverse and reverse of a Sequani
cast coin in bronze (potin)
1st century B.C.
Zurich
Schweizerisches Landesmuseum

Obverse and reverse
of a Horges-type quarter-stater
2nd century B.C.
Zurich
Schweizerisches Landesmuseum

The oriental flavor of these potins was derived from the Helvetii. In Zurich evidence has been found for the production of pieces with a double anchor and ibex (*Züricher Typus*). Shortly before the introduction of potins, the Helvetii produced quarter-staters in gold of the Horgen-Unterentfelden type, the appearance of which in the grave goods in La Tène C tombs is proof that they were coined in the first half of the second century B.C. These coins follow the model of the Philip stater and another group of staters, which is impossible to localize more precisely than in eastern Gaul, or Helvetia, and which, in its later, devalued form, is a typical example of the general drift toward inferior and lighter coinage.

The *quinarii* of central and southern Germany, originally based on Greek 3.75-gram drachmas and on the Roman *denarius* of around 3.8 grams, were actually no heavier than 1.5 to 1.8 grams. In Hesse, around the *oppida* of Goldgruber (near Oberursel) and Dünesberg, a selection of *quinarii* have been found, all made in the same place and bearing the same highly detailed figuring. Their common features are details such as small human figures, some birdlike, some strutting. The Mardorf-type stater from the same zone prove the existence of close links with southern Bavaria, home of the many groups of the Vindelici.

The Celtic coins of southern Germany are particularly well documented thanks to excavations carried out between 1955 and 1985 in Manching near Ingolstadt, by far the most important and most populated *oppidum* between the Bohemian forests and the Rhine. Among the thousand or so coins, those made locally are the staters dubbed *Regenbogenschüsselchen* after their concave shape and the superstition that they were created by the ends of the rainbow. Proof that they were coined at Manching is provided by the numerous clay plates with cavities for casting blanks similar to those found in other *oppida*. However, we cannot tell as yet which kind of *Regenbogenschüsselchen* were actually minted at Manching. The obscure images the coins bear, such as dragons, bird-heads, crowns, and spherical-ended torques, stag-heads, or other ornaments, give no more information—and the only ones with an inscription bear the wording ATVLL.

Almost all these motifs are represented on quarter-staters. Another common coin is the flat version of the full stater and quarter-stater, the dies of which were deliberately kept blank. Minting techniques and the presence of the Rolltier dragon itself are sufficient proof that the stimulus to produce gold coins reached southern Germany from Bohemia. This is further

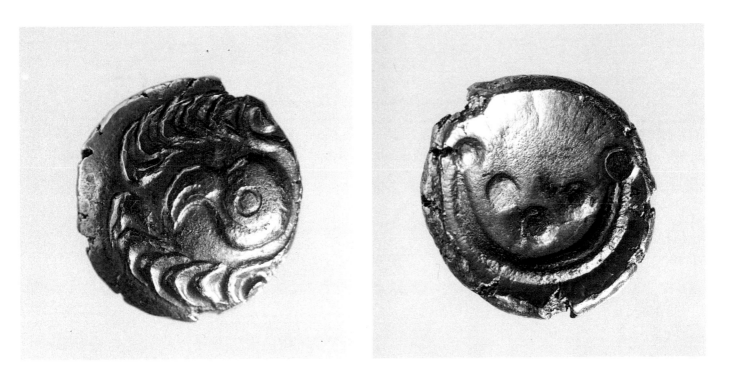

Obverse and reverse
of a "Regenbogenschüsselchen"
gold stater
2nd century B.C.
Zurich
Schweizerisches Landesmuseum

endorsed by the frequency of the 1/24th stater at Manching and in Bohemia alone. Several local manufacture. They prove that coin issues in Manching began with the onset of urbanization. One example was found in a grave dating to early La Tène C near Giengen (last third of the third century B.C.), and another in the cemetery of a settlement in Sicily, abandoned around 200 B.C. The range of denominations of gold coins is indicative of a developed and differentiated monetary economy, further proved by the great quantities of silver coins, which largely served as local currency. The most common coin was the *quinarius*, whose value is still unknown and has kept this approximate denomination for lack of a finer definition. It was subdivided into quarters of about 0.4 grams apiece; this coin's significance for the Vindelici was only discovered from excavations at Manching.

For decades leading experts continued to dispute the existence of a Celtic monetary system until finds at Manching gave final proof. There are still no precise analyses or publications on coin series from other *oppida*, and so it is impossible to compare finds at Manching with those made elsewhere.

Of special interest in this direction is the Hradiště *oppidum* at Stradonice, where a large quantity of coins have been found over the years. The Bohemian gold stater (the "shell" stater) with its subdivision into thirds, eighths, and twenty-fourths, together with numerous silver coins in small denominations seem to foreshadow similar conclusions as those from Stradonice. In the *oppida* in Hesse, recent excavations have yielded several hundred coins, so far unrecorded, which testify to similar coin circulation. Given the lack of precise information on the latest finds, it is difficult to assess the overall situation regarding the *oppida* in Gaul, such as Bibracte, Alesia, etc., but it is probably much the same. The finds made at Titelberg in Luxembourg were exemplary. In the case of this *oppidum*, however, urbanization began toward the end of Manching, and hence a very different situation transpired.

Manching was a crossroads for the trade routes from every direction. Although less numerous than elsewhere, the coins of Manching are therefore particularly varied. Owing to the site's position, coins with cross motif from southern Germany are relatively frequent. Corresponding to the *quinarius* of eastern Gaul (Kaleti) were the local currency, equivalent to the gold of the Boii, and the silver denominations of the Boii and Norici. It is impossible to establish the value of the many potins minted in eastern Gaul, and the *as* of the Roman republic.

One problem still to be solved concerns the vast hoards of staters found in the far west (Tayac) and east (Podmokl) and north (Niederzier, Rhineland). These coins are particularly common in Bavaria, such as at the *oppida* of Gaggers, Irsching, Grossbissendorf, Wallersdorf, Unterschondorf, and Sontheim. Interpretations have been varied: some say they are gold booty or votive offerings, others consider them treasures of a tribal group or chieftain. The hoards consist mainly of staters, with the occasional lower-denomination variants, or ornamental objects. Their marked uniformity seems to substantiate the theory put forward by Werner Krämer of a phase of burying treasures during the collapse of the Celtic world, at least in Bavaria.

Although coins from western Germany reached Noricum, and Noricum's coins found their way among the Vindelici, these two monetary areas have few common elements, being divided by a wide zone where hybrid types occur.

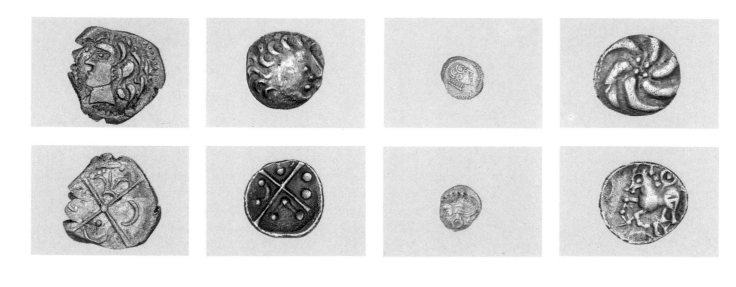

Obverse and reverse of a silver "monnaie à la croix" from southern Gaul from the Manching oppidum 1st century B.C. Munich, Prähistorische Staatssammlung

Obverse and reverse of a silver "à la croix" coin from southern Germany 1st century B.C. Munich, Prähistorische Staatssammlung

Obverse and reverse of a small silver Manching-type coin 1st century B.C. Munich, Prähistorische Staatssammlung

Obverse and reverse of a silver "Büschelquinar" 1st century B.C. Munich, Prähistorische Staatssammlung

For its own part, Noricum was already under the influence of the Balkans, which acted as a channel for the Philip II tetradrachma. The basic type arrived from western Pannonia through Transylvania (the Kroisbach- and Velem-types), and led to the issue of the group from eastern Noricum; these pieces weigh 12 grams or less, and bear a horse on their obverse. Immediately afterward, large coins of silver weighing around 10 grams appeared in western Noricum, with the reverse showing the name of a chieftain under a horseman holding a lance. R. Göbl succeeded in demonstrating that many types (though not all) were from the same mint, despite the range of names. Alongside these larger silver coins were smaller ones bearing a horse or cross on the reverse, which correspond in the western world (Karlstein hillfort) to the Manching standard type of 0.4 grams, becoming heavier toward the east.

As for the mints themselves, these have been more or less proved to be at Celeja, Teurnia, and Magdalensberg where (one of the only places in which this happened) the silver coinage of Noricum remained in currency until the reign of Tiberius (14-37 A.D.), together with the Roman *denarius*. Dies with the crossed reverse have been found at the hillfort sites of Karlstein and Gunina. Coin production in western Noricum began toward the end of the second

century B.C. and lasted through to the end of the first. The penetration of money from western Noricum to the Friuli region and to east Noricum during the first half of the first century can be explained by the historical expansion of the Celts who clearly brought money with them.

Macedonian silver coinage was not the only kind of money to reach Noricum through Pannonia—there were also the staters of Alexander the Great, with Athena and Nike, which arrived along the amber route leading north and northwest, toward Moravia and Bohemia. We know that the Celtic population there was made up of Boii whose first issue imitated this coin-type, passing through the Athena-Alkis-type to develop their characteristic "shell" stater. As mentioned above, there were also smaller denominations of a third, an eighth and a twenty-fourth. Some rare examples of staters with detailed designs have emerged, but are completely different and are considered to be a Bohemian subgroup, not attributable to the Boii themselves. The start of minting in Bohemia is dated to the second third of the third

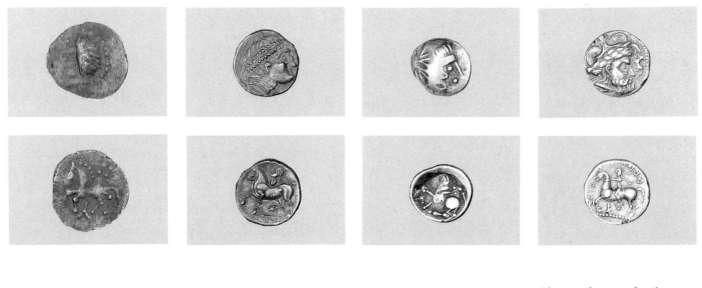

Obverse and reverse of a silver Nauheim-type coin
1st century B.C.
Munich, Prähistorische Staatssammlung

Obverse and reverse of a silver "Sattelkopfpferd" tetradrachma
2nd century B.C.
Munich, Prähistorische Staatssammlung

Obverse and reverse of a silver Kroisbach-type tetradrachma
1st century B.C.
Munich, Prähistorische Staatssammlung

Obverse and reverse of a silver tetradrachma with the inscription SASTHIENES
2nd century B.C.
Munich, Prähistorische Staatssammlung

century B.C.; and mints are thought to have existed at the *oppida* of Závist, Hradiště (near Stradonice), and Staré Hradisko (Moravia).

In the first century B.C. the Celts were probably forced out Bohemia by the Germani, and moved south toward central Danubia, where once again they set up a varied production of coins bearing the names of chieftains. The inscription BIATEC appears on shell staters and larger silver coins weighing on average 17.1 grams. This unusual denomination also appears with other names, including NONNOS, found earlier in Noricum. It is impossible to say whether the drachmas of the Zimmering type or Tótfalú versions—common along the border lands of Austria, Hungary and Slovakia—were manufactured by the Boii or by some other ethnic group.

Alongside the relatively limited number of staters, the main coinage circulating among Celtic groups in Hungary, part of eastern Slovakia, and part of Yugoslavia and eastern regions of Rumania, were the tetradrachmas of Philip II and their imitations.

A hoard found at Backi Obrovac in Serbia—the only one of its kind so far—contained 122 staters belonging to the previous so-called Athena-Alkis type issued by the Boii. Local imita-

*Obverse and reverse of a silver
tetradrachma with the inscription
SVICCA
1st century B.C.
Vienna, Kunsthistorisches Museum
Bundessammlung der Medaillen
Münzen und Geldzeichen*

*Obverse and reverse of a small
silver coin from Noricum
1st century B.C.
Vienna, Kunsthistorisches Museum
Bundessammlung der Medaillen
Münzen und Geldzeichen*

*Obverse and reverse of a silver
tetradrachma with the inscription
ADNAMAT
1st century B.C.
Vienna, Kunsthistorisches Museum
Bundessammlung der Medaillen
Münzen und Geldzeichen*

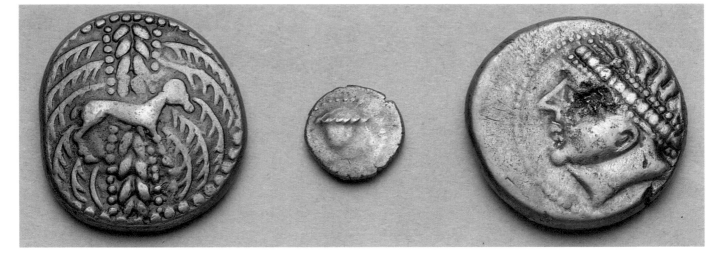

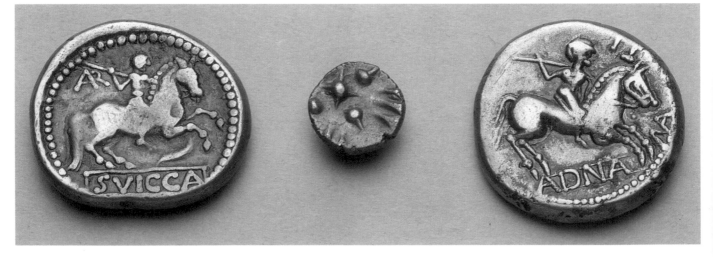

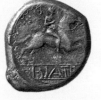

*Obverse and reverse of a silver
tetradrachma with the inscription
BIATEC
First half 1st century B.C.
Zurich
Schweizerisches Landesmuseum*

tions of various kinds multiplied as the Macedonian tetradrachma dwindled and eventually disappeared altogether. However, the Philip II prototype continued to determine coin types in the northern part of the Balkan peninsula.

Meanwhile, the equivalents of the drachma were issued in limited quantities only. It is virtually impossible to attribute single coin types to any ethnic group, since there is no clear ethnic distinction between the Getae and the Dacians. As a result, there is a common tendency to define the regional groups according to identifying features of the coinage, such as "saddled horse," or "horseman with pigtail," or "face to the front," or "reverse with beard and garland," and so on. Some territories developed thicker roughouts with a smaller diameter; others developed a slightly scooped form, with the obverse bearing a somewhat indistinct relief design. One exception is the tetradrachma with the inscription SASTHIENI, which has been interpreted as the name of a chieftain, Sosthenes. Details, such as a pony before a head representing Zeus, the inscription quoted above, and other variations, suggest that the non-Celtic Illyrians were also involved in coin production in the Balkans. The imitations of Alexander's tetradrachmas with the head of Heracles and Zeus seated, and those of the coins from the island of Thasos, can hardly be related to Celtic production. Furthermore, there are no known examples so far of coins produced by Celts who migrated to Asia Minor.

After the boom in Celtic coinage in the second and first centuries B.C. there was a third, though less prolific, spate in Gaul during the time of Augustus. These coins have so far only been found in copper alloy, and were almost exclusively discovered in Roman encampments of the period. Without doubt they were used to pay the Gaulish auxiliaries during Roman campaigns against the Germani. The most frequent of these are the so-called Aduatuci coins, which bear the inscription GERMANUS INDVTILLI, and the Bochum-type *Regenbogenschüsselchen*. Since these coins were issued during Roman domination, they cannot be termed properly Celtic.

*Obverse and reverse
of a "Gesichtstyp" tetradrachma
1st century B.C.
Vienna, Kunsthistorisches Museum
Bundessammlung der Medaillen
Münzen und Geldzeichen*

*Obverse and reverse of a silver
"Zopfreiter" tetradrachma
1st century B.C.
Vienna, Kunsthistorisches Museum
Bundessammlung der Medaillen
Münzen und Geldzeichen*

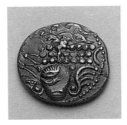
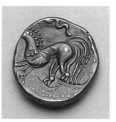
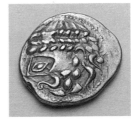
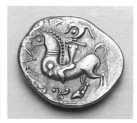

Painted terracotta vase
from Gambolò (Pavia)
3rd-2nd century B.C.
Gambolò
Museo Archeologico Lomellino

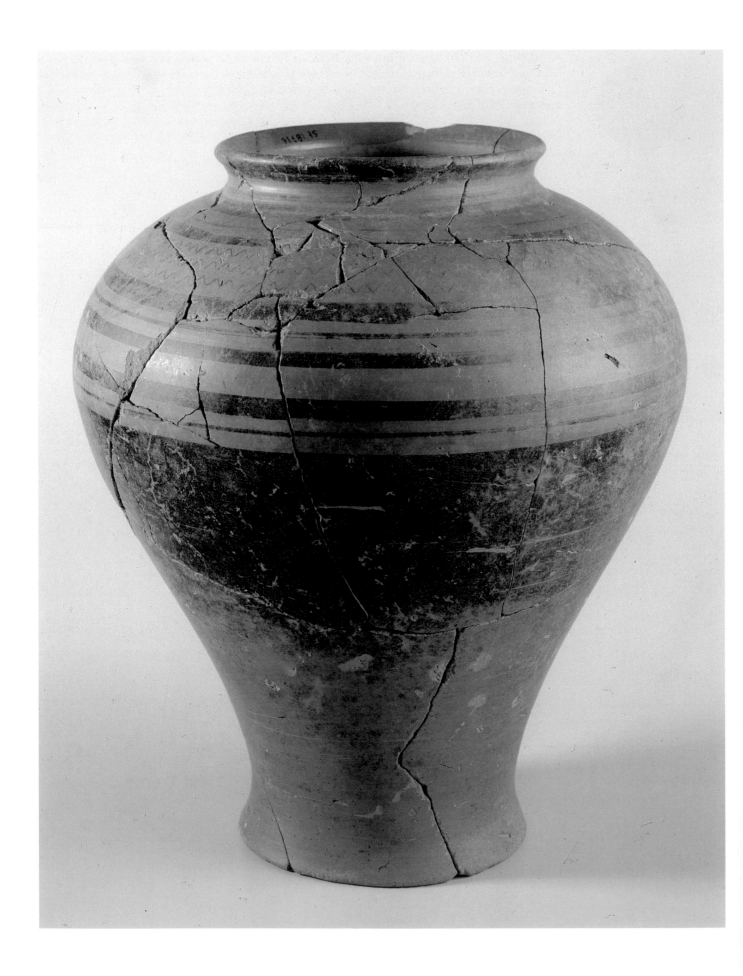

Ermanno A. Arslan

The Transpadane Celts

The wars that followed the one waged against Hannibal completely altered the political map of northern Italy. To begin with, the Gauls of the Po Valley were united and constituted a formidable enemy force for the Romans, who were still recovering from their long campaign against the Carthaginians. In 200 B.C., Cremona resisted an attack by the allies. Piacenza, on the other hand, fell; but the military superiority of Rome was to prove its might before long. In 197 B.C., C. Cornelius Cetego defeated the Cenomani in a battle fought on the banks of the Mincio river, forcing them to renew their treaty with the Romans. In 196 B.C., M. Claudius Marcellus overcame the Insubres (or Lombards) and the Comensi at Como, and two years later L. Valerius Flaccus quashed another uprising, this time by the Insubres allied with the Boii. In 194 B.C., Publius Cornelius Scipio Nasica finally conquered the Boii, most of whom were put to flight. Only a few remained, and may have been concentrated in separate areas—Brescello, for example—probably under terms dictated by a special *foedus* (treaty). Some smaller Celtic tribes stayed on land colonized by the Romans: we know that *accolae galli*, or local manpower, was hired to work the land, which had proved to be too vast for the Roman assignees to handle alone, at a time when slave labor was not yet available. Such incidences of survival left virtually no trace, except in place names. In other points, such as Aquileia, the Roman colonists became fairly well integrated with the indigenous society through marriages, adoptions and so on.

North of the Po, the territorial and political entity known as the "empire of the Insubres"—where certain distinct characteristics of "Insubration" may be noted in the funerary customs, or in the nature of the burial hoards found in Lomellina or the eastern Piedmont (Dormelletto)—was broken up. The Insubres, though not treated in the same way as the Boii, were forced to acknowledge the independent status of all the conquered tribes to the north (the Comensi, Orumbovii and others) and to the west (including the Libici, Salluvii, Laevi, Marici, Vertamocori—some of which coalesced in the fourth century B.C., others much earlier), and to leave them to fend for themselves in the negotiation of autonomous *foedera* with Rome. In this way, numerous "satellite states" came into being; indeed this may be the origin of the "false colonies" of 89 B.C.

By now, the territory of the Insubres was greatly reduced in size: to the north, it extended perhaps to just beyond present-day Monza, between the Ticino and Adda (or Oglio) rivers, and no further south than the Po River, where the relinquished land was annexed to the colony of Cremona, if it was not already occupied by the Cenomani. This ancient tribe, which had been disarmed (see below; this explains the absence of weapons in the burial hoards for most of this period), was to prove a decisive element, both culturally and economically, in the Transpadana, that is, the region to the north of the Po.

The other groups conserved their right to carry arms, as a formal sign of political and military autonomy, a fact that is borne out by the burial hoards relating to this period, where the warrior is always accompanied by his panoply (for example, in Garlasco, near Pavia).

According to the various literary sources, the Romans were far from feeling secure at this time. The Celtic world was still on the move and trust in the loyalty of the lands under their domination had waned. While the war with the Apennine Ligurians continued, in 186 B.C., the Carni invaded from the east, causing the evacuation of Aquileia. (In the end, the Romans did manage to drive the Carni back, in 183 B.C.) Seen in this light, Rome's fears of defection by its allies do not appear unfounded, and might explain M. Furius Crassipede's motion to confiscate the arms of the Cenomani, passed by the Senate in 187 B.C.

In the mid-second century B.C., the route of the Via Postumia skirted the south of Insubria, suggesting, perhaps, a certain respect for the confederate tribe, but also, and more likely, mistrust. As much as possible of the new strategic route was built on Roman territory. Any proposal of integration was still a long way off.

Of all the Celtic tribes north of the Po, only three (or perhaps four) seem to have emerged: to the east, the Cenomani; to the west, the Libici, who seem to have been the most active group, and possibly the Vertamocori, or Salluvii—this may have been their collective name; the Insubres were in the middle. The territorial position of these groups and the peace imposed by the Romans (who found a solution for every single internal bone of contention) laid the way for both internal mobility (even toward the Veneto) and economic development; change was in the air.

In particular, the southern rim of the Alps now became a true border that needed to be kept under control (a job usually delegated to groups of mercenaries who acted as buffers, such

Terracotta vase from the cemetery at Garlasco (Pavia)
3rd century B.C.
Milano, Civiche Raccolte Archeologiche del Castello Sforzesco

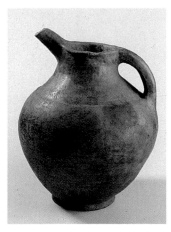

Terracotta jug from the cemetery at Garlasco (Pavia)
3rd century B.C.
Milano, Civiche Raccolte Archeologiche del Castello Sforzesco

as those at Ornovasso). Relations with the Alpine populations were fraught with problems; this much can be surmised from such incidents as the dispute between the Libici and the Salassi over the goldmines of Bessa in 143 B.C. and the destruction of *Comum Oppidum* at the beginning of the first century by the Rhaetians (the only center from which the Roman colonists were later evacuated) and by the Roman military forces pushing north: Marcius Rex in 188 B.C. and M. Licinius Crassus in 95-94 B.C.

In this context, the Alpine wars led by Augustus were the natural outcome of a situation that had been brewing over some time and, besides the Romans, involved the tribes living in the Transpadana, who had always been active middlemen in the north-south trade routes over the Alpine passes: they now set their sights southward, initiating a gradual process of integration with the cultures of the peninsula.

The importance of these routes now shifted to the regions further to the west (the Piedmont and the Aosta valley) and to the east (the area around Aquileia) at the foot of the Alps, under direct Roman control.

The integration of Celtic tribes in the Po Valley with peoples from autonomous territories on the southern slopes of the Alps (such as the modern Canton Ticino) continued, though to a lesser extent and exclusively in a south-north direction, bringing new cultural stimuli

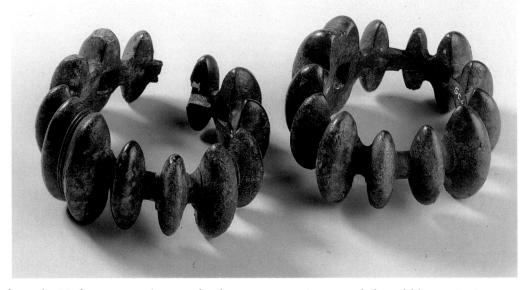

Pair of armlets or anklets from Milano-Bettola 3rd century B.C. Milano, Civiche Raccolte Archeologiche del Castello Sforzesco

from the Mediterranean. As a result, the *vaso a trottola*, a vessel shaped like a spinning top (rare beyond the Po), the cultivation of grapes and the consumption of wine (with all the inherent ideological and cultural implications), certain types of fibulae that change along with the fashions in clothes, and the use of coinage (later to be imitated by the Veragri of what is now Valais) all spread to the north.

The culture of the Celts north of the Po, therefore, evolved in isolation in the course of the second and first centuries B.C., apart from contacts with Italico-Roman culture which, in the end, was destined to prevail. The geographical area does not seem to have been regarded as marginal by the Romans, as a military force was always posted in the region.

We have little reliable information about the minor centers of habitation. Some clues, such as the abandonment of certain cemeteries and the formation of others, suggest that the network of settlements linked to military defense deployed along the river banks (for example, Carzaghetto) or on high ground (Monte Bibele) were adapted to a purely agricultural function once the areas gained their independence.

This evolution in land use, though unplanned, was no doubt welcomed by the ruling power, and does not seem to have affected the laws of Celtic tribal organization; these rejected the institutional superiority of the larger towns in the area and used administrative solutions that were to mark deeply the demographic distribution in Roman times *per vicos*.

The system was not unlike an aristocratic model of social structure, with *reguli* (chieftains) at the heads of scattered groups, and specific ethnic names, and it foreshadowed the large-scale Roman property scheme, with landlords (at first Celts, and, later, also immigrants),

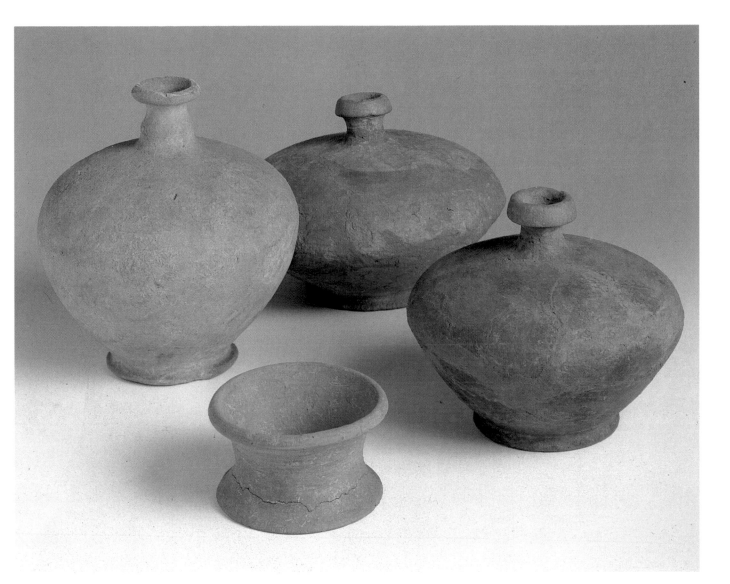

Terracotta vases from tomb no. 14
at Remedello (Brescia)
2nd century B.C.
Brescia, Museo Civico Romano

many of whom lived in the towns. Small landholdings did not exist before the Romans, nor while they were at the height of their power; this came later with the redistribution of manpower (*viritariae*) to bolster the populations of the late Republican colonies, and, moreover, was restricted to the area south of the Po. Polybius's description of the society north of the Po as a very primitive, pre-urban agricultural people who calculated wealth in terms of gold and livestock thus holds true only for the tribe in its earliest stage of development.

By the middle of the second century B.C., the momentum of the trend towards urbanization increased, both from the point of view of population (expansion) and town-planning. In the fourth and third centuries B.C., the old centers of Golasecca IIIA (fifth century) had taken on very vague urban characteristics—possibly as seats of tribal sanctuaries, or centers for tribal or federal assemblies—though they never disappeared entirely; indeed, Roman sources continued to recognize their importance as urban centers. For instance, when Milan was seized in 222 B.C. by the Romans (Polybius II, 34), it was described as the most important center of the Insubres. These events were reflected in the "cities" of the second and early first centuries B.C. by the first infrastructures of the Greek-Roman type, possibly with formalized town-planning and complex building techniques. This evolution must have seemed advantageous to the Romans, since in the past the job of keeping down the Celts scattered throughout the territory had created military problems—such as the war with the Boii—because of the typically Celtic capacity for dispersing and rejoining forces after a battle. A society based on leading urban centers was more secure, and offered a natural ally in the urban elite, a conservative group bound to the Roman government, which expected in return,

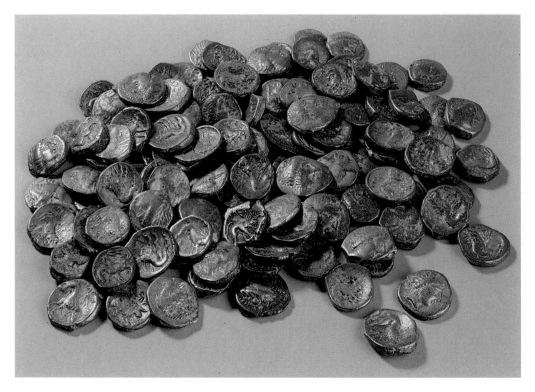

Hoard of silver Po Valley drachmas found at Rivolta d'Adda (Cremona) 2nd century B.C. Milano, Civiche Raccolte Archeologiche del Castello Sforzesco

however, protection of its own interests. They constituted the embryo of a local ruling class that was to Romanize very quickly in the cities that had become colonies and later the Roman *municipia* (towns subject to Rome, with their own laws).

Urban centers were also useful for those (especially the Italic tribes) who sought to create a safe system for importing, storing and distributing Roman products (pottery, metal and luxury articles, wine and so on). Capuan- or Italic-type bronze vessels, Aylesford-type pans, Gallarate- and Ornovasso-type jugs, Idria-type jugs, Pescate-type ladles, and so on become increasingly common among La Tène grave goods, suggesting a rising consumption of imported products that were later copied by local craftsmen. This was a powerful factor in the process of Romanization.

The greatest concentration of these luxury items has been found in the area of the Insubres; this implies that it underwent economic and spectacular development earlier than other areas. Despite this, its relations with the ruling power were a model of colonial exploitation, at least until 89 B.C.: northern Italy, which constituted a market for the distribution of Roman industrial products, became a producer of raw materials at the same time. This does not seem to have exerted a negative influence, since it meant intensified agricultural and livestock production with a ready market in central Italy. In this context, sources mention Insubria as an exporter of pork. To begin with, the marketing of products was probably carried out by the more developed colonial structures south of the Po, and then through groups of Italic immigrants or new, local entrepreneurs. After 89 B.C., there was probably an increase in investment in the production of articles destined for the new territories, which were now legally integrated within the territory under Roman rule. Now, using new techniques and shapes, there was a revival of local pottery production, which had previously declined in the face of massive importation of black-painted pottery from towns south of the Po. As a result, the way was cleared for entrepreneurial activity north of the Po in the period that lay ahead, a fact that is well documented. During this period, the gap widened between town-life (the material culture of which is little-known but which was by now undergoing a rapid and irreversible process of Romanization) and the rural communities, about which we know more, in particular that they lagged behind in a culture of residual La Tène character.

At first, it is still possible to detect cultural features typical of the larger Celtic groups of the previous period. This is manifested in the funerary record, such as in the tradition among the Cenomani of burying females wearing a torque around the neck and an armlet on the left arm. It is also known from literary sources, which cite, for example, the gold torques in the booty

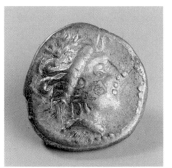

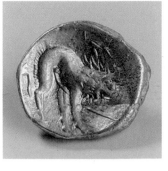

Po Valley silver drachmas from Rivolta d'Adda (Cremona) 2nd century B.C. Milano, Civiche Raccolte Archeologiche del Castello Sforzesco

Pair of bronze fibulae of so-called
"Pavese" type
from the cemetery at Valeggio
(Pavia)
2nd century B.C.
Gambolò
Museo Archeologico Lomellino

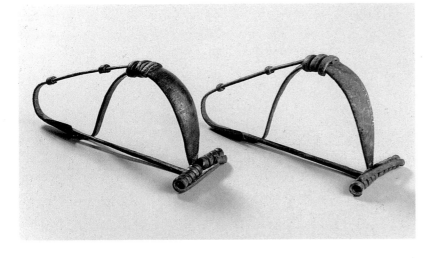

Bronze fibula from Valeggio
cemetery (Pavia)
2nd century B.C.
Gambolò
Museo Archeologico Lomellino

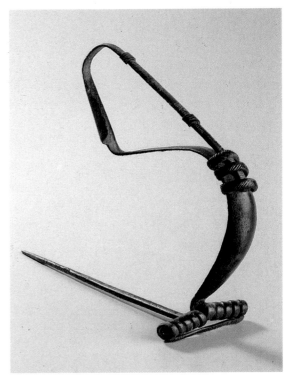

Painted terracotta vase of "trottola"
type with inscription
in northern-Etruscan characters
from Como-Prestino
2nd century B.C.
Como
Museo Civico Archeologico Giovio

465

Large silver phalera from the hoard
found at Manerbio sul Mella
(Brescia)
First half 1st century B.C.
Brescia, Museo Civico Romano

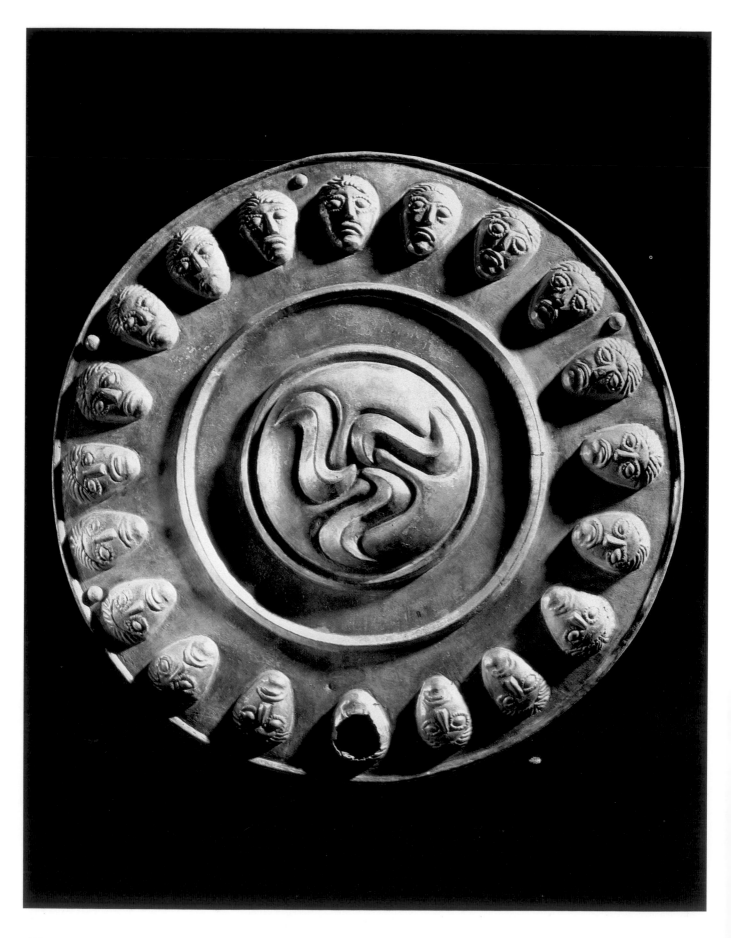

from the battle at Como in 196 B.C. (Livy, 33, 36, 13). These must have been part of the military dress of the Insubres during the last stage of their full independence from Rome.

However, by the middle of the second century B.C., there were reverse trends in the face of increasing isolation, though a residual capacity for development can be seen in the cemeteries of modest or very modest rural communities, alongside evidence of submission to Italico-Roman culture. For example, new local pottery forms emerged, including pottery with honeycomb decorations and the *vaso a trottola*, clearly linked to the production and consumption of wine, especially in the central-west. This area had evolved its own version of a form of pottery that can be traced up to the moment when it was replaced in the Roman era. As early as the late second century B.C., this type of pottery was decorated with original painted motifs. In the better-known contexts, such as the rural and peripheral areas of the late Celtic period around Lomellina, there is marked evidence of differentiation on a local scale. Each cemetery reveals customs and types of fibulae and bracelets contained in the burial hoards that vary considerably from one place to another, even within a small radius. With some types of object, it is also possible to detect areas of specific influence in the wider context of the Transpadana area, such as the case of the so-called Pavia fibulae from the Lomellina, the scorpion-shaped ones from the areas of Rhaetian tradition, and the leaf-shaped ones from Reggio Emilia.

Similarly each area seems to have had its own specific funerary rites. In the areas around Como and the Lomellina, cremations were predominant (with different rites for the burial of the ashes); in the area around Brescia, inhumation was the accepted form. Eventually, however, cremation was adopted universally, with rites deriving from the Italico-Roman world, occasionally with periods of transition when both rites were practiced, though the theory that this was applied according to sex (inhumation for women and children and cremation for men) has yet to be proved. There are also marked local variations in the types of ordinary pottery found beside the imported black-painted pottery, later produced by local craftsmen. Certain forms seem to be typical of given areas, and seem to correspond to ethnic groups: the egg-shaped jars from the area around Pavia, the "egg-cup" from the area near Como, the "pilgrim's flask" from the area near Brescia (as opposed to the *vaso a trottola*, which was possibly used for wine). But even these differences—which were the sign of a society that no

Obverse and reverse of a gold coin minted by the Danubian Celts found near Vercelli 2nd century B.C. Rome, Medagliere del Museo Nazionale Romano

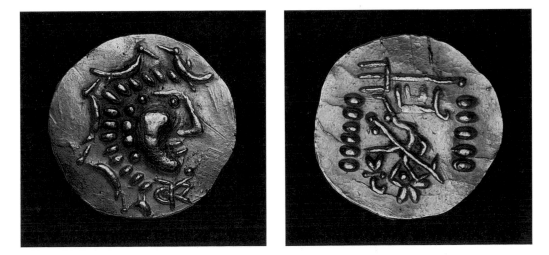

longer had its own form of expression but instead yielded to outside cultural influences—were destined to disappear during the reigns of Julius and Claudius, with the increasing spread of products typical of Roman culture: its glass and pottery, the use of the coin bearing Charon's head, and so on.

The enrollment in the Roman army of Celts from north of the Po—a fact documented in the literary sources—must have constituted a powerful stimulus in the process of Romanization. These combined factors led to the gradual abandonment of that model of rural society based on military and egalitarian principles, represented by its cemeteries containing a high percentage of graves with panoplies (sword, spear and shield), such as the one at Garlasco. Between the end of the second and the beginning of the first century B.C., warrior graves

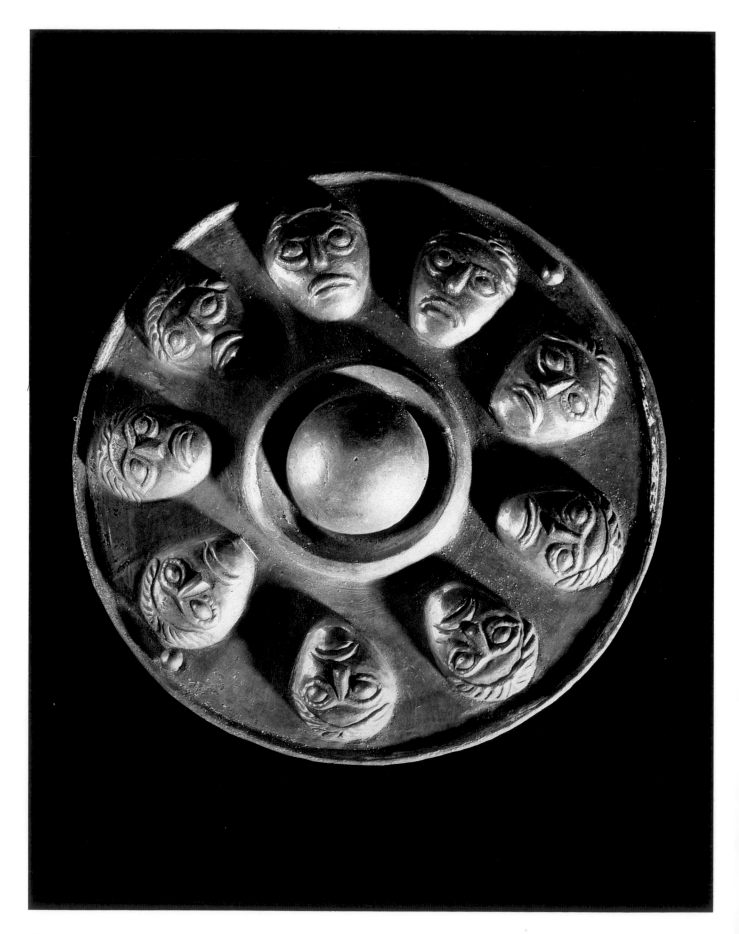

became very rare: instead of being important indicators documenting cultural change in the contexts of the cemeteries, they were sometimes reserved for the graves of chiefs, like the one at Remedello Sotto (grave XIV). The sword was still the fundamental symbolic element, and the last to survive. The shield, and that means for archaeological purposes the boss, disappeared. The later, round form has only been found at Isola Rizza near Verona.

From this we may deduce that by then in rural communities the chief had been stripped of the right to carry arms. By the time the Romanization process was complete, the great warrior tradition, too, had disappeared. The whole rural group seems to have been subjugated, and the individual inseparably linked to his job, his existence summed up in the tools buried alongside him in the grave; the problem of his role in society was obviously solved. At this stage, the Transpadane towns appear to have multi-ethnic communities. Here, two languages were spoken and written, as the first-century B.C. epigraph bearing the name of Milan in northern Etruscan characters testifies. There is evidence of forms of assimilation (*interpretatio*) of local cults into the official Roman religion: under Sulla, the *Capitolium* near Brescia had four *celle*, or sanctuaries (a local divinity was therefore worshipped beside the canonic colonial deities), and not until much later (after the reign of Flavian) was it reduced to three *celle*. Yet even after 89 B.C., local forms of judiciary persisted: the *argantocomaterecus* (master of the mint? treasurer?), for example, mentioned in the late bilingual epigraphs from Vercelli. In the development of human activity north of the Po during the second and first centuries, however, there seem to have been no particular traces left by the affair of the Cimbri, who were defeated at Vercelli in 101 B.C., and who also brought groups of Boii with them into the fray. Testimonials to their flight after defeat are the hoards of gold coins hidden around Vercelli (the so-called *Regenbogenschüsselchen*, which, in one case, were found together with gold torques)—coins that were completely alien to the local currency, now based on Celtic silver and Roman coins. The fall of the Cimbri, instead of provoking a break with Rome (which may have been their hope) caused the assimilation of the Transpadane tribes with the Romans to accelerate, through the arousal of new fears and because of the insuperable gaps now evident between groups of a common stock. Other finds alien to the local Italian context include the caches of coins found in the area of the Boii tribe from Siena and Campiglia Marittima and the isolated find of silver phalerae from Manerbio (near Brescia), which came to a world of completely different figurative traditions from the area of the

Terracotta vases from tomb no. 1 at Como-Pianvalle (Como) Early 1st century B.C. Como Museo Civico Archeologico Giovio

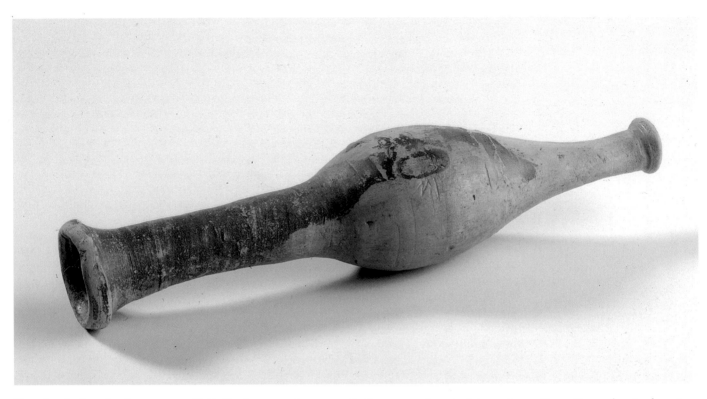

Terracotta vase from tomb no. 1
at Como-Pianvalle (Como)
Early 1st century B.C.
Como
Museo Civico Archeologico Giovio

Danube during the first century B.C. In the second century B.C., men and capital from the Roman world were already flocking to the towns. By the first century B.C., Roman *familiae* had put down roots alongside the most prominent local groups, households that were to produce such profoundly Roman figures (although linked in some way to the culture of the new territories) as Livy, Cornelius Nepote, Ti. Catius and others. By the first half of the first century B.C., Verona already had Roman senators. A rapid period of change affecting every aspect of public and private life was soon to follow. One example of this was the adoption of the Roman model of the *tria nomina* (the system of using three names), which we can follow in the genealogies of funerary epigraphs. North of the Po, Milan, once again, seems to be the driving force behind the whole process, from the middle of the second century B.C. In this new situation, the aggressiveness of the Insubres could no longer be expressed in military action or territorial expansion and now found an outlet in the economic arena.

We see proof of this in the technical and artistic quality of the coinage used by the Insubri, bearing inscriptions in northern Etruscan characters (*toutiopouos, pirakos, natoris, rikoi*), and apparently better suited than the equivalents issued by the Cenomani and the western groups (Libici, Salluvii) to support a true currency, parallel and complementary to Roman coins.

Perhaps it was the widespread use of the Insubri coinage that led, at the end of the second century B.C., to the suspension of the minting of coins northwest of the Po and the creation of a currency that was in circulation even after 89 B.C. along with Roman currency, the supply of which was to cause problems until the reign of Augustus.

In any case, at this stage, the Insubri undeniably had a leading role in events, though once again the Cenomani seem to have managed to escape. The area north of the Po had come into its own and had its say in the affairs of Roman government, into which it was, by now, fully integrated: in 81 B.C., the Transpadana became a *provincia*, and therefore a seat of the armed forces, with the possibility of representation in Rome, a fact which was to come about during Caesar's reign. It ceased to be a seat of military power in 42-41 B.C., but, by then, local affairs had merged into the wider context of Europe as a whole.

Dragan Božič The Taurisci

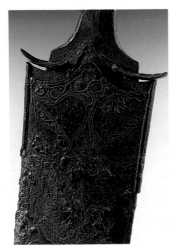

Detail of decorated section of iron scabbard from Mokronog (Yugoslavia)
3rd century B.C.
Ljubljana, Narodni Muzej

The works of ancient authors provide very little information about the Taurisci of the Eastern Alps who inhabited the territory of modern central and eastern Slovenia and northwest Croatia, or about their three-hundred-year long history, from the end of the fourth century to the end of the first century B.C. Strabo maintained that they were a Celtic people.

According to him, Nauportus, the modern Vrhnika, situated southwest of Ljubljana, was one of their settlements. Here, goods transported by cart from the Roman colony of Aquileia were transferred to ships that carried them down the Ljubljanica and Save rivers to Segestica in Pannonia (near Sisak) and thence to the Danube and the areas adjacent to it.

Their neighbors to the west were the Carni (who controlled Tergeste, Friuli, Carnia and the area which is now western Slovenia). To the north were the Norici (in what is now Austria, with their center in Carinthia), to the east were the Pannonii along the Sava River and the Scordisci along the Danube and to the south were the Iapodi, who lived in modern Lika and in the valley of the Una River.

It is possible that the Taurisci took part in the events during the years 171-170 B.C. mentioned by Livy. In 171 B.C., the consul, C. Cassius Longinus, left Gallia Cisalpina on his own initiative, and marched through Illyricum to reach Macedonia, where he wanted to fight in the war between the Romans and the Macedonians. Under orders from the Senate, he and his troops were forced to turn back, and, as they did so, his soldiers sacked the lands of the Carni, the Istri and the Iapodi, committing murder and arson.

They also sacked settlements belonging to Alpine peoples, of whom thousands were dragged away as slaves.

The following year, representatives of the Carni, Istri and Iapodi presented themselves in front of the Senate to dispute the damage incurred and the injustice suffered at the hands of the Roman soldiers. The brother of the Noric king Cincibilus went to Rome to represent the Alpine peoples. According to the itinerary that the consul's army must have followed, it seems probable that the term "Alpine peoples," allied with the Norici, actually refers to the Taurisci.

Some decades later, in about 147-132 B.C., according to Polybius, fairly pure gold was discovered two feet below ground level on land belonging to the Taurisci. The Taurisci exploited it along with the Italici for two months, until its price dropped by a third. When they realized this, the Taurisci expelled the Italici in order to have the monopoly of the market.

The expulsion of the Italici was to have its consequences. In 129 B.C., consul C. Sempronius Tuditanus defeated the Taurisci, the Iapodi, the Istri and probably also the Carni and the Liburni. In 115 B.C., M. Aemilius Scaurus did the same again with the Carni and possibly also the Taurisci.

Four small bronze animal heads from Šmarjeta (Yugoslavia)
3rd century B.C.
Ljubljana, Narodni Muzej

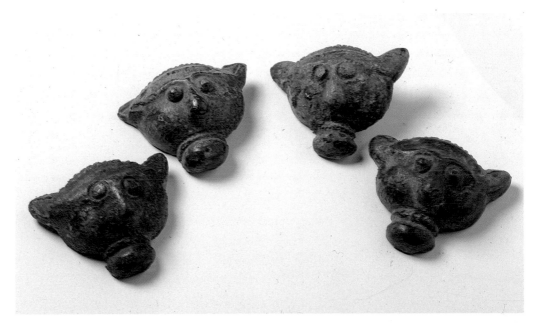

Gold rings from tomb no. 2
at Dobova (Yugoslavia)
End 3rd-early 2nd century B.C.
Brežice, Posavski Muzej

Iron belt-chain from tomb no. 2
at Dobova (Yugoslavia)
End 3rd-early 2nd century B.C.
Brežice, Posavski Muzej

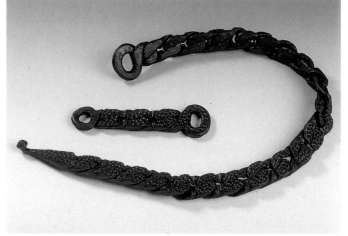

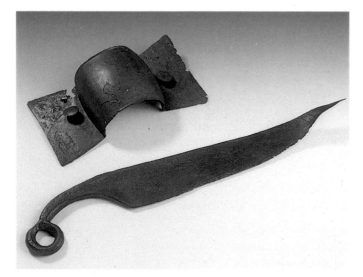

Iron knife and shield-boss
from tomb no. 2 at Dobova
(Yugoslavia)
End 3rd-early 2nd century B.C.
Brežice, Posavski Muzej

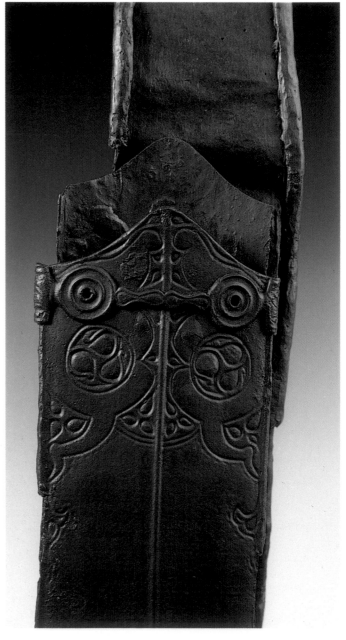

Detail of decorated scabbard
from tomb no. 6 at Dobova
(Yugoslavia)
End 3rd-early 2nd century B.C.
Brežice, Posavski Muzej

Around 60 B.C., the Taurisci fought alongside the Boii against the Dacians under the command of King Burebista, and suffered a crushing defeat. But, in the end, it was Octavianus who destroyed their power for good in the war against the Iapodi, the Pannonii and the Dalmatians (35-33 B.C.).

What little we know of the history of the Taurisci is completed by archaeological evidence, which can also offer us detailed records of events in the area of the foothills of the southeastern Alps before they were colonized. It concerns the fifth and fourth centuries B.C., when, in the cradle of the Celtic world in central Europe, the rich and original Early La Tène culture was already flourishing. Here, however, the peoples of the Hallstatt culture continued to live in high, well-fortified settlements. The dead were buried in burial mounds belonging to the family or the tribe. At that time, the Celts began to move towards the south and southeast. Their influences are manifested in the adoption of some examples of Celtic weaponry. The swords from the site at Magdalenska gora, near Šmarje and the helmet from Trbinc near Mirna must have been imported. On the other hand, the triangular perforated

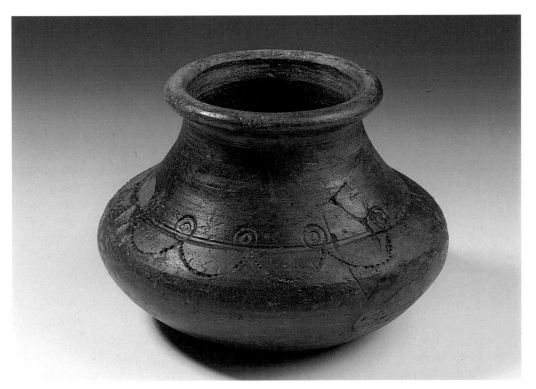

Terracotta vase from tomb no. 28
at Dobova (Yugoslavia)
End 3rd-early 2nd century B.C.
Brežice, Posavski Muzej

belt-hooks and the rings—the metal parts of the warrior's belt—are imitations of the Celtic originals. The grave of the warrior of Trbinc, containing a Celtic iron helmet, beside a battle-ax and a spear-head, all of which are typical of Hallstatt weapons, shows clearly that the assimilation of Celtic weaponry was not perfect. Among the jewelry found in Late Hallstatt graves, there are only a few examples that we can link with the Early La Tène artistic style. These include two bronze finger-rings from Vače, decorated with tiny human heads, and four bronze buttons, shaped like the head of a cat, from Šmarjeta (at least twelve were found in a grave under a burial-mound). Unlike similar heads which appear in the decoration on numerous products of Early La Tène craftsmanship, these are isolated buttons that may have been worn round the neck.

Towards the end of the fourth century B.C., a wave of Celtic migrations also swept over the southeastern foothills of the Alps. The Hallstatt era ended with the colonization of the Taurisci, who, according to archaeological evidence, arrived here from the Carpathian basin, and introduced the La Tène era, which lasted for three centuries. Excavations carried out in the huge Hallstatt-La Tène hillfort of Cvinger at Stična in Lower Carniola, have proved

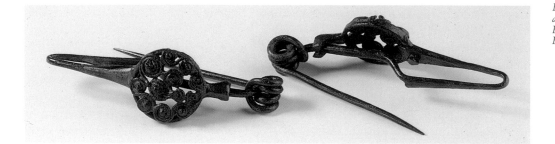

Bronze fibulae from tomb no. 49 and 56 at Dobova (Yugoslavia) End 3rd-early 2nd century B.C. Brežice, Posavski Muzej

that life continued there without any violent interruptions. However, after colonization by the Taurisci, the settlement was to remain without boundary walls for a time.

The numerical ratio of the Taurisci to the indigenous people is difficult to estimate as it is impossible to distinguish the graves of each group. This is due to the fact that, fairly early on, the indigenous tribe assimilated not only a great many of the material aspects of Taurisci culture, but also their funerary rites. The Hallstatt weapons, consisting of a battle-ax and one or two spears, were replaced by the typically Celtic combination of a sword in a metal scabbard, wooden shield with an iron boss and a spear with a much wider blade. The funerary assemblage for men also consisted of typical knives, shears and razors, while the scabbard of the sword attached to a heavy chain belt in two parts. Women, who had worn differently shaped fibulae of the Certosa type, now fastened their clothes with fibulae of the La Tène type, and wore bracelets with hemispherical decorative elements. Alongside pottery made without the use of a potter's wheel, they also began to produce wheel-turned pottery.

The most significant change was in the funerary rite. They began to cremate their dead and bury the ashes in "flat" graves. The graves excavated in 1885 at Mokronog are good examples of this rite. After cremation, the charcoal and ash was removed and the burnt remains of the bones were placed in simple burial pits, really holes dug in the Dolomite rock, measuring about half a meter in depth and a quarter of a meter in width. They were sprinkled with Dolomite sand and the objects to be buried with them were placed on top of the sand. In the men's graves, these were usually weapons, often deliberately deformed, heavy chain belts and personal utensils; the women's graves, on the other hand, only contained jewelry.

Despite this, there was not a complete break with the Hallstatt culture.

As has already been said, life in the settlements continued and La Tène cemeteries were situated beside burial mounds of the Hallstatt culture. Moreover, only a part of the pottery objects found in the graves are distinctly La Tène; most of the evidence points quite clearly to the continuation of the Hallstatt tradition in pottery.

What has been said here about the relations between the Taurisci and the indigenous population applies particularly to the Lower Carniola region. In Styria and the Sava Valley, we have quite a different picture: the local La Tène culture contains no traces of the Hallstatt culture. Here, it is obvious that the Taurisci settled in a previously uninhabited area.

Mitja Guštin has rightly divided the Taurisci culture into two phases. The earlier one, covering the third and second centuries B.C., is represented in the cemeteries at Dobova and Brežice near the Sava River, at Mokronog in the Mirna Valley, at Formin in the Drava Valley, and at Slatina v Rožni dolini near Celje, where objects typical of the Celtic world as a whole were found (for example, scabbards decorated with pairs of dragons or in the Swiss Style, sheet metal shield-bosses, heavy chain belts) as well as some peculiar to the eastern Celts: scabbards decorated in the Hungarian style, fibulae with pseudo-filigree decoration and anklets composed of three or four hemispherical elements. Weapons from this period are often richly ornamented (usually the scabbards, and sometimes also sword-hilts, heavy chain belts and spear shafts, as in graves 2 and 6 at Dobova). The jewelry of this phase, on the other hand, gives us quite a different picture. The most common female ornaments in various parts of the Celtic world at this time were light chain belts in bronze and glass bracelets—

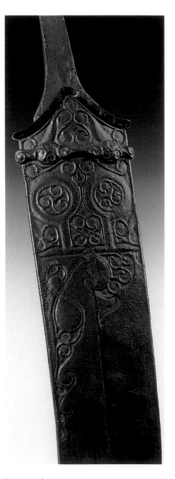

Detail of ornamentation on iron scabbard from tomb no. 47 at Brežice (Yugoslavia) End 3rd-early 2nd century B.C. Brežice, Posavski Muzej

*Iron helmet from tomb no. 1656.58
at Mihovo (Yugoslavia)
1st century B.C.
Vienna, Naturhistorisches Museum*

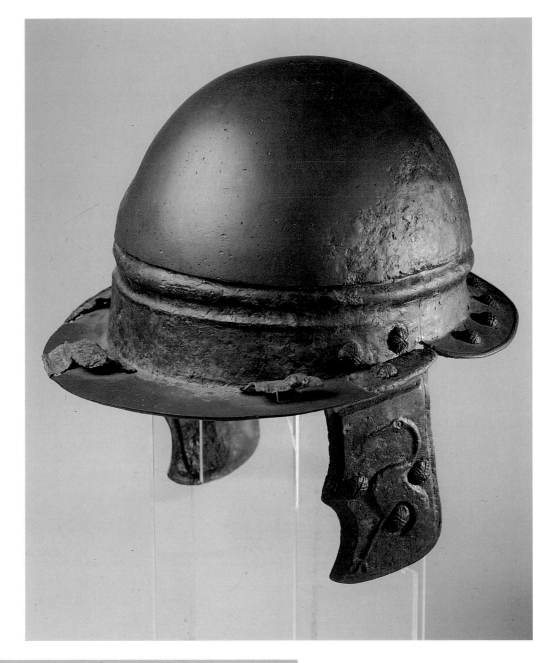

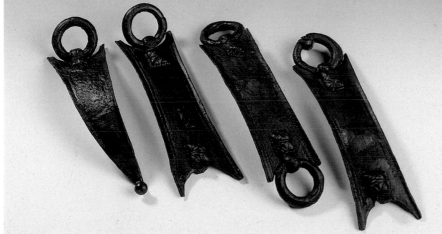

*Iron belt pieces from tomb no. 47
at Brežice (Yugoslavia)
End 3rd-early 2nd century B.C.
Brežice, Posavski Muzej*

both of which are rare in finds associated with the Taurisci. Nor is there any sign of the bracelets richly decorated with pseudo-filigree work or ornate plastic detail. The women, it seems, wore simple bronze armlets with a bulge and large anklets with three or four hemispheres. However, there are some exceptional finds: the scabbard from grave 47 at Brežice, decorated with a pair of dragons and the asymmetrical plant motif typical of the Hungarian Style; the belt with plaques and rings which is completely different from the heavy belts worn by men at the time; and the scabbard from grave 19 at Slatina v Rožni dolini, richly decorated in the Swiss Style and gilded in part. When compared with the nearest finds from the Carpathian basin, the *kantharos* from Novo mesto seems to perpetuate the iconography used by Early La Tène craftsmen: the human head is surrounded by two pairs of mythical characters.

The end of the second century B.C. was a moment of great cultural change. This was the beginning of the late phase of the Taurisci culture, which lasted until the end of the first century B.C. and to which the large cemeteries on the Strmec above Bela Cerkev, at Mihovo and in Beletov vrt at Novo mesto belong. Whereas in the early phase of their culture, the Taurisci had favored cremation burials, in the later phase, both cremation cemeteries (at Novo mesto, for example) and cemeteries where inhumation burials predominate (above Bela Cerkev, at Mihovo) are found. In some areas, however, at Magdalenska gora, for example, there are shallow cremation graves dug in Hallstatt burial mounds.

During this period, the Taurisci began to mint their own coinage, which is known from hoards and settlement finds, as well as a rich find from the bed of the Savinja River at Celje. One of their mints was also situated in this place. In addition to the large silver coins (tetradrachmas) with the stylized head of Apollo on the obverse and a horse on the reverse, smaller silver coins of lower face-value were also minted. Only in the four graves at Mihovo are small silver coins deposited as an offering to pay for the journey into the next world. There was a revival of certain aspects of the Hallstatt culture at this time. Once again, helmets were placed in graves. Some women wore bronze, ribbed bracelets which can only be

Terracotta cup from tomb no. 37 at Verdun (Yugoslavia) Second half 1st century B.C. Novo Mesto, Zavod za vastvo narovna in kulturne dediščine

Colored glass bracelets from tomb no. 53 at Mihovo (Yugoslavia) 2nd century B.C. Vienna, Naturhistorisches Museum

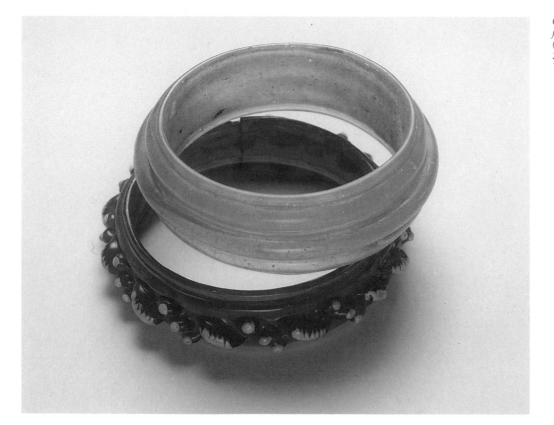

*Bronze helmet from Šmarjeta-Vinji Vth (Yugoslavia)
1st century B.C.
Ljubljana, Narodni Muzej*

distinguished from those of the Hallstatt culture by the terminals, which were usually in the shape of an animal head. The embossed animal decoration employed on the cheek-guards of three helmets is reminiscent of that found on situlae. While warriors were usually armed with swords and scabbards with a bridge formed by two S-shaped pieces, the women liked to wear colored glass bracelets. In the graves at Mihovo, there were at least twenty examples, the most beautiful of which (from grave 1657/53) is unique. Women's graves also contain fibulae mostly of bronze and sometimes of silver, with a long spring and a distinctive shape. The same applies to the painted pottery of this period produced by certain Celtic tribes and not found in any of the settlements or graves of the Taurisci. The explanation is simple. The local potters had a different way of formally distinguishing their work: they used cordons or the structure also to be seen on the cheek-guards of the bronze helmet found on the Strmec above Bela Cerkev. This helmet is the only bronze example of the eastern Celts in the first century B.C., and the buttons decorated with red enamel give it an especially colorful effect. It was found in 1897 in a grave also containing a bent Noric sword, the iron umbo of a round shield and a dagger. Like grave 37 at Verdun near Novo mesto (which contains an almost identical sword and umbo), this tomb dates from the Augustan age; that is, to the period following Octavianus' victory over the Taurisci.

Archaeological research indicates that under Roman domination the Taurisci abandoned their settlements but continued to bury their dead in the same places as before. On the Strmec side of Vinji vrh above Bela Cerkev, the oldest graves of the Late La Tène, situated higher up, are succeeded by Roman graves on the lower slopes. The same phenomenon can be seen at Novo mesto and Mihovo. They also retained some aspects of the funerary rites. This is clearly shown by the graves containing the classic Roman weapons, the *gladius* (sword), the umbo on the round shield with the long handle, and the helmet of the Weisenau type.

This situation could not last for long: the spread of Roman domination continued relentlessly: new peoples and new cultural waves arrived in this area from every direction. Consequently, with the passing of time, this also meant that all traces of the Taurisci disappeared.

*Reverse of coin in circulation
in Taurisci territory
2nd-1st century B.C.
Ljubljana, Narodni Muzej*

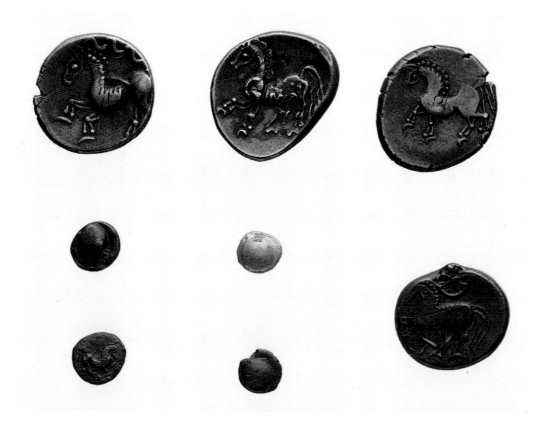

Otto Hermann Frey
Miklós Szabó

The Celts in Balkan Area

The Celts in Thrace

The contacts which the Celts established with the Scythians and Thracians during the Early La Tène period were clearly similar to those enjoyed by the Etruscans and Greeks. The Celts set up full trade relations with the Thracians, who sent their surplus products to the barbarians from the north, and in exchange received military aid and slaves, as well as natural products of various kinds. The process must have gradually matured from an initial, simple exchange of gifts, to full-scale barter and thence to a proper monetary economy.

The motivation for this exchange was the Celts' fondness for the superior products of the Mediterranean world, symbols of status and wealth which eventually had a decisive effect on the Celts' artwork.

Links with the skilled horsemen of the east followed a very different pattern. At a fairly early stage, the Danube acted as a channel for trade between the Celts and the Greek towns on the Black Sea; in as early as the fifth century B.C. Herodotus (IV, 48-49)) had extensive knowledge of the tributaries of the Danube as far as Moravia and the Iron Gates. Beyond this point his information is muddled, except that he sites the Celts themselves at the source of the river. However, the Celtic archaeological sites have yielded no Greek luxury goods that might have made their way through this channel probably without intermediaries. The Scythians and Thracians traded with the Greeks and Persians for goods that were often made expressly for them, on order, by Greek craftsmen. But neither the Scythians nor the Thracians are likely to have acted as intermediaries for the Celts in the west. Their experience of the Celts tended to be violent—when alliances failed and honorary gifts were not exchanged, the Celts went on raids for booty. Clashes apart, the exchange of gifts undoubtedly took place during contacts between the dominating classes in mutual recognition of status. Elsewhere, mention has been made of head-hunting practices by both parties. This shared custom was probably the outcome of an exchange of ideas. The entity of contacts is clearly proved by some Celtic finds bearing eastern-Greek or Persian stylistic features, the prototypes of which were perhaps honorary gifts which can only have been brought by the Scythians or Thracians.

The question is, what is meant by a gift? Xenophon (Anabasis, VII, 3, 26-27) speaks of a banquet offered in 400 B.C. by the Thracian sovereign Seute to which he had invited the

*Silver torque with iron core
from Trichtingen (Baden-Württemberg)
2nd century B.C.
Stuttgart
Württembergisches Landesmuseum*

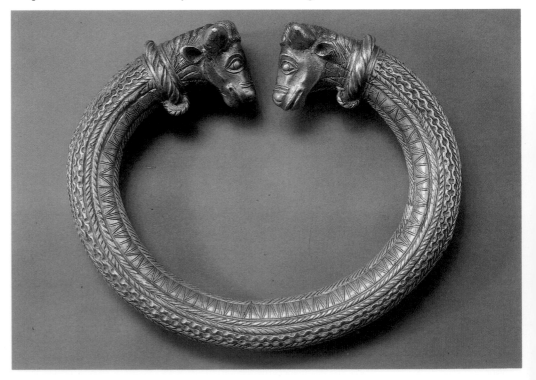

Gold sheet mount with stamped decoration from a drinking-horn from the princely tomb at Reinheim (Saarland) 5th century B.C.

Bone mount depicting animal from the Altai 5th century B.C.

survivors of ten thousand Greek mercenaries who, under Cyrus the Younger, had waged battle against the Persian king Artaxerxes II. Xenophon notes that while they drank from their drinking-horns, the king was presented with a swift horse, a slave, clothes, carpets, and silverware, all in quick succession. We know from other written sources that rings were also offered as a sign of esteem and deference to rank.

Various pieces of Celtic artwork betray similarities with the kind of products exchanged as honorary gifts.

Among the grave goods of a princely tomb at Weiskirchen on the Saar river, archaeologists found a gold drinking-horn decorated with ten die-stamped sphinxes, together with various gold mounts with impressed rosettes. The sphinx die may be of eastern-Greek origin. As stated earlier, due to the lack of corroborating finds, it must be excluded that this article reached its destination through Etruria. Nevertheless, it may be that the drinking-horn, to which the Scythians and Thracians traditionally attributed a special role, was an honorary gift to a Celt from a nobleman from the region of Pontus, where identical rosettes abound, used as decorative trim on clothing.

In the vicinity of the hillfort at Glauberg on the border of the Wetterau in Hesse, an unfinished, Early La Tène bronze torque was found; the decorations show two lions flanking a janiform head at 180° to each other, resting their forepaws on a further two janiform heads. This motif—a head between predatory animals or imaginary beasts—has equivalents in a whole range of Celtic works. However, completely alien to Celtic art are the lions whose bodies become one with the ring, wrapping round it; this only known in Persian artworks. A golden ring from Aleppo decorated with two griffin-lions also bears the corresponding steplike mane. The fact that in Thrace golden torques with lion-headed creatures after the Persian model were also an important personal ornament is proved by the illustration on a decorated shin-guard from Vraca in northwestern Bulgaria.

Stylistic traits of eastern-Greek origin are also found on the famous fifth-century fibula found at Panenský Týnec in Bohemia, particularly evident from the sheep's head terminating the foot of the fibula: the crown of curls on the head, the fine lines around the mouth, and the fact that it is not a ram but a sheep without horns, leave no doubts as to the cultural links involved. But it is not clear whether the bird in flight on the fibula can be traced to oriental prototypes.

Still on the question of parallels, other examples exist, though less certain. Experts have frequently puzzled over the gold ring found in the princely tomb of Rodenbach in the Palatinate. Alongside palmettes comparable with those on other La Tène artifacts, the Rodenbach ring is decorated with a mask enclosed by two pairs of rams. The motif, similar to the one on the Weiskirchen belt-clasp (which turned up in a rather different version with animals on the Glauberg ring, and in another belt-clasp from Stupava showing strong preda-

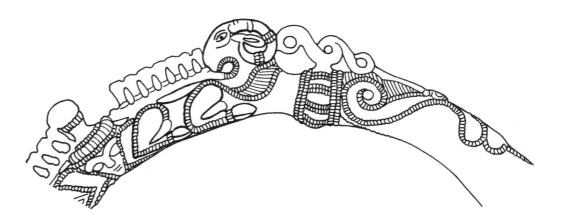

Detail of armlet from Rodenbach (Rhineland) 5th century B.C.

479

tory parallels with oriental craftwork) can only belong to the Celtic artistic milieu. The couchant rams have direct parallels with works from the Russian Steppes, as typified by inlaid bone mounts from the Altai region, which also have beaded lines on the bodies, and a matching layout.

Two cow-headed birds decorate the gold torque from the hoard found at Erstfeld in Switzer-

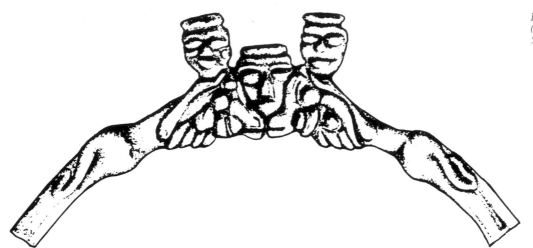

Bronze torques from Glauberg (Hessen) 5th century B.C.

land. Bulls with large horns are even more frequent in the Celtic world. But the symbolism of the cow and bullock is typical of eastern Greece and Persia. Numerous torques have come to light with the terminals decorated with the heads of these animals. The imaginary Celtic beasts must derive in some way from the iconographic legacy of the Orient.

There is a probable link with the silver torque found at Trichtingen, one of the many fascinating finds from southwestern Germany belonging to a more recent period, probably the third century B.C. The torque consists of a silver-plated iron ring weighing six and a half kilos, and was thrown into a pond or stream as a votive offering. The excellent bonding achieved between the two metals echoes the metalworking skills of Anatolia. The torque terminates in two rather short-horned ox-heads with small torques around their necks, a hallmark of the Celtic warrior. Persian and eastern-Greek torques, often in precious metals, have been found in abundance, where the calf symbol features conspicuously among the animal-head decorations. In this case, the realistic rendering of the hair betrays Greek influences. In the Near East and in Celtic art torques are often pictured as a mark of sovereignty. The heavy torque mentioned above can only be a symbol of this nature, made as a ritual offering to a deity. It was clearly manufactured in a workshop along the lower Danube area, where objects from eastern Greece and Near East were well-known; from here the torque found its way to southwestern Germany.

With this important find, we have come to the era in which the Celtic world was reaching out toward the orient. As a consequence, throughout the Balkans a direct merger of Celtic and Thracian traditions came about, heralding a new phase in the relationship between the two areas. (O.H.F.)

The gold torque discovered at Cibăr Varoš is the oldest relic of Celtic art found in Thrace to date. It is clearly of the utmost importance, although the exact circumstances of its discovery are unknown. It may be linked to Celtic presence in Thrace toward the close of the fourth century B.C. It appears that soon after the Celts had established diplomatic relations with Alexander the Great, they resumed their military operations in the Balkans. It is certain that, around 310 B.C. Cassander dealt them a crushing defeat in the region of Haemus (Mount Balkan). The ornamentation of a La Tène wagon included in the burial goods of a Thracian tomb at Mezek in Bulgaria (not far from the Turkish border), has some connection with the victory of Antigonos Gonatos in 277-276 B.C. over a Celtic army near Lysimacheia in Thrace. This defeat effectively checked any further Celtic attempts at penetrating the Hellenistic world.

The passage of the Celts through this Balkan region is not accompanied by a corresponding diffusion of La Tène-type artifacts. This is hardly surprising, as material evidence of invasions has so far proved scarce and sporadic. The situation changed, however, after the Celts failed to penetrate Greek lands. Polybius writes that, after defeating the Thracians, the Celts founded a kingdom not far from Byzantium. But Stephan of Byzantium locates Tylis much farther off, near Mount Balkan. This discrepancy makes it impossible to identify the precise whereabouts of the new state. But one thing is certain: the Celts never occupied towns along the Pontic coast, nor territories beyond Mount Balkan itself. Nevertheless, they had a considerable impact on the history of Thrace in the third century B.C., cutting off supply lines on numerous occasions, and threatening local and even Greek settlements in the area.

We should not, however, overestimate the importance of Tylis, which was neither particularly stable nor well organized. Celtic remains from this period in Thrace are infrequent and their origin often debatable. They are limited to a few weapons, fibulae and other sundry, isolated finds. The dearth of archaeological material may have something to do with the present state of research, but the general rarity of purely La Tène artifacts is also explained by the Celts' habit of blending local traditions with their own, and not least by the ongoing process of Hellenization. This was clearly fostered by the amity between the Lagidi and the people of Tylis, who in early times often drew on the services of the Celtic mercenaries, many of whom came from the kingdom of Tylis itself.

Celtic power in Thrace was destroyed in 213-212 B.C. The implications of this brief chapter in Celtic history are twofold. On the one hand, it shows the popularity enjoyed by La Tène-style arms among the Thracians, who were primarily "aristocratic horsemen." The invaders'

Bronze statuette of boar
from Mezek (Bulgaria)
3rd century B.C.
Sofia
Narodnija Archeologičeski Muzej

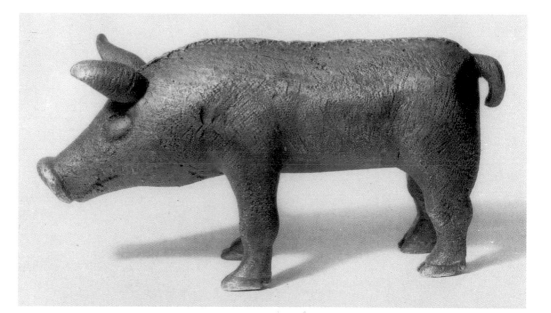

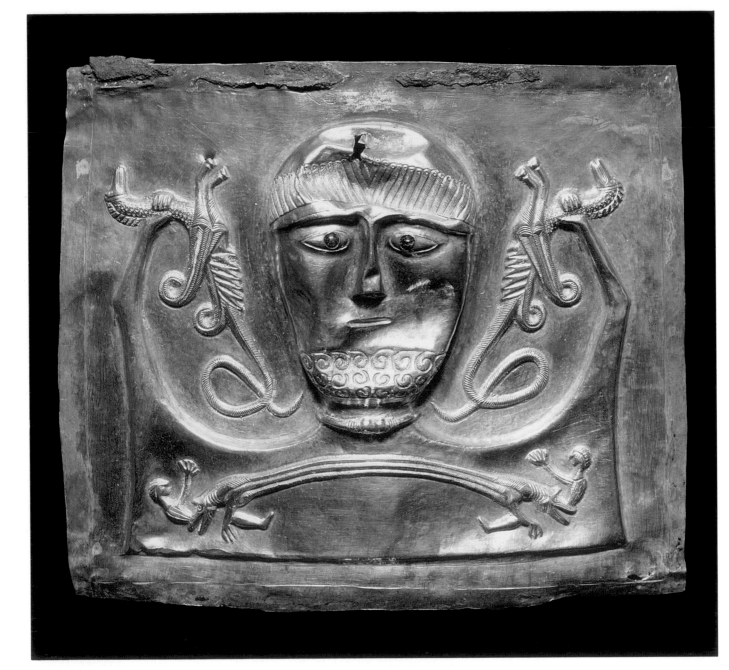

Embossed silver mount
from the Gundestrup cauldron
(Denmark)
First half 1st century B.C.
Copenhagen, Nationalmuseet

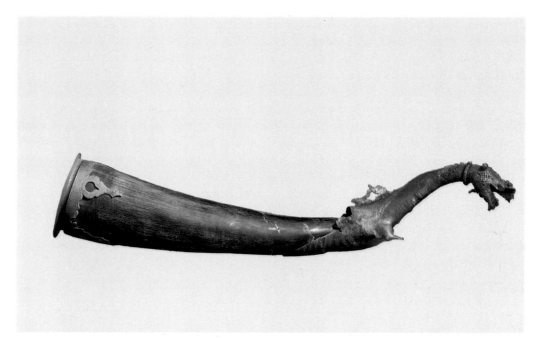

influence is also discernible in the local jewelry styles. On the other hand, the burgeoning Danubian strain of Celtic culture in the second quarter of the third century B.C. was markedly affected by the Celts' "sojourn" in the Balkans. There is a remarkable hoard of objects to prove that the La Tène township in the Carpathian basin was open to Thracian and Illyrian styles, whose diffusion northward was without doubt due to the rise to power of the Scordisci, who played a distinctive historical role during the third and second centuries B.C.

The Celts owed their talent for filigree and granulation techniques to the craftsmanship of Thrace and Illyria, as corroborated by artifacts foreshadowing La Tène style that have turned up in both areas. There are also cases where it is even possible to identify more precise roots, such as for the little filigree and granulated tubes found at Szarazd-Regöly, the closest parallels for which are found in Thrace. The proof of Thracian influence on eastern Celtic goldsmiths is incontrovertible. Another case attesting to the impact of Thracian art on La Tène style is the famous drinking-horn of Jászberény-Cseröhalom, the zoomorphic section of which is imitative of the Hellenistic *kétos*, the sea-dragon. However, the bronze relief protome from Devnia proves that the iconographic type in question was also well-known in Thrace. Nor can it be excluded that the reemergence of the *rhyton* in Celtic art during Middle La Tène is also a result of the diffusion of Thracian culture.

All these symptoms—which emerge in the wake of Celtic defeats in Macedonia and Greece—to some extent prefigure the so-called Istrio-Pontic style of Celtic art, which culminated in the masterful Gundestrup silver cauldron.

The Celts and the Dacians

The silver *parures* found in a Celtic tomb at Vršac-At in Yugoslavia reveal yet another artistic and technical influence which appears in eastern Celtic art toward the end of the second century B.C. The source this time was the Dacians, whose relations with the Scordisci must have been peaceable (at least in this period). The situation was utterly reversed at the end of the sixth decade B.C., when the Dacians (under Burebista) mounted successful campaigns first against "the Celts living among the Thracians and Illyrians," (i.e., the Scordisci), and thereafter against the alliance of Boii and Taurisci of Pannonia, led by the Boii warrior Kritasiros. The battle site continues to elude the search, but written sources point to the northeastern zone of today's Hungary, or eastern Slovakia.

The Dacian victory did not have lasting political effects: the death of Burebista midway through the fourth decade B.C. prompted the collapse of the newly founded state. The indirect consequences, however, such as the downfall of Boii supremacy, was decisive for the development of Celtic Danubia.

As for Dacian expansionism, the most indicative information comes from Slovakia, and suggests the seizure of both southeastern and southwestern areas of the region. Consequently, it would be opportune at this point to look again at the sources, which are cryptic. Tacitus deems the Cotini tribes to be of Celtic extraction, yet their descendants in Roman Pannonia had Dacian names. Studies of archaeological finds in Slovakia show that elements of Dacian culture were assimilated by the early Celtic settlers. Nevertheless, it is impossible to draw any historical conclusions from the sporadic finds of Dacian pottery in the northeastern part of Hungarian Transdanubia (such as Gellérthegy-Tabán in Budapest). And while the political structure of the Great Hungarian Plain in the second half of the first century B.C. is equally hard to ascertain, the relics found clearly indicate some extent of cohabitation between Dacians and Celts in the region from the third century onward. (*M.S.*)

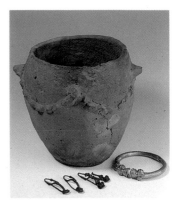

Terracotta vase, armlet and silver fibulae, from cremation burial at Vršac-At (Yugoslavia) Second half 3rd-early 2nd century B.C. Vršac, Narodni Muzej

Silver treasure from Kovin (Yugoslavia) 1st century B.C. Vršac, Narodni Muzej

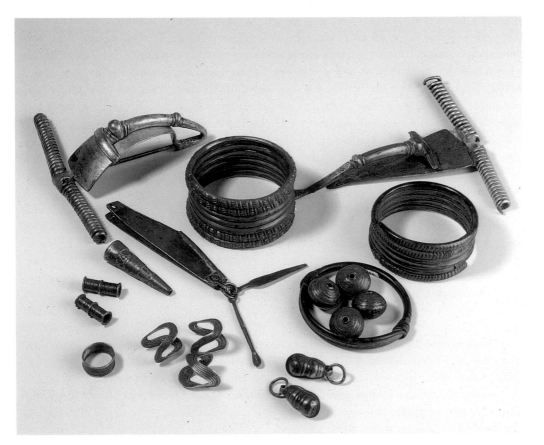

Celtic Society in the First Century B.C.

Celtic Europe probably reached its highest degree of complexity during the first century B.C. The age of great expansion was over, and the dynamism that had characterized both the third and the second centuries had died out. Moreover, the areas once occupied by the independent Celts had diminished: Celtic Italy had been subjugated and then assimilated by Rome, and the same fate had befallen the Galatians in the hands of Pergamum. From the year 125 B.C., southern Gaul was conquered and gradually subjected to Roman rule: the Languedoc Volcae were crushed at the turn of the century. From 58 to 51 B.C., Caesar conquered the whole of Gaul. And finally in the year 12 B.C.—just before the Germans dealt the last blow to the Celtic-Dacian Bohemia and Moravia—the Romans occupied Pannonia.

Despite all this, Celtic Europe had never enjoyed such unity as it did during the first century B.C.—a unity that encompassed ways of life and thinking, a language, a social organization, an economy, and religious practices that were very similar if not identical. Indeed, such differences as there were did not necessarily depend on questions of geographical distance between different peoples or groups of peoples. There were certainly fewer differences between the Boii of the Danube regions and the Burgundy Aedui of Gaul than there were between these same Aedui and the Celts who lived to the north of the Seine, in Belgian Gaul. The unifying factor in Celtic Europe in the first century B.C. was the spread of the *oppida*, the first cities created by the Celts. In Gaul, this development was not interrupted by the Roman conquest under Caesar, but at the beginning of the Common era, the strength of the *oppida* diminished, and many of them disappeared altogether.

1. The Civilization of the Oppida: Certainties and Mysteries

On the basis of studies carried out by specialists such as W. Dehn, J. Collis, V. Kruta and O. Buchsenschutz, the *oppida* can be defined as follows: they were vast fortified sites covering several dozen hectares, usually located on high ground. Defense consisted of a rampart and a ditch. The ramparts were continuous, and if necessary could take advantage of the natural contours of the land (Závist in Bohemia, Mont-Beuvray in France). The classic model, though not the only one, for the construction of the Celtic *oppidum* rampart is based on the *murus gallicus* described by Caesar (a mass of earth and stones arranged around a wooden structure made of transverse, crossed and vertical beams fixed to each other by means of large nails on the outer side, protected and decorated by stone facing). The fortifications contain large gateways, through which roads lead to the center of the *oppida*. These roads then divide into streets arranged according to various axes (Staré Hradisko in Moldavia). The streets thus delimit "blocks" of public religious buildings, or constructions containing residential and workshop areas. In fact it would seem that specialized districts can be identified: areas occupied by craftsmen, by the dwellings of the aristocracy, by particular religious functions, or by certain trades (like the enigmatic cross-shaped building discovered at Villeneuve-Saint-Germain in France). Add to this the network of carefully canalized fresh and waste water (Mont-Beuvray, France) and it can be appreciated that we are dealing with a proper urban center.

However, it should be pointed out that these definitions derive from the conclusions reached by J.-G. Bulliot following the excavations he carried out during the 1800s at Mont-Beuvray. They are definitions that have since been applied to all fortified sites. Further excavations at Mont-Beuvray (Bibracte) have raised questions about the exact dates of such urban phenomena: they appear to have emerged much later, shortly before the middle of the first century B.C. However, archaeologists are still discussing the matter. By way of a tentative hypothesis, it is reasonable to suggest that the phenomenon appeared early on among the eastern Celts (Závist. Staré Hradisko, Stradonice), and that it gradually spread west. This would explain the existence of *oppida* that were clearly built after the Roman conquest of western Gaul (Levroux, France), and of others whose urban character is now fully developed (Manching, in Bavaria).

Such discussions are pertinent to our image of Celtic society during this period. On the one

Metal grave goods: bronze vase and iron and bronze sword from the princely tomb at Châtillon-sur-Indre (Indre) Second half 1st century B.C. Nantes, Musée Dobrée

hand, a map of the *oppida* in Europe such as the one drawn up by J. Collis may group together sites that were occupied in different periods. Above all, however, the existence of cities in the strict sense presupposes precise political, religious and economic functions. This is why it has been suggested that the Celts developed a proper bourgeoisie *ante litteram*, that could produce and consume semi-luxury comodities, and exercise political power. The *oppidum* would thus have acted as a capital for a tribe or at least a region, using the resources of the hinterland. It may be helpful to return to notions that are both simpler and more complex. All things considered, the phenomena common to Celtic Europe as a whole are the following: the concentration of part of the habitat on open or closed sites; the organization of a communications network by rivers or roads; the development of regular handicrafts; the development of currency; and, in a more circumscribed area, an increase in the consumption of Mediterranean products, especially wine, but also oil, as the amphorae demonstrate. The influence of the Roman world on the birth and spread of these phenomena would seem to be unquestionable. It may be cautiously presumed that it was the demands of the aristocracy that started the process. Later, however, at least in certain regions, a distribution network had to be organized, so that part of the population could effectively live off production and trade. Yet we do not always know who the artisans depended on: were they free to organize and commercialize their output, or were they linked to the patrician or the equestrian classes? The material clues that have come down to us are in fact contradictory: on the one hand, certain objects were mass-produced with the aim of accelerating and expanding the output of a sturdier sort of item for what must have been a large number of potential purchasers (the fibulae are a case in point); on the other hand, there were specialized products such as the enamel-decorated objects that are very difficult to trace back to more than a handful of places of production: Mont-Beuvray, Tietelberg (Luxembourg), Heidetränk (Hesse, Germany), Staré Hradisko and a few others.

At all events, the movement of the *oppida* as such, or of other hillforts of less evident urban function, would seem to have derived from two main requirements: the first was "the need to protect the strategic points of an economic system that in developing had become highly complex and thus very vulnerable" (Venceslas Kruta); and the second was the need to organize the sites according to a number of fundamental criteria: geographical (an area that was

central to or in contact with a given tribal territory), economic (close to the major communication routes), and strategic (for facilitating defense). During the course of the first century B.C., this movement appears to accelerate. In fact it may be that the multiplication of both the types of coins produced, and the number of places in which they were made, actually corresponds to a fragmentation of the tribal territories: excavations in certain small regions have revealed absolutely nothing to differentiate them from the "mother regions" from which they had obtained a degree of real autonomy, or at least political independence. In fact this movement may have begun earlier, at the end of the second century B.C., within the great "empires" mentioned by certain authors, particularly the Aedui and the Segusiavi, the Averni and the Vollavi, etc. in Gaul. Toward the beginning of Christian age, certain *pagi* begin to assert their specificity: the *pagus catuslugus*, for instance, recently identified with the markets of Picardy.

How the *oppida* related to power has been a subject of debate. Were they subject to "kings" or "princes," or indeed to a small group of "nobles," of the sort described by Caesar as "senators"? In the northwestern and western parts of the Celtic area the situation was certainly different from that found elsewhere, as we shall soon see. Whether power was in the hands of a single person—either a hereditary or a designated ruler (the *vergobretos*)—or in those of an assembly, the fact remains that these were no longer the old tribal chiefs, but, as Miklós Szabó has pointed out, a "mercantile aristocracy."

2. The Rural World: A Permanent Reality

The prestigious *oppida* have often concealed the fact that the Celtic world was basically agricultural, that is, a world no longer founded on the forest economy, but also involved in farming. In certain regions, such as Gallic Armorica, deforestation was probably taken too far. It is worth recalling that traditional agricultural tools used in temperate Europe were essentially established by the Celts and the Dacians during the first century B.C.

Although farming certainly existed within the lowland settlements and the *oppida* (for instance, at Manching there is a large unbuilt area *intra muros*), the basic agricultural unit was the local farm. The generic term "farm" does not distinguish between the different types of farming, and so far too little excavation has been undertaken to establish a classification of types and to define a hierarchy. By the same token, our knowledge of the villages is limited, with the exception of cases like Eischweller Laurenzberg in the German Rhineland. Here the uneven distribution of wealth, and the hierarchical social structure that differs little from what was to be found in the preceding centuries can be established. The richest women were endowed with sumptuous jewelry, but there were no other signs denoting social rank, like the torques and the metal belts of the La Tène I and II periods. At the top of the male hierarchy was the warrior with his arms, including the long sword with a blunted point that could only be used on horseback (hence the reference to the *equites* mentioned by Caesar). An indigenous farm discovered recently in the ancient Armorican region of Brittany may well have been an aristocratic residence. It seems to have been fortified, and in a ditch dating back to the early first century B.C. excavations brought to light the famous "divinity with the lyre."

The northwest and the west of Celtic Europe thus appear to call for separate treatment as far as funerary adornments are concerned. For a start, from the late second century B.C. onward, warriors' tombs became very numerous (and certain of them are exceptionally rich). It is as though practices found in the Final Hallstatt age were being revived, for ceramic and metal vessels abound, as do accoutrements used for the funeral banquet (grills, andirons, amphorae, basins, paterae, the so-called Kelheim jugs). These sumptuous tombs are found across a vast curving stretch of land that goes from the Treveri territories (Clémency, Luxembourg) to England and central-western Gaul (Châtillon-sur-Indre). Some of these contain not a chariot, as has been erroneously claimed, but elements of one or more chariots: ornamental trimmings, wheel rims, hub ferrules, and so on. In the centralwestern part of Gaul, some of

these tombs also contain a weapon of great prestige which seems to symbolize the power of the deceased: the short sword, named the "anthropoid dagger" because of the human head that decorates the hilt.

Tombs that contain parts of chariots can be found on the eastern borders of the Celtic world. In both the west and the east, the tombs that contain a complete four-wheeled wagon do not seem to date back earlier than the Roman period. This is true for southwest Gaul (Boé, Saintes) and Pannonia.

Were the simple or high-ranking knights identifiable through those burial sites different from those living in the *oppida* (where fragments of "anthropoid daggers" have been found)? In other words, was Celtic society dominated by a single aristocracy that occupied both the *oppidum* and the countryside, or by two possibily competitive aristocracies, one of which lived from trade, from tax collection, and from minting coins, while the other lived in self-sufficiency from the land? This is a question that we are not yet able to answer.

3. Religion and Sanctuaries: New Revelations
For a long time the Celtic religion was studied on the basis of later sources dating back to the historic period. First and foremost, the work of K. Schwarz in Bavaria, and then that

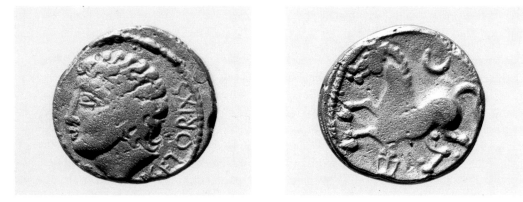

Obverse and reverse of the gold coin of Vercingetorix ca. 52 B.C. Saint-Germain-en-Laye Musée des Antiquités Nationales

of J.-L. Brunaux and of A. Rapin in France, have allowed us to identify certain religious practices of the independent Celtic world, and to formulate a number of questions that we can add to those already raised about the aristocracy. It would seem that the Celts developed two main types of sanctuaries: the *Viereckschanzen* and the sanctuaries with deposits of votive offerings. The *Viereckschanzen* are rectangular, slightly raised enclosures covering an area of around one hectare, and surrounded by an embankment and a ditch. They were initially identified and catalogued in Bavaria by Schwartz; however, others have since been found in Bohemia and in western and central Gaul.

The sanctuaries with deposits of votive offerings have long been classified using the term "indigenous fana," in that they have been identified in the very earliest vestiges of the sanctuaries of the historic age. We now know that these were the continuation, in the same sites or indeed in new ones, of the sanctuaries with arms of previous periods.

The present author has suggested that the *Viereckschanzen* may in fact have been related to the world of the living. Indeed, some of them are situated within the *oppida*. Moreover, the objects found in such sanctuaries have tended to be extremely poor (the wooden statuettes found at Fellbach-Schmidon, near Badon-Württemberg in Germany, constitute one of the rare excoptions). So far, however, no weapon deposit has been found, and no trace of human or animal bones. It is thus tempting to find correspondences with the ancient texts that mention ceremonies held within such enclosures in which the population was invited to eat and drink. The *Viereckschanzen* would thus have had a local, domestic function, reserved for the farm workers.

In contrast, the sanctuaries with deposits of votive offerings were meeting places for the

*Small bronze head
from an anthropomorphic sword hilt
from the oppidum at Stradonice
(Bohemia)
1st century B.C.
Prague, Národní Muzeum*

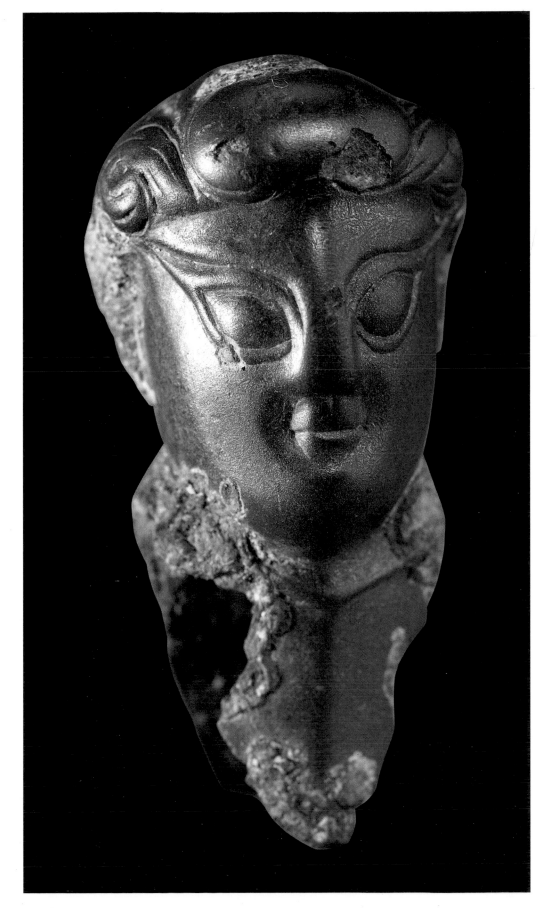

members of a tribe, or tribes. For this reason they had to be located in easily accessible places. The nature of the deposits is however quite different from that of the deposits of the fourth to second centuries B.C., in that the arms have largely given way to tools, or occasionally and somewhat later, to miniature arms. In certain cases pottery abounds, in others there are coins in great quantity, sometimes made of gold and still in good condition (this was the case at Eu-Bois-l'Abbé in France). Should such changes be interpreted as a sign of the weakening of the military aristocracy that held the reins of political power and thus stood as a symbol of the religious unity of a tribe or a group of tribes? Or are we dealing with different religious practices for the aristocracy, or indeed with an extension of the category of "divinities" to which the sanctuaries were consecrated? (The discovery of an image of Epona, the Celtic goddess of horses, at Villeneuve-au-Châtelot in France would appear to confirm this view.) At all events, the important role of these sanctuaries in religious life should be better defined in coming years.

So far we have not spoken of the practices witnessed by the authors of antiquity, and in particular, that of human sacrifice. Archaeology has not provided us with much information on the subject. We can cite a few examples of human skeletons found at the foot of constructions that are part of fortified sites: for instance, those of Danebury in Wessex (England). According to A. Furger-Gunti, there is more evidence forthcoming for the sacred rivers and ponds, and natural cult sites. One of the finest examples is the La Tène site on Lake Neuchâtel in Switzerland, where thousands of objects, including weapons, tools, pottery and coins, were found. The authors of antiquity are also our only source of reference for information concerning the priesthood, including the famous druid.

Jean-Louis Brunaux maintains that the druids' interests included philosophy and cosmogony as well as theology. The druids were the guardians and administrators of the great laws that upheld society, as well as the keepers of tradition and history. At a more profane level, it would seem that the bards were personal poets to the powerful. But here we enter the realm of the juridic status of the different categories of the population. This we cannot discuss, since archaeology is, once agan, silent on the subject and researchers are far from agreement.

Celtic Writing

The Celts did not invent an original form of writing for recording documents in their language, but rather adapted the written languages of the people they had contact with, all of which were, to a greater or lesser extent derived from Phoenician. The Etruscan, Greek, Iberian, and Latin alphabets were all, from time to time, borrowed. The regular use of other alphabets linked to these has not so far been attested, except in inscriptions whose Celtic content is perhaps limited to people's names. Fairly late on, the Celts in Britain did develop their own language which involved a notation known as Ogham script.

Unlike peoples such as the Etruscans, who attached considerable weight to collections of sacred texts, the Celts deliberately abstained from the use of writing for anything concerning religious matters. Any written documents relating to religion, such as brief dedications, and inscriptions associated with magical rites, derive from areas directly influenced by Mediterranean culture and appear often to be the expression of marginal phenomena. One exception is the Gallic calendar which is an outstanding testimony to the scientific knowledge attained by the intellectual elite known as the druids.

The oldest recorded use of writing for registering documents in a Celtic language comes from the area of the Golasecca culture, named after the locality lying between Somma Lombarda and Sesto Calende in the province of Milan by Lake Maggiore. It was an adaptation of the Etruscan alphabet, the use of which has been documented by an inscription found on a late-seventh-century vase found at Sesto Calende. While this inscription is probably in the Etruscan language, the first document which can be attributed to the Celtic language—the *graffito* ΧΟΙSOIO (the genitive of the name "Koisos")—was found on a grave at nearby Castelleto Ticino and dates from around the middle of the sixth century B.C.

These Celtic-language, Etruscan-script inscriptions, often referred to as Lepontic—erroneously, since the area inhabited by the Lepontic people is marginal compared to the geographical diffusion of such inscriptions—do provide incontrovertible proof that the people

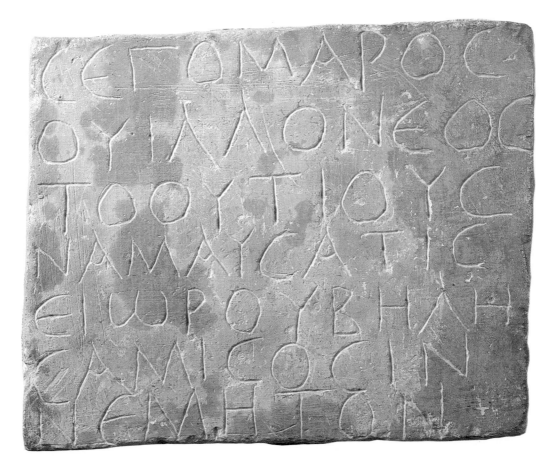

Stone slab with Graeco-Gaulish inscription from Vaison-La Romaine (Vaucluse) Segomaros, son of Villo(nos) citizen of Nemauso (Nîmes) dedicates this land to the goddess Belesama 2nd-1st century B.C. Avignon, Musée Calvet

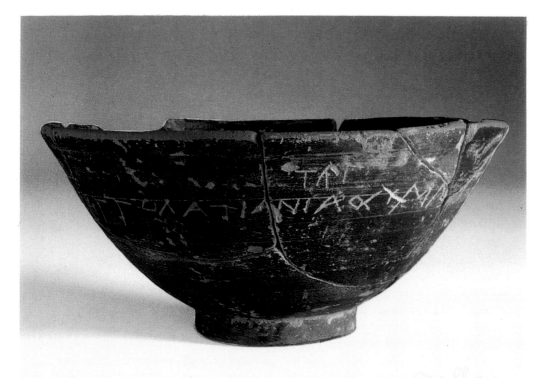

*Terracotta cup with graphite
inscription in Graeco-Gaulish
from the La Cloche oppidum
at Rennes-Mirabeau
(Bouches-du-Rhône)
End 2nd-first half 1st century B.C.
Marignane, Mairie-dépôt
des Fouilles de La Cloche*

*Bronze tablet with Celtiberian
inscription from Botoritta near
Saragossa, site of Contrebia Belaisca
(Spain)
1st century B.C.*

of the Golasecca culture were Celts. This confirms the Celtic presence in Italy well before the historic invasion of start of the fourth century B.C.

So far, more than a dozen inscriptions on vases—names of people which probably indicate ownership—in Etruscan characters that may be attributed to the Celts of the sixth and fifth centuries B.C. have been found. There is also a monumental inscription sculpted on a stone architrave in Como-Praestino, the dating of which, mid-fifth century B.C., is based on the context and on other information we have on carved inscriptions of the period.

The Celtic-Etruscan alphabet was in use in the Transpadana area until the period of Romanization around the mid-first century B.C. Most of the documents found using this alphabet appear to belong to the second through to the start of the first centuries B.C., by which time the Transpadana Celts were already economically, politically, and culturally subject to the Romans. Roman influence is manifest not only on monumental inscriptions—sometimes bilingual—such as the stelae at Todi and Vercelli but also on coins where names of people, possibly the magistrates in charge of minting, were featured, this particularly among the Insubres.

The evidence we currently have on the use of writing by the Gauls in Cispadania is scant. We have examples of what are known as Subpicenum characters, which are thought to be Celtic and probably indicate ownership, from two inscriptions on bronze helmets of the third century B.C. recovered at Canosa di Puglia in southern Italy and Bologna. It is not yet possible to draw general conclusions, however.

The second group of documents in Celtic language consists of inscriptions in Greek characters borrowed from the Ionic alphabet used in Massilia (present-day Marseilles). Principally found in the area of the Roman province *Gallia Narbonensis*, the earliest probably date from the third century B.C. Some, attributed to the first half of the first century B.C., have also been discovered in the central-eastern area of Gaul. The use of Greek characters is proved by Caesar's specific reference to tablets bearing Greek writing (*tabulae ... litteris graecis confectae ...*, *Gallic War*, I, 29) found in 58 B.C. in the encampment of the Helvetii. Additional proof is provided by the inscription KORISIOS on a sword recovered from the site of Port in Switzerland as well as from a vase-painting found in the *oppidum* at Manching in Bavaria which features a letter "theta." Other inscriptions on pottery found here, such as the one bearing the name BOIOS could just as easily be Greek or Latin script. Nothing currently enables us to confirm that the Greek alphabet used by the Celts of central Europe has Massiliot origins.

The total of Gallo-Greek documents currently consists of over seventy monumental inscriptions on stone—essentially short dedications or epitaphs; almost 200 inscriptions on pottery (mainly indicating ownership) and one dozen inscriptions on various materials such as silver, gold, lead, bone, and iron. Despite their brevity and the overall prevalence of personal names and patronymics, these documents provide important testimony that has, so far been little explored. They also reveal that objects were moved from place to place, the origin of which we would otherwise have no way of knowing. An example is the gold votive torque bearing the name of the Nitiobriges people of the Agen region appears discovered at Mailly-le-Champ in the Champagne region of France—about 600 kilometers from its place of origin.

In Gaul as in Italy, the use of writing, along with the use of currency in trading is a sign of an urbanized society, or one heading that way. A similar situation developed among the Celts living on the plateaux of present-day Old Castile. Here the use of a semi-syllabary writing form, which had probably been borrowed as early as the seventh century B.C. from the Phoenicans by the Tartessians of the southwestern Iberian peninsula, and later taken up by the Iberians of the Mediterranean coast, coincides with the development of towns. Here again, most of the documents found date from between the second and the first centuries B.C. They are, for the most part, very brief texts: some fifty inscriptions on coins (mostly the names of cities) as well as some thirty texts which, except in rare cases, consist of only a few words.

One outstanding specimen is the bronze tablet found in 1970 at Botoritta near present-day Saragossa, on the site of the ancient *Contrebia Belaisca*. Engraved on both sides, it contains about 200 words and, while there are still some uncertainties, it seems highly likely that it is a legal text of some sort.

Latin was the last form of writing to be adopted by the Celts but it was probably the most widely used, since we know that it was employed in central-eastern Europe, Gaul, Iberia, and possibly even in Britain. The earliest evidence appears to be from the first half of the first century B.C. at the latest, which would coincide with the increased influence of Rome. Inscriptions on coins are the most common examples found, these from two quite separate geographical areas.

The first was the territory of the Boii in Pannonia the main center of which was the *oppidum* where the city of Bratislava now stands. This people's silver tetra-drachmas, some of which bear images borrowed from Roman *denarii*, provide some fifteen names. BIATEC is the most common and is often used to denote the series as a whole. The others are: AINORIX, BUSSUMA-RUS, COBROVOMARUS, COISA, COUNOS, DEVIL, EVOIURIX, FARIARIX, IANTUMARUS, MACCIUS, NONNOS, and TITTO. These are probably the names of the magistrates of the city or other notables who were responsible for the minting activities. The majority of these names are of Celtic origin but some could also belong to the indigenous tribes of the Danubian lands. So far, we have no information on the alphabet used by the Boii of Bohemia but that they did write is confirmed by the bone frames which originally held wooden tablets coated with wax, along with the many bone and metal styli found in the *oppida* of Stradonice and Závist. These provide incontrovertible evidence of the influence of the Mediterranean cultures in this region, with Italy in the lead.

The second area subject to Roman influence during the first half of the first century B.C. was eastern-central Gaul. This is attested by the use of Latin characters on coins, particularly silver issues linked to the Roman *denarius*. We find names of people mentioned by Julius Caesar, such as the Aedui DUBNOREX (Dumnorix) and LITAVICOS (a military leader in 52 B.C.) but primarily VERCINGETORIXS, featured on the obverse of a gold coin of the Averni tribe. The vogue for inscriptions on coins continued after the Roman conquest, particularly on bronze coins. Here we find people's names, often accompanied by their function, such as REX (King), ARCANTODRAN (magistrate in charge of coinage), VERCOBRETO (supreme city magistrate) as well as the names of cities or of peoples, and, in some rare cases, the value of the coin.

The earliest written Celtic documents found in Britain are again brief inscriptions on coins in Latin characters. These can be dated to the second half of the first century B.C. and they mostly feature names (often abbreviated) and commemorate the Belgae tribes living around the Thames estuary, almost all of whom are mentioned in ancient texts. In addition to Commios, King of the Atrebates, and his sons Tincommios, and Verica, there is Tasciovanos, the king of the powerful Essex-based Catuvellauni, and his son Cunobelinos (Shakespeare's Cymbelline) whose coins bear the legend CAMU (Camulodunum—present-day Colchester) which was the capital of the Trinovanti, the other people forming part of the coalition.

Gallo-Latin inscriptions would appear to be few and far between—some fifteen brief dedications and epitaphs. Those found tend to be in the area of Narbonne and most would appear to date from the first century B.C., since the use of the Latin alphabet on memorial tablets in the central Gaul area seems to indicate a period later than that when Gallo-Greek was being used. There is, though, at least one example in which both alphabets are used: a mid-first-century B.C. votive stele at the source of the Seine, a Greek-Latin inscription is followed by the name of the engraver in Gallo-Greek.

Without a doubt, the most remarkable example of Celtic writing is the bronze tablet (150 by 90 centimeters) from the end of the second century B.C. Discovered in 1897 at Coligny (in the *département* of Ain), it was found in fragments mixed with those of the statue of a deity identified with Mars. In all probability it came from a nearby Gallic-Roman sanctuary.

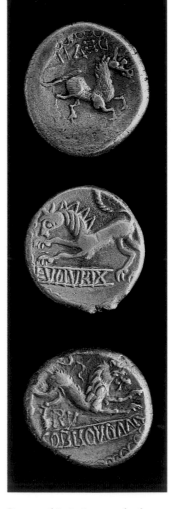

Reverse of Boii silver tetradrachma with the inscription: DEVIL EVOIVRIX, COBROVOMARVS from Bratislava (Slovakia) First half 1st century B.C. Bratislava Slovenské Národné Múzeum

*Reverse of an Aedui silver coin
with the inscription
LITA [VICCOS]
Mid-1st century B.C.*

*Lexovii bronze coin inscribed
to the vergobretus CISIAMBOS
and CATTOS
1st century B.C.*

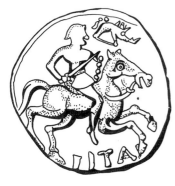

*Bronze tablet with Gaulish
calendar from Coligny (Ain)
End 2nd century B.C.
Lyon, Musée de la Civilisation
Gallo-Romaine*

Engraved in Latin characters are the sixty-two consecutive months of a five-year period in the Gaulish calendar. (The Gaulish system was quite different from the Julian calendar that had been in use for the past 250 years.) A few, smaller fragments of a similar calendar had been found in 1807 in Lake Antre, and yet others in the nearby sanctuary of Villard d'Héria (Jura) in 1967. The Coligny Calendar's 2021 lines make it the longest ancient Celtic document ever found. They are divided into sixteen columns, each covering four months, top to bottom, except in the case of the first and the ninth columns which each contain one intercalary month and two normal ones. At the start of each of the twelve months is its name, occasionally abbreviated, followed by the word MAT(U) ("good", i.e., complete) or ANM(ATU) (bad, i.e., incomplete) which refers to whether it had 30 or 29 days (there were six of each). The first fifteen days, in Roman numerals, are followed by the word ATENOVX (return of the dark period?). After this comes a second series of days, numbered 1-15 or 1-14. In the latter case, the gap left by the non-existent day is filled by the word DIVERTOMV (no value?) which probably means that one skipped from the twenty-ninth day of one month to the first of the next. In ordinary months each line corresponded to one day. Opposite each is a hole into which a peg was placed as a marker. These peg-holes were often denoted with symbols, the most frequent being D, MD, D, AMB. The two intercalated months, one before the first year and the other half-way through the third, are highlighted by their larger headings and by the fact that the notations for each day take up more than one line.

The Coligny calendar corresponds to a highly-complex lunar/solar system which presupposes a knowledge of celestial movements accrued over several centuries as well as the ability to create mathematical models to express them. While it is possible that the roots of this knowledge lie in the pre-Celtic European peoples of the Mediterranean, the calendar provides a remarkable illustration of the science of the "stars and their movements" that Caesar attributed to the druids (*Gallic War*, VI, 14). It is also highly likely that the very complexity of the calculations involved in measuring time this way explains why it was committed to writing by a local cult during the period of the Roman empire.

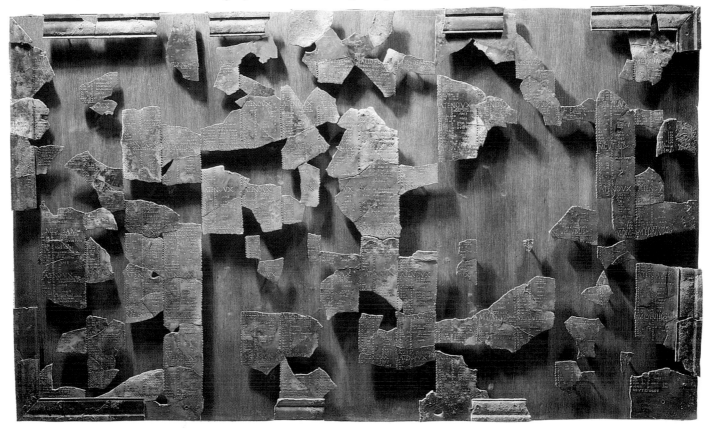

The tendency among the Gaulish elite to adopt Greek and Roman culture, to the detriment of the traditional teachings of the druids, must have led to increasing difficulty in recruiting and training young guardians. The sanctuaries still functioned according to the old calendar, which by this time, presumably, was relegated to a purely ritual role.

Read alongside a number of ancient texts, the Coligny calendar sheds light on the general principles of how time was calculated among most of the Celtic peoples. Pliny the Elder provides valuable information on the cyclical nature of the Gallic calendar and on the beginning of each month, year, and of the great cycle of thirty years (*saeculum*) which was fixed in the sixth moon—and thus at the end of the first quarter—when the moon has "enough strength without being at its height" (*Natural History*, XVI, 250). These points confirm the fundamental lunar nature of the Gaulish calendar with correction being effected by means of intercalations within one five-year period, and this is probably the period represented by the Coligny Calendar.

The great cycle of six five-year periods meant that, at the end of thirty lunar years, the start of the year coincided with the sixth lunation (or lunar month) and, by omitting one intercalary month, a whole number of lunations could probably be made to correspond to a whole number of solar years. Thus, as a result of the insertion of 30 days every thirty months, the Celtic year consisted of either 355 or 385 days. Each of the 30 days of the intercalary month bore the name of the preceding thirty months, thus providing a sort of selective recapitulation.

The year and the five-year cycle apparently began with the month called SAMON (Summertime) which is the first ordinary month shown on the Coligny Calendar and the only one to include a specific feast period—*trinox samoni*—equivalent to the "three nights of Samain" mentioned in Irish texts. The "positioning" of the second intercalary month after the sixth month of the third year suggests that the year was divided into two equal six-month periods. The intercalation would thus split the year into two equal parts, one starting with SAMON (summer-time) and the second, with GIAMONI (winter-time). These two six-month periods then corresponded to the two fifteen-day periods "clear" (full-moon) and "dark" (new moon). The Coligny calendar is the fruit of a lengthy and painstaking process in which complex data was handed down over several centuries. There is no doubt that the model was operative well as it appears here long before the Roman conquest of Gaul. Compared to the calendars used by other cultures before the first century B.C., this one offers a proven and very effective system. It is the most eloquent testimony to the intellectual abilities of the ancient Celtic populations and the remarkable level of knowledge they achieved.

Alongside monumental inscriptions written in capital letters of the Roman alphabet, the most recent records of Gaulish texts include a considerable number of examples in cursive script, largely on pottery. The numbering system kept by the potters reveals what the Gaulish ordinal numbers were. Lead tablets bearing texts with a magical significance are also of interest. One such, discovered in 1971 at Chamalières (Puy-de-Dôme) consists of sixty or so words and was probably a tablet through which a nail was driven during magic rites. Considered the longest continuous Celtic text for some ten years, this piece was easily outstripped by the one found in 1983 at a burial site dating to the second half of the first century B.C. at Hospitalet-du-Larzac (Aveyron). This is also a magical text consisting of over 160 words. While here again, there are many open questions as to its meaning, it would appear to be a description of a black magic rite that involved a number of witches. Similar tablets in tin and lead alloy have been found in the *fons Sulis* in present-day Bath in England. Two of these bear inscriptions with apparently Celtic features, and the text would not appear to be in Latin but it is not possible, at this stage, to confirm that it is Celtic.

The so-called Ogham alphabet is the last-known form of writing used by the ancient Celts. Examples of it have been found only in parts of British Isles—such as Ireland, Wales, the Isle of Man, Scotland, and Cornwall—that were not subject to extensive Roman influence. The twenty alphabetical units consist of between one and five strokes either to the left or

Bronze writing stylos from the Stradonice oppidum (Bohemia) 1st century B.C. Prague, Národní Muzeum

Funerary stelae with bilingual inscription in ogham and Latin script in memory of Voteporix king of Gaulish Demetia toward mid-6th century A.D.

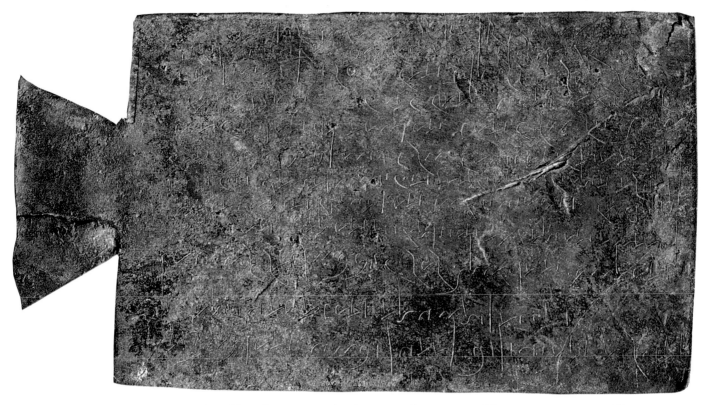

Lead tablet with magical Gaulish
text in Italic writing
from Chamalières (Puy-de-Dôme)
Early 1st century B.C.
Clermont-Ferrand Musée Bargoin

right, obliquely or perpendicular to an edge or vertical line on a monument. There were also about five diphthongs. Developed in all probability from a system of numbering based on notches made in wood, this secret writing may have been used originally for magic rites. Irish texts do in fact refer to wands made of yew bearing Ogham characters inscribed on them by the druids. Ogham script only lent itself to very short inscriptions and the stone monuments on which it appears are mostly funerary stelae of the fifth to the ninth centuries A.D.

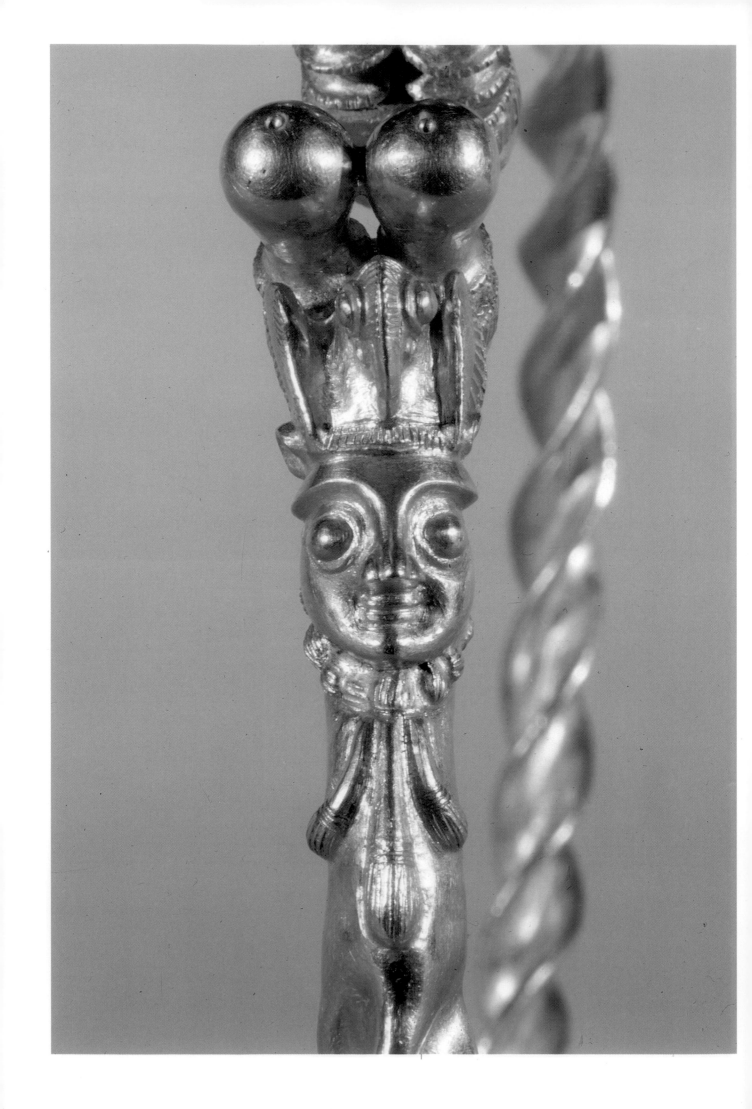

The most direct record of the spiritual universe of the independent Celts is their legacy of art works. Unfortunately, the images they have left are anonymous because, even when they had mastered writing, the Celts, unlike the Greeks and Etruscans, do not seem to have used it to identify the gods they depicted. The rare pre-Roman Celtic inscriptions linked to religious matters (such as certain dedications) all stem from regions in direct contact with the Mediterranean world, regions that were already urbanized or developing; similarly, the portraits accompanied by writing are all from the Roman era. The same applies to texts of any length: they are very few, and apparently relate to very marginal magical rites and hence throw little light on the official religion.

The idea that the ancient Celts had a common religion is based on comparative inferences from the corpus of records on Indo-European religions in our possession, and on iconographic studies made on La Tène art. It is actually impossible to establish any relationship, other than speculative, between these two sets of documentation. Furthermore, the same difficulties are encountered when attempting to draw parallels between the portraits of Gallo-Roman deities and those presumed to be from the La Tène pantheon. The reason for these difficulties probably lies in the basic incompatibility of the two systems of figurative expression.

Unlike most ancient religions, Celtic religion cannot have comprised a consistent and unchanging set of beliefs. It must have been a composite pantheon of tribal gods, local deities (often pre-Celtic), and cults pertaining to specific social classes, all bundled together in a flexible system organized around a handful of major pan-Celtic gods from a common mythological "pool." Something of this pool has filtered down through medieval Irish and Gaulish literature, precious vestiges of an oral tradition which continues to thrive on the islands, a tradition that the advent of Christianity freed from the prohibition of written records.

It emerges clearly that the hierarchy of the divine world was considered to be the outcome of fierce struggles between successive generations of gods who had dominated the universe, from primordial chaos until the appearance of an order the conservation of which was guaranteed by the supremacy of the great Celtic deities over their predecessors, who were either subjugated or annihilated. It was also thought that relationships between the gods were similar to those among humankind binding "clients" to their protectors, nobles to their sovereign, the king to his guardian spirit. Obviously this kind of rapport was no more definitive within the divine world than it was among human beings. As the hierarchy of the gods was a prefiguration of that of humans, victory or the preponderance of a human group over another was necessarily the upshot of changes in the power relations between their respective guardian deities. This structural variability compounds the difficulties we encounter today when trying to match up the Gallo-Roman iconography with the La Tène figures. Not only are they different visual idioms, but they are undoubtedly two different systems which, though made up of the same components, by no means overlap.

In the Greek texts mention is made of a people who lived in uncharted countries north of the Mediterranean, the "Hyperboreans," who, it is clear, had already attained legendary status. However, Diodorus gives little credence to the writing of Hecataeus (sixth century B.C.) in which he is alleged to have stated that north of the ocean, facing the Celtic countries, there was an island as large as Sicily, whose inhabitants observed a cult to Apollo. A magnificent enclosure, a circular temple adorned with numerous offerings, and an entire town, were all dedicated to the sun god, to which even the Greeks would come to show their respect...

The fabulous nature of the account induces disbelief but, perhaps coincidentally, the island peoples were familiar with round temples. The tradition of this type of building goes back to the megalithic monuments, of which Stonehenge is the most renowned. Generally they are associated with the invention and use of a calendar founded on a well-established knowledge of the movement of both sun and stars. It is therefore interesting to note how Hecataeus mentions in association with the cult of Apollo the existence of an astronomical cycle lasting nineteen years. This is not a coincidence, since it corresponds to the "Metonic cycle" introduced in the fifth century B.C. in Athens by the astronomer Meton to reconcile

Pyramidal stone cippus
from Pfalzfeld (Rhineland)
5th century B.C.
Bonn, Rheinisches Landesmuseum

Detail of the gold torque
from the princely tomb
of Reinheim (Saarland)
Second half 5th century B.C.
Saarbrücken, Landesmuseum
für Vor- und Frühgeschichte

the lunar and solar years. In this case too, congruity with known facts is perhaps entirely fortuitous.

Thanks to the engraved bronze plaque dating from imperial times found at Coligny, we know that the the original Celtic calendar, based on centuries of studying the heavens and a remarkable mathematical ability to calculate the movements of the stars, was the ingenious adaptation of a lunar calendar to solar rhythms, just as the Hyperborean calendar of Apollo was reputed to have been.

Regrettably, our reconstruction of the origins and evolution of the Celtic calendar is still only speculation. But there are some clear links between constructions in Ireland for use in astronomy (whether megalithic or more recent), and the mythological world described in the texts. The abodes of the gods (later transformed by Christian monks in legendary figures) were apparently the main loci of the island's sacred topography. The most spectacular example, which came to light in recent excavations, is the mythical site of *Emain Macha*, known today as Navan Fort near Armagh. The circular enclosure wall of the legendary abode of the Kings of Ulster encompassed an extraordinary circular monument in wood about forty meters in diameter, which seems to have been intentionally burned to the ground and covered over with a mound of earth. Unfortunately there is nothing to help us decipher the meaning of this strange ritual or the name of the deity involved.

The sites of Celtic sanctuaries discovered on the continent are not even accorded a distorted memoir in the tapestry of myths. Anonymous, they reveal vestiges of sacrifices which are eloquent on ritual practices, but silent on their significance or the gods to whom the sacrifices were dedicated.

For these gods and indeed only for a few of them we have nothing but their images and the symbols with which they were associated. The oldest images date from the early phases of La Tène, the fifth century B.C. Nearly all are borrowed from a repertoire of themes of oriental origin, at the time very much appreciated in northern Italy, such as the tree of life (the palmette), and its guardians (birds, ibex, griffins, serpents) and the lord of animals. The most widespread image is the male head, usually with beard and moustache, combined with the palmette or what seems to be its Celtic equivalent, the double mistletoe leaf. Frequently reduced to highly schematic form, the palmettes or mistletoe, framed in a pair of S-shapes evoking the snake-like guardians, are found in various versions everywhere—on the *Masken-fibeln* (mask fibulae), on weapons, on the various ring-shaped ornaments, on chariot fittings, and on ceremonial wine-jugs. The latter are particularly interesting, as comparisons between samples produced by different craftsmen allow us to identify recurring elements and their equivalents, confirming the coherence of the repertoire used, as well as its geographical distribution and period of utilization. Thus we find male heads combined with the same symbolic motifs (ram's head, palmette, mistletoe, and S-shapes) not only on coeval objects from all over the La Tène world, but also on many coins, derived in this case from different, earlier Mediterranean models.

The most remarkable figure is doubtless the human-headed horse, a creature of purely Celtic invention. The earliest example found so far, dating to the fifth century B.C., appears on the lid of the Rheinheim wine jug. Three centuries later it appears on the reverse of many Armoric coins, this time as a transformation of the chariot attachment that appears on the the stater of Philip II, a prototype of the Celtic coin. Often used in combination with a wheel or triskelion, this galloping horse probably evokes the course of the sun across the sky.

Other symbolic motifs are often used with this horse on coins, such as the "cauldron of abundance," but also the insignia of war with the boar and the birds with hooked beaks, sometimes resembling ravens. The Celts appreciated the warlike character of this bird, which also appears on a helmet found in Rumania, complete with movable wings to make a greater impression on the enemy. As for the wild boar, the boar's head formed the bell-end of the Celtic war-horn, the *carnyx*, whose raucous sound must have filled the enemy with terror. One of the heroes of the Irish epic in an eloquent song is likened to the "raven shredding meat in

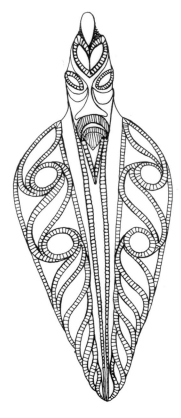

Detail of the wine-jug handle from Reinheim (Saarland) Second half 5th century B.C.

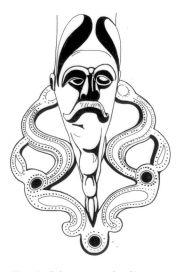

Detail of the wine-jug handle from Waldalgesheim (Rhineland) 4th century B.C.

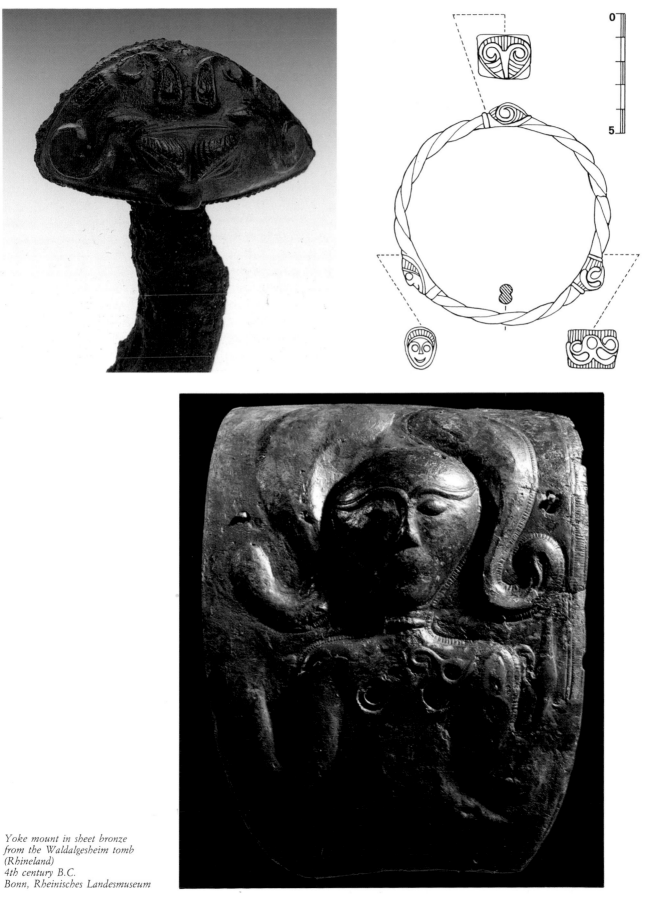

Iron and bronze linchpin
from Leval-Trahegnies (Belgium)
3rd century B.C.
Brussels
Musée Royaux d'Art et d'Histoire

Bronze armlet from Pössneck
(Thüringen)
3rd century B.C.
Jena, Friedrich-Schiller-Universität
Prähistorische Sammlung

Celtic Religion

Yoke mount in sheet bronze
from the Waldalgesheim tomb
(Rhineland)
4th century B.C.
Bonn, Rheinisches Landesmuseum

combat... powerful and protective boar... raven victorious in battle." As with the other motifs, these animals crop up throughout Celtic art from its origins in the fifth century.

Explicit or allusive as they may be, most of the known representations in La Tène art seem to evoke this deity. His companions, griffins or monsters with snake-like bodies, known to specialists as the "dragon pair," appear as emblems engraved on the scabbards of warriors of the historical expansion. Embellished at times with gold thread, the scabbards accompanied their masters on their quest for the "good death," which would transform them, on their pilgrimages across Europe, into heroes similar to the gods themselves. The "dragon pair" has also been found in votive deposits or in tombs from the British Isles to the newly-conquered Danubian territories.

Almost a thousand years later, a Welsh text mentions the "two gold serpents" engraved on the legendary sword of King Arthur, *Excalibur*, that made it hard for any man to gaze on. The powerful magic attributed to this symbol had still not lost its potency. Iconographic themes associated with this multiform sun deity with his warring, sovereign nature is found across a vast area, and persisted down through the centuries. His obvious association with the plant cycle links him to the mysteries of life and death, and we can infer that he was among the great deities of the Gauls, perhaps the most powerful of all. Our main source on pre-Roman Celtic religion, Caesar, associates him with Mercury, as the "inventor of all the

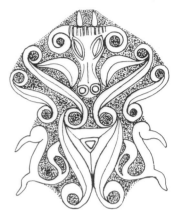

Ram's head and pair of monsters reconstruction of designs on gold torque from Frasnes-les-Buissenal (Belgium)
End 2nd-early 1st century B.C.

Bronze horse statuette from the lid of a wine-jug from Reinheim (Saarland)
Second half 5th century B.C.
Saarbrücken, Landesmuseum für Vor- und Frühgeschichte

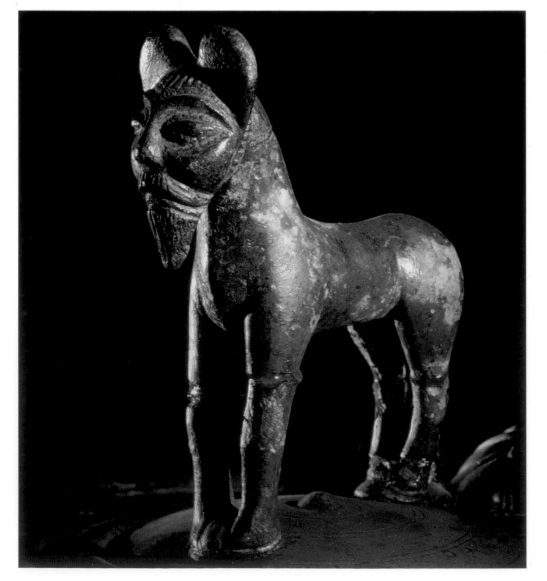

arts, the lord of roads and journeys, the patron of trade and earning." He is identified with the god Lugh, from whom many place-names are derived, such as *Lugudunum* ("the fortress of Lugh," today's Lyons) capital of the Three Gauls, whose foundation is associated with the raven, the warrior emblem mentioned above. In the year 12 B.C.,the feast-day of Augustus (August 1) took the place of the major annual Irish feast, the *Lughnasa*.

The "Luminary" (which is the meaning of "Lugh"), who was sovereign in Ireland over the *Tuatha Dé Danann* ("tribe of the goddess Dana"), the last generation of gods is well-known thanks to written texts. Lugh's nickname was *Samildánach* ("skilled in many arts") and his name is often followed by the epithet "of the long arm," underlining his connection with the

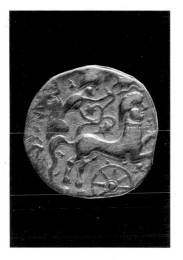
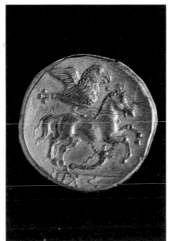
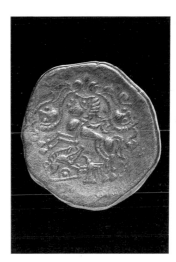
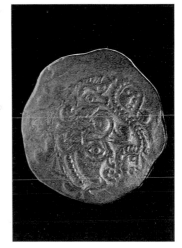

Reverse of Redones gold stater
3rd-2nd century B.C.
Paris, Bibliothèque Nationale
Cabinet des Médailles

Reverse of Turones gold stater
3rd-2nd century B.C.
Paris, Bibliothèque Nationale
Cabinet des Médailles

Obverse and reverse of an alloy
coin minted by the Osismi
1st century B.C.
Paris, Bibliothèque Nationale
Cabinet des Médailles

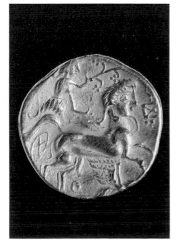
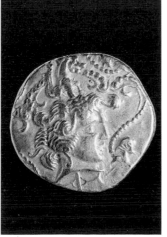
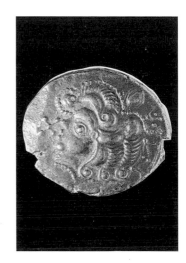

Obverse and reverse of gold stater
minted by the Veneti in Armorica
3rd-2nd century B.C.
Paris, Bibliothèque Nationale
Cabinet des Médailles

Obverse and reverse of a coin
minted in electrum by the Osismi
2nd-1st century B.C.
Paris, Bibliothèque Nationale
Cabinet des Médailles

sun, and his predilection for the use of the spear and sling, seen as long-distance weapons like the rays of the sun. Lugh is the divine archetype of kingship, and his union with *Eithne* (the land of Ireland) bore the Irish folk hero *Cú Chulainn*, the mythical tribal hero of the kingdom of Ulster, and the main protagonist in the epic cycle of Irish legends.

The identification of Lugh with the ubiquitous figure of Celtic La Tène iconography will remain mere supposition until the link between Lugh and this image is endorsed by tangible evidence.

The oldest known coherent account of the Celtic pantheon is Caesar's, who lists their major deities, defining their respective functions briefly though clearly. Unfortunately, Caesar does not give their Gaulish names, only their Roman equivalents. The first to be mentioned is Mercury, the most highly revered among the Gauls and presumably corresponding to Lugh, the supreme lord. Then comes Apollo, said to "drive away disease," then Minerva, who "transmits the principles of arts and crafts," then Jupiter, who "rules over the skies," and finally Mars, who "oversees war." Scholars agree that these deities correspond to the three main functions of the Indo-European system: the sacred (Jupiter), war (Mars), and productivity (Apollo and Minerva). Other clues to the identities of the Celtic gods behind these Roman names are found in a brief passage by the poet Lucan, who recalls the names of the three great Celtic gods to whom human sacrifices were made: *Teutates, Esus* and *Taranis*. The last is probably a celestial god (Jupiter), since he is linked to thunder (*taran* in Gaulish) and whose symbol is the wheel. The name of Esus is definitely synonymous with "good" and is therefore equivalent to the Irish *Dagdá* expressing the same concept. After Lugh, this god was the second in importance in the last generation of the gods and father of the great goddess *Brigid* (whom Caesar dubbed Minerva). As for Teutates, his name belongs to the same root as the Celtic world for tribe (*tuath* in Irish). This is presumably the god who guided and protected the tribe in war, Mars.

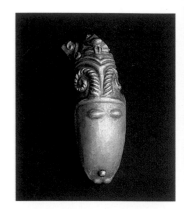

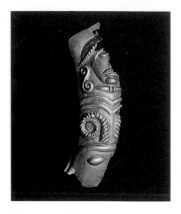

Fragmentary silver mount from the hoard of Manerbio sul Mella (Brescia) First half 1st century B.C. Brescia, Museo Civico Romano

According to Caesar, the Gauls "When they have decided to fight a battle, it is to Mars that they usually dedicate the spoils they hope to win; and if they are successful, they sacrifice the captured animals and collect all the spoils in one place. Among many of the tribes it is possible to see piles of these objects on consecrated ground." (*Gallic War*, VI, 17). Recent excavation of sanctuaries in Picardy have endorsed Caesar's observations of this practice.

Once again it is Caesar who provides us with the most complete information on the status and role of the druids in Gaulish society in his day. The druids were the exclusive intellectual elite, and were recruited among the ranks of the nobility. They enjoyed special privileges, such as exemption from tributes and were not obliged to bear arms. The case of the distinguished Aedui tribesman Divitiacus, recognized as a druid thanks to a passage in Cicero,

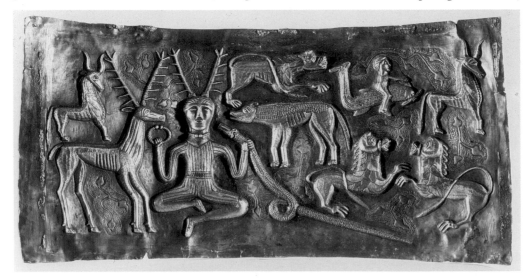

Gold plaque with Cernunnos holding serpent and ram's head in left hand, from the Gundestrup cauldron (Denmark) First half 1st century B.C. Copenhagen, Nationalmuseet

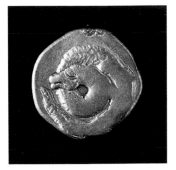

Obverse of a silver tetradrachma
with inscription to MACCIVS
with serpent and ram's head
from Bratislava (Slovakia)
First half 1st century B.C.
Bratislava
Slovenské Národné Múzeum

shows that they could still carry the same military equipment as others. Their education was very lengthy, and involved twenty years of memorizing sacred texts which religious taboo banned from being put in writing. The druids were acquainted with writing, however, and, according to Caesar, used an alphabet borrowed from the Greeks for "other purposes, for example, for public and private accounts." (*Gallic War*, VI, 14).

In their religious role, the druids insured the conduct of religious practices, presided over sacrificial rites, and received and interpreted omens. The only ones "to know the nature of the gods," they acted as intermediaries between the world of humankind and the domain of the supernatural. Guardians of the fundamental gnosis, they perpetuated a conception of mankind and the universe contained in an esoteric doctrine which, for obvious reasons, remains a mystery.

The few passages of the classical histories that mention the eschatological beliefs of the druids reveal that the life of the soul was not interrupted by the death of the individual, but could continue in two ways: in a world apart from that in which mortals dwelled, with which

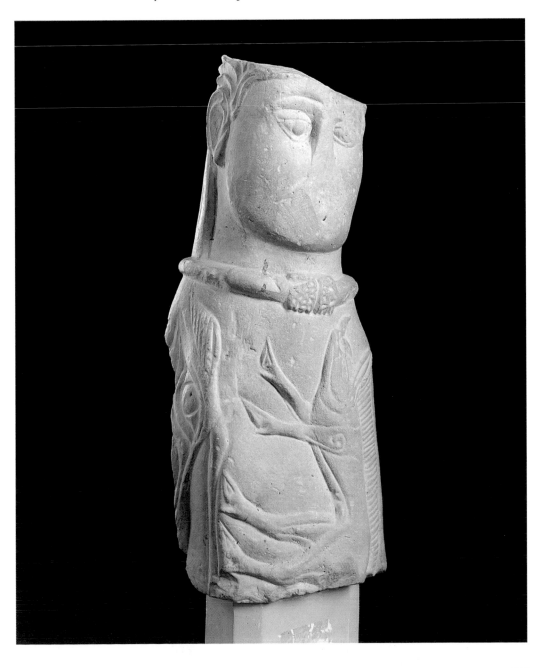

Stone statue of deity
from Euffigneix (Haute-Marne)
1st century B.C.
Saint-Germain-en-Laye
Musée des Antiquités Nationales

contact was possible only during the breach in time known as the night of *Samhain* (November 1) marking the end of one year and the dawn of the next; the Celtic year began with the cold and dark winter and the dormancy of plants. The alternative was to return to earth through the reincarnation of the soul, which was a new birth (metempsychosis). The former idea, which was more widespread, is first illustrated in the Early Iron Age by the burial goods of certain Celtic notables, consisting of everything they needed to reclaim the prerogatives of their rank in the next world. The second destination was perhaps originally reserved for a small group of initiates, as was the case with observers of the comparable doctrines of Orpheus and Pythagoras. The diffusion of this second belief might have engendered a different attitude toward funerary customs, which seem to change in the second century B.C. in parallel with the increasing urbanization of the Celts. Cremation was introduced, and the remains buried directly in the earth without burial goods or with a simple symbolic object. Deeply religious, the Celts believed in doing anything possible to insure the smooth running of the universe. Consequently, they did not hesitate to make human sacrifices when the situation made it necessary. They believed that if they failed to carry out the appropriate sacrifice in the allotted time, the worst would befall them. Caesar remarks on this sense of dread, and mentions how the druids banned individuals who flouted their judicial authority: "this punishment is the most severe. Those who are banned in this way are reckoned as sacrilegious criminals. Everyone shuns them; no one will go near or speak to them for fear of being contaminated in some way by contact with them. If they make any petitions there is no justice for them, and they are excluded from any position of importance." (*Gallic War*, VI, 13). In other words, anyone unable to perform the rites according to the prescribed methods becomes a threat from which society can only protect itself by denying his existence.

Granite stele depicting four deities from Karvadel at Plobannalec (Finistère)
1st century B.C.
Quimper
Musée Départemental Breton

Bronze statue with glass paste eyes representing deity with deer's feet from Bouray-sur-Juine (Essonne)
End 1st century B.C.-1st century A.D.
Saint-Germain-en-Laye
Musée des Antiquités Nationales

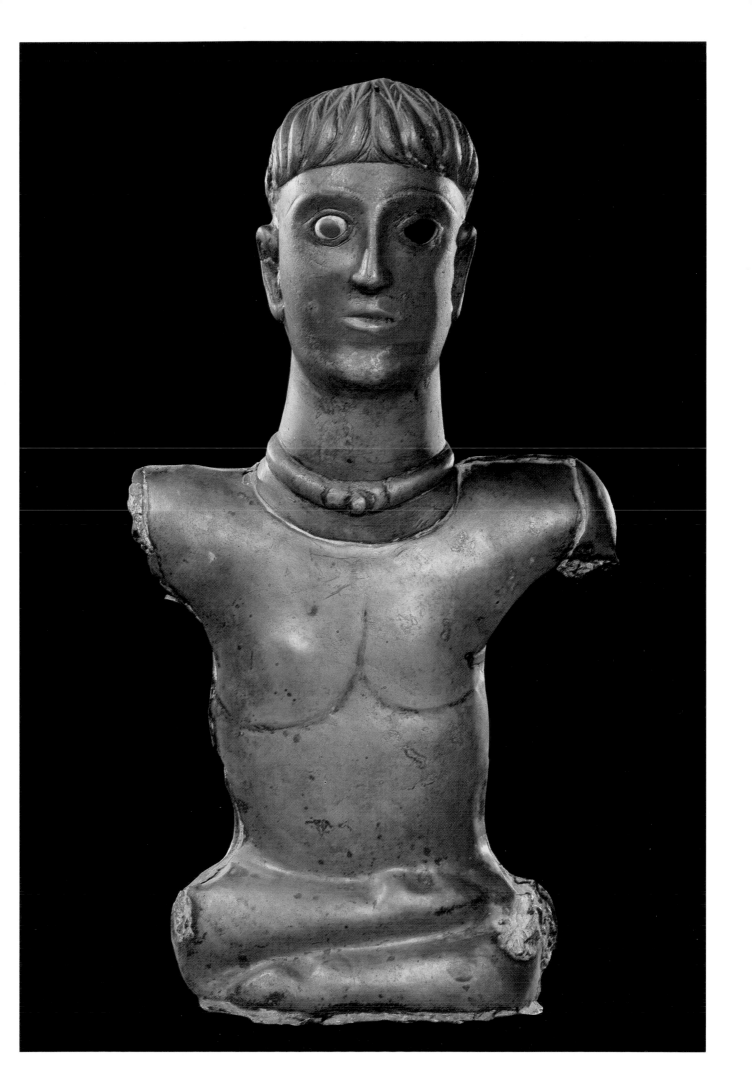

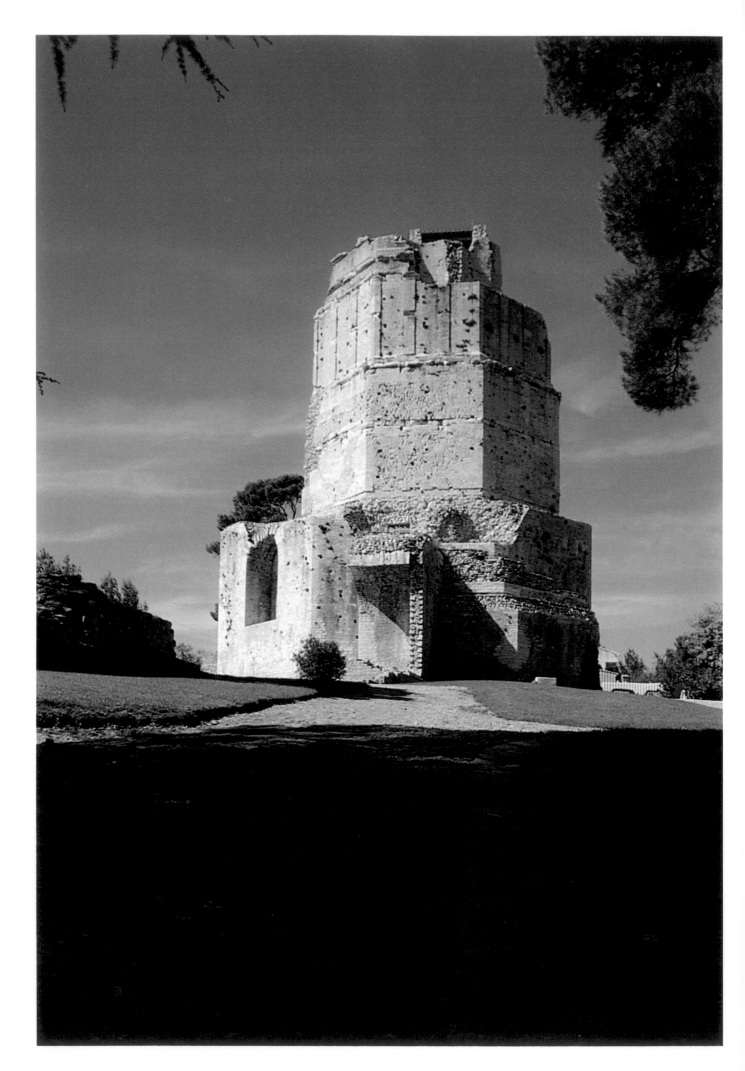

Christian Goudineau

The Romanization of Gaul

The Romanization of Gaul came about in three phases:

1. After two limited operations on the Ligurian coast in 181 and 184 B.C., from the year 125 B.C. Rome began sending troops into southern Gaul in reply to an appeal from one of its allies, the city of Massilia (Marseilles), which was at war with the Celts of Liguria. The victories of 124 and 123 B.C. against the Ligurians, Viconzi, and Salluvii were a resounding triumph for the consuls M. Fulvius Flaccus and C. Sestus Calvinius. In 122 and 121 B.C. Cn. Domitius Enobarbus and Quintus Fabius Maximus successfully routed the Allobroges and their allies the Arverni. Southern Gaul, from today's Nice to Toulouse and along the Rhône to Vienne, became a Roman province. Its organization was probably decided by Pompey (around 75 B.C.), and there are records of revolts that occasionally flared up, until the proconsulship of Caesar.

2. From the year 58 B.C. onward, Caius Julius Caesar, proconsul of Illyricum, Cisalpine Gaul and Transalpine Gaul, managed to subdue the interior of Gaul. After securing various alliances—particularly with the Aedui tribes, who were declared "allies and brothers of the Roman people," and with their associates—the proconsul found himself faced with widespread insurrection instigated by the chief of the Arverni, Vercingetorix, who marshaled a vast emergency army in a bid to repel the Romans from the capital Alesia. The town fell on August 52 B.C., marking the final defeat of Gaul.

3. Augustus Caesar and his lieutenants had the task of pacifying the Alpine and Pyrenean states that had not yet succumbed to Roman rule. A victory monument inaugurated between July 1 and June 30 of the year 7 B.C. (during the emperor's seventeenth *patria potestas tribunizia*) hailed the end of the conquest of Gaul.

Augustus proceeded to mark out four provinces (the *Provincia Narbonensis*, with Narbonne as its capital; the *Provincia Lionensis* the capital of which was Lyons; the *Provincia Belgica*, the probable capital of which was Reims; and the *Provincia Acquitana*, which probably had Saintes as its capital), and three Alpine districts: the Maritime Alps (capital *Cemelenum*, today's Cimiez near Nice); the Cottian Alps (capital Susa), and the Graian Alps (capital Susa). In these provinces and districts, the population levels of the *civitates* remained more or less unchanged, with the exception of the *Provincia Narbonensis*. In this province, the more long-standing presence and the evolution of Roman colonies (as in Narbonne in 118 B.C.; Arles under Caesar; Fréjus, Béziers, and Orange during the triumvirate or under Augustus), and of Latin colonies (Nîmes, Valence, Vienne, and perhaps others) modified the original patterns of the settlements. In the interior of Gaul, Lyons was the only colony to be set up (in 43 B.C.), with two Swiss towns, *Noviodunum* (Nyon) under Caesar, and *Augusta Rauricorum* (Augst) in 43 B.C.

As elsewhere, Romanization in Gaul was carried out through authoritarian rule imposed by Rome, and included the granting of legal statutes, urbanization, the fairly swift integration of the provincial elite, a tax system that led to the survey and registration of the countryside, various prohibitions (including the banning of Druidism and human sacrifice), and so forth. A sociological behavior program of "imitation" and "assimilation" was developed—leading kinsmen were encouraged to live like Romans. Finally, in a world in which the economy was essentially confined to the radius of the town and its immediate surroundings, the mass migrations that took place (which archaeology tends to overestimate) were due to the attraction of Rome and some large towns, and to the stationing of troops along the frontier of the Rhine. This was the basic overall situation. But since this exhibition is devoted to the Celts, the question we need to ask is what is left of the Gallo-Roman world that we can rightly call Gaulish (or Celtic)?

It should be pointed out that, once it became Roman, Gaul never questioned its integration with the Roman Empire. As with Etruria, Sicily, and Latium, Gaul managed to conserve certain traits of its own past which the Romans made no attempt to efface—there was need for this, and the question remains as to how Rome would actually have gone about it. The process of assimilation varied from region to region, but the Romans repeatedly won the sup-

The Tour Magne at Nîmes (Gard)
Second half 3rd century B.C.
and last third of 1st century B.C.
to early first century A.D.

port of the local elite; thus any idea of oppostion to Romanization is pure nonsense. Roman Gaul held on to certain characteristics, naturally, which, in time, forged the memory of the people. It is better therefore to leave theory behind and look at some concrete examples symbolic of the entire process.

One of the most cogent examples is the Tour Magne at Nîmes (then *Nemausus*). The town's walls and gates (*murus portasque*) were a gift from the Emperor Augustus. Most of the perimeter wall has been restored.

Recent research has shown that the Tour Magne (one of the most celebrated monuments of Gaul) was built under Augustus around a previous, protohistoric tower, dating from the second half of the third century B.C., erected on the highest point and visible from far off, even from the coast. The first to reinstate this monument to Gallic pride were not the Romans, but the Romanized Gauls, who made of it a tribute to the glory of the Emperor. Legend had it that the tower contained a concealed treasure, a "golden calf," and so in recent times the original protohistoric tower was dismantled and removed. The entire episode is an

Stage wall from the theater at Orange (Vaucluse) with the statue of Augustus Last third of first century B.C. to early 1st century A.D.

odd historical mosaic—a Gaulish city that became Roman, a medieval Celtic legend, and an archaeological quest centuries old.

A change of scene: the next example is the Triumphal Arch at Saintes in southwest France. It was dedicated in 18 or 19 B.C. to the Emperor Tiberius and heirs—his son Drusus and nephew Germanicus. The inscription states that the monument was the gift of one Caius Julius Rufus, a key figure of the *Civitas Santonum*, and a *sacerdos* at the grand federal sanctuary of the Three Gauls in Lyons, where he had an amphitheater built. The arch at Saintes reconstructs his genealogy: his father was Caius Julius Otuaneunos; his grandfather Caius Julius Gedomo; his great-grandfather Epotsoviridos. Hence it was a family of Gaulish descent, with Celtic names. The grandfather was granted Roman citizenship under Caesar, whom he had either accompanied in his campaigns or to whom had offered political support. Although he assumed the *tria nomina*, his original Celtic name Gedomo remained as a surname. The same goes for his son Otuanenunos. But the grandson Caius Julius Rufus was completely Romanized. In three generations, from roughly 60-50 B.C. to 10-20 B.C., this Gaulish family had changed its names and adopted Roman customs, as testified by the generous

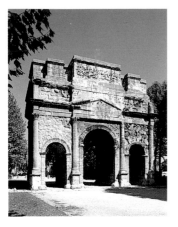

Arch of Triumph at Orange (Vaucluse) 1st century A.D.

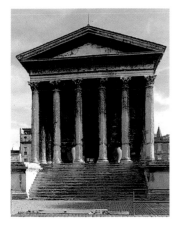

The Maison Carée at Nîmes (Gard) Early 1st century A.D.

Detail of dedication on the "nautae parisiaci" monument from Ile de la Cité, Paris Reign of Tiberius

dedication of the monument to the glory of the emperor of Rome.

In the first century B.C. the town of La Graufesenque (in the vicinity of Millau in Aveyron, then Muteni territory) rapidly became a major center for the production of *terra sigillata*, and eventually superseded the Italian workshops of Arezzo, Pisa and Pozzuoli, and their branches set up in Gaul (such as the one at Lyons). Excavations have yielded plates or dishes with the number and name of the potter inscribed on the surface with a stylus before firing. These "graffiti" offer further proof that, toward the mid-first century A.D., writing already existed in Gaul, and included names of people, common words and figures. The lettering is similar to that found at Pompeii, the names of the potters are Celtic, the terms designating the objects in pottery are mainly Latin (sometimes with variations). The calculations are entirely in Roman numerals. Curiously, the accounts were apparently supervised by priests (*flamini* perhaps?).

Another important feature is the calendar, which experts have tried to piece together from the various fragments of bronze plaques found at Coligny (in Jura, a department of Ain) datable to the second century B.C. It seems that during Roman times the Gaulish calendar differed (at least in certain places) from the official one sanctioned by Caesar. The *Tabula Peutingeriana* shows that, from Lyons, distances were calculated not in miles but in leagues (*leugae*), and yet a great many Roman milestones have turned up. Given the complexity of these data, it is impossible to define the system in use at the time.

Gaul has also provided significant examples of monuments closer to a more "classical" Roman style, such as the Maison Carrée, the arch at Orange, the amphitheaters at Arles and Nîmes, the monuments at Lyons and so forth. But, beside these "paradigms" there are many other curious details—such as the consecrated areas around monuments, for instance, which, unlike Graeco-Roman temples, are oriented to the east and not west, and have a circular or polygonal central nucleus crowned with an arcade of the same plan, creating a kind of elevated "tower," with high windows surrounded by arcades built into it. Many buildings of this kind are clustered within the same enclosure; alongside are wells, ditches and a full ritual assemblage, including votive offerings in stone, pottery or wood, sometimes dating back to neolithic times. These ritual sites are mainly rural buildings associated with peaks, freshwater

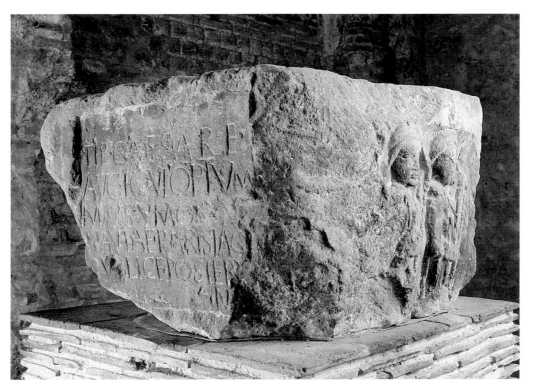

springs or other salient features of the landscape. But some have been found in towns (such as at Vienne) or on areas where tradesmen worked. They multiplied under the Roman empire (today 500 such buildings have been traced), and in many cases excavations have revealed the earlier structures. The cults represented are usually classical—Mercury, Apollo, Mars, *Dia Matres* (the Three Mothers), and Venus. But these Roman deities are often accompanied by "twin" gods with Gaulish names (Maia, Rosmerta, Sironna) or with toponymic figures, that is, linked to the place in question. Romanization in this case cohabited with ancient Celtic customs, manifested in stone structures and, sometimes, substituting the stone sculptures with wooden votive offerings.

In his descriptions of the religious customs of the Gauls (*Gallic War*, VI, 17ff.) Caesar effected a cultural transposition for the benefit of the cultured circles of Rome, perhaps with the idea of showing that Gaul, reputedly barbaric, was in fact assimilable. His analysis was actually confirmed: inscriptions from imperial times register the hierarchy of the gods in the order Caesar gave. Furthermore, indigenous portraits of Gaulish or Celtic gods complied with the new political conditions. Hence the pillar of the Nautes of the Parisii, which shows a horned god (*Cernunnos*), is dedicated to Tiberius; on an altar in Reims, the same god appears between Apollo and Mercury. Elsewhere we find Jove "complete with wheel," thought to represent the Celtic god of thunder, Taranis, who, hurling his wheel through the clouds, unleashed the terrible din. He turns up in "classical" styles which must surely be official. A link is thus established from the little "ritual wheels" of the Bronze and Iron Ages to the Gundestrup cauldron, and to representations of the Empires.

So far politics, mentality, and religion have been mentioned. But what about the economy? Without doubt this is the area in which recent archaeological discoveries have shed the most light. It has been shown that before the Roman conquest, the agriculture and livestock husbandry of Gaul were already well developed (as confirmed by both Caesar and Strabo). Consequently farms from both before and after the conquest are juxtaposed or overlap, the only difference being in construction materials or ground plan.

Romanization certainly introduced new forms of crop (such as grapevines and olives as grown in southern France) and a more efficient management of livestock. One of the effects of colonization was the exploitation of new land; but the techniques and social organization date back to La Tène I and II.

In conclusion, the Romanization of Gaul is often presented as a typical example of successful assimilation. With only material evidence to go on, we cannot probe into the psychology of the individual Celt, especially not those belonging to the more humble walks of life. But we may say that the practices introduced from Rome catered to two strong traits of the Gaulish temperament: a fierce need for autonomy within circumscribed territories (satisfied by the *civitas*), and their fascination with strong leadership, often willingly sublimated, and which in imperial times was lavished on the descendants of Caesar.

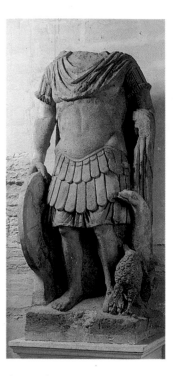

Statue of Jove at Séguret (Vaucluse)
End 1st century B.C
to early 1st century A.D.

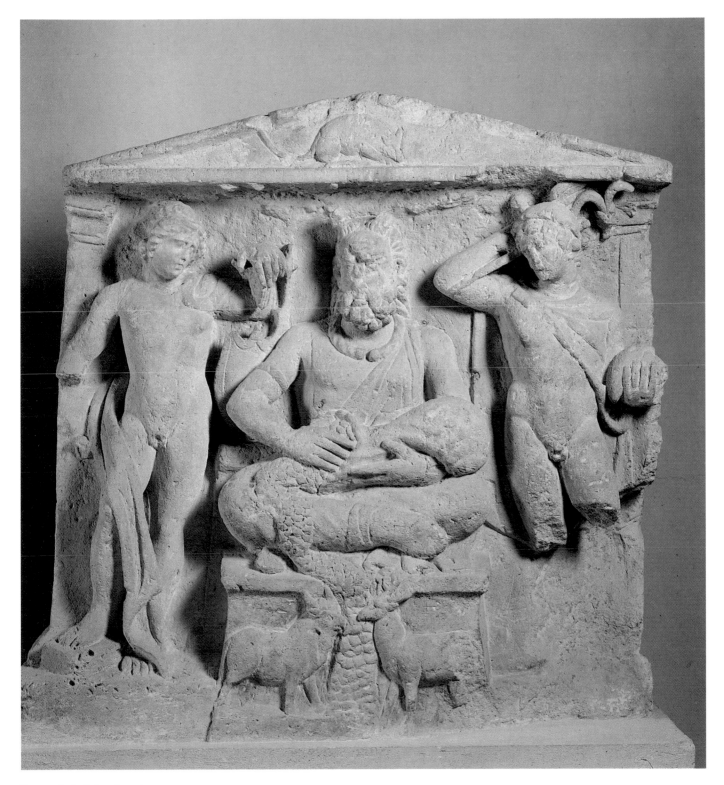

Stone stele depicting the god
Cernunnos sitting between Apollo
and Mercury from Reims (Marne)
1st century A.D.

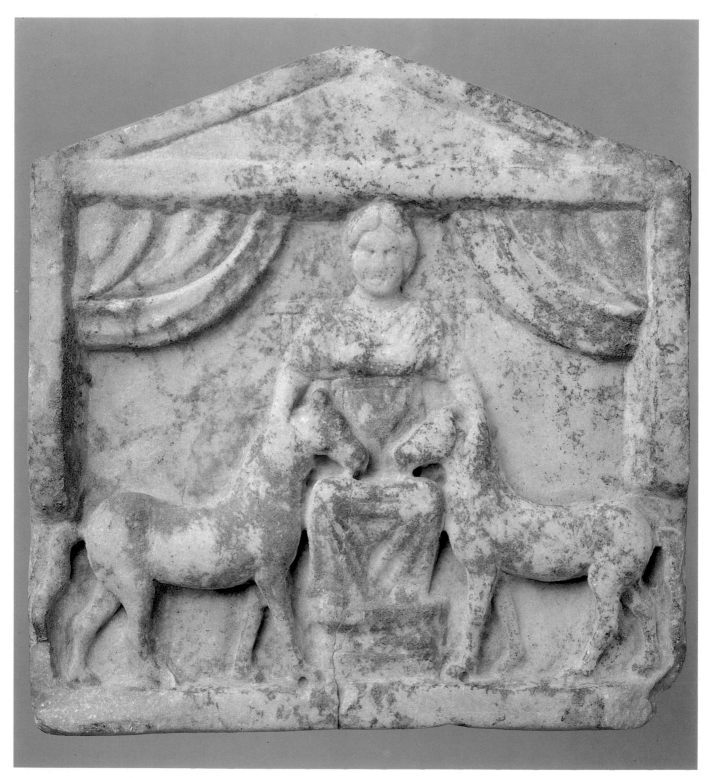

Marble stele depicting goddess
Epona with a pair of horses
from an unknown site in Dacia
Second half 2nd century B.C.
Budapest, Szépmüvézeti Múzeum

In 186 B.C., the upper Veneto region witnessed the emergence of a new Gaulish tribe, the Carnutes. Originally from Noricum, the new settlers clearly preferred peaceful coexistence, but in 183 B.C. Roman forces were sent in to oust them. The Carnutes were subjugated, but allowed to stay put, despite the fact that a colony had been founded at Aquileia. This colony represents a first and decisive step toward Noricum and Pannonia. Noricum was a rich land thanks to its thriving metal-forgers who produced a highly prized quality of iron and abundant silver. The tribes living in the area had formed a united kingdom from the beginning of the second century B.C., to which Latin authors gave the name of *Regnum Noricum*. Rather than occupy the area, the Romans initially wanted access to it for its geopolitical advantages and natural resources. In the course of the second century, Aquileia therefore became a new commercial power in the Mediterranean, organizing and controlling trade between northern Italy and the eastern Alpine regions. The main commodity shipped out of here was, naturally, iron from Noricum. The Austrian excavations carried out at Magdalensberg near Klagenfurt have brought to light a Republican emporium dating from 100 B.C., undoubtedly linked to a Celtic *oppidum*, thought to be the capital itself of the *Regnum Noricum*. The exploitation of Noricum's immense mineral wealth was organized by representatives of the trading companies of Aquileia.

In the area to the east of the Julian Alps, however, Aquileia had set up no such emporia. This is perhaps explained by Appian's remark that the Romans were unfamiliar with this region. There is thus a marked difference between Roman interest in on-site control of iron products from Noricum and their interest in the trading operations in the Aquileia market serving the Barbarians who inhabited the Sava Valley. For many years, Roman military intervention in the above areas was largely geared to defending Aquileia from attacks from nearby Alpine tribes, particularly the Taurisci and Iapodes (the culture of these tribes was probably a mixture of Celtic, Venetan and Illyrian components). The population indigenous to the Julian Alps actively participated in the traffic of goods across the Alpine passes between Aquileia and the Sava Valley, either as transporters or guides to others, and sometimes as brigands. In order to discourage the latter activity, the Romans carried out military operations in 156 and 129 B.C. in Siscia (today's Sisak in Yugoslavia), without involving the occupation of the upper section of the Sava Valley. This tactic of sending in small task forces against unruly Barbarians continued until around 50 B.C. In the Balkan area dominated by the Scordisci, despite the decisive defeat inflicted on this tribe by Scipio Asiagenus during the second decade of the first century B.C., Rome was unable to continue its advance to the north or northwest owing to the threat posed by the Balkan tribes. Only after the dismantling of the Dacian state after the death of Burebista (midway through the forties B.C.) were the Romans finally able to establish territorial links between Italy and Macedonia. Officially, their pretext was the Dacian threat, which justified Roman penetration of the Sava Valley, quite in contrast with the actual historical situation.

In 35 B.C. the future Augustus Caesar, Octavian, launched an offensive against the Iapode tribes ensconced in the eastern Alps. Once victory had been secured, the Roman army pushed through toward the Pannonic tribes, with the primary goal of taking Siscia which, from 34 B.C., became the main Roman occupational base of the future province of Pannonia. The campaign mounted by Caesar against the Dacians was actually carried out by Marcus Licinius Crassus in 29-28 B.C., and effectively brought Dobruja under Roman domination and pacified the various neighboring tribal populations. The central Balkan peoples did not return to the foreground of events until 16 B.C. when they made a foray into Macedonia. At the same time, the Pannones and the inhabitants of Noricum stormed Istria.

The defeat the invaders were dealt by Publius Silius Nervus is described by the classical authors as a new submission on the part of the Pannones, the first being without doubt the fruit of the so-called Iapodi campaign mounted by Octavian. The annexing of Noricum is part of this succession of events, though it is linked also to the massive offensive mounted by Tiberius and Drusus against the Rhaetians and Vindelici in 15 B.C., a date that marks

the first thrust of the occupation of what would later be Pannonia, the western end of which belonged to the *Regnum Noricum* from midway through the fourth decade B.C. The second phase, that is, the occupation of the regions between the Dráva and Sava rivers, was the result of Tiberius's successful war against the Pannonic tribes between 13 and 9 B.C. In the meantime, in the year 11 B.C., the imperial province of Illyricum came into being, comprising the entire Dalmatian bloc and most of future Pannonia. In order to harmonize the dimensions of the three provinces of *Illyricum Superius* (Dalmatia), *Illyricum Inferius* (Pannonia) and Noricum, the territory of the Boii including the zone of the renowned Amber Route was integrated with *Illyricum Inferius*, most likely toward the end of the reign of Claudius Caesar. It is therefore possible that the splitting of Illyricum into two parts dates from the time of Tiberius, but the organization of Noricum and *Illyricum Inferius* which, from Vespasian's time became known as Pannonia, did not take place until Claudius Caesar's rule.

The third phase of the occupation of Pannonia has given rise to much debate. The notion of Augustus Caesar's conquest of the northeastern reaches of Pannonia is based on an interpretation of a passage in the *Monumentum Ancyranum*, Augustus's last will and testament. The painstaking analysis of archaeological finds and accompanying examination of the historical and geographical sources seems to sanction this version of the facts, according to which the territories in question (that is, the eastern end of the current Transdanubian region) fell under Roman dominion only toward the middle of the first century A.D. It follows that this date signals the end of the La Tène era in eastern Pannonia; and as for the Great Hungarian Plain, the area soon saw the arrival of Iazigi tribes of Sarmatian origin toward the year A.D. 10, while further north in today's Czechoslovakia the Germanic offensive in 16 B.C. resulted in the foundation of the Marcomanni empire of Marobod in Bohemia toward 8 B.C.

This series of events involving Roman occupation clearly demonstrates that the most feared adversaries of the Romans were in fact the Pannones, because the Celtic peoples who had fallen under the hammer of the Dacians posed no threat to the new conquerors.

It is hardly surprising, therefore, that the first large-scale focus of Romanization was Magdalensberg which, under Augustus and Tiberius, reached a peak of glory. During Claudius Caesar's reign, however, the city was abandoned in favor of the new capital, Virunum, and only the original Celtic cult of Mars Latobius on the summit of the mountain retains any record of the area's glorious past.

*Marble funerary stele of PVLLIVS AELIVS and family
from ancient Gorsium (Hungary)
Era of Hadrian
Tác-Gorsium, archaeological site*

Generally speaking, the Romanization of the Danube countries was rather slow-paced, and it would be logical to surmise that the language and traditions of the indigenous populations were better preserved here than elsewhere. As it happened, things developed along quite different lines. In the places where the process of Romanization drew to a rapid halt, its effect had originally been merely superficial, with the population adopting Roman customs without these affecting local cultural roots. Hence the locals learned how to set up altars for venerating their own deities, and gave them Roman pseudonyms or even a Roman outward form. On the other hand, while altar-building proliferated in the region under discussion, beneath the apparently undisturbed surface all kinds of fundamental changes were taking place: the primitive local ideas began to fuse with those of the Romans in a process that led to the emergence of local cults of a mixed, syncretic nature.

Once the conquest was achieved, the Romans (who in the meantime had mastered their powers of organization) took over the management of the local population, content with setting up administrative nuclei called *civitates peregrinae*, which excluded interference with the inner workings of the tribes themselves. The Roman authorities nonetheless wisely disbanded any political formations that might have nurtured threats of rebellion. And nothing is more illustrative of the Celts' innocuous nature than the fact that, unlike the situation with the Pannones, Celtic tribal unions were left intact. A look at the names of the various *civitates peregrinae* reveals two main ethnic categories: those that played a role in pre-Roman developments (for instance, the Boii, the Eravisci, Latovici, Scordisci and so on) and those whose names do not turn up until Roman times. As for the second category, we can distinguish the races

that had no importance before the Roman conquests, and groups organized by the Roman administration. The names of races created artificially during Imperial times show up particularly in the Sava Valley, that is, in the zones that resisted Roman occupation. All in all, it was radical intervention that, through the dissolution of the main Pannonic tribes, aimed at routing potential pockets of resistance. In the Celtic zone, the creation of the Atrebates groups was designed to separate the Boii from the Taurisci, two traditionally allied peoples. Another well-known fact is the transfer of the population of the *Barbaricum* to Roman lands. The king of the Quadi, Vannius, who was most likely of Boii stock and whose kingdom stretched through northern Noricum and Pannonia, sought asylum with the Romans when his kingdom fell; toward A.D. 50 he was installed in Pannonia, complete with his court. The Cotini (of Celtic origin), who in the first century B.C. lived east of the curve of the Danube, made their first appearance in Pannonic territory only at the start of the second century A.D. But, given that in Pannonia they went by Dacian names, the Cotini must have experienced some Dacian influence in their country of origin.

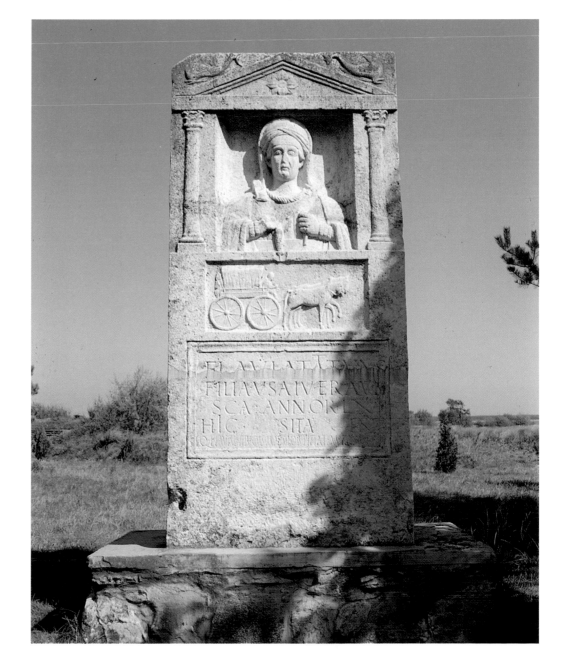

Limestone funerary stele of FLAVIA VSAIV from ancient Gorsium (Hungary) ca. 130 A.D. Tác-Gorsium, archaeological site

An analysis of given names in Roman times clearly reveals that, in the northern, southeastern and southern zones of Noricum, and likewise in the northeastern and northwestern areas of Pannonia, the Celtic linguistic enclave was very extensive and included the Taurisci, the Boii and the Eravisci. In southern Pannonia there was a fairly homogeneous Pannonic (Illyrian) linguistic enclave, with occasional patches of Celtic. The Venetic peoples were present in small scattered groups in the upper Save Valley and southern Noricum. Typical is the case of the Scordisci in southeastern Pannonia who, in assimilating the Illyrian civilization in pre-Roman times, lost their original Celtic language.

The indigenous community was initially placed under the surveillance of Roman officials. The Roman prefect governed jointly with the council of princes or chieftains—that is, the nobles of the subject population. An inscription discovered in the territory of the *civitas* of the Scordisci is one of the key pieces of evidence regarding the achievement of autonomy by the indigenous community from the time of the Flavians onward. The Romans therefore did their utmost to win over the tribal aristocracy, through which they aimed to gain control of the entire community in preparation for eventual Romanization.

The funerary stelae erected by the population of Celtic origin in Noricum and Pannonia offer a fair range of imagery, at least for women's clothing, and there are even regional variants in Norico-Pannonic fashion. Thanks to the grave goods, we have the metal originals of the ornaments illustrated on the various monuments erected in the tombs. The male population seems to have espoused Roman ways more readily, and the stelae show them in Roman costume.

The formation of the autonomous *civitates peregrinae* was accompanied by the process of municipalization, all of which was designed to transform the indigenous communities into full-fledged municipalities. The apogee of this urbanization process was under Hadrian, and it was in this period that the inhabitants largely adopted Roman customs. The altars and funereal stelae set up throughout the Danubian region often reflect local religious thinking. The Celtic tombstones depicting chariot scenes, and likewise the Eravisci aristocracy's chariot burials, refer back to the Celtic belief in the journey to the other world. Relief designs on an Eravisci funeral monument found at Bölcske in eastern Transdanubia confirm the survival of the cult of the wild boar—an animal which, for the ancient Celtic peoples, was linked to death. It is noticeable how, until the Marcomanni wars (that is, until the era of Marcus Aurelius) the epigraphic material, figurative monuments, ceramics and ornaments testify that local tradition—and in particular that of the local Celtic population—thrived in Noricum and Pannonia. There are plenty of indigenous cemeteries dating from the second century A.D., the grave goods of which are composed exclusively of locally made artifacts.

The history of the Danube countries becomes more eventful toward the end of the second century A.D. with the advent of the Marcomanni wars. But despite the devastation across the land, the indigenous population by no means disappeared overnight. This is proved by the prevalence of certain given names well into the third century. Furthermore, the names of Celtic deities, such as the supreme godhead of the Eravisci, Teutanus (equivalent to Jupiter), appear on third-century inscriptions. This is due to a conscious tendency toward archaism fostered by what might be called "patriotism" (that is, devotion to the homeland), which reflects the growing importance of Pannonia.

Side elevation of a funerary shrine depicting a woman carrying a boar's head on dish from Bölcske Mid-2nd century A.D. Budapest, Magyar Nemzeti Múzeum

Bibracte: An *Oppidum* of the Aedui People

J.-P. Guillaumet

The ancient site of Bibracte mentioned by Caesar stands on the southernmost tip of Murvan on an outcrop known as Mount Beuvray, which reaches a height of between 720 and 821 meters above sea level. The site is over four kilometers from the nearest village, and twenty-two kilometers from Château-Chinon (Nièvre) and twenty-seven from Autun (Saône-et-Loire). A road cutting the area almost exactly in half denotes the border of these two *départements*.

As a result of research carried out in the last century and the beginning of this by J. G. Bulliot and J. Déchelette, the Bibracte site became a model for France's earliest urban culture (ca. 150-20 B.C.), the so-called *oppida* civilization.

Bibracte, capital of the Aedui tribes, who were allied with Rome from 125 B.C., witnessed the first major events in the history of Gaul. In the year 58 B.C. the Helvetii in the neighboring region suffered a severe defeat which signaled the start of the war with Gaul. In 52 B.C. Vercingetorix was elected supreme chieftain of the Gauls. That winter Caesar stayed in Bibracte after the battle of Alesia. The Aedui's privileged relations with Rome earned them a capital of the same importance as the colonies themselves, namely, the new town of *Augustudunum* (today's Autun), founded by Augustus. The town controlled the passage of Mediterranean goods through the Saône and Loire valleys. The Aedui traded with the Parisian basin thanks to the course of the Yonne River, and with the Swiss plateau, through the hills of the Jura.

The wealth of the material from the site, which was well excavated in the last century, and the symbolic significance of its situation led to the promotion of a new mul-

tidisciplinary research program in 1984 under the aegis of the Ministry for Culture and Communications, with the support of an international board of scientific consultants. Research work is carried out by teams from various different European countries, including scholars from Bologna University. The program has various objectives—first of all to improve our knowledge of this historic site, systematically integrating early information with that from more recent excavations to ascertain the chronology and basic typologies of the site, the main purpose of the exploration. Secondly it aims to collate and harmonize research methods covering this particular period, a pivotal point between the Gallic and Gallo-Roman eras, by comparing new discoveries with those obtained from contemporary sites.

The 5.25-kilometer perimeter of Bibracte encloses an area of 135 hectares. At present, the perimeter is a pronounced rampart punctuated by a series of characteristic in-turned entrances which the German scholars call a *Zangentor*. The rampart was partially excavated in the nineteenth century. Recent excavations of the Rebout gateway have brought to light evidence for seven separate periods spanning the second and first centuries B.C., four of which comprise fortifications.

The vast area of the township is divided into quarters, each with its own distinct function. Near the access points were the sectors for crafts, where the main activity was working in iron, bronze and enamel; mass production techniques had not yet been introduced. In a recent experiment, a researcher, smelter and bronzesmith produced a bronze fibula using rudimentary manufacturing techniques and tools—hammers, flat files, anvils, a burin, a vice, a

smelting kiln and a crucible. In a few hours the team managed to turn out objects of the same quality and materials as those produced by the Aedui. The venture successfully proved the high level of technical skill of this period. The heart of the *oppidum* was arranged as a general market area, with a space set aside for meetings and religious ceremonies. A fully paved street seventy meters long was unearthed in one of the residential areas. At its center, a striking oval pond measuring approximately ten by four meters gave a clue as to the standards of urbanization the Aedui had attained. The streets and housing areas confirm the careful planning of the site, despite the very uneven ground. The residential area also boasted streets with paved surfaces over eight meters wide, complete with sidewalks and arcades, enclosing residential areas over fifty meters on each side. Here elaborate dwellings in Roman style complete with atrium, peristyle, garden and bathroom were built.

The first investigations made in the residential sector of Parc aux Chevaux showed signs of several construction phases of a Roman-style house. The first construction had a Roman plan, with floors in brick, and walls faced in lime-based mortar, complete with murals. This phase more or less coincides with the *Bellum Gallico*. The last construction was most likely destroyed around 20 B.C. These houses were the residences of Aedui nobles who wielded considerable political power and owned tracts of land and even mines, as well as being tollmasters. They were in fact future citizens of the Roman empire which would later suppress the township in favor of *Augustudunum* (Autun), which stood on the plain, twenty kilometers away.

View of enclosure wall at Bibracte on Mont Beuvray (Nièvre, Saône-et-Loire)

Late Celtic Horsemen's Graves
at Goeblingen-Nospelt
Jeannot Metzler

Four richly furnished graves of the second half of the first century B.C. were discovered in 1966 between Goeblingen and Nospelt in Luxembourg, seventeen kilometers from the important *oppidum* at Titelberg belonging to the Celtic people called the Treveri. Four low barrows, thirty to forty centimeters high covered graves 1.5 to 2 meters deep over which wooden funeral chambers had been built. The ashes of the dead had not been placed in an urn in any of the graves, but had been scattered over the floor of the chamber. Apart from the grave goods, which were conserved in the chamber and not burnt, the earth covering the graves contained very many fragments of vessels which had been burnt with the corpse on the pyre.

The grave goods revealed that the dead were horsemen probably belonging to the late Celtic aristocracy. This was even more evident in graves B and D which contained particularly long swords with highly ornamental openwork scabbards. The man of the early-Augustan grave A was equipped with a Roman *gladius*. The wheeled and pointed spurs lying in the ashes also suggested that they belonged to the cavalry. Other weapons included lance-heads, found

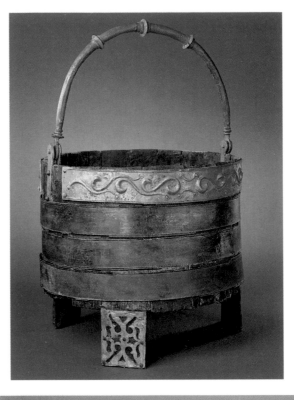

Bucket made from yew wood with bronze mounts from princely tomb B at Goeblingen-Nospelt (Luxembourg)
End 1st century B.C.
Luxembourg
Musée d'Histoire et d'Art

General view of the grave goods from princely tomb B at Goeblingen-Nospelt (Luxembourg)
End 1st century B.C.
Luxembourg
Musée d'Histoire et d'Art

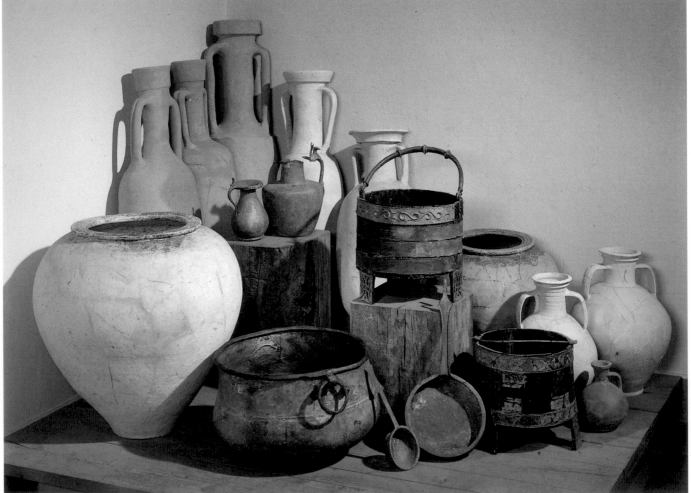

in all the graves, as well as the conical bosses of shields discovered in graves A and B. The composition of the assemblages is very different in each grave, but this can be explained in chronological terms. While graves C and D are typically Celtic-type graves, grave A presented a group of both late Celtic and early Roman objects. In contrast, the funeral offerings in grave B make it one of the earliest Roman graves in northeastern Gaul.

Graves C and D belong to the latest level of the Celtic epoch in the territory of the Treveri and should be dated, in the light of our present knowledge, to the third quarter of the first century B.C. Large open bowls, biconical flasks, black, wheel-made pottery bowls with built-up shoulders, porous vessels mostly hand-made with rims turned inward, as well as late *Schüssel* and *Kragen* fibulae were the characteristic objects of this phase which was the time when the *oppidum* at Titelberg was at its most flourishing. Only grave D contained an object imported from the south, a wine amphora of the Lamboglia Dressel 1B kind.

The material in the Early Augustan grave A presented a markedly different picture. It contained some purely Celtic vessels that contrasted with the new Roman or Roman-influenced shapes also present. Pottery made by Italic craftsmen can be distinguished from imitation Roman items coming from Gallic workshops among the Roman imports in grave A. Precious Italic bronze cutlery among the furnishings was an extraordinary find for a grave in Treveri territory. There were also a ladle and strainer belonging to a wine service and a bronze bucket together with a low basin which should be associated with the Italic wine amphora (Lamboglia Dressel 1B).

While the man in the Early Augustan grave B was clearly recognizable as a Treveri nobleman, there were only very few local objects included among the grave goods. Apart from the large bronze cauldron there were two yew wood containers with very decorative bronze bands that are certainly masterpieces of late Celtic craftsmanship. There was also a bronze object imported from Italy, a so-called Aylesford pan with a swan's head handle, a Kjaerumgaard-type jug, another larger jug, a low basin and a strainer. Two pointed amphorae (Pasqual-1-type) are part of the earliest evidence of imports of Spanish wine in northern Gaul. Apart from the bronze objects there were

more than fifty vessels on the floor of the funeral chamber.

The assemblages of the Goeblingen-Nospelt graves proves that the dead had belonged to the aristocracy of the Treveri people. The purely indigenous materials in graves C and D demonstrate that a long time after the conquest of Gaul, customs were still markedly Celtic in the territory of the Treveri. Grave A may be seen as the start of Roman influence which was considerably widespread by the time of grave B. A parallel change which highlights the transition from Late La Tène culture to Gallo-Roman culture was revealed by the material excavated in the levels of the Celtic *oppidum* at Titelberg.

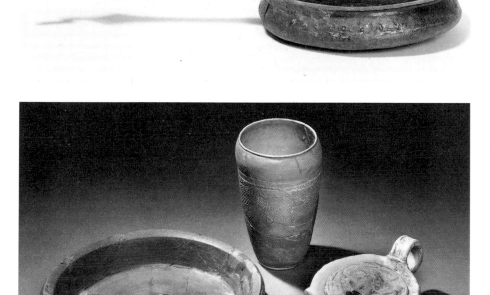

*Bronze pan, imported from Italy
from princely tomb B
at Goeblingen-Nospelt (Luxembourg)
End 1st century B.C.
Luxembourg
Musée d'Histoire et d'Art*

*Imported Italian pottery
from princely tomb B
at Goeblingen-Nospelt (Luxembourg)
End 1st century B.C.
Luxembourg
Musée d'Histoire et d'Art*

The Celtic Port of Geneva
Charles Bonnet

Reconstruction of the Celtic port of Geneva 1st century B.C.

Recent excavations have revealed the remains of a sizable port on the southern bank of the old harbor of Geneva. Together with the town that was situated at the foot of the hill not far from the Rhône and the Arve, this port is without doubt the original settlement of today's city.

This privileged site, some distance from the abandoned prehistoric coastal settlements, may have been a cult or ritual site. A small inlet containing strata of lake mud yielded numerous human remains, especially skulls and related skeletal matter. There are signs of bone fracture and, in one case, the base of a severed head, which may indicate some kind of rite involving human sacrifice. The material and pottery date this level to La Tène D1 (around 130 B.C.); the large oak statue of a protective deity found in this area in the nineteenth century probably dates to 80 B.C.

A later phase of occupation is characterized by a dense network of timber piles between forty and sixty centimeters long, finishing in a long circular tenon. The piles served to consolidate the banks, and perhaps to support the fascines, clayey soil and planks.

The discovery of several thousand piles facilitated the reconstruction of a long pier stretching thirty meters into the water, curving in the direction of the current of the Rhône. There are traces of a gangway running at water-level. There must also have been other structures along the bank for hauling boats out of the water, or for unloading goods. A set of palisades screened the port facilities from waves and wind.

Thanks to dendrochronology, it is possible to date exactly the phase of use of the port. The first piles date from between 123 and 120 B.C. A later phase of tree-felling dates a major reconstruction to around 105 B.C. The general organization of the structures suggests that the port belongs to an indigenous tradition, but we should remember that the left bank of the lake and river are on land that belonged to the Allobroges, who were crushed by the Romans between 122 and 120 B.C., and so we can draw tentative links between the building of the port of Geneva and the conquest of Transalpine Gaul.

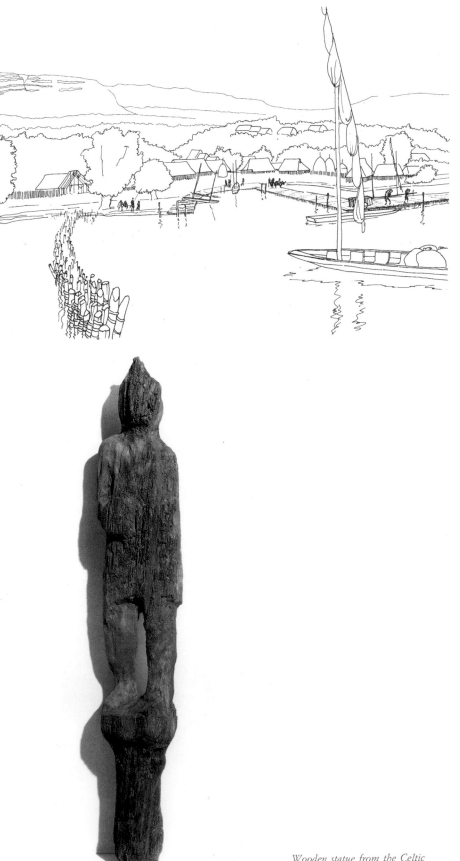

Wooden statue from the Celtic port of Geneva, ca. 80 B.C. Geneva, Musée d'Art et d'Histoire

Basle: The *Oppidum* of Münsterhügel and the Gasfabrik Settlement
Andres Furger-Gunti

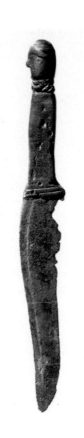

Basle is situated in the upper lowland of the Upper Rhine, where the river is easier to cross than farther north where it branches out. Bronze Age and Urnfield remains prove that there was once a pre-Celtic settlement in the area.

Literary sources suggest that the Rauraci occupied this area of northwest Switzerland during the late Celtic period. According to Caesar's *Gallic War*, in 58 B.C. these people joined up with the emigration of the Helvetii moving south, but were later driven back and forced to return to their own territories.

The distinctive characteristic of Basle is thast the area holds two fairly large settlements, one near the gas factory (Basel-Gasfabrik) in the Rhine plain, and the other near the cathedral on the hillside in the city center (Basel-Münsterhügel). The two date from different periods. The Basel-Gasfabrik settlement began in the Middle La Tène period and ended in the early part of the La Tène D phase. The Basel-Münsterhügel settlement began in the La Tène D phase and continued right through to the time of the Roman occupation. Recent excavations have given rise to the theory that the move from one site to the other took place around the middle of the first century B.C., and may be related to the emigration of the Rauraci in 58 B.C. and to their defeat at Bibracte. On the basis of these considerations, the two Basle settlements have acted as a sort of guideline for research into settlements dating back to the Late La Tène period.

Basel-Gasfabrik

Discovered in 1911, this settlement covers an area of over twelve hectares. No traces of fortifications have been found, and few strata of settlement. Nevertheless, two hundred tombs have come to light. In 1917, a cemetery consisting of a further one hundred tombs was discovered to the north of the settlement. The Basel-Gasfabrik settlement was also a trading station and a transfer and loading bay on the banks of the Rhine. This explains the presence of numerous fragments of amphorae containing wine from Italy. Outstanding among these finds are the pottery vessels, in particular a spherical carafe, decorated on the upper half with curvilinear designs on a white background. In one area of this settlement, surrounded by narrow tombs, three deep wells were discovered. The whole area could thus be identified as a place of worship. Another important find was a bronze knife with an earlier blade and the hilt-end in the form of a human head with a neckring.

In 1883, just beneath the Basel-Gasfabrik settlement, right on the bank of the Rhine, a Celtic hoard of the same period was discovered. It consisted of various gold objects, including fragments of two neckrings (one smaller and one larger), an armlet, smaller rings and numerous coins, most of them belonging to the convex type with the rainbow motif found in southern Germany (*Regenbogenschüsselchen*).

Basel-Münsterhügel

One and a half kilometers upstream, on the highland range between the Rhine and Birsig rivers, is the large *oppidum* of Basel-Münsterhügel. It covers an area of five hectares, and was fortified on the more vulnerable south side with a twelve meter-wide ditch and a large rampart built using the *murus gallicus* technique. In the entrance area, three different periods can be identified by means of the different construction techniques adopted. Only in 1971, however, was it possible to prove the existence of this Celtic settelement. Research in the area is made more arduous by the fact thast in Roman, medieval and modern times, the site was densely populated and thus subject to continual building programs. Within the settlement, in 1973-74, excavations beneath Basle Cathedral revealed traces of a wide street flanked by the remains of houses. Such archaeological finds, when compared in detail with those of the Basel-Gasfabrik settlement, reveal considerable differences, especially in the fibulae and coins. Here the Roman influence is more evident.

The remains of the Roman encampment and military equipment that have come to light immediately above the Celtic strata would seem to indicate that the Celtic *oppidum* on Münsterhügel was subjected to military occupation by the Romans, at the latest in the second decade B.C. The settlement that followed immediately after was undoubtedly a military installation. The civil center of the Upper Rhine was transformed in this period into the Roman city of Colonia Raurica, near the present village of Augst. Here the earliest material remains speak for the strong Roman influence.

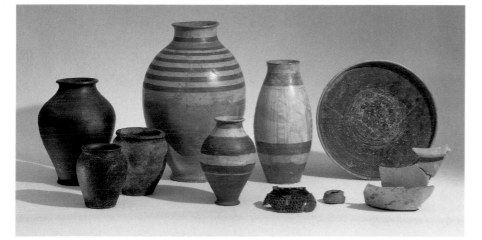

Selection of pottery from the Celtic settlement at Basel 1st century B.C. Basel, Historisches Museum

Berne-Enge The *Oppidum*
on the Engehalbinsel near Berne
Felix Müller

Three kilometers to the north of the modern city center of Berne is the Engehalbinsel, a plateau cut out by the meanders of the Aare River and surrounded by steep slopes and precipices. At various points along the edge of these precipices one can see the remains of ramparts. On the south-facing side of the plateau an imposing system of trenches and ramparts was still visible in the nineteenth century—these were subsequently destroyed during the construction of a road. The rampart on the northern edge of the site defended the access down to a point where, at the time, it was possible to ford the Aare. The internal area of this large fortified circle is about 140 hectares.

There are also internal ramparts, including the southern rampart which is the only section that archaeologists have thoroughly examined. The findings of the excavations carried out between 1956 and 1961 suggest various possible reconstructions for the external rampart, designed to resist possible aggressors. The model proposed by the excavators was that of a double row of pylons behind which were robust beams arranged horizontally. Though no parallel for this building technique has yet been found, the rear part of the wall reminds one of the well-known principle of the *murus gallicus*: a wide bank of earth reinforced internally by a wood frame that was held together with stout iron nails. Twelve meters in front of the rampart was a flat-bottomed ditch, ten meters wide. During the excavation of this south-facing rampart a cremation site was found with a number of Nauheim-type fibulae, which made it possible to date this section of the fortifications to the first half of the first century A.D. The entire series of tombs and groups of tombs (about ten sites with dozens of graves) found within the external defenses all date from an earlier period. The oldest are inhumation burials with grave goods dating to the La Tène C1 period, while the later burials are simple cremations.

The finds made here over a hundred-year period (above all, coins, fibulae and glass

*General plan of the oppidum
at Berne-Enge
2nd-1st century B.C.*

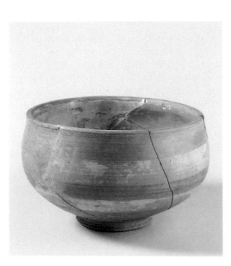

*Painted terracotta cup
from the Berne-Enge oppidum
1st century B.C.
Berne, Historisches Museum*

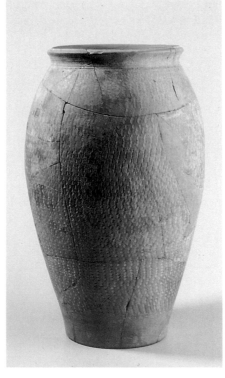

*Terracotta vase with stamped
decoration from the Berne-Enge
oppidum
1st century B.C.
Berne, Historisches Museum*

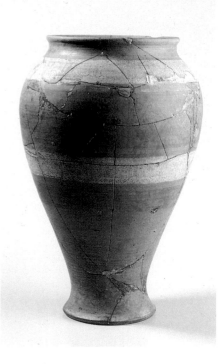

*Painted terracotta vase
from the Berne-Enge oppidum
1st century B.C.
Berne, Historisches Museum*

bracelets) suggest that during the Celtic period (from La Tène C1 to La Tène D2) the center of the settlement slowly expanded from the south towards the north. Few of the horizons on the site are archaeologically distinct. In many cases, Roman material is intermingled with the rest. Yet there is an abundance of material that is typical of the so-called *oppidum* culture; in addition to fibulae, coins, fragments of glass and ceramic bracelets, there are tools and utensils that are clearly La Tène. Apart from a few trenches, it has not been possible to identify structures dating from the La Tène period. Traces of the well-known Roman settlement can be found almost anywhere on the site.

The group of stone-built Gallo-Roman temples that occupy almost the precise center of the *oppidum* were built with a square groundplan, so it is possible that they were built in an area that was already considered sacred. During the 1968 excavations of this spot not only were several La Tène fibulae found but also part of the cheek-pieces of a helmet. Since it is not uncommon to find weapons in Celtic sanctuaries, one might suppose that the temples built here replaced structures that had the same religious function. A well-known, large deposit of weapons and parts of chariots, to be interpreted in the same way, was found at "Tiefenau," within the external ramparts of the *oppidum*.

The recent discovery on the Engehalbinsel of a zinc tablet with inscriptions has provoked debate about the ancient name of the *oppidum*. The Celtic text is written in Greek characters and refers to the locality as "Brenodor," which could mean "settlement at the loop in the river." It is thought that the Celtic name Brenodor is etymologically linked with the name of "Bremgarten" —a place near the Enghalbinsel—and may be at the root of the name of Berne itself.

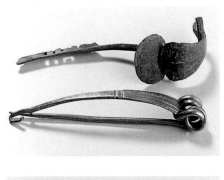

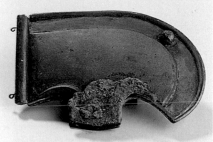

Bronze fibulae from the Berne-Enge oppidum 1st century B.C. Berne, Historisches Museum

Fragment of the paragnatide from an iron helmet from the Berne-Enge oppidum 1st century B.C. Berne, Historisches Museum

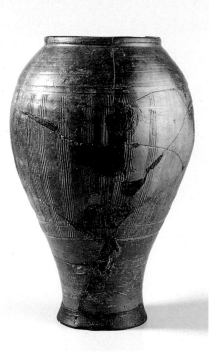

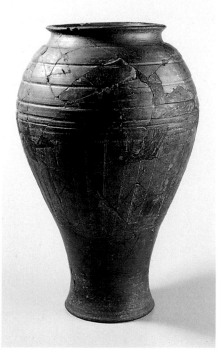

Terracotta vase from the Berne-Enge oppidum 1st century B.C. Berne, Historisches Museum

Terracotta vase with fluting from the Berne-Enge oppidum 1st century B.C. Berne, Historisches Museum

The Votive Deposit
at Tiefenau near Berne
Felix Müller

Bronze mound from a scabbard
from the votive deposit
at Tiefenau (Berne)
Early 2nd century B.C.
From the Berne-Enge oppidum
1st century B.C.
Berne, Historisches Museum

In July 1849, the workers constructing a road to the north of Berne—in an area known as "Tiefenau" (which means "a depression in the ground") came across a singular earth formation that aroused so much interest that the government itself ordered a more detailed investigation of the site. They found in the road embankment two layers of burnt black earth, full of the remains of pottery. Even more singular was the discovery nearby of a large quantity "of ancient iron implements: weapons, horse harnesses and parts of chariots, all lying in great confusion. And the more one dug, the greater the number of objects that appeared." The antiquarians who were called in by the city set about excavating the site and in the end they had to use a small wagon to remove their finds. It is now estimated that between 700 and 1,000 objects were found.

Other archaeological finds before this had attracted a great deal of attention, but what no one knew at the time was that the "Tiefenau" was right in the middle of the

Celtic *oppidum* on the Engehalbinsel. The composition of the "mass find"—and, in particular, the discovery that all the swords were bent or broken—led the excavators to think they were working on a battle site. There was, however, a sharp divergence of opinion as to the date of the battle in question.

A few years later came the discovery and sack of the La Tène site on Lake Neuchâtel. The scholars of the day immediately recognised a similarity between the objects found at the two sites—particularly the swords. Thanks to their wonderful state of preservation, the objects recovered from the water at La Tène soon became famous, whilst the objects at "Tiefenau" had been lying in the bare earth, and thus been exposed to rust. Many of them must have been reduced to small fragments at the very moment they were dug up. This is why delicate objects, such as iron fibulae, are almost totally absent from the inventory of objects found at the site.

The fact that the "Tiefenau" finds were

divided up among various museums has made it very difficult to examine them comprehensively. There are still questions to be answered.

During an overall re-examination of the material, I was able to get a more precise idea of the extent of the find. The most numerous group of objects consisted of chariot fittings and weapons. Of what must once have been about one hundred swords we now have only seventy fragments. Most of these weapons were carefully straightened immediately after their discovery, revealing the numerous notches hacked in the edges of the blades. It is also worth noting the many iron bars, coins and the small number of tools found. On the other hand, there were almost none of the glass arm bracelets that were a typical piece of female jewelry.

In 1967 and again in 1971 a settlement barely eighty meters away was also excavated, and a comparison of finds brought out the extraordinary nature of the first discovery. The relative proportions of the differ-

ent types of object were the very opposite: on this second site a number of fragments of glass arm bracelets were discovered, but not a single sword.

The greatest help in dating comes from the swords: a statistical comparison of their length shows that they belong to the La Tène C1 period.

Both the range of types and the manufacturing techniques to be found in this group of weapons link them with the objects recovered from the water at La Tène, Port and Cornaux. Bearing in mind the recent excavations of Celtic sanctuaries in France, one would be safe in concluding that one is dealing here with a deposit of weapons at a place of worship—booty, trophies or offerings to a divinity.

The votive offerings of metal at "Tiefenau" were collected with great care by the scholars of last century, but it would have been impossible for the excavators to recognize the presence a sanctuary, since these were constructed of wood and therefore would have perished.

Fragment of chain mail
from the votive deposit
at Tiefenau (Berne)
Early 2nd century B.C.
From the Berne-Enge oppidum
1st century B.C.
Berne, Historisches Museum

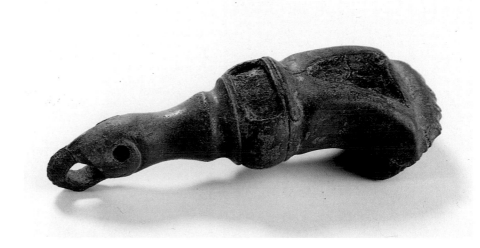

Iron harness mounts
from the votive deposit
at Tiefenau (Berne)
Early 2nd century B.C.
From the Berne-Enge oppidum
1st century B.C.
Berne, Historisches Museum

Iron chariot mounts from the votive
deposit at Tiefenau (Berne)
Early 2nd century B.C.
From the Berne-Enge oppidum
1st century B.C.
Berne, Historisches Museum

Bronze bird's head originally fixed
to wood from the votive deposit
at Tiefenau (Berne)
Early 2nd century B.C.
From the Berne-Enge oppidum
1st century B.C.
Berne, Historisches Museum

The River Site of Port Nidau
Felix Müller

*Iron sword-hilt from the site
of Port-Nidau (Berne)
End 2nd-early 1st century B.C.
Berne, Historisches Museum*

The 1869 construction work at the foot of the Swiss Jura mountains was to have important consequences for archaeology in Switzerland. The old meandering watercourses were partly canalized, partly redirected, so there was a subsequent drop of two meters in the water level in the lakes of Biel, Murten and Neuchâtel. Thus a number of archaeological sites were revealed.

During the construction of a new canal near Port a large quantity of objects were recovered from the old Zihl riverbed. Brought to the surface by the dredgers that were clearing the canal, the objects were collected by the workmen and local residents. The best were purchased by what was then the "Antiquarium der Stadt Bern." During a dramatic drop in water levels in the winter of 1888-89, a second series of discoveries was made: more iron weapons appeared on the banks of the new canal.

Particularly worthy of note among the objects recovered are nearly sixty swords (with or without sheaths) and an equal number of spearheads. Reliable reports say that the weapons were full of deep dents and notches caused by blows.

Perhaps this was booty, or else a votive offering deliberately damaged and thrown into the water. However, one cannot exclude the possibility that the weapons were affixed to a structure (in all probability, a bridge) as trophies, and fell into the water at a later date. What is certain is that archaeological finds have shown that there were numerous cases in early European history of religious devotions involving the consignment of objects to water.

Overall, the objects found at Port date from various periods. However, most of the swords date from the end of the Celtic era, the La Tène D phase.

The most famous of the Port finds is the so-called "Sword of Korisios," the blade of which has been bent and broken in accordance with the well-known practice at Celtic sanctuaries in France. Immediately below the handle there is a mark, a common feature on swords. What is uncommon is the design of the mark—two goats climbing a palm tree. The inscription immediately above this representation is equally without parallel: Greek letters forming the word "Korisios." The importance of the inscription is that it is one of the very first testimonies to the use of the Greek alphabet north of the Alps. It is supposed that Korisios was the smith who made the sword.

Port has also supplied us with the only two helmets found intact in the Swiss plateau. They are the model of Celtic helmet which would subsequently be taken up and improved by the Roman army. The hemispherical iron skullcap is extended with a wide *tesa*, or neckguard, which is riveted on. One of the Port helmets has a wing-shaped ornament on the front. In this case the cheek-guards have also survived.

The numerous Late La Tène swords have long blades, which are sometimes very wide, and it is not uncommon for them to have some sort of device marked on them. Of the sheaths, the bronze models are the best preserved. The Zihl has also produced some unusual swords, such as the sword with the knobbed-hilt (*Knollenknaufschwert*) or the short sword the handle of which is in the form of a man. The latter was found at Schwadernau, about 3.5 kilometers further down the valley from Port while exactly where the *Knollenknaufschwert* was found is not known.

A noteworthy bronze ring clearly served some religious purpose. One face of it is decorated with relief representations of a whole line of aquatic birds and cow or bull heads with long horns. It is worth pointing out that the name of the river "Zihl" is derived from the Celtic word "tela," meaning "cow."

*Iron helmet from the site
of Port-Nidau (Berne)
End 2nd-early 1st century B.C.
Berne, Historisches Museum*

*Bronze ring decorated
with ox-heads from the site
of Port-Nidau (Berne)
End 2nd-early 1st century B.C.
Berne, Historisches Museum*

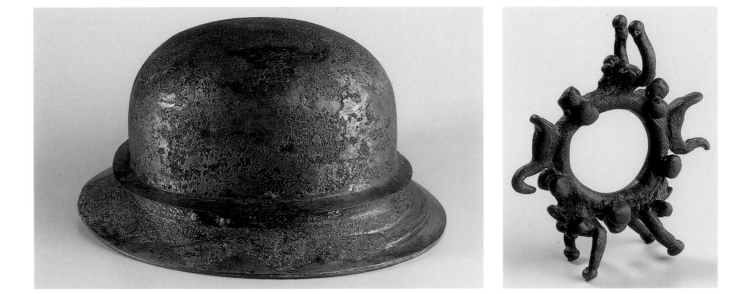

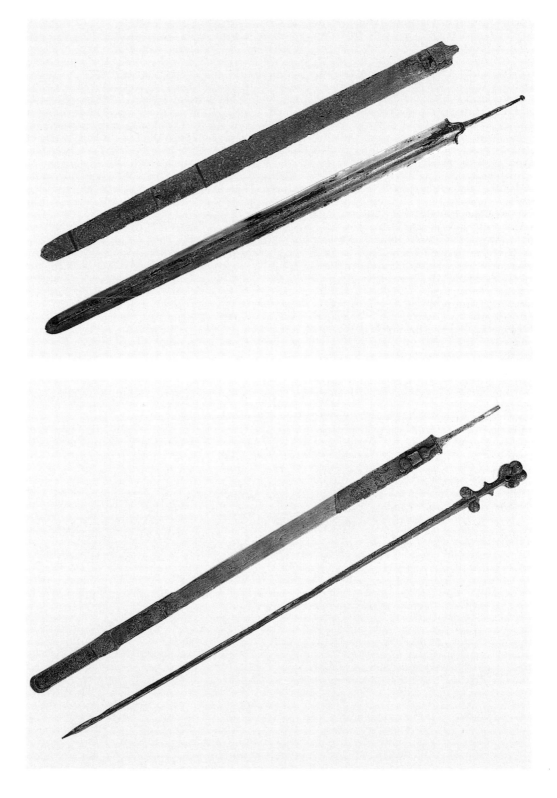

*Sword and scabbard, bronze
and iron from the site
of Port-Nidau (Berne)
End 2nd-early 1st century B.C.
Berne, Historisches Museum*

*Two iron swords from the site
of Port-Nidau (Berne)
End 2nd-early 1st century B.C.
Berne, Historisches Museum*

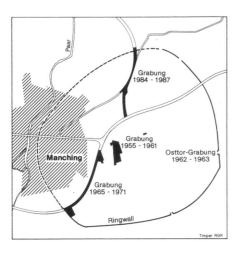

The Manching *oppidum* was protected by a seven kilometer long ring-wall. It enclosed a settlement and economic center of 380 acres. From the middle of the third century to the middle of the first century B.C. it was one of the most important sites of the late Celtic world. The complex is situated on the lower southern glacial terrace of the Danube Valley which, in this area, covers a width of up to ten kilometers. The natural waterway system must have been a fundamental factor in the choice of this particular site: to the north is the branched watercourse of the Danube, the tributaries of which reached the settlement. To the east, to the southeast and to the south lay marshlands and the Paar River with its vast alluvial grounds. Above all, the high well-drained area was perfectly suited to settlement and offered a vantage point over east-west traffic and a clear north-south routeway. On the other hand, the unusual position of the site on the plains necessitated the erection of massive ramparts, the remains of which are still visible today. The remains of the walls to the south, east and north-east and the eastern gate which were discovered during excavations carried out in 1962 constitute the only visible evidence of the Celtic city.

The story behind the exploration of the *oppidum* is directly associated with local construction activities. In 1936 the construction of an airport revealed the eastern half of the perimeter walls, which thus initiated the first archeological research work along the rampart and the consequent discovery of the internal structures. If the recent excavations carried out between 1984 and 1987 in the eastern side of the *oppidum*, are added to area excavated in 1955, it can be observed that these only cover a modest area of 11.05 acres, only 2.9 per cent of the total area of the *oppidum*. The areas excavated form a wide strip corresponding to the roadworks of 1965-1971 (south Manching) and those of 1984-87 (north of Manching), through the interior of the *oppidum*, interrupted in the center for 500 meters, and thus reaching the southwestern and northern fortified walls. This curvilinear strip is flanked by the large area excavated between 1955 and 1961.

The findings of the large, disconnected excavation in the fifties have built up a picture of Manching which is still considered valid. This is based on the traces of the post-hole constructions on storage or rubbish pits, on wells and ditches. Building took place over at least two or three phases completely differentiated in plan. One consisted of great complexes with long constructions while the other consisted of straight rows of smaller sized houses. Cult buildings, square simple houses with deposits, complete the picture. The frequent superimposition of the construction, particularly in the center, makes the recognition of the exact sequence of the settlement very difficult. Despite the isolation of the larger farms, the organization of the complex, with its streets, squares, cult structures, commercial districts of shops and work shops give the *oppidum* the character of an urban center. The building remains of the various phases, projected on a single excavation plan clearly indicate, as seen from the materials, that the settlement was in existence for at least two hundred years.

The beginning Manching settlement dates back to a third-century B.C. agglomerate of agricultural families with adjoining fields and pasture lands. The general consolidation of the Celtic group, during the second century must have caused a demographic concentration as well as the beginning of specialized jobs, together with the distinct signs of a new economy based on monetary circulation. The continuity of the site, with its solid agricultural background, until the insecurities and the confusion of the last third of the second century B.C. effected the Manching settlement. This phase coincides with the destruction and reconstruction of the site, in accordance with a new plan based on a different orientation and in particular the construction of the perimeter walls. The ancient commercial district was enclosed in these perimeter walls. The next sixty or eighty years must have been characterized by successive historical events which helped define the settlement as an *oppidum*. The first perimeter walls, the *murus gallicus*, were substituted in two phases by means of a construction of *Pfostenshlitzfronten* post sof the Kelheim type and the eastern gate, renovated during a final reconstruction, was destroyed by fire, lending support to this theory.

Soon after the middle of the last century B.C. the vital strength of the *oppidum* was evidently exhausted. It is not known whether the reasons lie in one of the remaining populations, in total devastation or in an economic crisis. The finds relevent to the farm houses consist of fire sets, kitchen and dinner sets, bowls and quern stones.

Site plan of the Manching oppidum (Bavaria)

Detail of the cult tree in wood and bronze with gold leaf mounts from the Manching oppidum (Bavaria) 3rd-2nd century B.C. Munich, Prähistorische Staatssammlung

Pottery, which after animal bones makes up the largest group of finds, is of local production, generally thin and decorated with various types of ornament. The spectrum ranges from large storage containers to thinner, wheel turned pottery. Horse harnesses and parts of carts give an indication of the type of transport and the importance of riding and of traveling. The work of the smith, wood, leather and material manufacturer is well attested in the tools. Metal waste gives evidence of a large production of iron objects. Certain types of coins and glass bracelets were also produced in the same area. Raw materials of importance, toiletry objects, particularly luxury products, were either bartered or purchased for money over a wide area of the Celtic world and even Italy. Weapons, jewelery and clothing underwent rapid changes unlike utensils and instruments. They provide, along with imports and certain features of the pottery, the most reliable fixed-points for the phases of occupation of the site. The inhabitants bred cattle, pigs, goats and sheep, which formed their staple diet as indicated by the finds of animal bones. Botanical analysis of the excavated soil provides evidence of the the vegetable diet and this, along with framework built up through pollen analysis, provides a sequence of vegetation and gives

a picture of the former landscape. The remains of a number of human skeletons, particularly skulls and long bones in secondary position, found inside the settlement have not yet been satisfactorily explained.

The most spectacular find of the 1984 excavation campaign was a small ritual tree, seventy centimeters in height, ornamented with ivy leaves, fruit and berries made entirely of wood and sheet bronze covered in gold. When found, the tree was situated on a large thin wooden plate covered in gold which was richly decorated. The tree must have been created by a Transalpine or Cisalpine goldsmith who was familiar with Italian techniques and the Hellenistic ornamental style. The tree with its leaves is part of that long tradition, which has been transmitted to us by the ancient authors, of the so-called cult of the trees.

Scale model of a section of the northern area of the enclosure of the Manching oppidum

The Votive Deposit at Niederzier
Hans-Eckart Joachim

*General view of the treasure
of torques armlets and gold coins
from Niederzier (Rhineland)
End 2nd-early 1st century B.C.
Bonn, Rheinisches Landesmuseum*

A fortified Late La Tène lowland settlement was fully excavated between 1977 and 1982 at Niederzier, the area with considerable lignite deposits, in the *Kreis* at Düren (northern Rhineland, Westphalia). It is one of the few settlements north of the Alps dating to the second and first centuries B.C. that have been fully excavated. The settlement was sited on a slight north facing slope. On the north side is one of two wide V-shaped ditches, which enclose an inner area measuring scarcely 2.7 hectares. The earth and wood rampart had been flattened by a later utilization of the ground in the Roman period. Inside the settlement was densely built-up in the central and southern areas whereas the northern and northwestern areas were used for economic activities. A deep well had been dug in both the eastern and western parts of the area inside the wall. On the sites of 80 houses a total of 270 buildings—houses, barns, and storerooms—were constructed; each site had been built on up to four times. They were all permanent buildings constructed using the *Fachwerk* technique (with timberlacing in the walls).

Since the settlement was abandoned in an orderly way without being destroyed, very few metal objects were left there. There were three interesting finds. A hoard was discovered in the western part of the settlement immediately next to a cult post. It consisted of two gold torques and an armlet and forty-five gold coins collected in a bowl. The decoration and shape of the torques have good parallels, for example in Vercelli, Italy and Pommereul, Belgium. The coins were twenty-six *Regenbogenschüsselchen* and twenty staters coined by the Ambiani. The total weight was 321.84 grams the equivalent of almost a Roman pound (327.45 grams). Niederzier represents the limit of the northern and eastern distribution of these coins. The hoard, with the ring-shaped objects, can be included among the Saint Louis/Basel-type discoveries, characterized by the presence of ring-shaped ornament and coins coming from other localities. Assemblages of this kind have been found as far apart as Italy, France, Germany and England.
The coins are accurately datable to between 120/100 and 80 B.C.. They belong to the

La Tène D1 phase. The dating is confirmed by the presence of two combinations of currency bars, composed of twelve and ninety-one *Schwarschwert*-type pieces respectively. Niederzier is the most western site to have bars of this shape.
Cultural influences from the south, east and west have been discovered at this site, a fact that can be explained by its geographical position. Since it was a centrally situated settlement, trading activity must certainly have been greater than in a peripheral settlement.
The pottery finds made it possible to establish the end of the Niederzier settlement as about 50 A.D. The abandonment of the fortified settlement is probably linked to the defeat of the Eburones by Caesar in 53 A.D.

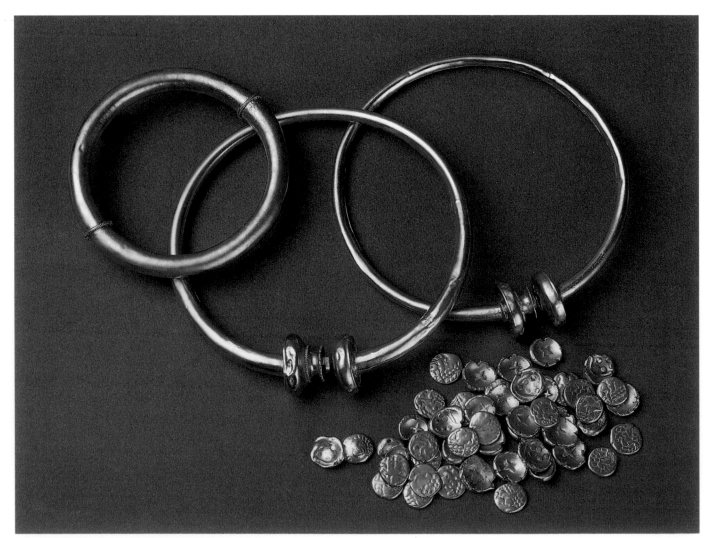

The Irsching Hoard
Bernhard Overbeck

This copious hoard was found at a depth of fifty to sixty centimeters during drain-laying operations in April 1859. The main hoard of over a thousand *Regenbogenschüsselchen* was complemented by fragments of black pottery, indicating that the treasure may have been hidden in one or more vessels. At first the discovery was kept a secret until a justice of the peace ruled in June 1858 that 917 of the pieces were the property of the municipality of Ingolstadt. Of this batch, 85 staters were sent to the Royal Numismatic Cabinet at Munich. The rest were allowed to be put on the market, and as a result most of the hoard was lost. Three hundred and one coins were sold to leading public figures such as the chemist Justus von Liebig and the poet Victor von Scheffel. The remaining 530 unsold coins were eventually melted down at the Bavarian mint and probably turned into koronas or ducats.

This occasioned the first close study of Celtic money by the royal mint. The staters weighed an average of 7.5 grams, with a gold content of 692/1000 and silver of 228/1000. All the more famous pieces of the hoard were closely studied by Franz Streber, conservation consultant to the Royal Numismatic Cabinet at Munich, and scientifically in the light of knowledge at the time. The essay published by Sieber in 1860 and 1861 on the *Regenbogenschüsselchen* is the first scientific publication on a Celtic find. The only earlier work is the leaflet by the brothers J. S. and G. B. Klauber of Augst printed in 1851 with illustrations of the Celtic coins found at Gaggers (Landkreis Dachau, Bavaria), comparable with the Irsching hoard.

In the attempt to date the Irsching finds, it is important to bear in mind the temporary assignation to La Tène D1: in absolute terms the hoard dates to roughly between the second half of the second century B.C. and the first half of the first century B.C. As far as we know, the Irsching hoard contained only Vindelici staters.

Obverse and reverse of the main types of gold "Regenbogenschüsselchen" from the cache at Irsching (Bavaria) Second half 2nd-first half 1st century B.C. Munich Prähistorische Staatssammlung

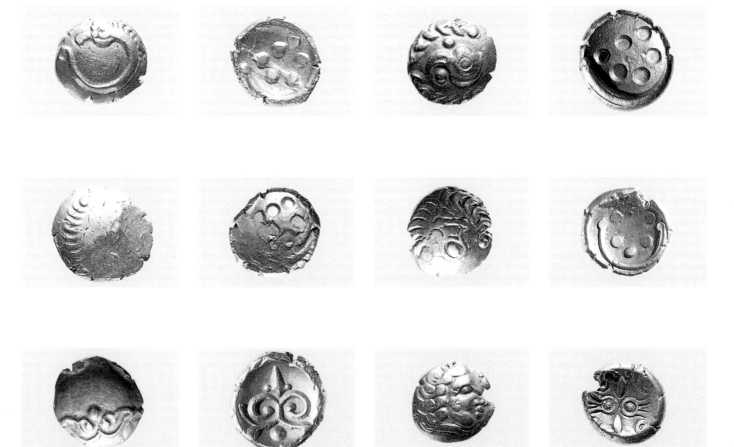

The Fellbach-Schmiden Sanctuary
D. Planck

Approximately one kilometer west of the center of Schmiden, in an area known as "Stiefeläcker," on the south side of the road that leads from Stuttgart-Hofan to Schmiden, there is a clay pit that has been worked for many years. In this area, parts of many prehistoric and protohistoric settlements have been found, with remains from the Paleolithic age, and the Urnfield and the Late Hallstatt periods.

During the autumn of 1977, on the north side of the road in a district known as "Langen," work began on widening the clay quarry. This led to the discovery by W. Joachim, the Director of Monuments (*Bodendenkmalphiege*), of ditches and remains from a settlement of the Late La Tène period. This paved the way for the vast 1978-80 excavations promoted by the local authorities under the direction of the present author. The local director of works was the excavations technician F. Maurer, and the outcome was a surface survey and study of a so-called *Viereckschanze* that was no longer recognizable on the surface. The enclosed area in question is situated in the middle of the Schmidener Feld, a fertile Löss-covered area between the Neckar and the Rems, on a gentle hillside providing a generous view east. The fact that this territory was hitherto held to be entirely lacking in traces of this sort is ample demonstration of the need to revise, radically, our image of late-Celtic sacred structures. At various points of the north and east sectors, discoveries and careful surveys were made of the narrow-bottomed graves and tombs called *Spitzgraben* by the German archaeologists (3.5 to 4.3 meters in width, and 1.5 meters in depth). The south side, no longer surveyable, would have run along what then became the clay quarry, on the south side of the road. In the middle strata of the ditch, a great many fragments of late-Celtic pottery were found, along with a bronze fibula of what is known as the Nauheimer type, and an iron fibula with a broad spiral, both of them typical of the previous stage of the Late La Tène period (phase D). The earth used for filling in the ditch also contained clay bricks and numerous animal bones. In view of the substantial soil erosion and the intensive farming, it was not possible to find traces of earlier enclosures or of earthworks.

Around 15 meters to the south of the tomb in the north sector, that is approximately 8 meters from the inner wall of the earthwork, a 20.5-meter deep round well was found. The first 19 meters of this were built up using a wooden structure composed of square panels 1.2 meters high. The two low-er meters of this frame had been preserved in remarkably good stater thanks to the constant flow of water. In contrast, the upper part had deteriorated continuously until it had disappeared completely. Nevertheless, traces of color left by the wood allow us to affirm that the structure originally stretched up almost as far as the top of the well. The well was supplied not by a water-bearing stratum, but by stagnant water found at a great depth. The elements that made up the wooden structure were joined together using mortise and tenon joints. In the northeast corner, between every second element, there was a peg; these formed a ladder that could be used for getting down into the well. Such constructions were common in the Roman age, between the first and the third centuries A.D. (for example at Welzheim, East Castle, well 2). The presence of the ladder is clear proof of the fact that the well was accessible. We can thus surmise that such a system was adopted in order to keep the water in the cistern clean.

Exploration of the wall took place over a period comprising six excavation campaigns. As a result, we have a very complete picture of the stratification of the installation. Botanical studies carried out by Professor U. Körber-Grohne of the University of Hohenheim has shown that the lower infill consists of the very fertile earth typical of settlements. Closer to the surface there was also a layer of compost almost one meter thick. This proved to be made up not of stable manure, but of the sort of dung that builds up in pasture land near the watering-troughs. Layers still closer to the surface did not present particular features. In the layer between 17 and 18 meters down, there was a stratum of infill made up of various woods in a good state of preservation. Since restoration is still in its earliest stages, for the moment it is not possible to formulate positive conclusions. The wooden fragments comprise both raw branches and pieces of trunk, and hewn elements used for building, many of them in oak and largely well preserved. It is interesting to note that such constructional elements often prove to have been burnt, which would appear to indicate that an abandoned well coincided with a fire. Certain of these wooden items are of particular significance for the installation as a whole. At the bottom of the well, which was tub-shaped and not paved, numerous fragments of a splendidly worked wooden bucket were found alongside horse and cattle bones, and a structure consisting of two spirals that face each other to create a figure of eight. The

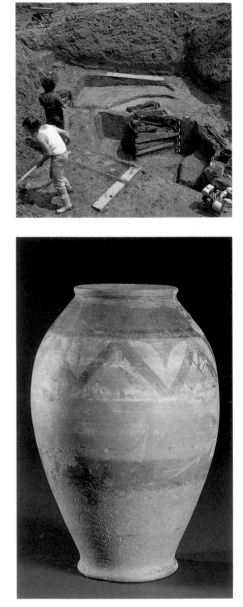

*The cult pit in the sanctuary
at Fellbach-Schmiden
(Baden-Württemberg)
currently being excavated*

*Painted terracotta vase
from the cult pit
at Fellbach-Schmiden
(Baden-Württemberg)
End 2nd-early 1st century B.C.
Stuttgart
Württembergisches Landesmuseum*

latter object was probably part of the device used for gaining access to the well. Along with the peg ladder for getting down into the well, the bucket also bears witness to the fact that the population was able to exploit seeping water by digging down deep. The lower strata have also revealed a wooden sword, clearly of no practical use, which I believe belonged to the sphere of worship. Between the collapsed building wood, in the third perpendicular and horizontal layer, finely sculpted animals in oak have been found, some of them with traces of yellow paint still on them. Their position would suggest that these objects were thrown from above. Two 90-centimeter tall figures represent billy-goats standing on their hind legs, the stance well elongated and the head adorned with large pointed horns fitting close to the body. Their flanks were encircled by a human forearm and hand. Although the human figure is missing, it would seem that it originally stood between the two animals placed opposite one another. A third figure was carved to represent the forequarters of a stag with splendid antlers and the eyes, like those of the goats, are almond-shaped. This is a wooden sculpture of great artistic merit that has no known parallel. Despite the lack of the hindquarters, we can presume that this creature was also portrayed standing up on its hind legs. The height of the surviving portion of the stag is 80 centimeters. Traces of a sort of tendril crown on its head show once again that the original composition was more complex. The three figures are obviously the work of a first-class artist who could handle the proportions of his subjects as well as the irregularities of oak wood. So far we are not able to establish how such items related to the rest of the wood structure: it may be that the three figures all belonged to a frieze that then fell apart. Likewise, we are as yet unable to ascertain whether the figures and the wood structure were part of a little "well-house," or indeed of another wooden building. By the same token, we cannot at present say how the wooden figures would have been positioned in the frieze, since no other elements of the structure have survived. Numerous handmade pottery vessels with scratched and combed decorative motifs, along with rougher pottery products, were also found among the materials used to fill in the well. On the bottom of the well, two other vessels were found in an almost perfect state of preservation. One was made of pottery with scratched and combed decorative motifs, and the other was a 23.5-centimeter tall painted cask, practically still in one piece.

Both are unique in the Württemberg region. The pottery unquestionably derives from a Late La Tène deposit. Some Roman fragments, found in the infill of the well, might suggest that the well was actually finished during the Roman age. In the meantime, both the wood used for the infrastructure and the well-preserved pieces that were part of the infill have been subjected to dendrochronological analysis. The evaluation and interpretation of data ragarding the wooden finds were entrusted to Doctor B. Becker of the Institute of Botany at the University of Hohenheim. His studies show that wood used for the well came from trees cut down in the year 123 B.C., just slightly after the date of the original well excavation, and at about the same time, in my opinion, as the production of the pottery that has since come to light. The discoveries made at Schmiden make it quite clear that the well was not part of a cult structure like those found beneath wooden buildings, where organic offerings were deposited; on the contrary, it was a water well. The water itself, abundant in view of the very depth of the well, would have been used for the sacred rites. Studies undertaken so far would suggest that the well was abandoned around the year 80 B.C., for reasons that we cannot explain with any certainty. The shaft was gradually filled with earth that at least partially derived from settlements comprising inhabited areas, and with a layer of dung that bears witness to the existence in the vicinity of pasture lands and a lot of cattle. Thanks to these results, the Schmiden discoveries throw a great deal of light on the meaning of the *Viereckshanzen* of the late Celtic period. Although it is still too early to establish parallels between these finds and those of other structures, nonetheless the results of the excavations indicate that established views need to be revised in many respects.

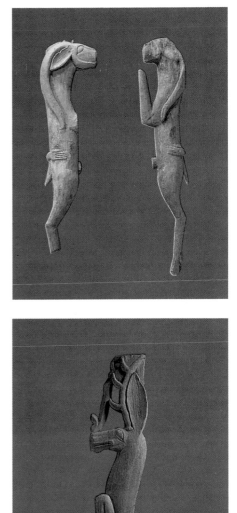

Pair of wooden statues with two heraldic goats from the cult pit at Fellbach-Schmiden (Baden-Württemberg) End 2nd-early 1st century B.C. Stuttgart Württembergisches Landesmuseum

Wooden statue of rampant stag from the cult pit at Fellbach-Schmiden (Baden-Württemberg) End 2nd-early 1st century B.C. Stuttgart Württembergisches Landesmuseum

The Dejbjerg Carts
Flemming Kaul

Figurative bronze mounts
from the chariot found
at Dejbjerg (Denmark)
1st century B.C.
Copenhagen, Nationalmuseet

Bronze mount with protome
from the chariot found
at Dejbjerg (Denmark)
1st century B.C.
Copenhagen, Nationalmuseet

In 1881 and 1883 the two famous carts were found in a bog in western Jutland. The archaeological examination showed that they had been taken to pieces and placed on a low, almost dry ridge in the middle of the bog. The wagonparts were enclosed by stakes driven into the ground, probably delimiting the sacred area of the offering. The two carts are four-wheeled with respectively twelve and fourteen lathe-turned spokes. The iron tires had been sweated on to the oaken felloes. The wooden hubs are of oak, accurately turned; in the center they bear cast and turned bronze collars. One of the wagons was almost fully preserved, and the body with its sides and cross-members is decorated with mountings of openwork sheet bronze, some of them also with geometric designs in repoussé. The uprights of

belts that one finds the most satisfactory resemblances, both with the Dejbjerg carts and the other carts of this type from Denmark (see below).

This, however, does not necessarily place the origin of the Dejbjerg carts in north Germany. Two recent finds of remains of carts quite similar to the Dejbjerg ones have shed new light on the problem of provenance: from a settlement at Fredbjerg in central north Jutland come comparable pieces of sheet bronze with punched decoration; the shape and the dimensions of the bronze collars of the hubs are identical. The Fredbjerg find also includes bronze mountings in the shape of bulls and ducks. Altogether Denmark can now offer five find-spots of these wagons. Two are from rich, almost princely cremation graves excavated

in the last century, Kraghede in North Jutland and Langa in the Island of Fyn, and two are settlement finds, from Fredbjerg, and Dankirke in southwest Jutland, whereas Dejbjerg itself must be regarded as a votive offering.

It is a remarkable fact that this Danish group of carts shows a striking interrelationship in details of decoration as well as in construction and craftsmanship—an interrelationship which cannot be shown with the central European carts. The similarities between one of the wagons from Dejbjerg, the Fredbjerg wagon and the Langa wagon are so close that they are probably products of the same workshop. With the new finds the splendid Danish wagons stand apart from the central European ones as a marked and homogeneous group, strongly indicat-

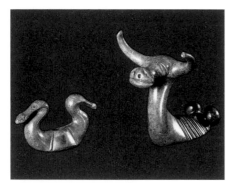

the sides of the cart bear repoussé male masks with characteristic "Celtic" arched moustaches. In the body there is a seat with four stout legs.

Owing to their many Celtic elements the carts have generally been regarded as being of Celtic workmanship, made in the first century B.C. For instance, the arched moustache is a familiar representation among the Celts, especially on Gaulish coin pictures, where the same facial form is seen. Also the openwork decoration and the geometric patterns are well-known among the Celts, even though exact parallels have not been found. The shape and decoration of the rivet heads are exactly paralleled in a number of Celtic finds, and the construction of the wheels using the technique of sweating for fastening the tires is regarded as an expression of the excellent Celtic craftsmanship. It has been suggested that the most probable place of manufacture is northern Gaul or the middle Rhine area.

Lately, that location has been reconsidered and the Celtic origin questioned. The best parallels to the punched geometric figures somehow reminiscent of the earlier Hallstatt style is not to be found in "the Celtic world" but on belt mountings from graves in the north, German provinces of Schleswig and Holstein. Even though patterns like triskeles, S-motifs, concentric circles, half-circles, etc. frequently occur on Celtic coins, it is on these so-called Holstein

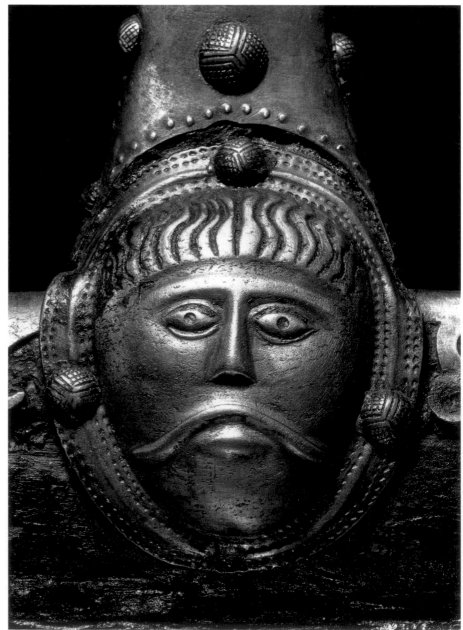

ing that they were made in Denmark. The Dejbjerg Carts and the rest of the group must be regarded as having been produced by one or more local workshops in the first century B.C. Nevertheless, the Celtic impact is apparent—and the art-style seen on the wagons can readily be characterized as "Celtic." As a "mediator" area north Germany might be pointed out—but for instance the heads on the Dejbjerg Wagon with their moustaches are so clearly of Celtic appearance that more direct contacts might be considered.

Like the ball torques, a type of indisputable Nordic origin (which share many stylistic elements with the wagons, including the mixture of artistic elements which can hardly be contemporary in central and/or western Europe), the Dejbjerg find pro-

vides testimony of the impact and potency of Celtic art and of how "Celtic" taste became dominant far from the "Celtic world," at any rate for luxury and/or religious objects. The carts, ball torques and certain types of brooches demonstrate that the areas where "Celtic art" was executed were not necessarily the areas of Celtic settlement—that Celtic art and Celtic "ethnicity" in this case must be seen as two quite different notions which can be geographically separate.

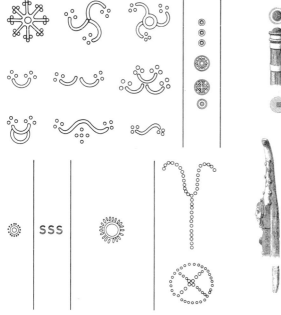

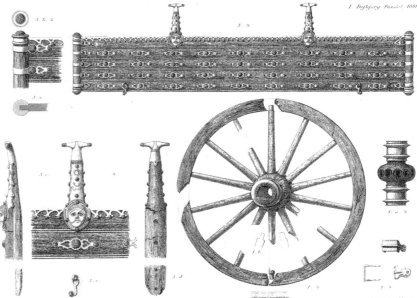

Geometric motifs from the chariot found at Dejbjerg (Denmark) 1st century B.C. Copenhagen, Nationalmuseet

Chariot components in wood with bronze mounts from Dejbjerg (Denmark) 1st century B.C. Copenhagen, Nationalmuseet

The chariot found at Dejbjerg (Denmark) Copenhagen Nationalmuseet

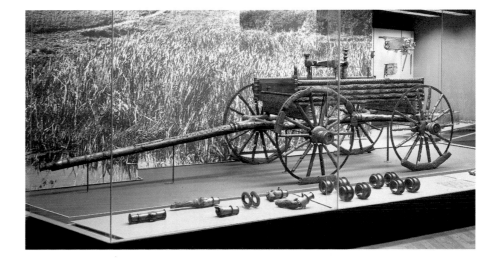

The Gundestrup Cauldron
Flemming Kaul

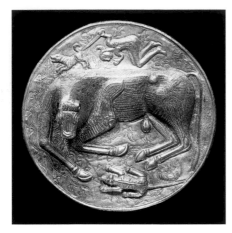

*Internal component from inside
the silver cauldron partially gilded
from Gundestrup (Denmark)
First half 1st century B.C.
Copenhagen, Nationalmuseet*

The Gundestrup Cauldron was found in a bog in Himmerland in Jutland in 1891. The silver cauldron, which weighed almost nine kilograms, had been dismantled and deposited on a dry piece of bog land (as shown by pollen analysis). The enigmatic depictions of deities and religious scenes on the thirteen silverplates make the cauldron one of the most important works of art of European prehistory, and probably no other work of craftsmanship has occasioned so much publication and dispute.

Weapons and ornaments depicted on the cauldron make it reasonable to assume that it was made around 100 B.C. There have been very different opinions as to its place of origin. Two areas have been preferred: present day France and the areas at the Lower Danube.

The reason for this divergence is the ambivalence of the testimony of the cauldron: on one hand the style and workmanship is clearly Thracian, on the other some of the motifs are clearly Celtic, some of them most frequently occurring in Gaul. Recent finds from Thracian silver hoards and graves in Bulgaria and Rumania have provided new material for comparison.

Let us consider a number of the more or less contradictory aspects of the cauldron. Firstly the cauldron itself is a clear Celtic type, which is never found among the Thracians. On the other hand the technique—silver embossed in high relief and partially gilded—is typical of Thracian craftsmanship from the fourth to the first century B.C. Also, the way of showing the hair of animals is very Thracian in conception: for instance feather-like patterns for long hair and rows of transverse strokes for shorter hair. The presence of dogs and fantastic animals like griffins shows a close relationship between the Gundestrup Cauldron and Thracian art. A particular pattern is the whorl on the forehead of the great bull on the bottom-plate. Although such whorls or triskeles are well known in Celtic art they never occur on the forehead of bulls, whereas this specific trait seems to be distinctively Thracian.

Similarities as to the style of the human heads can be seen both in Thrace and in Gaul. It has apparently been difficult to find satisfactory parallels for the dress seen on the Gundestrup Cauldron—but a very striking parallel is seen on a Thracian phalera found in a grave at Stara Zagora in Central Bulgaria. It shows Herakles fighting the lion (the central motif), wearing a dress completely identical with the one seen a number of times on the cauldron—the blouse and thigh trousers ending just above the knee with their striped pattern; also the broad, dotted belts are completely alike.

The evidence of the artifact types on the cauldron show a certain ambiguity as well. The majority of the torques are clearly Celtic types most frequently found in the West, but also used by eastern and southeastern Celts (e.g., "The Dying Gaul"). Two of the torques however, belong to a group of rare non-Celtic torques probably having their home in south Russia at the Black Sea. The shields depicted on the cauldron are the typical Celtic long shields, but evidence from Bulgaria and Rumania shows that this type of shield has also been used by eastern non-Celtic tribes. In the southeast of Europe the blowing horn, the *carnyx*, has never been found in the shape we see it on the Gundestrup Cauldron whereas renderings of it are very frequent in western Europe. Also the helmets seen on the cauldron are Celtic; the types with birds of prey or boars on their crest are known among both the western and eastern Celts.

Some of the iconographical motifs seem to have their best equivalents in Thracian silverwork, but on the other hand the god with the antlers can be identified with the western Celtic god Cernunnos, not evidenced in the East. Also the ram-headed snake accompanying him is a western Celtic element.

How can we explain this ambivalence of the evidence? Who produced the Gundestrup cauldron and where do we find a cultural or political situation satisfying the "demands" of this evidence?

The best solution to the problem is the Celtic Scordisci tribe who in the third century B.C. settled partly in the area of the Thracians. For many years the Scordisci, known from historical sources, seemed to be a rather enigmatic tribe, but recent archaeological studies have demonstrated that the very conditions which the contradictory evidence demands are to be found in their area of settlement. Especially in northwest Bulgaria several burial grounds document a seemingly peaceful coexistence of the Thracian Triballoi tribe and the Celtic Scordisci—a coexistence also hinted at by historical sources. In my opinion the only possible place of manufacture of the Gundestrup Cauldron is in the highest echelons of this interwoven symbiotic tribal society, where it could have served as a religious and political "medium" reinforcing the mutuality of power, on certain occasions consecrating that very power of dual "kingship."

We shall probably never learn how the cauldron found its way to Denmark. Perhaps it was brought back by Cimbri who on their raid through Europe also had contacts with the Scordisci. The region of Jutland where the cauldron is found still bears the name of the Cimbri tribe—Himmerland.

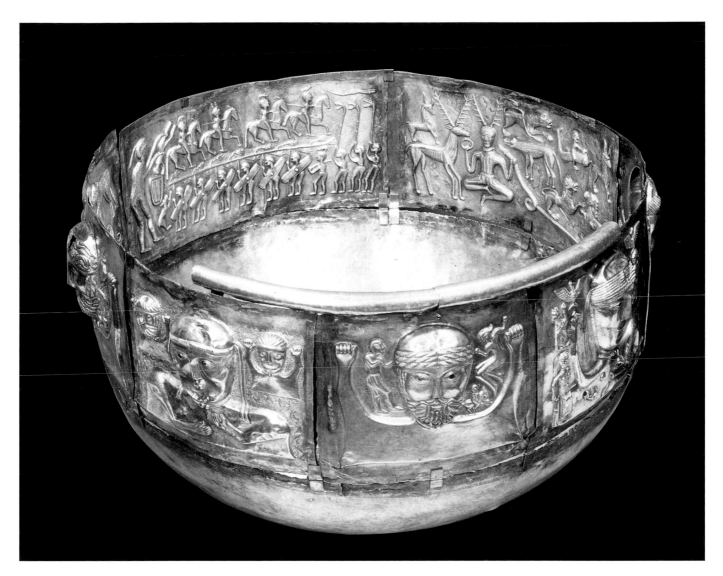

*General view of cauldron made
of embossed silver plaques
from Gundestrup (Denmark)
First half 1st century B.C.
Copenhagen, Nationalmuseet*

The Ball Torques
Celtic Art Outside the Celtic World
Flemming Kaul

Bronze torques from Gammelborg and Eggeslevmagle (Denmark) 2nd century B.C. Copenhagen, Nationalmuseet

Bronze torque from Tømmerby (Denmark) 2nd century B.C. Copenhagen, Nationalmuseet

The so-called ball torques provide an excellent example of how knowledge of Celtic art penetrated deeply into areas far north of the "Celtic world." These torques with their characteristic ball-shaped terminals decorated in obviously Celtic style are of indisputable nordic origin, since they were found in eastern Denmark, south and central Sweden and Norway.

The ball torques seem to be descendants of simpler necklaces of the Early Iron Age in which two hooked ends engage each other. Probably as a local answer to the Celtic torques with enlarged ends or ball-like protuberances, the terminals underwent a development into the distinctive, large balls. Several types are discernible, but since only some of them have been found in a datable context, it is very difficult to establish a firm chronological sequence. A torque found at Tommerup on Zealand provides a typologically early example. Its terminals are shaped like double-balls; the outer ball is decorated with raised spirals. The Celtic Plastic Style is being imitated here, closely associated with "classical" La Tène art of the third century B.C. The Tommerup torque, however, does not have to be dated alongside its nearest stylistic parallels in central and western Europe, for it is well known that stylistic feautures from these regions were "preserved" for long periods in northern Europe, and non-contemporary Hallstatt and La Tène features meet in a perplexing manner. The ball torques themselves offer an illustration of this, as the actual rings often carry stroke ornamentation in V-patterns, zigzags, semicircles, and other motifs reminiscent of the Hallstatt style.

Another group of ball torques, found mostly in central Sweden, is decorated with small knobs, also showing the influence of the Celtic Plastic Style. Some of these have been found in cremation graves associated with objects dated from 100 B.C. or the second century B.C.

The finest of the ball torques—perhaps a local east Danish type contemporary with the type mentioned above—is characterized by raised curved triskeles of strong and tense composition. In the open space between the arms of the triskele are engraved smaller versions of the same design with circular impressions. The actual rings bear engraved S-shaped designs, triskeles, and oblique lines. The torques found at Gammelborg, Isle of Møn, and in a bog at Eggeslevmagle, central Zealand, belong to this group. The triskele is indeed a very typical Celtic element of art, and its plastic appearance has counterparts on certain Celtic necklaces, while the engraved triskele with its small dot-like circles is a common motif on Celtic coins. Even though the ornamental elements are of clear Celtic design, they are not necessarily derived directly from central Celtic sources. The non-plastic engraved triskeles with their small circles and the S-patterns occur on a group of bronze belts from northern Germany and are also seen on the famous Danish Dejbjerg cart. Some details of the plastic ornamentation on the various types of ball torques seem to hint at influences from a cultural group at the fringe of the Celtic world proper, in central eastern Germany and Bohemia.

The deposition practice of the ball torques differs strikingly in central Sweden and Zealand—the two core areas of distribution with their local types. Whereas a large number of the central Swedish torques have been found in graves, those from Zealand never occur in this context—finds from bogs predominate, and consequently the Danish ball torques must be regarded as offerings.

The ball torques testify to the potency of Celtic art, being only one notable instance of its impact in the north. Directly and indirectly the nordic metal craftsmen could acquire—and to some extent elaborate—a quite foreign art style. The ball torques of irrefutably nordic workmanship—in some cases with almost pure Celtic decoration—also raise the question of whether objects like the famous Dejbjerg cart could be of local manufacture as well.

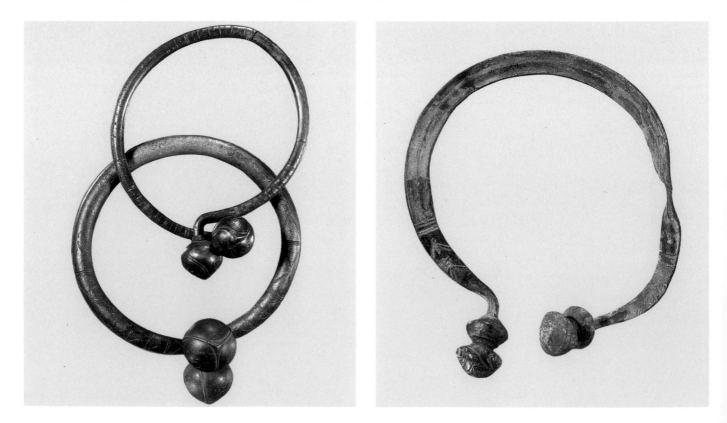

Stradonice: A Celtic *Oppidum*
Jiri Bren

The most famous Celtic *oppidum* in Bohemia is certainly the fortified site in Stradonice near Beroun. It was the first major Celtic fortified site in our country to have been "investigated." The fate of the *oppidum* is rather unfortunate. The first time that this monument was destroyed was towards the end of the first century B.C. when Germanic tribes invaded Bohemia; most of the dwellings were burned down in a fire. The *oppidum*, in effect, "vanished." The second time it was vandalized was at the hands of antique dealers during the last quarter of the nineteenth century when they plundered it and sold its relics all over Europe. Indeed, objects from Stradonice are to be found in practically every large museum abroad, in Vienna, London, St. Germain-en-Laye, Geneva, Dresden as well as in a number of museums in Bohemia. There are also large collections of finds from Stradonice in what used to be the Fürstenberg collection at Křivoklát castle and in the Donaueschingen château.

In the past, the fort was well-known as a great source of bones, which were collected by the people of neighboring communities and then resold for the manufacture of bone-meal. An estimated thirty railway cars full of bones were unearthed. This was in 1877, the same year in which a treasury full of golden coins was also discovered. It was only then that the fate of the *oppidum* was decided.

"Research" activities were redoubled, whereupon a large part of the castle site was uncovered in an utterly unscientific way. This "research" produced a great deal of exceptional material, amounting to some 80-100 thousand objects, but this particular collection is of minor historical value since the contexts in which the individual objects were found were never recorded. However, as a whole they suggest that what was destroyed had, perhaps, been Bohemia's greatest center of trade and commerce in the La Tène era. Among the most valuable artistic objects is a small collection of minia-

ture animal figures. Evidence also shows that pottery was the most successful trade item for the Celts. The most beautiful vessels are those painted and decorated in red and white tones with horizontal stripes and various geometric patterns. The most specialized trades represented were iron-founding, lock-making and jewelry-manufacturing. Certain types of metal tools found here are used to this day and their shapes have remained unchanged over the centuries (hammers, knives, spades, sheep shears and so on). The largest number of glass objects dating to the protohistoric period in Bohemia is from Stradonice (mainly fragments of bracelets and beads), about 600 pieces in all. Fragments of wine amphorae, bronze pots and pans, molds for rings and frames for small writing tablets provide evidence of considerable trade with the south, in particular with the region of Italy.

There is a remarkable collection consisting of hundreds of coins including gold Rainbow pieces (*Regenbogenschüsselchen*), others in silver with representations of a horse, and potins. Rectangular clay molds for casting coins indicate that these coins were minted on the site.

Perhaps the largest number of fibulae in Europe was discovered at this *oppidum*. Current estimates suggest that there are around 1,300 examples, including a gold spoon-shaped fibula. The others are made of silver, bronze and iron. On the evidence of the fibulae, the *oppidum* may be dated to around 120 to 15 or 9 B.C.

The first comprehensive analysis of the Stradonice discoveries was made by J.L. Píč in 1903. So far, this is the best publication on the *oppidum* from both the archaeological and the historical points of view. The close similarities between the material from Stradonice and that discovered at the French *oppidum* known as Bibracte was noted by the French archaeologist, Déchelette, who apparently learned Czech in order to read the original version of Píč's work.

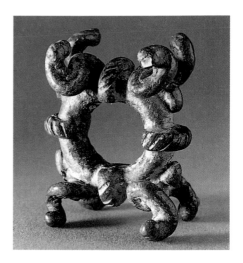

Bronze ring decorated with schematic ram's head from the Stradonice oppidum (Bohemia) 2nd-1st century B.C. Prague, Národní Muzeum

Terracotta vases from the Stradonice oppidum (Bohemia) 2nd-1st century B.C. Prague, Národní Muzeum

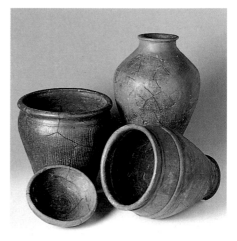

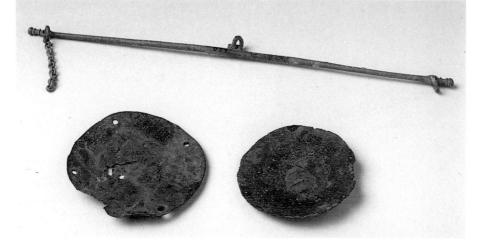

Bronze scales for weighing coins from the Stradonice oppidum (Bohemia) 2nd-1st century B.C. Prague, Národní Muzeum

The *Oppidum* of Závist
Karla Motyková, Petr Drda, Alena Rybová

The second-century B.C. protohistoric *oppidum* of Závist, a fortified town of considerable influence, grew on the ruins of an earlier Celtic settlement dating from the fourth and fifth centuries B.C. The original name of the site is unknown, but early texts of the sixteenth and seventeenth century A.D. speak of a lost town founded by the Boii that was the seat of power for the area's sovereigns long before the founding of Prague. It convered over 150 hectares, the enclosure was vast, and its elaborate defense wall ran a perimeter of over nine kilometers. Due to its size and to the wood which later grew over the site, systematic excavations did not start until 1963. The site's stratification is highly complex as the top levels were subjected to repeated renewal from the most remote prehistoric times through to the beginning of the Middle Ages. The lengthy, elaborate excavations campaign involved an entire squad of archaeologists and specialists.
Until 1989, various zones of the *oppidum* underwent a series of excavations of varying dimensions. The defense works were studied at five different points; the best known information has come from the main entrance, at Gate D. The oldest structures presented the typical inturned entrance in which visitors were channeled along a corridor thirty-two meters long flanked by fortified walls. At the end of the passage was a wooden portal. The passage walls and the ramparts were built using a technique common throughout Europe, consisting of a stone-faced wall reinforced with vertial timbers. The earthworks themselves were timber-laced. Both the gateways and ramparts needed constant maintenance, and the walls had to be rebuilt from scratch regularly. The causes for the deterioration of the wall were not all natural. In some case walls were destroyed by fire. Over the years, five successive main gates were built at the Závist *oppidum*. The series of foundations which came to light during vertical stratigraphy serve as a basis for speculating on the architectural evolution of the entire fortified settlement.
Almost immediately behind the defense works were the first dwellings together with simple trade outlets, following the countours of the inside terrain and planned around a road grid. The *oppidum's* development was so rapid that the only thoroughfare, beginning at Gate D was quickly unable to cope with the traffic. In the first century B.C. a second causeway was created,

along with three new gates, A, B, and C. All these conclusions were drawn directly from the careful study of Gate A and the immediate vicinity. At the same time, the size of the enclosure gradually grew, each time protected by new ramparts; this fostered the emergence of isolated clusters of dwellings.
In the final phase of development, the *oppidum* annexed a vast sector of land north of the fort, separated by a huge ditch. This area covered a surface area of fifteen hectares and was particularly well fortified, as if to offer a refuge.
Excavations in the religious precincts and clustered dwelling areas, and in the vicinity of Gates A and D together with other preliminary surveys have given a clearer picture of the settlement's structure, which consisted of large farms, and small houses built along the causeways. The finds from both the houses and the farms reveal the great variety and extent of the specialized craftwork and domestic activity. Metalworking, and particularly ironworking, was highly developed. The economic importance of Závist and its manifest political and administrative authority is apparent from the production of gold and silver coinage, as seen from various workshops found in the farm areas. It is no coincidence that a bone stylus, unfinished, turned up near the main entrance to the *oppidum*; this tool was used for drawing figures.
The basic diet of the inhabitants was farm produce. Traces of cereals, legumes, and other crops together with scattered vegetal remains have provided clues as to the natural resources of the settlement area.
Stratigraphic tests and a careful analysis of finds have proved that Závist was conceived as an *oppidum*, as part of the network of Celtic *oppida* in Bohemia. Its disappearance, resulting from a disastrous fire linked to the decline power in Bohemia and the invasion of Germanic Swanbians, can be dated to between 25 and 20 B.C.

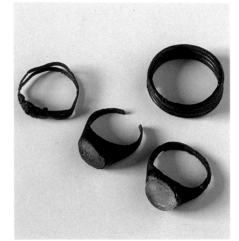

*Bronze and glass finger rings
from the Závist oppidum (Bohemia)
2nd-1st century B.C.
Prague, Archeologický ústav ČSAV*

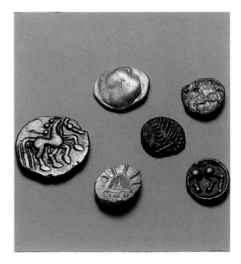

*Gold and silver coins from the Závist
oppidum (Bohemia)
2nd-1st century B.C.
Prague, Archeologický ústav ČSAV*

Bone stylus and bronze amulets
from the Závist oppidum (Bohemia)
2nd-1st century B.C.
Prague, Archeologický ústav ČSAV

Iron arrowheads from the Závist
oppidum (Bohemia)
2nd-1st century B.C.
Prague, Archeologický ústav ČSAV

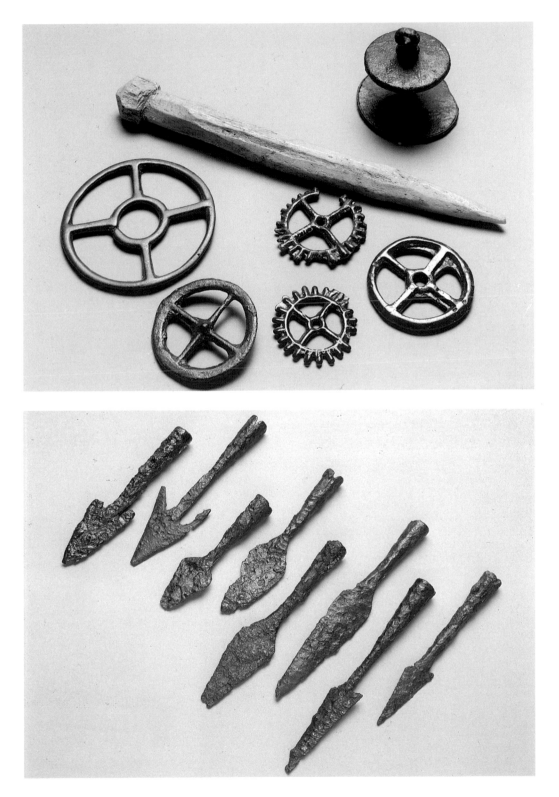

A Celtic *Oppidum*: Třísov
Jiri Bren

The Celtic *oppidum* in Třísov near Český Krumlov is the southernmost Celtic castle site in Bohemia. It is about 60 kilometers from the Linz area where the nearest other *oppida* are found. Třísov is 550 meters above sea level and 26 hectares in size. Although it is one of the smaller castle sites, it played an important role throughout prehistory. It is located in the middle of an area where there is good quality graphite, used by the Celts to make their graphite pottery. At that time, graphite pottery was used instead of the boxes and bags of today. Graphite ware, which is less permeable, was shipped south where it was filled with salt and distributed throughout the eastern Celtic area from the *oppidum* of Manching near Ingolstadt to that of the Gellért in Budapest and from the salt mines in Austria to central Bohemia. In the last century, the settlement in Třísov was ascribed to the Slavic tribe known as the Doudlebi; only as late as the 1930s was its Celtic origin acknowledged. Research in that field was carried out by B. Dubský and L. Franz, and at the end of World War II, the National Museum in Prague continued that effort. The *oppidum* was built on a headland on the confluence of the Krems stream and the Moldau River and was naturally protected by sheer slopes up to 120 meters in height. It was easily accessible only from the west, so the Celts built two belts of stone walls

(today in ruins), in front of which there were deep ditches as well as a so-called pincer-type gate. The ramparts had a wooden chamberlike structure including a clay and stone facing. The external stone wall fortification was laid down in a dry state and upheld by massive perpendicular posts. The building is unusual in that there are at least two horizontal bands of chiselled stone facing, similar to travertine slabs.

There were built-up areas situated in a broad, shallow hollow between two hills and in strips at the edge of the *oppidum*. An octagonal 12-meter building was discovered on the northern hill in an area demarcated by a shallow ditch; this represents one the first stages of future Gallic sanctuaries. On the southern hill huts were built with more advanced technology, that is, with a stone retaining wall. These were suitable as dwellings. A fireplace was also discovered there. Other inhabitable huts were located on the strips on the edge of the *oppidum*, including pit-dwellings with fireplaces. In the hollow between both hills there were post-buildings without fireplaces. However, they did include deep pits which served as warehouses for grain storage. It appears that the entire area of the *oppidum* had been divided into "districts" as follows: the sacred district on the northern hill, the governmental district on the southern hill, the residential district on the edge of *oppidum* and the

warehouse district in the middle of the hollow. In the warehouse area, special cisterns for collecting rainwater were uncovered. In all the residential huts, one could distinguish two separate layers, that is two phases of settlement differentiated by the types of fibulae found in them. Currently, graphite pottery discoveries (which amount to 75-80 percent of all the finds), are being analyzed. According to a chemical analysis, the ceramic objects in the lower layer contained about 13 percent of graphite whereas those in the upper layer had a higher percentage of lead, around 20 percent. The metal objects that were also discovered there consist primarily of tools and bronze jewelry as well as glass bracelets and beads. Pieces of imported bronze vessels, including fragments of a small post-Hellenistic-type pottery lamp and other items, indicate that commercial ties existed with the south. Some coins were minted in Třísov, with plaque-shaped molds. These discoveries point to the fact that the *oppidum* dates back to 90/80-15/9 B.C.

View of the site of the Trísov oppidum (Bohemia) toward the Moldau River

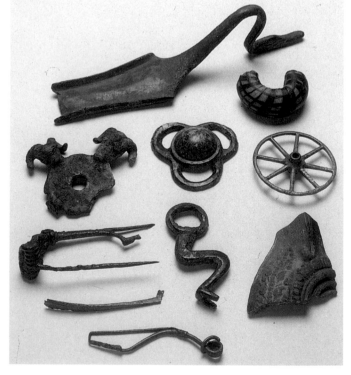

Selection of objects in bronze, iron glass, and terracotta from the Třísov oppidum (Bohemia) 1st century B.C. Prague, Národní Muzeum

The Kolín Tool Hoard
Karla Motyková and Alena Rybová

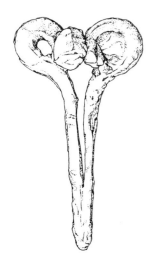

A hoard of sixty-eight objects datable to the Final La Tène period was accidentally discovered in the western part of the town of Kolín, on the left side of the Labe/Elbe River, in 1936. The position of the finds implies an original deposition in a kind of a bag or in some other organic wrapping. No settlement evidence has come to light in the area of the find. The objects weighed about fifteen kilograms and both their quality and their diversity indicate a high level of Celtic ironworking and blacksmithing. First, mention should be made of a fireside tool kit: a complete and highly articulated suspension device for a kettle, a rim fragment of a smaller iron pot, part of a kettle with an iron rim, and a ring-shaped handle with a shaft-shaped loop and a handle of a small hearth shovel. Another group is represented by ironworking tools: a hammer, a massive chisel and two rods—probably burins. Woodworking is attested to by an adze, spokeshave, three chisels with shafts and nine axes with shafts.

A prominent position is occupied by a group of agricultural implements for both cultivation and harvesting: two ploughshares, three hoes, a sickle, a scythe, a ring for fastening a scythe handle and a chopper for leaves. Such tools as choppers, massive and smaller knives and scissors probably belonged to common equipment of Celtic households though they might have been used for some of the arts and crafts or in hunting or agriculture. Four keys and a spring bar (from a lock?) belong to house furnishings. An other important component of the find is represented by weapons such as a lancehead and fragments of iron components of a shield. Elements of a wagon and harness turn up in the form of a fragment of a wheel fitting, a spring wheel peg and a ring-shaped cheekpiece of a horse-bit.

The remainder is made up of chain fragments, rings and clamps.

The analysis of the contents of the find indicates that some objects could have been made as late as the middle of the first century B.C. A number of tools show unequivocal traces of wear and none of the objects appears to have been a brand new product. Another interesting feature is the fact that the range of tools and other objects of the Kolín hoard covers all the principal occupations usual in ancient society. A certain kind of specialized work is represented by every functionally determinable tool. Even if a certain type of a tool occurs more than once (e.g. axes, chisels, hoes, ploughshares, choppers, knives), there is always a variation in form or dimensions. We can thus put forward a hypothesis that every item had been intentionally selected as representative of a particular kind of activity. On the other hand, there is a conspicuous absence of products of the goldsmith's trade, as ornaments for attire are missing.

The analysis thus points to an interpretation of the Kolín find as a votive offering rather than as the stock of a merchant or a craftsman. The wide range of its composition including even weapons and a specialized fireside kit permits its assignment to the Final La Tène find groups of Europe such as those of Attersee or Kappel, reflecting, in an eloquent fashion, Celtic religious practices. Such an explanation is supported also by the spot at which the find was buried, in a drainage area of a river and away from a settlement zone.

The objects contained in the finds were obviously manufactured in one of the major economic centers of Bohemia, either in one of the *oppida* or in a smithy belonging to their hinterland. Up to now, the existence of an *oppidum* has not been proved by ar-

chaeological excavations on the territory of the town of Kolín or in its vicinity. However, finds characteristic of this type of site here occur in concentrations over a wider area. In addition to painted pottery and other typical iron tools, this pertains especially to gold coins. A treasure of more than 300 gold coins, found on cadastral territory of the Starý Kolín community in 1932 and now at the Prague national museum, remains unpublished to this day.

The deposition of the hoard of iron objects of Kolín must have followed an impulse emanating from an individual or a group occupying an important position in ancient society. Its date, about 50 B.C., may imply that, in the spiritual sphere, it reflects the turbulent period of the fall of Celtic rule in Bohemia and the wars leading to gradual occupation of the land by Germanic tribal groups at the turn of the eras.

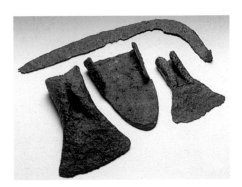

*Iron farming equipment, scythe
plowshare and axes from the votive
deposit at Kolín (Bohemia)
1st century B.C.
Kolín, Regionálni Muzeum*

545

The *Oppidum* of Staré Hradisko
Jiri Meduna

View of the oppidum of Staré
Hradisko (Moravia)

Stone roadbed inside the oppidum
of Staré Hradisko (Moravia)

The Celtic *oppidum* (fortified town) of Staré Hradisko is in Moravia, on the eastern side of the Drachany hills. The fertile Hana plain, which has been inhabited since Neolithic times, is bound on the west by these hills. The *oppidum* was built on a 1,070 meter-long triangular spur of land that runs east-west and overlooks the convergence of two small rivers in the valleys 80-90 meters below. The remains of fortifications built on this spur take the form of parapets up to 6 meters in height, which allow the entire perimeter of the enclosure (about 2,800 meters) to be followed. The enclosed area is divided into halves by a 550-meter internal parapet: on the eastern side of the partition is the upper section (highest point: 541 meters); aligned westwards on the other side of the partition is the lower section. At the eastern limit of the enclosure, above the gateway, is a small unfortified area triangular in shape. The area defended by the external parapets measures 37 hectares. A La Tène settlement has been discovered outside the fortified area, in the fields on the western slopes of the spur. There are three entrances to the *oppidum*: the first at the eastern extremity of the spur, the second in the southwest, the third at the center of the internal parapet.

Due to the discovery of amber and gold coins the site has been known since the sixteenth century. It was first discussed as an archaeological site by F. Faktor (1897), and then put in a correct historical and cultural context by F. Lipka and K. Snetina (amateur excavations, 1907-1912). Modern research was undertaken by J. Böhm (1934-37), who from 1935 onwards worked with J. Skutil. The work was continued by J. Meduna (1964-1966, 1972-1973) and M. Cizmar (1983-1988), who have explored a total area of 12,495 square meters in the eastern section of the *oppidum*.

The 1934-1937 excavations of the site's defences revealed that the internal circle consisted of a parapet with two ditches in front of it. The rampart was made of earth and rubble faced with a dry-stone wall supported by wooden pylons set at one-meter intervals (the construction known as *Pfostenschlitzmauer*). The imposing fortification of the west front seems to have been carried out in two phases, using almost identical construction methods to those used for the internal defences, except that here the wooden pylons were placed 120 centimeters apart. Near the gateways, however, there were no signs of pylons in the dry-stone wall. In 1989 M. Cizmar undertook new investigations of the fortifications.

Now that vast areas of the site have been cleared it is possible to make out a complex of buildings, consisting of farms surrounded by a ditch. The farmsteads are surely to be interpreted as individual dwellings and workshops. So far we have only uncovered one farmstead, which is roughly rectangular and has an irregular internal layout. Roads—sometimes as wide as 5 meters— ran between the farmsteads; some still had their paving stones. It is worth noting that, in front of the gateway of the internal rampart, the two ditches were dug in such a way that the route up to the gate proper is S-shaped.

Various types of objects were found in the farms. The plan of one house has been reconstructed: its outer walls were set in foundation trenches (in one of which was found the skeleton of child huddled in a foetal position—a sacrifice at the laying of the foundations?). Another type of structure uses the basic building technique of upright pylons. Since different building phases occurred on the same site, with new posts being driven into the ground above old posts, it is now impossible to reconstruct the perimeter of these buildings. A third type of structure consisted of rectangular huts, the foundations of which were dug out of the earth. The internal arrangement of these huts varies—some have posts driven in at the center of the two shorter walls, others have no posts at all, and some have posts arranged in different ways.

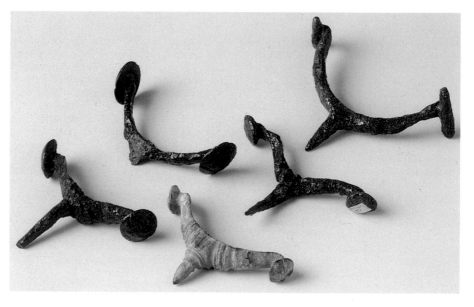

Bronze spurs from the oppidum
of Staré Hradisko (Moravia)
1st century B.C.
Boskovice, Muzeum

Fragment of a terracotta vase
with graffiti showing a crane
from the oppidum
of Staré Hradisko (Moravia)
1st century B.C.
Brno, Moravské Muzeum

These dwellings are of modest size (the longest side is never more than 5 meters) and are only to be found along the ditches surrounding the farms. As well as these three types of building, other structures were discovered within the farms (ditches, water tanks, pottery kilns).

The rich inventory of material found includes objects that are typical of the Celtic *oppida* in this region. Particularly worthy of note are those objects that reveal trading links with the Baltic area (amber) and Italy (drinking and eating vessels in bronze, glass and pottery). Local crafts were well-developed and specialized, and extended commercial links encouraged the minting of coins—of which we have splendid evidence at Staré Hradisko. Given the quantity of objects that have come to light, important new conclusions about the economic life of the *oppidum* were reached between 1983 and 1988; the flourishing trade in amber beads was an important factor in this reassessment.

The fibulae were the most important finds in terms of dating the *oppidum*. Apart from a few of more ancient type, the sequence we have shows the unbroken development of the fibulae, from the *Mötschwil* type right up to the *Allmgren* 65 type. This means that the site was inhabited from the La Tène C2 phase to La Tène D1. We do not know the precise reason for the decline of the *oppidum*. All we can say is that the end of Staré Hradisko is in some way connected with the changes brought about by the collapse of Celtic power in the area north of the middle section of the Danube.

Lead discoid piece with quadruple
markings of monetary accounts
(tests?) from the oppidum
of Staré Hradisko (Moravia)
1st century B.C.
Brno, Moravské Muzeum

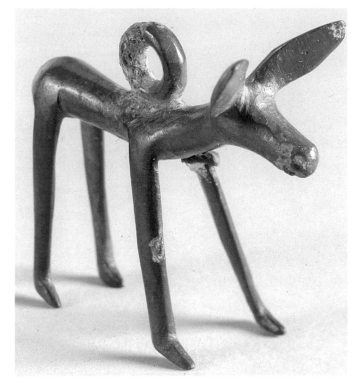

Animal-shaped bronze pendant
from the oppidum
of Staré Hradisko (Moravia)
1st century B.C.
Boskovice, Muzeum

Iron compass from the oppidum
of Staré Hradisko (Moravia)
1st century B.C.
Boskovice, Muzeum

The *Oppidum* of Bratislava
Lev Zachar

*Silver tetradrachmas minted
by the Boii of Pannonia inscribed
with the names
BIATEC NONNOS
and others probably coined
at the Bratislava oppidum
Found at Bratislava (Slovakia)
First half 1st century B.C.
Bratislava
Slovenské Národné Múzeum*

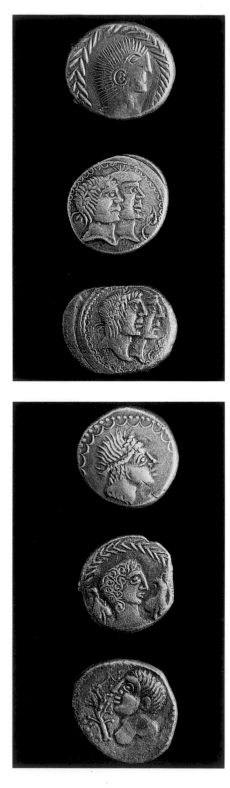

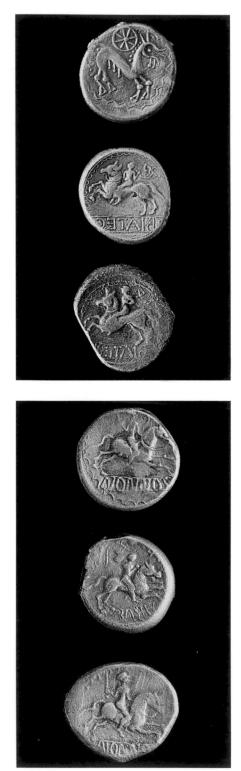

As various articles on the La Tène period in the mid-Danube regions have pointed out, the earliest traces of settlements in the area around modern-day Bratislava date from the Early La Tène period (450-370 B.C.). They are to be found at the Bratislava-Dúbravka and the Velká Lúka sites. Within the framework of settlements characterized by cemeteries of "flat" tombs—typical of the mid-Danube region—a change starts to develop. The number of non-fortified settlements exceeds the number of locally organized communities that had been seen up to that point. This development can be dated from the beginning of the second century B.C., and is to be linked with the new social structures in the Celtic world. It is likely that a decisive factor in the change was the decline of the Celtic monarchy and the growing power of the nobles. So far we know of two *oppida* (fortified centers) built in western Czechoslovakia.

The fortified Celtic enclosure of Pohanská, near Plavecké Podhradie in the Senica district, covers a total area of fifty hectares and is one of the most ancient structures of its kind in the region. It could date from the second century B.C. (Middle La Tène).

The *oppidum* of Bratislava is a more recent structure, perhaps dating from the end of the second century B.C. Two main settlements can be made out in an area now occupied by the modern city. One of these occupies almost the same area as the old city (51.71 hectares). It consists of a lower city (31.71 hectares) and an Acropolis, or upper city (approximately 20 hectares). The existence of fortifications is proved by the discovery of the Rudnayovo Námestie 3 site, with two intersecting V-shaped trenches and built-up layers. The other settlement was much smaller and probably unfortified. It housed the pottery kilns and covered an area of 9.07 hectares. The two are separated by an empty strip of land, about 550-600 meters wide, in which even the most recent excavations have failed to find any trace of La Tène settlements. Attempts to prove that these two areas were contemporaneous are hampered by the limited excavations that have been carried out on the different layers (for the same reason the strata cannot be dated with certainty). Crafts activities are noteworthy in both sites (in particular, pottery-making—so far ten kilns have been discovered). On the basis of our present information, it seems that the smelting of metals for the minting of coins was concen-

trated in an area on the southern border of the lower city. The foundations of a stone structure have been found at the eastern edge of the upper city. Some have claimed this is a *Zangentor*, but a final answer can only be given when the full results of the excavations and research are known. For the moment, however, one can say that although the foundations in question have not been completely excavated, the building techniques used might justify comparisons with constructions in the Austrian area (the fortified settlement on the Magdalensberg).

It is not possible to give an exhaustive account here of the material that has come to light at the Bratislava *oppidum*, so only a brief list is provided.

Most numerous of all are the pieces of pottery: pots made of graphite clay with vertical combed ornament (in many cases with basal combed decoration), vessels with out-turned nodular rim, flasks with funnel-shaped necks, various shapes of bowl and finally painted pottery. Coarse and Dacian, pottery accounts for only a small percentage of the material found. Two fragments of imported pottery are particularly worthy of note: a rimsherd of a so-called "black *sigillata*" vase (from Campania) and the upper section of an amphora-like vessel. Isolated fragments of Italian bronzeware (pans with moveable handles, of the Eggers 91-Sojvide type, etc.) are particularly useful for the detailed dating of the individual layers.

If the pottery found in the Bratislava site is of only limited significance for the dating of the layers, the fibulae from the various strata help us to establish a relative chronology. On the basis of the evidence they provide we can work out the development of the settlements in a particular area over a period of time that starts in the last quarter of the second century B.C. Most of these fibulae are of a Middle to Late La Tène type—mainly of the Late La Tène type (with the pin bent back into the curve of the fibula). The exceptions are a bronze Alesia-type fibula (a variant of the Feugère 21a1 type) and fragments of a Feugère 11a-type fibula. These belong to the horizon of the *Sharnier* and *Seiralbogenfibeln* (spiral hinged fibulae) which perhaps originated in the area of western Europe occupied by the Gauls, and fix an upper limit for the most recent phase of settlement at around 50 B.C. (if we take into account the historical information we have on the so-called "deserta Boiorum").

However, this information still gives us very few firm points of reference when it comes to fixing the date at which the settlement was abandoned. It is important however, that historians have accepted 44 B.C. as the latest possible date of the conflict between the Dacians and the Boii. Perhaps there is a relationship between this conflict and the clear traces of destruction that have been found (but so far only on the western and southern borders) in the inhabited center of the Bratislava *oppidum*. The violent end of the settlement put a stop to the minting of two types of coins: the local type (the Bratislava type with fifteen different inscriptions—most of the time BIATEC, NONNOS, DEVIL BVSV, BVSVNMARCVS, MACCIVS, etc.) and the Noric coins that are, roughly, of the Karlstein type (these occur mainly in the upper strata).

After its destruction, the role of the Bratislava *oppidum* was most probably taken over by the fortified Celtic-Dacian settlement of Devín, at the junction of the March and the Danube, which had once been part of the hinterland of the Bratislava *oppidum*. The Devín settlement—which survived until the end of the first century A.D.—was an interface for the complex political and ethnic relations in the mid-Danube region; relations which initially involved the Noric and Dacian peoples and subsequently included the Germani and Romans.

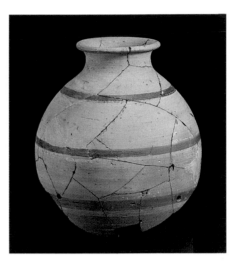

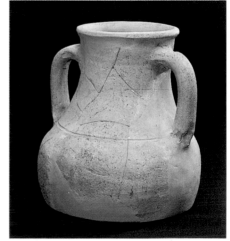

Terracotta vases from the district of the Bratislava-Devín oppidum (Slovakia)
1st century B.C.
Bratislava
Slovenské Národné Múzeum

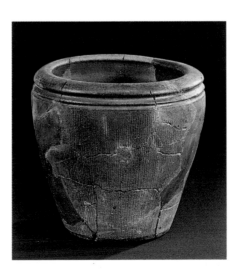

The Kingdom of Noricum and the City
on the Magdalensberg
Gernot Piccottini

The kingdom of Noricum (*Regnum Noricum*) was established towards the middle of the second century B.C. In a certain sense it was the last political manifestation of late Celtic power in Europe—but it was also the first state in the history of the countries of the eastern Alps (its borders were practically the same as those of modern Austria). Undoubtedly the kingdom resulted from the unification of different Celtic peoples (some of which are known to us by name) under the hegemony of the Noric people, who occupied the central region of the kingdom (central-eastern Carinthia). The area is rich in iron deposits, which were transformed into steel (*ferrum Noricum*). This steel was the basis of the trading and political links with the great power in the south—Rome. It finally led to the establishment of Roman business concerns within the Celtic kingdom itself.

One such settlement—undoubtedly the biggest of its kind—is located on the Magdalensberg, near the city of Klagenfurt, and has been the object of excavations since 1948. It gives us important information on the culture of a late Celtic/early Roman urban settlement in the southeast Alps, a settlement that enjoyed its best fortunes in the

few decades between the end of the first century B.C. and the middle of the first century A.D.

Within a central settlement of Noric Celts, which was probably called *Virunum*, a Roman trading post was set up around the middle of the first century B.C. The layout of this area was totally urban, and its establishment and subsequent development were obviously due to the above-mentioned trade in Noricum steel. This settlement also had a suburban area within a hilltop fortification, set up during the final period of independence enjoyed by the *Regnum Noricum*.

After the Roman conquest of the kingdom of Noricum in 15 B.C., the trading settlement became the political and administrative center of the conquered eastern Alps—which meant there was a flurry of building activity in the city, as well as more intensive "Romanization" of the local population. A last, great, phase of planned construction was left uncompleted in the fourth decade of the first century A.D. Towards the middle of the century, shortly after the region had been incorporated in the Roman empire as the province Noricum, the population of the city on the Mag-

dalensberg moved to the new provincial capital in the plain below. In a significant attempt to maintain continuity, this city was also called *Virunum*. In most of the layers excavated the finds consist mainly of local pottery that illustrates the late Celtic/early Roman nature of the population. In the lower layers there are vessels that repeat Late La Tène forms, while in subsequent layers one can find local reworking of imported Roman pottery. Towards the middle of the first century A.D. the emergence of the pottery that marks the final development of local production for decades to

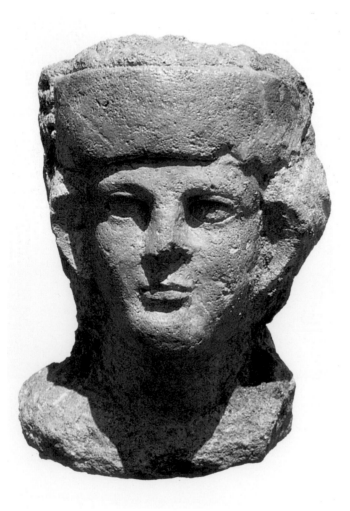

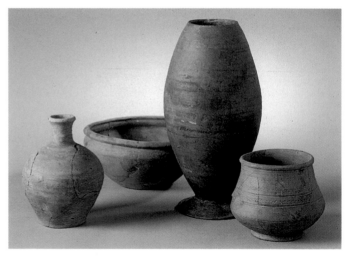

*Selection of pottery from the oppidum
of the Magdalensberg (Austria)
Second half 1st century B.C.
to early 1st century A.D.
Klagenfurt
Landesmuseum für Kärnten*

*Stone portrait of indigenous woman
from the Magdalensberg (Austria)
1st century A.D.
Klagenfurt
Landesmuseum für Kärnten*

come is apparent—this is characterized by a wide variety of shapes and by decorative techniques such as comb or wave ornament. Along with these finds there are Aucissa-type fibulae (Late La Tène), as well as early forms of Noric-Pannonian *Flügelfibeln* and *Doppelknopffibeln*—which have been shown to be of local manufacture. There is a large number of iron artifacts, with a wide range of tools and utensils, most of which—such as the different-shaped iron bars—were destined for export.

However, all the phases of settlement within the city are characterized by massive imports from the south. Not only were Roman building techniques and materials imported, but so were Italian concepts of art and culture. The first things to attract our attention are the finds of "black *sigillata*" pottery, as well as *sigillata* pottery from Arezzo and the Po Valley, fine pottery tableware and imported bronze and glass objects. The cultural-artistic aspect was fundamental to the Romanization of the Alpine region, and important evidence of it is provided by some excellent-quality frescoes and a series of portrait sculptures, which show that even in the Augustan age there were sculptors active in the city. So the

Magdalensberg is not only the site of one of the important milestones in the cultural development of the southeastern Alpine region, marking the transition from the independent late Celtic world to the first stages of Roman Austria, but it is also the location of the first political center of what was to become modern Austria.

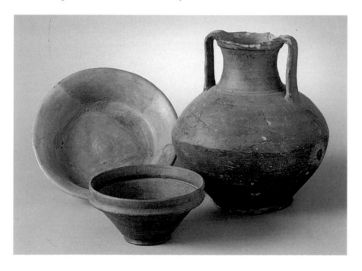

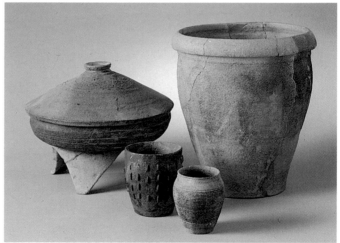

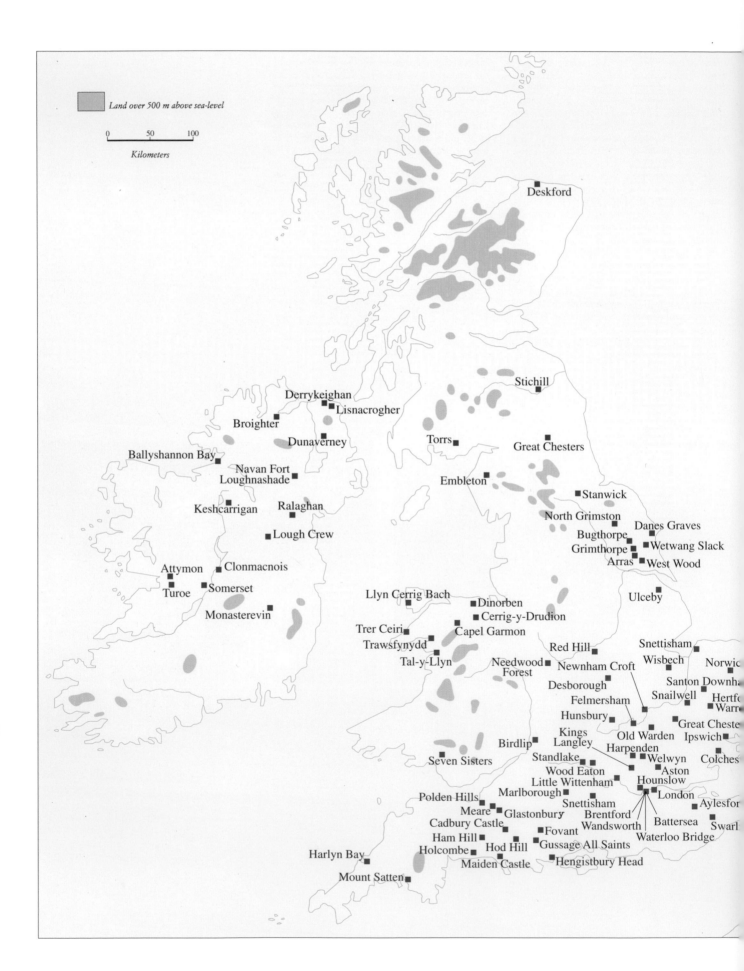

Land over 500 m above sea-level

0 50 100
Kilometers

Deskford

Stichill

Derrykeighan
Lisnacrogher
Broighter
Dunaverney
Torrs
Great Chesters

Ballyshannon Bay
Navan Fort
Loughnashade
Embleton

Keshcarrigan Ralaghan
Stanwick
North Grimston
Bugthorpe Danes Graves
Lough Crew
Grimthorpe Wetwang Slack
Attymon Clonmacnois
Arras West Wood
Turoe Somerset
Monasterevin
Ulceby

Llyn Cerrig Bach Dinorben
Cerrig-y-Drudion
Trer Ceiri Capel Garmon
Trawsfynydd
Red Hill Snettisham
Tal-y-Llyn
Needwood Newnham Croft Wisbech
Forest
Norwic
Desborough Santon Downha
Felmersham Snailwell Hertf
Hunsbury Warr
Birdlip Kings Old Warden Great Cheste
Langley Ipswich
Seven Sisters Standlake Harpenden
Wood Eaton Welwyn Colches
Little Wittenham Aston
Polden Hills Marlborough Hounslow
Meare Snettisham London
Glastonbury Brentford Aylesfor
Cadbury Castle Wandsworth Battersea Swarl
Ham Hill Fovant
Holcombe Hod Hill Gussage All Saints Waterloo Bridge
Harlyn Bay Maiden Castle Hengistbury Head
Mount Satten

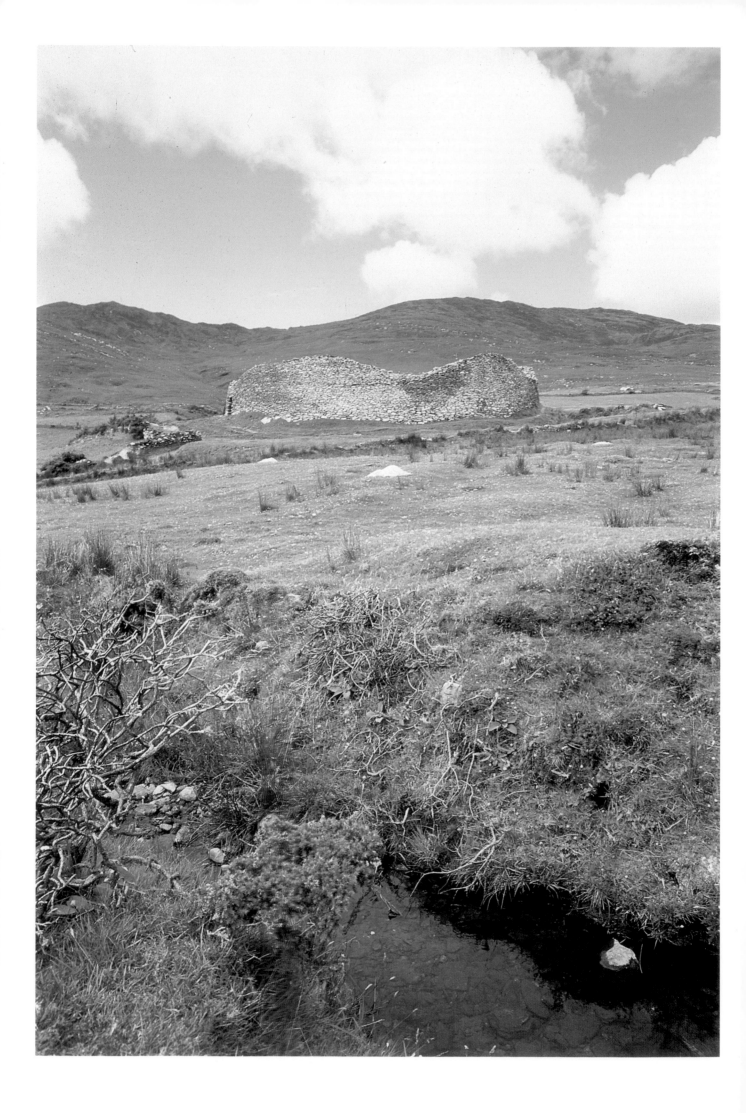

Barry Raftery

The Island Celts

It is by no means certain how and when the islands of Britain and Ireland became Celtic. Indeed, it is far from clear what precisely the term "Celtic" means in an insular context. Early written sources refer to the widespread presence of Celtic tribes in both islands and in immediately pre-Roman Britain, as in early historic Ireland, languages which were undoubtedly Celtic were spoken. It is thus scarcely surprising that the Celticization of the insular world has often in the past been explained in terms of the large-scale arrival of Celtic immigrants. This explanation does not, however, always accord with the available archaeological evidence, and for Ireland in particular it is difficult to substantiate on the basis of the surviving material remains. Undoubtedly there was movement to the islands (and between the islands) which played a part in the introduction of Celtic cultural elements and from time to time there may have been population incursions of some intensity (to Britain at least) bringing with them wholly exotic cultural traits. The Belgic invasions of southern England provide us with one such example.

By and large, however, the material culture of the insular Iron Age has an essentially local character and there are few identifiable imports in the archaeological record. Clearly, the simple invasion model alone is scarcely adequate to explain the complex and multifaceted processes of cultural change which combined, in the course of the last millennium B.C., to make the islands "Celtic." Moreover, it is likely that the dominant element in the ethnic composition of the "Celtic" Iron Age population, both in Britain and Ireland, had its roots in the indigenous Bronze Age.

The Earliest Iron Age

One aspect of the spread of so-called Celtic culture is the related dissemination of iron technology across Europe. Sporadic ironworking was, of course, being practiced far earlier than the Celtic period but the widespread, large-scale exploitation and use of iron in central and western Europe did not begin until the latter part of the eighth century B.C. These Iron Age beginnings are associated with population groups referred to archaeologically as the Hallstatt C culture and we may be justified in calling these people Celts. The knowledge of ironworking was rapidly diffused westward and had undoubtedly reached the Atlantic fringe before the end of the seventh century B.C. This is clearly demonstrated at a number of early sites in Britain where iron slag is present, and is especially well illustrated in the hoard of metal objects from Llyn Fawr, Glamorganshire, in Wales, where imported Hallstatt items (including an iron sword) were found along with indigenous Late Bronze Age bronzes and locally fabricated iron objects. Scattered bronze swords, chapes and a few other items of Hallstatt C character show that other parts of Britain, especially the southeast, were in close contact with the Hallstatt world outside, but the absence of burials and of exotic settlements emphasizes the insular nature of the Hallstatt cultural horizon in Britain.

The same appears to be the case in Ireland though there evidence for a primary Iron Age is more limited. A few iron objects, which might be indigenous copies in iron of Bronze Age types, could represent the presence of an early ironworking horizon in the country perhaps dating to the seventh century B.C. A few settlement sites which appear to be technologically transitional between bronze-using and iron-using societies, though by no means firmly dated, lend support to this hypothesis. There are also some bronze swords and chapes of Hallstatt type from the country but almost all surviving examples seem to be local copies of foreign models. As in Britain, there is nothing to indicate that these changes resulted from the arrival of immigrants, much less can we suggest that these changes reflect the appearance in the country of Celts.

Hallstatt D is represented archaeologically in Britain, but again by a relatively small body of artifacts, including daggers, razors, horse-trappings, a few metal and pottery containers, and some items of personal adornment. Some of these may be regarded as imports but the

majority are from native workshops. Again, as in the case of the Hallstatt C material, there are no associated burials and the few settlements which have produced objects of Hallstatt D type are all of decidedly local character. The presence of this material in Britain does, however, indicate continued links with Hallstatt Europe. In particular, an important southern English dagger series shows the extent to which the local workshops were fully acquainted with contemporary European developments in weapon manufacture.

By contrast, Ireland, for reasons which are not readily apparent, is virtually without Hallstatt D material. The island, undergoing some crisis which saw the collapse and disappearance of the flourishing late Bronze Age industries, slipped into a phase of isolation and seeming cultural stagnation. Various explanations have been offered for this—climatic, social, economic. None, however, has been conclusively demonstrated. For the moment at least, the two or three centuries after 500 B.C. in Ireland remain a dark age.

Appearance of La Tène

Important innovations occur in the insular archaeological record with the appearance of La Tène cultural elements. Fine metalwork is a prominent feature of this new horizon, both in Britain and Ireland, and because of its often spectacular quality this material has up to recently tended to dominate discussion, especially in Ireland, in our attempts to reconstruct the culture and chronology of the period. It is not, therefore, surprising that scholarly views have differed on fundamental matters of dating and of origins and the situation has not been helped by the frequency with which the most splendid objects have been found in isolation, in rivers, lakes and elsewhere.

Society in La Tène Britain

In Britain, in recent decades, it has however been possible to extend our attempted interpretations of Iron Age society beyond the narrow and biased focus of the metalwork largely as a result of the many large-scale excavations which have taken place in settlement sites. In many areas hillforts were the dominant settlement form, especially in the south and west. Less overtly defensive enclosed homesteads of varying type also occurred, such as Little Woodbury, Wiltshire or Gussage All Saints, Dorset and smaller, open settlements of varying character were probably widespread. Scotland, especially the highlands and islands, differed from other areas of Britain with its emphasis on massive stone forts, often timberlaced, and its unique development of the impressive towerlike brochs. Houses, where these have been recognized, were generally circular, emphasizing late Bronze Age cultural roots. Examples of rectangular ground plan were, however, also constructed.

The hillforts represented considerable concentrations of population and in many cases must have served as the foci of tribal power and authority, both secular and religious. They were also economic centers where the produce of surrounding fields could be stored and distributed as is suggested by the multiple storage pits and presumed granary structures which have been discovered at some sites. Though hillforts in Britain have an antiquity which predates the Celtic Iron Age, the finest and most complex examples are generally held to belong to the later phase of prehistory. These, along with other contemporary settlement sites have thus yielded much information about the material culture of the inhabitants of Britain in the last half-millennium or so B.C.

Clearly, the masses of the people were primary food producers engaged in agriculture and animal husbandry. High-status metalwork, however, as well as the very existence of massive hillforts, indicates the presence of an aristocratic ruling class which must have been the dominant element in a highly stratified society. Archaeology and the written sources are in agreement on this. Finely wrought swords in ornate scabbards, helmets, the magnificent British parade shields and the many horse and chariot fittings—the trappings of a warrior

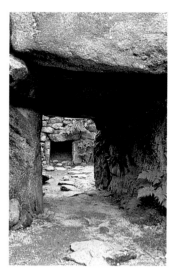

Underground galleries known as "fougou" in Cornwall at Carn Euny (England) 1st-5th century A.D.

class—give material expression to this elite upper stratum of society. The superb decorated mirrors of southern England show that females, too, shared in this material prosperity and, indeed, the wonderful gold torques of East Anglia could as easily have been the possessions of women as of men. Queen Boudicca herself is said to have worn such a torque.

Less spectacular, but arguably more representative of society as a whole, is the information on everyday life which has come from the excavated settlements. The picture which emerges suggests a country of scattered agricultural settlements of varying character and size, self-sufficient yet interdependent, existing in harmony with their physical environment. Each community doubtless contained people skilled in many of the peasant crafts necessary for the effective management of everyday affairs. There were also trained craftsmen specializing in individual skills. These are not always easy to detect in the archaeological record. There can be little doubt, however, that metalworkers were significant figures in the community and we can assume that major craft centers existed for the manufacture of high quality parade equipment and other prestige items. It is probable, too, that itinerant craftsmen also existed. Apart from a number of iron-smelting furnaces discovered at several settlements, the only clearly recognizable workshop is that at Gussage All Saints in Dorset where horse and chariot fittings were cast on a significant scale. Opinion is, however, divided as to whether this site represents the activity of a traveling craftsman or whether it was of more permanent character. Otherwise, we have only the finished products themselves from which to infer the procedures and processes of manufacture and distribution. These must have been highly organized and effective and within the country a complex network of social and economic interrelationships must have existed to insure the ready supply of raw materials and the dispersal of the finished products. A whole range of specialist tools, of which we have only the barest inkling, is also implied by the surviving artifacts.

Glassworking, bone-working, spinning and weaving, the production of salt and, of course, the widespread manufacture of pottery are also attested to in the material remains. As regards the latter, there were many regional styles with the southwest in particular standing out as a center for the manufacture of highly decorated pottery vessels. The appearance of the potter's wheel, probably in the last century B.C., led a trend toward mass-production and to a greater standardization of types. Woodworking was probably the most widespread of all the domestic skills but this is all too often represented in the archaeological record only by the tools used. It is only the occasional discoveries in wetland areas which testify to the competence of the British Iron Age peoples in the crafts of carpentry and joinery.

The introduction to Britain in the last century B.C. of imported wares of Mediterranean and Gallo-Belgic origin heralds the development of increasingly close links with the European mainland. A key site in the introduction and distribution of new types was the southern English coastal fortification at Hengistbury Head, Hampshire. The growing trend towards a market economy and the seemingly corresponding increase in the size of population centers in southern and eastern England are accompanied by the appearance of coinage in southern England at the end of the second century B.C.

The earliest coins are Gallo-Belgic and these are often regarded as physical evidence of the Belgic intrusions to Britain referred to by Caesar. It is an interesting archaeological conundrum, however, that the earliest burials which might be equated with such incursions, the cremations of the so-called Aylesford-Swarling culture, are scarcely datable before the second quarter of the last century B.C.

Ireland

The not inconsiderable body of evidence which is now available for a reconstruction of life during the Celtic Iron Age in Britain is not matched in the Irish archaeological evidence. In fact, there are very few aspects of Irish Iron Age society of which we have adequate

knowledge. We cannot, for example, point with confidence to the normal occupation sites of the pagan Celts in Ireland. Hillforts, though few in number, do exist in the country but in most instances their dating is obscure. There are as yet no indications to suggest that they are part of an Iron Age cultural horizon. Promontory forts, numerous around the Irish coasts could, at least in some cases, belong to the Celtic Iron Age but the limited excavation which has thus far taken place has failed to confirm this. A few important royal sites of the Celtic Iron Age in Ireland are known to us as well as a series of impressive linear earthworks which are contemporary with them. These are, however, clearly removed from the ordinary domestic constructions of the majority population.

Lacking the normal secular settlements we face an impossible task in trying to reconstruct a proper picture of the everyday life of the prehistoric Celts in Ireland. Our difficulties are further compounded by the fact that practically all of the objects which have survived are isolated finds so that the interrelationships between various artifact types are uncertain and our chronology tenuous. The clearly exceptional quality of most of the surviving material also shows it to be scarcely representative of the peasant farmers who would have made up the bulk of contemporary society.

Horse-trappings are of surprisingly frequent occurrence in the available Irish archaeological record, for these make up almost half the surviving metal objects of the period. The horse must have been an important status symbol and there are large numbers of ornate, cast-bronze bridle-bits which frequently display evidence of intense wear. Associated with them are curious Y-shaped objects of bronze which are obscure in function but were certainly elements of the horse harness. These are found only in Ireland. The chariot, in seeming contrast with the evidence of the earliest Irish literature, is, apart from a few mounts, scarcely represented archaeologically. Weapons are known, including iron swords and associated ornate scabbards of bronze but these are not numerous. The spear was also used and there is considerable variety in the types of butts which were attached to the wooden shaft-ends. Pins and brooches and items of personal adornment are also surprisingly few but the hoard of Late La Tène gold objects from Broighter, county Derry, is notable for the splendid buffer torque which it contained. This is a spectacular example of native craftsmanship in gold. Outstanding among the bronzes are the great sheet-bronze trumpets the manufacture of which seems to have been an Irish speciality. There is also a range of bronze mounts and other fittings, often elaborately decorated, which emphasize the originality and technical competence of local Irish workshops.

Domestic material of the Celtic Iron Age in Ireland, as already noted, is extremely rare. A series of isolated, unaccompanied rotary quernstones is known and a wooden plow has recently been found directly associated with the mid-second century B.C. roadway at Corlea, county Longford. A large number of wooden potstaves has also been recovered from this site and there were several other objects which give unique insights into the high quality of woodworking in Iron Age Ireland. No tools were found, however, and in fact for the whole of the country we can point to a mere handful of iron axes, adzes and miscellaneous implements. Glass beads are known but we cannot yet say if local glassworking centers existed. Spinning and weaving were certainly carried on as, of course, were boneworking and leatherworking. But surprisingly there is not the slightest evidence that pottery was in use during the Celtic period in Ireland nor has a single coin of Iron Age date ever been found in the country.

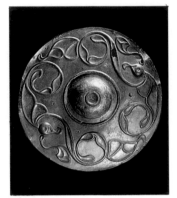

Circular bronze shield-boss found in the Thames at Wandsworth (England)
First half 1st century B.C. to first half 1st century A.D.
London, British Museum

Burial and Ritual

The archaeological remains give us some information about the spiritual life of the island Celts. In Britain we have extensive information of burial customs in certain areas, notably the inhumation cemeteries of the Arras culture of eastern Yorkshire and the cremation

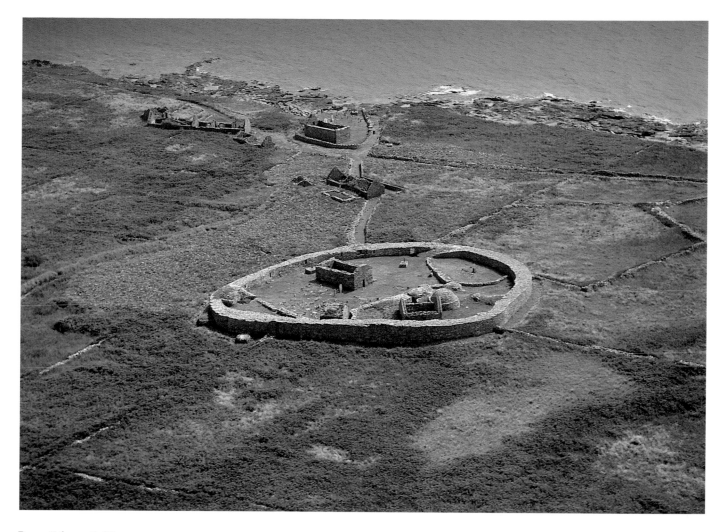

*Dry-wall fort at Oghil
on the island of Innishmore (Ireland)
1st-5th century A.D.*

cemeteries of the Aylesford-Swarling culture of the south. Burial evidence in the country is otherwise patchy and there are large areas which have, as yet, yielded little information about burial rites. Indeed, it is possible that the disposal of the dead was in some areas of an extremely casual nature to judge by the discovery of disarticulated human remains in rubbish pits of settlements and in the ditches of hillforts.

In Ireland, the available evidence indicates that Iron Age burial traditions were different from those in Britain. Cremation seems to have been the dominant rite, the remains being placed in simple pits in low circular unimposing mounds of varying types. Grave goods, when they are present at all, were modest and generally confined to a few pins and brooches, some beads and other items of personal adornment. It is only in the centuries after the birth of Christ, possibly under Roman influence, that inhumation gradually replaces cremation. Apart from the burial evidence we get other occasional glimpses of the spiritual life of the insular Celts. A few sites in England, such as the small rectangular structure found at Heathrow, Middlesex, have been identified as temples and in Ireland the great circular structure at Navan Fort, county Armagh has been similarly interpreted. In general, however, it is likely that cult activities took place in the open air and that wet sites such as rivers, lakes and bogs figured prominently in such practices. The decorated Irish standing stones doubtless also played a part in ceremonial activities under the open sky. The many carved stone heads, which are of common occurrence both in Britain and in Ireland, are also best considered as of votive character. These indicate that both islands shared in the pan-Celtic veneration of the human head.

La Tène Art

The earliest phases of La Tène art in Europe are scarcely represented in either of the islands. The oldest La Tène elements in Britain comprise a horizon of varied items, mostly stray finds, including some Early La Tène fibulae and other personal ornaments, daggers and sheaths, a bronze mount or two and a southeastern concentration of angular-profiled pottery. There may well also be an early phase of the Yorkshire Arras culture though this has yet to be clearly identified.

The daggers come mainly from the river Thames and its environs. Most are of local manufacture and reflect continuity of workshop practice from the preceding Hallstatt D period. There can, however, be little doubt that renewed influences from the continent played a part in the development of the series. A number of these exhibit early renderings of insular La Tène art which, on occasion, is accompanied by geometric designs of essentially Hallstatt character. A scabbard from Minster Ditch, Oxfordshire, with its sluggish wave motif and flanking triangles is a good instance of such stylistic juxtaposition. Even more interesting,

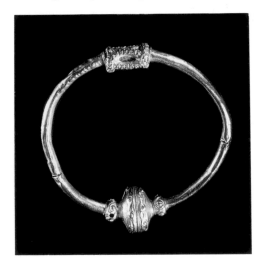

Gold torque decorated
with "nodus herculeus"
from Clonmacnoise (Ireland)
early 3rd century B.C.
Dublin, National Museum of Ireland

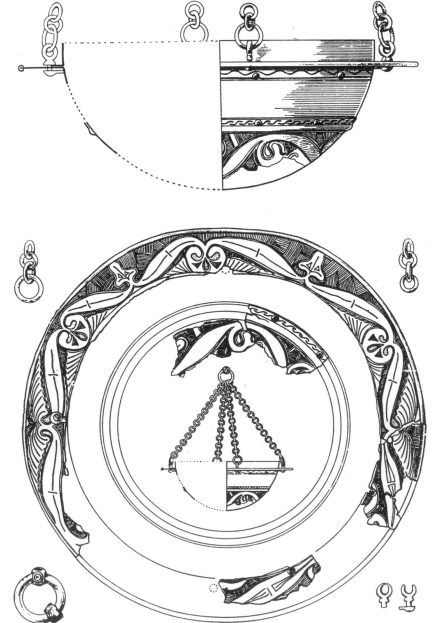

Bronze hanging cup (lamp?)
fragmentary from Cerrig-y-Drudion
(Wales)
4th century B.C.
Cardiff, National Museum of Wales

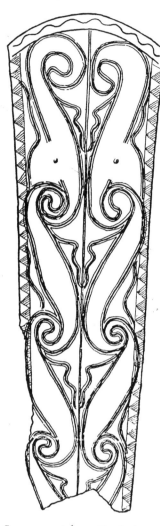

*Bronze mount from upper part
of scabbard found in the Thames
near Standlake (England)
End 4th-early 3rd century B.C.
Oxford, Ashmolean Museum*

*Fragmentary bronze scabbard mount
from Wisbech (England)
4th century B.C.
Wisbech and Fenland Museum*

however, is a sheath from the Wisbech museum in Cambridgeshire which has hatched triangles along the edges and a series of S-motifs extending on either side of the midrib in opposed pairs along its length thus creating interlocking lyre patterns each one of which encloses a stylized palmette. The S-figures are thick and fleshy and somewhat provincial in aspect. Clearly, with such an object, we are not far removed from the beginnings of British La Tène art.

Stylistically related to Wisbech, though immeasurably more accomplished, are the decorated sheet-bronze hanging bowl fragments from a cist (probably a burial) found at Cerrig y Drudion, Clwyd, in Wales. Sufficient evidence survives for the original ornament to be reconstructed. Present are the palmettes, the lotus blossoms, the tiny triple-dot motifs and other designs which lead directly to the Early La Tène pottery of Brittany, to the Marne and ultimately, of course, to the Mediterranean. Unlike the Wisbech scabbard, the Welsh bronzes may well be early imports from Gaul.

True Waldalgesheim art in the continental sense is rare in either Britain or Ireland. There can, however, be little doubt that it was this style which provided the overriding inspiration in the formation of insular La Tène art in the third and second centuries B.C. The decoration on a handful of British objects has been compared to continental Waldalgesheim, though objective dating of the relevant insular pieces is rarely possible. Close to mainland European traditions, however, are the decorative plates which once adorned an organic scabbard from the river Thames at Standlake, Oxfordshire. On one there is a relief, looped pelta design set against background hatching; on the other, at the lower end of the scabbard, there is a twisting wave-tendril of markedly continental appearance. The latter bears comparison with the writhing wave-tendril executed in *pointillé* on the antler handle of an iron rasp from Fiskerton, Lincolnshire. A similar wave-tendril design occurs on an ornate bronze bracelet from a burial (possibly a chariot burial) at Newnham Croft, Cambridgeshire, though the dating of this piece, along with that of the stylistically related "horncap" said to be from Brentford, Middlesex, is disputed and both could be several centuries later than is frequently supposed.

The picture of the earliest appearance of La Tène traditions in Ireland is vague. The initial stages, as represented on the continent, are absent and it seems as if the isolation which descended on the country during Hallstatt D continued during the phase of Early La Tène expansion across the European mainland. There is only a single item of undoubtedly Early La Tène date from the country and this belongs to the end of that period. It is a gold buffer torque from Clonmacnois, county Offaly, made around 300 B.C. It is a fine piece, with raised bosses and scrolls on the buffers and with a curious junction-box at the back, decorated with raised, interlocking loops which are highlighted by meander-loop designs of separately applied gold wire. The overall execution has been recognized as a Celtic rendering of the classical *Nodus Herculaeus*, a motif which was especially popular in northern Italian workshops during the Hellenistic period. The object, found in a bog in the west of Ireland with a gold ribbon torque of native character, is likely to be an import. Its place of manufacture was probably the middle Rhine.

Swords of Early La Tène type are known from southern England though it is not clear if their use overlapped in time with that of the daggers. Scabbards too, with ring-ended chapes of early continental form also occur in Britain, but in most instances there are detailed ideosyncracies which suggest local manufacture. The scabbard from Standlake earlier referred to is one of the very few examples for which fabrication on the European mainland can be argued. Laddering on some of the swords is also indicative of foreign influence but only one or two, notably that from the river Lee at Walthamstow, Middlesex, are likely to be imported pieces. Two swords found in their scabbards in the Thames are important. In each case the mouth of the scabbard is adorned with opposed dragon-pairs. This classic continental Celtic motif, known across Europe from France and Iberia in the west to the middle

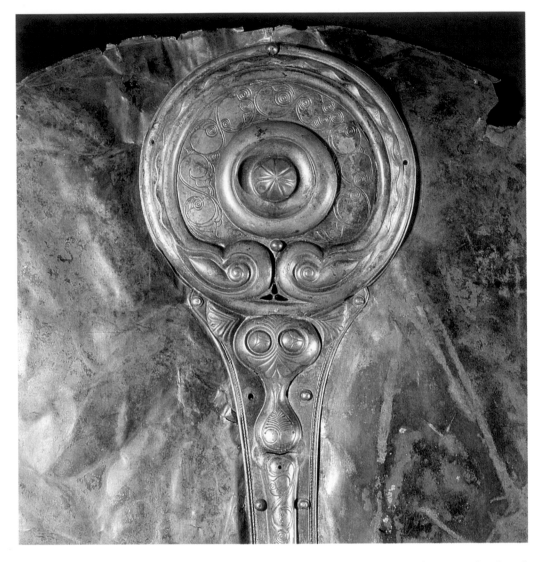

Danube in the east, demonstrates that direct links existed between southeast England and the continental Celtic heartland in the period around 300 B.C.

The Mature Phase

A series of high-quality metal objects of third and second century B.C. date clearly indicate the presence, both in Britain and Ireland, of established and mature craft centers peopled by artisans who were closely in contact with contemporary technical and artistic developments in the La Tène world outside. The material which they produced, however, displays an unquestionably insular character. The workshops on the two islands drew on common wells of artistic inspiration which undoubtedly emanated from the European mainland. The two insular traditions were also in contact with one another leading to cross-fertilization of ideas and to many instances of stylistic overlap.

Prominent among the metalwork objects of this mature phase of insular La Tène art are shields and scabbards. These were clearly prestige items which in many instances were designed primarily for purposes of display and ostentation. Not surprisingly, they often found their last resting places in watery locations doubtless as a result of ceremonial deposition. Two rivers in the south of England, for example, the Thames and the Witham, have produced important collections of particularly fine Celtic metalwork. Several graves of the Arras culture in eastern Yorkshire have, however, also produced fine metalwork which prob-

Emblematic pattern of "dragons"
on the iron scabbard found
in the Thames at Hammersmith
(England)
End 4th-early 3rd century B.C.
London, British Museum

Decorated part of bronze scabbard
from Fovant (England)
3rd century B.C.
Salisbury and South Wiltshire
Museum

ably indicates the former existence in that region too of significant craft centers. North Wales seems also to have had its local ateliers which specialized in the manufacture of decorative shields. Northeast Ireland too was an important focus of fine bronzeworking in the third or second century B.C.

Outstanding among the southern English objects is a large sheet-bronze shieldfacing found in the River Witham near Washingborough in Lincolnshire. This splendid object, 113 centimeters long, was remodeled several times in antiquity. Its initial decoration of a cut-out figure of a long-legged and spindly boar riveted to the front was replaced by a narrow raised spine with terminal roundels and a central, domed boss. The latter was elaborately embellished with swirling repoussé scrolls and studs of blood-red coral while each roundel was highlighted by a circular panel of engraved decoration.

Finely engraved decoration, in combination with repoussé ornament, is also present on a bronze scabbard-mount found in the river Witham near Lincoln. This too is a fine piece, important because of the diagonal arrangement of the ornament on it for this is strikingly reminiscent of the organization of decoration on scabbards of the so-called Hungarian Sword Style. The ornament is, however, of undoubtedly native British character. Clearly native, too, is the ornament on a scabbard from Fovant, Wiltshire which has a stylized, but recognizable, version of the pan-Celtic dragon-pair motif, two examples of which, as noted, above, have lately been recognized on scabbards from the river Thames.

The same river has also produced a complete bronze shield and two decorated bronze shield bosses. The shield is a recent discovery, from Chertsey in Surrey. It is oval in shape and without decoration. Its pointed oval boss and narrow midrib have good parallels on early continental shields and the object could be as early as the late fourth or early third century B.C. The two bosses, now detached from their shields, were recovered from the river in the vicinity of Wandsworth. One is in the form of a flattened dome with a broad mounting flange and bears both raised and engraved ornament. Among the abstract scrolls the striking representations of two unique winged birds are clearly recognizable. The other boss, broken at one end, is of elongated shape with relief, tooled ornament culminating at the complete end in a stylized human mask of stern and menacing appearance.

On the objects described above there is both relief and engraved decoration, a popular feature of British La Tène art. Engraved ornament alone occurs on the plates of three fine scabbards of bronze recently unearthed in graves of the Yorkshire Arras culture, two at Wetwang Slack, the third at Kirkburn. These are exceptional pieces adorned from end to end with tendril-scrolls, running waves and spirals. The quality of the swords clearly matched that of the scabbards which contained them. The best-preserved of them, from Kirkburn, had an elaborate hilt of iron with complex enamel inlays. Despite the presence of ring-ended chapes on these scabbards which are superficially of continental, Early La Tène character their local manufacture is scarcely in question and their dating is probably not earlier than the third or early second century B.C.

Another object from the Wetwang Slack cemetery, which is quite unique, is a small, hollow bronze canister with attached chain, which came from a rich female burial. The purpose of this empty but sealed container is unknown. The engraved decoration on the sides and ends of the object is closely similar to that on the scabbards and these objects together, along with other material from Yorkshire, leave little room to doubt that an important school of fine metalworking existed in the area of the Arras culture.

Contemporary with the scabbard engraving tradition of eastern Yorkshire is a northeast Irish school which also specialized in the manufacture and decoration of bronze scabbard-plates. In that area, in a bog deposit (possibly votive) at Lisnacrogher, county Antrim, and in the river Bann, seven scabbard-plates and a single substantially complete scabbard, still retaining its iron sword, have been found. Six of the eight bear overall decoration of distinctively Irish

character. The Irish craftsmen shared features with their Yorkshire counterparts but the organization of the patterns in the two regions is subtly different and in Ireland greater emphasis was placed on the varied and numerous micro-designs which fill the bodies of the main decorative figures and the spaces formed by them. The distinctiveness of the Irish school is also underlined by the clinging chapes, which are unrelated to those in Yorkshire and are best compared to examples from the Early/Middle La Tène transition on the continent. Clearly related to this Irish Scabbard Style is the ornament on some bronzes found together in the early decades of the last century in a bog at Torrs, Dumfries, and in Galloway, in the southwest of Scotland. The principal piece, believed to be a pony cap, now has the two sheet-bronze horns, with which it was found, riveted to it. The arrangement is, however, entirely modern and the horns are likely to have served another purpose, possibly as the terminals of drinking-horns.

The engraved designs on the horns are in many details, especially in many of the tiny filler

Bronze head-covering for pony from Torrs (Scotland) 3rd-2nd century B.C. Edinburgh Royal Museum of Scotland

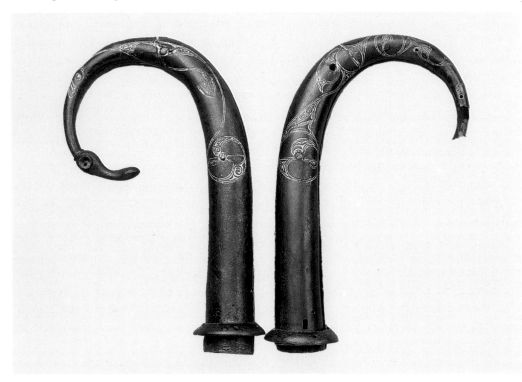

Pair of bronze horns from Torrs (Scotland) 3rd-2nd century B.C. Edinburgh Royal Museum of Scotland

motifs, closely similar to some of those on the Irish scabbards. It is thus possible that there is an Irish element in the decoration of the horns. There are, however, some clearly non-Irish features in the design, especially the tiny human face peering out of the vegetal scrolls which has good antecedents on the European mainland.

The pony cap is lavishly embellished in a swirling, repoussé pattern of balanced symmetry with boss-ended and spiral-ended scrolls skillfully arranged around a central line. On this piece, too, there are Irish links, for the ornament on it has much in common with that on the bell-disc of a bronze trumpet discovered, originally with three others, in a small lake at Loughnashade, county Armagh. The site is located below the hilltop royal center of Navan Fort and the trumpets, apparently found in association with human skulls, probably represent a votive deposit.

The Loughnashade trumpet is one of four surviving Irish trumpets of sheet-bronze manufacture. These are great curving horns, the largest and finest, from Ardbrin, county Down, being 142 centimeters in length from tip to tip. They were made in each instance of two joined tubular units. Each was of folded sheet bronze sealed by means of a narrow strip of bronze

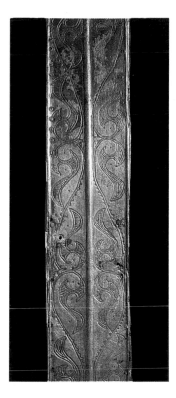

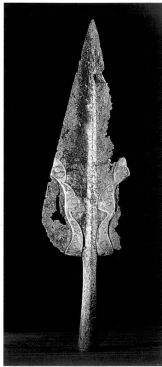

Detail of a decorated bronze scabbard from Lisnacrogher (Ireland)
3rd century B.C.
London, British Museum

riveted internally along the seam. On the magnificent Ardbrin example no fewer than 1,094 rivets were used in this process. Such objects produced a series of deep, bass sounds which would have sounded impressively on ceremonial occasions or, perhaps, on the field of battle. These Irish trumpets, which are quite unlike the cast specimens of the later Bronze Age, are outstanding masterpieces of the sheet metalworker's craft and testify, more than almost anything else, to the exceptional excellence of the Irish Celtic bronzesmiths.

First Century B.C. Developments
During the first century B.C., Britain was drawing ever closer to an increasingly Romanized continent and immigration from the Gallo-Belgic world, as well as extensive cross-Channel trading links, contributed greatly to the shaping of late Celtic British society. Ireland, as far as we can tell, did not have the same close ties with the European mainland at this time, though we can still recognize a few imports of likely continental origin such as a west-Gaulish early first-century B.C. anthropoid sword-hilt of bronze from Ballyshannon Bay, county Donegal. At this time, while La Tène art on the continent was in a process of inexorable decline, that in the islands was reaching peaks of originality and virtuosity. In Ireland, a land never occupied by Roman legions, the development continued into the early centuries A.D., laying the basis for the great achievements of the Early Historic Period. Among the important artistic innovations that emerge at this time is the rediscovery of the compass, virtually abandoned after the Early La Tène phase in Europe. From the end of the first century B.C. onwards, the trumpet-and-lentoid motif too becomes increasingly popular, and after the birth of Christ it is one of the hallmarks of insular Celtic art. Notable too in many artistic compositions of the last century B.C., especially in Britain, is a trend towards a greater emphasis on background forms so that the negative voids created by the positive elements of the designs acquire a character and importance of their own in the overall patterning.

Some items of the decorative metalwork from the Welsh votive deposit at Llyn Cerrig Bach on the island of Anglesey illustrate well the last point. A crescentic bronze plaque from that site is particularly important in this regard. On it there is a compass-drawn repoussé ornament, the main design being a somewhat lopsided triskele. The raised patterns create distinctive three-sided voids, each having one side convex, one concave, and one S-shaped. These are often termed "Llyn Cerrig" voids, after this piece, and are present on many objects of the two centuries or so spanning the birth of Christ.

Classic examples of such a deliberately contrived prominence for the background voids are to be found on an important group of southern British bronze mirrors. These have openwork handles and polished bronze discs with lavishly engraved ornament on one side. This uniquely British development represents a high point in insular La Tène craftsmanship. The designs, usually filled with hatched basketry, are compass-drawn executions of considerable complexity. The best of them are true masterpieces, where shapes twist and turn across the bronze, one form melting into another, patterns receding and advancing with the interplay of light and shadow as different elements of the decoration are allowed to take prominence in the eye of the beholder.

This Mirror Style is not confined to mirrors. Similar engraved ornament occurs, for example, on a first-century B.C. sword scabbard from Bugthorpe in Yorkshire, and on the decorative bronze plate of an iron spearhead from the river Thames. Several examples of a recently discovered (unfortunately unlocalized) group of miniature bronze shields from Britain also bear ornament comparable with that on the mirrors, and the same decoration, in three dimensional form, is present on the mouth of a scabbard from Little Wittenham in Oxfordshire.

The first century B.C. in Britain is also notable for the appearance of a significant regional school of gold torque manufacture centered in East Anglia in the territory of the Iceni. Occa-

Iron spearhead with decorative bronze applications from the Thames in London (England)
3rd-2nd century B.C.
London, British Museum

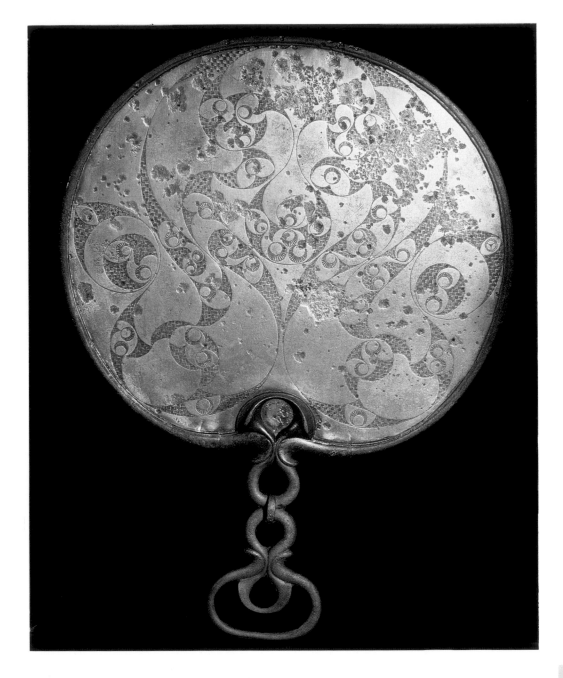

sional outliers from this school have been found as far north as New Cairnmuir, Netherurd in the Border area of Scotland. Most important examples, however, come from a series of hoards discovered over a number of years at Snettisham in Norfolk and at Ipswich in Suffolk. At Ipswich five certainly, and probably six, torques were found together. At Snettisham no fewer than eight deposits were found not far from one another in the same field. In all, the Snettisham find comprised a minimum of sixty-one torques, several bracelets, lumps of gold and tin as well as other items including a large number of coins.

These torques are of varying type. The most common are examples of twisted gold bars with looped ends, the latter sometimes finely decorated with raised curvilinear ornament. Occasionally such torques have buffer terminals and there are also three torques of typically Late La Tène tubular form which have this type of terminal. Multi-strand torques are also known and the most magnificent specimen is of this type. This torque—electrum rather than gold because of the high percentage of silver in its composition—is from Hoard E at Snettisham.

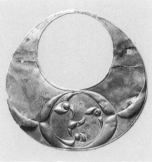

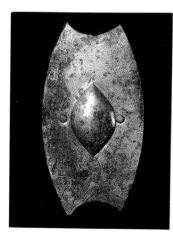

Miniature bronze shield probably for votive purposes found in the Thames (England) 3rd-2nd century B.C. London, British Museum

It is made of eight separately twisted strands soldered into hollow ring terminals. The ornament on these terminals, comprising raised designs set against a background of chased basketry, is clearly related to the two-dimensional Mirror Style. There is a range of other items, mainly in bronze, which belong to the same ornamental horizon. Among these, a horned helmet from the river Thames at Waterloo Bridge is outstanding.

An object which may well also date to the last century B.C. (though dates both earlier and later have been suggested) is the famous bronze shield (in fact shield cover) from the river Thames at Battersea. This piece is adorned on the front with a large central roundel with similar, smaller roundels above and below it. Each has a domed central boss with red glass inlay which is, in each case, surrounded by symmetrically arranged, high-relief repoussé ornament. The smaller roundels also have glass inlays. Stylized animal (or human?) heads link the individual roundels to one another. In Ireland, too, there were important stylistic developments in the last century B.C. The hoard from Broighter, county Derry, like Llyn Cerrig Bach for Britain, provides us with critical evidence in recognizing the new trends. At this site seven gold objects were found together. Some are probable imports (such as the two wire necklaces) but one object at least, a tubular buffer-torque, is certainly of native manufacture. Sinuous three-dimensional scrolls and trumpet curves of sub-vegetal character, combined with snail-shell spirals, adorn the tubular portion. These are set against a background web of overlapping, compass-drawn arcs. The joined buffers are secured by the insertion of a T-shaped tenon, projecting from one terminal face, into a small rectangular slot in the opposed face.

The Broighter torque belongs to the same typological grouping as the three tubular torques from Snettisham and the other Late La Tène tubular gold buffer torques in Europe. Its dating in the latter part of the last century B.C. is scarcely in question. The Irish example differs

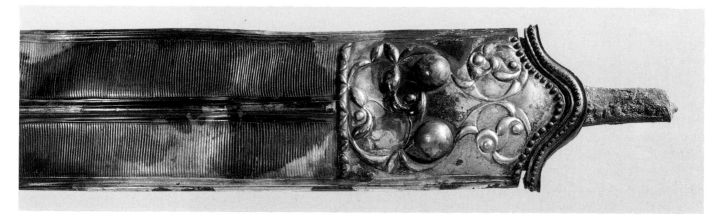

Detail of bronze scabbard from Little Wittenham (England) 2nd-1st century B.C. Oxford, Ashmolean Museum

in important details from both the British and the continental torques though its distinctive clasp mechanism places it closer to mainland European than to British schools of craftsmanship.

There can be no doubt, however, that the art which adorns it is entirely native and illustrates well the new emphasis on compass ornament and foreshadows the relief trumpet-and-lentoid curves which are to become a recurring element in Irish ornamentation from the early centuries A.D. onwards.

The Late Flowering

The Broighter collar leads stylistically to the so-called Lough Crew-Somerset style. Lough Crew is a cemetery of Neolithic passage tombs in county Meath, one of which contained within its burial chamber a large collection of polished animal ribs. The majority are plain, but decoration, when it occurs, is almost invariably compass-drawn. The designs are sometimes incomplete, at times even experimental, but the best of them are assured and balanced

geometric compositions of no little technical and artistic competence. The ornament is closely similar to that on the Broighter collar and is also closely mirrored on a range of unassociated items of bone, stone and bronze found in widely dispersed areas of the country. Most striking of all is the decoration on a monolith from Derrykeighan in county Antrim which repeats in almost exact detail, though on a much larger scale, the designs on one of the flakes.

The second element in the Lough Crew-Somerset Style takes its name from the hoard of metal objects found at Somerset, county Galway. This collection of objects, undoubtedly the stock-in-trade of a metalworker, included a series of small, circular mounts, decorated in openwork, repoussé or engraved ornament, a bird-head cup-handle of bronze, a bronze open-work brooch, a gold ribbon torque and an ingot, as well as a cake of bronze. It is the brooch and one of the repoussé mounts which are important, for on these the relief trumpet-and-lentoid curves present are divorced from the vegetal background, which is still recognizable on the Broighter collar. These are now produced in purely abstract, geometric form. The brooch, one of six now known from Ireland, is a uniquely Irish development, the individuality of which is underscored, in five of the six examples, by the ball-socket mechanism through which the pin is attached to the bow.

The hoard is especially important because of its virtually unique status as a closed association

Three sheet bronze horns perhaps part of a ceremonial headdress from Cork (Ireland) 1st-2nd century A.D. Cork, Cork Public Museum

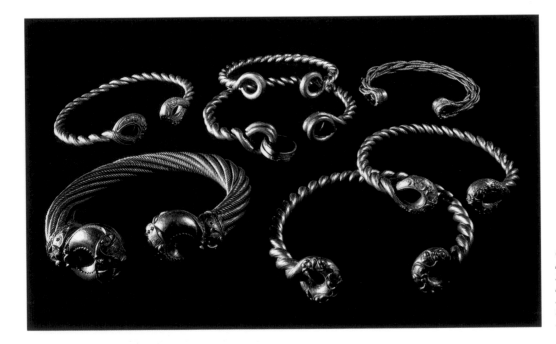

Gold torques from the votive deposits of Ipswich, Suffolk Snettisham, Norfolk and Needwood Forest (England) Second half 1st century B.C. to early 1st century A.D. London, British Museum

of varied Iron Age types from Ireland. Through it we can bring together a whole range of isolated objects scattered over different areas of the country. The bird-head handle is closely similar to the handle of a bowl from Keshcarrigan, county Leitrim, and to a number of other bird-head representations in the country which, after the turn of the millennium, appear to have become particularly popular in Irish Celtic art. There are also scattered circular mounts related to those from Somerset, notably an example from Ballycastle, county Antrim, with triskele design. Another such mount, from Cornalaragh, county Monaghan, has a hand-cut, openwork pattern of overlapping arcs, a motif which leads full circle to the ornament on the Broighter collar and to that on some of the Lough Crew flakes.

In different parts of Britain, dating to the first and perhaps also the second century A.D., horse and chariot fittings of bronze become an important vehicle for developed La Tène art. The compass continues to be dominant and there is considerable emphasis on engraved decoration. A feature of this group, however, is the greatly increased use of inlaid enamel orna-

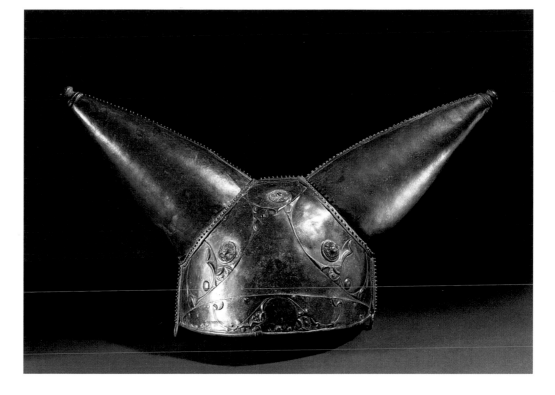

Horned bronze helmet found in the Thames, London near Waterloo Bridge (England) 1st century B.C. to early 1st century A.D. London, British Museum

Detail of tubular gold torque from Broighter (Ireland) 1st century B.C. Dublin, National Museum of Ireland

ment. Finds from Polden Hills, Somerset, Santon in Norfolk, and Westhall in Suffolk, are typical of this phase and several fine examples were exported to the European mainland. Among these the most notable is the harness mount, superbly decorated in red and yellow enamel, found at Paillart (Oise), twenty-five kilometers south of Amiens in France. Engraved ornament of similar type is present on some sword scabbards the most striking example being that on a bronze example from Isleham, Cambridgeshire.

In Ireland, while there are some instances of enameling in the early centuries A.D. the art of this period, the climax of native La Tène craftsmanship, is typified by a small but exceptional group of elaborately decorated and uniquely Irish bronzes. These include seven discs of unknown function, 20-25 centimeters in diameter, displaying high-relief repoussé curves. A small, slightly dished disc from Loughan Island on the river Bann is an even more impressive piece. Over its convex surface, revolving from a central whirligig, is an open-limbed, spiral-ended triskele with a separately tooled bird-head motif at the end of each spiral. The design is executed in raised, fine-line techique which was achieved, at least partly, by tooling away the background bronze. Two horned objects, which perhaps originally served as ceremonial headpieces, have raised fine-line trumpet ornament similar to that on the Bann disc. One consists of three hollow cones of sheet bronze, each folded and sealed by a riveted strip in the manner of the great curved trumpets. It was found in the coastal mudflats near Cork City in the south of Ireland. Leather fragments, said to have been adhering to the horns at the time of discovery, indicate in all probability that they were once attached to a leather headpiece. Decoration is confined to the base of each horn.

The second horned object is a fragmentary artifact, devoid of provenance. It is known as the Petrie Crown because it derives from the collection of George Petrie, a nineteenth-century collector. Only a single horn survives, attached to one of two dished discs which are in turn joined to an openwork frieze of sheet bronze. The horn was made in the same way as the three from Cork. The frieze, when complete, was probably stitched to a leather or textile backing and may have been worn on the head. All the surviving units have tooled ornament produced in the same manner as that on the Cork Horns and the Bann disc. The decoration

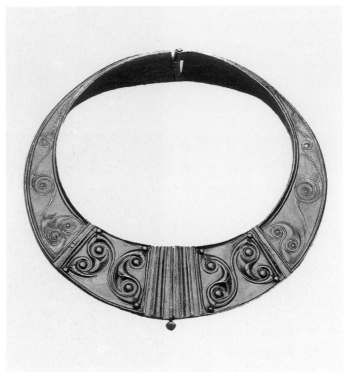

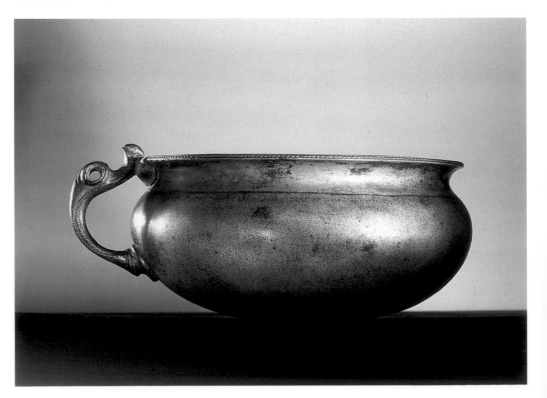

Disc with embossed
curvilinear ornament
in bronze
La Tène period
Dublin
National Museum of Ireland

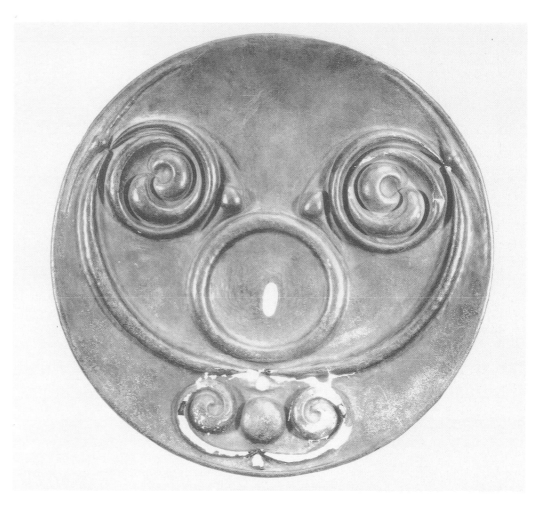

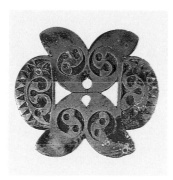

Harness mount with openwork
and enamel studs from Polden Hill
(England)
1st century A.D.
London, British Museum

on this object, however, is technically and aesthetically superior to that on either, and ranks as one of the truly great achievements of insular late Celtic art. There is an element of almost classic restraint as the thin curves, expanding delicately to their minute lentoid-boss ends, flow with liquid grace across the bronze in patterns of perfectly balanced beauty. Under the highest magnification there is no detectable imperfection. The curves have varied bird-head endings, reminding us of the Somerset and Keshcarrigan birds. The careful compass execution harks back to the technique on the Lough Crew flakes and on other bone objects.

Some of the crested bird-heads on the "crown" recall north British renderings and, indeed, there is at this time, in the early centuries A.D., good evidence to suggest that there was considerable technical and stylistic collaboration between Irish and Scottish workshops. Exports crossed the North Channel in both directions and common decorative trends are detectable. This is well illustrated by the decoration on a bronze collar from Stichill, Roxburghshire in Scotland which is related, both technically and stylistically, to that on the Cork horns. The trumpet-and-lentoid motif, so widespread on Irish bronzes of the early centuries A.D., is also common on contemporary Scottish pieces and is especially well represented on the well-known carnyx-head from Deskford, Banffshire.

Roman cultural influences gradually smothered and stifled the development of Celtic art in most of Britain. Ireland, free of the Roman yoke, retained its Celtic cultural identity. The continuity of La Tène art was unbroken. With the coming of Christianity, and through contact with the Germanic world, new motifs were added. For most of the first Christian millennium, however, the ancient traditions of La Tène craftsmanship formed a persistent backdrop to the art of the Early Christian golden age.

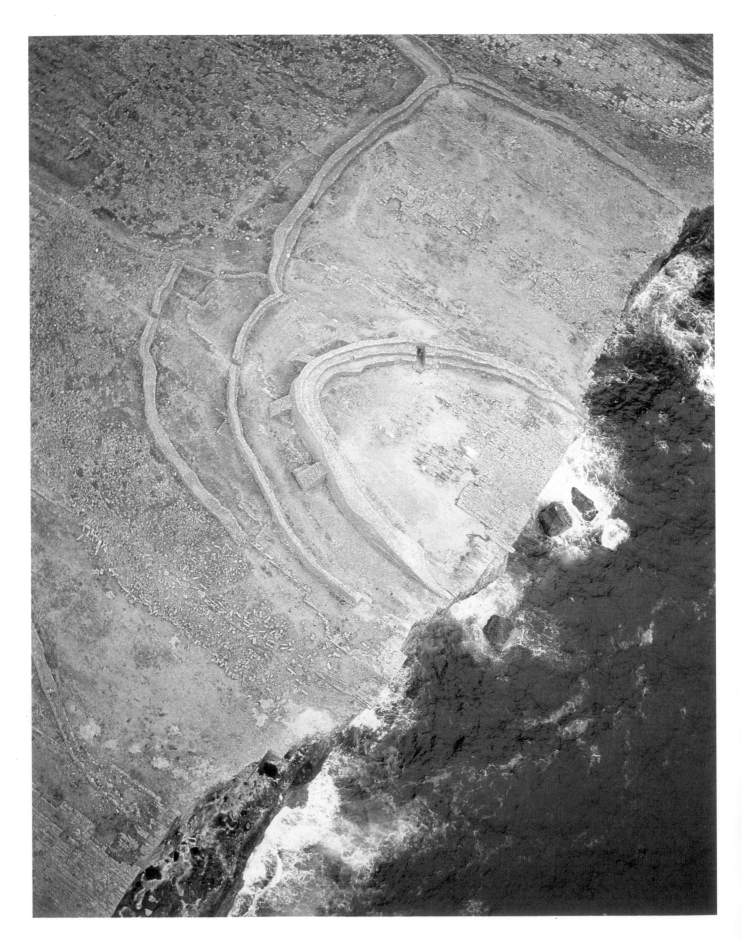

The establishment of the Phoenician trading port at Cadiz, traditionally dated to the eleventh century but archaeologically attested only after the eighth century, was a significant moment in the history of western Europe. Cadiz lay beyond the Pillars of Hercules, at the very limit of the Mediterranean trading network, facing the Atlantic. The port had been founded on an island on the eastern border of the metal-rich kingdom of Tartessos whose principal entrepôt was probably sited beneath modern Huelva at the confluence of the rivers Odiel and Tinto. From Cadiz the Phoenician entrepreneurs were well-placed not only to trade with Tartessos but also with the communities of the Atlantic seaboard stretching from the west African port of Mogador in the south to Ireland in the north.

These Atlantic communities had long been bound together in systems of exchange but the establishment of Cadiz cannot have failed to have intensified the movement of goods, in particular metals. A vivid reminder of this trade is given by a collection of bronze dating to c. 850 B.C. recovered from a shipwreck in the Odiel estuary near Huelva. Long slashing swords, helmets and spearheads had been collected together from many places as far afield as Ireland in a single cargo which ended its journey not in the markets of Tartessos or Cadiz but on the sea bed.

While it is possible that there were occasional long-haul journeys made by enterprising ships' masters in the interests of exploration and discovery, the bulk of the Atlantic trade would have been short haul, the small sea-going craft plying the coasts familiar to them and seldom venturing beyond. In this way commodities off-loaded in one port might in part be moved

Map showing the main seaways between Britain and the continent with main sites concerned

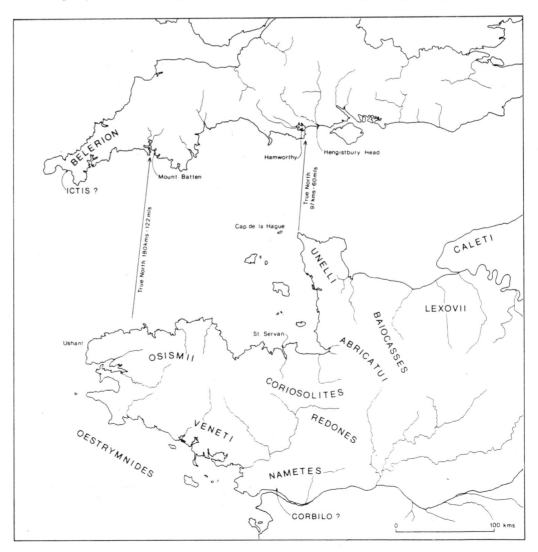

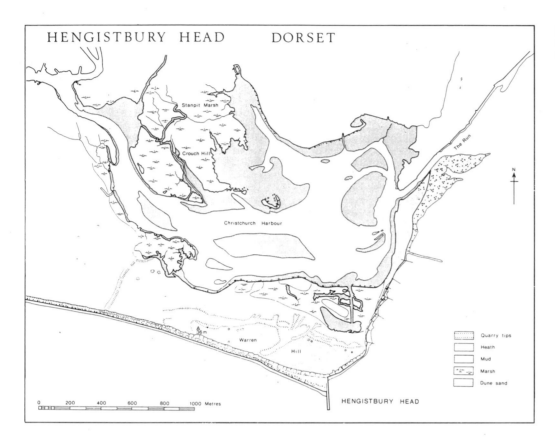

HENGISTBURY HEAD　　DORSET

Stanpit Marsh

Crouch Hill

The Run

N

Christchurch Harbour

Quarry tips
Heath
Mud
Marsh
Dune sand

0　200　400　600　800　1000 Metres

Warren

Hill

HENGISTBURY HEAD

Plan of the present situation
of the protohistoric port
of Hengistbury Head (England)

on, together with local products, by a different shipper used to seas alien to the first. This down-the-line trade would account for the blurred and overlapping patterns of artifact distribution all along the Atlantic coasts. The distinctive carp's tongue sword so common in the southeast of Britain is found scattered in decreasing numbers through western France and into Spain whilst the highly characteristic Armorican type of socketed axe, found in tens of thousands in Brittany, occurs much less frequently in southern Britain and western France south of the Loire.

Occasionally items manufactured in the Mediterranean found their way into the Atlantic zone, like the Sicilian shaft-hole axes known from Perigord, Montrichard (Indre et Loire), Rennes (Ille-et-Vilaine) and Hengistbury on the coast of Dorset.

Nothing is known of the ships used to carry these various cargoes but two wreck sites have been located off the southern coasts of Britain, both dating to the end of the second millennium B.C. One was found at Langdon Bay just to the east of the modern port of Dover in seven to thirteen meters of water in the lee of the chalk cliffs, the other at Moor Sand, Salcombe in Devon in five to six meters of water. In both examples all trace of the ships had long since disappeared but parts of their cargoes, of French-produced bronze tools and weapons destined for British markets, survive to indicate that these were probably sea-going vessels robust enough to make the Channel crossing between France and Britain. It can only be a matter of time before other wrecks are discovered not only along the Channel shores but around the coasts of the Irish Sea: exchange between Ireland and the rest of Britain must have been on a considerable scale.

One of the commodities much in demand in the Mediterranean was tin, and since the most prolific of the European deposits occur in Galicia (northern Portugal and northwest Spain), Brittany and the Cornish peninsula, it is reasonable to suppose that the transport of tin featured large in the intercourse between the Atlantic and Mediterranean exchange systems. One point of contact would have been the Spanish ports of Huelva and Cadiz but another, more direct route, lay across France by way of the Gironde estuary and the Garonne and

View of Hengistbury Head

then overland through the Carcassonne Gap to the Mediterranean. The foundation of Massalia (Marseilles) by the east Greek Phocaeans in about 600 B.C. may well have led to the development of this route which had the added advantage of cutting out the Phoenician middlemen who controlled the Straits of Gibraltar.

The earliest direct reference to the tin trade comes in a sailing manual, compiled by a Massaliot mariner in the sixth century B.C., but surviving in a somewhat mutilated form in a fourth century A.D. poem called *Ora Maritima* composed in Latin by Avienus. The account mentions Atlantic islands called the Oestrymnides, where tin was to be had. This was the northernmost point to which the Tartessians ventured. Where the Oestrymnides lay is a matter of debate—some scholars suggest the coast of Iberia while others prefer the Breton peninsula: the question is unlikely ever to be resolved.

Towards the end of the sixth century the Phoenician monopoly of the Straits of Gibraltar was tightened, an act which would have encouraged the Greeks to develop the cross-France route and to explore the Atlantic sea-ways for themselves. We know of one explorer, a Greek merchant called Pytheas, who some time about 330-325 B.C. reconnoitered the coastal routes between southern Spain and Britain. The fact that he specifically mentions Belerion, the Land's End peninsula of Cornwall, suggests that he was interested in seeing the tin-producing regions of Britain for himself. A contemporary of Pytheas, the Sicilian historian Timaeus, knew of further details (possibly derived from Pytheas's original work) but his account comes down to us only in a garbled version in Pliny's *Natural History*. He mentions an island called Mictis which he says "is distant inwards from Britain six days' voyage, in which tin is produced, and that the Britons sail to it in vessels made of wickerwork covered with hide." Although a variety of plausible interpretations have been put forward based on these words it is best to accept that they can be given no geographical precision.

A rather fuller account of the tin trade with Britain is given by the Stoic traveler Posidonius who may even have visited the island about 90 B.C. The original work of Posidonius does not survive but it was extensively quoted by the Sicilian writer Diodorus who mentions that

the inhabitants of Belerion were used to trading with foreigners and goes on to describe how they extract tin and make it into ingots which are carried by wagon at low tide to the island of Ictis. "Here then the merchants buy the tin from the natives and carry it over to Gaul and after traveling overland for about thirty days they finally bring their loads on horses to the mouth of the Rhône." Elsewhere he adds that the tin was carried to Marseilles and Narbonne.

Although Posidonius was describing the system as it was at the beginning of the first century B.C. it was clearly well established by then and had probably changed little since the sixth century. The route via the Garonne and Carcassonne Gap to the Mediterranean was probably the most favored but an alternative route up the Loire, across to the Rhône and thence down to Marseilles is also a possibility. The Greek geographer Strabo, writing at the end of the first century B.C., mentions this route as being one of the principal axes of communication across France. He also refers to the port of Corbilo at the mouth of the Loire which together with the Garonne, he says, was one of the points of embarkation for Britain. Corbilo had ceased to exist by the time when Strabo was writing but he tells how Scipio Aemilianus, in Marseilles about 135 B.C., met merchants from Narbonne and Corbilo. None of his contacts however could (or more likely would) give him any information about Britain.

The documentary evidence, therefore, implies that from the sixth to the early first century B.C., tin and no doubt a range of other commodities, were being traded from Britain and Brittany along the Atlantic coasts of western Europe and across France to the Mediterranean. Of the volume of this trade and its persistence we remain, however, entirely ignorant.

Direct archaeological evidence for Atlantic contact is surprisingly sparse. Two bronze figurines, one from the bank of the river Severn at Aust and the other from Sligo in Ireland, are sometimes claimed to be of Iberian origin but even if so, their date of arrival in the British Isles is unknown. Rather better evidence is provided by a small group of fibulae (three from Harlyn Bay in Cornwall and two from Mount Batten in Devon) which, though almost certainly manufactured in Britain, were clearly modeled on styles current in Aquitania and Iberia in the fifth or fourth century. Two similar fibulae have been found in western Brittany. Rather closer contacts between Brittany and western Britain are suggested by the decorated pottery which developed in both regions from the fifth to early first century B.C. The ceramic styles, though quite distinct, share certain elements of curvilinear decoration which may have been copied from high status bronze objects passing as gifts between the two communities along the traditional trading routes.

Finally we should mention the quite considerable numbers of Greek and Carthaginian coins found in Britain and western France. Many of these probably arrived much later than their date of issue (some as imports by collectors in the eighteenth and nineteenth centuries!), but a percentage are likely to be contemporary imports. The cluster of eight or more coins from around Poole Harbour, one of the main ports of entry into Britain, is strongly suggestive of long-distance trade.

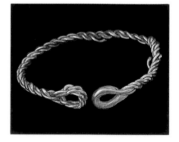

Gold torque from Hengistbury

Little is known of the ports-of-trade in this period. Ictis has not been certainly identified (in spite of many lengthy published discussions!). The only site which has the physical characteristics mentioned by Diodorus and has produced archaeological evidence of trade (including the two Iberian-style fibulae) is Mount Batten, now a promontory jutting into Plymouth Sound protecting a fine sheltered haven. Whether or not Mount Batten can be identified as Ictis must remain a matter of personal opinion. Other possible harbors on the south coast include Weymouth, Poole and Selsey but the evidence from each is slight and of unreliable quality. A more likely possibility has been recorded at Merthyr Mawr Warren near Bridgend in south Wales where artifacts associated with metalworking may indicate a trading settlement on the flank of a navigable estuary.

Maritime contact between eastern Britain and the adjacent Continent can be recognized in the range and volume of the imported metalwork found, spanning the period from the tenth to fourth centuries B.C. Much of it ended up as votive deposits in rivers particularly the

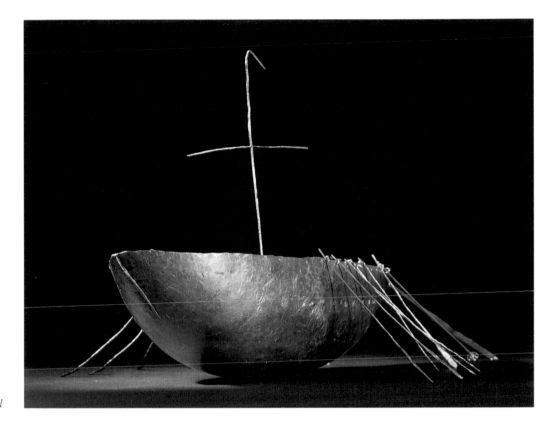

*Votive gold boat from the deposit
at Broighter (Ireland)
1st century B.C.
Dublin, National Museum of Ireland*

Thames. Vigorous contacts were maintained throughout this period but quantification is difficult and can be misleading. There does, however, seem to be some decline in the intensity of traffic for a century or two after the fourth century but this may be due to changing patterns of deposition rather than a severing of relations.

A distinct similarity between the material culture of the communities of eastern Kent and those of the adjacent region of France can be recognized. Since the two coasts are in sight of each other there is likely to have been a constant traffic between them using the ports of Folkestone and Dover as the most convenient landfalls. Major migratory movements are unnecessary to explain these similarities: processes of gift exchange would be quite sufficient. Throughout the second century B.C. Rome became increasingly involved in the politics of southern Gaul. The Greek towns and the native tribes of the hinterland were free to run their own affairs and this suited Rome so long as the overland route from northern Italy to Rome's Spanish conquests remained safe. But this was not to be: raids mounted by the hill tribes against the coastal cities threatened Rome's communications with increasing frequency until, by 120 B.C., the army, sent to restore stability, decided to remain, annexing the coastal zone to form the new province of Transalpina.

The creation of Transalpina dramatically altered the traditional exchange systems of the West in that it opened up the markets of barbarian Gaul to Roman entrepreneurs eager to rid themselves of the surpluses produced by the estates of northern Italy. One of the most profitable was wine for which there was a ready market among the Gauls. "Being inordinately fond of wine they gulp down what the merchants bring them quite undiluted," wrote Diodorus. "Many Italian merchants, prompted by their usual cupidity, consequently regard the Gauls' taste for wine as a godsend. They take the wine to them by ship up the navigable rivers or overland by cart and it fetches incredible prices: for one amphora of wine they receive one slave, thus exchanging the drink for the cup bearer."

Archaeological evidence for the wine trade is plentiful. Wrecks laden with amphorae have been identified in some number off the southern French coast and distribution maps of amphorae throughout France show marked concentrations along the principal rivers. There can

be little doubt that the long-established routes continued to be used to distribute the wine to the barbarians and to channel the raw materials and slaves, so much in demand in Rome, to the Mediterranean ports.

What we are seeing, then, is not something new, but simply an intensification of exchange patterns centuries old. To what extent the Roman entrepreneurs actively involved themselves in exploring and opening up the routes through barbarian territory is not certain, but a story told by Strabo throws some light on the question. In former times, he records, when Romans were tailing the Phoenician merchants in the Atlantic to discover their trade routes, a Phoenician captain drove his ship into shoal water, luring the Romans, and all were wrecked. This was preferable to losing his navigational monopoly. But, Strabo adds, by trying several times the Romans learned the secrets and after Publius Crassus had crossed to Britain to see the mining regions "he laid abundant information before all who wished to traffic over this sea." Clearly, then, enterprising souls were actually exploring the Atlantic shipping lanes.

The distribution of the distinctive Dressel 1A type of amphora, used to transport Italian wine in the late second and early first centuries B.C., gives a fairly precise indication of Atlantic trade in the pre-Caesarian period. Great quantities are found across southern Gaul from Transalpina to the mouth of the Gironde and then sporadically up the coast to Armorica where they cluster around the main ports at Quiberon and Quimper on the south coast and at St. Servin on the Rance estuary on the north side of the peninsula. The distribution can further be traced via Guernsey to the ports of central southern Britain and in particular Hengistbury Head. Further indications of this last leg of the journey are provided by the discovery of Breton-made pots on Guernsey and Jersey and in very considerable quantities at Hengistbury. From the same area of northern Brittany came the coins of the Breton tribe—the coriosolites—found scattered in central southern Britain. From St. Servin via the Channel islands to Hengistbury was the last haul of a complex system of transport and trans-shipment ultimately leading back to the ports of northern Italy.

Hengistbury itself seems to have served as a major port-of-trade. It was a place where British products, mainly from the southwest could be brought for refinement and trans-shipment— silver-rich lead from the Mendips, copper/silver alloy from west Devon, and gold possibly

from Wales. There is evidence for the importation and stockpiling of corn, and cattle may have been driven in to be converted into salted meat and hides. Local products included salt, Kimmeridge shale and iron. The list of possible exports from Hengistbury is interesting when compared to that given by Strabo of the principal products of Britain half a century later, "Corn, cattle, gold, silver, hides, slaves and clever hunting dogs."

The cargoes reaching Hengistbury were probably of a mixed nature. The wine amphorae and Breton pots (and their contents) would have been the most bulky items but rarer commodities such as raw purple and yellow glass and also figs were imported.

It is unlikely that Hengistbury was the only port of entry though it may have been the most important. Recent discoveries along the southeast coast suggest that local traffic may have sailed up the Channel. Discoveries of the Isle of Wight indicate a wreck. Amphorae found at Pulborough are suggestive of shipment up the river Arun while finds of amphorae and other material at Folkestone point to the location of another port. How much of this trade derived from the Atlantic system it is difficult to say. One of the other major routes through France followed the rivers Rhône, Saône and Seine. Writing of this Strabo records that cargoes passed down the Seine "to the ocean and to the Lexobii and Caleti, and from these peoples it is less than a day's run to Britain." He was describing the situation at the end of the first century B.C., but the route may well have been of some antiquity. There is ample evidence in the distribution fo Gallo-Belgic coins in Britain to show that the native communities on both sides of the Channel maintained the contact so evident in the material record of the previous period.

In our discussion of early first century B.C. trade there has been no mention of tin, a subject that bulked so large in the preceding period. The absence of evidence of direct trade with the tin-producing areas of the southwest at this time and the fact that Strabo does not mention the metal could be fortuitous but it could mean that British tin was no longer a commodity of value. Perhaps Iberian mines were now supplying sufficiently for Rome's needs.

Julius Caesar's conquest of Gaul in the 50s of the first century B.C. created an entirely new situation. Most significant was the fact that the Roman world now extended to the Channel coast. Caesar had established friendly relations with some tribes while decimating others. Among his particular enemies were the tribes of Armorica who had rebelled against him and had to be firmly put down. In Britain, he fought his way through Kent but soon entered into a treaty of friendship with the Trinovantes who occupied the eastern coastal region just north of the Thames. These various relationships may have had an effect on the patterns of trade which developed in the post-Caesarian period.

The volume of goods carried along the Atlantic route seems to have declined dramatically. One convenient indicator of this is the relative frequency of the Dressel 1B type of amphorae, which begin to replace the 1A type around the middle of the century. At Hengistbury and in Brittany the 1B amphorae were only about a third as numerous as the 1A type. If taken on face value it implies that the volume of trade had declined after the middle of the century even though a new type of wine amphora from Catalonia begins to make its appearance. Parallel with this progressive decline, the coinage of the native Durotriges becomes increasingly debased. Whether or not it was Caesar's harsh treatment of the Armorican tribes that caused the Atlantic trading to fail it is impossible to say but what is clear is that in the post-Caesarian period a new trading axis rapidly developed between Belgic Gaul, now under Roman control, and the Trinovantes of eastern Britain. Caesar's treaty of friendship with the Trinovantes may have been instrumental in initiating the readjustment.

Rome now occupied Gaul and Belgica up to the Rhine and by the time of Augustus a number of roads had been built linking the Channel ports and the Rhine frontier to Lyon and thence to Italy. Along these roads a range of commodities passed to be used as exchange goods with the Britons. Strabo lists them, rather disparagingly, as "ivory chains and necklaces, and amber-gems and glass vessels and other pretty wares of that sort," adding that the Britons submit easily to heavy duties levied both on exports and imports. Archaeology has added con-

siderably to the list. Wine drinking remained ever popular. Amphorae are commonly found in the graves of the elite together, less often, with bronze *paterae* and strainers, silver cups and a wide range of fine ceramics from northern Italy, eastern France and Belgica. The volume of trade was very considerable, to judge by the quantity of imports found not only in graves but also on settlement sites of eastern Britain. No doubt the tribes of the area guarded their monopolies jealously and on present evidence it seems that only imported wares of lesser value were allowed to pass into the hands of neighboring elites. The paucity of imports of high status along the south coast strongly suggests that the focus of contact was now firmly the Thames estuary and the coastal ports just to the north of it. Strabo was impressed by the degree of Romanization displayed by this region, remarking that friendly chieftains sent embassies to Augustus and paid him court: "not only have they dedicated offerings in the Capitolium, they have also managed to make the whole island virtually Roman." The native taste for imported wine, oil and fish sauce (all attested archaeologically), together with all the accoutrements of the symposium and the feast adds support to his generalization so long as we realize that he is referring to one small region of the island. Elsewhere, beyond this favored zone, Roman luxuries were largely unknown until the Roman armies of Claudius had swept across the entire southeast and were confronting the tribes of Wales and the Pennines.

Barry Cunliffe

Hillforts

The British Isles are rich in hillforts: on a conservative estimate England, Scotland and Wales can boast just over 3,000. But the term "hillfort" covers a multitude of fortified sites of different types and dates. Over half, occurring mainly in the north and west of Britain, are comparatively small, enclosing little over a hectare. These are best regarded as fortified homesteads and are no different in size, form and presumably social status from the settlements of the central southern region of which Little Woodbury and Gussage All Saints are typical examples. Leaving sites of this kind aside, the remainder of the hillforts proper—that is, defended enclosures of more than two hectares in extent occupying prominent locations—are unevenly distributed in Britain. The greatest concentration lies in the central southern zone stretching from the south coast (Dorset, Hampshire and Sussex) through the heartland of Wessex to the Cotswolds, the Welsh borderland and north Wales. To the east, west and north of this zone, though hillforts occur, their numbers are few. When compared with the adjacent regions of northern France and Belgium the dense distribution in central southern Britain stands out in marked contrast.

In Britain the study of hillforts is long established. Nineteenth-century antiquaries like General Pitt Rivers turned to them in the hope of redressing the balance of prehistoric studies which previously had focused almost exclusively on burial monuments. The first half of the twentieth century saw an intensification of hillfort studies with a series of regional campaigns in Wiltshire, Sussex, Hampshire and Dorset. For the most part this work focused on questions of defensive sequences and entrance structures, the notable exception being Maiden Castle in Dorset where, in the 1930s, Sir Mortimer Wheeler carried out a brilliant campaign, including area excavation in the interior, enabling him to demonstrate that some at least of the hillforts were densely occupied.

In the second half of this century excavators have been more concerned to examine the functions of hillforts. This has entailed large-scale excavations in the interiors. Notable examples are Midsummer Hill, Croft Ambrey and Breidden in the Welsh borderland, South Cadbury in Somerset, Crickley Hill in the Cotswolds and Danebury, Balksbury and Winklebury on the Hampshire chalkland. Together this work has shown something of the variety of occupation present in these otherwise superficially similar monuments: it has also allowed certain patterns of development to be recognized.

The hillfort phenomenon is of some antiquity. Recent work has shown that certain of our

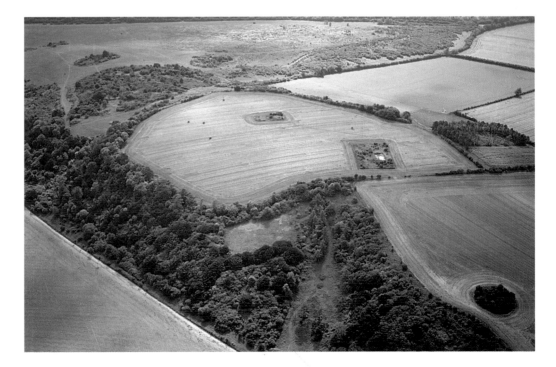

Hillfort settlement of Little Woodbury (England)

neolithic "camps," places like Crickley Hill (Gloucestershire) and Carn Brea (Cornwall), were built (or at least used) as defensive structures. Thereafter large-scale defensive works cease to be built until the middle Bronze Age, some time about 1300 B.C., when enclosures defended by ditches and banks, sometimes with palisades or timber lacing, were erected on prominent hilltop positions. This category of sites includes Norton Fitzwarren (Somerset) and Rams Hill (Berkshire) and somewhat later, in the late Bronze Age, Breidden (Powys). The later Bronze Age (roughly 1000-800 B.C.) also sees the appearance of a distinctive type of "ring fort" in eastern Britain stretching from Kent to Yorkshire. These enclosures, though massively defended, usually contain comparatively few circular houses and are best regarded as fortified homesteads. Objects found associated with them indicate the high status of the occupants.

By the eighth century B.C. a distinct pattern of enclosure can begin to be distinguished in central southern Britain comprising two principal types of fortification: large *hilltop enclosures* and smaller more strongly *fortified settlements*. The hilltop enclosures are usually extensive, covering areas in excess of six hectares and may often be between ten and twenty hectares. They are invariably situated on high upland areas with good defensive characteristics. The better known examples include Harting Beacon (Sussez), Balksbury (Hampshire), Bathampton Down (Avon), Ivinghoe Beacon (Buckinghamshire), Nottingham Hill and Norbury (Gloucestershire), and Nadbury and Borough Hill (Northhamptonshire). A few have been sampled by small-scale excavation. The defensive circuits tend to be comparatively slight comprising a shallow flat-bottomed ditch backed by a rampart which may be faced with vertical timber or more rarely drystone walling. Excavation in the interiors shows that the enclosures were lightly occupied, the most prominent features being settings of four posts which are generally interpreted as storage structures, perhaps fodder racks. Occasionally, as in the case of Balksbury, slight circular timber buildings, possibly representing houses, are found but evidence of occupation is slight and the general impression given is that the enclosures were only sporadically used. One possibility, bearing in mind their considerable size, is that they served as communal enclosures for livestock gathered together at certain times during the year.

The broadly contemporary fortified settlements are considerably smaller, usually within the two to four hectare range. They often occupy the ends of spurs or ridges and are strongly defended, sometimes with double banks and ditches. Examples include Highdown Camp (Sussex), Lidbury Camp (Wiltshire) and Dudbury (Avon). One of the principal characteristics of the type is that they all show evidence of intensive occupation of a kind which suggests high status. The simplest explanation, therefore, is that they represent the fortified homesteads of the elite and their entourages.

In the sixth century B.C. the pattern of hillfort building changes quite dramatically. For the most part (but not invariably) the earlier enclosures were abandoned and a series of new forts were built. In Wessex where the evidence is clearest, these new *early hillforts* show distinct similarities in size, form and location. Most average five hectares in area. They are sited on prominent hilltops and are enclosed by a single circuit of bank and ditch defenses following the contour of the hill. Almost invariably there were two entrances.

All of the early hillforts, for which there is evidence suggesting a sixth-century date, had ramparts revetted in the front and sometimes the back with a vertical wall of timber or stonework depending on the local geology. There is now some evidence to suggest that forts of similar plan built a little later, perhaps in the fifth century, were provided with ramparts without vertical facing but with rather more substantial V-profiled ditches: the continuous slope from the bottom of the ditch to the crest of the rampart could be as much as ten meters.

Excavations at Chalbury and Maiden Castle (Dorset) and Danebury (Hampshire) are providing an indication of how these forts were used. At Danebury, where more than half of the interior has been excavated, the settlement plan is quite clear. A road ran between the two gates with a number of subsidiary roads dividing the rest of the enclosed area. The main zone

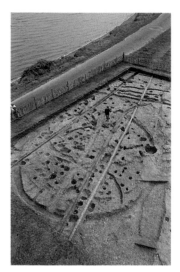

View of excavations in Dorset

of habitation, comprising circular houses and storage structures, lay around the periphery of the enclosure immediately behind the rampart. Other houses on either side of a road occupied the southern part of the enclosure. Elsewhere within the interior there were large numbers of storage pits and, in the center, a small rectangular building which may possibly have been a shrine.

A broadly comparable arrangement is evident at Chalbury (Dorset). Here, although excavation has been limited, surface features indicate the presence of circular houses and storage pits arranged roughly in zones. In this case the house walls were built of the local stone. Outside the Wessex area early hillforts are less well known but excavations at Moel y Gaer (Clwyd) and Crickley Hill (Gloucestershire) both indicate comparatively dense and well-ordered layouts of structures occupying much of the enclosed space.

The evidence at present before us, therefore, suggests that over much of the British Isles the sixth and fifth centuries were a time of hillfort construction and that, where the excavations have been on a large enough scale, it can be shown that many of the hillforts were intensively occupied by quite substantial communities.

Recent work in central Wessex is beginning to suggest that the pattern of hillfort development at this time was complex. Within a comparatively restricted area of western Hampshire

Aerial view of Danebury

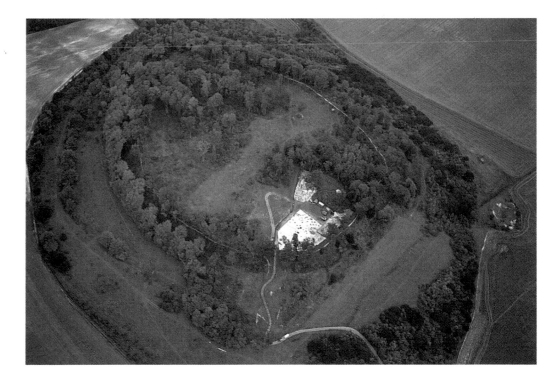

three hillforts are known, Danebury, Quarley Hill and Woolbury. Danebury was first fortified as an early hillfort in the sixth century with a timber-faced rampart. During the fifth century there is evidence of attack and refortification and it was at about this time that Quarely Hill and Woolbury were built, both with sloping (unrevetted) ramparts. While Danebury continued to be occupied on an intensive scale, evidence of contemporary occupation in Quarley and Woolbury is very slight. Although a number of interpretations of these observations are possible, it is tempting to suggest that the fifth century may have been a time of some social tension with local elites competing for power. In the event it was the original community at Danebury which survived. How widespread was this pattern it is difficult at present to say: it may have been restricted only to Wessex.

The fourth century B.C. seems to have been a time of considerable social change in Britain. Once more the evidence is at its most cohesive in the central southern zone where the majori-

ty of the excavation activity has been concentrated. In Wessex there is sufficient data to suggest that certain hillforts rose to a position of dominance over others. These *developed hillforts*, as they have been called, share certain characteristics. Most evident is that their defensive circuits were greatly strengthened: ditches were redug with deep V-shaped profiles while the ramparts were increased in volume and height, the additional material being derived from large quarries dug immediately behind the reconstructed rampart. In several cases, for example Danebury and probably Uffington Castle (Oxon), it is possible to show that one of the original gates was blocked while the remaining gate was monumentalized and provided with increasingly complex flanking outer earthworks.

At a number of sites the original defensive circuits were in part or in whole abandoned. At Yarnbury (Wiltshire) the new defenses lay some distance outside the original circuit while at Maiden Castle part of the original defenses was reused but one side was abandoned to allow a substantial new area to be enclosed for the first time.

Not all of the developed hillforts can have been of the same status. One has only to compare the colossal scale of Maiden Castle at this stage to Torberry Hill (Sussex) to appreciate the variety present: the coercive power needed to build and maintain Torberry was only a fraction of that behind Maiden Castle or Yarnbury.

The phenomenon of developed hillforts appears to hold good for other parts of the central southern zone. In the Cotswolds, although excavation has been limited, several forts like Bury Wood Camp (Wiltshire) and Uleybury Camp, Painswick Beacon and Sodbury (Gloucestershire) all share characteristics of defensive architecture common to the developed hillforts of Wessex. Further north, in the Welsh borderland larger scale excavations have identified a number of forts of this type including Midsummer Hill, Credenhill, Croft Ambrey and The Wrekin. Others, less well-known from excavation, are typologically similar in their defensive morphology. The evidence from northern England and Scotland is more ambiguous but some at least of the larger Scottish forts were occupied at this time.

One of the characteristics of developed hillforts is the intensity of their internal occupation. In the case of Danebury it is possible to show that the pattern was essentially a development of the earlier layout: even the main road which, as a thoroughfare was rendered redundant by the blocking of one of the gates, remained in use throughout. The most striking aspect of the occupation of this middle Iron Age period was the continuity of use represented by continuous rebuilding to broadly the same plan over two to three hundred years. There was a rigid zoning of buildings within the enclosure with discrete areas designated for structures of specific function. Evidence of planning was most noticeable in the southeastern part of the site where rows of four–and six–post structures were regularly laid out on both sides of metaled roads: many of these structures were rebuilt several times over on the same plot presumably as timbers rotted and needed to be replaced. Such regular and maintained planning implies a continuity of authority over a surprisingly long period of time. Danebury is by no means unique in this. Directly comparable rows of storage buildings were discovered at Croft Ambrey and Midsummer Hill showing that the phenomenon was geographically widespread.

Another feature of the Danebury interior was the use of the zone immediately behind the rampart for habitation. The deep quarry hollows dug to provide material for the heightened rampart were occupied by houses interspersed with storage buildings and open working areas. Although the arrangement of these various elements changed over time, during the six or so phases of rebuilding to which the zone was subjected, there is sufficient regularity of spacing to imply that the boundaries of the individual plots, representing perhaps space apportioned to individual family groups, remained consistent throughout much of the development. Once more the emphasis is upon maintained order.

Similar zones have not been extensively examined at other hillforts but limited work at Maiden Castle and South Cadbury has confirmed the existence of well stratified deposits of superimposed occupation levels associated with houses and other structures.

*Hillfort settlement of Uffington
(England) with the huge horse
carved into the nearby hillside
sometimes thought to be pre-Roman
but more likely medieval*

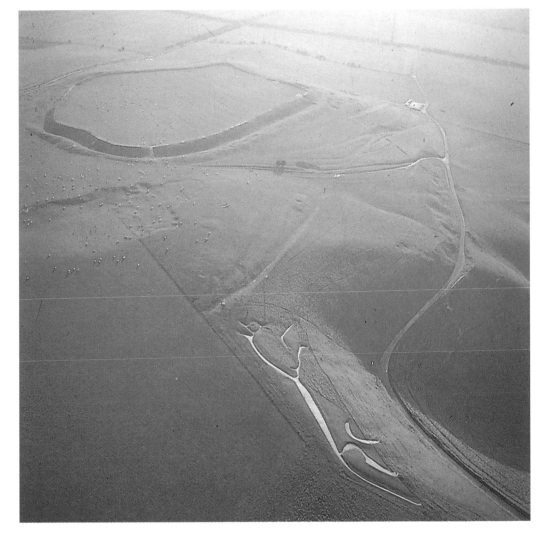

*Hillfort settlement of Uffington
(England) with the huge horse
carved into the nearby hillside
sometimes thought to be pre-Roman
but more likely medieval*

Evidence is now accumulating to suggest that some hillforts at least contained rectangular
buildings which can best be interpreted as shrines. Convincing examples have been excavated
at South Cadbury and at Danebury and there is circumstantial evidence to hint that one may
underlie the later Roman temples in the center of Maiden Castle. It is quite possible that
shrines were a regular feature of developed hillforts but the excavated sample is not yet large
enough to be sure.

The interiors of the developed hillforts were in continuous use over several centuries and
from the occupation debris deposited in them it is clear that the range of functions carried
out differed little from those practiced within the contemporary habitation sites densely scat-
tered in the countryside around. The only points of difference are that the forts supported
a much greater storage capacity per unit area and there is some evidence for the importation
and redistribution of raw materials. These observations have led to the suggestion that the
developed hillforts may have served as redistribution centers within discrete territories.

The social composition of the hillfort population is a matter of debate. There is no positive
evidence of elite residence but absence of evidence is not evidence of absence. Moreover we
do not yet know what, in archaeological terms, constitutes an elite residence in the British
Iron Age. Yet the hillforts themselves are redolent of coercive power and it is tempting to
suggest that in the massiveness of the defenses lies an affirmation of social superiority. The
earthworks at the gates of many of the forts are particularly impressive. Complex hornworks
create a maze of winding pathways building up a sense of mystery and surprise in the mind

of the approaching stranger. While it can be argued fairly that these structures served a defensive function, some had developed an elaboration far in excess of purely military needs. Maiden Castle in its developed form is more a monument to the status aspirations of its occupants than to the necessities of protection.

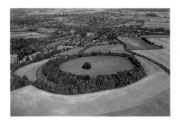

View of the hillfort of Maiden Castle (England)

In central southern Britain evidence is accumulating to suggest that a number of the developed hillforts ceased to be densely occupied and maintained in the early first century B.C. If this phenomenon proves to be as widespread as it appears to be, then we are clearly witnessing a significant dislocation in the socio-economic system. One explanation for this may lie in the fact that at about this time southern Britain was beginning to experience an intensification of long distance trade which may have caused a major reorientation in systems of exchange: this in turn is likely to have affected long established social patterns. However, those hillforts distanced from the direct effects of the revitalized trading networks continued to be occupied. In Wales and the north some were still occupied well into the Roman period but it is impossible to say on present evidence whether or not occupation was continuous. Some of the hillforts in the south that ceased to be maintained at the beginning of the Late Iron Age continued to be occupied, if only sporadically and on a limited scale. In some cases the type of occupation is reminiscent of contemporary farmsteads. In the southwest, however, in Dorset and Somerset there does seem to be a major phase of redefense in the middle of the first century A.D., which can best be interpreted as a response by the hostile tribes of western Britain to the Roman advance following the landing of A.D. 43. The clearest evidence comes from South Cadbury and Maiden Castle. It was this area across which the Second Legion, under the command of Vespasian, had to campaign, systematically reducing more than thirty fortified native *oppida*, before Roman rule could be established. The famous war cemetery in the main gate of Maiden Castle, thought to date to this event, provides a symbolic end to the hillfort phenomenon.

Ian Mathieson Stead

The Arras Culture

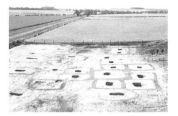

View of the cemetery during excavation at Wetwang Slack (England) with tombs encircled by a ditch 3rd–1st century B.C.

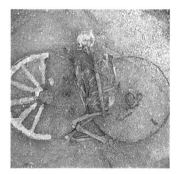

Tomb with dismantled chariot at Wetwang Slack (England) during excavations 1st century B.C.

The Arras culture takes its name from a large cemetery of small barrows in fields at Arras, near Market Weighton, in East Yorkshire. More than 100 barrows were excavated there between 1814 and 1816; the finds were divided among the excavators and some survive in the British Museum and in the Yorkshire Museum. Once there were many Iron Age barrow cemeteries in the area, but over the centuries they have been leveled by ploughing. Many had gone already by Medieval times.

One of the distinctive, though rare, features of the Arras culture is the cart burial, where a skeleton is found with the remains of a two-wheeled vehicle. Three such burials were found at Arras in the nineteenth century, and in 1959 an area of the cemetery was surveyed with a magnetometer in an attempt to locate some more. In this respect the survey was unsuccessful, but it did have an unexpected and important outcome in the identification of another feature of the Arras culture, the square barrow. Two plough-flattened barrows detected by the magnetometer at Arras were each defined by square-plan ditches from which the earth and chalk of the original mound had been excavated. A search through the literature showed that other square barrows had been recorded by earlier excavators, and seven sites were then listed. But within a few years this meager total was dwarfed as more and more square barrows were discovered; today they are numbered in the thousands.

Most of the recent discoveries came from the air, as air photographers gradually appreciated the wealth of East Yorkshire's past. Square barrows are now a typical feature of the landscape, showing mainly in July and August, as the cereal crops ripen. Concentrated on the chalk Wolds, their sharply-defined distribution extends southeast into Holderness, west to the middle of the Vale of York and north across the Vale of Pickering to the southern edges of the North Yorkshire Moors. Square barrows are particularly common along the eastern edge of the Wolds where they are often found not on the heights like Bronze Age barrows, but lying low along the valley floors. The valleys here, filled with chalk gravel, often with only a thin cover of topsoil, provide conditions ideal for air photography.

One of the most important concentrations of square barrows is between Burton Fleming and Rudston in the valley of the Gypsey Race, an intermittent stream that flows into the North Sea at Bridlington. Between 1967 and 1979, 250 burials were excavated there, but originally there must have been more than a thousand barrows in the area, in several different cemeteries. At the center of each barrow there was a single grave, and typically the skeleton was crouched or contracted and orientated north-south. Grave goods were not frequent, the most common item being a single brooch (in all 64 brooches were found) and very rarely a bracelet was also discovered. Thirty-five of the burials were accompanied by a single crude pot, and often the pot was associated with an animal bone—always the same bone, the humerus of a sheep. Such burials are typical of the Arras culture, found wherever square barrows are excavated, and they were the normal rite in the enormous Wetwang Slack cemetery. There, in a dry valley seventeen kilometers southwest of Rudston, 446 burials were excavated by J.S. Dent between 1975 and 1979 in advance of a gravel quarry. But at Rudston alongside these normal burials was a second, minority rite: 56 of the graves were orientated in the opposite direction, east-west, and the skeletons were not crouched but flexed or fully extended.

The range of grave goods was also different: there were no pots and only one brooch, but instead swords, spearheads, knives and spindle-whorls had been buried. Animal bones are sometimes found with the east-west burials, but they are not the same as those in the north-south graves—various pig bones instead of a single sheep-bone. The differences cannot be explained simply by the sex of the skeleton, for both types of burial include males and females; but there is evidence for a chronological difference, with the east-west burials being usually, perhaps always, later than the north-south. However, there is also a suggestion of family relationships between the two types of burial. Certain non-metrical variants of the skeletons, probably indicating genetic links, are shared by several adjoining east-west and north-south burials but are not common within the entire population. It seems that the

change in burial rite occurred within families, so the new rite does not represent an incoming population but a change in beliefs.

One disappointment in the campaign of excavations at Rudston and Burton Fleming was the failure to discover a cart burial. Several areas were thoroughly surveyed with detecting devices, especially the gradiometer, and it is clear than no vehicle had been buried there. But the surveyors were handicapped because they had no control: the gradiometer's reaction to a cart burial was unknown. That control should have come in 1970 when T.C.M. Brewster discovered a cart burial in Garton Slack (a continuation of Wetwang Slack) but his excavation was shrouded in secrecy and geophysical detecting was not attempted. However, in 1984 only 1.2 kilometers from Brewster's discovery, but over the parish boundary into Wetwang, J.S. Dent excavated three cart burials and A.L. Pacitto experimented with the gradiometer. The reaction was distinctive and surprisingly high, so in future surveys extensive areas could be scanned on a relatively coarse grid. In the autumn following the Wetwang Slack discovery

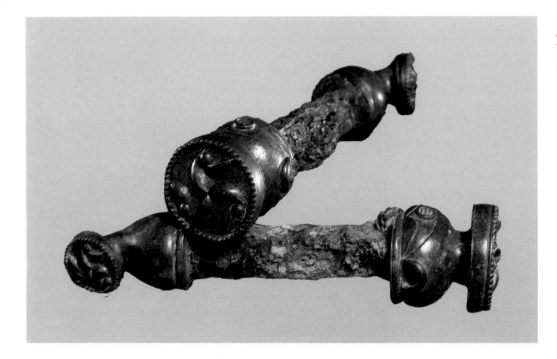

Pair of bronze linchpins from the chariot-grave at Kirkburn (England) 3rd century B.C. London, British Museum

Pacitto successfully detected a cart burial at Garton Station, and subsequently he found another in the next field, but in Kirkburn parish. A British Museum team excavated both burials, in 1985 and 1987.

So five cart burials have been excavated in recent years, and all are in the same gravel valley. One, Garton Station, was within a cemetery but the others were in small groups of two to five barrows. Cart burials are absent from the large Wetwang Slack cemetery, but the 1970 and 1984 groups were only a short distance away to the east and west, respectively. Four of the five carts had been buried in the same way. The wheels had been removed from the vehicle and set flat on the floor of the grave, before the corpse had been laid out over them with the yoke alongside. Then the T-shaped frame, axle and pole together, had been placed over the corpse. Finally it seems that the bodywork of the vehicle was buried; removed from the T-frame, like the wheels, it was probably inverted to form a canopy over the central part of the grave. The ritual was varied only at Gartoni Station, where the two wheels had been placed together against the side of the grave—but otherwise the arrangement of the rest of the grave was the same. The grave goods with the cart burials were more impressive than those with ordinary burials, and included one or two spectacular artifacts. There were two swords in decorated scabbards at Wetwang and a unique bronze canister, elaborately decorat-

*Hilt with enamel studs
from a sword from Kirkburn
(England)
1st century B.C.
London, British Museum*

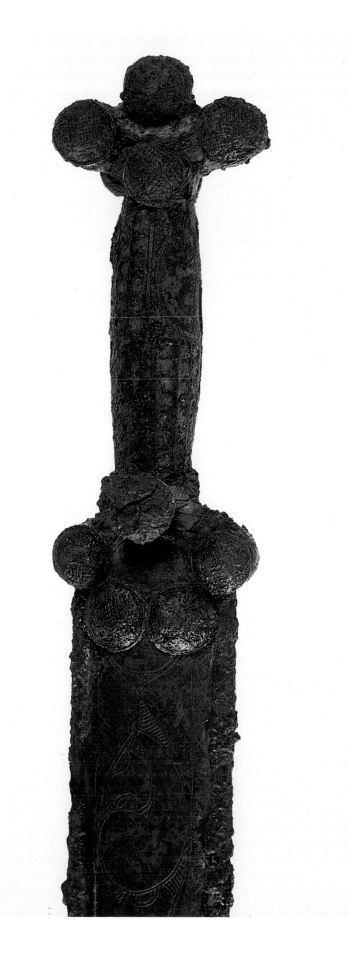

ed on all surfaces with engraved ornament resembling that on the scabbards. Artwork in a different technique, bronze cast by the lost-wax process, was represented on a horse bit from Wetwang, a terret from Garton Station, and a pair of linchpins from Kirkburn. But one of the most unexpected discoveries was in the Kirkburn cart burial, where the skeleton was covered by the remains of a complete tunic of mail. Judging from the grave goods the Kirkburn group (there is a hint of a family link between four of the five skeletons) belongs to the third century B.C., so the mail is amongst the earliest and is certainly the most complete to survive from the Celtic world. Another Kirkburn grave, but not a cart burial, included a sword with enameled handle in a scabbard with a decorated bronze front-plate—the handle is the finest ever seen on a Celtic sword.

In the last thirty years considerable effort has been devoted to understanding the burials of the Arras culture, but only recently has an attempt been made to learn something about the associated settlements. The air photographs that have shown so very many square barrows have also revealed domestic and other sites. East Yorkshire has an impressive concentration of crop-marks, but Iron Age remains are hidden amongst those of other periods—earlier prehistoric, Roman and medieval. Only by excavation can the Iron Age sites be distinguished, and they can be dated only by acquiring a clear idea of the sequence of pottery throughout the first millennium B.C. But existing museum collections are inadequate, so in 1988 the British Museum organized an excavation project aimed at recovering groups of domestic pottery. Initially the air photographs were searched for sites with concentrations of pits, because pits are typical of Iron Age settlements and they promise more useful groups of associated pottery than any other features. In order to achieve a reasonable sample it was decided to excavate a few pits at several different sites. In all, nine sites have been explored so far, and the outline sequence of pottery has been established: now it can be used to date other sites. Already this work on the settlements has produced two interesting results. First, the pottery evolved gradually throughout the first millennium B.C. without any marked external influence. The start of the Arras culture had no effect whatsoever on the development of the pottery tradition. Second, Arras culture pottery is found on unenclosed sites characterized by pits. Some sites have hundreds of pits covering more than twelve hectares, and some of them start well before the Arras culture and continue into early Roman times. Again, there are no sharp breaks and the emphasis is on continuity.

The intrusive element in the Arras culture is limited to the burial rite, indeed it is restricted to certain aspects of the burial rite. Non-intrusive aspects include crouched or contracted skeletons, which are extremely rare in European La Tène cemeteries, and the Yorkshire grave goods which are almost invariably British types. Only one piece, a hollow ring from Kirkburn, can be accepted as identical to a continental type. But two distinctive aspects of the burial rite, cart burials and square barrows, must have been introduced from the continent, probably at the same time, and no later than the third century B.C. It seems that the burial rite known as the Arras culture represents not the mass migration of a tribe, but the introduction of ideas. This argument is strengthened by considering what happened at Rudston in the first century B.C., when a new burial rite appeared and established families suddenly switched from one rite to the other. As with the start of the Arras culture, this is a change not of population but of beliefs.

Bronze fibula with sandstone studs colored red from Danes Graves 3rd century B.C. London, British Museum

Bronze fibula with coral applications from Queen's Barrow at Arras (England) 3rd century B.C. London, British Musem

Ian Mathieson Stead The Belgae in Britain: The Aylesford Culture

In 1890 Arthur Evans published the results of his excavations at Aylesford, in Kent, and opened a new chapter in British prehistory. Aylesford was a cremation cemetery, partly destroyed by gravel digging before Evans and his father discovered it when looking for Palaeolithic implements. Several graves had been excavated already, including one containing a wooden bucket with bronze fittings, two bronze vessels and two brooches, but further work uncovered six more cremations arranged in a "family circle." Evans was particularly impressed by the pottery that in itself suggested Kent, and indeed much of southeastern England, had been occupied by an intrusive tribe from Belgic Gaul. The introduction of the cremation rite supported this view, and its arrival might also have coincided with the first appearance in Britain of Belgic gold coins, two of which had actually been found in the Aylesford gravel pit. These archaeological discoveries gave substance to the close contact with the continent attested by Caesar who recorded, for instance, that Commius the Atrebatian had authority or influence extending over part of Britain.

Evans' conclusions were supported a generation later by the excavation of another Kentish cemetery, at Swarling, discovered in the same way—but this time it was Reginald Smith searching for palaeoliths. Buske-Fox's publication of Swarling dated the bulk of the pottery after 50 B.C. and the earliest probably after 75 B.C. The Belgic invasion of 75 B.C. thereafter became an established fact, and it was not seriously questioned until the 1960s.

The historical evidence for an invasion comes from Caesar who records Belgic immigrants in the coastal lands of Britain, most retaining tribal names from the homeland. These names are unknown, and the invasion is not dated. Perhaps it can be related to the appearance of Belgic gold coinage, though numismatists count invasion as only one of several possible reasons for its introduction, along with trade, plunder, payment of mercenaries and the adoption of coinage by native tribes. Whatever the motivation, Gallo-Belgic coins were circulating here before the end of the second century B.C. and insular production had started by the time of Caesar's expeditions (55 and 54 B.C.). The "elegant exotic" pottery that so impressed Evans was quite literally a revolutionary development, because the new forms were made on the potter's wheel. As this technological advance spread across southern Britain the shapes of local wares promptly changed, but this does not prove that the natives themselves were

Game pieces of colored glass from a grave in Welwyn Garden City (England) Last third of 1st century B.C. London, British Museum

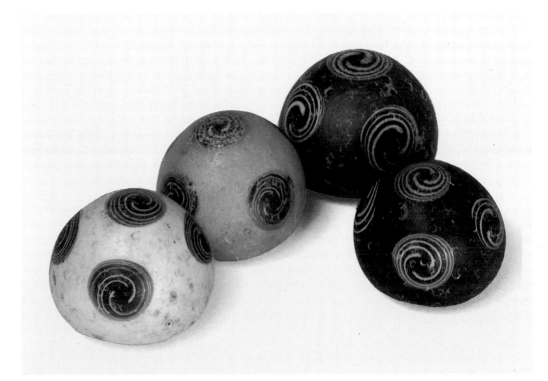

displaced. The introduction of cremation might indeed be linked with a movement of population, though few of the burials can be dated before 50 B.C. so they do not amount to a pre-Caesarian invasion. In the years before Caesar's expeditions there must have been considerable traffic in both directions across the English Channel, and cremation could have been adopted gradually as a result of political or social alliances. Whether by invasion or not, by the end of the first century B.C. southeastern England had developed much in common with a zone across northern France to the Rhineland, where cremation had become the standard burial practice well before the Roman invasion. In archaeological terms the British version is known as the Aylesford culture (some prefer the word "complex").

Many Aylesford culture cemeteries are small and served rural communities but some are large and associated with *oppida*, like the Lexden cemetery at Colchester (*Camulodunum*) and King Harry Lane at St. Albans (*Verulamium*). All the burials are in pits and the vast majority had little or no surface marking so today they are found entirely by chance. At Lexden the cemetery was discovered piecemeal in the foundations of houses and in their gardens, but by good fortune the King Harry Lane cemetery was a chance find on an archaeological excavation and time allowed for its complete excavation. Most sites are to the east and north of

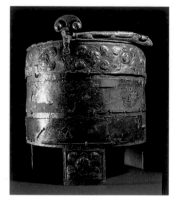

Wooden bucket (reconstructed) with bronze mounts from the grave at Aylesford (England) End 1st century B.C. London, British Museum

Detail of the bronze mount from the grave at Aylesford (England) End 1st century B.C. London, British Museum

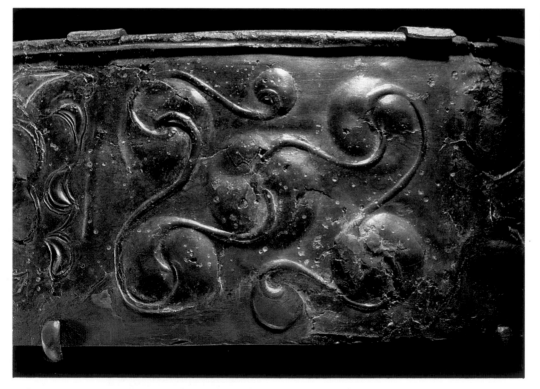

London, centered in Kent, Essex and Hertfordshire, but there is a scattered distribution to the west and south. The typical burial is a cremation, often with the calcined bones in an urn and sometimes accompanied by one or more accessory vessels. The simplest burials were piles of cremated bone with no container and no grave goods, but many of the more elaborate cremations also lacked surviving traces of a container for the bones. In such burials the cremated bones were heaped on the floor of the grave, together with any metal objects, and pots were grouped around them. Apart from pottery brooches were by far the most common of the grave goods, and there are a few knives (including triangular razor-knives), mirrors (including decorated mirrors), and toilet instruments, but weapons are almost completely absent. Rarely, contemporary inhumations are found.

Groups of burials are a feature of Aylesford culture cemeteries, with a prominent central burial ringed by less important graves in a square or rectangular enclosure defined by a ditch. There

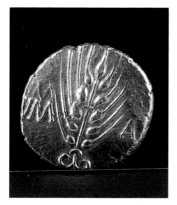

Obverse of gold coin minted by the king of the Catuvellauni and Trinovanti Cunobelino (A.D. 10-40) showing an ear of corn with the writing CAMV London, British Museum

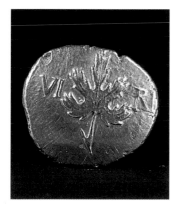

Obverse of a gold coin minted by Verica, king of the Atrebates contemporary of Tiberius (A.D. 14-37) and Claudius Design shows a vine leaf London, British Museum

were several such groups at King Harry Lane, including one with forty-seven graves. The "family circle" recorded by Evans at Aylesford suggests a similar arrangement, and there are others elsewhere—doubtless there would be more if there had been the opportunity to explore in the vicinity of chance finds. Enclosure ditches are slight and there would have been no real central mound. Farther west there are one or two small square barrows with a single central graves, including Hurstbourne Tarrant where a relatively rich grave was found.

Some Aylesford culture burials are in rather more spectacular large graves, accompanied by richer collections of grave goods including amphorae and sometimes firedogs. Known as Welwyn-type burials, they too have always been found by chance: ten are reasonably documented, but there are suggestions of several more—all of them north of the River Thames and most of them in the countryside, away from the *oppida*. The richest surviving grave was found at Welwyn Garden City in 1965 when a gas pipe trench was being excavated on a new housing estate. Many of the grave goods were smashed, but the pipe trench stopped slightly above the floor of the grave so a plan of the original arrangement could be reconstructed. Six Italian amphorae lined one side and on the floor were thirty-six pots—most of them native products but two platters and a flagon had been made in central Gaul. A silver cup and a unique bronze strainer reinforce the emphasis on wine: the tableware was the finest then available in southeast England. Burnt claws were found with the heap of human bones, suggesting that the body had been cremated wrapped in a bearskin. Near the calcined bones was a magnificent set of twenty-four glass game pieces.

Judging from the imports Welwyn Garden City dates from the decade 25-15 B.C. and very few British cremations can be shown to be earlier. One exception is a grave at Baldock where a collection of artifacts was crammed into a small circular pit: a bronze cauldron, pair of iron firedogs, two bronze bowls, two bronze-bound wooden buckets, and an amphora. Here again the body seems to have been cremated in a bearskin. The only pot is the amphora—the only Dressel 1A amphora to have been found in a British grave. Dressel 1B amphorae, known from other graves, seem to have replaced the 1A variant about the middle of the first century B.C., so the Baldock grave might well be pre-Caesarian.

Baldock belongs to a phase when amphorae reached Britain probably via Hengistbury Head—well to the southwest of the distribution of Aylesford culture burials. But Hengistbury lost its position as an important trading post about the middle of the first century B.C., possibly because of the dislocation caused by Caesar's Gallic war, and subsequent trade was direct with southeast England. The amphorae in Aylesford culture burials are from Italy, and the earliest flagons and platters are central Gaulish—possibly added to cargoes of amphorae transported by river across Gaul. The silver cups from Welwyn and Welwyn Garden City are Italian, too, and it may be that British silver brooches of this period provide another link with Italy. The imported bronze jugs and pans from Aylesford and Welwyn belong to types with scattered distributions apparently spreading from the Alps if not from Italy. But the most fascinating Italian connection is in a burial in the Lexden cemetery, where a medallion of the Emperor Augustus was found, as well as an iron stool—the symbol of power. Unfortunately this Lexden grave had been thoroughly disturbed long before it was excavated in 1924, but it was obviously very important. Unique among the cremations in southeast England, the gravepit had been covered by a huge barrow: the Lexden tumulus was 30 meters in diameter and still 2.15 meters high at the time of the excavation. Perhaps one of the local royal family was buried here, and it is even possible that the idea of the barrow was taken from the mausoleum of Augustus at Rome. Certainly British princes are known to have visited Augustan Rome.

From about 15 B.C. there was a change in Britain's continental contacts, with the import of Gallo-Belgic pottery from Champagne and the Rhineland, and the use of a range of brooches identical with those in northern Gaul. The burials differ little from those at Wederath, near Trier, where they are also grouped in square enclosures. This is the period of the King Harry Lane cemetery, which started with some of the relatively elaborate central burials

around 15 B.C. and continued beyond the Claudian conquest but was finally desecrated when the major road from Verulamium to Silchester was driven through the middle of it in about A.D. 70. Elsewhere, too, the burial tradition was unaffected by the Roman conquest. Coins are rarely found with burials, but they were in general use in southeast England at this time and they give some indication of the political organization. Uninscribed coinages have distributions suggesting tribal territories, but by the end of the first century B.C. inscribed coins clearly identify two kingdoms separated by the river Thames. The northern kingdom corresponds roughly with the distribution of cremations in Essex and Hertfordshire and included two tribes, the Catuvellauni to the west of the Trinovantes, united about A.D. 10 by the Catuvellaunian king, Cunobelin. King of the Britons, according to Suetonius, Cunobelin extended his kingdom to include Kent, where the earlier distribution of potin coins compares favorably with Aylesford Culture cremations. The southern kingdom was to the west and south of London, where there is only a scattered distribution of cremations. There successive kings, Commius, Tincommius and Verica, pursued a pro-Roman policy symbolized on coins by the vineleaf as opposed to the Catuvellaunian ear of corn.

Individual artifacts, such as coins, and small groups of artifacts, from graves or even cemeteries, are relatively easy to study. Settlements, by their very size, are more daunting. The largest sites, *oppida*, are ill-defined as Caesar himself discovered—the *oppidum* of Cassivellaunus was "fenced by woods and marshes." Camulodunum (*Trinovantes*) and Verulamium (*Catuvellauni*) were political centers, minting coins and burying their dead in Aylesford Culture cremation cemeteries. Camulodunum, at least, was partly defined by dykes enclosing a vast sprawling settlement that included the Lexden cemetery and the Gosbecks Farm temple complex. But excavation within such an enormous site (perhaps 2,000 hectares) has to be very selective, and Iron Age remains can be obscured by later features. Occupation in the last quarter of the first century B.C. is clearly attested, but finds include residual sherds from about fifty years earlier. At Verulamium the limits of pre-Roman settlement are vague; Prae Wood, once regarded as a major Iron Age settlement, now seems a relatively minor feature. In the vicinity of the Roman town there is nothing earlier than the inscribed coins minted

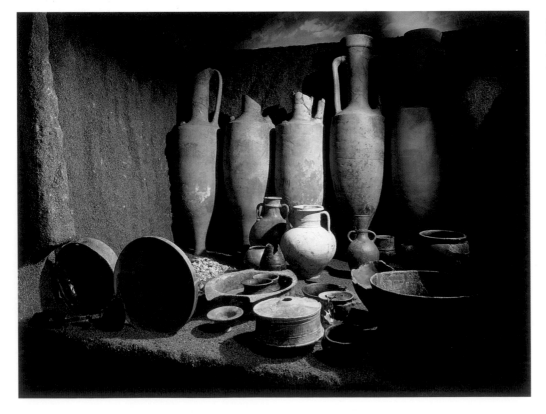

Museum reconstruction of a rich princely tomb at Welwyn Garden City (England) Last third of 1st century B.C. London, British Museum

*Small bird-shaped terracotta vase
from King Harry's Lane (England)
End 1st century B.C.
to early 1st century A.D.
London, British Museum*

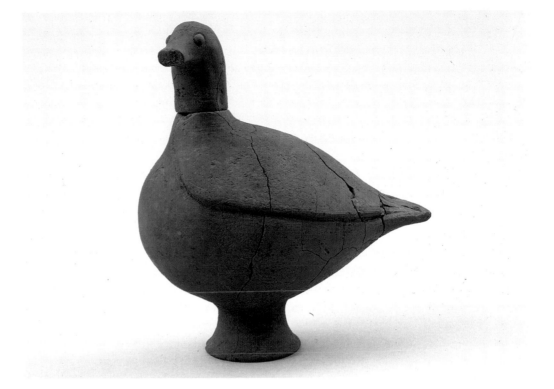

there by Tasciovanus, a contemporary of Augustus, though the nearby fortified site at Wheathampstead is earlier. Other major settlements in the area were less important, and are not known to have minted coins; Braughing has produced the best collection of Augustan imports, and Baldock was occupied from Caesarian times (contemporary with the firedogs burial). In Kent, coinage and pottery imply that a major settlement had been established at Canterbury by the start of the Augustan period. Just as the burial rite continued beyond the conquest, so these major settlements developed into Roman towns. Gradual infiltration had left southeast England well prepared for Romanization.

Celtic Religion and Mythology

The Celts were not unique among ancient peoples in evincing a vivid sense of the sacred throughout the various occupations and activities of their everyday lives, but their concern with the supernatural was sufficiently profound and pervasive to attract special comment from classical commentators. Caesar's statement that they were "exceedingly given to religion," or perhaps "to religious superstition" (*Natio est omnis Gallorum admodum dedita religionibus*) implies a marked disparity with his own experience of religious awareness. It is, moreover, an observation which might have been applied—and indeed has, in substance, been applied by later commentators—to the prehistoric and medieval Irish, descendants of those Celts who had colonized Ireland from the Continent several centuries before Caesar undertook his campaign for the subjugation of Gaul in the first century B.C. To judge from the recorded remains of their tradition the ancient Irish had little sense of a clear and palpable line of demarcation between the supernatural and the secular, and life for them was a flexible combination of routine pragmatism and unquestioning belief in the power of ritual and mythic precedent. As Marie-Louise Sjoestedt has said with special reference to early Ireland, "The supernatural and the natural penetrate and continue each other, and constant communication between them ensures their organic unity. Hence it is easier to describe the mythological world of the Celts than to define it, for definition implies a contrast."

The Sources

But there are also more prosaic reasons why it is difficult to clearly define Celtic mythology and the system of religious belief and practice to which it belongs. They have to do with the nature and provenance of the extant evidence, which is broadly of two kinds, the first comprising Celtic monuments on the continent and in Roman Britain together with the comments of several classical authors, the second the corpus of insular Celtic vernacular literature

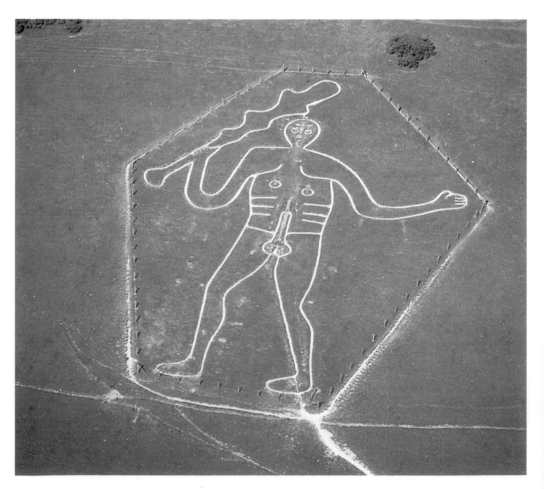

Huge image of Hercules or similar deity carved into the topsoil at Cerne Abbas (England) 1-4th century A.D.

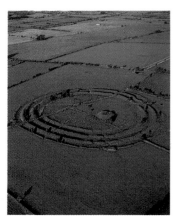

Typical Celtic cult formation

that has survived in writing. Each poses its own peculiar problems of assessment and interpretation. Most of the plastic images of the deities and the dedicatory inscriptions belong to the Roman period and may have been effected ideologically as well as artistically by Roman influence. What makes it difficult, however, to measure the extent of this influence, as well as the mythico-religious significance of the monuments themselves, is the fact that the liturgy and mythology which constituted their frame of reference are almost wholly missing. The druids did not commit their teaching to writing, and consequently the whole of their sacred literature perished with the eventual extinction of their language. It is this circumstance that lends particular importance to the accounts of those classical authors who reported their own or others, ethnological observations on the Celts. Posidonius (c. 135-50 B.C.) was the most important of them, and much of his Celtic ethnography survives in the works of later writers, notably in the *De Bello Gallico* (*Gallic War*) of Julius Caesar. Despite the obvious limitations of this testimony, delivered for the most part at second hand by foreign writers who brought their own social and political preconceptions to bear on the subject, a close comparison with the later insular literatures shows that it contains a core of authentic information. They tell us, for example, that there were three classes in Gaul associated with learning and literature: the druids, the bards, and, between them, a class which seems to have been best known by the Gaulish term **vatis*, cognate with Latin *vatis*; and it cannot be coincidence that a similar threefold classification is attested for early Ireland, with its druids, *filidh* (semantically close to the *vates*) and bards.

When we turn to the insular vernacular literature of the medieval period, which in effect means the literatures of Ireland and Wales, we confront problems of a somewhat different order. On the positive side is the fact that it comprises a remarkably rich and varied body of native tradition; on the negative, the fact that it is, in its extant written form, much later than the continental evidence and has been filtered through the scribal system of the Christian monasteries where virtually all of it was recorded. The writing of native tradition began in Ireland in the sixth century, but the production of fairly extensive narrative texts seems to have begun in the seventh to the eighth century (considerably later in Wales), already a century or two after Christianity had substantially displaced indigenous paganism. Indeed almost all the extant texts survive in capacious manuscripts of the late eleventh and succeeding centuries, but by dint of close textual and linguistic analysis it is possible to assign dates to the earlier manuscript sources from which they had been copied or redacted. On the other hand, the relative lateness of the surviving literature is balanced by a strong conservative strain that is amply confirmed by comparison with older Indo-European traditional literatures and accounts for many striking archaisms of style and content in the texts. It is this conservatism which makes the insular, and particular early Irish, literature such a valuable complement to the continental evidence, provided account is taken of the probable selectivity of monastic scribes as well as of the Christian-Latin influence mediated by the Church.

Pan-Celtic Deities

Given the diversity and frequent inadequacies of our sources it would be unrealistic to expect from them a clear image of a unified, consistent order of religious belief. Nowhere have we the integral tradition as it might have been transmitted and interpreted by the druids and their associates in an independent Celtic society. No source or group of extant sources was designed to furnish an ordered, comprehensive picture of native religion as seen from within its own cultural community. The effect of this has been to accentuate the heterogeneity of Celtic religion, and it has sometimes led scholars to exaggerate its local and tribal character and to ignore the many features which reflect the underlying unity of Celtic myth and ritual. One or two instances of this unity will suffice. Continental iconography (including for our present purpose that of Roman Britain) lays great emphasis on the symbolism of the triad, the concept of threeness, and the mythico-literary referent which it lacks there is amply supplied by the endless variation on the motif found in Irish and Welsh literature. On a more

general level, it has long been recognized that all the evidence, whether literary or archaeological, attests a deep concern with the land, with its sacred geography, its borders and its natural features and configurations; one important branch of Irish learned tradition is called *dindshenchas*, "the lore of (famous) places," and has to do with furnishing etiological tales to account for hundreds of place names, for virtually every distinguishable feature in the landscape had its mythic significance, though some were more highly charged with spiritual virtue than others; the same phenomenon is reflected in Gaul in the extensive repertory of deity names attached to individual sites: hill and mountain tops, clearings and cultivated fields, rocks, fords, confluences, rivers and springs. One instance of this geographical dimension to religious usage is the fact, noted by many scholars on the basis of the archaeological evidence, that Gaulish sanctuaries were often situated near territorial boundaries, and it is significant that the Irish evidence, mainly historical and literary, reveals a very similar pattern of distribution. Evidently their function was to mark the bounds of tribal unity just as other sanctuaries at the center designated its core.

This essential spiritual identity is reflected amongst the Celtic deities, even if it is somewhat obscured by the diversity of the sources. For the continental evidence the *point de départ* is Caesar's succinct catalogue of the principal gods: "Of the gods they worship Mercury most of all. He has the greatest number of images; they hold that he is the inventor of all the arts and a guide on the roads and on journeys, and they believe him the most influential for money-making and commerce. After him they honor Apollo, Mars, Jupiter, and Minerva. Of these deities they have almost the same idea as other peoples: Apollo drives away diseases, Minerva teaches the first principles of the arts and crafts, Jupiter rules the heavens, and Mars controls the issue of war."

What he offers us here is a thumbnail sketch of the Gaulish pantheon modeled on that of Rome. He does not call them by their native names but instead, in characteristic Roman fashion, refers to them by the names of the Roman gods they most closely resemble. He also assigns to them more precisely defined functions than is warranted by the insular evidence. But once allowance is made for his professional and ethnic bias, there is no reason to believe that his account is not in substance authentic. The fact that his gods, minus their native names, are not always easily identified with the gods of insular tradition, or even with those of continental iconography, has more to with the contrast between his schematic catalogue and the protean abundance of the living mythology than with any inherent discontinuity within Celtic religion.

Some modern scholars, faced with the apparent conflict between Caesar's clear-cut picture and the fertile chaos of insular tradition (not to mention the variant nomenclature on Gallo-Roman dedications), came to the conclusion that the Celts lacked universal deities and that they had instead a multiplicity of gods whose cults were local and tribal rather than national. They cite Lucan's mention of the god *Teutates*, "the god of the tribe" (from Celtic *teutā* "tribe"). In fact, of course, since the operation of such trans-tribal institutions as traditional law and sacred kingship was organized primarily on the basis of the petty kingdom (Irish *tuath* from *teutā*), there is no inherent contradiction in the notion of pan-Celtic deities who were also regarded as tribal protectors (and sometimes given special epithets). What is more important is that there were in fact individual gods whose cults extended over all, or over large parts of, the Celtic areas of Europe. "Mercury," the most widely venerated of the Gaulish gods according to Caesar, is a case in point. There are some fifteen places in Europe named after him, including Lyons (Gallo-Roman *Lugudunum*), which Augustus chose as capital of colonial Gaul, Laon and St. Lizier also in France, Liegnitz in Silesia, Leiden in Holland, and Carlisle (Romano-British *Luguvallum*) in England. His native name, which Caesar omits from his account, is identifiable from the place names as *Lugus*, which corresponds exactly to the Irish deity name *Lugh* and the Welsh *Lleu*. Moreover, Caesar refers to Mercury as "omnium inventorem artium" ("inventor of all the arts"), which reads like a paraphrase of Lugh's sobriquet in Irish, *(sam)ildánach* ("skilled in many arts together"), the difference being

that Irish has an early mythological tale which confirms Lugh's mastery of all the arts and crafts. He is the youthful god who conquers malevolent otherworld figures, and his feast, the great harvest festival of Lughnasadh, was celebrated throughout the Celtic lands, as it still is to some extent in Ireland and Britanny. He is the divine exemplar of sacral kingship, and in one Irish tale he is represented as king of the otherworld attended by a woman identified as the sovereignty of Ireland, a pairing reminiscent of the Gaulish Mercury's association with the goddess Rosmerta (or Maia). His usual epithet, *lámhfhada* (of the long arm), reflects an ancient concept of kingship traceable to Indo-European origins. No doubt he was, under the name *Lugus*, as important and colorful in continental tradition as he was in Ireland, but his legends are glimpsed only vestigially in stone images and dedications.

Pan-Celtic Goddesses

If we were confined to Caesar's note on "Minerva" for our information, we would have a very inadequate notion of the important role of the goddess in question, and indeed of the whole prolific class of Celtic goddesses. On the continent there is an extensive gallery of female deities—Rosmerta, Nantosvelta, Damona, Sirona, Nemetona and others—who figure as the consorts of male deities, thus replicating the prototypal coupling of the mother-goddess with the protecting god of the tribe or nation. It is not possible to draw any permanent distinction between them and the numerous divinities honored under the title of *Matres*, or *Matronae*, anonymous epiphanies of the divine mother, whose cult was no doubt partly autochthonous and runs deep in the mythological tradition of all the Celtic areas. In her maternal capacity, the goddess was also conceived as genetrix of peoples, a belief which is well attested in Irish literature, as also in Welsh, where Branwen in the second branch of the *Mabinogi* is described as "one of the three great ancestresses of Britain." In continental iconography she often bears cornucopias, baskets of fruits and other symbols of her fertility, and this association with fecundity, both physiological and terrestrial, is a familiar feature in the insular tradition. It is bound up, of course, with her role as personification of the earth, not merely the earth in general, but also as defined and delimited by cultural and political boundaries: the eponymous triad of Ériu, Fódla and Banbha represents both the reality and the abstract concept of Ireland in its totality, as numerous other Irish goddesses are identified with its individually defined provinces and regions.

Where the region is a kingdom, the goddess embodies not merely its fertility but also its sovereignty, and from this nexus comes one of the most prolific of Celtic myths, that of the solemn union of the ruler and his kingdom. It is much older than the Celts, but among them it found a congenial and remarkably productive context. It is probably reflected in the coupling of god and goddess in Gaulish sculpture, but it is only in the insular literatures (including the derivative Arthurian cycle) that it appears in all its varied profusion. From the countless versions of the theme recorded in Irish one gains some idea of the ritual union as it must have been performed before the Christianization of the political establishment in the fifth and sixth centuries. It presumably consisted in the marriage of the new ruler to a surrogate of the goddess (perhaps she who was, or was to become his wife). It comprised two main elements (though with many ancillary motifs): a libation offered by the bride to her new partner and the actual coition. Queen Medhbh of Connacht, a superficially euphemerized version of the goddess, was notorious for the number of her successive husbands; appropriately, her names means "the intoxicating one." Because of its enduring resonance, the myth was often used to eulogize individual rulers or to justify the ambition of political dynasties. Bereft of her rightful mate and ruler the kingdom became widowed, impoverished and decrepit, reflecting the material and political misfortunes of the land and its people, and this is graphically highlighted in numerous tales and poems in which the woman becomes repulsively old and ugly only to be restored to radiant youth and beauty by the act of intercourse with her new ordained partner.

The goddess was nothing if not versatile, and the literature presents her in all her moods and

Twin hills known as the Paps near Killarney (Ireland) In Gaelic they were called "the breasts of Anu" the mythical mother of the last generation of gods that ruled the earth, Tuatha Dé Dánann

aspects: young or old, fair or ugly, benign or destructive. Often she is the charming emissary who comes to invite and accompany chosen heroes to the land of primeval innocence where love is untainted by guilt and where sickness and death are unknown, and so typical is she and her kind of certain versions of this happy Otherworld that it is sometimes referred to as *Tír inna mBan*, "The Land of Women." But she also appears as the goddess of warfare, like Buanann "The Lasting One" or Scáthach "The Shadowy One," who taught Cú Chulainn his fighting skills, or, still more typically, like the fearsome trio of Morríghan "The Phantom Queen," Bodhbh (Chatha), "The (carrion) Scald-crow (of Battle)," and Nemhain "Frenzy" or Macha, who haunt the battlefield to incite the fighters or entangle them by their magic. In this guise she had her counterparts in the Romano-Celtic areas. The *Cathubodua* in an inscription in Haute-Savoie is the Gaulish equivalent of Irish *Bodhbh Chatha*; the trio to whom the latter belongs is echoed in a British inscription *Lamiis Tribus* "To the Three Lamiae" (or Furies); the Welsh river-name Aeron means "The Goddess of Slaughter"; the formidable queen of the British Iceni invoked the goddess *Andraste* before engaging in battle, and so on. It is clear then that, despite the mobility of their nomenclature, the goddesses of Gaul, Britain and Ireland were essentially similar. Caesar did not give us Minerva's own Gaulish name, but certainly the most striking insular pendant to her is the Irish goddess Brighid, who achieved the remarkable feat of becoming abbess (or at least being assimilated to the abbess) of the great monastery of Kildare and the most famous woman saint of the Irish Church. Brighid, whose legends flourish in popular oral tradition down to the present day, is described in early Irish texts as patron of poetry and learning, of healing and of craftsmanship. Allowing for linguistic change, her name identifies her with Briganti, Latinized as Brigantia, "The Exalted One," tutelary goddess of the powerful British tribe of the Brigantes. It occurs extensively in place and river names and implies a widespread cult in western Europe. There is therefore a strong presumption that Brighid-Briganti is to be equated with Caesar's "Minerva."

There was at least one other pan-Celtic goddess who failed to find a place in Caesar's terse list. Epigraphic and iconographic documents in many Romano-Celtic areas commemorate Epona "The Divine Horse" or "Horse Goddess": the inventory comprises some 350 items. Her recorded attributes connect her with the fecundity of the land and of nature, but, as

her name indicates, she was also the patron or protector of horses, and in this capacity she was widely venerated among the Roman cavalry. Because of her equine and other associations she has frequently been compared with the Welsh Rhiannon "Divine Queen" (as well as with Macha, eponym of the pagan sanctuary at Ard Macha "Height of Macha" which later became the metropolis of the Christian Church in Ireland), and one can with some confidence explore the lost mythology of Rhiannon through the extant mythology of Rhiannon, some of which has filtered through the polished prose of the First and Third Branches of the Middle Welsh *Mabinogi*.

The Divine Family

The cult of Maponos "The Divine Son" seems to have been particularly popular in northern Britain, but it existed also in Gaul, in the vicinity of healing springs. He may be identified with Caesar's Apollo, though this may embrace more than one Celtic god: he is equated at least once with Apollo *Citharoedus* "the Harper." His name regularly became Mabon in Welsh, and in medieval Welsh literature he appears as Mabon son of Modron, that is to say, son of *Matrona* "The Divine Mother," eponymous goddess of the river Marne in France. Despite his undoubted importance, only scraps of his myth survive in the written literature, but they indicate that he was known as a hunter and that he was carried off to the Otherworld as an infant. He survives in continental Arthurian romance under the names Mabon, Mabuz and Mabonagrain. The centrality of his role, however poorly it is documented, is underscored by the fact that he is a member, probably the most prominent in tradition, of the triadic family of father-god, mother-god and divine son: Teyrnon "Divine Lord," Modron and Mabon. It is clear from the incidence of Maponos and Matrona that this familial paradigm was common to all the Celts, and we should not be surprised to find it reproduced in Irish, where it is embodied in a rich corpus of mythic narrative and verse. But Celtic deities are never restricted to a single name form, and in Irish the commonest names for the mother and father gods are, on the purely morphological level, divergent. The divine father is the Daghdha "Good God," otherwise Eochaidh Ollathair "Eochaidh the Great Father" or the Ruadh Rofhessa "The Mighty One of Great Knowledge," and the divine mother, like Matrona and many other Celtic goddesses, is the personification of a river, in this case *Boand*, the modern river Boyne, the sacred river of Ireland which under its dual guise is the subject of a prolific mythology. Their son is Mac ind Og "The Young Son/Youth" (also called Oenghus), which is the semantic equivalent of British and continental Maponos. According to Irish literature there is a touch of the trickster in his make-up, as for instance when he dispossessed his father from the great tumulus dwelling of Bruigh na Bóinne (Newgrange) by a piece of word-play.

Overlapping Functions

The universality of the deities discussed so far is confirmed by a substantial correspondence of title and function throughout the Celtic world. But, as we have seen, specific names are not used consistently of the Celtic gods, if only for the reason that individual gods could have several titles or epithets, any one of which might be used as his appellative in a given context. This is no problem in Irish literature, where the contextual reference furnishes clear identification, but in Romano-Celtic inscriptions variant nomenclature may appear to indicate so many different deities, and some scholars who have read the evidence in this way have been led to imagine a multitude of local and barely distinguishable gods. This tendency is heightened by the fact that the functions of the Celtic gods are not in reality quite as precisely defined as a casual reading of Caesar might suggest. There is a good example of this in relation to a famous passage in Lucan's *Civil War* where he refers to bloody sacrifices offered the three gods Teutates, Esus and Taranis. A later commentator on Lucan has used two main sources, one of which equates Teutates with "Mercury," the other with "Mars." This is no great problem. If, as already suggested, *Teutates* is primarily a title ("god of the tribe") rather

than a name, such confusion is easily understandable: the god of sovereignty and the arts, Mercury, will naturally function also as a warrior, while the god of war, Mars, will often appear as defender of the tribe. Their functions will therefore overlap, and the main emphasis in any particular instance may be largely a matter of circumstance. Mars is especially difficult to confine within any narrow equation, since his association with fighting is a universal rather than a differentiating feature within the heroic environment of Celtic tradition, and Irish alone has a proliferation of originally divine heroes who are obvious multiforms, or avatars, of the warrior-god whom Caesar designated as Mars.

The essential point is that a living mythology such as is reflected, however inadequately, in early Irish and, to a lesser extent, Welsh will inevitably be far removed from the laconic precision of Caesar's notes, and in the case of Celtic the normal switching of names and shifting of regional and functional emphasis is increased by the fact that the Celts of Britain, Ireland and Gaul existed for lengthy periods as separate cultural entities. The great Finn ("The Fair One") mac Cumhaill, leader of a legendary band of warrior-hunters and protagonist of a whole traditional cycle in Irish was in origin a god. He is probably to be equated with the Welsh Gwynn (= Irish Finn) ap Nudd, another magic warrior-huntsman, and, more importantly, some of his core legends suggest that he is a variant reflex of the god Lugh. Furthermore, such is the essential resemblance between his cycle and that of the British king Arthur that we can hardly avoid the conclusion that both represent a common insular Celtic myth of the heroic defender of the realm against demonic forces of chaos. In the absence

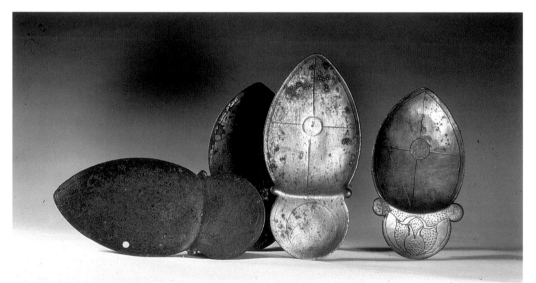

Ritual bronze spoons
from unknown site in Ireland
1st century A.D
Dublin, National Museum of Ireland

of a surviving literature we have no means of knowing whether such a protector myth existed in Gaul, and, if so, to which hero-deity it might have been attached, but no doubt, were we in a position to retrieve the lost mythology of Gaul, we would find a similar proliferation of stories and poems overlaying an inner order and economy as we do in the insular literatures.

For even as shorthand Caesar's notes are selective. He makes no separate mention of a number of deities, such as Epona, who seem to have been favored with distinctive cults. Thus we cannot know where he would have accommodated the "god with the hammer," Sucellus "The Good Striker," of whom there are two hundred monuments, mostly in Gaul, some identifying him by name; perhaps he would have identified him with his "Jupiter," the father god, as many modern scholars have done. And what of the horned god who is famous under the name Cernunnos, even though that name occurs in a sole inscription on a Paris relief of the Roman period? In the well-known plaque from the Gundestrup Cauldron he sits typically cross-legged with a torque in one hand and a serpent in the other and surrounded by animals,

Janiform stone head from Corleck (Ireland)
1st-5th century A.D.
Dublin, National Museum of Ireland

a scenario which suggests he may in fact be the father-god under the aspect of Lord of the Animals. Indeed Caesar himself acknowledges the incompleteness of his list when he makes separate mention of a Gaulish Dis Pater from whom the Gauls, in accordance with druidic teaching, believed that they were all descended. It is significant that he should assimilate this deity to the Roman god of the dead, for here Irish tradition furnishes a parallel which can hardly be fortuitous. Donn "The Brown/Dark One" dwells on a small rocky island, known as Tech Duinn "The House of Donn," off the southwest coast of Ireland, and he bids his descendants, in other words the people of Ireland, to come to his house when they die. In the early literary tradition he represents the somber side of the otherworld god as lord of the dead and even tends to be assimilated to the devil of Christian belief, but popular, modern tradition, while retaining this underworld characterization, reveals him also as a god of contrasting facets, benign and terrible, creator of storms and shipwrecks and protector of cattle and crops. Naturally all this was unknown to Caesar, but the essential concord between his reference and the scattered Irish evidence is telling testimony to the fundamental unity of Celtic religion and mythology.

Continuity and Innovation

It is this underlying unity which warrants our using the insular literary evidence to complement the artistic and archaeological evidence from the Continent and Roman Britain, but subject to the important caveats already referred to: that there was conscious as well as unconscious censorship of oral tradition by monastic redactors and that our extant texts were written long after druidic paganism had ceased to be the received religion of the country; to which one might add the related fact that the reworking of traditional mythic narrative came more and more to be informed with a literary rather than a religious sensibility, resulting eventually in what Dumézil has referred to as *de la mythologie littérarisée*. The effect of these is to qualify but not to nullify the retrospective and comparative value of the insular texts, as a few selected instances will illustrate. Georges Dumézil, who did perhaps more than any other scholar to reveal the continuities of Indo-European ideology in Irish and other conservative traditions, had this to say of a certain instance of analogous tales of kingship in India and Ireland (one which brings together two mythic heroines, the Irish Medhbh and the Indian Māhdavī):

"Certainly we have here, conserved on the one side by the druids, on the other in the unwritten 'fifth Veda' from which the post-Vedic narratives of India in large part derive, a fragment of Indo-European politico-religious philosophy, that is, some of the speculations made by the Indo-Europeans on the status and the destiny of kings... As is typical in accounts from medieval Ireland, which no longer rely upon a religion or even upon a living ideology, the story of Eochaid, of his daughters Medb and Clothru and his grandson Lugaid, is still more laicized and worked over as literature—despite the marvels that are still found in it. But the lessons, as we have seen, are the same."

Dumézil himself adduced many other residual instances in Irish and Welsh tradition of Indo-European myths and ideological structures which presuppose the earlier existence of a complex system of socio-religious doctrine consciously maintained and cultivated over many centuries. He saw confirmation of this theological system in the fact that, as the French scholar Joseph Vendryes had shown, the Celtic languages, in common with Italic and Indo-Iranian, retain many elements of an old Indo-European terminology relating to religious belief and ritual: "le maintien, sur les deux marges du domaine indo-européen, à l'extrême est et à l'extrême ouest, d'un vocabulaire aussi fortement lié à l'organisation soci ale, à des actes, à des attitudes ou à des représentations religieux, n'est concevable que si des fragments importants du système de pensée préhistorique auquel appartenaient d'abord ces notions ont aussi subsisté."

One notable absence from the insular texts is any kind of organized cosmogony, though Caesar and other classical authors would seem to have heard of such doctrines among the Gaulish

druids, and parts of the medieval Irish "Book of Invasions" (*Leabhar Gabhála Éireann*), dealing with the shaping of the land of Ireland and the invention of its institutions, would seem to presuppose a structured corpus of cosmogonic lore. This was evidently one of the partial casualties of the ecclesiastical filter. A less obvious target for the Christian revisers was the related area of cosmography, and here Irish literature, and to a lesser extent Welsh, complements the continental evidence. The tradition that Ireland comprised five provinces is prehistoric and is already attested in archaic legal texts: the very word for province, *cóigedh*, literally "a fifth," implies a conjunction of five provinces within a transcendent unity. This pentarchy consisted of the four provinces of Ulster, Leinster, Munster and Connacht representing the cardinal points and enclosing within them the province of *Midhe* "Middle, Center." Within Midhe stood Tara, the focus of sacral kingship, and within Tara the royal court would appear to have been structured as a microcosmic replica of the Irish macrocosm. Obviously this schema derives from a druidic doctrine of cosmography which had close analogues in India, China and others of the "great traditions" of the world. The complete pattern seems to be clearly attested only in Irish literature, though an essential element of it, the cult of the center, can be shown to be virtually universal among the Celtic peoples: the *locus classicus* for Gaul is, of course, Caesar's statement that the Gaulish druids used to foregather at a holy place in the territory of the Carnutes which was believed to be the center of all Gaul. This notion of a sacred center symbolizing a transcendent cultural unity is a commonplace of medieval Irish literature. Like certain other features of traditional ideology it survived the declension of native ritual following the establishment of Christianity because it was intimately bound up with those central institutions of Irish society which carried much of their ideological baggage with them into the Christian era: sacral kingship and the order of learned poets, the *filidh*, literally "seers," who retained much of the status, socio-political influence and conservatism that characterized the druids before them. The fact that traditional kingship was already in rapid decline in Gaul by the time of Caesar's conquest cautions us against assuming that Gaulish religion is substantivally older because it is attested earlier than that of the insular Celts, particularly those beyond the bounds of Roman rule. Taken together, however, the two bodies of evidence compose a fascinating if incomplete tapestry of human aspiration and imagination, and one that has an unmistakable inner consistency that is peculiarly Celtic.

Barry Raftery

Bogs

Wooden trackway in the peat-bogs of Corlea (Ireland) dated with dendrochronology to 148 B.C.

Though the environment of Celtic Europe was largely dominated by forest, along the northern and western fringes, boglands too played a significant role in contemporary life. The most important of these occur in Denmark, north Germany, the Netherlands, Britain and, above all, in Ireland. For the archaeologist, bogs are of exceptional significance because of the outstanding preservative properties of the peat. Thus organic materials, including human bodies, survive frequently in almost perfect condition giving us unique insights into the culture of early man.

The bogs undoubtedly had a major impact on the way of life of those Iron Age peoples who lived in their vicinity. For these were often vast expanses of soggy wasteland, full of hummocks and hollows, dominated by pools and areas of open water. The bogs thus offered a degree of protection and were an important source of materials and of wild fowl for the local inhabitants. But they were also obstacles to travel, for they were dangerous places where the deep pools and the quaking peat lay in silent ambush to engulf the unwary traveler. Thus, during the Celtic period, as in earlier times, wooden causeways were laid across them and these achieved levels of quite considerable technical sophistication.

It seems that the bogs also had a significant place in the spiritual life of the people and that goods, animals and, indeed, humans were deliberately sacrificed in them. This is not, of course, always easy to prove archaeologically. Individual finds can be variously interpreted. However, some, at least, must have been deposited with votive intent. The famous silver cauldron, for example, found dismantled in a bog at Gundestrup in Denmark can hardly be otherwise viewed. Groups of weapons and other precious items, often deliberately damaged, are more readily explained in this way. Several large weapon hoards from northern Europe, for instance, are taken to be victory offerings. Carved wooden figures of humans are also found in bogs and these too are generally accepted as of votive character.

The discovery of bog bodies belonging to the Celtic Iron Age is also frequently seen as evidence of the ritual sacrifice of humans. Clearly, however, there are other possibilities in individual cases such as secular execution, murder, the burial of social or political outcasts, to say nothing of the victims of accidental drowning. Some of the bog burials may well be votive, however. These include the naked man from Tollund in Denmark who was hanged and the elderly man and the teenage girl found together at Windeby in north Germany who seem to have been deliberately drowned by weighing them down in a bog pool with heavy branches. The young adult from Lindow Moss in Chesshire, England who was poleaxed, garotted and finally had his throat slit before being thrown into the bog is also regarded by most commentators as an Iron Age ritual sacrifice.

Perhaps the most common finds from bogs are the wooden causeways. By the time of the Celtic Iron Age these had developed in some areas into massive corduroy roads of elaborate construction. Some of the most important of these have been uncovered in Lower Saxony in north Germany. Here, roadways of oak planks three to four meters long were laid down which were clearly designed to facilitate the passage of wheeled vehicles. In fact, numerous wagon parts of wood have been found in association with them. One especially interesting example is the Bohlenweg XLII in the Wittemoor. There a pair of stylized human figures carved from wooden boards was found which had once stood at the edge of the track. They may have been deities erected to invoke protection at a particularly treacherous point in the bog where the track crossed a small water course.

One of the largest Iron Age wooden roadways in Europe occurred in Corlea bog, county Longford in the Irish midlands. Its total length was about two kilometers. It was built of heavy oak planks, up to four meters in length, laid transversely on parallel pairs of longitudinal runners. The planks were secured by wooden pegs hammered through mortices in their ends. The road has been dated by tree-ring analysis to 148 B.C.

Danebury
Barry Cunliffe

Overview of the hillfort settlement
of Danebury (England)
7th century B.C.-1st century A.D.

Horse bits from Danebury (England)
1st century B.C. - 1st century A..D.

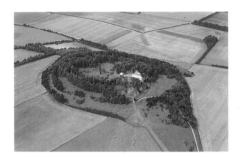

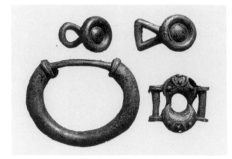

Danebury is an Iron Age hillfort situated in the rolling chalk uplands of Wessex in central southern Britain. It is one of many similar forts in the area distinguished only by the fact that since 1969 it has been the scene of twenty successive seasons of large-scale excavation.

The earthworks of the fort are well preserved. The principal enclosure, of some five hectares, was defended by a substantial rampart with a deep ditch in front. The main, east entrance still retains its complex flanking earthworks while the southwest entrance, blocked in the fourth century B.C., can just be made out. Between the two gates, on the southeast side, lies the middle earthwork defining a corral attached to the main fort. Outside this, and enclosing the entire hilltop, is a slighter, outer earthwork, integrated with a linear ditch system which can be traced running for several kilometers across the countryside towards the valley of the River Test.

Excavation has allowed the development of the fort to be worked out in some detail. In the first stage, dating to the seventh and sixth centuries B.C., the hill seems to have had two enclosing circuits: the outer earthwork and probably a palisade which occupied the position taken by the later inner ditch. In the middle of the sixth century the palisade was replaced by the first phase of the inner rampart and ditch with its two gates. A little later the middle earthwork was added. In the middle of the fourth century the fort was remodelled: the main defensive circuit was increased in strength; the southwestern gate was blocked and the eastern gate widened and strengthened. Occupation continued until the beginning of the first century B.C. when the gate was destroyed by fire and occupation ceased except for sporadic reuse on a far more limited scale.

The sequence demonstrated at Danebury is broadly similar to that recognized at a number of Wessex hillforts. What sets Danebury apart is the fact that half of the interior has now been excavated and in consequence it is possible to say something of how hillforts of this kind were used. The story seems to be one of intensification, with the accretion of a variety of social, economic and religious functions.

The earliest enclosure, of the seventh and sixth centuries, seems to have been lightly occupied, the only recognizable features being pits and small four-post structures, the former for storing grain, the latter possibly serving to support fodder ricks for animal feed. The fact that very little occupation debris was found hints at the possibility that the prime function of the enclosure was as a communal storage area for agricultural produce and, at certain times of the year, for animals.

After the original palisaded enclosure had been replaced with a bank and ditch in the middle of the sixth century, evidence for occupation increases. Storage pits become numerous: so too do four- and six-post storage structures, now substantial enough to have supported above-ground granaries. In addition circular houses were built all around the periphery of the site in the lee of the rampart and there is clear evidence of internal roads with rows of houses laid out along them in the southeastern sector. Rather more occupation debris accumulated in this period with large middens developing between the houses backing onto the rampart. It was also at this stage that the earliest of a succession of buildings interpreted as shrines was erected in the center of the fort facing the east entrance.

After the refurbishment of the middle of the fourth century, the network of roads branching out from the east gate becomes firmly established and the shrines in the center continue to be rebuilt. Much of the northwestern part of the central area seems to be used for storage in pits while the southeastern half of the site was filled with four- and six-post storage buildings arranged in rows along the streets and rebuilt, as need arose, on a number of occasions. The zone around the periphery of the fort, immediately behind the rampart, was now densely packed with circular houses, storage buildings and working yards. These deposits were extremely well-stratified and showed a minimum of six phases of rebuilding over a period of 250 years.

In this last phase considerable quantities of occupation material accumulated within the enclosure. There is evidence, in the form of stone weights, that commodities were being carefully measured, and the presence of salt containers, iron ingots, imported shale for making bracelets and bronze working suggests that the fort may have been used as a center where commodities were exchanged and where some degree of manufacturing took place.

The end of intensive occupation came about 100 B.C. when the main gate was destroyed by fire. Several pits near the entrance, containing mutilated bodies, may belong to this last phase.

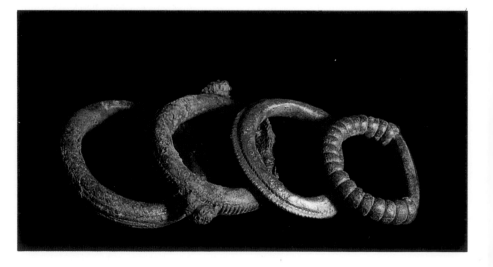

Maiden Castle, Dorset, Britain
Niall Sharples

View of the earthworks at Maiden Castle (England)

Maiden Castle is the largest hillfort in the British Isles and is one of the largest Celtic fortifications in Europe. The fort was placed on a fairly insignificant chalk ridge amidst the rich agricultural land of south Dorset near the country town of Dorchester. In its final form it comprised three massive earthen banks and two steep-sided ditches with an extra bank and ditch on the gentle slopes of the southern side. Access to the fort was at the east and west end of the ridge and was controlled by an elaborate arrangement of overlapping banks and ditches. The area covered by the fortifications was just over 45 hectares.

Preserved underneath the earthworks is a long sequence of occupation which commenced in the Neolithic period around 4000 B.C. By 2000 B.C., however, there seems to be a hiatus in the sequence of occupation and the hilltop was primarily used as an agricultural resource. Originally this was open downland grazing, probably for sheep, but around 1000 B.C. there is some evidence that the hilltop was partitioned by a series of large linear boundaries. Similar boundaries are found throughout central southern England at this time and represent a major division of the landscape. They indicate the increasing importance of controlling primary agricultural resources which leads to the construction of the early Iron Age hillforts around 700-600 B.C.

The first hillfort on Maiden Castle was constructed around 600 B.C. and consisted of a single bank and ditch enclosing an area of about 6.47 hectares. The defenses formed a considerable barrier rising over 10 meters from the base of the ditch to the top of the rampart. For most of their circuit the bank was simply a dump of earth excavated from the ditch but around the eastern entrance an elaborate timber wall was built. Later the entrance was further enhanced by the construction of an extra outwork with a timber and stone walled bank.

Forts similar in size and defensive strength to Maiden Castle are common throughout the area of central southern England known as Wessex. Two very similar forts occur within four miles of Maiden Castle and the evidence from these forts suggests that they were inhabited by small village-sized communities. One of the principal features of these forts is the provision of storage facilities for large quantities of grain. It implies that the communities were self-sufficient and indicates a breakdown in the exchange mechanisms that were characteristic of the preceding period when smaller farmsteads were common.

Around 400-300 B.C. the hillfort began a period of prolonged reconstruction which transformed its appearance and significance to the surrounding communities. The first stage was an expansion of the area enclosed to over seventeen hectares. Initially the defenses were the same as the original fort, a single bank and ditch, but very soon after the expansion was complete, a program of rampart heightening and elaboration was begun which culminated in the multiple ramparts that survive today. During this period it is clear that the number of inhabitants increased. The two neighboring hillforts were abandoned and a field survey suggests that the landscape immediately adjacent to the fort was depopulated. It was only after the major phase of rampart construction was complete, however, that the occupation expanded to fill the interior of the hillfort.

During the second century B.C. Maiden Castle is at its most impressive. Work on the defenses has been completed and the interior is fully occupied. Circular houses are arranged in rows to create streets and large areas are given over to grain storage in underground silos. In this form Maiden Castle is not only the largest but the most elaborately defended and most densely occupied hillfort in southern England. The construction and reconstruction of the ramparts would have involved large numbers of people and could not have been carried out solely by the inhabitants of the fort. Likewise the grain storage facilities are too substantial to be solely for the use of the inhabitants. It is not unreasonable, therefore, to suggest that this was the capital of a large territory, perhaps as large as the present county of Dorset.

In the succeeding centuries the significance of the hillfort seems to have diminished. There is evidence that the ramparts became neglected and much of the interior was abandoned. The bulk of the inhabitants appear to have moved back into small settlements scattered around the hillfort. These settlements were associated with their own fields and paddocks and it seems likely that there was a movement away from communal farming controlled from the hillfort to individual autonomous farms. The hill-fort must have retained some preeminence in the community, however, as in the abandoned earthworks of the eastern entrance there is one of the largest and richest cemeteries known from southern England in this period. Several hundred burials are likely to be present and many individuals have elaborate grave goods indicating their status and role in the community. These offerings include pots, presumably containing food and drink, joints of animals, weapons and ornaments.

Amongst these burials are a group of individuals who show signs of violent death. Several have sword cuts across the skull and principal limbs, one has the clear impression of a spearhead which has pierced the skull and another has a spear actually embedded into his backbone. These burials testify to the violent nature of Celtic society in the late Iron Age of the British Isles and it is possible that they result from a vain attempt to impede the Roman occupation of southern England in A.D. 43. The hillfort was abandoned within fifty years of the invasion and other than a short period in the fourth and fifth centuries, when it was the site of a Romano-Celtic temple, it has remained unoccupied since then.

Gussage All Saints
Jennifer Foster

Articles found in a bronzesmith's workshop at Gussage All Saints (England): crucible, mold for casting chariot pins, broken mold for horse bits, with cast bit in foreground terret ring and another mold for a bridle decoration
1st century B.C.
London, British Museum

In 1972 the Iron Age settlement at Gussage All Saints, Dorset, England, was completely excavated by Dr. G.J. Wainwright in order to provide information about a type of Iron Age enclosed settlement widely represented in southern England. The 500-year occupation of Gussage from the middle of the first millennium B.C. to the end of the first century A.D. straddles the major part of the British Iron Age. Within the enclosure were round houses, pits for grain storage and four-post structures, and a range of pottery, iron tools and bone artifacts. The settlement was self-supporting; there were querns for grinding corn (mainly wheat and barley), pottery was produced on the site and cloth production is attested by loomweights and spindle whorls. Cattle, sheep and goat were herded for milk, with occasional culling for meat, and other animals kept included pigs, ducks and fowl. It was not a rich settlement, at least in terms of personal ornaments, which were restricted to a few brooches, bangles and beads.

An unexpected bonus of the excavation was the discovery of a dump of bronze-working debris in a disused storage pit (Pit 209). Among layers of ash and charcoal were fragments of furnace debris, crucibles, waste bronze and iron, and 7,318 mould fragments. Although metalworking was practiced on a sporadic basis throughout the life of the settlement, joins between pieces showed that the debris was from a single intense episode of bronze casting. It dated to the end of the occupation: 150±65 B.C. (390-10 CAL B.C.) and 70±70 B.C. (190 CAL B.C.-CAL A.D. 50).

The crucibles were typical of the late Iron Age, three-cornered, round-bottomed and small, about 40 cc capacity; they were made on the site of local clay. They would be held by long-handled iron tongs, a type known from the Welsh hoard at Llyn Cerrig Bach, and the bronze melted over a simple charcoal fire.

The molds were not piece molds, but investment molds for lost-wax casting. A beeswax original was made of the object to be cast, a clay mold formed around the wax with a hole (or gate) at the top. The mold was then heated, the wax poured out leaving a cavity inside, and the mold was fired. The molten bronze was poured in and, when cold, the mold could be broken off and discarded. The collection of molds from Gussage is not only very large, giving examples of every stage of the process, but also in excellent condition.

The molds were used to make about fifty sets of equipment for chariots and harnesses for the ponies that drew them: terrets (or rein rings), bridle bits, iron linchpins with decorated bronze terminals, and strap fasteners. Chariot burials and reconstructed chariots suggest that chariots carried five terrets. Many from Gussage were plain, but there were also fourteen varieties of decora-

tion, only eight of which are known from archaeological examples. The decoration was executed on the wax original, not on the bronze after it was cast, and is often perfectly reproduced on the molds. Many cast objects, even in gold, show that decoration was executed on the wax before casting. Four bone modeling tools found in Pit 209 were probably used for shaping the wax originals.

The bridle bits were three-link snaffle bits of a type widely distributed across Britain. They were small to fit the ponies from Gussage, which measured 10-14 hands (102-145 cm); osteoarthritis on the horse bones indeed confirm that they were used for draught purposes. A pair of ponies would pull a chariot and the outer link of each bit would be decorated; the Gussage molds show a variety of decoration, from plain triangles to more elaborate hatched basketry and intricate raised designs familiar from pieces of Celtic art.

Bronze casting was carried out on many other Iron Age sites from Colchester to Glastonbury, as attested by bronze drips, scrap metal and crucible fragments. Wrought bronze work was also common, and iron smithing very widespread. It is not clear whether the bronzesmiths were fulltime in these communities or itinerant. Their technology was certainly advanced, including casting bronze onto iron, coating iron with bronze, and casting interlocking rings. Only on a few other late Iron Age sites do molds themselves survive, and interestingly they are mainly items for chariots, although molds for brooches and other objects are occasionally found. A particularly good group of molds comes from Weelsby Avenue, Grimsby, a small enclosed settlement where a limited range of chariotry similar to that at Gussage was manufactured. It is interesting that relatively small farming communities had sufficient economic resources to support metalsmiths and provide raw materials (wax, charcoal, metal and clay) in order to produce the trappings of war chariots.

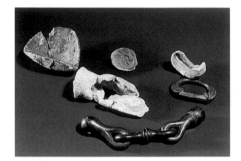

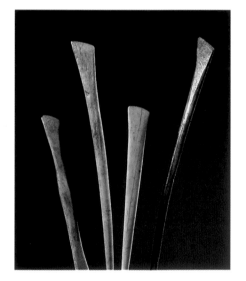

Bone spatulas for modeling wax and clay, from the bronzesmith's workshop, Gussage All Saints (England)
1st century B.C.
London, British Museum

Metalwork from Llyn Cerrig Bach
Stephen Green

*Shield-boss in copper alloy
with engraved decorations
from the votive deposit
at Llyn Cerrig Bach (Wales)
2nd-1st century B.C.
Cardiff, National Museum of Wales*

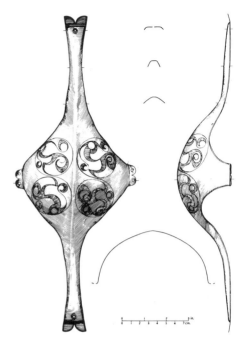

A large and important hoard of bronze and iron objects was found between 1942 and 1943 in a peatbog at Llyn Cerrig Bach, Anglesey, during the construction of a wartime airfield. The objects were found near the edge of the bog at the foot of a 3.5 meter high cliff. It is generally believed that in Iron Age times the site was a lake and that the objects were thrown into it from the clifftop in the course of ritual activities.

The date of the artifacts ranges from the second century B.C. to the early first century A.D., probably up to the time of the Roman invasion of Britain (A.D. 43) and the later campaigns in North Wales, by Suetonius Paulinius (A.D. 60-61). Although it is difficult to tie the find to the druids and their followers, the island of Anglesey is known to have been a druidic stronghold. Fox, who published the find definitively had no doubt of this: "...who... would supervise such rites of dedication... but members of this priest-seer class."

The number of objects (or fragments) preserved from the hoard is 144 but it is likely that the original tally was larger. The majority are clearly high-status items including 11 swords (2 still in their scabbards), 7 spearheads, 1 bronze shield boss and possibly associated crescentic plaque, at least 10 bridle bits, chariot components, 2 iron gang chains, portion of a bronze trumpet of Irish origin, 5 iron currency bars and a few tools and domestic items such as 2 "gripping" tongs, 2 fragmentary cauldrons and a sickle. Bones of ox, sheep, pig, dog and horse were also found but human bones were absent.

The swords are of the long Celtic slashing type and, with the possible exception of one example which may be Irish, are of local manufacture. One shows a pelta-shaped stamp, which could be a swordsmith's mark, or an apotropäic sign to keep the user safe in battle. Recent x-rays have shown that the swords have an iron center, which makes for flexibility, together with strong steel edges. One sword had been bent double before being deposited in the lake. This is a common Celtic ritual practice on the continent and emphasizes the votive character of the deposit. At least one of the spearheads may have been too long to be practical in combat and might thus also have been used in ceremonial rituals. Recent conservation work on one of the smaller examples has revealed that the surface of the high quality iron blade is covered with small raised dots.

The copper alloy decorated shield boss was probably part of a composite shield decoration, similar to an example from Tal-y-Llyn, Gwynedd, with pelta-shaped side pieces. The decoration on the shield boss and the crescentic plaque, with the asymmetric triskeles and stylized "bird-heads," is characteristic of the Celtic art of Britain which developed in the late second-first century B.C. as the tradition began to decline on the continent. A significant innovation of this "Llyn Cerrig Bach style" is the importance of the background voids in the ornamental compositions.

The bridle-bits are of varying type. The majority are the normal, insular, three-link variety (one example of which is an import from Ireland) but there is also a two-link bit, a more typically continental form, and several which have a mouthpiece made of a single unit. The most ornate speciment is of the three-link type. At the end of one of the side-links there is a concave terminal which probably held an ornate stud. As this extra piece appears only on one side, it may indicate the use of a team of two ponies. The side rings of the bit are hollow, and have studs which prevent the movement of the rings through the loops, and restricts the area of wear.

Among the chariot-fittings are the metal remains of at least ten, and possibly as many as twenty-two, wheels, a bronze yoke terminal with swastika decoration formed by small punched dots, linchpins, terrets and a range of miscellaneous mounts. On the basis of these finds, Fox was able to put forward a reconstruction of an original Celtic chariot.

Among the most interesting of the finds were the two gang chains. The complete example has five neckrings; the other, broken at one end, has four such rings. It may have held either slaves or prisoners (perhaps awaiting sacrifice), both of which are attested to by the observations of the classical writers. The hinged neckrings were closed by drawing the whole line of chain and rings through a loop in the first ring, then repeating this with the next ring and so on. The chain itself is made up of loops pinched into a figure of eight.

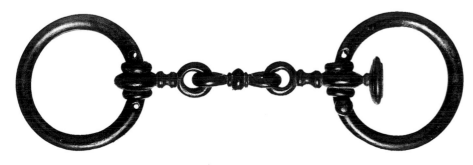

*Horse bit in copper alloy
from the votive deposit
at Llyn Cerrig Bach (Wales)
2nd-1st century B.C.
Cardiff, National Museum of Wales*

Navan Fort is a large earthwork situated obliquely around the summit of one of a number of small glacial hills. It stands in pleasant countryside 2.6 kilometers west of the historic center of Armagh city in the north of Ireland. Immediately outside the enclosure (in State Care), some 300 meters to the east, is a small lake in the margins of which four large bronze horns and a number of human skulls were found in the eighteenth century. Only one of the horns now survives (National Museum of Ireland) and a disc around its mouth is decorated in the La Tène style.

There is an unusual group of prehistoric monuments in the vicinity of Navan Fort, including two destroyed stone circles or megalithic tombs and an artificial pool, "The King's Stables," apparently dug for ritual purposes in the later Bronze Age, perhaps around 800 B.C. A number of early Iron Age objects, including three fibulae and a spearbutt, dating from around 100 B.C.-A.D. 100, have been discovered on separate occasions during cultivation in and around the Navan enclosure.

The monument is a circular earthwork about 230 meters in internal diameter, with a large bank immediately downslope from a ditch, best preserved on the west. The bank is now a maximum of 2.5 meters high and the ditch is 9 meters wide. Parts of the earthwork have been leveled and the site of an original entrance cannot be determined with confidence. This earthwork has not been excavated, but it is not a "fort" as the modern name implies and is certainly a prehistoric ritual monument. On top of the hill inside the enclosure are two smaller monuments both of which have been excavated. One, "site A," can be described as a ploughed-out ring-barrow, the other, "site B," is a large mound, 6 meters high and 50 meters in diameter at the base.

Navan Fort is famed in early Irish literature from the seventh century A.D. onwards as *Emain Macha*, the ancient capital of the Ulstermen. The meaning of the name *Emain Macha* is not entirely clear, but Mach, appears to be the name of one of a trio of war-goddesses associated with fertility and valor who gave her name to the surrounding district including a hill on which stands the small city of Armagh (*Ard Macha*), the ecclesiastical capital of Ireland. The early rise to preeminence of Armagh as a Christian religious center may well be related to the district's importance in earlier ritual, as well as its claim to have been established as his chief seat by St. Patrick, Ireland's national "apostle." It has been suggested that the earliest written reference to *Emain Macha* is in the geographical tables of Ptolemy of Alexandria (second century A.D., based on an earlier source), but the identification is not certain.

The large hilltop mound (site B) was meticulously excavated by D.M. Waterman from 1963 to 1970. The excavation re-

vealed a complex of intercut circular gullies and remains of early Iron Age houses and outbuildings in the old ground surface under the mound. The earlier phases were represented by a number of bronze artifacts including a socketed sickle and an axe as well as a quantity of coarse domestic pottery. Especially significant is a fragment of a winged chape of Hallstatt C form. The latest material includes a finely decorated ringheaded pin, a bone gaming die and several small objects of iron. This was evidently a settlement of some prestige because among the animal bones from the circular slots, the skull and jaw of an ape (*Macaca sylvanus*) were identified. These testify to contact with the Mediterranean region, probably in the second or third century B.C. It is the superimposed mound, however, and the remarkable wooden structure it contained, which are of unique interest in the present context.

Early in 94 B.C. (dendrochronological date) an oak tree greater in diameter than 0.55 meters was felled for use as the centerpiece of a large circular wooden building. The structure was laid out to fit neatly within the partly silted ditch of an older enclosure, perhaps dating from around 700 B.C. The main wall of the Iron Age building, 37.3 meters in diameter, was marked by 34 evenly-spaced pairs of timber uprights in pits linked by a foundation-trench for horizontal timbers. At first each of the

peripheral pits contained only one post, but in every case a second post was inserted beside the original one, probably after the rest of the structure was completed. A narrower, outer wall-trench containing upright stakes was cut in places by the secondary post-pits of the main wall and may have been used only in the setting-out and construction phase.

Inside the building were four concentric rings of posts (the butts of some, all of oak, were preserved deep in the damp subsoil), each post probably around 0.3 meters in diameter. The posts were set vertically in narrow sockets 0.8 meters deep on average. The ring system was interrupted on the west by the construction of an aisle-like feature running from the wall of the building up to and around the central post. In all, about 275 posts were used in the structure, but the central post was clearly larger than the others and required the digging of a long ramp for its setting up in a pit 2 meters deep. The alignment of the aisle with the large post, and stratigraphic evidence that this post was the last to be erected, suggest that it has a significance beyond that merely of a central support for the building.

The 40-meter structure was carefully and competently laid out. It was not simply a series of rings of timber posts in which the uprights were more or less evenly spaced by eye. Analysis of the excavation plans and of the field records of the individual post-pits

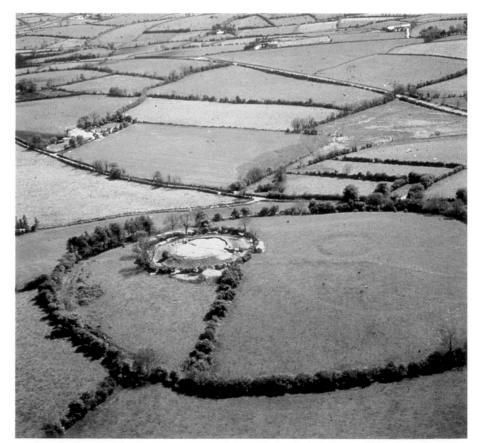

shows that the posts in the rings were carefully aligned radially and that the posts in the internal rings were *erected as radial sets* and not as sequential ring sets. This careful planning, and evidence for pressure and movement of some post-butts, strongly suggests that the posts carried a superstructure or roof.

There was no evidence of any activity inside the structure. Its floor was the surface of the occupation deposits of the previous phase with spreads of cleaner clay (surplus from the digging of its post-pits). Resting directly on these surfaces was the base of a large cairn of limestone blocks, piled up to a height of 2.5 meters inside the standing wooden building. The outer edge of the cairn sloped down to rest against the inside of the timber wall and the positions of the timber uprights were represented by post-voids, many of which rose nearly to the top of the cairn. The cairn has normally been regarded as convenient filling material for the wooden building, but the possibility remains that the wooden building was constructed in order ultimately to enshrine the cairn.

The exposed wall of the structure then burned, apparently set on fire deliberately. In a few places the cairn collapsed over and protected the burnt remains of the wall, but no trace was recovered of the superstructure. Perhaps it had been dismantled or it burned away completely. Not long after the fire the whole cairn was covered with a mound of cut turves, 2.5 meters higher than the cairn at the center, the reconstructed surface of which we see at the site today. The construction of the wooden building, its use, the heaping up of the cairn, the fire and the mound of turves may well have been planned from the beginning as a single series of ritual acts. It has been suggested that the sequence can be explained as a fertility sacrifice to the "otherworld," a place said to be accessible in later traditions through "elf mounds" such as this one at Navan.

While it is not possible to demonstrate exact contemporaneity, there seems little doubt that the sacrificial deposit of bronze horns and human bones in the nearby lake was related to this major phase of ritual activity on the hilltop. The use of the La Tène art style on the terminal disc of at least one of the horns from the lake immediately links their depositors with the other peoples of Europe whose culture is termed "Celtic" at this time. The ceremonial structure at Navan can be described, therefore, as the most remarkable single wooden building so far known from Celtic Europe. This complicated structure is without close parallel, but at Dún Ailinne, county Kildare, Ireland, Bernard Wailes excavated a series of very large, circular, timber ceremonial structures of the Early Iron Age. This shows that the use of large wooden structures in Irish Iron Age ceremonial was not restricted to Navan,

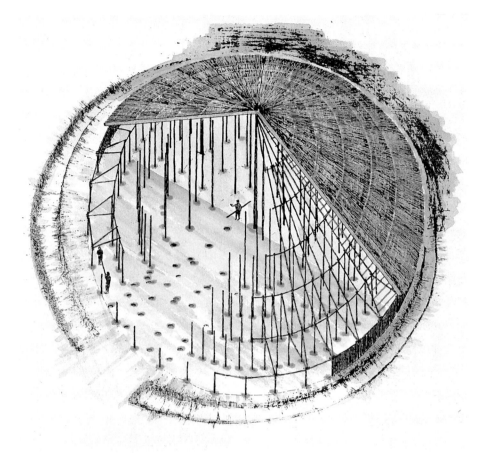

where it is most dramatically exemplified.

In this final phase of site B we have seen evidence for ritual activity in the first century B.C. But many questions remain to be answered. What beliefs were given physical expression by the structures? Is the Iron Age wooden structure related in some way to the rings of posts associated with late Neolithic henge monuments excavated in southern Britain? Did activity or settlement continue at Navan into the first centuries A.D.? To what extent do the legends about Navan, which have come down from the early Christian period, reflect society and traditions from the preceding Iron Age? Do they, on the other hand, merely represent an interpretation, modeled on contemporary early Christian society, of a long-abandoned site?

Tara is, perhaps, the best known of the Irish Celtic royal sites. By the historic period it had achieved an eminence in the contemporary cultural consciousness which it has retained almost to the present day. Its importance appears to have been largely symbolic, however, but in our earliest sources it is clearly identified as the focus or "capital" of the ancient kingdom of Brega. In later times aspirants to the notional High Kingship of Ireland laid claim, almost of necessity, to the kingship of Tara, thus emphasizing the enduring status of the site even after it had been abandoned and reduced to little more than a series of grass-grown mounds.

The precise function of Tara and the related royal sites is difficult to determine as the distinctions between history, myth and legend are often extremely blurred. Thus it is not clear to what extent such sites were the scenes of secular, permanent occupation or if they served a solely ceremonial purpose. There can, however, be little doubt that Tara was the seat of a sacral kingship where important tribal rituals were enacted. Most significant of these was the inauguration of a quasi-divine king who ritually married the earth to ensure the fertility of the crops and the animals.

Today Tara is a complex of earthworks scattered along a commanding northwest/southeast orientated ridge which rises to a maximum height of some 130 meters above sea level. The monuments are scattered over a length of almost 900 meters along the ridge. Some are well-preserved; others, long since plowed out, are only recognizable from the air. The antiquarian names by which the individual sites on the hill are known today derive from an early eleventh-century text but these are fanciful.

There are about twenty-four sites now discernible on the hilltop. These include a variety of enclosures and tumuli of varying size and shape, a pair of linear earthworks and traces of possible routeways which may be ancient. To date only three sites have been archaeologically examined so that in most cases dating is speculative. It seems likely, however, that the majority of the structures at Tara belong to the Celtic Iron Age.

Dominating the ridge is a large enclosure, 5.9 hectares in area, known as *Rath na Rí-ogh* (the Fort of the Kings) within which is a series of prominent earthworks. It is defined by an earthen rampart with internal ditch, a feature of doubtful defensive purpose which it shares with two other documented royal sites, Emain Macha (Navan Fort), county Armagh and Dún Ailinne, county Kildare. Excavation in the

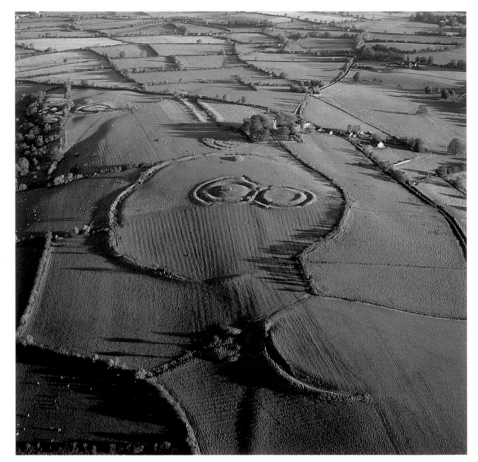

1950s showed that the ditch had been cut to a careful V-section 3 meters deep into the bedrock. Along its immediate inner edge was found a vertical-sided trench which must once have supported the timbers of a substantial palisade.

The monuments within the enclosure include *Dumha na nGiall* (the Mound of the Hostages) which was revealed by excavation to be a late Neolithic passage grave and two conjoined, irregularly circular earthworks each comprising a pair of high earthen banks with a raised, flattened interior. Their date and purpose are unknown. Within one stands a round-topped stone pile said to have once crowned the Mound of the Hostages. This is the *Lia Fáil* (Stone of Destiny), almost certainly of Iron Age date, which according to legend cried out when the proper king was inaugurated.

Further mounds and enclosures occur to the north and south of the Fort of the Kings. Most important are those to the north which include a much damaged triple-ringed earthwork known as *Rath na Seanaid* (the Rath of the Synods). This was shown

by excavation to be a multi-period site which was used, at varying times, both as a burial site and as a place of habitation. Finds of Roman pottery, glass and other contemporary items indicate an important phase of activity there in the first three centuries A.D. About 75 meters north of this is the *Teach Miodhchuarta* (Banqueting Hall). This comprises a pair of straight, parallel banks, 30 meters apart, extending gently downslope for a distance of about 180 meters. Medieval writers viewed this as a great roofed building and detailed descriptions of the seating arrangements are given. This is, however, fantasy. It may, in fact, have been a ceremonial way or possibly even an Irish version of the rectangular Celtic ritual enclosures which are known elsewhere in Celtic Europe.

Dun Aengus, Inishmore,
Aran, County Galway, Ireland
Barry Raftery

*View of the Dun Aengus fort
on the cliffs of the west coast
of Inishmore (Ireland)
1st-5th century A.D.*

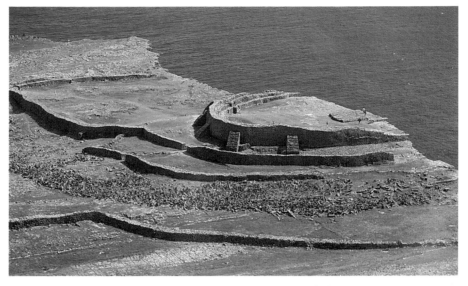

The fort of Dun Aengus is located on the largest of the three Aran islands which lie at the mouth of Galway Bay 15 kilometers distant from the west coast of Ireland. Situated on a vertical cliff-edge 100 meters above the Atlantic the fort is undoubtedly one of the most spectacular examples of its type in western Europe.

Three more or less complete stone walls are present, with the remains of a fourth, to form a roughly D-shaped enclosure 4.6 hectares in area. The innermost wall is the most massive. It stands today some 4 meters high and is about 4 meters thick at its base. Though it was substantially restored at the end of the last century it is likely that its present form is a reasonable reflection of the original. The wall was built in three vertical sections with two terraces along its inner face. These are reached by stone steps arranged sideways to the wall in X-formation or constructed in ladder-like form. There are small chambers in the wall and access to the interior is through a linteled entrance in the east.

Outside this is the second wall which is less massive and is kinked at the center suggesting that there might have been two phases in its construction. It is up to 4 meters high with a single terrace along the inside. There are three narrow entrance gaps through it, in the northwest, north and northeast. A short distance outside this, along the northwest, is a fragmentary, internally-terraced wall about 2.50 meters high, running for a length of about 80 meters. This presumably belongs to an earlier phase and was left standing after the restructuring and expansion of the defenses.

Outside this section of walling and continuing around the second wall at a short distance from it is a stone *chevaux-de-frise*. This consists of a concentration of stone spikes closely packed together in a band which varies in width from 10 meters to about 23 meters. The stones, which are from 1 to 1.70 meters in height, have been wedged into the limestone bedrock and stand either vertically or sloping to the exterior. A narrow, diagonal passage leads through the *chevaux-de-frise* to the north-

eastern entrance in the second wall. The *chevaux-de-frise* was presumably a defensive device intended to impede access to the wall by attackers on foot or on horseback. The view of E. Rynne that Dun Aengus had a purely ritual character has not gained widespread acceptance.

The outermost wall is the most ruinous. It survives to a height of about 1.50 meters and is 2.50 meters thick. There is a low, linteled entrance through it in the north.

Dun Aengus is the finest of four Irish forts with *chevaux-de-frise* defenses. All occur in western regions of the country and all are on, or not far from, the coast. None has been excavated so that the period of their construction and use is largely speculative. Surprisingly, there are no historical references to the site. Early legends attributing its building to a Celtic tribe known as the Fir Bolg, who are said to have been pushed westward from their eastern Irish home, are of little assistance in this regard. A date within the Celtic Iron Age is, however, a distinct possibility. A bronze fibula of insular Late La Tène form, found in the innermost enclosure at Dun Aengus in 1839, is in keeping with this hypothesis. Unfortunately, the stratigraphical position of the object

was not recorded.

The origins of the *chevaux-de-frise* form of defense at Dun Aengus have not, as yet, been clearly established. Such constructions are best known from central and west-central areas of the Iberian peninsula but there are also scattered examples in parts of Britain and one or two possible instances are recorded from France. It has, thus, been frequently suggested that the idea of *chevaux-de-frise* defense was introduced to Ireland from the Iberian peninsula some time in the last half-millennium or so B.C. An alternate view, proposed by P. Harbison, suggests that the *chevaux-de-frise* in stone, as found along the western fringe of Europe, is simply a translation into a more durable material of a form of defense which was once widespread in timber in Europe throughout most of the last pre-Christian millennium.

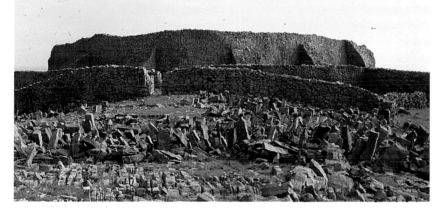

*View of the Dun Aengus fort
at Inishmore (Ireland)
with the stone "frisian horses"
(foreground) which defended
the entrance 1st-5th century A.D.*

Dún Ailinne
Bernard Wailes

Medieval Irish texts identify Dún Ailinne as the "royal site" of Leinster (see Grabowski 1990 for a review of the historical sources). It was one of several such sites which were believed to have been the residences of the regional high kings, to have had pagan religious associations, and to have been, in effect, the "capitals" of early Ireland. It is clear from these texts that, although they remained *symbols* of high kingship, the royal sites had been abandoned before Christianity—and literacy—became well-established in Ireland. Thus it may be inferred that they were built and used during the Iron Age.

Dún Ailinne is the largest prehistoric site in Leinster; a 16-hectare hilltop enclosed by an oval bank and ditch. An 8-meter wide roadway leads through the entrance, on the eastern side, toward the top of the hill. Here, geophysical survey and test excavation showed abundant evidence for Iron Age occupation (the small earthworks are medieval and modern), and here, therefore, excavation was concentrated.

This excavation of an area some 3,500 square meters revealed a complex archaeological sequence, beginning in the Neolithic. This earliest occupation, however, was very badly damaged by subsequent Iron Age construction, which began when a circular timber palisade ("White" phase), about 22 meters in diameter, was built of posts set in a foundation trench. After some time this was dismantled to make way for a far more ambitious structure ("Rose" phase), which was not only much larger (about 36 meters in diameter) but also had an "annex" on its south side and a very elaborate entrance. The main "Rose" enclosure had three concentric timber palisade walls, graded from smallest on the inside to largest on the outside: these suggest that the original structure may have supported two tiered platforms, from which people could view spectacles or ceremonies taking place within the enclosed area.

This "Rose" structure was dismantled, in turn, to clear the area for the construction of "Mauve" phase, larger still (about 42 meters in diameter) and of a different design. Two concentric foundation trenches suggest a platform between two walls, not unlike the main "Rose" structure, but the interior was not an open space, as it had been in "Rose." In the center of "Mauve" was a circular building which was not only constructed of much larger posts than its small size (about 6 meters) required, but was surrounded by an additional circle of posts. These features imply that this building was unusually high in proportion to its small surface area and reinforced by external buttresses. In the space between this central "tower" and the outer palisade walls was erected a ring of twenty-nine very large posts, each about 0.5 meters in diameter. Stratigraphically, it can be shown that the "Mauve" structures were dismantled in stages, probably over a number of years, leaving the ring of large posts until last. The site continued to be in use for some time, however, as shown by considerable accumulation of debris over the sockets from which the last posts had been removed. Eventually, the site was abandoned, and has remained so to this day, apart from the transitory activities associated with the small earthworks.

Radiocarbon dates suggest that Iron Age activities started not earlier than the third or second century B.C., and ceased not later than the second or third centuries A.D. The artifacts, too, support this dating. A typically Irish short La Tène C sword probably dates to the second or first century B.C. and is unlikely to have been later than the first century A.D. Fragments of glass armlets are similar to those from first century B.C. *oppida* in continental Europe. And two bronze fibulae are most closely parallelled in first century A.D. Britain.

Over 18,000 pieces of animal bone were recovered from the excavation, and these provide significant information (Crabtree 1990). Over half of these bones were from cattle, and most of the rest from pig. Most of the cattle bones were from young animals, six months or less in age, and the

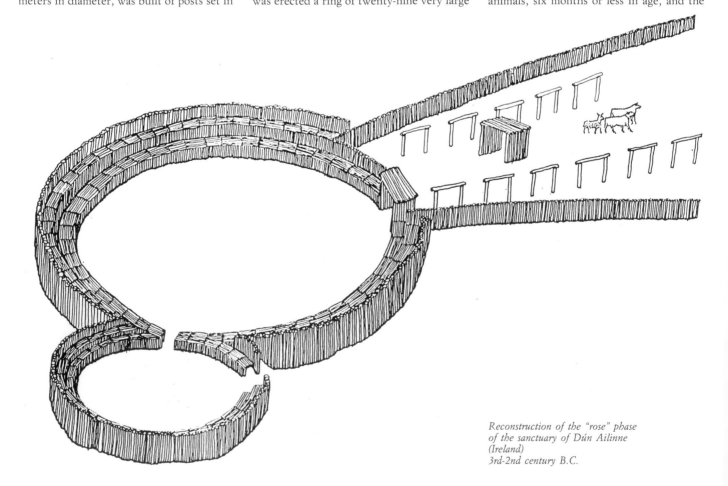

Reconstruction of the "rose" phase of the sanctuary of Dún Ailinne (Ireland) 3rd-2nd century B.C.

*Bronze fibulae from the sanctuary
at Dún Ailinne (Ireland)
1st century A.D.*

bulk of the remainder were from elderly females. This evidence not only attests to the Celtic taste, so well known from literary sources, for feasting on pork, but also tells us three important things about cattle: first, that cattle were the mainstay of the livestock economy; second, that they were kept mainly for dairy products rather than for meat or for traction; and third, that they were slaughtered in April/May and in September/October. Hazelnut (*Corylus avelana*) and sloe (*Prunus spinosa*) remains also show autumn activity at the site.

There can be little doubt that Dún Ailinne was, at least primarily, a ritual or ceremonial site. The enclosing bank is outside the ditch and so is clearly not defensive; on the contrary, this arrangement is characteristic of the ritual "henge" monuments of Neolithic Britain and Ireland. The impressive roadway leading through the entrance and up the hill toward the successive timber structures is also reminiscent of henge monuments, several of which have "avenues." And the circular timber structures themselves are not unlike the timber circles inside a number of henges. Indeed, this royal site of Iron Age Leinster appears to be an impressive and deliberate revival of an archaic form of insular ritual site, at which seasonal festivals and ceremonies took place.

Whether or not Leinster really had a high king at this time we do not know for certain, traditional historical lore notwithstanding. But certainly medieval writers were not wrong in regarding Dún Ailinne as the most important pagan religious site in Leinster.

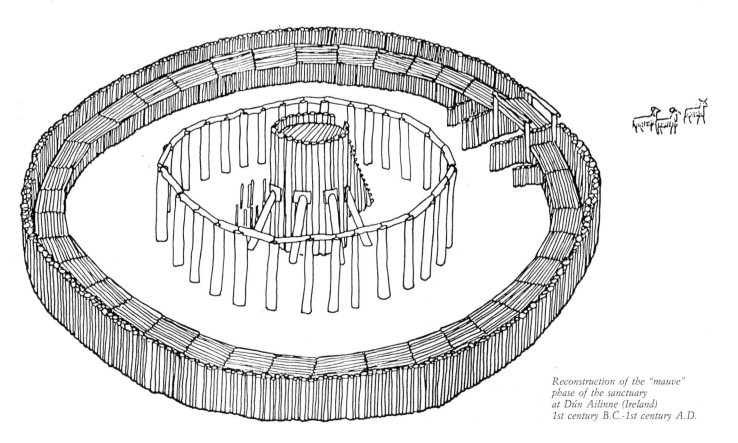

*Reconstruction of the "mauve"
phase of the sanctuary
at Dún Ailinne (Ireland)
1st century B.C.-1st century A.D.*

The Turoe Stone
Barry Raftery

*Richly sculpted granite cippus
from Turoe (Ireland)
1st century B.C.-1st century A.D.*

The Turoe stone is a domed granite monolith, of flattened cylindrical shape which now stands in the grounds of Turoe House, near the village of Bullaun close to Loughrea in county Galway. It was originally situated not far away in the townland of Feerwore where it once stood a few meters to the north of a small, enclosed habitation site (ringfort). The latter, excavated in 1938, revealed evidence of domestic occupation probably dating to the Late La Tène period. A more or less contemporary inhumation burial was also found.

The stone now stands about 120 centimeters above ground level. Its total length is 168 centimeters and its weight has been estimated at about four tons. The upper 78 centimeters of the stone bears curvilinear decoration which is delimited along the base by a horizontal band of "meandroid" or step ornament.

The curvilinear designs are of high-quality craftsmanship produced in false relief by carving away the background voids to varying depths. The step pattern along the base, on the other hand, has been created by simple incision and the workmanship is of indifferent quality.

The curvilinear ornament on the stone has been laid out in four distinct fields, two D-shaped and two triangular. Though once regarded as belonging to the Waldalgesheim phase of Celtic art, it is now generally accepted that the decoration is of insular character and not earlier in date than the first century B.C. Good parallels for the ornament on the stone are readily forthcoming in insular metalwork, not merely in Ireland, but also on objects of the "mirror-style" school of southern Britain.

Turoe is one of the major achievements of Irish La Tène art. The curvilinear elements twist and writhe across the surface of the stone conveying at once the feeling of restless movement and dynamic tension. There is considerable diversity in the individual motifs present but these are skillfully interlinked so as to flow with liquid grace across the granite, each shape melting into the next in a masterly display of perpetual motion. Recognizable are the palmettes and their many derivatives, trumpets and fans with spiral, knobbed or tendril-ends, lobe or comma shapes, triskeles, a diversity of sub-triangular elements, often with concave sides and a variety of more elaborate multi-spiral designs.

The Turoe stone is one of five decorated examples from Ireland. There are also undecorated standing stones which, in some instances at least (e.g. Tara), are likely to belong to the Iron Age. Four of the decorated stones are unequivocally Celtic. The fifth, from Mullaghmast, county Kildare, is a late survival of the type and could postdate the middle of the first Christian millennium. The others, including Turoe, probably date between 100 B.C. and A.D. 100.

Though there appears to be general consensus among scholars as regards the dating of these Irish stones, there continues to be some debate on the question of their ultimate origins. Insular workmanship is clearly evident in the art which adorns them but the possibility of stimulus from overseas, emanating from as far away as Armorica, has been suggested by some writers. Others have, however, forcefully dismissed such a hypothesis. Certainly, there are many standing stones of probable Iron Age date in Brittany and in shape good parallels may be found there for the Irish examples. Only a tiny fraction of the Breton stones are, however, decorated and, apart from a few details, the ornament in France differs from that in Ireland. In addition, there is no unambiguous archaeological evidence which links Ireland with the Breton peninsula.

It is, nonetheless, possible that it was the idea alone which was introduced from Brittany to Ireland, by a means as yet unknown to us, perhaps a movement of religious ideas with which the stones might conceivably have been associated. It must be admitted, however, that the Irish stones could equally well represent an independent native development wholly unconnected with Brittany. Indeed, the intriguing possibility has been put forward by one commentator that the background to the Irish series might best be sought in native wooden carvings which have not survived.

The precise function of the Turoe and related stones is, of course, speculative but there can be little doubt that they served a cult purpose and were originally associated with some form of magico-ritual activities. Inevitably, in the modern literature on the subject, the stones are not infrequently imbued with phallic properties. In Brittany, such stones occasionally occur as focal points within Iron Age cemeteries but we cannot say if they were similarly used in Ireland.

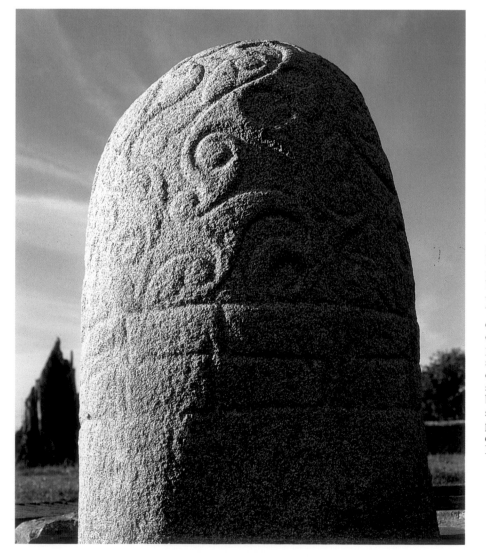

The Broighter Hoard
R.B. Warner

*Gold votive boat from the deposit
at Broighter (Ireland)
1st century B.C.
Dublin, National Museum of Ireland*

It has been said that a characteristic of the Celtic people was their love of ambiguity, demonstrated particularly by their art (Jacobsthal 1941, 308). The Broighter hoard, a collection of seven splendid gold ornaments and "models" of the first century B.C. discovered on the shore of Lough Foyle in the north of Ireland, epitomizes this ambiguity in every aspect, from the time of its creation to the present day.

The hoard, whose contents are all of gold, is neither completely native nor completely intrusive but betrays every variation possible between those extremes drawing items and inspiration from the classical and Celtic worlds (Evans 1897; Warner 1981; Raftery 1984, 181-194). On the one hand there are two fine gold-"wire" bracelets of undoubted eastern Mediterranean (Alexandrian?) origin and Republican Roman date. Then there are two twisted-rod bracelets whose origin is difficult to assess but which may be local copies of provincial Roman types. The finest ornament is a tubular torque, or more strictly collar, whose basic Continental Celtic origin cannot be doubted but which is decorated, to bring us to the other extreme, in a style of insular Celtic art (Irish boss style) whose local origin is easily demonstrated. Indeed there is reason to believe that the workshop in which the collar was decorated, and indeed probably made, was only some 25 kilometers to the east of the findspot. However the craftsman who made the collar seems to have received some inspiration, for instance the use of decorative granulation, from one of the Alexandrian bracelets and there is a strong suspicion that the platinum-rich gold used in all the objects in the hoard came from the Mediterranean region.

The repoussée decoration on the collar is a local variant of the various insular boss styles, and is at first glance based on a simple balanced group of S-shaped figures, filled out with three-dimensional spirals and lobes, attached "snail-shells" and "machine" tooling. It has, however, been claimed that the decorative motif is based on a mythical form of "sea horse," symbol of the sea god. It is typical of such art that it is at one and the same time both abstract—with traits and characteristics that can be found anywhere in the Celtic world—and symbolic. It is a fine example of the illusive image and it is very much up to the viewer which aspect he sees, or claims to see.

The findspot (Warner 1981) was in a physical location which was poised between land and water—a salt-marsh, on the edge of a sea-lough, which was periodically inundated both by the sea and by a flooding river, the Roe (in Irish this means "roarer"). That the hoard was a propitiary offering to a sea god, possibly *Manannan mac Lyr* (an Irish equivalent of Poseidon or Neptune), can hardly be doubted. This supposition is strengthened by the presence in the hoard of gold models

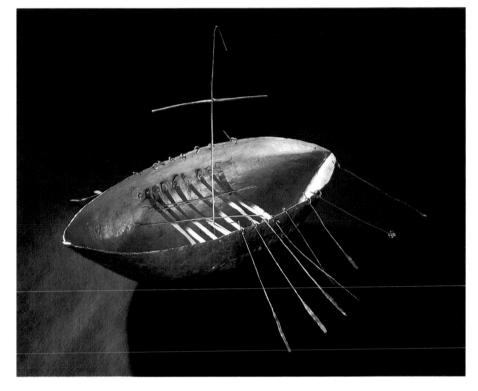

of a nine-benched-and-oared sailing boat and a cauldron, both attributes of the sea-god, and the fact that Lough Foyle itself was in early Irish legend the home of this god.

Curiously the general area is not one in which Iron Age material has been found in any quantity. Indeed there is growing evidence that the findspot is at the interface between two disparate cultures. To the east were a people whose material culture, or at least that of their aristocrats, can be described as "La Tène derivative," and who we believe to have been pastoralists. It is within this group that the collar was fashioned and decorated, as I have described above. To the west, on the other hand, were a people whose cultural identity in the first century BC is not clear but who were certainly not La Tène inspired. Two centuries later at any rate they were a cereal growing people with strong Roman links, already hinted at, perhaps, by the Roman material and inspirations in the hoard.

The final ambiguity lies in the recent history of the hoard. Shortly after its discovery it was acquired by the British Museum. The Royal Irish Academy claimed its return on grounds of the ancient law of "Treasure Trove" and won the complicated case on the strength of the refusal of the judge to believe anything but hard fact (in which he was, thankfully for Ireland, almost completely wrong). (Praeger 1937, 63-7 gives a summary of the evidence.) The ambiguity lies in the fact that the barrister who won the return of the hoard to Dublin is the same Edward Carson who later led opposition to Home Rule for Ireland and helped

bring about the separation of northern Ireland (where the hoard was found) and southern Ireland (where it now resides). It is a nice irony that Belfast, the city inspired into near insurrection by Carson, has as its emblem (a symbol of its maritime industry) a seahorse!

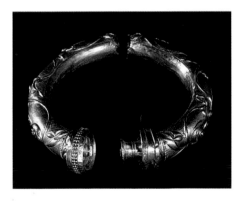

*Gold tubular torque
from the deposit at Broighter (Ireland)
1st century B.C.
Dublin, National Museum of Ireland*

617

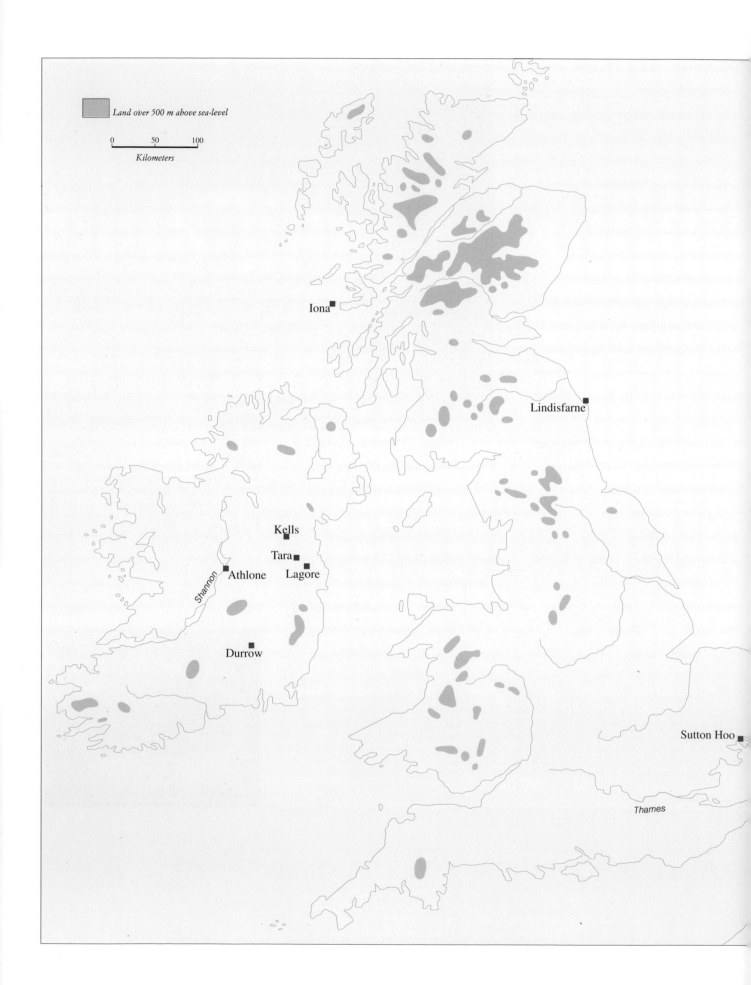

Land over 500 m above sea-level

0 50 100
Kilometers

Iona

Lindisfarne

Kells

Tara

Athlone Lagore

Shannon

Durrow

Sutton Hoo

Thames

Michael Ryan

The Early Medieval Celts

At the opening of the early medieval period the Celtic-speaking peoples of Europe were confined to the islands of Britain and Ireland and the peninsula of Brittany in northwest France. The Celtic people of continental Europe had long been subsumed by the Roman conquest and while local cultural traits may have subsisted for a time, effectively Gaul and northern Spain had ceased to be Celtic in any overtly meaningful sense. The presence today in the Breton peninsula of a vigorous Celtic-speaking population is the result of migration from Britain in the fifth century.

The medieval Celtic languages are divided into two broad categories—the *Goidelic* (represented now by modern Irish, Scots Gaelic and Manx, spoken until recently in the Isle of Man) and *Brythonic*, formerly widespread in Britain and now represented by modern Welsh, Cornish (spoken until at least the eighteenth century in the southwesternmost county of England) and Breton.

The Roman conquest of Britain was not complete. The northern part of the island, comprising most of modern Scotland, lay outside the province and in those regions, powerful medieval kingdoms arose. Although border fortifications were built (Hadrian's and the Antonine walls) the frontier was under constant pressure and the walls marked varying views of what constituted a frontier zone which extended considerably to the south of the formal boundary (Smyth 1984,1-35; Laing, L. and J. 1990, 117). North and west of Hadrian's Wall were tribes of British whose kingdom of Stratchlyde was powerful in early medieval times and retained its identity until the tenth century. Eastwards, between the Walls, the Votadini had their principal fort at Traprain Law and there, too, a Celtic kingdom survived into the early medieval period only to succumb to the advance of the Northumbrian Angles in the early seventh century. Northumbria was a strong and aggressive kingdom which by the end of the seventh century had advanced not only in what is now eastern Scotland but also westwards to incorporate Dumfries and the peninsula of Galloway. Early Welsh heroic poetry records the traditions of British resistance to the advance of the Angles. The *Goddodin*—a name derived from the tribal name Votadini—records a heroic raid from the neighborhood of Edinburgh to a place which may be identified as Catterick in the modern English county of Yorkshire, which shows how far south the resistance was as late as about A.D. 600. It also gives a flavor of the atmosphere of a Celtic heroic society.

"Wearing a brooch in the front rank, bearing weapons in battle, a mighty man in the fight before his death day, a champion in the charge in the van of the armies: there fell five times fifty before his blades, of the men of Deira and Bernicia a hundred score fell and were destroyed in a single hour. He would sooner the wolves had his flesh than go to his own wedding, he would rather be a prey for ravens than go to the altar: he would sooner his blood flowed to the ground than get due burial, making return for his mead with the hosts in the hall.

"The men went to Catraeth with the dawn, their high courage shortened their lives. They drank the sweet yellow ensnaring mead, for a year many a bard made merry. Red were their swords (may the blades never be cleansed), and white shields and square-pointed spearheads before the retinue of Mynyddawg the Luxurious."

It is noteworthy that the society which produced this poetry was, at least nominally, Christian.

North of the river Forth were the people known in later Roman and in early medieval sources as the Picts, a name thought to be derived from Roman army slang and to denote the practice of painting the body as Caesar had described earlier among the southern Britons. Scholarly writing has tended to compound the confusion created by credulous early medieval historians who developed fanciful theories about the origins and social institutions of the Picts (Smyth 1984, 36-83; Anderson 1987; Alcock 1987a). Recent research has tended to emphasize the elements in surviving tribal names and archaeology which show that the essential patterns of Iron Age society and material culture prevailed among the Picts. A critical evaluation of historical sources (these are all external because no authentic Pictish documents, apart from a few corrupt king-lists from later medieval times, survive) places these people in their correct

context as another group of Celtic tribes who had by the later sixth century begun to achieve a semblance of cultural and political unity (Smyth 1984; Alcock 1987a). The sophisticated art of the Picts is one of the brightest ornaments of later Celtic history (Ritchie 1989). A complex of processes brought their political independence to an end in the ninth century when the Scots of Dal Riada finally united the kingdom of the Picts with their own under Cinaed, son of Alpin. By this time they had been considerably weakened by pressure from the Scots and the Vikings and had been ruled by a number of intruded kings. It is customary to tie material cultural developments—especially the sequence of sculpture—to the historical framework just sketched, but there is no link in evidence and certainly none in logic to this. Within the colony the degree of Romanization must have varied with the density of urban settlement. Some of the old native nobility were probably educated as Romans but the rural dependant classes may have been considerably less Romanized and in some areas, parts of Wales and the north of what is now England, the Celtic social order may have persisted largely unaffected, in areas remote from the authorities (Smyth 1984, 1-35).

Ireland had never been invaded by Rome. Trading with the Empire was important and there is no doubt that merchants knew Ireland well. As the Empire ran into difficulties in the third century, the Irish (*Scotti*) and the Picts began to raid Britain. They were soon joined by Germanic raiders from the east. The defense of Britain was made difficult in the fourth century by the rise of pretenders to the imperial throne who stripped it of the legions needed to protect it as they pursued their own ambitions on the continent. An old expedient was resorted to—the very people causing the problem were recruited to help solve it. It now seems clear that Germanic mercenaries were being established in eastern England in the later fourth century. By this time the Irish were forming colonies on the western seaboard in what is now Wales and further north also, outside the province, in western Scotland out of which emerged the kingdom of Dal Riada on both sides of the sea (Nieke and Duncan 1988: Smyth 1984 *passim*). Scholars have been tempted to see in later manifestations of respect for Roman prestige evidence that Celtic chieftains were in formal alliance with Rome but this is very difficult to substantiate. The evidence, mostly linguistic and literary, is difficult to disentangle from the later widespread *imitatio imperii* of the medieval world (Thomas 1981a, 278). The legions withdrew in A.D. 406 In A.D. 410 in response to an appeal from Britain, the Emperor Honorius told the Britons to look to their own defense. The Empire was entering its terminal crisis in the west.

There was a resurgence of native nobility in Britain after the withdrawal of the legions, partly within the province and partly as a result of incursions of groups from north of the frontier. Society seems to have reverted rapidly to something like Iron Age patterns (Alcock 1971, 88-113 for a general survey). All this suggests that Romanization may have been only skin-deep although there are archaeological indications that a Romanized culture, including the continued occupation of towns, was maintained for a time in fifth century Britain.

The Germanic raids on eastern Britain continued to be a problem and later tradition records that British kings continued the policy of employing them as mercenaries. During the fifth century the Germanic settlements grew until in the east the demographic balance changed in favor of the newcomers and they began to assume power from their former masters. The people of diverse Germanic origin, now referred to as Anglo-Saxons, gradually came to dominate what is now England in a long, often fiercely contested process of conquest which was essentially continuous throughout the early medieval period. This is certainly a generally held view but recent estimates (surveyed in Laing, L. & J. 1980, 81-85) have been made which suggest that the influx of Germanic people was quite small and they essentially settled in and assumed leadership in rural areas, for a time leaving the ethnic mix and institutions of the towns unchanged. Thus, so the theory runs, the overwhelming majority of the population were Romano-British who had come to be dominated by a small elite from overseas. Nobody seriously maintains that the entire pre-existing population was wiped out by the newcomers, but the evidence for massive survival of the natives is difficult to demonstrate, the

622

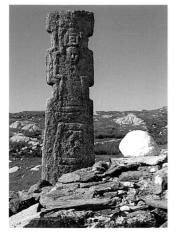

*Stone cross from Caher Island
(Ireland)
7th century A.D.*

artifactual evidence being particularly weak. There was a significant shift in population as a result of the Anglo-Saxon expansion in southern and eastern Britain and this is reflected in burial ritual and religion, settlement patterns, language, social institutions and place names and as their gradual conquest progressed, so Celtic culture, however Romanized, declined. We can deduce from later sources that in Ireland an ancient political order was breaking up in the fourth and fifth centuries. New and aggressive dynasties arose which were to dominate for the next half millennium and their conflict with older declining kingdoms provided the material for later sagas which have often been taken too literally to describe Iron Age society (Jackson 1964; Mallory 1981). In the northern half of the island the Ui Neill—a loose federation of kindreds—held the prestigious kingship of Tara. In the south a similar group, the Eoganacht, predominated, taking according to later texts, the title of King of Cashel or King of Munster (Ó. Corrain 1972, 1-27; Byrne 1973, 165-201).

Early Irish society is described in the ancient laws (Kelly, F. 1988). There were many small kingdoms which in historical times were increasingly coming under the control of larger over-kingdoms. It is probably not realistic to speak of a high-king of Ireland before the tenth century. Although it was often claimed before then, the degree of significant opposition to a claimant was such that the claims appear hollow. Aggressive dynasties gave it a semblance of reality in the period between the tenth and twelfth centuries but it was often even then subject to dispute. The economy was agricultural and cattle were very important. Law was customary and status was reckoned by a combination of birth and wealth. Kings were primarily war leaders and acted as judges but the preservation of the law and its interpretation were in the hands of *brehons*. These were consultant jurists and formed one of a number of hereditary learned classes. There were no towns or coinage and writing in the form of *ogham* was confined to simple memorial inscriptions. The *ogham* alphabet was a system of strokes carved on either side of or crossing a stem-line, often the corner of a stone. It has been shown to have derived from Latin script. It is probable that this form of writing was developed in Ireland but *ogham* stones occur in Wales, where they may mark the Irish presence, the Isle of Man and Scotland. A number of Pictish *oghams* have defied translation.

Christianity was well established in Roman Britain by the fourth century (Thomas 1981a). There was a Christian community of some kind in Ireland at the beginning of the fifth century and in A.D. 431, the pope sent Palladius as a bishop to the Irish "believing in Christ." He was followed later by St. Patrick, a Briton who had been enslaved in his youth in Ireland following capture by Irish raiders. His was the most successful mission and his church became the primatial see in later times. The Irish church was founded as an episcopal one. Monasticism was embraced enthusiastically in the sixth century as a result of influence from Britain and Gaul, and by the seventh century great monastic federations imparted a special flavor to Irish Christianity. The degree of monastic dominance in church affairs and the deviation of Ireland from regular church administration in early times are disputed (Sharpe 1984).

The fifth century probably also saw missionary activity in southwestern Scotland from the native British church (Thomas 1981a, 275-285). Tradition places the church of Nynia ("Ninnian") at Whithorn in Galloway and the best guess is that his mission took place in the earlier fifth century. A later somewhat barbarous inscribed stone in memory of a certain Latinus and his daughter suggests, according to Thomas, a period of at least three generations of Christianity by the sixth century. At Kirkmadrine, also in Galloway, there is an early inscribed stone in memory of the two bishops, Viventius and Mavorius, who are otherwise unknown. Christianity appears to have spread across most of what is southern Scotland among both British and southern Picts by about A.D. 600 but the sources are vague and archaeology is of relatively little help.

Things are much clearer when we come to consider the work of Christianization among the Scotti of the west of Scotland and the northern Picts. St. Columba, an aristocrat, member of a powerful north Irish dynasty, in A.D. 563 established a monastery at Iona, a small island off the west coast of Scotland which grew to become one of the most important centers of

learning in northwestern Europe. It was also the principal church of the Scotti of Dal Riada in Scotland. From Iona, missions to the Picts were launched and the monastery became a vital mediator in the politics of the time which involved the rivalries of Pict, Scot, Briton and Angle. The abbots of Iona, through their aristocratic connections and their dependent monasteries in Ireland, enjoyed great prestige and exercised significant influence (Smyth 1984: Herbert 1988, 36-46). None was more influential than Columba's kinsman and biographer, Abbot Adomnan, friend of the king of Northumbria and of the Venerable Bede, related to leading Irish kings, and for all his apparent isolation, cosmopolitan author of elegant Latin works which were widely circulated in early medieval Europe.

Iona, because of its peculiar position, became perhaps the single most important medium of transmission of cultural exchanges between Ireland and Britain in the later sixth and seventh centuries. Anglian political refugees were educated there and so when one of them, Oswald, ascended the throne of Northumbria, he looked to Iona to provide a bishop to complete the conversion of his people begun, but not completed, by the Roman mission to the English. Aidan was sent and from his work stemmed the great monasteries of Melrose and Lindisfarne and many others. To the culture of Anglian Northumbria, a strong Celtic element was grafted, an element which probably embodied both Pictish and Irish strands. This was to bear spectacular fruit in the Northumbrian Renaissance from the later seventh century onwards despite bitter disputes about the method of calculating Easter. (The Irish church adhered to an older method and was often out of step with the Roman date.) The dispute was settled in favor of Roman ways at the Synod of Whitby in 664 AD. Despite the withdrawal of some Irish monks and some Saxon adherents, the influence of the Irish church lived on in northern England and contact between the two islands remained strong (Ó. Croínín 1984). These contacts were the conduit through which Anglo-Saxon influences continued to flow northwards to Pictland, and westwards to Ireland, and Iona remained a critical link.

Wider church contacts provided means whereby other influences could come. Irish monks were working in Europe from the end of the sixth century. Columbanus, founder in A.D. 614 of Bobbio, had previously labored in Gaul where he had established houses at Annegray and Luxeuil to which he bequeathed his influential *Rule*. His disciple, Gall, established a foundation at Sankt Gallen which still retains an important collection of insular manuscripts, and there were many others. Pilgrimage to Rome was also a significant factor and as early as the 630s the Irish church sent a delegation there to obtain guidance on the correct method of celebrating Easter.

The church provided more than a mere veneer of religious and aesthetic ideas. Christianity changed the Celtic lands profoundly. Learning to read Latin opened up the knowledge of the ancient world—philosophy, literature, law and, not least, technology. The church had a social attitude which manifested itself most strongly by the seventh century with the formulation of conventions for the protection of non-combatants in warfare. Monastic organization was such that it provided a direction and enlisted a consent for communal action that a petty king, who had to bribe or cajole his kinsmen and dependents with their traditional rights, might well envy. The practice of sanctuary, the tradition of devoting children to the church and the protection of widows and orphans combined with the accumulation of lands and tenants, gave leading monasteries an enviable concentration of manpower to undertake work such as land improvement and road building, to develop specialized groups of craftsmen and consequently to grow economically. Monasteries became important depositories of secular goods and lucrative places of pilgrimage and were the recipients of the donations of the pious. They constituted a new and powerful force in society and royal dynasties which neglected to control them did so at their peril (Doherty 1980; 1985; Ryan 1988, 32-35). For the Celtic peoples who had not been conquered by Rome, the church was the principal bearer of the culture of the Empire.

The most common habitation site in Ireland was the rath or ring-fort—a small circular enclosure ranging in size from about 30 meters to about 100 meters in diameter, enclosing a

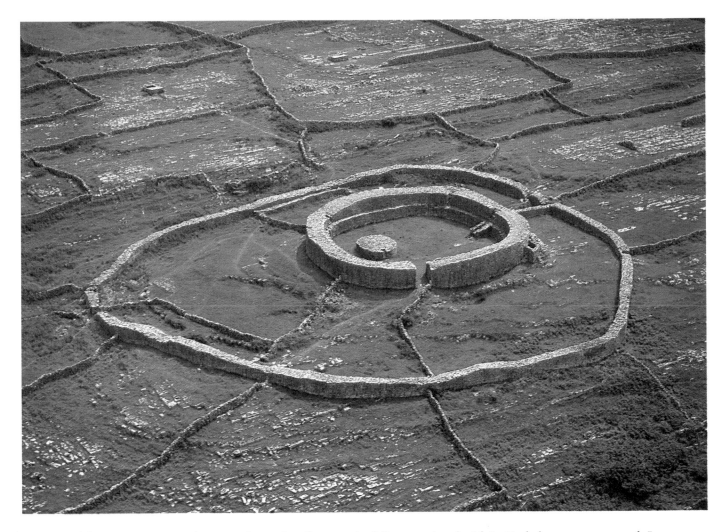

Aerial view of the monastery on the island of Inishmurray (Ireland) 6th-8th century A.D.

house and occasionally an outbuilding associated with it. Early houses were round. Later, rectangular ones became common. The material culture is that of the self-sufficient and well-to-do farmer, a picture confirmed by the ancient laws which describe the possessions of the various grades of nobles in great detail and relate the size of the house and the number of ramparts to the status of the occupant, although we must allow for lawyerly idealization. Simple subsistence ironworking is evidenced on most sites—but a few raths yield evidence of high-quality fine art metalwork and some such as Garranes in county Cork (O. Riordain 1941-2) produce evidence of trade including exotic eastern Mediterranean pottery of the fifth and sixth centuries. An enigmatic few have produced no evidence of occupation at all and may have been cattle-pounds. In the western part of Ireland and on stony uplands, the equivalent of the rath is the stone-built cashel. Excavation produces the same range of material. Of the dwellings of the dependent classes we know nothing.

In the wetlands of the Irish midlands high-status dwellings were erected on artificial or artificially enlarged natural islands called crannogs after the Irish word *crann*, a tree. The tradition of the crannog can be traced back to the later Bronze Age and some were in use as late as the seventeenth century A.D. The inhabitants of these also shared the material culture of the rath. Some crannogs—such as Lagore, county Meath (Hencken 1950-1), can, like certain raths and cashels, be identified as royal sites. Lagore produced a rich material culture of the seventh and eight centuries including traces of the manufacture on-site of fine metalwork. In Scotland the crannog is also present—Buston crannog in Ayrshire produced an assemblage like that of the Irish sites. The picture is very varied, however, with large fortified hilltop sites in use especially in Pictland and amongst the Strathclyde Britons (Alcock 1987a, esp.

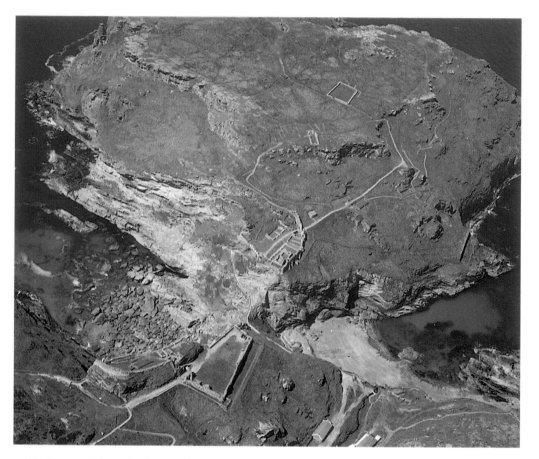

Aerial view of Tintagel (England)
site of a monastery
of 5th-8th century A.D.

82ff). Some of these had seen a long occupation. This contrasts with Ireland where the large hillforts of Iron Age times saw little use in the medieval period but retained immense prestige into early medieval times and, in some cases, may have been the sites of assemblies. The large hilltop enclosure of Traprain Law just south of Edinburgh was occupied throughout the Roman period and excavation there has revealed in some detail the development of material culture in a period crucial for the understanding of later developments. Dunadd in Argyll—claimed on somewhat flimsy grounds to have been a center of the Kingdom of Dal Riada—was, perhaps, first a Pictish settlement (Nieke and Duncan 1988). Other sites of this general type included Dumbarton and Edinburgh. At Burghead a large promontory was enclosed by a rampart. In the west and north of Scotland and on the islands there was a long tradition of building in stone extending back to the prehistoric Iron Age. Round houses and others of elaborate multi-chamber ground plan were built and stone defenses not unlike Irish cashels were built in a tradition which can be traced to the local Iron Age. Unenclosed settlements are attested in northern Pictland.

In both Ireland and southern Pictland, *souterrains* were common. These were underground chambers of drystone walling often entered by means of long passages incorporating defensive features. They were mainly associated with habitation sites. In Wales and southwest England large-scale forts seem to have seen renewed use in the immediate post-Roman period and smaller enclosed settlements are also known (Alcock 1987b, 153-167; Alcock 1988, 23-29 and 40-46). In Cornwall, "rounds," small enclosed sites, not unlike the Irish rath but more variable in plan, continued in use into early medieval times. It is nowadays suggested that the larger enclosures, rebuilt or repaired in early medieval times in western and northern Britain may not have been military, but may have served as centers of administration or redistribution. In Wales, the small fortlet of Dinas Powys—with its exotic pottery from the eastern Mediterranean and later from western Gaul, and Roman and Germanic glass, together with its fine metalworking—provides an understanding of the trading connections and economic

activities of the time comparable with many Irish sites (Alcock 1987 b, 7-19).

Indeed the chronology of this early period is largely based on the occurrence of this eastern Mediterranean pottery on domestic sites. Later, pottery from western Gaul becomes more common and widespread. (Thomas 1959 and Thomas 1981b). It is a common mistake to assume that these imports were in bulk and that imported pottery was frequent on high-status sites but in many cases, the amount recovered from excavations can be accounted for by a handful of vessels and we may be seeing the effects of a number of a short-lived but direct trade with the northeast Mediterranean in the period between the late fifth and mid-sixth centuries A.D (Fulford 1989). It has often been remarked that the earlier imports include wine and oil jars and these reflect Christian liturgical needs but tableware is also found.

Whereas Britain had seen over three hundred and fifty years of Roman building, the architecture brought by the church to Ireland was novel (Craig 1982, 25-48). The earliest churches seem to have been of wood. Stone churches belong to the eight and tenth centuries in monasteries of high status (Hamlin 1985, 283-286). Wood however continued to be used. Some evidence for wooden construction has been excavated under later stone churches but it is not clear if what has been found represents the traces of wooden supports of stone roofs or the genuine remains of structures . No church belonging to the earliest phase of Irish Christianity has been excavated but the typical monastic layout is known from the seventh and eighth centuries (Hamlin 1985, 280-283). Enclosed by an earthwork or stone wall, often sub-circular, the church is placed off-center. Early grave-markers include pillar stones with lightly incised simple crosses and sometimes, as at Reask, county Kerry, simple scrollwork. These stones, which are known also in Scotland and Wales, are notoriously difficult to date. Occasionally, also at Reask, they carry simplified versions of common early Christian iconographical themes or symbols such as the *chirho*, the monogram of Christ. Later these are replaced by recumbent slabs often highly decorated with the repertoire of the mature native art style.

In the ninth century, the form of the monastery became standardized. Two enclosing walls were the norm. The inner one separated the holy place from the area in which the more worldly activities of monastic life were pursued. In the central area, public buildings were erected—the abbot's house, the round tower (belfry), a large stone church and large sculptured stone crosses in those monasteries which could afford them. The churches were plain, rectangular buildings; they had trabeate doorways sometimes embellished with an incised cross. A distinctive Irish development was the stone roof which in its ultimate form was propped by a barrel vault which may have been a borrowing from continental sources. Later, chancels were sometimes added and in the twelfth century, romanesque features, particularly ornament, were applied. It has often been pointed out that these churches, with their distinctive gable finials, *antae* (projections of the side-walls beyond the gable ends) and barge courses, mimic features of wooden construction (Craig 1982, 28-30).

The round tower, tall and tapering with a conical cap, represented an adaptation of native techniques of building to imitate continental bell-towers. They seem to have developed in the ninth century and continued to be built until the twelfth, and examples with romanesque detailing are known. In a few cases the round tower was adapted to form a spire springing from the stone roof of the church. There is really only one native church in Ireland which closely follows romanesque patterns. Cormac's Chapel at Cashel, county Tipperary betrays the influence of English traditions in its carvings. Despite its exotic feeling, it retains the traditional stone roof.

Architecture in Scotland faintly echoes Irish patterns with simple stone churches and even examples of round towers at Abernethy and Brechin. Monastic layout, especially in the west and north, mirrors the Irish experience (Thomas 1971, 1-90). There was another tradition of building, historically attested, which depended on influence from Romanizing Northumbria when Abbot Ceolfrith of Jarrow sent masons to the king of the Picts to build a church. The romanesque style penetrated Scotland in a pure form earlier than in Ireland as Queen

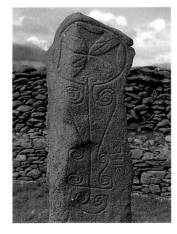

Stone cross Reask (Ireland)

Margaret's Church on Castle Rock, Edinburgh, shows. On the Isle of Man, simple enclosed church sites, the keeils, follow in broad terms the Irish pattern although on a reduced scale. In the Viking Age, crosses and cross-slabs with runic inscriptions and ornament of Scandinavian derivation were erected.

The Celtic La Tène style was established in Britain and Ireland in the prehistoric Iron Age and appears to have survived the Roman colonization, however tenuously, in the south of Britain but more vigorously in the north and in Ireland. There is controversy about the place and degree of survival of this art in the two islands partly because the style which emerges in the early medieval period, while owing its spirit to the La Tène tradition, is strongly influenced by provincial Roman types and motifs such as palmette derivatives and peltae (fleshy C-scrolls). Of the most common motifs which can be traced to the Iron Age tradition, two, the trumpet scroll (two divergent curves with a lentoid feature forming the mouth) and the spiral with a bird-headed (frequently a crested duck-head) ending are the most obvious. The earliest medieval style is most frequently expressed on metalwork often in the form of engraved enameled scrolls and later of reserved scrollwork seen against a background of *champlevé* red enamel. The most commone types are cloak fasteners—the penannular brooch with its terminals in the form of stylized animal heads and "hand pins." These were stick pins with heads in the form of a semicircular plate surmounted by a number of tubular beads resembling a human hand with the fingers projecting forwards. Both types can be traced to the late Roman period but enjoyed their principal vogue in the fifth to seventh centuries. The only substantial sculpture of this period is a monolith from Mullaghmast, Co. Kildare, Ireland (Kelly 1983). This bears the characteristic decoration of the period as it appears on personal ornaments. At the same period in Scotland a series of metal ornaments were made which carry the enigmatic symbols which were to characterize Pictish sculpture later (Youngs 1989, 27-8). Of these the best known are the silver leaf-shaped objects from the Norries Law, Fife, hoard and also on a series of massive silver chains.

Another type which displays the Celtic style at its most sophisticated is the hanging bowl. These vessels were based on late Roman protoypes and equipped with suspension hooks. The escutcheons of these hooks were often framed enameled plates which deploy the range of motifs and techniques available to the Celtic ateliers in the period between c. A.D. 550 and A.D. 650. The overwhelming majority of these have been found in Anglo-Saxon graves in the southeast of Britain and this, at first sight so surprising, can largely be explained by the fact that our knowledge of metalworking in the Celtic areas comes from chance finds and occasional discoveries on habitation sites. The Anglo-Saxons however continued the custom of burying grave goods long after it had died out in Celtic Britain and Ireland. The hanging bowls must be seen as imports buried in the pagan graves in the same way as exotic Byzantine, Coptic and Merovingian goods. Efforts have been made to see in the hanging bowls evidence for the continued survival of British ateliers in conquered areas. This is not very plausible. All the artistic comparisons are with the vigorous traditions outside the regions of Anglo-Saxon conquest and mainly with Ireland when the more elaborately decorated bowls are considered.

The metal types document a growing sophistication of ornament—the scrollwork becomes more complex and florid and new colors of enamel are employed. In Ireland, millefiori begins to be used in the later sixth century and some penannulars and hand pins are decorated with platelets of this material floated in fields of red enamel. Some hanging bowls are decorated with millefiori; the largest bowl from the Anglo-Saxon burial of Sutton Hoo is the most impressive of these. Recent discoveries make it clear that the artistic background for this piece lies in the Irish midlands, as some scholars have long suspected (Bruce-Mitford 1987; Ryan forthcoming). Excavation has demonstrated that workshops capable of producing this material existed both in Ireland and in northern and western Britain. The only certain location of a workshop producing a hanging bowl is Craig Phadraig in Invernesshire where a mold for a plain openwork escutcheon was found.

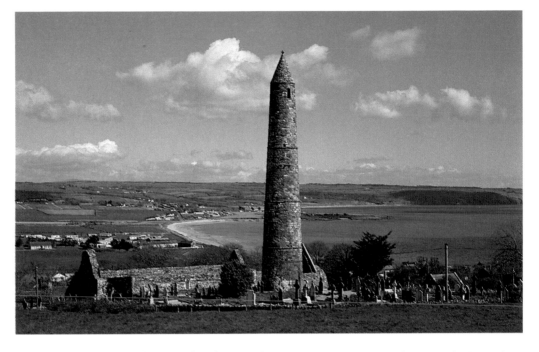

Tower of Ardmore (Ireland)
10-11th century A.D.

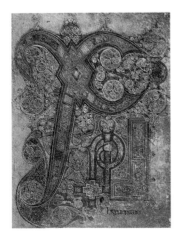

Page with the initials "XPI"
from the Book of Kells
Ireland
8th century A.D.
Dublin, Trinity College

It is clear that the craftsmen of Ireland and Celtic Britain were in close touch throughout the fifth and sixth centuries and produced largely similar material. In general terms, work produced in Ireland was mainly in bronze and millefiori was popular. In Scotland silver was more common but millefiori does not appear. The corpus from Wales is disappointing but the site of Dinas Powys yielded slight evidence of millefiori working. It is misleading to assume that millefiori was confined to the Celtic lands at this time—there is splendid millefiori on the purely Germanic jewelry from the Sutton Hoo ship burial which was custom-made for the settings provided.

The close contacts with the Anglo-Saxons in the seventh century began significant changes in the arts of the Celtic lands. Contact was probably due in the main to the activities of missionaries but the various campaigns of conquest of the kings of Northumbria in southern Scotland ensured a continuing and by no means always warlike interaction of the Picts and Angles which is later reflected in the art of the time. The result for the metalworker was a great increase in the techniques available—gilding, filigree, casting to simulate faceted engraving (*kerbschnitt*), the adoption and transformation of Germanic-style animal art and the imitation of a whole new range of types and visual effects. Attention has focused on the Anglo-Saxon component because of the well-documented Irish presence in both Scotland and northern England but the obvious links of the Irish missionary church with Europe are often overlooked. While in both Ireland and Scotland there is a clear debt to the Germanic world, in the art of the time in neither area have we identified many imported objects which can confidently be regarded as Germanic in the widest sense. Our evidence consists of reflections of imported models and influences, already transformed into a new style when we encounter them on native objects. In the case of Ireland, there is documentary evidence of Anglo-Saxon students flocking to her monasteries for their education and by the end of the seventh century there were at least three Anglo-Saxon foundations.

The Celtic metalworkers were not slavish copiers of borrowed exemplars but imaginative adaptors who combined their native traditions with Mediterranean influences to develop a new decorative style of great complexity and refinement. It was above all a polychrome style. It is often thought of as purely ornamental, abstract and aniconic but in the eighth century it marries these traits successfully with Christian iconography on metalwork and in manuscripts and in the ninth century with ambitious programs of figural scenes in stone. The development of the style is usually traced in manuscript illumination in the seventh and

earlier eighth centuries (Alexander 1978). This is inspired by the mistaken view that these are closely dated and reasonably well-provenanced. They are not. Of the major manuscripts in the insular style the only examples with original colophons dating them clearly to two or three decades or so, belong to the ninth century or later. The dating of the earlier ones, including the very greatest, is either inferential or based on the acceptance of non-contemporary witness. Some things seem clear. There was a massive Irish contribution to the insular style of manuscript painting. Irish traits of script are present in the earliest manuscript of the tradition—the Psalter known as the Cathach of St. Columba written, it is thought, about A.D. 600. Gradual reduction of letter size to merge with the text (so-called *diminuendo*), scrolled elaboration of capitals and incipient zoomorphism of ornament are already in use. A near contemporary manuscript in Milan (Ambrosian Library, D. 23. sup.), formerly in St. Columbanus's monastery of Bobbio, has a page of pure ornament of simple type. It is a prototype of the so-called carpet pages of luxury codices of later times.

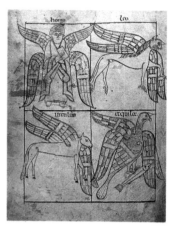

Miniated page with the symbols of the four evangelists from the Book of Armagh Ireland ca. 807 A.D. Dublin, Trinity College

There is no doubt that the Columban missions to northern Britain played a major part in the genesis of the high style of illumination. Most would regard the *Book of Durrow* as the earliest of the luxury gospel books to survive. It was painted either in Ireland where there is a solid artistic context for it or in a monastery of strong Irish orientation in north Britain. It deploys the full apparatus of the mature insular gospel book—*diminuendo*, elaborate initials and carpet pages. Most of the ornament is of trumpet scrolls, spirals and lentoids. Interlace, an innovation in the Celtic canon, is used for the first time: dot-outlining, and above all, one page of animal ornament of Anglo-Saxon type. The dating of Durrow is controversial but it is often suggested to belong to the later seventh century. This is by no means demonstrated.

A fragmentary manuscript in Durham Cathedral Library may be a link in the development of the manuscript animal style. It also has a full page miniature of the crucifixion. The maturity of the new art is achieved in manuscripts with the *Book of Lindisfarne* painted at the monastery of that name in Northumbria and, in metalwork, with the "Tara" brooch from eastern Ireland—both produced probably towards the close of the seventh or the beginning of the eighth centuries.

A tenth-century ascription written into the *Book of Lindisfarne* states that it was written "for God and St. Cuthbert" by Eadfrith the Bishop of Lindisfarne Church, and it is now widely assumed that the occasion of writing was the translation of the relics of the saint in A.D. 698. This is by no means proved but it is not an issue of great importance in view of the general uncertainty of dates for objects of all types at this time. The ornament of Lindisfarne is superb (Bruce-Mitford 1960). It has elaborate canon tables, evangelist portraits, carpet pages and embellished initials. Trumpet scrollwork, often with zoomorphic elements, spirals, animal interlace and contorted beasts with credible anatomical detail, and birds provide the ornamental repertoire. The animal is often a long-bodied quadruped shown in profile with the torso turned through hind-legs which are spread compass-like. The portraits of the evangelists show the artistic influence of the Romanizing aspect of the Northumbrian Renaissance clearly, but the ornamental style has clear links to that of a number of objects from the east midlands of Ireland.

The "Tara" brooch is the most lavish of a new type of cloak fastener. It is made of cast-silver in the form of a ring about half of which is expanded for the display of ornament. It is fitted with an elaborate free-swiveling pin with a decorated head. It is one of the earliest of the annular type which was fashionable in Ireland in the eighth and ninth centuries (O. Floinn 1989). Its ornament is laid out in panels which recall the form of penannular brooches but its lavish filigree ornament and marginal birds and beasts recall features of Germanic work. It is a hybrid product showing the assimilation of borrowed traits to native taste to produce a new style. Its ornament of animals, bird processions and trumpet scrolls with abstract zoomorphic elements strongly recalls the paintings of Lindisfarne. It has a close analogue in the Hunterston brooch found in Ayrshire, Scotland (Stevenson 1973). Another close comparison

is the ornament of the hoard of door or shrine furniture found recently at Donore near Kells in county Meath. Here too the Tara-Lindisfarne repertoire is reproduced in cast *kerbschnitt* and on a lightly-engraved tinned bronze disc in an effect very close to painting. The Donore material includes a stylized composite lion-head ringhandle which represents the attempt of the metalworker to adapt classical models to native taste and technology. The material was probably associated with a church (Ryan 1987a).

Hoarding in Viking times and chance finds have preserved a great deal of metalwork from eighth- and ninth-century Ireland. The greatest of these are the finds of altar vessels from Ardagh, county Limerick and Derrynaflan, county Tipperary (Ryan 1985). A large two-handled ministerial chalice from Ardagh and a great paten from Derrynaflan take the poly-chrome style to its height (Organ 1973; Ryan and Ó. Floinn 1983). Cast glass studs in imita-tion of cloisonné gemstones, filigree animal interlace of remarkable refinement, cast orna-ment, engraving, stamped foils and knitted wire mesh are combined in a complex assemblies to produce pieces of stunning beauty and distinctive appearance. They belong to the later eighth century and on close examination much of their ornament shows strong parallels with Anglo-Saxon work of that time, though modified and transformed and rendered in a distinc-tive Irish manner. Despite the insular style of ornament, they are firmly based on late Roman models which provide the only satisfactory ancestry for their friezes of panels of beast-ornament (Ryan 1987b; Ryan 1990).

The chalice from Derrynaflan, although a much less colorful piece, is nevertheless an ambi-tious composition which demonstrates that the high style of ornament survived the initial impact of the Viking raids on Ireland. Its filigree panels are more disjointed in their iconogra-phy and belong more to the tradition of the annular brooches but they are nevertheless vigorous and well drawn in places. There is no enamel on the chalice and this accords with

Miniated pages
from the Lindisfarne Gospels
London, British Museum

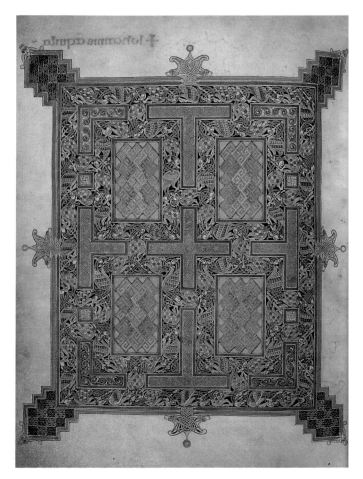
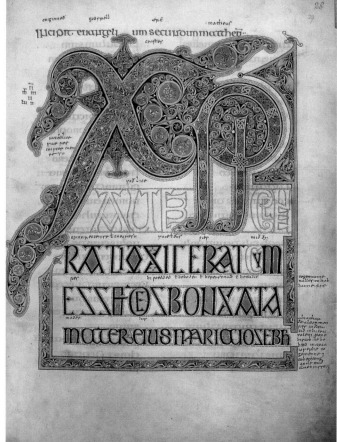

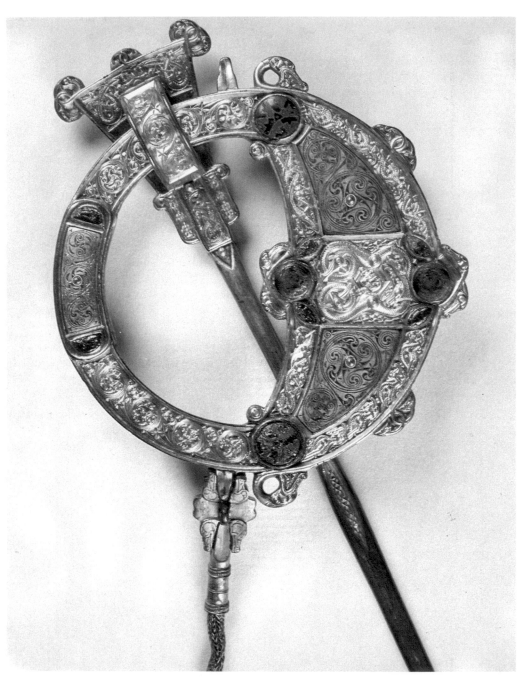

Gilded silver clasp of Tara
from Bettystown (Ireland)
8th century A.D.
Dublin, National Museum of Ireland

the decline in polychromy which seems to have coincided with the beginning of the Viking period (Ryan 1987c, 71).

In Scotland, the penannular brooch remained popular but its ornament matched that of the Irish annulars. Some filigree brooches of high quality were made, as well as many more simply decorated with *kerbschnitt*. A large hoard from St. Ninian's Isle, Shetland, contained decorated bowls and many brooches of debased silver, testifying to the continuation of metalworking styles among the Picts. The ancestry of the bowls in late Roman traditions of vessel-making has been demonstrated by Wilson (1973) who has also rejected attempts to define the material as liturgical.

Reliquaries are amongst the most common objects to survive from the period. A book shrine from Lough Kinale, county Longford, recently found, shows that the Irish practice of enshrining revered books had begun by the eighth century. Much more widespread is the house- or tomb-shaped shrine of which complete and fragmentary examples have been found in

Silver mount with embossed spiral ornament from Morrie's Law, Fife Edinburgh National Museums of Scotland

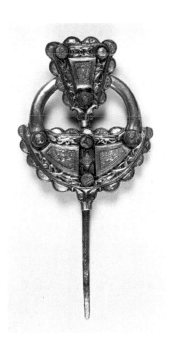

Silver clasp from Roscrea (Ireland) 9th century A.D. Dublin, National Museum of Ireland

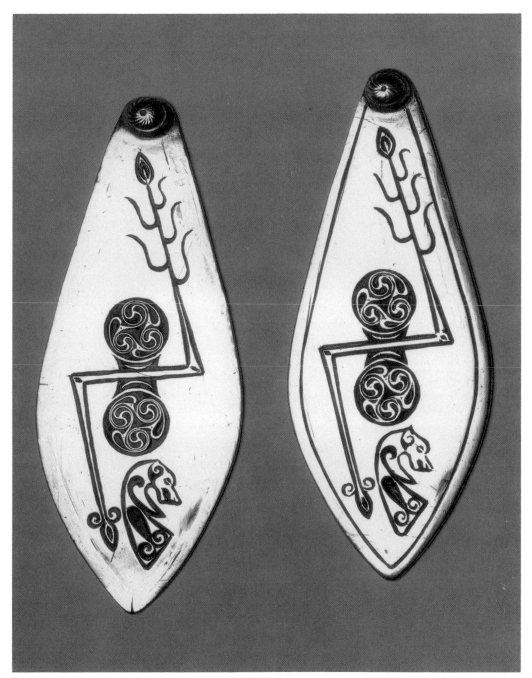

Ireland, Scotland, France, Italy and also Scandinavia, where they may have been taken in Viking times (survey in Blindheim 1986). They take the form of small portable caskets which mimic the appearance of hip-roofed buildings, perhaps churches or tombs. The early examples may be divided into three broad types—those in which metal decoration is inlaid into the wood of the casket (the Emly and abbadia San Salvatore shrines), those where the wooden box is sheeted in metal plates, often decorated (Monymusk and Copenhagen for example) and all-metal examples (the recently discovered Bologna shrine). All the known examples have applied medallions and elaborate ridge-poles sometimes with beast-heads. Two examples —Abbadia San Salvatore and Copenhagen—contain corporeal relics which may be original. The finials of a very large example are preserved in the museum of St. Germain, Paris, and almost exact analogues, perhaps from the same shrine were found at Gausel in Norway. The design of these reliquaries may reflect the form of early churches in Ireland and Scotland depicted on ninth-century high crosses and on the Temptation page of the *Book of Kells*.

The cult of relics was very highly developed in Ireland and other important reliquaries survive intact—the Moylough Belt-shrine made to enclose the girdle of an unknown saint in the eighth century combines *champlevé* enamel, millefiori and die-stamped silver to beautiful effect. Its background seems to lie in ornamental belt-garnitures of early seventh-century France though it was not made until much later, but no such imported belt fittings have ever been found in Ireland.

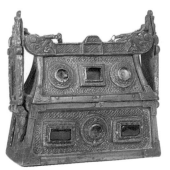

Reliquary chest in copper, iron, glass and enamel
8th-9th century A.D.
Bologna, Museo Civico Medievale

By the time the Derrynaflan chalice was made, the Viking raids had begun and conventional wisdom is that their effect on Irish art was devastating, but this is exaggerated. True, both in Ireland and amongst the Picts of Scotland, there was hoarding of precious materials—the St. Ninian's Isle hoard was concealed sometime after A.D. 800, thus fortuitously preserving a range of high-quality Pictish bowls, brooches and other objects which show close relationships to both the high style in Ireland and to the arts of Northumbria (Wilson 1973). It is also true that Viking graves in Norway and elsewhere contain a range of Irish and related objects, both broken-up and reused and complete, and that some of these were religious (Wamers 1985). Irish annals speak of the devastating effects of the Vikings and fashionable revisionism of modern times should not blind us to the terrible and shocking effect that they had on contemporaries. Nevertheless, metalworking continued in Ireland and some of the greatest artistic achievements in all media belong to the later eighth and earlier ninth centuries. In manuscript painting, the *Book of Kells* was illuminated about that time as well as the ambitious *Book of MacRegol* and the elegant *Book of Armagh* notable for its accomplished pen-and-ink drawings (Alexander 1978, 71-78). The same period also saw an astonishing flowering of stone sculpture.

From humble beginnings in both regions, the simple inscribed pillar gave way to more elaborate carvings. The rich but ill-understood symbolic system of the Picts was carved on monoliths perhaps as early as the seventh century (Henderson 1967; Jackson 1984). Some of their animal devices bear a close resemblance to the style of evangelist symbols in the *Book of Durrow*. In the eighth and ninth centuries, large slabs with gable-shaped tops were carved. These carry a high-relief cross on one face and narrative scenes of great liveliness on the other. The traditional symbols also appear on these Christian monuments although some with high-relief ornament lack them. On the most sophisticated Christian stones, such as the Nigg slab, elaborate iconographical scenes occur. Highly complex interlaced snakes, spiral and trumpet scrollwork are common; so is the trick of combining these with bosses in strong relief. Links to the manuscript art of the *Book of Kells*, which was partly at least created on Iona, are strong (Ritchie 1989 for best recent illustrations). Free-standing monumental crosses are known in southern Scotland especially in areas of Northumbrian influence. Examples carved on Iona and related sites in the Western Isles appeared about A.D. 800. It is to these that the tradition of the Irish high cross can best be related (De Paor 1987).

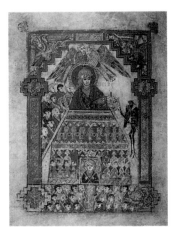

Miniate page from the Book of Kells illustrating the temptation of Saint Luke
Ireland
8th century A.D.
Dublin, Trinity College

The monastery of Columba was transferred to Kells in the Irish midlands at the beginning of the ninth century in the face of Viking raids. There, a tradition of monumental ringed crosses drawing on influences from Iona developed. It now appears that the fully-fledged Irish high cross is no earlier than this time (Henry 1964 and chapters of Henry 1965 and 1967 for the best surveys of the material). Within a century a variety of local traditions had emerged, some emphasizing ornament (those at Ahenny, county Tipperary and related examples), others dominated by a sophisticated figural iconography (the finest example is Muiredach's Cross at Monasterboice, county Louth, erected in the early tenth century) and still others partaking to an extent of the characteristics of both. There are some idiosyncratic examples, such as the cross of Moone, county Kildrare, carved in the ninth century. Its naive-seeming figure renderings do not disguise the sophistication of its iconography and the diversity of the cosmopolitan influences which it embodies—Italian and Northumbrian as well as native. All have in common the organization of figured scenes and abstract ornament into discrete panels, almost all have the so-called Celtic ringed head which first appeared in metal-work and on grave slabs in the eighth century and must represent some form of triumphal

wreath honoring the Cross of the Redemption (Roe 1965), although elaborate typological explanations have been developed to explain the feature. The sculptural tradition remained vigorous in the tenth and eleventh centuries and became transformed in the twelfth under romanesque influence, when high crosses carved as large crucifixes without rings or small paneled scenes appeared. These mark in monumental form the triumph of regular Roman church organization over the native monastic-dominated church effected in the twelfth century by reformers.

What then were the effects of the Vikings in Ireland? They established the first secular towns—their coastal settlements (Dublin, Wicklow, Wexford, Waterford, Cork, Limerick) grew to be important centers of trade and manufacture and major concentrations of manpower. These towns consisted in the main of wattle buildings which, it has been argued, belong largely to the native tradition. Excavation has yet to reveal much about the public buildings and concourses of these settlements and as yet we lack a satisfactory model to explain how exactly they grew up and what degree of planning was involved in their establishment. None of earliest Dublin has been excavated apart from haphazard investigations of its cemetery in the nineteenth and early twentieth centuries. All other deposits examined have been of no earlier than the second third of the ninth century although the settlement was first established in the mid-eighth century. We do not know how such Viking towns related to the native monastic sites in their vicinities—there were several at or near Dublin. At Waterford, more ambitious remains were found; sunken houses with stone-flagged steps were excavated and a number had stone cellars.

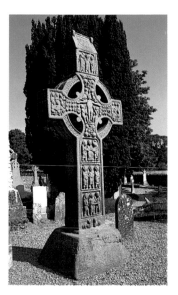

Stone cross of Muiredach at Monasterboice (Ireland) early 10th century A.D.

Nothing like these new settlements had been seen before in Ireland. They undoubtedly influenced the great monastic centers which had previously fulfilled some of the role of towns. It was especially in the ninth and tenth centuries that the larger monasteries developed their standard layout and urban characteristics. The wealth of the towns could not be ignored by native kings. From the later tenth century, native rulers exacted tribute from Dublin and in the eleventh began to intrude their own puppet kings or officials to rule the coastal towns. In Scotland, Viking conquests were extensive in the north and in the Hebrides, Orkneys and Shetlands. They conquered the Isle of Man and with settlements along the western seaboard of Britain, they dominated the Irish Sea for over three hundred years. Mixed populations rapidly appeared and hybrid art styles formed. The ornament of the Manx crosses is not purely Scandinavian but contains elements peculiar to the Irish Sea area.

Artistically, early, direct borrowings from Viking sources are difficult to detect in Ireland. The eastern trade of the Scandinavians introduced large quantities of silver. This prompted the emergence of brooch styles which abandoned the colorful effects of enamel and gilding for "the cold gleam of silver" (Henry 1967, 112). Undoubtedly also, the Viking wars created disruption but there is no compelling reason to believe that dislocation was enough to extinguish native artistic production. Viking art styles did not become influential in Ireland until the eleventh century by which time their political and military power was in decline and any Scandinavian traits in Irish art may have been mediated through Danish England (Graham-Campbell 1987, 150-1).

In the eleventh century a series of important reliquaries were either repaired or created (Ó. Floinn 1987). One, the Soiscel Molaise, a book shrine, was covered with decorative plates in the early eleventh century. Some of these are decorated with motifs of Viking inspiration but the main ornament has a strong native flavor (Ó. Floinn 1983, 161-3). The shrine for the seventh century manuscript, the *Cathach* of St. Columba, was made in the later eleventh century at Kells and its original decoration embodies elements of the Scandinavian *Ringerike* style. An ambitious bishop's staff, the Innisfallen crozier, was made about the same time or a little earlier and bears fine filigree in a style matched on a recently-discovered "kite" brooch from eleventh-century deposits at Waterford. Dublin has yielded evidence of a school of wood- and bone-carving which supplements the impression of the shrines and other metalwork.

The Scandinavian *Urnes* style enjoyed a vogue in twelfth-century Ireland at a time when it had already been superseded in the homeland. The shrine of St. Patrick's Bell, made about A.D. 1100 is one of the most elegant expressions of the style but the *summa* is the Cross of Cong made about A.D. 1123 to enshrine a relic of the true cross, probably at Roscommon. Croziers are amongst the most common of the major pieces of the time and that from Clonmacnoise, county Offaly, carries on its crook a fine composition in inlaid silver and niello animal interlace in an Irish variant of the *Ringerike* style. The Lismore Crozier, made before

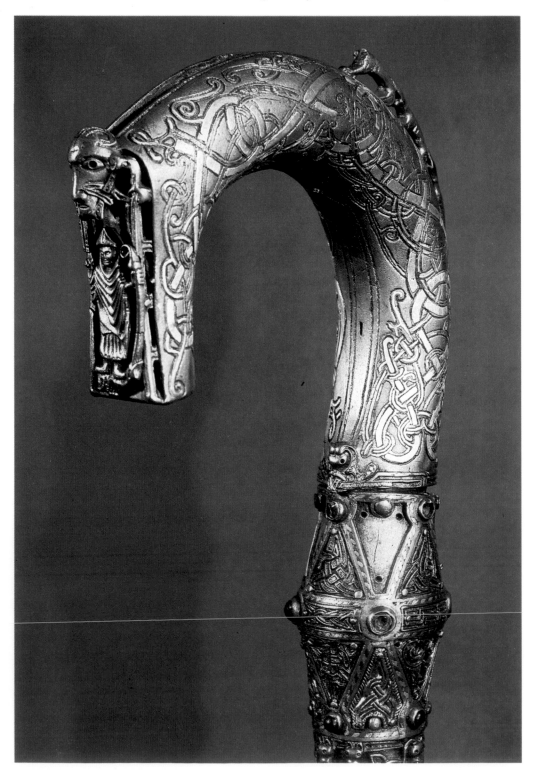

Pastoral in bronze sheet on wooden board from Clonmacnoise (Ireland) End 11th-15th century A.D. Dublin, National Museum of Ireland

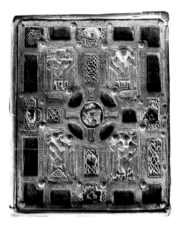

*Umbilical bowl with
embossed mount
in silver, gold, and enamel
from St. Ninian's Isle, Shetland
8th century A.D.
Edinburgh
National Museums of Scotland*

*Reliquary book known
as "Soiscel Molaise"
from Devenish (Ireland)
End 8th century A.D.
and early 11th century A.D.
Dublin, National Museum of Ireland*

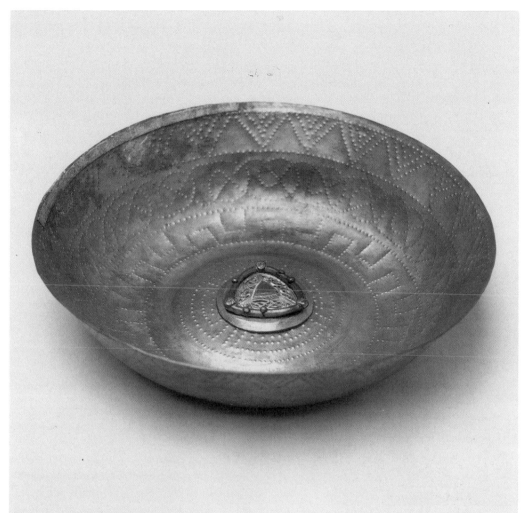

A.D. 1118 not only deploys sophisticated *Urnes*-style ornament but also motifs which hark back to the art of the eighth and ninth centuries. These later pieces, all in their distinctive way, mark a return to polychromy and a conscious revival of much of earlier times. The vigor of church reform, the surmounting of the Viking threat, the rise of powerful kings who introduced new ways of administering their realms, all contributed to this partly new, partly renascent art. The arrival of regular monastic orders from Europe, the decline of the great native monasteries and finally, the Anglo-Norman invasion of A.D. 1169 meant the loss of customary patrons for native artists. So a tradition which preserved the spirit of Migration Period, and even Iron Age aesthetics, finally dwindled away in Ireland as it had in Scotland. There were to be a few fitful attempts at revival in the later Middle Ages but nothing of comparable greatness was ever again achieved in the visual arts. The greatest monuments of the Celtic peoples thereafter were in literature.

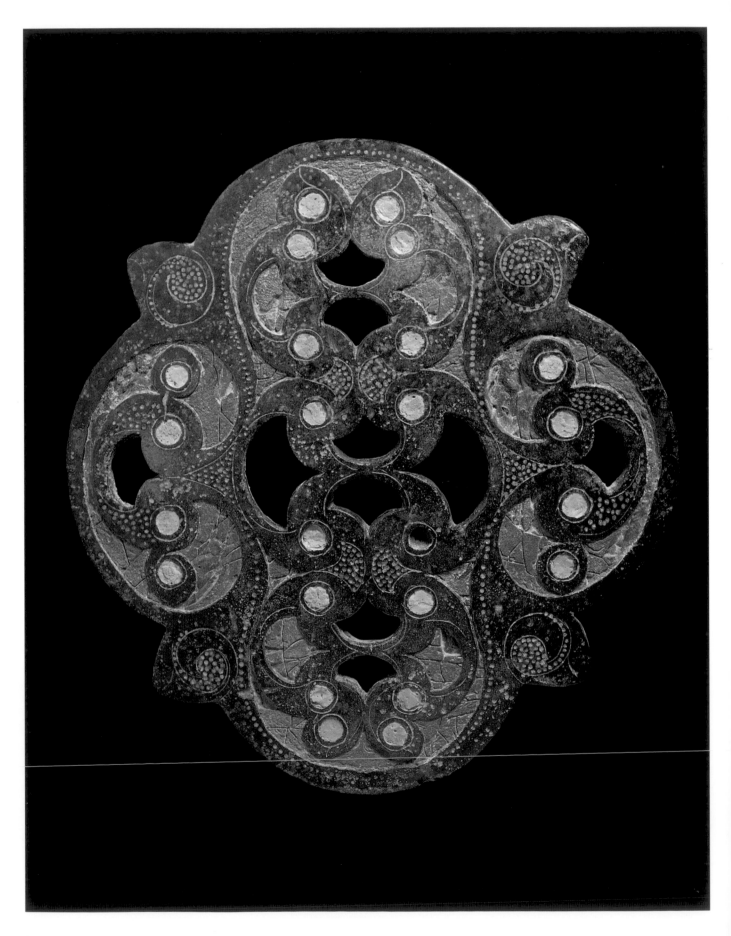

Celtic Enamel

La Tène Enamelwork

During the La Tène period the Celts used enamel inserts as a colored ornament for their metalwork. Enamel was frequently used in conjunction with coral, and was always red—though the tone has changed due to aging. Until recently it was thought that enamel was a later substitute for coral because of the latter's scarcity. Research carried out by P. Jacobsthal has shown instead that coral and enamel were used together in ornamentation.

The Chemical Composition of Red Enamel

The red enamel used by the Celts consists of quartz glass with a small quantity of added lead. The glassy mixture was turned red by adding cuprite, Cu_2O. During the normal heating process, cuprite is transformed to cupric oxide, CuO, murky green in color; the copper oxide therefore had to be processed further and the oxygen removed. It seems that in most cases the glass mass was heated just until it became soft and then pressed into the cavities of the metalwork after roughening the surfaces to insure adhesion. The enamel workshops discovered at Bibracte (Mont-Beuvray) yielded a great many objects the enamel of which had clearly come away from the setting.

Techniques

Two techniques were used in enameling. In the first, the enamel was poured in semiliquid form into the settings (*émail champlevé*); in the second the enamel was secured to the surface of the metal with rivets.

Examples of the *champlevé* technique can be seen in the Amfreville helmet, the terret rings from the Waldalgesheim burial (which have lost their enamel), the Cuperly disc on which four convex studs are adorned with red enamel, and finally the two beaked flagons of Basse Yutz on the Moselle (the lids of which were decorated using the *champlevé* technique).

Fine examples of the second kind of application of red enamel can be seen on the helmet of Saint-Jean-Trolimon (Finistère)—which also bears traces of coral—and particularly the *Scheibenhalsringe*, the discs of which are decorated with enamel fixed with rivets. The more plastic enamel decorations are often engraved with additional motifs, as with the Nebringen torques of Baden-Württemberg and "Marne" (in the museum of Saint-Germain) with their radial patterns of overlaid enamel sections, and a fibula from Münsingen (tomb 63), the foot of which is decorated with enamel.

Examples of the combined use of enamel and coral are the terret rings of Waldalgesheim, the discs of Berru, and the Marne *Scheibenhalsringe*, which has three discs with enamel appliqué in excellent condition, and grooves at either end with enamel inlay. Finally, the beaked flagons of Basse Yutz are mainly decorated with coral, and the lids, as mentioned above, are decorated with *champlevé* enameling.

Celtic Enamel in the British Isles

Celtic enameling reached its peak in the British Isles, inhabited in pre-Roman times by the Celts. From the third century B.C. there is evidence of the use of enamel in Britain, first in combination with coral. Celtic enameling from this period was strictly red. Despite the Roman conquest of the islands, as late as the first century A.D. and perhaps even until the second, decorative items with high-quality Celtic-style enamel work were produced in quantity.

The bronze shield found in the Witham river (now in the British Museum) is decorated with inserts in red coral, a technique also found in Arras culture fibulae. The use of coral continued in England through to the end of La Tène III.

The bronze Battersea Shield found in the Thames bears a metal grid pattern in the form of a swastika in which the enamel was applied from the back. Likewise, the helmet found in the Thames near Waterloo Bridge and another helmet of unknown provenance are decorated with flat studs with deep grooves in the surface in which semi-molten red enamel had been applied.

Most Celtic enamelwork from Britain consists of chariot-fittings and harness-mounts, largely from deposits dating from around the mid-first century B.C., that is, during the Roman conquest. The decoration consists of the traditional Celtic motifs of spirals and S-shapes with overlapping and alternating figures (e.g., finds from Polden Hill in Somerset, and Stanton, Norfolk).

Occasional examples of yellow enamel turn up, usually on the heavier bracelets of Scottish origin, with floral motifs or red-and-yellow chequered pattern.

Celtic Enamel in Ireland

Ireland was never actually part of the Roman Empire, and Celtic enamel production continued uninterrupted. It mostly consisted of small surfaces or grooves, as in the spear butts. Worthy of note are the Somerset-type applications. On the Petrie Crown the stylized bird-eyes were originally decorated with inserts of red enamel. Irish enamelwork of this kind is generally dated to the birth of Christ, reaching a peak of perfection in the first century A.D.

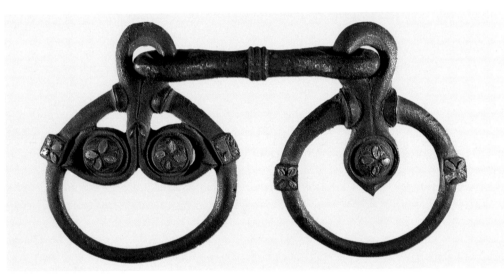

Bronze horse bit decorated with enamel from Rise (England) 1st century A.D. London, British Museum

Bronze mirror with handle decorated with enamel from Nijmegen (Netherlands) Second half 1st century A.D. Nijmegen Provinciaal Museum G.M. Kam

No enamels have yet turned up datable to the second to fourth centuries A.D., but in the Early Christian Period, which spans the fifth to the eighth century, the enamelwork became extraordinarily varied. The finds in the oldest groups include penannular brooches, hand-pins, and latchets, with decorations in red enamel partly derived from late-Roman palmette motifs, and partly from traditional Celtic curvilinear designs. A novelty that emerges is the use of millefiori technique, probably produced in Ireland itself (Garranes, county Cork). Another important object bearing enamelwork is the hanging-bowl, bronze cups with decorated escutcheons through which hooks were attached for hanging the vessels. Alongside the traditional early Celtic spirals, the hanging-bowls feature highly dynamic patterns of thin spirals with splayed ends, dubbed "developed trumpet pattern." The finest example is the large hanging-bowl from Sutton Hoo. Although most hanging-bowls come from Anglo-Saxon tombs, there is no doubt that these typically Celtic works were manufactured in western Celtic Britain or Ireland. The range of Irish enamelwork produced between the end of the seventh century B.C. and A.D. 800 is remarkable. Masterpieces include the Ardagh cup, the Tara brooch, and the Derrynaflan paten. Each of these is decorated with enamel or glass using completely novel techniques. In the glasswork, the colors range from translucent blues and opaque reds to opaque yellows. There are also enamel- or glass-filled bosses and flat fields of enamel, where each color is contained by a sliver of silver. A third variant is offered by a molded glass receptacle decorated with engraved patterns into which molten glass of different colors was poured. Unlike the earlier Irish enamelwork, the virtuoso patterns of the Early Christian period represent the zenith of Irish enamel production.

Detail of the bronze shield with red
enameling found in the Thames
at Battersea (England)
End 1st century B.C.
to early 1st century A.D.
London, British Museum

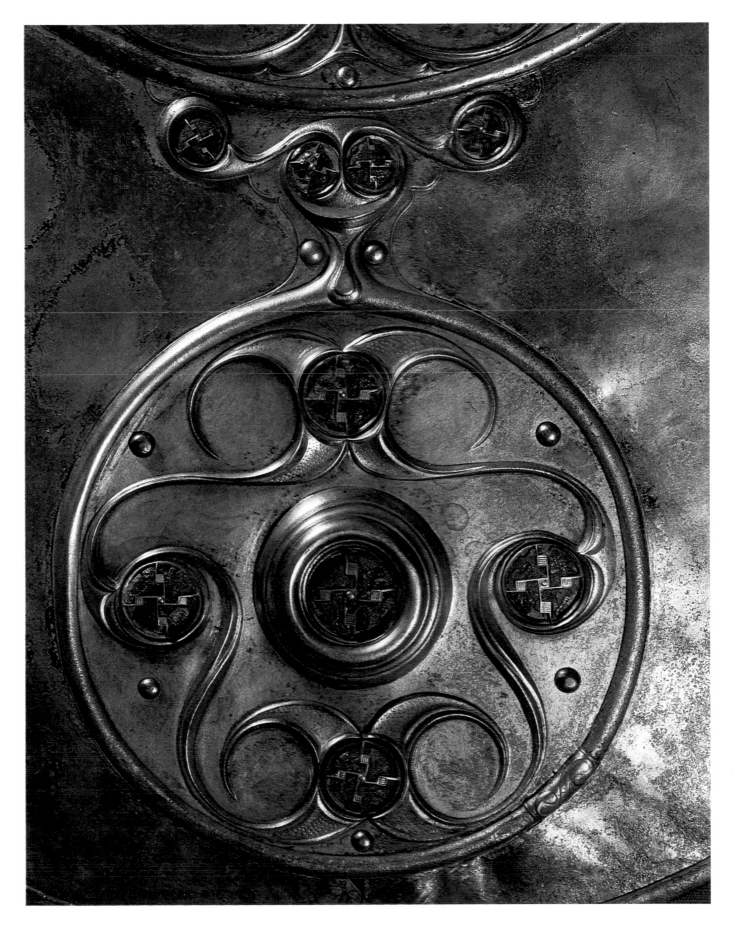

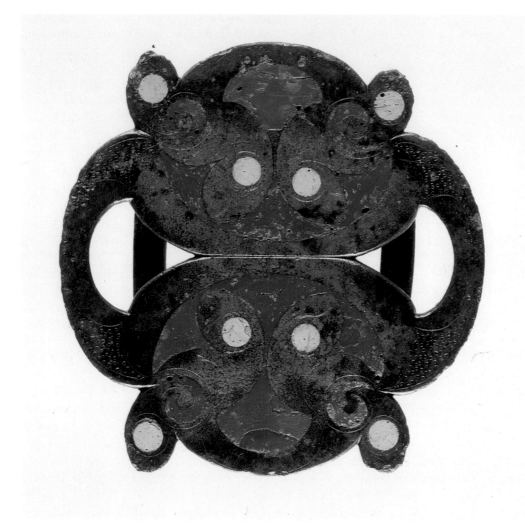

*Bronze openwork plaque
with enamel studs from Hambledon
(England)
1st century A.D.
Houston, Menil Collection*

In the late eighth to ninth centuries new enamel motifs appear. On the Moylough belt, a holy relic dating from the second half of the eighth century A.D., in addition to the grid of studs, there are elongated enameled surfaces made up of little L-shaped or T-shaped cells filled with red and yellow enamel to produce a millefiori effect. A strikingly beautiful example is this Irish type of enameling on the bucket from the Oseberg tomb whose support hooks portray two buddha-like figures decorated with an elaborate millefiori design in red and yellow enamel.

Music Archaeology and the Ancient Celts

Bronze statuette of flute-player from Százhalombatta (Hungary) 6th century B.C.

For a society which, in popular belief and historical description, seems to have been inextricably concerned with music, poetry and dance, the ancient Celts have left us scant material evidence of their skill as instrument makers and performers. Such actual objects as can be authoritatively identified as musical instruments come largely from the fringes or even from beyond the boundaries of the prehistoric Celtic world as usually defined in time or space. Only in the early centuries A.D. with the introduction—or re-introduction—of Mediterranean musical instruments with the expansion northwards of the Roman Empire does the evidence markedly improve.

It is not only the virtual absence of artifactual evidence in most areas which makes the task of reconstructing the ancient sound of music impossible. In the La Tène period from the midfifth century B.C. to the introduction of coinage, the very nature of most Celtic art, with its basically aniconic and non-narrative form, means that for much of the period under review the record is almost non-existent. That music and the dance were closely interrelated and formed a major feature of ritual behavior particularly associated with funerary rites is, however, clearly demonstrated for the central and eastern Hallstatt zone of the Early Iron Age and the contemporary cultures of northern Italy and the head of the Adriatic. For the earlier part of the Iron Age (Hallstatt C or from the beginning of the seventh century B.C.) there are two iconographic sources from this period: the decorated bronze situlae of the Venetic region and related metalwork from the eastern Hallstatt zone on the one hand, and the squat-bellied *Kegelhalsgefässe* also from the eastern Hallstatt zone as found in the rich graves of the barrow cemeteries of the Sorpon region of northwestern Hungary, Steiermark, and Slovakia on the other.

While the situlae seem to depict music and musicians as accompanying the feast, in central Europe the playing of musical instruments forms part of ceremonial processions and dancing. Of the four main classes of musical instruments shown, the lyre predominates in both zones and is usually a version with four strings as in Homer's Greece. The syrinx, or panpipes (usually shown with five tubes) is, together with the lyre, the instrument most often illustrated in situla art. Panpipes are most probably of eastern European rather than of Mediterranean origin. In the eastern Hallstatt region, at least three different types of lyre seem to be illustrated, always carried before the player in procession, or accompanying dance, while the musicians shown in the feasting scenes depicted on the situlae are usually seated. Beating reed pipes, either single or double, comparable to the Etruscan or ancient Greek *aulos*, are more commonly found in the eastern Hallstatt zone, while the warrior figure depicted with a simple up-curving horn as shown on stelae in northern Italy suggests that such horns are of Etruscan origin.

Further to the west, in south Germany and southern France, also around 700 B.C., pots decorated with groups of dancers with upraised arms, female when identifiable, have also been found; these, however, show no musical instruments. Discoveries of what have been identified as simple end-blown bone pipes have been made in Austria itself, while a single pottery globular flute comes from the cemetery at Hallstatt. As in the case of the cow's horn with carefully cut mouthpiece discovered in a layer of human feces in the Hallstatt salt mines,

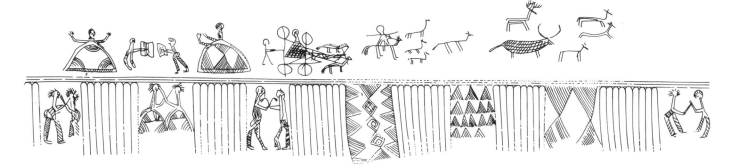

these pipes are likely to be nothing more than signal instruments. Certainly they contrast with the nine-tubed panpipes cut from sheep or goat metapoidals found in what the excavators have identified as a shaman's grave in the Montelius V (Hallstatt C) Lausitz culture inhumation cemetery of Przeczyce near Katowice in Silesia. A tiny bronze figurine of the late Hallstatt period, possibly a mount from a bronze vessel or cult model such as the wagon from Strettweg, Steiermark, was found at Százhalombatta, south of Budapest; this offers the clearest evidence we have to date of an actual central European player on the double pipes or *aulos*, something which is not otherwise to be found in the Celtic world until the coming of the Romans. Like all central and northern European instrumentalists, when their sex can be determined, the Hungarian figurine is clearly male. But none of these examples can be regarded as part of the mainstream Celtic or proto-Celtic tradition. Indeed it has been suggested that the Celts were so unmusical that the absence of actual musical instruments from much of the archaeological record of the later Iron Age is due to their expansion eastwards during the La Tène period.

However this may be, it is clear that the late Hallstatt chieftains of southern Germany imported from the Mediterranean world not only portable and potable luxury goods but also musical elements associated with the feast. One obvious example is the Eberdingen-Hochdorf, Kr. Ludwigsburg, bronze couch with its scenes of confronted sword-dancers and wheeled vehicles, which reflect the ritual scenes on the indigenous eastern Hallstatt pottery. The Hochdorf couch, like other (wooden) examples from rich Hallstatt graves, was clearly made north of the Alps but follows the pattern of Etruscan furniture. From the nearby robbed princely grave at the Grafenbühl, below the Hohenasperg, comes an actual Etruscan ceremonial rattle of iron with bronze jangle plates.

From the end of the Hallstatt period in the fifth century B.C. until the last century B.C., the evidence for musical instruments virtually vanishes. It certainly is remarkable that, despite the considerable faunal remains obtained in recent years from later European Iron Age settlement sites and cemeteries, there is practically no example of that simplest and most widely found folk instrument of the early historical and medieval periods, the end-blown

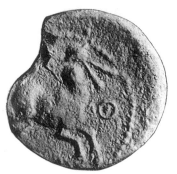

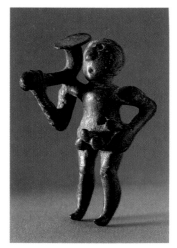

Reverse of bronze coin of Tasciovano king of the Catuvellauni showing a centaur playing a double flute First half 1st century A.D. Paris, Bibliothèque Nationale Cabinet des Médailles

Bronze statuette known as "the trumpet player" from the Stradonice oppidum (Bohemia) 1st century B.c. Prague, Národní Muzeum

Bone flute from Seaty Hill Malham Moor (England) 3rd-2nd century B.C. Leeds, City Museum

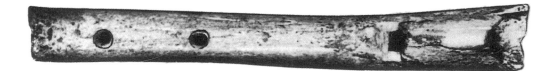

bone pipe with three or more finger-holes. Such evidence as there is will be reviewed in the following order: pipes, horns and plucked stringed instruments.

From Britain there are two fragmentary bone pipes from the Glastonbury "Lake village," each with three apparent finger-holes; from the central burial of thirteen secondary Iron Age inhumations added to an early Bronze Age barrow mound at Seaty Hill on Malham Moor in western Yorkshire comes a third pipe made from a sheep's tibia with two finger-holes and a thumb-hole. The latter shares with the much earlier Przeczyce panpipes an apparent pentatonic tuning, generally considered to be basic to the musical traditions of much of central and eastern Europe. For the double- or single-reed pipe with the exception of Iberia and the famous painted pots from San Miguel de Liria, which are not earlier than the third century B.C., there is the sole evidence of a British bronze coin of Tasciovanus showing a most un-Celtic centaur wearing, however, a native Celtic helmet. It is of course the bagpipes which are the member of the beating reed pipe family most generally associated with the latter-day Celts. Like all reed pipes in northern and western Europe, the evolution of bagpipes must

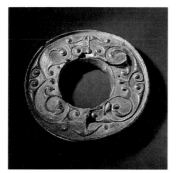

Bell of bronze trumpet
from Loughnashade (Ireland)
1st century B.C.
Dublin, National Museum of Ireland

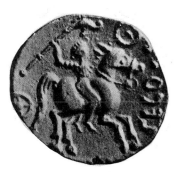

Reverse of gold coin of Tasciovano
king of the Catuvellauni showing
a horseman holding a carnyx
in his right hand
First half 1st century A.D.
London, British Museum

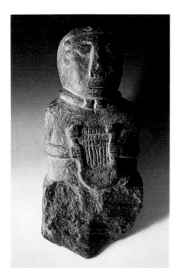

Stone statuette of a deity
from Paule (Côtes-d'Armor)
1st century B.C.
Saint-Brieuc, Nouveau Musée

be associated with an origin and spread from the Balkans and the eastern Mediterranean, but there is no prehistoric and archaeological evidence which would indicate their use in the west before the Middle Ages.

Given the warlike reputation of the Celts, it is perhaps not surprising that Iron Age music archaeology is well-provided with evidence for the Celtic trumpet, the instrument described by such contemporary writers as Polybius and Diodorus Siculus. Nowadays it is usually referred to as a *carnyx* after the (very late) Greek name for an animal-headed horn or trumpet. Except on coinage, however, most of the instruments found or represented come not from the heartlands of La Tène culture, but from the fringes of the Celtic world. From the Middle La Tène period there are pictures of animal-headed horns from the second century B.C. frieze of the sanctuary of Athena at Pergamum which commemorates the victory of Attalus I over the Galatian Celts in what is now Turkey in 240 B.C.; this was probably executed by Attalus's son Eumenes II sometime before 181 B.C. In the west there are Roman depictions of the Celtic war trumpet amongst the native booty shown on the triumphal arch at Orange which is dated to the time of the Emperor Tiberius. The great silver-gilt cauldron, found at Gundestrup in Jutland and dating probably from the very late second century B.C. is not of Celtic workmanship, but in the Thraco-Gaetic style of eastern Europe; it depicts on one of its inner plates what are obviously intended to be contemporary Celtic war-horn players. The bells of the horns are shown decorated in the form of the head of a boar, that most common of all Celtic animals associated with war, death and the feast.

Celtic coinage provides us with representations not only of the simple signal trumpet, most likely, as with the earlier actual example from Hallstatt, made of cattle horn, but also of the vertically held and played *carnyx*. Continental representations always show the horn-player on foot, while, in contrasting fashion, British coins represent the *carnyx* as being carried by a man on horseback. Fragments of at least two such war trumpets are known to have been found in the British Isles. That from Tattershall Ferry on the River Witham in Lincolnshire was unfortunately destroyed by its scientifically-minded owner, Sir Joseph Banks, in an over-enthusiastic attempt early in the nineteenth century to analyze the metal of which it was made. The splendid surviving head of a *carnyx* from Deskford in northeastern Scotland is in the form of a boar; when originally found in 1874 in peat the head contained not only the still surviving palate of the boar, made in bronze, but also "a wooden tongue, movable by a spring." In continental Europe, the bell of a *carnyx* has been identified among material from a Late La Tène metal hoard presumed to have been buried at Dürnau in the region of the Federsee at the time of the uprising of Ariovistus in the mid-first century. A complete bronze horn was dredged from the River Nogat in Poland in the vicinity of Malbork on the ancient "amber road" once more from outside the confines of the strictly Celtic world. This horn, though it is best paralleled by the Roman *lituus*, such as that found in the Rhine near Düsseldorf, may possibly be of Late La Tène date. Undoubtedly Celtic is the tiny first-century male figurine in bronze from the Bohemian *oppidum* site of Hradiště near Stradonice; the naked warrior—for such he must be—brandishes a simple, straight-stocked horn with an expanded mouth. Of somewhat earlier date must be the duck-headed *carnyx* with birds' wings recently identified by Raffaele de Marinis from the bronze fragments contained in the Middle La Tène grave of Castiglione delle Stiviere in the province of Mantua, the ancient territory of the Cenomani.

The British Isles also produce evidence of a different type of horn with a curved rather than straight stock, representing perhaps a local development from the famous Late Bronze Age horns of Ireland. Like the contemporary and certainly musically more sophisticated Scandinavian *lurer*, these seem likely to be metal versions of wind instruments earlier made of animal horn. Finest of the Irish Iron Age horns is that from Loughnashade, county Antrim, reportedly found in 1798 with three other horns which have since been lost; on stylistic grounds it dates probably to the second century. An intact two-piece horn from Ardbrin, county Down, has a simple rolled-over mouthpiece; like its putative Irish Bronze Age ances-

Detail of a silver plaque
from the Gundestrup cauldron
(Denmark) with carnyx-players
First half 1st century B.C.
Copenhagen, Nationalmuseet

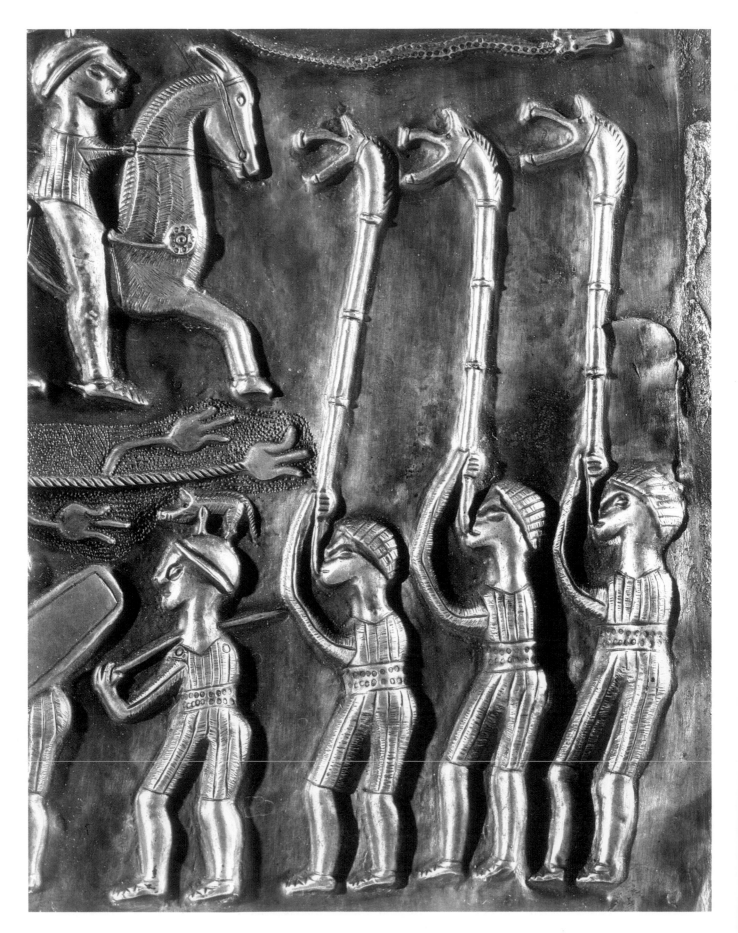

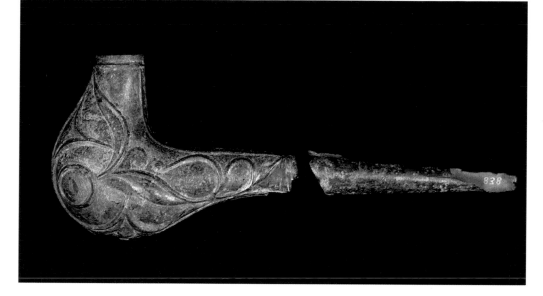

Bronze object sometimes interpreted as being a carnyx from Castiglione delle Stiviere (Italy)
3rd century B.C.
Mantua
Galleria e Museo di Palazzo Ducale

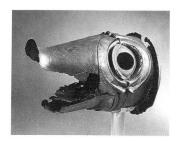

Bell of bronze carnyx in the form of a boar's head from Deskford (Scotland)
Mid-1st century A.D.
Edinburgh
Royal Museum of Scotland

tors, it is capable of sounding only a very restricted range of notes. Like the fragment of another bronze horn from the lake deposit of Llyn Cerrig Bach on the Isle of Anglesey, the ancient druid stronghold of Mona, the Irish horns cannot be considered as evidence of a highly developed musical system. Both from our contemporary written sources and the surviving instruments themselves, it is clear that Celtic horns, like their classical counterparts, were largely employed, not to produce music as such, but rather to add to the stirring cacophony of battle and high ritual.

The importance for music archaeology of Celtic coinage has been cited several times already in this short study. One must of course heed the warning of the late Derek Allen, musician as well as numismatist, that with representations on coins, as in other areas of the Celtic visual arts, it is never possible to know where realism ends and symbolic association begins. Nevertheless, lyres and lyre-like motifs are frequently represented on Celtic coins from Britain to Germany. Unlike the earlier stringed instruments of the eastern Celtic zone, rather than rectilinear, all late Celtic lyres are shown as basically U- or V-shaped in the manner of the *kithara* of the classical world. Certain scenes such as that of the seated Apollo with a lyre on a (British) coin of Cunobelin are obviously based on non-Celtic models, in this case the figure of Mercury on Roman *denarii*. There is in fact little textual or iconographic evidence of an instrument-playing Celtic deity; only in North Britain in the region of Hadrian's Wall does one find the local god, Maponus, the "divine youth" associated with "Apollo the lyre player." On the other hand, there seems absolutely no reason to doubt that lyres such as those on coins of the Redones of Brittany are based on first-hand knowledge of such instruments.

This supposition is strengthened by the recent remarkable find from northern France of a statuette from a Late La Tène farming settlement at Saint-Symphorien-en-Paule, Côtes d'Armor, which probably dates from the time of the Roman conquest of Gaul. The figure certainly appears to be that of a Celtic Apollo, wearing a torque with large buffer terminals and clasping before him a seven-stringed lyre; this is the clearest extant confirmation so far known of a native lyre. In the figure from Saint-Symphorien is visual proof of those Gaulish "lyric poets called *bardoi*" singing to the accompaniment of a stringed instrument of whom Diodorus Siculus wrote in the first century B.C. There are other hints of the existence of a late prehistoric Celtic version of the lyre. A possible lyre wrest-plank dated to the third century B.C. was found below the rampart of the hillfort of Dinorben in north Wales, and a second example in a first or second century A.D. midden at Dùn an Fheurain, just south of Oban in western Scotland. To these one may add the frequent references to stringed in-

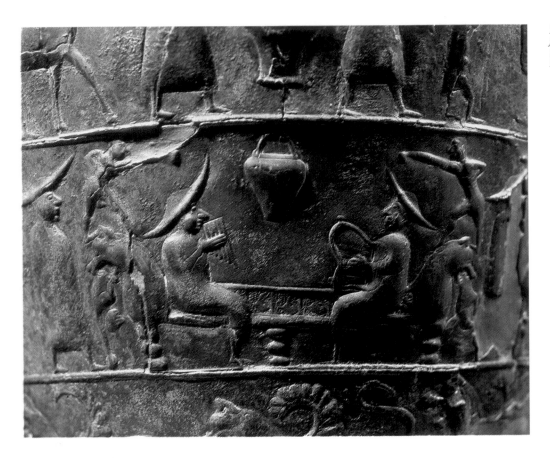

Detail of the bronze situla
from the Certosa di Bologna (Italy)
6th century B.C.
Bologna, Museo Civico Archeologico

struments in the Irish early medieval texts such as the Ulster Cycle. These may reflect the customs and the artifacts of insular Celts of at least as early as the first century B.C. Here are the clearest indications we have of the long survival of certain sophisticated musical instruments in the traditions of Celtic Europe, instruments whose earliest origins may lie in the Balkans or even further east. In contrast, that other plucked musical instrument par excellence of the Celtic Far West, the asymmetric harp, is neither described nor illustrated in contemporary sources before the ninth century A.D.

As to the melodies played, however, or the songs sung by the ancient Celts, the evidence still remains mute.

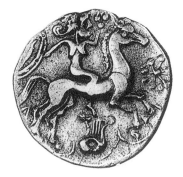

Reverse of gold coin minted
by the Redones 2nd century B.C.
Paris, Bibliothèque Nationale
Cabinet des Médailles

Celtic Heroic Tradition

The heroic ethos of the Celts, as of many other peoples, is neatly epitomized in the words of the Irish hero Cú Chulainn: "Provided I am famous, I do not care whether I live but a single day in this world." In such a society, in which life—and individual status—was dominated by an extremely sensitive regard for personal honor, it was essential that one should earn the respect of one's peers and, especially, of those poets, seers and learned men whose responsibility it was to shape and to interpret the mythology, the laws and the historical traditions of the tribal community. For the hero, as for the king, posthumous fame was the hallmark of achievement, and for the hero, if not always for the king, the price of fame was extraordinary, and sometimes reckless and extravagant, prowess and valor. Where the king of Indo-European origins acted as a surrogate for society and its mediator with the supernatural world, the essential role of the hero par excellence was socially ambivalent, and, as typified by Cú Chulainn, he characteristically stands alone; by the same token, it is significant that in Irish tradition whereas the great king fights battles, the great hero fights single combats. The emphasis is on individuality, however, rather than on personality, and the hero himself remains very much a paradigm of heroic behavior. He belongs to a warrior aristocracy which engages in warfare for glory rather than for territorial conquest, though plunder provides an adequate practical motif for what they enjoy doing anyway.

It is a fact of cultural history that in pre-modern societies in various parts of the world such warrior aristocracies, whether themselves historical or mythico-historical, have often provided a generative core for complexes or cycles of epic narrative. Such narrative was evidently prolific among all the Celtic peoples, but it is one of the accidents of history and of cultural survival that it is only from the very periphery of the great Celtic diaspora, from Ireland, and from a period long after the Celtic languages of the continent had declined to the point of extinction, that a representative corpus of this narrative has been transmitted in writing. From mainland Europe nothing of this tradition has survived in written form, though there are many indications that it once flourished orally. The plastic representations of Celtic deities and their very names presuppose a substantial oral tradition, heroic as well as mythological, and this is borne out by later medieval tales attached to their insular namesakes and congeners. Marie-Louise Sjoestedt once observed that several figurative motifs in Irish literature relating to the hero Cú Chulainn in battle appear to have visual analogues in the imagery of some Gaulish coins, though her suggestion that the former derive from the latter is untenable; it is much more likely that both derive from familiar heroic motifs in common Celtic oral tradition. There are elements in the Celtic commentaries of Posidonius and other classical authors which smack of heroic storytelling rather than of anthropological observation, and one suspects from some of the classical accounts of the Celtic migrations—the incursion of Brennus against Delphi in the third century B.C. for example—that some of these had already become the stuff of heroic story.

Britain and Wales

One inevitable consequence of extended migration in ancient times was that ideology and the verbal traditions which gave it expression had to adapt themselves to new physical environments and to the contiguity of existing inhabitants possessing their own languages and cultures. Thus even where many of the essential social institutions and mythological and heroic paradigms remained largely unchanged, they had gradually to anchor themselves in a new landscape and readjust to reflect changed relations with neighboring peoples, and, in the process, they tended to generate new nomenclatures even while the substance stayed much the same. The hero-tales of those Celts who came to the island of Britain between the fifth century B.C. and the first century A.D. have perished for want of a written record and can only be glimpsed dimly and indirectly through the much later narratives of Middle Welsh. The name of Cassivelaunus, king of the Catuvellauni, he who in 54 B.C. led the resistance to Caesar's invasion of Britain, survives in Middle Welsh literature as Caswallawn son of Beli who had dominion over Britain and was remembered as its defender against the Romans,

and it has been suggested that the popularity of the name Caradawg among early Welsh princely families may have been due to the legendary resonance of the deeds of Caratacus, also of the Catuvellauni, who led the Britons energetically, if unsuccessfully, against Aulus Plautius's campaign of conquest in A.D. 43; but if these and others like them once had their own hero-tales, it is clear that they were eventually displaced by the growing fame of a still more mythogenic, if historically less documented, protector of the island of Britain: King Arthur with his company of heroes.

The major difficulty in tracing the evolution of the heroic tradition in Britain is that written narrative prose was a late development (and among the Insular Celts prose was the normal medium of narrative). The earliest of the extant Welsh tales known as the *Mabinogi* cannot have been composed in written form much before the second half of the eleventh century, and most are rather later, later in fact than Geoffrey of Monmouth's *History of the Kings of Britain* which was to launch Arthur on a dazzling conquest of Europe that far outstripped anything he may have achieved in his lifetime c. A.D. 500. But it is clear from the story of *Culhwch and Olwen*, which antedates Geoffrey, that the legend of Arthur had already generated a substantial body of oral narrative in Welsh by the eleventh century, and it would appear from other scattered evidence that the process of accretion and elaboration had already begun before the end of the sixth century. In the course of the intervening centuries the rising popularity of the Arthurian legend attracted to it originally independent heroes and stories, so that by the eleventh century it already constituted a comprehensive and varied cycle of heroic storytelling that only required the learned pretension of Geoffrey and the artistic and courtly sophistication of Chrétien de Troyes to turn it into the richly symbolic fabric of Arthurian romance.

This transition from hero-tale to romance marks an important change of temper in Welsh narrative. Three of the eleven tales of the *Mabinogi* have close affinities to romances of Chrétien, while the group known as the Four Branches of the *Mabinogi* are concerned with the ancient British gods rather than with heroes *pur sang*, and, whereas all the tales of the series embody motifs drawn from heroic tradition, only *Culhwch and Olwen* reflects something of the old heroic ethos, and even there it is retailed with a strong admixture of irony and caricature. Written prose narrative begins too late in Welsh to preserve the heroic spirit intact, and its most authentic reflex is to be sought rather in the great body of medieval verse, particularly in two early series of poems attributed to the sixth-century poets Taliesin and Aneirin. Both are preoccupied with kings and warriors of northern Britain who fought fiercely to repel the English advance in the second half of the sixth century, and it is clear that this struggle for Celtic Britain was already even then assuming something of the character of a heroic age. The genuinely early poems ascribed to Taliesin are dominated by the ancient spirit of ritual eulogy, while Aneirin's composition, *The Gododdin*, comprises a long series of separate lyric poems (not all of which can be of his time) commemorating individual heroes who went forth three hundred strong on a glorious if hopeless expedition against the English from which only one (or, in a variant version, three) survived. The mood of these poems and their whole imagery are markedly heroic, yet they are, in the manner of Celtic verse, almost wholly devoid of narrative content. For that one must turn to early Irish literature.

Ireland

For a variety of reasons the written redaction of traditional vernacular literature began and flourished remarkable early in Ireland: the writing of verse goes back as far as the sixth century, and the writing of narrative prose seems to have been well established by the end of the seventh. Between then and the end of the twelfth century a vigorous scribal tradition ensured the survival of a substantial body of secular narrative. Most of it is in some sense heroic, just as most of it is in some sense mythological. Heroes *qua* heroes are two a penny in the early literature, particularly if we include all the legendary kings who share some of the noteworthy characteristics of the conventional hero. Ever since it was first demonstrated in

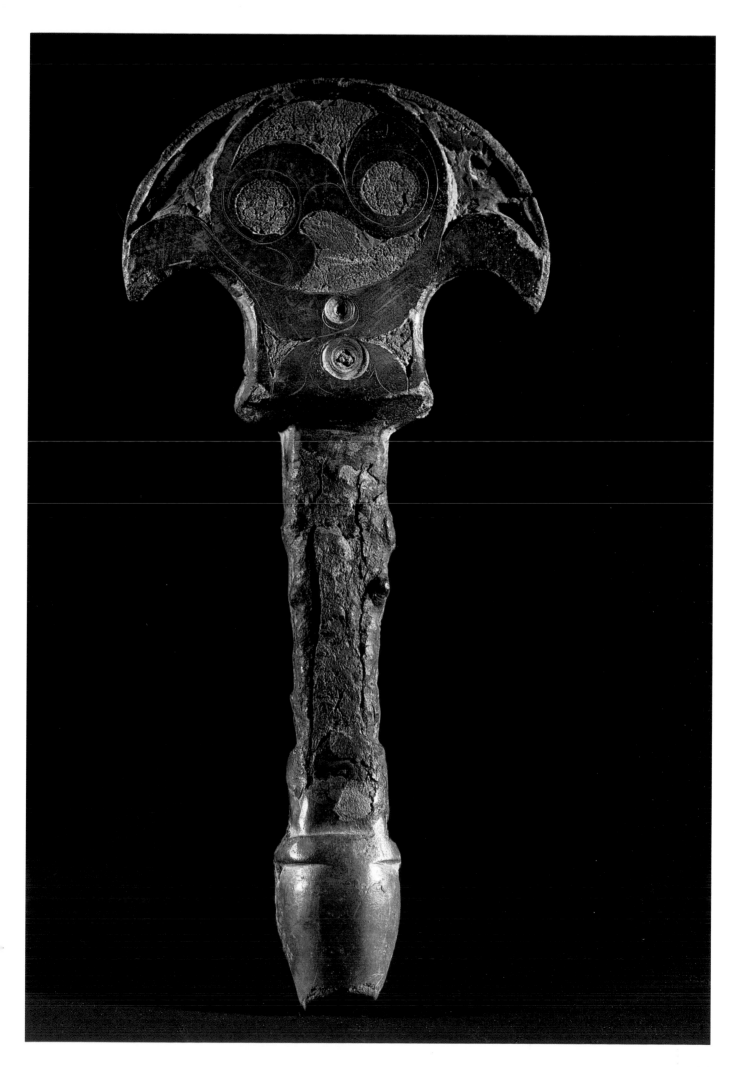

the nineteenth century that a special schematic life-cycle underlies the legends of various Indo-European heroes (and indeed others beyond the Indo-European domain), commentators have presented versions of this biographical paradigm which vary mainly in the degree of detail which they include. Not surprisingly, the begetting and birth, death and marriage of the hero are events fraught with special significance and are typically attended by extraordinary and even preternatural circumstance: thus his mother may be a virgin, his father a god, or he may be conceived in incest. Further, one of the presages of his future greatness is that his life is threatened in childhood and that he must be brought up in a place hidden away from the eyes of his enemies. When in time he comes to assert himself publicly, his great feat is to destroy a dragon or some other monster, which may be the prelude to his winning a desirable maiden. As someone larger than life but less than divine, he is frequently in contact with the supernatural and his most audacious expedition is that which brings him, sometimes more than once, into the other- or the underworld. These and other relevant elements were so familiar in Irish literature that they came to form the basis for a native taxonomy of traditional narrative, so that tales were classified under such thematic headings as *comperta* (tales of conception and birth), *echtrai* (expeditions or otherworld journeys), *tochmharca* (wooings), *oirgne* (raids, slayings), *catha* (battles), *aidhedha* (heroic deaths).

The Hero King

As it is represented by modern commentators the biographic schema of the hero does not normally distinguish between the hero *stricto sensu* and the heroic king, for these share most if not all the constituent elements of the paradigm. However, to read the literature is to see that kings and heroes are distinguished by essential disparities of emphases. In one important respect there is a built-in contrast between their roles: whereas the hero's status is wholly bound up with his martial prowess, the primary responsibility of the early Irish king was to exercise wise leadership and good judgment, and thereby to maintain his tribal kingdom in peace, security and prosperity. Consequently, while the king tales embody the traditional heroic values, these are not their main preoccupation. They are concerned rather with the explanation and validation of existing socio-political realities: the status and function of the king himself, the origins of tribes and dynasties, battles of historic moment, the deeds and judgments of famous rulers, and so on. The sacral kingship was both the pivot and the foundation of the social order, and the king its personification; if his conduct or even his person were blemished in any way, this would be visited on his kingdom, affecting its integrity and prosperity. As the arbiter and instrument of justice his decisions must be fair and flawless. Thus the legendary Cormac mac Airt is pictured as a paragon of kingship and as an Irish Solomon: his accession came about when he proposed a just judgment after his predecessor had delivered an unjust one.

Conaire Mór is likewise an exemplary king whose reign brings peace and well-being to the land—until he pronounces an improper judgment out of a misplaced tenderness towards his three marauding foster-brothers. Immediately there is set in motion a train of events which lead inexorably to his death in a welter of violence. Like great heroes, great kings are subject to mystic *geissi* or taboos, and in *Toghail bruidhne Da Derga* "The destruction of Da Derga's hostel," a story drawn upon most subtly by James Joyce in "The Dead," the storyteller has used this as a device to plot out the ominous route to Conaire's destruction: each time Conaire is brought unavoidably to violate another of his *geissi* we are aware that he draws ever nearer to the tragic dissolution of his glorious reign.

The Ulster Cycle

The king tales have a clear social orientation, centered as they are on the paramount institution in Irish society, the sacral kingship, whose incumbent stands as the focus of a vast and complex web of myth and ritual and customary law, which, even at their most formal and didactic, lend these tales a rich symbolic and connotational value. On the other hand, when

we turn to the quintessential heroes of tradition we find that they are bound less by social responsibility than by fraternal convention; they appear to act autonomously, and sometimes arbitrarily, and even while they are the protégés of their king and the defenders of his kingdom they may, at the very climax of their heroic *élan*, display a dangerous ambivalence and inability to discriminate between friend and foe. Such exemplary heroes are associated with all periods of Irish legendary "history," but the concept of a heroic age as such for some reason crystallized around the kingdom of the *Ulaidh* or men of Ulster who in ancient times dominated the whole north of the country. Their capital was Emain Macha, a hillfort a couple of miles from the later ecclesiastical capital of Armagh. Their king during the high noon of their ascendancy was Conchobhor mac Nessa, and his entourage comprised a company of aristocratic warriors representing the several types who tend to recur wherever the heroic scenario is realized: Cú Chulainn, the Irish Achilles and youthful non-pareil among champions; Ferghus mac Roich and Conall Cernach, both mature experienced warriors; Sencha mac Ailella, wise counselor and arbiter of disputes; Bricriu Nemhthenga "Poison-tongue," Sencha's counterpoise, who exacerbates enmities and sows dissension between friends; and many others who are less preeminent. The events in which they participate are on the whole treated realistically: they may have little enough to do with actual history, but they take place in a clearly defined terrain with firm political boundaries, innocent of romanticism, and while the gods and other magic forces have a part to play in them, generally it is restricted to particular times and to particular precincts; for the rest the men of Ulster are free and independent agents relying upon their own essentially human, if extraordinary, resources.

It is almost axiomatic of heroic cycles that they reflect political situations that have been outstripped by history. In the case of the Ulaidh we know that their dominance was broken and their capital at Emain Macha destroyed probably in the early or mid-fifth century, so that the basis of the extant tales must be referred to some indeterminate time before that. The conquerors of the Ulaidh were the Uí Néill, the descendants of Niall of the Nine Hostages, who created a powerful dynasty which controlled most of the northern half of Ireland from the fifth century onward. The Uí Néill were themselves originally part of the Connachta, the descendants of Conn of the Hundred Battles, who held sway over most of the midland area when the Ulaidh dominated the north and who held possession of Tara, the focus of sacral kingship for all Ireland. The Connachta gave their name to the western province and in most of the tales of the Ulster Cycle the Ulstermen's principal enemies are Ailill and Medhbh, king and queen of that province, who had their court at Cruachain in the present county Roscommon.

No doubt most of the main characters of the cycle are mythic in origin, but none still bears the marks of its origin so clearly as does the formidable Medhbh, a mixture of vamp and virago, who brazenly cuckolds her husband with Ferghus mac Roich, the Ulster hero whose prodigious virility ranks him among the superhuman. She passes many partners through her hands, which is only as it should be considering that she is in fact the goddess of the land and its sovereignty, whose sacred function it is to mate with those who merit kingship and cast aside those who do not. She has a dominant role in the great central story of the Ulster cycle, *Táin Bó Cuailnge* (The Cattle-raid of Cuailnge), and, if we were to believe the introduction to the later of the two main recensions in which it survives, it was a fit of peevish pride on her part that set off the whole train of warlike deeds which make up the tale.

The central theme is simple: Medhbh and Ailill lead an expedition into the province of Ulster to capture the famous bull called Donn Cuailnge "The Brown One of Cuailnge." What happens afterwards is conditioned by the strange circumstance that all the Ulstermen with the exception of Cú Chulainn, are afflicted by a mysterious debility which leaves them as weak as women in childbirth (there are two independent stories which explain this disability through the curse of an outraged goddess). In consequence the whole responsibility for defending the province falls upon the youthful Cú Chulainn, and a large part of the tale is a serial account of his devastating attacks on the enemies' encampment and of the single com-

Decorated bronze scabbard
from Bugthorpe (England)
End 1st century B.C.
to early 1st century A.D.
London, British Museum

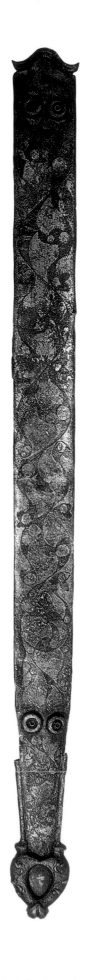

bats by which he hinders their progress. One of the most memorable of these episodes, though the style is a little florid, describes Cú Chulainn's encounter with Fer Diadh, to whom he was bound by old ties of friendship dating from the days of their common tutelage with the woman Scáthach, a Celtic Amazon who ran a kind of Otherworld finishing school for young heroes. They are thus virtual foster-brothers, than which there is no closer bond in Irish society, but both are constrained by circumstance and convention to engage in a combat which they abhor. This is the kind of situation in which the Irish hero finds himself trapped time after time: he has a choice between two conflicting loyalties and whichever he chooses brings upon him inevitable dishonor or tragedy. It is part of the perennial dilemma of the supreme hero, caught in the insoluble contradictions of his ambiguous status, neither divine nor merely human, within the tribe nor yet wholly of it, member of a heroic confraternity who characteristically stands alone.

Cú Chulainn's Initiation

The individuality of the ideal hero emerges clearly in the section of the *Táin* devoted to Cú Chulainn's *macghnímhartha* or "boyhood deeds," and it may be worth—as an illustration of the large corpus of Irish saga—devoting some space to a summary account of them. Linguistically this is not part of the oldest stratum of the text—it may belong to the ninth century—but its content is unquestionably archaic. Essentially it is an account of the young Cú Chulainn's initiation (though obviously it is not described as such) to the status of hero. It tells how he left his mother's protection, made his abrupt entry into the royal court at Emain Macha, took up arms and performed his first warrior exploit beyond the provincial border. Whoever wrote the "Boyhood Deeds" as we have them did so as a man of literature, not as a didactic recorder of ritual procedures, and the same can probably be said of most of the accounts of initiation found in other early literatures. Specialist descriptions would have run counter to the emphasis on ritual mystery and secrecy, and it has therefore been assumed that when a poet or storyteller recounts events belonging to the initiatory complex, as in the case of the Greek Achilles or the Indic Indra, he is in fact drawing upon elements of communal ritual and ascribing them specifically to the *res gestae* of a given hero. The inherent risk of distortion which this entails is heightened in the Irish instance by the fact that it was written in a monastic scriptorium long after the Christianization of the country at large. On the other hand, one must have regard to the retentiveness of elitist oral learning such as was maintained in Ireland by the specialist class of the Irish *filidh* or poet seers, in addition to which, if we compare the "Boyhood Deeds" with the documentation which has been accumulated by modern ethnologists on initiation in contemporary or near-contemporary societies, there can be little doubt that the Irish narrative about Cú Chulainn is a genuine, if fictionalized, reflex of a Celtic ritual.

It tells how the young boy left his home in southeast Ulster to make his way to King Conchobhor's court at Emain Macha, where, he had heard, there was a company of student or novice heroes.

When he arrives there, he finds the boys on the playing field and promptly joins them, unaware of the quasi-legal conventions to be observed when a stranger makes his entry. The others, three fifties in number, attack him and he routs and manhandles them singlehandedly. As Marie-Louise Sjoestedt has remarked, "It seems to be the rule for a great hero to enter always by violence, even into his own social group, and that, before becoming a member of society, he must establish himself against it in disregard of its customs and even of the royal authority."

The next stage in his initiation is his taking of a new name; hitherto he was called Sétantae. He goes to a feast at the house of Caulann the Smith, is attacked by his ferocious guardhound (a common mythic figure this for a valiant champion), and casually slays it without interrupting his ball game. When Caulann complains that his property will now be left without protection, Cú Chulainn undertakes to replace it until another whelp of the same

litter is ready to do so. At which appropriate point Cathbadh the Druid solemnly names him "the Hound of Culann," that is Cú Chulainn.

Subsequently he overhears Cathbadh declare that that particular day will be of good omen for those taking up arms and that if a warrior were to do so, his name for deeds of valor would be known throughout Ireland and his fame would last forever. With King Conchobor's permission he tests the spare chariots and sets of arms in Emain Macha and smashes them all, so that finally Conchobor has to give him his own. He goes off to the southern boundary of Ulster, obviously seeking trouble, and on the way his charioteer explains to him the names of some of the prominent features of the landscape (this no doubt representing the initiand's instruction in tribal history). Hearing of three fearsome brothers, the sons of Nechta Scéne, who are given a wide berth by other experienced warriors, Cú Chulainn deliberately provokes them and beheads them.

As Georges Dumézil has shown, this deceptively short episode is evidently a Celtic reflex of an old Indo-European initiatory myth of the hero's victory over a group of three adversaries or a single, three-headed monster, and probably cognate with the defeat of the three Curiatii by Horatius (as told by Livy) and of the terrible three-headed son of Tvastar by Trita Aptya in Indic tradition. When he approaches Emain with his battle fury unabated he turns the left side of his chariot towards it—a familiar token of hostility—and, in order to deflect his irresistible anger, they adopt a procedure which occurs in other tales of the Ulster Cycle: Mughain, Conchobor's queen, and her womenfolk go out from the fort naked to meet Cú Chulainn, and when he lowers his eyes on seeing them he is seized by other warriors and immersed in three vats of cold water, one after the other, until his battle ardor is subdued. Here again we seem to have a very old motif, for which analogues have been proposed from initiatory texts in other traditions. Finally, Mughain clothes the boy-hero, now restored to normality, in a blue mantle and he takes his rightful place at King Conchobor's knee.

The motif of the hero's boiling battle-fury is well attested in other parts of the Indo-European area, and beyond, and is almost commonplace in early Irish. Some of the instances seem grotesque or humorous, as mythic or heroic hyperbole often does, but the underlying concept is essential to Irish heroic tradition, and a number of the important terms for the champion and his attributes are etymologically connected with the central notion of heat, the heat generated by his warlike fury. It is often, but not always, connected with the idea of extreme physical distortion, and the medieval redactors of *Táin Bó Cuailnge* and other Ulster tales exploited to the full the possibilities for extravagant description that this opened up to them. The motif has deep and far-ranging roots, however, and Dumézil has discerned analogous representatives, like the Scandinavian Berserkir, in several areas of Indo-European heritage. What seems to have happened in Irish literature is that this twin feature of fury and physical distortion which characterized Indo-European warrior bands or fraternities, *Männerbunde*, came to be connected especially with individual heroes and above all with the incomparable Cú Chulainn.

Táin Bó Cuailnge is only one, albeit the longest and most famous, of all the tales comprised in the Ulster Cycle, but it is the most comprehensive embodiment within a single tale of the classic heroic environment, and for that reason our brief survey of it may be taken as representative of the rest of the cycle. It was, of course, redacted in monastic scriptoria, with all the possibility of change which that involves, but the oral tales from which the written text derives continued much of the heroic tradition that was current before the coming of Christianity, and it is this which explains the many archaic features in the content and style of the extant narrative. For example, the emphasis among the continental Celts on taking the heads of defeated opponents as trophies is amply paralleled in the Irish tales. So is the Gaulish use of the chariot in warfare: it is the norm in the Ulster Cycle, and this despite the fact that chariot burials as found on the Continent are as yet unknown in Ireland.

Fionn and Arthur

There is another warrior cycle in Irish which is perhaps less relevant to our immediate purpose, but which, through its British cognate, had a profound influence on late medieval European literature and thought. Early Irish literature mentions several fraternities of free-lancing warrior bands (*fiana*, sing. *fian*) who are hunters as well as fighters and whose activities cut across tribal boundaries. One of them, led by the legendary Finn mac Cumaill, overshadowed the others and gradually came to be known simply as "the *fian*." Finn himself was probably a deity originally, and in all the recorded traditions of him he appears consistently as the adversary and conqueror of malevolent otherworldly beings, a mythic paradigm that was also easily construed in terms of defending Ireland against historical invaders from overseas, in particular the Vikings. His cycle was always more popular in character and less integrated than the Ulster cycle and, though it is attested as early as the seventh century, it was not actually recorded in volume until the eleventh and twelfth centuries.

Much of it has a lyric and romantic cast which sets it apart from the Ulster tales and seems to reflect an old deep-seated duality that runs throughout the whole of Celtic narrative literature. In contrast to the heroes of the Ulster Cycle who act in close relation to a clearly delimited tribal kingdom or province, the *fian* is a rootless fraternity of men who have severed their tribal affiliations and given themselves up to the hazardous freedom of the great no man's land that lies beyond the borders of organized society. They roam, phenomenally fleet of foot, throughout the untamed lands of Ireland and Gaelic Scotland fighting and hunting and trysting. They are in continuous and close association with nature, animate and inanimate, and their legends are bound up with the nature lyric almost from the time it appears as a clearly defined genre in Irish literature. In moving beyond the confines of settled society they opt for an environment which mediates the secular and the supernatural worlds and which is marked by constant mobility and ontological fluidity of categories.

This whole corpus of story and poem has many striking analogies with the British cycle of King Arthur, especially when account is taken of its very different transmission and evolution, and one is more or less compelled to the conclusion that the legends of Finn and Arthur both derive from a common insular Celtic tradition of a fraternity of hunter-warriors led by a formidable chief who protected the realm against destructive incursions from abroad (primarily from the Otherworld) and who, in Britain, was eventually identified with the historical Arthur to become the legendary embodiment of British resistance to the Anglo-Saxon invasions. As the late A.G. Van Hamel once commented, the "essential identity of Fenian [i.e., pertaining to Finn and the *fian*] and Arthurian shows that the religion of the land, and its expression in the form of paradigmatic hero-tales, continues a deeply-rooted Celtic tradition."

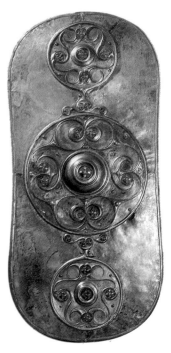

Bronze shield with enamel decoration found in the Thames at Battersea (England) End 1st century B.C. to early 1st century A.D. London, British Museum

A large body of legal material has survived among the written records of the Insular Celts. This provides us with considerable insight into the legal ideas and practices of the Celtic peoples at various stages of their histories. The best-preserved law texts are those of Wales, which have traditionally been attributed to the tenth-century king Hywel the Good. Though the core of this material may well have been brought together under his direction, the main period of compilation seems to have been the twelfth-thirteenth centuries.

The Irish law texts are more extensive than their Welsh counterparts, but less well preserved. Indeed, some of them are clearly mere fragments. On linguistic grounds it can be shown that most of these texts were written in the seventh or eighth centuries. However, they survive in copies of varying quality in manuscripts of much later date, mainly from the fourteenth-sixteenth centuries. In these manuscripts the original text is usually accompanied by explanatory glosses and commentary added subsequently in the law schools. Legal writing in Irish, therefore, extends more or less continuously from the seventh to the sixteenth centuries. Towards the end of this period, the records of English officials also provide us with information on native Irish law—which they generally refer to as "Brehon law" (from the Irish word *breithem* "judge").

There was a substantial Celtic element in the legal ideas and terminology of Scotland down to the Jacobite rebellion of 1745, though no body of law texts in Scots Gaelic survives. The Breton situation is similar; the legal terminology used in the *Cartulary of Redon* (containing charters from the ninth and tenth centuries) agrees in many respects with that of medieval Wales. However, the absence of law texts limits our knowledge of legal practice in medieval Brittany.

The fact that the Celtic languages share many legal terms is proof that a basic system of law was already in existence in the Common Celtic period (approximately 1000 B.C.). For example, the Old Irish term for "surety" is *macc*, which is cognate with Welsh and Breton *mach*. This indicates that the institution of suretyship among the early Irish, Welsh and Bretons derives from Common Celtic times. But obviously no legal system can remain totally static. Different conditions and influences molded the laws of the Celtic peoples in separate ways. Thus the law relating to kingship in medieval Wales owed much to the ideas of the neighboring Anglo-Saxons.

Celtic legal records agree in assigning a crucial importance to a person's honor. Each freeman had an honor-price, which is referred to as "the worth of his face." This is the sum which had to be paid to him (or to his relatives) in the event of any offence against his honor, ranging from insult to murder. Honor-price normally related to a person's rank in society. For example, in early Irish law a provincial king had an honor-price twenty-eight times greater than that of the lowest grade of freeman. However, if a person behaved in a manner unworthy of his rank, his honor-price was reduced or even canceled altogether. Thus one Irish law text states that if a king demeaned himself by doing manual work with mallet, spade or axe, his honor-price was reduced to that of a commoner. Similarly, a lord who sheltered a fugitive from the law or ate food known to be stolen suffered loss of his honor-price, and with it his status in society. Irish law also allowed for the raising of a person's honor-price if he acquired further professional skills or significantly increased his wealth. This was based on the legal principle "a man is better than his birth."

A dependant did not have an honor-price in his or her own right. In the Welsh laws, for example, a woman was accorded half her brother's honor-price before marriage, and one-third of her husband's honor-price after marriage. Similar proportions obtained in Irish law, depending on the status of the marriage.

Unlike Welsh law, Irish law recognized polygyny, i.e. a man's possession of more than one wife at the same time. The honor-price of a main wife was half that of her husband, whereas a subsidiary wife's honor-price was one-third. A wife had certain rights to overrule unwise contracts made by her husband, but in general she was without independent legal capacity. Both Irish and Welsh law stress that only in limited cirumstances could a woman carry out

such basic legal acts as buying, selling or giving evidence. Irish law does however recognize certain categories of women—such as a physician or craftswoman—who achieved independent legal capacity because of their professional accomplishments.

As in most legal systems, children and insane persons were under the guardianship of an adult male relative who was responsible for any offenses which they might commit. Irish law was concerned that the insane should not be exploited: one text lays down the general principle that the rights of the insane should take precedence over all other rights. Slaves, on the other hand, had no protection in either Irish or Welsh law and were regarded simply as the property of their masters.

In the records of all the Insular Celts we find great emphasis on the kin group, commonly the descendants through the male line of the same great-grandfather. The kin group was both a landowning unit and a support system for the individual kin members. If a kin member was illegally killed, the head of the kin—its public representative—had to ensure that the culprit paid the appropriate fine, of which a proportion was divided among the kin members. If payment was withheld, the kinsmen were obliged to initiate a blood feud against the culprit.

The kin-group also possessed considerable legal powers over its members, and could prevent anyone selling his share of the kin land. If a person failed to fulfill his obligations to his kin group, he could be formally ejected from it and thereby lose his rights in society.

Finally, mention should be made of the rules governing legal procedure, as this topic is treated in detail in Irish and Welsh law texts. In both systems great stress was laid on the importance of the correct formalities being observed in the charging of a suspect, his appearance before a court and his subsequent trial. The texts devote particular attention to the rules of evidence. In Irish law doubtful cases might be decided by single combat or ordeal, but these methods were not permitted in Welsh law.

On being found guilty, an Irish or Welsh offender could be fined, put to death or sold into slavery. In Welsh law the death penalty was applied particularly in cases of serious or repeated theft. As far as one can judge from the Irish texts, an offender could pay his way out of most crimes. But if he or his kinsmen were unable or unwilling to pay, he could be put to death or sold into slavery by those whom he had wronged.

Detail of the manuscript of law H2.15A at Trinity College Dublin
The large-character text dates from the 8th century A.D. and speaks of the rights of women
The smaller writing includes comments added in the 12th century

The earliest Irish missionary activity of which we have any record was directed to the neighboring island, Britain, and began with the foundation in A.D. 563 of the island monastery of Iona, off the western coast of Scotland, by the famous St. Columba (Colum Cille). Like most prominent Irish churchmen of the period, Columba was of aristocratic birth and could claim affiliation with perhaps the most powerful political dynasty in the north of Ireland. His foundation at Iona became the center of a far-flung and highly influential network (*paruchia*) of monastic houses which dominated Irish ecclesiastical affairs for the best part of two-hundred years. From Iona the Christian message was carried by Irish missionaries to the north of England, and from their new base at Lindisfarne (now Holy Island), founded in A.D. 635, they established in the northern half of England a system of church organization very similar to their own.

By the end of the sixth century the Church in Ireland had taken on most of the features that historians regard as peculiarly "Celtic": the Irish followed a distinctive method of calculating the date of Easter, had some different liturgical and ritual practices, and had developed an organization which encouraged resistance to episcopal control. All these features, and more, were to raise a storm when the Irish undertook missionary activity abroad, and the chorus of complaint extended as far as Rome. The missionary group sent to England in A.D. 597 by Pope Gregory the Great had encountered these peculiar Irish ways en route, and in a letter to the Irish clergy they wrote: "Knowing the British, we had expected the Irish to be better." Through such channels Irish habits and customs spread first to Britain and then to the continent. The Irish brought their books with them wherever they went, and the script they used became the common property of all the peoples in the British Isles, whence it is sometimes called "Insular" script, with the result that modern scholars are frequently at a loss to distinguish the nationality of a scribe from the evidence of the handwriting alone. The result was that Northumbria in the seventh century became in effect a cultural province of Ireland.

Irish missionary activity on the continent was inaugurated shortly before the death of Columba (A.D. 597) with the departure from Bangor (county Down) of Columbanus and twelve companions destined for Burgundy. Columbanus's three foundations in Burgundy, Luxeuil, Fontaine and Annagray, were to become important centers of Irish influence on the Frankish church in the seventh century, an influence which was in large part due to the extraordinary personality of Columbanus himself. His letters (which miraculously survived) depict an Irish church with the air of an autonomous and self-confident institution. He brought with him, for example, the notion of a church which accorded primacy of authority to the abbot, not to the bishop, and which went its own way in matters of liturgy and ritual. Indeed, in A.D. 600 Columbanus wrote a letter to Pope Gregory himself, chastising him for views which did not accord with those of the Irish! The combination of Columbanus's fiery temperament and the unique practices he had brought with him soon led to difficulties with the local Frankish bishops. The result was a series of synods at which the Irish and their ways were roundly condemned.

Columbanus was eventually expelled, in A.D. 610, from Burgundy (though some followers remained at Luxeuil) and from there he traveled to Switzerland and down into northern Italy, where he finally settled at Bobbio, near Piacenza, a monastery which still hosted an Irish bishop Cummianus in the eighth century who spent the last seventeen years of his life there and was remembered in a carved stone epitaph in the church. A forceful and charismatic personality, Columbanus's effect on the Frankish Church was little short of revolutionary; he was to have the same impact in Italy, until his death in A.D. 615 cut off his career. Columbanus left a lasting personal memory and two monastic rules which—along with the more famous Benedictine Rule—were to provide the model for a whole generation of monastic foundations throughout Europe. Perhaps his most distinctive contribution, however, was the institution of private penance: in the early Church confession of wrongs was a very public affair; the Irish *anamchara* ("soul friend") heard individual, private confession, and the peniten-

tial discipline imposed was based on handbooks of penance (*libri poenitentiales* "penitentials") which graded the severity of the punishment according to the gravity of the offence. Columbanus's penitential has also survived, the oldest code which is known to have been used on the continent. This personal confession enjoyed immediate and widespread success, particularly amongst the laity, and in fact it was from Ireland that the medieval Church derived its characteristic discipline of penance.

Columbanus's death marks the end of the first phase of Irish missionary activity on the continent, but a second wave of Irish pilgrims was to follow in his footsteps. There is in fact evi-

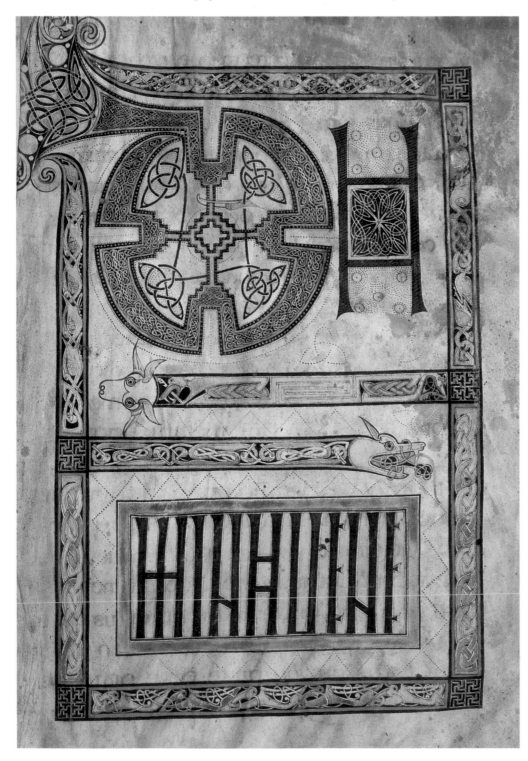

Miniated page
from Collectio canonum
7th century A.D.
Cologne, Erzbischöfliche Diozesen
und Dombibliothek

dence for a steady stream of Irish missionaries from the early seventh century, some of them solitary travelers but most of them in the company of companions, often making up the number of the apostles, as was the case with both Columba and Columbanus before them. Among the earliest was Fursa, founder of the Irish monastery at Péronne in Picardy (*Perrona Scottorum* "P. of the Irish") who had labored first in England, from which he was expelled. He was followed to France and Belgium by his two brothers, Ultán and Foíllán, who founded monasteries at Lagny (near Paris) and Fosses (near Namur); these family foundations formed a network (*paruchia*) in the Irish style with Péronne and Nivelles (family monastery of the early Carolingians) and they maintained distinctively Irish traditions in Picardy and Flanders until the end of the eighth century. Writings associated with Péronne and Nivelles in fact preserve the oldest continental evidence for a cult of St. Patrick, the apostle of Ireland. Like Columbanus before them, the rulers of these Irish foundations also involved themselves in local political affairs, and the civil wars of the Frankish kingdoms frequently affected the fortunes of Irish missionaries such as Ultán and Foíllán on the one side and bishop Tommianus of Angoulême on the other.

While some Irish clerics were evangelizing in southern Gaul, others were bringing the Christian message to the Germanic peoples on the eastern and western frontiers of the Frankish kingdoms. In Bavaria the names of Marinus and Annianus were remembered as apostles, probably in the first half of the seventh century. At Würzburg in Bavaria the celebrated Kilian is still revered, though the details of his career are almost entirely lost. In the Low Countries, on the other hand, Irish missionary activity provided the example for the efforts of Anglo-Saxon monks in the 690s and beyond. First Willibrord and his companions inaugurated the Frisian mission, setting out in A.D. 690 from Rath Melsigi in Ireland, and the Anglo-Saxon foundation at Echternach carried on the tradition of Irish influence into the eighth century in manuscripts and in monastic personnel. Subsequent Anglo-Saxon missionary efforts among the Saxons likewise had their inspiration in the activities of the Irish.

Some of these Irish missionaries and pilgrims have left us a glimpse of their world in letters of theirs that have survived. Others brought with them their books from Ireland, and these are among the oldest and most valuable records of the Irish language. In St. Gallen, Würzburg, and Milan, and in other places where the Irish stayed or visited, these *libri Scottice scripti* ("books written in the Irish script") are still to be seen, vivid reminders of an earlier age. Among the best known are the famous *Vita Columbae* now in Schaffhausen (Switzerland), formerly in the island monastery of Reichenau in Lake Constance, and written around A.D. 700, and the Antiphonary of Bangor in the Ambrosiana at Milan, written before A.D. 962, a priceless record of the liturgy and hymns used in Columbanus's first monastery of Bangor in Ireland. Two other manuscripts, from Columbanus's own foundation of Bobbio, now also in the Ambrosiana, are perhaps the oldest of all; they are written in the characteristic Irish script of the early seventh century and show some of the earliest traces of Irish manuscript decoration.

The *Anglo-Saxon Chronicle* for the year A.D. 891 reports that three Irishmen "came to King Alfred in a boat without any oars... because they wished to go on pilgrimage for love of God, they cared not where." Perhaps it was such a group of *Scotti vagantes* who left the letter now preserved in a copy at Bamberg (Bavaria) in which they recorded how, en route for the continent, they stopped over at the court of King Mervyn Vrych in Wales, where they were challenged to decipher a secret script. The Irishmen consulted their books, proceeded to "crack" the code, and announced their triumph in a letter to their teacher at home in Ireland. Another Irishman, a scholar and poet who penned the famous verses about his cat Pangur into a manuscript now in Carinthia (Austria), must have traveled a similar route, for Pangur is a Welsh name, not an Irish one! Such episodes encouraged continentals in the belief that every Irishman was a scholar, and indeed many of them were. One poor pilgrim, however, returning home via Liège in Belgium, had to apologize to the local bishop for the fact that he was not a grammarian (*non sum grammaticus neque sermone latino peritus*). Another, travel-

ing in the opposite direction, found the journey too arduous for a man of his years, hindered as he was by sore feet, while a third exclaimed indignantly to his local bishop, who had provided him with meagre hospitality: "I cannot live in such squalor, with nothing to eat or drink except dry bread and awful beer."

For many of these travelers, of course, the ultimate goal was the *Limina Apostolorum*, Rome. Irish sources record that two sixth-century Leinster clerics, Fiachra Goll and Émíne, died on the same day in Rome (*uno die quieverunt in Roma*). They were only the first of a steady stream of Irishmen who made their way to the Holy City. Columbanus had expressed the desire to visit the Pope; others after him included the burial places of their Irish compatriots in their pilgrim routes. Not all Irishmen were enamoured of the Eternal City, however: "To go to Rome—great labor, little profit," wrote one of them, though his attitude may be explained by the unfortunate experiences of another pilgrim, returning from Rome and passing through Liège, who was "mugged"—all his belongings stolen. He took his complaint to the bishop (whose men had in fact perpetrated the crime) and sent him an itemized list, with valuation, of all the missing property: an alb and a stole, two corporals and a good black cloak worth three *unciae*, a leather coat with puttees worth two *solidi*, a shirt worth two *solidi*, and four worn Irish garments plus a skin-coat, and other things "trifling but important to me." These were obviously the modest belongings of an ordinary pilgrim; a bishop, on the other hand, could call on much greater resources. The *Casus Sti Galli*, a history of that monastery written in the tenth century, has a story about a ninth-century Irish bishop Marcus who visited St. Gallen in the company of his nephew and an entourage of Irish followers. Both bishop and nephew—who was "exceedingly learned in sacred and profane knowledge"—were persuaded to remain in the monastery, much to the disgust of their companions. "On the appointed day Marcellus distributed much of his uncle's money through a window, because he was afraid that his fellow-travelers might assault and batter him. For they were furious with him, thinking that he had persuaded the bishop to remain. The bishop gave his horses and mules to such persons as he chose by name; his books, his gold, and his clothes he kept for himself and St. Gall. At last, clad in his stole, he blessed his departing companions, and with many tears on both sides they separated. The bishop remained with his nephew and a few servants who spoke their tongue."

These were clearly not missionaries in the strict sense, but Irish men of learning, part of that "herd of philosophers" (as a later scholar of Auxerre described them) who flocked to Europe in the eighth and ninth centuries. Their books survived long after them, and nineteenth-century scholars of philology like the great pioneer Graziadio Isaia Ascoli (1829-1907) took a prominent part in recovering the memorials of Old Irish contained in them. The wheel of history had come full circle and the debt which Europe owed to Irish "saints and scholars" began to be repaid in kind.

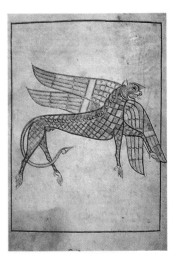

Page from the Stowe Missal
8th century A.D.
Dublin, Royal Irish Academy

Miniated page with the symbol of Saint Luke from the Book of Armagh
Ireland
ca. 807 A.D.
Dublin, Trinity College

King Arthur

The legend of King Arthur is the greatest contribution of the Celts to world literature. The body of Arthurian literature which it inspired throughout medieval Europe was immense. A standard encyclopedia on it is a book of nearly six hundred pages, written by thirty different experts dealing with literature in eleven languages.[1] Yet the origins of the legend are so obscure that many have doubted whether King Arthur ever existed. The classic opinion on the Arthur of history is that we do not know if he existed, but he may well have.[2] If he did, he must have been a British military leader of the early sixth century, defending the native Celts from the English who were then conquering Britain; he may have been the general at the British victory of Mount Badon (somewhere in southern England?) won between about 502 and 516.[3]

Up to the twelfth century the legend of Arthur can be traced only in obscure fragments of Welsh poetry, Welsh heroic story, and folktales in Welsh-Latin chronicle and saints' lives. Perhaps the earliest reference to Arthur occurs in the Welsh heroic poem *The Goddodin* (attributed to the bard Aneirin of c. 600), where it is said of the warrior Gwawrddur, "He glutted black ravens on the rampart of the stronghold, though he was no Arthur."[4]

If this passage really was composed in about 600, people who knew Arthur might have heard it. Unfortunately, it is possible that the passage (and the poem as a whole) may be no older than the tenth century.[5]

We are on slightly firmer ground with certain poems in the *Black Book of Carmarthen* (c. 1250) and *Book of Taliesin* (c. 1300-25). The first of these two manuscripts of Welsh poetry, both in the National Library of Wales, includes a strange dialogue between Arthur and the gatekeeper Glewlwyd in which Arthur lists his companions, "Nabon son of Nellt, he made blood stain the grass, and Anwas the Winged and Liwch of the Striking Hand" and others, amongst them Cai Wyn and Bedwyr, the Keu and Bedoier of later French romance. Cai is a doughty fighter who "pierced nine witches; Cai the Fair went to Anglesey to destroy lions; against the Scratching Cat his shield was backed small." The last is no ordinary cat, but a ferocious monster which eats warriors by the score.[6]

Even more peculiar is the poem on the Spoils of Annwin in the *Book of Taliesin*, describing a disastrous raid made by Arthur and his men in his ship Prydwenn on the Celtic otherworld, to obtain a magic cauldron which "boils not the food of a coward." At one point Arthur's host attacks Caer Wydr, the "City of Glass", its walls guarded by 6,000 sentinels who do not respond when addressed, but who inflict terrible losses on Arthur's army; the motif of the sentinel who makes no response features in other Celtic sources, such as the ninth-century Latin chronicle attributed to Nennius.[7]

The Arthurian lore in the early poetry is supplemented by the Arthurian tales *Culhwch and Olwen* (before 1100) and *The Dream of Rhonabwy* (c. 1220-25) in the collection of Welsh romances called *The Mabinogion*. Together, these sources give precious information on Arthur before the influence of Geoffrey of Monmouth had become complete. It may be noted that in the earliest tradition Arthur's court is not at Caerleon or Camelot, but at Celliwig, in Cornwall, and that he is represented as a fierce, rough Celtic chieftain, rather than the chivalrous emperor-king of Geoffrey and later romance. At the close of *Culhwch and Olwen*, for example, Arthur's warriors have problems with a witch in a cave; there is much grabbing of hair and flinging to the ground, but the witch drives the men off "squealing and squalling." It takes Arthur to solve the problem.

"And then Arthur seized the entrance of the cave, and from the entrance he took aim at the hag with Carnwennan his knife, and struck her across the middle until she was as two tubs. And Cadw of Prydein took the witch's blood and kept it with him."[8]

Then, about 1136-38, the Norman cleric Geoffrey of Monmouth published his *Historia Regum Britanniae*, a pseudo-history of Britain which glorified Arthur and spread his fame throughout Europe. Although Geoffrey seems to have used some Celtic tradition, the Arthur familiar to modern readers is almost entirely Geoffrey's invention. The image of Arthur as

an all-conquering emperor, for example, surrounded by his knights at his magnificent court of Caerleon in south Wales, is due to Geoffrey; so too is the legend that Arthur was defeated, not by fair fight, but through the treachery of his nephew Modred in the final battle of Camlan.[9]

Even in Geoffrey's time serious historians like William of Newburgh protested at the falsehoods of the book, especially Arthur's alleged defeat of the Romans and conquest of Italy. Gerald of Wales (1146-1223) has a wry story of a warlock persecuted by devils which fled when a copy of St John's Gospel was laid on his breast, but which flocked back in greater number when the gospel-book was replaced by Geoffrey's *Historia*.[10]

The effect of Geoffrey's *Historia*, "one of the most influential books ever written," may be calculated by the number of surviving manuscripts of it (over 200), and the speed with which it was translated into other languages.[11] The most important translation into French is the *Roman de Brut* completed in 1155 by Wace (born on Jersey in the English Channel); his poem of 15,300 lines is the first account featuring Arthur's Round Table, not mentioned by Geoffrey. There were also no less than six separate translations of Geoffrey's *Historia* into Welsh, the earliest of c. 1200, while a loose rendering into Old Norse, under the title *Breta sögur*, was made before 1334. The direct influence of Geoffrey's history extended even to Poland, where Wincenty Kadtubek, Bishop of Cracow 1208-18, used it as a basis for his *Chronica Polonorum*.[12] In English literature Geoffrey's influence extended up to the time of Spenser, Shakespeare (*King Lear, Cymbeline*) and Milton.

The early translations and adaptations produced their own offspring. Wace's *Roman*, which

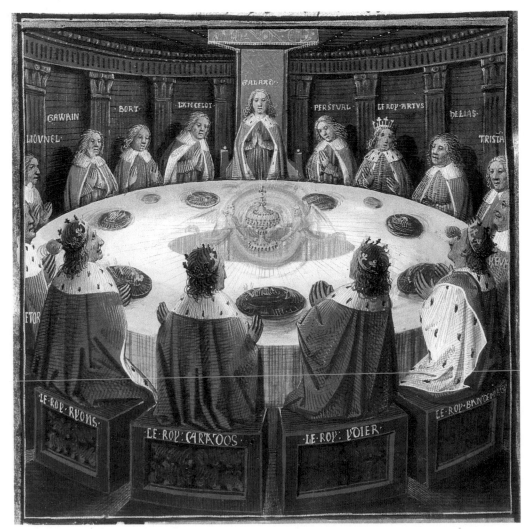

The appearance of the Graail to the Knights of the Round Table from the "Livre du Messire Lancelot du Lac" by Gautier Map 15th century A.D. Paris, Bibliothèque Nationale

influenced the French *Mort Actu*, *Didot Perceval* and *Livre d'Artus* and was translated into English verse by Layamon, exercised a profound effect by inspiring the work of Chrétien de Troyes, particularly his early *Erec* of 1170 and *Cligés* of 1176. But by this date evidence in also accumulating to prove the spread of tales about King Arthur throughout the West thanks to wandering minstrels and storytellers.

Some of this evidence suggests the ways in which even a well-educated writer like Wace, who had studied at Paris and Caen, could use oral tradition in addition to formal literary sources. When he alludes to the Round Table, he remarks that "the Bretons tell many a tale" of it, and there is no reason to consider this statement merely Wace's invention.

Now, Arthur had been the national hero of the entire British people from Scotland to Brittany; and it is particularly the activity of Breton storytellers at Norman and other courts which seems to have been responsible for the diffusion, not only of tales about Arthur himself, but of a great variety of heroic and mythical narrative which he had attracted to himself over the centuries. By the end of the twelfth century the Normans had carved out territories for themselves from the west of Ireland to the Jordan, and the French language had become the most important vernacular of western Europe. This period therefore presented ideal conditions for the diffusion of the Arthurian legend by oral means.

Some remarkably early evidence for this circulation of Arthurian legends comes from northern Italy. The personal name *Artusius* is found in the region of Padua and Modena from 1114 onwards, while *Walwanus*, representing the name of Arthur's nephew, Gawain, appears from 1136 in Paduan charters. The name "Arthur" must therefore have been given in baptism before 1100. Arthur and his knights, including "Galvaginus" and "Che," are represented rescuing the lady Winlogee from a castle in a famous sculpture of c. 1106 at Modena cathedral. The form *Winlogee* for Arthur's queen derives from Breton; the story thus reached Modena via Breton story-tellers, not Welsh ones. Other twelfth-century evidence for Arthurian tales in Italy comes from the far south: in a mosaic of 1165 in Otranto cathedral (in the "heel" of Italy), showing Arthur bearing a sceptre and riding a goat, and in legends from Sicily, known to English and German writers of the time, of Arthur as still alive in a cave underneath Mount Etna. To this day the mirage seen near Messina which in English is called the *Fata Morgana* takes its name from Morgain la Fée, the witch who was Arthur's half-sister and who, according to Geoffrey of Monmouth's *Vita Merlini*, was the chief of nine sisters ruling the mysterious island where Arthur was taken after his last battle. She seems to have been located in Calabria by the Norman settlers (familiar with Breton legend) who ruled Sicily from 1072 to 1189.

It is through Breton influence on Normans and others that certain Celtic legends which are poorly recorded or not recorded at all in early Welsh literature emerge in French texts. Examples of these are the Hunt of the White Stag (a dynastic sovereignty myth in which the ruler of a land mates with a goddess representing the land itself); the Waste Land; the King Wounded through the Thighs; the Queen's Abductions; and the Raid on the Otherworld. These feature variously in the poems of Chrétien de Troyes. The legend of the Queen's Abductions becomes the story of Lancelot's affair with Queen Guinevere in *Lancelot*; the Otherworld Raid, more strangely transformed, becomes the Quest for the Holy Grail in *Percival*.

The last inspired a major cycle of works on the Grail in thirteenth-century France and, in Germany, the *Parzival* of Wolfram von Eschenbach (early thirteenth century), and, through him, Wagner's music-drama *Parsifal* (1882).

The growth of the Arthurian legend after about 1200, with the Vulgate Cycle in French, the work of Hartmann von Aue and his successors in German, *Sir Gawain and the Green Knight* and Malory's *Morte D'Arthur* in English, and Boiardo and Ariosto in Italian, is of less concern to the Celtic heritage of European culture. But two passages in Dante's *Divine Comedy* are

665

too important not to mention. At *Inferno*, XXXII, 61-62, Dante mentions the fierce blow Arthur struck the traitor Modred in battle (light passed through the hole it left); while, most famously, in *Inferno* V, Francesca da Rimini tells the poet how, after reading of the first kiss between Lancelot and Guinevere in the prose *Lancelot*, Paolo turned to her and first, tremblingly, kissed her, causing an end of reading for that day.

> Quando leggemmo il disiato riso
> esser baciato da cotanto amante,
> questi, che mai da me non fia diviso,
> La bocca mi baciò tutto tremante:
> Galeotto fu il libro e chi lo scrisse:
> quel giorno più non vi leggemmo avante.

If the Celtic legends of Arthur and the abductions of his Queen had not existed, Dante's art would have lost; but Francesca herself (whose nephew Dante knew well) might have been saved.

Merlin the Magician

Merlin was the famous magician of Arthur's court. His modern reputation is a sensational one, as a child fathered by a devil on a nun in her sleep. Half-human, half-demon, he was thus naturally possessed of prophetic powers. However, this lurid account of his birth seems to be due, not to a native Celtic source, but to the journalistic invention of Geoffrey of Monmouth. The French writer Robert de Boron (c. 1200), in the life of Merlin attached to his *Joseph d'Arimathie* (a poem on the Holy Grail), goes one better by ascribing Merlin's conception to a conspiracy of thwarted devils, anxious to place an agent in the world who will further their plans. Devils or no, the original Merlin seems to have been nothing more sinister than a Welsh poet (as has been argued), or a place name (as is now usually held).

The development of the Merlin legend shows his transformation from this blameless origin. One of the legends of post-Roman Scotland was of Lailoken, a hairy "Wild Man" living alone and deranged in the wilderness, like Nebuchadnezzar in the Bible (Daniel, IV, 33). Some time after about 650, the story of Lailoken was transferred from North Britain to Wales. (One may compare to this the story of Tristan at a later date.) Here Lailoken was renamed "Myrddin," a ghost-name deriving from *Caerfyrddin*, the town of Carmarthen in south-west Wales. The original name of Carmarthen was British *Moridunum*, "Sea-fort", but when British evolved into Welsh, this became *Myrddin*; the meaning "sea-fort" was no longer understood, and *Myrddin* was taken as a personal name. Hence *Caerfyrddin*, "Myrddin's fort", in English, *Carmarthen*.

During the ninth and tenth centuries, Welsh poems and prophecies were placed in the mouth of Myrddin, his madness giving him a reputation for prescience. In "The Prophecy of Britain," a poem (written about 930?) in the *Book of Taliesin*, the Celts are told of their forthcoming victory in battle against the English, and Myrddin is quoted in support of this. (When the battle came, in 937, the English won it.) Poems attributed to Myrddin prophesying victory for the Welsh continued to be written and studied in Wales through the Middle Ages, and some occur in the *Black Book of Carmarthen*.

The man responsible for changing Myrddin's name to Merlin, and propelling him to international fame, was Geoffrey of Monmouth. This he did in three works: the *Prophetiae Merlini*, the *Historia Regum Britanniae*, and the *Vita Merlini*. The first, published perhaps in 1134, was instantly successful and was incorporated shortly afterwards into the *Historia*, while the *Vita* dates from about 1149. Although the *Prophetiae Merlini* (which seem largely to be Geoffrey's invention) were taken very seriously, and were recopied and provided with a pseudo-

King Mark discovers Tristan and Isolde in the forest from a miniated volume of ca. 1260 A.D. Paris, Bibliothèque Nationale

Lancelot crosses the sword-bridge from the "Livre de Messire Lancelot du Lac" by Gautier Map 15th century A.D. Paris, Bibliothèque Nationale

learned paraphernalia of commentary throughout western Europe, the *Vita Merlini* (where Geoffrey uses the legend of Merlin as the "Wild Man of the Woods") seems to have found little favor.

Geoffrey's treatment of Welsh tradition in these texts is characteristic of his unscrupulous treatment of his sources. An instance is his appropriation of the story of Ambrosius. The ninth-century Latin chronicle of Nennius tells of a marvellous boy, Ambrosius, who explained to the British tyrant Vortigern why the fort he was trying to build in Snowdonia, in northwest Wales, kept disappearing into the ground overnight. The subsidence was due to two dragons struggling at the bottom of a nearby pit. (This took place at Dinas Emrys, near the village of Beddgelert, and over thirty years ago the pit where the dragons struggled, or were thought to have struggled, was excavated by archaeologists.) Geoffrey lifted this quite separate story of the prophetic child Ambrosius from Nennius, called the child Merlin, and located him at Carmarthen in southwest Wales. It will be noticed that the legend of Merlin originally had no connection with that of King Arthur, and it is again through the influence of Geoffrey that we now envisage Merlin as magician-royal to Arthur's court at Camelot.

Tristan and Isolde

Although no early Celtic source tells the love-story of Tristan and Isolde, there can be no doubt that its origins are strongly Celtic, that they involve almost all of the Celtic realms, and that it was through Cornish or Breton storytellers that the tale became known to the world.

The names of the lovers are both Celtic. Middle Welsh *Essyllt* has been explained as from British *Adsiltia*, "she who is gazed at," or "Miranda"; one may compare form (and meaning) with French *Iseult* and German *Isolde*, the latter found in Old High German as early as the eighth century and interpreted as "Ice-rule." The name "Tristan," on the other hand, is common in Pictish, an extinct Celtic language (with a non-Indo-European element) of eastern Scotland. A Welsh triad, perhaps of the twelfth century, refers to a lost tale in which "Drystan son of Tallwch guarded the pigs of March ap Meirchiawn, while the swineherd went to ask Essyllt to come to a meeting with him. And Arthur kept trying to get one pig from among them, either by deceit or by force, but he did not get it." Scottish historical sources actually mention a Drust who was son of the Pictish king Taloro ruling about 780. If he is the same as our Drystan son of Tallwch, as seems likely, we can see how a legend from North Britain might be relocated in the South, and how a historical figure who lived some 250 years after Arthur's *floruit* might yet be drawn into association with him in legend.

The history of the love-legend has been reconstructed as follows. The Pictish Tristan was originally the hero of a story (like that of Perseus and Andromeda), in which he rescued a maiden and became her lover. This tale, known from a ninth-century Irish version, was taken by the Welsh, who relocated the story in Cornwall, made Isolde the wife of King Mark, and added the familiar theme of the eternal triangle with the motif of the love-potion accidentally taken by the couple on the voyage from Ireland. This story seems to have been well-known to Welsh story-tellers, though the only direct evidence for this is two fragments of poetry in the *Black Book of Carmarthen*, the Welsh triad cited above, allusions in *The Dream of Rhonabwy*, and a Welsh folk-tale of the fifteenth or sixteenth century which quotes earlier verse.

This version of the story was adopted for the Anglo-Norman *Tristan* (surviving only in fragments) written about 1160 by Thomas, and the later more complete version of the tale by Béroul. It was Thomas's text that was translated, somewhat freely, into German about 1220 by Gottfried von Strassburg, whose version is the basis of Wagner's opera *Tristan und Isolde* (1888). However, a reference to Tristan as the ideal lover by the troubadour Cercamon (fl.

1137-49) shows the legend was known at an early date in Languedoc. As with the legends of Arthur mentioned above, it may have been Breton storytellers who were responsible for spreading the story to the south of France.

Inferno, Purgatorio, Paradiso

The missions of the Irish saints throughout Europe have been discussed elsewhere in this volume. But it is worth saying something about certain legends of Celtic saints as they influenced European literature, in particular of those concerning visions of Hell.

These go back to an early date. In III, 19 of his *Ecclesiastical History*, Bede describes a vision of Hell seen by Fursey, an Irish saint working in eastern England in the 630s. Bede notes that when Fursey afterwards related his experiences, even if it was a frosty winter's day, they made him sweat with terror "as though it were the middle of summer." Another Irish vision, this time of both Heaven and Hell, is the eleventh-century "Vision of Adamnáh." Hell here presents the timeless picture of the damned, who have "streams of fire in the holes of their faces; others, nails of fire through their tongues, and others through their heads from outside. Now those who are in this torment are thieves and perjurers and traitors and slanderers and robbers and reavers and unjust judges and litigious people, witches and satirists, renegade brigands and professors who preach heresy."

Other visions of Hell of Irish origin are the "Vision of Tnugdal" and "St. Patrick's Purgatory," both of the twelfth century and read throughout medieval Europe. The former, written in Latin by an Irish monk at Regensburg in Bavaria, tells what was seen by Tnugdal's soul while his body was in a trance; the latter is based on the account given by an Irish knight called Eoghan or Owen, who in about 1153 descended into a cave (said to have been revealed by Christ to St. Patrick as a place where man might see the other world) on an island on Lough Derg in northwest Ireland. (To this day the island, in county Donegal, is a center of mass pilgrimage, though the cave has long disappeared.) The Latin version of what Eoghan saw of Heaven and Hell, from a version brought back to England, spread through the West and was translated into many languages. It also influenced art: a fine quattrocento painting of St. Patrick's Purgatory was noticed by the late Cardinal Ó Fiaich in the church of the Franciscan nuns at Todi (between Rome and Perugia), showing St. Patrick himself above the oven of Purgatory and the Blessed Virgin Mary helping people get out of it. And, above all, this and similar legends influenced the *Divine Comedy* of Dante Alighieri—a fact in which the Irish have taken legitimate pride.

Visions of heaven and hell are also part of the *Navigatio Sancti Brendani*, the "Voyage of St. Brendan" which could be described as a kind of religious *Odyssey* in Latin prose. St. Brendan is said to have been a sixth-century Abbot of Clonfert (in county Galway), but to have come from Kerry, in the rugged southwest of Ireland. The entertaining account of his voyage in search of the promised land in the west was written, it seems, in the early tenth century, perhaps by an Irish bishop called Israel, who, following Moorish attacks on his diocese at Aix-en-Provence, moved to Trier in Germany, where the oldest manuscript of the story still is. Gaston Paris remarked of St. Brendan, whose adventures were soon translated into French and German, that he wandered "*sur l'océan pendant sept années, y découvrit mille merveilles, et vit le séjour des damnés aussi bien que celui des bienheureux,*" including the abode of Judas, released from Hell for a while to perch on a rock in the sea. The cult of St. Brendan was popular in northern Germany and around the Baltic, and the town of Brandenburg takes its name from the saint. The Brandenburg Gate in Berlin is thus ultimately named after an Irishman, a fact not one in a hundred thousand of those passing it can know.

Druids

About the historical druids we know almost nothing; and for practical purposes "druidical"

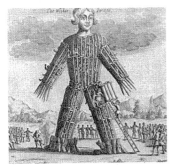

Druids burning victims in a wicker effigy, from Aylett Sammes "Britannia Antiqua Illustrata" (1676)

remains do not exist. The statements of classical writers on the druids are contradictory, and in any case perhaps say more about the writers themselves than about those they describe. According to classical writers, the druids were a powerful class of priests in Gaul and Britain, in both of which the Romans liquidated them. They were said to believe in the transmigration of souls, to burn human victims alive within a wicker frame shaped like a man, to study stars and planets, and to teach students in remote caves and valleys. They were also said to use golden sickles to gather mistletoe from oak trees for their religious ceremonies.

Much of this may well be fantasy. It has, none the less, provided a goldmine for speculation from the Renaissance until today. Is seems as if, with the decline of medieval religion, druids came forward to occupy "a vacuum of the mind" (Geoffrey Grigson). In the sixteenth century French scholars (later followed by the English) elevated the druids for patriotic reasons, in the flattering belief that their ancestors could be shown to be noble, venerable, philosophic beings who believed in the immortality of the soul and resisted the foreign tyranny of Rome. With the beginnings of archaeology in the seventeenth century, the standing stones and circles of England, Ireland and Brittany began to be attributed to the druids; the belief that Stonehenge in Wiltshire was connected with the druids persisted until recently. In the eighteenth century druids were seen less as proto-Protestants than as precursors of the Enlightenment, believers in liberty and undogmatic religion; in Wales this developed strong links with the growth of the Eisteddfodic movement, whose leaders still dress up each year in druidic garb to perform the ceremonies of this (admirable) popular literary and cultural festival. In England, white-robed druids have continued to meet at Stonehenge before dawn on May 1 to greet the coming of summer, with rival white-robed groups meeting by the Tower of London. Fantasies apart, though, in the European heritage the druids have persisted as powerful feeders of the imaginations of poets and artists.

Ossian

It is with the poetry of Ossian in the eighteenth century that we can speak of a European cult of (one might say a craze for) things Celtic that brings us to the threshold of modern thought. It is ironic that this is due neither to a great artist nor to much that is genuinely Celtic. The poetry of Ossian is due almost entirely to the forgeries of the minor Scottish man of letters, James Macpherson (1736-96), born in a Gaelic-speaking parish near Inverness, and educated at the Universities of Aberdeen and Edinburgh. In 1760 he published *Fragments of Ancient Poetry Collected in the Highlands of Scotland, and translated from the Gaelic or Erse language.* Macpherson claimed he had translated the epic poems of this and the later *Fingal* (1762), *Temora* (1763) and *The Works of Ossian* (1765) from the Gaelic poems of Ossian, warrior and bard, who was supposed to have lived in the third century A.D. However, when challenged, he could not produce the manuscripts he said he had used. It seems he took his material from certain oral ballads and his own vast (and lying) imagination.

This work was an instant success in Britain and on the Continent; it figured prominently in Goethe's *Die Leiden des jungen Werthers* (1774), and was admired by Napoleon, who figures (with his marshals) in a painting being received by Ossian into a somewhat theatrical heaven. This success *Ossian* owed to a growing interest in the primitive, which was to play a large part in European Romanticism.

Macpherson's work had important consequences for the Celts. It stimulated enquiry into the Celtic languages, both in Scotland and also in Ireland, where Charlotte Brooke's *Reliques of Irish Poetry*, the first anthology of translations from a Celtic language, appeared at Dublin in 1789. It showed that Scottish themes could appeal to a wide readership, thus paving the way for the novels of Sir Walter Scott (1771-1832). The clansmen of the Scottish Highlands had previously been seen as lawless, superstitious semi-savages speaking an uncouth tongue; but Scott's novel *Waverley* (1814), set in the Jacobite rising of 1745, helped establish the

stereotype of the Romantic Highlander of legend (though Scott was too intelligent not to see the problems modern life posed the Celts). The cult of the kilt and tartan (and the modern Scottish tourist industry) thus owe much to Scott. More substantially, the historical novel, and our whole way of looking at the past, bear the imprint of his profound originality.

The Celtic Twilight

The latest Celtic contribution to Europe's heritage, the "Celtic Revival" at its peak between 1890 and 1914, is in many ways the most dubious, even if in W.B. Yeats (1865-1939) and J.M. Synge (1871-1909) it included two Irish writers of genius. Criticism of it has been strong. Conditioned by the pre-Raphaelite and Aesthetic movements, the revival gave rise to the belief that Celtic literature (which few of its leaders knew at first hand) is full of "mournful, languishing, mysterious melancholy, of the dim 'Celtic Twilight' (Yeats's term)," though this is quite untrue. Jackson makes the point vigorously that, until lately, a Welshman "could not publish a book of the most realistic and cynical short stories without some reviewer tracing in them the evidences of 'Celtic mysticism.'" Even Synge, who knew spoken Irish well, had the habit of making the Irish country people of his plays use phrases lifted by him from medieval French and Spanish literature. In this, as in earlier periods, the Celtic heritage in European culture seems often to link the bogus with Art.

*Miniated page from "Le Roman de Lancelot du Lac et de la Mort du Roi Artu" King Arthur is wounded and Excalibur disappears into the lake
14th century A.D.
London, British Museum*

When one speaks of the Celtic peoples in modern times, one normally means the Bretons, Cornish, Irish, Manx, Scots, and Welsh. These are the people who inhabit the islands of Ireland, Man, and part of Britain, as well as the peninsula of Brittany which was settled from Britain in the sixth century A.D. Today the Bretons are citizens of France, the Cornish, Northern Irish, Scots, and Welsh are citizens of the United Kingdom, while the Manx have an independent legislature under the British crown. The greater part of Ireland is an independent republic. All the Celtic countries, with the exception of the Isle of Man, are part of the European Community. Thus, apart from the Republic of Ireland, all Celtic communities are minorities in states which are dominated by national groups which, whatever the historical accuracy of the designation, would not be called Celtic. This has led to demands varying in strength and radicalism for national independence in all the Celtic countries, but the only one to attain statehood is Ireland, which after a fruitless seventy years of parliamentary pressure in the nineteenth century resorted to armed revolt in the years 1916-21, becoming thereafter a partly independent state which achieved full independence in 1949.

The Celtic countries are located on the western extremes of their states on the western periphery of Europe. This geographical position served in the past to isolate them from the economic and cultural developments of the more centrally located areas of the continent. On the economic front this led to underdevelopment and poverty during the eighteenth and nineteenth centuries, at a time when much of Europe was experiencing the industrial revolution. During that time there were famines and land-clearances which resulted in heavy emigration, particularly from Ireland and Scotland, to North America, Australia and New Zealand. Even today the Celtic countries are only partly industrialized and rely on agriculture, fishing, and tourism for their income. Apart from the coalfields of South Wales there are few mineral resources, but Eastern Scotland has in recent years become the shore base for North Sea oil exploitation.

These countries suffer from a general sparseness of population with its attendant inefficiency of communication and distribution. Populations are static or declining due to emigration from the periphery towards the centers of industry where employment can be found. As a consequence some of the more remote areas of Ireland and Scotland are almost totally depopulated. Here the settlement pattern was generally in isolated farmhouses each on its own landholding. In Brittany, where the population tended to live rather in villages, the reduction in population was not so severe. Urban settlement was not native to the Celtic countries but had been first introduced by the Romans. During the Middle Ages towns were founded by the Vikings and the Normans so that they were always centers of outside settlement and administration thus giving rise to an urban-rural opposition which can be felt even today.

The rural settlement pattern of the Celtic countries resulted in the survival of a conservative lifestyle until the present century: attitudes and customs associated with the routine of the year's work, religious beliefs and practices which had survived the coming of Christianity in the wake of the Roman Empire and the division of Christianity in the Reformation, and social mores deriving from a form of social organization older than feudalism or even the Roman order. All over the land there were sacred places which had earned their status in pre-Christian times and which had been only gingerly adopted by the Christian church and given a garnish of Christian names or dedications to take the harm out of them; hills, stones, and especially wells which can still be seen festooned with rags in observance of an old ritual. Certain days in the year were marked as festivals, and time was counted forwards and backwards from them without reference to the ordinary calendar. Such days were the first of the four seasons, all of which were converted into Christian feasts. In her fine study of the festival of the beginning of harvest, in Irish *Lughnasa*, Máire MacNeill has demonstrated the continuity between the myth known from the early Middle Ages and the customs which survive to our own day.

In their pilgrimages the people combined the celebration of a holy place and a holy day. Pil-

grimages are still an important feature of country life, particularly in Ireland and Brittany. The most impressive of them is probably that to Croagh Patrick on the shores of Clew Bay on the west coast of Ireland, where each year on the last Sunday in July (the beginning of harvest) over 50,000 pilgrims climb the 765-meter high mountain. While the pilgrimage is for most a religious occasion and many observe the traditional ritual, it is nonetheless carried out with great good humor and in a spirit of enjoyment. Though the clergy are in attendance and Mass is celebrated on the mountain-top throughout the day, the pilgrimage is independent of the church and would probably take place even if there were no clergy present. Until recent times social life in the Celtic countries changed little with the passage of time. The people provided their own entertainment, music, songs, dance, and storytelling, whether on festive ocasions or simply in neighboring houses where they met to pass the long winter nights. The strong folksong tradition in all the Celtic countries stems from these times. In

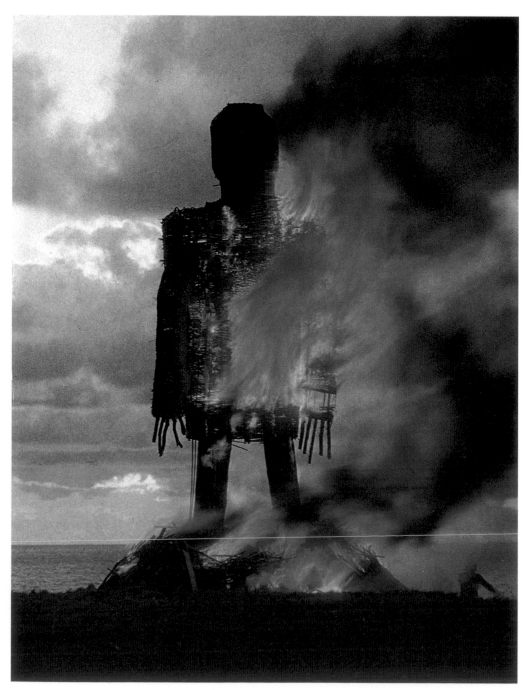

The sacrifice in the wicker effigy from "The Wicker Man" by Robin Hardy (1973)

our own day Irish *sean-nós* ("old style") and Welsh *penillion* (voice and harp) singing as well as Scottish working songs are familiar from many recordings made both by traditional singers and by others who have learned technique and style from these. Traditional tales were told to receptive but critical audiences well-acquainted with the story but ready to be entertained by the new version which each telling produced and by the verbal art of the narrator who clothed the old tale in new garments. It is still possible to hear traditional storytelling in Ireland and Scotland, but the advent of radio and television, together with the increased mobility of potential audiences enabling them to seek their entertainment outside their home district, has brought an end to the demand for it in the present generation.

That which all the Celtic countries have in common and which distinguishes them from other countries of western Europe is that they have all in recent centuries had a Celtic language as their vernacular. The Celtic languages, though today mutually unintelligible, are closely related to one another and belong to a group which was once spoken throughout all of western and much of central Europe. Through pressure from neighboring Germanic and Romance languages, the Celtic languages have been in decline since Roman times. By the seventh century A.D. they had disappeared from the continent, though by then the southern British dialect which later became Breton had been brought to the Armorican peninsula by British people fleeing before the Saxon onslaught. During the medieval period the Celtic languages continued to weaken in their struggle with English and French. Cornish died out in the eighteenth century and Manx in the twentieth. Today there are only four languages surviving. Irish, in spite of having had the support of a native state for the past seventy years, is the vernacular of only some tens of thousands of speakers in scattered communities on the west coast of Ireland. On the other hand, there are many hundreds of thousands elsewhere in the country who have acquired some knowledge of the language at school but make little use of it. In Scotland, Gaelic, which is very closely related to Irish, is now confined to the Hebrides and some minimal communities on the adjacent coasts, the number of speakers being no more than 90,000. In Wales, the Welsh language is superficially the strongest of the surviving languages, with approximately 500,000 speakers and boasting some Welsh-speaking urban centers, a favorable situation not shared by any other of the Celtic languages. Nonetheless, the indications are that even in Wales the language is on the decline, though at a slower rate than the others. The percentage of Welsh speakers in the population has declined steadily from about fifty percent at the end of the last century to a mere twenty percent today. Many Welsh speakers live in the large English-speaking cities of the south and so would not have occasion to use the language on a daily basis. Breton is spoken in rural districts of the west of Britanny, though there are no official figures to show the number of speakers and unofficial estimates differ widely, from a pessimistic 20,000 to an over-optimistic 700,000. Even though there may be a substantial number of people speaking Breton they do not seem to be handing on the language to the next generation, and a disastrous fall in the number of speakers may be anticipated as the present generation passes.

Besides losing the battle for the number of speakers, the Celtic languages are also losing ground geographically to their stronger neighbors. This retreat is illustrated vividly, for example, in the tables and maps published in Aitchison and Carter's *Atlas* for Welsh and in Donald MacAulay's article on the state of Scottish Gaelic. The bilingual tensions which exist at the edge of the area where the minority language is spoken almost always resolve themselves in favor of the majority language, leading to the further contraction of the territory of the minority language.

The age-profile of the speakers of the Celtic languages shows that more speakers belong to the higher age-groups than to the lower, indicating a decline in the proportion of speakers among the younger generation. This is due not only to the change of language in many homes but also to the emigration of young people from their native districts to further their education or to seek employment. The corollary to this is that there are relatively few marriages within these communities, so that it is only with difficulty they renew themselves.

A further result of the remoteness and economic weakness of these communities is that they provide an attractive location for the building of holiday or retirement homes by people from outside the community, usually from big cities far away. These newcomers rarely have any knowledge of or sympathy for the linguistic situation of the communities into which they move and can upset an evenly balanced linguistic equilibrium in a bilingual area. These newcomers, since they have no roots in the community, are not investors and bring no economic benefit with them.

The dire economic situation of these communities has led the governments of some of the states concerned to initiate industrialization schemes. In the absence of natural resources the industries established under these schemes were frequently of a kind that had no relation to the ecology or natural potential of the district. In the absence of an industrial tradition in these remote districts management and expertise had to be imported from outside, thus introducing a new factor into the linguistic situation. Some of the workers thus introduced made brave efforts to integrate both socially and linguistically with the local community. If they did not themselves always succeed in this, their children who attended the local schools frequently did.

Today the prognosis for the four surviving languages is gloomy. The trends which in recent centuries have reduced them to such a state of weakness continue to affect them. These trends seem to be leading to the loss of perhaps three of the languages as traditional community vernaculars during the twenty-first century. A hundred years from now there will still be native speakers of Irish, Scottish, Gaelic, and perhaps of Breton living. There may even be houses in which the languages are spoken in the privacy of the family. But it is unlikely that there will be any districts left in which these languages will be the accepted medium of communication outside the home. The Welsh language too may be expected to decline further in the next century, but it will probably be still surviving as a community language in a reduced area one hundred years from now.

With the final disappearance of the Celtic languages there will be no further excuse for referring to the peoples of Brittany, Ireland, Scotland, and Wales as Celts, for there was never any justification other than the linguistic one for that appellation. Without their languages the populations of these countries will more easily lose their identity and be absorbed into the dominant cultures of Britain and France, ultimately to be swallowed up in a greater European identity. Thus will end a cultural and literary tradition which reaches back on the islands of Britain and Ireland to the end of the Roman Empire. This will be the first time that a European linguistic family with such a long and distinguished literary history will have passed into oblivion.

The Celtic alphabet in a wall poster created by T.C. Evans and drawn by Chr. Evans Wales 19th century

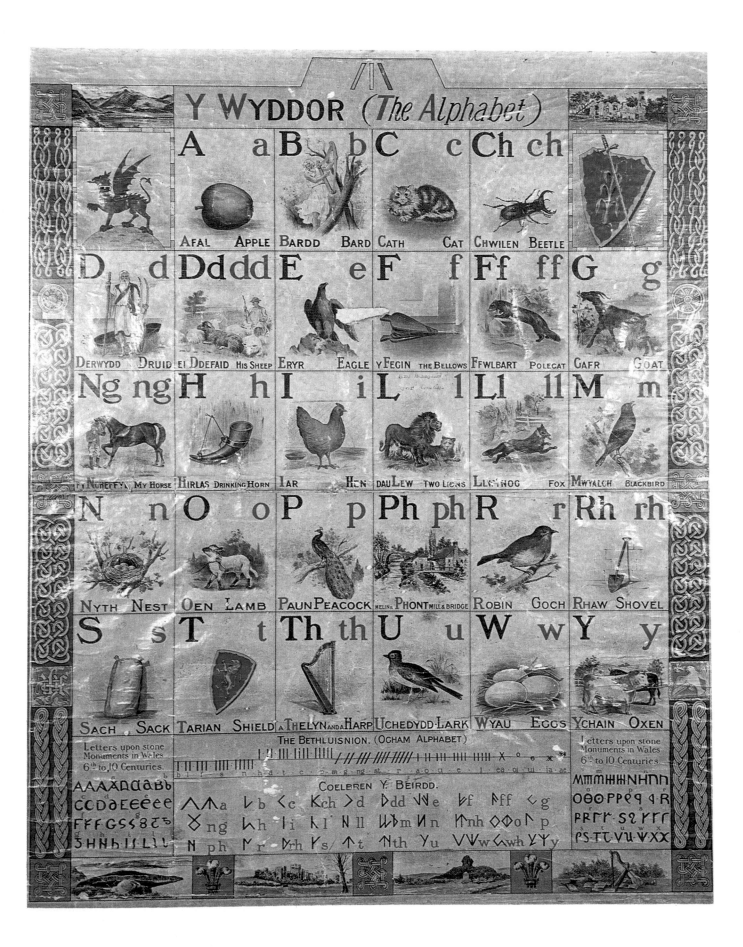

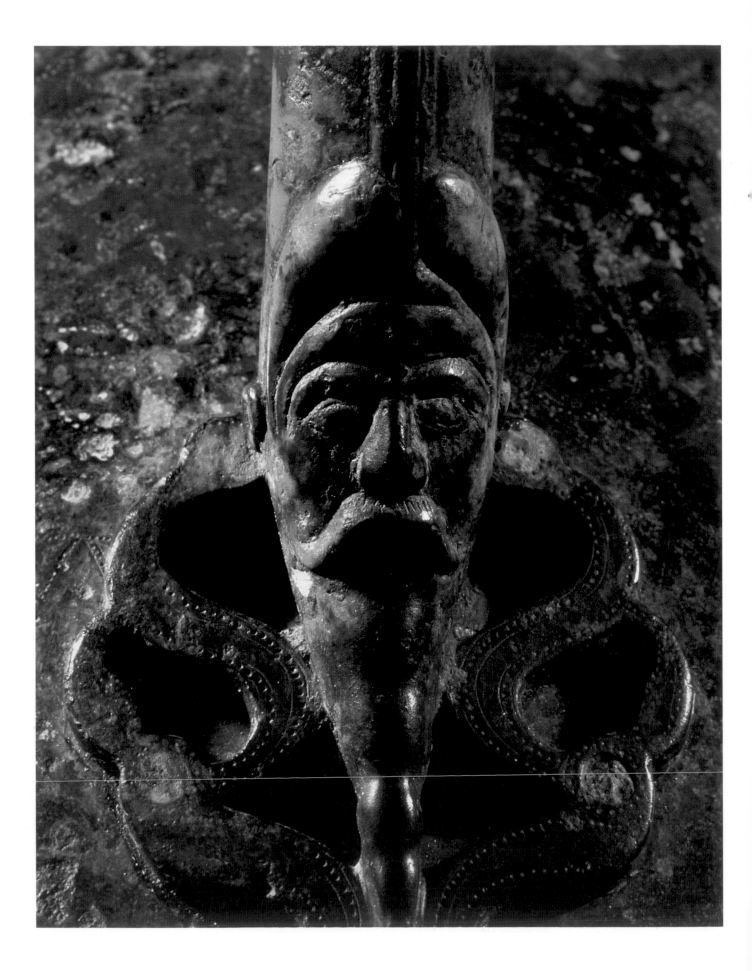

Sabatino Moscati

Final Considerations

When the visitor to the Venetian exhibition has finished reading or glancing through this catalogue, he will be struck by three things: its importance, its complexity and its originality. Importance: a work of this scope about the Celts has never before been attempted. It is not merely a question of appearances. A vast équipe of scholars from all over Europe took part in the project, eloquent proof of how much can, and should, be said by those people who, for one reason or another, have made this subject a life-interest. It means that as a result of the exhibition our knowledge has been enormously increased, and that is certainly the first, most important achievement.

One cannot fail to notice how the exhibition and the catalogue complement one another. The exhibition offers a vital visual demonstration of that increase in knowledge; the catalogue perpetuates that knowledge in images, classifies it, but above all integrates it by pooling the expertise of the scholars of the Celtic world. The result of this joint endeavor is unique and will be very hard to equal, at least in the immediate future.

Complexity: the ample space devoted in the catalogue to specific areas and even simply to specific localities is not simply a pedantic whim, indeed it was not even planned. The fact is that once we started moving in to take a closer look, we realized that analysis far outweighed synthesis, that is to say, every region and every place possessed its own special features that could not be ignored if the risk of falling not only into generalities but into generalizations was to be avoided.

So the general background material has remained, but even more space has been given over to specific subjects (to areas and localities, as mentioned earlier, but sometimes to special topics). The result is something in the nature of an encyclopaedia, a work meant not only to be read but to be consulted. And, as an encyclopaedia on the Celts had never been produced, it is clear that the present catalogue will provide that which all valid works of the kind provide: an inexhaustible store of knowledge for future study and research.

Originality: whoever compares this catalogue (and the relative exhibition) with past catalogues (and exhibitions) on the Celts will be struck by how much more we now know about this people, and how greatly our perception of them has changed. Whole eras that were once cloaked in shadow have now come looming forth into the light; little-known places have gained identity, some unique feature having been revealed by recent research. What emerges is not only a synthesis of prior knowledge, throroughly studied or not, but previously known evidence and fresh evidence flow together to create an utterly different perspective, in which old equilibriums vanish and new ones leap to take their place.

A few specific cases, not to give examples (which could go on forever) but to lend force to the argument: the discoveries at Monterenzio, near Bologna, not only enrich our knowledge of the penetration of the Celts into central-north Italy, but shed new light on how and when they encountered other peoples, first the Etruscans, then the Romans; the discoveries at Hochdorf, near Stuttgart, not only enhance our resources on the oldest Celtic civilization, but open fresh perspectives on the structure and "nature of an aristocratic society."

As to the ancient Bibracte (mod. Mont-Beauvray), it introduces a particularly striking novelty in its organizational implications. Excavations uncovered the amazing and grandiose urban structures of a famous Celtic settlement, but no less amazing is the fact that, for the first time, they were unearthed by an international team of archaeologists. New Europe looking for old Europe.

So much for the first impression created by the exhibition and the related catalogue. Let us now go on into greater detail.

Regarding the Celts themselves, the main phase of their history and civilization is the one that began in the fifth century with what is known as the La Tène culture, then expanded vigorously in the fourth and third centuries, reaching its peak in the second and first centuries with the remarkable advent of the *oppida*. But before this phase (actually a series of phases) is a seventh-to sixth-century period that has taken on greater and greater importance, the so-called Hallstatt culture, noted for the frequent occurrence of aristocratic "wagon burials."

This Hallstatt period, which is not only the oldest Celtic culture, but also extremely homogeneous and of outstanding quality, now has to be taken seriously into account. The typology of the settlements, burial rites and particular objects seems to indicate a relatively compact area north of the Alps, a sort of point of departure for later developments. The appearance in precisely this period of certain crafts, goldworking, for example, points to the existence of workshops attached to aristocratic courts and organized according to precise and unchanging rules and regulations.

Moving on to the next phase, and stopping in particular to consider the Celtic expansion over all of Europe, the very extent of the phenomenon becomes more and more impressive, characterized, by an enduring and highly qualitative material culture. Other contemporary peoples, the Scythians and Iberians, for example, had no comparable cultural influence in Europe. Varied as the distinctive regional features of Celtic culture may be, there is undoubtedly a common denominator which makes it possible to describe it as "early European."

What is most striking about Celtic culture is its continuity and the survival of certain elements well beyond antiquity. Truly extraordinary, indeed unique, is its appearance in the British Isles which became a permanent "repository" of Celtic forms of culture whence the Celtic heritage in Irish Christian art and the epic legends of the Middle Ages.

The art of Ireland, which was converted to Christianity in the fifth century A.D., also spread to the continent with its illuminated manuscripts, reaching its zenith between the seventh and eighth centuries. This art of Celtic origin is also distinguished by a series of carved tombstones and metal work. The geometric and ornamental motifs which appear on the stones along with Christian symbols compare with the illuminations, eloquently pointing to an enduring tradition in which the ancient heritage of the Celts lives on. On the other hand, the goldwork that has recently come to light continues the ancient curvilinear patterns, leaf motifs and interlacings of stylized human figures, inspiring the decorations on the stone cross.

As for Irish Celtic literature, preserved in manuscripts of the tenth-twelfth century A.D., but in their earliest versions going back to the seventh-eighth century, it gathers and transmits those epic legends which make up the first great European body of vernacular literature, representing the main source for reconstructing a society and a spiritual world silted over by time. So the language not only helps preserve a centuries-old heritage, but perpetuates it as well. Celtic dialects are still spoken today, and this is the only known instance of the preservation of a language of the vanished civilizations of the ancient world.

While seeking to focus on all cultural aspects, an exhibition clearly cannot help emphasizing the so-called material evidence, the works, that is, of craftsmanship and art. In this respect, the visitor to the exhibition (and the reader of the catalogue) will immediately notice that the "minor" arts take precedence. Celtic architecture certainly existed, but mostly in wood, of which little remains. Sculpture certainly existed too, also in wood, as is testified by the recent discoveries of several votive heads. There are examples of stone, carved into images of deities or heroic likenesses of the dead. But, generally speaking, it must be admitted that as important as these finds are, they are rare.

Instead, small objects prevail, especially in metal; first of all gold, which appears in jewelry but also in the plating of weapons, and then silver and electrum. Tin and copper are rather uncommon, used mostly for trimming or decoration. Bronze was very popular and was used for ornaments, arms, receptacles, chariot fittings. Iron, used mainly for arms, appears to have been very skillfully cast.

Clay was another common material, and though the articles never achieved the importance they had in other cultures, they are unique for the introduction of other materials into the clay matrix, such as the graphite pottery of Bohemia. Glass was relatively widely used for making ornaments of various kinds, and vitreous paste for fusing a polychrome glaze on gold and bronze. Coral and amber, which point to the existence of two important early European trade routes, must also be mentioned.

As for technical expertise, the shaping of raw metal into finished products involves several

methods: hammering, embossing, mold casting, and "lost wax." The surfaces of finished metal objects were further decorated by means of chasing, piercing, engraving, pricking, embossing, often in combination. Enameling, tin- and silver-plating were "multimedia" techniques. But granulation and filigree, so popular in the Mediterranean area, were lacking (and the lack itself became a distinguishing feature).

Of particular interest in all Celtic crafts is the tendency toward polymaterialism, that is, the combination of diverse materials in a single object. This tendency—which the Celts shared with other artistic cultures specialized in decoration and ornament—clearly shows a fondness for bright colors; had their painting and multicolored fabrics survived, we would know much more about this.

The weapons stand out for their diversity. Attack weapons include swords, with mounts and incised ornament on their scabbards, daggers with simular mounts and ornament, spears with iron spearheads and shafts decorated with mounts and incised ornament. Bows and arrows, on the other hand are rare, and the only record we have of them are in representations on coinage. Defensive weapons included metal helmets, with incised or embossed ornament and numerous accessories, such as horns, plumes, and crests and wooden shields overlaid with metal or leather and with bronze mounts and a central boss.

Ornamented bronze phalerae and belt buckles complete the warrior equipment. Battle and processional chariots were found in early period tombs and were decisive in reconstructing the society. They were the hallmark of the aristocracy, as is borne out by the rich decorations on the metal-plated wooden boxes, the hubs, and rings. Each "princely" tomb presents an aspect of Celtic life, and as such may be held up as the symbol of a society.

The array of ornaments is rich, for both men and women. Fibulae are particularly abundant, and women sometimes wore them several at a time to fasten clothes over their shoulders and breasts. Such quantitites of them were found that they became instrumental in identifying different periods and areas of influence. Also frequently found were sheet gold and bronze strips and finely wrought enameled belt-chains. In addition there are rings, bracelets, earrings, necklaces and anklets, as well as that most characteristic of Celtic ornaments, the torque.

Other finds are related to the eating habits of the aristocracy: cups, bowls, goblets, as well as receptacles for carrying liquids such as basins, buckets, cauldrons and the characteristic drinking horns, often in pairs. The richly molded ornament, together with the preciousness of the metal, gave evidence of the fine quality of this production and was probably an accessory to its ultimate purpose, which was also votive, ritual magic elements being associated with the figures of serpents, dragons and various symbols. Some examples of ornaments with mythological figures appear, bearing out this supposition.

Lastly, the coins are one of the finest achievements of Celtic craftsmanship. And also one of the most significant in that they stem from contact with other cultures (Graeco-Roman and also Etruscan), illustrating the principle of action, reaction, interaction that came into play during the late phase of the Celtic world and in whatever milieu the Celts happened to be. If in other aspects of Celtic craftsmanship there was neither reaction nor interaction, in their coins both were present to the highest degree.

It has been a necessary and worthwhile step to linger over the distinctive elements of Celtic craftsmanship, as afforded by archaeology and featured in the present exhibition, in order to form an opinion of the culture they express. In the broad sense of the term, the Celts were, well, a "barbarian" civilization, like others that were to appear between the end of antiquity and the start of the Middle Ages—but only provided the word "barbarian" is purged of all negative connotations and restored to the original meaning given it by the Greeks and Romans, that is, "foreigner."

Coping with "barbarians" at the borders is a dominant (and often distressing) theme in the history of the ancient world. But the absolute originality of the Celts lies in the fact that they set a precedent for—were not simply antecedent to—the Roman Empire. They are in

a certain sense the first "barbarians" in history or, if you will, the forerunners of the "barbarians." The dearth of architectural remains, the prevalence of the minor arts, the flamboyant imagination that overrides the borders of reality, the widespread use of metals and chromatic effects achieved with the juxtaposition of various materials, and even the lack of an old substantial (and conserved) literary tradition, at a time when Greek literature was at its peak and Roman literature was fast evolving: these are all idiosyncracies attributed (we repeat, with no negative implication) to "barbarian" peoples.

And lastly, let us speak of art in metaphysical terms. Let us ask if, aside from the formal aspects we have dwelt upon, this art possesses intrinsic qualities of its own. Well, let the visitor to the exhibition observe the extraordinary way human and plant forms are stylized, schematized, shaped into ornamentation. While in the Graeco-Roman world, classical beauty triumphed, here the disintegration of organic form runs wild: human faces take on fantastic shapes, animals turn into complicated geometric patterns, a world of curves and ornamentations in which organic form turns into abstraction and abstraction leans towards (or harks back to) organic form.

We are without question in the presence of the oldest, the greatest, and the most illuminating ornamental art Europe has even known. It is the first instance in history of the great tension between illusion and reality, between the instinct to copy natural figures and the instinct to alter them in order to express meanings that are complex, symbolic, often rendered ambiguous under the very pressure of allusion, certainly surreal. And if in the history of art the trend is sometimes from the organic to the abstract and sometimes the opposite, Celtic art is certainly an instance of the former.

All of which is very modern. And an element returns that struck us as peculiar to the Palazzo Grassi projects from the start: the desire to understand "others" as a way of understanding ourselves. Is it mere coincidence that the first two great exhibitions were devoted to Futurism and the Phoenicians? We think not, and even if it were a coincidence, we would suggest that it be disregarded as such and applied as a general rule, an afterthought, if you will, but a good one.

It is, in fact, the fate of initiatives that seek to be completely new, international and intercontinental in scope, up-to-date in their reflection of emergent and highly reputable scholarship; it is their fate to so discriminate themselves that they end up antagonizing, or at least alienating themselves from, the necessarily restricted milieu that is ours. There are exhibitions galore of Italian antiquities. Naturally they receive the support of government agencies, whose job it is to watch over those Italian territories where the relative cultures sprang up. But who is to watch over the territory of the Phoenicians or the Celts, or tomorrow the ancient peoples of America and Africa who, we thought, were completely devoid of antiquities and who, instead, are overflowing with them, their apparently modern cultures springing from deep hidden roots. To preserve an ever greater, ever more original, ever more illuminating openness of mind, alive to the enormous impact its first two undertakings had on the cultural world at large: that is Palazzo Grassi's fond wish.

The Ancient Writers

The Celtic Image

The Gauls are tall of body, with rippling muscles, and white of skin, and their hair is blond, and not only naturally so, but they also make it their practice by artificial means to increase the distinguishing color which nature has given it. For they are always washing their hair in lime-water, and they pull it back from the forehead to the top of the head and back to the nape of the neck..., since the treatment of their hair makes it so heavy and coarse that it differs in no respect from the mane of horses. Some of them shave the beard, but others let it grow a little; and the nobles shave their cheeks, but they let the moustache grow until it covers the mouth...
The clothing they wear is striking—shirts which have been dyed and embroidered in varied colors, and breeches, which they call in their tongue *bracae*; and they wear striped coats, fastened by a buckle on the shoulder; heavy for winter wear and light for summer, in which are set checks, close together and of varied hues.
Diodorus Siculus, *Library of History*, V, 28-30

The whole race which is now called both "Gallic" and "Galatic" is war-mad, and both high-spririted and quick for battle, although otherwise simple and not ill-mannered. And therefore, if roused, they come together all at once for the struggle, both openly and without circumspection, so that for those who wish to defeat them by stratagem they become easy to deal with (in fact, irritate them when, where, or by what chance pretext you please, and you have them ready to risk their lives, with nothing to help them in the struggle but might and daring); whereas, if coaxed, they so easily yield to considerations of utility that they lay hold, not only of training in general, but of language-studies as well. As for their might, it arises partly from their large physique and partly from their numbers. And on account of their trait of simplicity and straightforwardness they easily come together in great numbers, because they always share in the vexation of those of their neighbors whom they think wronged.
Strabo, *Geography*, IV, 4.2

In addition to their trait of simplicity and high-spiritedness, that of witlessness and boastfulness is much in evidence, and also that of fondness for ornaments; for they not only wear golden ornaments—both chains round their necks and bracelets round their arms and wrists—but their dignitaries wear garments that are dyed in colors and sprinkled with gold.
Strabo, *Geography*, IV, 4.5

All the tribes there immediately surroundered to him, for while the Gauls are quick and eager to start wars, they lack the deter-mination and strength of character needed to carry on when things go against them.
Caesar, *Gallic War*, III, 19

I was aware that almost all the Gauls were eager for political change, and were quickly and easily roused to war.
Caesar, *Gallic War*, III, 10

...the Gauls had to resort to all kinds of devices; they are a most ingenious race, very good at imitating and making use of any ideas suggested to them by others.
Caesar, *Gallic War*, VII, 22

It is a custom of theirs to force travellers to stop, even if they don't wish to, and question them about what they have heard or found out on this subject or that; in the *oppida* a crowd gathers around traders and forces them to say what country they have come from and what information they have gathered there. Influenced by these reports, even when they are hearsay, the Gauls frequently adopt plans about important matters, which they are bound to regret almost immediately, since they are slaves to unsubstantiated rumours and most of the people they question make up answers they think will please them.
Caesar, *Gallic War*, IV, 5

For when something important or remarkable happens, the people shout the news of it to one another through the whole country; one after another they take up the report, passing it on to their neighbours. That is precisely what happened.
Caesar, *Gallic War*, VII, 3

...when they meet together they converse with few words and in riddles, hinting darkly at things for the most part and using one word when they mean another; and they like to talk in superlatives, to the end that they may extol themselves and depreciate all other men. They are also boasters and threateners and are fond of pompous language, and yet they have sharp wits and are not without cleverness at learning.
Diodorus Siculus, *Library of History*, V, 31

Institutions and Customs

Throughout Gaul there are only two classes of men who are of any account or importance... the druids and the knights... the druids act as judges. If a crime is committed, if there is a murder, or if there is a dispute about an inheritance or a boundary, they are the ones who give a verdict and decide on the punishment or compensation appropriate in each case. Any individual or community not abiding by their verdict is banned from the sacrifices, and this is regarded among the Gauls as the most severe punishment... There is one druid who is above all the rest, with supreme authority over them. When he dies, he is succeeded by whichever of the others is most distinguished. If there are several of equal distinction, the druids decide by vote, though sometimes they even fight to decide who will be their leader.
On a fixed date each year they assemble in a consecrated place in the territory of the Carnutes; that area is supposed to be the centre of the whole country of Gaul. People who have disputes to settle assemble there from all over the country and accept the rulings and judgments of the druids.
Caesar, *Gallic War*, VI, 13

The second class is that of the knights. Whenever a war breaks out and their services are required they are all involved in the campaign, each one attendend by as many retainers and dependants as his birth and wealth make possible.
Caesar, *Gallic War*, VI, 15

When their enemies fall they cut off their heads and fasten them about the necks of their horses; and turning over to their attendants the arms of their opponents, all covered with blood, they carry them off as booty, singing a paean over them and striking up a song of victory, and these first-fruits of battle they fasten by nails upon their houses, just as men do, in certain kinds of hunting, with the heads of wild beasts they have mastered. The heads of their most distinguished enemies they embalm in cedar-oil and carefully preserve in a chest, and these they exhibit to strangers, gravely maintaining that in exchange for this head some one of their ancestors, or their father, or the man himself, refused the offer of a great sum of money. And some men among them, we are told, boast that they have not accepted an equal weight of gold for the head they show, displaying a barbarous sort of greatness of soul; for not to sell that which constitutes a witness and proof of one's valour is a noble thing...
Diodorus Siculus, *Library of History*, V, 29

Crafts and Economy

For money they use bronze or gold coins, or iron ingots of fixed standard weights.

Caesar, *Gallic War*, V, 12

The Gauls' own ships were built and rigged in a different way from ours. Their keels were somewhat flatter, so they could cope more easily with the shoals and shallow water when the tide was ebbing; their prows were unusually high, and so were their sterns, designed to stand up to great waves and violent storms. The hulls were made entirely of oak to endure any violent shock or impact; the cross-beams, of timbers a foot thick, were fastened with iron bolts as thick as a man's thumb; and the anchors were held firm with iron chains instead of ropes. They used sails made of hides or soft leather, either because flax was scarce and they did not know how to use it, or, more probably, because they thought that with cloth sails they would not be able to withstand the force of the violent Atlantic gales, or steer such heavy ships. When we encountered these vessels, our only advantage lay in the speed and power of our oars; in other respects the enemy's ships were better adapted for the violent storms and other conditions along that coast.

Caesar, *Gallic War*, III, 13

The inhabitants of Britain who dwell about the promontory known as Belerium... work the tin, treating the bed which bears it in an ingenious manner. This bed, being like rock, contains earthy seams and in them the workers quarry the ore, which they then melt down and cleanse of its impurities. Then they work the tin into pieces the size of knuckle-bones and convey it to an island (*where*) at ebb-tide the space between this island and the mainland becomes dry and they can take the tin in large quantities over to the island on their wagons ...On the island of Ictis the merchants purchase the tin of the natives and carry it from there across the Strait to Galatia or Gaul; and finally, making their way on foot through Gaul for some thirty days, they bring their wares on horseback to the mouth of the river Rhone.

Diodorus Siculus, *Library of History*, V, 22

Consequently many of the Italian traders, induced by the love of money which characterizes them, believe that the love of wine of these Gauls is their own godsend. For these transport the wine on the navigable rivers by means of boats and through the level plain on wagons, and receive for it an incredible price; for in exchange for a jar of wine they receive a slave, getting a servant in return for the drink.

Diodorus Siculus, *Library of History*, V, 26

Directly opposite the part of Scythia which lies above Galatia there is an island out in the open sea which is called Basileia. On this island the waves of the sea cast up great quantities of what is known as amber, which is to be seen nowhere else in the inhabited world... and (*which*) is brought by the natives to the opposite continent and conveyed through the continent to the regions known to us, as we have stated.

Diodorus Siculus, *Library of History*, V, 23

Throughout Gaul there is found practically no silver, but there is gold in great quantities, which Nature provides for the inhabitants without their having to mine for it or to undergo any hardship. For the rivers, as they course through the country, having as they do sharp bends which turn this way and that and dashing against the mountains which line their banks and bearing off great pieces of them, are full of gold-dust. This is collected by those who occupy themselves in this business, and these men grind or crush the lumps which hold the dust, and after washing out with water the earthy elements in it they give the gold-dust over to be melted in the furnaces. In this manner they amass a great amount of gold, which is used for ornament not only by the women but also by the men. For around their wrists and arms they wear bracelets, around their necks heavy necklaces of solid gold, and huge rings they wear as well, and even corselets of gold.

Diodorus Siculus, *Library of History*, V, 27

The Art of War

The Gallic armour is commensurate with the large size of their bodies: a long sword, which hangs along the right side, and a long oblong shield, and spears in proportion, and a "madaris," a special kind of javelin.

Strabo, *Geography*, IV, 4, 3

The Insubres and Boii were clothed in their breeches and light cloaks; but the Gaesatae from vanity and bravado threw these garments away, and fell in front of the army naked, with nothing but their arms...

Polybius, *Histories*, II, 28, 7-8

They (*the Romans*) had learned from former engagements that Gallic tribes were always most formidable at the first onslaught, before their courage was at all damped by a check; and that the swords with which they were furnished, as I have mentioned before, could only give one downward cut with any effect, but that after this the edges got so turned and the blade so bent, that unless they had time to straighten them with their foot against the ground, they could not deliver a second blow. The Tribunes accordingly gave out the spears of the Triarii, who are the last of the three ranks, to the first ranks, or Hastati: and ordering the men to use their swords only, after their spears were done with, they charged the Celts full in front.

Polybius, *Histories*, II, 33, 2-4

Some of the enemy hurled spears, others advanced on us with their shields held up to form a protective shell, and as their men became exhausted, fresh troops came up to relieve them.

Caesar, *Gallic War*, VII, 85

The Helvetii pursued us with all their wagons. They collected their baggage together in one place, then lining up in very close order, they drove our cavalry back, formed a phalanx, and moved up toward our front line.

Caesar, *Gallic War*, I, 24

Although the fighting lasted from early afternoon until evening, in this entire engagement, we saw not a single one of them running away. Around their baggage pile the fighting went on well into the night; they had made a barricade of their wagons and kept hurling weapons down on our men as they came up, and there were some low down between the wheels of the wagons, who were causing casualties among our men by hurling spears and javelins up at them.

Caesar, *Gallic War*, I, 26

Some documents, written in Greek script, were discovered in the Helvetian camp and brought to me. The grand total was 368,000, made up of 263,000 Helvetii, 36,000 Tulingi, 14,000 Latovici, 23,000

Raurici and 32,000 Boii. About 92,000 of these were capable of bearing arms.

Caesar, *Gallic War*, I, 29

...for the enemy, standing up and holding their weapons in chariots and wagons, bore down on them with a fearful noise of horses' hooves and wheels, and terrified the Romans' horses with the unusual din. Their confusion spread to the standards of the legions, and many of the first line were trampled underfoot by the horses and vehicles sweeping through the army.

Livy, *History of Rome*, X, 28

These are the tactics of chariot warfare. First they drive in all directions hurling spears. Generally they succeed in throwing the ranks of their opponents into confusion just with the terror caused by their galloping horses and the din of the wheels. They make their way through the squadrons of their own cavalry, then jump down from their chariots and fight on foot. Meanwhile the chariot-drivers withdraw a little way from the fighting and position the chariots in such a way that if their masters are hard pressed by the enemy's numbers, they have an easy means of retreat to their own lines. Thus when they fight they have the mobility of cavalry and the staying power of infantry; and with daily training and practice they have become so efficient that even on steep slopes they can control their horses at full gallop, check and turn them in a moment, run along the pole, stand on the yoke and get back into the chariot with incredible speed.

Caesar, *Gallic War*, IV, 33

All Gallic walls are built roughly on this plan. Wooden beams are laid on the ground at regular intervals of two feet along the whole length of the wall and at right angles to it. They ware fastened together on the inside and covered with a thick layer of rubble; at the front large stones are used to form a facing, which fills in the spaces between the timbers. When this first course has been laid and made firm, another is added. This is set on top in such a way that although there is a two-foot space between its timbers as well, they do not touch those of the first course but are separated from them by a vertical interval of two feet. A large stone is inserted to keep every beam apart from each of its neighbors and so the timbers are held firmly in position. One course is added to another in this way and the fabric is built up until the wall reaches the required height. The varied appearance resulting from this method of construction is not unsightly, with alternating timbers and stones running in straight rows at proper intervals from each other. It is also a very useful structure, ideally suited for the defense of towns. The stonework pro-

tects against fire and the timber against battering rams; for rams cannot pierce or shake to bits such a structure, secured as it is on the inside by continous timbers up to 40 feet long.

Caesar, *Gallic War*, VII, 23

(*The Aduatuci*) had fortified this place with a very high double wall on which they were now setting heavy stones and great wooden beams sharpened to a point.

Caesar, *Gallic War*, II, 29

(*The Aduatuci*) threw a great number of weapons down from the wall into the ditch in front of their *oppidum*; there were so many that the piles of weapons reached nearly to the top of the wall and of our siege-terrace. However, as became clear afterwards... some of them were armed with the weapons they had kept hidden, others with shields made of bark or wickerwork, which they had hastily covered with skins for they had no time to spare.

Caesar, *Gallic War*, II, 32-33

The Gauls and the Belgae use the same method of attacking such places. They begin by surrounding its entire wall with a large number of men and hurling stones at it from all sides. When this has stripped the wall of its defenders, they hold up their shields to provide a protective shell, set fire to the gates, and begin to undermine the wall.

Caesar, *Gallic War*, II, 6

The Aristocratic Society

By far the richest and most distinguished man among the Helvetii was one Orgetorix... He started a conspiracy among the nobles of the tribe and persuaded the people to move out of their territory, taking all their forces with them.

Caesar, *Gallic War*, I, 2

Dumnorix was popular and generous and so had great influence with the Sequani; he was a friend of the Helvetii because his wife, the daughter of Orgetorix, was one of them. His ambition was to be king, he was eager for political change and wanted to have as many tribes as possible bound to him by ties of gratitude.

Caesar, *Gallic War*, I, 9

...there were among the Aedui some men who had very great influence over the people and who, though private individuals, had more power than the magistrates themselves.

Caesar, *Gallic War*, I, 17

Religion

The Gallic people as a whole are extremely superstitious. Consequently, people suffering from serious illnesses, and people involved in the dangers of battle, make, or promise to make, human sacrifice; the druids officate at such sacrifices.

The Gauls believe the power of the immortal gods can be appeased only if one human life is exchanged for another, and they have sacrifices of this kind regularly established by the community. Some of them have enormous images made of wickerwork, the limbs of which they fill with living men; these are set on fire and the men perish, enveloped in the flames. They believe that the gods prefer it if the people executed have been caught in the act of theft or armed robbery or some other crime, but when the supply of such victims runs out, they even go to the extent of sacrificing innocent men.

The god they worship most is Mercury, and they have very many images of him. They regard him as the inventor of all the arts, the guide of all their roads and journeys, and the god who has greatest power for trading and moneymaking. After Mercury they worship Apollo, Mars, Jupiter, and Minerva, having almost the same ideas about these gods as other peoples do: Apollo averts diseases, Minerva teaches the first principles of industry and crafts, Jupiter has supremacy among the gods, and Mars controls warfare.

When they have decided to fight a battle, it is to Mars that they usually dedicate the spoils they hope to win; and if they are successful, they sacrifice the captured animals and collect all the rest of spoils in one place. Among many of the tribes it is possible to see piles of these objects on consecrated ground. It is most unusual for anyone to dare to go against the religious law and hide his booty at home, or remove any of the objects that have been placed on such piles. The punishment laid down for that crime is death by the most terrible torture.

Caesar, *Gallic War*, VI, 16-17

The Gauls claim that they are all descended from Father Dis; they say this is the tradition handed down to them by the druids. For this reason they reckon periods of time not in days but in nights; in celebrating birthdays, the first of the month, and the beginning of a year, they go on the principle that night comes first and is followed by day.

Caesar, *Gallic War*, VI, 18

However, not only the druids, but others as well, say that men's souls, and also the universe, are indestructible, although both fire and water will at some time or other prevail over them.

Strabo, *Geography*, IV, 44

The druids are exempt from military service and do not pay taxes like the rest. Such significant privileges attract many students, some of whom come of their own accord to be taught, while others are sent by parents and relatives.

It is said that during their training they learn by heart a great many verses, so many that some people spend 20 years studying the doctrine. They do not think it right to commit their teachings to writing, although for almost all other purposes, for example, for public and private accounts, they use the Greek alphabet. I suppose this practice began originally for two reasons: they did not want their doctrines to be accessible to the ordinary people, and they did not want their pupils to rely on the written word and so neglect to train their memories. For it does usually happen that if people have the help of written documents, they do not pay as much attention to learning by heart, and so let their memories become less efficient. The druids attach particular importance to the belief that the soul does not perish but passes after death from one body to another; they think that this belief is the most effective way to encourage bravery because it removes the fear of death. They hold discussions about the heavenly bodies and their movements, about the size of the universe and the earth, about the nature of the physical world, and about the power and properties of the immortal gods, subjects in which they also give instruction to their pupils.

Caesar, *Gallic War*, VI, 14

The Celts in Italy

...the most northerly plains of Italy, the largest and most fertile of any with which I am acquainted in all Europe.

Polybius, *Histories*, II, 14

The yield of corn in this district is so abundant that wheat is often sold at four obols a Sicilian medimnus, barley at two, or a metretes of wine for an equal measure of barley.

The quantity of panic and millet produced is extraordinary; and the amount of acorns grown in the oak forests scattered about the country may be gathered from the fact that, though nowhere are more pigs slaughtered than in Italy, for sacrifices as well as for family use, and for feeding the army, by far the most important supply is from these plains.

The cheapness and abundance of all articles of food may also be clearly shown from the fact that travellers in these parts, when stopping at inns, do not bargain for particular articles, but simply ask what the charge is per head for board. And for the most part the innkeepers are content to supply their guests with every necessary at a charge rarely exceeding half an as (that is, the fourth part of an obol) a day each.

Polybius, *Histories*, II, 15

Their chief intercourse was with the Celts, because they occupied the adjoining districts; who, envying the beauty of their lands, seized some slight pretext to gather a great host and expel the Etruscans from the valley of the Padus, which they at once took possession of themselves.

Polybius, *Histories*, II, 17

There is a tradition that it was the lure of Italian fruits and especially of wine, a pleasure then new to them, that drew the Gauls to cross the Alps and settle in regions previously cultivated by the Etruscans. Arruns of Clusium, the story goes, had sent wine into their country deliberately to entice them over, as he wanted his revenge for the seduction of his wife by his ward Lucumo, a man in too powerful a position to be punished except by the help of foreigners called in for the purpose.

It was he who guided the Gallic hordes over the Alps and suggested the attack on Clusium.

Livy, *History of Rome*, V, 33

Now I have no wish to deny that Gauls were brought to Clusium by Arruns, or some other citizen of that town, but it is, none the less, generally agreed that these were by no means the first Gauls to cross the Alps.

Two hundred years before the attack on Clusium and the capture of Rome, men of this race came over into Italy...

Livy, *History of Rome*, V, 33

The gods were duly consulted, with the result that so Segovesus were assigned the Hercynian uplands in South Germany while Bellovesus was granted the much pleasanter road into Italy; whereupon collecting the surplus population—Bituriges, Arverni, Senones, Aedui, Ambarri, Carnutes, Aulerci—he set out with a vast host, some mounted, some on foot, and reached the territory of the Tricastini at the foot of the Alps...

There, then, stood the Gallic host, brought to a halt by the towering wall, and looking for a way over those skiey peaks into another world... they then themselves crossed the Alps by the Taurine passes and the pass of Duria, defeated the Etruscans near the river Ticinus, and, having learnt that they were in what was known as the territory of the Insubres, the same name as one of the cantons of the Aedui, took it as another favourable omen and founded the town of Mediolanum (*Milan*).

Livy, *History of Rome*, V, 34

...(*the lands near*) the Padus (*were*) occupied by the Laevi and Lebecii; after them the Insubres settled in the country, the largest tribe of all; and next them, along the bank of the river, the Cenomani. But the district along the shore of the Adriatic was held by another very ancient tribe called the Veněti, in customs and dress nearly allied to Celts, but using quite a different language, about whom the tragic poets have written a great many wonderful tales.

South of the Padus, in the Apennine district, first beginning from the west, the Ananes, and next them the Boii settled. Next them, on the coast of the Adriatic, the Lingones; and south of these, still on the sea-coast, the Senones.

Polybius, *Histories*, II, 17

They lived in open villages, and without any permanent buildings. As they made their beds of straw or leaves, and fed on meat, and followed no pursuits but those of war and agriculture, they lived simple lives without being acquainted with any science or art whatever.

Each man's property, moreover, consisted in cattle and gold; as they were the only things that could be easily carried with them, when they wandered from place to place, and changed their dwelling as their fancy directed. They made a great point, however, of friendship: for the man who had the largest number of clients or companions in his wanderings, was looked upon as the most formidable and powerful member of the tribe.

Polybius, *Histories*, II, 17

Accordingly the two most extensive tribes, the Insubres and Boii, joined in the despatch of messengers to the tribes living about the Alps and on the Rhone, who from a word which means "serving for hire," are called Gaesatae...

The Gaesatae, then, having collected their forces, crossed the Alps and descended into the valley of the Padus with a formidable army, furnished with a variety of armor, in the eighth year after the distribution of the lands of Picenum.

Polybius, *Histories*, II, 22-23

The Celts beyond the Alps

The name Transalpine is not tribal, but local, from the Latin proposition *trans*, "across".

Polybius, *Histories*, II, 16

Gaul as a whole consists of three separate parts; one is inhabited by the Belgae, another by the Aquitani and the third by the people we call Gauls, through in their own language they are called Celts. In language, customs and law these three peoples are quite distinct. The Celts are separated from the Aquitani by the river Garonne, and from the Belgae by the Marne and the Seine.

Of all these peoples the toughest are the Belgae. They are the farthest away from the culture and civilized ways of the Roman province, and merchants, bringing those things that tend to make men soft, very seldom reach them; moreover, they are very close to the Germans across the Rhine and are continually at war with them. For the same reason, it is the Helvetii who are the bravest of all the other Gauls because they have almost daily skirmishes with the Germans, either keeping them out of Helvetian territory or else starting hostilities on German land themselves.

The part of the country that the Celts occupy faces north; it starts at the river Rhône and is bounded by the Garonne, the Atlantic, and the territory of the Belgae, and where the Sequani and the Helvetii are, it reaches the river Rhine. The area occupied by the Belgae, which faces northeast, starts at the northernmost boundary of the Celts and extends to the lower Rhine. Aquitania starts at the Garonne and stretches to the Pyrenees and the section of Atlantic coast nearest to Spain; this part faces northwest.

Caesar, *Gallic War*, I, 1

In Gaul, not only every tribe, every canton, and every subdivision of a canton, but almost every individual household is divided into rival factions. The leaders of these factions are men thought by their followers to have the greatest prestige, and it is to their judgment and assessment that they turn in any question or discussion of policy. The reason for this long-established custom seems to have been to ensure that every man among the common people should have protection against those more powerful than himself; for no leader allows his supporters to be oppressed or cheated, and if he fails to protect them, he loses all his authority over them.

Caesar, *Gallic War*, VI, 11

Now of all the peoples of the coastal part of that area, the Veneti are by far the strongest. They have a great many ships and regularly sail to and from Britain. When it comes to knowledge and experience of navi-

gation, they leave all the other tribes standing. The sea on that coast is extremely violent and open, and the harbours few and far between. Since the Veneti control these, they are able to exact tolls from almost all those who regularly use those waters.

Caesar, *Gallic War*, III, 8

The interior of Britain is inhabited by people who claim, on the strength of their own tradition, to be indigenous. The coastal areas are inhabited by invaders who crossed from Belgium for the sake of plunder and then, when the fighting was over, settled there and began to work the land; these people have almost all kept the names of the tribes from which they originated. The population is extremely large, there are very many farm building, closely resembling those in Gaul, and the cattle are very numerous.

For money they use bronze or gold coins, or iron ingots of fixed standard weights. Tin is found there in the midland area, and iron near the coast, but not in large quantities. The bronze they use is imported. There is timber of every kind, as in Gaul, but no beech or fir. They think it wrong to eat hares, chickens, or geese, keeping these creatures only for pleasure and amusement. The climate is more temperate than in Gaul, the cold season being less severe.

The island is triangular in shape, with one side facing Gaul... The second side of the island faces westward, towards Spain. In this direction lies Ireland, which is thought to be half the size of Britain... Midway between Ireland and Britain is the Isle of Man, and it is believed that there are several smaller islands too, where, some writers say, there is continual darkness for 30 days in midwinter...

By far the most civilized of the Britons are those who live in Kent, which is an entirely maritime area; their way of life is very like that of the Gauls. Most of the tribes living in the interior do not grow grain; they live on milk and meat and wear skins. All the Britons dye their bodies with woad, which produces a blue colour and gives them a wild appearance in battle. They wear their hair long; every other part of the body, except for the upper lip, they shave.

Caesar, *Gallic War*, V, 12-14

(*Posidonius*) goes on to say that in earlier times the Boii dwelt in the Hercynian Forest, and that the Cimbri made a sally against this place, but on being repulsed by the Boii, went down to the Ister and the country of the Scordiscan Galatae, then to the country of the Teuristae and Taurisci (these, too, Galatae), and then to the country of the Helvetii—men rich in gold but peaceable; however, when the Helvetii saw that the wealth which the Cimbri had got from their robberies surpassed that of their own country, they, and particularly their tribes of Tigyreni and of Toygeni, were so excited that they sallied forth with the Cimbri. All, however, were subdued by the Romans, both the Cimbri themselves and those who had joined their expeditions, in part after they had crossed the Alps into Italy and in part while still on the other side of the Alps.

Strabo, *Geography*, VII, 2

The Galatians, then, are to the south of the Paphlagonians. And of these there are three tribes; two of them, the Trocmi and the Tolistobogii, are named after their leaders, whereas the third, the Tectosages, is named after the tribe in Celtica. This country was occupied by the Galatae after they had wandered about for a long time, and after they had overrun the country that was subject to the Attalic and the Bithynian kings, until by voluntary cession they received the present Galatia, or Gallo-Graecia, as it is called. Leonnorius is generally reputed to have been the chief leader of their expedition across to Asia. The three tribes spoke the same language and differed from each other in no respect; and each was divided into four portions which were called tetrarchies, each tetrarchy having its own tetrarch, and also one judge and one military commander, both subject to the tetrarch, and two subordinate commanders. The Council of the twelve tetrarchs consisted of three hundred men, who assembled at Drynemetum, as it was called. Now the Council passed judgment upon murder cases, but the tetrarchs and the judges upon all others.

Strabo, *Geograpy*, XII, 5, 1

The Gauls and Rome

When therefore (*the Gauls*) entered on the following day, it was coolly and calmly enough. They left a reasonably strong guard in case of attack from the fortified heights and then dispersed in search of plunder; finding the streets empty, crowds of them broke into the first houses they came to; others went further afield, presumably supposing that buildings more remote from the Forum would offer richer prizes... (*near the Forum*) they found the humbler houses locked and barred but the mansions of the nobility open; the former they were ready enough to break into, but it was a long time before they could bring themselves to enter the latter: something akin to awe held them back at what met their gaze—those figures seated in the open courtyards, the robes and decorations august beyond reckoning, the majesty expressed in those grave, calm eyes like the majesty of goods. They might have been statues in some holy place, and for a while the Gallic warriors stood entranced; then, on an impulse, one of them touched the beard of a certain Marcus Papirius—it was long, as was the fashion of those days—and the Roman struck him on the head with his ivory staff. That was the beginning: the barbarian flamed into anger and killed him, and the others were butchered where they sat. From that moment no mercy was shown; houses were ransacked and the empty shells set on fire.

Livy, *History of Rome*, V, 41

Quintus Sulpicius conferred with the Gallic chieftain Brennus and together they agreed upon the price, one thousand pound's weight of gold—the price of a nation soon to rule the world. Insult was added to what was already sufficiently disgraceful, for the weights which the Gauls brought for weighing the metal were heavier than standard, and when the Roman commander objected the insolent barbarian flung his sword into the scale, saying 'Woe to the vanquished!'— words intolerable to Roman ears.

Livy, *History of Rome*, V, 48

Authors of the Texts Quoted

Polybius (201-ca. 120 B.C.)
The forty volumes of his *Histories*, written in Greek, cover the events in the Mediterranean from 264 to 146 B.C. The Cisalpine area (where he actually visited) and the Celts are discussed in Book II. Only a few fragments remain of Book XXII which deals with Gaul. Polybius was a primary source for Livy.

Caius Julius Caesar (100-44 B.C.)
Caesar's commentaries on the Gallic War cover the period from 58 to 51 B.C. and include his observations on the Gaulish lands and their inhabitants.

Diodorus Siculus (early first ca. B.C.-ca. 20 B.C.)
Writing in Greek, Diodorus Siculus traced world history up to the end of the Gallic War in his 40, volume *Library of History*.

Titus Livius (66 B.C.-17 A.D.)
Titus Livius (Livy) wrote 142 volumes of his *History of Rome*, but only 35 survive. His approach was to take sources such as previous Roman chroniclers' work as well as Polybius, and compare them. Books V and XXI are those that contain the most information about the Celts.

Strabo (64 B.C.-21 A.D.)
A Greek historian and geographer, Strabo wrote a 17-volume *Geography* which, after Caesar's, offers the most comprehensive overview we have of the world of the Gauls.

General Bibliography

General Bibliography

edited by Luana Kruta Poppi

Within the bounds of a restricted bibliography we have tried to select publications which reflect the contents of the remainder of the catalogue, and extend the arguments treated therein.
For more detailed information, readers are recommended to consult the periodic country-by-country bulletins published by Etudes celtiques *(Paris).*

Abbreviations

ANRW
Aufstieg und Niedergang der Römische Welt
ASSPA
Annuaire de la Société Suisse de Préhistoire et d'Archéologie
Arch. ért.
Archeologiai értesitö, Budapest
BRGK
Bericht der Römisch-Germanische Kommission
HBA
Hamburger Beiträge zur Archäologie
JbBHM
Jahrbuch des Bernisches Historisches Museum, Mainz
JRGZM
Jahrbuch des Römisch-Germanisches Zentralmuseum, Mainz
NAC
Numismatica e Antichità classiche, Quaderni Ticinesi
RA Como
Rivista archeologica di Como
Rend. Linc.
Rendiconti dell'Accademia Nazionale dei Lincei
PB
Prähistorische Bronzefunde, München
RGZM
Römisch-Germanisches Zentralmuseum, Mainz
Zpravodaj SVK
Zpravodaj Středočeské Vlastivědy a Kronikářství, Roztoky u Prahy

General Works

Déchelette, J., *Manuel d'archéologie préhistorique, celtique et gallo-romaine, IV: Second âge du Fer ou époque de La Tène*, Paris, 1927².
Chadwick, N., *The Celts*, Pelican Books, 1970.
Grenier, A., *Les Gaulois*, Paris, 1970.
Ross, A., *Everyday Life of the Pagan Celts*, London, 1970.
Hubert, H., *Les Celtes et l'expansion celtique jusqu'à l'époque de La Tène et Les Celtes depuis l'époque de La Tène et la civilisation celtique*, Albin Michel, "L'évolution de l'humanité" series, Paris, 1973³.
Various, *The Celts in Central Europe*, Székesfehérvár, 1975.
Filip, J., *Celtic Civilisation and Its Heritage*, Collet's-Academia, Wellinborough-Prague, 1977.
Various, *Kelstske Študije*, Posavski Muzej Knjiga 4, Brežice, 1977.

Kruta, V., Lessing, E., Szabó, M., *Les Celtes*, Hatier, Paris, 1978 (reprint 1982).
Cunliffe, B., *The Celtic World*, London, 1979.
Duval, P.M., Kruta, V., ed., *Les mouvements celtiques du V^ème au I^er siècle avant notre ère*, Paris, 1979.
Die Kelten in Mitteleuropa, Kultur-Kunst-Wirtschaft, catalogue to exhibition at Keltenmuseum, Hallein, Salzburg, 1980.
Powell, T.G.E., *The Celts*, London, 1980².
Filip, J., *I Celti alle origini dell'Europa*, "Paperbacks Civiltà scomparse" series, Newton Compton ed., Rome, 1980.
Lessing, E. et al., *Hallstatt. Bilder aus der Frühzeit Europas*, Vienna/Munich, 1980.
Spindler, K., *Die Frühen Kelten*, Stuttgart, 1983.
Kruta, V., Forman, W., *I Celti occidentali*, De Agostini, Novara, 1986.
Trésors des Princes Celtes, exhibition catalogue, Paris, 1988.
Various, *Les Princes Celtes et la Méditerranée*, Paris, 1988.
Kruta, V., *Les Celtes*, P.U.F., "Que-sais-je?" series, n. 1649, Paris, 1990⁵.

Art

Jacobsthal, P., *Early Celtic Art*, Oxford, 1944 (reprint 1969).
Fox, C., *Pattern and Purpose. A Survey of Early Celtic Art in Britain*, Cardiff, 1958.
Early Celtic Art, exhibition catalogue: Edinburgh-London 1970, Edinburgh, 1970.
Megaw, J.V.S., *Art of the European Iron Age, A Study of the Elusive Image*, Bath, 1970.
Finlay, I., *Celtic Art. An Introduction*, London, 1973.
Kruta, V., *L'Art celtique en Bohême, Les parures métalliques du V^e au II^e siècle avant notre ère*, Paris, 1975.
Brailsford, J., *Early Celtic Masterpieces in the British Museum*, British Museum, London, 1975.
Hawkes, Ch., Duval, P.M., ed., *Celtic Art in Ancient Europe-L'art celtique en Europe protohistorique*, London, New York, San Francisco, 1976.
McGregor, M., *Early Celtic Art in North Britain. A Study of Decorative Metalwork from the Third Century B.C. to the Third Century A.D.*, Leicester, 1976.
Duval, P.M., *Les Celtes*, Paris, 1977.
Krämer, W., Schubert, F., *Zwei Achsnägel aus Manching. Zeugnisse keltischer Kunst der Mittellatènezeit, Jahrbuch des Deutschen Archäologischen Instituts* 94, 1979, 366 sg.
Duval, P.M., Kruta, V., ed., *L'art celtique de la période d'expansion, IV^e et III^e siècles avant notre ère*, Geneva-Paris, 1982 (includes a bibliography on Celtic art from 1944 to 1979).
L'Art celtique en Gaule, exhibition catalogue: Marseilles, Paris, Bordeaux, Dijon, 1983-1984, Paris, 1983.
Kruta, V., et al., *Les fourreaux d'Epiais-Rhus (Val-d'Oise) et de Saint-Germainmont (Ardennes) et l'art celtique du IV^ème siècle a. J.C., Gallia* 42, 1984, 1-20.

Stead, I.M., *Celtic Art*, British Museum, London, 1985.
Szabó, M., *Nouvelles vues sur l'art des Celtes orientaux, Etudes celtiques* 22, 1985, 53 sg.
Megaw R. & V., *Early Celtic Art in Britain and Ireland*, "Shire Archaeology" n. 38, Aylesbury, 1986.
Kruta, V., *Le corail, le vin et l'arbre de vie: Observations sur l'art et la religion des Celtes du V^e au I^er siècle avant J.-C., Etudes celtiques* 23, 1986, 26 sg.
Duval, P.M., Kruta, V., *Le fourreau celtique de Cernon-sur-Coole I. Analyse et description, Gallia*, 44, 1986, 1 sg.
Kruta, V., *Le masque et la palmette au III^e siècle avant J.-C.: Loisy-sur-Marne et Brno-Maloměřice, Etudes celtiques* 24, 1987, 20 sg.
Moosleitner, F., *Arte protoceltica a Salisburgo*, exhibition catalogue: Florence 1987, Salzburg, 1987.
Zachar, L., *Keltische Kunst in der Slowakei*, Bratislava, 1987.
Megaw, R. & V., *Celtic Art. From its Beginnings to the Book of Kells*, London, 1989.
Duval, A., *L'art celtique de la Gaule au Musée des antiquités nationales*, Paris, 1989.
Duval, P.M., *Travaux sur la Gaule (1946-1986)*, Rome, 1989.
Raftery, B., ed., *L'art celtique*, Paris, 1990.

Religion

Sjoestedt, M.L., *Dieux et héros des Celtes*, Paris, 1940.
Vendryes, J., *Les religions des Celtes, "Mana" Introduction à l'histoire des religions*, 2. III, Paris, 1948.
De Vries, J., *Keltische Religion*, Stuttgart, 1961.
Chadwick, N.K., *The Druids*, Cardiff, 1966.
Ross, A., *Pagan Celtic Britain*, London, 1974².
Piggott, S., *The Druids*, Pelican Books, 1974².
Duval, P.M., *Les Dieux de la Gaule*, Paris, 1976².
Mac Cana, P., *Celtic Mythology*, Feltham, 1983.
Blasquez, J.M., *Primitivas Religiones Ibéricas II. Religiones Prerromanas*, Madrid, 1983.
Le Roux, F., Guyonvarc'h, Chr. J., *Les Druides*, Rennes, 1986.
Sterckx, C., *Eléments de cosmogonie celtique*, Brussels, 1986.

Society and Tradition

Rees, A. & B., *Celtic Heritage*, London, 1961.
MacNeill, M., *The Festival of Lughnasa, A Study of the Survival of the Celtic Festival of the Beginning of Harvest*, London, 1962.
Byrne, F.J., *Irish Kings and High-Kings*, London, 1973.

Language and Inscriptions

Holder, A., *Alt-keltischer Sprachschatz*, Leipzig, 1896 (reprint Graz, 1961).

Lejeune, M., *Celtiberica*, Salamanca, 1955.
Lewis, H., Pedersen, H., *A Concise Comparative Celtic Grammar*, Göttingen, 1961.
Tovar, A., *The Ancient Languages of Spain and Portugal*, New York, 1961.
Lejeune, M., *Lepontica*, Paris, 1971.
Untermann, J. *Monumenta Linguarum Hispanicarum I, Die Münzlegenden*, Wiesbaden, 1975.
Baldacci, P., *La bilingue latino-gallica di Vercelli, Rend. Linc.*, XXXII, 5-6, 1977, 335 sg.
Campanile, E., ed., *I Celti d'Italia*, Pisa, 1981.
Beltrán, A., Tovar, A., Porta, E., *Contrebia Belaisca (Botorrita Zaragoza) I. El bronce con alfabeto "iberico" de Botorrita*, Saragossa, 1982.
Krämer, W., *Graffiti auf Spätlatènekeramik aus Manching, Germania* 60, 1982, 489-499.
Untermann J., *Die Keltiberer und das Keltiberische, Problemi di lingua e di cultura nel campo indoeuropeo*, Pisa, 1983, 109-128.
Lejeune, M., *Textes gallo-grecs, Recueil des inscriptions gauloises* (R.I.G.), I, Paris, 1985.
Lejeune, M., Various, *Le plomb magique du Larzac et les sorcières gauloises*, Paris, 1985.
Prosdocimi, A., *I più antichi documenti del celtico in Italia, La Lombardia tra protostoria e romanità, Proceedings of the 2nd Regional Archaeology Conference, Como, 1984*, Como, 1986, 67-92.
Duval, P.M., Pinault, G., *Les calendriers (Coligny, Villards d'Héria)*, R.I.G., III, Paris, 1986.
Tibiletti Bruno, M.G., *Nuove iscrizioni epicoriche a Milano, Scritti in ricordo di G. Massari Gaballo e di U. Tocchetti Pollini*, Milan, 1986, 99-109.
Hoz, J., de, *La epigrafía celtibérica, Reunión sobre Epigrafía Hispánica de época Romano-Republicana*, Saragossa, 1986, 43-102.
Gambari, F.M., Colonna, G., *Il bicchiere con iscrizione arcaica da Castelletto Ticino e l'adozione della scrittura nell'Italia nord-occidentale, Studi etruschi* LIV, 1986 (1988), 119 sg.
Lejeune, M., *Textes gallo-étrusques. Textes gallo-latins sur pierre*, R.I.G. II.1, Paris, 1988.

Literature
Thurneysen, R., *Die irische Helden- und Königsage bis zum siebzehnten Jahrhundert*, Halle/Saale, 1921.
Binchy, D.A., *Studies in Early Irish Laws*, Dublin, 1936.
Jones, J., Jones, T., *The Mabinogion*, London, 1950
Duanaire Finn, the Book of the Laws of Fionn, 3, Dublin, 1953.
Murphy, G., *Saga and Myth in Ancient Ireland*, Dublin, 1955.
Myles, D., *Irish Sagas. Essays*, Dublin, 1959.
Jackson, K., *The Oldest Irish Tradition: a Window on the Iron Age*, Cambridge, 1964.
Táin Bó Cúailnge from the Book of Leinster, Dublin, 1970.
Jenkins, D., *Celtic Law Papers, The Law of Hywel Dda*, Brussels, 1973.

O' Rahilly, C., *Táin Bó Cúailnge: Recension I*, Dublin, 1976.
O' Cathasaigh, T., *The Heroic Biography of Cormac mac Airt*, Dublin, 1977.
Jenkins, D., Owen, M., *The Welsh Law of Women*, Cardiff, 1980.
Lambert, P.Y., *Les littératures celtiques*, P.U.F. "Que sais-je?" n. 809, Paris, 1981.
Gantz, J., *Early Irish Myth and Sagas*, London, 1981.
Gray, E.A., *Cath Mige Tuired: The Second Battle of Mag Tuired*, London, 1982.
Nagy, J.F., *The Wisdom of the Outlaw: The Boyhood Deeds of Finn in Gaelic Narrative Tradition*, Berkeley, 1983.
O' Corràin, D., Breatnach, L., Breen, A., *The Laws of the Irish, Peritia; Journal of the Medieval Academy of Ireland 3*, 1984.
Kelly, F., *A Guide to Early Irish Law*, Early Irish Law series 3, Dublin, 1988.

Coinage
Tour, H. de la, *Atlas des monnaies gauloises*, Paris, 1892 (reprint 1965).
Blanchet, A., *Traité des monnaies gauloises*, Paris, 1905 (reprint 1971).
Forrer, R., *Keltische Numismatik des Rhein- und Donaulande*, Strasbourg, 1908 (reprint 1968).
Paulsen, R., *Die Münzprägung der Boier*, Leipzig, Vienna, 1933 (reprint 1974).
Pink, K., *Die Münzprägung der Ostkelten und ihrer Nachbarn*, Budapest, 1939 (reprint 1974).
Castelin, K., *Die Golprägung der Kelten in den bömischen Ländern*, Graz, 1965.
Pautasso, A., *Le monete preromane dell'Italia settentrionale. Sibrium* 7. 1962/1963 (1966).
Colbert de Beaulieu, J.-B., *Les monnaies gauloises des Parisii*, Paris, 1970.
Reding, L., *Les monnaies gauloises du Tetelbierg*, Luxembourg, 1972.
Colbert de Beaulieu, J.-B., *Traité de numismatique celtique, I Méthodologie des ensembles*, Paris, 1973.
Preda, C., *Monedele Geto-Dacilor*, Bucharest, 1973.
Arslan, E.A., *Appunti per una sistemazione cronologica della monetazione gallica cisalpina, NAC Quaderni Ticinesi*, 1973, 43-51.
Göbl, R., *Typologie und Chronologie der keltischen Münzprägung in Noricum*, Vienna, 1973.
Pautasso, A., *Sulla cronologia delle monetazioni padane, NAC Quaderni Ticinesi*, 4, 1975, 45-54.
Saves, G., *Les monnaies gauloises "à la croix,"* 1976.
Kos, P., *Keltski novci Slovenije*, Ljubljana, 1977.
Scheers, S., *Traité de numismatique celtique, II La Gaule Belgique*, Paris, 1977.
Kolnikovà, E., *Keltské Mince na Slovensku*, Bratislava, 1978.
Zedelius, V., *Die Goldmünzen aus dem Goldring-Depot vom Hambacher Forst, Das Rheinische Landesmuseum Bonn*, Sonderheft 1979, 59-62.
Allen, D., Nash, D., *The Coins of the Ancient Celts*, London, 1980.

Kruta, V., *Archéologie et numismatique: la phase initiale du monnayage celtique, Etudes celtiques* XIX, 1982, 65 sg.
Szabó, M., *Audoleon und die Anfänge der ostkeltischen Münzprägen, Alba Regia*, XX, 1983, 43 sg.
Castelin, K., *Keltische Münzen*, Katalog der Sammlung des Schweizerischen Landesmuseum, Zurich, I, 1978, II, 1983.
Arslan, E., *La circolazione monetaria nella Milano di II e I sec. a.C. e le emissioni "insubri,"* Scritti in ricordo di Graziella Massari Gaballo e di Umberto Tocchetti Pollini, Milan, 1986, 111-121.
Allen, D., *Catalogue of the Celtic Coins in the British Museum, I. Silver Coins of the East Celts and Balkan Peoples*, London, 1987.
Haselgrove, C., *Iron Age Coinage in Southeast England, the Archaeological Context*, BAR 174, 1987.
Popović, P., *Le monnayage des Scordisques*, Belgrade, Novi Sad, 1987.
Duval, P.M., *Monnaies gauloises et mythes celtiques*, Paris, 1987.
Kellner, H.-J., *Die Münzfunde von Manching und die keltischen Fundmünzen aus Südbayern, Die Ausgrabungen in Manching*, Bd 12, Munich, 1990.

Ancient Sources
Duval, P.M., *La Gaule jusqu'au milieu du V^e siècle*, Les sources de l'histoire de France des origines à la fin du XV^e siècle, I, Paris, 1971.
Dobesh, G., *Die Kelten in Österreich nach den ältesten Berchten der Antike*, 1980.
Goudineau, Chr., *César et la Gaule*, Paris, 1990.

The Celts in Ancient Art
Bienkowski, P., *Die Darstellung der Gallier in der hellenistischen Kunst*, 1908.
Bienkowski, P., *Les Celtes dans les arts mineurs gréco-romains*, 1928.
Zuffa, M., *Il frontone e il fregio di Civitalba nel Museo Civico di Bologna, Scritti in onore di A. Calderini ed Enrico Paribeni*, 1956, 267-288.
Künzl, E., *Frühhellenistische Gruppen*, 1968.
Künzl, E., *Die Kelten des Epigonos von Pergamon*, 1971.
Wenning, R., *Die Galateranatheme Attalos I, Pergamische Forschungen* 4, 1978.
Özgan, R., *Bemerkungen zum großen Gallieranathem, Archäologischer Anzeiger*, 1981, 489-510.
Palma, B., *Il piccolo donario di Attalo, Xenia* 1, 1981, 45-89.
Traversari, G., *La statuaria ellenistica del Museo archeologico di Venezia*, 1986, 94-94.
Mattei, M., *Il Galata Capitolino*, exhibition catalogue, Rome, 1987.
Queyrel, F., *Art pergaménien, histoire collections: le Perse du Musée d'Aix et le petit ex-voto attalide, Revue archéologique*, 1989, 254-196.

Andreae, B., et al., *Phyromachos-Probleme, 31. Ergänzungsheft der Mitteilungen des Deutschen Archäologischen Instituts*, 1990.

Agriculture

Schüle, W., *Eisenzeitliche Tierknochen von der Heuneburg bei Hundersingen*, Stuttgart, 1960.

Jewell, P., *Cattle from British Archeological Sites*, in Mourant, A.F., Zeuner, F.E. (ed.), *Man and Cattle*, Royal Archeological Institute, Occasional Paper, n. 18, London, 1963, 80-100.

Bökönyi, S., *Data on Iron Age Horses of Central and Eastern Europe*, Bull. of the Amer. School of Prehist. Res., 25, 1968, Cambridge, USA.

Boessneck, J., et al., *Die Tierknochenfunde aus dem Oppidum von Manching*, Die Ausgrabungen in Manching Bd 6, Wiesbaden, 1971.

Bökönyi, S., *History of Domestic Mammals in Central and Eastern Europe*, Budapest, 1974.

Reynolds, P.J., *Iron-Age Farm. The Butser Experiment*, London, 1979.

Körber-Grohne, U., *Pflanzliche Abdrücke in eisenzeitlicher Keramik Spiegelbild damaliger Nutzpflanzen*, Fundberichte aus Baden-Würtemberg 6, 1981, 165-211.

Clutton-Brock, C., *Domesticated Animals from Early Times*, London, 1981.

Bökönyi, S., *Animal Husbandry and Hunting in Tác-Gorsium. The Vertebrate Fauna of a Roman Town in Pannonia*, Budapest, 1984.

Küster, H., *Werden und Wandel der Kulturlandschaft im Alpenvorland*, Germania 64, 1986, 533-559.

Meniel, P., *Chasse et élevage chez les Gaulois*, Paris, 1987.

Arbogast, R.M., Meniel, P., Yvinec, J.H., *Une histoire de l'élevage. Les animaux et l'archéologie*, Paris, 1987.

Marinval, P., *L'alimentation végétale en France du Mésolithique jusqu'à l'Age du Fer*, Paris, 1988.

Marek, J., *Das helvetisch-gallische Pferd und seine beziehung zu den prähistorischen und zu den recenten Pferden*, Abhandl. d. scheiweiz. paläont. Ges. 25, 1988, 1-62.

Crafts

Rieth, A., *Zur Technik antiker und prähistorischer Kunst, Das Holzdrechseln*, Jahrb, prähist. u. ethnograph. Kunst 13/14, 1939/40, 85 sg.

Drescher, H., *Der Überfangguß*, 1958.

Fisher, F., *Der spätlatènezitliche Depotfund von Kappel (Kr. Saulgau)*. Urkunden zur Vor- und Frühgeschichte aus Südwürttemberg-Hohenzollern, Heft 1, 1959.

Haevernick, T.E., *Die Glasarmringe und Ringperlen der Mittel- und Spätlatènezeit auf dem Europäischen Festland*, Bonn, 1960.

France-Lanord, A., *Les lingots de fer protohistoriques*, Revue d'histoire de la sidérurgie 4, 1963, 166-177.

Schulz, E.H., Pleiner, R., *Untersuchungen an Klingen eiserner Latèneschwerter*, Technische Beiträge Zur Archäologie 2, Mainz, 1965, 38-50.

Schwarz, K., Tillmann, H., Treibs, W., *Zur spätlatènezeitlichen und mittelalterlichen Eisenerzgewinnung auf der südlichen Frankenalb bei Kelteim. Jahresbericht der Bayerischer Bodendenkmalpflege* 6/7, 1965-1966, 35-66.

Hundt, H.-J., *Vorgeschichtliche Gewebe aus dem Hallstätter Salzberg*. JRGZM 6, 1959, 66 sg.; 7, 1960, 126 sg.; 14, 1967, 38 sg.

Hundt, H.-J., *Über vorgeschichtliche Seidenfunde*, JRGZM 16, 1969, 59 sg.

Ellmers, D., *Keltisher Schiffbau*, JRGZM 16, 1969, 73 ff.

Kappel, I., *Die Graphittonkeramik von Manching*, Wiesbaden, 1969.

Thouvenin, A., *L'étamage des objets de cuivre et de bronze chez les Anciens*, Revue Hist. Mines et Métallurgie 2/1, 1970, 101 sg.

Maier, F., *Die bemalte Spätlatène - Keramit von Manching*, Wiesbaden, 1971.

Pingel, V., *Die glatte Drehscheiben - Keramit von Manching*, Wiesbaden, 1971.

Hundt, H.-J., *Gewebereste aus dem Fürstengrab von Worms-Herrnsheim*. Jahrb. RGZM 18, 1974, 113 sg.

Jacobi, G., *Werkzeug und Gerät aus dem Oppidum von Manching. Die Ausgrabungen in Manching 5*, Wiesbaden,1974.

Spehr, G., *Zum wirstchaftlichen Leben und sozialökonomischen Gefüge im Steinsburg-Oppidum*, Moderne Probleme der Archäologie, Berlin, 1975, 141-175.

Emmerling, J., *Metallkundliche Untersuchungen an latènezeitlichen Schwertern und Messern*. Alt-Thüringen 13, 1975, 205-220.

Capelle, T., *Holzefäße vom Neolithikum bis zum späten Mittelalter*, 1976.

Capelle, T., *Bemerkungen zum keltischen Handwerk*. Boreas 2, 1979, 62 sg.

Stökli, W.E., *Die Grob- und Import Keramik von Manching*, Wiesbaden, 1979.

Domergue, C., (ed.), *Mines et Fonderies de la Gaule*, Paris, 1982.

Pleiner, R., *Untersuchungen zur Schmiedetechnick auf den keltischen Oppida*, Památky archeologické 73,1982, 86-173.

Rybová, A., Motyková, K., *Der Eisendepotfund der Latènezeit von Kolín*, Památky archeologické 74, 1983, 96-174.

Pleiner, R., Princ, M., *Die latènezeitliche Eisenverhüttung und die Untersuchung einer Rennschmelze in Mšec, Böhmen*, Památky archeologické 75, 1984, 133-182.

Beck, F., Guillaumet, J.P., *La métallurgie du bronze en pays éduen.*, Les Ages du Fer dans la vallée de la Saône, 1985, 237 sg.

Sperl, G., *Die Technologie des ferrum noricum*, Lebendige AltertumsWissenschaft (Festschrift F.H. Vetters), Vienna, 1985, 410-416.

Ehrenreich, R.M., *A Study of Iron Technology in the Wessex Iron Age*, Scott and Cleere ed., The Craft of the Blacksmith, Belfast, 1987, 105-112.

Feugere, M. (ed.), *Le verre préromain en Europe occidentale*, Montagnac, 1989.

Gebhard, R., *Der Glasschmuck aus dem Oppidum von Manching*, Ausgrabungen in Manching, 11, Wiesbaden, Stuttgart, 1989.

Bucsek, N., Pernot, M., Challet, V., Duval, A., *Etudes de l'Email rouge du Mont Beuvray*. Revue Arch. Est et Centre Est, 41, 1990, 147 sg.

Venclová, N., *Prehistoric Glass in Bohemia*, Prague, 1990.

Mohen, J.P., *Métallurgie préhistorique. Introduction à la paléométallurgie*, Paris, 1990.

Oppida

Schaaff, U., Taylor, A.K., *Spätkeltische Oppida im Raum nördlich der Alpen. Kommentar zur Karte, Ausgrabungen in Deutschland*. RGZM 1, 3, 1975, 322 sg.

Kruta, V., in Duby, G. (ed.), *Histoire de la France Urbaine, 1 La ville antique (La Gaule Intérieure)*, 1980, 195 sg.

Collis, J., *Oppida. Earliest Towns North of the Alps*, Sheffield, 1984.

Frey, O.H., *Die Bedeutung der Gallia Cisalpina für die Entstehung der Oppida-Kultur. Studien zu Siedlungsfragen der Latènezeit*. Veröff. Seminars Marburg, Sonderband 3, 1984, 1 sg.

Buchenschutz, O., *Structures d'habitats et fortifications de l'Age du Fer en France Septentrionale*, Paris, 1984.

Audouze, F., Buchsenschutz, O., *Villes, villages et campagnes de l'Europe celtique*, Paris, 1989.

Geographical Areas and Sites

Italy

Piana Agostinetti, P., *Documenti per la Protostoria della Val d'Ossola. San Bernardo di Ornavasso e le altre necropoli preromane*, Milan, 1972.

Graue, J., *Die Gräberfelder von Ornavasso*, HBA Bhft 1, Hamburg, 1974.

Negroni Catacchio, N., *I ritrovamenti di Casate nel quadro del celtismo padano*, Atti del Conv. celebrativo del Centenario RAComo, Como, 1974, 171 sg.

Kruta Poppi, L., *Les Celtes à Marzabotto (province de Bologne)*, Etudes celtiques, XIV, 1975, 345-376.

Zuffa, M., *I Celti nell'Italia adriatica*, Introduzione alle antichità adriatiche, Pisa, 1975, 97-159.

Vannacci Lunazzi, G., *Le necropoli preromane di Remedello di sotto e Ca' di Marco di Fiese*, Reggio Emilia, 1977.

Kruta, V., *Celtes de Cispadane et transalpins au IVe et au IIIe siècle avant n.è.*, Studi etruschi XLVI, 1978, 149 sg.

I Galli e l'Italia, exhibition catalogue, Rome, 1978.

Arslan, E., *Celti e Romani in Transpadana*, Etudes celtiques XV, 1978, 441-481.

Kruta Poppi, L., *Les vestiges laténiens de la région de Modène*, Etudes celtiques, XV, 1978, 425-439.

Peyre, Ch., *La Cisalpine gauloise du IIIème au Ier siècle avant J.C.*, Paris, 1979.

Calzavara Capuis, L., Chieco Bianchi, A.M., *Osservazioni sul celtismo nel Veneto euganeo*, Archeologia Veneta III, 1979, 7-32.

Kruta Poppi, L., *La sépulture de Ceretolo (prov.de Bologne) et le faciès boïen du IIIe siècle avant n.è.*, Etudes celtiques XVI, 1979, 7-25.

Kruta, V., *Les Boïens de Cispadane. Essai de paléoethnographie celtique*, Etudes celtiques XVII, 1980, 7-32.

Fogolari, G., *I Galli nell'alto Adriatico*, Antichità Altoadriatiche XIX, 1981, 15-49.

Kruta, V., *Les Sénons de l'Adriatique d'après l'archéologie (prolégomènes)*; Etudes celtiques XVIII, 1981, 7-38.

De Marinis, R., *Il periodo Golasecca IIIA in Lombardia*, Bergamo, 1981.

Tizzoni, M., *La cultura tardo La Tène in Lombardia*, Studi Archeologici, I, Bergamo, 1981, 3-40.

Kruta Poppi, L., *La sépulture de Casa Selvatica à Berceto (prov. de Parme) et la limite occidentale du faciès boïen au IIIᵉ siècle av. n.è.*, Etudes celtiques XVIII, 1981, 39-48.

Tizzoni, M., *La Tarda Età del Ferro nel Lodigiano*, Archivio Storico Lodigiano, 101, 1982, 189-202.

Negroni Catacchio, N., *Per una definizione della facies culturale insubre: i rinvenimenti tardo celtici di Biassono (MI)*, Sibrium XVI, 1982, 69-82.

Kruta, V., *L'Italie et l'Europe intérieure du Vᵉ siècle au début du IIᵉ siècle av. n.è.*, Savaria 16, 1982, 203-221.

Szabó, M., *Rapports entre le Picenum et l'Europe extra-méditerranéenne à l'Age du Fer*, Savaria 16, 1982, 223-241.

Vannacci Lunazzi, G., *Un aspetto della romanizzazione del territorio: la necropoli di Gambolò-Belcreda*, RAComo 165, 1983, 199-254.

Various, *Popoli e facies culturali celtiche a nord e a sud delle Alpi dal V al I sec. a.C.*, Atti del Colloquio Internazionale, Milano 14-16 November 1980, Milan, 1983.

Tizzoni, M., *I materiali della tarda Età Ferro nelle civiche raccolte archeologiche di Milano*, Milan, 1984.

Arslan, E., *Le culture nel territorio di Pavia durante l'Età del Ferro fino alla romanizzazione*, Storia di Pavia I, L'Età antica, Pavia, 1984, 107-150.

Ruta Serafini, A., *Celtismo nel Veneto: materiali archeologici e prospettive di ricerca*, Etudes celtiques XXI, 1984, 7-33.

Kruta Poppi, L., *Contacts transalpins des Celtes cispadans au IIIᵉ siècle avant J.C.: le fourreau de Saliceta San Giuliano, province de Modène*, Etudes celtiques XXI, 1984, 51 sg.

Vannacci Lunazzi, G., *Aspetti della cultura tardo La Tène in Lomellina*, Papers in Italian Archeology IV, BARint 245, 1985, 69-88.

Tizzoni, M., *The Late Iron Age in Lombardy*, Papers in Italian Archeology IV, BARint 245, 1985, 37-68.

Kruta, V., *I Celti e la Lombardia*, La Lombardia dalla Preistoria al Medioevo, Milan, 1985, 83-103.

Negroni Catacchio, N., *Indigeni, Etruschi e Celti nella Lombardia orientale*, Cremona romana, Cremona, 1985, 57-70.

Luraschi, G., *Nuove riflessioni sugli aspetti giuridici della romanizzazione in Transpadana*, Atti de II Convegno Archeologico Regionale. La Lombardia tra protostoria e Romanità, Como, 1984 (1986), 43-65.

Kruta, V., *Quali Celti?, La Lombardia tra protostoria e Romanità. Atti de II Convegno Archeologico Regionale*, Como, 1984 (1986), 323-330.

De Marinis, R., *L'età gallica in Lombardia (IV-I sec. a.C.): risultati delle ultime ricerche a problemi aperti*, La Lombardia tra protostoria e romanità, Atti del II Conv. Arch. Regionale, Como 1984, Como, 1986, 93-173.

Gabba, E., *I Romani nell'Insubria: trasformazione, adeguamento e sopravvienza delle strutture socio-economiche galliche*, La Lombardia tra protostoria e romanità, Atti del II Conv. Arch. Regionale, Como 1984, Como, 1986, 31-41.

Vitali, D., *Una tomba di guerriero da Castel del Rio (Bologna). I problemi dei corredi con armi nell'area cispadana tra IV e II sec. a.C.*, Atti e memorie della Deputazione di Storia Patria di Romagna, 1986, 9-35.

Various, *Celti ed Etruschi nell'Italia centrosettentrionale dal V secolo a.C. alla romanizzazione*, Bologna, 1987.

Piana Agostinetti, P., *Per una definizione dei confini delle Civitates celtiche della Transpadana centrale*, Scienze dell'Antichità 2, 1988, 137-218.

Kruta, V., *I Celti in Italia, Italia omnium terrarum alumna. La civiltà dei Veneti, Reti, Liguri, Celti, Piceni, Umbri, Latini, Campani e Iapigi*, Milan, 1988, 263-311.

Filottrano e Moscano di Fabriano: Frey, O.H., *Das keltische Schwert von Moscano di Fabriano*, Hamburger Beiträge zur Archäologie, I, 2, 1971, 173-179.

Landolfi, M., *Zum Grab II der Necropole von Paolina di Filottrano*, Beitträge zur Eizenzeit-Kleine Schriften vorgeschichtlichen Seminar Marburg 19, 21-26.

Landolfi, M., *Museo Archeologico Nazionale delle Marche* (ed. D. Lollini), Rome, 43-45 (Moscano di Fabriano) e 45-47 (S. Paolina di Filottrano).

Monte Bibele: Vitali, D., *L'elmo della tomba 14 di Monte Bibele a Monterenzio (prov. di Bologna)*, Etudes celtiques XIX, 1982, 35-49.

Vitali, D. (ed.), *Monterenzio e la valle dell'Idice, archeologia e storia di un territorio*, catalogo mostra, Monterenzio, 1983.

Vitali, D., *Un fodero celtico con decorazione a lira zoomorfa da Monte Bibele (Monterenzio, Bologna)*, Etudes celtiques XXI, 1984, 35-49.

Vitali, D., *Monte Bibele: criteri distributivi nell'abitato ed aspetti del territorio bolognese dal IV al II sec. a.C.*, La formazione della città preromana in Emilia-Romagna, Atti del colloquio di Studi Bologna-Marzabotto 1985, Bologna, 1988, 105-142.

Iberian Peninsula

Almagro Basch, M., *La España de las invasiones célticas*, Historia de España I, 2, Madrid, 1952.

Maluquer de Motes, J., *Pueblos Celtas*, Historia de España, I, 3, Madrid, 1963.

Schüle, W., *Die Meseta Kulturen der Iberischen Halbinsel*, Madrider Forschungen 3, Berlin, 1969.

Schulten, A., *Geografía y Etnología antiguas e la Península Ibérica*, Madrid, Baden-Baden, 1974.

Bosch Gimpera, P., *Paletnología de la Península ibérica*, Graz, 1974.

Colloquios sobre lenguas y culturas paleo-hispánicas, I Salamanca, 1974; II Tübingen, 1976; III Lisbon, 1980; IV Vitoria, 1985; V Cologne, 1989.

Blásquez, J.M., et alii, *Historia de España Antiqua I. Protohistoria*, Madrid, 1980, 53-126.

I. Symposio sobre los Celtíberos, Saragossa, 1987.

Burillo, F., *Celtiberos* (Exposición), Saragossa, 1988.

Almagro-Gorbea, M., *La celtización de la Meseta: estado de la cuestion*, Acta del I Congreso de Historia de Palencia I, Palencia, 1987, 313-344. *Los Celtas en el valle medio del Ebro*, Saragossa, 1989.

Montenegro, A. et al., *Colonizaciones y formación de los pueblos prerromanos (1200-218 a.C.)*, Historia de España 2, Madrid, 1989.

Marco, F., *Los Celtas*, Biblioteca Historia 16, Madrid, 1990, 93-117.

Various, *Los Celtas en España. Revista de Arqueología*, Special issue 5, Madrid, 1990.

France, Belgium and Luxembourg

Bretz-Malher, D., *La civilisation de La Tène I en Champagne - Le faciès marnien*, Paris, 1971.

Hatt, J.-J., Roualet, P., *La chronologie de la Tène en Champagne, dans Revue archéologique de l'Est et de Centre-est*, XXVIII, 1-2, 1977, 7-36.

Giot, P.-R. et al., *Protohistoire de la Bretagne*, Rennes, 1979.

Kruta, V., *Le port des anneaux de cheville en Champagne et le problème d'une immigration danubienne au IIIᵉ siècle avant J.-C.*, Etudes Celtiques, XXII, 1985, 27-51.

Roualet, P., Charpy, J.J., *La céramique peinte gauloise en Champagne, du VIᵉ siècle au Iᵉʳ siècle avant J.C.*, Musée d'Epernay, 1987.

Kruta, V., Rapin, A., *Une sépulture de guerrier gaulois du IIIᵉ siècle av. n.è. découverte à Rungis*, Cahiers de la Rotonde, 10, 1987, 5-35.

Rozoy, J.-G., *Les Celtes en Champagne. Les Ardennes au second Age du Fer: le Mont Troté, les Rouliers, Charleville-Mézières*, 1987.

Charpy, J.-J., *Les épées laténienne à bouterolles circulaires ajourées du IVᵉ et IIIᵉ siècle av. J.C. en Champagne*, Etudes Celtiques XXIV, 1988, 43-102.

Leman-Delerive, G., *Les habitats de l'Age du Fer à Villeneuve d'Ascq (Nord)*, Revue du Nord, Coll. Archéologie 2, 1989.

Les Celtes en France du nord et en Belgique, VIᵉ-Iᵉʳ siècle avant J.-C., exhibition catalogue, Brussels, 1990.

Chaume, B., Feugere, M., *Les sépultures tumulaires aristocratiques du Hallstatt ancien de Poiseul-la-Ville (Côte d'Or)*, Dijon, 1990.

Agris: Gomez de Soto, J., *Le casque du IVᵉᵐᵉ siècle avant notre ère de la grotte des*

Perrats à Agris, France, Archäologisches Korresponenzblatt, 16, 1986, 179-183.

Bragny: Feugere, M., Guillot, A., *Fouilles de Bragny, 1, les petits objets dans leur contexte du Hallstatt final, Revue Archéologique de l'Est*, XXXVII, 1986, 159-221.

Guillot, A., *Le confluent de la Saône et du Doubs au Premier Age du Fer, Revue Archéologique Est*, XXVII, 1976, 109-113.

Chouilly-Les Jogasses: Hatt, J.-J., Roualet, P., *Le cimetière des Jogasses en Champagne et les origines de la civilisation de La Tène, Revue Archéologique de l'Est et du Centre-Est*, XXVII, 1976, 421-448, XXXII, 1981, 17-37.

Ensérune: Rapin, A., Schwaller, M., *Contribution à l'étude de l'armement celtique; la tombe 163 d'Ensérune (Hérault), Revue archéologique de Narbonnaise* 20, 1987, 155-183.

Goeblingen-Nospelt: Thill, G., *Ausgrabungen in Goeblingen-Nospelt, Hémecht*, 1966, 483-491.

Thill, G., *Die Metallgegenstände aus vier spätlatènezeitlichen Brandgräbern bei Goeblingen-Nospelt, Hémecht*, 1967, 87-98.

Thill, G., *Die Keramik aus vier spätlatènezeitlichen Brandgräbern bei Goeblingen-Nospelt, Hémecht*, 1967, 199-213.

Metzler, J., *Treverische Reitergräber von Goeblingen-Nospelt*, Trier, Augustusstadt der Treverer, 1984, 87-99, 289-299.

Gournay: Brunaux, J.L., Meniel, P., Poplin, F., *Gournay I, Les fouilles sur le sanctuaire et l'oppidum (1975-1984)*, supp. to la *Revue archéologique de Picardie*, 1985.

Brunaux, J.L., *Les Gaulois, sanctuaires et rites*, Paris, 1986.

Rapin, A., Brunaux, J.L., *Gournay II - Boucliers et lances. Dépôt et trophée*, supp. to la *Revue archéologique de Picardie*, 1988.

Mont Beuvray: Bertin, D., Guillaumet, J.-P., *Bibracte (Saône-et-Loire). Une Ville gauloise sur le Mont Beuvray*, Guides Archéologiques de la France 13, 1987.

Beck, F. et al., *Les fouilles du Mont Beuvray, rapport biennal 1984-1985, Revue Archéologique de l'Est et du Centre-Est*, XXXVIII, 1987, 285-300.

Beck, F. et al., *Les fouilles du Mont Beuvray, rapport biennal 1984-1985, RAE*, XXXIX, 1988, 107-127.

Almagro-Gorbea, M., *Les fouilles du Mont Beuvray, Revue Archéologique de l'Est et du Centre-Est*, 40, 1989, 205 sg.

Buchenschutz, O., *Neue Ausgrabungen im Oppidum Bibracte, Germania* 67, 1989, 541 sg.

Almagro-Gorbea, M., Granaymerich, J., *Le bassin monumental du Mont Beuvray (Bibracte). Monuments et Mémoires, Académie des Inscriptions et Belles Lettres*, 71, Paris, 1990, 21-41.

Roquepertuse: Gantes, L.F., *A propos du matériel trouvé sur le sanctuaire préromain de Roquepertuse à Velaux: fouilles de Gérin-Ricard 1919, 1924 et 1927, Bulletin archéologique de Provence* I, 1978, 37-46.

Vix: Joffroy, R., *Vix et ses trésors*, Paris, 1979.

Egg, M., France-Lanord, A., *Le char de la tombe princière de Vix*, Mainz, 1987.

Switzerland

Schaaff, U., *Zur Belegung latènezeitlicher Friedhöfe der Schweiz, JRGZM*, 13, 1966, 49-49.

Hodson, F.R., *The La Tène Cemetery at Münsingen-Rain, Catalogue and relative Chronology*, Berne, 1968.

Osterwalder, Ch., *Die Latènegräber von Münsingen-Tägermatten. JbBHM*, 1971/1972, 51/52, 7-40.

Martin-Kilcher, S., *Zur Tracht und Beigabensitte im keltischen Gräberfeld von Münsingen-Rain (Kt. Bern), Zeitschrift für schweizerrische Archäologie und Kunstgeschichte*, 30, 1973, 26-39.

Stähli, B., *Die Latènegräber von Bern-Stadt. Schriften des Seminars für Urgeschichte der Universität Bern 3*. Berne, 1977.

Sankot, P., *Studie zur Socialstruktur der nordalpinen Flachgräberfelder der La Tène-Zeit im Gebiet der Schweiz, Zeitschrift für schweizerische Archäologie und Kunstgeschichte* 37, 1980, 19-71.

Martin-Kilcher S., *Das keltische Gräberfeld von Vevey, VD, ASSPA* 64, 1981, 107-156.

Suter, P., *Neuere Mittellatène-Grabkomplexe aus dem Kanton Bern. Ein Beitrag zur Latène C-Chronologie des Schweizerischen Mittellandes, Annuaire de la Société suisse de préhistoire et d'archéologie* 67, 1884, 73-93.

Furger Gunti, A., *Die Helvetier. Kulturgeschichte eines Keltenvolkes*, Zürich, 1984.

Müller, F., *Die Frühlatènezeitlichen Scheibenhalsringe*, Röm.-Germ. Forsch. 46, Berlin, 1989.

Kaenel, G., *Der Beginn der Latènezeit in der Westschweiz, Kleine Schriften vorgesch. Seminar* 23, Marburg, 1989, 27-39.

Kaenel, G., *Recherches sur la période de La Tène en Suisse occidentale. Analyse des sépoltures, Cahiers d'archéologie romande* 50 (1990).

Basel: Furger-Gunti, A., *Die Ausgrabungen im Basler Münster I. Die spätkeltische und augusteiche Zeit (1. Jahrhundert v. Cr.), Basler Beiträge zur Ur- und Frühgeschichte* 6, 1979.

Furger-Gunti, A., *Der murus Gallicus von Basel, Jahrb. der Schweiz. Gesell. für Ur- und Frühgeschichte* 63, 1980, 131 sg.

Bern-Enge: Müller-Beck, H., Ettlinger, E., *Die Besiedlung der Engehalbinsel bei Bern, BRGK* 43-44, 1962-1963, 108-153.

Kohler, P., *Die latènezeitliche Besiedlung der Tiefenau, Bern-Engehalbinsel, Jahrbuch der Schweizerischen Gesellschaft für Ur- und Frühgeschichte* 71, 1988, 191-194.

Bern-Tiefenau: Müller, F., *Der Massenfund von der Tiefenau bei Bern*, Basel, 1990.

Genève: Blondel, L., *Le port gallo-romain de Genève, Geneva* 3, 1925, 85-104.

Bonnet, Ch. et al., *Les premiers ports de Genève, Archéologie suisse* 12, 1989, 2-24.

La Tène: Vouga, P., *La Tène*, Leipzig, 1923.

De Navarro, J.-M., *The Finds from the Site of La Tène I. The Scabbards and the Swords found in them*, London, 1972.

Egloff, M., *Des premiers chasseurs au début du christianisme, Histoire du pays de Neuchâtel 1. De la Préhistoire au Moyen Age*, Hauterive, 1989, 9-160.

Port: Wyss, R., *Das Schwert des Korisios, Jahrb. BHM* 34, 1954, 201-222.

Wyss, R., *Funde aus der alten Zihl und ihre Deutung, Germania* 33, 1955, 349-354.

Germany

Driehaus, J., *Fürstengräber und Eisenerze zwischen Mittelrhein, Mosel und Saar, Germania* 43, 1965, 32-49.

Engels, H.J., *Das Wagengrab von Weilerbach. Mitt. Hist. Ver. Pfalz* 67, 1969, 47-60.

Schaaff, U., *Keltische Einsenhelme aus vorrömischer Zeit, JRGZM*, 21, 1974, 152-171.

Haffner, A., *Die westliche Hunsrück-Eifel-Kultur. Röm. - German. - Forsch.* 36, Berlin, 1976.

Haffner, A., *Die frühlatènezeitl. Goldscheiben vom Typ Weiskirchen, Festschrift 100 Jahre Landesmuseum*, Trier, 1979, 281-296.

Bittel, K., Kimmig, W., Schiek, S. (ed.), *Die Kelten in Baden-Württemberg*, Stuttgart, 1981.

Haffner, A., *Hinweise auf unbekannte Fürstengräber im Trierer Land. Trierer Zeitschrift* 45, 1982, 35-43.

Sievers, S., *Die Mitteleuropäischen Hallstattolche*, P.B. VI, 6, Munich, 1982.

Kimmig, W., *Die Griechiche Zivilisation im westlichen Mittelmeergebiet und ihre wirleung auf die landschaften des westlichen Mitteleuropa, J.R.G.Z.M.*, Mainz, 1983.

Maier, F., *Das Heidetränk-Oppidum. Topographie der befestigten keltischen Höhensiedlung der Jüngeren Eisenzeit bei Oberursel im Taunus, Führer zur Hessischen Vor- und Frühgeschichte* 4, 1985.

Krämer, W., *Die Grabfunde von Manching und die latènezeitlichen Flachgräber in Südbayern, Ausgrabungen in Manching* Bd 9, Wiesbaden, 1985.

Various, *Vierrädrige Wagen der Hallstattzeit*, Mainz, 1987.

Fellbach-Schmiden: Planck, D., *Eine neuentdeckte keltische Viereckschanze in Fellbach-Schmiden, Germania* 60, 1982, 105 sg.

Giengen: Biel, J., *Ein mittellatènezeitliches Brandgräberfeld in Giengen a.d. Brenz, Archäologisches Korrespondenzblatt* 4, 1974, 225 sg.

Kleinaspergle: Kimmig, W. et alii, *Das Kleinaspergle. Studien zu einem fürstengrabhügel der frühen Latènezeit bei Stuttgart*, Stuttgart, 1988.

Manching: Krämer, W., Schubert, F., *Die Ausgrabungen in Manching 1955-1961. Einführung und Fundstellen-Übersicht, Die Ausgrabungen in Manching* 1, Wiesbaden, 1970.

Endert, D. van, *Das Osttor des Oppidums von Manching, Die Ausgrabungen in Manching* 10, Wiesbaden, 1987.

Schubert, F., *Neue Ergebnisse zum Bebauungsplan von Manching, BRGK* 64, 1983, 5 ff.

Denmark

Klindt-Jensen, O., *Foreign Influences in Denmarks Early Iron Age, Acta Archælogica* XX, 1949, Copenhagen, 1950.
Brå: Klindt-Jensen, O., *Bronzekedelen fra Brå*, Aarhus, 1953.
Dejbjerg: Jensen, S., *Fredbjergfundet. En bronzebeslået pragtvogn på en vesthimmerlandsk jernalderboplads*, Kulm 1980, Copenhagen, 1981.
Schovsbo, P.O., *Henry Petersen og vognfundene fra den ældre jernalder*, Aarbøger for nordisk Oldkyndighed og Historie 1981, Copenhagen, 1983.
Hansen, H.J., *Fragmenter af en bronzebeslået pragtvogn fra dankirke*, Aarbøger for nordisk Oldkyndighed og Historie 1984, Copenhagen, 1985.
Schovsbo, P.O., *Oldtidens vogne i Norden*, Bangsbomuseet, Frederikshavn, 1987.
Harck, O., *Zur Herkunft der nordischen Prachtwagen aus der jüngeren vorrömischen Eisenzeit, Acta Archæologica* 59, 1988, Copenhagen, 1989.
Gundestrup: Klindt-Jensen, O., *Le chaudron de Gundestrup; Relations entre la Gaule et l'Italie du Nord, Analecta Romana Instituti Danici* I, Copenhagen, 1959.
Nylén, E., *Gundestrupkitlen och den thrakiska konsten, Tor* 12, Uppsala, 1967, 68 sg.
Powell, T.G.E., *From Urartu to Gundestrup: the Agency of Thracian Metal-work, the European Community in Later Prehistory. Studies in Honour of C.F.C. Hawkes*, London, 1971.
Willemoes, A., *Hvad nyt om Gundestrupkarret*, Nationalmuseets Arbejdsmark 1978, Copenhagen, 1978.
Klindt-Jensen, O., *Gundestrupkedelen*, Copenhagen, 1979.
Bémont, C., *Le Bassin de Gundestrup: remarques sur les décors végétaux, Etudes celtiques* XVI, Paris, 1979, 69-99.
Benner Larsen, E., *The Gundestrup Cauldron, Identification of Tool Traces, Iskos* 5, *Proceedings of the third Nordic Conference on the Application of Scientific Methods in Archaeology*, Helsinki, 1985.
Bergquist, A., Taylor, T., *The Origin of the Gundestrup Cauldron, Antiquity* 61, 1987.

Austria

Dürrnberg: Penninger, E., *Der Dürrnberg bei Hallein*, I, Munich, 1972.
Moosleitner, F. et alii, *Der Dürrnberg dei Hallein* II, Munich, 1974.
Pauli, L., *Der Dürrnberg bei Hallein* III, Munich, 1978.
Hallstatt: Barth, F.E., *Das prähistorische Hallstatt. Bergbau und Gräberfeld, Die Hallstattkultur*, 1980, 67 sg.
Magdalensberg: Egger, R., *Die Stadt auf dem Magdalensberg, ein Grosshandelplatz*, Vienna, 1961.
Piccottini, G., *Die Stadt auf dem Magdalensberg - ein spätkeltisches und frührömisches Zentrum im südlichen Noricum. ANRW* II/6, Berlin, 1977, 263-301
Piccottini, G., *Bauen und Wohnen in der Stadt auf dem Magdalensberg, Denkschriften*

Ö.Akad.Wiss., phil.-hist. K1. 208, Vienna, 1989.
Piccottini, G., Vetters, H., *Führer durch die Ausgrabungen auf dem Magdalensberg*, Klagenfurt, 1990[4].
Mannersdorf: Schutzbier, H., *Mannersdorf am Leithagebirge, Fundberichte aus Österreich* 15, 1976.
Neugebauer, J.W., *Die Urgeschichte von Mannersdorf a. Lgb. und Umgebung, Museum Mannersdorf am Leithagebirge und Umgebung, Katalog* 1, Ur-und Frühgeschichte, 1979.
Melzer, G., *Mannersdorf am Leithagebirge, Fundberichte aus Österreich* 23, 1984.
Skt. Pölten: Engelmayer, R., *Latènegräber von Ratzersdorf, p. B. Skt. Pölten, Archælogia Austriaca*, 33, 1963, 37 sg.
Neugebauer, J.W., *Skt. Pölten-Wegkreuz der Urzeit, Sieben Jahre archäologische Rettungsgrabungen im unteren Traisental, Niederösterreich, 1981-1987, Antike Welt* 18/2, 1987.

Bohemia and Moravia

Filip, J., *Keltové ve Střední Evropé*, Prague, 1956.
Ludikovský, K., *Akeramisher Horizont reicher Frauengräber in Mähren, Památky archeologické* LV, 1964, 321-349.
Meduna, J., *Ein latènezeitliches Gräberfeld in Brno-Horní Heršpice, Památky archeologické* LXI, 1970, 225-235.
Čizmář, M., *Die relative Chronologie der keltischen Gräberfelder in Mähren, Památky archeologické* LXVI, 1975, 417-437.
Meduna, J., *Die latènezeitlichen Siedlungen in Mähren*, Brno, 1980.
Waldhauser, J., *Keltische gräberfelder in Böhmen. Dobrá Voda und Letky, sowie Radovesice, Stránce und Tuchomyšl, BRGK* 60, 1987, 15-179.
Čizmář, M., *Frühlatènezeitliche Funde aus dem Burgwall "Černov" Gemeinde Ježkovice, Bez. Vyškov, Die vorgeschichtliche und slasche Besiedlung Mährens*, Brno, 1990, 196-204.
Brno-Malomeřice: Hucke, K., *Ein keltisches Grab mit Bronzebeschlägen von Brünn-Malmeritz, Zeitschrift des Mährischen Landesmuseums*, N.F. 2, 1942, 87 sg.
Gebhart, R., *Zu einem Beschlag aus Brno-Malomeřice, Hellenistische Vorbilder keltischer Gefäßappliken, Germania* 67/2, 1989, 566 sg.
Chýnov: Rosolová, I., *Záchranný archeologický výzkum časně laténského sídliště v Chýnově-Libčicích nad Vltavou, Zpravodaj SVK* VI, 1974, 152-158.
Sankot, P., *Revizní výzkum mohylového pohřebiště v Chýnovském háji v roce 1978, Středočeské muzejnictví*, 1979/5, 4-10.
Sankot, P., Vojtěchovská, I., *Excavations of an Early-La Tène Settlement with a Hoard of Iron Implements at Chýnov near Prague, Archæology in Bohemia 1981-85*, Prague, 1986, 119-124.
Duchcov: Kruta, V., *Le trésor de Duchcov dans les collections tchécoslovaques*, Ústi nad Labem, 1971.

Staré Hradisko: Meduna, J., *Staré Hradisko I. Katalog nálezů uloených v muzeu města Boskovic*, Brno 1960.
Meduna, J., *Staré Hradisko II. Katalog der Funde aus den Museen in Brno (Brünn), Praha (Prag), Olomouc, Plumlov und Prostějov*, Brno, 1970.
Meduna, J., *Das keltische Oppidum Staré Hradisko in Mähren, Germania* 48, 1970, 34-59.
Čizmář, M., *Erforschung des keltischen Oppidums Staré Hradisko in den Jahren 1983-1988, Archäologisches Korrespondenzblatt* 19, 1989, 265-268.
Stradonice: Drda, P., Rybová, A., *Hradiště de Stradonice-Nouvelles, notions sur l'oppidum celtique, Památky Archeologické*
Drda, P., Rybova, A., *Hradiště de Stradonice-Nouvelles, Notions sur l'oppidum celtique, Památky Archeologicke* 80, 1989, 384 sg. 80, 1989, 384 sg.
Třísov: Břeň, J., *Třísov, A Celtic Oppidum in South Bohemia*, Prague, 1966.
Závist: Jansová, L., *Zur Münzprägung auf dem Oppidum Závist, Památky archeologické* 65, 1974, 1-33.
Jansová, L., *Two Fragments of Stone Sculptures from Závist, Památky archeologické* 74, 1983, 350-365.
Jansová, L., *Závist und Hrazany an der Schwelle der Latènezeit, Studie Archeologického ústavu ČSAV v Brně* XI-1, Prague, 1983.
Motyková, K., Drda, P., Rybová, A., *The Position of Závist in the Early La Tène Period in Bohemia, Památky archeologické* 68, 1977, 255-316.
Motyková, K., Drda, P., Rybová, A., *Metal, Glass and Amber Objects from the Acropolis of Závist, Památky archeologické* 69, 1978, 259-343.
Motyková, K., Drda, P., Rybová, A., *Závist, ein keltischer Burgwall in Mittelböhmen*, Prague, 1978.
Motyková, K., Drda, P., Rybová, A., *Fortification of the Late Hallstatt and Early La Tène Stronghold of Závist, Památky archeologické* 75, 1984, 331-444.
Motyková, K., Drda, P., Rybová, A., *Die bauliche Gestalt der Akropolis auf dem Burgwall Závist in der Späthallstatt- und Früh-latènezeit, Germania* 66, 1988, 391-436.
Motyková, K., Drda, P., Rybová, A., *Oppidum Závist. Der Raum des Tors A in der vorgeschobenen Abschnittsbefestigung, Památky archeologické* 81, 1990.

Poland

Woźniak, Z., *Osadnictwo celtyckle w Polsce*, Wroclaw, Warsaw, Krakow, 1970.

Carpathian Basin

Benadík, B., *Obraz doby laténskej na Slovensku, Slovenská archeológia* 19, 1971, 465 sg.
Vízdal, J., *Záchranný výskum keltského pohrebiska v Ižkovciach, Slovenská archeológia* 24, 1976, 151-190.

Romsauer, P., *The Hallstatt Period, Archaeological Research in Slovakia. Xth International Congress of U.I.S.P.P. - Mexico 1981*, Nitra, 1981, 85-96 - Jerem, E., *Südliche Beziehungen einiger hallstattzeitlichen Fundtypen Transdanubiens, Materijali* (Novi Sad) 19, 1981, 201-220.

Jerem, E., *Zur Späthallstatt- und Frühlatènezeit in Transdanubien, Die Hallstattkultur; Symposium Steyr 1980*, Linz, 1981, 106-136.

Jerem, E., Kaus, K., Szönyi, E., *Kelten und Römer um den Neusiedlersee*, Catalogue, Györ, 1981.

Bujna, J., *Spiegelung der Sozialstruktur auf latènezeitlichen Gräberfeldern im Karpatenbecken, Památky archeologické* 73, 1982, 312-431.

Kruta, V., Szabó, M., *Canthares danubiens du IIIᵉ siècle av. n.è. Un exemple d'influence hellénistique sur les Celtes orientaux, Etudes celtiques* XIX, 1982, 51-67.

Jerem, E., *An Early Celtic Pottery Workshop in North Western Hungary: some Archæological and Technological Evidence, Oxford Journal of Arch.* 3, 1984, 57-80.

Jerem, E., Facsar, G., Kordos, L., Krolopp, E., Vörös, I., *The Archæological and Environmental Investigation of the Iron Age Settlement Discovered at Sopron-Krautacker, I-II, Arch.ért.* 111, 1984, 141-169, 112, 1985, 3-24.

Furmánek, V., Sankot, P., *Nové nálezy na stredním Slovensku, Slovenská archeológia* 33, 1985, 273-305.

Furmánek, V., Sankot, P., *Nové nálezy na stredním Slovensku, Slovenská archeológia* 33, 1985, 273-305.

Jerem, E., *Bemerkungen zur Siedlungsgeschichte der Späthallstatt- und Frühlatènezeit im Ostalpenraum (Veränderungen in der Siedlungsstruktur: Archäologische und Paleoökonomische Aspekte), Hallstatt Kolloquium Veszprém, MittArchinst Beiheft 3*, Budapest, 1986, 107-118, 363-365.

Jerem, E., *Bemerkungen zur Siedlungsgeschichte der Späthallstatt- und Frühlatènezeit im Ostalpenraum, Hallstatt-Kolloquium Veszprém 1984*, Budapest, 1986, 107-118.

Kovács, T., Petres, E., Szabó, M., *Corpus of Celtic Finds in Hungary, I. Transdanubia 1*, Budapest, 1987.

Szabó, M., *Les Celtes en Pannonie. Contribution à l'histoire de la civilisation celtique dans la cuvette des Karpates*, Paris, 1988.

Bujna, J., *Das latènezeitliche Gräberfeld bei Dubník I, Slovenská archeológia* 37, 1989, 245-354.

Bratislava: Zachar, L., *Príspevok k problematike bratislavského oppida, Zborník Slovenského národného múzea* LXXVI - História 22, 1982, 31-49.

Zachar, L., Rexa, D., *Beitrag zur Problematik der spätlatènezeitlichen Siedlungshorizonte innerhalb des Bratislavaer Oppidums, Zborník Slovenského národného múzea* LXXXI - História 28, 1988, 27-72.

Yugoslavia

Various, *Kelti v Sloveniji, Archeoloski vestnik* 17, 1966, 145-426.

Todorović, J., *Kelti u jugoistočnoj Evropi*, Belgrade, 1968.

Majnarić-Pandžić, N., *Keltsko-latenska kultura u Slavoniji i Srijemu*, Vinkovci, 1970.

Todorović, J., *Scordisci. Istorija i kultura*, Novi Sad, Belgrade, 1974.

Petru, P., *Die ostalpinen Taurisker un Latobiker: Aufstieg und Niedergang der römischen Welt*, II, 6, Berlin, New York, 1977, 473-499.

Keltoi. Kelti in njihovi sodobniki na ozemlju Jugoslavije, exhibition catalogue, Ljubljana, 1983.

Jovanović, B., *Les chaînes de ceinture chez les Scordisques, Etudes celtiques*, XX-1, 1983, 43-57.

Guštin, M., *Die Kelten in Jugoslawien, Jahrbuch RGZM* 31, 1984, 305-363.

Božič, D., *Keltska kultura u Jugoslaviji: zapadna grupa, Praistorija jugoslavenskih zemalja, 5: Željezno doba*, Sarajevo, 1987, 855-897.

Jovanović, B & M., *Gomolava*, Novi Sad, Belgrade, 1988.

Horvat, J., *Nauportus*, Ljubljana, 1990.

Pécibne: Jovanović, B., *Les sépultures de la nécropole celtique de Pécine près de Kostolac (Serbie du nord), Etudes celtiques* XXI, 1984, 63-93.

Romania

Zirra, V., *Beiträge zur Kenntnis der keltischen Latène in Rumänien, Dacia*, 15, 1971 sg.

Ciumeşti: Rusu, M., *Das keltische Fürstengrab von Ciumesti in Rumänien, Germania* 50, Berlin, 1969.

Piscolt: Németi, I., *Necropola Latène de la Piscolt, Kr. Satu Mare, Thraco-Dacica* IX, 1988, 49 sg.

Greece and Bulgaria

Jacobsthal, P., *Kelten in Thrakien, Epitymbion C. Tsounta*, Athènes, 1940, 91 sg.

Maier, F., *Keltische Altertümer in Griechenland, Germania* 51, 1973, 459 sg.

Danov, C.M., *The Celtic Invasion and Rule in Thrace in the Light of Some New Evidence, Studia Celtica* 10-11, 1975-76, 29 sg.

Domaradzki, M., *Présence des Celtes en Thrace au IIIᵉ siècle av. n.è., Thracia antiqua*, Sofia, 1976, 25 sg.

Woźniak, Z., *Die östliche Randzone der Latènekultur, Germania* 54, 1976, 382 sg.

Galatia

Stähelin, F., *Geschichte der kleinasiatischen Galater*, 1907.

Schaaff, U., *Ein keltischer hohlbuckelring aus Kleinasien, Germania* 50, 1972, 94 sg.

Bittel, K., *Die Galater in Kleinasien archäologisch gesehen, Assimilation et résistance à la culture gréco-romaine dans le monde ancien*, Bucharest, Paris, 1976, 241 sg.

Nachtergael, G., *Les Galates en Grèce et les Sôtéria de Delphes*, Brussels, 1977.

Müller-Karpe, A., *Neue galatische Funde aus Anatolien, Istanbuler Mitteilungen* 38, 1988, 189 sg.

Great Britain

Hawkes, C.F.C., Dunning, G.C., *The Belgæ of Gaul and Britain, Archæological Journal* 87, 1930, 150-335.

Fox, C., *A Find of the Early Iron Age from Llyn Cerrig Bach, Anglesey*. Cardiff, 1946.

Stead, I.M., *A La Tène III Burial at Welwyn Garden City, Archæologia* 101, 1967, 1-62.

Cunliffe, B., *Iron Age Communities in Britain*, London, 1974.

Harding, D.W., *The Iron Age in Lowland Britain*, London, 1974.

Hogg, A.H.A., *Hillforts of Britain*, London, 1975.

Harding, D.W., *Hillforts. Later Prehistoric Earthworks in Britain and Ireland*, London, 1976.

Forde-Johnston, J., *Hillforts of the Iron Age in England and Wales*, Liverpool, 1976.

Megaw, J.V.S., Simpson, D.D.A., *Introduction to British Prehistory*, Leicester, 1979.

Stead, I.M., *The Arras Culture*, York, 1979.

Guilbert, G., *Hill-fort Studies*, Leicester, 1981.

Muckelroy, K., *Middle Age Trade between Britain and Europe: a Maritime Perspective, Proc. Prehist. Soc.* 47, 1981, 275-298.

Macready, S., Thompson, F.H., *Cross-Channel Trade between Gaul and Britain in the Pre-Roman Iron Age*, London, 1984.

Haselgrove, C., *Romanization before the Conquest: Gaulish Precedents and British Consequences. In Blagg, T.F.C. and King, A.C., Military and Civilian in Roman Britain*, BAR 136, Oxford, 1984, 5-64.

Stead, I.M., *Celtic Dragons from the River Thames, The Antiquaries Journal* LXIV, 1984, 269 sg.

Dent, J.S., *Three Cart Burials from Wetwang, Yorkshire, Antiquity* 59, 1985, 85-92.

Stead, I.M., *The Battersea Shield*, London, 1985.

Foster, J., *The Lexden Tumulus, British Archæological Reports* 156, 1986.

Stead, I.M., Bourke, J.B., Brothwell, D., *Lindow Man, The Body in the Bog*, London, 1986.

Stead, I.M., Rigby, V., *Verulamium, the King Harry Lane site, English Heritage, Archæological Report* 12, 1989.

Danebury: Cunliffe, B., *Danebury, Anatomy of an Iron Age Hillfort*, London, 1986.

Gussage All Saints: Wainwright, G.J., Spratling, M., *The Iron Age Settlement of Gussage All Saints, Antiquity* 47, 1973, 109 sg.

Wainwright, G.J., *Excavations at Gussage All Saints, HSMO Archæological Report* 10, 1979.

Foster, J., *The Iron Age Moulds from Gussage All Saints, British Museum, Occasional Paper*, 12, 1980.

Maiden Castle: Wheeler, R.E.M., *Maiden Castle, Dorset*, London, 1943.

Sharples, N.M., *Maiden Castle Project 1985: An Interim Report, Proc. Dorset Nat. Hist. Archæol. Soc.* 108, 1987.

Ireland

Jope, M., *A Bronze Butt or Ferrule from the River Bann. City of Belfast Museum and Art Gallery Bulletin* 1, 1951.

Raftery, J., *A Hoard of the Early Iron Age*, Journ. Soc. of Antiq. of Ireland 90, 1960, 2-5.

Henry, Fr., *Irish Art in the Early Christian Period to A.D. 800*, 1965.

Harbison, E., *The Date of the Moylough Belt-Shrine. Irish Antiquity. Essays and Studies presented to Professor O'Kelly*, 1981.

Raftery, B., *A Catalogue of Irish Iron Age Antiquities*, Marburg, 1983.

Raftery, B., *La Tène in Ireland: Problems of Origin and Chronology*, Marburg, 1984.

Raftery, B., *The Loughnashade Horns*, Emania 2, 1987, 21-24.

Warner, R.B., Mallory, J.P., Baillie, M.G.L., *Irish Early Iron Age Sites; a Provisional Map of Absolute Dated Sites*, Emania 7, 1990, 46-50.

Raftery, B., *Trackways Though Time*, Dublin, 1990.

Dún Ailinne: Wailes, B., *Dún Ailinne: a Summary Excavation Report*, Emania 7, 1990, 10-21.

Crabtree, P., *Subsistence and Ritual: the Faunal Remains from Dún Ailinne, Co Kildare, Ireland*, Emania 7, 1990, 22-25.

Grabowski, K., *The Historical Overview of Dún Ailinne*, Emania 7, 1990, 32-36.

Dún Aonghus: Westropp, T.J., *The Fort of Dun Aengusa in Inishmore, Aran*, Proc. Roy. Irish Acad. 28C, 1910, 1-46.

Navan Fort: Waterman, D.M., Selkirk, A., *Navan Fort*, Current Archæology 22, 1970.

Mallory, J.P., *The Literary Topography of Emain Macha*, Emania 2, 1987, 12-18.

Baillie, M.G.L., *Dating of the Timbers from Navan Fort and the Dorsey, Co Armagh*, Emania 4, 1988, 37-40.

Lynn, C.J., *Navan Fort: a Draft Summary of D.M. Waterman's Excavations*, Emania 1, 1986, 11-9.

Warner, R.B., *Preliminary Schedules of Sites and Stray Finds in the Navan Complex*, Emania 1, 1986, 5-9.

Tara: Macalister, R.A.S., *Tara: A Pagan Sanctuary of Ancient Ireland*, London, 1931.

O'Ríordáin, S.P., *Tara, The Monument on the Hill*, Dundalk, 1971.

Swan, D.L., *The Hill of Tara, County Meath: The Evidence of Aerial Photography*, Soc. Antiq. Ireland 108, 1978, 51-66.

Christian Celts

Stokes, M., *Six Months in the Apennines in Search of Vestiges of the Irish Saints in Italy*, London, 1892.

Stokes, M., *Three Months in the Forests of France: a Pilgrimage in Search of Vestiges of Irish Saints*, London, 1895.

Gougaud, Dom L., *Les chrétientés celtiques*, Paris, 1911.

Gougaud, Dom L., *Gaelic Pioneers of Christianity. The Work and Influence of Irish Monks and Saints in Continental Europe (VI-XIIth Cent.)*, London, 1923.

Clark, J.M., *The Monastery of St Gall as a Centre of Litterature and Learning*, Cambridge, 1926.

Waddell, H., *The Wandering Scholars*, London, 1927.

Kenney, F., *The Sources for the Early History of Ireland 1: Ecclesiastical*, New York, 1929.

Tommasini, A., *Santi irlandesi in Italia*, Milan, 1932.

Kendrick, T.D., *British Hanging Bowls, Antiquity*, 1932.

Gougaud, Dom L., *Les Saints irlandais hors d'Irlande*, Oxford, 1936.

Henry, F., *Hanging Bowls, Journ. Soc. of Antiqu. of Ireland* 66, 1936, 209-246.

O'Riordain, S.P., *The Excavation of a Large Earthen Ring-Fort at Garranes, Co. Cork. Proc. of the Royal Irish Acad.* 47, 1941.

O'Neill, Hencken, H., *Ballinderry Crannog, No. 2. Proc. of the Royal Irish Acad.* 47, 1942.

Hencken, H., *Lagore Crannog: An Irish Royal Residence of the 7th to 10th Centuries A.D.*, Proc. of the Royal Irish Acad. 53, 1950.

Walker, G.S.M., *Sancti Columbani opera, Scriptores Latini Hiberniæ*, 2 Dublin, 1957.

Bruce-Mitford, R., *Decoration and Miniatures, Evangeliorum quattuor codex lindisfarnensis II*, Olten and Lausanne, 1960, 109-258.

Anderson, A.O. e M.O., *Adomnan's Life of Columba*, Edinburgh, 1961.

Bieler, L., *Ireland, harbinger of the Middle Ages*, London, 1963.

Henry, F., *Irish High Crosses*, Dublin, 1964.

Hednry F., *Irish Art in the Early Christian Period to A.D. 800*, London, 1965.

Henry, F., *Irish art During the Viking Invasions 800-1020 A.D.*, London, 1967.

Organ, R.M., *Examination of the Ardagh Chalice - A Case History. Explication of Sciece in Examination of Works of Art. Proc. of the Seminar Boston*, 1970, 15-19.

Alcock, L., *Arthur's Britain*, London, 1971.

Thomas, A.C., *The Early Christian Archaeology of north Britain*, Oxford, 1971.

Angenendt, A., *Monachi peregrini*, Munich, 1972.

Longley, D., *Hanging Bowls, Pennannular Brooches and the Anglo-Saxon Connexion*, B.A.R. 22, 1975.

Alexander, J., *Insular Illuminated Manuscripts 6th. to the 9th. Century*, London, 1978.

Doherty, C., *Exchange and Trade in Early Medieval Ireland, Journ. Royal soc. Antiq. Ireland* 110, 1980, 67-89.

Kilbride-Jones, E., *Zoomorphic Pennannular Brooches. Reports of the Research Commitee of the Soc. of Ant. of London* 39, 1980.

Clarke, H., Brennan, M., *Colombanus and Merovingian Monasticism*, BAR int. 113, Oxford, 1981.

Löwe, H., *Die Iren und Europa im früheren Mittelalter*, Stuttgart, 1982.

Craig, M., *The Architecture of Ireland from the Earliest Times to 1880*, London and Dublin, 1982.

Bruce-Mitford, R., *The Sutton Hoo Ship-Burial*, 3, 1983.

Thesaurus Hiberniæ. Irish Kunst aud drei Jahrtausenden, 1983.

Ryan, M. (ed.), *Treasures of Ireland: Irish Art 3000 B.C. to 1500 A.D.*, Dublin, 1983.

Ryan, M., *The Derrynaflan Hoard. I. A preliminary Account*, 1983.

Jackson, A., *The Symbol Stones of Scotland*, Kirkwall, Orkney, 1984.

Doherty, C., *The Monastic Town in Early Maedieval Ireland, The Comparative History of Urban Origin in Non-roman Europe*, Oxford, 1985, 44-75.

Ryan, M., *Early Irish Communion Vessels: Church Treasures of the Golden Age*, Dublin, 1985.

Blindheim, M., *A House-shaped Irish-scots Reliquary in Bologna and Its Place among the other Reliquaries, Acta Archæologica* 55, 1986, 1-53.

Charles-Edwards, T., Owen, M., Walters, D., *Lawyers and Laymen*, Cardiff, 1986.

Alcock, L., *Pictish Studies: Present and Future, The Picts a New Look at Old Problems*, Dundee, 1987, 80-92.

Anderson, M., *Picts - the Name and the People, The Picts a New Look at Old Problems*, Dundee, 1987, 7-14.

Bruce-Mitford, R., *Ireland and the Hanging Bowls-a Review, Ireland and Insular Art AD 500-1200*, Dublin, 1987, 30-39.

De Paor, L., *The High Crosses of Tech Theille (Tihilly), Kinnitty and Related Sculpture, Figures from the Past: Studies on Figurative Art in Christian Ireland*, Dublin, 1987, 131-158.

Alcock, L., *Economy Society and Warfare among the Britons and Saxons*, Cardiff, 1987.

Graham-Campbell, J., *From Scandinavia to the Irish Sea: Viking Art Reviewed, Ireland and Insular Art AD 500-1200*, Dublin, 1987, 144-152.

Alcock, L., *The Activities of Potentates in Celtic Britain, AD 500-800: a Positvist Approach, Power and Politics in Early Medieval Britain and Ireland*, Edinburgh, 1988.

Prinz, F., *Frühes Mönchtum im Frankenreich*, Darmstadt, 1988.

Herbert, M., *Iona, Kells and Derry*, Oxford, 1988.

Fulford, M.G., *Byzantium and Britain: a. Mediterranean Perspective on Post-roman Meditteranean Imports in Western Britain and Ireland, Medieval Archæol.* 33, 1989, 1-6.

Ritchie, A., *Picts*, Edinburgh, 1989.

Youngs, S. (ed.), *The Work of Angels: Masterpieces of Celtic Metalwork, 6th to 9th Centuries*, London, 1989.

Index

Countries are listed according
to the following abbreviations

A	=	Austria
B	=	Belgium
BG	=	Bulgaria
CH	=	Switzerland
CS	=	Czechoslovakia
D	=	Germany
DK	=	Denmark
E	=	Spain
F	=	France
GR	=	Greece
H	=	Hungary
I	=	Italy
IRL	=	Ireland
N.IRL	=	Northern Ireland
L	=	Luxembourg
N	=	Norway
NL	=	The Netherlands
P	=	Portugal
PL	=	Poland
R	=	Rumania
S	=	Sweden
SU	=	USSR
TR	=	Turkey
UK	=	United Kingdom
YU	=	Yugoslavia

Iconographical Credits

Cover photographs: Mario Carrieri

Aerofilms
p. 585, 596, 628

Piero Baguzzi
p. 37, 58, 63, 67-69, 94, 97, 116-119, 121-122, 128, 138-139, 147-154, 176, 196, 198 (bottom), 199-203, 206-208, 210, 212, 234-235, 240-241, 244-250, 286, 305, 307 (bottom), 320, 322, 330, 332, 349-351, 352-356, 361-365, 381-383, 388-407, 412, 414 (bottom), 419, 420, 423, 436 (bottom), 442, 448, 450, 451, 486, 491, 492, 497, 501 (top), 503, 505 (bottom), 508-511, 638

Alberto Bertoldi
p. 28, 32, 130, 132-133 (bottom), 137, 141-142, 146, 165, 167, 168, 171-173, 180-187, 189-191, 205, 211, 222-223, 270-276, 279-280, 295, 297-299, 318, 373, 376-377, 418, 424, 432-433, 436, 440-441, 444, 447 (top), 458, 461-463, 475 (top), 476 (bottom), 489, 504 (top), 541-547, 550-551

Lothar Beckel
p. 42, 45 (top), 92, 131, 163, 166

Werner Forman
p. 31, 236-237, 506, 554-558, 560, 562, 565-566, 569, 570 (bottom, left), 572, 577-578, 592-593, 600, 602, 608, 616, 641, 645-656

Ingrid Geske
p. 200, 267, 319

Klaus Göken
p. 135-136

Photo Josse
p. 66 (top)

Erich Lessing
p. 26, 74-75, 77, 79-81, 84-88, 104, 115, 126, 164, 166, 178, 194, 213, 214, 217, 242, 263, 294 (bottom), 368, 377, 410, 430, 436 (bottom), 437-439, 466, 468, 498, 499, 501 (bottom), 502, 504 (bottom), 544 (bottom, left), 568, 594, 651, 646, 676

Mario Matteucci
p. 33, 34, 96, 99, 144, 177, 198 (top), 208, 220, 226-229, 232, 233, 251-259, 282-285, 306, 307, 309, 311-316, 318 (right), 323, 326, 337-340, 342-346, 354, 356, 369, 373, 379, 380, 413, 416 (bottom), 417 (bottom), 431, 443, 445, 446 (bottom, left), 447 (bottom), 460, 469-475, 476 (top), 477, 484, 524-529

Petr Paul
p. 133 (top), 277-279, 281, 310, 329, 423-427 (top), 494, 505 (top), 548, 549

Foto Pedicini
p. 66 (bottom)

Réunion des Musées Nationaux
p. 197, 199 (bottom), 238 (bottom), 304, 348, 422, 488, 502

Maps: Studio Aguilar

Robert Vance
p. 559, 612, 620

Giorgio Vasari
p. 64 (top), 65, 70, 290, 291, 467

and

Michael Harity, University of Dublin
Irish Tourist Board